AFRICA

The Art of a Continent

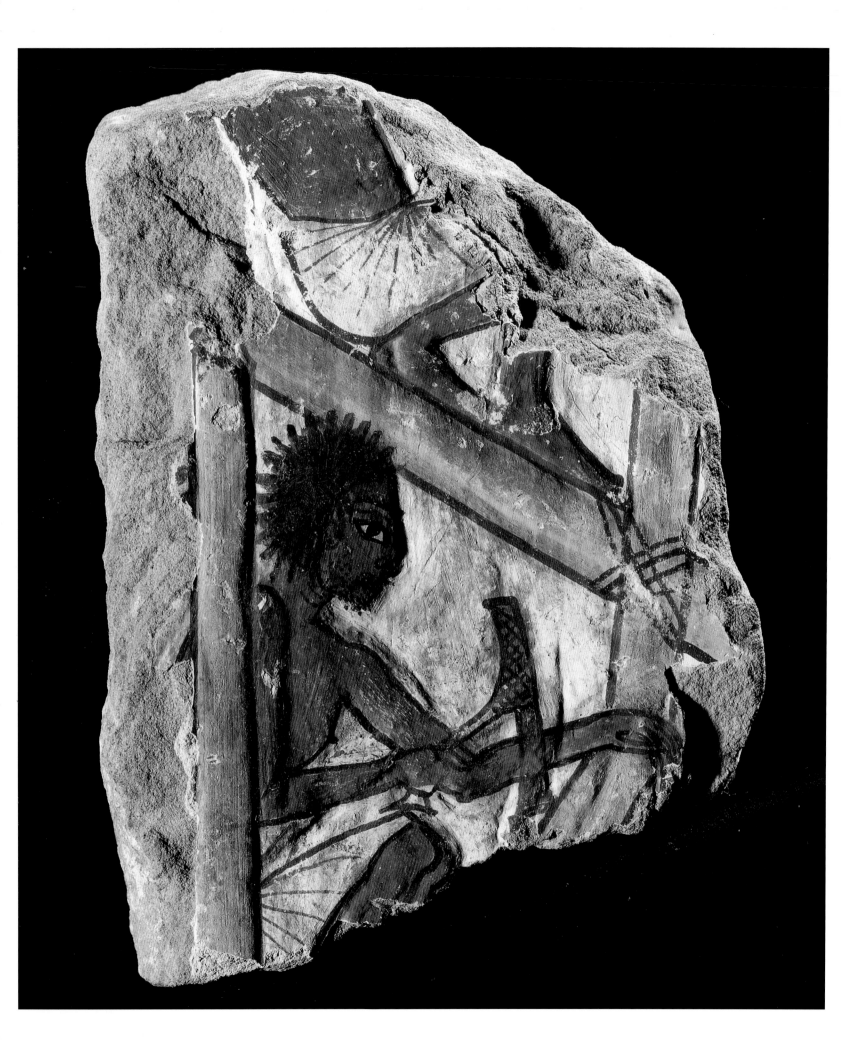

AFRICA

The Art of a Continent

Edited by
Tom Phillips

Prestel
Munich · London · New York

First published on the occasion of the
exhibition *Africa: The Art of a Continent*,
Royal Academy of Arts, London,
4 October 1995–21 January 1996

Front cover: **Figure of a woman**,
Benin, Nigeria, 17th–18th century
(detail, cat. 5.60h)
Back cover: **Lyre** (*kissar*), Nubia, Sudan,
late 19th century (cat. 2.13)
Frontispiece: **Tomb relief**, Egypt,
c. 1200 BC (cat.1.59)

© Prestel Verlag, Munich · London ·
New York, and Royal Academy of Arts,
London, 1999

Library of Congress Cataloging-
in-Publication Data is available

Prestel books are available worldwide.
Please contact your nearest bookseller or
write to one of the following Prestel
offices for information concerning your
local distributor:

Mandlstraße 26,
D-80802 Munich, Germany
Tel.: (89)38170990; Fax: (89) 38170935

16 West 22nd Street,
New York, N.Y. 10010
Tel.: (212) 627-8199; Fax: (212) 627-9866

4 Bloomsbury Place
London WC1A 26A
Tel.: (0171) 3235004; Fax: (0171) 6368004

Catalogue design by Petra Lüer
in association with Hansjörg Mayer
and Tom Phillips

Maps by ML Design
Offset lithography by ReproLine, Munich
Printed and bound by
Passavia Druckservive GmbH, Passau
Printed in Germany on acid-free paper

ISBN 3-7913-2004-1

CONTENTS

Patrons of **africa95**

Her Majesty The Queen
President Nelson Mandela
President Léopold Sédar Senghor

Honorary Advisory Committee for Africa:
The Art of a Continent
Dr John Mack
Dr Rowland Abiodun
Dr Codjovi Joseph Adande
Dr Claude Daniel Ardouin
Sir David Attenborough
Ms Viviana Baeke
Mr Omar Bwana
Mr Vivian Davies
Dr Ekpo Eyo
Etienne Féau
Dr Yaro T. Gella
Mr Lorenz Homberger
Mr Frank Herreman
Dr Hans-Joachim Koloss
Dr Germain Loumpet
Mme Francine N'Diaye
Dr John Picton
M. Jean Polet
Dr Doran H. Ross
Dr Christopher Roy
Dr Mohammed Saleh
Dr John Wembah-Rashid

Executive Committee
Piers Rodgers, Secretary,
Royal Academy of Arts (chairman)
David Barker,
Director of Finance and Administration,
Royal Academy of Arts
Annette Bradshaw,
Deputy Exhibitions Secretary,
Royal Academy of Arts (secretary)
Diana Brocklebank, Sponsorship Manager,
Royal Academy of Arts
Lisa Brown, *The Times*
Trevor Clark, Bursar,
Royal Academy of Arts
Carina Corbett,
Public Affairs Manager, Minorco
Katharine Jones, Press and Promotions
Officer, Royal Academy of Arts
Emeline Max, Exhibition Coordinator,
Royal Academy of Arts
Rory More O'Ferrall, Manager,
Special Events, De Beers
James Robinson, Assistant to the Secretary,
Royal Academy of Arts
Norman Rosenthal, Exhibitions Secretary,
Royal Academy of Arts
Sarah Seex, Sponsorship Executive,
British Airways
Fleur de Villiers, Public Affairs Consultant
to Anglo American Corporation of South
Africa and of De Beers

Exhibition Curator
Tom Phillips
Exhibitions Secretary
Norman Rosenthal
Assistant Exhibition Curator
Simonetta Fraquelli
Exhibition Coordinator
Emeline Max

Exhibition Designers
Eva Jiricna Architects:
Eva Jiricna with Carolina Aivars

Catalogue
Editorial Committee
Petrine Archer Straw
Vivian Davies
Patricia Davison
Simonetta Fraquelli
John Mack (*chairman*)
Jane Martineau
Tom Phillips
John Picton
Norman Rosenthal
Rachel Ward

Catalogue Editor
Tom Phillips
Coordinating Editor
Petrine Archer Straw
Catalogue Supervisors
Jane Martineau, Michael Foster
Assistants
Vivienne Redhead,
Zachary Kingdon
Text Editors
Ruth Thackeray, Kate Harney
Proof Reader
Antony Wood
Photographic Editor
Simonetta Fraquelli
Photographic Coordinator
Miranda Bennion
Translations from the French by
Caroline Beamish

Acknowledgements
We would like to extend our thanks to the
advisors, lenders, directors and curators,
and to the following people who have
contributed to the organisation of the
exhibition and the preparation of the
catalogue in many different ways:

Sir David Attenborough, Georg Baselitz,
Ezio Bassani, Lance Entwistle, Roberta
Entwistle, Bernard de Grunne, Etienne
Féau, Frank Herreman, Lorenz
Homberger, Julie Hudson, Jacques
Kerchache, Hans-Joachim Koloss, Hélène
and Philippe Leloup, Hansjörg Mayer,
Francine N'Diaye, Heini Schneebeli,
Sylvia Schoske, Louis de Strycker, Marie-
France Vivier, Dietrich Wildung

We are also grateful to the following
for their help:
Noelle Adams, Peter Adler, Dr Johanna
Agthe, Chief M. A. Ajao, Tola Ajao,
Dorothea Arnold, Ray Ayres, Dirk Bakker,
Glyn Balkwill, Walter Bareiss, Peter
Barker, Nigel Barley, Rayda Becker, Simi
Bedford, A.V. M. Abdul Bello, Sylvia Bello,
Prof. Feliciano Benvenuti, Olivier
Berggruen, Morris Bierbrier, Dr Adotey
Bing, Tim Boon, Christopher Chippindale,
Dr Michael A. Cluver, Jeremy Coote,
Kevin Conru, Susan Davidson, Louise
Davies, Kent and Charles Davis, Sheila de
Vallée, Victoria Dickie, Roberto di
Giacomo, Sylvia Duggan, Stuart Emmens,
Marc Felix, Genevieve Fisher, Bert Flint,
Matthi Forrer, Rita Freed, Jane Freeman,
Annabel Teh Gallop, Hubert Goldet, Jim
Hamill, William Hart, John Hayman,
Josef Herman, Lindsay Hooper, Udo
Horstmann, Barry Iverson, Fred Jahn,
Tony Jackson, Michael Kan, Alan
Keohane, Helen O. Kerri, John Kinahan,
Ruth Klumpp, Wulf Kopke, Nessa
Leibhammer, Jacqueline Leopold, Prof. J.
David Lewis-Williams, Luc Limme,
Louise Lincoln, Rainer Lienemann,
Lawrence Lipkin, Robert Loder, Wulf
Lohse, Eve Lowen, Jonathan Lowen, Katie
Marsh, Marilyn Martin, Laurence Mattet,
Evan Maurer, Margaret McCord, Trevor
McDonald, Gwyn Miles, David Noden,
David O'Conner, Bernard O'Kane, Allyson
Rae, Ian Rogers, James Romano, Halina
Sand, Yaya Savane, Dr Karl-Ferdinand
Schaedler, Kevin Smith, Thyrza Smith,
Chris Spring, Robin Symes, Dominique
Taffin, Julie Taylor, Keith Taylor, Pat
Terry, Anne Teuwisson, Kate Todd, Eleni
Vassilika, Iris Walsh, Kirsten Walker,
Helen Whitehouse, Robert Williams,
Christiane Ziegler

Sir Philip Dowson CBE

President
Royal Academy of Arts

For many years it has been the dream of the Royal Academy to stage an exhibition devoted to the art of Africa. In 1982 the travelling exhibition *Treasures of Ancient Nigeria* was shown at the Academy. For many visitors it was a revelation, including as it did not only the justly famous bronzes from Benin, but also the far older terracottas and bronzes from Nok, Ife and other sites in Nigeria which had been recovered comparatively recently. It demonstrated the existence of artistically sophisticated cultures in the continent of Africa stretching back over millennia. The idea was born that we should attempt to make a bold, synoptic survey of the visual culture of Africa stretching back in time to the very beginnings of artistic endeavour and geographically over the entire continent. The attempt to show the art of the continent in a single exhibition has never been made before. Much still remains to be learned, and our principal aim is to encourage a spirit of enquiry.

Many individuals in Africa, Europe and the United States, as well as in Great Britain, have helped and encouraged us as we steered the project towards realisation. Tom Phillips, a Royal Academician, who for many years has been passionately involved in African art, has acted as the principal curator of the exhibition with assistance from Norman Rosenthal, Exhibitions Secretary. Advice and support have come from many quarters. In particular we wish to thank the scholars in Africa and elsewhere whose encouragement and counsel have supported us throughout the planning of the exhibition. In the early stages of planning, Susan Vogel, then director of the Museum of African Art in New York, gave us much help and encouraged us to take on the idea of representing the entire African continent, including the north as well as sub-Saharan Africa. The curatorial staff at the British Museum has been exceptionally supportive. Simonetta Fraquelli has relished the burden of coordinating the exhibition. Over 180 lenders, both private individuals and public institutions, thirty of the latter in Africa itself, have been exceptionally generous in allowing us to show works in their collections. In particular we wish to thank the major public collections in Berlin, Cairo, Cape Town, Lagos, London and Paris who have lent some of their most precious and fragile works. We are particularly happy that the exhibition will be seen at the Solomon R. Guggenheim Museum in New York from June 1996.

We wish to extend our thanks for the help of many individuals who, realising the importance of the exhibition, worked tirelessly to see it come to fruition. In particular we thank the High Commissioners for Nigeria and South Africa and the Ambassadors in London for Egypt, France, Morocco and Tunisia. We are also grateful to HM Ambassadors in Ethiopia and the Sudan as well as to the Hon. Kent Durr, Mr Howard Thompson, Director of the British Council in Egypt, and the museum authorities in Namibia.

For the generosity of our sponsors and supporters we are deeply grateful, in particular for the help of those companies from South Africa. We have worked closely with the organisers of the festival, Africa 95, an ambitious demonstration of the richness of African culture today which was launched to coincide with our exhibition, and which has succeeded in putting together a remarkable programme of new art, theatre, music, literature, dance and many other events from contemporary Africa. We are deeply honoured that Her Majesty The Queen, President Nelson Mandela and President Léopold Sédar Senghor have graciously agreed to act as patrons of Africa 95.

Finally, we hope to provoke a positive response from the British public, both from those who visit the Academy on a regular basis and from those doing so for the first time. The arts in Great Britain have been greatly enriched by the cultural contribution of those from Africa and the Caribbean; this exhibition seeks to celebrate the grandeur and diversity of the arts of the continent of Africa and their contribution to the art of the world.

PREFACE

Cornel West

This monumental exhibition is unprecedented in the history of the art world. Never before has there been gathered such a rich and vast array of African art-objects and artefacts from such a broad timespan. And rarely has any exhibition embraced the artistic treasures of the whole of Africa, from Egypt to Ife to Great Zimbabwe.

This historic public showing of beautiful and complex African gems takes place at an upbeat moment in African art criticism and a downbeat time of African political life. With fascinating new breakthroughs in archaeological and anthropological investigations into African empires and societies, we are able to appreciate better the complex diversity and incredible creativity of past and present African artists. Yet the pernicious legacy of European imperialism coupled with the myopic and corrupt leadership of many African élites has left much of the continent politically devastated and economically impoverished. Gone are the old intellectual frameworks predicated on crude white supremacy and subtle Eurocentrism. The once popular categories of 'barbarism', 'primitivism' and 'exoticism' have been cast by the academic wayside. The homogeneous definitions and monolithic formulations of 'African art' have been shattered. The Whiggish historiographical paradigms of cultural 'evolution' and political 'modernisation' have been discredited. Instead we are in search of new ways of keeping track of the fully fledged humanity of Africans by seriously examining their doings, makings and sufferings under circumstances not of their own choosing. By taking their humanity for granted, we are in danger of being neither apologists for European colonialism nor romantic celebrants of African achievements. Rather we take Africans seriously by taking African history seriously – an ambitious endeavour still in its embryonic stage in the West. This important exhibition is a crucial step in such a world-historical endeavour. To take African history seriously requires a careful and cautious scrutiny of the distinct and sometimes disparate contexts of particular African traditions, rituals, kinship networks, patronage relations and disciplines of craftsman-ship. This kind of historicist enquiry – with its stress on the complex interplay of the local with the regional, continental and global forces at work – enables us to highlight the specific ways in which African artists, critics, patrons and communities create, sustain and deploy art-objects.

An intellectually challenging and morally humane approach of this order – be it to metalwork, rock art, male masked performance, female pottery sculpture, body decoration or architecture – rests on a deep knowledge and sophisticated analysis of the particular histories of specific African peoples. Intellectual ferment in the art world in regard to African artworks may contribute to overcoming the invisible status of African life in late 20th-century international relations. The tragic plight and predicament of most present-day Africans remains forgotten on the world scene. And the old ugly stereotypes of African persons as exotic and transgressive objects – as hypersexual and criminal abstractions in the white imagination – are still pervasive in much of the post-modern West.

Art never simply reflects reality. Rather it forces us to engage our past and present so that we see the fragility and contingency of our prevailing views of reality. In this way, art can and does change the world. This unparalleled exhibition at the end of a barbaric century confirms the tenacious human will to survive and thrive – with artistic beauty and worldly engagement – in history, then and now.

MEDITERRANEAN SEA

MOROCCO

Rabat
Alger
Tunis
TUNISIA
Tripoli

ALGERIA

LIBYA

EGYPT

Cairo
Nile

RED SEA

MAURITANIA

S A H A R A

Nouakchott

MALI

NIGER

CHAD

Khartoum

SUDAN

ERITREA

Blue Nile

DJIBOUTI

Dakar
THE
GAMBIA
SENEGAL
Banjul
Bissau
GUINEA
BISSAU
Conakry
GUINEA

Bamako

BURKINA
FASO
Ouagadougou
Niamey
Niger

Ndjamena

White Nile

Adis Abeba

ETHIOPIA

Freetown
SIERRA
LEONE
Monrovia
LIBERIA

CÔTE
D'IVOIRE
Abidjan
GHANA
TOGO
BENIN
Accra
Lomé
Porto-Novo
Lagos

NIGERIA

CENTRAL
AFRICAN
REPUBLIC

Lake Turkana

SOMALIA

Mogadishu

Douala
CAMEROON

Uele

Ubangi

Zaire (Congo)

UGANDA

Kampala

KENYA

Nairobi

EQUATORIAL
GUINEA

Libreville

GABON

CONGO

ATLANTIC
OCEAN

Brazzaville

CABINDA

Kinshasa

Congo

ZAIRE

Kasai

Lualaba

RWANDA
Kigali
BURUNDI
Bujumbura

Lake
Victoria

*Lake
Tanganyika*

TANZANIA

Dar es Salaam

Luanda
Cuanza

Rufiji

ANGOLA

*Lake
Nyasa*

MALAWI

Ruvuma

Lilongwe

ZAMBIA

Lusaka

Zambezi

Zambezi

MOZAMBIQUE

MADAGASCAR

Cubango

Harare

ZIMBABWE

NAMIBIA

Windhoek

BOTSWANA

Limpopo

Gaborone

Pretoria
Mbabane
Maputo

*KALAHARI
DESERT*

Johannesburg
Vaal
SW

Orange

Maseru
LES

SOUTH
AFRICA

Cape Town

INDIAN
OCEAN

Ancient Egypt and Nubia

Eastern Africa

Southern Africa

Central Africa

Western Africa and the Guinea Coast

Sahel and Savanna

Northern Africa

0 600 miles

0 1000 km

INTRODUCTION

Tom Phillips

Vellinger took the fetish again from Rima's hand. 'You see,' he said, 'Wherever our art goes, whatever it decides to do it can look back into creative Africa and find corroboration, for the African past is always one step ahead of the European present.'

W. K. Collam, *Unhaunted Comma,* 1937

I

With a bold and sweeping gesture of words, President Nelson Mandela, who honours this project with his patronage, in his address to the Organisation of African Unity in 1994, set the agenda for the exhibition which this catalogue chronicles. In the first sentence of that speech he, who had spent so many unwilling years at the southernmost reach of the continent, pointed the long finger of African memory towards Carthage, its northernmost corner, the destruction of whose splendour by the colonising Romans began 'a long reign of humiliation for the continent' which is only now drawing to a close. In terms of space and time and largeness of imagination the Royal Academy's present exhibition tries to live in the grace of that idea of a new era for Africa and a new unity for the continent.

The time is at last ripe perhaps for such an assertion of Africa's artistic wealth to need no alibi, either political or ethnographic, nor require some sociological peg to hang it on, nor a link to some new-minted piety or rectitude. It may even dispense with titles which sell art short by means of loaded or lurid words (blood, power, thrones etc.). Best of all it might start not to require the service of European art to give it its credentials of definition, labels as misleading and anachronistic as 'cubist' or 'gothic'. As Henry Louis Gates, Jr. affirms in his essay, it no longer needs such mediation.

Under the plain wrapper of a simple title therefore, and in the Royal Academy's long tradition of enlightened foolhardiness, is presented a sampling of the art of the entire continent. There has been no previous attempt, either in terms of an exhibition or a book, to cover with relative even-handedness the visual culture of the land-mass as a whole: the endorsement of being associated in this enterprise with the Guggenheim Museum in New York gives pleasure and courage. Needless to say the selection falls into the traps of its own time: it can only be an interim statement whose best critique will be provided

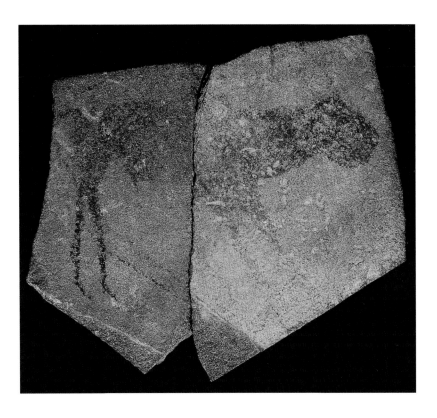

Fig. 1 Charcoal painting of animal-human figure, Namibia, 27,500–25,500 BP (cat. 3.3b)

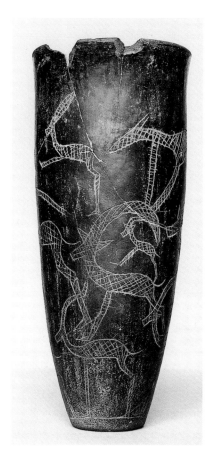

by subsequent surveys. It should, however, be regarded as a heartening sign that the many voices from Africa, Europe and America that sound in the essays and entries of this catalogue make no attempt to agree with each other except in their common and manifest willingness to take part in its forum.

The two major organising principles of the selection echo President Mandela's vision of geography and time. No area has been more sliced up and divided by conquest, campaign, annexation and subjugation than Africa, and none more arbitrarily. Later boundaries conceal and contradict its ancient kingdoms and territories. Even that great natural divide, the Sahara Desert, is a relatively recent interpolation: art itself (in the Tassili frescoes) documents its prior state as pastoral land. The exigencies of making a coherent exhibition demanded that it be split up yet again so that visitors would know at each point where they were in a journey that takes them clockwise around the continent beginning and ending in Egypt. For this purpose national frontiers have been ignored and Africa is segmented into seven broad areas using dispassionate lines of latitude and longitude.

Each of these areas in the catalogue has an editor who has provided or supervised the introductory material and corralled the necessary scholarship that annotates every work. Specialists may quibble (indeed *have* quibbled) at the precise delimitation of the areas. Yet no expert could be satisfied with any circumscription since the whole continent is a continuum of people, their movements, commerce and influence. Indeed doubts about division underline the unities of Africa which provide one of the themes of the exhibition.

There is an Africa beneath Africa, as yet only patchily understood since outside the Nile Valley archaeology is still in its infancy, and even there new versions of history are beginning to be worked out. At this moment archaeology is busy reversing our understanding of Ancient Nubia and its relationship with Egypt; ten years ago an exhibition such as this would have given Nubia less prominence and the catalogue would have presented a radically different account.

Fig. 2 Vase decorated with hunting scene, Egypt, predynastic, c. 3800–3600 BC (cat. 1.9)

Fig. 3 Tortoise-headed god, Egypt, 18th Dynasty, c. 1320 BC, from the tomb of Horemheb, Valley of the Kings, Thebes. The Trustees of the British Museum, London, E. A. 50704

II

The civilisations of the Nile (Section 1) begin this expository tour with an explosion of artistic invention in predynastic Egypt, one of the world's earliest laboratories of formal experiment, especially in the representation of the human figure. This is the Burgess Shale of art, a repertoire of figuration and abstraction that has scarcely been extended in modern times (fig. 2). Towards the end of this period there are works of great complexity whose emblematic content as well as artistic command still look freshly relevant. The five-thousand-year-old Battlefield Palette (cat 1.18), whose two substantial pieces are brought together for the first time, describes on one side that turmoil of a warring Africa we see on the news; the other shows an idyllic scene of nature at peace that is the received Africa of the travel brochure. Five hundred years later in the Mycerinus Triad (cat. 1.30), still the supreme three-dimensional statement of human confidence, the Egyptian artist announces that no feat of carving either technical or stylistic is beyond his powers.

Amid the gigantic proto-fascist statuary that dominates the great halls of museums the world over it is difficult to appreciate the more humanistic virtues of Egyptian art, some of it like the jewellery made for display and some, though still executed with artistic devotion, like the wooden tomb figures of Horemheb (fig. 3) and the wrappings of the mummified cats (cat. 1.69) never to be seen by human eye again. The tale of Egypt in its later Coptic and Islamic flowerings is taken up in Section 7. Ancient Nubia ends the first section, starting with its own less well known prehistory and ending with kingdoms whose names are slowly becoming more familiar to the non-specialist world, Meroë and Kush.

The journey southward is taken up in Section 2 with the neglected area of eastern Africa. In most general works on African art there is a map whose dots represent the distribution of pieces illustrated or mentioned in the text. Invariably the picture resembles a beehive situated in central west Africa obliterated by its swarm, whereas to the east and south the few stragglers suggest vast areas of visual inarticulacy, while none strays north at all. The reason for this lies in colonial history as can be seen if the traditional distribution map is overlaid with one showing the francophone ex-colonies and their immediate neighbours. The art literature of Africa has for most of this century been produced by connoisseurs, collectors and scholars from France and Belgium, the basis of whose connoisseurship has been the material gathered by their compatriots. German ethnographers also visited the peoples of Africa (while the English tended to concentrate on places). Perhaps it is fitting that an exhibition originating in Britain should belatedly start to redress that imbalance.

In fact from modern Sudan and the splendours of Christian Ethiopia in the north to the distant architectural complexes of Great Zimbabwe with which Section 3 begins, this region presents a series of cultures subject to more disparate influences than any other, including those artistic incursions from the East which flavour the culture of the coastal region and give a unique character to that of the island of Madagascar.

It is in east Africa also that we first meet the single most important unifying element in the wood-carving pattern of Africa south of the Sahara; the practice of making virtually all objects (from a spoon to a funerary post many feet high) from a single piece of wood. This monoxylous tradition leads, to take examples from this region, from the cunning adaptation of the chance form of a branch in a Dinka head-rest (cat. 2.17a) to the virtuosity of a Nyamwezi throne (fig. 4) and the multiply pierced architectural structure of a Mahafaly post (cat. 2.30). The monoxylous carver gives himself problems, but gains great potential advantages of artistic unity. He has a threefold power: the power over abstraction by what he removes, the power over figuration by what he causes to remain and the power over nature by the continued presence of the form of the original tree. In terms of figure sculpture there is also the rising growth present in the vertical grain of the wood: all are present in another more austere ceremonial

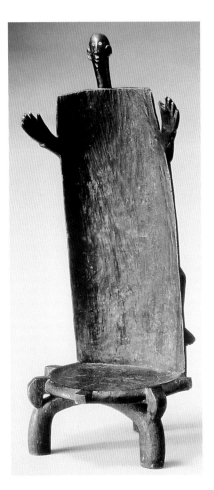

Fig. 4 High-backed chief's stool, Nyamwezi, Tanzania, late 19th century (cat. 2.49)

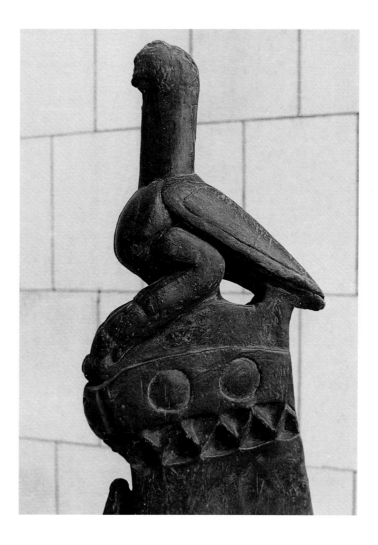

Fig. 5 Bird, found at Great Zimbabwe,
13th–15th century, steatite, National
Museums and Monuments of Zimbabwe

throne from the Nyamwezi (cat. 2.50). Perhaps the most extreme example, however, of the extra dimension of negative space (where what is taken away is as much part of the sculpture as what remains) is the remarkable Songye-Sungu stool (cat. 4.54); although the shape of the tree is vitally present in the final work, almost all of it has been removed to create an object of almost perverse fragility, whose wit and virtuosity was no doubt appreciated by a sophisticated client.

This region now commands our special respect, for it is only late in this century that archaeology, anthropology and genetic research have jointly confirmed that here, in the border area of Kenya and Tanzania, the whole adventure of humanity began.

Nearly every book on the art of Africa moves more or less in the contrary direction to that taken in this exhibition, coming to east Africa as an afterthought and representing southern Africa, the subject of Section 3, rather perfunctorily with a bowl and a spoon or two. One reason for this invisibility has been that its art seldom takes the form of those staples of the European image of African art, the figure and the mask. With the recent habilitation of South Africa this perspective has slowly begun to change and the exhibition aims to reinforce that trend by making southern Africa the pivot of its journey. Luckily, as can be seen, scholarship has been thriving even in dark years, as witness the outstanding work of David Lewis-Williams and his colleagues at the University of Witwatersrand who have largely unravelled the secrets of San rock art. This is the longest continuous artistic tradition in Africa whose beginnings can be noted in the world's earliest portative paintings from Namibia (cat. 3.3a and fig. 1), dated with some certainty to *c.* 25,000 BC.

The monumental architecture of Great Zimbabwe with its magnificent stone birds (cat. 3.12 and fig. 5) is not the only trace of an ancient civilisation in this area. The seven Lydenburg heads, the most

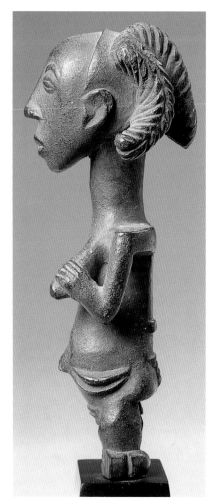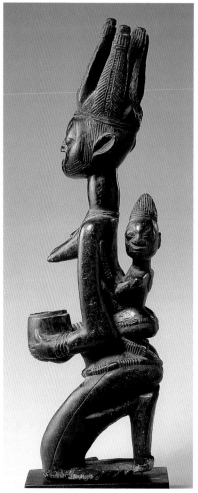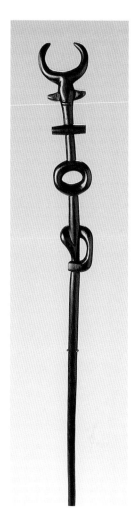

imposing of which (cat. 3.10) can stand comparison with the terracottas from Djenne (cat. 6.4), which they predate, indicate the existence of a highly developed pre-10th-century culture.

From the more recent past come the many variations on the theme of the headrest with its play of symmetry and asymmetry; the snuff bottles whose delicacy and elegance of design recall the art of Japan and the abstract triumphs of a Zulu staff or meat dish (cat. 3.27 and fig. 8, cat. 3.41b).

Section 4 is where the exhibition reunites itself with the customary expectations engendered by the words 'African art', i.e. those statues and masks from the Congo region which have already become canonical. To quote a canonical film (and one despite its title, *Casablanca*, with only the most tenuous African connections since every inch of it was shot in Hollywood), there is a great temptation in this and in the succeeding section merely to 'round up the usual suspects', those works that appear in virtually every book (invariably seen from the same viewpoint in a familiar photograph). To some extent this happens here: a masterpiece is after all a masterpiece, and since this is a non-specialist venue the large majority of its audience will be seeing such works for the first time. The compact strength of Chokwe figures, the solemn and otherworldly Hemba statues (fig. 6) and the densely magisterial Fang reliquary pieces are still touchstones of a sculptural quality equal to that of the great epochs of European art. Textiles and pottery extend the range together with sculpture less frequently fêted. Even those familiar with this material may well be surprised by the different aspects shown in the illustrations, almost all of which were specially commissioned for this catalogue (e.g. figs 4, 6, 7).

Section 5 contains the largest number of objects, since the southern part of what is broadly called the Guinea Coast is inhabited by so many stylistic groups (the word 'tribe', though noble sounding, has become for good post-colonial reasons inadmissible).

Putting their artistic heritage before the public gaze would not seem strange to the royal chiefs of Cameroon whose palace treasuries act as museums housing spectacular (often beaded) sculpture by court artists which is frequently brought out for display. Nigeria is particularly difficult to compress since it contains layer upon layer of cultures. The city of Benin, which perhaps in the general consciousness stands for the older African civilisations, occupies only the late middle period of Nigeria's history. Nevertheless, the great series of bronze plaques that once covered the palace walls represent, however formulaic some of them became, a prodigious achievement of technical ingenuity and organisation over centuries (fig. 9).

As one moves west via the panoply of the Asante one encounters an endless range of solutions for invoking (without merely copying) the human face. The visitor might expect to see a huge gathering of masks especially in this and the previous section: in many books they outnumber all other works as part of the mythology of modernism. While it is true that the African masquerading tradition is the richest in the world, the mask itself without dancer or movement or paraphernalia of costume is the most incomplete of objects and must be considered a fragment. Many, even thus denuded and stilled, yet transcend their fate in the collections of the world and some, like the 'Tetela' example (cat. 4.53), retain that arresting power that can almost stop one's heart in a firelight masquerade with drums and pounding feet.

One kind is, however, complete in itself: over twenty miniature masks from Dan-related groups (cat. 5.128) have the advantage in the space allowed of giving an idea of the range of expression and interpretation within a single format. Like the headrest, the mask is found in virtually all parts of Africa, and our earliest examples of either come from dynastic Egypt. The mask of Anubis (cat. 1.64) is a sole survivor of what perhaps was a thriving tradition; it seems to question the interpretation of images of Egyptian ritual.

Section 6 poses particular problems in that it covers an area not conventionally treated as a unit, including as it does the northern regions of Nigeria, Ghana etc. Where the true continuities and discontinuities lie between the various ancient cultures this area embraces and their more recent counterparts is still the subject of active debate. Systematic and scientific archaeology is scarce, while unofficial digging and treasure seeking is rife (as it has been on and off in Africa since the robbers of later dynasties rifled the tombs of the earlier). Aesthetics play no part in this except at the very end of the line where those whom John Picton describes in his essay with wily irony as 'art-hungry savages' wait to see, enjoy and own what turn out to be bronzes and terracottas of revelatory interest: thereby artistic experience is extended, but at the expense of scientific knowledge. The rest of the story is about money, however the moral absolutes are phrased in treaty and resolution.

What lends irony to the situation is that archaeologists are, in the strict sense, indifferent to aesthetic quality. All objects, be they marvellous or mawkish, are of equal value to their declared priority, the archaeological record, that scientific documentation of site and find from which pictures of a culture are built up. This is not incompatible with the needs of museums and collectors, especially at sites like those of Djenne where artefacts are found by the thousand. That African archaeology is underfunded compounds the irony since, given this present stance, it cannot benefit from the large sums available in the art market. Until some dialogue is entered into and some compromise is reached the status quo will continue. The general public will be denied even a glimpse of the treasures that exist since the collector, though invariably willing, cannot share by lending, nor can the institution show for fear of reprisal. In many cases the relevant state intervenes when the art market has given value to the objects in question. Archaeology in more senses than one has its head in the sand. It is the Academy's conviction that in the long term to show such works in this present context would not only enhance the artistic reputation of

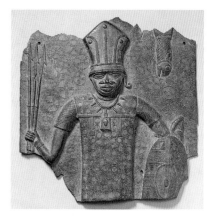

Fig. 9 Plaque, Benin, Nigeria,
16th century, brass
upper half: h. 38 cm, Staatliche Museen zu
Berlin, Preussischer Kulturbesitz, Museum
für Völkerkunde, III C. 10879
(ex catalogue)
lower half: h. 40 cm, Museum für
Völkerkunde, Hamburg, C. 2434
(ex catalogue)

countries like Mali and Nigeria, but provoke public interest in the furtherance of archaeological activity in Africa, even to the point of attracting enabling funds. Its equal commitment to present loyalties makes it, however, desist from breaking an unproductive stalemate.

The last of the sections concerns the region least often brought under the rubric of African art. This necessarily gives a broad picture of an Africa north of the Sahara which continues to have in some European museums a separate department, 'l'Afrique Blanche', as if the Mediterranean were the positive, attractive end of a magnet and the Sahara the repelling negative. Throughout there are at least two layers of culture; that preceding Islam or running independently and in tandem with it, like the nomadic groups and the Berbers of Morocco, and the largely Islamised world itself. Colonisation here has a long history; the Maghrib is full of well-preserved Roman ruins often with fine mosaics in a markedly individual style (cat. 7.10). Here also we meet the other end of Nelson Mandela's image in the ruins of Phoenician Carthage. Since, however, the exhibition is dedicated to art actually made in Africa and not imported by colonising groups from their place of origin (and guesswork must play some part) it was decided not to include some Roman works of great quality found in Africa, which are in effect the equivalent of those statues of Queen Victoria still to be seen in the capitals of the ex-colonial nations.

Although Moslem influence penetrates deep into sub-Saharan African, where, like Christianity, it can prove a mixed artistic blessing, the pure character of Islamic art reaches its African peak in that medieval Cairo whose Arabian Nights atmosphere is conjured up by Rachel Ward in her essay and whose genius is expressed in the massive 15th-century *minbar* (fig. 10), the final exhibit, which acts as an imposing and perhaps prescient ending to the exhibition.

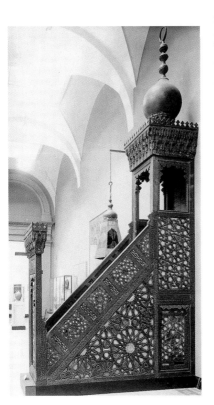

Fig. 10 Minbar *for the Sultan Qa'itbay, Egypt, Mamluk, late 15th century (cat. 7.67)*

III

As this last object could be seen to be emblematic of the imminent future so the very first exhibit (to return to the beginning in every sense) announces an important theme of the exhibition: the age of Africa and the unique length of its cultural history. The handaxe from Olduvai (cat. 2.1), over a million and a half years old, a first thing made by man, prefigures the whole world of making and shaping. No earlier artefact exists on earth, and all art and technology begins here (as all history begins with those miraculously recorded proto-human footsteps on Tanzanian soil; fig. 11). Since no aesthetic criteria apply to it, it stands as a prologue to the exhibition in general, accompanied by other stone axes the first of which, from South Africa and half its age (to speak of a time span where even tens of thousands of years would be a mere quibble), announces the entry of the artistic imperative (cat. 3.1). Almost ceremonial in size, this axe shows that in a world where tools are the only things made, their inherent qualities were sometimes brought to a visual and tactile perfection far beyond the needs of practicality. Symmetry and surface elegance speak of that pride in creation, pleasure in contemplation and prestige in possession that will eternally give art its motivation.

This prelude of shaped stones serves to introduce the aspect of time which is emphasised in all the sections. Each has its own chronology or chronologies as it moves from one culture to another. There is much common ground in man's early artistic aspirations that is overlaid by later developed cultural differences. Beneath the accretions of localised structures of belief and hierarchy there are universals; the desire for containers or the need to rest one's head. Similar solutions can arise independently, as in the case of the decorated ostrich eggs to contain liquids which occur both in predynastic Egypt and among the San far away in the south of the continent (cat. 1.11; 3.9). Coincidence can look like influence, but it needed no messenger hot foot from the Nile to tell a Bushman that an ostrich egg can be a ready-

made pot or that it could be individualised with engraved lines. Thus the presence of such rhymes in the exhibition is usually not an attempt to imply connection but rather to furnish the enjoyment of affinities.

In some cases of course there may prove to be unexpected cultural links or a chain of such. In the rock engraving from the western Sahara for example (cat. 7.7a) the drawing of the upper parts of the animals, as taut and economical as a Matisse, seems at variance with the drifting elongation of the legs. That this phenomenon is one of the central observations about the San rock paintings in Lewis-Williams's thesis of trance and ritual provokes speculation, as does the similarity between the spiral markings seen both in rock engravings from Morocco (cat. 7.8) and South Africa (cat. 3.8) that the same author relates to entoptic phenomena (those abstractions seen by otherwise unseeing eyes on entering trance). The Linton panel (cat. 3.4), the grandest separated fragment of rock art in Africa, is here making a unique journey from Cape Town and gives an opportunity to link such scattered examples to a great narrative painting tradition.

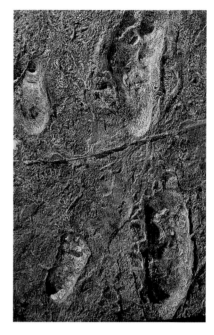

Fig. 11 The footprint trails from Site G, Laetoli, near Olduvai Gorge, Tanzania, 3,500,000 BP

What the gathering of earlier works in each section clearly demonstrates is that in no century when art thrived in Europe and elsewhere was there inactivity in Africa. To take examples from within the present-day boundaries of Nigeria alone, the Nok civilisation (cat. 6.45–54 and fig. 12) before the dawn of the Christian era gives proof of a highly organised urban society, while around the 10th century the complexities of developed social existence, technological brilliance and refinement of spiritual values are clearly to be seen in the terracottas and bronzes so far excavated at Igbo-Ukwu (cat. 5.45–53). Contemporary with the European Renaissance is both the high elegance of Ife culture and the beginnings of the artistic virtuosity of Benin which lasts (as can be seen in the remarkable ivory leopard [cat. 5.60q] whose seldom-photographed profile shows a stunning command of formal language) well into the period from which the bulk of our material comes, i.e. from the 19th and early 20th centuries, collected in the age of pioneering ethnographers (Torday, Frobenius etc.) whose massive gleanings fill the storerooms of European museums. What of this largely wooden treasure would have survived if not collected at the turn of the century is an intriguing question in the light of recent debates about artistic patrimony. With the possible exception of missionaries, there are no more effective vandals and destroyers than the termite. In most areas only the chance survival of the occasional fragment like the 9th-century animal head from Angola (cat. 4.1) remind us of what has disappeared.

The aspect of the age of things, limitless at one end of the scale, faces problems at the other. To have made a fixed cut-off date would seem to imply that art in Africa just came to a halt. The opposite is the case, for in recent decades there has been an explosion of individual talent. The festival of which this exhibition is part provides a more properly expansive arena for the new art of Africa to show itself on its own terms. The work of the most senior of such artists would be roughly contemporary with what is likely to be our most recent exhibit, a pair of Zulu earplugs (cat. 3.36b,d) whose use of vinyl asbestos would date it to the 1950s.

As with the breadth of space and the length of time covered here the distance between a stone axe and a vinyl asbestos earplug indicates the vast range of materials used. In terms of hierarchy this runs from dung to gold, and in terms of the unfamiliar from carpet tacks to animal intestine. Recycling has a long pedigree throughout Africa where little goes to waste. The remains of Soba, the capital of the Christian kingdom of Alwa in the Sudan, were used to build Khartoum, and the brass taps from colonial bathrooms in the Gold Coast became the goldweights of the Akan (cat. 5.103–7). The millions of beads often cynically manufactured in Europe for exchange were transmuted into the splendour of a Cameroon royal throne (cat. 5.14), or a prestige object at the command a Yoruba chief (cat. 5.85), or the spectacular marriage train of an Ndebele bride in South Africa (cat. 3.35). Thus countries as unlikely as Czechoslovakia are embedded into the history of African art. Discarded silk clothing from England was unpicked to make *kente* cloth for Akan dignitaries. Strip by strip they begin to return to Britain to make hatbands for Rastafarians.

The majority of works, however, are made in the more traditional materials, especially in wood, which is the dominant medium even in a survey which tries to cast a wide net. The frontispiece (cat 1.59) shows an Egyptian using an adze, the tool with which almost without exception all the wooden objects here were made. He is a carpenter, however, and south of the Sahara carpentry is rare. Even when it is alluded to or imitated, as in Cetshwayo's Chair (cat. 3.26), the derived object is monoxylous.

This chair alone reveals the futility in terms of Africa of introducing into the selection that cultural apartheid which in Europe and America separates art from craft. Such a demarcation has led, for example, to the neglect of the art of nomadic people whose artistic investment is in portable objects such as jewellery. The necessaries of a travelling life can none the less be spectacular as witness the Tuareg bed (cat. 7.1d) which when assembled commands a large space with its ornately decorated poles. It is precisely such objects of daily use like the snuff bottles of the Zulu (cat. 3.31) that announce their owners' prestige and discernment. Basketry seems the lowliest of forms, yet the Tutsi reserve their greatest skill for the condensed elegance of their Lilliputian baskets (cat. 2.44). More secretive are the loin-cloths of the forest Pygmies of Zaire, humdrum pieces of barkcloth which provide as it were the canvases upon which women make drawings of breathtaking intricacy and freedom of linear language (cat. 4.74). At the furthest extreme are those groups documented by Jeremy Coote whose art could not be shown without filling these rooms too fashionably with cows, since it is located in the comparative colour and disposition of the markings on their cattle.

The absence of perpetuated names among the artists of Africa (whose work was well-known enough in its time for patrons to travel long distances to seek them out) has led to a practice, not extended in this exhibition, of imitating historians of European art in giving what might be called adze-names to stylistically identifiable masters. This soon complicates itself into the issues of 'school of' and 'apprentice of', and so on. A name such as the 'Buli Master' (fig. 13) has already attracted peripheral and disputed works, and possibly even a fake or two.

This lack of easy labels has marked certain epochs and cultures as 'primitive'. One still occasionally hears the term 'Italian primitives' used of those artists who worked up to and including the time of Giotto. In both cases this cunning and insidious word has been an alibi for ignorance; regularly applied not to art that lacks sophistication but to that art for whose sophistication the world was not yet ready. Thus the art of other societies is only validated when our own artists have caught up with it. We clutch the handrail of Western art to discover stage by stage through its mediation the abstract, the minimal, the assemblage etc. (which then are found also to have their equivalents in our own past): in this way we obscurely take the credit for the idea. This attitude was unintentionally but dangerously compounded by the 'Primitivism' exhibition in New York some years ago, after which it became even more common for collectors to describe some etiolated Dogon masterpiece (which may well date back to medieval times) as 'my Giacometti' or to call anything with sharp edges, be it from the 9th or 19th century, 'cubistic'.

In his essay, Henry Louis Gates, Jr. describes how it was believed first that Africans had no art and, if by accident they were found to, had no aesthetic interest in it: most 'tribes', it was maintained, had no word for art. This would of course be like saying that lacking a word for economics they did not know if they were affluent or broke. Such talk continued well into the post-war period. Recently the tide has turned with the invention of a mysterious quantity called African aesthetics (largely the province of Europeans and Americans), a means of appropriation which can be as divisive as that which preceded it. Aesthetics follows in the wake of art, and no simple category of people has special access (that is, after all, the virtue of art). The lid was definitively put on the topic by Barnett Newman's epigram 'aesthetics is to the artist as ornithology is to the birds'. The aesthetic response as understood in this exhibition is best put by the

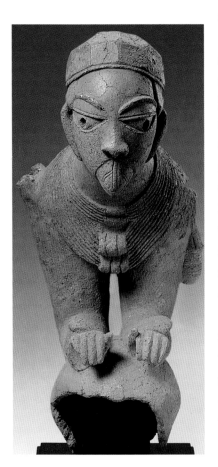

Fig. 12 Human/bird-figure, Nok, Nigeria (cat. 6.52)

Bamana of Mali (as reported by Kate Ezra) who refer to special artefacts as 'things which can be looked at without limit'.

The matter of context is at the heart of such debate, and works so recently redeemed from the bank of ethnography still carry their stamp and question: the issue of 'decontextualisation' seems more alive for them than for the Venus de Milo or the Mona Lisa, both of which have suffered a loss of context as absolute as any African object. In the same museum that houses those two masterpieces, works from Ancient Egypt and Islamic north Africa enjoy that state of honourable retirement which the art institution provides (though it should be noted that the museum in question has barred its gates as yet to art from the rest of Africa). As Théophile Gautier says, 'only art is robust.... the bust outlives the Emperor', and the very test of what we call art is its capacity to survive independently of a context it can never revisit.

In essence the problem of looking at the works in this exhibition is no different from a visit to the National Gallery where, representing the continent of Europe, a similar variety of style and reference is on view, divided between countries whose art developed in radically different directions. Those accustomed to the psychic shift necessary to move from a Duccio to a Rembrandt or from a Van Dyck to a Picasso should not be daunted by this survey. There, as here, the eloquent reminder that Patricia Davison gives in her essay would serve the visitor well: 'All the works selected for this exhibition once evoked other meanings, for other people, in other places.... Sensitivity to historical and social context enriches an understanding of art forms, but it must also be acknowledged that the sensory presence of a work of art can transcend historical context and move the viewer, even if it is not fully understood.'

These words can stand as an epilogue to the experience of *Africa: The Art of a Continent* in their encouragement to enjoy, respect and engage with what is shown. The first task in any exhibition is to open oneself to the art itself: this will reward as it has rewarded the many people, not least the present writer, who have had a hand in selecting and bringing the exhibition together. For each of them the experience has given rise to a growing love for the work on view and an ever more profound admiration for its makers. It is a privilege to celebrate for the first time, in these rooms, the fertile contribution to the visual culture of the world from the whole of this vast and infinitely various continent; and to make here a praise song for Africa.

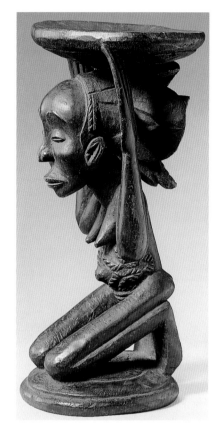

Fig. 13 Stool, Hemba, Zaire, late 19th century (cat. 4.64), attributed to the Buli School

WHY AFRICA? WHY ART?

Kwame Anthony Appiah

Tenabea nyinaa nse.

(All dwelling-places are not alike.)

Asante proverb

I learned about art growing up in my home-town, Kumasi, the capital of Asante, an old kingdom at the heart of the new republic of Ghana. There were paintings and drawings on our walls; there were sculptures and pots, in wood and ivory and earthenware and brass; and there were art-books in the bookcases. But above all, my mother collected Asante goldweights: small figures or geometrical shapes, cast in brass from wax originals, that had been used for weighing gold-dust when it was (as it was well into this century) our currency. The figurative goldweights are wonderfully expressive: they depict people and animals, plants and tools, weapons and domestic utensils, often in arrangements that will remind an Asante who looks at them of a familiar proverb.

Quite often, for example, you will find a weight that represents two crocodiles with a shared stomach (fig. 1), which will evoke the proverb: *Funtumfunafu ne Denkyemfunafu baanu yafunu ye yafunkoro; nanso woredidi a na woreko no, na firi atwimenemude ntira.* It means, roughly: Stomachs mixed up, crocodiles' stomachs mixed up, they both have one stomach but when they eat they fight because of the sweetness of the swallowing. The idea of the proverb – which expresses one of the dilemmas of family life – is that while the acquisitions of each family member benefit the whole family (there is only one stomach), the pleasure of enjoyment is an individual thing (the food has to get into the stomach through one of the mouths).

Even the abstract geometrical weights, with their surfaces decorated with patterns, often use the *adinkra* symbols, which are found as well on Akan stools and funeral cloths, each of which has a name – Gye Nyame, for example – and a meaning – in this case, the power of God. But quite often, also, you will find that one of these elegant weights, so obviously crafted with great skill and care, has a lump of un-worked metal stuffed into a crevice, in a way that completely destroys its aesthetic unity; or, sometimes, a well-made figure has a limb crudely hacked off. These amputations and excrescences are there because,

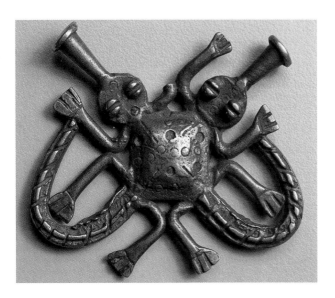

*Fig. 1 Goldweight, Asante,
18th–19th century, Private Collection*

after all, a weight is a weight: and if it does not weigh the right amount, it cannot serve its function. If a goldweight, however finely crafted, has the wrong mass, then something needs to be added (or chopped off) to bring it to its proper size.

There is, thus, an extremely elaborate cultural code expressed in these miniature sculptures; and with the patina that comes from age and human handling, and the exquisite detail produced in the lost-wax process that made them, many of them have an obvious aesthetic appeal. It does not take long to recognise that the goldweights of Asante differ from those of other Akan societies: Fante or Baule, say. Nor is it hard to recognise stylistic change over the centuries. There are histories of taste written in these objects, if only we could read them. Goldweights, in sum, have many of the features that we expect of works of art. In Ashanti itself, they were appreciated for their appeal to the eye; or for the proverbial traditions they engaged. But in the end, as I say, they were weights: and their job was to tell you the value of the gold dust in the weighing pan.

The best of the Asante goldweights are among the splendours of African creativity. But they were not the product of a culture that valued these objects *as art*. Their decorative elegance was something prized and aimed for, of course; but it was an ornament, an embellishment, on an object that served a utilitarian function. It is clear that some people – chiefs among them, but also the richest commoners – made particularly fine collections of weights, and that, in using them in trade, they advertised their wealth at the same time, by displaying the superior craftsmanship of their possessions. Perhaps once, when the weights were still being used, people knew the names of those who made them best; but no one now knows the names of the great casters of goldweights from the past. Still, to insist upon my point, in appreciating and collecting these weights as art we are doing something new with them, something that their makers and the men and women who paid them, did not do.

The goldweight tradition is also very particular. The use of figurative and abstract weights, made in brass by the lost-wax process, is not widespread in west Africa, let alone Africa more generally. Outside the Akan region of Ghana and Ivory Coast, there are, so far as I am aware, no traditions that have produced objects that could be mistaken for Akan goldweights. Akan goldweights are African, because the Akan cultures are in west Africa: but these traditions are local, and while they reflect the complex cultural and economic exchanges between, say, Asante and the Islamic traders of the Sahel, or Baule culture and the European trade of the coast (and thus reflect currents of life wider than those of the societies in which they were made) it would be a mistake to see them as capturing the essence of the vast gamut of African creativity.

Anyone who has looked at collections of masks from western and central Africa will tell you that you can soon learn to recognise roughly where most of them come from: the traditions of each society in masking, even those that have influenced and been influenced by neighbouring traditions, are still quite recognisably distinct; as are the roles masks play in the different forms of performance where they have their fullest life. The point here is the same: Africa's creative traditions are various and particular. You will no more capture the essence of Africa's arts in a single tradition than you can grasp the meaning of European art by examining Tuscan painting of the 15th century. And what goes for art, goes, even more, for life. Africa's forms of life are too diverse to capture in a single ideal type. An understanding of our goldweights requires that you know something not of African but of Akan life: the generalities about African life are, by and large, human generalities.

So we might as well face up to the obvious problem: neither *Africa* nor *art* – the two animating principles of this exhibition – played a role *as ideas* in the creation of the objects in this spectacular show.

Africa

Take, first, 'Africa': through the long ages of human cultural life in the continent, and, more particularly, in the half-dozen or so millennia since the construction of the first great architectural monuments of the Nile Valley, most people in the continent have lived in societies that defined both self and other by ties of blood or power. It would never have occurred to most of the Africans in this long history to think that they belonged to a larger human group defined by a shared relationship to the African continent: a hundred years ago, it would not have occurred to anyone in my home-town. Only recently has the idea of Africa come to figure importantly in the thinking of many Africans; and those that took up this idea got it, by and large, from European culture.

The Europeans who colonised Africa thought of sub-Saharan Africa as a single place, in large part because they thought of it as the home of a single – Negro – race. (That is why, when we speak of Africans, black people come to mind: despite the fact that lighter-skinned north Africans – Arabs, Berbers, Moors – are unequivocally inhabitants of continental Africa.) In the European imagination, the cultures and societies of sub-Saharan Africa formed a single continuum, reflecting an underlying racial unity, which expressed itself in the 'savage rhythms' of African music, the 'sensuality' of African dance, the 'primitive vigour' of sculpture and masks from what was called the 'Dark Continent'.

As intellectuals in Africa came to think of themselves, for the first time, as members of a Negro race – and as Africans – they drew not only on this general Western framework, but also on the ideas of African-American intellectuals – Alexander Crummell, E. W. Blyden, W. E. B. Du Bois – who had been taught to understand themselves as Negroes in the context of the New World system of racial domination, the framework left by slavery. In the New World, where so many dark-skinned people had been brought together from Africa, and deprived of the specific cultural knowledge and traditions of their ancestors, the common experience of the Middle Passage and of enslavement bonded together people whose ancestors had lived very diverse styles of life, hundreds, sometimes thousands, of miles apart. In the New World – in Brazil, or Cuba or the United States – people of diverse African ancestries, bound together in each place by a shared language, might end up experiencing themselves as a unity.

But in Africa itself, the great diversity of societies and cultural forms was not homogenised by the slave trade. Over the last millennium, as Islam spread across north Africa and into west Africa, and down the east African littoral; over the last few centuries, as Christianity came (with its multiple inflections) in the footsteps of European trade and colonisation; over the last century, as colonial empires bound African societies increasingly tightly into the new global economic system and into the modern order of nation-states; over the last decades, as the global spread of radio and television and the record and film industries has reached its tentacles into villages and towns all over Africa; there have, of course, been enormous forces bringing the experiences of African societies closer together. But despite all these forces, the central cultural fact of African life, in my judgement, remains not the sameness of Africa's cultures, but their enormous diversity. Since many of the objects in this exhibition antedate some or all of these energies of incorporation, their origins are more diverse yet.

This should not be surprising. We are speaking of a continent, of hundreds of millions of people. But the fact is that the legacy of the old European way of thinking, in which what unites Africa is that it is the home of the Negro, makes it natural for us, here in the West, to expect there to be a shared African essence: and that tradition makes us equally likely to expect that this essence will show itself in the unity of African art. In this older way of thinking, after all, all the arts everywhere expressed the common genius of a people. (This is one reason why so many of the objects collected by Europeans in Africa in the last two centuries are labelled not with the name of a maker, but with the name of a 'tribe', an ethnic group whose shared conceptions these masks or bronzes or shrine-figures were thought to

express.) But, as you will see as you travel through the works on display here, it would take an eye completely insensitive to the particular to reduce this magnificent miscellany to the expression of the spirit of a singular, coherent, African nature.

What unites these objects as African, in short, is not a shared nature, not the shared character of the cultures from which they came, but our ideas of Africa; ideas which, as I have said, have now come to be important for many Africans, and thus are now African ideas, too.

Art

It is time now to explore, for a moment, the second side of the difficulty I have been adumbrating: the fact that what unites these objects as art is our concept as well. There is no old word in most of the thousand or so languages still spoken in Africa that well translates the word 'art'. This, too, is not too surprising once you think about it: there is, after all, no word in 17th-century English (or, no doubt, in 17th-century Cantonese or Sanskrit) that carries exactly that burden of meaning either. The ways of thinking of 'art' with which we live now in the West (and the many places in the world where people have taken up this Western idea) began to take something like their modern shape in the European Enlightenment. And it is no longer helpful to try and explain what art has come to be for us by offering a definition; in an age in which, as John Wisdom liked to say, 'every day, in every way, we are getting meta and meta', the art-world has denizens whose work is to challenge every definition of art, to push us beyond every boundary; to stand outside and move beyond every attempt to fix art's meaning. Any definition of art now is a provocation, and it is likely to meet the response: Here, I have made (or found) this thing that does not meet your definition and I dare you to say it is not art.

Still, we have received ideas about art and about artists: and my point is that most of these ideas were not part of the cultural baggage of the people who made the objects in this exhibition. For example: since the 19th century especially, we have had an important distinction between the fine and the decorative arts, and we have come increasingly to think of fine art as 'art for art's sake'. We have come, that is, increasingly, to see art as something we must assess by criteria that are intrinsic to the arts, by what we call aesthetic standards. We know art can serve a political or a moral or even a commercial purpose: but to see something as art is to evaluate it in ways that go beyond asking whether it serves these 'extrinsic' purposes. Many of the objects in this exhibition, on the other hand, had primary functions that were, by our standards, non-aesthetic, and would have been assessed, first and foremost, by their ability to achieve those ends. Something about our attitude to art is captured by the incomprehension we would feel for someone who looked at a painting and said: 'It's profoundly evocative, of course, but what is it for?'

A response

If African art was not made by people who thought of themselves as Africans; if it was not made as art; if it reflects, collectively, no unitary African aesthetic vision; can we not still profit from this assemblage of remarkable objects?

What, after all, does it matter that this pair of concepts —*Africa, art* — was not used by those who made these objects? They are still African; they are still works of art. Maybe what unites them as African is our decision to see them together, as the products of a single continent; maybe it is we, and not their makers, who have chosen to treat these diverse objects as art. But it is also *our* show — it has been constructed for us now, in the Western world. It might be anything from mildly amusing to rigorously instructive to speculate what the creators of the objects celebrated here would make of our assemblage. (Consider:

some of these works had religious meanings for their makers, were conceived of as bearers of invisible powers; some, on the other hand, were in use in everyday life.) But *our* first task, as responsible exhibition-goers, is to decide what *we* will do with these things, how *we* are to think of them.

In presenting these objects as art objects, the curators of this exhibition invite you to look at them in a certain way, to evaluate them in the manner we call 'aesthetic'. This means, as you know, that you are invited to look at their form, their craftsmanship, the ideas they evoke, to attend to them in the way we have learned to attend in art museums. (It is hard to say more exactly what is involved here – at least in a brief compass – but most adults who go regularly to exhibitions of painting and sculpture will have practised a certain kind of attention and found it worthwhile: and if they have not, it is hard to see why they should keep going.) So what is important is not whether or not they are art or were art for their makers: what matters is that we are invited to treat them as art, and that the curators assure us that engaging our aesthetic attention will be rewarding.

We can also accept that they were selected on a continental basis that guarantees nothing about what they will share, nothing about how these objects will respond to each other. Provided you do not expect to discover in these creations a reflection of an underlying African artistic unity, an engagement with the whole exhibition will be more than the sum of the unrelated experiences of each separate object, or each separate group of objects from a common culture. How these individual experiences add up will depend, of course, as much as anything else, on the viewer; which is as it should be. But there are questions that might guide a reading of this show – it is part of the pleasure we can anticipate from it that there are so many – and, in closing, I would like to suggest a few of mine.

Let me start with a datum: this exhibition decisively establishes that anyone with half an eye can honour the artistry of Africa, a continent whose creativity has been denigrated by some and senti-mentalised by others, but rarely taken seriously. I have been arguing that to take these African art works seriously does not require us to take them as their makers took them. (If that were so, we should, no doubt, be limited to religious evaluations of Western European art of the High Middle Ages.) And one other way to take them seriously would be to reflect through them on how the enormous temporal and spatial range of human creativity exemplified in this exhibition has been adapted in our culture over the last few centuries to an interpretation of Africa as the home of people incapable of civilisation.

What does it teach us about the past of Western culture, that it has had such great difficulty learning to respect many of the art works in this exhibition, because they were African? Many of these objects come from European collections, and were assembled as curiosities or as puzzles or as scientific data: they were undoubtedly appreciated – loved even – by many of the individuals who gathered them. But they have rarely lived at the heart of our aesthetic consciousness; and when they have, it has often been with astonishing condescension: Ladislas Szesci told readers of Nancy Cunard's *Negro* (a work published in 1934 in celebration of black creativity; see Cunard, 1970):

> The Negroes have been able to create works of art because of their innate purity and primitiveness. They can be as a prism, without any intentional preoccupation, and succeed in rendering their vision with certitude and without any imposition of exterior motive.

It is part of the history of *our* culture – something that bears reflection as we travel among these African artefacts – that half a century ago, this was an obvious way of speaking up for African art.

What (more hopefully, perhaps) does it tell us about our cultural present that we have now, for the first time, brought together so many, so marvellous African artefacts not as ethnographic data, not as mere curiosities, but for the particular form of respectful attention we accord to art? How, in short, may

we interpret our exhibition itself as part of the history of our Western culture: a moment in the complex encounter of Europe and her descendant cultures with Africa and hers? This is a question that everyone who visits this exhibition is equipped to reflect on: all of us can dredge up a common sense that we have picked up about Africa, and we can test that common sense against these uncommon objects.

These, then, are some questions that I bring to this show. But, like each of you, I will bring many others, some of them peculiar to my own history, some more widely shared.

These artefacts will speak to you, and what they say will be shaped by what you are as well as by what they are. But that they speak to you – as the goldweights of Asante spoke to my English-born mother – should be a potent reminder of the humanity you share with the men and women that made them. *As* they speak to you, they will draw you into an exploration of the worlds of those who made them (this is always one of our central responses to art). What you will discover in that exploration is not one Africa, but many: a rich diversity reflected in – but by no means exhausted by – the parade of wonders in this extraordinary exhibition.

EUROPE, AFRICAN ART AND THE UNCANNY

Henry Louis Gates, Jr

I have felt my strongest artistic emotions when suddenly confronted with the sublime beauty of sculptures executed by the anonymous artists of Africa. These works of a religious, passionate, and rigorously logical art are the most powerful and most beautiful things the human imagination has ever produced. I hasten to add that, nevertheless, I detest exoticism.

Pablo Picasso

African art? Never heard of it.

Pablo Picasso

Charles de Gaulle was frequently heard to wonder aloud if, without black Africa from which he mounted the resistance to the Nazi regime, modern France would even exist. One might also wonder whether or not, without black African art, modernism as it assumed its various forms in European and American art, literature, music and dance in the first three decades of the 20th century could possibly have existed as well. Especially is this the case in the visual arts, where dramatic departures in the ways of seeing, particularly in representing the human figure, would seem to be directly related to the influence of sub-Saharan African art. In this sense, it is not too much to argue that European modernity manifested itself as a mirrored reflection of the mask of blackness.

European encounters with visual arts in Africa have long been fraught with a certain anxiety, often calling to mind Freud's account of the anxieties accompanying encounters with the uncanny, encounters that elicit a feeling of 'dread and creeping horror'. In the second edition of an essay entitled 'Of National Characters', David Hume, writing in the middle of the 18th century at the height of the European Enlightenment, maintained that one could survey the entire area of Africa below the Sahara and find not even one work of visual or written art worthy of the name. In a survey of the world's major cultures, civilisations and races, which in its first edition excluded completely any reference to Africans, Hume concluded in a footnote added to the second edition that all of black Africa contained 'no arts, no sciences'. Beauty, as perceived in all its sublimity in European cultures, at least since the time of the Ancient Greeks, is not to be found in black human or plastic forms.

Writing just a decade later, Immanuel Kant, in his *Observations on the Feeling of the Beautiful and the Sublime* (1764), meditated on Hume's conclusions about Africa, ratifying and extending them without qualification. In Section IV of his essay entitled 'Of National Character', Kant cites Hume's opinion favourably, then makes the startling claim that 'blackness' denotes not only ugliness, but stupidity as well:

> In the lands of the black, what better can one expect than what is found prevailing, namely the feminine sex in the deepest slavery? A despairing man is always a strict master over anyone weaker, just as with us that man is always a tyrant in the kitchen who outside his own house hardly dares to look anyone in the face. Of course, Father Labat reports that a Negro carpenter, whom he reproached for haughty treatment toward his wives, answered: 'You whites are indeed fools, for first you make great concessions to your wives, and afterward you complain when they drive you mad.' And it might be that there were something in this which perhaps deserved to be considered; but in short, this fellow was quite black from head to foot, a clear proof that what he said was stupid.

Here we see the bold conflation of 'character' – that is, the foundational 'essence' of a culture and the people who manifest it – with their observable 'characteristics', both physical and, as it were, metaphysical.

Three decades later a more liberal, or cosmopolitan, Kant would allow in *The Critique of Judgement* (1790) that black Africans no doubt had standards of beauty among themselves, even if they did not correspond to European standards of beauty – a bold speculation given the revolutionary transforming role that the cotton gin had begun to play in the nature of New World slavery and the increased traffic in African human beings that this major technological innovation engendered. (Hegel, however, was not persuaded by Kant's new generosity of spirit; in the *Philosophy of History*, written around the same time,

he reaffirmed implicitly Hume's claim about the absence of civilisation in black Africa, and added that because Africans had not developed an indigenous script or form of writing, they also lacked a history.)

If Europe's traffic in black human beings needed a philosophical justification, Enlightenment philosophy, by and large, obliged sublimely. European aesthetic judgement of African art and culture, in the 18th and 19th centuries at least, was itself encapsulated in, and became an integral part of, the justification of an economic order largely dependent upon the exploitation of cheap labour available to an unprecedented degree on the west coast of Africa, from Senegambia to Angola and the Congo. Never could the European encounter with the African sublime be free of the prison of slavery and economics, at the expense of African civilisation and art themselves. The prison-house of slavery engendered a prison-house of seeing, both African peoples and their attendant cultural artefacts.

This curiously tortured interrelation between ethics and aesthetics, between an economic order and its philosophical underpinnings, remained largely undisturbed until the turn of the century. For a variety of reasons, too numerous and subtle to be argued here, revaluations of African art gathered momentum at the turn of the century. Dvořák's admiration, and formal uses, of African American sacred music as a basis for a bold, new approach to orchestral music is only the high-culture equivalent of Europe's and America's obsession with black-faced minstrelsy as a popular mode of debased theatre and dance. The role of the Fisk Jubilee Singers in this process of revaluation, performing spirituals on worldwide tours during these decades, cannot be gainsaid. But it would be in the visual arts where the role of African ways of seeing would become pivotal, in a manner unprecedented in the history of European aesthetics. The experience of African art profoundly shaped the forms that modernity assumed early in the 20th century.

Modern art is often considered to have taken its impetus from the day in 1907 when Pablo Picasso visited the Musée d'Ethnographie in the Palais du Trocadéro, Paris. Indeed, Sieglinde Lemke has argued that there could have been no modernism without 'primitivism' – a term, I confess, that I detest – and no 'primitivism' without modernism. They are the ego and the id of modern art. How uncanny that encounter was for Picasso – and, by extension, for European art, its critics and historians – can be gleaned not only from his own account of the discomfort he felt at that moment, but also from the curious pattern of denial and affirmation propagated both by Picasso himself and later critics in relation to that great moment of transition in the history of European and African aesthetics, *Les Demoiselles d'Avignon*.

Picasso's discomfort – and the discomfort of critics even today – with the transforming presence of African art in painting underlines the irony of an encounter that led to the beginning of the end of centuries of European disapprobation of African art – art that is now taken to be neither 'primitive' nor 'ugly', but to embrace the sublime.

Picasso's ambivalence about the significance of his chance encounter with the faces of Africa that day at the Trocadéro manifested itself almost as soon as critics asserted its importance. As early as 1920 Picasso was quoted in Florent Fels's *Action* as saying 'African art? Never heard of it!' The literature is full of Picasso's denials, the energy of which seems only to emphasise Picasso's own anxieties about his African influences. Eventually, in 1937, in a conversation with André Malraux not reported publicly until 1974, Picasso admitted the African presence in his work:

Everybody always talks about the influences that the Negroes had on me. What can I do? We all of us loved fetishes. Van Gogh once said, 'Japanese art – we all had that in common.' For us it's the Negroes.... When I went to the old Trocadéro, it was disgusting. The Flea Market. The smell. I was alone. I wanted to get away. But I didn't leave. I stayed. I stayed. I understood that it was very important: something was happening to me, right? The masks weren't just like any other pieces of sculpture. Not at all. They were magic things... The Negro pieces were *intercesseurs*, mediators.... I always looked at fetishes. I understood; I too am against everything. I too believe that everything is unknown, that everything is an enemy! Everything! Not the details – women,

children, babies, tobacco, playing – the whole of it! I understood what the Negroes use their sculptures for. Why sculpt like that and not some other way? After all, they weren't Cubists! Since Cubism didn't exist. It was clear that some guys had invented the models, and others had imitated them, right? Isn't that what we call tradition? But all the fetishes were used for the same thing. They were weapons. To help people avoid coming under the influence of spirits again, to help them become independent. Spirits, the unconscious (people still weren't talking about that very much), emotion – they're all the same thing. I understood why I was a painter. All alone in that awful museum, with masks, dolls made by the redskins, dusty manikins. *Les Demoiselles d'Avignon* must have come to me that very day, but not at all because of the forms; because it was my first exorcism painting – yes absolutely.

Françoise Gilot had reported a similar comment a full decade before Malraux's publication. It is even more dramatically open about his conscious indebtedness to African sources:

When I became interested, forty years ago, in Negro art and I made what they refer to as the Negro Period in my painting, it was because at the time I was against what was called beauty in the museum. At that time, for most people a Negro mask was an ethnographic object. When I went for the first time, at Derain's urging, to the Trocadero museum, the smell of dampness and rot there stuck in my throat. It depressed me so much I wanted to get out fast, but I stayed and studied. Men had made those masks and other objects for a sacred purpose, a magic purpose, as a kind of mediation between themselves and the unknown hostile forces that surround them, in order to overcome their fear and horror by giving it a form and image. At that moment I realized what painting was all about. Painting isn't an aesthetic operation; it's a form of magic designed to be a mediator between this strange, hostile world and us, a way of seizing the power by giving form to our terrors as well as our desires. When I came to that realization, I knew I had found my way. Then people began looking at those objects in terms of aesthetics.

In these idiosyncratic and cryptic statements, Picasso reveals that his encounter with African art was a seminal encounter. Yet, he dismisses the primary influence that African art had upon his work, its *formal* influence, a new way of seeing, a new way of representing. But why would Picasso suddenly identify with modes of representation peculiar to African art, thereby breaking the long-held tradition of disparaging those same black traditions as 'ugly' or 'inferior'?

What these passages reveal is Picasso's aesthetic wrestling with his own revulsion at the forms of African art, and, by extension, the traditional revulsion of the West towards African aesthetic conventions generally. Picasso vividly describes his encounter in terms that Freud used to describe the uncanny. His description of the smell, followed by the realisation that he was alone and his desire 'to get out fast', which he managed to resist, are all symbolic. The description serves as a metaphor for a visceral repulsion of the artist and, as it were, the visceral repulsion of Western aesthetics itself. What is also striking about Picasso's recollections is his denial of the formal influence of African art – to which he was patently indebted – and the fact that 30 years later (when he made his confession to Malraux) he was still haunted by the memory of a tormenting odour. The unpleasant sensations are metaphors for Picasso's anxiety and for the very sublimity of this encounter with the black uncanny.

Perhaps even more bizarre, Picasso substituted for his own obvious embrace of formal affinities with African art a cryptic and obviously bogus claim to be embracing African art's *affect*, its supposed functionality, its supposedly 'exorcist' uses, about which he knew nothing. In a way that he did not intend, this curious dichotomy would come together in his use of the forms of African art to exorcise the demons of his artistic antecedents.

Picasso's anxieties with his shaping influences are, in part, those of any artist wishing to be perceived as *sui generis*. But it is impossible to separate the anxiety about influence, here, from Europe's larger

anxiety about the mask of blackness itself, about an aesthetic relation to virtually an entire continent that it represented as a prime site of all that Europe was not and did not wish to be, at least from the late Renaissance and the Enlightenment. Even in those rare instances early in the 20th century when African art could be valued outside a Eurocentric filter, the deepest ambivalences about those who created the art still obtained. Thus Frobenius on his encounter with a classic work of Yoruba art, some time between 1910 and 1912: 'Before us stood a head of marvellous beauty, wonderfully cast in antique bronze, true to life, encrusted with a patina of glorious dark green. This was, indeed, the Olokun, Atlantic Africa's Poseidon.'

'Yet listen', Wole Soyinka, the Nigerian playwright, argued in 1986 at his Nobel Laureate address, 'to what he had to write about the very people whose handiwork had lifted him into these realms of universal sublimity':

> Profoundly stirred, I stood for many minutes before the remnant of the erstwhile Lord and Ruler of the Empire of Atlantis. My companions were no less astounded. As though we have agreed to do so, we held our peace. Then I looked around and saw – the blacks – the circle of sons of the 'venerable priest', his Holiness the Oni's friends, and his intelligent officials. I was moved to silent melancholy at the thought that this assembly of degenerate and feeble-minded posterity should be the legitimate guardians of so much loveliness.

The deep ambivalences traced here were not peculiar to white Europeans and Americans; African Americans, for their part, were at least as equivocal about the beauty of African art as were Europeans. As Alain Locke – the first black American Rhodes Scholar, who was to graduate from Harvard with a PhD in Philosophy, and then become the first sophisticated black art critic – put it in his pivotal essay 'The Legacy of the Ancestral Arts' (1925), they 'shared the conventional blindness of the Caucasian eye with respect to the racial material at their immediate disposal'. Racism – aesthetic and other – Locke concludes ruefully, has led to a 'timid conventionalism which racial disparagement has forced upon the Negro mind in America', thus making even the very *idea* of imitating African art for African American artists a most difficult ideal to embrace.

Locke's solution to this quandary, as Lemke argues, is as curious as Picasso's waffling about influences upon him: by imitating the European modernists who so clearly have been influenced by African art (of whom Locke lists Matisse, Picasso, Derain, Modigliani, Utrillo and ten others) African Americans will become African by becoming modern. The route to Africa, in other words, for black as well as white Americans and Europeans, is by way of the Trocadéro. Locke even points to the work of Winold Reiss, whom he chose to illustrate his classic manifesto of African American modernism, *The New Negro*, 'as a path breaking guide and encouragement to this new foray of the younger Negro artists'.

Judging by the 'African-influenced' work that artists such as Aaron Douglas produced, and given the circuitous route that Locke mapped out for them as their path 'back' to Africa, perhaps we should not be surprised that these experiments led not to the 'bold iconoclastic break' or 'the ferment in modern art' that Picasso's afternoon at the Trocadéro yielded, but rather to a sort of Afro-Kitsch, the use of decorative motifs such as cowrie shells, Kente cloth patterns and two-dimensional reproductions of 'African masks', in which 'Africa' never becomes more than a theme, as an adornment, not a structuring principle, a place to be visited by a naive tourist. Ways of seeing, these experiments tell us, are not biological. Rather, they result from hard-won combat with received conventions of representation. They are a mysterious blend of innovation and convention, improvisation and tradition. And if the resurrection of African art, in the court of judgement that is Western art, came about as a result of its modernist variations, this exhibition is testament to the fact, if there need be one, that African art at the end of the century needs no such mediation. It articulates its own silent sublimity most eloquently. For centuries it has articulated its own silent sublimity most eloquently.

Bibliographical note

Quotations of Picasso are taken from *Les Demoiselles d'Avignon*, ed. William Rubin, Studies in Modern Art, 3, MOMA, New York, 1994; quotation of Immanuel Kant from *Observations on the Feeling of the Beautiful and Sublime*, translated by John T. Goldthwait, Berkeley and Los Angeles, 1960, p. 113. References to Sieglinde Lemke's ideas are based on her book *Was Modernism Passing?*, forthcoming from Oxford University Press.

THE AFRICAN PAST

Peter Garlake

To begin to penetrate the African past of the last 12,000 years, it is essential first to assess the nature and quality of the evidence on which interpretations of African history depend as well as the concerns and preconceptions of the practitioners and limitations of their disciplines. Oral histories, traditions, genealogies and folklore are an uncertain guide for all but the past few centuries and require as skilled analysis and reinterpretation as any other form of evidence. Indigenous historical records scarcely exist outside the literate worlds of Egypt and Islam. Other than these there are travellers' stories written by outsiders whose experiences were limited and whose perceptions survived from the world from which they came; for them Africa was the exotic other.

Inadequate though they still are, the most significant contributions to an understanding of the African past have come from archaeologists. The early history of a continent is intertwined with the history of a discipline. It began in Egypt with the revelations of the monuments and treasures of the pharaohs and the recording and reading of hieroglyphic texts. Philology has so skewed our understanding of that civilisation that, until the archaeology of settlements is fully addressed, Egypt's place in African history and the influences that permeated to and from the far interior will remain in the realm of polemic. The concern with dramatic visible monuments and artistic treasure goes further than Egypt. Ife and Benin in west Africa, Kilwa on the east African coast and Great Zimbabwe (fig. 1) in the southern

Fig. 1 The Conical Tower within the Great Enclosure at Great Zimbabwe, photographed during the first rudimentary excavation at the site in 1891

African interior have been the subjects of debate ever since they came to the attention of the outside world.

It was only some 40 years ago in the twilight of colonialism that the richness and importance of indigenous African history began to receive the attention that it deserved. The first researchers were concerned with origins – the ambiguous minutiae of the earliest domesticated crops or animals or ceramic or metal technologies. These were all envisaged as having single points of origin, usually outside the continent, which were dispersed and diffused through successive migrations and within a framework of unilinear evolutionary development. Foreign trade and trade routes were seen as prime stimulants of change for their passive recipients. Change was equated with the movements, invasions and conquests of successive tribes, with no awareness that the very identities of many of these tribes were as much foreign colonial concepts as the boundaries that were imposed on them. Some of the tribes that were once believed to be major historical protagonists and that once most concerned archaeologists, like the Bacwezi of Uganda or the Shirazi of the east African coast, have subsequently proved to be almost entirely legendary.

Whether it is made explicit or not, archaeologists bring to their researches particular concepts, theories, techniques and biases. These are still almost all derived from outside Africa and were originally intended to meet problems of other continents and periods. Within Africa, the theoretical bases that must form the foundations of any significant research programmes remain stunted. The archaeologist's traditional tools were ceramic classifications. Interest in the typologies of ceramics, however, lessened as their relationships to social identity were recognised to be complex and problematic. Though they continue to provide chronological indicators, even here their usefulness has decreased now that reasonably firm and precise temporal frameworks can be built up using radiocarbon dating.
Most researchers have now become increasingly engaged with the realities of the societies of Africa themselves. Archaeologists have seldom recognised the potential contributions of other human sciences. On the few occasions that alliances have been formed, the results can be dramatic. The understanding of the art of the Drakensberg San, almost the last Stone Age hunters and gatherers of southern Africa, has been transformed in the last twenty years by the cautious and sensitive incorporation into these studies of 19th- and 20th-century ethnographic work on San beliefs and religious practices. Comparative iconographic analysis, a traditional tool of art historians, has enabled these insights to be extended to the much older art and more extensive concerns of the long vanished San of Zimbabwe. Later we shall see how art historians and anthropologists have helped in an understanding of more recent periods.

Archaeologists have almost entirely abandoned grand theory for research programmes and strategies on the level of defined ecological regions. They now study people, resources and settlements regionally rather than concentrating exclusively on single sites, however important. This has led to the recognition of the autonomy, creativity and innovative dynamism of indigenous local societies at every technological, economic and social level as, through conscious rational choices and decisions, they have recognised and responded to the challenges and opportunities of new lands, resources, products and technologies, and changing patterns of rainfall, vegetation and fauna. Archaeologists are also now much more aware of how important to an understanding of the past are studies of the internal dynamics, structure, institutions and beliefs that underlay the processes by which wealth and power became concentrated in the hands of the few, of the ways in which control or coercion was exercised to maintain the stability and permanency of states and their economic, political and institutional management.

As detailed knowledge of more regions accumulates and recognition of the creative responses of any community to its situation grows, many of the old sharp distinctions fade and blur. Categories like the

Later Stone Age, Neolithic, Early and Later Iron Ages lose their separate identities and much of their meaning. They may remain a useful descriptive shorthand, but become restrictive concepts. Ceramic groups no longer have the same sharp definition and many seem arbitrary creations of archaeologists. Distinctions between hunters, pastoralists, farmers and craftsmen also often become difficult to sustain. The hunter becomes a fisher, builds semi-permanent villages by lakes and rivers and collects wild cereals habitually and intensively. The pastoralist plants grain after good rain and hunts when his herd diminishes with disease or drought. Cultivators shift their energies to cattle-raising when they occupy new environments. Innovative responses to new conditions and new challenges, the exploitation of the new opportunities and new ecological niches are the stuff of the African past.

All this can be seen first in what is now the most unpromising location, the central Sahara. Yet, for at least 4000 years after about 10,000 BC, this was a land of lakes and rivers with populations living off fish and the riverine mammals, collecting wild sorghum and millets, and grinding these for meal and, in some areas, concentrating their hunting on the indigenous wild Barbary sheep. By 8000 BC, people everywhere in the region had developed pottery for their cooking and storage vessels, though they continued to make all tools and weapons in stone and wood.

As the region became drier, many turned to a pastoral life, herding sheep in the Atlas and cattle elsewhere, and tended to move south and east towards the Nile. In the river valley, hunting, fishing and the gathering of tuberous food plants could continue, but in villages on the desert edges people also began to cultivate domesticated wheat and barley to provide a more predictable, controlled and varied addition to their diet when the plain was flooded and food was short. By 4000 BC villages in the Fayum, at Merimda at the head of the Nile Delta and elsewhere could rely almost completely on their domestic-ated grains and livestock.

At Kintampo, on the edges of the rainforests of what is now Ghana, the continuity between later Stone Age groups and the first cultivators has been established. Evidence of domesticated stock or crops from this site looks less certain, but it is clear how, from 1600 BC, people made progressive economic adjust-ments to the opportunities of agriculture. The forest was gradually cleared – as shown by the new animal species attracted to the clearings. People settled down; the quantity and variety of their possessions increased, particularly pottery; systems of local exchange were established; and dwellings were made more substantial and durable.

In the central Rift Valley of east Africa during the second and first millennia BC, ecological variety permitted peoples with very different lifestyles and economies to coexist in close proximity for many centuries. Interactions between them then took many different forms, comprehending traditional archaeological concepts like migration, diffusion, assimilation and economic transformation. People who were predominantly foragers settled in the dry, lightly wooded floor of the valley and its margins and adapted their hunting to different habitats. Goat herders lived in rock shelters on the forested sides of the valley and in large settlements in the highlands. Open grasslands were grazed by the cattle of at least five different pastoralist groups whose forebears lived in northern Kenya throughout the second millennium BC and had their ultimate origins on the Ethiopian highlands. Some were nomadic; others settled near permanent waterholes. Their pastoralism can even be seen as an ideological system in which a cultural bias towards herding exceeds its functional value and herding defines identity.

On the southern edge of the Sahara substantial evidence for very early metal working has been recovered, particularly around Agadez in Niger. Native copper began to be smelted here before 2000 BC on a small scale (and probably seasonally) by craftsmen who traded with Saharan pastoralists. It was over a thousand years before technology advanced sufficiently for copper ores to be smelted successfully. Development was then rapid. Between 700 and 500 BC, the difficult task of smelting iron ores was

mastered, and along a hundred-mile stretch of small smelting settlements, craftsmen were making iron ornaments and weapons as status symbols. Within a hundred years iron smelting furnaces could be found as far south as the central plateau of Nigeria.

In the east African interior, on the western Buhaya shores of Lake Victoria, there is evidence of intensive iron smelting industries from 600 BC. These were sophisticated, extensive, specialised and almost industrial, incorporating technological innovations that enabled the furnaces to reach high temperatures that were not developed outside Africa until centuries later. The environmental impact of metal production on this scale, of the amount of mature hardwood that had to be felled and burnt to produce the charcoal for the furnaces, and of the devastation that this caused has been emphasised. This may have had some advantages as it turned forests into pasture that allowed cattle herds to multiply, but it also forced communities to move frequently.

The most far-reaching changes to society and its institutions, economy and culture come with the aggregation of peoples in towns or cities. Their development in sub-Saharan Africa is best traced in the delta of the Middle Niger, where the river splits into a changing silting network of a myriad temporary channels, lakes and swamps and has at its head the city of Djenne. Timbuktu stands at the lower end of the delta and Gao further downstream, where the course of the river swings south. In the flat and otherwise featureless floodplain around Djenne, inundated to a considerable depth each year, over 400 tells of ancient occupation have been identified from aerial photographs suggesting a population density ten times that of today. By 300 BC the delta was drying up, the areas of permanent lakes in it decreasing and the dangers of waterborne diseases diminishing. The first signs of permanent settlement, small hamlets of mixed agriculturalists, appeared about 250 BC. Their inhabitants fished, hunted wild bovids and collected wild grasses but they also grew rice, sorghum and millet and herded goats and cattle. From the start, they also imported stone grindstones, stone beads and iron ore from beyond the floodplain. Over the following five or six centuries the settlements remained predominantly rural but few in numbers and size. Resources were drawn from further afield – copper, probably from the Sahara, appeared by AD 400 and gold, probably from the far south, by AD 800. Crafts diversified and some were clearly the products of at least part-time specialists. By AD 500 several settlements had coalesced into a fully urban town. At the height of its prosperity, about 800, Djenne covered over 100 acres, many buildings were of brick and the town was surrounded by a massive wall. However, there is no evidence that it had a ruling group or any system of coercion or authoritarian control; it had no palaces, temples or citadel, very few luxury imports and little wealth concentrated in the hands of a few. What is significant is rather the way specialised craftsmen in a variety of manufactures were organised into cohesive bodies, physically separated and living in their own settlements round the edge of the town, identified by village mounds slightly over a quarter of a mile apart, with three to fifteen villages forming a cluster, each in its way an independent manufacturing and social centre. These units may have had an ethnic as well as a productive basis. Nevertheless, town, craft villages and country formed a single social and economic system. The ambiguities of personal and group identity within this system may well have been expressed and resolved through the proliferation of art, particularly ceramic statuary, which is a feature of Djenne: symbols of the disparate, interacting and overlapping loyalties of groups with different origins, ethnic allegiances, occupations, beliefs and values.

The intensity and spread of the regional trade through the delta is shown by the homogeneity of the material culture, particularly pottery, over a wide area, evidence either of the spread of objects from the urban manufacturing centres or of the way the high fashion of the city was everywhere emulated by local craftsmen. Downstream large grave mounds or tumuli, built with ever-greater elaboration over wooden burial chambers, contain rich gravegoods and Djenne pottery. They have now been dated to between the

8th and 11th centuries, contemporary with Djenne's greatest prosperity. More than anything in the city, they suggest that some people grew wealthy and powerful through control of the flow of trade goods through the delta. North African, Arab and Islamic influences only appear at Djenne after 1000, when the city was already over 500 years old. At this point the climate became wetter. The river floods were more extensive, higher and longer, and rice growing had to be largely abandoned and with it many settlements. The population of the floodplain declined, and settlements were reduced to a cluster round Djenne itself. The end came by 1400 when the town was abandoned.

The eastern edges of the Kalahari Desert, monotonous flat open country, covered in thorn scrub and grass and broken by isolated flat-topped sandstone hills, contain the earliest evidence in southern Africa of the growth of wealth, inequalities, a ruling group, sustained political control over wide territories, considerable populations and rich herds. This occurred in a place far from any foreign trade contacts, in an area without the gold of Zimbabwe and far less attractive for farmers or ranchers with even less rain and a sparser vegetation than its eastern neighbour. Cultivation, even of drought-resistant and fast-maturing indigenous grain crops, is hazardous. Today it is the heartland of traditional Tswana cattle owners and their almost feudal economy with client herders guarding their cattle, for much of the year at cattle posts far from the vast traditional towns where the owners live. Until very recently, so little was known of the prehistory of this part of the subcontinent that it was assumed that it had only been the hunting grounds of nomadic San foragers. A single research programme has discovered over 250 Iron Age settlements, occupied between AD 600 and 1300.

Settlements centred round cattle pens. Debris from these, hardened and burnt over the centuries, encourages so distinctive a grass cover that sites can be identified from aerial photographs. The settlements vary considerably in size, depth of occupation deposits and length of occupation and fall into four distinct categories. The largest were substantial hilltop towns, with cattle middens 25 acres in extent, sited for defence and taking little account of distance from water or agricultural land. Large villages, though little more than a tenth of the size of the towns, were built on smaller hilltops around the town. In the plains below were hamlets and homesteads comparable in size to contemporary Tswana cattle posts and occupied for two generations at most. They differed from the villages and towns in being located near water courses and within reach of both heavy and light soils: crops planted on one or other of these soils would survive whatever the rains brought.

By the 9th century, there were three hilltop towns, 60 miles apart from each other. Large villages clustered at some distance from the towns and hamlets in turn clustered round the villages: a distinctive pattern and hierarchy of settlements indicative of three independent, self-sufficient and competing city states, each in control of its own territories and each with its own infrastructure of agricultural villages and cattle posts. Their control over their populations was strong enough for them to extract cattle, presumably in the form of tribute, to sustain the town. The pattern of culling shows that the townsfolk subsisted on the meat of cattle killed in their prime while in the lesser settlements only young bulls and animals past reproduction were killed: the characteristic pattern of ranchers seeking to maintain and increase herd growth. Although external contacts certainly existed, and glass beads and sea shells reached the Toutswe settlements, the real trade was internal, with cattle and grain passing between the settlements, and skins, hides, ivory and probably salt being exchanged with San hunting groups beyond the Toutswe territories.

The developments in Botswana were not unique. Far to the west lies a dramatic monument that still suffers from more speculation than serious research. Great Zimbabwe is the largest and one of the earliest of some 200 granite masonry enclosures demarcating rulers' courts that were built around the high plateau of the southern African interior between the 12th and 18th centuries (fig. 1). It is the apogee

Fig. 2 The minaret of the Friday Mosque in Mogadishu, one of the earliest port cities in east Africa. The entrance to the minaret bears a dedicatory inscription dated AD 1238 (636 AH). The photograph was taken in 1963

of the progressive aggregation of population and power in southern Africa. It is unnecessary to posit any direct ethnic or cultural connection between such very different centres as Toutswe, Mapungubwe in the valley of the Limpopo River and Great Zimbabwe, let alone assume migration of their populations or ruling classes. Rather they are each in their own way culminations of similar, though autonomous, indigenous processes of centralisation and hierarchical differentiation; responses to the ways that cattle ownership can be manipulated to meet the human quest for wealth and power like that traced so well in Botswana. Certainly it can be demonstrated that at least one *zimbabwe* (Shona: palace) lay at the node of seasonal cattle movement and that there, as at Great Zimbabwe, cattle were brought to the court and slaughtered in considerable numbers in their prime to provide meat exclusively for the inhabitants of the stone courts. The pattern of the major courts across the plateau, almost certainly independent politically and eonomically but sharing a common culture, suggests that this was the case everywhere. Here archaeology must give way to other, more sophisticated disciplines. Cattle were not simply an economic resource, but mediating symbols of relationships in marriage, between chiefs and their subjects and between people and their ancestors and gods. In the same way, the great granite structures themselves are not fortifications but primarily symbolic expressions of the political, cultural and religious, embodying beliefs about relationships between land and people, ruler as custodian of land and its wealth responsible to ancestors and subjects, between ruler and spirit medium.

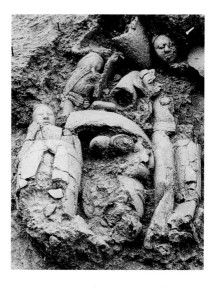

Fig. 3 A group of broken pottery torsos and heads, both naturalistic and reduced to simple conical shapes, buried in Ife in the 14th century and excavated in 1972. Broken pottery statuary and dismembered human bodies were treated in similar ways at this site

All this demands investigation far deeper than inappropriate, superficial and unproven ethnographic analogies that archaeologists too often grasp at to flesh out their material. Their 'cavalier and often inaccurate' misuse and 'gross misinterpretation' of his material can drive the anthropologist to despair. Witness the almost universal rejection of the interpretations of Great Zimbabwe based on South African Venda customs of the very recent past.

Great Zimbabwe was one of the extremities of a communication system that stretched from the deep African interior to the farthest reaches of Asia and the Mediterranean. Its node was the Swahili cities along the Indian Ocean. A common Swahili culture based on a local, coastal seaborne trade, carried by traditional indigenous craft with sewn wood hulls and square matting sails, had mastered difficult reefs, winds and currents to spread 3000 miles along this coast from Somalia to Mozambique. The first villages in the 8th century were traditional African round houses of clay arranged round a central cattle pen. Their inhabitants still hunted, but developed inland fishing techniques of spearing and trapping to exploit the inshore reefs. Tiny mud-walled mosques, which could accommodate only a minuscule fraction of the growing population, mark the beginnings of the Swahili conversion to Islam in the 10th century. This in turn began the integration of products of the African interior into a far-flung network reaching first to Mesopotamia and Tang China and, when these became unstable, exporting African gold, ivory and rock crystal to the Mediterranean to such an extent that a convincing claim can be made that these new imports stimulated an artistic revival in Byzantium, Muslim Spain and Sicily and the Holy Roman Empire that lasted for nearly a century between AD 960 and 1050.

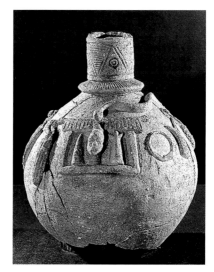

Fig. 4 A pottery vessel buried up to its neck at the centre of a 14th-century patterned potsherd and quartz pavement in Ife, excavated in 1972. The reliefs include a small shrine containing three ceramic heads and a basket from which protrude the up-ended legs of a sacrificial victim

The populations of the larger towns of the coast grew to up to 10,000 people (fig. 2). Local coinages were minted in several of them, the forms of the inscriptions derived from Fatimid Sicily. Building in coral masonry began, reaching its peak in the early 14th-century complex of palace, warehouses, caravanserai and market of Husuni outside the town of Kilwa. The geometry of the domes, vaults, pools and courtyards was Islamic, but the arrangements of the domestic quarters were Swahili and later reproduced in substantial houses in every town on the coast. They are evidence of the great prosperity that trade stimulated.

Its effects on the interior were more complex and problematic. Numerous pre-existing indigenous networks of local exchange systems transmitted the new imports, whose value and meaning changed

as they passed from society to society. By the time they reached the courts of the far interior, as small quantities of glass and glazed wares were to reach Great Zimbabwe, their effects are still imponderable. Certainly no cultural or political influences accompanied them. Such trade was incorporated in complex pre-existing indigenous productive, political and economic systems. The causal connections between long-distance trade and internal changes have yet to be analysed and established.

A contemporary site to Great Zimbabwe and the Swahili cities both in its rise and decline is Ife, or Ile-Ife, sacred to the Yoruba people of west Africa as the place where the world and humanity were created, and the location of some of Africa's great works of sculpture. Its origins remain obscure though much speculated about. Sadly, the full results of the many excavations undertaken before 1970 have not been published. The only firm evidence we have is the immediate context of some of the celebrated sculptures (fig. 3). On the outskirts of the present city and just beyond the ancient city walls, after an initial occupation in the late 12th century, large and substantial family compounds were built in the 13th century, the clay walls falling into decay less than a century later. These houses were arranged around rectangular courtyards precisely oriented north to south, the walls and columns decorated with mosaics of pottery discs and paved in geometric patterns which draw attention to semicircular altars and the neck of a pot buried in the centre of the yard. An art historian has been able to interpret the altars as Yoruba *ijoko orisa*, the god's seat, and the central pot as *ojubu*, the face of worship. The sculpted reliefs on at least one of these pots (fig. 4) can be shown to illustrate the apparatus and insignia of extant Yoruba secret societies, Oro and Osugbo, both once concerned with law and order and with executions such as that depicted on the same pot. The same vessel also depicted a small shrine containing both highly stylised and realistic sculpted heads: the first firm contemporary evidence to bring the sculpture into the context of now lost Yoruba religious practice. Outside the compounds, a small wooden shrine contained dismembered human heads mixed with sculpted heads broken from their bodies and depicting men deformed and distorted by disease and anger: a demonstration of the perceived equivalence between sculpture and reality. Here small-scale archaeological excavations combined with art-historical analysis have been able to establish the age of the sculptures, something of how they were perceived and used and the time depth of key Yoruba institutions.

Yoruba institutions have their roots deep in the past. The structures of Great Zimbabwe, as yet unstudied, are best seen as controlled forms and spaces symbolising deep and ancient communal relationships. In the end it will not be only through technological, ecological or economic studies that the distinctive characteristics of the African past will be best understood, but also through consideration of its very varied modes of social organisation and structure, its institutions and symbols. It is these that archaeology has so far proved insufficiently sensitive and adaptable to penetrate. When it comes to terms with such deficiencies, and this is by no means impossible, we can expect new and greater understanding of a rich and varied past.

Bibliographical note

Reports of archaeological work in Africa are most rapidly and readily accessible from journals such as *African Archaeological Review* (Cambridge University Press), *Journal of African History* (Cambridge University Press), *Azania* (British Institute in Eastern Africa), *South African Archeological Bulletin* and *West African Journal of Archaelogy*. Important work on the early settlement of Egypt has been done by O'Connor, on revision of the Kintampo, Ghana, sequence by Stahl, on early east African settlement by Robertshaw and ironworking by Schmidt, on Djenne by the McIntoshes, on the Toutswe sequence by Denbow, and on the Swahili coast by Horton. Papers by all except Schmidt and Denbow, though not always their most recent or comprehensive ones, appear in a collection of conference papers, Shaw et al., eds. This also includes a synopsis by Muzzolini of research on early Saharan food production. For aspects of the controversies over Great Zimbabwe discussed here see Garlake, 1978[2] and 1982; for rejections of the 'initiation school hypothesis' by archaeologists see Collett et al., and by the anthropologist whose material formed its basis see Blacking, 1985. For Ife, archaeological work is reported in Garlake, 1974 and 1977, and interpreted by the art historian Drewel in Drewel and Pemberton, 1989. For the interpretation of rock paintings in South Africa see Lewis-Williams and Dowson; for Zimbabwe see Garlake, 1995.

EDITORIAL NOTE

Catalogue entries are signed with the initials of the following contributors

AA	Alden Almquist
BA	Barbara Adams
CARA	Carol Andrews
CJA	C. Joseph Adande
DA	David Attenborough
JA	James Anquandah
MA	Monni Adams
APB	Arthur Bourgeois
EB	Ezio Bassani
HvB	H. van Braeckel
JB	Jean Brown
JDB	J. D. Bourriau
JRB	John Baines
MCB	Marla Berns
MLB	Marie-Louise Bastin
NB	Nigel Barley
PB	Peter Beaumont
RAB	René A. Bravmann
RB	Rayda Becker
AC	Anna Contadini
CC	Christopher Chippindale
ELC	Elisabeth Cameron
HMC	Herbert Cole
JC	Joseph Cornet
JXC	Jeremy Coote
KC	Kevin Conru
LHC	L. H. Corcoran
MC	Margret Carey
MWC	Michael Conner
HJD	Henry Drewal
JD	Janet Deacon
PD	Patricia Davison
PJD	Patricia Darish
WD	William J. Dewey

WVD	Vivian Davies
EE	Ekpo Eyo
ME-K	Marianne Eaton-Krauss
NE	Nadia Erzini
AF	Angela Fagg-Rackham
EF	Etienne Féau
JMF	Joyce Filer
REF	Rita Freed
RFF	Renée Friedmann
TFG	Timothy Garrard
BH	Barry Hecht
LdeH	Luc de Heusch
RH	Rachel Hoffmann
SH	Stanley Hendrickx
LH	Lorenz Homberger
TNH	Thomas Huffmann
WH	William Hart
RI	Robert Irwin
TAI	Timothy Insoll
FJ	Frank Jolles
CK	Curtis Keim
CMK	Christine Kreamer
JK	John Kinahan
FK	F. Klenkler
SK	Sandra Klopper
TK	Timothy Kendall
ZK	Zachary Kingdon
BL	Babatunde Lawal
FL	Frederick Lamp
RL	Raoul Lehuard
JDL-W	David Lewis-Williams
LL	Luc Limme
NL	Nessa Liebhammer
CM	Carla Marchini
DM	David Morris
JM	John Mack
MRM	Rachel MacLean

PdeM	Pierre de Maret
PMcN	Patrick McNaughton
PRSM	Roger Moorey
SJMM	Stanley J. Maina
WM	Wyatt MacGaffey
AN	Anitra Nettleton
FN	François Neyt
KN	Keith Nicklin
KNe	Karel Nel
NIN	Nancy Nooter
DO	David O'Conner
JP	Judith Pirani
JP III	John Pemberton III
JWP	John Picton
LP	Louis Perrois
MP	Merrick Posnansky
RP	Robert Papini
TP	Tom Phillips
SGQ	S. G. Quirke
AFR	Alan F. Roberts
CDR	Christopher Roy
CHR	Catherine Roehrig
DHR	Doran Ross
ERR	Edna R. Russmann
JFR	J. F. Romano
MNR	Mary Nooter-Roberts
PR	Patricia Rigault
PLR	Philip Ravenhill
AS	Abdul Sheriff
BS	Bettina Schmitz
CS	Christopher Spring
EMS	E. Margaret Shaw
ES	Enid Schildkrout
HS	Hamo Sassoon
HSa	Helmut Satsinger
HSo	Hourig Sourouzian
JvS	Jan van Schalkwyk

RS	Roy Sieber
TS	Thurstan Shaw
WS	William Siegmann
ZSS	Zoe Strother
JHT	John Taylor
NT	Natalie Tobert
RFT	Robert Farris-Thompson
TT	Tanya Tribe
EV	Eleni Vassilika
MFV	Marie-France Vivier
DAW	Derek Welsby
DW	Dietrich Wildung
FW	Frank Willett
HW	Helen Whitehouse
JW	Justin Willis
RAW	Rosalind Walker
RJAW	Roger Wilson
RW	Rachel Ward
AY	Abd'el-Rauf Youssouf
KY	Kenji Yoshida
CZ	Christiane Ziegler

Bibliographical citations in the text and at the foot of the entries refer to the general bibliography

Dimensions are given in centimetres; height precedes width and depth.

The phonetic symbols /, !, /', ≠ are standardised representations of the click sounds in various khoisan languages. /Xam is the name of a southern San group, Ju/'hoan and !Kung refer to northern San groups.

The following abbreviation is used: BP, Before the Present time

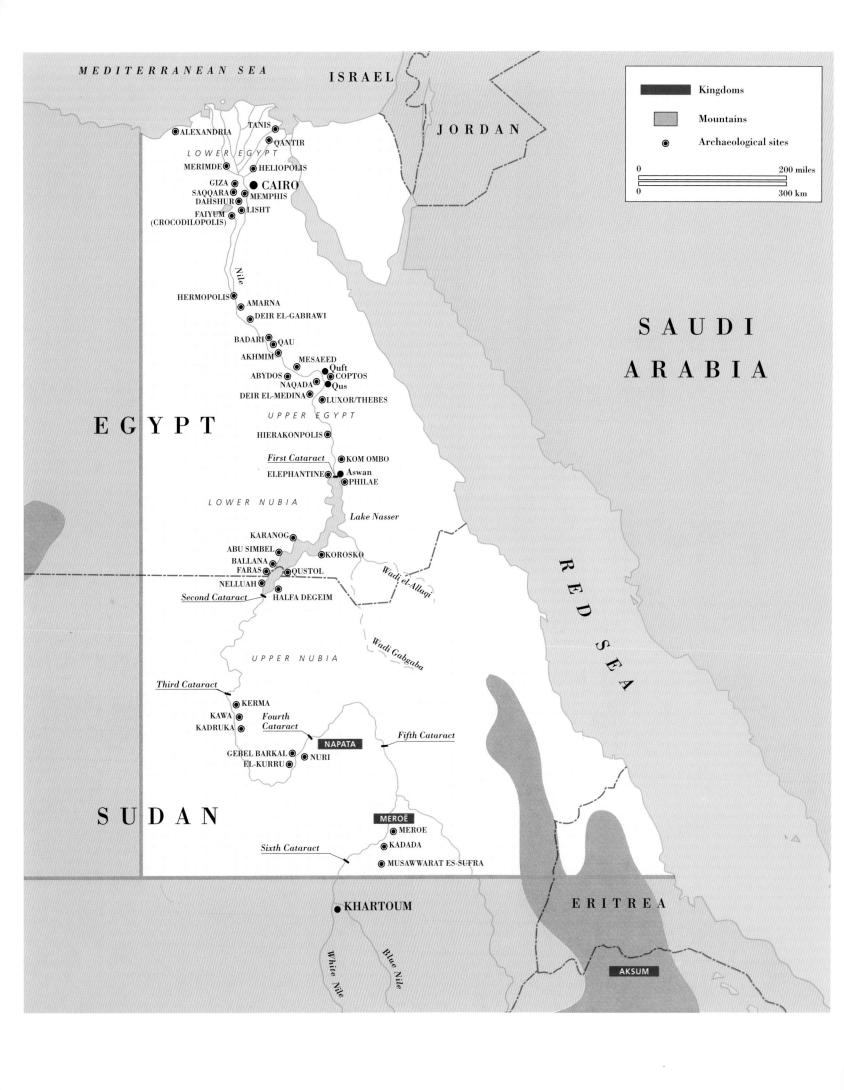

MEDITERRANEAN SEA

ISRAEL

JORDAN

Kingdoms

Mountains

Archaeological sites

0 200 miles
0 300 km

⊙ALEXANDRIA TANIS
 ⊙QANTIR
LOWER EGYPT
MERIMDE⊙ ⊙HELIOPOLIS
 GIZA⊙ ●CAIRO
SAQQARA⊙ ⊙MEMPHIS
DAHSHUR⊙
 FAIYUM⊙ ⊙LISHT
(CROCODILOPOLIS)

Nile

HERMOPOLIS⊙
 ⊙AMARNA
 ⊙DEIR EL-GABRAWI

 BADARI⊙ ⊙QAU
AKHMIM⊙
 ⊙MESAEED
 ⊙Quft
ABYDOS⊙ ⊙COPTOS
 NAQADA⊙ ⊙Qus
DEIR EL-MEDINA⊙
 ⊙LUXOR/THEBES

UPPER EGYPT

HIERAKONPOLIS⊙

First Cataract ⊙KOM OMBO
ELEPHANTINE⊙ ●Aswan
 ⊙PHILAE

LOWER NUBIA

Lake Nasser

KARANOG⊙

ABU SIMBEL⊙
 ⊙KOROSKO
BALLANA⊙
FARAS⊙ ⊙QUSTOL
NELLUAH⊙
Second Cataract HALFA DEGEIM

EGYPT

Wadi el-Allaqi

RED SEA

SAUDI
ARABIA

UPPER NUBIA

Wadi Gabgaba

Third Cataract

 ⊙KERMA
KAWA⊙ Fourth
KADRUKA⊙ Cataract
 Fifth Cataract
GEBEL BARKAL⊙ NAPATA
EL-KURRU⊙ ⊙NURI

SUDAN

MEROË
 ⊙MEROE
 ⊙KADADA
Sixth Cataract
 ⊙MUSAWWARAT ES-SUFRA

●KHARTOUM

ERITREA

White Nile

Blue Nile

AKSUM

1 ANCIENT EGYPT AND NUBIA

ANCIENT EGYPT

Edna R. Russmann

The art of Ancient Egypt is the art of a people who tended to think in terms of concrete, graphic images. Throughout their history, they persisted in using the original pictorial forms of hieroglyphic writing, often carving or painting them in great detail, despite the fact that scribes had long since developed more abstract scripts that were much easier and faster. Hieroglyphic forms were retained partly because they were sanctified by religious tradition; but they also satisfied a deep-rooted taste for pictorial imagery. Thus, more than in most societies, Egyptian art was a vital expression of its culture.

It was a religious art, the visible focus for a complex system of beliefs and practices, many of which were based on magic: in the earliest periods, this magical element was particularly predominant. The objects placed in a grave were believed to be magically at the disposal of the deceased in the afterworld; images of people and animals in the tomb would accompany and serve him or her. Temple images had the same magical life; the bound captive carved on the socket of a temple door was believed to suffer real agony every time the door post inserted in his back was pivoted open or closed (cat. 1.24).

Much Egyptian art was made for tombs and was never intended to be seen again by the living. In the temples, the most precious works of art were hidden in the innermost chambers, accessible only to a few high-ranking priests. None the less, there is a distinct public element to the art of Ancient Egypt. Many of its most spectacular creations, clearly designed to impress, were placed where they would be widely seen. Such considerations may have influenced the size and siting of the Giza pyramids and Great Sphinx (fig. 1). They certainly encouraged the use of monumental scale and rich decoration on temple façades, the soaring obelisks and colossal statues that flanked their entrances. Considerations of this kind come

Fig. 1 The sphinx and pyramids at Giza

Fig. 2 Abu Simbel: view of façade of main temple

very close to modern ideas of propaganda in monuments such as the famous temple of Abu Simbel, with its gigantic statues of Ramses II. Situated on the Nile some distance south of Egypt's southern border, this monument was planned, in part, to intimidate travellers approaching the land of this mighty king (fig. 2).

Artistic production was so fully integrated into a religious context that Egyptians never felt the need for a specific word for art. In a similar spirit, Egyptian artists almost never signed their work, for it was not, in any real sense, 'theirs'. Anonymous though they may be to us, however, the builders, sculptors, painters and fabricators of Ancient Egypt were well known to their contemporaries. Artists were judged by the quality of their work; the best of them worked for the king and on the great temples.

Few societies have been more resistant to change than that of Ancient Egypt. This deliberate conservatism is very apparent in their visual culture. Whenever possible, the Egyptians would respond to change by ignoring it; alternatively, aspects of change would be 'corrected' by reference to examples from the past. A striking example of such a correction occurred during the New Kingdom (1550–1069 BC) in the aftermath of the Amarna period. Not only was the memory of the heretical king Akhenaten expunged from official records, but the visible evidence of his reign was destroyed: his temples and statues were dismantled and their remains hidden; the distinctive new style in which they had been made was repudiated. The style of temples, wall decoration and statuary made in the years after the Amarna period reflects a conscious attempt to return to that of the time of Akhenaten's great predecessors, Amenhotep III and Thutmose III. Evidence of archaism – the deliberate imitation or evocation of earlier styles – can be found in every major period of Egyptian art, most notably during the Late period (664–332 BC).

The fact that tombs and temples were the focus of Egyptian art did not inhibit artists from expressing humour, generally at the expense of the labourers and semi-skilled craftsmen who were their social inferiors (cat. 1.58–9). For those who could afford it, enjoyment of art was an important part of life. The many personal items that people treasured and caused to be placed in their tombs – jewellery and fine vessels, furniture and clothing that they had actually used – showed the pleasure they took in beautiful, elegant and rare objects. It is important to note, however, that the symbolic forms and decoration of such things show that they were often designed to serve the added function of magical protection for their owners, both in this world and the next (cat. 1.31,33–4,53).

The culture of Ancient Egypt was a single entity that spanned more than five millennia. Its rise and development were closely linked to its geographical situation at the north-eastern corner of Africa, where the Nile flows unimpeded from the cataracts at Aswan, north to the Mediterranean Sea. It was, as it still

is, a subtropical land with little rainfall, but the annual flooding of the Nile provided an almost unparalleled reliability for early methods of agriculture. This huge natural advantage helps to explain Egypt's emergence as one of the earliest complex societies. The Nile also provided efficient, fairly rapid transport and communication, indispensable to the government of this long, narrow land. Egypt's natural boundaries – the cataracts that interrupt the river at Aswan in the south, the sea to the north, and the deserts on the east and west – protected the land from invasion and left it free, through most of its ancient history, to develop along its own lines.

From beginning to end, Ancient Egypt was essentially an indigenous culture. It is not known when the area was first settled, or where the people came from, but communities along the Nile were well established by earliest predynastic times. As in most early societies, pottery-making was a major craft, and the main stages of predynastic development have been defined primarily in terms of their increasingly sophisticated ceramic production: the fine, rippled-wares of the Badarian period (c. 4500–4000 BC; cat. 1.7), the attractive, often inventive white-painted redware vessels of the Naqada I period (c. 4000–3600 BC; cat. 1.8); the red-painted buffware of Naqada II (c. 3600–3200 BC), decorated with subjects that are often more elaborate, but also more standardised, than before. Only in the latest stage, Naqada III (3200–3000 BC), does stone sculpture and relief really begin to come into its own (cat. 1.18) but throughout the predynastic period, as in all later Egyptian art, some of the finest objects are statues representing the human figure, in ivory (cat. 1.1–2,20c), clay (cat. 1.3–4), wood and stone (cat. 1.6,19). Most of these early figures are extremely stylised, but some are quite naturalistic in their depiction of maternal poses (cat. 1.2) and even physical deformity (cat. 1.20c).

Although they were originally independent settlements, predynastic communities had considerable contact, to judge from the similarity of pottery, figurines and other objects found at different sites. In time, some of the more powerful centres began to exert control over their neighbours, a process which accelerated during the later part of the period. Representations of fighting on many objects made towards the end of the predynastic period suggest that expansion was achieved at least partly through military conquest (cat. 1.18), although the rapid development of the arts and the beginnings of hieroglyphic writing in this same period give evidence of intense cultural activity. Even if the battle scenes are exaggerated, the late predynastic wars among Egyptians and perhaps also with foreigners helped to define the role of the king as protector of his land and guardian against all evil which, throughout Egypt's subsequent history, was graphically symbolised by the representation of bound and helpless captives (cat. 1.24,35).

The dynastic period began about 3100 BC, with the unification of the whole of Egypt and the establishment of the 1st Dynasty, under the semi-legendary King Menes. Menes is also credited with the founding of Memphis, Egypt's great capital near the strategic juncture of the Nile Delta and Nile Valley (very near modern Cairo). The art of the first two dynasties continued the forms and traditions of the latest predynastic period, but was notably more ambitious, producing large-scale stone sculpture and massive funerary architectural complexes, in which stone began to be used as a building element.

A burst of creativity in the first part of the Old Kingdom established the basic artistic conventions that were to govern Egyptian art for the rest of its history. Early in the 3rd Dynasty (c. 2700 BC), the Step Pyramid, the first monumental stone structure, was built in the Memphite cemetery of Saqqara for King Djoser, whose sculptural and relief representations, though still somewhat stiff and archaic in style, show the beginnings of portrait likenesses. These achievements were consolidated and surpassed in the 4th Dynasty (c. 2613–2494 BC). This is the age of the huge stone royal pyramids and the Great Sphinx at Giza, near Memphis (fig. 1). The Great Sphinx, one of the first of the human/animal composites so characteristic of Egyptian art, established a tradition of colossal sculpture, while the

increasing sophistication of portraiture in the statues of the kings and their courtiers (cat. 1.25,30) was matched by the development of a convincing, though highly idealised, way of representing the human form. These traditions continued throughout the rest of the Old Kingdom; pyramids were smaller, but the increasing use of relief as wall decoration encouraged sculptors to portray complicated scenes in a vivid manner. With the 6th Dynasty (*c.* 2345–2181 BC), sculptural forms became much less naturalistic and more expressive: the musculature of the body was suppressed in favour of emphasis on an unnaturally large head dominated by huge eyes. This style was to persist into the first years of the Middle Kingdom (cat. 1.28).

The Old Kingdom collapsed under the weight of political and economic problems that degenerated into civil strife and episodes of famine. The Middle Kingdom (*c.* 2055–1795 BC) began with the reunification of Egypt achieved by Mentuhotep II, a prince of the southern city of Thebes (modern Luxor). His dynasty, the 11th, was short-lived; the first king of the 12th Dynasty (1985–1955 BC) moved his capital north, probably to be near Memphis. Here, the royal artists had access to the imposing works of the Old Kingdom and, under their influence, once again built pyramids for the burial of their kings and created a suavely naturalistic style of sculpture and relief. Late in the dynasty, under Senusret III (*c.* 1874–1855 BC), portraiture was reintroduced in statues representing this king (fig. 3) and his successor, Amenemhat III (*c.* 1854–1808 BC). Unlike those of the Old Kingdom, however, these Middle Kingdom portraits convey a strong impression of weary or disillusioned age.

The Middle Kingdom was brought to an end by the conquest of foreigners from the east, the Hyksos, an episode terminated by a military revolt led by princes from Thebes. Their remarkable family, the 18th Dynasty (*c.* 1550–1295 BC), dominated the first part of the New Kingdom (*c.* 1550–1069 BC). Members of this dynasty include the female King Hatshepsut, the military genius Thutmose III, whose extensive conquests in the east and the south established Egypt as the great imperial power of its day, and the magnificent, self-aggrandising Amenhotep III. Much of the enormous wealth that poured into Egypt during the New Kingdom was lavished on the building and furnishing of great temples such as Karnak, and on the kings' funerary establishments which, in this period, consisted of vast underground tombs in the Valley of the Kings, and separate funerary temples of a magnificence that rivalled the temples of the gods. Much wealth was also at the disposal of the upper ranks of priests, officials and military men, who spent it on their own impressive tombs, on extravagant fashions and on some of the most luxurious and engaging decorative objects ever made (e.g. cat. 1.43).

The ferment of new ideas under Amenhotep III, developed by courtiers with great sophistication and much leisure, and perhaps influenced in part by the many foreigners now in Egypt, took a curious turn in the reign of his son, Amenhotep IV. Soon after coming to the throne, the new ruler changed his name to Akhenaten and took up residence at a new city, Akhetaten. The modern name of this site, Amarna, has given its name to the entire period of his reign (*c.* 1352–1336 BC). Akhenaten's moves were part of his attempt to impose a new religion centred on worship of the sun-disc (the Aten), which he intended should replace the many cults of the traditional gods. It is entirely characteristic of Ancient Egypt that these radical religious ideas were accompanied by almost equally revolutionary changes in the style of art. It was an art of exaggeration, centred on Akhenaten's own image which showed him with a grotesquely elongated head and jaw, and an almost female fleshiness of body. These features were also imposed on his queen, Nefertiti, and the couple's six daughters. At Amarna, however, they were softened into a more attractive, naturalistic form (cat. 1.44–5) probably under the influence of the only great Egyptian artist whose name we know, the sculptor Thutmose.

At Akhenaten's death, his religion was repudiated, and with it his artistic canons. The greatest king of the later New Kingdom, Ramses II (*c.* 1279–1213 BC), was a great builder of temples which were adorned

Fig. 3 Statue of Senusret III
grano-diorite, h. 122 cm
The British Museum, London, EA 686

with numerous statues of the king, often on a colossal scale. Egypt was still an empire, but its power began to dwindle under his successors of the 19th and 20th Dynasties (*c.* 1213–1069 BC), by virtue of the twofold pressures of struggles within the royal family and the rising power of neighbouring states.

Once again, Egypt's government and economy broke down. The next reunification, at the start of the Late period, was imposed by the conquering Kushites from the south, who formed the 25th Dynasty (*c.* 747–656 BC). The rest of Egypt's dynastic history is a succession of native dynasties, interspersed with conquests by the Persians and the Assyrians. Finally, following the conquest in 332 BC by Alexander the Great – who was welcomed by the Egyptians because he drove out the hated Persians – Egypt came under the rule of a dynasty founded by Alexander's general Ptolemy. The long period of Ptolemaic rule (305–30 BC) was ended when Cleopatra VII and Mark Antony were defeated by Augustus Caesar, who incorporated Egypt into the Roman Empire, not as a province, but as an imperial possession. During all these centuries, Egyptian art maintained its vitality, the cultural tradition was still strong and it was re-inforced by continual reference to art of the Old, Middle and New Kingdoms. Archaism is a major factor in art of the Late period; in some cases, we can see actual copying from earlier monuments (cat. 1.60).

This brief discussion of Ancient Egypt's history and art has necessitated many references to foreigners. Natural boundaries were distinct, but they were never so strong as to prevent constant movement among and contact with surrounding peoples: the Egyptians themselves were often tempted to campaign abroad, and their prosperity was an even greater magnet for people from all the surrounding lands. Some foreigners came to trade, others to stay. All had some impact on the culture, although these contributions, being largely intangible, are extremely difficult to evaluate.

The most constant – and probably, overall, the most important – contributions to Egyptian culture came from the south, particularly from the adjacent area now known as Nubia. During predynastic times, the settlements along the Nile both north and south of Aswan may even have formed a sort of cultural continuum. Throughout the dynastic period, Nubians were constantly arriving in Egypt, some as captive slaves, but many as voluntary immigrants who established themselves as soldiers, agricultural workers and household servants (cat. 1.43). Some of them moved to the top of Egyptian society. In the early Middle Kingdom, the wives of Mentuhotep II included at least three Nubian women; and the founder of the next dynasty, Amenemhat I, is said to have had a Nubian mother. As the 'African' features of a royal daughter-in-law of the Old Kingdom (cat. 1.25) suggest, these were certainly not isolated cases. Reliable documentation, however, is almost non-existent, and theories about the Nubian ancestry of other specific Egyptian kings and queens are almost entirely speculative. Contact between Nubians and Egyptians increased during the Middle and New Kingdoms; eventually Egypt's control over Nubia was intensified to an almost colonial form of occupation. Many Egyptian temples were built throughout Nubia, and some Nubians were schooled in Egyptian practices. In the 8th century BC, long after the collapse of the New Kingdom and Egypt's withdrawal from Nubia, an Egyptianised ruling family from Nubian Kush took advantage of a weakened Egypt to invade and rule as the 25th Dynasty. The Kushite kings made no pretence of being Egyptian, but they claimed full pharaonic legitimacy by the grace of the Egyptian gods, particularly Amun, whose worship was well established in their homeland. Their claim appears to have been accepted by many Egyptians, especially in the south.

The Egyptians often skirmished with the peoples of the Libyan desert, to the west. Like the Bedouin herdsmen of the eastern desert, Libyans sometimes sought refuge in Egypt during times of famine; such refugees, on the verge of starvation, were represented in some royal tombs of the Old Kingdom. Libyans also enlisted in the Egyptian army, and many of them eventually settled in the western Nile Delta, from which their descendants began to rule parts of Egypt and finally the entire land as the 26th Dynasty (664–525 BC).

Some of the most visible contributions to Ancient Egyptian culture came from the lands to the east. During the late predynastic period, contacts with the emerging civilisations of Sumeria and Elam (modern Iraq and Iran) seem to have provided a stimulus to writing and the arts at this crucial time in Egypt's development. In dynastic times, eastern traders were regular visitors. At the end of the Middle Kingdom, eastern warriors managed to impose themselves as the Hyksos kings of Egypt. The powerful kings of the New Kingdom conquered much of the civilised east. Late in Egypt's history, the tables were turned again as the Achaemenid Persians, then the Assyrians, then again the Persians conquered and ruled or looted the land. Whatever their nature, all these events left their mark on Egyptian art: ideas and decorative motifs were borrowed from the east, and probably also knowledge of the techniques for working with bronze and glass.

Minoans and Myceneans from the north were represented in Egyptian paintings of the New Kingdom; their pottery, and even fragments of their wall-paintings, have been found in Egypt, and their spiral and meander patterns were incorporated into Egyptian art. Much later, during the 6th century BC, Egyptian canons influenced Greek art. At the end of its history, under the Ptolemies and especially under the Roman emperors, Egypt was gradually but inexorably drawn into the orbit of an emerging new world order.

NUBIA

Nubia is in Africa, is part of Africa, and has been essentially African in Antiquity as it is today. Therefore it is surprising how art historians, much more than anthropologists and traditional historians, have overlooked this rich field of painting and sculpture. If anything, they have stressed the connections with Egypt, Egyptian influence, the Egyptianizing derivatives found in abundance in Nubia and the northern Sudan. Instead it is now essential to search under the stratum of antiquities which show an affinity with Egypt for the native element which can truly be called Nubian and to formulate from this material a new chapter of art history, of African art history.

Lásló Török

In these sentences Bernard V. Bothmer, the organiser of the first great exhibition of Nubian art in 1978, gave clear expression to what historians and archaeologists dealing with the ancient cultures of the Middle Nile Region – i.e. Lower Nubia between the first and second Nile cataracts, Upper Nubia between the second and sixth Nile cataracts, and the northern Sudan – had begun to feel, and had tried to explain, ever since the first great archaeological discoveries were made in the course of the UNESCO Nubian Salvage Campaign in the early 1960s. This generation of scholars was participating in the greatest rescue campaign in the history of modern archaeology: the investigation of the Lower Nubian Nile Valley from Aswan to the second Nile cataract before it was submerged by the waters of the new Aswan High Dam, and the saving of the monuments of the area – among them the temples of Abu Simbel and Philae. They realised at an early stage of the work that, though deeply influenced by the powerful northern neighbour, Nubian culture was a genuine expression of indigenous experience and perceptions.

Thirty years later, students of the Middle Nile Region regard Ancient Nubia more as a rival than a dependent of Egypt; the Nubian adoption of the vocabulary of Egyptian civilisation is interpreted as having been a means of giving more precise formal expression to Nubian religion and state ideology.

From the colonial presence of Egypt in Ancient Nubia, interest has shifted to the investigation of the vestiges of Nubian social structures, institutions and intellectual achievements as they may survive in the historical and archaeological record. New confidence in their subject has inspired scholars of Nubian history to create from the fragmentary evidence a different picture, showing now an ethnic and cultural continuity through the millennia of alternating independent and colonial periods, instead of reconstructing, as their predecessors did, alternating cycles of Egyptianisation and cultural decline in the absence of Egyptian impetus. While old clichés about Nubia's cultural subordinacy and the imitative character of Nubian art have been abandoned, it has also become clear that the genuine features of Nubian culture cannot be understood without appreciating their relation to Egyptian ideas, conceptual and stylistic inspirations, influences and imports. The investigation and apperception of the arts of Nubia as a province of African art history does not mean a denial of the impact of the northern neighbour but requires instead the analysis of the interaction between Egyptian and Nubian cultural achievements.

The history of Nubian–Egyptian contact is determined by the geographical situation, which explains the similarities in their historical development as well as the conflicts between them. Life in both Nubia and Egypt depended entirely on the waters of the Nile. Each also needed the gold and other material resources of the desert area east of Upper Egypt and Nubia as well as the exotic wares to be acquired from the interior. Nubia as a trading corridor and entrepreneur was vitally important for Egypt; the management of commerce between Egypt and the Mediterranean world on the one side, and the interior of Africa on the other, continued to determine the relationship of the two countries and explains their constant struggle for political control over stretches of that corridor. A further important factor in their contact was, from the Egyptian Old Kingdom onwards, the expansionist nature of the Egyptian state which was primarily based on the ideology of universal regency and not, as 19th-century rationalism would have it, economic interest.

The inhabitants of prehistoric Upper Nubia were nomadic cattle herders who did not live in permanent settlements. Around 3500 BC and in the subsequent centuries the Lower Nubians developed a sedentary agriculture based on flood irrigation, similar to that of Egypt. They came to live in increasingly complex and expanding chiefdoms. Around 3100 BC, in the period when in Egypt the political unification of the country was being achieved, Lower Nubia seems to have been united into a powerful chiefdom whose rulers were buried for several generations in the same monumental cemetery at Qustol. They were in contact with Egypt and borrowed Egyptian symbols of royal power (e.g. maces), decorating them with symbolic figures of animals. Their pottery production included fine vessels with extremely thin walls and painted geometrical decoration (cat. 1.76), indicating that they were prestige objects rather than artefacts of daily use. Early 1st-Dynasty Egyptian aggression drove out the Lower Nubians from their land in order to gain direct control over the trade corridor leading to the sources of gold, minerals, precious stones and African wares. The towns built by the Egyptian conquerors became the agents of the Egyptianisation of material culture when Nubians started to return to Lower Nubia around the middle of the 3rd millennium BC.

In Upper Nubia a powerful chiefdom with its centre at Kerma began to emerge in the course of the second half of the same millennium. Contemporary with the Egyptian Middle Kingdom and Second Intermediate period (c. 2055–1550 BC), the Kerma chiefdom developed from a tribal society into a real state with a social stratification comparable with that of Egypt. This was a centralised state structure extending over increasingly large areas of Upper Nubia and was in control of Lower Nubia as well from around 1650 BC. Its capital was the earliest settlement in Africa south of Egypt which may be termed a city. In the Classic Kerma phase (c. 1750–1580 BC) its core was enclosed by fortified walls about 10 metres high with four gateways, and was dominated by monumental edifices serving the cults, royal representa-

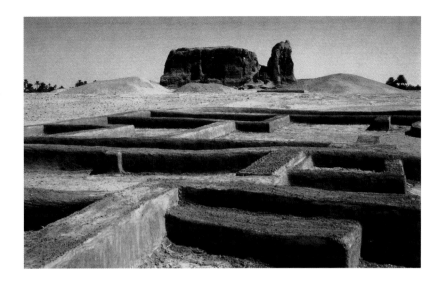

tion and centralised economy (fig. 4). In the centre stood the royal residence, a large temple and a circular building. The latter was erected of wood and mudbrick with a diameter of *c.* 16 metres, doubtless a royal audience hall: the monumental version of an African house type. The temple, occupying 1,400 square metres, also reflects indigenous developments and an independence from the influence of Egyptian architecture. It was a solid brick mass with a stairway leading up to a long, passage-like sanctuary with an altar of stone and with a further stairway to the temple roof. The great cemetery of Kerma east of the city contained royal burials of an enormous size (average diameter over 80 metres), with an earth mound covering a funerary chamber, storerooms and the burials of hundreds of sacrificed attendants. The kings and élite were buried on wooden beds with artefacts of partly Egyptian origin. The mound-covered royal tomb represents a monumental variant of an ancient tomb type of the Middle Nile Region and may be regarded ideologically as well as architecturally as a counterpart of the Egyptian royal pyramid. Two mortuary cult temples in the cemetery show the influence of Egyptian architecture and are, among other features of the city's culture, a testimony to the presence of Egyptians. Their ritual use differed greatly, however, from that of the Egyptian equivalents.

While techniques such as the manufacture of faience objects were adopted from Egypt, other industries had indigenous origins as, for example, the carving of ivory inlays for the footboards of the funerary beds. The small inlays (about 5–10 centimetres high) represented animals and mythical creatures. Some of the motifs indicate the spread of Egyptian popular beliefs (rather than the official cult of deities), and the animals and birds, though their rendering shows Egyptian influence, are all taken from African fauna. Copper daggers, knives and mirrors display unmistakably Nubian forms, and clay figurines of animals and human beings and zoomorphic pottery vessels reflect types of sculpture in the round which, remaining completely untouched by contemporary Egyptian art, seem to represent an unbroken tradition from prehistoric figures that are thought to have had religious significance (cat. 1.72–3).

The highest achievement of Kerma art was without question its distinctive pottery (cat. 1.77). The sophistication of the manufacturing technique of the extremely thin-walled, black-topped, red-polished vessels, the elegance of the tulip-formed, oval or long-spouted spherical vessels, the playfulness of cup types with ribbed or corrugated walls all point towards the origins of this industry in royal workshops. Though products of a court, they were nevertheless manufactured, as prestige objects, in considerable quantity. Thus being widely distributed, the fine Kerma pottery wares provide an example of the standardisation of a high level of technology and, what is equally significant, the cultural influence of a court art exerted through the medium of artefacts of general daily use.

With the restoration of central power after the troubled times of the Second Intermediate period, Egypt set out to crush her wealthy rival at Kerma and regain control over the resources of Nubia. After almost a century of strong resistance by the Nubians, by the middle of the 15th century BC Egypt had conquered Nubia and established her domination as far south as the fourth Nile cataract. In the course of the next four centuries, Nubian culture was substantially Egyptianised, although important elements of native social structure and culture survived. In the shadow of the monumental Egyptian cult temples erected in Nubia during the New Kingdom (1550–1069 BC), native mortuary religion persisted and Nubian gods merged with Egyptian divinities.

The Egyptian domination collapsed in the early 11th century BC and a native kingdom grew from its ruins around the early 10th century BC. The ties of the new indigenous state with both the native traditions surviving under Egyptian domination and the Egyptianised vocabulary of government and cultural self-expression of the preceding centuries are obvious. By the 8th century BC the Nubian rulers were overlords of a vast kingdom extending from the first Nile cataract to the region of the sixth, organising it with the help of an ideology in which pharaonic kingship dogma and religious concepts were intertwined with native traditions. Taking advantage of a divided Egypt, the rulers of Nubia, encouraged by the powerful priesthood of the Theban Amun, conquered Egypt and succeeded in re-establishing her political unity for almost a whole century (c. 747–656 BC) during which they combined rule over their native land with rule over Egypt.

Fig. 5 Sphinx of King Taharqo,
25th Dynasty, granite, height 40 cm
The British Museum, London, EA 1770

Nubian culture was Egyptianised; the language of expression was Egyptian, literally so in the case of monumental royal inscriptions and other texts, and stylistically in the case of architecture, sculpture, relief and the minor arts. New temples modelled on Egyptian New Kingdom buildings were erected in various centres, the most important being those dedicated to the Nubian counterpart of the Theban god Amun in the temple-towns centred around royal residence-temple compounds. A hieroglyphic inscription even informs us of the work of Egyptian sculptors from Memphis in one of the most spectacular temples (Kawa, Amun temple of King Taharqo). In their kingship ideology Nubian rulers amalgamated the concept of the king as maintainer of order in the cosmos and the world (related to the imperial past of Egypt) with a more recent interpretation of the king's dependence on the favour of the gods. Their new, eclectic kingship dogma also greatly influenced the attitude towards the themes and styles of earlier periods of Egyptian art.

While the period of Nubian rule over Egypt and the subsequent 'Napatan' period (c. 664 BC–the mid-4th century BC) represent indeed the most profoundly Egyptianised centuries of Nubian culture, it must be emphasised that the most intense Egyptianisation occurred during the century when Nubian kings ruled Egypt, and not in a period when Nubia was under the Egyptian thumb. This must be realised if the pattern of the interaction of the two cultures is to be understood; and it also has to be stressed that the adoption of the Egyptian cultural vocabulary served the articulation of a culture that made an organic unity of Nubian and Egyptian traditions and experiences.

Works of architecture, monumental sculpture and reliefs continued to be executed under the impact of the eclectic style that emerged in the 7th–6th centuries BC (cat. 1.77,79; fig. 5). In the repertoire of themes, however, Nubian gods and the pictorial aspect of Nubian kingship came increasingly to the fore. Two periods of intense contact with Egypt – preceded by major military conflicts – in the early Ptolemaic period (in the 3rd century BC), and then at the beginning of Roman rule (from the late 1st century BC to the late 1st century AD), brought new stylistic influences and an influx of architects, sculptors and artisans. The influence of Hellenistic Alexandrian sculpture explains, however, only partly the creation of a water sanctuary complex at Meroe City in which Nubian renderings of classical sculptures were erected side by side with Egyptianised and Nubian divine figures. The iconographical programme of the water

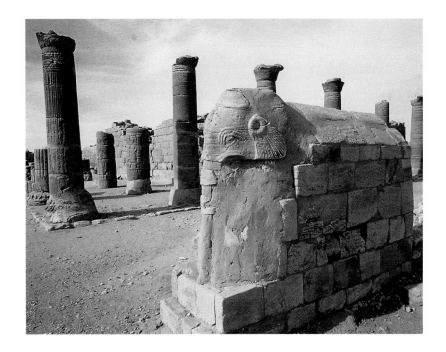

Fig. 6 Remains of a royal building in the 'Great Enclosure' at Musawwarat es Sufra, with a statue of an elephant in the foreground

sanctuary sculptures was derived from the representation of the Ptolemaic king as Dionysus with his entourage and from the depiction of the Nubian royal ancestors as fertility gods. The apparently heterogeneous ensemble was unified by the closely related religious and political significance of its individual elements.

Between the 3rd and 1st centuries BC there was considerable urban development. In the walled enclosure of central Meroe City, in the southern part of the kingdom, palaces for the aristocracy and high priesthood were built. These had an Eastern Greek-type ground-plan, unknown in Egypt (except for Alexandria), and were decorated with polychrome faience tiles and Hellenistic architectural elements. Initially in the 2nd century BC, and then in the 1st–2nd centuries AD, monumental avenues were opened through the city to connect the royal residence with the temples. The later avenue was flanked by smaller sanctuaries of different, partly traditionally Nubian, partly Ptolemaic-Egyptian, types. Other urban settlements, presumably of a similarly planned character, await scientific excavation. A desert palace of the kings of Meroe at Musawwarat es Sufra, going back to 5th-century BC origins, was decorated with monumental architectural sculptures of unparalleled types, displaying Nubian artistic invention at its apogee: columns with relief scenes supported by figures of lions and elephants, walls terminating in monumental elephant figures (fig. 6), bold relief images of divinities flanking doors, and sculptured protomes of divine triads decorating door lintels (cat. 1.80). Audience halls and cult chapels in the vast palace were erected on high podia and interconnected by ramps and long corridors. While the architectural plan and some of the details betray a remote Egyptian influence, the whole of the ensemble reflects one of the remarkable moments in the development of Nubian art when a special function – in this case the desert palace of the ruler who was identified with the Nubian hunter and warrior gods – generated new structural and formal solutions.

Meroitic vase painting also emerged as an art form during this period. In the early phase (2nd– 1st centuries BC) Nubian potters worked under the influence of Upper Egyptian workshops, which in turn absorbed inspirations derived from Hellenistic-style luxury wares from Alexandria. In the course of the 1st century BC and the 1st century AD, however, Nubian artists developed a variety of painting styles based on a bold interpretation of traditional Nubian motifs – mostly religious symbols – and Hellenistic patterns. The finely executed decoration usually covers the whole surface of the superbly wheel-turned vessel; and the polychromy of the painting reflects a genuine development, independent of any Egyptian

influence. Workshop styles and even individual hands are clearly distinguishable in the surviving large ceramics traded originally to all parts of Nubia and reflecting, as in Kerma pottery, the impact of court art on the taste of the whole population.

The contribution of Roman Egyptian art is manifest in the fine pottery produced from the late 1st century BC, mainly at the royal manufactories at Meroe City, in which Nubian technology and Eastern and Western Mediterranean vessel shapes and decorations were united with the traditional late Ptolemaic Egyptian decorative style to form a homogeneous and unmistakably Nubian ceramic art. As in earlier encounters with Egyptian art, Nubia used borrowed forms and styles in order to articulate indigenous discoveries and concepts. The same sort of cultural interaction continued to take place in the course of the subsequent centuries when Nubia received the remote echo of Late Antique art and also when, after the Christianisation of the country in the 6th century AD, churches were erected all over Nubia. These are richly decorated with frescoes and display again the results of a fruitful amalgamation of Coptic Egyptian and Byzantine models with Nubian iconography and the functional demands of Nubian church liturgy.

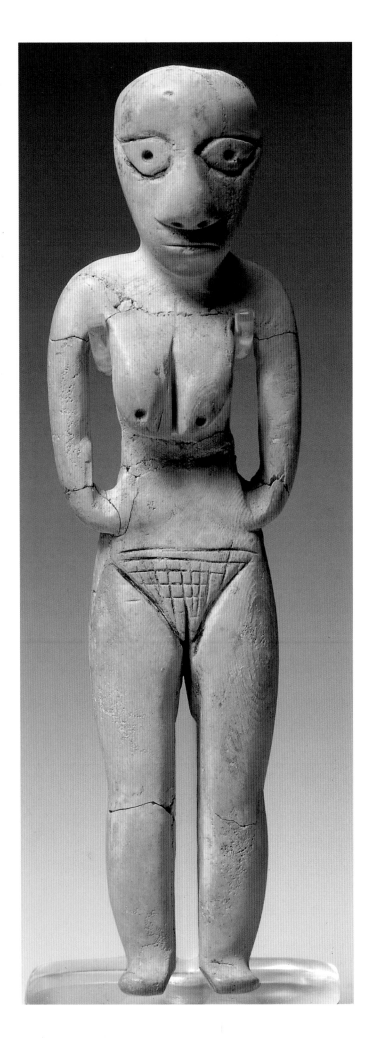

1.1

Female figurine

Egypt
predynastic, Badarian, *c.* 4500–4000 BC
hippopotamus ivory
14.3 x 4 cm
The Trustees of the British Museum,
London, EA. 59648

The remarkable face with its huge almond-shaped eyes, large triangular nose and small slit of a mouth belongs to one of the oldest human figures in the round known from Egypt. The great attention given to details and the evocative, if somewhat robust, modelling show that the Badarians, the first settled inhabitants of the Nile Valley, were already highly skilled craftsmen, adept in the use of carving, incision, drilling and polishing.

Within the disproportionally large, bald and slightly off-centre head, details of the face have been indicated with care: the incised eyes have drilled pupils; the modelled nose has large drilled nostrils; the thin lips and small chin are well realised. The body is skilfully smoothed and polished. From the bent and slightly sloping shoulders, two separately carved arms hang down the side of the body and merge with the hips without any indication of hands. Each leg is carved separately and ends in a small out-turned foot.

Long pendulous breasts, set unequally with a crudely incised line dividing them, and the wide incised and cross-hatched pubic triangle with a deep vertical incision for the vulva serve to indicate the sex. Unlike many female statuettes of the predynastic period, these elements are not accompanied by other attributes of the idealised female anatomy. The somewhat flattened buttocks protrude only slightly, perhaps owing to the nature of the medium; nevertheless, the exclusively feminine lumbar dimples have been carefully placed at the base of the back and expertly drilled. It is possible that the drilled nipples, like the eyes and the pupils, may originally have been inlaid with coloured paste or shell.

The statuette was found in a heavily plundered grave which contained in addition only a polishing pebble and some beads, but no remnant of the tomb owner's body. As a result, its purpose or function, whether as representative of the deceased, as servant or as goddess, remains uncertain. *RFF*

Provenance: 1924–5, Badari grave 5107, excavated by Guy Brunton

Exhibition: London 1962

Bibliography: Brunton and Caton-Thompson, 1928, pp. 7, 29, pl. xxiv.2, xxv; Petrie, 1939, pl. iv.46; Vandier, 1952, pp. 221–2, fig. 141; Ucko, 1968, p. 70, fig. 2; Spencer, 1993, p. 25, fig. 9

1.2

Mother and child

Egypt
late predynastic/Naqada III, *c.* 3100–3000 BC
ivory
h. 7.5 cm
Staatliche Museen zu Berlin, Preussischer
Kulturbesitz, Ägyptisches Museum und
Papyrussammlung, 14441

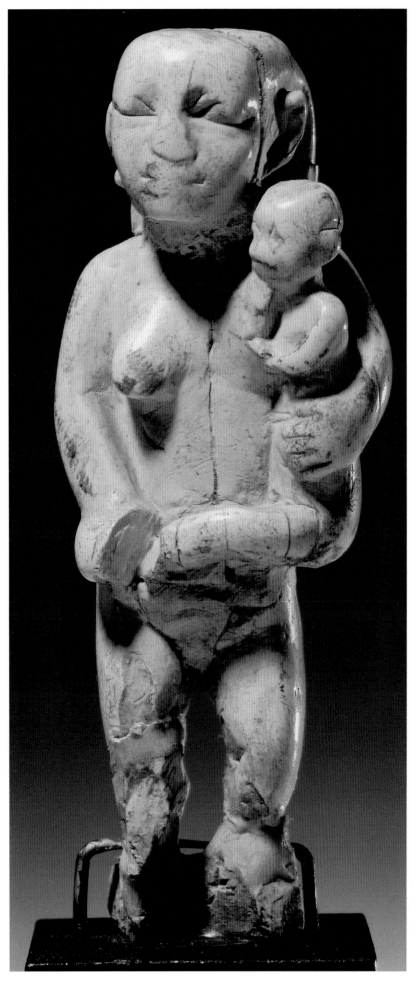

At different epochs Egyptian tombs contained as part of the funerary equipment small figurines of naked women, often called 'concubines of the dead'. No doubt they were a guarantee of fertility in the afterlife, since many of them are combined with figures of children. This ivory figurine is one of the early examples of this type, showing a standing naked woman. Her left arm holds a baby sitting on her left hip, its legs clasping the body of the mother. The only iconographic detail is the long hair falling on her shoulders and back, leaving the forehead completely bald. This coiffure is typical of pregnant women and mothers.

Notwithstanding the lively posture of this statuette, the principles of Egyptian art are already applied: frontality, axial symmetry, expressionistic exaggeration of the essential part of the motif. One key element of the plasticity and the volume of this statuette must not be overlooked – the rectangular basis, partly preserved at the back of the sculpture. It creates an imaginary, virtual space around the figure, defines its orientation and makes it a part of the cosmic order. *DW*

Provenance: 1900, acquired by the museum

Exhibition: Berlin 1990, no. 5b

Bibliography: Smith, 1949, p. 3, fig. 4; Wolf, 1957, p. 53, fig. 18

1.3

Female figurine

Egypt
predynastic, Badarian, *c.* 4500–4000 BC
fired clay, ochre wash
11 x 4.6 cm
The Trustees of the British Museum,
London, EA. 5964

This charming figure is not only an exceptionally fine example of the Egyptian ideal of feminine beauty, but also one of the earliest. Complete except for the head and the bottom of the legs, the figurine was found in the fill of a badly plundered grave at Badari in conjunction with some fine Badarian rippled pottery. Thorough sifting of the contents of the tomb and a considerable area around it failed to produce any trace of the head.

The separately modelled arms bend at the elbow and cross over the abdomen, the right hand resting on the palm of the left. The wide pubic triangle is indicated by shallow incised lines across the belly and over the tops of the legs. The separately formed legs are divided by a deeply incised line and on the reverse an incision also separates the protruding buttocks. The suggestion that the exaggeration of the posterior and thighs is a representation of steatopygia, a condition which leads to excessive storage of fat in the buttocks, seems unfounded, as the emphasis of that area is better explained in terms of the balance of the upper and lower parts of the body.

The five human figurines datable to the Badarian period are the earliest three-dimensional human representations in the Egyptian Nile Valley. All are female figures and this and the ivory figurine (cat. 1.1) are two of the most outstanding examples. Although the female form is approached in a different manner in each case, the experimentation of the Badarian artists resulted in the full range of prototypes for later predynastic and Early Dynastic female representation. In accordance with the interests of their time, earlier scholars sought to identify each type as an accurate reflection of the different strains of humanity populating prehistoric Egypt. For example, Petrie distinguished an advanced energetic type in the ivory figurine (cat. 1.1), which he believed represented the progressive element in predynastic society, a heavy forbidding type, and a steatopygous type in this figure which he considered to reflect Egypt's earlier, less-developed, native population. The apparent evidence of steatopygeity in this and the other figurines is now rejected. *RFF*

Provenance: 1924–5, Badari grave 5227, excavated by Guy Brunton

Bibliography: Brunton and Caton-Thompson, 1928, pp. 9, 29, pls xxiv.1, xxv.6–7; Petrie, 1939, pl. iv.47; Vandier, 1952, p. 222, fig. 142; Ucko, 1968, p. 69, fig. 1; Spencer, 1993, p. 25, fig. 10

1.4

Female torso

Egypt
predynastic, Gerzean (Naqada II),
c. 3500–3300 BC
fired Nile silt
6.6 x 4.4 x 2.15 cm
Petrie Museum of Egyptian Archaeology,
University College, London, UC. 9601

This Nile silt pottery torso is a fragment of a female figurine, fired a brown-patched red, from a predynastic cemetery at Qua in Middle Egypt. Up to 1974 its ancient authenticity was doubted. Although not as accurate as might be hoped, the thermoluminescence date obtained then of 5020–2835 BC at least confirmed its antiquity.

The upper part of the torso remains with a featureless head merely drawn up from the clay and laterally pinched; the fingermarks left by this operation can still be seen. There are no arms and the shoulders are cut off sharply, as may be seen in other predynastic figurines (but in this case the left shoulder is raised). As the rest of the body is so slender and shapely, the tilt to the right gives it an arresting stance while accentuating the small waist. The upper chest slopes naturally down to the carefully modelled breasts, which are in proportion to the whole. The body is broken below the pinhole navel, where the horizontal incised lines indicating the pubic triangle can just be seen.

The very truncation of the form adds to its charm, which might have been less attractive to modern eyes had it been complete with its blocked, rounded-off legs, normal in the period. In the centre of the back there is an incised design like a fan, its meaning unknown, which indicates one of the tattoos that were employed at this time. Whether it was a mark of ownership or locality, or can be given the sort of religious interpretation so beloved of archaeologists, is uncertain. It is entirely possible that it was made by a female potter at the dawn of the Gerzean age who knew her craft and her sex, as well as the mores of her time. *BA*

Provenance: 1922–5, found by Guy Brunton in cemetery 23/100 at Qua and Badari

Exhibition: Marseilles 1990

Bibliography: Brunton, 1927, pls XXXIV, 6, LIII, 48; Ucko and Hodges, 1963, pp. 219–20; Ucko, 1968, p. 106; Adams, 1988, fig. 38, p. 56

1.5

Pig deity

Egypt
predynastic period, end of
4th millennium BC
fired clay
h. 56 cm
Staatliche Museen zu Berlin, Preussischer
Kulturbesitz, Ägyptisches Museum und
Papyrussammlung, 1/69

Terracotta sculptures are rare in
Egyptian art except during the
prehistoric period in the second half
of the 4th millennium BC. This pig
deity shows close similarities to a
group of sculptures dated to late pre-
dynastic times (3200–3000 BC). Its
unusual conical lower part resembles
the offering stands of the Middle
Kingdom (2050–1759 BC), but
thermoluminescence tests have
confirmed the early date of the
sculpture.

The animal face is reduced to the
essential, vital organs such as mouth
and eyes. The female human body is
conveyed by the simplified formula
of two breasts. The arms are placed
horizontally in front of the chest –
a typical gesture of early pharaonic
sculpture. The Egyptian idea of god
finds its most impressive artistic
expression in these mixed figures
combining human and animal
elements to create a new being
outside the normal world.

Egyptian religious iconography of
the historical period ignores the pig
almost completely. Its meaning is
mostly negative; as one of the forms
of the god Seth it is the symbol of
evil. A positive aspect can be found in
rare pictures of the sky goddess as a
pig. In daily life the pig is attested as
a domestic animal through all periods,
but it ranks among the least popular.
The relatively large size of this pig
deity signals its religious role in late
prehistoric and predynastic times,
before the decline of the pig's import-
ance in religion and mythology. *DW*

Exhibition: Berlin 1989, no. 3

1.6a

Bearded male figure

Egypt
predynastic, Amratian-Gerzean
(Naqada I–IIb), *c.* 3800–3400 BC
breccia
50 x 20 x 20 cm
Musée Guimet, Lyons, 90000171

1.6b

Bearded male figure

Egypt
predynastic, Amratian-Gerzean
(Naqada I–IIb), *c.* 3800–3400 BC
schist
32 x 7 x 5 cm
Musée Guimet, Lyons, 90000172

Exceptional in their material,
dimensions and economy of form,
these two stone statuettes are clearly
derived from a mysterious class of
object known as 'tusks'. Adopting the
form of the hippopotamus canine or
incisor after which they were carved,
the slender cylindrical tusks were
often plain except for a groove or
perforation to ensure secure attach-
ment to a leather thong. Only
occasionally were they decorated at
the top to represent a man with a
pointed beard, either schematically
with crude incision, as seen on
the dramatic dark schist statuette
(cat. 1.6b), or more realistically with
fine modelling, as seen on the white
example (cat. 1.6a). The long
cylindrical body always remained
plain and without any indication of
the limbs.

Such figures are almost always
found in pairs, one solid and the other
hollow; a magical or fertility function
has been suggested. Their placement
in intact predynastic graves indicates
that they were not worn as personal
adornment, but were perhaps sus-
pended as protection for a house, boat
or other personal property, including
a grave. Derived from these tusks and
apparently serving a similar purpose
is another class of object known as
'tags'. These small amuletic charms,
made of ivory, bone, slate, limestone
or alabaster, which took the form of
cylindrical or flat 'imitation tusks' or
rectangular plaques surmounted by
a bearded head, seem to have been
inspired by the same beliefs that
created the long tradition of bearded
figures.

It is unknown whether the two
statuettes exhibited here would have
formed a dramatically contrasting
pair. The wide shoulders of cat. 1.6a

suggest that the form of contemporary amuletic tags also played a part in its unique conception. Like many human-headed charms, the head is bald, the ears are pronounced and the body is decorated, although the complete perforation of the body as a decorative unit is unique. The characteristic perforation or knob by which the tusks were suspended is missing, and both statuettes, it seems, may have been meant to rest on their bases and as such may be early precursors of the bearded figure of MacGregor Man (cat. 1.22). *RFF*

Provenance: said to have come from Gebelein

Exhibition: Marseilles 1990, nos 359 and 358

Bibliography: Vandier, 1952, pp. 416–21; Baumgartel, 1960; Needler, 1984, pp. 346–7; Pierini, in Marseilles 1990

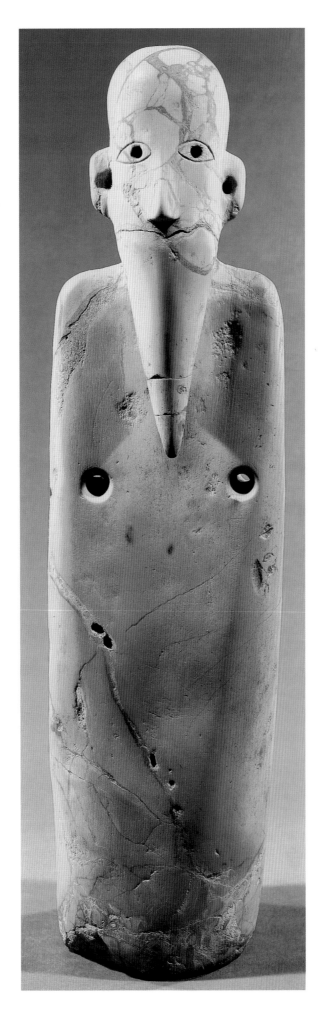

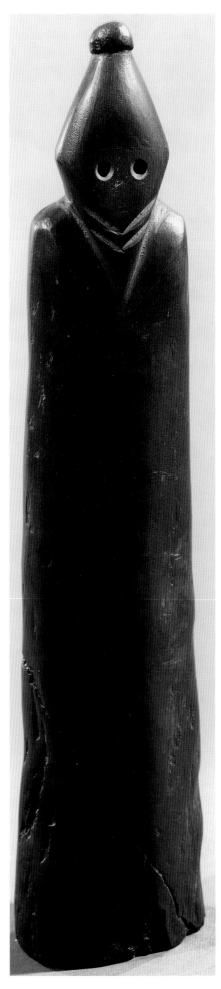

pebble run perpendicular to it so as to obscure and smooth out the grooves and create a pleasing, spiralling, rippled effect. The rim and interior were intentionally blackened by placing the vessel top down in a bed of smoke-producing matter (dung, straw or ashes) either during or after firing. The carbon in the smoke and a lack of oxygen together worked to transform the iron oxides in the clay and the ocherous coating into an almost metallic black.

Jars of this size are extremely rare. Their thin walls made them very fragile and few have survived the collapse of the shallow graves into which they were placed as offerings. This pot, pieced together from fragments found *in situ* must have been a prized possession. This is also suggested by the ancient repair visible at the base. Many fine Badarian vessels show evidence of damage and repair before their deposition in the grave. The base, which cracked in ancient times, was repaired by drilling a series of holes on either side of the break. A leather thong would then have been threaded through the holes to bind the pieces together. *RFF*

Provenance: 1924–5, Badari grave 5104, excavated by Guy Brunton

Bibliography: Brunton and Caton-Thompson, 1928, p. 7, pl. xiv.10F

1.8

Bowl with hippopotami

Egypt
predynastic, Amratian (Naqada I),
c. 4000–3600 BC
fired Nile silt
h. 6.8 cm; diam. 19.4 cm
Museum of Fine Arts, Boston
Harvard-Boston Expedition, 11.312

Egypt's earliest pottery is among its finest, and this bowl offers a splendid example. Shaped by the coil method from local Nile clay, it was subsequently coated with a thin clay wash (known as slip) and then painted on the interior only with a white line decoration. This type of white linear decoration on pottery is characteristic of an early phase of predynastic development known as the Amratian or Naqada I period. Although these vessels share the geometric style of decoration, most are unique in their design and layout.

Not only decorative, this bowl is also 'readable'. It features an abstract landscape of Upper Egypt, the area in which it was found. The rosette in the centre represents the Nile and the marshes beyond its banks, inhabited by hippopotami. High cliffs, represented by continuous zigzag lines, define the limit of visibility. Profile and aerial views are thereby combined into a balanced composition. Although Egyptian art was in its infancy when this bowl was

1.7

Vessel with rippled decoration

Egypt
predynastic, Badarian, *c.* 4500–4000 BC
fired Nile silt
h. 39 cm; diam. 24 cm
(wall thickness: 0.04 cm)
The Trustees of the British Museum,
London, EA. 59634

The earliest of the well-attested predynastic cultures in the Egyptian Nile Valley is known as the Badarian after the Middle Egyptian village of el-Badari in whose vicinity most of the evidence has been retrieved. The most distinctive product of this early culture is its pottery. Characteristic are simple but elegant bowls and canisters of exceptional thinness with a combed or 'rippled' surface. It was this unique peculiarity which led to the discovery of the Badarian culture in 1923. The finest efforts of the Badarian potters with respect to the care taken in

thinning the wall, refining the clay and enhancing the vessel's surface were never equalled in any subsequent period in Egypt, and this vessel is an excellent example of their abilities.

Like all early predynastic pottery, the Badarian wares are entirely hand made without any traces of turning. Careful polishing has obliterated any marks that might indicate how the vessel was manufactured. In the case of such a large pot, it is likely that coils of highly refined clay were added to a moulded base to create walls that were beaten to remarkable thinness and hardness through the use of a paddle and anvil. The distinctive surface decoration was produced by running a serrated tool or comb, or in this case perhaps a fish spine, diagonally across the damp surface of the unfired pot. As is usually the case, the combing runs down to the left, while the strokes of the burnishing

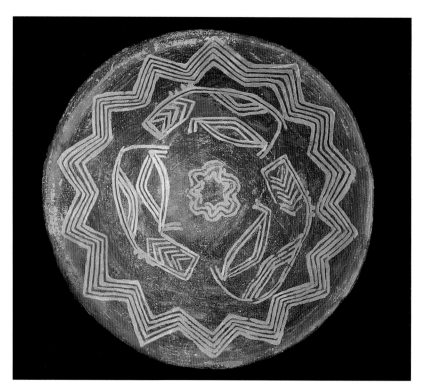

made, some of its canons are already apparent. For example, the hippopotami are outlined in profile and their salient aspects – their powerful mouths and swollen bodies – are emphasised. Four bumps on top of the heads represent two eyes and two ears. Although in fact only one of each would have been visible, the depiction of both was apparently deemed necessary.

Hippopotamus amphibius found a home in Egypt until the beginning of the 19th century. Their rotund forms led to their deification as Taweret, goddess of childbirth, and their brute strength caused them to be identified with the forces of evil and chaos which had to be overcome so that order (*ma'at*) might prevail. *REF*

Provenance: 1911, excavated at Mesaeed
Bibliography: Bothmer, 1948; Berlin 1974; Finkenstaedt, 1980

1.9

Vase decorated with hunting scene
Egypt
predynastic, Amratian (Naqada Ic–IIa),
c. 3800–3600 BC
fired Nile silt
h. 33.1 cm; diam. 15 cm
Musées Royaux d'Art et d'Histoire,
Brussels, E. 2631

Among the late Neolithic cultures of predynastic Egypt, the south Egyptian Naqada culture (4th millennium BC) is the best documented. Black-topped pottery is the most diagnostic characteristic of the period from Naqada I to early Naqada II. These vessels were polished before firing. The black and red contrast was most probably obtained by placing the vessels upside down in the kiln and covering them partially with ashes. The decoration of the present vase was carved after firing. Incised

decoration is exceptional and the vase under discussion is the only published example decorated over its entire surface. However, engravings are well attested for the predynastic period. Numerous rock drawings of that date can be found in southern Egypt and Nubia. The style of the decorated vase is equally well attested. The simplified but naturalistic contours allow the identification of the animals, but the bodies are filled with motifs which show no relation to reality. These motifs were also used for animal representations on contemporaneous White Cross-lined vases, as well as a number of rock drawings.

One can recognise three superimposed rows of animals. Their identification is primarily possible from the shape of the horns. The lower register shows four gazelles. The middle register contains four large animals and a far smaller fifth, placed between the horns of one of the former. All of them can be identified either as oryx or Nubian ibex. In view of the small tail the ibex is to be preferred. The upper register shows more variety. One can recognise a gazelle, a hare and two dogs. The last two are especially interesting because they have collars and are therefore evidently domesticated. Similar dogs, with the profile of a greyhound, a long head with pointed ears and a short upward pointing tail, are well attested among pharaonic representations of hounds. In contrast to the two other registers, the animals of the upper register are represented running. One may therefore consider the dogs as hunting the hare and the gazelle and, by extension, all the animals on the vase. Like the ibex, the hare and the gazelle are desert animals. Between the legs of one of the gazelles in the lower register, three triangles can be seen. These occur frequently on decorated predynastic vases and are generally taken to symbolise mountains and the Egyptian desert. The whole can be interpreted as a scene of hunting in the desert, without the human hunters being depicted.

Finally, the question remains as to why this scene occurs on a predynastic vessel. Hunting in the desert figures regularly in Old Kingdom mastabas, as one of the activities the deceased wished to repeat in the hereafter. A similar funerary purpose might be

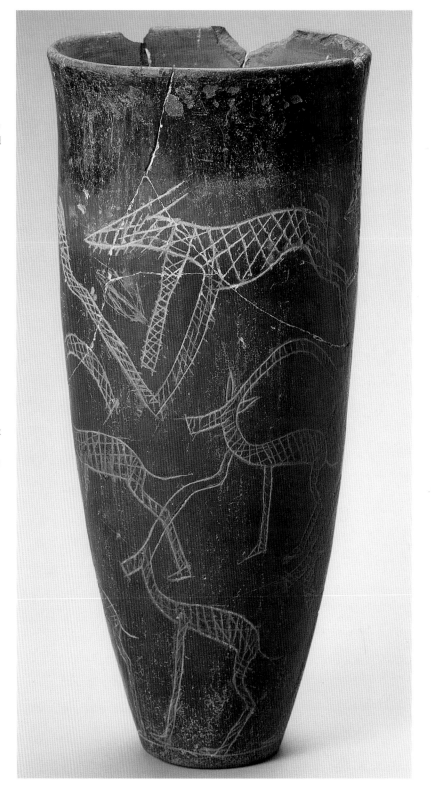

suggested for the predynastic period, but unfortunately the provenance of the vase is unknown and its funerary context cannot be proven. A more complex socio-religious explanation may also be admissible. In this case the dogs are to be considered symbols of power or even of kingship, while the rows of animals could reflect the maintenance of social order through this power. *SH*

Provenance: 1908, purchased Cairo
Exhibition: Marseilles 1990, no. 289
Bibliography: Capart, 1909; Balty et al., 1988, p. 12; Hendrickx, 1992; Hendrickx, 1994, pp. 18–191.9

1.10

Vase decorated with victory scene

Egypt
predynastic, Amratian (Naqada Ic–IIa),
c. 3800–3600 BC
fired Nile silt
h. 28.6 cm; diam. 11.8 cm
Musées Royaux d'Art et d'Histoire,
Brussels, E. 2631

Red polished pottery with painted white decoration is characteristic of the early part of the Naqada culture. Only a few of such vessels show elaborate figurative decoration and the present vase is one of the most important of the type. Eight figures can be distinguished, all of them probably male. The neck of the vase is decorated with seven horizontal bands. From an eighth band hangs a row of drop-lines and two other enigmatic objects. The two largest figures raise their arms above their heads, with their palms turned inwards. This gesture is common in the Naqada II period, but is used mainly for female figures, whether fertility goddesses, concubines for the dead, mourning figures or representations of the *ka*, the 'life force'. On their heads are branches and small bulges probably indicating the coiffure. The two

figures wear large penis gourds, a feature known from contemporary sculpture (cf. cat. 1.20a–b, 22) and which could also be a symbol of power.

Of the six remaining figures, four are roped together two by two at their neck, the rope held by one of the larger figures. The other two stand below the smaller of the two enigmatic objects. The first four figures seem to be captives; their arms are not depicted, perhaps indicating that they are trussed behind their backs. They seem to have rather long dishevelled hair (or blood streaming from their heads), and no penis gourds.

The larger of the enigmatic objects may represent a palm tree. The smaller object could be an animal hide, functioning as a standard or symbol representing a god or a geographic region. Because of the ropes connecting the figures, there can be little doubt that the decoration represents a single scene and that the 'palm tree' occupies an equivalent place to the large figures, each of the three separated from the other by two smaller ones; similarity in shape between the figures with raised arms and the 'palm tree' is also discernible. The scene most probably represents a victory in which military, political and religious symbols are combined. *SH*

Provenance: 1909, bought Luxor

Exhibition: Marseilles 1990, no. 302

Bibliography: Scharff, 1929; Kantor, 1944, fig. 6F; Baumgartel, 1955, fig 14; Asselberghs, 1961, p. 302; Williams, 1988, pp. 47–8; Balty et al., 1988, p. 12; Hendrickx, 1994, pp. 22–3

The ostrich is the first species of bird for which there is physical and pictorial evidence in Egypt. Its distinct form can be recognised from rock drawings carved by predynastic hunters on the cliffs lining the Nile Valley and in the deserts of Upper Egypt and Lower Nubia. As the ostrich is often depicted beside or as part of a spirited chase of desert fauna by a hunter, it is not surprising to find desert animals, perhaps in an abbreviated chase scene, decorating an ostrich egg. The simple lines are filled with a black pigment and depict two elegant quadrupeds with twisted or lyrate horns and short tails, perhaps intended to be gazelles or hartebeest. The diagonal placement and the shortened forelegs suggest that the animals are in flight. The zigzag bands incised on the bodies are decorative features common to early predynastic animal representation, whether painted on White Cross-line pottery or incised on pots and other ostrich eggs; probably they do not represent leashes.

Throughout historic times, the ostrich was valued for both its plumage and its eggs. The eggs are so large that a single one can feed as many as eight people. In the predynastic period, once emptied or blown, the shells were carved into beads and inlays. More rarely, intact eggshells were used as light and durable containers. Excavations have revealed only a few ostrich eggs or clay models of them in graves of the predynastic period in Upper Egypt. Many are plain, some are painted with white spots or black zigzag bands in imitation of woven holders, but only a very few excavated pieces are incised. More common in the graves and settlements of the A-Group in Nubia, ostrich eggs have been found most frequently in the graves of children. This custom does not appear to have been current in Egypt, where ostrich eggs are found only in the most wealthy of predynastic tombs. *RFF*

Provenance: 1895, Naqada tomb 1480, excavated by W. M. Flinders Petrie

Bibliography: Petrie and Quibell, 1896, p. 28; Capart, 1905, p. 39, fig. 16; Kantor, 1948, pp. 46–51; Houlihan and Goodman, 1986, pp. 1–5; Payne, 1993, p. 253, fig. 85, no. 2104

1.11

Decorated ostrich egg

Egypt
predynastic, Gerzean (Naqada IIa),
c. 3600–3400 BC
ostrich egg
h. 15 cm; diam. 13.4 cm
The Visitors of the Ashmolean Museum,
Oxford, 1895.990

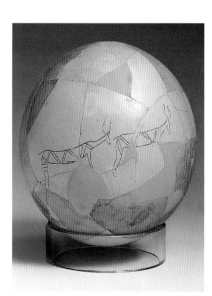

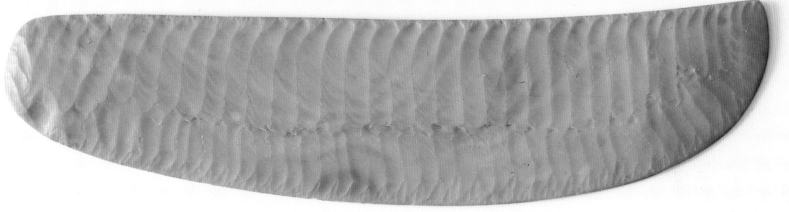

1.12a

Ripple-flaked knife

Egypt
predynastic, late Gerzean
(Naqada IIc–IIIa), c. 3400–3200 BC
flint
l. 23.2 cm
The Trustees of the British Museum,
London, EA. 59235

1.12b

Ripple-flaked knife

Egypt
predynastic, late Gerzean
(Naqada IIc–IIIa), c. 3400–3200 BC
flint
l. 26.8 cm
The Trustees of the British Museum,
London, EA. 29286

The most admired of prehistoric stone tools and perhaps the most beautiful flint implements ever made by man are the pressure- or ripple-flaked knives. Their outstanding characteristics are the two rows of pressure-induced, long, parallel fluted facets meeting at a carefully centred median line, the very particular marginal retouch and the extremely fine serration of the cutting edge, which is best seen under magnification.

Production of these blades required high precision, extreme regularity and the right combination of a number of simple but delicate steps. There were six basic steps, each involving different technologies, which suggests that a number of craftsmen (each with his own separate skills) were involved. Nevertheless, a surprisingly small number of tools were necessary: a range of copper-tipped pressure-flaking points, some grinding stones and a slotted block to support the blade during work.

Ripple-flaked knives are made of superb flint, which is often glossy and has practically no visible grain. Although more than one quarry source was used, each slab of flint must have been carefully selected and checked before being flaked to shape and then ground smooth. These steps set the stage for the pressure-flaking, the overlap of each flake being responsible for the rippled effect. Starting from the upper rounded end and progressing anti-clockwise, the pressure-flaking was done with great discipline and an emphasis on visual beauty. A combination of the correct depth and spacing of the pressure

point and the proper angle resulted in just the right amount of flake overlap. The edges of the knife were then retouched with extremely fine pressure-flaking and in the final stage the cutting edge was ground down and then carefully serrated with some 10–13 microscopic teeth per cm.

Only one face was worked, the other was ground smooth. The smooth face being the back of the knife, the cutting edge is always to the left as a right-handed man would hold it. The rounded or butt end of the knife was probably covered in leather, wrapped in cord or covered with gold sheathing to form a handle. If hafted to a more elaborate ivory or wooden handle, a short tang was roughly flaked out of the rounded end. Each perfect specimen means 60 faultless ripple flakes in a row, 200 successful microflakes and 250 serrations. Needless to say, not all are perfect, but regularity and rhythm were clearly given high priority from a technical and aesthetic point of view.

There must have been a significance attached to these knives which is not explained merely by their function. The duality within the two

ranges of pressure flakes and between the two faces, one plain and one worked, has been considered symbolic. Although these knives are not uncommon in museum collections, the discovery of them in context is rare. A limited number have been found in relatively wealthy graves, sometimes intentionally broken or ritually 'killed'. Fragments of such knives and sharpening flakes have been found in the courtyard of an early temple at Hierakonpolis and must have been associated with ritual sacrifices. Although the shape continued to be popular into the Old Kingdom, high-quality ripple-flaked knives were produced for only about 200 years. *RFF*

Provenance: cat. 1.12a: 1929, purchased by the museum; cat. 1.12b: 1897, purchased by the museum (said to have come from Abydos)

Bibliography: Kelterborn, 1984; Midant-Reynes, 1987; Holmes, 1992; Spencer, 1993, fig. 27; Payne, 1993, pp. 172–5

host of other palettes which embody animal references with similar virtuosic simplicity and account for the beardlessness of an assumedly male face from this epoch. *TP*

Bibliography: Beltor and Valloggia, 1990

1.14
Barrel-formed figure
Egypt
predynastic, *c.* 5th millennium BC
stone
h. 26 cm
Private Collection

For anyone studying the range of human representations in predynastic art there can be no certainty of expectation. As seen in this exhibition the earliest artists of Egypt explored a huge range of possibilities in the depiction of the human figure (cat. 1.1–3 etc), so comprehensive in fact that there have been few additions to the repertoire up to the present day (many variations we think new turn out to have ancient precedent). Here the whole fecundity of the female figure is suggested with the highest invention and minimal formal fuss. Although a solid piece, there is evident reference to woman as container, the vessel of the future. This theme reappears independently throughout Africa where so many societies are strongly based on lineage. It can be seen as far away as Zaire, and with almost uncanny similarity in a wooden vessel from the Zulu (cat. 3.44). In this particular small statuette (idol?) the position of the breasts at the pregnant point of swelling gives unambiguous meaning to ambiguity of form. *TP*

1.13
Anthropomorphic (?) palette
Egypt
predynastic, *c.* 5th millennium BC
sandstone
19 x 7 x 2.7 cm
Musée Barbier-Mueller, Geneva, 203-38

As evidenced by spectacular examples from later periods (cat. 1.18) the grinding palette for the preparation of cosmetic pigments has in early Egyptian culture a significance far beyond its apparently quotidian function. Like the flywhisk in some west African societies it is capable of huge symbolic, ritual and ceremonial accretions. This Neolithic example is finely carved as an object of evident value. The economy of suggestion whereby the incorporation of a head in an otherwise abstract form leads that form to have physical resonance as a body with legs, torso, even coiffure is typical of predynastic mastery of sculptural language. Though described as anthropomorphic, it suggests (in the bilobate process around the tiny face) other primates as they appear in later dynastic representations, for example the upper section of the representation of a baboon in cat. 1.38. This would link the present object with the

1.15
Boat-shaped mortar
Egypt
predynastic, Gerzean (Naqada II),
c. 3600–3300 BC
breccia
7 x 16.5 cm
Musée Guimet, Lyons, 90000091

From the earliest periods down to modern times, the Nile has been the main artery for commerce and communications in Egypt. Boats plying its waters carried grain, wine and cattle from farm to market; hauled stone and building materials to cities and temples; brought luxury goods from afar. They bore officials on their rounds and armies on the move.

Boats also carried images of gods from temple to temple and served as houses for the gods within their temples. They transported the dead from this world to the next and moved the gods across the sky. Thus, it is not surprising that boats were a dominant feature in the lives of the Ancient Egyptians and profoundly affected their mental processes and religious thinking.

The earliest evidence for boats comes in the form of simple models made of clay. Throughout the predynastic period, boats were common motifs on decorated pottery and rock art and also lent their outline to cosmetic palettes carved of grey slate. It is to the boat-shaped slate palettes that this unique stone mortar corresponds most closely in form and function. Like the flat, two-dimensional palettes, one end is turned in on itself, perhaps in imitation of the prow terminals composed of the bundled papyrus stalks out of which ships were made. The accompanying grinding-stone may represent the cabin placed in the centre of the palettes.

Regardless of shape, slate palettes served as a platform upon which to grind ores such as malachite or galena for use as cosmetic paints. The size and quality of this mortar suggests that it, too, was used for cosmetic production rather than food preparation. Crude, roughly boat-shaped sandstone mortars have frequently been found in predynastic settlements and occasionally in cemeteries, some twice the size of this example. In a few cases traces of malachite and ochre show that they were occasionally used for the preparation of pigments, but their primary purpose was to grind cereals. The fine modelling and polishing of the highly valued red breccia indicates that this mortar was not meant for such hard labour. It may be possible to view the mortar and grinding pebble as a threedimensional rendition of the boat-shaped cosmetic palette. *RFF*

Provenance: said to have come from Rizakhat

Exhibition: Marseilles 1990, no. 386

Bibliography: Landstrom, 1970; Needler, 1984, p. 298; Vinson, 1994

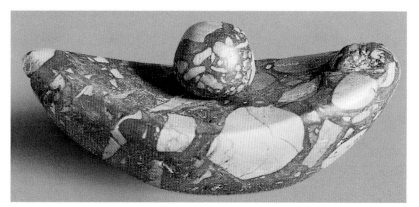

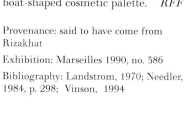

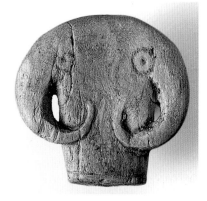

1.16a
Bull's head
predynastic, Naqada IIa, *c.* 3500 BC
hippopotamus ivory
3.2 x 3.3 x 1.25 cm
Petrie Museum of Egyptian Archaeology,
University College London, UC.6005

1.16b
Bull's head
predynastic, Naqada IIa, *c.* 3500 BC
elephant ivory
4.9 x 4.3 x 1.9 cm
The Visitors of the Ashmolean Museum,
Oxford, 1895.908

The broadly abstract style of these amulets symbolises a bovine animal that is usually considered to be a bull, although it may represent a cow. The horns are turned down and curled into the face, with hollows separating them from the columnar neck which, in cat. 1.16a, terminates in a thin ridge around the flat base. On cat. 1.16a the eyes are not hollowed for inlay with another material, as is often the case in other examples of this genre, but indicated with two concentric incised circles. The back is pierced horizontally for stringing to wear on the person, and the vertical surface ridges of the curved hippopotamus tusk are still clearly visible below the perforation.

The grave where cat. 1.16a was found also contained a companion amulet of the same type (cat. 1.16b), of elephant ivory and very similar to the first, but without a ridge around the base. The eyes are indicated as pinholes which still contain what might be traces of resin. There is green staining on the front owing to an earlier proximity to copper. The condition of the elephant ivory amulet is poorer than that of the hippopotamus pendant, a result of the more rapid decay of the elephant ivory. The distinctive cross-section of the elephant ivory tusk can be seen on the back of the head.

This type is well attested in pre-dynastic times, and probably dates from at least the beginning of Naqada II. The size ranges from small examples in bone and ivory which were threaded onto necklaces to larger examples in stone from votive deposits in temples. It seems to evolve from a squat, rounded version in the middle predynastic period to an elongated, more cursory version in the Early Dynastic period. Although the

supernatural power that it represented is unknown, it no doubt conferred the benefit of protection and stability on the wearer, and the strength of the bull was later associated with the king. Cow goddesses existed in the predynastic period, but are usually depicted with their horns turned up.

Price, an assistant on the excavation at Naqada, recorded the grave as that of a child whose body lay crouched on its left side with the head south facing to the west. Three bone hairpins lay behind the head and there was a collection of objects in front of the face and over the hands. These included agate and cornelian beads, a clay wig from a figurine and a haematite plummet with a suspensory knob. A small metal cup was found next to the plummet and an elephant ivory pendant, which explains the green staining. Similar staining, indicating the original presence of copper jewellery, was also observed on the forearms and one knee of the skeleton. Metal and ivory objects such as these signify the importance of the grave's occupant. Although no pottery remained, Petrie assigned a relative date for the grave, equivalent to Naqada Ic–IIb in modern terminology. During this part of the predynastic period, hippopotami were still extant in the Egyptian Nile Valley, but the elephant ivory would have been brought in from further south in Africa, indicating access to a wide trading network. *BA*

Provenance: cat. 1.16a: 1895, excavated by W. M. Flinders Petrie and J. E. Quibell from Naqada tomb 1788

Exhibition: cat. 1.16a: Erbach 1986

Bibliography: Petrie, n.d., no. 137; Petrie and Quibell, 1896, pl. LXI, iv, p. 46; Baumgartel, 1970[1], pl. LVIII; Drenkhahn, 1986, p. 46, no. 49; Adams, 1988, fig. 31, p. 51; Payne, 1993, p. 207, no. 1693

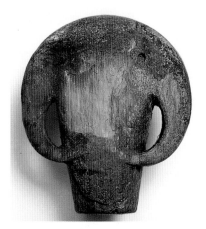

1.17
Bull's head
Egypt
late predynastic/Naqada III, *c.* 3100 BC
limestone, faience
3.6 x 3.7 x 2.2 cm
Lent by the Syndics of the Fitzwilliam Museum, Cambridge, E.G.A. 3205. 1943

Although stylised and represented frontally, this head captures the visual characteristics of a bull's head. The delicate, raised-relief modelling of the horns continues the convex contour of the top of the head; by bringing the horns onto the face, the sculptor avoids the difficulty of carving them free. Inlaid eyes give an impression of depth and liveliness to the otherwise flat, almost abstract face, whose lower part is nearly cylindrical, with a raised disk at the end of the nose. The top of the head curves back to the underside and is pierced laterally.

The domestication of cattle in Egypt seems to have begun around 4500 BC, under the influence of nomadic Saharan people moving into the Nile Valley. The wild ancestor of domesticated cattle, living in the Saharan desert fringes and perhaps in the swampy areas of Egypt, must have already exerted a powerful influence on the imagination. Celebrated in later texts for his physical strength and sexual power, the bull was identified with the Egyptian king as 'Strong Bull' or 'Bull of his mother'. From predynastic and Early Dynastic times there is already evidence for important bull cults throughout Egypt which were gradually submerged into the kaleidoscope of Egyptian beliefs. The Early Dynastic image of the wild bull trampling and goring a prostrate enemy is the most powerful image of early kingship and possibly survived in the royal regalia as the bull's tail worn at the back of the king's kilt.

The bull's head may have been worn as an amulet to ensure good fortune and protection in a ritual wild bull hunt, or to bring to the wearer strength and fecundity. In funerary contexts, the amulets were buried with their owners (cat. 1.16a), perhaps as prized possessions or so as magically to endow the dead with the strong life force of the bull in the afterlife. Such amulets may also have been brought as votive offerings to shrines, for example at Hierakonpolis, so that the divine aspect of the bull would act

favourably on behalf of the offerer (cat. 1.16b). These early votive offerings show that the beginnings of the complex system of temple and state economy in Egypt were already well advanced by the Naqada II period. The bull's head is one means of expressing control over the innate forces of nature, both in a super-natural and economic sphere. Those who controlled the herds of cattle and the supply of meat undoubtedly encouraged their association with the animals, in order to increase their own status and prestige. *EV*

Provenance: ex collection Major R. G. Gayer-Anderson

Bibliography: Adams, 1974, p. 22, no. 110/15, 17; Störk, 1984, pp. 257–63

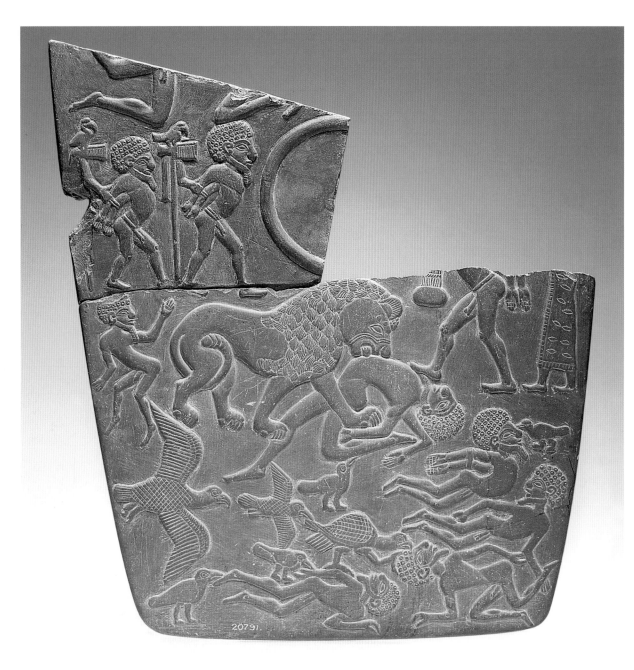

1.18

Decorated ('Battlefield') palette

Egypt
late predynastic/Naqada III, c. 3100 BC
slate
16.5 x 17 x 0.9 cm (upper section); 32.5 x
31 x 1 cm (lower section)
The Visitors of the Ashmolean Museum,
Oxford, 1892.1171, and The Trustees of
the British Museum, London, EA. 20791

Understanding the development of pharaonic art and civilisation depends in large part on interpreting the antecedents of its characteristic images. The great decorated palettes created at the cusp of the historic period provide important illustrations of the developments in imagery and iconography that led to the crystallisation of the distinct dynastic style.

Exhibited together for the first time is the lower half of a grey slate plaque known as the 'Battlefield palette' from the British Museum, with its adjoining fragment from the Ashmolean Museum, Oxford. The palette is carved on both sides in low raised relief with a good deal of interior modelling of the forms. Each figure has been elaborated with many

minute rounded details of anatomy: incised lines depict feathers, hair, eyebrows, claws, leg muscles, knee-caps and so forth. The surface bears many fine scratches made in the process of carving out the background with tools of copper and flint. Placed at the original centre of the palette is an undecorated once-circular area defined by a raised ridge. This was reserved for the grinding of ores such as malachite or ochre for cosmetic use, and it is for this reason that such objects are called palettes. Although decorated on both faces, the side with the cosmetic pan was the more important and on this and other palettes bears the more complex scenes. The reverse was often dedicated to large central figures in more straightforward compositions, this palette being a good example.

On the reverse, two long-necked giraffe antelopes browse among the fronds of a date palm. The better preserved animal appears to inhale with extended nostrils the appetising scent of the cluster of fruit at the apex. The textured treatment of the palm branches and trunk forms a decoration of great elegance set in the simplicity of the remainder of this face of the palette. The palm tree flanked by giraffes is a composition which also appears in the art of Nubia and may have originated there. It has been suggested that this combination is a metaphor for the king in his temporal aspect as the balance and mediator between symmetrical and complementary elements – a concept of kingship maintained throughout the dynastic period.

Behind the head of one animal is a bird with a hooked beak, which has been identified as a helmeted guinea fowl (*Numida melegris*), later encountered in Egyptian art only as a hieroglyph used in the spelling of the word 'eternity'. Uncommon in Egypt but significant in Nubia for a long time, the guinea fowl in this, its earliest depiction is characterised by the two protuberances on its head common to the dynastic hieroglyphic sign, although in reality the bird has only one. An additional fragment of this palette in a private collection preserves an identical guinea fowl placed to balance the composition. Fragments of the upper scene, visible above the heads of the animals, are unclear but may include the hull of a boat.

The other, more celebrated, face of the palette portrays the gruesome aftermath of a battle. A flock of vultures and crows preys upon the bodies of fallen men. Dominating the battlefield is a stylised lion, which has seized one of the corpses by the abdomen and is attempting to tear it to pieces. The other vanquished soldiers on the battlefield are depicted in the extraordinary twisted attitudes typical of dynastic scenes of the slain, but never again in such grisly detail. The defeated are bearded, have curly hair and are circumcised. It is unclear whether they are meant to be Egyptians or foreigners similar to those depicted on the famous palette of Narmer (Egyptian Museum, Cairo).

Above, on either side of the raised ridge outlining the cosmetic saucer, men with bird-topped standards (on the left) and an official wrapped in a long-fringed mantle (on the right) march with bound captives. In front of one of the prisoners is an enigmatic oval object which has been variously identified as a stone hanging around his neck or an ideogram representing his land of origin. The common Egyptian convention of supplying inanimate objects with human features is evident in the anthropomorphic representation of the ibis- and falcon-topped standards from which issue human arms that seize other captives.

The top of the palette seems to have been devoted to more representations of the vanquished. The Ashmolean fragment shows a dead soldier and a scavenging jackal. As no more than one half of the palette is preserved, it is difficult to interpret the scene. Should it be seen as a vignette accompanying a depiction of the king on the now lost upper portion? Or should it be viewed as the main focus of attention, a celebration of the power of the king and the rout of the enemy?

The large lion probably represents the king defeating his enemies, but, like the vultures and crows, it scavenges among the bodies of the dead, humiliating rather than attacking the enemy. The vulture tearing at its victim was also used as a symbol of royal victory in predynastic iconography. In this formative period, the king is associated with various wild animals, his power being naturally derived and unchallenge-

able. Thus it has been suggested that this battlefield scene should be interpreted as a sort of expanded litany detailing the victorious king in his many manifestations.

The form of this and other great plaques was clearly inspired by the common cosmetic palette, which in the predynastic period was sometimes adorned with surface decoration. That it was conceived as a cosmetic palette is evident from the circular pan for eye paint integrated into the decoration. The elaborately decorated palettes, however, are quite distinct in quality, size and function from the common type; all probably came from temples. Only two, from archaeological excavations of the temple at Hierakonpolis, have a known context,

but it is highly likely that this one, among others, came from an early temple at Abydos. Their traditional function may have been connected with the ritual of the god's toilet, but the explicit symbolism of the carving makes it clear that they were primarily dedicated as votive objects by the rulers to celebrate great events and great, if perhaps only symbolic, victories. *RFF*

Provenance: unrecorded (said to have come from Abydos); 1888, lower section acquired by the British Museum; 1892, upper section acquired by the Ashmolean Museum

Exhibition: lower section: London 1962, no. 12

Bibliography: Petrie, 1953, p. 14, pls D–E; Capart, 1905, pp. 238–42, figs 177–80; Vandier, 1952, pp. 584–5, figs 384–7; Spencer, 1980, pp. 79–80, pl. 64; Houlihan and Goodman, 1986, pp. 41, 82–3, 132, fig. 117; Seipel, 1983, p. 28, figs 13 a–b; Spencer, 1993, pp. 57–8, fig. 34

1.19

Female figurine

Hierakonpolis, Egypt
1st–2nd Dynasty, c. 3000–2700 BC
Lapis lazuli
8.9 x 2.5 x 1.8 cm
The Visitors of the Ashmolean Museum,
Oxford, 1896-1908 E.1057 + 1057a
Gift of the Egyptian Research Account
and Harold Jones

The body of this naked female figurine, with a wooden peg surviving in the neck socket, was found in 1898 during excavations in the temple enclosure at Hierakonpolis beneath a brick wall to the south of the Main Deposit. Remarkably, eight years later, renewed excavations in the same area revealed the detached head, which fitted perfectly on the peg. It is probable that the figurine never had feet, but was fitted directly to another object at that point, possibly to serve as the handle of a spoon. In later Egyptian art naked servant girls appear in this role.

The use of lapis lazuli, the most highly valued ornamental stone in Ancient Egypt, immediately distinguishes this object. The closest source of lapis lazuli known to have been exploited in antiquity is that in Afghanistan, whence it had been reaching Egypt, perhaps by sea from Syria, for some time before this figurine was made. Neither in Egypt nor in the Near East would an object like this normally have been made from separate pieces of stone. The lapis lazuli used for the head is the rarer, deep blue type most admired, whereas the body is of the commoner, more mottled variety. It is likely that the juxtaposition is either a deliberate economy with the more valuable variety or else the result of an accident during manufacture (or afterwards) requiring a replacement head.

It has been suggested that this figurine might have been made outside Egypt, closer to the lapis lazuli mines. However, the distinctive gesture of the hands and the stylisation of the hair in tight little curls close to the head – characteristics found on other contemporary works of art certainly made in Egypt – make it more likely to have been created there. Indeed, such parallels suggest that this woman may have been a member of one of the peoples on the periphery of the earliest centralised state in Egypt drawn into it in the late 4th millennium BC by the military activities of the first pharaohs.
PRSM

Provenance: Hierakonpolis, temple enclosure: body excavated by Garstang and Jones 1897–8; head excavated by Quibell and Green 1905–6

Bibliography: Quibell, 1900, p. 7, pl. XVIII.3; Quibell and Green, 1902, p. 38; Garstang, 1907, p. 135, pl. II.2–3; Porada, 1980

Ivory figures from Hierakonpolis

The site of Kom el-Ahmar ('The Red Mound') in Upper Egypt, ancient Nekhen, has important associations with kingship and the formation of Egypt as a unified state (late 4th millennium BC). The city was the major cult place of the god Horus, to whom every king of Egypt was assimilated and whose sacred bird figured in the town's later Greek name, Hierakonpolis, 'City of the Falcon'. The enormous growth of the settlement and cemetery in late predynastic times testifies to the importance of Nekhen as a regional centre of power.

'The Red Mound' was the site of successive shrines of the falcon god from predynastic times to the New Kingdom (1550–1069 BC). Excavations of the 1890s in the enclosure on the mound revealed the so-called Main Deposit – caches of temple furnishings and votive offerings, seemingly cleared from the temple in the Early Dynastic period and buried within the sacred precinct. Among them were hundreds of ivory figures and fittings, found as a tangled mass in a muddy trench run through by plant roots. When disentangled and conserved, the ivories were seen to fall into distinct categories by size and form – models of boats and animals, decorated cylinders which may have been the handles of ceremonial maces, figures of women with long hair, men wearing penis-sheaths, and bound captives. Many figures have tenons or sockets, indicating that they were components of furniture or fitted into bases made of other materials. Despite the lack of clear archaeological evidence for their date, the ivories' distinctive style suggests that they belong to the earliest unified period of Egyptian civilisation, now commonly called Dynasty 0.

No trace survives of any surface painting on the ivories, although some had incised decoration or were inlaid with other materials. It is possible that they were brightly coloured in addition. *JW, HW*

1.20a

Fragmentary statuette of a man

Egypt
late predynastic/Naqada III, c. 3100–3000 BC
hippopotamus ivory
23 x 4.8 x 4.7 cm
The Visitors of the Ashmolean Museum,
Oxford, 1896-1908 E.180 E.174 (00)
Gift of the Egyptian Research Institute

1.20b

Fragmentary statuette of a man

Egypt
late predynastic/Naqada III, c. 3100–3000 BC
hippopotamus ivory
20.8 x 6.8 x 3.7 cm
The Visitors of the Ashmolean Museum,
Oxford, 1896-1908 E.174

1.20c

Fragmentary statuette of a woman

Egypt
late predynastic/Naqada III, c. 3100-3000 BC
hippopotamus ivory
11.9 x 6.1 x 3.5 cm
The Visitors of the Ashmolean Museum,
Oxford, 1896-1908 E.299
Gift of the Egyptian Research Account

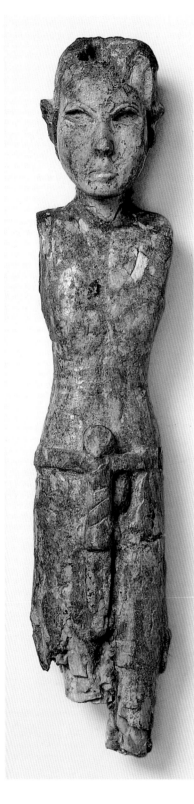

iconography with the goddess Hathor. In the succeeding Old Kingdom (2600–2150 BC) dwarfs are frequently attested as members of the households of the élite, serving as personal servants, animal-keepers, entertainers and jewellers. In the Early Dynastic period their service may have been the preserve of royalty, to judge by the presence of dwarfs among the retainers at court. Their burials and grave stelae in the funerary complexes of the kings of the 1st Dynasty show that they accompanied their masters into the next life. This figure and others like it in the cache may have been associated with the exalted persons of royal dwarfs, but their attire suggests a more specific connection. The iconography of dwarfism was later associated with fertility and protection of the child at birth, and was embodied in particular in the dwarf god Bes, who in turn was closely connected with Hathor.

Many figures from the Main Deposit show men wearing elaborate penis-sheaths, standing with their legs together or striding with the left leg forward. Their size, technique and iconography vary, but all are very well carved. The smaller of these two statuettes (cat. 1.20b) was made in several pieces. The arms (now lost) were separately attached; the hands, however, remain as they were carved with the legs against which they are held. There is no trace of an attachment of arm to hand. The legs are missing from the knee down. The head, which was broken into two pieces, has been re-attached to the body.

The face is finely carved, with the eyebrows and lips shown in detail, and a distinctive, downcurving mouth. The eyes, which have the appearance of plain sockets, were probably inlaid, but no trace of any material remains. The cheeks are full and rounded, the head and face clean-shaven. The damaged ears projected some way from the head and were subtly modelled in considerable detail.

The body is slender and elongated, with careful carving of the central depression of the chest, beneath which the navel is indicated. The arms, too, were elongated, ending against the lower thighs. The back is quite plainly modelled, again with a vertical division; the buttocks are placed very low. The only garment is

Cat. 1.20c is depicted with the physical characteristics of disproportionate dwarfism arising from a condition such as achondroplasia, with a notable pelvic tilt and bowed legs. She wears a knee-length dress and heavy bouffant wig which frames the face with long, curling strands and falls at the back in a single curled or braided mass to waist level. The curling front strands were associated in later Egyptian

a penis-sheath suspended from a thick belt around the hips. The sheath has a rounded knob above the belt, and is divided into two sections with the scrotum visible behind the junction. The upper section, which appears to have details of a knot next to the belt, is rounded, with diagonal incised lines suggesting wrapping or cordage. Below is a damaged and much thinner section of uncertain form.

The larger fragment (cat. 1.20a) represents part of a similar figure, but differs in technique and iconography. The head is lost and the legs are preserved only to the knee. The body is rather flat and the torso small and thin in proportion to the hips and thighs. Similar bodily proportions are known on other works of the same general period and may have signified the figures' strength. The torso

appears not to have been decorated. The arms, which are partially separated from the torso, are very thin and long, as are the hands, which are pressed against the thighs. A thin belt on the hips supports a penis-sheath with a rounded knob at the top that comes down nearly to the knees, ending in a loop with a central depression. On the figure's back an unidentifiable object, flat and elongated in shape, is tucked into the belt above the right buttock and extends upward to the middle of the torso.

It is difficult to say who is represented by this category of figure. The penis-sheath was a relatively common piece of late predynastic attire, but was largely replaced in dynastic times by kilts or belts with strips covering the genitals. A few later examples of penis-sheaths are on figures of deities, the king and military personnel.

Both these ivory statuettes and the later parallels suggest that the penis-sheath was a status item; hence these figures depict high-ranking persons, perhaps with military associations. In form, the sheath in cat. 1.20b resembles the dynastic period hieroglyph for 'life', or *ankh*; the hieroglyph may well derive from a sheath, or both the sign and the sheath may evoke a piece of cloth arranged in a specific amuletic knot. In dynastic Egypt 'life' was a gift of the gods to the king and through him to others, so that this association would emphasise the prestige of the penis-sheath. In dynastic times there was also a clear association between penis-sheaths and sheathed daggers tucked into kings' belts. Despite the parallel with the god Min (cf. cat. 1.21) and the implications of the penis-sheaths, none of the ivory statuettes has features that are exclusively royal or divine. No other objects from votive deposits of the period clearly represent deities, and it is probable that later rules of decorum, according to which deities could only be depicted directly in special contexts, already applied. The ivories are therefore likely to represent human beings rather than deities. Those shown may include royalty or members of the royal retinue – suggested by the presence of statuettes of dwarfs (cat. 1.20c) – as devotees of the falcon god. They are thus probably among the oldest

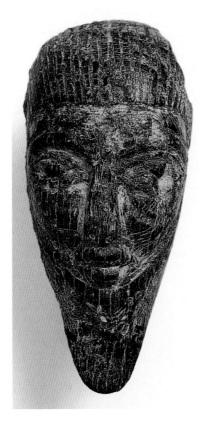

sculptural representations of the élite in an early civilisation.
JRB, HW

Provenance: 1897–8, excavated by Quibell and Green at Hierakonpolis, temple enclosure, Main Deposit

Bibliography: cat. 1.20c: Dasen, 1993, pp. 39, 108, 275, no. 107; cat. 1.20a–b: Quibell, 1900, p. 6, pls VIII.1, X.2; Quibell and Green, 1902, pp. 29–30; Capart, 1905, p. 157, fig. 120; Baines and Málek, 1980, p. 78. On penis sheaths, see Ucko, 1969; Baines, 1975

1.21

Head of a man

Egypt
late predynastc/Naqada III, *c.* 3100–3000 BC
hippopotamus ivory
5.1 x 2.3 x 1.8 cm
The Visitors of the Ashmolean Museum,
Oxford, 1896-1908 E.342
Gift of the Egyptian Research Account

This head, of which the back is lost, has sheared almost vertically from the object of which it formed part. The carving is very detailed and of the finest quality. The head has an elaborate wig, or possibly natural hair, arranged in parallel strands running back from the forehead. The wig or hair merges with a beard that covers much of the face and descends almost to a point, finishing well below the face. The face is modelled as a protrusion within the area framed by wig and beard. The chin recedes beneath the beard, giving a characteristic downward cast to the face as a whole. The eyebrow ridges are marked and above them a line is incised for the eyebrows; this could have been inlaid with another material. Beneath the eyebrows, the eyelids are carefully indicated and the pupils of the eyes brought out in raised relief. Below, the damaged nose forms a group with the narrow mouth, which stands out from the surface of the face.

This head could have belonged to a figure with penis-sheath (cf. cat. 1.20a–b). The finished carving behind the beard would, however, have been difficult to execute on a statuette and it is possible that the head formed part of some other type of object, perhaps as a knob or finial. The piece has a different style of head from the statuettes. The treatment of the beard and wig is paralleled on the colossal head of the god Min from Koptos (Ashmolean Museum, Oxford) and on other pieces of the same general date as the Main Deposit. The statue to which the head of Min belonged is ithyphallic, but otherwise resembles the iconography of the Hierakonpolis figures in several respects. There is also a very close parallel between the treatment of this ivory head and of the basalt statue (cat. 1.22).
JRB, HW

Provenance: 1897–8, excavated by Quibell and Green at Hierakonpolis, temple enclosure, Main Deposit

1.22

Statuette of a man

Egypt
late predynastic/Naqada III, *c.* 3100 BC
basalt
39.5 x 10.8 x 7.5 cm
The Visitors of the Ashmolean Museum,
Oxford, 1922.70

This figure of a man wearing a belt and penis-sheath was one of the most remarkable items in the collection of Egyptian antiquities formed by the Rev. William MacGregor (1848–1937). 'MacGregor Man', as he has come to be known, seems to have been acquired between 1898 and 1900, together with a group of ivory figures said to have been found at the site of Naqada in Upper Egypt, where Flinders Petrie had excavated a vast predynastic cemetery in 1894–5 (cat. 1.16–17).

The statuette is reassembled from three fragments and the legs are missing from below knee-level. It has a pronounced cylindrical form, flattening at the shoulders and expanding below the waist to accommodate the neat buttocks and the large sheath at the front. A belt around the waist holds the sheath in place and is tied over it. Above, the projecting top of the sheath is broken away; below the belt it is divided into two sections, with the scrotum visible behind the dividing line. The long, amorphous arms, held against the body, end at mid-thigh in sharply detailed hands. The face is rendered schematically, with eyebrows and nose (now damaged) executed as a single unit. The eyes are given an unnatural largeness by their emphatic raised outlines, and the mouth is cut with overhanging upper lip and receding lower. The rounded ears, also damaged, would have projected well beyond the head and have bored ear-holes. Over the head is a cap or stylised representation of hair which merges into a long, pointed beard that virtually covers the chest.

Ever since this figure first came to the notice of scholars, its authenticity has been disputed, not least because of the lack of an extant statuette in hard stone with which it might be compared (only recently has a similar figure been recorded on the American art market). Its technical accomplishment, with sharp angles and high surface finish, has been contrasted with the more rudimentary work

observable on other early pieces of stone sculpture, such as the colossi of Min from Koptos or the Hierakonpolis torso (cat. 1.19), and many features of its iconography and style have been used as arguments against its genuineness.

None the less, telling comparisons may be drawn with the smaller-scale figures in ivory which display the same iconography; these were seen for the first time in 1897, and were not widely known until a few of them were published in 1900 – little opportunity for a master forger to absorb their iconography and create 'MacGregor Man'. The detail of the head, including the prominent lips and pointed beard, the heavy shoulders, long arms, and complex, knobbed sheath on a belt all appear on the ivories (cat. 1.20a–b); a similar figure, now in Birmingham Museum and Art Gallery, was among the ivories acquired with 'MacGregor Man'. The projecting ears are also known from ivory figures wearing close-fitting caps (cf. cat. 1.20b). Even the one detail that is not paralleled in the ivories may be found in other early works – the relief-like cutting of the eyes is identical to the treatment of eyes on the ceremonial palettes cut in the hard medium of greywacke (cat. 1.18). The cylindrical form in itself suggests a transition to stone from ivory, where the medium would constrain the shape, and may be observed also on the Min statues.

The details of beard, belt and sheath have been compared with representations of these as ethnic attributes of Libyans from west of the Nile Delta, seen on the ceremonial palettes in scenes of subjugation (e.g. cat. 1.18). The ivory figures show that such features also appeared on native Egyptians, while the head of Min from Koptos shows that the beard may be the attribute of a deity. The bearded heads on earlier stone and ivory 'tags' are also relevant here. The parallels with Libyans suggest that Egyptians and Libyans, who may have had similar ethnic origins, shared items of attire that were later seen as ethnic markers as well as symbolising status.

In the absence of reliable information on the statuette's provenance, it is bound to remain enigmatic and its identity uncertain, although a dating in the late predynastic period or

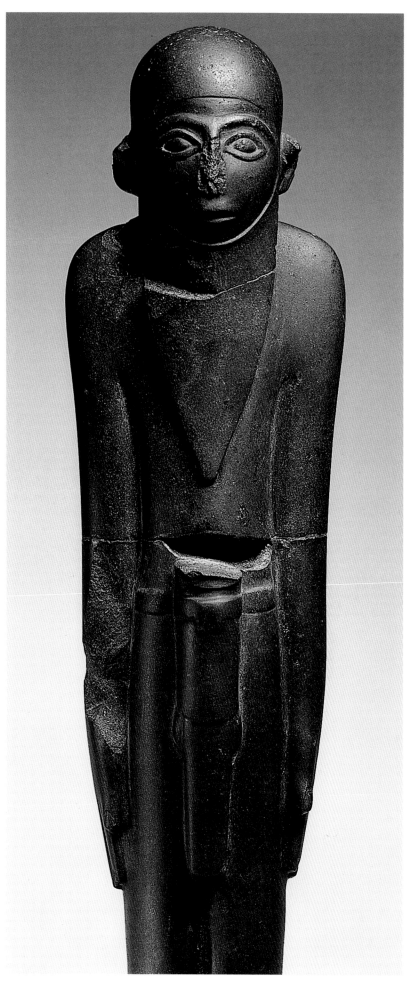

Dynasty 0 seems plausible. It is unlikely that it formed a cohesive group with the ivory figures that accompanied it onto the antiquities market. There is no parallel for statuary in tombs until the fragmentary wooden pieces found in major tombs of the 1st Dynasty, and it is most likely to have been set up in a temple. It is conceivable that it could have come from Hierakonpolis, whose temple area was being excavated at the date at which 'MacGregor Man' emerged. *JRB, HW*

Provenance: 1965, said to have been found at Naqada; ex MacGregor Collection

Exhibition: Vienna 1992

Bibliography: Ucko, 1968, p. 151, no. 196; Baumgartel, 1970, p. 10; Ucko, 1970, p. 47; Malek, 1986, pp. 24–5; Davis, 1989, pp. 173–4, 177, 179; Bianchi, 1990, p. 35; Seipel, in Vienna 1992, pp. 78–9, no. 6; Payne, 1993, pp. 13–14, no. 5.

1.23

Hierakonpolis torso

Egypt
predynastic (Naqada III), *c.* 3150 BC
limestone
h. 1.37 m (estimated original h. *c.* 2 m)
The Visitors of the Ashmolean Museum,
Oxford, E 3925

The most important art form produced in Ancient Egypt was stone statuary representing the human figure. Although sculptors created a variety of types over three millennia of pharaonic history, there were only two basic postures: the seated statue and the striding figure. This headless sculpture, named after the site where it was found, is the earliest preserved example of the striding type. It was created before the founding of the 1st Dynasty.

The left leg strides forward and bears the weight of the torso. In dynastic times a back pillar, carved in one piece with the figure, was introduced into the composition of striding statues to maximise stability. As in the Hierakonpolis torso, the left leg was advanced, but in later, canonical sculpture the figure's weight was displaced backwards onto the right leg; this shift resulted in a less convincing rendering of movement.

The torso's legs are preserved only to the knees. Their massive form contrasts markedly with the shallowness of the torso and reflects the sculptor's concern to ensure that the figure remain upright. The base, now missing, was probably quite high to allow for its insertion deep into the ground as another precaution against toppling.

The left arm is bent at the elbow and the hand is held flat on the chest underneath a garment that leaves the right shoulder bare and ends just above the knees. The right arm is pressed against the figure's side and the right hand was pierced for the addition of a sceptre or the like in another material, as in some other early statues.

The slightly raised surface of the break on the upper chest attests to the original presence of a full beard; it is therefore certain that the statue depicts a male figure.

By contrast with dynastic limestone statues, which were carved with a chisel, the torso was shaped by hammering, as were three roughly contemporary limestone statues found at Coptos. Justly called colossi (they were originally more than 4 m tall), all three statues from Coptos depict an ithyphallic figure with legs together, a posture specific to Min, the god of the temple in front of which they once stood. Their monumental scale suggests that they signalled the presence of the deity, regardless of other functions that they might have performed in the cult.

Hierakonpolis, with its temple mound, was a crucial centre for the evolution of the Egyptian state during the period leading to the establishment of the 1st Dynasty about 3100 BC. The torso was excavated from a secondary context outside the town's mudbrick wall. Whether it was originally set up in association with a temple inside the town or near the gateway close to the spot where it was found is a matter for speculation.

The series of cup-like depressions down one side of the figure is another feature that the torso shares with the Coptos colossi. They were apparently made after the statues no longer stood in their appointed places but lay on the ground. It has been suggested that people grinding away at the figures in ancient times made the depressions 'to obtain magically efficacious dust' (Kemp, 1989, p. 82). Their presence would then document the power attributed to all these statues long after they ceased to perform the function for which they were created. *ME-K*

Provenance: 1898–9, Hierakonpolis, excavations of the Egyptian Research Account

Bibliography: Quibell and Green, 1902, pp. 15–16, 47, pl. LVII; Williams, 1988; Kemp, 1989, pp. 80–2

1.24

Door-socket

Egypt
c. 3100 BC
dolerite (diabase)
19 x 45 x 78 cm
University of Pennsylvania Museum of
Archaeology and Anthropology,
Philadelphia
Gift of the Egyptian Research Account,
1898, E. 3959

This very rare example of early
Egyptian three-dimensional art is of
exceptional aesthetic, symbolic and
functional interest. Carved from a
single block of stone, the door-socket
evokes, rather than fully depicts, a
bound prisoner, imagined prostrate or
as doubled up in a kneeling position.
The head projects from one end and is
expressively uplifted; the arms, bent
inwards to suggest that the elbows are
bound, are outlined more schematic-
ally on top of the block. A deep
depression between the arms is
regularly striated, and served as the
socket for the pivot – metal, or metal-
sheathed – of a wooden door. The top
of the block and of the head are
carefully flattened, so that the door
could swing freely.

The door-socket was found *in situ*
(some doubt this) at Hierakonpolis in
a context suggesting that it was once
part of a now largely vanished early
temple. The socket's base was left
rough, as were the other three sides,
for they were concealed by adjacent
masonry: one corner was dressed,
perhaps to fit against an adjacent,
irregularly shaped stone, possibly the
threshold of the doorway itself, which
would have provided access to temple
or precinct. In this same temple the
famous Narmer palette (Cairo) was
perhaps once housed.

The head faced outwards, and
the socket as a whole is the earliest
example of a frequent symbolic
element in later temples, representa-
tions of bound prisoners (nearly
always foreigners) being subjugated
by the pharaoh. Most relevant are
slabs, a similar head or heads, and
used for doorways and windows in
which the pharaoh literally appeared,
seemingly treading on their prostrate
bodies. Foreigners (or Egyptian rebels)
were emblematic of cosmic disorder
or chaos manifest on earth. The
Hierakonpolis door-socket is how-
ever a unique variation, for here the
emblematic prisoner repeatedly has

the pivot of a temple door (daily
opened and closed for ritual) cruelly
grinding into his back, the temple
itself, rather than the Pharaoh,
representing the triumphant order.

The rendering of the head is
powerful but simplified into strongly
defined planes, lacking the more
careful detail seen in later but still
relatively early examples, and prob-

ably dates to Naqada III, *c.* 3100 BC
or even earlier. Whether a foreigner
or, in the turbulent days of national
unification, an Egyptian is meant
cannot be determined. *DO*

Provenance: 1898, Hierakonpolis (Kom el
Ahmar), Egypt

Bibliography: Quibell, 1990, p. 6, pl. 3;
Quibell and Green, 1902, pp. 34–6, pl. 62;
Vandier, 1952, ch. 5; Adams, 1974, pp. 2,
52; Page, 1976, pp. 2–3; Helck, 1977, cols
315–21; Ranke, 1980, pp. 26, 30; Bothmer,
1982, pp. 30–7; Williams, 1988, pp. 57–8;
Dorf, in preparation

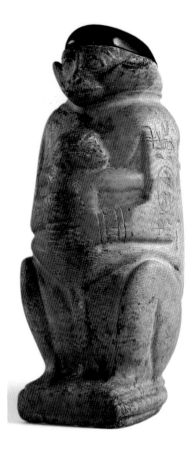

for embalmers who reconstructed the face (and sometimes also the torso) of the deceased in plaster over the mummy as one of the final stages of the mummification process. Most, including this example, were found neither in the above-ground chapel nor in the burial chamber, but seemingly discarded in the vertical shaft leading to the latter. Most are either damaged or unfinished in some way, as if to destroy their magical potency.

Giza tomb 4440 is a mastaba in the cemetery west of the Cheops pyramid (Western Cemetery), where that king's high-ranking officials were buried. Found in the burial shaft with cat. 1.25 was a second head with strikingly different features. The identity of the owners of the tomb was not preserved. *REF*

Provenance: Giza, Tomb G 4440, excavated by George Reisner

Bibliography: Reisner, 1915, pp. 32, 34; Smith, 1949, pp. 23, 25, 29; Vandersleyen, 1975, p. 223

1.25

'Reserve head' of a woman

Egypt
4th Dynasty, *c.* 2630–2524 BC
limestone
29 x 19 x 25 cm
Museum of Fine Arts, Boston
Harvard-Boston Expedition 14.719

Egyptian artists generally created idealised likenesses of their subjects rather than true portraits, but in a small number of instances there are possible exceptions to the rule. Such is the case with this life-size head, one of a category of similar pieces known as 'reserve heads', most of which come from Giza and date to the 4th Dynasty. Complete in itself, the sculpture consists of a head wearing a close-fitting wig (as indicated by a line across the forehead). The features are rendered naturalistically but sparingly, and consist of faintly modelled brows

surmounting high arching eyes, set far apart, and high cheekbones. Shallow furrows and a 'love cup' connect a short, straight nose with drilled nostrils and a full but unsmiling mouth. Its excavator, George Reisner, labelled it a Negroid princess because of its striking and non-Egyptian facial characteristics. The round face with its pronounced cheekbones and full sensuous lips is comparable with much later representations of Nubian kings from Kush, Egypt's southern neighbour. Whether it is a true portrait of a Nubian or a more generic representation, it is a striking and beautiful sculpture which incorporates the Old Kingdom ideals of restraint and aloofness.

Exactly how these 'reserve heads' functioned has never been properly explained. Recent research has suggested that they served as models

1.26

Unguent vessel in the form of a monkey with young

Egypt
6th Dynasty, reign of Pepy I,
c. 2320–2280 BC
calcite (Egyptian alabaster)
14.4 x 6 x 6.5 cm
Kunsthistorisches Museum, Vienna,
ÄS 3886

The monkey squats on the ground, pressing its young one to its chest. There is a groove around the mother's neck, showing less patina than on the rest of the surface. It can be deduced from similar pieces that it was originally filled with paste or stone inlay, indicating a necklace or rather a collar.

This is a functional vessel; it is carefully hollowed out, with the top of the head, worked of a different stone of black colour, serving as a lid. In Ancient Egypt vessels of stone were preferred as containers of unguents and cosmetic oils because,

unlike pottery, the material does not absorb the contents and probably preserves them better. The favourite stone for this was what is generally termed 'alabaster'; its more accurate scientific designation is calcite. The majority of these unguent vessels have a cylindrical or slightly conical shape. Cosmetic articles are often fancifully shaped and have symbolic meaning. The form of a loving monkey-mother may be intended to evoke the care she bestows on her baby and thus serve as a reminder that unguents are meant for the care of the body, in particular for the skin.

The vessel bears an inscription on the upper right arm in the form of the royal name 'Mery-ra', enclosed by a cartouche. This is the praenomen of king Pepy I of the 6th Dynasty. One may assume that the vessel – filled with costly cosmetics – was presented by that king to a person of high merit. *HSa*

Provenance: reportedly from Elephantine Island at Aswan

Exhibitions: Vienna 1961, no. 50; Speyer, Mexico City and Zurich 1993–4, no. 58

Bibliography: Demel, 1932; Demel, 1947, 8, fig. 16; Leibovitch, 1959, pp. 118–120; Valloggia, 1980; Satzinger, 1987, p. 78; Vienna museum guide 1988, p. 43; Satzinger, 1994, p. 52, fig. 34

1.27

**Statue of Queen Ankhnesmeryre II
and King Pepy II**

Egypt
6th Dynasty, *c.* 2269–2181 BC
calcite (Egyptian alabaster)
38.9 x 17.8 x 25.2 cm
The Brooklyn Museum
Charles Edwin Wilbour Fund, 39.119

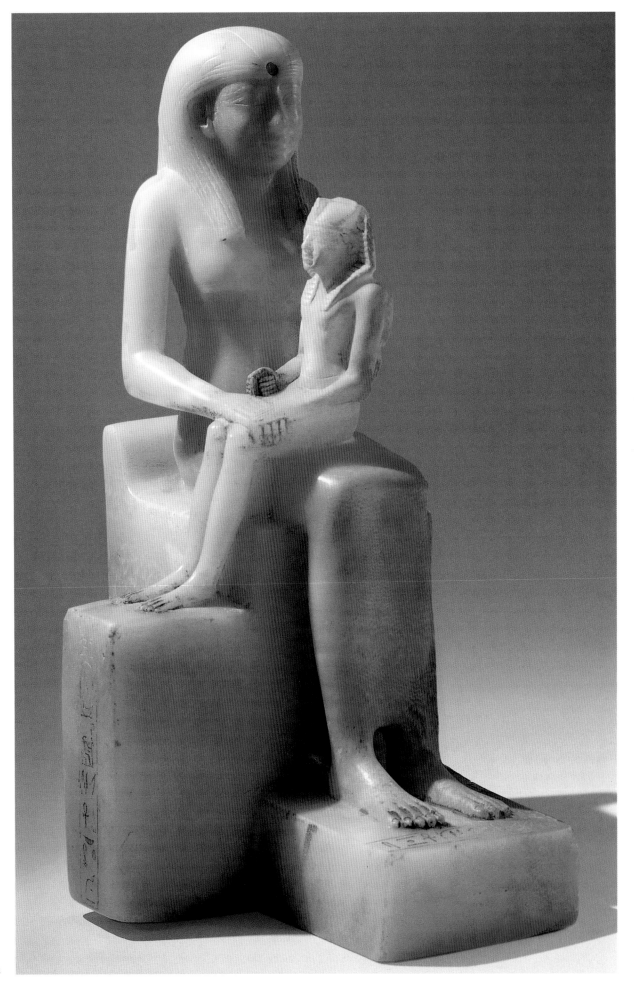

Sculptors of the Old Kingdom not only carved colossal stone statues of their rulers but also fashioned royal images on a far more intimate scale. One of the most accomplished of these smaller royal works depicts the 6th-Dynasty Queen Ankhnesmeryre II seated and holding her young son, King Pepy II, on her lap. The queen supports the boy's back with her left hand while extending her right hand over his thighs. A tight-fitting, ankle-length dress reveals the contours of her body. She wears a vulture head-dress on top of a striated tripartite wig; the circular hole on her forehead once accommodated a vulture's head (now broken off). This emphasis on the vulture — the Egyptian hieroglyph for 'mother' and the symbol of the goddess Nekhbet — signifies the queen's role as divine mother. Pepy II, shown much smaller than his mother, sports two traditional elements of royal iconography on his head: the *nemes*-headcloth and the uraeus (cobra), which protected Egyptian kings from harm.

Pepy II enjoyed one of the longest reigns in Egyptian history. When he came to the throne following his brother's death, Pepy II was a true 'boy king', probably no more than six years old. He reigned for at least 64 years. Shortly after his death, the Old Kingdom collapsed into a century or so of political disunity called the First Intermediate period.

Although the Egyptian king was the most powerful individual in pharaonic society, on this statue, at least, his mother is the primary focus of attention. Scholars interpret the piece in various ways. Some would see it as an expression of Ankhnesmeryre II's role as queen mother or as regent for her son during his minority. Others view the statue from a religious angle. A passage in the Pyramid Texts, a series of spells carved on the interior walls of later Old Kingdom pyramids, mentions the king's ascension to the sky after death in metaphorical terms, relating the act

to climbing onto a goddess's lap: 'the king ascends upon the thighs of Isis; the king mounts the thighs of Nephthys.'

The statue probably came from either Ankhnesmeryre II's as yet undiscovered burial place or a shrine dedicated to her memory. The historical record documents at least one such shrine. A royal edict, almost certainly issued by Pepy II, mentions that a statue of the queen was set up in the temple of the god Khenty-imentyu at Abydos.

This is the finest Old Kingdom example of the traditional Egyptian motif of the mother and child. Much earlier, in the predynastic period and the first two dynasties, craftsmen made mother-and-child figures in bone, stone and faience. They may have represented mortals or deities. Later, particularly in the Late period, the theme was used to depict the goddess Isis suckling the infant god Horus. *JFR*

Exhibitions: San Francisco 1975, no. 19; Berlin 1976, no. 17; Brussels 1976–7, no. 17; San Juan 1979, no. 9; Tokyo et al. 1983–4, no. 15; Hildesheim 1985, no. 105; Vienna 1992, pp. 102–3, no. 16

Bibliography: Cooney, 1949, p. 75; Wolf, 1957, pp. 175, 187; Vandier, 1958, p. 38; James, 1974, p. 28; Seidel and Wildung, 1975, p. 228; Aldred, 1979, p. 205; Bianchi, in San Juan 1979, no. 9; Aldred, 1980, p. 95; Smith, 1981, pp. 144–5; Ferber et al., 1988, p. 28; Fazzini et al., 1989, no. 15

1.28
Tomb statue of Hetep

Egypt
12th Dynasty, reign of Amenemhat I
(1985–1955 BC)
grano-diorite
h. 73.7 cm
Museum of Egyptian Antiquities, Cairo,
JE 48858

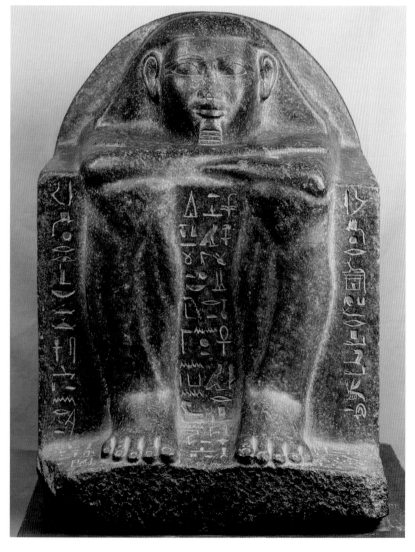

Among his other duties, Hetep served as a priest in the funerary cult of Tety (*c.* 2345–2322 BC), who reigned during the late Old Kingdom. Hetep's tomb, which he had built near Tety's pyramid, was provided with a pair of large statues; these are similar in most respects, although the one exhibited here (the better preserved example) is of a hard dark stone, while the other was carved in white limestone. The use of contrasting materials probably had meaning, but its significance is unclear.

Hetep sits or squats, with his crossed arms upon his bent knees. Little can be seen of him, however, except the front of his head, his forearms and hands, his massive lower legs and big, stumpy feet. Everything else is encased in a rectangular construction with high arms, a rounded back and a seat that also serves as a footrest. The composition has a geometric solidity, which is emphasised by the flatness of the arms.

Apart from its companion piece and a second pair in an adjacent tomb of the same date, this statue appears to be unique. Its curious form has provoked considerable comment, especially because of its similarity to block statues, which first appeared at about this time and were to become one of the most important of all Egyptian statue types. Block statues show men in the same squatting pose as Hetep, but their bodies are covered only by a cloak or long skirt. Hetep, on the other hand, appears to be enclosed in an awkwardly shaped piece of furniture, the form of which resembles a carrying chair, a prestigious mode of transport.

Carrying chairs were prominently featured in the tomb reliefs of some officials of the late Old Kingdom. The style of Hetep's statue – the flaring curve of its wig, its big staring eyes and its taut grimace of a smile – also derives from the art of the late Old Kingdom. Both the form and the style of Hetep's statue thus reflect art from the time of Tety, whose cult he maintained. This may be an example of archaism, but more probably it reflects the extraordinary longevity of traditions characteristic of Egyptian culture. *ERR*

Bibliography: Russmann, 1989, no. 19, pp. 52–4, 215; Schultz, 1992, i, no. 173, pp. 310–11, ii, pp. 753–4, fig. 96

1.29
Two model sceptres

Egypt
11th Dynasty, *c.* 2030 BC
faience
h. 29 cm (tallest)
Museum of Ancient Egyptian Art, Luxor,
J224

When the Ancient Egyptians constructed a building, especially a temple, they placed in substructure pits groups of miscellaneous objects. These two pieces come from such 'foundation deposits' found beneath the central structure (possibly a pyramid) of the funerary temple of Mentuhotep II at Deir el-Bahri.

The taller has a top that resembles a poppy-head; the binding beneath suggests that the piece might represent a form of architectural column. If so, no trace of any such column-type has been found. The other object also appears to be based on a plant prototype.

Another suggestion is that both pieces are sceptres, symbolic of the ones that were carried by the king during the final rites of the temple's foundation ceremony. Unfortunately, neither conforms to any known type. These two pieces are unique among objects found in Ancient Egyptian foundation deposits. *CARA*

Provenance: 1970; Deutsches Archäologisches Institut, Cairo,
Bibliography: Arnold, 1971, p. 128; Luxor catalogue 1979, no. 16

1.30

King Mycerinus with deities
Egypt
4th Dynasty, reign of Mycerinus
(c. 2529–2501 BC)
stone, greywacke
92.5 x 46.5 cm
Museum of Egyptian Antiquities, Cairo,
JE 40679

Mycerinus's pyramid at Giza is much
smaller than those of his predecessors,
Cheops and Chephren, but the sculp-
ture in his two pyramid temples has
been much better preserved. Among
the statues found in the Valley Temple
was a series of triads representing
Mycerinus with the goddess Hathor
and a personification of one of the
nomes (districts) of Ancient Egypt.
Four, including this one, were intact.

Mycerinus stands in the centre,
wearing the tall White Crown of
Upper Egypt, an artificial royal beard
and the pleated, wrapped royal
shendyt kilt. At his sides, cylindrical
objects are held in his fists. As on most
Egyptian statues of standing men, his
left leg is advanced. The depiction of
his youthful, muscular body (its
strength emphasised by the tension
apparent in the clenched forearms,
the high, broad pectorals, and the
tautness of the torso) clearly
represents a masculine ideal rather
than an individual. The expression-
less face seems equally impersonal,
although its rather bulging eyes and
fleshy cheeks, the slightly bulbous
nosetip and the contours of the full
mouth are features found on all
statues of Mycerinus. This is a portrait
of the king, even though it is highly
idealised – the face of a god on earth.

Hathor stands to the king's right.
She holds a *shen*-sign, symbolic of
universality, and wears a headdress
composed of cow horns, emblematic
of her manifestation as a cow, and
a sun-disc, signifying her close
connection with the sun god, Re.
The shorter stature of the nome
personification suggests her lesser
importance. Her headdress, carved in
relief on the broad back slab, is the
emblem of her nome, the Cynopolite
or Jackal nome of Upper Egypt. Each
woman has an arm around the king,
and both stand with their feet nearly
together, in the passive stance of
Egyptian female images. Hathor's left
foot, however, is slightly advanced, to
betoken her status as one of Egypt's
great deities. The women wear the

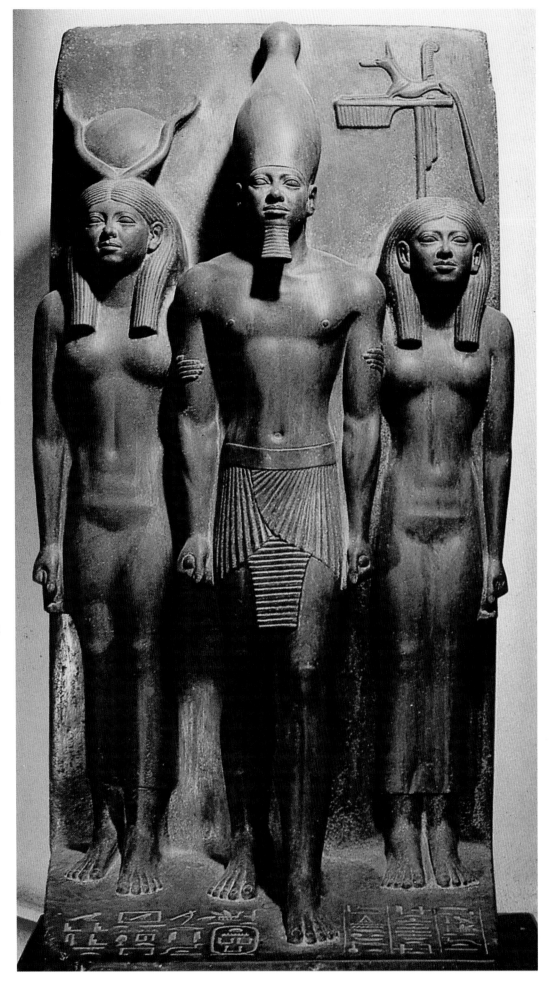

thick-tressed wigs of goddesses and long dresses, whose shoulder straps would have been indicated in paint. This dress, a standard garment of Egyptian women, was actually a sack-like linen tube. It was represented as unrealistically tight, in order to display the body. This is the Old Kingdom feminine ideal: young and athletic-looking. The emphasis on the pubic area clearly indicates a woman's paramount function in Ancient Egypt as the bearer of children. The faces of the goddesses, modelled on the features of the only god on earth, are softer, rounder versions of the king's. *ERR*

Provenance: 1908, found in the Valley Temple of the Mycerinus pyramid complex at Giza

Bibliography: Reisner, 1931, p. 109, pls 37b, 38c, 43a–d, 46e; PM III, 1, p. 28; Woods, 1974, pp. 82–93; Saleh and Sourouzian, 1987, no. 33

1.31

Girdle

Egypt
12th Dynasty, reigns of Amenemhat II–Senusret III, *c.* 1922–1855 BC
gold, lapis lazuli
l. 78.5 cm
Lent by The Metropolitan Museum of Art, New York
Rogers Fund, 1934, 34.1.154

In Egyptian jewellery, cowrie shells were used as a decorative motif from prehistoric times. The cowrie seems to have been associated with female fertility and was used in girdles to be worn around the hips. Real shells continued to be used in dynastic times but, in 12th-Dynasty jewellery of upper-class and royal women, imitations of gold or silver are common. Metal cowries were made in two halves that were either cast or punched with the same stamp and then finished by hand. Most metal cowries have small pellets inside which would have made a noise as the wearer moved. One of the present examples retains its pellets.

The elements of this girdle were found in the coffin of a young girl named Hepy, whose intact burial was discovered in a small chamber of the construction shaft of a mastaba tomb. The stringing of Hepy's jewellery had decomposed, leaving eight metal cowrie shells and a variety of

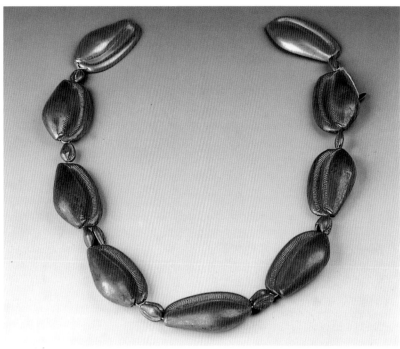

cornelian and lapis lazuli beads lying loose in the coffin. Only the small lapis barrel beads were numerous enough to have formed a girdle and they were restrung with the metal cowries in the present form. One metal shell forms a sliding clasp. The date of the burial is still under discussion, but pottery and stone vessels seem to place it in the middle of the 12th Dynasty. *CHR*

Provenance: Lisht, south cemetery, coffin of Hepy

Bibliography: Lansing, 1934; Hayes, 1953, p. 232, fig. 140

1.32

Girdle

Egypt
12th Dynasty, *c.* 1830 BC
gold
l. of each larger shell 5.7 cm
Museum of Egyptian Antiquities, Cairo, 53074, 53165

Each of the cowrie shells is made in two halves punched into a mould and soldered around the outer edge. The larger contain loose pieces of metal which would have rattled as the wearer walked (cf. cat. 1.31). The shell forming the clasp has a base-plate soldered to the underside of each half bearing a tongue-and-

groove closing device. Each large shell is pierced by two stringing holes and the smaller shells are strung in pairs between them; it is not certain, however, that the latter were originally part of this girdle.

Girdles with elements in the shape of cowrie shells were the prerogative of women. Because of the shell's fancied resemblance to the female genitalia it was believed to provide special amuletic protection to that part of the female anatomy. As a girdle element it would be worn in the right place to ward off evil forces.

Although actual cowrie shells must have served this purpose in pre-dynastic burials, already by the 6th Dynasty (*c.* 2300 BC) the form was being imitated in other materials. Hollow cowries of precious metal are particularly characteristic of the Middle Kingdom: examples in silver and electrum as well as gold have been found in non-royal burials of the period (cat. 1.31). Of the other royal ladies of the 12th Dynasty whose jewellery has survived, Sithathor owned a girdle of identical cowries.

Contemporary cosmetic containers in which female figures act as a supporting element and so-called 'concubine' figures, the latter at least intended to stimulate sexual activity whether in this life or the next, are frequently depicted wearing a cowrie girdle. However, Mereret, the owner of this girdle, was a queen, daughter of the 12th-Dynasty pharaoh Senusret III, which suggests it was funerary in nature, to stress her feminine allure in the other world rather than to be worn in this life in company with dancing girls and courtesans.

Although Mereret's burial was robbed in antiquity, the contents of her jewellery box escaped the notice of the ancient tomb robbers. Some of her jewellery can be dated to the reign of her father, other pieces to that of his successor Amenemhat III; all demonstrate the skill of the jeweller during the 12th Dynasty, probably never surpassed during the remainder of the dynastic period. *CARA*

Provenance: 1894, excavated from the burial of Mereret at Dahshur, near the pyramid of Senusret III, by J. de Morgan, Director of the Egyptian Antiquities Service

Bibliography: de Morgan, 1895, p. 65, no. 7, p. 66, no. 11; Aldred, 1971, p. 196; Wilkinson, 1971, p. 80; Andrews, 1990[1], p. 141

1.33

Anklet

Egypt
12th Dynasty *c.* 1895 BC
gold, turquoise, cornelian, lapis lazuli
l. of claws 2.15 cm
Museum of Egyptian Antiquities, Cairo,
52911-2

These matched amuletic claw pendants, one facing right, the other left, originally would have formed the main elements of a pair of anklets. The claws are of gold, the section at the top of the upper surface incised to look like granulation, the area below inlaid with semi-precious stones to look like feathering. The single suspension loop shows that, unusually, they were intended to be strung with a single row of beads, some of which must have been gold discs, rather than with a double row of amethyst ball beads (as in other contemporary examples). The hollow gold clasp is made in two parts, each punched into a mould, with a tongue-and-groove closing device on the base-plates of the undersides.

Cloisonné work involved inlaying shaped pieces of semi-precious stone into metal cells or *cloisons* formed by soldering strips of metal at right angles to the baseplate. Granulation was usually formed by attaching tiny precious metal balls in a pattern to a precious metalwork base.

Khnumet, the owner of this piece (and of the clasps at cat. 1.34), was the daughter and wife of 12th-Dynasty pharaohs.

Hollow gold knots are characteristic of the Middle Kingdom. All other royal ladies of the 12th Dynasty whose jewellery has survived owned a number of them; like Khnumet's, these served as clasps. However, contemporary solid semi-precious stone examples show they had an amuletic function, possibly funerary, of protection by binding or union, for the Egyptians had a terror that their limbs, head and torso might become separated in the other world.

Amuletic claw pendants were worn exclusively by women and are also a particular feature of the Middle Kingdom: Sithathor, Sithathoriunet and Mereret owned pairs, and further examples have been excavated in contemporary non-royal burials. A dancing girl is depicted wearing anklets with attached claws in a 12th-Dynasty tomb.

Amuletic claws are usually of precious metal, sometimes (as in this instance) with *cloisonné* inlays, but others are of semi-precious stones; real claws have been found in burials of predynastic date some thirteen centuries earlier. Their symbolism is unclear. They are usually identified as those of a leopard, but examples like these with imitation feathering suggest that a bird's claw was intended. Perhaps the speed and swooping actions of a bird were to be assimilated by the women who wore them. *CARA*

Provenance: 1895, excavated from the intact burial of Khnumet, at Dahshur, near the pyramid of Amenemhat II, by J. de Morgan, Director of the Egyptian Antiquities Service

Bibliography: de Morgan, 1903, p. 59, no. 11; Aldred, 1971, pp. 180–1; Wilkinson, 1971, p. 62; Andrews, 1990[1], pp. 163, 173

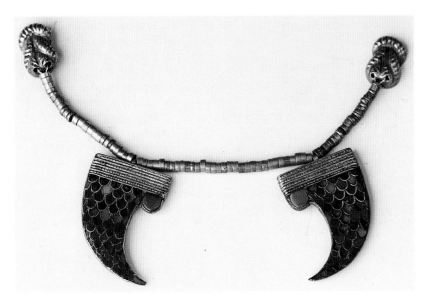

1.34a

Motto clasp

Egypt
12th Dynasty, c. 1895 BC
gold, turquoise, cornelian, lapis lazuli
h. 1.9 cm
Museum of Egyptian Antiquities, Cairo,
52956

1.34b

Motto clasp

Egypt
12th Dynasty, c. 1895 BC
gold, turquoise, cornelian, lapis lazuli
h. 3.3 cm
Museum of Egyptian Antiquities, Cairo,
52955

Both these clasps are of gold, inlaid with semi-precious stones in *cloisons*. They are currently strung with short lengths of tiny gold disc beads, but the suggestion is that they were originally worn on longer strings so as to hang on the chest as pendants. Each has a horizontal suspension tube at the back which divides into two, one half remaining attached to a fixed T-shaped rod over which slips a sleeve attached to the other half of the suspension tube. The *cloisons* or cells into which the shaped pieces of semi-precious stone are inlaid are formed from strips of metal (cf. cat. 1.33). Khnumet, the owner of these clasps, was the daughter and wife of 12th-Dynasty pharaohs.

The amuletic motto clasp in the shape of an *ankh*-sign flanked by a looped *sa*-sign and papyrus clump over a semicircular basket spells out to the wearer the hieroglyphic message 'all life and protection are behind (her)'. The other takes the shape of the hieroglyphic sign *mes* formed from three knotted fox skins, possibly representing a primitive apron, which is used to write such words as 'birth'. Perhaps this piece was intended to endow its wearer with the capability for new birth or resurrection. *CARA*

Provenance: 1895, excavated from the intact burial of Khnumet at Dahshur, near the pyramid of Amenemhat II, by J. de Morgan, Director of the Egyptian Antiquities Service

Bibliography: de Morgan, 1903, p. 63, nos 34, 63; Aldred, 1971, p. 188; Wilkinson, 1971, pp. 57–8; Andrews, 1990[1], p. 177

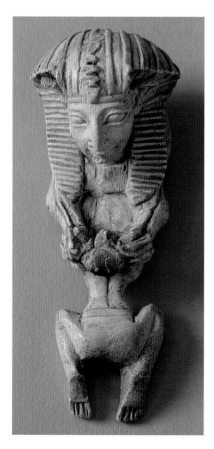

1.35
Miniature sphinx holding a captive

Egypt
Middle Kingdom,
c. 1985–1800 BC (?)
ivory
3 x 2.5 x 6 cm
The Trustees of the British Museum,
London, EA. 54678

The forepart of a sphinx – a composite creature with a king's head and a lion's body – holds in its claws the head of a prostrate captive, probably a Nubian, one of the traditional foes of Egypt (cf. cat. 1.48). The king wears the characteristic *nemes*-headdress with the royal uraeus at the front, its tail winding backwards over the head, the end now lost. The captive's knees are drawn up and his arms extended beneath the sphinx's legs. He appears to be naked except for a belt at the waist and a short wig. The line of his backbone is clearly indicated, as are his toes. His back is concave and his head tilted up towards the king, the face expressionless. The king's gaze is directed, regally, above and beyond his victim. The latter's rear and legs are disproportionately large, balancing the bulk of the royal head and headdress.

This ivory is a masterpiece of small sculpture, showing minute and very

skilful attention to significant detail, outstandingly so in the case of the royal features, which form a striking and distinctive portrait. The king has wide eyes with slightly bulging orbs, a prominent aquiline nose, high cheekbones, a small mouth with protruding lips – curved into a perceptible smile – a narrow pointed chin and enormous ears, which are splayed against the wings of the headdress (the latter feature a commonplace of royal sculpture of this period). In contrast to the delicacy of the face, the lion's body is suitably robust, with the underlying bone and muscle, particularly of the forelegs, strongly emphasised and the long sharp claws individually modelled, so as to indicate both the great power of the sphinx and the hopeless predicament of the captive. The composition symbolises, albeit on a small scale, the archetypal view of the king as the strong, invincible protector of Egypt.

The piece was not made to stand by itself, the presence of two peg-holes in its base indicating that it was originally meant to be attached to something else. It may perhaps have served as the handle to the lid of a box, for which its shape and size would have been well suited. Unfortunately its date is uncertain. Although it comes from an excavation, the context was disturbed and so ill-recorded as to allow at best only a general dating to the Middle Kingdom or Second Intermediate period. The head was once thought to be a portrait of one of the foreign 'Hyksos' kings who ruled Egypt for part of the latter period, but this view is now discounted. Recent stylistic analysis favours an attribution to the 12th Dynasty and, more particularly, to the reign of Senusret I, although the evidence remains inconclusive.

The ivory is in a very good state of preservation, although it is cracked and abraded in parts. Discoloration at the rear of the captive's head looks like charring. *WVD*

Provenance: 1908, excavated from tomb 477 by Garstang at Abydos; 1920, given to the museum by Mrs Russell Rea

Exhibitions: Cambridge and Liverpool 1988, no. 138; Vienna 1994, no. 362

Bibliography: Garstang, 1928, pp. 46–7, pl. vii; Schweitzer, 1948, p. 40, pl. ix, 3; Bourriau, in Cambridge and Liverpool 1988, pp. 136–8; Quirke, in Vienna 1994, no. 362

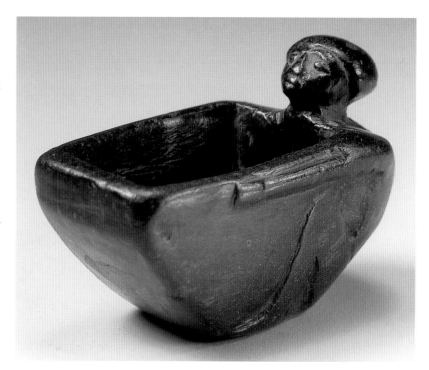

1.36
Figurine of a man holding a container

Egypt
late Middle Kingdom, *c.* 1700 BC (?)
stone (steatite)
4.2 x 3.6 x 6.7 cm
The Trustees of the British Museum,
London, EA. 74328

This cosmetic object is in the form of a squatting man, his knees bent and his arms extended on either side of a large rectangular basin with a sloping front. The man's head is rendered fully in the round, his limbs in shallow relief. He is shown wearing a short wig and a belt but is otherwise naked. He is possibly meant to represent a Nubian. The treatment of detail is economical with the slope of the vessel neatly balanced by the curve of the man's back, which is further complemented by the upward tilt of the head.

The combination of round and relief work was a popular technique of decoration on cosmetic objects, with animals, particularly monkeys, being favoured subjects (cat. 1.26). Human figures are less common in such contexts and the iconography of this piece, which partly anticipates that of the more formal type of statue represented by cat. 1.39, is highly unusual for its date. *WVD*

Provenance: 1994, purchased by the museum

1.37
Decorated ostrich egg

Egypt
2nd millennium BC or later
ostrich egg
h. 13.5 cm; diam. 11.5 cm
Musées Royaux d'Art et d'Histoire,
Brussels, E. 2338

In northern Africa ostrich eggs have been used as containers for water from epipalaeolithic times, and even after the introduction of pottery they continued to be used for this purpose.

In Egypt ostrich eggs were only exceptionally used as a containers. A number of eggs, some of them decorated, have been found in tombs (cat. 1.11) dating to the predynastic period, and especially in Nubia. Their use as material for beads was also mainly restricted to Nubia.

The decoration of cat. 1.37 consists of 37 spirals, linked in one running motif, starting at the base of the egg and leading to the small opening in the top. The spirals are incised with great care, and they are evenly distributed over the surface of the egg. Running spiral motifs are unknown in Egypt before the First Intermediate period, although they occur far earlier in the Eastern Mediterranean region. From the 2nd millennium BC onwards, they are especially characteristic of Aegean art. Nevertheless, there is no reason to accept a foreign origin for the running spiral motifs found in Egypt, since the earliest examples on early Middle Kingdom scarabs were

probably derived from an Egyptian hieroglyph. Nothing definitive can be said about a symbolic meaning for this motif within the Egyptian context. *SH*

Provenance: 1905, bought Cairo
Exhibition: Brussels 1988, p. 116, no. 11
Bibliography: Scharff, 1929, p. 85; Kantor, 1948, p. 46, n. 4

1.38

Baboon in adoring posture with small figure of a king

Egypt
18th Dynasty, most probably reign of Amenhotep II, *c.* 1427–1400 BC
red granite
h. 130 cm
Kunsthistorisches Museum, Vienna
Miramar Collection, 1878, ÄS 5782

The baboon is standing on its hind-legs, hands raised with open palms turned outwards. This is the canonic posture that signals 'adoration' both in Egyptian art and in hieroglyphic writing. In front of the animal is the figure of a king, exactly three-fifths its size. He is in another, specifically royal, posture of prayer that signifies 'to adore the god four times': his palms are lying flat on the protruding triangular front part of his royal kilt. Apart from the kilt and the royal *nemes*-headcloth, the figure is naked.

The surface has suffered in some areas, including of the king's face; his ceremonial beard is also broken away.

The carving is done in a rather summary way, owing largely to the hardness of the material, which could be worked only by hammering and grinding. Nevertheless, it is a fine composition and an impressive piece of sculpture.

In religious iconography, the baboon has several meanings. It is best known as the sacred animal of Thoth, god of wisdom and the local god of Hermopolis. Equally important is its relation to the solar cult. The baboon with its hands raised in adoration signifies the greeting of the morning sun when it emerges from the under-world and rises above the horizon. The origin of this imagery is thought to lie in the fact that when baboons leave their sleeping places in the early morning they indulge in great noise and commotion; Egyptian symbolism equated this with the greeting of the sun.

The sun is the symbol of death and rebirth. Sunset and sunrise are the critical phases in its imagined orbit. When the sun god passes the horizon in the solar boat, either upwards or downwards, he needs the co-operation of all his crew and entourage. On earth the pharaoh, his son and his deputy must assist the process. This is obviously what the sculpture expresses: the king performs the appropriate rites for sunrise.

A fragmentary group of a baboon and a king (in Berlin) may have formed a pair with this piece. It is probable that both pieces originate either from an obelisk or from the sun altar of a royal mortuary temple. Stylistically, the dating of the sculpture has recently been narrowed down to the reign of Amenhotep II. On the baboon's chest, a king's name is incised rather carelessly in shallow relief. It can be identified as that of Sety I of the 19th Dynasty. However, the stylistic evidence, indicating an earlier date for the sculpture, is so strong that the inscription must be regarded as secondary.

The temple-building activities of Amenhotep II, included the erection of obelisks, are attested at Heliopolis and Elephantine Island; he also contributed to the great temple of Karnak. His own mortuary temple, which lay north of the Ramesseum, on the west bank at Thebes, has been destroyed and there are no traces of a sun altar. In the publication of the

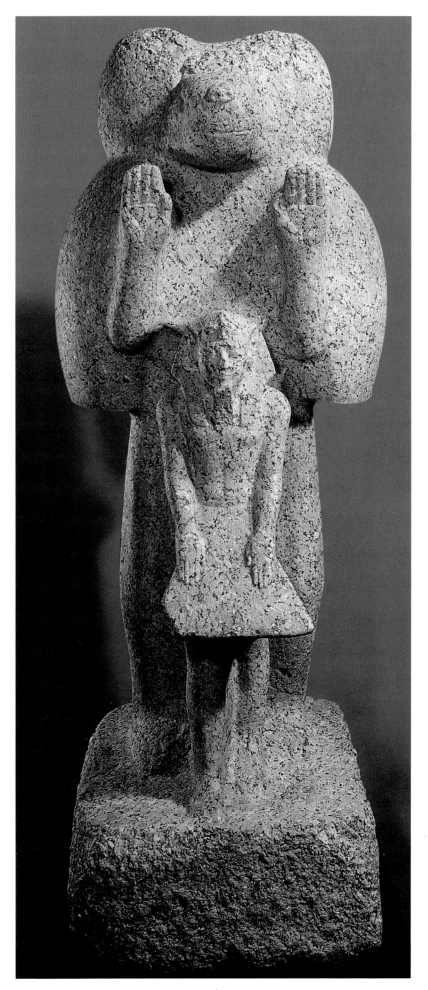

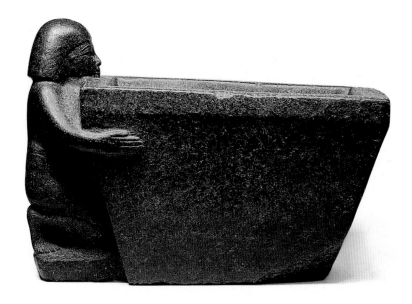

Miramar Collection (Reinisch, 1865) it is stated that this statue comes from the ruins of ancient Memphis. If this is to be taken seriously, it can be assumed that it originated from a Memphite sanctuary that has now completely disappeared (like nearly all buildings of that city), unless it was transported there from Heliopolis in antiquity. This might have occurred in the reign of Sety I, whose name can be read on the baboon. *HSa*

Provenance: reportedly from Memphis
Exhibitions: Essen 1961, no. 112; Stockholm 1961, no. 96; Vienna 1961, no. 116; Zurich 1961, no. 167; Trieste 1986, no. II. 24; Vienna 1992, no. 89; Speyer, Mexico City and Zurich 1993–4, no. 85
Bibliography: Reinisch, 1865, p. 243, no. 59 Porter and Moss, 2nd edition, 1981, III/2, 864; Jaros-Deckert, 1987, pp. 132–8; Satzinger, 1987, p. 19; Vienna museum guide, 1988, p. 31; Sourouzian, 1991, p. 72; Satzinger, 1994, p. 74, fig. 50; Satzinger, in preparation

1.39

Kneeling figure with offering basin

Egypt
18th Dynasty, *c.* 1390–1352 BC
gabbro
24 x 19 x 33.5 cm
Private Collection

One of the extraordinary qualities of Ancient Egyptian art is the visualisation of complex and abstract ideas though simple icons. The Last Judgement, for example, is represented in a balance where, in the presence of Osiris, the heart of the dead is outweighed against the symbol of Maat, the goddess of justice. In an equally simple and impressive motif the dependence of men on the blessing of god is formulated in this statue. The kneeling male figure embraces a rectangular offering tank. The chin slots into one of the sides of the basin; the lips touch its upper rim and seem to drink from the liquid to be offered in the container.

Hieroglyphic texts run around the rim and cover the opposite side of the basin. Their offering formula addresses the goddesses Astarte and Kadesh, both foreign gods introduced into Egypt from Syria at the beginning of the 18th Dynasty and venerated especially in the city of Memphis, at this time the political centre of Egypt. Ptah-ankh, the owner of this statue, was assistant of Ptah-mose, the high priest of the Memphite god Ptah. It is remarkable that Ptah-ankh does not address 'his' god Ptah but puts faith in more popular gods such as the foreign goddesses Astarte and Kadesh – typical for a cosmopolitan city like Memphis. The attitude of this statue expresses his devotion to these two goddesses and his hope that he might participate in the offerings presented to them. *DW*

Exhibition: Paris 1993, no. 40bis
Bibliography: Wildung, 1985, pp. 17–38

1.40

Vase in the form of a kneeling woman

Egypt
Amenhotep
1390–1352 BC
fired clay, dark red slip
13.9 x 6.2 x 6.8 cm
The Visitors of the Ashmolean Museum, Oxford, 1896–1908 E2432

This vase, more sculpture than container, depicts a pose passive but alert, suggesting a maidservant awaiting instructions. It is mould-made and there is a trace of a side seam under the left arm. The head may have been cast in a separate mould, as shown by a fragmentary second vase either from the same mould or, since it is slightly larger, used to create the moulds for this vase. The arms and spout were shaped by hand and applied. The fabric is a fine marl clay and the surface has been coated with a dark red slip. Red pigment has been used to emphasise the mouth and to indicate jewellery: necklace, breast ornament and girdle.

The vase was found in the intact burial of a young girl, datable by pottery to early in the reign of Rameses II, *c.* 1270 BC. The context is thus approximately 100 years later than the vase itself, and this is confirmed by the fact that the second vase comes from the 18th Dynasty. The vase exhibited here was either reused or was an heirloom and the

surface shows some loss of detail through handling. A string of beads had been placed around the neck, a reminder of the Egyptian belief that images of living beings held a latent power of life which could be animated by magic, in this case perhaps with the purpose of providing a serving maid for the dead girl in the afterlife.

Between *c.* 1450 and *c.* 1300 BC figure vases were popular in Egypt and the most common subject was a female servant in a variety of poses. They were the product of specialist workshops, since both their material and their technology distinguish them from the coarser, wheel-thrown pottery of their time. Their Egyptian origin is now recognised, although their excavators assumed they were Aegean in inspiration and manufacture. It is an archaeological accident that all the excavated examples have been found in tombs, since the vases were not made for funerals but show signs of everyday use as containers for perfumes and medicines, precious commodities used in the smallest quantities. *JDB*

Provenance: Abydos, grave W 1; given to the museum by the Egyptian Exploration Society

Exhibition: Cambridge 1981

Bibliography: Randall-MacIver and Mace, 1902, pl. XLVIII. D29; Ayrton et al., 1904, pp. 49–50, pl. XVI; Murray, 1911, pl. XXV. 66; Cambridge 1981, pp. 34–5; Bourriau, 1985, pp. 35–6, fig. 10; Bourriau, 1987, p. 90, pl. XXXIX.1; Hope, 1987, fig. 51

1.41

Temple monument dedicated by Nebnefer

18th Dynasty, reign of Amenhotep III (1390–1352 BC)
grano-diorite
55.5 x 30 x 30.5 cm
Museum of Ancient Egyptian Art, Luxor, J. 136

This unusual monument was found in a temple of the crocodile god Sobek, where it had been dedicated by the Overseer of the Treasury of Amun, Nebnefer. Carved from a block of dark grano-diorite, it consists of the statues of two crocodiles on top of a pedestal-like, decorated base. The animals are shown crouching, with their tails hanging down at the back and their long snouts supported by the kind of

reinforcing fill employed on most Egyptian stone sculpture. The sculptor, obviously an accomplished stone carver, may have deliberately shortened the bodies, in order to make the statue's overall scale as large as possible, within the dimensions of the block.

Nebnefer is represented in sunk relief on both sides of the base. On one side, wearing the wig and costume of an official, he raises his hands in adoration of Amenhotep III. As often in Egyptian art, the king's image is represented by his name, enclosed within the royal oval or cartouche. His divine status, alluded to by Nebnefer's worshipful pose, is made explicit by a god's headdress of sun-disc and plumes, which crowns the cartouche. On the other side of the base, Nebnefer, his head shaven to denote the priestly aspect of his office, is shown worshipping both Sobek and the goddess Hathor.

The front of the base is filled with a sunk relief depiction of the emblem of Hathor: a woman's face with the ears of a cow, incorporated into a shrine-topped sistrum (a musical instrument particularly associated with her cult). The neck of the Hathor head rests on three hieroglyphs which again spell out the name of Amenhotep III. Thus, while worshipping Sobek within his temple, Nebnefer emphasised his devotion to the king and to Hathor. Since the goddess, who was often depicted as a cow, could also manifest herself in other animal forms, it is likely to be she who is represented by the second crocodile statue. *ERR*

Provenance: 1967, found at Dahamsa (ancient Sumenu), south-west of Luxor, in a temple of Sobek

Bibliography: Bakry, 1969, p. 21; Bakry, 1971, pp. 138–9, pls 30–1; Luxor 1979, no. 123, pp. 94–5, figs 71–2

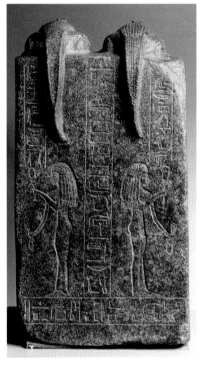

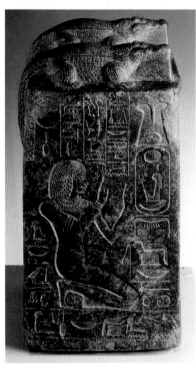

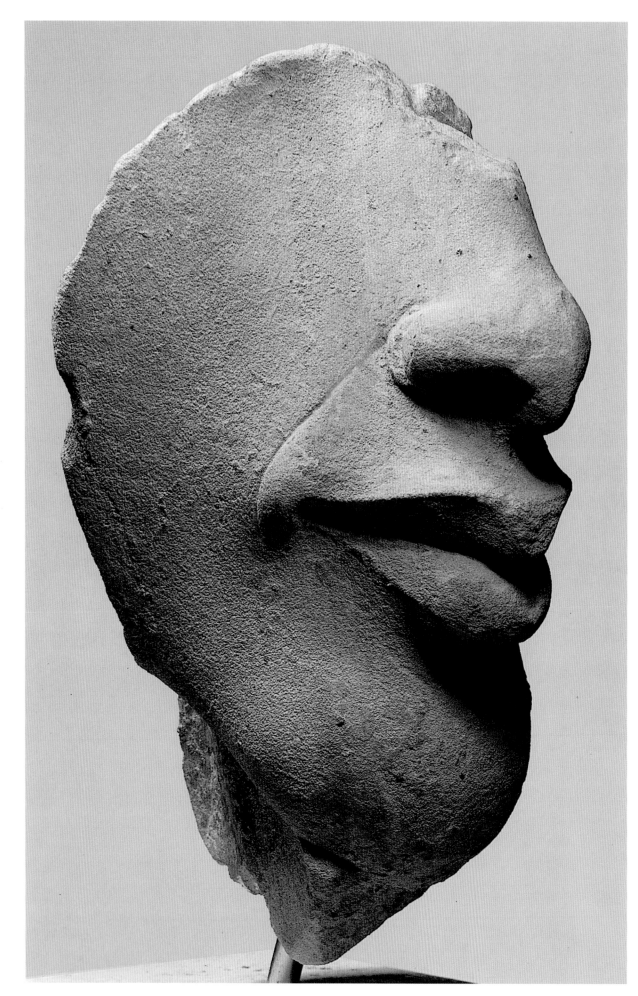

1.42

Fragment of a colossus of Akhenaten

Egypt
18th Dynasty, *c.* 1350 BC
sandstone
32.2 x 18.8 x 23 cm
Staatliche Sammlung Ägyptischer Kunst,
Munich, 6290

More famous than any other period of pharaonic history, the epoch of Akhenaten and Nefertiti, called the Amarna period after the modern name of the capital founded by the king in Middle Egypt, is not at all typical of Egyptian art. The highly impressionistic style is marked by the exaggerated features of the king himself.

The established proportions of Egyptian art having been set aside, the individual forms took on a new appearance: the face thin and elongated with a drooping chin, the lips turned up, and deep lines drawn from the fleshy sides of the nose to the corners of the mouth.

The more the personal, individual style of Akhenaten came to the fore in Amarna art, the less distinctive became the representation of others. Everything was subordinated to the image of the king, and thus his appearance determined the representation of man himself.

This fragment of a face comes from one of the colossal statues of Akhenaten erected in the temple of Aten, the monotheistic god, in Karnak, Thebes, during the first years of the reign. These statues show the king as both male and female, with voluptuous hips and full thighs, thus taking upon himself the role of the creator god. *DW*

Provenance: Karnak, temple of Aten east of Amun temple

Bibliography: Hamburg 1882, pp. 50–1; Munich 1993, no. 27

1.43

Nubian girl with monkey and dish
Egypt
18th Dynasty, *c.* 1390–1352 BC
ebony
17.5 x 8.7 x 5.6 cm
Petrie Museum of Egyptian Archaeology,
University College, London, UC. 9601

This figure of a Nubian child is set on
a rectangular base made separately of
the same wood. It was reconstructed
from fragments by the restorer Martin
Burgess when he worked at the Petrie
Museum in the 1950s. The girl is
naked with her left foot forward, in
striding mode; her head is shaved
except for four round patches of
tightly curled hair. Her ears are
pierced. The arms are made in two
parts, joined at the shoulders and
elbows. As is usual in Egyptian
wooden statuary, the feet are made
separately and attached to the legs.
Pegs through the right and left sides
of the base join the two pieces
together.

The slave girl carries a large
serving-dish, decorated on the interior
with a daisy-wheel design with dotted
petals. This design is found impressed
into bronze dishes of this period, and
the shape is common in stone and
faience in the New Kingdom. The
zigzag decoration on the rim is also
found on spoons of this period. The
long, splayed foot of the dish rests on
the head of a monkey, which faces out
to the left side. This type of monkey
was especially popular in the reign of
the pharaoh Amenhotep III towards
the end of the 18th Dynasty. The
material of which this object is made
would have been imported from else-
where in Africa, as would the monkey
and the object itself, a fashionable
accessory for New Kingdom ladies.
BA

Provenance: 1896, bought by W. M.
Flinders Petrie in Cairo (said to be from
Thebes)

Exhibitions: Boston 1982; Cleveland 1992

Bibliography: Capart, 1905, pl. LXVIII;
Page, 1976, no. 88; Brovarski et al., 1982,
no. 239; Kozloff and Bryan, 1992, no. 88

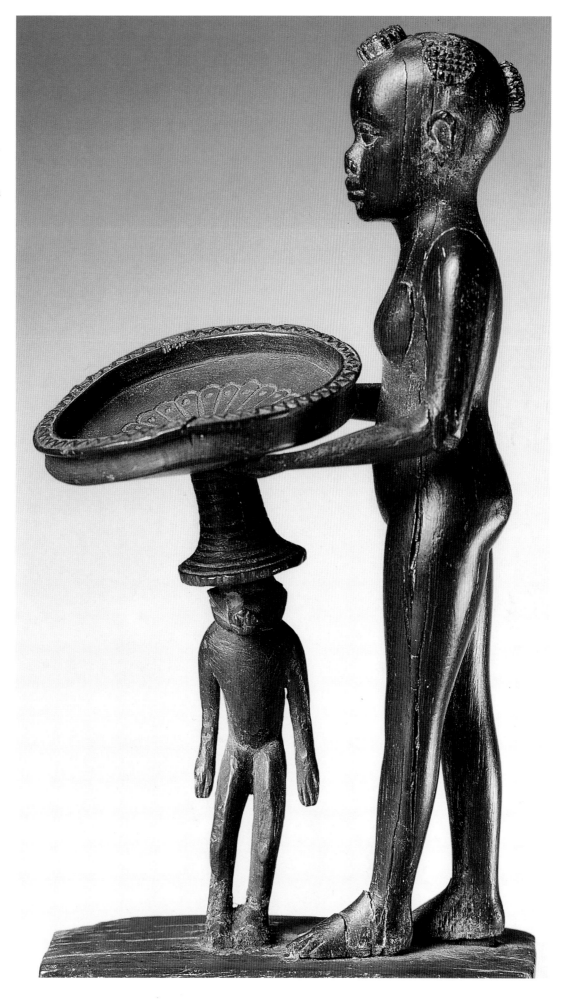

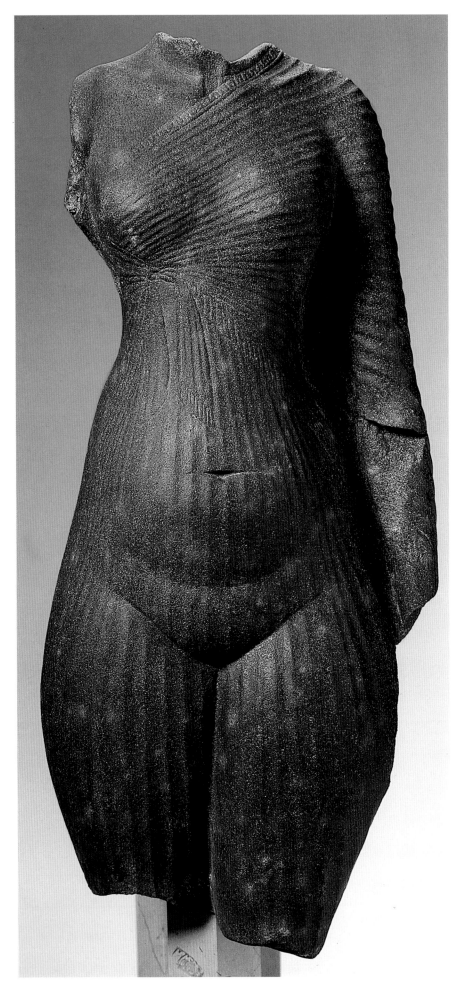

1.44

Female torso, probably Queen Nefertiti

Egypt
18th Dynasty, Amarna period,
c. 1352–1345 BC
quartzite
h. 29 cm
Musée du Louvre, Paris, E 25409

This admirable statue, unfortunately fragmentary and without inscription, probably represents Queen Nefertiti, wife of the Pharaoh Amenhotep IV (Akhenaten). The head, the right arm, the left hand and the legs from the knees down are lost, as is the top of the pillar behind the figure. She is wearing a clinging pleated dress; a shawl with a border and a fringe covers her left shoulder and arm, leaving her right shoulder bare. The clothing is knotted below her right breast. Under the sheer fabric the curvaceous body is sensuously modelled. This statue illustrates the virtuosity of the sculptors of the Amarna period, who created a new, naturalistic manner of representing the female form: every detail can be seen under the careful pleating of the dress, the latter revealing more than it conceals.

The top part of the body is modelled with great delicacy and this is accentuated by the fan-shaped disposition of the narrow pleats; in contrast, the lower half is much heavier and the pleats are broad and vertical. The shoulders are straight, the top of the back flat and the bust small but finely modelled: the effect is elegant and regal. The slim waist and long torso contrast with the amply proportioned hips and thighs. A long furrow underlines the base of the softly curving stomach.

The exaggeration of the forms, very evident from the side view, is typical of the art of the early Amarna period. In the case of Nefertiti it may be a symbol of her priestly status in the Aten cult, of which sensuality is an important feature.

This piece of sculpture is a superb example of the artistic innovations of its period; innumerable later female statues were to echo its style and lines.
PR

Bibliography: Vandier, 1958, pp. 340, 351–2; Aldred, 1975; Aldred, 1988, pp. 223–4, figs 69–70

1.45

Head of an Amarna princess

Amarna, Egypt
18th Dynasty, Amarna period
(1352–1336 BC)
brown quartzite
h. 21 cm
Museum of Egyptian Antiquities, Cairo,
JE 44869

This head was made for a composite statue of one of the six daughters of Akhenaten and Nefertiti. The long tang that extends below the neck was intended to fit into a body made of white stone or some other material that simulated the colour of her linen dress. Hands and feet would have been carved in the same brownish quartzite, and the completed statue would probably have been embellished with gilding, and perhaps with the attachment of real jewellery.

The princess's shaven skull and her lack of a wig suggest that she was still a child, but her features indicate that she was well past infancy. The depressions in her earlobes show that she was old enough to wear the heavy, ornately jewelled earrings fashionable in this period for both men and women.

The most striking element of this representation is the girl's elongated skull which, though beautifully balanced in terms of sculptural form, is greatly in excess of normal physical proportions. By contrast, the face is attractive and appears quite normal. Its features, however, are also somewhat exaggerated: the eyes are large and heavy-lidded; the narrow-bridged nose is quite long; the full mouth is large in relation to the narrow jaw; the long chin juts forward in an oversized knob. All of these exaggerations derive from the images of Akhenaten, whose physical peculiarities were imposed on the representations of his wife and children. Nevertheless, the portraits of the princess's mother, Nefertiti, achieve her likeness by the use of slight but distinctive variations in the shapes of her lips and other features. The face of this princess may well be a similar kind of portrait, but with features too subtly distinguished for us to recognise. In any case, her distended skull is certainly fictitious, an artistic rather than a genetic inheritance from her father.

In the earliest representations of Akhenaten and his family, physical

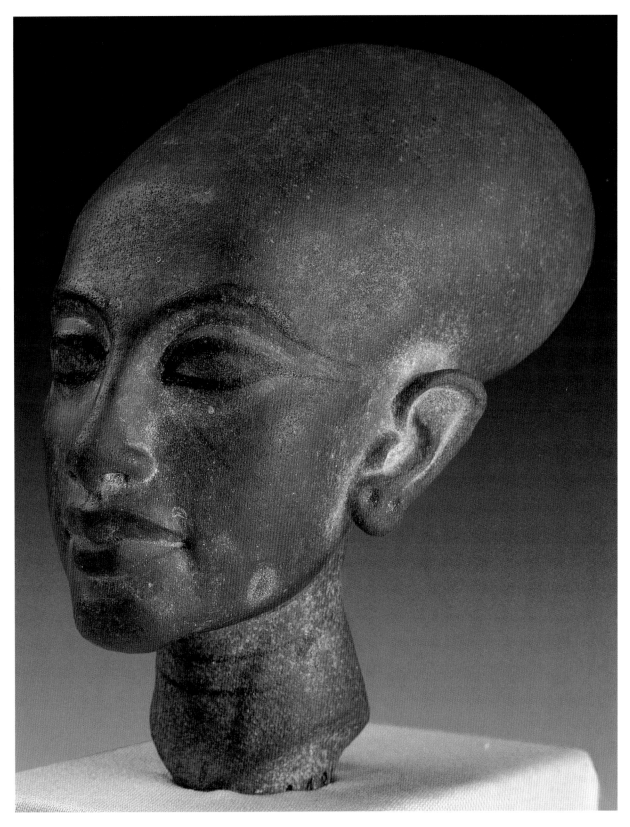

peculiarities were emphasised to an almost grotesque degree. Later in the reign, this harshly unflattering style was superseded by the softer, more naturalistic version seen in this head. This new style may have been the contribution of the master sculptor Thutmose, in whose workshop the head was found. If it, and other works

from his studio, were indeed made by him, Thutmose must be counted among the world's great sculptors; statues like this not only exemplify the feat of transmuting the king's revolutionary ideas into attractive images, but also evidence a refined handling of sculptural volumes and planes, combined with an

extraordinary ability to infuse the human face with a beauty that seems to emanate from the spirit as well as the flesh. *ERR*

Provenance: 1912, found at Amarna, in the workshop of Thutmose

Bibliography: Aldred, 1980, fig. 26; Saleh and Sourouzian, 1987, no. 163

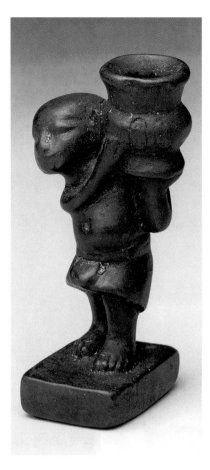

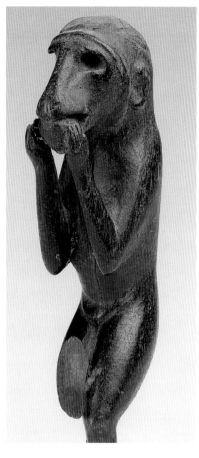

1.46

Dwarf bearer

Egypt
18th Dynasty, Amarna period,
c. 1352–1336 BC
wood
5.9 x 1.8 x 2.6 cm
Museum of Fine Arts, Boston
Helen and Alice Colburn Fund, 48.296

Whether colossal in scale or just a
few centimetres in height, Egyptian
art is monumental, and that is no-
where better conveyed than in this
representation of a dwarf carrying a
jar. Wearing a short, wrap-around kilt,
he strides forward on his left leg and
uses both hands to balance a vessel on
his shoulder. This is a true master-
work in miniature, with every aspect
of the dwarf's tiny body bending to
accommodate the weight of the jar.
The jar is hollow and may have been
used to hold a small amount of a
precious unguent, judging by larger
examples. On the jar are two tiny
cartouches bearing the names of the
royal couple, Akhenaten and Nefertiti.
The entire composition, includ-
ing the rectangular base on which
the dwarf stands, was made
from a single piece of wood. It is
possible that it was intended as a
royal gift.

Dwarfs are frequently represented
in Egyptian art and mentioned in
texts. They seem to have enjoyed a
special place in the royal household,
particularly in the Old Kingdom,
when their dancing both amused the
king and served a ritual function.
(Pygmies were imported from central
Africa for the same purpose.) Beauti-
fully decorated tombs of dwarfs at
Giza indicate that at times they
achieved considerable status. Dwarfs
also served in private households as
artisans or attendants. A number of
gods, including Bes and Patek, are
so represented and religious texts
associate dwarfs with aspects of the
sun god. At Tell el-Amarna, the site at
which this object is said to have been
found, representations from private
tombs show dancing dwarfs
accompanying Akhenaten and his
family as they worship the sun.
REF

Provenance: said to be from Tell el-
Amarna

Exhibition: Boston, Baltimore and
Houston 1982, p. 205

Bibliography: Keimer, 1949, p. 139,
n. 10 E; Bothmer, 1949, pp. 9ff.; Terrace,
1968, pp. 49–56

1.47

Monkey nibbling fruit

Egypt
New Kingdom, 1550–1186 BC
wood
h. 12 cm
Museum of Fine Arts, Boston, 148.70
On loan from the William Kelly Simpson
Collection

Although native to Egypt, at least
until the Middle Kingdom, monkeys
were also imported from further south
in Africa. Here, a crouching monkey
nibbles on a piece of fruit that he
holds in his mouth with both hands.
On his face, which is set off by a
raised ridge, deep-set eyes merge into
a long snout with nostrils indicated by
two nicks. The body is sparingly
modelled.

Unlike baboons, which were deified
and worshipped as the reckoners of
time and messengers of the sun god,
monkeys served to amuse and to
entertain. They may have been kept
as pets (cf. cat. 1.43). Their human-
like antics made them a popular
favourite of Egyptian artists, and they
are frequently depicted in the round,
in relief and in painting. They may
assist women at their toilette or help
in the harvest. In other examples they
replace humans and mimic their
actions. Crouching monkeys nibbling
food were especially popular in the
18th and 19th Dynasties, the period to
which this example is attributed. Its
function is uncertain. *REF*

Exhibitions: Katonah 1977, p. 64; Boston,
Baltimore and Houston 1982, p. 276

1.48

Protome of a lion with the head of a Nubian in its jaws

Egypt
early 19th Dynasty, reign of Ramses II,
c. 1279–1213 BC
Egyptian blue, gold
l. 4.3 cm
Lent by The Metropolitan Museum of
Art, New York
Given by the Trustees of the Norbert
Schimmel Trust in 1989, 1989.281

In Egyptian iconography the lion
symbolises the power of the king, and
the animal is a common decorative
element in minor arts. One of the
duties of the pharaoh was to protect
Egypt from its traditional foreign
enemies – Asiatics to the east,
Nubians to the south and Libyans to
the west. Thus, the image of a lion
subjugating a foreigner is a frequent
theme in early Ramesside art,
especially under Ramses II. The
common rendition shows a bound
captive kneeling before a lion who
holds the back of the man's head in
his jaws. This protome (representation
of the animal's forepart) employs
the theme in an abbreviated form.
The contours of the faces of the lion
and the Nubian are modelled with
superb naturalism, while details of
the animal's mane, ears and mouth
are more stylised. Three of the lion's
eight gold teeth are preserved on the
proper right side and the stub of
another may be seen on the left.
The gold linings of the animal's eye
sockets are preserved, but the inlaid

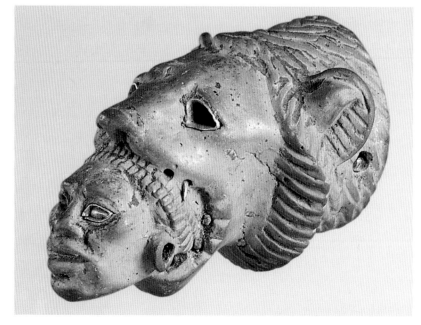

eyes are gone. The Nubian's right eye, rimmed and inlaid with gold, remains intact.

Two flywhisks, decorated with gilded lion heads, were found in the tomb of Tutankhamun. Although somewhat smaller, this protome also may have decorated a royal flywhisk or whip handle. The neck of the lion is hollow, with two small holes allowing the piece to be dowelled in place.

An 18th-Dynasty date has been suggested for this piece. However, the animal's head, especially its profile, closely resembles those of the lions that once decorated newel posts in the palace of Ramses II at Qantir. Like those from Qantir, this lion lacks any indication of the tear lines beneath the eyes that are a common feature of late 18th-Dynasty representations of felines, but are usually lacking in early Ramesside examples. *CHR*

Bibliography: Muscarella, 1974, no. 202; Settgast and Gehrig, 1978, no. 232; Kozloff, 1983; Roehrig, 1992; Kozloff, 1992, p.224

1.49

Relief depicting soldiers

Egypt
18th Dynasty, Amarna period,
c. 1352–1336 BC
limestone
17.5 x 25 x 6 cm
Lent by the Syndics of the Fitzwilliam Museum, Cambridge, E.G.A. 4514. 1943

The Amarna period is traditionally thought of as a time when military preoccupation was suspended while king and court devoted themselves to the new cult. However, written documents and representational evidence (such as this relief) indicate that the Egyptian military establishment held firm throughout.

This scene shows how the Amarna artisans experimented and challenged traditional representational conventions. Two soldiers moving to the right, one armed with spear and axe and a shield slung over his near shoulder, the other with shield under his arm and a rope in his near hand, are both pitched forward at the waist, the second more markedly than the

first, in apparent great haste. The men are depicted with large heads, sharply sloping foreheads, but horizonal and centrally positioned eyes whose lids are sculpted naturalistically and without the artificial rims and cosmetic stripes previously represented. The jaws jut out prominently, and all the features follow the iconography of the royal family. The size of the heads equals the breadth of the shoulders, the waist is sculpted high at the midriff and the limbs are thin. Gawkiness is emphasised by the deep but uneven contours.

All these artistic mannerisms are characteristic of the Amarna style, yet artistic licence was clearly permitted to the extent that details could be handled differently from scene to scene. Thus, one soldier in this relief wields his axe with one hand implausibly twisted, whereas his spear is more correctly held in a closed fist.

To avoid serial repetition, so common in traditional Egyptian multiple figure representations, the Amarna artisan spaced his figures more

generously and has varied their positions. This scene, probably part of a narrative over a large expanse of wall, is unencumbered by the usual texts, and it should not be surprising that the figures were not firmly fixed to ground lines; they were possibly surrounded by landscape. Although the relief is sunk, there is some overlapping of forms and a consequent interplay of raised and sunk relief. *EV*

Provenance: given to the museum by R. G. Gayer-Anderson

Bibliography: Vassilika, 1995, no. 29

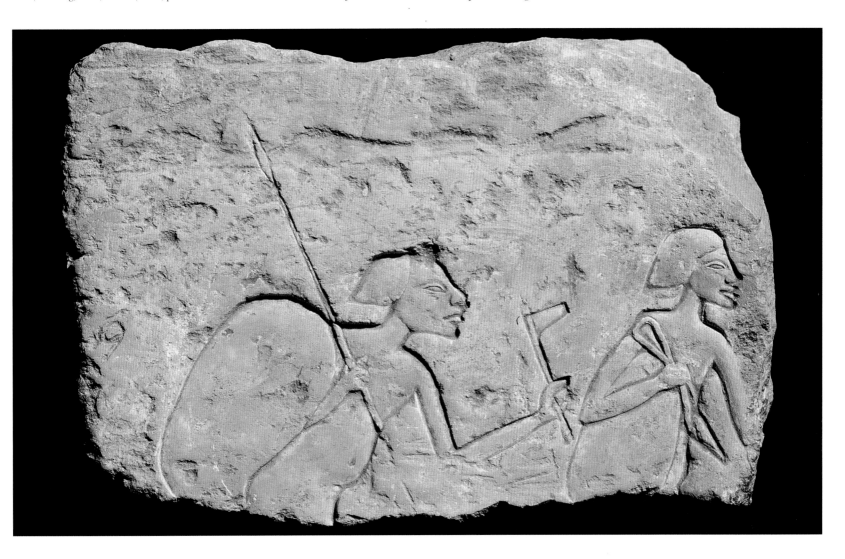

1.50

Statue of Ramses I

Egypt
19th Dynasty, c. 1294 BC
wood (sycomore fig), black resin
180 x 51 x 48 cm
The Trustees of the British Museum,
London, EA. 883

Two life-size wooden figures were found by Belzoni in a royal tomb at Thebes, which is now believed to be that of Ramses I. First of the modern surveyors of the Valley of the Kings, Belzoni started his investigations on 6 October 1817, in an area where most of the tombs had been plundered in antiquity; some lay open and accessible to visitors, others were filled with rubble (as a result of heavy rains). On 11 October, when Belzoni cleared his passage through the third of the rediscovered tombs, he found in a corner of the burial chamber a wooden statue standing erect and a similar one (cat. 1.51) in a side room to the right. The figures were later transported to Cairo and joined the famous collection of the British consul Henry Salt.

At that time, hieroglyphic writing had yet to be deciphered and the owner of the tomb was unknown, as was the purpose of such statues. The discovery, at the end of the 19th century, of similar wooden figures in other major tombs of the Valley of the Kings and, most significantly, of the intact pair of Tutankhamun flanking the sealed entrance to his burial chamber, was to show that this type of statue, now commonly known as a 'guardian figure', was an integral part of royal funerary equipment. In fact, wooden sculptures are attested in royal tombs from the 1st Dynasty.

This figure represents the king standing, left foot forward. From the companion piece in the British Museum (EA. 854) and analogous statues, it is known that the left arm was bent forward to hold a long staff while the right hung straight down the body, the hand holding a mace. The king wears the bag-shaped headgear called *khat*, as opposed to the companion piece which wears the *nemes*-headcloth. The costume consists of a short kilt with a projecting triangular apron.

Like all wooden figures of this type, the statue was carved from separate pieces of wood, joined together by means of tenons and mortises. The uneven joins were concealed with gesso, the whole piece coated by a thin layer of black resin, and the attire, consisting of the headgear, the kilt, the broad collar, bracelets and armlets, was overlaid with gold on a base of gesso and linen. The face of this statue was fixed into the head, which in turn fitted into the torso. The eyes and the eyebrows were inlaid – a remnant of the original mortar backing can be seen in the right eye. The beard (now lost) was fixed under the chin and the ears were likewise fitted into the sides of the head. A large appendage in the form of a flap was once attached to the back of the headdress, and on its forehead the royal uraeus was inserted in a rectangular slot. Traces of a collar are discernible on the chest. The arms, usually worked in two jointed pieces, were fixed to the torso by tenons and mortises that are visible on the sides. On the triangular forepart of the kilt, several slots attest to the fact that an apron was once attached; this would have been overlaid with gold leaf. One leg, both feet and the base of the statue are modern restorations.

Although very badly damaged, the characteristic features are still discernible on the preserved parts. The top of the headdress is domed. The face is oval-shaped, the forehead very low and the chin rounded. The eyebrows are arched above the eyes and prolonged obliquely on the temples; the eyes are narrow and slanting, elongated by horizontal cosmetic bands. The upper torso is bent forward, the collarbones rendered by oblique ridges. The chest is smoothly modelled, the waist is thick, the hips are slightly projecting and a belt curves under the stomach, which protrudes somewhat; the latter is marked by a vertical depression ending at the navel, rendered by a circular hollow.

These features coincide with the style of the late 18th Dynasty, which was likely to have been still current in the early 19th. This statue and its companion piece seem to be the only preserved sculptures to represent the king Ramses I. Owing probably to the short reign of the sovereign, very few figures of him exist. Of seven fragmentary stone sculptures bearing his name, only two statue-bases remain. Three other sculptures were dedicated to him by his son and successor Sety I. The preservation of these wooden figures is a stroke of good fortune, not only advancing knowledge of royal iconography of the early 19th Dynasty, but also pointing to the fact that the provision of such sculptures was compulsory in the royal tomb.
HSo

Provenance: Thebes, Valley of the Kings, tomb no. 16; ex collection Henry Salt

Bibliography: Belzoni, 1820, pp. 229–30; British Museum guide 1909, p.190 (685); Christophe, 1959, pp. 257–65; Mayes, 1959, pp. 178, 206, 310, 330, no. 685; Porter and Moss, 1973, p. 535; James and Davies, 1983, p. 49, fig. 55 (right); Reeves, 1990, pp. 91–2; Penny, 1993, pp. 125–6, fig. 115

1.51

Statue of Ramses IX

Egypt
20th Dynasty, c. 1126–1108 BC
wood (sycomore fig)
188 x 54 x 38 cm
The Trustees of the British Museum,
London, EA. 882

Once thought to represent Ramses II, this wooden figure has been recently attributed to Ramses IX, in whose tomb it appears to have been discovered in the early 19th century.

It is worked in the same technique as all royal funerary figures of similar type (see cat. 1.50), with some differences. The coating was simple paint instead of shiny black resin. Traces of paint on a layer of stucco around the neck suggest that the gold leaf for jewellery was also in this case replaced by polychromy. The piece of wood inserted in the headdress shows that the broken uraeus was made entirely of wood. The eyes and eyelids are not inlaid but shaped on the face. As usual, each of the arms (now missing) was fixed to the torso by a pair of tenons and sockets. A recess situated beneath the kilt was perhaps designed to conceal a funerary papyrus roll. The legs and the base are modern.

The king is represented in the same attitude as his remote forebear, Ramses I, standing, with his left foot advanced. He wears the triangular kilt on which the lower half of a starched apron was once fixed with the help of three tenons. Only the *nemes*-headcloth is here dissimilar, corresponding to the companion statue of Ramses I (British Museum, EA. 854).

The style is also different. The eyebrows are rendered naturalistically by slightly raised arches; the eyes are bulging and have heavy eyelids. The nose is narrow and aquiline. The mouth is well defined by sharp-ridged contours and sinuous lips. The stern expression is accentuated by lateral furrows and an incurved depression under the lower lip, which enhances the projection of the large chin. The head seems disproportionately large in relation to the upper torso; the chest is schematically modelled; the waist is very high and slim. The hips are narrow and the stomach is a simple bulge, without any detailed modelling.

One of the last rulers of the New Kingdom, Ramses IX, whose tomb is among the best preserved in the Valley of the Kings, is otherwise known only from a small number of statues: cat. 1.51 is important for confirming that this type of tomb sculpture remained in use up to the late New Kingdom. It was certainly one of a pair, as the earlier examples show, differing from each other in their headgear. According to the inscriptions preserved on the kilt of the similar statues of Tutankhamun, the king standing on the east side with the *nemes*-headcloth was 'living forever like Re, each day'; and the western counterpart, wearing the *khat*, is 'the royal Ka of Re-Harakhty, the Osiris, King and Lord of the Two Lands, Tutankhamun, justified'. Thus such statues represented the two aspects of the sun god with whom the king was united after his death: the diurnal sun, Re-Harakhty, and his nocturnal *ka*, Osiris. Representations of these statues are found carved on the descending corridors of royal tombs. A long sequence of funerary scenes depicts priests performing rites on the statues, which are being towed down to the grave.

More than mere guardians, even though they seem to watch over the burial chamber, these wooden figures, indispensable to the royal funerary equipment from the earliest dynasties, act as substitutes for the king and his *ka*, as diurnal and nocturnal sun, and stand there to participate in all the rituals through which the king will live for ever. *HSo*

Provenance: Thebes, Valley of the Kings, tomb no. 6; ex collection Henry Salt

Bibliography: Arundale, Bonomi and Birch, 1840, p. 112, pl. 47, fig. 171; Porter and Moss, 1973, p. 507; James and Davies, 1983, p. 49, fig. 55 (left); Reeves, 1985, pp. 40–1, 45, no. 16; Reeves, 1990, pp. 119–20, no. 56; Penny, 1993, pp. 124–6, fig. 114

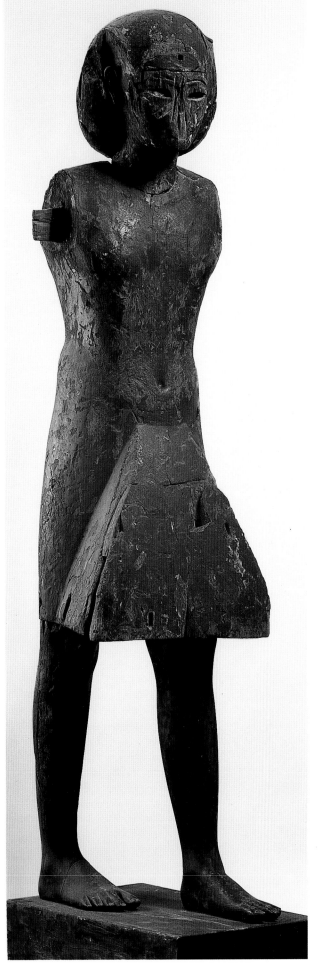

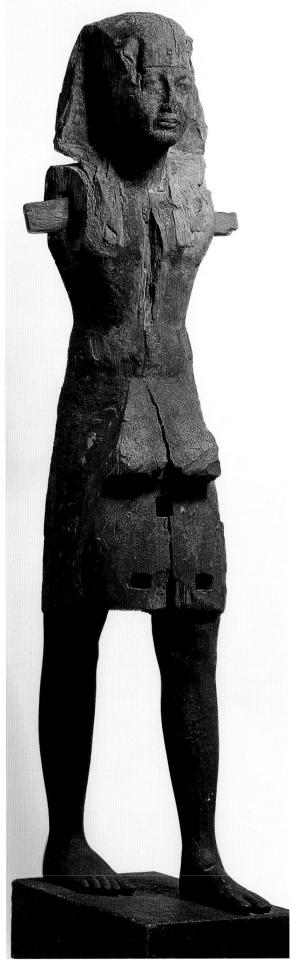

1.52

Box with conical lid

Egypt
New Kingdom (?), 1300–1100 BC
faience
h. 15.5 cm.; diam. 11.9 cm
Musée du Louvre, Paris
Fould Collection, E 3610

The original painting on this small, flat-bottomed, cylindrical receptacle, with its lid shaped like an upturned lotus flower, is almost intact. The box is decorated in black and bright blue, the latter having become almost blue-green in places.

The scene depicts a man standing facing the ibis-headed god Thoth, with his left leg forward and his arms hanging at his side; his hair is shoulder-length and cut in a curve; he is wearing a full-length loincloth. Thoth is slightly less tall and wears a short loincloth and a collar. In his left hand he holds an *ankh*, the cross symbolising life, and in his right, which is outstretched, a *was* or sceptre. The relief is somewhat sketchy, as are the details, probably on account of the materials and technique employed. Between the two

figures a text, shared between two vertical columns separated by the divine sceptre, places the harem scribe (?), Hor (?), the owner of the box, under the protection of Thoth, Lord of Hermopolis.

The background of this scene is decorated with (below) four zigzagging lines on a black background, symbolising water, and (above) five lines in the form of a chequered pattern, composed of blue and black squares. On the upper edge six small, regularly spaced holes still contain the remains of the cord that must have kept the lid in place. The lid also has a cord passing through a hole at the top. The decoration of the lid is not in good repair, but a few details of lotus petals in dark blue can still be made out. The interior and base of the box and the interior of the lid are black.

Containers of similar shape and with similar decoration have been found in a number of places, in particular the tumuli at Kerma in the Sudan; but this piece is most closely paralleled by a small receptacle in stucco found in a tomb at Deir el-Medina. The boxes are similar both

in size and shape; the chequerboard design and their lids in the shape of an upturned lotus flower suggest a shared source of inspiration and an obvious relationship with wicker baskets. *PR*

Exhibition: Boston 1982, p. 151, no. 159
Bibliography: Wenig, 1978, p. 160, no. 68; Bruyère, 1937, p. 56, fig. 27

1.53

Headrest in the form of a hare

Egypt
New Kingdom (?), *c.* 1550–1069 BC
wood (tamarisk)
19.6 x 38.4 cm
The Trustees of the British Museum, London, EA. 20753

Headrests are normally tripartite, consisting of a central shaft placed on a flat base and surmounted by a concave platform, a form well known from Ancient Egypt (cat. 1.54), the Sudan and other parts of Africa (cat. 2.9a). The present example is unusual in shape and concept. It is carved from a single piece of wood in the form of a crouching hare. Imaginative use is made of the hare's long ears to form the headrest's concave platform. The piece was polished after carving, although chisel marks remain in the more inaccessible parts. There are no traces of paint. It is well preserved but there are small areas of damage and the surface is cracked in a number of places, largely owing to dessication of the wood. The front left of the base was once broken and subsequently repaired with the aid of wooden dowels.

Although a fine and unusual sculpture, this hare is unlikely to have been simply the result of an artistic fancy. Egyptian headrests were often decorated with inscriptions or with figures of apotropaic deities, whose function it was to protect the owner against various dangers in this life or the next. Amulets in the shape of the hare were worn by the living and the dead in Ancient Egypt. The exact purpose of this amulet is unknown. The hare potentially embodied both dangerous and benevolent properties. As a wild thing of the desert, the animal might have represented the forces of chaos, against which the amulet would have provided protection, while at the same time perhaps endowing its wearer with the hare's special attributes: alertness, speed of limb, fertility and the power of regeneration.

The date of the headrest is uncertain. A similar one is in the Petrie Museum, London, without provenance. The wood species was recently identified by Caroline Cartwright of the British Museum. *WVD*

Provenance: 1888, given to the museum by E. A. Wallis Budge

Bibliography: Budge, 1904, p. 70, no. 58; Petrie, 1927, p. 35, pls XXXII, 35; Costa, 1988, p. 44, fig. 13; Hart, 1990, pp. 42–3; Andrews, 1994, pp. 63–4

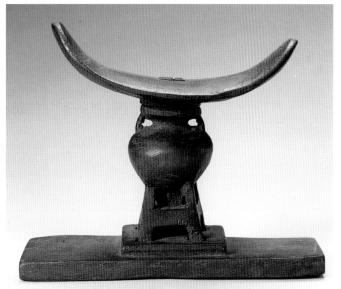

is quite flat and the bevelled edge would permit the labourer to use the tool in corners without disturbing the plaster on the adjacent wall. However, the masons' trowels that have survived are not generally shaped like this. They are shorter and broader with a horizontal handle. If the function of this tool was to smooth, perhaps it belonged to a different craft; could it, for example, have been used in the processing of papyrus, a function for which it appears equally well adapted? *PR*

Exhibition: Boston 1982, p. 56, no. 28
Bibliography: Petrie, 1917, p. 42, pl. XLVII

1.54a

Headrest

Egypt
New Kingdom (?), *c.* 1550–1069 BC
wood
18.4 x 17.6 x 6.4 cm
Musées Royaux d'Art et d'Histoire,
Brussels, E. 7220

1.54b

Headrest

Egypt
New Kingdom, *c.* 1550–1069 BC
17 x 21.2 x 8.1 cm
Musées Royaux d'Art et d'Histoire,
Brussels, E. 2406

The Ancient Egyptians, like certain African peoples today, were in the habit of sleeping on their side, with the flat part of their head, below the ear, placed on a headrest. Headrests were particularly common during the Old Kingdom and through to the New Kingdom. They are made in a wide variety of materials (limestone, calcite, ivory, clay, faience, wood, etc.) and in various shapes. Most consist of three main parts: the base (generally oblong), a vertical part that acts as a support, and a top part, usually crescent-shaped; this could be wrapped in several layers of fabric to make it more comfortable to sleep on. Although headrests were used in everyday life, surviving examples come mostly from tombs. In a funerary context the headrest became a talisman with magical properties: it would ensure the resurrection of 'he who went to sleep' (the deceased) by keeping malevolent spirits at bay, in particular the gods who 'cut off heads and rip out hearts'.

Cat. 1.54a bears no decoration and no inscription and is an extremely simple shape. Two slightly curved columns rise from an elliptical base. As usual, the top part is crescent-shaped; it has a rectangular support that serves as an abacus to the columns. The headrest is made from four pieces of wood, carved separately and held together by pegs.

Cat. 1.54b has a rectangular and very elongated base and a vertical support of an original and decorative shape, that of a pointed vessel with two handles, standing on a trapezoid support. The top part of the headrest is attached to the vase with a tenon and mortise. *LL*

Provenance: cat. 1.54a: ex collection C. W. Lunsingh Scheurleer; cat. 1.54b: 1905, purchased Cairo
Bibliography: Vaulathem, 1983, pp. 42–43; Lefebvre and van Ruisveld, 1991, p. 119.

1.55

Tool in the shape of a finger

Egypt
period unknown
wood
40.1 x 4.2 cm
Musée du Louvre, Paris, N 1527

This curious object, made of a single piece of wood, has two distinct parts. One is cylindrical and is carved in the shape of a finger with a very pronounced curve; the fingernail is carved in detail. Traces of wear can be seen under the curved part of the finger. The other part, longer and wider, is rounded on top and almost flat beneath. The end has a bevelled edge, meticulously rounded.

The use to which this object was put can only be surmised. The hypothesis suggesting that it was an instrument used during the 'opening of the mouth' in the ritual of the dead seems implausible because the flat part of the object is too large, disproportionately so in comparison with the finger; the finger appears to have been used for picking things up. The suggestion that it was a mason's smoothing trowel is supported by small details: the base of the long part

1.56

Ostracon depicting a bull

Egypt
19th Dynasty, *c.* 1295–1186 BC
limestone
11.8 x 16.2 x 2.2 cm
Musées Royaux d'Art et d'Histoire,
Brussels, E. 6371

The Egyptians often used fragments
of limestone or shards of pottery, to
be found in abundance around their
dwellings, for writing on or for
sketching or painting. Documents
of this kind, called *ostraca* (plural of
the Greek word *ostracon*, 'inscribed
shard'), have come down to us by the
thousand. *Ostraca* bearing drawings
are often very attractive; most have
been discovered in West Thebes, in

Deir el-Medina and other villages,
where the labourers and artisans
responsible for digging and decorating
the tombs of the pharaohs and the
queens of the New Kingdom lived.
These *ostraca* were decorated using
the same technique that was used for
walls of tombs; many of them are
small masterpieces.

A variety of members of the ox
family were known in the Nile Valley,
and they were a favourite subject with
Egyptian artists. The Brussels *ostracon*
shows a walking bull. The animal
bears a strong resemblance to a zebu,
a semi-domesticated bull distinguish-
able by its short, inward-curving horns
and by a pronounced hump on its
back. Although this drawing shows

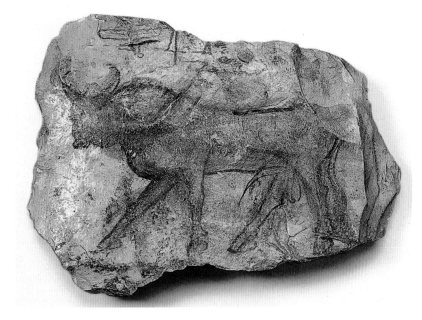

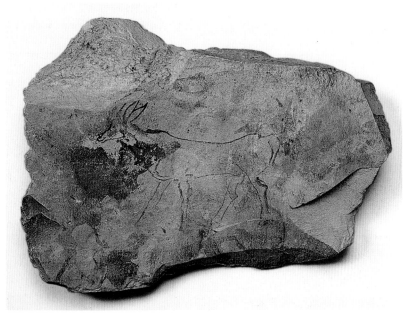

little detail, the eye and muzzle of the
bull are noticeably emphasised. From
a stylistic point of view, this small
picture looks very much like some of
the representations of bulls found at
Deir el-Medina. This example there-
fore probably comes from that site or
nearby.

Above the bull some hieroglyphic
signs can be made out, with the word
pa-ian ('the baboon'). Although this
inscription bears no relation to the
picture of the bull, it has been
suggested that it is a name, perhaps

the name of the artist; or it may be
just an exercise in writing.

The reverse side of the *ostracon*
bears a rather clumsy drawing of an
antelope. *LL*

Provenance: originally from Deir el-
Medina (?); 1930, purchased Luxor

Bibliography: Werbrouck, 1932, p. 107;
Werbrouck, 1953, pp. 100–1, fig. 17;
Brunner-Trant, 1956, p. 107, n. 4

1.57

Queen of Punt

Egypt
20th Dynasty, *c.* 1150 BC
limestone
14 x 8 cm
Staatliche Museen zu Berlin, Preussischer
Kulturbesitz, Ägyptisches Museum und
Papyrussammlung, 21442

By far the most extensive account of Egypt's contact with the rest of Africa is presented in the reliefs and inscriptions in one of the colonnades of Queen Hatshepsut's temple at Deir el-Bahri in Thebes. This historical report relates in texts and pictures an expedition of Queen Hatshepsut (1479–1458 BC) to the land of Punt, which can be localised on the east African coast, probably modern Somalia.

The reliefs give a detailed illustration of housing, plants and animals, population and behaviour in this remote area of the world. Special attention is given to the representation of the royal couple of Punt. The queen is extremely obese and, with her short arms and legs and her steatopygeous bottom, appears reminiscent of the royal women of Karagwe in present-day north-west Tanzania.

This temple relief, carved *c.* 1470–1460 BC, excited the interest of artists at a much later date. The ostrakon, bearing the artist's sketch, was made by a Ramesside painter living and working in nearby Deir el-Medina. He did not copy the temple relief at Deir el-Bahri, but seems to have made his sketch from memory. Some iconographical details are his invention, but the characteristic features of this African queen had left a lasting impression on him *DW*

Provenance: 1913, Deir el-Medina, area D3 (Deutsche Orient-Gesellschaft, excavation no. 189)

Exhibition: Berlin 1967, no. 729

Bibliography: Brunner-Traut, 1956, pp. 75f., pl XXVIII, no. 76

1.58

Decorated ostracon

Egypt
late 19th Dynasty–early 20th Dynasty,
c. 1200–1153 BC
limestone
15 x 13.5 cm
Lent by the Syndics of the Fitzwilliam
Museum, Cambridge, E.G.A. 43240. 1943

The extensive remains of the congested settlement at Deir el-Medina give some idea of the lives of the stone masons, artisans and workers who made the richly decorated tombs at Thebes. The bald stone mason or sculptor illustrated on this ostracon gripping the tools of his trade, the chisel and mallet, may have dwelt at this site.

A cheerful, brawny man with a short wide neck, shown correctly in profile view, a rare occurrence in Egyptian art, is bent at his task. The stone mason's beard is stippled; his open mouth might suggest that he is singing while at work. He is endowed with an over-large ear and bulbous nose with a prominent nostril. Despite the uncharacteristic subject and approach, the man's eye is elegantly drawn with a pencil-thin eyebrow, according to the Egyptian ideal of beauty.

The ostracon is decorated on the verso with a scene showing a kneeling figure before the snake goddess Meretseger with a line of dedicatory text below. The Egyptians worshipped the subject of their fears, and snakes were a considerable worry to the workmen who made and decorated the royal and private tombs of western Thebes. It is not clear whether this drawing served as a practice model for a stele that was more permanently decorated in relief or whether this was the ultimate dedicated object which was subsequently irreverently decorated with the stone mason on the recto. *EV*

Provenance: 1943, given to the museum by R. G. Gayer-Anderson

Bibliography: Vassilika, 1995, no. 37

1.59

Tomb relief

Egypt
19th Dynasty, *c.* 1200 BC
painted sandstone
Staatliche Museen zu Berlin, Preussischer
Kulturbesitz, Ägyptisches Museum und
Papyrussammlung, 23731

Many aspects of everyday life in
Ancient Egypt are known through
representations in paintings, reliefs
and three-dimensional models. The
extremely rich iconography of tomb
reliefs and paintings from the early
Old Kingdom (*c.* 2700 BC) to the end
of the dynastic period (*c.* 330 BC) is
a manual of Egyptian civilisation
through almost three millennia
containing numerous details not
reported in texts.

This relief fragment, made of
stuccoed and painted sandstone,
constitutes a small detail of a much
larger scene of building activities.
The building site is indicated by parts
of a scaffolding of wooden beams tied
together by ropes. Two carpenters are
working at finishing this construction.
The lower one holds an adze, the
typical tool for woodwork. Several
details of the head of the carpenter
characterise him as belonging to the
lower classes. His rough, uncombed
hair and his stubby beard distinguish
him from idealised representations of
Egyptians of the upper orders. His
orange-red, almost yellowish skin may
be an indication of foreign origin,
perhaps Syrian since these and other
foreign workmen had been recruited
in Nubia from the early Old Kingdom
onwards. *DW*

Provenance: 1935, acquired by the
museum

Exhibition: Berlin 1990, no. 52

Gebrawi. Perhaps the later Aba considered his much earlier namesake to be an ancestor, or else he was simply fascinated by the coincidence.

It is impossible to know why Mentuemhat's artisans chose to borrow from an 18th-Dynasty tomb. What *is* certain, however, is that they did not slavishly copy the 18th-Dynasty model. Rather, they adapted the earlier images, changing certain details while working in a style far removed from the freehand sketchiness of Menena's paintings. *JFR*

Provenance: Thebes, tomb of Mentuemhat

Exhibitions: San Francisco 1975, no. 96a; Berlin 1976, no. 68; Brussels 1976–7, no. 68; Tokyo et al. 1983–4, no. 59

Bibliography: Cooney, 1949, pp. 193–203; Wolf, 1957, pp. 636, 640; Fazzini, 1972, p. 60; Smith, 1981, pp. 411–12; Bianchi, in Fazzini et al., 1989, no. 71; Der Manuelian, 1994, pp. 18–19; Russmann, 1994, pp. 13–14

1.60

Relief

Egypt
late 25th Dynasty–early 26th Dynasty,
c. 670–650 BC
limestone
23.9 x 28.7 cm
The Brooklyn Museum
Charles Edwin Wilbour Fund, 48.74

Scenes of everyday life are among the most common themes in the decoration of Ancient Egyptian private tombs. The upper register of this fragmentary relief shows the partially preserved figures of two seated girls; the maiden on the left raises one leg, enabling her companion to extract a thorn embedded in her foot. The lower, more complete scene shows a woman with a child nestled in a sling wound around her body. She is a true 'working mother' who picks fruit from a tree while caring for her offspring.

The fragment came from the Theban tomb of Mentuemhat, Fourth Prophet of the god Amun at Thebes and mayor of that city. He lived during the troubled times bridging the transition from the 25th to the 26th Dynasty. Many artisans of this era sought inspiration from the art of earlier periods. The two vignettes on this relief were almost certainly appropriated from similar painted scenes in a nearby 18th-Dynasty tomb (Theban tomb 69, of a man named

Menena) that dates some seven-and-a-half centuries before Mentuemhat's time.

Archaism, the conscious evocation of the style and iconography of an earlier era, was one of the most influential forces in Ancient Egyptian art. Throughout Egyptian history, but primarily in times of political and social uncertainty, artisans sought to recapture the spirit of bygone 'classical' ages. For example, in the first decades of the 18th Dynasty, following the expulsion of the detested Hyksos, royal sculptors carved images of kings reflecting the court style of the early 12th Dynasty, an era the Egyptians called the 'repeating of births' (i.e. 'renaissance').

Other examples of archaism are more idiosyncratic. A 26th-Dynasty official named Aba, for instance, had the walls of his Theban tomb decorated with scenes copied from the tomb of another Aba, who had lived approximately fifteen centuries earlier in the distant village of Deir-el-

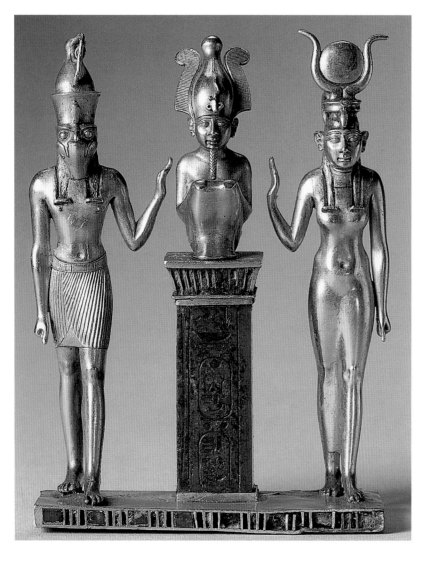

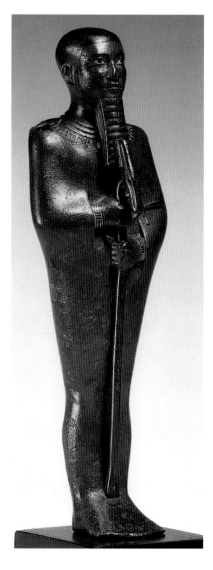

1.61

Triad of Osorkon II

Egypt
22nd Dynasty, reign of Osorkon II,
c. 874–50 BC
gold, lapis lazuli, glass
9 x 6.6 cm
Musée du Louvre, Paris
Rollin-Feuardent Collection, E 6204

This superb example of the gold-smith's art represents the god of the dead, Osiris, standing between his wife Isis and their son Horus, with his falcon head. Osiris is portrayed in an unusual position, squatting on a pillar of lapis lazuli, the dark blue of which contrasts strongly with the brilliant gold in which the divinities are cast. The costume details – hair, beard, loin cloth – are delicately chased. The wigs worn by Isis and Horus, no longer extant, were probably executed in lapis lazuli; contemporary texts refer to gold – the flesh of the gods – and to their lapis lazuli hair. On the slab of precious metal that forms the base of the plinth there is an inscription

placing King Osorkon II under the protection of Osiris. The cartouches, engraved on the pillar with a border of plant motifs, bear the name of the same king. The central statuette evidently represents Osorkon II under the aspect of the god of the dead, while Horus and Isis indicate their protection by their raised hands.

The squatting position of the main figure, and his small size, evoke the theme of the child appearing on the lotus flower, symbolising the recurring rebirth of the sun.

With its rich symbolism, typical of the 1st millennium, this precious group almost exactly echoes the triads carved for the Pharaoh Mycerinus over 1500 years earlier (cat. 1.30).
CZ

Exhibition: Paris 1987, no. 46, pp. 172–3

Bibliography: Montet, 1960, p. 59; Stierlin-Ziegler, in Paris 1987, figs 107–10

1.62

Statuette of the god Ptah

Egypt
Late period, 26th Dynasty, c. 600 BC
bronze, partly blackened and inlaid with gold and electrum
17.9 x 6.1 x 3.9 cm
The Visitors of the Ashmolean Museum, Oxford, 1986.50

As a creator the god Ptah is often described in religious texts as 'forming' or 'sculpting' the bodies of other gods or the king, and he was the patron of all kinds of handicraft: his especial care for smiths and sculptors is appropriately recalled in this statuette, which is a masterpiece of bronze casting.

The god is shown in his canonical form as a standing figure enveloped in a wrap from which only his head and hands emerge. Around his neck is a broad bead collar, the counterpoise of which is a tasselled pendant that hangs over the back of his robe. He wears a close-fitting cap, the false beard exclusive to gods and kings, and bracelets. In his hands are the *ankh*-sign (or *crux ansata*) symbolic of 'life' and the forked *was* (sceptre) which terminates in the head of the animal of the god Seth – a fabulous beast for which various models have been suggested, including the wild pig, dog, okapi and ant eater.

The figure is a solid lost-wax cast in bronze with a high copper content. The sceptre has been cast separately in three parts. The rich colour of the metal has been enhanced by the blackening of specific areas and the addition of contrasting inlays – electrum for the whites of the eyes, and gold in the collar and bracelets. 'Black bronze' inlaid with gold or electrum is mentioned in Egyptian texts as a particularly prestigious material; the coloration of the metal could have been achieved with sulphides.

Small bronzes of human or animal divinities are a notable feature of the later stages of Egyptian culture. They mark a significant change in religious thought, when the major gods were no longer seen as remote beings with whom only the pharaoh could intercede: an individual might also place himself in the divine presence or sue for some personal benefit by dedicating a votive image, set on a base that would carry the donor's name and a dedicatory inscription.

The presence of large numbers of such figures in shrines would have necessitated periodic clearances, hence the occasional discovery in temple precincts of caches of bronzes. The spare but subtle modelling of this figure, with the suggestion of the anatomy beneath the enveloping wrap, and the god's air of tranquil self-possession suggest a date in the 26th Dynasty. During this period there was a renewed interest in the cult of Ptah and his monuments at Memphis, and also a revival of the sculptural ideals of the Old Kingdom, when divine figures projected a timeless image of serene confidence.
HW

Provenance: ex collection J. W. Trist; 1986, bequeathed to the museum by Miss M.R. Tomkinson

Bibliography: Trist and Middleton, 1887; Whitehouse, 1986; Penny, 1993, pp. 225–6, pl. 199

1.63

Figure of a jackal

Egypt
25th–26th Dynasty, *c.* 747–525 BC
wood (sycomore fig)
30 x 51.5 x 10 cm
The Trustees of the British Museum,
London, EA. 61517

The dogs and black jackals that frequented the cemeteries in the desert strip close to the banks of the Nile came to be associated in the minds of the Ancient Egyptians with deities who were believed to look after the dead and guide them on their journey into the west, the kingdom of the dead. The most prominent of these canine divinities was Anubis. According to mythology, he embalmed the murdered god Osiris and, by thus preserving his body, was instrumental in restoring him to life. Anubis was closely associated with mummification throughout the pharaonic period and continued to play a part in the Isis Cult of the Roman world. Beginning

in the New Kingdom (*c.* 1550–1069 BC), he was regularly depicted in tombs, on coffins and on funerary papyri completing the process of mummification, conducting the deceased to Osiris and supervising the weighing of the dead person's heart to determine whether or not his conduct on earth merited entry into the netherworld.

Wooden statues of recumbent Anubis jackals were sometimes included among funerary furnishings during the New Kingdom; examples have been found in the tombs of Tutankhamun and Horemheb in the Valley of the Kings, and others are known from non-royal burials, where they were mounted on the lid of the canopic chest (a box to contain the embalmed viscera of the deceased). In the late 8th century BC, wooden jackals were frequently placed on the vaulted tops of the rectangular outer coffins made for the more affluent members of Egyptian society, and a large number of them survive from

the necropolis of Thebes. The body and limbs of this example are carved from a single piece of wood, to which the separately made head and neck have been attached. The tail (now lost) was also originally a separate piece, fitting into a slot cut into the body. Examples which survive in a complete state show that the tail was meant to hang vertically over the end of the coffin. The shape of the face and paws, carved in a summary fashion, served as a basis for more detailed modelling in the gesso with which the entire figure was originally coated. This is now largely lost, together with all but the smallest traces of paint which show that the finished statuette was coloured black. The wood species was recently identified by Caroline Cartwright.
JHT

Provenance: ex collection Henry Salt (probably found at Thebes)

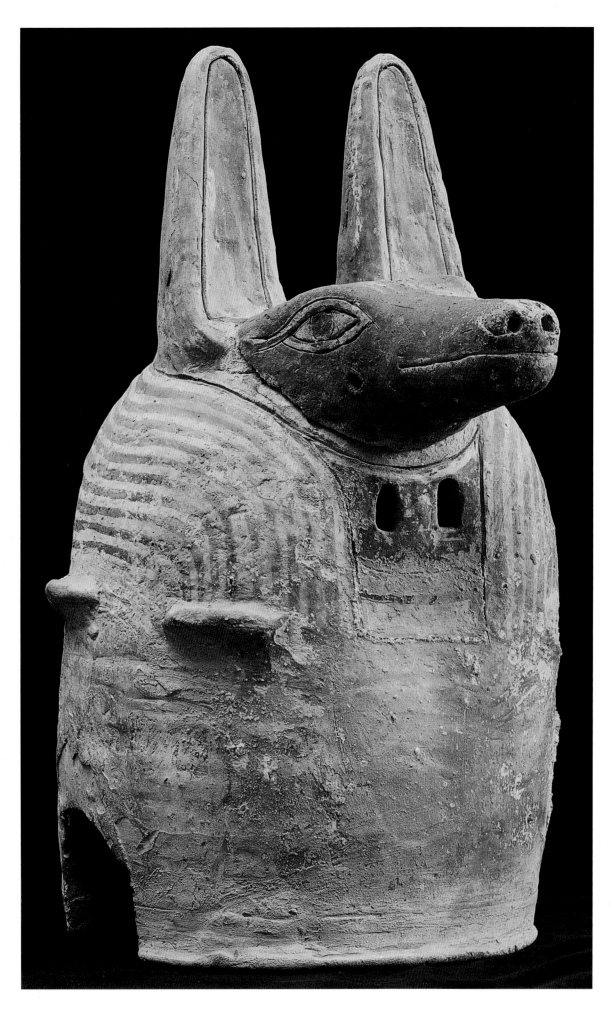

1.64

Anubis mask
Egypt
Late period, 6th–4th century BC or later
fired clay, paint
49 x 27 x 40 cm
Pelizaeus Museum, Hildesheim, 1585

This object, 8 kilograms in weight, of a delicate ceramic material, is without parallel in any collection, the only example of its kind to have survived the millennia.

Practical experiments have demonstrated that the functional designation 'mask' can indeed be applied to this item: the two semi-circular sections cut from the sides are large enough for very narrow shoulders, and it is possible to see and breathe through the two angular openings under the snout of the Anubis jackal. However, the weight and fragility of the material argue against practical use and raise the question of whether this might not rather be a model of a mask. It could have served as the prototype for the production of masks in a light, portable material such as painted linen or cartonnage. A solution to this problem will probably never be possible in the absence of parallels. The sole clear image in which an Anubis mask is worn dates no earlier than the Greco-Roman period.

The numerous scenes in tombs depicting a figure with the head of Anubis bending over a mummy are open to various interpretations. It is possible that they represent the god Anubis himself. However, they might instead depict a funerary priest who, with the help of the mask, has changed into Anubis and thus performs the embalming ritual as a substitute for the deity. In the ritual itself a priest carried out the ceremonies, but no textual evidence exists to determine whether the funerary priest remained in human guise in this role, or whether he disguised himself and 'played' the funerary god Anubis. At least in the case of the priest responsible for the preparation of the corpse, there would be a logical explanation for the latter interpretation. The preliminary stages of mummification involved the opening – and thus the violation – of the body, an action that only Anubis himself would have been entitled to perform. If the priest took

the form of Anubis, he would be magically raised to the status of the funerary god himself and thus receive the necessary legitimation for the treatment of the corpse.

The mask consists of two parts: the head section with the snout and eyes is a separately formed element, attached to the lower section by means of a tenon. It is made of fired and painted clay; the colours are now extremely faded. Nevertheless, the black hue of the skin remains clearly discernible; this does not correspond to the natural colour of the Anubis jackal but indicates in symbolic manner both the realm of the dead and survival for eternity. *BS*

Exhibitions: Linz 1989, no. 125; Hildesheim and Mainz 1990, pp. 34f., T3
Bibliography: Roeder, 1921; Roeder and Ippel, pl. 127, fig. 49; Kayser, 1973, p. 103, fig. 74; Seeber, 1980; Eggebrecht, 1993, p. 87, fig. 84; Sweeney, 1993

1.65
Fragment of a female figure
Egypt
Ptolemaic period, *c.* 305–30 BC
faience
10.6 x 5.2 x 3.4 cm
The Brooklyn Museum
Charles Edwin Wilbour Memorial Fund, 64.198

Ancient Egyptian artisans lavished so much of their skill and attention on the modelling of faces that their proficiency at handling the human body is often overlooked by the modern viewer. For this reason, headless fragments such as this example can be particularly instructive. The female figure wears a sheer dress that clings tightly to her body, creating the illusion of nakedness. Unlike the slender women of earlier eras, this Ptolemaic example displays full firm breasts, a thick waist, a swollen fleshy stomach with pronounced navel, and broad hips. These features reflect the Egyptians' ideal female form in the last three centuries BC.

This full-figured treatment of the torso has two possible sources. Traditionally, scholars have interpreted it as evidence for Hellenistic Greek influence on Egyptian sculpture. They argue that the Ptolemaic 'ideal' differs so markedly from earlier Egyptian forms that it must owe its appearance to Hellenistic tastes. Recently, however, it has been suggested that the Ptolemaic model of the perfect feminine body owes nothing to Greek inspiration: instead it is seen as an outgrowth of pharaonic artistic tradition. Each of the elements of the Ptolemaic female body – the ample breasts, the treatment of the lower abdomen etc. – can be found, in isolated examples, on earlier statuary. By incorporating these features into a single image, the Ptolemaic sculptor was creating something new that was based on Egyptian models.

This fragment is made of faience, a man-made compound consisting of ground quartz held together by an alkaline binder. Faience manufacture began in the predynastic period and continued in use well into the period of the Roman occupation of Egypt. Faience was either modelled or pressed into a mould and then fired in a kiln. Egyptian craftsmen almost always glazed their faience pieces. *JFR*

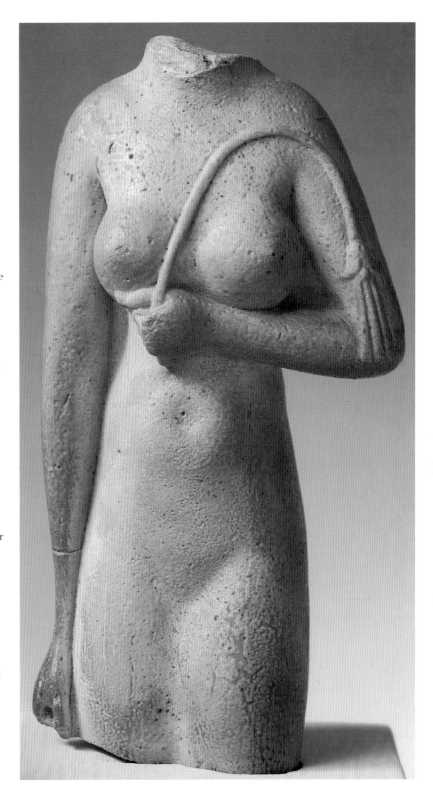

Provenance: ex collection Sir Bruce Ingram

Exhibitions: San Francisco 1975, no. 113; Berlin 1976, no. 80; Brussels 1976–7, no. 80; San Juan 1979, no. 35; Tokyo et al. 1983–4, no. 75

Bibliography: Riefstahl, 1968, pp. 72, 109, no. 72; Fazzini, in San Francisco 1975, no. 113; Fay, in Berlin 1976, no. 80; Quaegebeur, in Brussels 1976–7, no. 80; Bianchi, in San Juan 1979, no. 35; Quaegebeur, 1983, p. 119; Bianchi, in Tokyo et al. 1983–4, no. 75; Bianchi, in Fazzini et al., 1989, no. 83

1.66

Funerary bead-net

Egypt
Late period, after 600 BC
faience
116 x 43 cm
Musée du Louvre, Paris, E 13223

This funerary net covered the body of the deceased from shoulder to ankle; it is composed of tubular beads in blue faience, laid diagonally in regular lozenge shapes to form a very elegant mesh. The larger beads are joined together by means of smaller ones.

At chest height a dark blue faience scarab appears among the beads; its wings are formed from small, multi-coloured beads with flared ends, creating the effect of a lotus flower. On either side of this winged scarab, the solar symbol of rebirth, there are four mummiform figures in bright blue faience. These represent the four sons of Horus, protectors of the entrails placed in the canopic vases during mummification. Their iconography is standard: Duamoutef has a dog's head, Imsety a human head, Qebehsenuef a falcon's head and Hapy a monkey's head.

One of the earliest examples of funerary netting was found in Tanis, on the mummy of Sheshonk, a king of the 22nd Dynasty; the mesh was used with increasing frequency from the 25th Dynasty onwards. Such netting was designed to fit over the winding-sheet covering the mummy; it is generally composed of blue or green beads or, occasionally, beads made of gold or semi-precious stones. The network of beads fits round the funerary mask and bears symbols that will ensure the protection of the deceased. The winged scarab here replaces the usual heart-shaped scarab; the four sons of Horus are common-place, as are other symbols such as the winged goddess Nut or the pillars of Djed (the symbol of stability). This wrapping technique was invented to offer maximum security to the mummy, enclosing it in a protective mesh to guarantee its survival; its use persisted until the Roman period.
PR

Bibliography: Marcq-en-Baroeul 1977, p. 33, no. 61; Andrews, 1984, p. 27, fig. 27; Boston and Dallas 1992, p. 175

This full-length painted linen shroud, now missing its lower end, would have enveloped a mummified body, the painted portrait head positioned directly over the mummy's face. The scarab beetle that now appears to be suspended above the head would have been at the back of her head, its outstretched wings encircling and protecting it. The rows of deities on either side of the main figure (right side preserved) would have been at right angles to it, along the sides of the wrapped body.

The dead woman's regalia is identical to that of both Osiris, King of the Dead (shown in the upper right register), and Sokar, whose figure (now missing, with only the lower leg visible) is known from parallel examples. She holds (in the reverse order of the Osiris figure) the symbols of kingly power: crook and flail. Flanking her head are the tutelary deities who protect a king: the goddesses Nekhbet and Edjo in the form of winged cobras, each wearing the crown of her respective domain (Upper and Lower Egypt).

Although the attributes of her costume are undeniably royal, the deceased may not here be emulating the funerary god Osiris, but the sun god Re. The scarab beetle whose wings enfolded the deceased's head is the young form of the sun god Khepri. In a famous representation of the 4th-Dynasty pharaoh Chaphren, the wings of the falcon god Horus embrace the king's head. Horus and the king together signify 'the god manifest in the person of the king' (Terrace and Fischer, 1970). The intent may be: to identify the deceased with the reborn sun god.

The imagery that decorates the body field appears to imitate the horizontal registers of the painted, wrapped bodies of red-shrouded and of stuccoed portrait mummies. The upper scene depicts a mummy on the back of a lion (bed) flanked by human-headed *ba* (soul) birds. Above the mummy is the sun, whose energising rays revivify the lifeless corpse. The scene below also depicts a mummified body on a lion bed. A masked, jackal-headed priest, in imitation of the mortuary god Anubis, performs a funerary ritual to rejuvenate the limbs of the deceased. At the head and foot of the funerary bed the goddesses Isis and Nephthys

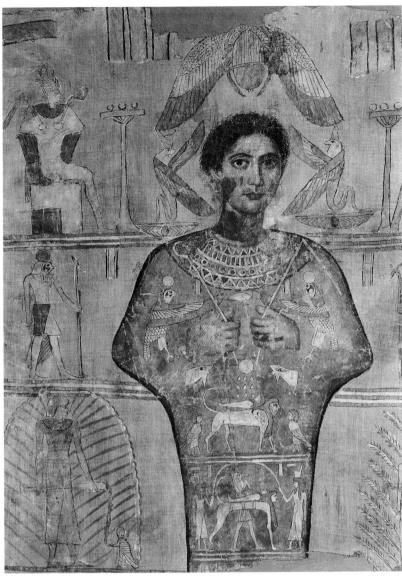

1.67

Funerary shroud

Akhmim (?)
Roman period, third quarter of
1st century AD
linen
115 x 88.5 cm
Museum of Fine Arts, Boston
Martha A. Wilcomb Fund, 1950, 50.650

1.68

Plaster head of a crocodile

Egypt
2nd–4th century
plaster, glass
18 x 43.5 x 19 cm
Staatliche Sammlung Ägyptischer Kunst,
Munich, 6809

Mummification of sacred animals was not uncommon in Ancient Egypt from the New Kingdom onwards. Venerated as living manifestations of god on earth, sacred animals were kept in temples, and after death they were buried in nearby cemeteries. Large catacombs at Sakkara contain the burials of bulls, cows and thousands of ibises, falcons, cats (cf. cat. 1.69) and baboons. Similar installations can be found at various other places. Mummified crocodiles have been excavated near temples of the god Sobek, in Kom Ombo in Upper Egypt and in Crocodilopolis in the Fayum oasis.

This life-size plaster head of a crocodile originally belonged to a crocodile mummy. It has been modelled in wet plaster over the head of the animal wrapped in linen strips. Impressions of these bandages are still visible inside the hollow head. The lively expression of the face results from the modelling of the teeth and the technique of the eyes with the pupil covered by a thin layer of glass. Thus the sacred animal retains its efficacy even after death. *DW*

Bibliography: Schoske, 1986, pp. 221–2

hold a canopy above the scene. The disparity in artistic skill between the rendition of the portrait head and that of the mythological characters on the body field suggests that the two were executed by different artists. Perhaps the shroud was 'ready-made' and the portrait head commissioned at greater expense.

The deities arranged in horizontal registers at either side of the main figure (and beneath the enthroned figures of Osiris and Sokar) depict (at right) Re-Horakhty, and the tree goddess offering cool water to a human-headed *ba* bird. The registers at left are broken off. There would have been a striding figure to complement that of Re-Horakhty, and across from the tree goddess is a scene depicting the young Horus child hidden by his mother Isis amidst the rushes of Chemmis. None of the vertical bonds was ever inscribed.

The shroud was said to have been purchased at Akhmim. There are no similarly decorated pieces from the site; although it may well have been discovered in a cemetery there, typological factors suggest a Lower Egyptian provenance, possibly Sakkara. *LHC*

Exhibitions: Boston 1978, no. 5; Boston 1988, no. 153

Bibliography: Hermann, 1962; Parlasca, 1963; Parlasca, 1966; Terrace and Fisher, 1970; Parlasca, 1977; Ritner, 1985

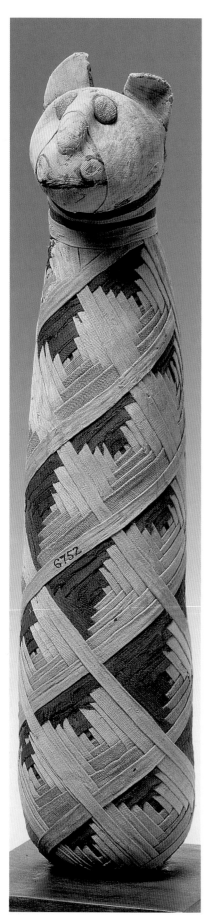

1.69a

Cat mummy

Egypt
Roman period, after 30 BC
bone, soft tissue, linen
h. 51 cm
The Trustees of the British Museum,
London, EA. 6752

1.69b

Cat mummy

Egypt
Roman period, after 30 BC
bone, soft tissue, linen
h. 45.5 cm
The Trustees of the British Museum,
London, EA. 55614

Animals were always highly regarded in Ancient Egypt and the cat in particular seems to have been revered from early times. During the Late period (664–332 BC) animal cults became increasingly important, reaching the peak of their popularity during the Ptolemaic period (332–30 BC). The Egyptians did not worship the animal itself but rather viewed each species as a representative of a particular god or goddess, believing that their deities could appear on earth in the form of their associated sacred animal. One of the most prominent animal cults was that of the cat, which was associated with the goddess Bastet at Bubastis in the Nile Delta. The intense religious significance attached to cats is reflected in Herodotus' account of Egypt (5th century BC) and in the large cemeteries designed to receive their embalmed bodies. Many thousands of mummified cats have been discovered at these sites. Recent radiological studies have revealed that some of these had been deliberately killed by having their necks broken, and the indications are that this occurred within two specific age ranges: between one and four months or between nine and twelve months. It is possible that those which had their necks broken before being mummified were temple cats bred specifically to become votive offerings. The mummified cats with intact neck vertebrae may have been household pets.

These two specimens illustrate the manner in which cat mummies were prepared. X-rays reveal that the larger mummy (cat. 1.69a) is that of an adult cat. The hind legs are pushed up against the pelvis and the forelegs

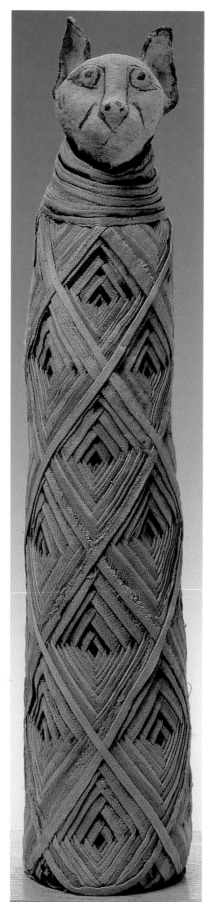

drawn down the body, producing a compact, elongated shape. All of the skeleton appears to be present and there is some indication of soft tissue. The smaller mummy is that of a kitten (cat. 1.69b). In this case, the hind legs have been pushed up on either side of the pelvis, with the forelegs again positioned in front. Most of the bones appear to be present, but the skeleton, measuring about 12 cm in width, occupies only about one-third of the package; X-rays show that the remaining two-thirds are filled with a dense mass, probably linen. The neck vertebrae of both cats are intact and show no signs of trauma.

Both cats are wrapped in strips of linen cloth of different colours, carefully applied in overlapping layers to create a repeating lozenge pattern. The elaborate arrangement of the outer wrappings imitates the appearance of human mummies of the Roman period, many of which were treated in a similar way. The representation of the features also parallels the practice followed in the embalming of humans, whereby an image of the face was either painted on the shroud or on a wooden panel, or modelled as a mask in cartonnage or plaster. The shape of the cats' faces and upturned ears have been skilfully modelled in linen; on the smaller mummy the features have been drawn in black paint. The larger specimen has been more elaborately fashioned; the eyes are represented by 'buttons' of coarse linen, while the corners of the mouth have been internally padded to give a raised appearance. The mouth itself and the whiskers are formed of linen threads and both the eyes and the mouth are outlined in brown. *JMF, JHT*

Exhibition: cat. 1.69a: Canberra and Melbourne 1990, no. 50

Bibliography: Armitage and Clutton-Brock, 1980, p. 187; Andrews, 1990[2], p. 65; Malek, 1993, pp. 73–6; Filer, in preparation

1.70
Shrine and skeletal figure

Egypt
Late period, 1st millennium BC
ebony, linen
h. 9 cm (shrine); 5.7 cm (figure)
Staatliche Museen zu Berlin, Preussischer
Kulturbesitz, Ägyptisches Museum und
Papyrussammlung, 20472

Several specimens of this strange kind
of object are preserved. The small
standing skeletal figure, originally
wrapped in a piece of linen, belongs
to a wooden shrine imitating the form
of a chapel. The Egyptians believed
that at the moment of physical death
body and soul were separated. The
soul took the shape of a human-
headed bird, flying up from the body.
The corpse had to remain in the tomb;
through mummification it was
transformed to an eternal entity.
Despite the elaborate system of
funerary beliefs, death remained a
permanent threat. These skeletal
figures may find their explanation
in the following report by Herodotus
(II, 78): 'At rich men's banquets, after
dinner a man carried round a wood
image of a corpse in a coffin, painted
and carved in exact imitation, a cubit
or two cubits long. This he shows to
each of the company, saying "Drink
and make merry, but look on this; for
such shalt thou be when thou art
dead." Such is the custom at their
drinking-bouts.' This text corresponds
to the Harper's Songs of the New
Kingdom and reflects a deeply human
attitude to death. *DW*

Provenance: 1912, acquired by the
museum

Exhibitions: Berlin 1967, no. 956; Stuttgart
1984, no. 86

1.71
Rock engraving

Nubia
5th millennium BC
sandstone
20.5 x 27.5 cm
Staatliche Sammlung Ägyptischer Kunst,
Munich, 5522

Besides the influences from the
neighbouring Near East, the most
important root of pharaonic Egypt's
civilisation is north-eastern Africa.
Before they reach the Egyptian Nile
Valley, technological innovations such
as the invention of pottery are first
attested in the Sudan and in Nubia
(including the Western Desert), signs
of the transition from Late Palae-
olithic to Early Neolithic.

The rock engraving of a long-
horned cow comes from the desert
north-west of Lower Nubia, from an
area where cattle-breeding was prac-
tised by nomads living in the steppe
while it was still humid enough to
feed cattle.

Basic principles of Egyptian art are
formulated in the representation of
the cow. Its body is seen in profile; the
horns are shown frontally. The com-
bination of both views in one image
constitutes the structure typical of
reliefs and paintings of pharaonic
times and analogous to experimental
representations in modern art. *DW*

Provenance: Naga Kolofanda, north-west
of Korosko, Nubia; given to the museum
by Professor H. Stock

Bibliography: Munich 1972, p.17, no. 14

1.72

Figurine

Sudan
Neolithic, 4th millennium BC
Nubian sandstone
19.6 x 5 x 2 cm
Sudan National Museum, Khartoum,
SNM. 26.861

This representation of the human form is very stylised. The stone, dressed with a hammer and pick, has been polished all over. The sculptor has skilfully used the minimum of anatomical features, principally the sloping shoulders and the head, to leave no doubt that this is an anthropomorphic figure. From the shoulders the body tapers to a rounded base at one end and to the rounded head at the other. Two pairs of parallel incised grooves on the 'face' suggest the position of the eyes. These

extend up to a vertical groove which, together with another groove above the eyes, indicates the hairline. The front of the body is a smooth curve from head to foot, but on the back a marked change of direction at the point of maximum thickness suggests the transition from the buttocks to the thighs.

No close parallels to this figurine are known from the Nile Valley. It contrasts markedly with figurines such as cat. 1.73. Among the most characteristic features of these are their explicit female nature and their very broad hips. Cat. 1.72, although identified by the excavator as female, displays no obvious gender characteristics and is of totally different proportions, with the greatest width at the shoulders and no attempt to mark the position of the hips. It clearly relates to a totally different artistic tradition.

It was recovered from the grave of a man of more than 40 years of age in the northern Dongola Reach, 50 km south of the third cataract. The prominent location of this grave within the cemetery, together with the rich gravegoods which accompanied the burial, suggest that he was the chief of the community which buried its dead in this cemetery. *DAW*

Provenance: 1986–9, Kadruka, cemetery 1, tomb 131 (Section Française de la Direction des Antiquités du Soudan, find no. KDK 1/131/8)

Exhibition: Lille 1994, no. 72

Bibliography: Reinold, 1991, p. 28, fig. 6; Reinold, 1994, pp. 96–7, fig. 7

1.73

Female figurine

Sudan
Neolithic, 4th millennium BC
fired clay
9 x 4 cm (max.)
Sudan National Museum, Khartoum,
SNM. 26.895

This steatopygous figure of a woman has a spherical lower body, with no indication of the legs apart from a T-shaped incision suggesting the position of the top of the thighs. The prominent hips give way to the narrow waist and to the ample bust. The arms are rounded stumps projecting a little from the shoulders. The only facial features provided are the eyes, indicated by two narrow slits; the neck is carried up to the hairline with an absence of a chin. The head sports hair tightly drawn back from the face, an abundant pigtail reaching to the small of the back. The pigtail is made from a separate piece of clay. The breasts and much of the body below the waist are covered in an incised herringbone decoration and three parallel grooves run around the base of the neck.

This is one of a number of similar figurines dating from the Neolithic to the late Meroitic periods which have been found on sites throughout Nubia, usually (although not invariably), in a funerary context. The basic steatopygous form of all these statuettes, although they differ in detail, testifies to the continuity of artistic tradition in Nubia over a period of several thousand years. On most examples there is incised decoration on the body, curvilinear, geometric or dotted. This is usually interpreted as representing tattooing rather than clothing. The grooves at the neck, however, may represent some type of necklace. It is assumed that these figurines had a religious significance.

The statuette was found in the grave of a child (five to seven years of age) within the cemetery at el-Kadada, 200 km downstream from Khartoum. It had been placed in front of the neck of the deceased. The cemetery contained graves of Neolithic, Meroitic and post-Meroitic date. *DAW*

Provenance: 1976–83, el-Kadada, cemetery C, section 76, tomb 9 (Section Française de la Direction des Antiquités du Soudan, find no. KDD 76/9/2)

Exhibition: Lille 1994, no. 54

Bibliography: Reinold, 1987, p. 34, fig. 7

navel and running in a swirl around each buttock and on to the inner thigh are several incised parallel grooves which are probably representations of tattoos, although they have also been identified as clothing and as folds of fat.

Steatopygous figures are a feature of the early cultures on the Middle Nile and continued to be produced as late as the Meroitic period. This figurine was found together with another of rather different form in the grave of an adult woman and child. The presence of these two figurines, one of an adult female, the other of a juvenile, parallels the human occupants of the grave. This led the excavator to suggest that the figures must represent the deceased and were buried in the grave to secure their eternal vitality, rather then being sexual partners for a deceased male or figures of fertility goddesses. *DAW*

Provenance: 1963–4, Halfa Degeim, Site 277, grave 16B (Scandanavian Joint Expedition, find no. 277/16 B:3)

Exhibiton: Brooklyn 1978, no.1

Bibliography: Säve-Söderbergh, 1967–8, p. 228; Nordström, 1973, i, pp. 27, 127, ii, pls 56, 3, 197; Brooklyn 1978, p. 114

1.74

Female figurine

Sudan
Classic A-Group, *c.* 3100 BC
unfired clay
8.4 x 3.2 x 8.5 cm
Sudan National Museum, Khartoum,
SNM 13729

The torso of this steatopygous figurine of a naked woman, bent at the waist to suggest a sitting posture, is moulded in a naturalistic manner in contrast to the stylised legs and the head. The plump legs, divided by a deep cleft, stick straight out and taper a little towards the stumps, no attempt being made to indicate the ankles and feet. The long neck merges imperceptibly into the head where a deep gash, extending most of the way around it, marks the mouth. Two grooves angled downwards to their point of junction in the centre of the face represent the eyes with a slight ridge for the nose. The well-endowed lady has her arms hugging and lifting her breasts. Beginning immediately below the

1.75

Beaker

Sudan
Neolithic, 4th millennium BC
fired clay
h. 27.7 cm; diam. 23.4 cm
Sudan National Museum, Khartoum,
SNM. 26.899

The whole exterior and the interior as far as the waist of this hand-made vessel in the form of a calyx has a reddish-brown burnished surface. The exterior decoration is divided into panels by incised bands. Below the waist it is divided into four equal quarters by a vertical band. Above the waist it is again divided in the same way but the bands are offset from those in the lower part of the vessel. Each panel is filled with parallel scored lines in groups alternating to form a herringbone pattern. Three of the five triangles below the rim have the incised lines arranged vertically, the other two have two groups of lines, one group arranged vertically, the other obliquely.

This type of vessel is characteristic of the Neolithic in Sudan and examples have been found as far apart as el-Kadada and Kadruka; a related form is known from contemporary contexts in Egypt. Caliciform beakers have been recovered from funerary contexts only, suggesting that their function was intimately connected with funerary ritual. The quality of the vessels varies considerably, some being rather crude. Regional variations in the form have been noted, the markedly bulbous lower part of this vessel being a characteristic of the more southerly type.

This example was recovered together with three other vessels from a grave in the cemetery at el-Kadada. *DAW*

Provenance: 1978–9, el-Kadada, cemetery C, section 76, tomb 3 (Section Française de la Direction des Antiquités du Soudan, find no. KDD 76/3/59)

Exhibition: Lille 1994, no. 63

Bibliography: Geus, 1980, fig. 4, pl. VII

1.76

Bowl with dentelle decoration

Nubia
Classical A-Group culture, *c.* 3100 BC
fired Nile silt
h. 19.4 cm; diam. 20.6 cm
Lent by the Syndics of the Fitzwilliam
Museum, Cambridge, E.G.A. 4668. 1943

This bowl represents the highest point in ceramic achievement of A-Group culture. The 'eggshell' ware is uniformly fine, with walls of about 3 mm in thickness. At the base, the pattern of triangles gives way to columns of horizontal lines, diminishing in length with the narrowing of the body of the bowl. The interior is painted black and polished.

The A-Group culture predominated in Lower Nubia and parts of Upper Nubia contemporary with the Naqada III period in Egypt and just before the unification of Egypt. At this time, *c.* 3100 BC, there was a dramatic change in the previous trade and exchange relationship between the two cultures. Objects from the A-Group are no longer found, and the Egyptian interest turns more to domination and control of Lower Nubia. The material remains of the A-Group suggest that the people were farmers and hunters and extracted gold at goldwashing sites. They made ivory combs, pins and pendants for personal adornment

and were buried in tumuli with places where offerings could be left for the dead. Though this may be due to Egyptian influence, their pottery combines Nubian and Naqadan elements to create individual and exquisite vessels.

This vessel is of pink fired clay. Its shape would have been formed by successive coils of clay, built up from the base and then smoothed together, perhaps through the use of a paddle and an anvil. Hardly any trace of the coils remains, owing to the skill of the potter and the quality of the local clay. The pattern was applied in a paint of red ochre before firing, a thin brush-like implement probably being used for the outlines. The paint within the triangles and the thicker lines of the base pattern was applied with a broader implement and with the fingers. The decoration at the base is in imitation of basketry, perhaps a pot-stand on which to place the bowl. The dentelle effect may also be derived from painted or specially woven baskets. The leather-hard surface was burnished with a smooth, well-rounded pebble or piece of leather to create the required lustre.

The fragility of the ware implies that it could not have been intended for everyday use. By imitating basketry, so much in daily use, the

vessel is evidently designated as an object to be taken out of this world for use in the next. *EV*

Provenance: ex collection Major R. G. Gayer-Anderson

Bibliography: Brooklyn 1978, no. 119; Bourriau, 1981, no. 197, p. 99

1.77

Beaker

Sudan
Classic Kerma, 1750–1550 BC
fired Nile silt
h. 14 cm; diam. (rim) 11.5 cm;
diam. (base) 4.9 cm
The Trustees of the British Museum,
London, EA. 55424

This beaker has a cavetto profile rounding in to the small sagging base. The interior, the rim and the upper part of the exterior wall are covered in a lustrous black slip, the lower part of the exterior and the base in a red slip. Overlying the red-slipped zone and the point of junction of the red and black is a very pale grey stripe bounded by darker grey margins. The quality of execution is superb, and the vessel is extremely regular and fine with walls only 3 mm thick.

The caliciform beaker is a typical product of the Classic Kerma potters and vessels of this type are found throughout the kingdom, often in great profusion. These beakers are among the finest products of the potter's art to have been made in the Nile Valley at any period. The characteristic feature of the pottery of this period is the grey band, the idea for which may have come from observation of the accidentally produced grey spots noted on some pots of the immediately preceding period. It is not certain how the potters were able to produce the band as a consistent feature. This beaker was recovered from a funerary context, although the type is also a common find on occupation sites where they tend to be much less well preserved. It came from a subsidiary grave within one of the massive royal tumuli at Kerma (tumulus IV), where it was one of a stack of five beakers and a bowl placed close to the head of the individual in the north-east corner of the grave. *DAW*

Provenance: 1915–16, Kerma, Eastern Cemetery, Grave K451 (Harvard University – Museum of Fine Art Egyptian Expedition, Find no. 14.3–913)

Bibliography: Reisner, 1923, p. 239; Taylor, 1991, fig. 24; Quirke and Spencer, 1992, fig. 158

1.78

Leg of a chair, stool or bed

Egypt or Nubia
Napatan, 8th–7th century BC (?)
wood (*spina Christi*)
42.3 x 6.4–9 cm
The Trustees of the British Museum,
London, EA. 24656

The rectangular-sectioned, slightly tapering foot of this leg is decorated with shallow carved hieroglyphs. The inscription on the front face reads 'all life, all power' and on each side 'all health, all joy'.

Upon this sits a human-headed sphinx wearing a collar with tear-drop beads hanging from its lower edge and with a scale pattern covering the chest and the forelegs to below the knee. The eyes were originally inlaid and the hair is represented by a smooth raised area upon which is a central forelock, a sidelock to left and right and long tresses running down the back of the head to the nape of the neck on either side of the 'back pillar'. The top is rounded and pierced by rectangular mortise holes running right through the timber. The front face is decorated with an incised papyrus motif, the symbol of Lower Egypt, beneath the mortise and with a petal motif above. All the decoration is infilled with a white pigment. The function of the two small circular holes that enter behind the left ear and in the left side of the lower abdomen and are angled towards the back of the piece is uncertain.

The treatment of the head with its round and fleshy face is characteristic of Kushite sculpture of the 25th Dynasty and can be paralleled, for example, on the *shabti* of Taharqo (cat. 1.79) from Nuri. Similar hair-styles with the hair gathered in four tufts are found on a number of Egyptian representations of Nubian girls and also occur on Egyptian faience female figures and female-headed sphinxes dated to the later Third Intermediate period and Late period. These have been associated with the rituals surrounding childbirth.

It is impossible to be certain whether this piece is the leg of a chair, stool or bed. Examples of these items of furniture from Egypt use legs of this type. Beds with rails tenoned into the four corner legs of this basic form are also common in Nubia from at least the Kerma period; known as

angereebs, they are still used today. They were frequently associated with burials, the deceased being placed upon them. *SGQ, DAW*

Bibliography: Quirke and Spencer, 1992, fig. 162; Killen, 1980, pls 38, 51–4; Boston 1982, p. 204, no. 239; Bulté, 1991, esp. pl. 28c.

1.79

Shabti figure

Sudan
Napatan, *c.* 664 BC
stone, ankerite
h. 52.6 cm
The Trustees of the British Museum,
London, EA. 55485

The body of this mummiform figure of a male is entirely covered apart from the opposed hands which each hold a hoe and a cord. On the head is worn a *khat*-headcloth with a pigtail at the back and a single uraeus. The broad beard was probably curled at the end (in this piece broken off). The cord in each hand runs over the shoulder and carries a rectangular bag with a diamond lattice pattern.

At an early stage in the development of the kingdom the Napatan rulers adopted a number of features of Egyptian religious beliefs, kingship ideology and culture. In the realm of funerary religion it was Piye, who died around 716 BC, who adopted the Egyptian practice of providing *shabtis* in the grave. These were models of the king which would act as surrogate workers in the afterlife, hence the provision of the hoes and bags. In the tomb of Taharqo, the first of the Napatan kings to be buried at Nuri, 1070 complete and many fragmentary *shabtis*, of granite, green ankerite and calcite, were found, originally arranged in three rows along the wall of the chamber. All bear texts from the Book of the Dead, chapter 6. The robust form of the *shabtis* and the choice of formulae from the Book of the Dead (by that time long obsolete in Egypt) are among many manifestations of the Napatans' predilection for Old, Middle and New Kingdom features, which they utilised in an eclectic manner. The facial features of these *shabtis* are typically Napatan and can be compared with the head of the sphinx on the wooden furniture leg (cat. 1.78).

The provision of a single uraeus on the Taharqo *shabtis* calls for comment. One of the distinctive features of representations of Napatan rulers is the presence of two uraei, their own way of illustrating their dominance over the lands of Upper and Lower Egypt. However, this iconography was by no means invariably used, and statues and reliefs showing rulers with one – as in this case – or no uraeus are known. *DAW*

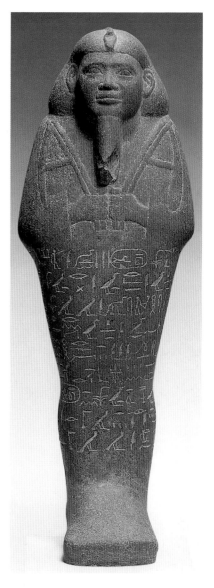

Provenance: 1916–17, Nuri, Tomb of Taharqo Nu. 1 (Harvard University – Museum of Fine Arts Egyptian Expedition)

Bibliography: Dunham, 1955, p. 10; Taylor, 1991, fig. 53

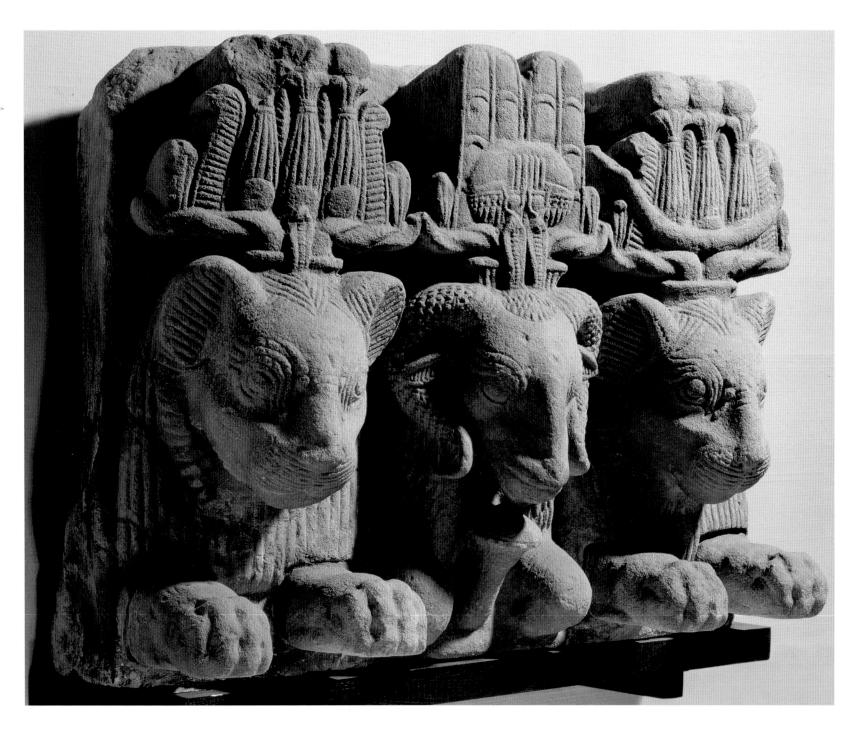

1.80

Divine triad

Sudan
Meroitic period, *c.* 200 BC
sandstone
64.3 x 88.3 x 36.6 cm
Staatliche Museen zu Berlin, Preussischer
Kulturbesitz, Ägyptisches Museum und
Papyrussammlung, 24300
Permanent loan from Humboldt
Universität zu Berlin

Architectural sculpture was constantly used in Egypt from the beginning of the 3rd millennium BC onwards. Thresholds of palaces show the heads of foreigners (cf. cat. 1.24); gargoyles high up on temple walls take the shape of apotropaic lion heads.

The central head shows a ram, combining in its horizontal horns and the horns winding around the ears of two different species of the animal sacred to Amun. Its crown is composed of uraei with sun-disks and cow horns, a huge sun-disk surrounded by a frieze of uraei and two falcon feathers flanked by two more uraei. Between the legs emerges a papyrus plant. Two lion heads flank the central motif: their crowns consist of horizontal ram horns, three bundle crowns with two sun-disks each, flanked by two ostrich feathers and two uraei. On the right head a crescent is added above the horizontal ram horns.

The identification of these lion gods depends on the choice between Egyptian or Meroitic. In Egyptian iconography the two lions are Shu and Tefnut, the children of the primeval god Atum, representing sun and moon. In Meroitic iconography one of the most frequently represented gods is Apedemak, normally as a lion or a lion-headed man. The second lion could be the moon-god Khonsu, the son of Amun.

The triad combines purely pharaonic elements of religious iconography with typical Meroitic features.

The Lion Temple of Musawwarat es-Sufra where this block was excavated is one of the first examples of pure Meroitic style. Its founder, King Arnekhamani, contemporary of Ptolemy IV, extended the kingdom of Meroë to the southern border of Egypt at the first cataract near Assuan. *DW*

Provenance: 1960, Musawwarat es-Sufra, Lion Temple (Humboldt Universität zu Berlin Sudan Expedition, exc. no. IIC/24)
Exhibitions: Brooklyn 1978, no. 145; Berlin 1990, no. 159

Bibliography: Vandersleyen, 1975, fig. 435

1.81

Model of Gebel Barkal

Sudan
Meroitic period, 2nd century BC–2nd
century AD
sandstone
h. 62.8 cm; diam.59.2 cm
Museum of Fine Arts, Boston
Harvard-Boston Expedition, 21.3254

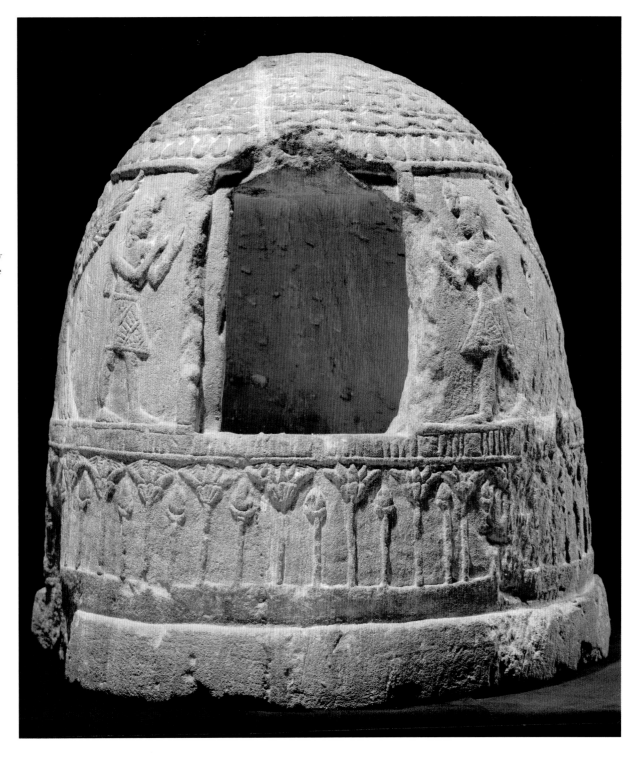

Once thought to be a shrine imitating
the form of a traditional African hut,
this hollow dome-like object of
sandstone can now be identified
quite confidently as a model of Gebel
Barkal, the 'Pure Mountain' of
Napata, which was the chief sanctuary
and coronation centre of Kush and the
site of the oracle of Amun, said to
select each new king following the
death of his predecessor. The object
imitates in form the unique Napatan
hieroglyphic symbol for Gebel Barkal,
which appears several times in the
stele of Nastasen (c. 335–315 BC) in
Berlin. As a hieroglyph, the mountain
is shown as a dome with a uraeus or
cobra diadem (symbol of kingship)
rising from one side and is used
interchangeably for the ordinary
'mountain' hieroglyph in writings of
the name 'Amun of Napata'.

From the Egyptian New Kingdom
onwards, Gebel Barkal was believed
to be the residence of the southern
(and primeval) form of the Theban
god Amun, who was known as 'Amun
of Napata, dweller in the Pure Moun-
tain'. Because of the curious 75-m-
high pinnacle on the southern corner
of Gebel Barkal, which in silhouette
looks like a rearing uraeus, the
mountain was not only identified as
the dwelling-place of Amun, but was
also identified by the Kushites as the
true source of kingship in the Nile
Valley, from which derived the
legitimacy of the 25th Dynasty and
their successors in the Sudan. In
several ancient reliefs, the mountain
is shown in cutaway section, with the
god Amun enthroned within it, and
with a giant uraeus rearing up before
him from the mountain's cliff. One
can only speculate that the lost
doorway of this model, probably of
cast bronze, once had such a uraeus
attached to its front.

The object is hollowed out on the
inside, with a rectangular socket cut in
the floor for the placement of a small
seated statuette, now lost. Originally
this statuette was hidden behind a
door, made of a separate panel, which
was sealed shut. Chips around the
doorway reveal that this panel had
been anciently prised open, probably
by those who took the statue. The
exterior surface is carved with three
registers of relief. The lowest
represents a stylised papyrus swamp,
rendered as a series of parallel stems
capped by alternating blossoms and
buds. The upper border of this
register forms the baseline for the
doorway. On each side of the doorway
are symmetrically carved rows of four
figures facing it. Each row is led by a
king in short kilt, with arms upraised
in adoration, followed by a winged
goddess, followed in turn by a similar
pair, except that the goddesses have
alternating human and leonine heads.
This register terminates at the rear
with a double cartouche naming the
royal donor, an otherwise unknown
Meroitic king with the Egyptian
throne name Neb-maat-Re. The upper
register forms a necklace-like
ornament of six bands of beads, the
lowest being a series of drop-shaped
pendants. A finial, now broken, once
projected from the summit, perhaps in
the form of a ram's head, the animal
form of the Nubian Amun. The sur-
face is grey-brown in colour, but was
originally gessoed and still bears
traces of red ochre pigment. *TK*

Provenance: Gebel Barkal, Great Temple
of Amun (Room B 503), in debris

Exhibitions: Brooklyn, Seattle, New
Orleans and The Hague 1978–9;
Brockton, MA, and Providence, RI,1981–4

Bibliography: Wenig, 1978, pp. 209–10;
Kendall, 1982, pp. 58–9

1.82

Vessel in the form of a bound oryx

Sudan
Napatan, early 7th century BC
calcite (Egyptian alabaster)
8.2 x 17.3 x 6.5 cm
Museum of Fine Arts, Boston
Museum Expedition, 24.879

One of the richest early graves discovered at Mero was a rectangular pit burial, without superstructure, that contained the body of an adult female apparently lying on a bed. This burial had much in common with the contemporary tombs of the early 25th-Dynasty queens at El-Kurru. The deceased was surrounded by her funeral goods: toilet articles, jewellery, a pair of mirrors, pottery, nearly 30 bronze vessels and nine in calcite, of which three, like this one, were nearly identical and took the form of bound oryxes. Although no exact parallel for such vessels is known, the stone from which they were made derived from Egypt. Since many vessels of calcite are found in Kushite graves, it seems probable that they were made in Egypt and shipped to Nubia as containers for expensive oils and unguents.

The ovoid form of the animal's body approximates to that of the contemporary type of unguent vessel known as an *alabastron*. The normal alabastron rim has been altered to form the open-mouthed head of the animal, made as a separate piece, while the expected lugs have been replaced by the bound legs, which form a convenient handle. The animal's mouth, which is the vessel's mouth, would evidently have been stoppered. The tail and ears are rendered in low relief, and the testicles are carved in the round. The eyes were once inlaid, and there was an inset triangle of reddish material on the forehead, of which traces survive. Two holes drilled at the top of the head held horns in another material, now lost. On the surviving original mate to this vessel in Khartoum the horns are made of carved slate, and the restored horns here duplicate these. *TK*

Provenance: Mero, West Cemetery, Tomb Beg. W. 609

Exhibitions: Brooklyn, Seattle, New Orleans and The Hague 1978–9; Brockton, MA, and Providence, RI, 1981–4

Bibliography: Wenig, 1978, p. 186; Kendall, 1982, p. 43

1.83
Jar

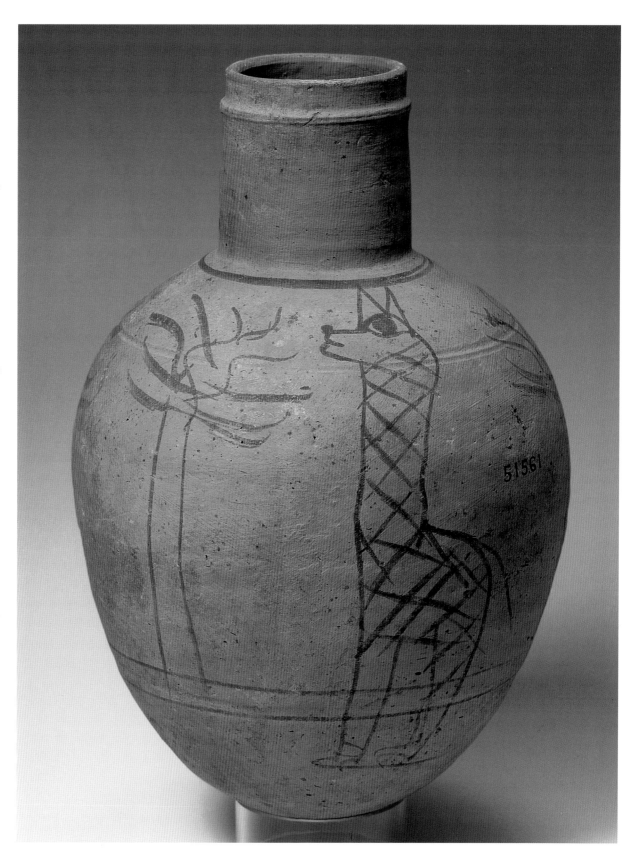

This wheel-made jar has a globular body and a cylindrical neck. The whole of the exterior and the interior just over the rim is covered in an orange slip which shows clear traces of wipe marks. The decoration is painted in brown on the body. Beneath a horizontal line at the base of the neck is a single register of seven elements. Running clockwise around the pot from a tree is a giraffe facing right, a man facing left, a giraffe facing left, a tree, a giraffe facing left and finally another tree. Two lines run around the lower part of the body, the upper not continuously. The lower line acts as the ground on which the trees stand, while the figures all extend below this and each has its individual ground line. The trees are probably to be identified as date palms. The giraffes are all very similar, drawn in profile (apart from the pointed ears) with body, neck and legs featuring a crudely drawn diamond lattice. The tail is represented by a single line. The man is depicted in the typical Egyptian (and Meroitic) manner, the torso shown frontally, the rest of the figure in profile. On his head he wears a helmet with ear-flaps and a nose-guard held in place by a chin-strap. There is possibly some indication of clothing with a clear neckline and two arcs running from the centre under the arms. From the evidence of other similar representations, however, the arcs may represent the chest muscles.

Giraffes are a common motif in Meroitic art and are frequently painted on jars. There is considerable variation in the style of drawing, with some being rendered in a naturalistic manner and some almost as cartoon figures. This vessel can be closely related to a number of others from Faras where they were presumably made. The figure of the man and the giraffes are so similar to those on vessels painted by the so-called Prisoner Painter as to suggest that they are either by the same man or by a close associate.

This pot came from the grave of an individual who was accompanied by several ceramic and copper-alloy vessels. His head rested on a wreath of leaves. *DAW*

Provenance: 1910–11, Faras, cemetery 1, grave 2006 (The Oxford Excavations in Nubia)

Bibliography: Griffith, 1925, p. 138; Brooklyn 1978, p. 290

much more naturalistic, with lentoid eyes delimited by upper and lower lids, arched orbital ridges and realistically modelled ears. However, a number of parallel details can be found on the *ba* statues, particularly the incised lines on the forehead, thought to represent cicatrices rather than a diadem. The register of decoration around the base of the neck is also a feature of several *ba* statues. By the treatment of the eyes the sculptor of this piece has been able to impart a powerful, brooding aspect to the head.

Significantly, the lower end of the neck has been dressed flat. This head thus falls into the category referred to as 'reserve heads' (cat. 1.25) rather than to that of the *ba* statue. It is thought that it may have taken the place of the more traditional *ba* statue in the pyramid chapels as a representation of the deceased. Reserve heads are rare in Nubia but another is known from Gemai, again with the diamond lattice pattern used to represent the hair but with the facial features executed in a very different manner. An interesting painted representation of reserve heads is to be found on a Meroitic jar from the cemetery at Nag Gamus in Egyptian Nubia. *DAW*

Provenance: 1963, Nelluah (South Argin), found near the surface between mastabas 26 and 27 (Spanish Archaeological Mission in the Sudan)

Exhibition: Brooklyn 1978, no. 160

Bibliography: Almagro et al., 1965, p. 87, pl. 14a–b; Almagro, 1965[1], pp. 62, 167, no. 17, pl. 39a–c; Leclant, 1976, p. 128, fig. 138; for the Gemai head see Bates and Dunham, 1927, pl. XXXVI; for the 'reserve heads' on the jar at Nag Gamus see Almagro, 1965[2], fig. 41

1.85

Head of a ba statue

Nubia
2nd–4th century AD
sandstone
18.3 x 11 x 15.5 cm;
base 12.5 x 11 x 15.5 cm
Lent by the Syndics of the Fitzwilliam Museum, Cambridge, E.12. 1910

Although the head is heavily weathered, it is clear that its modelling was never intended to be crisp. The face is long and narrow; the eyes are cursorily modelled and set so far apart that the outer corner of the preserved right eye wraps around the side of the face. The eyes bulge within a continuous hollowed-out orbital zone below the ridge of the forehead, presumably to emphasise the strong ridge of the brow. Only a faint hint of a rimmed contour survives around the eyes. The nose has completely weathered away, whereas the firmly pursed lips are emphatically drilled at the corners and set off from the flat plane of the chin. From the height of the head and the stepped contours above the face, this figure could be interpreted as wearing a helmet with a curved brim. Similar heads from Karanog are known, but with elements that look more like closely cropped natural hairlines

1.84

Male head

Sudan
Meroitic period, 2nd–3rd century AD
sandstone
26.7 x 15.5 x 18.4 cm
Sudan National Museum, Khartoum,
SNM. 13.365

Resting on a long columnar neck, this head of a man has a register of short vertical lines between two horizontal lines near its lower edge. The opening between the pouting lips is indicated by a straight narrow slit. There is little modelling of the long, pointed nose and no indication of nasal arches and nostrils. Slight depressions mark bags beneath the eyes. The upper lids are not indicated, their position being occupied by horizontal orbital ridges

cut back vertically to the eyeball. Towards the hairline the smooth brow has a shallow horizontal groove with another, much deeper groove above. The hair is close-cropped and represented by a square lattice on the top of the head and by a diamond lattice on the back and sides. The ears are simple protrusions without modelling. The skin was painted a reddish-brown and the hair was black. The eyelids, upper line on the brow and the neck bear traces of white paint.

The stylised form of this piece is highly unusual and it is difficult to find convincing parallels among the large number of human heads from northern Nubia that come from *ba* statues (cat. 1.85–6). These are all

under a wig than brimmed helmets. At the back is a curved engaged strut which is broken off at the crown of the head. Perhaps this was a plume or some sort of (solar?) attribute now lost. Unusual are the three irregularly spaced, vertical scored marks at the right side of the head. The irregular break at the neck suggests that the head has broken off from a figure and was not sculpted as a 'reserve head' (cf. cat. 1.84).

This head is thought to come from a so-called 'ba' statue, a bird sculpture with human head depicting the soul of a deceased (cf. cat. 1.86). The imagery is well represented in Egyptian New Kingdom tomb decoration and on coffin scenes of the mid-2nd and 1st millennium BC. The ba was believed to flutter about, often seeking repose in the shade of the sycamore trees planted beside small pools, where the sycamore goddess could pour a refreshing drink. In Meroitic Nubia of the 2nd to 4th centuries AD, ba statues representing the deceased could be positioned near tombs, often in close proximity to offering-tables where the living might set food and drink for the nourishment of the dead. The fact that these tables were decorated with foodstuffs and inscribed suggests that food and drink were magically provided for the ba statute after the living no longer came. *EV*

Provenance: F. W. Green, from Aniba

Bibliography: Mills, 1982, p. 36, pl. xc.6; Woolley and Randall-MacIver, 1910, nos 7048, 7069, 7070; Brooklyn, 1978, nos 151–60

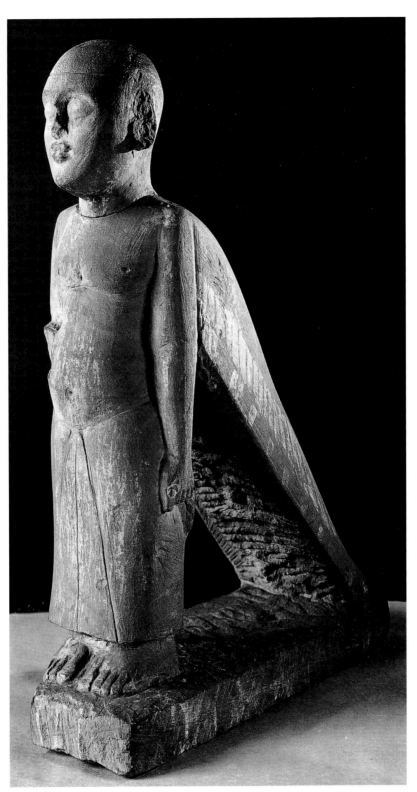

1.86

Ba statue

Lower Nubia
Meroitic periode, *c.* 2nd–4th century AD
sandstone
69.9 x 20. x 49 cm
University of Pennsylvania Museum of Archaeology and Anthropology, Philadelphia, E 7004

Meroitic 'ba statues' of Lower Nubia are a well-established genre. Normally, the statue combines a fully human figure with a pair of furled wings. Despite strong Egyptian influence upon Meroitic culture, this type of ba statue is not found in Egypt or around Meroe itself. In Egyptian belief, the ba was the mobile, transformational aspect of a dead person's personality, often represented as a human-headed bird, while the ka (typically depicted in human form) was the embodied capacity of the deceased to absorb life and the nourishment needed to sustain it. Meroitic ba statues might in fact combine the notions of ka (the human figure) and ba bird (the attached wings); they typically also had a solar disc rising from the head, made separately and hence usually lost. Ba statues stood outside tombs as a focus for offering cults, but their exact location is uncertain (nearly all were found out of context).

This statue is allotted to Grave 133 in a cemetery at Karanog, Lower Nubia, perhaps incorrectly; the owner of this tomb was a woman, according to an inscription, and the statue is male. The head is schematically rendered, with simplified facial planes, unrealistically large eyes and protuberant, seemingly pursed lips. A hole in the top of the head supported the stem of a circular sun-disc, now gone. Traces of dark red paint, overlying a white ground, occur on the body, while the feather pattern on the wings was laid out in green, overlying a white ground. Stylistically, it can be seen as a provincial variation on the proportions and style of official divine and royal statuary of the period.

One arm extends down the side and grasps a piece of cloth (?); the other was once partially extended and has broken off. Like other ba statues, it may originally have held a cone-like object or a staff. The portly form (indicative of prosperity) wears a long kilt, with front panels; while the carefully delineated feet are bare. *DO*

Provenance: 1910, Karanog, Lower Nubia (E.B. Coxe, Jr. Expedition)

Bibliography: Woolley and Randall-Maciver, 1910, pp. 48, 134, pl. 16; Hoffmann, 1991, pp. 35–41; O'Connor, 1993, ch. 7

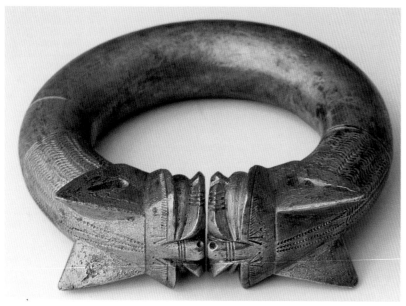
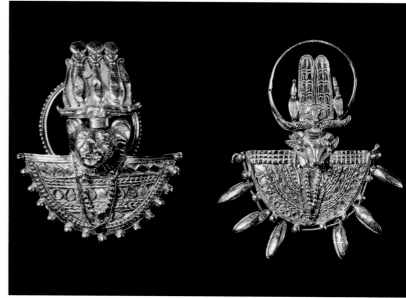

1.87

Bracelet

Nubia
X-Group, early 5th century AD
silver
external diam. 8.9 cm;
diam. of cross-section 2.7 cm
Museum of Egyptian Antiquities, Cairo,
JE 70296

This bracelet has terminals in the form of lions' heads. A number of similar bracelets were found in graves at Ballana and at the contemporary cemetery at Firka, a little upstream of the Dal Cataract. These are thought to be of Nubian manufacture. This piece was found, along with another of very similar type, *in situ* on the left wrist of a male buried within a burial pit at Ballana. On his head he wore a crown, anklets of leather with silver discs on the left leg and two silver toe-rings. An archer's silver brace lay by his right hand. Török suggests that this was the burial of a prince. *DAW*

Provenance: 1933, Ballana, tomb B6, burial C (Archaeological Survey of Nubia 1929–34, find no. B.6-23)

Exhibition: Brooklyn 1978, no. 270

Bibliography: Emery and Kirwan, 1938, p. 87, no. 23, p. 187, no. 19, pl. 39a; Török, 1988, p. 117, fig. 71, no. 23

1.88

Two shield rings

Sudan
Meroitic period, *c*. 15 BC
gold, fused glass
h. 3.9 cm
Staatliche Museen zu Berlin, Preussischer Kulturbesitz, Ägyptisches Museum und Papyrussammlung, 22872

Shield rings are especially characteristic of Meroitic royal jewellery. Their formal structure is dominated by a semicircular necklace (or aegis) surrounding the head of a god or goddess. Consisting of a solid plate of gold, the aegis has on its reverse a gold ring fastened by a hinge. The divinities represented on these shield rings are a selection of those encountered in the reliefs of Meroitic temples and pyramid chapels, where Egyptian gods are mixed with typical Meroitic divinities: the lion-headed Apedamak, the anthropomorphic Sebiumeker and the foremost of the ram-headed gods. The latter group is the only one used in the iconography of these rings.

The ram head in the centre of this shield ring, made of solid gold, combines two different species: *ovis longipes*, with horizontal horns; and *ovis aries*, with horns winding around the ears. Its headdress consists of a sun-disk, a pair of falcon feathers and two uraeus snakes surmounted by the pharaonic crowns of Upper and Lower Egypt. A gold wire, passing through small loops at the outer rim of the aegis, supports six gold shells. Named after the Egyptian god Amun, these ram-headed gods are genuine Meroitic divinities. The Egyptian

Amun, originally represented in pure human form, assumes the shape of a ram only at a later date as a secondary manifestation whose origin clearly lies in the Upper Nubian culture of Kerma. Throughout the iconography of Amun, the Egyptian anthropomorphic figure is distinguished from the Nubian and Sudanese form of the ram.

These shield rings have been explained as functioning finger-rings. Their dimensions and fragility, however, tell against such a use. Shield rings can be found in relief figures of Meroitic queens as an ornament over the forehead, supported by a diadem or by a lock of hair. Similar ornaments do still exist in the oasis west of the Nile Valley. *DW*

Provenance: 1834, Begrawija (Meroie), Pyramid N5 of Queen Amanishakheto (Giuseppe Ferlini)

Exhibitions: Berlin 1990, no. 162; Berlin 1992, fig. 9b

Bibliography: Schäfer, 1910

1.89

Incense burner

Nubia
X-Group, late 4th–early 5th century AD
copper alloy
h. 25.7 cm; w. of pedestal 11.4 cm
Museum of Egyptian Antiquities, Cairo,
JE 70924

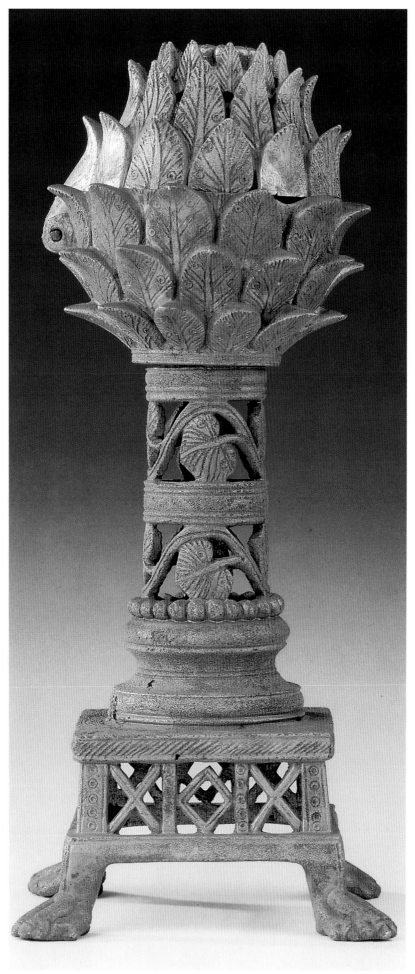

This incense burner is in the form of a pine cone. The scales on the upper half of the cone are tightly closed, those on the lower half are open. Each is decorated with a veined pattern and with small concentric circles. A lid on the top of the cone is hinged and pierced by a large hole and a row of smaller holes to allow the fumes to escape. The cone is supported on an openwork, slightly tapering cylinder decorated with two registers of a swirling leaf and tendril motif. At the base of the cylinder a band of spherical beads masks the point of contact with the 'Attic' base. This sits on a square pedestal, the sides of which are decorated with an openwork floral pattern, as on the cylinder. Each panel is delimited by a vertical register at the corners of incised concentric circles and with a register of rope pattern above. *Ankh*-signs are incised in the top corners. The pedestal is supported by four lion's paws.

The character of this piece puts it firmly among the repertoire of the Late Antique period. There is some doubt as to its place of manufacture, whether it is a Nubian product or whether it was made in Egypt north of Aswan. Török has compared it with a similar piece, probably from Faiyum. There was certainly much imported material among the gravegoods found in the X-Group graves at Ballana and the nearby cemetery at Qustul. It was found lying on the floor adjacent to the burial of a female adult in the antechamber of the tomb, probably that of a queen. *DAW*

Provenance: 1932–4, Ballana, tomb 47 (Archaeological Survey of Nubia 1929–34, find no. B.47-10)

Exhibition: Brooklyn 1978, no. 275

Bibliography: Emery and Kirwan, 1938, p. 108, no. 10, pp. 362–3, no. 804, pl. 97A; Török, 1988, p, 123, fig. 81, no. 10, pl. XII

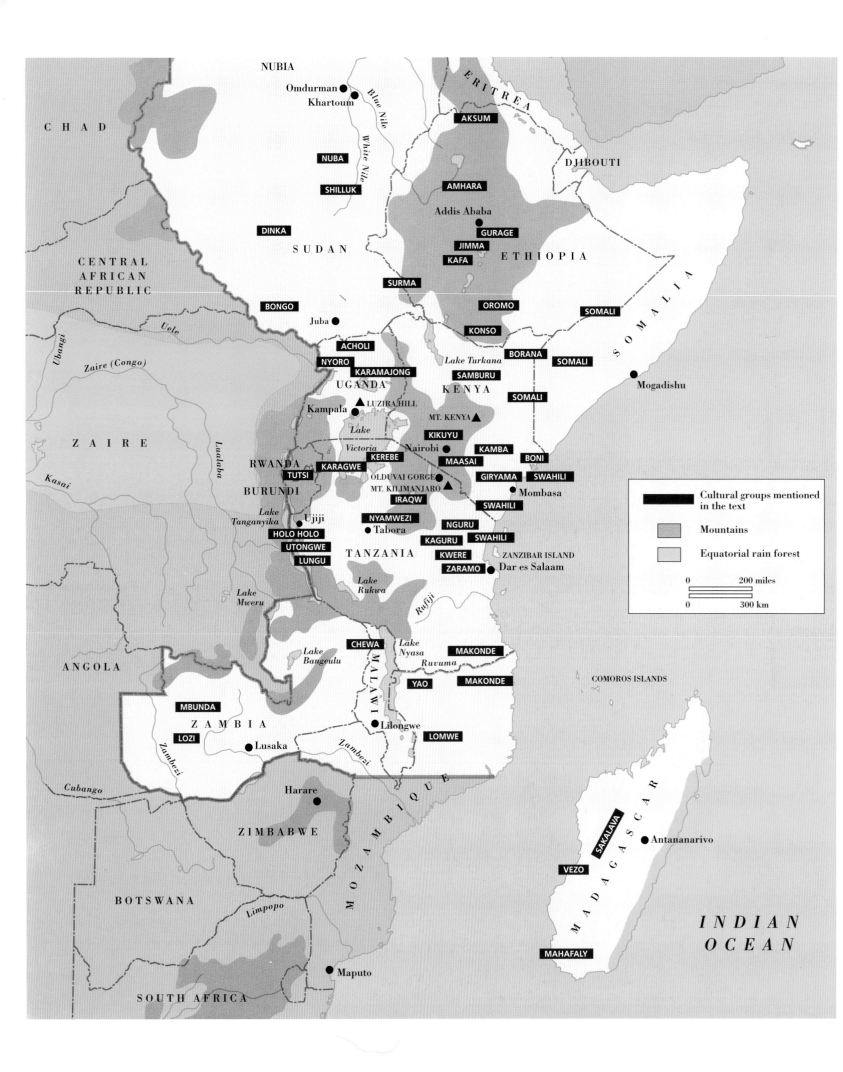

NUBIA

CHAD

Omdurman ●
Khartoum ●

Blue Nile

ERITREA

AKSUM

DJIBOUTI

CENTRAL
AFRICAN
REPUBLIC

NUBA

SHILLUK

White Nile

AMHARA

Addis Ababa ●

DINKA

SUDAN

GURAGE

JIMMA

KAFA

ETHIOPIA

Uele

Ubangi

SURMA

Zaire (Congo)

BONGO

Juba ●

OROMO

KONSO

SOMALI

ACHOLI

NYORO

KARAMAJONG

Lake Turkana

BORANA

SOMALI

SOMALIA

ZAIRE

Lualaba

UGANDA

KENYA

SAMBURU

SOMALI

Kampala ● ▲ LUZIRA HILL

MT. KENYA ▲

SOMALI

Mogadishu ●

Kasai

Lake
Victoria

KIKUYU

Nairobi ●

KAMBA

RWANDA

KARAGWE

KEREBE

MAASAI

BONI

Lake
Tanganyika

TUTSI

BURUNDI

OLDUVAI GORGE ●
MT. KILIMANJARO ▲

GIRYAMA

SWAHILI

Ujiji ●

IRAQW

SWAHILI

Mombasa ●

NYAMWEZI

NGURU

HOLO HOLO

Tabora ●

KAGURU

SWAHILI

UTONGWE

KWERE

ZANZIBAR ISLAND

LUNGU

TANZANIA

ZARAMO

Dar es Salaam ●

Lake
Rukwa

Lake
Mweru

Rufiji

ANGOLA

CHEWA

Lake
Nyasa

MAKONDE

Lake
Bangeulu

MALAWI

Ruvuma

COMOROS ISLANDS

YAO

MAKONDE

MBUNDA

LOZI

ZAMBIA

Lusaka ●

Lilongwe ●

LOMWE

Zambezi

Zambezi

Cubango

Harare ●

MOZAMBIQUE

ZIMBABWE

MADAGASCAR

SAKALAVA

Antananarivo ●

BOTSWANA

Limpopo

VEZO

Maputo ●

MAHAFALY

SOUTH AFRICA

INDIAN
OCEAN

	Cultural groups mentioned in the text
■	
▨	Mountains
▨	Equatorial rain forest

0 200 miles

0 300 km

2 EASTERN AFRICA

John Mack

Eastern Africa provides the earliest evidence anywhere in the world of the development of distinctive human activity. The earliest of what might be termed 'cultural' objects were fashioned in those parts of the Rift Valley that run from the Olduvai Gorge in Tanzania to Lake Turkana in Kenya, including its extension into neighbouring Ethiopia. The area is also bordered along one side by the Indian Ocean, one of the more benign of seaways, which provides it with a maritime context comparable with that of Africa's Mediterranean and Red Sea shores. Given an area with such a long history of human occupation, and a hinterland that has proved relatively accessible both from within and beyond the continent's shores, its cultural and linguistic diversity is not unexpected; nor is overlap with other areas considered elsewhere in this catalogue and its accompanying exhibition.

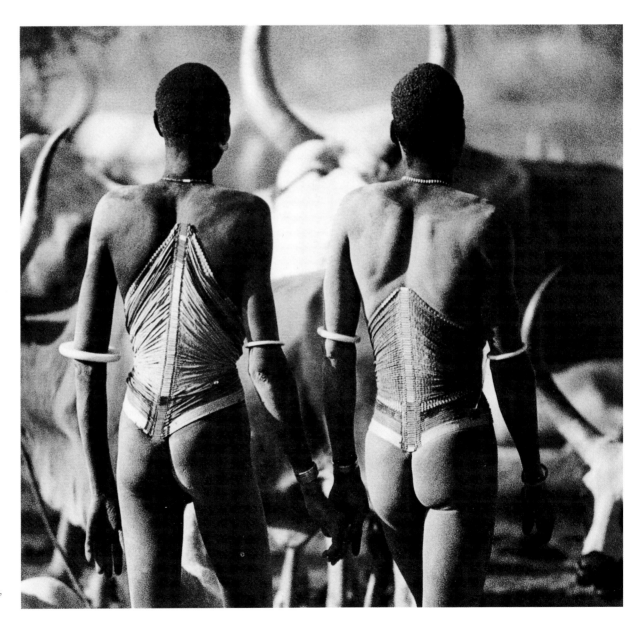

Fig. 1 Dinka men wearing beaded corsets, southern Sudan

Historical and geographical background

Regional definitions are, of course, always somewhat arbitrary. Two tendencies are evident in the familiar treatment of the eastern side of the continent. On the one hand, in the anglophone world, east Africa is often shrunk into the former British colonial entities that comprised the separately administered territories of Kenya, Tanganyika and Uganda, and perhaps Zambia and Malawi. Yet, most general surveys of African art embrace much more: they tend to consider together everything in sub-Saharan Africa that is not from the rich artistic heartlands of west and equatorial Africa; east Africa is taken as a kind of afterthought. Indeed, where sculpture has been found it is often presented as an overspill from the 'art-producing' areas on its borders. The tone of most discussions of art in eastern Africa is unremittingly apologetic. In this survey significant weight is accorded to this neglected area and to objects other than the figurative.

This is to be welcomed. However, the nature of the exhibition and its catalogue has necessitated a somewhat broader sweep than might have been ideal. The heart of the region extends from the coasts of Kenya and Tanzania across to the Ruwenzori Mountains and Lake Tanganyika. It takes in Uganda, Rwanda and Burundi, an area dominated by high plateau grasslands that in the north merge into areas of desert and arid scrub. To the south, Zambia, Malawi and parts of northern Mozambique are considered, as are the offshore islands – Zanzibar (now joined with Tanganyika in the modern state of Tanzania) and the large and environmentally varied island of Madagascar. Included also are the contrasting cultures of the north-east – Somalia and Ethiopia, and adjacent parts of the Sudan. Ethiopia, in particular, whose rugged highlands have effectively isolated it from wider contacts with other parts of the continent, is heir to a unique set of historical circumstances.

The present topography and vegetation of this region offers several possible modes of livelihood. Indeed, depending on circumstances, different peoples may be obliged to adopt a mix of strategies. Hunting and gathering as the sole means of sustenance is extremely rare in eastern Africa. It is the main activity of only a few small and isolated groups such as the Boni in Somalia and Kenya, the Hadza in Tanzania and the Mikea in south-west Madagascar. On the other hand, many of the peoples who occupy difficult environmental niches, or are subject to periodic drought conditions, often revert to a hunting and gathering livelihood when occasion arises. Most are otherwise cattle or, in northern Kenya, camel pastoralists driving their herds in search of distant water holes in the driest seasons. This sometimes gives rise to a dual system of material culture. There is often an emphasis on multi-functional, portable and replaceable objects for those following a periodic semi-nomadic existence, such as some of the headrests and stools illustrated here; a more stable and substantial set of objects is appropriate to those who remain in the permanent villages that pastoralists also usually maintain.

Just as at one extreme pastoralism shades off into hunting and gathering, so at the other it merges with mixed farming. Even those (e.g. the Dinka and related peoples in the southern Sudan) who conceptualise the world through their impressive herds of humped cattle do not rely uniquely on cattle products to sustain themselves; they also take advantage of the crops grown at their home villages. Mixed farming proper, however, involves a comprehensive range of such activities, from agriculture to animal husbandry. It is practised in some measure in all parts of the region, but predominates in northern and central Ethiopia, in western Kenya, Uganda and southwards, and in central Madagascar. Sorghum, millet and manioc are the main crops, as well as rice in Madagascar.

A third strategy is trade – and with trade the tendency towards urbanisation. Along the continent's eastern shores a series of trading centres arose in the early decades of the first millennium, linking eastern Africa to the wider Indian Ocean. This maritime trade connected ports and islands from as far south as present-day Mozambique to southern Arabia and beyond. The main items imported into Africa appear to

Fig. 2 View of Aksum showing standing stelae, some of the tallest monuments in the world

have been iron goods (though iron production was already established on a limited scale in eastern Africa by about AD 200) and glass. These were exchanged for gum, spices, ivory and horn. Mangrove swamps provided straight poles for building purposes. By about AD 800 this series of linked centres had become the instrument through which the Islamic faith spread along the coast. The first mosques were built and with them came the emergence of a distinctive Swahili culture at centres such as Lamu, Mombasa, Zanzibar and the Comoros. Here, a technique of chip-carving was applied to wooden doors and to other domestic objects, giving an interlaced geometric form of decoration that characterises the arts of the western Indian Ocean – as exemplified on the Swahili door shown here (cat. 2.27).

In northern Ethiopia another link to Arabia was similarly associated with moves towards urbanisation. As with the Swahili, the developments that took place were the result of a fusion of external and local tradition. Aksum, the centre of an elaborate kingdom, came to prominence in the 1st century AD. By the 4th century it had already become a Christian capital, predating the spread of Islam along the Indian Ocean coast. The influence of Aksum, which lies in the province of Tigray, stretched northwards to the modern state of Eritrea and the port of Adulis, which linked it in one direction with Rome and in another with India and Ceylon. The kings of Aksum even conquered parts of the Yemen – a reversal of the standard fate of continental Africa. Aksum, in addition to its monumental architecture and its series of dramatic tall stone stelae (fig. 2) – among the largest stone monuments ever created – retains a local tradition that it preserves the Ark of the Covenant reputedly carried there by Menelek, the son of King Solomon and the Queen of Sheba. By the 17th century the capital of the Christian kingdom had been established at Gondar, which in the 19th century emerged as the centre of a unified Empire in Ethiopia's northern and central highlands.

The linguistic map of eastern Africa is aligned in very broad terms with this distribution of economic strategies. Thus, the pastoralist tradition is largely associated with Nilotic populations, which include the main cattle-keeping groups in southern Sudan (fig. 1), the Turkana and related peoples in northern Kenya and Uganda, and the Maasai in Kenya and Tanzania. To the east of Lake Turkana and into adjacent areas of Ethiopia and Somalia the pastoralist tradition is maintained by Cushitic-speakers, who include the Somali and, more distantly, the Iraqw who are established in northern Tanzania. Northern Ethiopia is heir to a separate tradition of Semitic speakers, while the mixed farming areas of much of Uganda, Kenya and regions to the south of them are occupied by members of the different Bantu-speaking peoples who moved into and through the area from the early centuries after Christ. Swahili is also reckoned a Bantu tongue, though the Indian Ocean context of Swahili culture is evidenced in the extensive Arabic influences.

The oddity in the linguistic geography of the western Indian Ocean is the presence in Madagascar of a dominant language – Malagasy – which is of Malayo-Polynesian rather than African origin. The nearest cognate languages so far studied are found in central Borneo, 6400 km away across the Indian Ocean. The original occupation of this large island appears to be contemporary with the development of Islam and of the generation of Swahili culture on the east African coast about AD 800 or shortly before.

The most likely explanation of this situation is that groups from distant parts of the Indian Ocean were already established on the east African coast before the development of a distinctive Swahili culture. The disruption of their long-distance trade occasioned by competition from local traders with links to the Arabian Sea led to their occupation of the large and, until then, uninhabited island. A number of factors support this view. One is the mix in the affinities of the art styles within Madagascar. A second is the general comparability of some sculptural forms and, equally importantly, of their associated contexts of use between Madagascar and the immediate hinterland of the Swahili coast. The construction of cenotaphs at a distance from the graves of significant people, for instance, is paralleled in parts of Madagascar

and among the Giriama, Zaramo and others in the immediate hinterland on the continent. This suggests the hypothesis that the development of a Swahili wedge along the coast separated peoples who, if not at one time united, were at least once more closely in touch.

The 19th and 20th centuries

Most of the objects in this selection, and indeed most discovered in non-archaeological contexts, are inevitably of 19th- or 20th-century manufacture. No cast-metal works known to have been produced in eastern Africa have survived. A figurative casting found in excavations from the island of Manda off the Kenyan coast turned out to be of Indian origin. Equally, there are none of the impressive ceramics from the more distant past that characterise the archaeological cultures of parts of west Africa or the early Bantu presence in South Africa. A possible exception is the Luzira head and figure from Uganda (cat. 2.21), though this comes from an otherwise undocumented context and has never been securely dated. The suggestion is that it may be no more than a few centuries old. There are also rock paintings at a number of sites in the region, the most fully recorded being from Tanzania. Again, however, dating has proved difficult.

Unfortunately, many of the 19th-century sculptures are also poorly documented, at least by comparison with west and central African art and material culture. This, of course, goes hand in hand with the persistent representation of eastern Africa as being, with few exceptions, without art. Yet, there are extenuating circumstances that explain, even if they do not explain away, this overriding impression.

The first is that written texts concerning the interior of eastern Africa began to accumulate somewhat later than those for other parts of the continent. Early accounts, such as the Periplus of the Erythraean Sea (written in Greek by an anonymous traveller from Alexandria probably towards the end of the 1st century AD), deal almost entirely with the coastal region. Later Arab and Portuguese sources are likewise silent on the deeper interior of the continent. In effect the Swahili coast had few documented relations with the interior. Coastal trading stations were maintained in significant part by the gold trade established between Great Zimbabwe and the coast to the south of the region considered here, and carried on up and down the shipping routes. It was not until late into the second half of the 19th century that accounts of the more distant parts of the interior began to appear. After all, in 1871 Stanley's famous presumption about the identity of Dr Livingstone still seemed entirely reasonable to an outside world uninformed about the interior, and assuming it to be the ultimate in isolation.

None of this would matter greatly in terms of the understanding of the earlier chronology of the area if detailed oral histories were being systematically repeated locally and subsequently written down. Most societies in eastern Africa, however, have not had the kinds of 'keepers of tradition' (indigenous historians) whose knowledge is instrumental in confirming the legitimacy of ruling groups. It was not that the societies in question lacked history; rather, their unstable political character and generally small scale left them without the official historians whose recounting of traditions made possible the extensive reconstruction of lengthy dynastic genealogies like, say, those of the Asante, the state of Benin, the Kuba kingdom or – the main exception in the region under discussion – the chronicles of the Merina royalty in central Madagascar. In recent years historians and archaeologists, many of them from the region itself, have begun to fill this void. Where the general historical context of complex social and political events is less certain, the evolution and character of any associated aesthetic complex is more difficult to determine.

The period immediately before the advent of colonialism was one of profound change. Most of the populations that are now identified under particular 'tribal' names did not exist in that form until more recently. This is especially so in parts of what is now Tanzania, from which comes much of the major

sculpture included here. The area was criss-crossed in the second half of the 19th century by Swahili caravans seeking to exploit the interior of Africa for slaves and for ivory. Their dominion stretched across east Africa to Lake Tanganyika and deep into what is now eastern Zaire. It has been said that 'East Africa in 1870 is best defined as the economic hinterland of the commercial entrepot of Zanzibar' (Wright, 1985, p. 539). Yet, the impact of coastal populations on the interior varied considerably from area to area. Indeed, not all the major Swahili traders were themselves alike. In some cases weak chiefs were reduced in influence and power; elsewhere alliances were created and strong rulers continued to maintain a powerful and essentially peaceful influence over large areas. The net effect was that whereas some groups fared badly, others (the Nyamwezi, for instance) absorbed or acculturated surrounding groups. Those peoples living along the shores of Lake Tanganyika itself, especially at the major ports, such as Ujiji, were often able to benefit from their control of passages across the lake. Thus some groups are found in significant numbers on both sides, for example the Holoholo. Others, such as the ethnically diverse Jiji, were themselves greatly increased in numbers by incorporating outsiders and by buying into the slave trade. Ethnic affiliation was set on a course of flux that only the advent of colonialism halted.

These factors are an important background to the consideration of the distribution and significance of artworks in this area. Long-distance trade routes brought with them the possibility of a thoroughly mobile population, which, of course, included itinerant craftsmen. Thus, many of the works from central and western Tanzania are often identified as Nyamwezi. Most are from the turn of the century or earlier, by which time a Swahili community was established at Tabora in the heart of their territory. By then, there were also Nyamwezi established as far afield as Zanzibar, south-eastern Zaire and Zambia, often as agents or members of the Swahili–Arab caravans that were passing back and forth through Tabora. They were also to be found as ivory traders on Kerewe island in Lake Victoria, where they created work not only for their own use, but also for the Ukerewe who were the longer-term residents of the island (cat. 2.46–7). Figures carved here were also given as diplomatic gifts to more distant rulers, such as the Kabaka (or king) of Buganda. Similarly, Luba carvings have turned up among the Bemba in Zambia, and figures in a broadly south-eastern Zairean or Angolan style are known from the kingdom of the Lozi on Zambia's western borders. The so-called Wiko in Zambia maintain a tradition of carving and of masking that is evidence of their origins among the Chokwe in Angola. The Mbunda living among the Lozi in southern Zambia are the creators of the decorated lidded bowls (cat. 2.56) associated in innumerable catalogue captions with their host community.

In other words, the clients for artworks were not necessarily of the same tribal or ethnic background as their creators. Indeed, the clients for such works did not even have to possess a pre-existing tradition of plastic arts for itinerant carvers or traders to find a ready market. In the 20th century this situation has developed still further with the creation of works for a market that has increasingly included colonial officials and settlers, and nowadays tourists. Figure carvings include stereotyped images of the colonial period – the askari (i.e. the guards and servants of colonial properties), different tribal groups with their identifiable material culture, and portraits of colonial officials themselves and of members of different ethnic groups (cat. 2.25). The main creators of these works are often themselves the descendants of the traders and middlemen of the 19th century: the Kamba in Kenya or the Zaramo in Tanzania.

The function of artworks

But such set-piece carving for an external clientele was by no means the only motivation for the production of artworks. Another implication of the changing fortunes of leaders in the interior heartlands of eastern Africa was the general association of artworks with the more stable offices

of chieftaincy. The objects created often included such items as regalia or high-backed chiefly chairs, and on the Swahili coast this extended to the richly ornate architecture and furniture of the upper classes. For the peoples around Lake Tanganyika the use of chiefly thrones – and, associated with these, the carving of figures standing on stools (cat. 2.53), and even of figures seated on the shoulders of another figure – have a common conceptual source. Among many Bantu societies in Zaire and adjacent areas to the east and south there is a shared restriction on installed chiefs coming into direct contact with the earth: they are furnished with elaborate stools or chairs and, when passing over terrain where matting is not possible, may be carried on the back of a slave. This emphasises their status as greater than ordinary mortals.

Smaller sculpture is also often integral to other prestige objects. In the region this includes canes or swagger sticks that act as staffs of office, and – especially in Tanzania – the projections on musical instruments, which often have a head or full figure carved at the end. Many sculpted objects, however, are also associated with the possession of ritual expertise or with ritual paraphernalia. Thus the lids or stoppers of medicine containers and other parts of medicinal and magical apparatus are often carved in figurative form, particularly among the Mijikenda groups in Kenya and related peoples in Tanzania. Small, often highly stylised, dolls are also found in various parts of Tanzania and northern Zambia; these are carried by unmarried girls and women who have yet to bear children, rather like the akuaʼ ba of the Asante in Ghana. A link between these two objects, the medicine gourd whose medicinal contents bubble up causing the carved stopper to move when potent, and the images carried by those hoping to become pregnant, seems possible both conceptually and artistically.

Perhaps the most consistent events with which artworks are associated in eastern Africa (as more generally within the continent) are the procedures that take place at initiation of boys and of girls into adulthood. Sometimes such events are in the hands of secret societies who, in addition to overseeing initiation, are often involved with funerary procedures, and perhaps also are responsible for masking. This is so among groups in Zambia and Malawi and among the Makonde in Tanzania and Mozambique. The masks themselves are not necessarily as numerous as they are in some of the masking complexes of Zaire and adjacent areas of Angola, though the nyau society masks of the Chewa (fig. 3) and the lipiko masks of the Makonde (cat. 2.61) are often expressive of an eclectic range of subjects. The masks are worn principally by the members of the relevant secret society rather than necessarily by the initiates.

As in parts of Zaire, images are also produced in various places as a kind of teaching aid in conveying to initiation candidates the knowledge and behaviour appropriate to adulthood or to the next grade of the society. In many places clay images are made for this purpose, especially for female initiation. Usually they are left unfired. Indeed, few of these exist in either indigenous hands or museum collections, since most of the objects are made for use on specific occasions and are buried or otherwise destroyed when no longer required. Such ephemeral creations often escape mention, though like the arts of the body or of architecture, they are inevitable absentees in any exhibition of the artistic achievements of eastern Africa.

Of the larger sculpture produced in the region, much is intended for funerary purposes. In some instances this may be a figure placed directly on or beside a tomb, as occurs among such widely dispersed peoples as the Mahafaly in southern Madagascar (cat. 2.30), the Konso (cat. 2.12), Gato and Galla in Ethiopia and the Bongo (cat. 2.18) in southern Sudan. It is not, of course, everyone whose tomb is thus identified. Such sculpture is usually reserved for the tombs of royal or chiefly clans, and for the most significant individuals within them. In each case there seems to be little suggestion that portraiture is intended.

Tomb sculpture should not be confused with what are strictly cenotaphs – that is, sculpture set up as a memorial at some other site, though usually a place in a particular relationship to the cemetery (fig. 4). There may be several quite different reasons for this practice. In some cases cemeteries are not regarded

Fig. 3 Kasiya maliro, *the eland mask, Chewa, Zambia. This* nyau yolemba *is believed to capture the spirit of the deceased person (photograph October 1984)*

as proper places to be visited other than at times of burial. Death itself may be seen as a dangerous event, disorientating for descendants and disruptive of the community. Cemeteries are often seen as polluted grounds, frequented only by those set upon witchcraft. In parts of southern Madagascar, sculpture, standing stones and other devices are erected at a site distant from the graveyard and at a later date. This physical separation parallels the distinction between the potential for pollution from the recently deceased and the vitality to be derived from a properly and ritually consecrated ancestor. Among the Mijikenda (and especially their largest subgroup, the Giryama) in Kenya (cat. 2.26), and the Zaramo to the south in Tanzania, memorial posts are also associated with the spirits of the dead, in particular the deceased members of an influential society of male elders.

In these cases the sculpture is normally grouped at a particular site, just as the bodies of the dead are laid to rest together at the cemetery. Isolated sculpture (or some equivalent device), however, is also found, placed perhaps at the junction of a path and a road or at a crossroads. In such cases it is often to commemorate those who have died or are presumed dead but whose bodies have not been recovered: people lost in the bush or drowned. The sculpture substitutes for the missing body and incorporates the dead into the community of ancestors. Where sculpture intended for tombs is usually generalised, that placed at memorial sites is sometimes personalised, in which case the sculptural programme may refer to the circumstances of the death or to the main events in the life of the deceased. Examples are known primarily from Madagascar, but also occur in southern Sudan (and possibly elsewhere).

As in much of the continent, the arts of eastern Africa focus on those moments that mark major changes in the life of individuals or communities. Artistic endeavour, however defined, concentrates on festivals that themselves effect transition: art is associated with fertility and birth, with bad health or fortune and the possibility of restoration to vigour, with advancement to adulthood or installation to chieftaincy, and ultimately with death. The arts of death may seem the final phase in such acts (and arts) of transition. However, in conception, most funerary and commemorative images are also evocations of life: they both recollect the dead and assert the continuity of the living with the community of their ancestors. In the end human vitality is derived from the embodying of such continuity, whether literally in a physical birth, or artistically in a created image.

Fig. 4 Tanosy memorial site in south-eastern Madagascar. The sculpture records a group of canoeists drowned in a nearby harbour and was carved by the local sculptor Fesira in the 1930s

2.1

Oldowan core

Olduvai Gorge, Tanzania
c. 1.6–1.7 million BP
quartzite
h. 8.9 cm
Cambridge University Museum of
Archaeology and Anthropology,
1934.1101 D

Human beings are not the only creatures that use tools, but coherent habits and traditions of tool-making are one of the definitions of humanity. Artefacts made of robust stone, the only material that survives over the very long term, are our main source of insight from the earliest times, well over a million years ago. Such objects as this mark the visible beginning of those human skills from which our artefacts and art, in

Africa and throughout the world, have developed their material complexity.

The earliest tradition of artefact-making known anywhere in the world was in eastern Africa. First recognised at Olduvai Gorge, in Tanzania, it is now known from other very ancient strata where the great Rift Valley cuts through the sediments of prehistoric lakes; this early African tradition was named 'Oldowan' (after the type-site of Olduvai) by the celebrated archaeologist Louis Leakey. This worked piece, technically a 'core', shows rough facets, now smoothed and rounded, where several flakes have been struck off. It was excavated by Leakey in 1931, many years before the early hominid fossils were found that made Olduvai and Leakey famous, from the

base of the site now known as HWK East.

Subsequent work has much expanded our knowledge of Oldowan, distinguishing an earlier phase from a later 'Developed Oldowan'. The Oldowan, confined to eastern Africa, precedes those later traditions of stone-working among hominids, spreading from their place of origin in Africa with other distinctive habits of tool-making.

Geological dating of volcanic ashes, among which the artefact-bearing beds are stratified, establishes the base of HWK East as some 1.6–1.7 million years old. *CC*

Provenance: 1931, excavated by Louis Leakey; 1934, presented to the museum

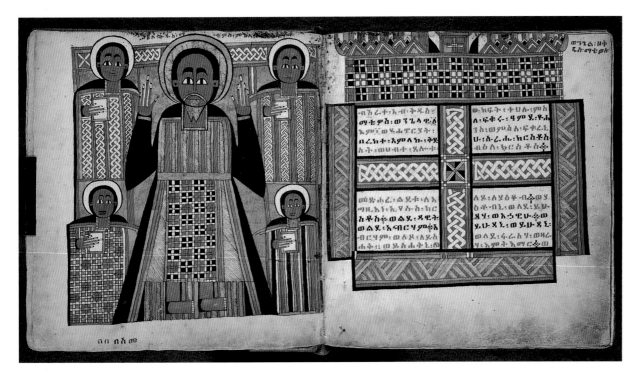

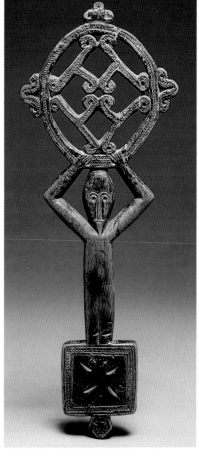

2.2

Four Gospels

Lasta
Ethiopia
17th century
parchment
26.8 x 24.9 cm
The British Library, London, Or. ms. 516

Christianity reached the old Ethiopian kingdom of Aksum from Alexandria in the 4th century and became widespread during the next two centuries with the missionary activities of the Nine Saints from Syria. As elsewhere in the Christian world, the Four Gospels dealing with the life and teachings of Christ must have played an important role in this conversion work. Initially, translations from Greek into the local language, Ge'ez, would have been used; with the arrival of the Nine Saints, translations from Syriac may well have been added. Writing materials and techniques too were probably introduced into Ethiopia at the time of the Nine Saints' arrival, because all the available evidence points to a widespread use of parchment there, rather than papyrus. No Ethiopic gospel manuscripts from before the 13th century survive, but some 500 later examples are known. Until the 10th century they were all produced in the same way, with goat, antelope, horse and gazelle skins as supports, and charcoal black and red ink for the writing. Pens were cut from reeds, and

powdered vegetable matter was used for colour – rose petals for reds and fruits of the *wäyra* plant (*Olea chrysophyla*) for blues – mixed with such binding agents as skin glues, sugar or resins. Mineral pigments were also used, like earth oxides for reds. Gold was not widely employed.

This illustration is taken from one of the many gospels produced in Ethiopia in the 17th century. The texts are introduced by full page portraits of the Evangelists linking the Word of God to its translators. The example selected depicts Matthew standing in the early Christian attitude of prayer. *TT*

Bibliography: Murphy, 1967; Ullendorf, 1968, pp. 34, 56–8; Galavaris, 1979, pp. 50 and 65; Medhin, 1980–2, pp. 219–22; Zuurmond, 1989, pp. 37–9; Heldman, in Baltimore et al. 1993–6, p. 247

2.3

Handcross

Ethiopia
17th century
wood
h. 33 cm
Staatliches Museum für Völkerkunde, Munich, 86-307629

The cross as an image of Christianity has been associated with Ethiopia since the Aksumite emperor Ezana adopted the new faith in the 4th century and issued coins engraved with the symbol that would spread his message. Several types of cross were used: large processional crosses (cf. cat. 2.4), with a hollow shaft mounted on a long wooden stick, which date back to the 12th century and are the property of churches and monasteries; staff crosses carried by pilgrims on their shoulders; pendant crosses worn on a long chain by women; neck-crosses worn by children and men; crosses used as paragraph signs in manuscripts and as protective devices in 'magic scrolls'.

Handcrosses large or small are the property of individual priests, who present them to the faithful for kissing whenever they meet and who use them for individual blessing. Made of metal (iron, bronze, brass), leather or, more commonly, heavy wood, they consist of the cross proper on top, often with additional decorative and/or symbolic elements; the handle, usually about 10–12 cm

long; and a rectangular, square or diamond-shaped base tablet at the end. Handcrosses connote a whole range of religious symbolism: the tablet base is said to symbolise Adam's tomb on Calvary, whereas the handle refers both to Christ as the 'New Adam' and to the notion that Christ's cross stemmed from the Tree of Life. Ethiopian priests also relate the tablet base to the *tabot* (Ark of the Covenant) and the alliance between God and man, while the handle is seen to carry the hope and life that accompany Christ's resurrection from the tomb. Such elaborate symbolism turns the handcross into a visual metaphor for theological concepts that were shared by the Eastern Fathers, including Athanasius and Cyril. Anthropomorphic handles like the one exhibited, where the man-figure is seen to represent Adam carrying the cross, reinforce the idea that Christ, the second Adam, inaugurated a new humanity. *TT*

Bibliography: Moore, in Stuttgart 1973, pp. 67–87; Hecht, Benzing and Kidane, 1990, pp. 2–18; Heldman, in Baltimore et al. 1993–6, p. 132

2.4

Processional cross

Ethiopia
before 1868
metal
47 x 35 cm
The Trustees of the British Museum,
London, 1868. 10-1.16

For the Ethiopian church, the cross is not merely a symbol of Christ's suffering and death but, more importantly, a mark of his resurrection. The image of the cross is often portrayed in Ethiopian paintings in place of the Crucifixion, not only signifying respect for the dead Christ but also functioning as an icon that conveys the salvational and protective effect of averting evil. Such a function is clearly expressed in the prayer known as 'The Rampart of the Cross'. Cruciform decorative designs fill in the window openings of the 13th-century rock-hewn churches of Lalibela, one of which is itself shaped like a cross, and the cross can be seen on the roofs of churches, signalling the building's holy function.

The numerous processional crosses held by priests during religious services and ceremonies also powerfully establish a space of holiness and salvation, and act as symbolic markers pointing out the way for the faithful. Processional crosses are mostly made of metal – iron, copper, bronze, silver, rarely gold – or occasionally wood. The early processional crosses of the 12th and 13th centuries were mainly of copper and bronze, cast in the lost-wax method. Another technique involved the tracing of the desired cross image on to a sheet of metal, which was then cut or punched out. Iron staff crosses of the 17th and 18th centuries were cast and then hammered. To reinforce the Christological message of the Ethiopian church, designs were incised or stamped on the cross, communicating well-accepted truths and thus increasing the rhetorical power of these holy insignia. Their iconography included God the Father, the Archangels Gabriel and Michael and the Four Evangelists. The image of the Virgin and Child was also popular, particularly after Emperor Zara Yaeqob bolstered her cult in the 15th century. In the example shown here the intricate interlocking design echoes decorative forms found on the screens and friezes of Ethiopian medieval churches. *TT*

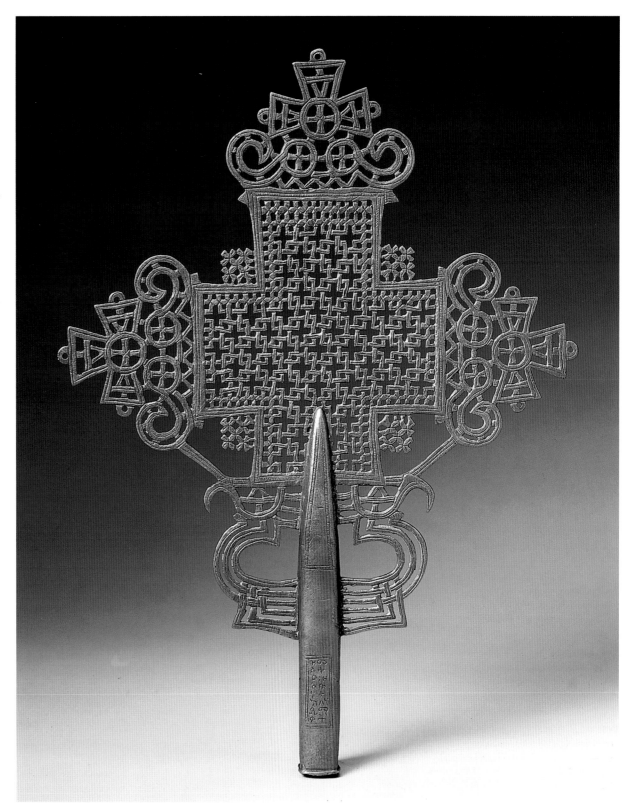

Provenance: 1868, collected by R. R. Holmes

Bibliography: Mercier, 1979, p. 44; Hecht et al., 1990, p. 7; Lepage, in Paris 1992–3, pp. 62–70; Heldman, in Baltimore et al. 1995–6, p. 137

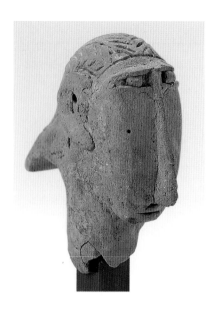

2.5

Head (Beta Israel)
Ethiopia
terracotta
8 x 4.5 x 7.5 cm
Private Collection

The Ethiopian 'Beta Israel' (House of Israel) is a Jewish group that speaks the Agaw language. Known by the dominant Ethiopian communities as Falashas (from the Ge'es root *fälläsä*, 'to emigrate', 'to wander'), these people live north of Lake Tana in the provinces of Begemder and Semien. Their origin has been a matter of controversy, with scholars disagreeing on whether they descend from the Jewish diaspora community of Elephantine (Egypt) or if they are Ethiopians that were converted to Judaism through the influence of South Arabian Jews. What is certain is that some Jews did settle in Ethiopia, and eventually converted the Agaws. Apart from their religious practices, which derive from Old Testament prescriptions, they do not differ significantly from Ethiopian dominant groups. They do not speak Hebrew, and their sacred books – Genesis, Exodus, Leviticus, Numbers and Deuteronomy – are written in Ge'ez. Despite having been called *buda* ('evil eye') by the dominant society, and treated with fear and repugnance, they are a recognisably industrious and serious agriculture people, who are also skilled in many crafts. Their subjugation by the dominant Amharas took place in three stages. Between 1270 and 1632 several Ethiopian monarchs of the Solomonic and Gondarine periods

waged war against them and succeeded in depriving them of all political independence and of any rights to inheritable land. In the second stage (1632–1755), those of the Beta Israel living in the Gondar area became more respected, working as masons and soldiers. A few received higher-ranking titles, involving administrative duties, and were granted land rights. In the third stage, patterns of social and ideological separation became increasingly rigid, and the Beta Israel became a despised and feared occupational caste, with its own concepts of impurity reinforcing its separation from other groups. As the demand for masons and carpenters declined during this period, individuals reverted to their traditional occupations as blacksmiths, weavers and potters. Their unique ceramic statuary, produced by women and sold in markets, depicts family and religious life. It also portrays animals and people in small individual statuettes, like the head exhibited here. It is not clear how far back in time this tradition goes, nor how it started. The iconography of some of these pieces (for instance, representations of Jewish priests holding the Torah) clearly conveys a sense of 'Beta Israel' identity, and no doubt has contributed to reinforcing the group's perception of its unique social and cultural values. *TT*

Bibliography: Trimingham, 1952, pp. 19–22; Leslau, 1957, pp. 1–6, 53; Ullendorf, 1968, p. 117; Kidane and Wilding, 1976, p. 42; Quirin, 1979, pp. 133–43

2.6

Shield
Amhara
Ethiopia
19th century
gold, leather and textile mountings
h. 54.5; diam. 19 cm
Lords of the Admiralty

In 1632 a permanent capital of the Christian empire of the northern and central highlands of Ethiopia was established at Gondar. The actual power of the emperor was dictated by the allegiance shown to him by the rulers of numerous and, at times,

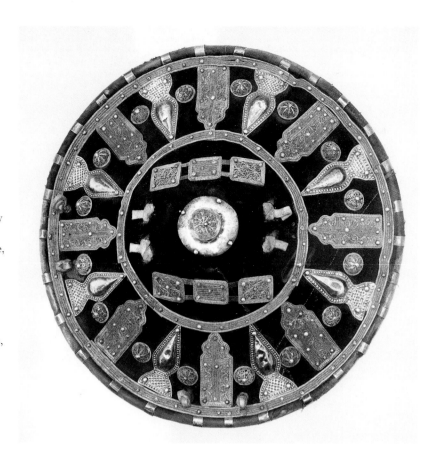

virtually independent kingdoms. It was not until the mid-19th century that the first of a succession of enlightened emperors began to unify the country. The increased internal stability brought about by this unification, together with an economy revolutionised by the widespread use of the Maria Theresa dollar, helped to stimulate a flowering of Ethiopian material culture during this period. Jewellery, textiles and elaborately embellished regalia and weaponry helped to define the complex hierarchy that existed in church, state and army. Shields were used as part of a complex etiquette of display that could be used to reinforce – or occasionally to question – this hierarchy.

Shields were made by pegging a section of untreated hide over a conical wooden mould upon which it would be oiled and shaped, its surface being decoratively embossed by means of specially designed hammers. Delicate metalwork might then be added before the shield was allowed to dry and harden. The possession of a fine, perfectly round shield, and the type of embellishment applied to its surface, were indications both of an Ethiopian's valour on the field of battle and of his standing in society.

Shields given as marks of distinction by the emperor to the *rases* (governors of provinces), and by the *rases* to their chiefs, would often be covered in velvet, and further embellished with silver or other metals. As with a warrior's other arms and accoutrements, his shield, covered in a red cotton cloth, was carried on his mule when he was on the march. An important man would employ a young boy to hold his shield behind him when he was engaged in any sort of important discussion, effectively to add weight to his argument. Shield attachments were also significant indications of a warrior's achievements, and often took the form of a lion's mane, tail or paw mounted on the boss of the shield. The significance of shields extended far beyond their functional capabilities, and they continued to be produced well into the 20th century, even though firearms were probably more widely used from an early date in Ethiopia than in any other part of Africa. *CS*

Bibliography: Pankhurst, 1990; Spring, 1993, pp. 99–100

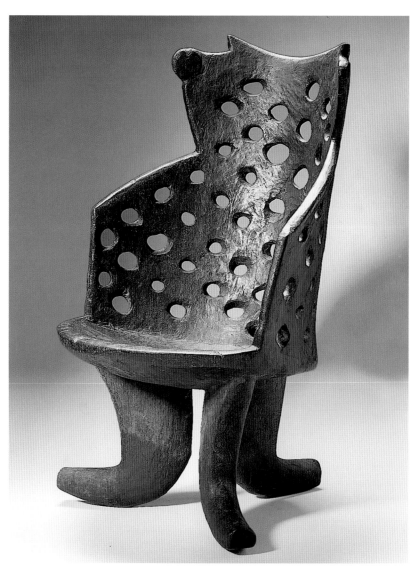

2.7a

High-backed stool

Jimma or Gurage
Ethiopia
wood
99 x 58.4 x 68.5 cm
Private Collection

2.7b

Stool

Malawi
wood
h. 13 cm; diam. 25 cm
Jonathan Lowen Collection

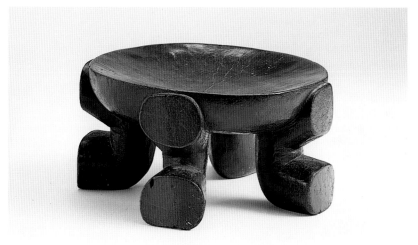

The style of the larger stool (cat. 2.7a) is common to a widespread region in eastern Africa. Ethiopia seems to have the most northerly examples of this type of stool construction in an area that extends southwards to Tanzania and westwards to the Tabwa of Zaire and Bemba of Zambia. They are used as political emblems as well as at the conclusion of female initiation ceremonies in Tanzania.

Throughout the region a stool-like form is used as a base; the artist then embellishes upon the idea by adding a backrest of some sort.

High-backed stools figure prominently in the installation of chiefs among the Gurage. The ritual installation of a new chief takes place at an earth shrine (belonging to a male deity) with an official of the female deity administrating. Despite their former renown for bravery in warfare, the chiefs have little political power and now act only as mediators in clan affairs. Chieftaincy is hereditary, passing from father to son, and on the death of a chief the heir is not permitted to enter the house of his deceased father until completing the installation ritual. The new chief is never allowed to touch the ground while going to the shrine and is then placed on the 'Chief's Seat'. He sits on this chair (described as an elaborately carved 'throne-like' seat of the three-legged type) for seven days, collecting gifts from his subjects before proclaiming himself king.

Although inherited from the chief's ancestors, the chair is not sacred and when broken can be replaced by the skilled 'caste' of woodcarvers known as the Fuga (cf. cat. 2.8). These are presumably part of the category of stools with backrests known as *wängyäba*, a highly elaborated form of the more common three-legged stools known as *bärcema*. The Gurage councils of elders also use such chairs. High-backed stools with perforated designs, often surmounted by a crescent form, come from the Jimma area. In what context and by whom they are used remains to be established. *WD*

Bibliography: Shack, 1966, pp. 152–4; Shack, 1974, p. 112; Roberts and Maurer, 1985; Felix, 1990; Nooter, 1994

The art of Ethiopia has only recently begun to gain much attention in African art historical studies. Information about Ethiopian headrests unfortunately remains meagre.

Many groups in southern Ethiopia make carved wooden headrests to enable people to sleep without interfering with their complicated coiffure. Hairstyles frequently declare their owner's age, gender, rank or status, and are often embellished and/or empowered by accoutrements and/or charms of a magico-religious nature. They then become signs, symbols and potent empowering devices that must be protected.

Some headrests look very much like those of the southern Ethiopians' pastoral neighbours in Kenya, Uganda, Somalia and Sudan. This is not surprising as the different peoples overlap political borders and headrest styles are often regionally rather than ethnically based. These two examples basically consist of a crescent-shaped head support on a conical base, a style that seems to come from the southwestern Ethiopian areas of Kafa and Gurage. There are often subtle differences in surface treatment, ranging from smooth surfaces to incised designs covering the base. One type, as in cat. 2.8b, has appendages curving down from the ends of the upper platform to the base of the cone.

Pankhurst and Ingrams illustrate two headrests from a 19th-century engraving with essentially the same conical base and crescent head support shape, while Huntingford declares the Kafa use wooden headrests of 'a similar Egyptian shape' (perhaps meaning a single tapered column). The same shape of headrest is also used among the Gurage, except that theirs usually have the surface of the conical portion covered with incised geometric decorations. These Gurage headrests, known as *gemma*, are carved by the Fuga, a 'caste' of woodcarvers (such classes of artists and artisans are a common feature of many Ethiopian societies). The importance of such people is illustrated by the words of Menjiya Tabata, a Fuga headrest carver: 'People generally call us Fuga, which is a term that means "despised". My people call themselves Gamas. We are not allowed to marry anyone from

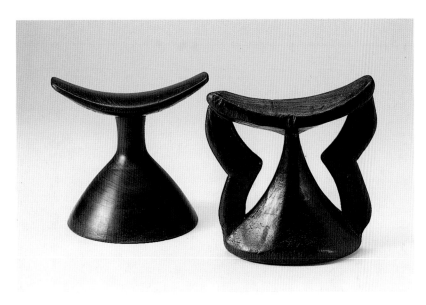

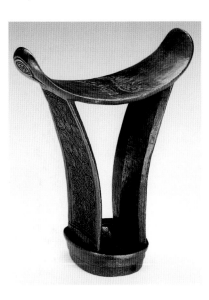

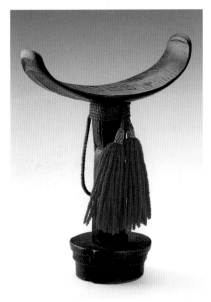

2.8a

Headrest

Kafa or Gurage
Ethiopia
wood
18 x 17 x 10 cm
Jonathan Lowen Collection

2.8b

Headrest

Kaficho (Kafa)
Ethiopia
wood
16 x 16 x 13 cm
Jonathan Lowen Collection

another clan, formerly [before 1974] we were not allowed to own land, and we cannot enter Gurage religious shrines. We are denied certain privileges ... but we have our religious beliefs, our own language, our own traditions. Fuga are important. We make things that Gurages cannot live without – most of the furniture and kitchen utensils found in the house, even the central supporting pole and roof beams of their houses are carved by the Fuga.' *WD*

Exhibition: East Lansing 1994

Bibliography: Huntingford, 1955, p. 128; Pankhurst and Ingrams, 1988, p. 128; Dewey, 1993, pp. 36–8; Abbink, 1994

Headrests with crescent-shaped upper platforms, small circular or oval bases and double, flat supporting columns, as in cat. 2.9a, are used by nomadic Somali in both southern Somalia and north-eastern Kenya. Very similar forms but with squatter proportions are made by the Boni of north-eastern Kenya and the extreme south of Somalia. Somali nomads also use another type of headrest with a single supporting column, often cylindrical or with vertical intertwining elements, as in cat. 2.9b. Whether the distribution of the two types always coincides is uncertain, but both types are found in some areas. Where this occurs it has been reported that the different styles were for men of different status, with the simpler variety being for young men, the double-column variety for elders.

The headrests are carved of a very fine-grained tough but lightweight wood. Acknowledged artists are sometimes commissioned to create them but any man can make his own. The double-column variety is made from a tree branch that has forked into equal sections: the basic shape is roughed out by cutting a hole through the centre; the shapes are then refined and the intricate surface patterns cut last. The wood is usually left its natural colour, but men occasionally paint their own red or black.

Somali headrests are used by both men and women. While the male type, such as those exhibited here, have relatively small bases and are thus somewhat unstable to sleep on, the examples used by women are more rectangular in form. Somali men carry the double-column headrests by slipping a wrist through the central hole, while the single-column type often has a leather loop attached for this purpose. Herders will sometimes rest by standing on one leg, placing the headrest on a shoulder and twisting their heads so as to rest their necks upon it. While the usual image is of nomadic herdsmen carrying their headrests, they are also used on the constructed raised beds on which Somalis sleep.

The headrests also function as symbols of vigilance. Young men chared with the care of their family's herds travel with them in their search for suitable grazing. Headrests with such small bases will soon tip, and the herders will unceremoniously be

2.9a

Headrest (*barkin*)

Somali or Boni
Somalia and Kenya
wood
h. 17.1 cm
Gift of Blake Robinson, 87-3-1
National Museum of African Art
Smithsonian Institution, Washington

2.9b

Headrest (*barkin*)

Somali
Somalia
wood, fiber
h. 20 cm
Gift of the Loughrans, 76-16-13
National Museum of African Art,
Smithsonian Institution, Washington

reminded ot their responsibilities. The headrest also plays a role in nuptial ceremonies. The groom places currency for the defibulation price under his bride's headrest. The morning after the marriage is consummated, the bride may take this money, but only if she had been a virgin. She then uses it to buy an amber necklace, the symbol of her new status as a married woman.

The intertwine or guilloche pattern seen on the base and sides of the double–column headrest is typical and probably reflects extensive Islamic influence in the region. Images of snakes, scorpions and even lories are often incised on the surface of the upper platform. The idea is to portray sources of danger as a means of protection. Both figurative and guilloche patterns have been interpreted as 'a form of shorthand for a prayer' (Allen) to ensure God's protection for the sleeper. *WD*

Bibliography: Puccion, 1936, pp. 21–33, pl. V; Cerulli, 1959, pp. 92–3; Prins, 1965; Allen, 1976; Arnoldi, in Loughran et al., 1986, pp. 17–25; Dewey, 1993, pp. 40–1

2.10a

Covered milk vessel

Borana
Southern Ethiopia/Northern Kenya
20th century
twine, gourd, silver
h. 36 cm
Private Collection

2.10b

Covered milk vessel

Borana
Southern Ethiopia/Northern Kenya
20th century
twine, gourd, silver
h. 31 cm
Private Collection

Traditionally the Borana Galla are cattle-keeping pastoralists who now keep camels in the more arid parts of their territory. Their containers for liquids are firm, closely woven watertight baskets of wrapped twine. In size they range from large, urn-shaped vessels capable of holding three to six gallons to vessels, such as these, that have a smaller capacity. The former, contained in openwork wicker baskets, are used solely for the transport and storage of water; the latter rarely leave the home and are used for milk and milk products. Smaller and more decorated vessels are generally reserved for visitors or the head of the household; they may be hung on the wall as decoration and rarely used. One is always filled with thick rich milk ready to be offered to honoured guests: they last from three to nine years.

The containers take three to nine months to complete, and all are made by women. Fibre from the roots of *Asparagus africanus* is preferred but *Commiphora*, *Acacia*, *Zizyphus* and *Hyphaene* species may also be utilised. An awl and stick are used as weaving aids and the fibre is softened with water. New baskets may be waterproofed by being steeped in an infusion of acacia bark, smeared inside with melted fat or paste of sorghum flour or smoked with smouldering sticks which give off a resinous gum to coat the inside. *JB*

2.11

Phallic ornament (*kalaacha*)

Konso/Borana
Ethiopia
ivory, aluminium
5.7 x 4.9 x 9 cm
Jean and Noble Endicott

This phallic metal horn (*kalaacha*), worn vertically on the forehead, is an important emblem of the Gada system of generation sets and age grading common to the Konso and Borana and other Oromo (Galla) peoples of Ethiopia (cf. cat. 2.12). It is regarded as a sacred symbol because it is a replica of the great *kalaacha* found with the first ritual leader when God sent him to earth and revealed the basic values and institutions of society.

A generation set is named and recognised when its warrior members have each earned the right to wear a stiffened hair tuft by killing an enemy or a dangerous wild animal. As their set enter the system the set of their fathers takes office and the set of their grandfathers retires. The two most important stages in a man's life, when he reaches full adulthood (taking office and assuming ritual responsibility for maintaining the peace and prosperity of the nation) and when he retires from the system to enter a condition of sanctity, correspond with two of the Gada grades. The *kalaacha* is first worn when a man enters the Gada grade, and 'makes his head', i.e. he 'puts up' his *kalaacha*, which an eldest son

inherits from his father. Only the owner and his senior wife may touch the *kalaacha*. After his period in office, when his set continues in an advisory capacity, it is kept upturned in a full milkpot and worn only for ceremonies. Each man then allows his hair tuft to sag limply until a few years before the retirement ceremony, when he 'completes his head', i.e. he unravels his hair tuft, grows his hair into a halo style and 'puts up' his *kalaacha*, which is regarded as replacing the lost hair tuft. A *kalaacha* worn by such men serves to destroy evil influences and provides sanctuary to those who touch it. In some Galla groups the whole set wear the *kalaacha* at this time, in others it is worn only by ritual dignitaries, some of whom wear a two-horned variety. At the culminating ceremony the set retires from the system and a man 'takes down' his head, i.e. his hair (including his unravelled tuft) is shaved off and his *kalaacha* is removed.

Kalaacha were previously made of ivory or brass, sometimes of wood. Metal *kalaacha* are made by the lost-wax method. The Galla obtain them from smiths of other groups, such as the Konso, who often reside among them. *JB*

Bibliography: Jensen, 1936; Jensen, 1942; Jensen, 1954; Haberland, 1963; Brown, 1971; Hallpike, 1972; Baxter and Almagor, 1978

The Konso who produce these pole sculptures live in walled hilltop villages from which they practise intensive agriculture. The welfare of people and crops is believed to depend on the satisfactory functioning of the all-pervading Gada system and its rituals. Sexual activity is restricted to preserve masculinity. Hunting is a prestigious activity and bravery is highly regarded. Men who have killed an enemy or a dangerous wild animal are regarded as heroes.

When a hero is buried a phallic stone is placed over his grave. If he was also wealthy and of senior Gada grade, a group of carved figures (which only the wealthy can afford) is erected there some weeks or months later. A thatched roof stands over the group, which may be surrounded by a paved area delineated by a low wall. The group demonstrates the rank, wealth and lifetime achievements of the deceased.

The sculpture representing the hero himself occupies a central position flanked by representations of his wives and slain enemies. In front are carvings of the lion or leopard killed by the hero, the pet monkey or monkeys kept by him and stones representing the fields that he owned. The hero is portrayed as aggressively masculine with prominent erect penis. His hairstyle, phallic forehead ornament and bracelets denote his senior Gada rank and his status as a hero. The figures of his slain enemies are emasculated, it being the custom of the Konso to remove the genitalia of a slain enemy as a trophy.

These sculptures do not have legs, and the women and slain enemies are also armless, but the arms of the hero are carefully carved to show the bracelets. The figures, when new, are painted with red ochre, and have bone eyes and teeth and black painted eyebrows and beards.

Carved gravestones are erected by the neighbouring Borana and Sidamo Galla and grave posts are used by the Bongo of the Sudan (cat. 2.18); the closest analogy to Konso grave posts is in Kenya, where the coastal Mijikenda erect similar sculptures to their dead (cf. cat. 2.26). *JB*

Bibliography: Jensen, 1936; Jensen, 1942; Jensen, 1954; Nowack, 1954; Hallpike, 1972

2.12a

Grave figure (*waaga*)

Konso
Ethiopia
wood
h. 213 cm
Private Collection

2.12b

Grave figure (*waaga*)

Konso
Ethiopia
wood
h. 174 cm
Private Collection

2.12c

Grave figure (*waaga*)

Konso
Ethiopia
wood
h. 186 cm
Private Collection, Brussels

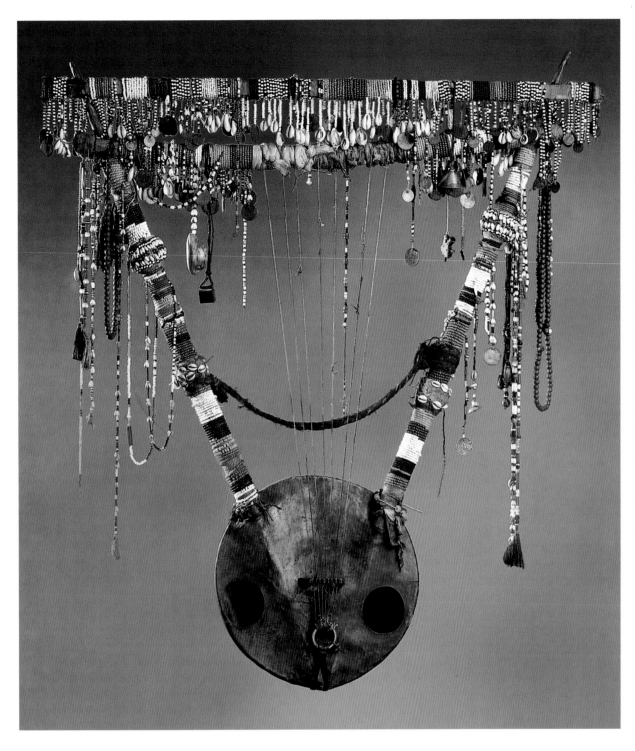

This lyre has a wooden hemispherical body. The skin soundtable displays its animal hair and contains two circular holes. Seven twisted gut strings run from the lower crossbar of the yoke, and pass over a wooden bridge to an iron ring. The wooden arms and the double crossbar are elaborately decorated with glass beads, cowries, amulets and rosaries, all of which are suspended from the upper bar. Both uprights and crossbars are wrapped with a loose weave cotton cloth over which strings of tiny coloured glass beads have been coiled. The arm-strap consists of bundles of plaited red cotton thread. Hundreds of pierced coins and cowrie shells hang on beaded strings from both upper and lower crossbar, and they ring and rattle when the instrument is moved. The coins are mostly Sudanese with Arabic inscriptions, and many of these are dated 1899 (1277 AH). Among them, however, are at least three coins of British origin: one a halfpenny dated 1861 with the head of Queen Victoria, and two other smaller coins dated 1832. There is also one coin from Sumatra dated 1804. Also hanging from the crossbars are several wooden prayer rosaries, a leather-bound Koranic amulet, two brass bells, the trigger mechanism from a gun(?), decorative mounts from a dagger, and a round key-hole escutcheon plate.

The instrument is used in *zar* ceremonies in Sudan. There is a belief that evil spirits can invade the body or mind of a person, and these can cause illness or pain and need to be exorcised. Sometimes the musician has special knowledge of curative rituals, and can use the instrument's sounds to call the evil spirits from the affected person. Ceremonies are carried on throughout the night and the singing and praying, accompanied by drumming, could often produce trance in the participants. During trance evil spirits are most easily exorcised. Numerous necklaces of glass beads and cowrie shells are suspended from the crossbar. These are of various designs and it is probable that each time the instrument was used in a ceremony, the person receiving the rituals offered an item of personal adornment. *NT*

2.13

Lyre (*kissar*)

Nubia, Sudan
late 19th century
wood, leather, gut, glass, cowries
101 x 95 x 20 cm
The Trustees of the British Museum,
London, 1917. 4-11.1

Provenance: 1917, bequeathed to the museum by Dr Southgate

Bibliography: Engel, 1864, p. 40; Musée Royal du Congo belge, 1899, p. 132; Metropolitan Museum of Art, 1902; Jenkins, 1970

2.14

Slit drum

Bahr el-Ghazal, Omdurman
Sudan
19th century
wood
80 x 271 x 60 cm
The Trustees of the British Museum,
London, 1937. 11-8.1

Wooden slit drums like this have long
been associated with prominent chiefs
and leaders in the southern Bahr el-
Ghazal region of Sudan and in
neighbouring portions of the Central
African Republic and Zaire. Massively
conceived, such drums serve as voices
of authority: they are 'tongues of
chiefs' and their scale is dependent on
the rank of their royal owners. The
grand scale of this particular drum
attests to its pivotal place in late 19th-
century Sudanese history. Captured by

H. H. Kitchener, Commander of the
Anglo-Egyptian forces, from the
Khalifa Abdullahi, it acts as a
memorial of the decisive British
victory at the Battle of Omdurman in
1898. The defeat of the Khalifa
brought to an end Sudanese resistance
to British and Egyptian rule as well as
the dream of Mohammed Ahmad, the
self-proclaimed Mahdi or Messiah, of
establishing an independent state
based upon the principles of Islam.

The Holy War against the British
Empire lasted nearly twenty years and
left both sides exhausted. In triumph,
the British returned home with ample
evidence of the defeated foe – the
sheer quantity of war trophies
testifying to the epic dimensions of
the struggle against the Mahdist's
forces. Of the thousands of objects
brought back from the Sudan, few can

compare with this impressive drum,
presented by Kitchener to Queen
Victoria. Apparently owned by Khalifa
Abdullahi, who succeeded the Mahdi
upon the latter's death on 22 June
1895, it had surely been used in order
to lift the spirits of the Khalifa's
troops.

It is distinguished not only by its
size, but also by the incised designs
carved along both flanks of the
bullock. Slit drums in the form of
cattle, goats or other animals from the
Bahr el-Ghazal are typically not only
smaller, but their bodies are sculpted
smoothly and devoid of decorative
effects. In this instance, however,
mathematically precise floral patterns,
a fretted crescent, meander patterns
and a single reference to a long-
bladed scimitar are carved in broad
bands across the flank surfaces, their

geometric regularity and precision
reminiscent of ancient Islamic shapes
expressing God's unity and presence.
It is assumed that the drum was
probably originally carved in the
distant non-Muslim parts of southern
Sudan (or by someone from that
region) and adapted to a militant
Islamic context. A traditional southern
Sudanese figurated drum, used in the
service of the Khalifa and for fighting
in the path of God, has been
emblazoned with the signs and
patterns of Muslim belief. *RAB*

Provenance: 1898, captured by Commander
H. H. Kitchener, who presented it to
Queen Victoria; 1937, given to the
museum by H.M. King George V

Bibliography: Seligmann, 1911; Bravmann,
1983, pp. 48–57; Mack, in Schildkrout and
Keim, 1990

2.15a

Replica throwing knife

Mahdist state
Sudan
late 19th century
iron with crocodile skin grip
30.6 x 3.2 cm
Manchester Museum, University of
Manchester, 0.8720

2.15b

Replica throwing knife

Mahdist State
Sudan
late 19th century
iron with crocodile skin grip
45.6 x 3.4 cm
Manchester Museum, University of
Manchester, 0.5036

The increasing unrest among the peoples of central and eastern Sudanic Africa during the 19th century culminated in the rebellion of 1881 in Kordofan Province, Sudan, led by Muhammad Ahmad, who declared himself Mahdi ('The Rightly Guided One'). By 1885 he had overthrown the corrupt Turco-Egyptian government in Khartoum and had established the Mahdist state. He died shortly after the fall of Khartoum and was succeeded by the Khalifa, who was committed to perpetuating the ideology of the Mahdiyya, a movement of ostensibly religious inspiration, but with revolutionary political and social aims. The Mahdist state was effectively dissolved following the battle of Omdurman in 1898, but Mahdism lived on and remains a vital political force in contemporary Sudan.

Peoples from a vast area of northeastern and central Africa joined the Mahdist armies, either of their own free will or as slaves. Workshops set up in towns such as Omdurman produced a range of artefacts, including regalia, weaponry and armour, which in one way or another reflected the Mahdist ideology, but which occasionally also displayed stylistic influences from much more diverse sources. Among such objects were these non-functional, replica throwing knives, cut out of sheet metal and covered with the acid-etched Arabic script known as *thuluth*, in which exhortations to the faithful from the Koran are written. However, these artefacts derived their distinctive form from the prestigious missile weapons of certain non-Islamic, central African peoples such as the Ngbaka, who lived many hundreds of miles to the south-west, and who were greatly diminished in number by the slave trade at this time.

It may be that throwing knives were gifts to the central African chiefs who assisted the slave raiders operating from Sudan in the late 19th century. However, it seems more likely that they were given as Islamicised (though still potent) status symbols to the leaders of those elements of the Mahdist armies that consisted mainly of central African slaves. There is evidence to suggest that other artefacts, slit-gongs for example, were transmuted in a similar way. *CS*

Bibliography: Zirngibl, 1983, pp. 48–9; Westerdijk, 1988, pp. 170–83; Spring, 1993, pp. 78–9

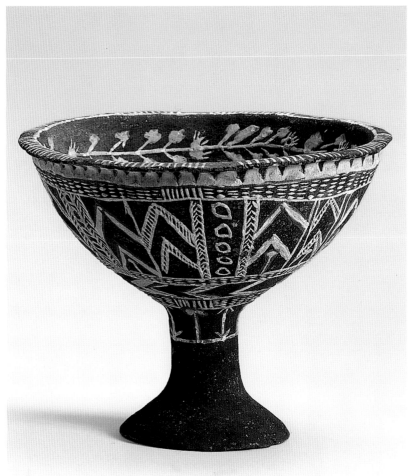

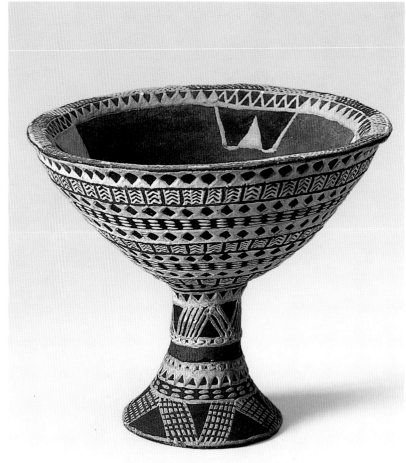

2.16a

Pot (*kadaru*)

Nuba Hills, Sudan
c. 1910
animal dung, paint
17.5 x 21 x 21 cm
Horniman Public Museum and Public
Park Trust, London, NN 5456

2.16b

Pot (*kadaru*)

Nuba Hills, Sudan
c. 1910
animal dung, paint
21 x 24.8 x 24.3 cm
Horniman Public Museum and Public
Park Trust, London, NN 5457

Such vessels as these bowls with foot-rings are made of a paste of animal dung and water, shaped by hand, then painted with a thin layer of gum mixed with a red earth slip and left to dry in a cool place. The entire surface was slipped again with black colour, obtained from the soot outside a cooking-pot. Inside the vessel, however, the black was not applied to the whole surface and a reddish band was left. The inner design was carried out in white pigment. A white painted band of creeper-like design was made around the rim, and a sun-burst pattern was painted in the centre of the bowl.

The designs used on these vessels are similar in style to patterns on Nuba house walls, and to those used as part of male body decoration. The design is asymmetrical, but is symmetrically structured in bands picked out in white along the vessel walls. The patterns include chevrons, arrows and sun-bursts, described in a white paste made from chalky lime-stone and applied with a feather. There is some suggestion that the

design is first traced onto the raw pot with a length of grass. The white decoration is made with a thick paste and is raised. Occasionally it is embellished with red pigment, possible haematite.

Both vessels are made of dung, possibly cow or donkey dung which is quite malleable when made into a paste. Vessels such as these are extremely fragile: unlike pottery, they can be consumed by fire, and they are less strong than a calabash since they can be destroyed by water. They are only air dried, and cannot be used in food preparation, though they could perhaps serve as storage bowls for dried foodstuffs. Hawkesworth suggests that they were an essential part of a girl's trousseau, and at a marriage ceremony were filled with wedding perfumes, flour and dried powdered vegetables. *NT*

Provenance: *c.* 1910, South Kordofan, collected by Sir Harold MacMichael

Bibliography: Hawkesworth, 1932; Faris, 1972, p. 62; Barley, 1994, p. 13

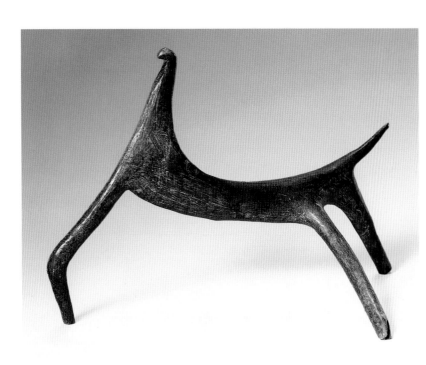

2.17a

Headrest

Dinka (Agar)
Sudan
wood
l. 52 cm
Staatliche Museen zu Berlin, Preussischer
Kulturbesitz, Museum für Völkerkunde,
III A 4172

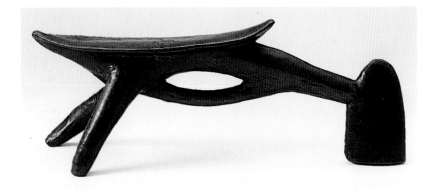

2.17b

Headrest

Shilluk
Sudan
wood
17.5 x 46 x 15 cm
Jonathan Lowen Collection

As many peoples of eastern Africa make headrests/stools, it is difficult to attribute these objects to specific groups unless they have been collected in the field. Most are three-legged with one side flattened. Mack and Coote aptly describe the carving process as 'opportunistic', going on to say: 'The simple forms produced by the Dinka and Nuer are often little more than the result of judicious pruning of a found branch to produce a three- or four-legged stool cum headrest. Zoomorphic features, such as a tail, are sometimes "brought out".' Riefenstahl shows a Shilluk warrior of the Sudan using one to protect his elaborate coiffure.

Among the Shilluk, Westermann noted that neckrests were used by men so that their hairstyles would not be spoilt during sleep. Many east African pastoralists regard coiffure primarily as an indicator of status. Among these groups a young man is entitled to begin wearing the distinctive coiffure that marks him as an adult only after he is initiated. As each member of the age set rises through the hierarchical society, changes in jewellery, hairstyle and feather decorations for the hair often mark each promotion. The use of headrests is often associated with this advancement and the headrests themselves become status symbols. Whether this pattern is true for the Shilluk and Dinka is unknown, but it certainly seems likely as Shilluk men still wear elaborate coiffures, and among the Dinka headrests/stools are primarily used by older men (Jeremy Coote, personal communication). The Dinka multi-purpose headrests/stools also provide a convenient place to sit as it is not considered proper for elderly men to sit directly on the ground.

No special skills were associated with the construction of headrests by the Shilluk and any man could make them alongside such activities as house-building and weapon-making. Headrests were made to resemble the forms of various animals, including ostriches and other birds. Cat. 2.17b perhaps could be interpreted as a bird, although it seems more like a stylised branch, while cat. 2.17a has the shape of an antelope or giraffe.

The symbolic importance of such objects is highlighted by the Shilluk belief that this headrest form was invented by Nyakang, their most important ancestor, culture hero and the founder of the Shilluk dynasty. The Anuak held that if the king-elect was able to balance on a three-legged stool during his investiture ceremony he was acknowledged as the rightful heir. *WD*

Provenance: cat. 2.17a: collected by Konietzko

Bibliography: Westermann, 1912, pp. xxiv, xxxiii; Seligman and Seligman, 1932, p. 110; Riefenstahl, 1982, p. 229; Krieger, 1990, pls 13–6; Mack and Coote, in *The Dictionary of Art*, in preparation

2.18a
Grave figure

Bongo
Sudan
late 19th or early 20th century
wood, metal
h. 200 cm
Musée Barbier-Mueller, Geneva, 1027-1

2.18b
Grave figure

Bongo
Sudan
late 19th or early 20th century
wood
h. 132 cm
Private Collection, Belgium

The Bongo of the south-western Sudan are an agricultural central Sudanic-speaking people who suffered greatly from the depredations of slavery and the expansion of the Zande kingdoms in the 19th century. In the mid-19th century they may have numbered a quarter of a million or more, but by the 1870s their population was estimated at no more than 100,000 and by the 1920s at no more than 5000. By this time the remnant population was dispersed in a number of centres.

A category of tall, slim figure sculptures is attributed to the Bongo. These share a general pole-like form in which a human figure (apparently exclusively male) stands with flexed knees on a post and, generally, with arms held close to the body. Apart from facial features (including occasionally the inlaying of eyes with beads, as in cat. 2.18a), there is rarely any other sculptural detail. (At least in the 1920s some figures were painted, the face with blue commercial dye and the body with red ochre. The antiquity of this practice is not known.) These Bongo figures are often classified with the memorial figures of such east African peoples as the Konso and Gato of Ethiopia and the Giriama of Kenya. There are few formal similarities between them. It is the paucity to date of east African art scholarship that has led to these traditions being lumped together. Future historians might do better to look westwards to the traditions of the Zande and other Zairean and central African peoples for meaningful comparisons with Bongo art.

While there are detailed provenances for a number of grave figures in museums in Khartoum, little is known about the origins of most examples

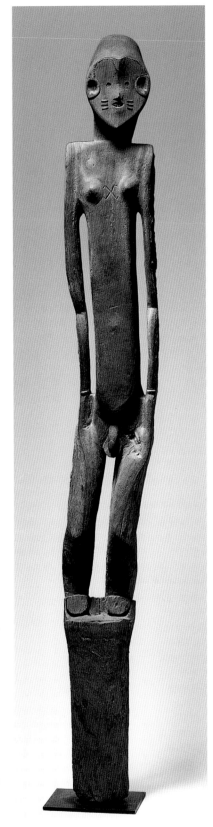 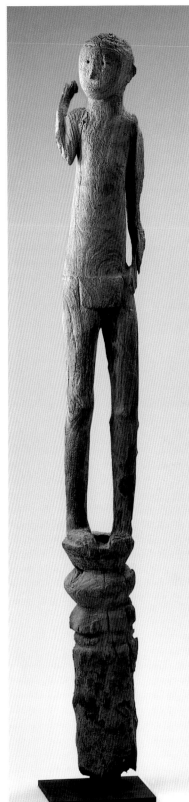

in European collections. Much of the published material is based on notoriously unreliable 19th-century accounts of travellers and explorers. It is not clear if figure sculpture was produced among all groups, nor is it clear that all figures identified as 'Bongo' were produced by them rather than by sculptors among such of their neighbours as the Belanda.

It was the practice among at least some Bongo groups to honour a deceased hunter-warrior by erecting on his grave a carved wooden effigy (*ngya*). This was done by his relatives at a feast held at the graveside a year or so after his death, the intention being to ensure for him a good place in the village of the dead. During his lifetime, a Bongo man could gain prestige and status through successfully hunting large animals and killing enemies in battle, as well as through performing meritorious feats. The effigies erected on graves were a reflection of title and rank achieved. They were often accompanied by notched posts that recorded the number of the deceased's successful kills and sometimes by effigies of his victims. Notches indicating successful kills were sometimes carved on the effigy post itself. The notches on the figure at cat. 2.18b would indicate that the deceased had killed four large animals (Evans-Pritchard).

It is not clear to what extent the effigies were supposed to resemble the features of the dead man, but in some cases at least the sculptor represented some of the deceased's personal adornments, such as scarification patterns and bracelets. It may well be that the scarification marks on cat. 2.18a – made by applying metal strips to the surface of the face – represent those borne in life by the deceased. The apron on cat. 2.18b may also have had a particular personal significance, though aprons were part of the everyday dress of Bongo men. The series of metal nails running from ear to ear across the brow of the figure may have formerly held in place a headdress, a possibility strengthened by the report that Bongo men and women wore feather headdresses at feasts and dances. It has also been reported, however, that the effigies of victims were represented with carved legs, so that cat. 2.18a may represent a victim. This possibility is strengthened by the fact that the face seems to

represent a non-Bongo, at least to the extent that the inserted metal teeth do not obviously lack the lower incisors, which were extracted from all Bongo people when young. It is not clear how the Bongo regarded the removal of effigies from the graves of their ancestors. It seems that they received little if any attention after their erection and were left to the depredations of bush fires and the weather – as can be seen in the surface condition of cat. 2.18a, which presumably reached its present condition *in situ*. It must, however, be at least possible that they would have minded less about the removal of the effigies of victims, and that therefore at least some of the figures in European collections may be of his kind. *JXC*

Provenance: cat. 2.18c: 1973, acquired by the museum

Exhibitions: cat. 2.18a: Düsseldorf et al. 1988–9, no. 194; cat. 2.18b: Antwerp 1975; Brussels 1977, no. 119

Bibliography: Schweinfurth, 1873; Schweinfurth, 1875, pl. VIII; Evans-Pritchard, 1929; Kronenberg and Kronenberg, 1960; Kronenberg and Kronenberg, 1981

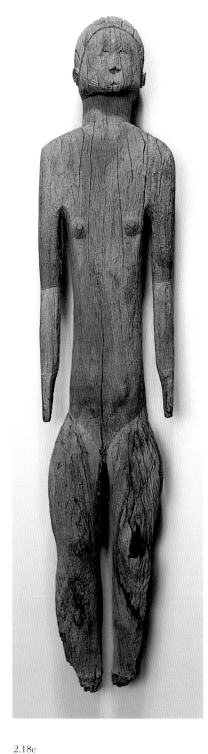

2.18c
Grave figure
Bongo
Sudan
late 19th or early 20th century
wood
145 x 30 cm
The Trustees of the British Museum, London, 1973. AF. 35.1

2.19

Lip plate
Surma peoples
Sudan/Ethiopia
20th century
wood
12 x 18 x 2 cm
Mimi Lipton

This is a challenging object to discuss in the context of an exhibition selected in large measure on aesthetic principles. It is challenging because the object itself – a lip plate – acts to alter dramatically the appearance of the wearer in ways that might be thought 'aesthetic'; once in use, however, the plate becomes effectively invisible. To that extent it is arguably an instrument of broadly 'aesthetic' manipulation, rather than a consciously created aesthetic device in its own right.

In general it would rarely be seen as a separable object once created and inserted – rather like false teeth. This example has a suggestion of eyes and mouth, as if the plate were intended as a minimalist representation of a face. As such it is a striking object. This form, however, is not duplicated on other plates and may be either a fanciful interpretation on the part of the viewer or whimsy on the part of the creator.

Such plates are worn by women among the Surma-speaking peoples who occupy the Sudan/Ethiopia borders. While still young, women have a small wood splint inserted in the lower lip; this incision is gradually enlarged by increasing the size of the splint until the lower lip is capable of holding a wood disc of greater dimension. Though there are photographs of women wearing such plates that go back at least to the 1930s (see, for example, the photographs by Dr John Bloss in the British Museum Ethnography Department archives), the ethnography of the area is limited and largely silent on the local understanding of this practice. Such speculation as there has been is largely confined to the observation that slavers in the 19th century were put off taking into captivity women wearing such plates. This, however, is also an explanation offered of the origin of the same practice elsewhere in Africa – for instance, among the Fali in Cameroon. Like much in indigenous explanation it seems calculated more to prevent further fatuous inquiry into essentially unanswerable questions than to present a solid factual account. In the end two contradictory explanations contest the interpretative ground: on the one hand the lip plate promotes beauty, on the other ugliness. *JM*

Bibliography: Nalder, 1937, p. 151; Lebeuf, 1953; Fisher, 1987, p. 216

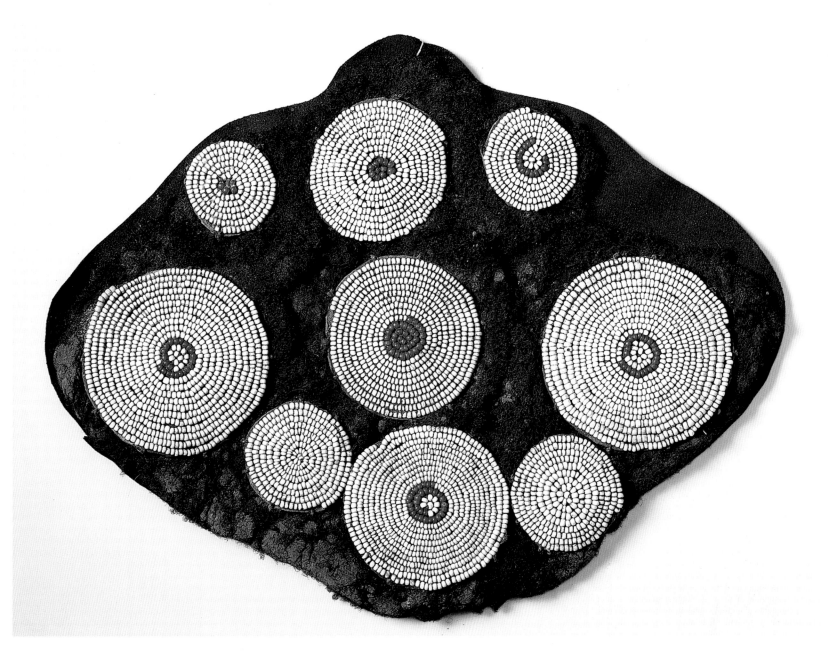

2.20

Bonnet

Acholi (?)
Uganda
human hair, beads
w. 33 cm
Museum für Völkerkunde, Leipzig,
MAF 8780

Among the cattle-keeping people along the borders of Uganda, southern Sudan and north-western Kenya, men have historically adopted a series of elaborate coiffures on initiation into the senior age grades associated with warriorhood. Frequently, as among the Karamajong of Uganda or the Turkana in Kenya, the hair is built up with mud and the resulting pack painted and set with feathers. An alternative is the creation of a large basin-shaped hairstyle which is then decorated with discs of coloured beads. The best documented of these occur among the Didinga who occupy the hills on the borderlands of southern Sudan, where they were recorded and photographed by Powell-Cotton at the turn of the century. Although most of these hairstyles are built up as attached coiffures, some seem to have been made as separable objects; the circumstances in which this happened are not clear. In one case known to the author a separate headdress was created by prisoners from the hair shaved off when warriors were convicted and jailed.

This example is identified in the records of the museum from which it comes as of 'Schuli' (i.e. Acholi) origin. The Acholi are neighbours of the Didinga and close trading partners. It is entirely possible that this object could have been collected in Acholi country, for the style is to some extent shared between Didinga and Acholi. In an area where material objects are all fabricated locally and easily replaced, styles are prone to change rapidly. These are not hierarchically organised societies with centralised institutions, but fluid groups among whom the expression of ethnic – as opposed to clan or age set – affiliation is of little significance. Most groups in this area, however, often incorporate clans with a generic name which in local dialect approximates to 'strangers'. Such strangers may retain elements of the groups with which they were formerly affiliated. Even among groups whose warriors raid for cattle and who are otherwise enemies, the adoption of clans and of neighbouring material styles – even of trade – is not uncommon. *JM*

Bibliography: Powell-Cotton, 1904; Mack, 1982, pp. 111–30

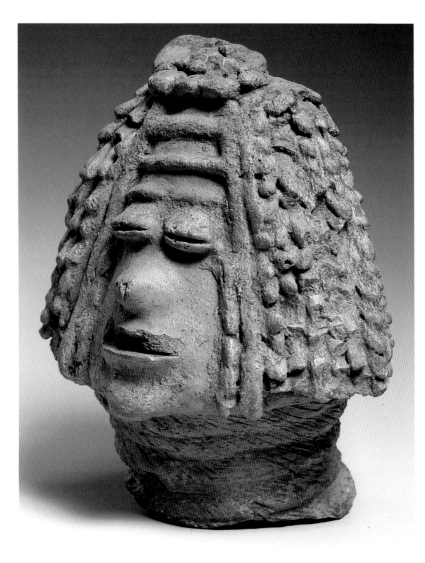

2.21

Luzira Head

Buganda
Uganda
before *c.* 1750
fired clay
20 x 17 x 17 cm (head),
22 x 16 x 16 cm (body)
The Trustees of the British Museum,
London, 1931. 1-5. 14/18

The Luzira Head consists of two pieces found in a collection of fourteen broken terracotta objects among some 150 pot shards. Plastic arts are a rarity in east Africa and there are no parallels to the Luzira Head in the whole area. Several reconstructions have been attempted, none of which is wholly convincing. An analysis of the fragments suggests that there were possibly four figures originally, which were broken before being placed in a pit. The associated ceramics, and part of a polished stone axe, locally known as thunderstones, suggest that the site was occupied for a long period, possibly from the early part of the 2nd millennium AD until the 19th century. There is at present no reliable indication of the exact age of the figures.

The head is hollow and was probably completed separately from the body. The decoration and all features were applied rather than being modelled on the figure. It is neither well fired nor burnished. The reconstructed pieces that comprise the figure are damaged, including the top of the head, the lips and the junctions between the head and body. The applied clay on the head represents either a wig or more probably hair dressed in clay, a not uncommon practice among priests or other ritual practitioners. Below the head there are five coils, which could possibly indicate a necklace of some kind, though probably not of beads. The lower solid section has rings that match those below the head. There are two strangely placed nipples. The arms are decorated with disc bracelets. The lower part of the trunk has what appears to be a small navel. There are indications of two small feet at the centre of the base of the trunk. The arms, terminating in schematically represented hands, rest on columns at the foot of which are further coils. Wayland originally suggested that the figure was a man. The nipples are small, but as no certain genitals are indicated it is impossible to tell the gender.

Luzira was the site of a shrine whose guardians were of the Buganda Otter clan (Ng'onge), barkcloth makers to the royal household; a more modern shrine existed on the hill above. It is assumed that the figures were shrine furniture with the pots for offerings or belonging to the priest or priestess. Location of both the original and later shrine suggests that it was associated with the religion of nuclear Buganda around the lake where other shrines, mostly devoted to the original lake spirits or nature deities, were also located. The original shrine, as well as others, including that at Entebbe, where another enigmatic and anthropomorphic figure was found in 1964, was probably destroyed by followers of Kabaka Kamanya in the early 19th century during their attacks on the strongholds of the traditional Balubale. It would appear that the broken fragments were buried in the pit, but whether intentionally or as rubbish cannot now be ascertained. *MP*

Provenance: 1929, discovered during the building of a prison at Luzira on the shoreline of Lake Victoria near Kampala; later excavations by E. J. Wayland; 1931, given to the museum by E. J. Wayland

Bibliography: Wayland, 1930, p. 41; Wayland, Burkitt and Braunholz, 1933, pp. 25–9; Chaplin, 1967, pp. 195–210, 263–8; Posnansky and Chaplin, 1968, pp. 644–50

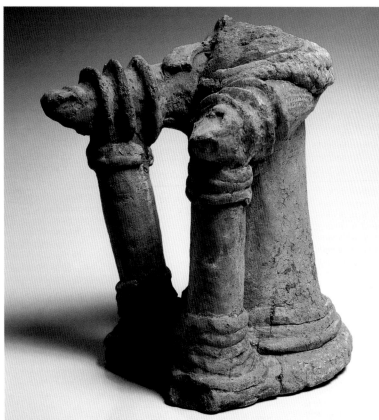

Headrests are indispensable items of the portable material culture of eastern Africa pastoralists, as are spears and other weapons. They are in effect more than just forms of pillow. Whether carried on the arm or in the hand by means of a leather thong, they indicate that their owners are warriors. They often have other small but essential items attached to them – tweezers, knives or chewing tobacco. When not required for sleeping they may just as easily provide an impromptu stool; whereas most examples, have a single column as support, cat. 2.22a is unusual in being furnished with three legs, making it equally useful for sitting or sleeping on.

These two examples in divergent styles are identified with the Karamajong of Uganda. In practice, however, either could just as readily have been attributed to other pastoralists, to the Turkana in Kenya, the Toposa in the southern Sudan or the Nyangatom and related peoples in the Omo Valley of Ethiopia. All share a somewhat similar material culture, and all – despite periodic outbursts of warfare – harbour within their midst clans of foreigners who have been displaced in the unpredictable search for water for their cattle. Such intermingling is reflected in the eclectic material styles found throughout the region. *JM*

Bibliography: Tornay, 1975; Fedders and Salvadori, 1977; Mack, 1982

2.23

Milk-pot suspended in a string holder

Nyoro
Uganda
c. 1900–25
fired clay, graphite, vegetable fibre string
h. 16.5 cm, diam. 14 cm; carrier *c.* 114 cm
Manchester Museum, University of Manchester

The group of peoples known as the 'Interlacustrine Bantu' are so called because they inhabit the area bounded by a series of lakes to the north and north-west of Lake Victoria. These peoples include the Ganda, Nyoro, Nkole, Soga, Toro and Hima of Uganda, and the Tutsi of Ruanda and Burundi. The cultures of these peoples had many features in common, and their artefacts are often very similar.

This pot is shaped like a wooden grooved milk-pot, although about two-thirds the size. The form is associated with a cattle-keeping culture such as that of the Nyoro or Hima of south-western Uganda bordering on Rwanda. Roscoe has described how the graphite, after mining, was powdered, and all the light-coloured stone removed. Usually the powder was mixed with water and the gelatinous juice of the *rukoma* shrub; this was painted on the unfired pot and left to dry. When 'leather hard', the pot was then well burnished with barkcloth scraps and a smooth stone. Alternatively, the graphite was mixed with butter and blood, and was made into balls that, when hard, were rubbed all over the unfired pot. When fully dry, it was fired, and when cool it was again polished with a smooth pebble to a lustrous silvery-black finish. This process had decorative and also practical value, since the burnishing compacted the outer surface of the pot, making it less permeable.

Graphite-burnished ware was reserved for the royal family and nobility. Roscoe illustrates a number of similar pots in slings hanging up in the dairy of the *Mukama* (king) of the Bakitara (also known as the *Nyoro*), and also a servant presenting the king with milk in a similar vessel. Graphite pottery was made by the Nyoro and not by the Ganda, although it could be exported; the main source of graphite was in Nyoro country.

While pottery in Africa is usually made by women, quality pots like this

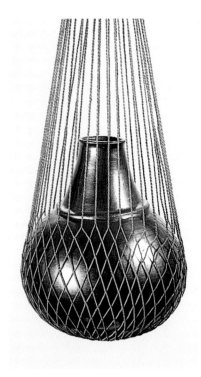

are produced by men, and there are sanctions against women making pots or even approaching clay-pits and pottery workshop areas. 'Royal Potters', such as those working for the Kabaka of Buganda, have a special status and title, insignia, and privileges such as exemption from tax. A different type of pottery was used for beer-drinking, which was, and still is, an important element of social life, with special large drinking-vessels and finely plaited drinking-straws with filter ends for communal beer-drinking.

The sling, made of fibre cord, serves to hand the milk-pot up in the dairy. Netted slings made by women in a variety of patterns are found all over the Interlacustrine Bantu area. *MC*

Provenance: before 1926, F. H. Rogers
Bibliography: Johnston, 1904, p. 308; Roscoe, 1923, pp. 225–8, pl. VIII; Trowell, 1941, pp. 56, 64; Trowell and Wachsmann, 1953, pp. 109, 117–18, 163, pls 17 A, 38

2.22a

Headrest

Karamajong (or related people)
Uganda, Kenya, or neighbouring area
wood
18 x 14.5 x 14 cm
Jonathan Lowen Collection

2.22b

Headrest

Karamajong (or related people)
Uganda, Kenya, or neighbouring area
wood
13.5 x 19 x 9 cm
Jonathan Lowen Collection

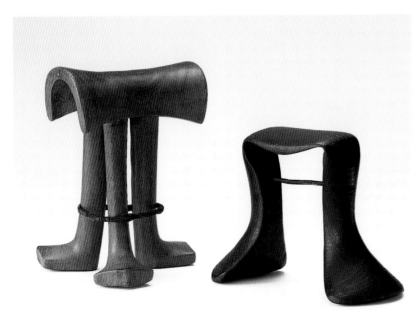

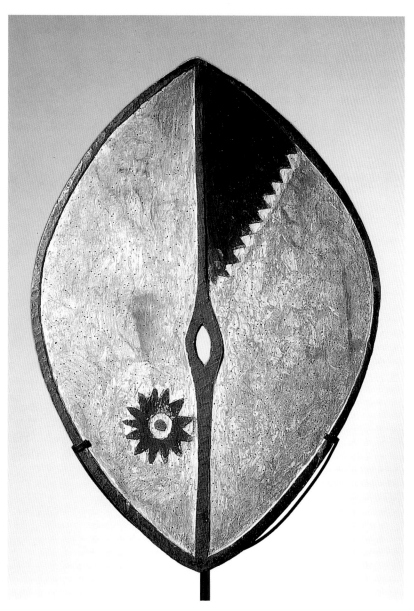

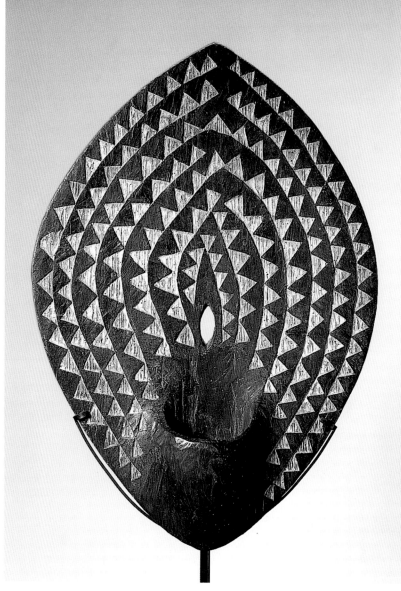

2.24a

Dance shield

Kikuyu
Kenya
early 20th century
wood
60 x 42 x 8 cm
Lucien van de Velde, Antwerp

Among the Kikuyu in central Kenya, as in many parts of Africa, initiation is – or has been – a significant spur to artistic activity. For boys, initiation is the prelude to entering the social status formerly associated with warriors; and indeed those initiated together in a particular territory once formed a unit within the wider age group for the execution of raids and the defence of villagers. Some aspects of the initiation process, such as the display of shields in initiation 'dances', make reference to this militaristic expectation of initiated men.

Initiation shields were of various kinds; unlike the war shields (*ngo*), which were crafted from animal hide, they were constructed of wood or bark. Those of the type shown here were usually carved from a solid piece of light wood by specialist craftsmen for a display of dance known as *muumburo*. As they have an armhole on the inner face of the shield, they can be manipulated by flexing the arm rather than being held in the hand.

All the wood shields were decorated with non-figurative motifs on the outer surface and usually on the inside as well. These designs were by no means arbitrary. The patterning had to be agreed in advance of successive initiations, which in some areas may have been annual, and was then applied to the new shields used on that particular occasion. Such pattern-

ing thus varied both by territorial unit and by initiation period. Shields used at the same initiation were not necessarily identical. Boys usually passed their dance shields on to their younger relatives. Many scraped off the old decoration, replacing it with the pattern agreed as the 'insignia' of their particular initiation group. Only when more than one boy from a family was to be initiated on the same occasion was a wholly new shield commissioned with a pattern selected for that year. Patterns were also applied to the back of the wooden shields – often in a form reminiscent of an eye and eyelid. *SJMM*

Provenance: cat. 2.24b: 1921, given to the museum by Mrs Selous

Bibliography: Routledge, 1910 (1968)

2.25

Figure

Kamba
Kenya
c. 1933
wood, metal, cloth
h. 21.3 cm
Bareiss Family Collection

The Kamba made their original home in the drought-prone scrub-lands of the eastern slopes of the Kikuyu highlands in southern Kenya. Rural Kamba keep livestock and farm along the banks of rivers and in the better watered depressions. In the 19th century they are known to have traded extensively with Arab and Swahili caravans. Today many Kamba are involved in a major trade in wood-carvings based on an industry that was initiated after World War I. Before the war the Kamba were skilled in working metal and carved utilitarian objects out of wood, including stools that were elaborately decorated with inlaid metal coil-work. They appear to have produced very little in the way of figurative wood carving, although a few examples of early anthropomorphic figures from Kambaland are to be found in European collections. Such figures were probably used in connection with the cult of the ancestors and may have represented clan founders and important elders. They are typically stocky with straight legs and their round heads are generally carved with pursed lips and protruding, S-shaped ears. Most are decorated with simple bead ornaments and inlaid metal eyes.

It is generally acknowledged among contemporary Kamba artists that the first person to begin carving figurative items intended exclusively for sale to Europeans was Mutisya Munge. Mutisya was a skilled carver of utilitarian objects who had served in the Carrier Corps in what was then Tanganyika during World War I. While in Tanganyika he had come into contact with Zaramo carvers involved in the production of figurative models of local styles of dress and ornament for the European market (which had apparently developed before 1914 with the encouragement of Lutheran missionaries). When he returned to his home village of Wamunyu after the war he took up figurative carving as a full-time occupation and the practice soon spread to other men in this area of Kambaland.

This figure depicts a Kamba man engraved with typical scarification marks of the early colonial period. In its stocky frame and straight legs it bears some resemblance to the form of early wooden figures used in connection with the ancestor cult. It is carved in a similar style to a fine figure of a Kamba woman in the British Museum that was evidently made for the European market and is recorded as having been collected in 1933. A number of remarkable carvings of this kind, often decorated with wire ornaments, metal inlay and pigment, appear to have been produced by Kamba carvers during the inter-war period.

Finely carved figures such as this probably ceased being made after World War II when demand for Kamba carvings from overseas buyers began to outstrip the carvers' capacity for production, thus encouraging them to organise themselves into an efficient handicraft industry geared to fulfilling bulk orders for simpler, standardised figures. *ZK*

Bibliography: Lindblom, 1920; Elkan, 1958; Troughear, 1987; Felix, 1990

2.24b

Dance shield

Kikuyu
Kenya
early 20th century
wood
62 x 41 x 10 cm
The Trustees of the British Museum, London, 1921. 10.28.12

The *vigango* (sing. *kigango*) of the Giryama are not necessarily grave-markers, although there has been much confusion over this in the literature: *vigango* are sometimes placed on the site of graves, but normally not. Their role is not to indicate the location of physical remains but to provide a new abode – a new body, indeed – for the spirit of the deceased. Like the smaller and less elaborate *koma* pegs, together with which they form a sort of genea-logical map for the household, *vigango* are erected some time after the death of an individual, usually only when the spirit of the deceased indicates discontent with its lack of a body by appearing in a dream to some living relative.

Among the Giryama (but perhaps less so among some neighbouring groups, such as the Jibana, Chonyi and Kauma, who also erect *vigango*) *koma* and *vigango* often stand in the men's conversation hut in a homestead, readily accessible to the elder male of the homestead, whose prerogative it is to pour palm wine into small coconut-shell cups set at the base of these ancestral memorials. This is done at regular intervals. If dreams or mis-fortune recommend it, the elder male may also slaughter a chicken or goat by the memorials, so that the blood goes to nourish the spirits. Generally, it is only the ancestors of the male head of the homestead who are so embodied within the homestead; his wife or wives will not usually have *vigango* or *koma* for their ancestors, and if they do these are not prominently placed.

There is some debate about the distinction between the *koma* pegs and these *vigango*, and what this signifies. Physically, the differences are readily apparent. *Koma* are small soft-wood pegs, standing only about 30 cm out of the ground, and carved in the most rudimentary way, with a slight waisting (possibly phallic) indicating that the *koma* is that of a male ancestor; they are occasionally 'dressed' with strips of cloth. *Vigango* are much taller, standing 130–200 cm out of the ground, and are carved from hardwood (which resists the attentions of termites); they are evidently anthropomorphic, usually decorated with incised triangles and often also originally painted with red, white and black. In the 19th century

some had silver dollars in place of eyes. They are much more expensive, elaborate and enduring. Although they are rather rarely made now, some relatively recent examples exist.

The difference – the fundamental question of to whom a *kigango* may be erected, and to whom only a *koma* – is partly one of gender: there seem to be no *vigango* for women. But not all men get them either. Some suggest that this has to do with membership of one of the several societies that structure Giryama life in important ways. *Vigango*, some would argue, are erected only for members of the *gohu* society, which is essentially concerned with the conspicuous consumption of wealth; admission to membership of it is similarly a sign of wealth. Even if they are not solely associated with *gohu* members, it would seem that only the wealthy would be likely to get *vigango*, as the rituals involved in the erection of a *kigango* are very much more costly than those for a *koma* peg. The very name *vigango*, which comes from a verbal root referring to 'binding, splicing', sug-gests the special power of wealthy elder males and the healing force which that power may have when used by the spirits of the deceased.

There are, however, suggestions that the difference between *koma* and *vigango* essentially relates to mobility (and perhaps reproducibility), and that there is a historical process of change. *Vigango* may be moved at most once from their original position, whereas *koma* may be more mobile, or may be replaceable (although there is some variation in practice over this). Since the early 19th century, the Giryama population has expanded both numerically and geographically: from being a relatively small group centred on the *kaya* ritual centre a little way inland from Mombasa, with a mixed farming economy that emphasised cattle pastoralism, the Giryama have multiplied and spread to areas some way north of the *kaya* and as far east as the coast, relying heavily on rather marginal maize farming and on involvement in the tourist economy of the Kenya coast. As part of this process, homesteads have tended to become smaller, as men leave those of their fathers rather earlier to establish their own – and therefore may seek to erect their own ancestral memorials. As the

population has expanded and dis-persed, so it might be argued that *koma* have become more common than the more static *vigango*.

In either case, these wooden bodies for spirits have a limited period of use. Just as they are erected only when the spirits of the deceased make them-selves remembered, so they are neglected once the spirits begin to be forgotten. This restricted sense of genealogy is emphasised by the fact that the Giryama alternate their names between generations, which tends to blur more distant ancestors into a stereotyped succession of names. Once an individual ancestor is forgotten, their *koma* or *vigango* are forgotten too – the soft-wood *koma* rot away, and after a time the more enduring *vigango* are left behind as homesteads move, no longer import-ant because their spirits have faded from memory.

These four examples all have particularly carefully carved heads, whereas on many *vigango* the heads are essentially two-dimensional, and in some cases a geometric pattern is carved, no effort being made to represent human features. Two of them have the characteristic incised triangles, which perhaps represent human ribs, as well as the circular decorations that are common. The other two are predominantly incised with the rather less common recti-linear forms, and one is unusual in that the notches cut into the body serve as part of the pattern rather than terminating it.

While there are apparent simil-arities between these pieces and grave-markers of the Oromo, and some from Madagascar, no historical link has ever been demonstrated. *JW*

Bibliography: Barrett, 1911; Champion, 1967; Hollis, 1909; Ngala, 1949; Wolfe, Parkin and Sieber, 1981

2.26a
Funerary post (*kigango*)
Giryama
Kenya
wood
h. 130.5 cm
Private Collection

2.26b
Funerary post (*kigango*)
Giryama
Kenya
wood
h. 190 cm
Private Collection

2.26c
Funerary post (*kigango*)
Giryama
Kenya
wood
h. 206.5 cm
Private Collection

2.26d
Funerary post (*kigango*)
Giryama
Kenya
wood
h. 145 cm
Private Collection

 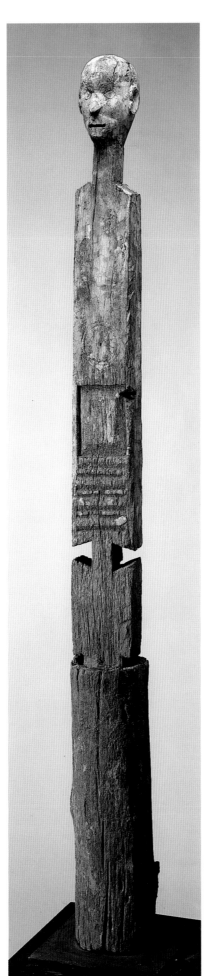 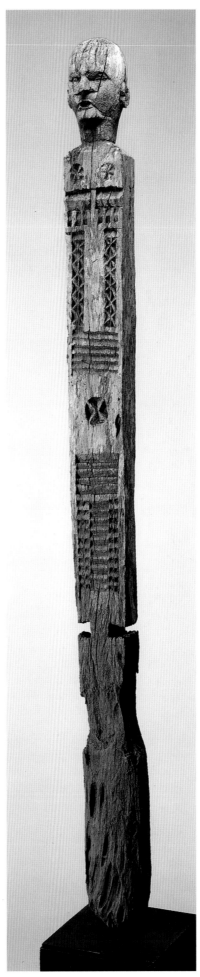 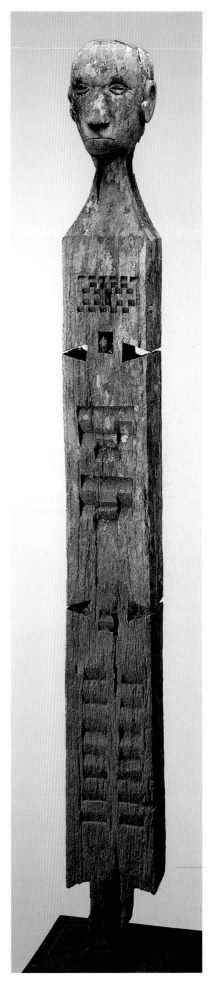

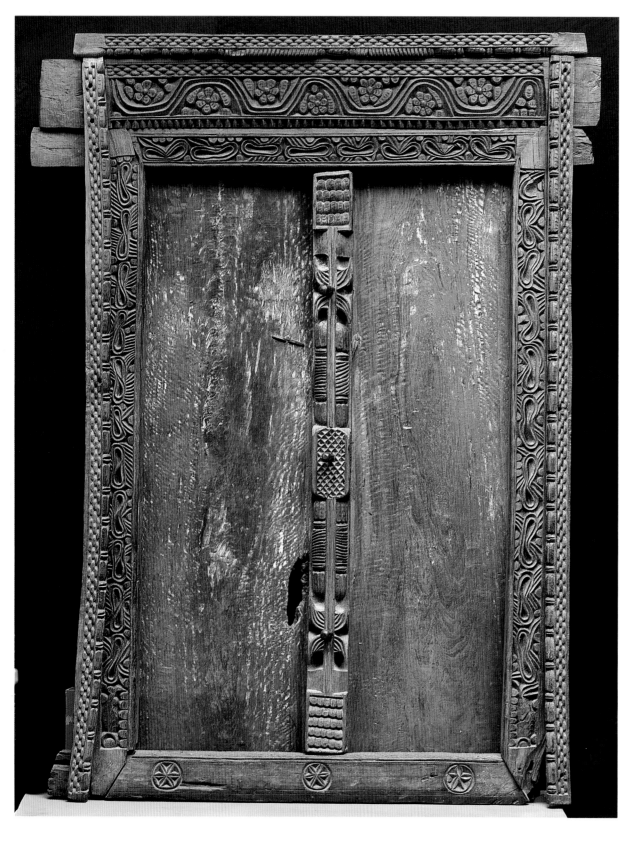

2.27

Door

Swahili
Tanzania
c. 1900
wood
h. 200 cm
Staatliche Museen zu Berlin, Preussischer
Kulturbesitz, Museum für Völkerkunde,
III E 8932

The carved doors of the east African coast, variously described as Swahili, Arab or Zanzibari, represent variants within an ancient and widespread tradition in the western Indian Ocean (the earliest reference is by the 16th-century Portuguese writer Barbosa, who described them as 'well carved'). It declined after the Portuguese invasion but revived in the 19th century. The largest concentrations of such doors occur in Zanzibar town (500), Lamu (200) and Mombasa (100).

The carved door, which consists of a number of interlocking members, is often the only striking external feature on an otherwise plain, white-washed building. Its quality and size were an indication of the social status of the owner. All doors are double and open inwards from the centre. The most traditional Swahili-type doors occur at Siyu in the Lamu archipelago; these are engraved and painted in red rather than carved, and lack a central post. In Lamu they are simple with only the central post carved with rosettes or round geometric designs, ending with fish-scale decoration at top and bottom.

The tradition of carving doors reached its zenith in the 19th century when it was underpinned by the wealth flowing into Zanzibar and its subsidiary ports from commerce and clove production. The somewhat simpler carved doors in the smaller ports on the mainland, such as that illustrated here, were greatly elaborated in the doors of the ruling Omani élite in Zanzibar. The square-framed doors were carved with a variety of motifs: the fish and wavy lines point to an important source of livelihood for the Swahili; the chain is said to symbolise security; the rosette and the lotus suggest Indian influences; and the frankincense tree and date palm, which are indigenous to Somalia and Arabia, are said to denote wealth and plenty. Frequently these decorations centred upon a Koranic inscription in the middle of the lintel which may contain the date and name of the owner or artist. The leaves of the door were often decorated with rows of iron studs and fitted with a hasp and chain to lock the door from the outside.

Carved doors are one manifestation of the culture of the Indian Ocean region. Islam, the dhow trade and availability of timber and craftsmen provided the basis upon which the tradition flourished. There has been constant cultural interpenetration between the east African coast and the northern rim of the Indian Ocean. Some doors were imported into Oman from east Africa already carved, and probably exerted influence on the local craft. *AS*

Bibliography: Adie, 1952, pp. 114–16; Aldrick, 1990, pp. 1–18, pls 1–16; Bonnenfant and al-Harthi, 1977, pp. 128–30, pls XXVII, XLa,b, XLIa–c, XLIIa; Barbosa, in Freeman-Grenville, 1962, p. 131; Krieger, 1990, pl. 296, p. 45

For centuries, the most popular boardgame along the east African coast has been *mankala*, a generic name for a family of boardgames akin to draughts and believed to be the oldest and most widely distributed in the world. It is played on boards with two, three or four rows of cuplike depressions or 'holes'. Two-row games are the most widely distributed in the world, while three- and four-row games are rarely found outside Africa. Africa is unique in being home to all three types.

The peoples of Kenya, Tanzania, Zanzibar and the Comoro Islands call the game *bao KiSwahili*, indicating a method of play that originated among the Swahili and Bajun Muslims of northern Kenya. It is played by two people on a *bao* (Swahili for 'board') containing four parallel rows of eight holes. Each player has 32 pieces and owns half of the board. The goal is to capture the opponent's pieces and redistribute them on one's own side of the board. This is done by sowing the pieces one by one in the appropriate inner and outer rows during the two stages of the game. A capture is made when a player's last piece falls into an occupied hole in his inner row. This hole must be opposite two occupied holes in the opponent's inner row. The hole in each inner row that is larger or of a different shape than the others is called *kuu* and houses accumulated pieces that may play a strategic role. Like chess, *bao KiSwahili* is a contemplative game of strategy. However, unlike chess, African *mankala* is played with great speed, requiring both mental and physical agility, and in the presence of a vocal audience.

The pieces are pebbles or inedible, hard, grey seeds from a thorny shrub. The *bao* may be simply holes scooped out of the ground or a board carved from a hardwood. In the past, decorated gameboards with a projecting storage hole at either end were prestige objects made by professional wood carvers. This one is decorated with carved geometrical designs reminiscent of those found on the doors of 19th-century Swahili houses in Zanzibar. *RAW*

Bibliography: Ingram, 1931, p. 257; Townshend, 1992, pp. 175–91; Nooter, 1984, pp. 34–9; Washington 1984; Aldrick, 1990, pp. 1–18; de Voogt, 1994, p. 3; Rollefson, 1992, pp. 1–6

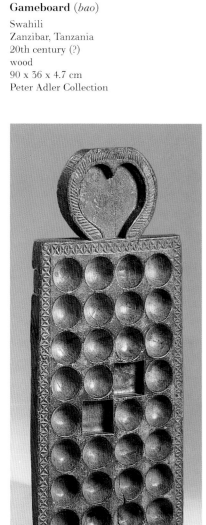

2.28
Gameboard (*bao*)
Swahili
Zanzibar, Tanzania
20th century (?)
wood
90 x 36 x 4.7 cm
Peter Adler Collection

2.29

Figures in intimate embrace
Mahafaly (?)
Madagascar
early 20th century
wood
h. 8 cm
Private Collection, Paris

This miniature panel showing two figures intimately entwined has been attributed to the Mahafaly of southern Madagascar. Its small scale suggests that it was carved as a virtuoso piece on its own or, more likely, as a panel for some small domestic object such as a comb. Mahafaly combs became more widely known when published between the wars, and the subject-matter of this piece also suggests a derivation in the colonial culture of Madagascar during the first part of the 20th century.

Sexually explicit sculpture is principally associated with the large-format carvings placed at the corners of Vezo graves (cat. 2.31b). These have become known among the Vezo themselves as *sary porno*, or pornographic images, not because their subject-matter was viewed locally as in any sense titillating, but because of the perceived interest of *vazaha* (white outsiders) who visited the funerary sites to photograph and eventually remove the sculpture. This, in its turn, led to the production of erotic sculpture purely for the amusement of a foreign clientele. Although the sculptors were generally of Sakalava or Vezo origin, carvers elsewhere picked up the theme, and sometimes reapplied it, as in this Mahafaly example, to objects intended for their own use. *JM*

Bibliography: Boudry, 1933, pp. 12–71; Université de Madagascar, 1963; Astuti, 1994, p. 112

The carving placed on tombs by the Mahafaly of south-western Madagascar are arguably the most familiar, yet the least understood of all the art forms produced on the island. Indeed, although the term by which the sculpture is known, *aloalo*, is now often applied to other un-related types of object, the word itself remains inadequately translated.

The Mahafaly live in an extensive area of thorny semi-desert. They are predominantly cattle pastoralists, and the humped zebu cattle which are the basis of their livelihood also provide a leading theme in their figurative art, not least on *aloalo*. In visual terms the most prominent feature in their land-scape are tombs, vast solid box-like structures of cut and natural stone which sit isolated in the countryside, often topped with a series of tall sculpted poles. As many as 30 such sculptures are recorded at single sites. Such graves are reserved to chiefly or royal lineages, one large tomb for each of the deceased of sufficient standing to be worthy of the expenditure involved in their creation.

The sculpture displayed on these stone platforms, though it has con-tinued to evolve in form and content until today, retains an identifiable set of elements. The whole construction is generally carved from single pieces of wood, the lower part sometimes plain and sometimes with a standing figure. Above is an openwork structure of geometric forms, usually crescent shapes and circles which are con-ventionally interpreted as referring to the full and half moons. The image on the top of the whole sculpture shows the greatest variability. Humped cattle and birds are the most frequent subjects, cattle being sacrificed as part of funerary rites and the horns planted in the stone tomb alongside the *aloalo*. The birds are generally those which return at the end of the day to the same place, ducks or teal. This would seem to be a reference to the tomb as the new residence of the deceased. More recent *aloalo* also include groups of figures, aeroplanes, buses and other attributes of modern life which personalise the sculpture in a way not found on older versions.

At one level the sculpture, as the construction of the tomb itself, has a clearly honorific function. However, the term *aloalo* is normally inter-preted as deriving from the word *alo*, a messenger or intermediary. They are distinguished from another category of Mahafaly carving known as *ajiba*, figurative sculpture in a different style erected away from sites as a form of cenotaph. This contrast tends to support speculation that the purpose of the *aloalo* is less that of a directly commemorative device than as an intercessor of some kind between the world of the living and that of the dead. As in many parts of Madagascar, the ancestors (*razana*) provide a point of reference in seeking to understand the tide of human affairs and a channel by which to influence their course.

Yet *alo* has a more general mean-ing. It is a word applied to situations which create linkage of any kind. In this sense it is sometimes used of techniques of weaving. In the case of Mahafaly funerary sculpture, it can refer to the interlocking geometry of circles and crescents which provide the central element of the sculpture, and which, by comparison with carving elsewhere on the island, is its distinctive feature. *JM*

Bibliography: Huntingdon and Metcalf, 1979; Mack, 1986, pp. 86–92

2.30a

Tomb sculpture (*aloalo*)

Mahafaly
Madagascar
wood
h. 193 cm
Private Collection

2.30b

Tomb sculpture (*aloalo*)

Mahafaly
Madagascar
wood
h. 226.6 cm
University of Pennsylvania Museum of Archaeology and Anthrophology, Philadelphia, 62-4-1

2.31a

Male funerary figure

Vezo
Madagascar
wood
h. 44 cm
Private Collection

2.31b

Female funerary figure

Vezo
Madagascar
wood
h. 57 cm
Private Collection

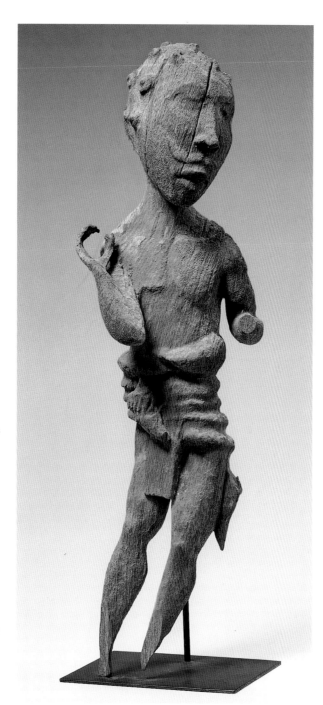

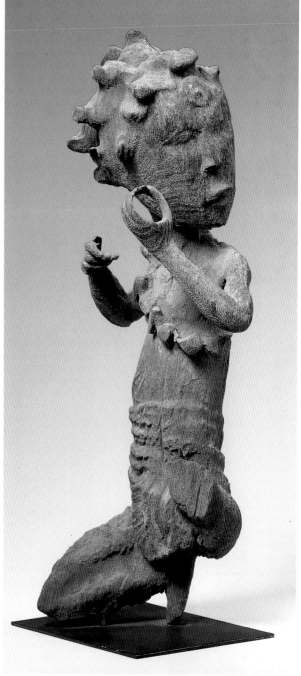

These two pieces are by an unknown Vezo artist whose sculptural intentions have been adapted by the abrasive action of sand. The objects seem to come from one of the nine or so funerary sites in the region of Morondava on Madagascar's western coast. The Vezo are a fishing population who should be distinguished from the surrounding Sakalava with whom they are often confounded and to whom Vezo funerary art is sometimes erroneously attributed. Vezo tombs are located in forests and sandy clearings distant from villages and are visited only for the purpose of burying the dead. The sculpture placed on tombs is to that extent largely invisible both to Vezo and to visiting ethnographers. Indeed, there is no unique indigenous term by which it is known, unlike the *aloalo* which surmount Mahafaly tombs.

A significant number of the carved figures were stolen in the post-war period from isolated Vezo cemeteries, mostly sawn from the poles which supported them (such pieces have been excluded from the selection in this exhibition). There is no tradition of re-erecting the tomb complexes which fall over and it would seem from the extensive abrasions on these pieces that they may have been removed at some unknown time, seemingly directly from the sand rather than from a standing monument.

The two pieces here have been photographed in the past as if in intimate relationship. Some figures are carved in amorous embrace (as in the Mahafaly piece, cat. 2.29). It is, however, possible that, as with other Vezo tomb sculpture, they would originally have stood at opposite corners of a rectangular box-like wood structure. That at the sacred north-east corner would be male or female depending on the gender of the deceased. The north-east, the place where the sun rises, is associated both with dawn and with the most propitious of events: it is a good time to be born, the ideal moment for circumcision, or for the removal of a corpse which has been laid out in a hut. It is a sacred ancestral direction. At the opposite, south-western corner would have stood his or her partner – a relationship in terms of direction which expresses the ideal union of people, and of destinies as calculated by the time and date of birth of individuals and applied to directions.

There are, however, features of these two pieces which are striking and unusual. Both are much more poised than is common; the tilt of the head and gesture of the hands contrast with the upright single figures which are more familiar. In the end, however, it is difficult to say how far these attributes are fully representative of the original sculptural programme of the carver and how far they are the chance result of extensive weathering. *JM*

Bibliography: Oberle, n.d., pp. 134–42; Lombard, 1973; Mack, 1986, pp. 88–9; Astuti, 1994, pp. 111–22

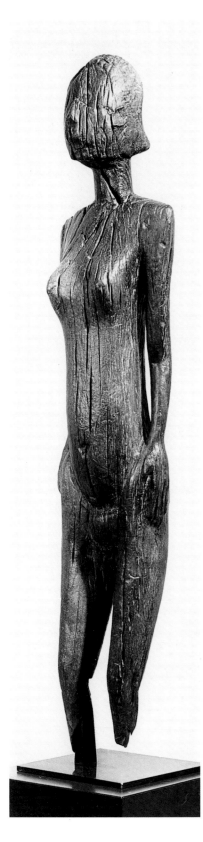

This sculpture is said to have been collected in Madagascar many years ago. Its general form and its glossy patination would seem to make both claims possible (and to suggest collection at a period predating the deliberate thefts from funerary sites on the island which have taken place since the 1970s). The patination, however, may not be original, for most Malagasy sculpture is created for exposure at ancestral sites outdoors and attains a highly weathered appearance. There is no handling, oiling, or other indigenous treatment of surfaces subsequent to completion as occurs in much of mainland Africa.

For Malagasy the ancestors (*razana*) in effect underwrite human existence. This is asserted in many actions: private, domestic and public. The most dramatic of these are ceremonies at which numbers of skeletal remains are taken for an afternoon from their tombs, rewrapped in new, preferably silk, shrouds and danced round the funerary site. Interestingly, there is no tradition of funerary or commemorative sculpture in central Madagascar where such ritual, with its direct contact with deceased ancestors, occurs. Rather, sculptural traditions are associated with the south and especially the south-west of the island. Here, it might be argued, the creation and erection of sculpture at tombs or at some nearby place, and the crucial ritual process which accompanies it, is equivalent to the rewrapping ceremonies. Both events serve to acknowledge the incorporation of the dead into the community of ancestors and to ensure the flow of vitality from the dead to the living which is the basis of life itself.

It is most likely that this figure is from the Vezo (as cat. 2.31a–b), though this is not the only possibility. In that case it is probable that it was not displayed singly but as part of a complex structure incorporating both male and female figures. It is very rare in Madagascar for female sculpture to be shown other than in relationship with a paired male figure (see also cat. 2.33). *JM*

Bibliography: Bloch, 1971; Mack, 1986

2.32
Female sculpture

Vezo (?)
Madagascar
wood
Private Collection

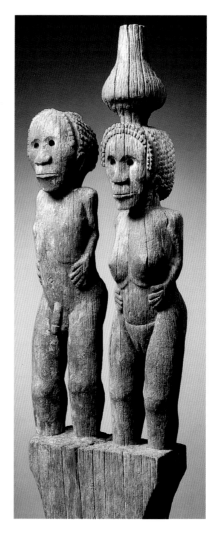

2.33
Mortuary post figure

Sakalava
Madagascar
19th century
wood
h. 99 cm
The Carlo Monzino Collection

Bibliography: Bassani and McLeod, n. d., pp. 66–7; Leenhardt, 1947; Urbain-Faublée, 1963; Kent, 1970, p. 236; Vogel, 1985, pp. 190–2

Very few works of African sculpture from the eastern side of the continent have had much influence on Western art. This is one of the rare exceptions. It was originally in the collection of the sculptor Jacob Epstein and appears in photographs of his studio, prominently displayed on his mantelpiece. The piece might well have been the inspiration of a study in pencil and watercolour of a male and female pair completed by Epstein in 1913. A companion piece, probably by the same hand, is in the Musée de l'Homme. Yet the purpose and origins of both pieces remain confused.

The Musée de l'Homme example is a complete post, unlike this one, which is only the upper part, and is recorded as having been collected among the southern Sakalava. This provenance, however, has been disputed. The piece has been variously reattributed to the Betsileo and the Bara. Vogel describes it as one of up to twenty posts which surmount tombs; she thereby unwittingly implies a Mahafaly origin as they, and some neighbouring Antandroy, are the only people in Madagascar who erect poles in this way.

The main problem arises from the assumption that the piece has been intended for use in a funerary context, whether to be placed singly or in combination directly on a tomb or set up as a memorial. Urbain-Faublée's reattribution to the Bara is based on the observation that the Sakalava were at the time of collection too independent 'to accept the erection of a religious monument'. The tomb sculptures associated with the Sakalava (but in fact the work of the Vezo, an independent maritime group on Madagascar's western coast) have a restricted distribution and are generally slotted into the corners of large box-like wooden tombs. There is no evidence on the complete post of any such jointing.

There are reasons to think that the pieces are nonetheless of southern Sakalava origin, as the Musée de l'Homme records suggest. A field photograph in archives in Madagascar shows this post not in an isolated cemetery but with a dwelling directly behind it. It appears to have been taken in a village. A caption suggests that it is a *hazomanga*, that is a village post at which sacrifice and circumcision take place. *JM*

2.34

Spoon with male figure

Southern Sakalava (?)
Madagascar
wood
l. 31 cm
The Trustees of the British Museum,
London, 1947. AF.18.103

This spoon is a puzzle. It entered
the museum's collection from an
undocumented source via the large
and wide-ranging collection of Philip
Smith. The suggestion that it might
be from the island of Madagascar was
probably made by William Fagg, the
African curator of the day (an identi-
fication which has been tentatively
followed in at least one publication:
Mack, 1986, p. 65). Yet there would
seem to be no other directly compar-
able spoons from the island that would
confirm Madagascar as the unequi-
vocal source. Indeed, a recent general
survey of African spoons includes a
somewhat similar example to this
(though of a female figure) which is
identified as Yaunde–Fang and from
the Cameroon–Gabon borders.

That said, there are certainly many
decorative spoons produced in
Madagascar, particularly in the south
and south-west. If correctly identified
as of this origin, this one may be of
southern Sakalava manufacture.
Throughout Madagascar sculpted
spoons are found in use for the serving
of rice on ceremonial occasions. Rice
itself is consumed in large quantities
in Madagascar, and is regarded as an
indispensable element in any meal. It
is more than mere sustenance, how-
ever; it is seen as the source of life and
of human vitality. Rice is a sacred
substance (*masina*), the product of the
toil of ancestors. So, too, the spoons
with which it is presented at special
events may be handed down in
villages as an appropriate ancestral
inheritance. *JM*

Provenance: ex collection Philip Smith
Bibliography: Falgayrettes et al., n.d.;
Mack, 1986; Homberger, 1991

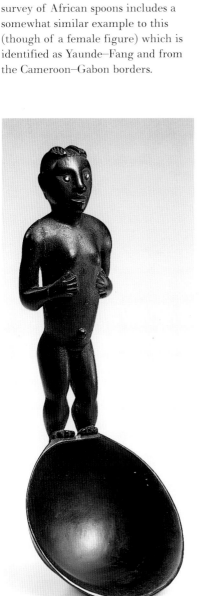

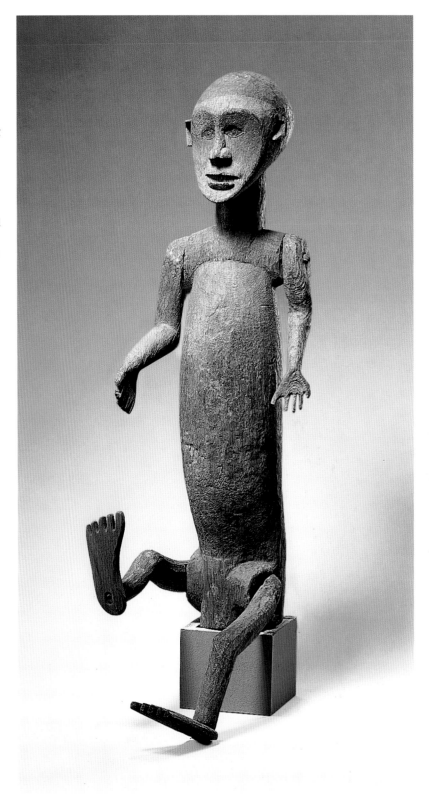

2.35

Funerary figure

Zaramo
Tanzania
late 19th century
wood
h. 85 cm
Staatliche Museen zu Berlin, Preussischer
Kulturbesitz, Museum für Völkerkunde,
III E 7260

The Zaramo was one of the first
groups to be encountered by Euro-
peans in east Africa yet, paradoxically,
they remain little known. They live
mainly in the coastal region of eastern
Tanzania and are primarily dependent
on cultivation of food crops, although
fishing, cash crops and, in some areas,
blackwood carving are also important
economic activities. In pre-colonial

times the Zaramo had no centralised system of authority and leadership was held by lineage elders and by the heads of each autonomous village or village grouping (as was the case among most of the other related matrilineal peoples who inhabit eastern Tanzania). Village and matrilineage heads performed various judicial functions and conducted certain religious ceremonies, such as those intended to propitiate the ancestors or to purify the land. In the past some Zaramo leaders appear to have gained influence through their success in raiding Arab and Swahili caravans. Another way in which both men and women were able to achieve a degree of influence beyond their immediate matrilineage was by progressing through the ranks of a 'secret' association whose membership cut across kin and residential groups and whose highest ranks carried considerable prestige in the community. Initiation rites were staged in order to promote members and special rites were performed at the funerals of those of high rank.

Prominent Zaramo elders often had posts carved with anthropomorphic figures erected beside their graves and the figure illustrated here would appear to represent the top section of a rare form of Zaramo funerary monument of this kind. Very little is known about the circumstances that governed the erection of this particular form of funerary post but it would appear that such objects date from pre-colonial times. Based on the testimonies of two Zaramo informants, Felix suggests that this type of monument may have been constructed for prominent elders who died without leaving male offspring to praise them at the graveside. The figure would originally have been dressed in cloth and it was made with articulated limbs, apparently because the arms and legs were intended to be manipulated by a ritual expert at the burial ceremony. The ritual expert, who may have been a ventriloquist, made the figure move and talk as he sang the praises of the deceased elder.
ZK

Provenance: 1899, collected by Stuhlmann

Bibliography: Beidelman, 1967; Felix, 1990, pp. 193–4

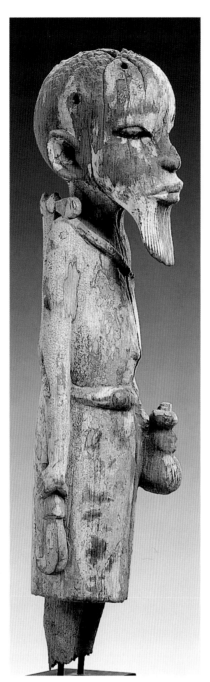

2.36
Funerary figure
Zaramo
Tanzania
19th century
wood
h. 36.8 cm
Musée Barbier-Mueller, Geneva, 1027-59

Zaramo commemorative monuments, erected over the graves of important elders, exhibit a variety of forms. Some examples are topped with sculpted heads, others are carved with full human figures, while a third category are carved with trunk-like (*Mwana hiti*) figures (see also funerary figure, cat. 2.35). Many of the more recent examples portray human figures, carved in realistic style, which are thought to represent the individuals whom they are intended to commemorate. The grave monument figure illustrated here probably represents an elder who was a successful farmer because it portrays a bearded man carrying axe, bush-knife and water-gourd. The particular style in which this figure is carved recalls that of some of the finest Zaramo 'export' sculpture. This suggests that the well-developed mimetic skills of the carver, who would almost certainly have been involved in the creation of realistic wooden figures for foreign patrons, were called upon, in this instance, to serve the requirements of an indigenous sculptural practice. The figure may have been collected in the vicinity of Maneromango (a village about 64 km south of Dar es Salaam) where Lutheran missionaries first encouraged Zaramo carvers to begin producing realistic figures for European patrons before World War I.
ZK

Bibliography: Elkan, 1958; Felix, 1990

2.37
Pole
Kwere/Zaramo
Tanzania
wood and metal
h. 128 cm
Private Collection

This unusual pole may be of a kind used in spirit possession ceremonies. Among the Zaramo, poles of this kind are called *mkomolo* or 'tree of recovery'. They are stood in the ground at the ritual site where they serve as a kind of backrest for the afflicted person. The staffs are carved with a hook from which gourds containing efficacious ritual substances are hung and they are decorated with strips of red and white material. The *mkomolo* is usually surmounted with a carved figure of a woman and child or with a stylised female trunk-like figure. This staff is unique for its tree-like, branching form surmounted by two large trunk-like female figures with a third, smaller, less stylised, bird-like figure below.

The trunk-like figure represents a core symbol in most of the matrilineal societies of north-eastern Tanzania. It combines both male and female iconography in that it takes the general form of a phallus yet is carved with breasts and represents a stylised, limbless female figure. Such figures may embellish a variety of culturally significant objects. The dual nature of the figure expresses the unity of life principles and it plays an especially important role in the female initiation rites. During her seclusion period a girl initiate is given a trunk-like figure which she ritually feeds and cares for in order to promote her growth, health and fertility.

Before primary spirit possession ceremonies, for example the *madagoli*, which is performed among the Zaramo, prayers are said and offerings made to the patient's ancestors, especially those who are known to have practised as possession cult healers. The ceremonial site is marked in a cleared space where the *mkomolo* staff (which represents the male life principle) is planted in the ground (which represents the female, regenerative life principle) in an act suggestive of copulation. The ceremony takes the form of a feast held in honour of the affecting spirit, which is called to participate and

which rises into the heads of patient and healer. The healer becomes possessed and is able to divine the spirit's wishes and also the identity of the particular ancestor who sent the spirit to afflict the patient. Once the ancestor is identified, the healer specifies the steps to be taken by the patient and his or her relatives to propitiate the offended ancestor. By emphasising the patient's links with the corporate kin group in this way, primary possession cults would seem to reinforce the unity and cohesion of the group and so reduce internal conflict between classes or factions. *ZK*

Bibliography: Swantz, 1970; Felix, 1990

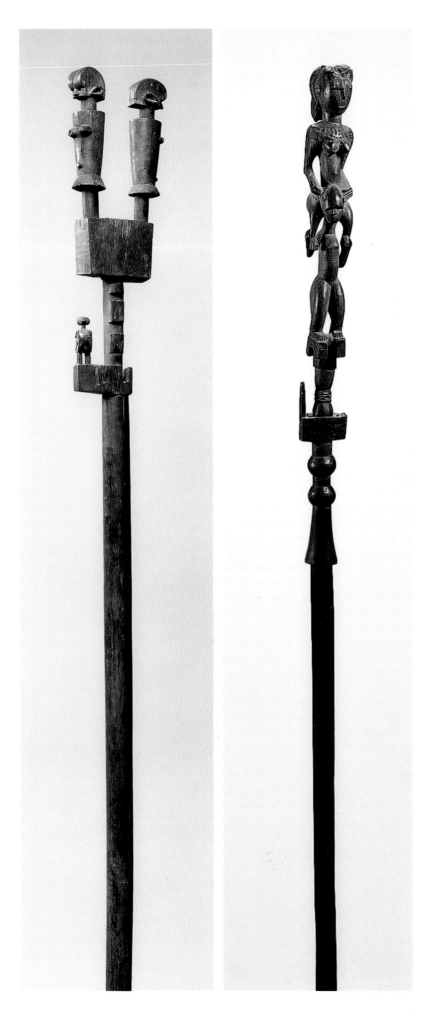

2.38

Staff

Kwere
Tanzania
early 20th century
wood
h. 142 cm
Felix Collection

The Kwere mainly inhabit the hinterland stretching inland from Bagamoyo town in north-eastern Tanzania. They have a predominantly agricultural economy and, as was the case with their southern neighbours, the Zaramo, had no centralised political organisation until an administrative hierarchy was imposed by European colonial powers in the late 19th century. The Kwere matrilineage was an autonomous political unit whose head was elected by the lineage elders; each village was also, to a large extent, autonomous and had its own head.

The rich cultural life of the Kwere includes elaborate ceremonial occasions. These are presided over by ritual specialists who may be lineage elders, leaders of spirit possession associations, diviners, healers or anti-witchcraft specialists. Ritual specialists were able to gain considerable social prestige and their influence sometimes extended well beyond their local kin and residential groups. Figurative staffs served to legitimate their special role and abilities and as tools in the ritual process. Staffs depicting the pickaback motif such as the one illustrated here were probably used in the context of male and female initiation rites, although they would also have been used in other contexts. They are carved with hooks on which gourds containing ritual substances were hung. Both male and female initiates are carried pickaback to the site where important rites in the initiation complex take place. In the male rites the initiates and their bearers are led to the ceremonial site by the ritual expert, who may carry a staff carved with the pickaback motif. According to Felix, staffs of this kind were sometimes also planted at the ceremonial ground and served to consecrate the site. *ZK*

Bibliography: Brain, 1962; Felix, 1990, pp. 167–8

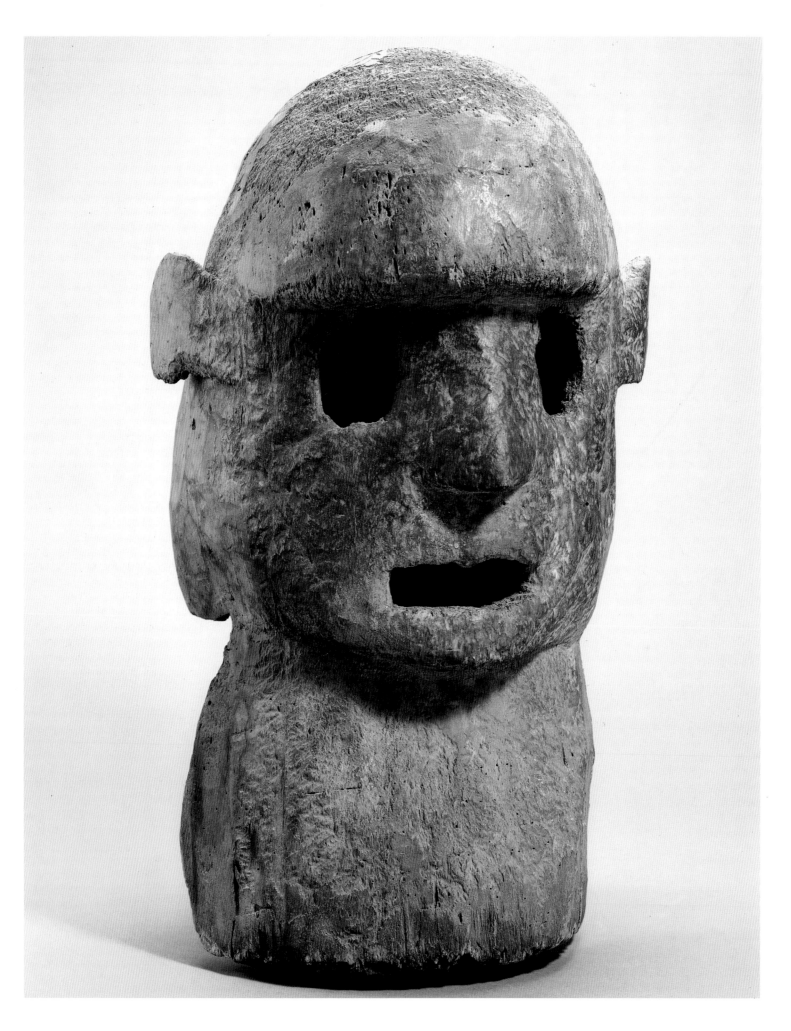

2.39

Mask

Kwere
Tanzania
early 20th century
wood
h. 50.5 cm
Fred Jahn Gallery

A variety of initiation associations or 'secret' societies existed among the Kwere and the other matrilineal peoples of eastern Tanzania during pre-colonial times. These were hierarchically organised institutions whose membership was drawn from a number of different lineages and villages. Both male and female associations existed and some may have permitted both men and women to become members. High ranking members held insignia in the form of objects such as figurative staffs (see cat. 2.38), animal tail whisks and bracelets. During the period of German rule initiation associations were instrumental in co-ordinating opposition against an oppressive colonial regime. They were therefore banned after the *maji-maji* uprisings of 1905, and by the beginning of World War I had largely died out.

Progress through the ranks was effected through the staging of special initiation ceremonies involving song and dance. Masked dancers also performed during special funeral rites for association members. Very few examples of Kwere masks have ever been collected and almost nothing is known about Kwere masquerade. According to evidence collected by Felix, however, the Kwere and the Zaramo may have used several types of mask including a 'war mask' and a mask danced at ceremonies connected with initiation. *ZK*

Bibliography: Felix, 1990, pp. 185–6

2.40

Pole

Kaguru
Tanzania
wood
215 x 20 x 22 cm
Felix Collection

The Kaguru inhabit the Itumba Mountains in north-eastern Tanzania, the plateau region to the north-west of the mountains and the lowland area to the east. They are predominantly agriculturalists. Social life traditionally centred primarily on the matrilineage, with male members of senior lineage segments generally inheriting ritual and jural authority.

Much of Kaguru ritual appears to have involved manipulation of symbols and ideas concerning the interplay of male and female life principles. Figurative poles and other objects (male symbols) were frequently carved with female imagery to create ritually powerful conjunctions of male and female symbols. Such artefacts were used in a variety of ceremonial contexts. Felix indicates that figurative poles were erected in meeting houses used by the 'secret' associations (now extinct). They were also erected outside Kaguru houses, often under thatched shelters, and served to protect the village from mystical dangers.

The pole illustrated here would originally have formed the central post of a Kaguru girls' initiation hut, although it is possible that similar poles may also have been used in the contexts mentioned above. The form of the pole is intended to represent an abstract female figure, as is suggested by the prominent breasts. The bifurcation at the top of the pole is thought to represent the traditional divided hairstyle which is a motif common to much of the figurative art of the matrilineal peoples of north-eastern Tanzania. Like certain other forms of ceremonial paraphernalia, including staffs and poles, formerly widely used during initiation rites in the region (and best known from Zaramo and Kwere examples), this pole may have served to help protect and ritually empower female initiates during their seclusion within the initiation hut. *ZK*

Bibliography: Beidelman, 1972, p. 41; Felix, 1990; Felix, in Berlin and Munich 1994, p. 223

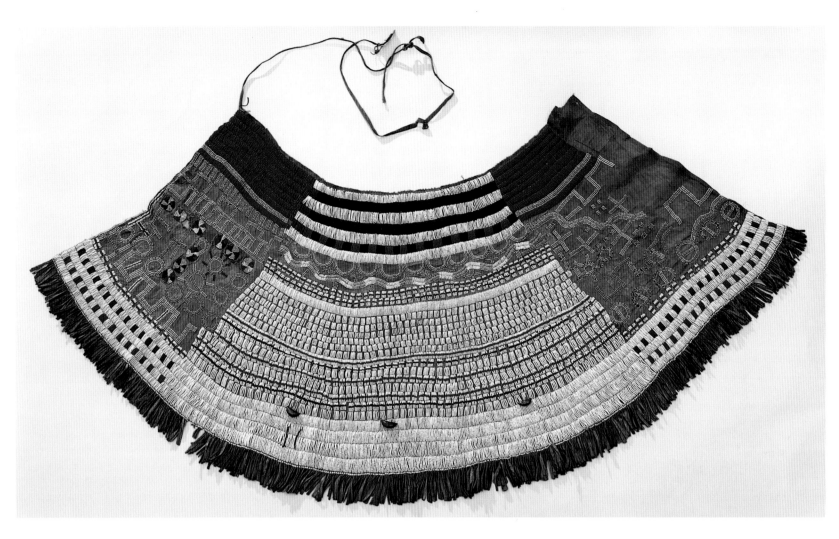

2.41

Skirt

Iraqw
Tanzania
early 20th century (?)
dressed animal skin, glass beads,
sinew thread, metal bells
170 x 70 cm
Commonwealth Institute, London,
T/TANZ/134

The Iraqw peoples, numbering today perhaps as many as 300,000 or more, inhabit the Arusha region of northern Tanzania. Although they are often said to be Southern Cushitic-speaking, the classification of their language remains disputed. The Iraqw keep livestock and grow crops on a plateau to the west of the Rift Valley. Their neighbours are the Maasai, Hadza, Barabaig and Gorowa, as well as several Bantu-speaking peoples. Their art and material culture have been little studied.

Iraqw beaded skirts are arguably the most elaborately decorated items of dress in eastern Africa, and this one is an excellent example of the tradition. It consists of four hide

panels, on which thousands of glass beads have been applied with a lazy-stitch to form a number of bands and geometric motifs. It is also adorned with three bells. The central panel was worn at the back, while in front the right edge was wrapped over the left, the two ends being tied. The skirt must be imagined wrapped around the waist of a young woman whose movements, whether walking or dancing, are constrained by the weight of the skirt (perhaps 15 kg or more) and emphasised by the swaying of the fringe and the tinkling of the bells. A fully dressed girl would also be adorned with anklets, wristlets, bracelets and necklaces, as well as having oiled and perfumed skin and specially dressed hair. The range of colours of the beads employed here – predominantly the basic contrasting colours white, red and black, with some dark blue and a little yellow – is typical of earlier eastern African beadwork; later examples incorporate a range of other, complementary colours, such as light green and light blue.

The history of this skirt before 1979 remains uncertain; any attempt to date it is speculative. The traditional context in which such skirts were made and used, the girls' initiation ritual Marmo, was abolished by the government-appointed chief, at least publicly, in 1930. In this rite of passage girls of the age of fourteen or so were secluded for a period of between six months to a year and underwent a symbolic death and rebirth: during this time they were fed rich foods so that they became fat; their bodies were oiled, perfumed and decorated; and they were taught sexual manners and the secrets of the exclusively female Marmo Society. The rite also seems to have had an important purifying aspect, so that the young girls were reborn with a new innocence and dignity. In addition, during this period each girl turned the leather cape with which she entered seclusion into an elaborately beaded skirt to her own design.

Despite its public abolishment, elements of Marmo have survived. Songs associated with the ritual

continue to be sung at ceremonies and beaded skirts to be worn. It is also possible that at least some women have continued to practise a version of Marmo, the secrets of which remain guarded by initiated Iraqw women; therefore, while it seems likely that the motifs decorating this and similar skirts have symbolic significance, their meanings are unknown to outsiders. In other contexts at least, however, the colour white (*awaak*) has associations with light, clarity, health, well-being, healing, curing and purification. It may be that the white beads that dominate this and other skirts symbolise in some way the new purity of the Marmo initiate. *JXC*

Provenance: by 1979, Commonwealth Institute, London

Exhibition: London and New York 1979–83

Bibliography: Wembah-Rashid, 1974, covers and p. 4; Perham, 1976, p. 95; Picton and Mack, 1979, p. 180; Thornton, 1980; Oliver and Crowder, 1981, p. 422; Wada, 1984; Carey, 1986, pp. 21–2, 26, fig. 17

2.42

Omusinga holder

Banyambo
Karagwe, Tanzania
18th–19th century
wrought iron
h. 72 cm
Marc and Denyse Ginzberg

Omusinga holders were used to hold
sticks of the plant *Hibiscus fuscus*, a
much-branched shrub growing to
three metres. Clearly these holders
were important items in the royal
insignia as there were at least 50 of
them, representing a considerable
labour of highly skilled blacksmith-
ing. Photographs of the Karagwe
insignia taken in 1928 show a number
of holders planted in the ground and
holding long straight sticks which
were named by a local informant as
omusinga. And in 1966, when the
former king, Rumanyika II, was
visiting a village, he was presented
with sticks of this plant. An oral
tradition records that during new
moon ceremonies the holders with
sticks were placed in the ground to
screen the royal drum *Nyabatama*.
The fibrous quality of *omusinga* made
it useful as a toothbrush, and it was
also used to beat sour milk. But
perhaps most significantly, its long
straight sticks were used for spear
shafts.

 In this virtuoso example the seven-
ply plaited iron shaft supports seven
sockets; the distal end is pointed.
HS

Bibliography: Stanley, 1878, p. 473;
Stuhlmann, 1910, pp. 77–8, figs 41–5

2.43

Wrist guard (*igitembe*)

Tutsi
Burundi
first half 20th century
wood, copper
21.5 x 17.5 cm; thickness 10 cm
The Trustees of the British Museum,
London, 1948. AF. 30.5

There is very little written docu-
mentation about the wrist guards
worn by bowmen. Normally
functional, with no special claim to
artistic merit, they are usually worn
on the left wrist, to protect the
archer's forearm from being bruised
by the recoil of the bowstring. In the
Western world a wrist guard is likely
to be a leather gauntlet; in some parts
of Africa a pad may be worn; in
Rwanda the Tutsi used a thick brace-
let made of a grass hoop covered with
plaited grass in a chequer pattern of
black and white.

 A massive wooden wrist guard
(*igitembe*) is a rare object. As de-
scribed by Celis, this one comes from
Burundi. There seems to be no other
mention of such guards in the
literature. This may in part be due
to the fact that they do not look like
archers' wrist guards, and may be
taken for bracelets. The present
example is heavy, penannular with a
gap of only 28 mm; the central hole
measures 55 mm at its greatest width.
The wood is inlaid with thirteen small
copper squares, three sunbursts of
radiating lengths of copper wire and
numerous small copper circles,
making a balanced design. The copper

would have come from Katanga in
Zaire, and the wire appears to be
hand-drawn. Such a wrist guard
would appear to belong to an archer
of high rank, perhaps one of the royal
bodyguard, as an insignia of office.
MC

Provenance: Daniel P. Biebuyck; purchased
by the museum from M. de Beer, Brussels
Bibliography: Celis, 1970, p. 41; Sieber,
1972

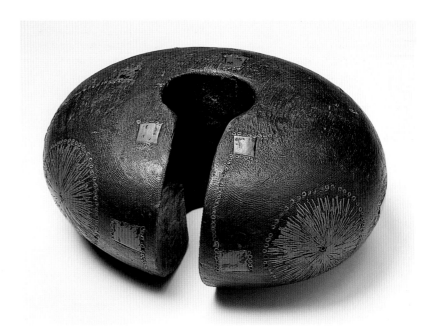

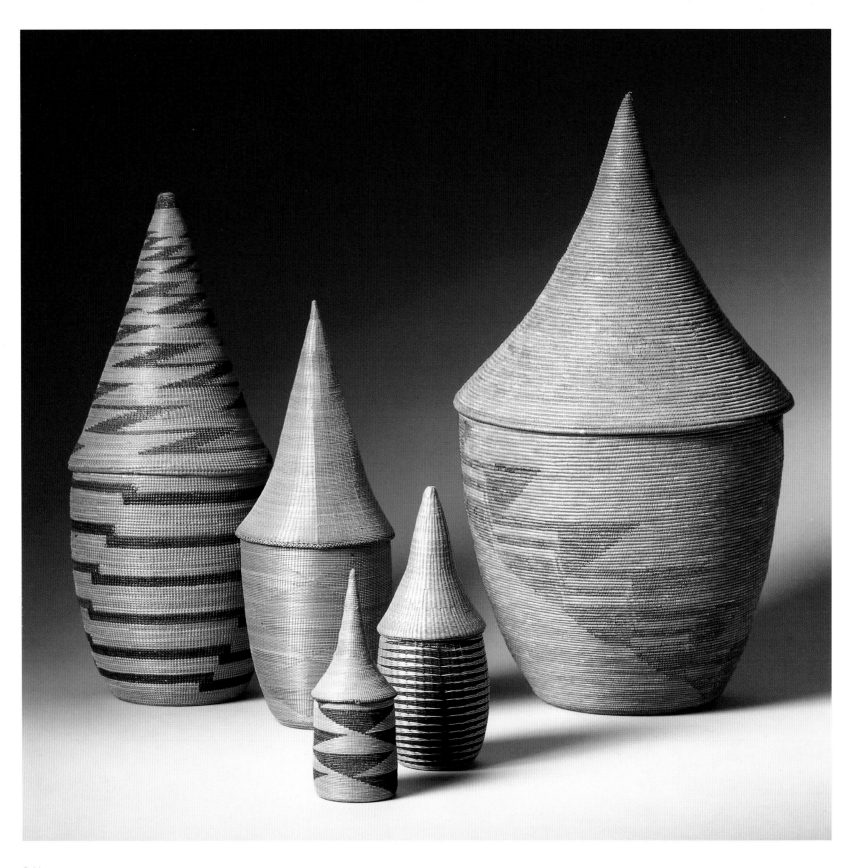

2.44a

Five miniature baskets

Tutsi
Rwanda and Burundi
first half 20th century
grass; black and red dye
h. 28 cm; 23 cm; 11 cm; 14 cm; 33 cm
W. and U. Horstmann

Coil-sewn baskets (*agaseki*) with conical lids were made by Tutsi women of the aristocracy. The fine coil sewing and the precisely worked out spiral patterns, many of which have names, was time-consuming, and called for exact calculations in the stitching. Since the Tutsi were the ruling group in Rwanda, their women had the leisure they needed to perfect their skill in making these ultra-fine and elegantly patterned containers, which were often miniature marvels, some no more than 15 cm high overall. Small, flat, saucer-shaped basketry trays (*agakoko*) were made originally for presentation. The restrained colour palette and subtle variations of pattern, based on spiral lines and zigzags with triangles incorporated, make this among the world's most refined achievements in basketry.

The traditional colours were the natural pale gold of the grass with the pattern in black or red. Black came from boiling banana flowers – the sap gave the black dye *inzero*. The red dye came from boiling the root and seeds of the *urukamgi* plant. By the 1930s imported dyes had expanded the range of available colours to include green, orange and mauve.

Earlier baskets, such as these lidded ones, show a delicacy of design that later examples, made at craft centres for sale to tourists, lack. Baskets made in Rwanda have a plain, undecorated lid; lids of those made in Burundi may be patterned. *MC*

Provenance: 1948, the larger tray collected for the museum, with documentation, by J. Lister

Bibliography: Trowell and Wachsmann, 1953, pp. 141–2, pl. 31A; Celis, 1970, pp. 40–2

2.44b

Two basketry trays

Tutsi
Rwanda
1940s
grass; orange, mauve and dark blue imported dyes
diam. 9.5 cm, 12 cm
The Trustees of the British Museum, London, 1948. AF. 8.422/1

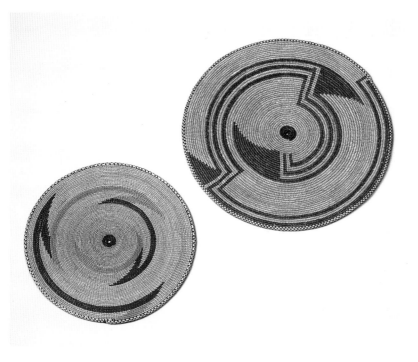

2.45

Shield

Kerebe/Kara
Tanzania
wood, fibre and pigments
125 x 34 cm
Museum für Völkerkunde, Vienna, 60751

Bukerebe is a large fertile island in south-eastern Lake Victoria which supports dense banana groves and cultivation of millet and other crops. Originally settled by sections of Bantu-speaking clans from the mainland (including a large segment of the Jita group and a smaller section of the Kara) Bukerebe came under the control of Sese immigrants from the western lakeshore area whose ruling clan, the Silanga, established a chiefdom on the island in the 17th century. Sese power was concentrated in a chiefly court which appointed regional headmen from the Silanga clan. Before the colonial era and the deposition of chief Rukonge in 1895, Kerebe society was organised according to a strict ethnic hierarchy in which the majority Jita and Kara inhabitants held a subservient position with respect to the Sese. The activities of missionaries and European administration, along with the introduction of the cash economy, set in motion a process of 'democratisation' and a breakdown in the old order which has more or less continued to the present.

Although the shield illustrated here is typical of the kind found on Bukerebe and Bukara islands, similar shields also appear to have been used by Zinza people who inhabit the mainland south-west of the lake. The pattern of repeated isosceles triangles, carved in relief and painted, is a common form of decoration on shields from this area. The juxtaposition of white, red and black colours is a widespread motif in Bantu-speaking Africa and may relate to a common underlying element in the belief systems of these societies. However, the particular significance of these three colours as they are painted on the shield is not known. Shields of this kind would probably have ceased being made in the 1940s. *ZK*

Bibliography: Hartwig, 1969[1]; Hartwig, 1976; Plaschke and Zirngibl, 1992, pp. 78–9

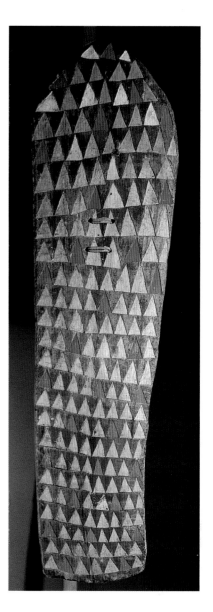

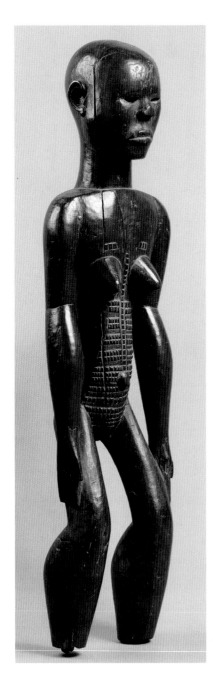

2.46

Presentation figure

Nyamwezi/Kerebe
Tanzania
wood
83 x 21 x 6 cm
Private Collection, London

This female figure represents something of an enigma. The Kerebe from the island of Bukerebe in south-eastern Lake Victoria are not known to have produced any figurative wood sculpture until some time after the deposition of 'Chief' Rukonge by the Germans in 1895 when a man called Buzuzya (who was originally a carver of shields for Rukonge) began making human figures mainly for the European market. The few available published illustrations of Buzuzya's work show that his figures were generally straight-limbed with short arms and large, somewhat spherical, heads. The long arms, bent limbs and more realistic head of the figure illustrated here would therefore indicate that it is not one of Buzuzya's works. The cross-hatched scarification marks which decorate the chest and abdomen of the piece also suggest that it is not the work of a Kerebe carver. In its posture and proportions the sculpture bears a certain resemblance to a *kigiilya* figure (cat. 2.47). The *kigiilya* figure was carved on Bukerebe island by a Nyamwezi member of an ivory trading expedition, and it would seem likely that the sculpture shown here is also the work of a Nyamwezi carver. The production and presentation of such figures probably represented one way in which Nyamwezi traders or trader emissaries were able to enhance their standing with powerful chiefs in the lake region. The *kigiilya* figure is known to have been used by the Kerebe chiefs Machunda and Rukonge in the exercise of power, although other figures of this kind appear to have been used only for show by their Kerebe recipients. ZK

Bibliography: Hartwig, 1969[1];
Hartwig, 1976

The improbable tale which accompanies this sculpture is highly instructive about the nature of art history in eastern Africa. The story was unravelled by the late Gerald Hartwig. The comments which follow derive mainly from his detective work both in eastern Africa and in relevant museum archives elsewhere.

The first problem which arises concerns the identification of the piece. It is generally said to be of Kerewe (or better, Kerebe) origin, that is from the people who occupy the island of Bukerebe in the south-eastern corner of Lake Victoria; and indeed, the figure was certainly originally in the care of a Kerebe chief (*omukama*) called Rukonge. He had obtained it on inheritance of his title from his father Omukama Machunda. Furthermore, the piece was much respected in Kerebe society for its reputed powers. On the day of its completion Machunda's uncle died and the two events were inseparably linked. It became common knowledge that the man in question had not died but had mysteriously translated into the figure, and that Machunda himself had enabled this transformation. The event took place sometime before 1869, the year of Machunda's death. Until the figure was removed in a military mission in 1895, it was kept securely in the chiefly quarters and seen only by leading Kerebe and privileged visitors. It has thus an undeniable place in the context of Kerebe chiefly power in the second half of the 19th century.

Hartwig, however, was able to confirm that the work was not, in fact, created by a Kerebe carver, and indeed that there was no extensive tradition of Kerebe carving before this century. Bukerebe island was much frequented by the Nyamwezi who acted as emissaries of the Arab–Swahili trading outpost set up at Tabora, in what is now Tanzania. The figure, it seems, was created by a Nyamwezi carver who accompanied an ivory trading expedition to the island. Its naturalistic style and large format certainly bear little relationship to the figures from the eastern side of Lake Tanganyika which have more in common with Zairean traditions of carving.

A second figure in a similar style to this piece – this time of a female – is in the collections of the British

Museum. This piece was acquired by a well-known missionary, the Rev. John Roscoe, in Uganda; here it was said to have been created for the Ganda king (*kabaka*) Sana, who died in 1856. But Machunda and Sana were contemporaries and are known to have engaged in diplomatic exchanges. This second piece would seem to have been one example of such gift-giving. It is remembered by the Kerebe that the arm was broken when Kabaka Sana received the figure (a feature that still distinguishes it). It too is probably of Nyamwezi manufacture.

The sculpture illustrated here also had a chequered history once it left the keeping of Omukama Rukonge. It first fell into the hands of the resident White Fathers who used it to demonstrate the supposed perils of paganism. Its present battered appearance is testament to its treatment. The object was reputedly beaten with sticks, its eyes gouged and its sex organs removed – victim of acts of revenge against the Omukama and his people who had attacked a group of native converts. Thus this piece, like its companion sculpture in the British Museum, has been recontextualised at least twice within Africa itself before it ever reached a museum collection. *JM*

Bibliography: Fagg, 1965, p. 115;
Hartwig, 1969

Nyamwezi

The people known as Nyamwezi are a large, loosely connected agrarian group with shared cultural traits but diverse origins who live in north-central Tanzania. Since the early 19th century they have been organised into small semi-autonomous chiefdoms, except for a period in the late 19th century when two strong chiefs, Mirambo and Nyungu ya Mawe, established separate hegemonies in extensive portions of Unyamwezi (the land of the Nyamwezi). At this time the Nyamwezi were increasingly involved in the caravan trade that crossed their territory, and many of them travelled between the Congo (now Zaire) and the Indian Ocean trading towns. It was on the coast that they were given the name 'Nyamwesi', meaning 'people of the west' (sometimes translated as 'people of the moon', because the new moon is visible only as it sets in the west).

Because of the extensive size and ethnic diversity of Unyamwezi the art from this area shows considerable variation in style, even though the principal art forms, such as discrete human figures and figured high-backed stools, are of similar type. Ancestors and chiefs have been of considerable importance in the belief system and socio-political structure of the Nyamwezi, and consequently most of their art relates to these themes: theirs is one of the richest art traditions in Tanzania. *NIN*

Bibliography: Murdock, 1959, p. 359; Abrahams, 1967, pp. 11–12; Were and Wilson, 1972, pp. 79–86

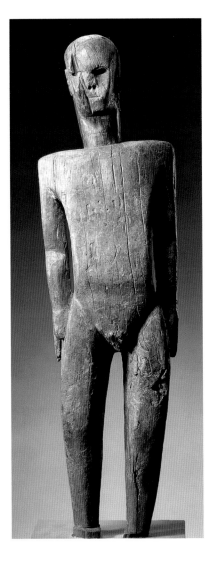

2.47

Presentation sculpture and power figure (*kigiilya*)
Nyamwezi/Kerebe
Tanzania/Lake Victoria
wood
h. 114 cm
Staatliche Museen zu Berlin, Preussischer Kulturbesitz, Museum für Völkerkunde, III E 5529

2.48

Female figure
Nyamwezi
Tanzania
c. 1900
wood
h. 74.5 cm
Private Collection

This figure exemplifies some of the finest qualities of Nyamwezi sculpture, seeming almost to burst with dynamism and exuberance. Its animated facial expression, enhanced by the beaded eyes and open mouth garnished with teeth, as well as its

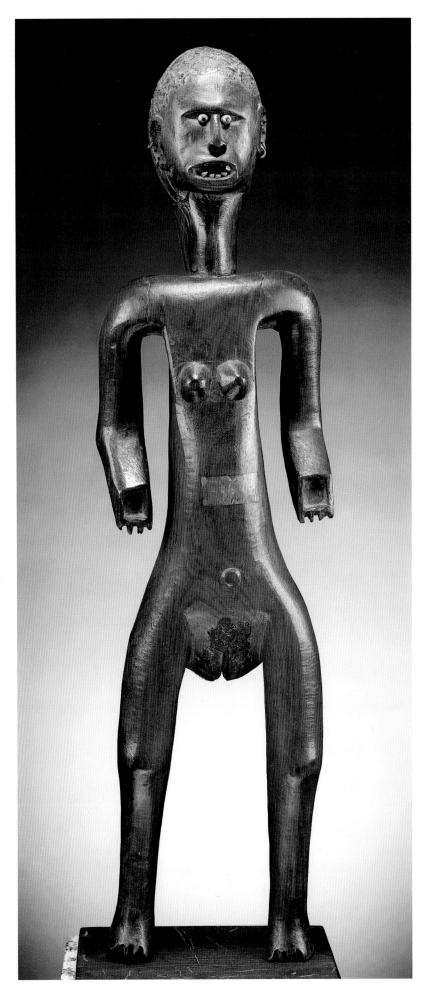

taut and vigorous posture, are expressive of strong feeling and kinetic energy. Like the Nyamwezi high-backed stool (cat. 2.49) it has a compelling emotional quality.

The figure's grimacing countenance and the addition of hair and teeth suggest that it comes from an outlying area of Unyamwezi, probably influenced by the art traditions of an adjacent people to the east, such as the Sukuma who form part of the Nyamwezi group; similar features are sometimes seen on Sukuma masks or figures. While the central Nyamwezi style is usually characterised by a contained serenity of aspect and form, Sukuma art is more expressionistic and animated. Like virtually all free-standing sculptures of the Nyamwezi, this piece probably represents an ancestor. *NIN*

Provenance: 1900, collected in Tanzania
Bibliography: Holy, 1967, pp. 34–5; Gillon, 1984, p. 327; Leurquin and Meurant, 1990, pp. 19-20; Felix, Kecskési et al., 1994, pp. 233–4, 266–82, 408–13

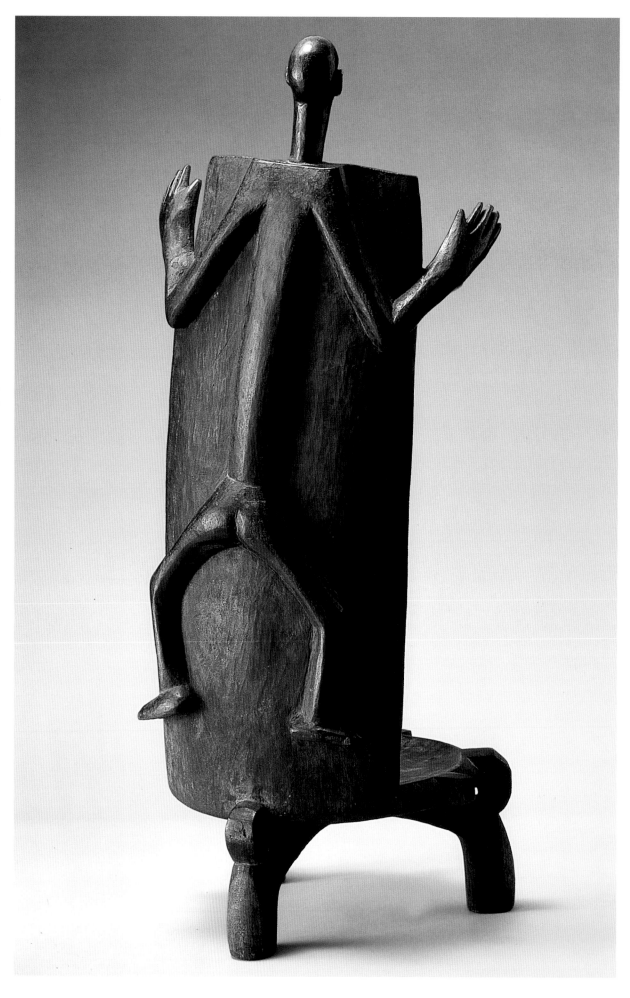

2.49

High-backed chief's stool

Nyamwezi
Tanzania
late 19th century
wood
h. 107 cm
Staatliche Museen zu Berlin, Preussischer
Kulturbesitz, Museum für Völkerkunde,
III E 6720

This is arguably the most famous
piece of Nyamwezi art, known for
both its history and its aesthetic
qualities.

Collected by Lt von Grawert in
1898 from the Sultanate (or chiefdom)
of Buruku in eastern Unyamwezi, this
stool had been the property of the
Sultan. The term Sultan, used in east
Africa to designate chiefs along the
Swahili coast, was also applied to
important non-Arab chiefs who ruled
in areas along the caravan trade routes
that passed through the heart of
Unyamwezi.

Stools with high carved backs were
reserved for chiefs and sometimes
used in pairs (one for the chief, the
other for the consort), generally
revealing male or female attributes.
This example has a human figure
carved on the dorsal side of the high
back, with head and hands projecting
from the edge of the backrest as if to
embrace or protect the occupant of
the throne. The head of the figure
shows strong Nyamwezi character-
istics, with beaded eyes, lean facial
structure and prominent, pursed
lips. But the object is most readily
identified by the form of the stool
base. The three convexly curved legs
alternating with three protruding lugs
are typical of Nyamwezi stool forms.
NIN

Provenance: 1898, collected by Lt. von
Grawert from the Sultan of Buruku

Bibliography: Blohm, 1933, pp. 140–1;
Fagg, 1965, p. 117; Wembah-Rashid, 1989;
Krieger, 1990, p. 22, pls 102–3; Nooter, in
Felix, Kecskési et al., 1994, pp. 294ff.

2.50

Female figure on stool

Nyamwezi
Tanzania
wood
h. 94 cm
Private Collection

Throughout Africa, stools signify
status and rank. Figures shown seated
or standing on stools are thus imbued
with special meaning as expressions
of spiritual or temporal power. This
Nyamwezi figure probably represents
a female ancestor, or refers to a chiefly
lineage.

The tradition of using high-backed
stools among chiefly societies in east
Africa appears to have followed
migration and trade routes. Similarly,
stool-figures show patterns of
occurrence on both sides of Lake
Tanganyika among peoples governed
by chiefs. In this part of the continent
the most prolific expression of the
convention has been found among
the Tabwa people of south-eastern
Zaire. It is known that there has long
been communication between the
Tabwa and groups across the lake in
Tanzania, including the Nyamwezi.

This Nyamwezi stool-figure differs
from Tabwa examples in several
respects. The figure is female, whereas
the illustrated Tabwa figures on stools
are male. All Tabwa pieces are full
figures, while the Nyamwezi is a
trunk; only the head and torso are
depicted. Its style conforms to that
of the central Nyamwezi, with such
features as an erectly held head,
prominent ears, beaded eyes and
pursed lips. The typically long and
slender torso rises from a stool form
that is prevalent in Unyamwezi. Even
though other Tanzanian peoples are
known to have stool-figures – for
example, the Jiji figure in the Linden-
Museum, Stuttgart, and the Tongwe
figure (cat. 2.53) – their large number
among the Tabwa suggests that
the idea originated in Tabwaland
and spread eastward to the (Tabwa-
related) Jiji, the Tongwe, the
Nyamwezi and others further east.
NIN

Bibliography: Hartwig, 1978, p. 64;
Roberts and Maurer, 1985, pp. 106, 116,
122, 148, 246; Nooter, 1994, pp. 294–306

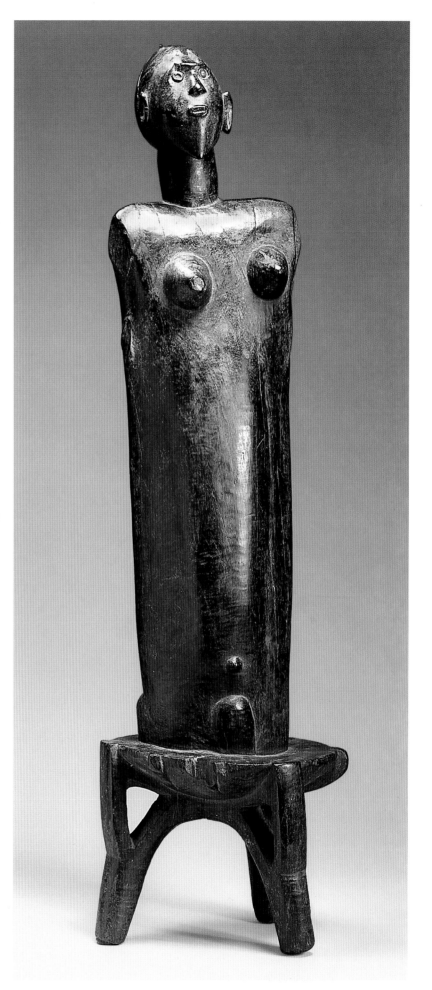

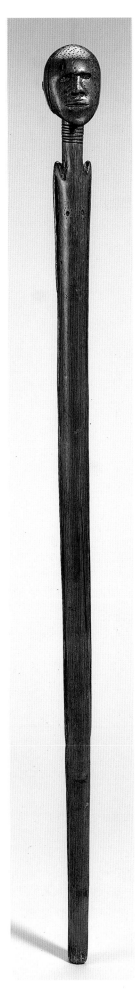

2.51

Staff

Nyamwezi
Tanzania
wood
h. 97.5 cm
Private Collection

In Africa, staffs have long had numerous and varied uses, ranging from their purely utilitarian function as walking-sticks to more exalted roles pertaining to spiritual, political or prestige matters. In addition, they sometimes communicate specific messages through their iconography, thus serving as documents whose sculpted forms can be understood as narratives. The degree of specialisation in the use of staffs by any group generally corresponds directly to the complexity of a staff's decoration.

This spare and elegant Nyamwezi staff probably served as the prestige emblem of a local chief. The integrity of its form and design does credit to the artist, who understood its role as both body support and statement of rank. The staff's overall structure and the delicate details of its carving are in artistic harmony, with facial features that are finely pared, strong, and enhanced by small pierced patterns indicating hair and beard. The notched shoulders and the arms rendered in relief along the sides of the staff are characteristic of its understated refinement. *NIN*

Bibliography: Felix, Kecskési et al., 1994, p. 262; M. N. Roberts, in A. F. Roberts, 1994², p. 24

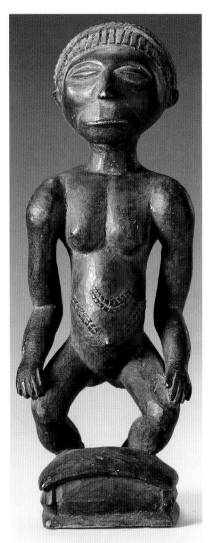

2.52

Female figure

Holoholo
Eastern Zaire/Tanzania
wood
h. 26 cm
Staatliche Museen zu Berlin, Preussischer Kulturbesitz, Museum für Völkerkunde, III E 12750

The Holoholo are a small group who occupy a portion of land on the western shore of Lake Tanganyika and some of whom have migrated to the Tanzanian side of the lake. They live in close proximity to the Hemba and Tabwa peoples, and fall within the Luba sphere of influence. Stylistic similarities to the art of these groups are very marked in this piece, as they are in other examples collected from the Holoholo at around the same time.

The matrilineal Holoholo are descended from the Baguha and other small ethnic groups of eastern Zaire. Although they now are governed by hereditary village chiefs and councils of elders, they maintained until the late 19th century a more stratified type of political organisation that is reflected in their early figural sculpture. Holoholo statuary known from this previous period bears the hallmarks of high social status, with elaborate coiffures, patterns of scarification, delicately rendered facial features and smoothly patinated surfaces, as are seen in this example. Balanced upon a base, with the feet only barely indicated by a single curved platform, this figure radiates confidence, serenity and strength. *NIN*

Provenance: collected in the former Belgian Congo (Zaire); 1907, donated to the museum by Schloifer

Bibliography: Schmitz, 1912, pp. 425–6; Murdock, 1959, pp. 296–300; Fagg, 1965, p. 104; Krieger, 1978, pl. 244, p. 115; Felix, 1989, pp. 201–3

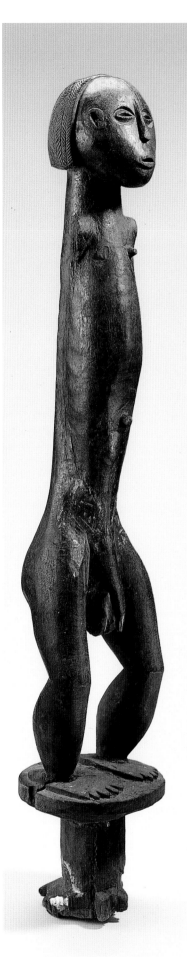

2.53

Male figure on stool

Utongwe
Western Tanzania
wood
h. 78.5 cm
Bareiss Family Collection

The term Utongwe refers to the area or place of the Tongwe, a small group living among the Bende of western Tanzania on the central part of the eastern shore of Lake Tanganyika. Except for this object, virtually no art is known from the Tongwe, and very little has been discovered from the Bende who surround them.

Since the early 1900s chieftainship has been a strong institution in western Tanzania, largely influenced by the political system of the Interlacustrine kingdoms to the north. Therefore it is not surprising that figural art and chiefs' thrones from this general area relate to power and prestige.

This male figure from Utongwe eloquently expresses the qualities of dignity and leadership. Its carving bears stylistic similarities to that of the Jiji just to the north, who are an offshoot of the Tabwa people across Lake Tanganyika in Zaire, as it also does to the art of the Tabwa themselves. Allen Roberts points out that several groups, including the Bende and Tongwe, claim a common origin with the Tabwa. The facial features and elaborated coiffure of this figure show strong Tabwa influence, as does the convention of a human figure standing on a stool, which according to Evan Maurer is a sign of rank and status. These attributes suggest that the figure probably represents a chief.
NIN

Bibliography: Murdock, 1959, pp. 359–62; Fagg, 1965, p. 116; Holy, 1967, pl. 29, p. 45; Krieger, 1978, pls 104–7, pp. 22–3; Roberts and Maurer, 1985, pp. 116, 148, 161; Felix, Kecskési et al., 1994, pp. 359–60

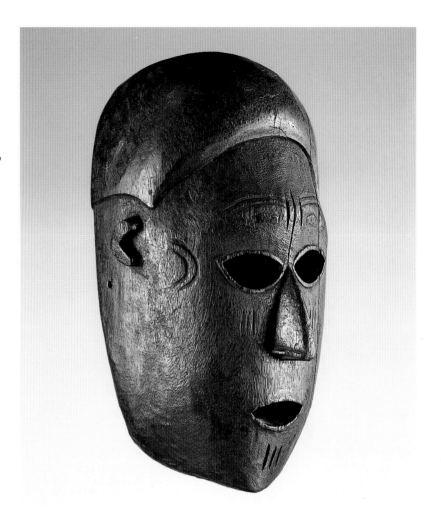

2.54

Mask

Lungu
Zambia or Tanzania
wood
h. 29.5 cm
Felix Collection

The Lungu (sometimes called Rungu) inhabit a broad area around the southern and south-eastern shores of Lake Tanganyika mainly in north-eastern Zambia and into south-western Tanzania. During the 19th century they were greatly reduced in number through the depredations of Ngoni, Arab and Bemba raiders.

The Lungu are predominantly horticulturalists with fishing constituting an important economic activity. They are divided into a number of dispersed, exogamous, patrilineal clans within a collection of chiefly districts headed by a titular paramount chief who appears to have had considerable ritual authority but little real power beyond the chiefly village. Although Lungu boys are not known to have undergone male initiation rites, the British missionary Swann, who visited the area in 1883, reports that Lungu girls were put through initiation rites characterised by 'extremely harsh discipline', during which they underwent a variety of painful and humiliating ordeals. These rites appear to have been aimed principally at preparing the girls for marriage, which took place at an early age and involved onerous obligations and duties. Masks of various kinds were worn by the initiators at a particular stage in the female initiation rites in order to terrify and impress. Masks, such as the one illustrated here, are very rare and no longer used during female rites among the Lungu. Thus nothing can be inferred about the ideology or ritual observances that may have accompanied their creation and use.
ZK

Bibliography: Swann, 1910, pp. 193–4; Willis, 1966

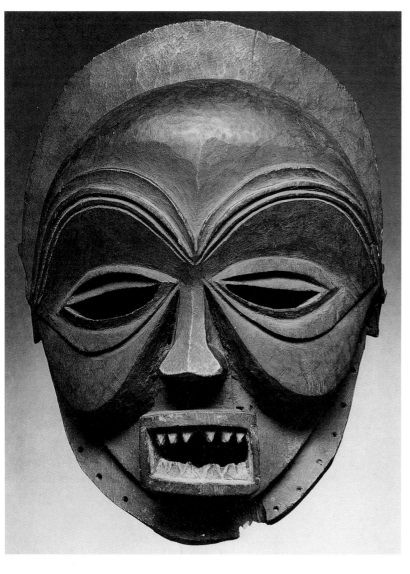

2.55

Mask (*samahongo*)

Mbunda
Zambia
19th century
wood
h. 43 cm
The Carlo Monzino Collection

The Mbunda people migrated from Angola into the area of the Lozi kingdom (Barotseland) during the 18th and 19th centuries and have become largely assimilated both culturally and politically by the Lozi. They are now scattered throughout the Western Province of Zambia.

Mbunda men enjoy the reputation of being expert at wood carving. This wooden mask is intended for use during the period of the boys' circumcision ceremony called *mukanda*. Among the Mbunda young boys who have reached puberty are secluded in a specially created circumcision camp for a period of between three and six months. During this time they are

circumcised and taught the behaviour and accomplishments necessary for adulthood. When they have recovered from the operation and are considered to have been sufficiently educated, *makisi* dancers, who are said to be the ancestral spirits of the boys, go to entertain the villagers, especially the women. Various types of *makisi* appear at this celebration. Many of them wear masks made of barkcloth; among them are *munguli* (hyena), *liweluwelu* (guinea fowl), *chizaluki* (chief), *kaluluwe* (hunter). Wooden masks, such as this one, are also used on the day following *makisi* dancing, when the boys are brought back to the village. Some *makisi* dancers are also invited to dance in the Lozi villages on other festive occasions.

The mask shown here used to be in the collection of the sculptor Jacob Epstein. Although there is no direct ethnographic information, the mask seems to be one of the type of mask called *samahongo*. *Samahongo* plays

the role of an old diviner. Common features are convex forehead and cheeks, and recessed eyes. In many of them, cheeks are inflated into two globular forms. In this mask, ridged arcs marking the cheek bones and the eyebrow surround the eyes with protruding eyelids; the eyes are situated in the middle of circular frames. This linear treatment of the eye area may suggest the carver's connection or familiarity with the style of the neighbouring Chokwe people. *KY*

Provenance: ex Jacob Epstein Collection
Exhibitions: London 1960, no. 42; New York 1984, no. 136; Florence 1989, no. 134
Bibliography; Fagg, 1960, no. 47; Fagg and Plass, 1964, p. 57; Pericot-Garcia et al., 1967, p. 180; Rubin, 1984, p. 145; Vogel, 1985, no. 136; Bassani, 1989, no. 134; Holy, 1971, p. 11, Papstein, 1994, pp. 152–5

The Lozi live in and around the flood plain of the Zambezi River in the Western Province of Zambia. Since the 18th century they have assimilated elements of many neighbouring ethnic groups including the Ndundulu, Kwangwa, Mbunda, Ila, Tonga, Lunda and Chokwe. The term 'Barotse' gained currency through usage by the Paris Evangelical Mission, and has been used to refer to the whole kingdom, of which the Lozi are the dominant group. In 1890 and 1900 a British Protectorate was established over Barotseland under treaties with the British South Africa Company which to a large extent endorsed the powers of the Lozi king. Even after the independence of Zambia in 1964, the political power of the Lozi king over the area has been substantially retained.

While the Lozi are noted for their fine basketry, they do not normally work in wood, except for making dugout canoes. It is the carvers from several subjugated groups such as the Kwanga and Mbunba who meet the demand for wooden objects at the Lozi court. Among the best known objects are the lidded bowls used for meat and vegetables. The surface of the bowls is usually smooth, and the top knobs or handles of the lids form the main decorative element. In many examples, the handles are modelled into highly stylised figures. Bertrand (1898) provides one of the earliest illustrated records of this type of lidded bowl. He was given a bowl with an elephant carved on the lid by King Lewanika in 1895 and calls it a 'royal plate (*plat royal*)'.

It is worth noting that the figures are not only stylised but arranged in conformity with the shape of the bowls. For example, the oval shape of the bowl cat. 2.56b is repeated in the form of the ducks. *KY*

Bibliography: Sydow, 1932; Schmalenbach, 1953; Leuzinger, 1960; Leuzinger, 1972; Leuzinger, 1978; Bertrand, 1898

2.56a
Bowl with lid

Lozi (Barotse)
Zambia
wood
diam. 37 cm (bowl); 35 cm (lid)
Linden-Museum, Stuttgart, F50686

2.56b
Bowl with lid

Lozi (Barotse)
Zambia
wood
15.1 x 21.3 x 35 cm
Museum Rietberg, Zurich, RAF 1101

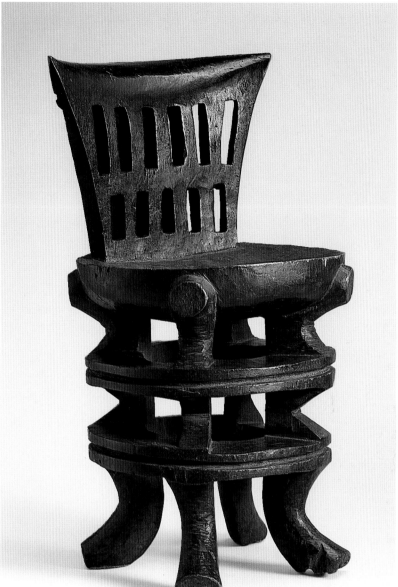

2.57
High-backed stool

possibly Chewa
Central Region, Malawi
wood
53.5 x 29.5 x 29.5 cm
Horniman Public Museum and Public
Park Trust, London, 1981.130

Throughout Malawi woodcarvers have been able to hew mortars, gaming boards, large meat-trays, stools and even entire boats from the tall trees that grow in the higher altitudes throughout the country.

A traditional style of high-backed chair is unknown in Malawi. Typically, both royalty and commoners preferred to sit close to the ground, on a skin, a mat or a small stool. This spectacular chair reflects a blend of foreign and traditional influences frequently found in prestige objects. Here, the carver has announced the high status of the owner by carving three separate tiers of a traditional-style four-legged stool, one stacked on top of the other. The legs are concave in shape, which gives a slightly zoomorphic look to each tier. The surface of the chair shows none of the delicate, zigzag decoration typical of most Swahili-inspired artwork, yet the pattern of rectangles that pierce the back support echoes grille-work patterns carved on the back of early Swahili chairs. *MC*

Bibliography: Pullinger, 1982; Allen, 1989, pp. 54–64

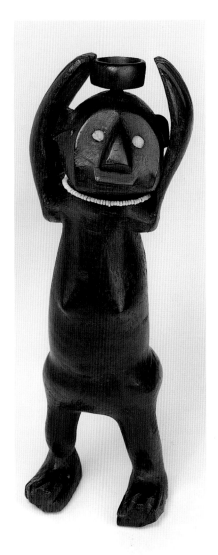

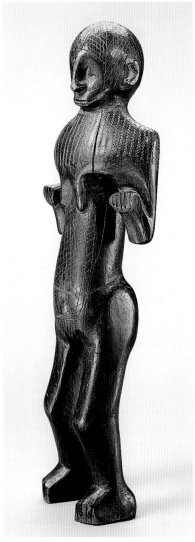

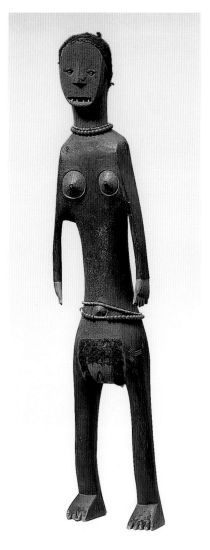

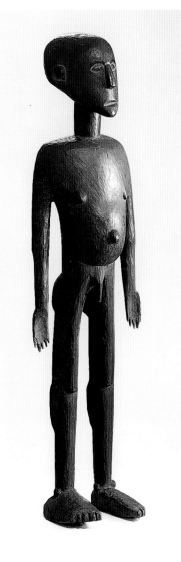

2.58a

Female figure

Malawi
wood, glass
27 x 7 x 5 cm
Museum für Völkerkunde, Vienna,
122.136

2.58b

Female figure with scarification

Malawi
wood
h. 48 cm
Bareiss Family Collection

2.58c

Female figure

probably Yao
Malawi
1909
wood
76 x 18 x 11 cm
The Trustees of the British Museum,
London, 1909.24

2.58d

Male figure

Malawi
wood
103 x 30 x 20 cm
Felix Collection

Artistically, the peoples of Malawi have been known only for their decorative utilitarian objects such as baskets, combs, bowls, snuffboxes, spoons, axes, pipes and mortars. Some personal items occasionally incorporated figurative elements, but free-standing sculpture was regarded as rare and idiosyncratic. Without specific ethnographic information relating to context, all figurative sculpture from this region had to be dismissed as the work of self-inspired artists responding to the demands of expatriates for African souvenirs.

However, so many new figures have come to light, some with early collection dates, that the issue must now be re-examined. The four pieces exhibited here, for example, draw upon canons of style too complex to be dismissed as spontaneous invention. 'Tourist' pieces are usually much more transparent in intent. Recent scholarship on pre-colonial educational systems suggests an educational purpose for some of these carvings – a function which would have been hidden from all but the most tenacious early visitor.

Secret, age-initiation schools (*unyago*, *chisungu*) were widespread in south-eastern Africa. They helped to instil traditional cultural values. Tangible objects, including masks, paintings, wooden and clay figurines, were used as didactic aids to inculcate important cultural information. Most were fragile and ephemeral. They were made to be discarded at the close of the initiation 'school'. However, other items, perhaps these wooden figures, would have been difficult and expensive to recarve. These would therefore be carefully preserved,

perhaps stored in caves until needed by the next 'class', or generation of initiates.

The female figure (cat. 2.58a) wears an *ngoti* on top of her head to facilitate carrying loads. The ethnic group from which it comes is not identified. The large, complex female figure (cat. 2.58c) portrays the classic cultural markers associated with the Yao – the nose-plug, a half-circle hairline, blue and white bead jewellery, and a distinctive pattern of parallel line scarification on the buttocks. Like other figures, this

sculpture may have once been used as a didactic aid, in this case to epitomise Yao ideals of beauty, deportment, and the social markings of a mature Yao woman. The fierce abstraction of the face, the figure's archetypal stance and its paddle-like hands link it to other Yao sculptures believed to have been used during initiation. Both boys and girls learned through initiation, but Yao girls were expected to undergo a more thorough and protracted series of classes, culminating in the initiation of First Birth. Consequently, most figures in this style depict the various conditions or stages of womanhood.

At the turn of the century both men and women customarily trimmed their hair, often in very stylish ways, yet the Yao would carefully remove all pubic hair. In this instance (cat. 2.58b) the presence of pubic hair around prominent female genitals (the Yao appreciated large, stretched labia) probably indicates pregnancy or ritual abstention from sexual congress. The Yao initiation master was responsible for managing the community of participants, for performing any surgical operations and for all didactic paraphernalia used in teaching. Therefore, any similarity in the form or style of some of these works may be a reflection of the patronage of the same initiation master rather than being in the hand of the same artist. *MWC*

Provenance: cat. 2.58c: 1909, collected in Blantyre, Malawi; 1909, given to the museum by H. S. Stannus; cat. 2.58d: 1918, Private Collection, Germany

Bibliography: Werner, 1906; Stannus, 1922, pp. 229–372; Heckel, 1935; Harries, 1944; Cory, 1956; Mitchell, 1956; Richards, 1956; Rangeley, 1963, pp. 7–27; Dias, 1964; Alpers, 1966; Holy and Carey, 1967; Kubik, 1978[1], pp. 1–37; Kubik, 1978[2], pp. 37–51; Kecskési, 1982, pp. 52–6

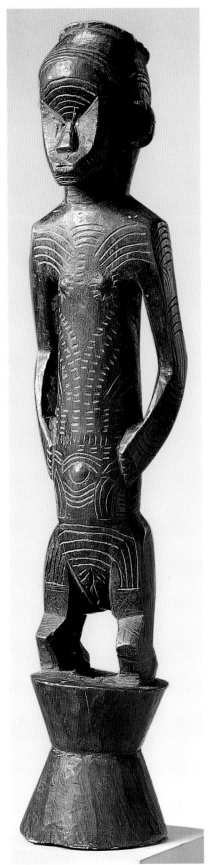

2.59

Female figure

Lomwe/Nguru
Malawi or Mozambique
1901
wood
h. 41 cm
Staatliche Museen zu Berlin, Preussischer Kulturbesitz, Museum für Völkerkunde, III E 9535

The Lomwe comprise a large number of related groups who live mainly in the fertile valley systems running north and south off the Namuli hills situated in northern Zambezia Province, northern Mozambique. Lomwe groups (called Nguru in official reports) also extend into southern Malawi, where they have lived since the famine of 1900 forced them to migrate into the area from further east. Ethnic boundaries are particularly difficult to draw with respect to the Lomwe, as many have intermixed with closely related neighbouring groups such as the Makua on their north-eastern frontier and the Yao on their western frontier. Like the Makua, the Yao and the Makonde, the Lomwe are primarily agriculturalists with a social organisation based on exogamous matrilineal clans.

In response to the upturn in the slave trade in the area during the 19th century some Yao and Lomwe groups became fully involved in the export of slaves and increased their ivory trade with the coast. The resultant acquisition of wealth and enlarged followings by local leaders contributed to the processes whereby the Lomwe developed a 'confederation' of independent territorial chiefdoms. These developments contrast with the situation of the Makonde, who retained a chiefless political organisation and whose response to the increase in the slave trade was to look to their defences on the Makonde plateau and reduce their involvement in trade with the coast.

Among the Lomwe different groups tattooed their bodies with distinctive markings. The type of motif as well as its position on the body indicate status. Persons of high status tended to be more profusely tattooed than others and their tattoos could be applied in various techniques. The elaborate pattern of engraved lines that decorates this figure is undoubtedly intended to represent tattoo marks: the profusion of the lines and their complexity indicate high status. This conclusion is confirmed if one interprets the base of the sculpture to represent a stool. Figures carved seated or standing on a stool are common in many areas of eastern Africa and are frequently intended to represent leaders or others of high rank. The figure illustrated here may have the identifying marks of the ancestress of a particular chiefly matrilineage. It would probably have been used in the context of the chiefly ancestor cult, in which case it would originally have been kept in a shrine in the chief's house. Records of the Museum für Völkerkunde in Berlin indicate that the figure was collected from Mataka village on the shores of Lake Chirua (situated just within the border in south-eastern Malawi). *ZK*

Provenance: Wiese
Bibliography: O'Neill, 1883–4; Tew, 1950; Dias, 1964; Alpers, 1969; Schneider, 1973; Krieger, 1990, p. 66

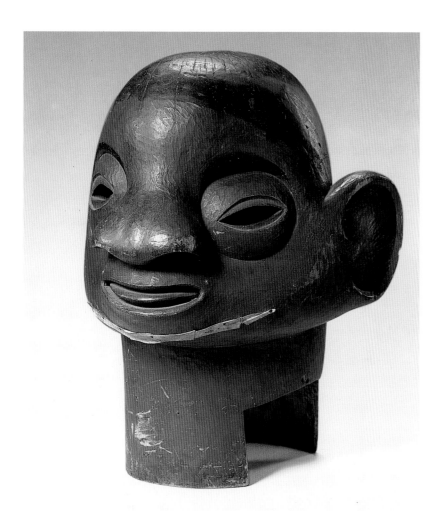

2.60

Mask

Makonde, Malaba
South-eastern Tanzania
early 20th century
wood, leather, pigment
h. 52 cm
Staatliche Museen zu Berlin, Preussischer
Kulturbesitz, Museum für Völkerkunde,
III E 17810

This unusual helmet-like mask, apparently collected in the Lindi District, south-eastern Tanzania, cannot be assigned, on formal grounds, to any of the major categories of Makonde mask. Although at first glance it may appear to resemble the *lipiko* helmet mask (see cat. 2.61) of the Mozambican Makonde male masquerade association, it is stylistically anomalous. It has no bottom rim around which a cloth might be tied, as is the case with the *lipiko* mask, and its pedestal-like base with side sections cut out suggests that it was worn on the shoulders in a way that would have restricted any turning or nodding movements of the head. The mask displays certain stylistic affinities, notably in the way the eyes are carved,

with *midimu* masks of the Tanzanian Makonde collected in the same area but true *midimu* masks (see cat. 2.67) are invariably face masks, a classification to which this does not belong.

An intentional element of grotesque exaggeration, especially in the size and shape of the nose, makes the most likely explanation for its anomalous characteristics that it would have belonged to a comic masker. Comic masks are not true *mapiko* or *midimu* masks. They are usually owned, and often also made, by individual youths who take them along to perform, of their own accord, at initiation celebrations where they try to draw attention away from the main masquerade. They come in a great variety of forms that reflect, more than anything else, the individual creativity of their makers.
ZK

Provenance: Brink-Cronau, 1937
Bibliography: Wembah-Rashid, 1971; Krieger, 1990

2.61

Helmet mask (*muti wa lipiko*)

Makonde
Mozambique/Tanzania
wood and human hair
22.3 x 36 cm
Bareiss Family Collection

This particular mask was apparently collected in southern Tanzania, which would suggest either that it was made by Mozambican Makonde migrants settled there or that it was traded from its place of origin. Before their conquest by Portuguese colonial troops in 1917 the Mozambican Makonde kept mainly to their plateau stronghold. During colonial times, however, a great many migrated across the Ruvuma River to work on sisal estates or farms in Tanzania. Many remained to settle on available agricultural land or to find work in urban areas. Wherever they have settled, Makonde migrants continue to hold initiation rites for boys and girls, and masquerade remains an important fixture at the public celebrations connected with these rites.

Lipiko (pl. *mapiko*) is the name that Mozambican Makonde men give to the masker of their masquerading association, who is brought from the bush into the village for initiation celebrations. The dances are accompanied by an orchestra of drummers. The 'head of the *lipiko*' (*muti wa lipiko*), or mask, is carved out of very light, balsa-like wood and fits over the masquerader's head like a helmet. It is always worn with a cloth tied around its bottom rim that falls loosely over the masquerader's shoulders, forming part of an elaborate costume designed to conceal completely his identity.

The mask is typically carved in a realistic style and its realism is often accentuated by the inclusion of human hair. Many of the older masks portray a Makonde woman complete with lip plug and decorated with the typical raised tattoos applied with beeswax. They are invariably carved with the face angled upwards, often with hooded eyes and with the ears positioned low, more or less level with the mouth. *Mapiko* masks in use today display greater stylistic diversity and tend to portray a variety of contemporary characters. The lip plug and the somewhat sunken features exhibited in the mask illustrated here suggest that it is intended to represent a woman elder. The form of the mask

is unusual in that the face displays a marked horizontal prognathis.

Makonde men conceal the true identity of their masker from the uninitiated and tell them that the *lipiko* is something non-human that has been conjured back from the dead. The secret, true identity of the masker is revealed only to Makonde boys during the male initiation rites, when they are forced to undergo a frightening ordeal in which they must overpower and unmask the *lipiko*.
ZK

Bibliography: Dias and Dias, 1970; Wembah-Rashid, 1971; Kingdon, 1994

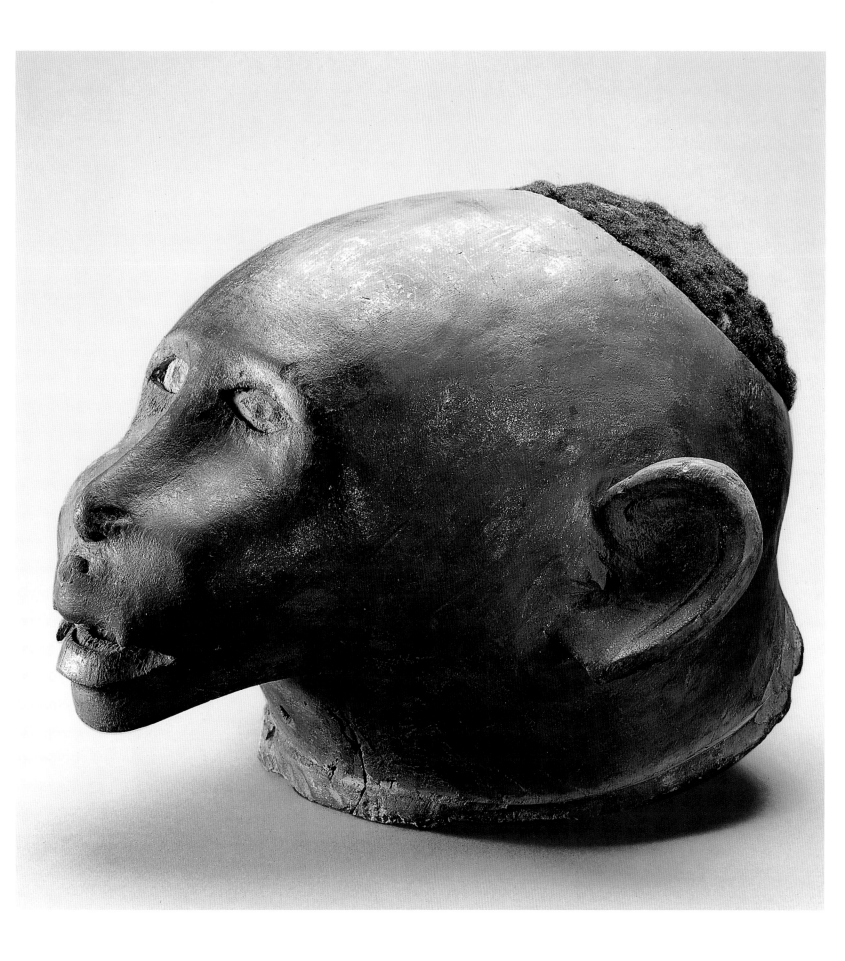

Initiation rites for boys and girls among the Mozambican Makonde are held during the dry season between May and November and must be begun at a time that the community considers to be auspicious. Several kin and residential groups co-operate in the organisation and sponsorship of the rites, and the various associated celebrations thus provide occasions on which members of different groups can come together in a festive atmosphere involving feasting, dance, music and masquerade. The celebrations associated with initiation rites provide the Makonde youth with opportunities to meet members of the opposite sex from marriageable groups. Young people dress up and adorn themselves in order to make an impression and stand out from the crowd. Rival *mapiko* (see cat. 2.61) groups vie with each other to put on the most accomplished masquerade performance and individuals compete for recognition of their style and abilities on the dance ground.

In previous decades Makonde men (and especially youths) would sometimes commission from a carver, or would make for themselves, decorative sticks called *disimbo* (sing. *simbo*), carved with figurative designs, which they used as dance accessories at initiation celebrations. In 1992 the late Chanuo Maundu (a blackwood carver originally from Ntoli village on the Makonde plateau in northern Mozambique) was shown a picture of the object illustrated here and immediately identified it as a *simbo* of this sort. He stated that this particular example was designed to balance comfortably on the arm of a person, facing outwards (the better to catch the attention of other participants at a dance).

The long, narrow nose and thick, flowing beard of the finely carved head that surmounts this *simbo* suggests that it is intended to represent a European. The words 'MIMIMA MAKAKA' conspicuously engraved on its shaft may be the name of its original owner. *ZK*

Provenance: 1954, donated to the museum by Mrs Webster Plass

Bibliography: Dias and Dias, 1970; Wembah-Rashid, 1971

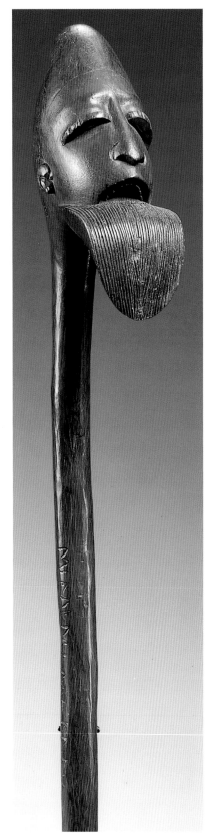

2.62

Dance accessory (*simbo*)

Makonde
Mozambique
wood
63 x 8 x 14 cm
The Trustees of the British Museum, London, BM 1954. AF. 12.4

The Mozambican Makonde mainly inhabit the high plateau in Cabo Delgado Province. Their traditional way of life was augmented by hunting expeditions into the game-rich lowlands. Most aspects of Makonde social life were organised according to a kinship system based on exogamous matrilineal clans. In pre-colonial times the Mozambican Makonde had no chiefs as such and leadership was held by clan elders and an authoritative clan ritual specialist ('medicine man' or *humu*; pl. *vahumu*). They had a well-developed ancestor cult in which clan ancestresses and prominent elders who died very old and full of knowledge of *ntela* ('medicine') were venerated as minor divinities. The major life-cycle rituals continue to be staged in Makonde communities.

Wooden figurines called *masinamu* (sing. *lisinamu*) representing mythical clan ancestresses and deceased elders (now only to be found in museums) were apparently kept in the houses of village leaders and *vahumu* where they were probably associated with ancestor shrines. They were often painted and decorated with the Makonde raised tattoo marks. This double figure unique in that it depicts a female figure carrying a smaller figure (probably an initiated male from the indication of the painted facial scarification marks). Ethnographic accounts from the Ruvuma region indicate that boys and girls were carried pickaback at certain stages during the initiation rites, and it has been argued that the double figure may represent an initiate being carried. However, no evidence exists to indicate that Makonde boys were carried by women during the rites. Furthermore, there are no ethnographic records to suggest that sculptures of this kind may have been used in this context. Another explanation for this double figure may be that it expresses a special status relationship between two personages. It is possible that the sculpture would have been used in connection with the ancestor cult and it may have been intended to portray two deceased persons. *ZK*

Provenance: F. Schroder Collection

Bibliography: Dias, 1961; Dias and Dias, 1970; Kecskési, 1982

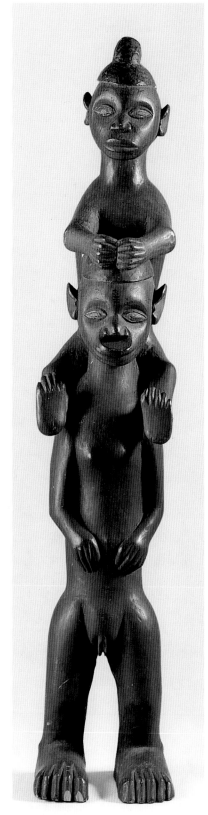

2.63

Double figure

Makonde
Mozambique
early 20th century
wood, pigment
h. 73.5 cm
Museum für Völkerkunde, Hamburg, 25.63.1

2.64

Water-pipe (*nyungwa*)
Makonde
Mozambique
terracotta, wood, coconut shell, beads
h. 27 cm
Private Collection

Tobacco has long been an important, high desirable commodity among the Makonde and it was widely exchanged for goods and services. It appears to have been regarded as a commodity associated with personal qualities such as generosity. Use of tobacco constituted one of the principal pleasures and privileges of elders. It was usually smoked or taken as snuff in a social context, especially by elderly men as they sat in the central men's house (*chitala*) conversing or reminiscing about the past.

The water-pipe exhibited here is characteristic of the finest Makonde utilitarian art in its inventiveness, in its witty suggestion of the human form and in its remarkable economy of design. Constructed from four detachable components, it is a masterpiece of suggestion. By sculpting a pair of lower legs to complete the N-shaped stem-holder-cum-stand, the maker (or makers) of this pipe created a form which subtly alludes to that of a seated human figure, with the bowl of the pipe representing the head and the coconut-shell reservoir representing the buttocks.

Figuratively elaborated and finely decorated water-pipes generally belonged to individuals of high status such as village or clan leaders and ritual experts. This example is unique in that it incorporates a terracotta stem-holder decorated with a delicate pattern of incised lines typical of some Makonde pottery. Modelling and potting in clay were women's arts in Makonde society and the virtuosity displayed in this rare piece suggests that it was made by an expert potter; the stems and bowl of the pipe were probably carved by a man, carving being a male art. The terracotta stem-holder includes a convenient carrying handle and its sculpted legs are decorated with miniature beadwork anklets. It may have been made for the potter's own use or she may have made it for another in exchange for other goods. In either case the pipe would have been intended to serve not only as an effective smoking apparatus but also as an object of display to be

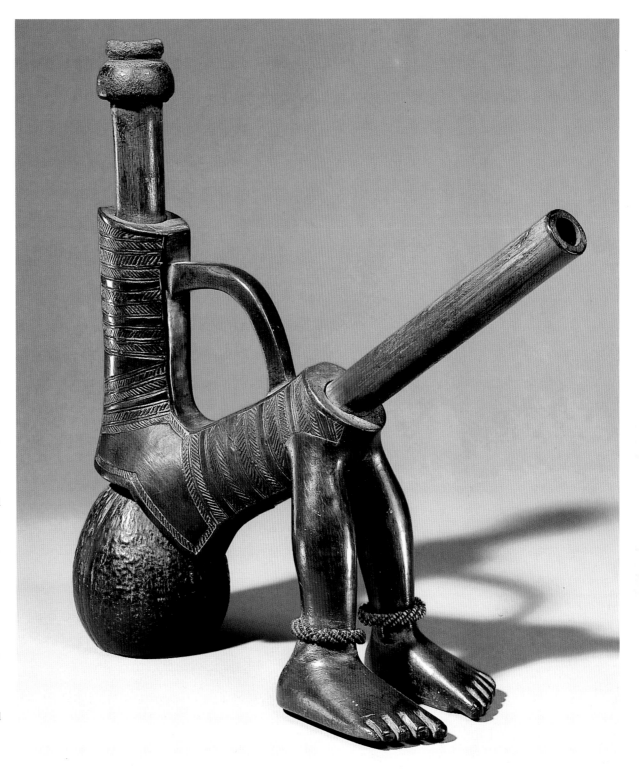

carried around, handled, admired and contemplated. It would have been closely linked with the identity of its owner and it represents one of the most intimate and treasured of Makonde personal objects. *ZK*

Bibliography: Dias and Dias, 1970; Wanless, in Johannesburg 1991; Washington 1991

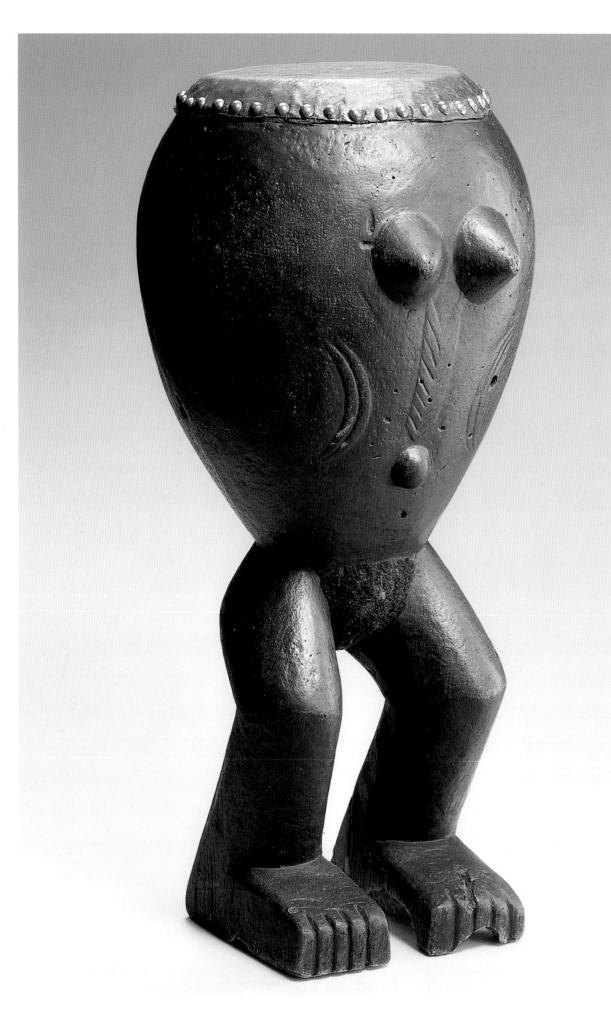

2.65

Drum (*likuti*)

Makonde
Tanzania/Mozambique
late 19th or early 20th century
wood, leather, hair, copper nails
63 x 30 x 30 cm
W. and U. Horstmann Collection

The five or six distinct types of drum used by the Makonde to accompany their various dances and masquerade performances are not usually figuratively elaborated (although they are often carved with relief decorations). This unusual Makonde drum of the goblet-shaped variety (called *likuti* by the Mozambican Makonde) is carved with anthropomorphic legs and female imagery, suggesting that it would have served a special social function. The drum's imagery recalls that of wooden cult figures of lineage ancestresses now found only in museums. The tattoo marks, in the form of a vertical line of nested chevrons between two mirrored crescents carved in relief on the body of the drum, are common motifs found on ancestor figurines and also on body masks (see cat. 2.66) of the Tanzanian Makonde.

In pre-colonial times the Makonde groups who settled in the Ruvuma region were skilled in the arts of defence. They protected their villages against the attacks of enemy lineages, hostile external groups and wild animals by enclosing them within carefully maintained hedges of impenetrable thicket. The entrances to these villages were guarded by heavy gates, which were securely locked each evening. According to Kashimiri Matayo (a Makonde originally from Miula village on the Mozambican plateau) special drums of the *likuti* type were widely used by the Makonde in order to alert villagers and members of neighbouring settlements in the event of a threat.

Makonde warning drums continued to be used during colonial times and were typically sounded when a person had either been attacked by, or had wounded, a lion or leopard. At the sound of the drum beaten in a way that resembled, for example, the roar of a leopard, all the men of the local area would take up their weapons and assemble for a leopard hunt. *ZK*

Bibliography: O'Neill, 1885; Blood, 1935, p. 12

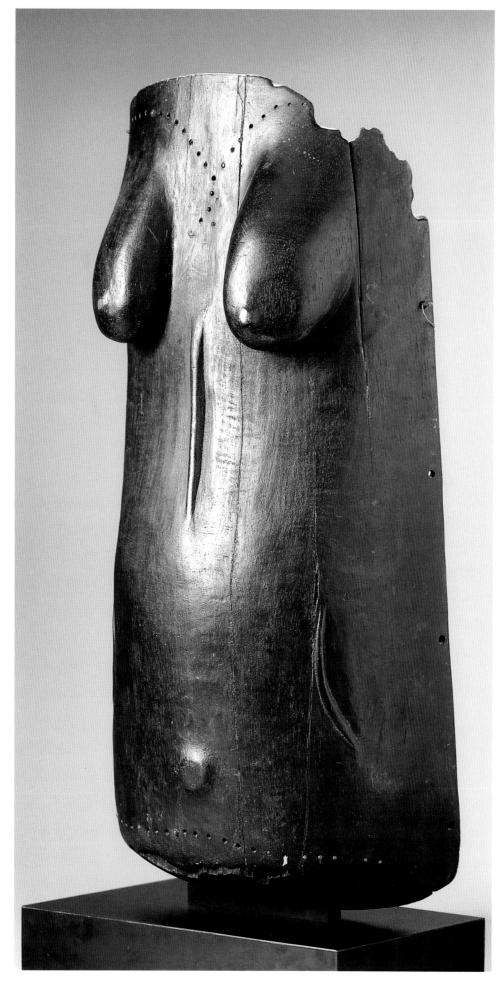

2.66

Body mask (*ndimu*)
Makonde
Southern Tanzania/Mozambique
late 19th century
wood
61.2 x 30.7 x 15 cm
Private Collection, London

Among the Makonde of south-eastern Tanzania initiation is still one of the most important ritual cycles. Both boys and girls must undergo a period of seclusion, generally six months, during which they learn songs and dances and are taught various practical activities. The initiation rites involve male circumcision and indoctrination into the secrets of gender. Everyone is taught the rules of adult behaviour, about sex and about the rights and obligations of married life. The celebrations that accompany the coming-out ceremonies involve feasting, dance and the masquerades of the *midimu* (sing. *ndimu*) spirit maskers.

The female body mask was part of the costume of a special *ndimu* masker called *amwalindembo* that was intended to represent a young pregnant woman. It was usually carved with a swollen abdomen decorated with the typical Makonde raised tattoos applied with beeswax (but in this case they are carved in relief) and was always worn by a male masquerader together with a matching female face mask. The *amwalindembo* performed a sedate dance, usually accompanied by a male *ndimu* masker, which dramatised the agonies of childbirth. Although the body mask is no longer in use today, dramatic scenes depicting various aspects of community life continue to be performed by masked or maskless performers during the celebrations. *ZK*

Bibliography: Wembah-Rashid, 1971

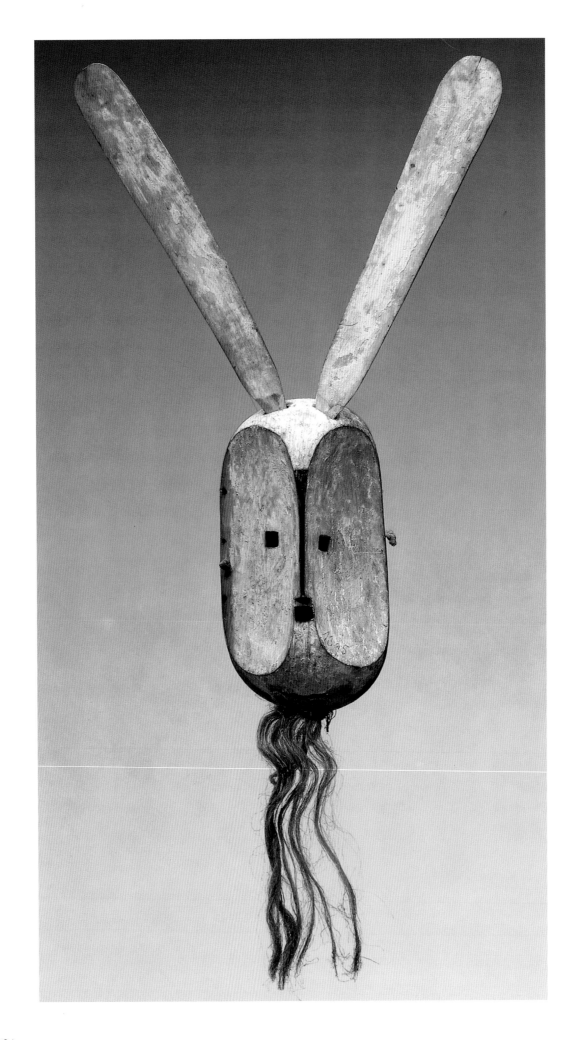

2.67

Face mask (*ndimu*)

Makonde
Southern Tanzania
early 20th century
wood, white pigment, vegetable fibre
h. 47 cm
Museum für Völkerkunde, Leipzig,
MAF 16593

The Makonde who now live in south-eastern Tanzania and those who remain in Mozambique have had to contend with different recent historical forces. Whereas the Mozambican Makonde were successfully able to repel all external invaders of their plateau stronghold until 1917 (when they were conquered by Portuguese colonial forces), the Tanzanian Makonde, in contrast, suffered enormous turmoil during the 19th century. An upturn in the slave trade, later aggravated by Ngoni raiders, led large numbers of people from several groups in the area to take refuge on the Newala plateau. These groups included sections of certain Yao and Makua clans whose continued presence on the plateau bears witness to a considerable interchange of peoples. This might have contributed to the diversity of styles and forms of the dancers of the Tanzanian Makonde, which contrast somewhat with the equivalent *lipiko* masquerading tradition of the Mozambican Makonde (see cat. 2.61). *Ndimu* (pl. *midimu*) is the generic name for all types of masker who impersonate spirits and wear wooden face masks. Both the face masks and the costumes of the *midimu* maskers (as well as their associated dances) vary according to the particular human- or animal-like spirits they are intended to personify. Some *midimu* can be divided into distinct categories, such as those which dance on stilts and those which incorporate a female body mask (see cat. 2.66). All are performed by members of the male masquerading associations during the coming-out celebrations for both male and female initiates.

The long spatula-shaped ears of the *ndimu* mask shown here were evidently carved separately and then attached. The length of the ears suggests that the mask is probably intended to represent a hare spirit.
ZK

Bibliography: Weule, 1909; Franz, 1969; Wembah-Rashid, 1971; Clayton, 1993

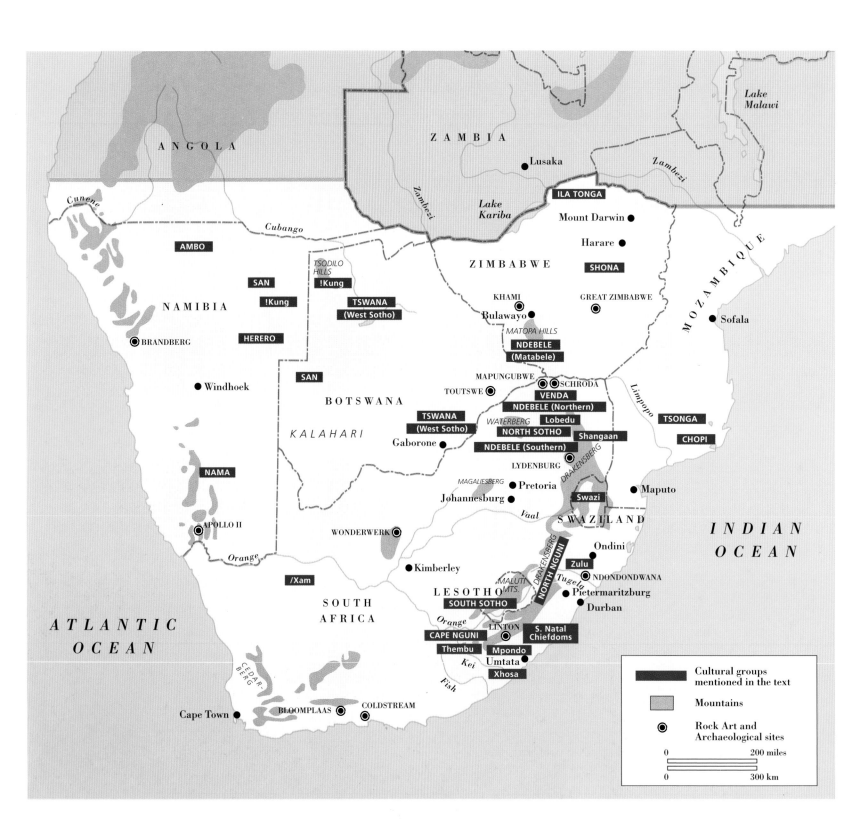

3 SOUTHERN AFRICA

Patricia Davison

Some of the oldest and most complex expressions of human creativity in Africa come from the areas south of the Zambezi and Cunene rivers. Nevertheless, the significance and range of art forms from this region have yet to be fully recognised. African art in southern Africa has a heritage of misunderstanding, arising from wider misconceptions regarding the history and culture of the subcontinent. During the colonial period African cultural identities were classified by outsiders, and complex historical relations among the inhabitants of the region tended to be reduced to a few well-worn categories that fast became stereotypes. Persistent lack of attention to historical detail has led to many works in collections being incorrectly attributed, misinterpreted and, with the notable exception of rock art, underrated within the field of 'African art'. Over the past two decades, however, both knowledge and appreciation of the arts of this area have been growing. In presenting a selection of significant works from southern Africa, together with art from the entire continent, this exhibition and its catalogue provides an unprecedented occasion for both reflection and celebration.

All the works selected for this exhibition once evoked other meanings, for other people, in other places. Although outside specialists have furthered an understanding of art in Africa, it is well to remember that African people themselves were the original keepers of the knowledge and beliefs that animate the history and material culture of the continent. Sensitivity to historical and social context enriches an understanding of art forms, but it must also be acknowledged that the sensory presence of a work of art can transcend historical context and move the viewer, even if it is not fully understood.

From another angle, some understanding of the processes by which works of art from one culture are given recognition in another can be illuminating. It is generally accepted that early 20th-century responses to art forms from Africa were shaped by preoccupations within European art practice, in particular the move away from naturalism, and were limited in certain respects by Western pre-

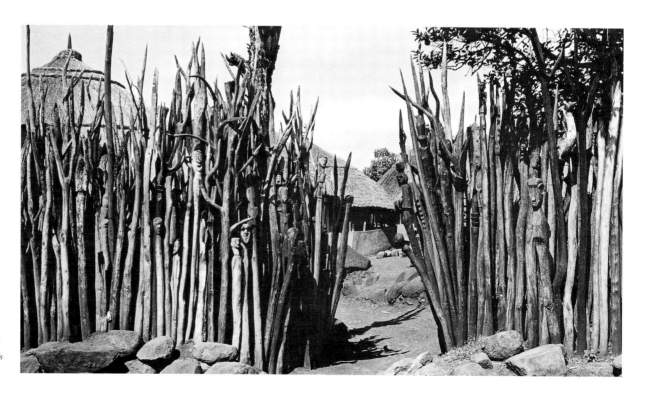

Fig. 1 Carved pole figures in the palisade surrounding the khôrô of Chief Modjadji's capital, 1960s

conceptions of what constituted 'art'. The absence, in most of southern Africa, of masking traditions comparable with those of west and central Africa, coupled with the fact that religious practices did not involve the use of carved ancestor figures, contributed to the relative neglect of this region by connoisseurs in the field that came to be known as 'African art'. As the works shown here affirm, aesthetic sensibility was certainly present but often in forms that integrated art and utility, and bridged the secular and sacred realms. Finely carved objects of everyday use, such as headrests and snuff containers, merged functional, symbolic and aesthetic attributes. Figurative carvings were produced but mainly for use in the secluded context of initiation schools. Such figures were hidden when not in use and, therefore, few found their way into private hands or museum collections. Furthermore, the ephemeral nature of objects made from organic materials reduced their archaeological visibility and limited their survival in collections. A tendency to draw rigid lines of distinction between the categories of fine art and applied art, a selective focus on durable sculptural forms and the paucity of reference works encouraged the misconception that art was rarely found south of the Zambezi River. Rock art commanded sustained attention but, in this case, sites were often inaccessible and known only to the relatively few specialists working in the field.

Since the 1970s a growing interest in the arts of southern Africa has been reflected in exhibitions and publications, both locally and abroad, as well as in the marketplace. Academic research has advanced considerably, and many objects housed in ethnographic collections have been reconsidered, now being regarded as both artefacts and works of art. In response to changing perceptions, art museums in several South African cities, led by Durban and Port Elizabeth, changed their collecting policies to include works that derived from local African traditions. Growing institutional collections have, in turn, stimulated interest and provided the basis for scholarly research. A notable moment in this process occurred in 1978 with the establishment of the Standard Bank Foundation of African Art at the University of the Witwatersrand. A more recent landmark was the exhibition in 1991 of the Brenthurst Collection at the Johannesburg Art Gallery, showing a wide range of accomplished works that had previously been in a private collection abroad. Coinciding with the return of many political exiles, this 'homecoming' exhibition proclaimed and celebrated the artistic heritage of southern Africa. Subsequent exhibitions at the South African National Gallery in Cape Town have underlined this message. Political transformation has been accompanied by an embrace of African culture and history, and a growing confidence in the artistic achievements of the subcontinent.

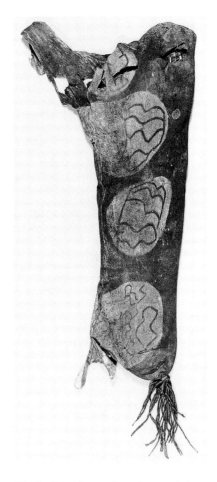

Fig. 2 Skin of a small antelope made into a shoulder bag, used by /Xam hunter-gatherers in the Gordonia district of the Cape Province in the 19th century. Ovoid patterned areas, formed by removing the nap of the hide, recall the designs on ostrich eggshell flasks. Length 68 cm, South African Museum, Cape Town, AE 1546

The earliest art in southern Africa

Unlike those art forms that have only recently been accorded the status of art, rock paintings and engravings, found throughout southern Africa, have been recognised as works of 'prehistoric' art for over a century. This did not, however, prevent them from being widely misinterpreted. Only in the last two decades has progress been made in understanding what the art meant for its creators, the early inhabitants of southern Africa, known in recent times as the Bushmen or San. (Both of these names have assumed negative connotations in certain historical contexts. 'San' is used here, as 'Bushman' continues to have derogatory connotations for some people.) The sheer number of sites, estimated at over 15,000, attests to the importance of rock art in San culture. Although pastoralists may have been responsible for some of the later art, and agriculturists are known to have depicted the layout of their settlements in engravings, these sites constitute a very small fraction of the entire body of rock art.

Painted shelters, some containing hundreds of individual paintings, are situated mainly, although not exclusively, in the mountainous regions of the subcontinent – the Matopo hills in Zimbabwe, the Tsodilo

hills in Botswana, the Namibian Brandberg, the Waterberg, Magaliesberg, Cedarberg and Drakensberg in South Africa, and the Maluti mountains of Lesotho, to name but the best-known regions. Engravings have a complementary distribution to the paintings, occurring mostly on exposed rocky outcrops and hillslopes or in the open veld of the inland plateau. They tend to depict individual animals, geometric patterns and occasionally human figures, while paintings range from single images to complex narrative compositions including people, animals, therianthropes (figures that combine animal and human features), scenes that appear to depict conflict and camp life, as well as enigmatic handprints and abstract forms.

White clay, black manganese or charcoal, and ochres shading from deep red, through vermilion to pale yellow (possibly mixed with blood, water or egg tempera) were used to produce arresting monochrome and bichrome images, as well as the shaded polychrome paintings that distinguish the most accomplished compositions. The clarity of line and detail in certain paintings suggests that quills, bone splinters or fine brushes of animal hair were used to execute these works. Over long periods of time, sites were revisited and acquired ritual significance. Many of the painted images are superimposed and connected to elements of earlier paintings and to features on the rock surface, as in the superb panel from the farm Linton in the Eastern Cape Province. Although incomplete – part of the panel remains in the shelter from which it was removed in 1918 – the composition and detail reveal both aesthetic sensibility and cognitive depth (cat. 3.4).

Paintings and engravings also occur on smaller stones, some of which have been excavated from archaeological deposits. Although less spectacular than large painted panels, stratified fragments are immensely valuable in that they can be dated if found in association with carbon remains. Unfortunately, when the painted stone from Coldstream (cat. 3.6) was excavated in 1911, isotopic dating methods had not yet been developed, so its age remains unknown. Painted stones excavated more recently from the southern Cape have been dated to between 2000 and 6000 years before the present (BP). Very much older, however, are the painted stones excavated from the Apollo 11 shelter in southern Namibia and dated by associated charcoal to 27,500 BP, making them the earliest dated rock paintings in Africa (cat. 3.3). This antiquity makes them far older than the painted sites of the Sahara and in the same time range as the rock art of Spain, southern France and Australia. Consequently, any suggestion that rock art spread from Europe to north Africa, the Sahara, east Africa and eventually south of the Zambezi cannot be sustained. It seems that these ancient aesthetic traditions developed independently.

After Apollo 11, the earliest dates for painted fragments come from two sites in Zimbabwe dated to about 10,000 BP. The earliest dated engravings, from Wonderwerk Cave in the northern Cape, span a period from about 10,000 to 4000 BP. The gap in time between Apollo 11 and the other dated sites is probably related to the need for more fieldwork rather than the absence of art production during the intervening period. It is well established that, about 30,000 years ago, nomadic hunter-gatherers were not only producing a range of fine stone and bone tools, but wearing ostrich eggshell beads and mollusc-shell pendants. Grinding-stones from this period may have been used to pound earth pigments for cosmetics or painting.

Artistic expression in the form of decorated ostrich eggshell vessels is known from 15,000 years ago in the eastern Cape. This art form, as well as the making of beads from ostrich eggshell, continued through the millennia to the 20th century (cat. 3.9), and ovoid forms that echo the designs on ostrich eggshell flasks are also found on bags made from animal skin (fig. 2). Bags like these were frequently depicted in rock paintings, which are known to have continued well into the colonial period. The final phase of painting, dating to the second half of the 19th century, includes depictions of ox-wagons and mounted colonists with rifles. Sadly, the rifles were too powerful for the artists. It is ironical that after the resistance

of hunter-gatherers had been quelled and they no longer posed a local threat to the colonists, their culture increasingly became the subject of intellectual discourse in the metropolitan centres of Europe. Evolutionist ideas prevailed; both the hunter-gatherers and their art were ranked low on the scale of civilisation. Fortunately, however, for the future understanding of rock art, the German philologist Wilhelm Bleek devoted his attention in the 1870s to understanding San languages and transcribing their oral literature. Eventually, over 12,000 pages of /Xam (southern San) folklore were recorded by Bleek and his sister-in-law, Lucy Lloyd. The evocative narratives of //Kabbo, Dia!kwain and /Han≠kass'o, who were serving prison sentences in Cape Town, have provided a key to the beliefs that animated rock art in San culture.

A century after Bleek had recognised the religious nature of San paintings, anthropologist David Lewis-Williams returned to the Bleek and Lloyd papers, to unravel the complex conceptual motivation of the art, and to refute the fallacy that it was simply a prosaic record of hunter-gatherer life. In essence, rock art depicts the rituals and experiences of healers who went into trance to harness supernatural potency for benevolent purposes, such as curing illness, preventing danger, attracting game or making rain. Certain animals were perceived as being potent sources of ritual energy. Elephant, giraffe, rhinoceros, zebra and lion were significant in particular contexts, but most powerful of all was the largest antelope, the eland. Depicted more frequently in most regions than any other animal, the eland evoked multiple meanings that mediated different realms of experience, as in the trance dance when the shaman 'died' like the eland to enter the spirit world, or when the eland dance was performed at girls' puberty rites. Visions experienced in trance were represented in the paintings, which then embodied spiritual power that could be invoked for ritual purposes.

Engravings, incised, scraped or pecked into the rock, were expressions of the same system of beliefs as the paintings. Grids, chevrons, circles and other abstract forms (cat. 3.8) are believed to depict hallucinatory entoptic phenomena seen during the early stages of trance, while many of the animals in engravings are associated with supernatural potency (cat. 3.7). The positioning of sites in the landscape, the angle of the sun, as well as the patina of the rock surface added to the impact of rock engravings in situ. When rock art is viewed in a gallery setting, however, the original ambience can only be imagined.

From about 2000 years ago, the presence of herders (later known as Khoikhoi) in the south-west is reflected in the archaeological remains of sheep and distinctive conical-based pottery. In other respects the material residues of herder sites were not markedly different from those of hunter-gatherers. Meanwhile, in the east and centre of the subcontinent, people who were both physically and culturally different from the hunters and herders were spreading southwards, bringing an economy and technology that was to transform the landscape. By about AD 300 these people, who lived in semi-permanent settlements, smelted and forged metal, produced distinctive pottery and cleared land to cultivate crops, had established themselves south of the Zambezi in present Zimbabwe, the eastern Transvaal and the subtropical coastal regions of Mozambique and Natal. Within the following two centuries they were also keeping herds of domestic cattle, and the importance of cattle grew beyond the economic realm to become of central cultural and symbolic significance.

The art of the southern African Iron Age

During the first millennium AD, known to archaeologists as the Early Iron Age, fine domestic pottery was ubiquitous, but by far the most important works from this period are the seven terracotta heads (cat. 3.10) from the eastern Transvaal site of Lydenburg, dated to between AD 500 and 700. Although the heads remain of unequalled quality, modelled figures from other sites in the Transvaal, Natal and Zimbabwe

suggest they were not unique. The 8th-century site of Ndondondwana on the Lower Tugela River in Natal has yielded fragments of a hollow ceramic sculpture, as well as modelled animal horns and human figures, and hundreds of figurines were recovered from the site of Schroda on the Limpopo. Many of these seem to be symbolic representations (cat. 3.11), possibly for use in initiation schools.

From about AD 800 very large settlements emerged in certain places, usually on hilltops or other elevated sites, and important centres were established near the confluence of the Limpopo and Shashi rivers. Toutswe and related sites in eastern Botswana reveal increased numbers of cattle, a growth of wealth and political stratification. The site known as K2 or Bambandyanalo, adjacent to Mapungubwe on the Limpopo, yielded extensive evidence of ivoryworking, as well as ivory ornaments and large quantities of imported glass beads, indicative of links with trade networks on the east coast. This site declined as Mapungubwe rose to power around the year 1100 to become the capital of a trading empire. Gold replaced ivory as the most prestigious item traded for glass beads, cloth and Chinese celadon ware. Trade links extended to Sofala, Kilwa and indirectly to Arabia, India and China. The rulers of Mapungubwe lived and were buried on an élite hilltop area surrounded below by villages occupied by their subjects. The graves on Mapungubwe hill contained a large quantity of precious objects, including the remains of two small rhinoceroses, a bowl and a sceptre, all of which had been made of gold plates riveted to inner cores, probably of wood. The arms and neck of a human skeleton were found encircled by hundreds of gold-wire ornaments and beneath its head were pieces of curiously shaped gold plate, suggesting that they had adorned a wooden headrest. If this was so, it affirms that headrests have a long history of being regarded as intimate personal possessions that were buried with their owners. This practice continued among Shona and other southern African people to the early 20th century (cat. 3.20–1).

Mapungubwe was eventually succeeded by Great Zimbabwe in about 1250. For the next two centuries, Great Zimbabwe was the most important capital of a vast Shona kingdom that stretched between the Zambezi and Limpopo rivers (p. 31, fig. 1). From 1450 power shifted again, this time to Khami (near present Bulawayo) and to Mutapa (near Mount Darwin) in the north. Smaller Zimbabwe-like settlements extended southwards to the Zoutpansberg where cultural practices that have their origin in Zimbabwe traditions continue among the Venda people of the Northern Province of South Africa. Dry stone walling, in some places carefully patterned, is characteristic of all these sites but the magnificence and monumental scale of the stone architecture at Great Zimbabwe is unsurpassed. The site encompasses a hill complex, which was the residence of the ruler or mambo, the spiritual centre of the entire nation. The upper valley included a massive walled enclosure with inner walling and conical tower, while the lower valley was where the royal wives are believed to have lived. Six of the acclaimed soapstone birds (cat. 3.12) were found in the Eastern Enclosure of the hill complex, as were carved ceremonial bowls (cat. 3.13), monoliths and figurines. This is thought to have been a sacred place visited by the ancestral spirits of past rulers, who were commemorated symbolically by the birds.

The distinctive pillar with a crocodile carved below the bird came from the Lower Valley area associated with the royal wives, and possibly marked the ancestral shrine of the king's senior wife. Crocodiles were symbolically linked with chieftainship and wisdom, as well as the ancestral spirits by virtue of dwelling in deep pools. Both Shona and Venda divining implements (cat. 3.17) are inscribed with crocodile symbols, and the doors used by Venda chiefs are often carved with designs that have metaphorical associations with the crocodile (cat. 3.18a). Venda ethnography has been skilfully used by Thomas Huffman to suggest that the spatial arrangement and material remains of the Great Enclosure in the Upper Valley signify a site appropriate to girls' initiation ceremonies. The many stylised female and male figurines, as well as other unusual objects found in this area, are reminiscent of the figures known in recent times to have been used for teaching purposes in initiation schools. Although the scale

of building at Great Zimbabwe was exceptional, the underlying architectural layout was common to all Zimbabwe capitals, and similarities are still discernible in the present capitals of Venda chiefs. However, while the presence of pole figures (cat. 3.19; fig. 1) among the Lobedu people of the Transvaal lowveld may seem to echo the Zimbabwe birds, their positioning in the public court of the capital emphasises political rather than religious connotations.

The wealth of Great Zimbabwe, like that of Mapungubwe, hinged on control of the Indian Ocean gold trade, as well as local trade and tribute networks in tin, iron, copper, salt, cattle and grain. The reasons for the decline of Great Zimbabwe are not fully understood, but social and political factors, coupled with vastly diminished environmental resources, may have contributed to its demise. In the mid-15th century Great Zimbabwe was abandoned in favour of Khami and Mutapa, and by the early 16th century the Portuguese had taken control of the east coast trade.

Fig. 3 Mpande on his chair of state, from A. J. F. Angas, The Kaffirs Illustrated, *1849. The Zulu king is sitting on one of the four hand-carved chairs that he is known to have owned. The chair shown here is believed to have been made by the carver Mtomboti kaMangcengeza*

In the south-eastern parts of southern Africa during the later part of the Iron Age a pattern of subsistence farming continued but between 1300 and 1600 settlement spread from the savanna areas into the unwooded grasslands. As in earlier times, the summer rainfall requirements of grain agriculture limited the geographical expansion of these early farmers. Regional differences in pottery styles and architecture became more pronounced and localised centres of metal production thrived in the wooded savanna regions – hoes, spears and other metal implements were traded to grassland communities. The arid western parts of the subcontinent were occupied predominantly by Khoisan hunter-gatherers and herders, but during the 16th century groups of Herero pastoralists and Ovambo agriculturists from the north-east moved into the area and settled on the fringes of the arid and semi-arid zones.

Cattle were important throughout. Ethnographic sources reveal that cattle were associated with patrilineal authority and the ancestral spirits. Among Nguni-speaking people this was emphasised by each homestead being arranged around a central cattle enclosure. In the concentrated Tswana settlements of the western highveld, cattle were kept in outposts but they remained of central cultural significance. Among Herero pastoralists, cattle were so strongly linked with the ancestral spirits that a sacred fire was kept alight continually beside the cattle byre in the centre of the homestead. Aesthetic sensibility was inseparable from cultural values, as is evident in the allusions to cattle in headrests and staffs (cat. 3.27a,c–d), as well as in the use of materials derived from cattle for making personal objects, such as snuff containers. Among predominantly agricultural communities, where beer brewed from sorghum or millet was the preferred offering to the ancestral spirits, vessels used for this purpose symbolised the link between everyday life and the spiritual realm. In general, women were precluded from cultural practices associated with cattle but were important in the domain of agriculture. They were also the potters and, in many parts of southern Africa, pottery vessels were symbolically associated with women and fertility.

From the late 18th century southern Africa was caught up in unprecedented processes of transformation. Although it would be incorrect to assume that interaction between groups was minimal before colonial contact or that traditional practices were unchanging, the dynamic of former historical relationships was completely altered by events that took place from the late 18th century onwards. The rise of military chiefdoms and the establishment of the Zulu kingdom (fig. 3) under Shaka in the early 19th century, the waves of migration that ensued, together with the advance of European colonists, the subsequent dispossession of land, and the undermining of chiefly authority irrevocably changed the cultural landscape of the subcontinent.

Impact of colonialism

Some of the most accomplished works of art had been produced for chiefs and rulers in tribute and in recognition of their elevated status (cat. 3.26,40a,46). Processes of colonisation changed both the nature of subject-ruler relationships and the material culture that was implicated in sustaining them. In some places access to raw materials was denied to craftsmen, and everywhere the introduction of taxation, a money economy and industrial goods had an impact on former cultural practices; as a result the production of hand-wrought metal artefacts declined. The migrant labour system undermined rural productivity and changed the balance of labour. In addition, missionaries set out to eradicate practices that were rooted in ancestor beliefs, and evolutionist theories had a negative effect on perceptions of African material culture.

As elsewhere on the continent, conquest resulted in the removal of significant cultural objects from southern Africa. Many colonial collections were enriched by insignia of office that had been appropriated from chiefs, and by trophies of war looted from battlefields. Reactions to conquest, however, were by no means passive or uniform. The case of the powerful Ndzundza Ndebele chiefdom, which was defeated by Boer forces in 1882, illustrates both cultural resilience and creative energy. The now famous mural art of the Ndebele people emerged in the 20th century in defiance of the threat to their cultural integrity when they were forced to disperse and live on white-owned farms. Significantly, both Ndebele wall-painting and beadwork, which predates the mural art, were developed by women drawing on traditions of the past with immaculate skill but also an openness to innovation (cat. 3.35). The earliest Ndebele beadwork goes back about a century, but the use of beadwork ornaments by Xhosa-speaking people in the eastern Cape is mentioned in records dating back to the 18th century.

The system used to classify both the people and the arts of the subcontinent derives in part from colonial processes of creating conceptual order in unknown territory. Standardising dialects and languages was a prerequisite for both effective government and mission work. Language classification then formed the basis of ethnographic classification. The African languages spoken in southern Africa form part of a large family of languages that stretches southwards from Cameroon and the Great Lakes of equatorial Africa. Although classificatory categories, such as 'Zulu', have often been misused in relation to cultural and stylistic attributions, it could be argued that even incorrect labels are part of the history of an object – part of its biography, as it were. From another viewpoint, however, both labels and stylistic classifications can mask historical relationships. For example, the presence of a headring, often taken to be diagnostically 'Zulu', may relate to a more complex historical situation in which headrings were adopted by members of other groups. The early production of curio works further complicates the issue of classification and raises questions about the notion of authenticity.

It is perhaps pertinent to note in conclusion that, once objects are removed from their original contexts and reclassified, they acquire new connotations and values; they embody different narratives. These are as varied and cosmopolitan as the histories of individual works. Exhibitions such as this tell not only of the art on view but of the vision of the curators, and contemporary processes of selectivity. Rock art, however, has a history so long and is so embedded in the landscape that it seems to proclaim the creative human spirit of the continent. In drawing attention to the unique aesthetic heritage of southern Africa, this exhibition pays tribute to the artists, whose names are lost to us, and adds significantly to the continuing narrative of artistic expression in Africa.

Bibliographical note

A useful introduction to southern African rock art is found in Lewis-Williams (1983) and Lewis-Williams and Dowson (1989). Dowson (1992) provides a more detailed study of rock engravings, while the volume of essays edited by Lewis-Williams and Dowson (1994) covers current issues in rock art studies, including interpretations that emphasise gender relations in San society. Solomon (1992) discusses the issue of gender in rock art in some detail. Hall (1987) and Maggs (1984) cover the southern African Iron Age in general, while Huffman is concerned with the symbolic dimensions of the layout of Great Zimbabwe (1984) and has also written about the Zimbabwe birds (1985). A volume edited by Nettleton and Hammond Tooke (1989) contains essays that provide an introduction to historically known African art traditions, including studies of Venda and Lobedu art forms. The catalogue essays for the exhibitions held in Johannesburg, 1989 and 1991, cover the arts of the region, including essays on Ndebele beadwork, Venda art, figurative carving, pipes and snuff boxes and headrests.

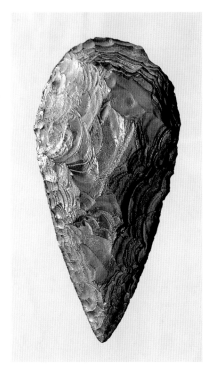

3.1

Handaxe
South Africa
c. 600,000 BP
banded ironstone
23 x 11.4 cm
McGregor Museum, Kimberley,
MMK 6538

Handaxes were all-purpose tools made in Africa by *Homo erectus* and archaic *Homo sapiens* during the Early Stone Age, between about one and a half million and 200,000 years ago. This fine example comes from Kathu Pan where an ancient sink-hole once provided access to artesian water in an arid area on the edge of the Kalahari. A small excavation, through eleven metres of layered sediments, yielded a few hundred thousand stone tools that came mainly from one level. The assemblage includes handaxes, cleavers, rare trimmed points, and a great variety of side and end scrapers, in addition to the debris resulting from their production. Most of the artefacts are made from locally available banded ironstone, but others are made from rocks that occur about 30 km away.

After they were discarded, many of these tools became coated with a shiny film of silica, which precipitated out at times when the alkaline ground-waters became saturated. These geochemical circumstances also resulted in faunal remains from the site being represented only by teeth,

which ranged from those of small springhares to those of an elephant species that became extinct in the African savannas about 600 millennia ago. It should be noted that this fact provides a minimum age for the associated tools.

Excavations at Wonderwerk Cave in the same region have yielded hand-axes of similar age, together with evidence for the regular making of fire, discrete grass bedding areas, exotic pebbles or crystals, and red ochre that was presumably used for body decoration. These are among the earliest known traces of cultural patterns that reflect aesthetic sensibility. *PB*

Provenance: 1978–9, Kathu Pan, Site 1, Stratum 4b

Bibliography: Beaumont, 1990[1]; Beaumont, 1990[2]

3.2

Handaxe
Namibia
Early Stone Age (Acheulean)
Rhyolite
34 x 13.5 x 8.5 cm
State Museum of Namibia, Windhoek,
B1419

The Pleistocene archaeology of Namibia is well represented by artefacts belonging to the Acheulean industrial complex, which first appeared more than a million years ago and lasted until approximately 200,000 years ago. Handaxes and cleavers, made by hammering on cobbles, blocks and flakes, are among the most characteristic of these artefacts and include examples of near perfect symmetry that exhibit complete mastery over the raw material.

Artefacts of wood, bone and other organic materials are extremely scarce and in Namibia the majority of Acheulean sites are open scatters in which only the stone artefacts survive. As a general rule, the artefacts are seldom found very far from the source of their raw material. Many such sites are located in saddles or gaps between hills where they may have formed part of communal game drives. Others are found on the margins of what would have been marshes or evapora-tion pans in the past, and it is con-ceivable that these locations also played a part in hunting strategies. The axes and cleavers, particularly, are thought to have been used in heavy woodworking and butchery of large animals, while a range of other artefacts including points, picks and scrapers reflect the variety of other

tasks. It is, however, arguable that workmanship of the handaxes and similar large pieces goes well beyond functional requirements. While it is not possible to attach to them any particular significance as, for example, prestige items, some apparently point to an aesthetic sense that is otherwise not well preserved in the archae-ological record of the period. Certainly, the middle Pleistocene in southern Africa coincided with major developments in human cultural and biological evolution, and these would have included the cognitive advances associated with art and language.

The example shown was collected from the surface in the vicinity of the Shambyu Roman Catholic Mission, near Rundu, on the Kavango River in northern Namibia. The site is exceptionally rich in Acheulean artefacts made of quartzite and rhyolite. The surface patina on the handaxe is mainly the result of polishing by the wind. Large numbers of the artefacts are cemented into a conglomerate outcrop that is partly submerged in the river. Similar outcrops occur elsewhere in the region and indicate the relatively young development of the river course relative to the Acheulean occupation. *JK*

Provenance: surface find, Shambyu Mission, Rundu, Okavango Province, north-eastern Namibia

Bibliography: Sampson, 1974; Jones, 1979, p. 836; Szabo and Butzer, 1979; Volman, 1984

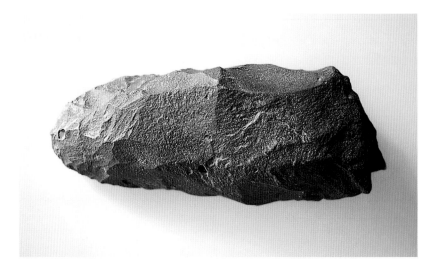

3.3a

Charcoal drawing of an antelope

Namibia
27,500–25,500 BP
charcoal and ochre on shale
9.5 x 12.5 x 1.5 cm
State Museum of Namibia, Windhoek,
B2104

3.3b

Charcoal drawing of animal-human figure (two pieces)

Namibia
27,500–25,500 BP
charcoal on shale
11 x 8 cm; 9 x 5 cm
State Museum of Namibia, Windhoek,
B2104

(illustrated p. 11)

Excavations at the Apollo 11 site have revealed an occupation sequence extending over the last 80,000 years, with a series of macrolithic, blade-dominated assemblages being replaced about 20,000 years ago by a series of increasingly microlithic assemblages and the eventual abandonment of the rock shelter in the last few centuries. Associated with the final macrolithic assemblage is a group of seven small slabs of rock showing traces of animal figures in charcoal, ochre and white. It is noteworthy that the rock slabs were apparently brought to the site from elsewhere; they are not spalls from paintings on the roof and walls of the rock shelter. The most remarkable of these is broken in two (cat. 3.3b), and bears what appears to be a feline creature with heavy head, deep chest and thin tapering legs. However, the two slightly curved horns and male genitalia are characteristic of bovid (cloven hoofed herbivores). More interesting still, the drawing appears to have been retouched at some stage, with the possible alteration of the hind legs to resemble those of a human figure.

The other paintings are less complex, but they clearly belong to the same tradition. These include a headless antelope in charcoal, with a superpositioned line in red ochre (cat. 3.3a). The antelope is shown in an extended position and has the same tapering legs as the animal-human figure. A similar style is displayed by a third slab, bearing what appears to be a giraffe, or possibly a zebra. The short upright mane is found in both animals, as is the pronounced cheek,

but the body markings are a stylised chequer pattern of fine black and white lines. The remaining three slabs have very indistinct traces of charcoal lines, one possibly depicting a rhinoceros.

The same motifs are common among the surviving (and presumably much younger) paintings found in open rock shelters elsewhere in Namibia and southern Africa. Similarities in subject-matter and stylistic convention point to a remarkable continuity in the artistic tradition and in the religious beliefs to which it relates. Superpositioning, as shown by one of the Apollo 11 paintings (cat. 3.3a), is an important feature of the more recent rock art and reflects definite syntactical relations rather than disregard for earlier works. Furthermore, the combination of human and animal traits reflects the underlying beliefs of ritual healing practices of hunter-gatherers in which shamans employed the supernatural potency of particular

wild animal species. Details such as the long, tapering legs and the chequered body markings shown in the paintings are probably conventions for the depiction of physical symptoms experienced by shamans in trance. The rising sensation associated with the onset of trance is shown most suggestively in the depiction of the legs in the animal-human figure (cat. 3.3b), and the equally well-attested trance symptom of fractured vision probably influenced the body markings of the other animal paintings. In all likelihood, correspondence between the animals and the symptoms of ritual trance guided the artist's selection far more than their importance as quarry for the hunt.

The implication of this evidence is that southern African hunter-gatherer ritual and art remained stable for an extremely long period. However, the length of this period depends at present on the accuracy of the Apollo 11 dating. While attempts to date the art directly have so far proved incon-

clusive, there are promising new advances in the dating of extremely small samples from carbon-rich paintings. Although there are not many accurate radiocarbon dates available for stratified finds, the painted stones recovered from archaeological excavations in southern Africa appear relatively recent, dating to within the last 9000 years. The very much earlier dating of the Apollo 11 paintings, evidently Africa's oldest works of art and contemporary with some of the Upper Palaeolithic art of western Europe, is potentially of great significance.

It should be borne in mind that the painted slabs were found in a concentrated group, in the uppermost layer of the macrolithic blade-dominated assemblages, where they were dated to between 25,500 and 27,500 before the present (BP). The next layer, containing an essentially microlithic assemblage is dated to between 18,500 and 19,760 BP. While the younger dates currently provide a

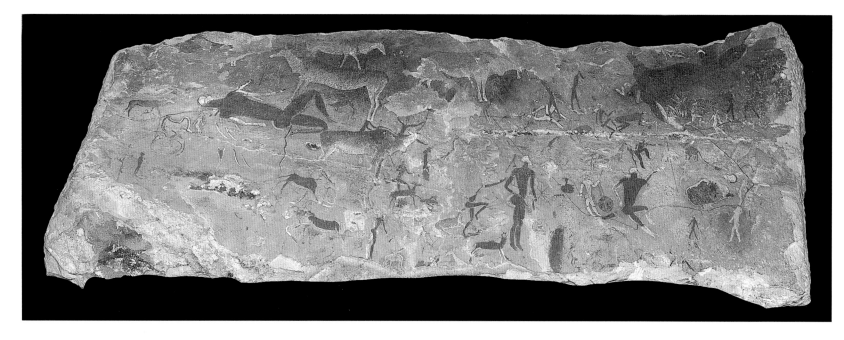

minimum age for the painted slabs, the excavation indicated that the association with the older dates was firm. Direct dating of the paintings themselves would resolve this ambiguity. *JK*

Provenance: 1969–72, Apollo 11 Cave, Huns Mountains, Karas Province, southern Namibia

Exhibition: Bonn 1991

Bibliography: Lewis-Williams, 1974; Wendt, 1974; Siegel, 1977; Rudner, 1983; Thackeray, 1983; Volman, 1984, p. 215; Kinahan, 1991

3.4

Linton panel

San
South Africa
possibly 18th or 19th century
stone, ochre and other pigments
85 x 205 x 20 cm
South African Museum, Cape Town,
SAM-AA 3185

The paintings of the Linton panel constitute an interconnected congeries of San religious symbols, metaphors of shamanic experience and depictions of shamanic hallucinations. Many of the images are connected by a bifurcating red line fringed with meticulously made white dots. This line, a common motif in the region, is thought to represent the route of shamanic travel or, perhaps simultaneously, the supernatural potency that permeated the San universe and that San shamans harnessed in order to enter the spirit world (trance), control the movements of animals, heal the sick, make rain and go on extracorporeal journeys in the form of animals. The southern San believed that this potency resided in certain large animals, chief of which was the eland (*Taurotragus oryx*), an animal that had, for the San, multiple symbolic associations. The depictions of eland in the Linton panel are symbols of this potency and, at the same time, 'reservoirs' of spiritual power on which San shamans, and possibly other people, could draw.

Depictions in the left part of the panel constitute a cluster of metaphors of shamanic trance experience.

The large supine figure depicts a shaman partly transformed into an animal; it has cloven hoofs rather than feet. The figure holds a fly switch, an artefact used almost exclusively in the trance, or medicine, dance. A key San metaphor, 'death' (entry into the spirit world), is represented by the antelope that impinges slightly upon one of the supine figure's legs: it bleeds from the nose, as San shamans often did when they entered trance. 'Death' is also represented by the buck-headed snake that lies brokenly on its back; it too bleeds from the nose. The spotted rinkhals snake feigns death in this way and then springs to life. The fish that surround the supine figure and the eels below it represent another metaphor, the 'underwater' experience of which San shamans speak. A sense of weightlessness, difficulty in breathing, affected vision and hearing, and eventual unconsciousness are experienced by people underwater and by shamans entering trance.

Visual hallucinations experienced by shamans in trance are also depicted in the panel. A small dog-like creature with six legs is painted to the right of the central figure, which depicts a standing shaman. Just above this creature is an antelope head peering from a circle of paint that, like the red line, is marked with white dots. The spirit world was believed to lie behind the rock, and creatures of that world could be coaxed out of it by the application of paint. Further to the right, a human head, bleeding from the nose, also emerges from an area of paint.

The Linton panel was removed in 1918 from a rock shelter in the southern Drakensberg. Many associated paintings were destroyed in the process of removal. Those that were left in the rock shelter were subsequently severely damaged by natural weathering processes. The Linton panel probably comprises the richest and most complex set of rock paintings in any museum collection. *JDL-W*

Provenance: 1918, removed from the farm Linton in the Eastern Cape Province, South Africa; 1918, South African Museum, Cape Town

Bibliography: Lewis-Williams, 1988; Lewis-Williams and Dowson, 1989

3.5

Rock painting

San
South Africa
age unknown
stone, paint
16 x 25 x 7 cm
University of the Witwatersrand,
Johannesburg, 25/45

This rock painting was removed in 1945 from the wall of a rock shelter in the Eastern Cape Province. It depicts a recumbent rhebuck (*Pelea capreolas*), painted in the shaded-polychrome technique. Its delicacy and the movement implied by its posture are typical of San art, but it is unique in that the central part of the body has been left unpainted. This was apparently an isolated image, but the San often painted animals in large groups that in size and sex ratios conform to herds as they are naturally constituted at different seasons of the year.

Animals had symbolic value for the San. Commenting on rock paintings of human figures with rhebuck heads, a 19th-century San man used a series of metaphors, some of which are depicted in the Linton rock paintings (cat. 3.4). He said that they were shamans who had 'died' and were then transformed in the 'underwater' spirit world and took on animal features.

The relationship between rhebuck and the spirit world is seen in the art in other ways as well. Sometimes 'spirit' rhebuck are depicted without legs and with trailing 'streamers'. In the region from which this painting comes, the number of paintings of rhebuck is exceeded only by depictions of eland (*Taurotragus oryx*), the central, or key, symbol in San cosmology.

It has also been suggested that, because rhebuck live in small groups, they were conceptually associated with individual family groups among the San. Eland, on the other hand, were associated with larger aggregated San groups because eland herds amalgamate and break up into small groups seasonally, as do San communities. *JDL-W*

Provenance: 1945, removed from a rock shelter in the Eastern Cape Province, South Africa

Exhibition: Johannesburg 1995

Bibliography: Vinnicombe, 1976; Lewis-Williams, 1981; Lewis-Williams and Dowson, 1989; Lewis-Williams, 1990

3.6

Coldstream stone

San
Southern Cape, South Africa
probably *c.* 2000 BP
quartzite, paint
24 x 30 x 7.1 cm
South African Museum, Cape Town,
SAM-AA 6008

This painted stone is one of the best-preserved and best-known pieces of southern African *art mobilier*. Some comparable painted stones from the same area have been dated to between 4000 and 2000 years ago; more recent examples have not been found.

The paintings depict three striding human figures. The right-hand figure has an arm raised in a gesture that is repeated in the rock paintings of the south-eastern mountains. The legs of all three figures are outlined partly in white, another feature found in paintings on the walls of rock shelters of the area. All three figures have some sort of decoration on their arms and legs. The first two figures from the left seem to be wearing some sort of white-edged caps; the figure on the right has a three-pointed red cap. They have the characteristic 'hooked' head with white face that is common in southern African rock art. It has been suggested that the lines painted on these faces may represent scarifications, but in some instances they clearly radiate from the nose, and therefore more probably depict nasal blood. When San shamans entered trance (the spirit world), they frequently bled from the nose. The central figure holds what may be a feather and what seems to be a flat object. These items have led to the suggestion that it may depict a painter. Louis Péringuey thought that the black bars across the so-called 'feather' suggest that the object is a jackal's tail. While numerous figures in southern African rock art are depicted carrying animal-tail flywhisks, the object in the hand of the Coldstream figure is in fact extremely difficult to identify. A hunting bag from which a bow and arrows protrude is slung over this figure's shoulder. The stone was excavated in 1911 from a cave near the mouth of the Lottering river on the southern coast of South Africa. It was found, painted side up, lying on the shoulder of a skeleton. This suggests that it was implicated in funerary rituals. The excellent preservation of the paintings is remarkable and has led to suspicion that some of the natural ochres found in the excavation were used to touch up the images. Tests on the pigments have proved inconclusive. *JDL-W*

Provenance: 1911, excavated from Coldstream Cave, southern Cape coast, South Africa

Bibliography: Lewis-Williams, 1984; Wilson, van Rijssen and Gerneke, 1990

game animals near to death. As a visual cue for the peculiar rising sensation in ritual trance, the extreme height of the giraffe would have further reinforced its ritual importance. Despite these suggestive associations, no specific meaning seems to have been attached to the giraffe in rock art, and in all likelihood it would have served as a general metaphor of the continuity between ritual, social life and the natural environment.

The engraving shown was produced by the pecking technique on a block of indurated shale, at the foot of the Dome ravine on the southern side of the remote Brandberg massif in western Namibia. The Dome ravine site is unusual in that it combines both paintings and engravings in an area containing more than 1000 painted sites. Although the site and the engraving are undated, archaeological surveys conducted in the same area have revealed evidence of intensive hunter-gatherer occupation over the last 5000 years. Many of the rock art sites were used repeatedly during this period as dry season refuges. While the giraffe engraving might not be as old as 5000 years, it is probably over 1000 years old, for in this area the hunting way of life, together with the ritual and rock art traditions, was rapidly displaced during the last millennium by the rise of nomadic pastoralism. *JK*

Provenance: surface find, Dome ravine, Brandberg, Erongo Province, western Namibia

Exhibitions: Rotterdam 1993; Cambridge 1995

Bibliography: MacCalman, 1964; Pager, 1980; Lewis-Williams and Dowson, 1989; Kinahan, 1990, p. 5; Kinahan, 1991

3.7

Rock engraving of giraffe

San
Namibia
1000–5000 BP
shale
70 x 66 x 45 cm
State Museum of Namibia,
Windhoek

The arid western Erongo Province of Namibia contains one of the largest concentrations of rock art in Africa, including many superbly painted rock shelters and extensive open-air engraving sites. While the paintings are dominated by human figures and the engravings by representations of animals, some subjects are common to both. Prominent among these is the giraffe, a species that also shows great variety in treatment, colour and style of execution.

Although naturalistic depiction is uncommon, and many examples show only the backline and profile, such paintings and engravings are not necessarily incomplete, for the rock art resonates with imagery and physical experiences associated with states of altered consciousness. The belief of shamans in southern African hunter-gatherer communities, that the spinal column serves as a conduit for ritual potency, might explain the evident importance of the giraffe in the art. Indeed, paintings of serpents in Namibia are often identifiable as permutations of the giraffe, owing to the consistent presence of a small curve in exactly the position of the withers. Other features of the species that receive unusual emphasis include the pattern of the body markings and the short upright mane. The variegated markings of the giraffe are redolent of the fractured vision associated with the onset of trance, while the erect mane evokes one of the common physical symptoms of

Southern Africa's remarkable wealth of rock art is known not only for its extraordinary abundance, but also for its diversity. In addition to the famous paintings found mainly in rock shelters, there are the less widely appreciated engravings or petroglyphs, usually in open air settings on the interior plateau. These engravings manifest great variety in technique, content and history. For all their diversity, most of the engravings and paintings are believed to be linked within broadly similar Later Stone Age social and motivational contexts.

The oldest dated engravings go back about 12,000 years. On the other hand, oral history indicates that some rock art was made as recently as the 19th century. These two engravings were found near Kimberley in a region that is richly festooned with engraving sites. Animal and human images, as well as geometric or 'entoptic' forms such as these, occur in numbers ranging from just a few on hilltop boulders, to many hundreds or even thousands on the larger sites. A hard stone was used to form the images by chipping the outer crust of the rock.

The symbolism of San art is believed to be associated with religious beliefs and the experience of trance. The engravings may have been inspired by trance-induced visions, which were depicted on rocks at special places so that others could draw spiritual inspiration from them. Their palpable connection with land-scape features, reflecting a 'topophilia', which is also revealed in some 19th-century San folklore, is one of the reasons why every effort is made today to preserve this art in its natural setting. *DM*

Bibliography: Wilman, 1933; Fock and Fock, 1979–89; Deacon, 1988; Morris, 1988; Beaumont and Vogel, 1989; Dowson, 1992

3.8a

Rock engraving

San
South Africa
c. 1000–2000 BP
Andesite rock
53 x 54 x 24 cm
McGregor Museum, Kimberley,
MMK RAC 28

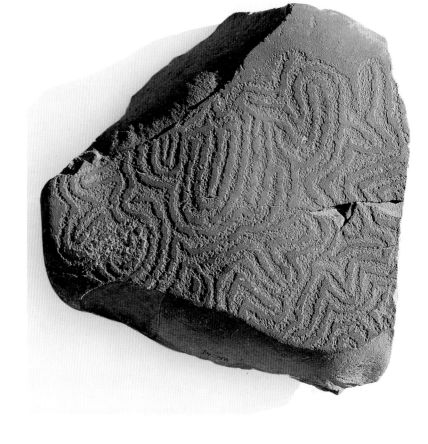

3.8b

Rock engraving

San
South Africa
c. 1000–2000 BP
Andesite rock
48 x 50 x 12 cm
McGregor Museum, Kimberley,
MMK RAC 47

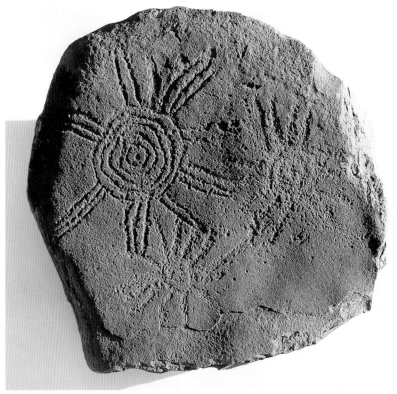

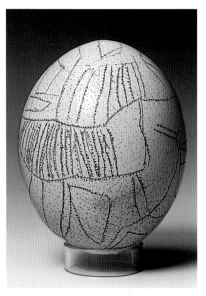

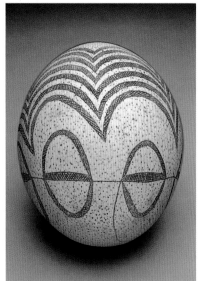

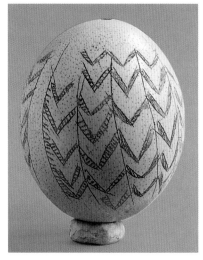

3.9a

Engraved ostrich eggshell flask

/Xam San
Griquatown, South Africa
1870s
ostrich eggshell
h. 15.5 cm; diam. 12.5 cm
Pitt Rivers Museum, Oxford, 1938.37.20

3.9b

Engraved ostrich eggshell flask

San
Windhoek, Namibia
early 20th century
ostrich eggshell
h. 14.8 cm; diam. 12.3 cm
South African Museum, Cape Town,
SAM-AE 1746

3.9c

Engraved ostrich eggshell flask

Masarwa
Molepolole, Botswana
early 20th century
ostrich eggshell
h. 15.4 cm; diam. 12.7 cm
University of Cape Town Collection at the
South African Museum, Cape Town,
UCT 38/46

3.9d

Engraved ostrich eggshell flask

San
Botswana
1920s
ostrich eggshell
190 x 110 x 112 cm
Natal Museum, Pietermaritzburg

Ostrich eggshells can remain well preserved for tens of thousands of years in archaeological deposits, and have been used as containers by hunter-gatherers, ancestors of the San, for at least 15,000 years. The oldest dated fragments of smoothed apertures, which indicate that eggshells were undoubtedly used as flasks, have been found in an archaeological context at Boomplaas Cave in the southern Cape region of South Africa. These are associated with Later Stone Age artefacts, though the practice of engraving patterns on eggshells is even older. Engraved fragments, but as yet without evidence for smoothed apertures, have been found at a small number of sites in South Africa and Namibia associated with Middle Stone Age artefacts more than 40,000 years old.

Until fairly recently, ostrich eggshell flasks were still used as water containers, particularly in areas where surface water was scarce. They were often buried for storage – caches of fifteen or more ostrich eggshell flasks have been found buried in the sand, and in the Kalahari several hundred eggshells, buried together, have been reported. In the 1960s Ju/'hoan in Botswana took about an hour to make a hole in an ostrich egg, remove the contents, clean the inside, and shape and smooth the aperture, which was most commonly at one end, but also found in the middle of the shell. When in use, the eggshells were sealed with a plug of beeswax or grass.

Engraving, done by both men and women, often took place over an extended period. Sharp stone flakes were the earliest tools, but metal implements were preferred when they became available. Charcoal or ochre was rubbed into the incisions to colour them black or red and to heighten the contrast and decorative impact. While very elaborate designs are seen, most cover only a portion of the surface. The designs are usually based on a 'ladder' or grid pattern, filling in triangles, parallel lines and curves. These patterns are also found in archaeological examples but both the fragments and the samples are too small to reveal any trend or change through time in pattern preferences. Some 20th-century engravers have taken advantage of the shape of the egg to design variations on an oval or ovoid form, while others focus designs

around the aperture. Naturalistic designs such as birds and antelope are known, but the majority are non-representational.

The flasks were not used exclusively for water. Records from the 19th and 20th centuries indicate that they were used for a variety of purposes, including the storage of ant larvae ('Bushman rice'), pieces of shell, as well as finely ground red ochre and powdered specularite, both used for cosmetic purposes. At least one finely engraved eggshell has been found with other grave goods in a Khoisan burial site.

Engraved decoration occurs on only a small percentage of ostrich eggshell flasks seen in use or recovered from abandoned caches. With little ethnographic knowledge on the special use of engraved eggshells, there is some disagreement among anthropologists as to whether the engraving had more than just a decorative purpose. Typically, old abandoned caches include only one or two decorated flasks, suggesting that engraving was relatively rare. Similarly, fragments of broken eggshells recovered at archaeological sites usually have only a small percentage of decorated pieces.

The highly decorated 20th-century examples on exhibition here could even reflect responses to the 'tourist' trade, which goes back several centuries. This is attested by an elaborately engraved eggshell obtained by the Swedish traveller Sparrman, who visited the Cape in the 1770s. Today, painted as well as engraved ostrich eggshells are available for sale throughout southern Africa.

The meaning of the 'traditional' patterns and motifs engraved on ostrich eggshell flasks has not been recorded. Although there is some similarity between the patterns of ladders, grids, parallel and zig-zag lines, chevrons and nested U-shapes used on ostrich eggshells and those in rock engravings and paintings, the religious metaphors, so evident in rock art, appear to be absent. The patterns on eggshells that have been used persistently for tens of thousands of years do not seem to have influenced the patterns in San beadwork (made only after glass trade beads were introduced from Europe in the last 400 years), nor the impressed designs

on clay pots made by some San groups in the last millennium.

The individualistic and seldom-repeated character of the designs has led to the assumption that their purpose was to indicate ownership. This has not been confirmed and the lack of agreement among Western observers probably stems from different perceptions of ownership. Anyone who has engraved an eggshell would be able to recognise his or her own work, but in traditional San society the engraver would not expect to have exclusive ownership or use of the eggshell and its contents. Instead, such items were widely shared and even exchanged within a *hxaro* network of gift-giving that established and maintained social relations and reduced risks. Designs assumed to imply ownership may have allowed an engraved flask to be recognised as the work of a particular individual, but would not have implied exclusive ownership either by the person who made it or by his or her social group. Irrespective of their possible meanings, however, engraved ostrich eggshell flasks manifest a combination of art and utility that has considerable antiquity. *JD*

Provenance: cat. 3.9a: Cape Town, *c.* 1932, from the Estate of E. J. Dunn; cat. 3.9b: 1913, donated to the South African Museum, Cape Town; cat. 3.9c: 1938, University of Cape Town Collection; since 1981, University of Cape Town Collection at the South African Museum

Bibliography: Bleek and Lloyd, 1911, pp. 261, 313; Dunn, 1931, pp. 95–6; Rudner, 1971; Marshall, 1976, p. 77; Lee, 1979, pp. 122–3, 276; Deacon, 1984, p. 237, table 11; Lee, 1984, pp. 97–102; Morris, 1994

3.9e

Engraved ostrich eggshell flask

San
Southern Africa (country of origin unknown)
ostrich eggshell
h. 15 cm; diam. 11 cm
The Trustees of the British Museum, London, 1910.363

3.9f

Engraved ostrich eggshell flask

San
Southern Africa (country of origin unknown)
ostrich eggshell
h.15 cm; diam. 11.5 cm
Staatliche Museen zu Berlin, Preussischer Kulturbesitz, Museum für Völkerkunde, III D 3519

3.9g

Engraved ostrich eggshell flask

San
Southern Africa (country of origin unknown)
ostrich eggshell
h. 14 cm; diam. 12 cm
Staatliche Museen zu Berlin, Preussischer Kulturbesitz, Museum für Völkerkunde, III D 3513

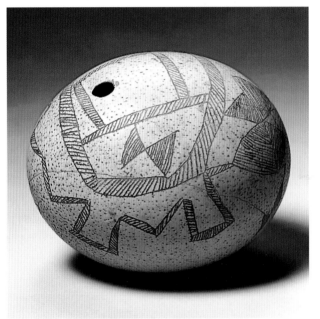

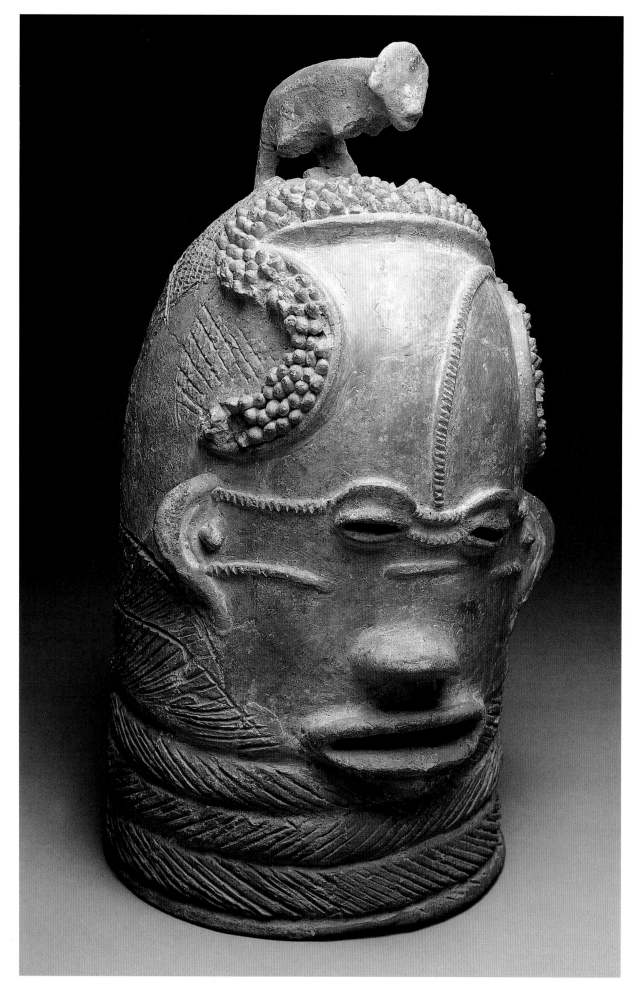

3.10a
Lydenburg Head
Eastern Transvaal, South Africa
c. AD 500–700
clay; traces of white pigment and
specularite
38 x 26 x 25.5 cm
University of Cape Town Collection at the
South African Museum, Cape Town,
UCT 701/1

Seven terracotta heads, known as
the 'Lydenburg Heads' after the site
where they were found, have the
distinction of being the earliest
known forms of African sculpture in
southern Africa. Fragments of the
modelled heads, together with shards
of domestic pottery, beads and metal
ornaments, were found in an eroding
gulley, and charcoal from the site was
later dated by the radiocarbon method
to the 6th century AD. Later excava-
tions confirmed this date and
indicated that the heads had been
buried in a pit, suggesting that they
had been deliberately hidden when
not in use.

Reconstruction of the fragments
yielded seven fired earthenware heads,
resembling inverted U-shaped vessels.
Incised bands of diagonal hatching
encircling the necks of the heads echo
the characteristic decoration of
domestic pottery from the site. Two of
the heads are large enough to have
been worn as helmet masks, and the
smaller heads have a hole on either
side of the neck that might have been
used for attachment to a structure or
costume. Distinctive facial features are
formed by the application of modelled
pieces of clay. All the heads have
cowrie-like eyes, wide mouths,
notched ridges that may represent
cicatrisation, and raised bars across the
forehead and temple to define the
hairline. Panels of incised cross-
hatching are found on the backs of all
the heads. The large heads, however,
differ from the others in having clay
studs applied behind the hairline bar,
and in being surmounted by modelled
animal figurines. One of the small
heads is atypical in having animal-like
facial features (cat. 3.10b). Traces of
white pigment and specularite are
visible on all the heads.

Although the original function and significance of the heads remains elusive, archaeologists have suggested that they were possibly used in the performance of initiation rituals. If this was so, the heads would have been ceremonial objects used during the enactment of rites that marked the transition to a new social status, or membership of an exclusive group. The aesthetic power of the heads, enhanced by white slip and shimmering specularite, adds credence to the argument that they were used in a ritual drama to enthral spectators, and mediate visually between the spirit world and that of everyday experience. Ultimately, the meaning of the heads remains enigmatic but they testify to a complex aesthetic sensibility among early agricultural communities in southern African, a millennium before the advent of European colonisation. *PD*

Provenance: late 1950s, discovered by K.L. von Bezing; 1960s, University of Cape Town; 1979, permanent loan to South African Museum. (In the 1970s the large head [cat. 3.10a] was restored by the British Museum)

Bibliography: Von Bezing and Inskeep, 1966, p. 102; Inskeep, 1971, p. 493; Inskeep and Maggs, 1975, pp. 114–38; Maggs and Davison, 1981, pp. 28–33; Evers, 1982, pp. 16–30

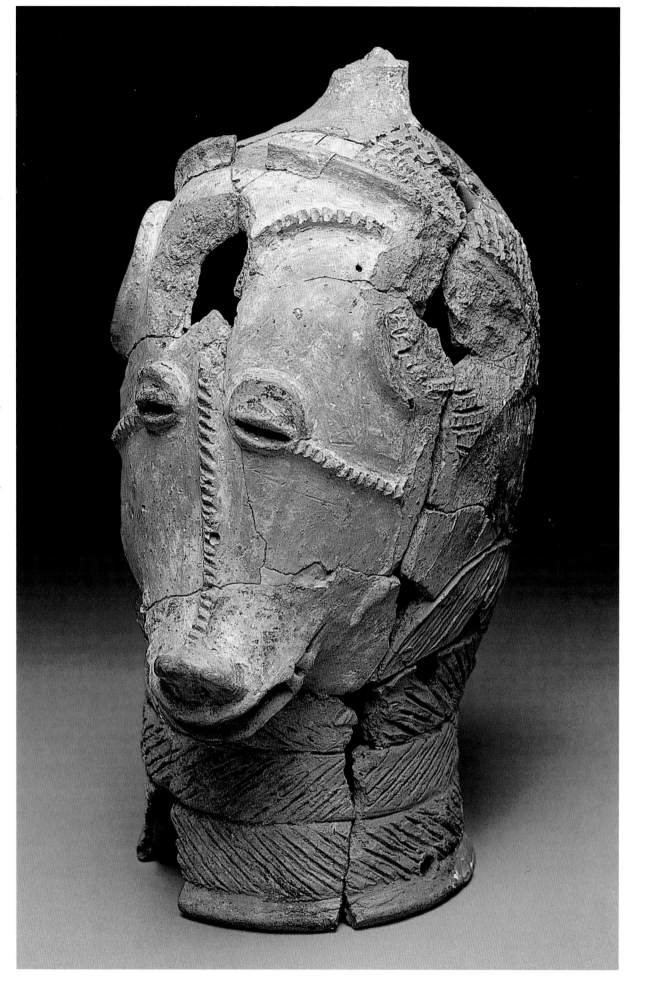

3.10b

Lydenburg Head
Eastern Transvaal, South Africa
c. AD 500–700
clay; traces of white pigment and specularite
24 x 12 x 18 cm
University of Cape Town Collection at the South African Museum, Cape Town, UCT 701/7

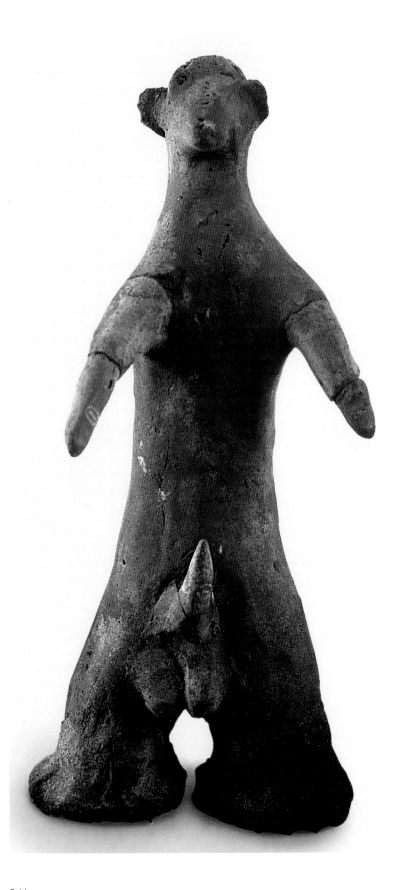

3.11a

Figurine

Northern Province, South Africa
9th century AD
clay
20 x 8.2 x 7 cm
On loan from the National Cultural
History Museum, Pretoria, OHG 254

These three figurines form part of a much larger collection that was excavated on the farm Schroda, situated near the junction of the Shashi and Limpopo rivers. Fragments of modelled figurines occur throughout the site. A single cache, covered with potsherds, included over 400 fragments. The Schroda figurines may be divided broadly into three groups – realistic and stylised anthropomorphic (male and female), zoomorphic (including elephant, giraffe, cattle and birds) and mythological. Some have applied decorative features and were coloured with red ochre and graphite. Similar clay figurines have also been found at a number of other sites in the area.

The inhabitants of Schroda were able to exploit the vast herds of elephant in the Limpopo valley and the alluvial gold from the gold reefs in the south-west of present-day Zimbabwe. About the year 1000, Schroda was abandoned when a powerful group of newcomers settled in the vicinity and made their capital a few kilometres to the west at the site known as K2. This site became a wealthy trade centre, attested by the fact that more glass beads and ivory objects have been found at K2 than virtually all the previous settlements in the area put together.

Archaeological evidence shows that ritual activities were practised during the Early Iron Age even though they are not clearly understood. In particular, ceremonial sacrifice of animals is probably reflected by the pottery, ash and burnt bones that are often found in cattle enclosures. The best known artefacts indicating ritual behaviour in the Early Iron Age are the Lydenburg Heads (cat. 3.10) and the clay figurines from Schroda. Ethnographic sources suggest that collections of unusual figurines found within villages probably indicate the sites of former girls' initiation schools. As Schroda was a regional capital, occupied by between 300 and 500 people, large initiation schools were probably held there, explaining the profusion of these small clay sculptures. *JvS*

Provenance: 1976, excavated by E. Hanisch
Exhibitions: Pretoria 1982; Pretoria 1989
Bibliography: Richards, 1956; Hanisch, 1980, pp. 156–63; Grobler and Van Schalkwyk, 1989, p. 70

3.11b

Figurine

Northern Province, South Africa
9th century AD
clay
18.5 x 8.5 x 6 cm
On loan from the National Cultural
History Museum, Pretoria, OHG 252

(not illustrated)

3.11c

Figurine

Northern Province, South Africa
9th century AD
clay
21 x 10 x 6.5 cm
On loan from the National Cultural
History Museum, Pretoria, OHG 251

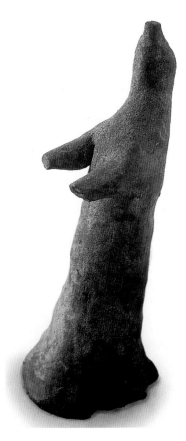

3.12
Carved soapstone bird

Zimbabwe
13th–15th century
steatite
h. 100 cm
Groote Schuur Collection, Cape Town

Eight soapstone birds were found at Great Zimbabwe, the 13th–15th century capital of the Shona kingdom. All came from areas originally reserved for private and sacred functions. Seven came from the Hill Ruin, the secluded palace of a sacred leader. One of these stones was associated with the king's *chikuva*, or sanctuary, at the back of the Western Enclosure. The other six had apparently been mounted on low stone terraces in the Eastern Enclosure, a national ritual centre. The eighth bird was placed in a *chikuva* in the Philips Ruin or Lower Homestead, near where the king's pregnant wives were confined. These locations alone point to a religious significance.

Although each carved bird is different, they all have eagle mixed with human elements. The one from the Western Enclosure, for instance, has lips rather than a beak, and they all have four or five toes rather than three talons. Their meaning thus involves the roles of both birds and humans.

In Shona belief birds are messengers, and eagles, such as the bateleur, bring word from the ancestors. Ancestral spirits in turn are supposed to provide health and success. Soaring like an eagle to heaven, the spirits of former leaders were supposed to intercede with God over national problems such as rain. Indeed, this ability to communicate directly with God was the essence of sacred leadership in the Zimbabwe culture. The carvings, then, were a stone metaphor for the intercessionary role of royal ancestors.

Since each bird is unique, they probably represented specific leaders. Furthermore, their postures may have had gender significance. For example, the stone bird from the royal wives' area perches in a 'sitting' position, while the one associated with the king's *chikuva* is 'standing'. According to custom, the king's first wife, or *vahozi*, would have been in charge of the royal wives, and the sanctuary in the Lower Valley was probably established to propitiate her ancestors. The most important woman in the capital, however, would have been the king's ritual sister, the senior woman of the ruling line and the great 'aunt' of the nation. The 'sitting' birds from the Hill Ruin probably signified the ancestral spirits of such women. The 'standing' birds of course symbolised the spirits of important male leaders.

Somewhat surprisingly, similar carved birds have not been found in other Zimbabwe culture settlements. This uniqueness may be due to the rise of Great Zimbabwe. When Great Zimbabwe became the capital, the supporting population was not familiar with sacred leadership because this feature had evolved 300 km away at Mapungubwe. To legitimise the new social organisation, the Zimbabwe leaders would have needed to glorify their ancestors. This would explain why all the birds from the Hill Ruin appear to have been carved by the same person. By the time Great Zimbabwe was abandoned, sacred leadership was widespread, and ideological justification of a new dynasty was no longer necessary.
TNH

Provenance: 1889, removed from the Eastern Enclosure of the Hill Ruin, Great Zimbabwe; 1889, sold by W. Posselt to Cecil John Rhodes

Bibliography: Bent, 1896, pp. 180–4; Hall, 1905, pp. 106–8; Posselt, 1924; Summers, 1961[1]; Summers, 1963, pp. 70–4; Garlake, 1973, pp. 119–21; Huffman, 1985

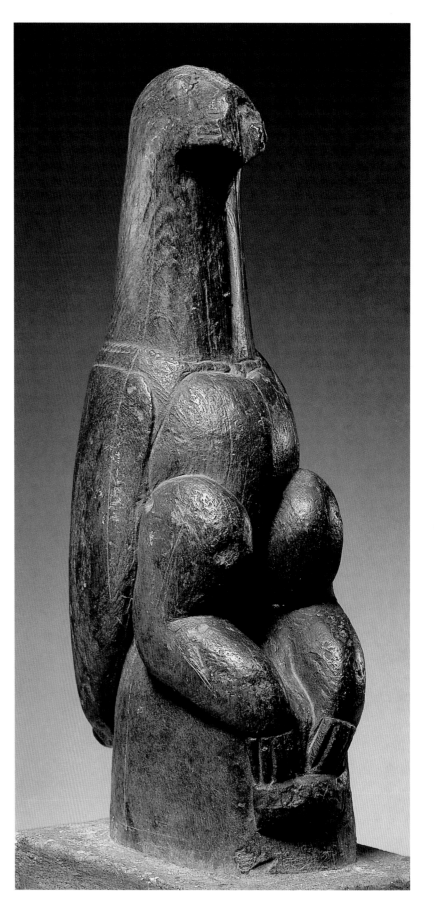

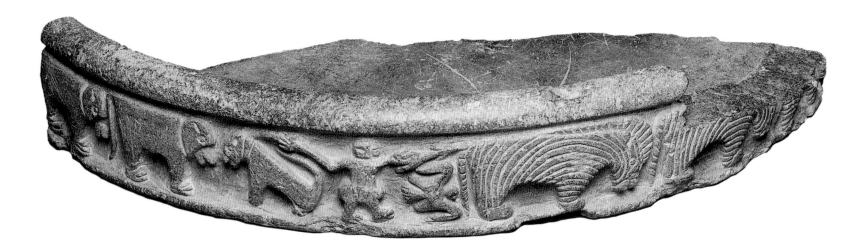

3.13

**Fragment of carved
soapstone bowl**

Zimbabwe
13th–15th century
steatite
7.1 x 43.7 x 17.7 cm
South African Museum, Cape Town,
SAM-AE 7859

Soapstone bowls have been found in several areas at Great Zimbabwe. They were recovered from the Lower Valley (an area reserved for the king's wives), the Great Enclosure (a centre for initiations similar to the *domba* school of the Venda) and in the Hill Ruin (a palace complex that among other things provided ritual seclusion for the sacred leader).

The front (Western Enclosure) of the Hill Ruin was the more public compartment that contained the leader's audience chamber. The back (Eastern Enclosure) was a private and sacred area that housed some of the famous Zimbabwe birds (cat. 3.12) as well as soapstone bowls. Larger examples bear marks on the inside, possibly caused when cutting up meat: it seems that they may have been used in rituals that involved offerings to the ancestors.

The bowls vary from 30 to 60 cm in diameter with vertical sides 7 to 10 cm high. Usually the vertical sides have been carved with geometric designs such as hatching, cord and herringbone patterns. In the Zimbabwe culture, symbolic geometric designs usually represented crocodiles or snakes and were part of a complex of symbols that included mountains and pools, referring to protection. Thus a bowl with cord designs around the outside may have represented the 'snake of the water' that guarded female fertility.

Bowls with naturalistic designs are less common and more difficult to interpret. They are unlikely to have been divining bowls, because of their size and location of the designs. Most divining bowls in southern Africa are marked along the rim rather than on the vertical walls, so that the designs can be easily seen. A soapstone bowl with a crocodile and bull carved on the walls was found in the Great Enclosure near a stone cairn that had been covered in burnt cattle bones. The primary function of all soapstone bowls, then, probably had to do with rituals propitiating ancestor spirits.

The carved fragment exhibited here has the most complex frieze on any bowl from Great Zimbabwe. It depicts a procession of zebra, followed by a bird and a human-like figure leading a dog, which faces a baboon. These symbols could have totemic significance but their meaning is not yet known. *TNH*

Provenance: 1891, discovered at Great Zimbabwe by T. Bent (possibly placed there in 1889 by W. Posselt)

Bibliography: Bent, 1896, pp. 195–203; Hall, 1905, pp. 108–10; Posselt, 1924; Summers, 1961[1], pp. 267–8; Blacking, 1969, pp. 231–3; Nettleton, 1984, pp. 226–31; Huffman, 1986

3.14
Khami figurine

Zimbabwe
15th–17th century
elephant ivory
h. 16.7 cm
Queen Victoria Museum,
Harare, Zimbabwe

Khami, near modern-day Bulawayo, was the capital of the Torwa dynasty after the abandonment of Great Zimbabwe. Established between 1420 and 1450, it was the largest settlement of the Zimbabwe culture until the Portuguese helped to destroy the palace in 1640.

The ivory figurine was found in the 1940s by K. R. Robinson during excavations in the Vlei Ruin above the court. It was among some large rocks towards the back of the ruin, embedded in a thin midden deposit along with bone fragments and broken pottery. It had, therefore, probably been discarded. The figurine appears to have been mounted on top of a staff, for the bottom 3 cm had been drilled to form a socket and the loop at the end was probably used for attachment. The figure itself appears to be a man sitting with his right arm flexed against his chest. Although the left forearm is missing, the left hand could have covered the pubic region.

The Vlei Ruin was probably the office of the second most important man in the capital, the king's brother. When a king came to power a brother was appointed with him. The brother became a legal expert and took charge of court proceedings after the previous legal expert had died. Typically, this brother's office was located on a low rise where he could overlook the court physically, a position that paralleled his official responsibilities.

Ivory objects in general are rare from Zimbabwe culture sites, while this kind of figurine is unique. Considering the extensive trade networks that would have included Khami, this object could have come from several sources outside the Zimbabwe culture area. *TNH*

Provenance: *c.* 1949, found by K.R. Robinson, Khami Ruins, Vlei (or No. 5) Ruin

Bibliography: Summers, 1949; Robinson, 1959, pp. 16–17, 156

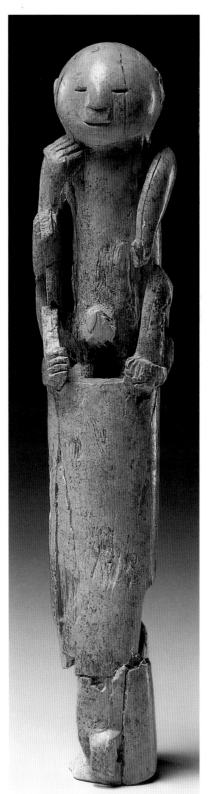

3.15
Kenilworth Head

South Africa
19th century or earlier
stone
15.8 x 9.6 x 10.8 cm
McGregor Museum, Kimberley,
MMK 85

Siege Avenue, Kenilworth, in Kimberley, was under construction during the Anglo-Boer War (1899–1902) when road builders unearthed, from a depth of almost 2.5 m, a stone sculpture now known as the Kenilworth Head. A schist-like material has been carved to make a face – a wide nose, clearly defined almond-shaped eyes, slightly parted lips and small lobeless ears. Almost nothing is known of its original context but inferences can be made on the basis of comparison with other stone heads found in the area, in particular one that was recovered at Transvaal Road, a site quite close to Kenilworth.

The Transvaal Road head was found, along with five iron bracelets, in a burial disturbed during drainage excavations in 1946. Morphological research has established that the skeletal remains represent an individual with Negro/Khoisan features, and radiocarbon tests provide a probable date of 1650. This significantly predates colonial penetration of this area in the early 19th century, implying that these enigmatic carvings can be placed provisionally in an African context.

Another clue to understanding the head is a tantalising comment by Maria Wilman, former director of the McGregor Museum. She recalls that 'from an elderly Boer visitor to the museum we learned that, in his youth, the Bushmen on his father's farm... had a similar head, which they were in the habit of bringing out on festive occasions and dancing round'. This seems to confirm an indigenous use of stone heads and gives an indication of their significance. The northern Cape area has a wealth of petroglyphs, including rare small portable rock engravings, that are known to have had religious significance. It is not impossible that both portable engravings and carved stone heads were used in ceremonial contexts. However, in the absence of supporting evidence this must remain in the realm of speculation. *DM, PB*

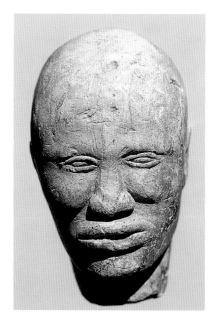

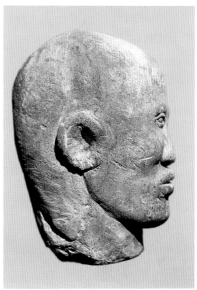

Provenance: 1908, presented to the McGregor Museum

Bibliography: Wilman, 1933, pp. 24–5; Power, 1951; Holm, 1963, pp. 52–4; Derricourt, 1974; Beaumont and Vogel, 1984, p. 86; Morris, 1990

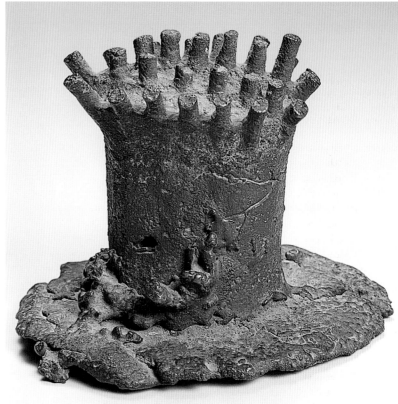

3.16a

Ingot (*musuku*)

Venda
Northern Province, South Africa
copper
h. *c.* 9.7 cm
Museum für Völkerkunde,
Frankfurt am Main, NS 35 283

3.16b

Ingot (*musuku*)

Venda
Northern Province, South Africa
copper
10 x 13 x 13 cm
U. and W. Horstmann Collection

Musuku ingots are attributed to the Venda people of the Northern Province of South Africa and are historically associated with early copper mining at Messina. Another type of copper ingot, known as *lerale*, comes from the Phalaborwa area of the eastern Transvaal and differs from *musuku* ingots in having a distinctive rod-like shape. Both types of ingot usually have irregular projections extending from the body.

Musuku were probably cast in an impression made in sand, with the studs at the bottom. Successive layers of molten copper were poured into the mould, the overflow at the top forming the 'base' of the ingot. *Musuku* ingots vary considerably in size and weight, some weighing as much as several kilograms. Some *musuku* are hollow, others are solid, or filled with sand or slag, and some have been found on examination to contain something, such as a granite pebble. These ingots may have been ceremonial objects rather than currency or items of trade but there is uncertainty regarding their use. The significance of the projecting studs is also enigmatic.

The production of metal in southern Africa goes back to the 3rd century AD. Around the beginning of the 11th century there is evidence of large-scale mining of copper and tin at centres like Messina and Rooiberg in the Transvaal. Generally, both copper and iron were used for personal ornaments, while iron was used for tools and weapons; tin ingots and gold are known to have been traded extensively. Mapungubwe and its neighbouring site, K2, in the Limpopo River valley were powerful trading centres and the earliest known southern African bronze artefacts have been found there.

Both *musuku* and *lerale* ingots probably date from the 16th century onwards when Sotho-Tswana speaking people had taken over many of the mining centres. From the amount of mining that was carried out in southern Africa in pre-colonial times, one would expect to find large numbers of ingots, or products derived from them. This is not the case, however, which suggests that many copper and tin ingots were exported via the east coast. The few *musuku* ingots still owned by Venda chiefs are revered as objects of authority and spiritual power. JvS

Bibliography: Stayt, 1931; Van Warmelo, 1940; Miller and Van der Merwe, 1994

3.17
Divining bowl (*ndilo*)

Venda
Northern Province, South Africa
19th century
wood, fibre and bone
h. 10 cm; diam. 32 cm
The Trustees of the British Museum,
London, 1946. AF. 4.1a

Divining bowls, *ndilo*, were made up to the end of the 19th century for use at the courts of Venda chiefs to divine witchcraft. Venda chiefs trace their ancestry back to the founding hero, Thoho ya Ndou, who is said to have led his people into the northern Transvaal from Zimbabwe. After founding his capital at Dzata in the Soutpansberg (*c.* 1700), Thoho ya Ndou is said to have disappeared into Lake Funduzi, and to remain there to this day presiding over a court beneath the water, which is a replica of those of living chiefs. These *ndilo* appear to depict this lake kingdom of the founding hero, while simultaneously being metaphors for the courts of living chiefs.

The subjects of the king were summoned to the central court of the capital, where they were seated according to their subgroups in concentric circles around the bowl and the diviner. The bowls were filled with water so that the crocodile on the bed of the bowl became immersed within a lake. The central mound, topped by a cowrie shell, was filled with magical substances: it projected above the water level, apparently referring to the mountains against which chiefs' capitals are built. Maize kernels were floated on this water and, as the bowl tipped or rocked on the bosses of its convex underside, the places in which they touched the rim were noted. Carved all around the rim are images representing animals which denote the different emblems of Venda subgroups, as well as designs drawn from Venda divining tablets, *thangu*. Thus the points at which the kernels touched the rim would indicate which subgroups the witches belonged to, as the divining tablet would shape their gender.

Any kernels which sank to the bed of the bowl would be interpreted according to which signs they touched there. These include two pronged shapes indicating the chief's wives, a semicircular enclosure indicating the cattle byre, a straight zigzag line denoting both the path to the capital and lightning, and a bird-like form referring to the 'lightning bird' said to lay eggs at the point that lightning strikes.

The designs on the underside of the bowl further amplify this picture. Around part of the rim of the underside, the bowl is decorated with a further chevron pattern said to represent the python that writhes on the edges of pools and lakes. Concentric circle designs are called 'the eye of the crocodile' and interlace designs refer to its skin.

This particular bowl is one of the few that have survived and is an exceptionally elaborately carved example. It has attached to it other objects used by diviners. Bowls of this kind were counted among the *dzingoma* (mysteries/relics) of the chiefdom. *AN*

Provenance: 1946, given to the museum by D. Allan

Bibliography: Giesseke, 1930, pp. 257–310; Stayt, 1931, pp. 263–308; Van Warmelo, 1971, pl. 9; Nettleton, 1985, pp. 304–66

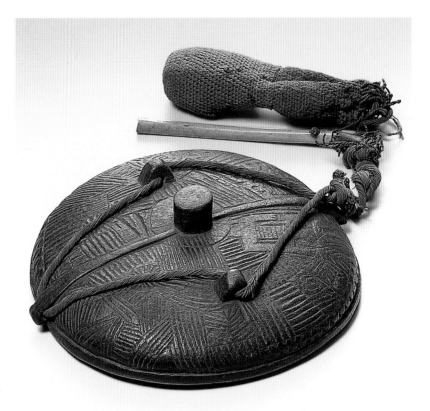

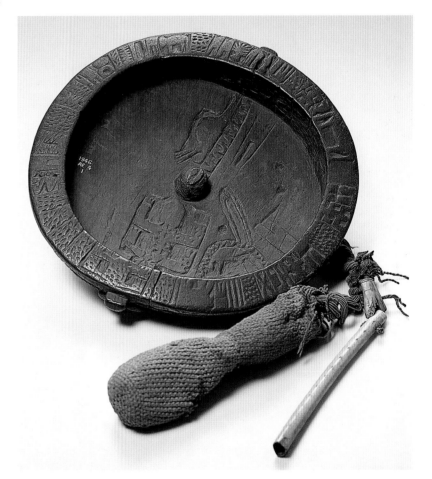

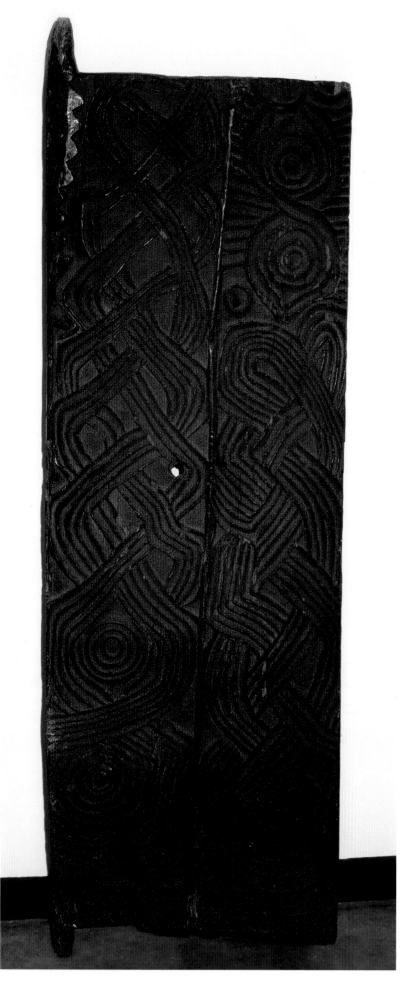

3.18a

Door (*vhothi/ngwena*)
Venda
Northern Province, South Africa
19th century
wood
154 x 50 x 5 cm
The National Cultural History Museum,
Pretoria, ET 1935/750

3.18b

Headrest
Venda
Northern Province, South Africa
19th century
wood
17 x 44 x 8 cm
The National Cultural History Museum,
Pretoria, ET 4570

Solid hung wooden doors were carved for high-ranking nobles and chiefs among the Venda. Doors with elaborately carved relief designs were, however, originally reserved for the most important chiefs of the houses of Ramabulana, Tshivhase and Mphaphuli. These doors were placed on the dwellings of the chiefs (*pfamo*) at the highest point of the capital, which was built on stone terraces against the southern sides of the Soutpansberg mountain ranges. They were thus not seen by most ordinary people during the chief's lifetime. At the death of the chief, a special burial hut might be erected with the carved door in place, used in succession disputes to give entrance only to the rightful heir to the chiefship.

The doors with elaborate carvings were called *ngwena* (crocodile) in the metaphorical speech used at chiefs' courts. Although no longer made and used, old examples are kept among the *dzingoma* (mysteries/relics) of one Venda chiefship where they are used in the initiation of young women. The sayings recited in this context give us more insight into 'meanings' generated by the forms of the door and its decoration.

The *harre* projections at the top and bottom of the door are referred to as the 'teeth', the holes at the centre of the door for the attachment of the leather thong to open and close the door are the 'nostrils', the interlace designs on the surface are the 'skin' and the concentric circles are the 'eyes' of the crocodile. Thus, while only one of the recorded doors bears a recognisable depiction of a crocodile, all the doors constitute generic images of crocodiles in their parts and design. When the door was closed, it was said that the 'crocodile bites', and when it was open, that the 'crocodile unbites'.

The relevant chiefs were themselves likened to the crocodile in his pool. Some were said to possess stuffed crocodiles in their dwellings which they used as pillows, and the same motifs as are found on the doors appear on the few known Venda headrests (cat. 3.18b). It was also maintained that, on their investiture, chiefs swallowed stones (*mmbe*) which had been taken from the stomach of a crocodile, and these the chief retained in his own stomach until he died.

Thus the doors on the chiefs' dwellings announced the presence of the immensely powerful chief/crocodile at the pinnacle of the Venda political and religious hierarchy. They were made by professional carvers, who were also responsible for the production of sacred drums, xylophones and divining bowls (cat. 3.17), all of which share the same decorative motifs and iconography. The last recorded instance of the use of such a door was at HaTshivhase in the 1950s. *AN*

Exhibition: cat. 3.18a: Pretoria 1982
Bibliography: Stayt, 1931, p. 55; Walton, 1954, pp. 43–6; Van Warmelo, 1971, pp. 361–5; Walton, 1974, pp. 129–30; Nettleton, 1985, pp. 232–50; Nettleton, 1989, pp. 70–6

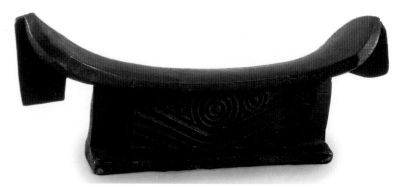

3.19a

Pole figure

Lobedu
Northern Province, South Africa
early 20th century
wood
h. 162.5 cm
South African Museum, Cape Town,
SAM-AE 9751

3.19b

Pole figure

Lobedu
Northern Province, South Africa
mid-20th century
wood
h. 164.8 cm
Johannesburg Art Gallery, JL-A-58

A palisade of carved poles is a distinctive feature of courts and places of authority among the Lobedu and related people. These two pole figures come from the palisade surrounding the court (*khoro*) of the Lobedu capital, situated in the wooded foothills of the Drakensberg. It is the residence of chief Modjadji, famed for her rain-making powers and ruler by ancestral right. The *khoro* is a circular arena that was formerly used for hearing court cases as well as for public gatherings and ceremonial performances. It was the domain of men, and the carved poles of the *khoro* were brought there by men from all the districts that owed allegiance to Modjadji. Skilled carvers produced individual poles that would distinguish their contribution to the *khoro* and acknowledge their obligation to the chief. Collectively the poles of the *khoro* expressed the solidarity of the disparate groups within Modjadji's realm; they were visual reminders of social and political ties and played a part in sustaining these relationships.

Pole figures follow the elongated shape of the pole itself, the carving being confined to the upper section. Each pole was carved by an individual, drawing on shared cultural references. Most poles had pointed or forked ends but some were carved in the form of utensils, weapons, stylised animals or human figures. The verticality of the poles suggests masculine symbolism but many of the poles depicted women and activities associated with them. An early 20th-century example (cat. 3.19a) represents a woman with the characteristic Lobedu hairstyle of a girl initiate. It could be inferred that

this pole acknowledged the importance of women and fertility, a recurrent theme during initiation rites and other ceremonies. A different interpretation is needed for the pole that represents a man wearing a headring (cat. 3.19b), as this was not a customary practice among Lobedu men. This pole figure was probably carved by a Tsonga-Shangaan immigrant to Modjadji's territory. Its presence in the *khoro* reflects political inclusion but its style signifies cultural difference.

During the 1960s the traditional court system changed and a Western-style courthouse was built. Changes in administration and legal procedures undermined the political relationships that were formerly central to the *khoro* system. Not surprisingly, the aesthetic traditions associated with the *khoro* declined. *PD*

Provenance: cat. 3.19a: 1936–8, collected by E. J. and J.D. Krige from the Lobedu capital; cat. 3.19b: 1970s, collected from the Lobedu capital

Exhibition: cat. 3.19a: Cape Town 1978–92; cat. 3.19b: Johannesburg 1991

Bibliography: Krige and Krige, 1943, pp. 186–208; Davison, 1989, pp. 84–102

3.20a

Headrest (*mutsago*)

Shona
Zimbabwe
late 19th to early 20th century
wood
16 x 16.5 x 6 cm
The Trustees of the British Museum,
London, 1949. AF.46.813

3.20b

Headrest (*mutsago*)

Shona
Zimbabwe
late 19th to early 20th century
wood
14.3 x 15.6 x 6.1 cm
South African Museum, Cape Town,
UCT 30/2

3.20c

Headrest (*mutsago*)

Shona
Zimbabwe
late 19th to early 20th century
wood
15 x 18 x 6.5 cm
The Trustees of the British Museum,
London, 1921. 6-16.43

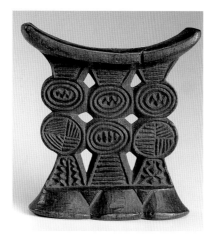

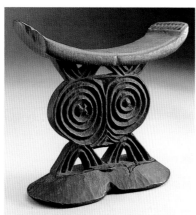

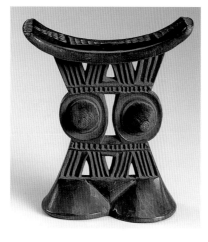

Headrests of this type with lobed
bases, carved supports and horizontal
platforms, all carved in one piece, are
used with variations of design by a
number of different southern African
peoples. The examples which are
conventionally classified as 'Shona'
have supports which all vary to some
extent in their composition, but which
also demonstrate the persistent use of
common motifs. These include two
concentric circle motifs sandwiched
between two triangles, the upper
triangle being inverted vertically over
the lower (cat. 3.20b). There is often a
rectangular element placed either
horizontally between the two circles
or vertically from base to platform.
In some cases two or more circular
elements are inserted vertically piled
up between the triangles (cat. 3.20a).

Headrests using these design
elements have been claimed to be
common to Shona-speaking peoples
living in eastern, central and north-
central Zimbabwe, i.e. among the
Manyika, Zezuru, Korekore and
possibly Karanga sub-groups. One of
these headrests (cat. 3.20c) has further
decoration in the form of engraved
triangles on the upper surface of the
platform, a feature which may be
associated with the Manyika of the
eastern regions of Zimbabwe. Many
of these headrests have designs com-
posed of chevrons or rows of keloid
shapes along the upper edge of the
short ends of their upper platforms.

Many commentators have
remarked on how headrests of this
style appear to represent a human
figure with the upper platform as the
shoulders, the vertical support as the
torso and the base as the lower limbs,
although the fixity of this identifica-
tion has been challenged. One
example illustrated here (cat. 3.20c)
has very clearly delineated breasts
where others have only concentric
circle designs. There is further
reference to the female in the

composition of the lobed bases with
the central inverted triangular shape
calling to mind the female genitals.

The designs on the headrests
appear to have a semiotic multi-
valence. For example, the concentric
circle motifs may refer to the discs cut
from the base of white conus-shells
(*ndoro*) and thus bearing the ridges of
the shell's spiral, which were worn as
signs of status especially by chiefs and
diviners. Another reference suggested
for this motif has been the ripples in
the pool made after a stone has been
thrown into it, and, possibly by
inference, the eyes of a crocodile,
especially where such motifs appear
on Shona divining apparatus (*hakata*).
Pools are an important locus for many
Shona groups in contacting their
ancestors. The raised keloid shapes at
the centres of some of these circular
motifs make a clear reference to
bodily scarification which used to be
common among the Shona, but only
for women. Such scarification patterns
were often quite abstract, but there
are records of patterns which depicted
lizards or crocodiles on the abdominal
regions of women, possibly linking
the womb of the woman metaphor-
ically to the ancestral realm envisaged
as a pool.

All the decorative motifs on the
headrests are called by the same name
as scarifications, *nyora*, and have been
claimed to indicate the patriclans
from which their users come. Thus
the designs, through their reference to
scarifications (keloids, triangles and
chevrons), to the ripples in pools and
to *ndoro* shells (concentric circles), call
to mind both the ancestors (*mudzi-
mu/mhondoro*) of the lineage as well
as the women who guarantee its fertil-
ity. As it was only women who were
scarified in this fashion, with designs
on the shoulders, lumbar region,
chest, abdomen and around the pubis,
this reference to *nyora* must indicate a
feminine identity for the headrests.

Headrests were, however, used only
by mature men among the Shona.
When a man slept and dreamed he
was said to be visiting his ancestors,
the source of knowledge and
prosperity. The headrests as female
figures without heads further amplify
this ancestral connection. When a
man marries a woman the Shona say
that he owns her body, but that her
head (i.e. the seat of her ancestral
'being') belongs always to her father.

This clearly refers to the fact that,
among the Shona, a woman's fertility
is considered to be on loan to her
husband's lineage, of which she
never becomes a part, and thus the
vast majority of the headrests do not
have heads of their own. When a man
sleeps on a headrest of this type, it is
his head, his ancestral affiliation,
which completes the human and
specifically female image suggested
by the headrest itself. When he died,
this vehicle of ancestral communica-
tion, which also symbolised the
reproductive potential of the wife
(or wives) transferred to his lineage
on his marriage, was buried with
him or passed on to his descendants.
Headrests of this type are also used
today by Shona diviners as part of
their symbolic paraphernalia linking
them with the spirit world.

While very few such headrests are
still being used today among the
Shona, and even fewer are made, the
tradition can be traced back to ancient
ruins in Zimbabwe, including Khami
and Danangombe (also known as
Dhlo Dhlo), and possibly even Great
Zimbabwe itself.

Headrests were personal items and
appear to have been cherished by their
owners. They were often carried on
long journeys and were generally
buried with their owners at death.
Most of the older Shona headrests
are carved in a hard wood and have
acquired a deep dark brown patina
and shiny surfaces from continual
handling and use. A man using such
a headrest would be able to protect
his elaborate hairstyle, the wearing
of which was common among Shona
men until the end of the 19th century.
In this way his head would be doubly
adorned, both by the visible physical
elevation afforded by the headrest and
by the physical decorative elaboration
afforded by the hairstyle. But,
simultaneously, the female character
of the headrest and its design would
act as an affirmation of the
importance of women in the social
fabric of Shona life and in the
perpetuation of lineages. *AN*

Provenance: cat. 3.20a: 1949, donated to
the museum as part of the Oldman
Collection; cat. 3.20b: 1921, given to the
museum by Miss Hirst

Bibliography: Berlyn, 1968, p. 70;
Nettleton, 1985, pp. 121–82; Nettleton,
1990, pp. 148–50; Dewey, 1993, pp. 98–133

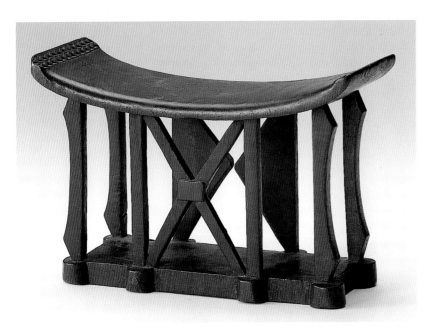

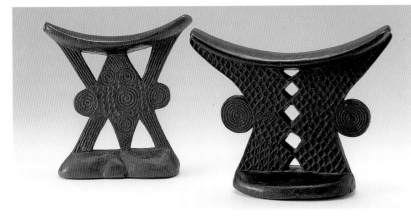

3.21a

Headrest (*mutsago*)

Shona
Zimbabwe
late 19th–20th century
wood
14 x 21 x 8.5 cm
Jonathan Lowen Collection

3.21b

Headrest (*mutsago*)

Shona
Zimbabwe
late 19th–20th century
wood
16.5 x 16 x 6 cm
Jonathan Lowen Collection

3.21c

Headrest (*mutsago*)

Shona
Zimbabwe
late 19th–20th century
wood
16.5 x 20.5 x 9 cm
Jonathan Lowen Collection

Headrests are made by the Shona-speaking peoples of Zimbabwe and Botswana in an array of different styles and motifs, with variations appearing for almost all of the canonical types that have been identified by scholars. This, together with the areas of overlap in both patronage and production with Tsonga-speakers in the eastern regions of Zimbabwe, makes classification according to narrow ethnic categories almost impossible. These three headrests show some elements which are not found on those conventionally associated with Shona-speakers.

In the case of one of the headrests (cat. 3.21a) only the upper platform suggests a Shona provenance, the base and supports being very close to forms more commonly made by Tsonga-speakers in Mozambique and the Transvaal. It appears further to incorporate forms derived from European furniture, this being especially visible in the way in which the columnar supports on the sides and the scalloped supports on the ends have each been supplied with their own circular base, although these are in fact carved integrally with the rectangular base of the whole. The shape of the upper platform, particularly the treatment of the ends with their relief chevron patterns, complies with conventional Shona practice. The cross-shapes at the centres of the long sides also conform to the kinds of design used in headrests by the Karanga (south-east and central Zimbabwe) and Kalanga (south-west Zimbabwe and Botswana). The horizontal orientation and open design of this headrest are also similar to Tsonga-Shangaan examples collected by Swiss missionaries in the eastern Transvaal at the turn of the century. The absence of any decorative motifs, besides those on the upper platform, and the particular abstraction of the base, make it impossible to detect any symbolic content. This example throws into question many of the formal means of classification used to differentiate African art objects from one another, and also raises questions of change and adaptation of traditions in response to outside influences. It is clearly constructed from forms and ideas gleaned from a number of sources.

The other two headrests (cat. 3.21b–c) have been classified as Shona. Although they depart from generally accepted canonical norms of Shona headrest sculpture (as it is found in the northern, central and eastern regions of Zimbabwe) they nevertheless display many of the same elements. But the makers of these headrests, through a process of displacement of elements, create different relationships of motifs to one another, thus possibly effecting a different symbolic reading.

In both examples the circular elements have been shifted sideways so that they project outwards from the middle of the support. In one example (cat. 3.21b) the support itself is implicitly formed by the apical opposition of pairs of triangles, expressed in the triangles which pierce the thickness of the support itself. But in the other example the support has simply been treated as a single hourglass-shaped slab, with vertically superimposed diamonds penetrating the support along its central axis; such open-work effects are common in the more canonical Shona substyles. In both examples the upper platform is supported along its entire length without projecting beyond the support at the narrower ends. This arrangement is not common in most Shona headrest types and the non-canonic arrangement is repeated in the deployment of decorative motifs and in the compositions of their bases.

The concentric circles of cat. 3.21b have been used in relief decoration not only on the projecting circular forms on either side of the form, but also on the central diamond shape of the support. These are set against a background of simple spots hollowed out of the surface of the central shape, and the straight line decoration on the outer arms of the triangles. The concentric circles probably refer to the symbolic complex surrounding the use of white conus-shells. Among Shona-speakers, white is particularly linked with ancestors through a number of associations, but most relevant here is the special attention paid in the past to the droppings made by fish-eagles in pools: the pools were associated with the ancestral world, fish-eagles with powerful spirits, and their white droppings were considered a powerful substance used by many *n'anga* (healer/diviners). The concentric circles may thus well recall both pools and conus-shells.

In cat. 3.21c the concentric circles are confined to the circular projections from the support whose surface is covered with raised lines forming a carpet-like covering of diamond shapes. These diamonds, together with the diamond-shaped spaces, suggest female scarification patterns. But these designs are also very similar to the designs on Venda doors on which concentric circles are interpreted as crocodile eyes and the patterned surfaces as crocodile skin. The ruling groups of the Venda are an offshoot of the Shona and have retained many practices associated with their forebears: it is possible that such a headrest might denote a link with pool imagery and thus with the ancestors.

It may also be significant that in neither of these examples does the base conform to a type that denotes the human female through a rendering of her genital area. Cat. 3.21b has roughly formed pro-

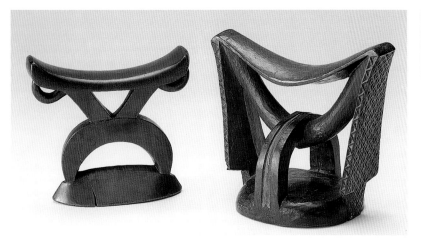
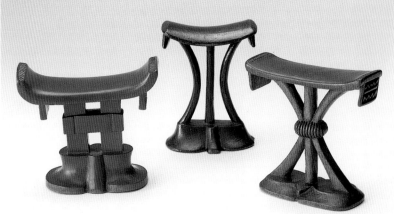

jections on the base, while cat. 3.21c has a simple oval-shaped and relatively thin base. It might thus be suggested that these headrests promote notions connected with the sources of ancestral power, while female imagery is underplayed. This also appears to be the case with most of the headrests apparently produced by southern Shona-speakers. *AN*

Bibliography: Nettleton, 1985, pp. 121–82; Becker and Nettleton, 1989, pp. 13–14; Nettleton, 1990, pp. 147–54; Becker, 1991, pp. 58–75; Dewey, 1993, pp. 98–133

3.22a

Headrest

probably Tsonga-related group
South Africa
wood
13.5 x 15 x 6.5 cm
Jonathan Lowen Collection

3.22b

Headrest

probably Tsonga-related group
South Africa
wood
14 x 11.5 x 7 cm
Jonathan Lowen Collection

3.22c

Headrest

probably Tsonga-related group
South Africa
wood
14 x 14 x 6 cm
Jonathan Lowen Collection

3.22d

Headrest

probably Tsonga-related group
South Africa
wood
14 x 16 x 16 cm
Jonathan Lowen Collection

3.22e

Headrest

probably Tsonga-related group
South Africa
wood
16.5 x 19 x 12 cm
Jonathan Lowen Collection

Although these headrests form a regional group, they show marked variation in the treatment of the base and the central support. Bases are either lobed, shaped, raised or chamfered and the central supports consist of combinations of curved vertical columns, upright beams and cross-bands. The shape of the central element, which reveals the greatest inventiveness, has provided the basis for formal classification undertaken by Jaques in the 1940s and more recently by Nettleton. The cross-bar, on which the head rests, is usually left un-decorated except for single rows of small chevrons or triangles. A dis-tinctive feature of the group is the presence of vertical lugs extending from both sides of the cross-bar. Another feature on two of the four headrests in this group is that the height exceeds the width, a relation-ship that differs from headrests found further south and west.

Headrests were utilitarian, protect-ing the hairstyle of the sleeper, but over extended periods of ownership and use they might become invested with complex spiritual associations. It is known that headrests were often buried with their owners, but in some cases they were retained as vehicles through which the late owner might be contacted in the ancestral realm.

Headrests have long been collect-able objects. The large number that have survived tell of the removal of small portable objects by traders, soldiers, missionaries and others. Many headrests were removed from their places of origin without docu-mentation, making it difficult to reconstruct particular histories. Moreover, attributing historical head-rests to modern ethnic groupings, such

as Tsonga or Shangaan, is equally problematic. A regional grouping is more plausible.

The region from which these four headrests probably derive overruns modern political borders and includes south-eastern Zimbabwe, southern Mozambique and the north-eastern Transvaal. Waves of migration during the 19th century make this a cultural-ly complex area, which demands an approach to art history that goes beyond single ethnic categories. *RB*

Bibliography: Kasfir, 1984; Nettleton, 1984, 1990, 1992; Dewey, 1986, 1993; Harries, 1988, 1989; Becker, 1991, Klopper, 1991, 1992

3.23

Headrest (*xiqamelo*)

Shangaan
Eastern Transvaal, South Africa
early 20th century
wood
15 x 20 x 9 cm
Johannesburg Art Gallery,
Jaques Collection, 1987.3.66

This is one of the most remarkable headrests from the southern African region. Its reputation is based on its quality and virtuoso carving, and on the fact that it is like no other known headrest from the area. Four tube-like forms rising from each corner of the base twist around each other, and around a central suspended knob, supporting the cross-bar. Within the confined space determined by the base and the cross-bar there is a sense of contained and compressed energy – a sense made all the more palpable when one realises that the headrest is

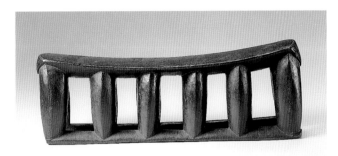

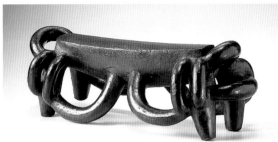

carved from one piece of wood. The base is a flat rectangular plane with a slight protrusion echoing the triangular protuberances of other headrests from within the Shona-Tsonga grouping (cat. 3.22b). The lugs, which could be considered a feature of Shangaan-Tsonga headrests, have been reduced to a simple double volume on the underside of the cross-bar. These understated extensions contrast with the vigour and complexity of the central section. The headrest appears to be unused and whether it was made for local consumption or for sale is not known.

The collector A. A. Jaques was a member of the Swiss Mission in South Africa. His documentation is incomplete and cannot be accepted uncritically. The names of owners and makers are not recorded, nor is there information on the age of the piece and where it was made. The attribution 'Shangaan' is a derivative of Soshangane, the Nguni chief who dominated what is now southern Mozambique from the 1820s to the 1850s. Following their defeat during the 1890s, the Shangaan fled to the eastern Transvaal where they settled among other people. *RB*

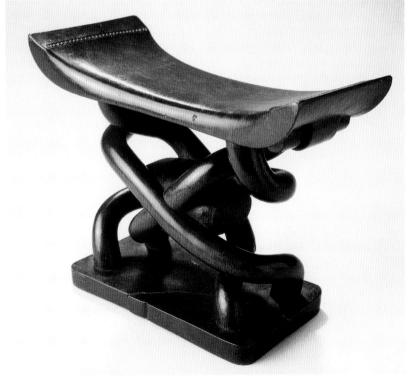

Provenance: 1925–40, collected by A.A. Jaques in the eastern Transvaal; 1940–59, Lemana Training College, near Elim, northern Transvaal; 1959–87, Africana Museum (now Museum Africa), Johannesburg; 1987, Johannesburg Art Gallery

Exhibitions: Johannesburg *c.* 1940; Johannesburg 1991, pl. 29

Bibliography: A.A. Jaques, *c.* 1941; L. Jaques, 1949; Wanless, 1987, p. 203; Becker, 1991

3.24a

Headrest (*isigqiki*)

Zulu
KwaZulu-Natal, South Africa
late 19th or early 20th century
wood
17 x 44 x 9 cm
The Trustees of the British Museum, London, 1917. 11-3.3

3.24b

Headrest (*isigqiki*)

Zulu
KwaZulu-Natal, South Africa
late 19th or early 20th century
wood
12 x 42 x 8 cm
The Trustees of the British Museum, London, 1917. 11-3.2

3.24c

Headrest (*isigqiki*)

Zulu
KwaZulu-Natal, South Africa
late 19th or early 20th century
wood
16 x 56 x 9.8 cm
Royal Albert Memorial Museum and Art Gallery, Exeter City Museums, 3/1921.2

3.24d

Headrest

Nguni
South Africa
wood
19 x 55.5 x 21.5 cm
Kevin and Anna Conru

Headrests of Zulu manufacture are remarkably diverse both in form and in the extent to which they are decorated. Some examples have comparatively delicate, incised patterns both on their legs and at either end, while others, like those having the raised *amasumpa* motif (sometimes translated as 'warts'), suggest a boldly sculptural approach that is often echoed in the size and shape of the legs. Likewise, whereas most headrests have only two or three legs, some 19th-century examples have as many as six or even eight.

The reasons for this proliferation of styles remains unclear, but regional variations suggest that particular Zulu-speaking groups or 'clans' may have favoured particular forms and patterns. Certainly, there is considerable evidence to suggest that the *amasumpa* motif, found on headrests originating in the heartland of the Zulu Kingdom, may once have been reserved for people belonging to the royal family, and to the collateral groups through which it sought to extend its power.

What the majority of these headrests have in common is a covert or, more often than not, explicit allusion to the form of an animal, presumably a bull, ox or cow. Split legs and tails are not uncommon and some even have abstractly rendered bellies. Those with numerous pairs of legs probably were intended to invoke the idea of a large herd, which may

also be true of the *amasumpa* pattern. This reference to cattle is entirely understandable given that cattle are a major source of wealth and that it is through them that people maintain communication with their ancestors.

The use of cattle in bride wealth transactions may also be relevant in this regard. Historically, headrests formed part of the dowries young Zulu-speaking brides took with them to their husbands' homesteads. But today only ardent traditionalists still commission headrests for this purpose. *SK*

Provenance: cat. 3.24a–b: given to the museum by Dowager and Viscount Wolsely

Bibliography: Nettleton, 1990; Klopper, in Johannesburg 1991

3.25

Headrest

South-eastern Africa
South Africa, Swaziland, Zambia, Zimbabwe, Mozambique, Malawi (?)
wood
h. 38 cm
Linden-Museum, Stuttgart, 116890

The Linden-Museum identifies this headrest as Zambezi. In the early part of this century, however, objects from anywhere in southern Africa were often labelled Zambezi. Complicating matters further, several Nguni-speaking groups from the north-east of southern Africa moved to the Zambezi River valley in the 19th century bringing their artistic traditions with them. The style of the Linden-Museum headrest seems closest to those from either the Swazi area or a neighbouring Nguni group and thus was probably made by one of the peoples from southern Africa or Swaziland or by one of the migrating Nguni groups who moved to the north.

In the south the Zulu- and Swazi-speaking groups have distinctive headrest styles which are easily distinguishable from those of their neighbours to the north, such as the Shona or Tsonga. While these latter groups typically make headrests with a base, central support and upper platform, the Zulu and Swazi headrests are usually made without a base and have a series of two to eight legs supporting a longer horizontal upper platform. In some headrests the legs have been turned into loops and the parallel loops carved on the side of the Linden-Museum headrest certainly mimic this style. In a few

examples the legs have been eliminated and the shape becomes an elongated rectangle like the Linden one. While there are many substyles, Zulu headrests as a general rule have horizontal ridges carved on the legs, while the Swazi ones mostly have vertical ridges. The Linden example has both.

During the period of intense war that engulfed much of southern Africa in the early 1800s, an Nguni-speaking group known as the Ngoni, originally from the Swaziland Trans-vaal area, left led by Zwangendaba. They moved northward through Mozambique and Zimbabwe to settle eventually in eastern Zambia, Malawi and southern Tanzania. Headrests that are very similar to the Swazi ones are found among both the Tanzania Ngoni (see Krieger) and the Malawi Ngoni.

Conner, who has studied the Jere and Maseko Ngoni of Malawi, reports that several known headrest styles relate to where a man or his ancestors lived before being assimilated into the Ngoni. He notes: 'Headrests, *chigogo*, were one of the many valuable personal objects which were normally broken and buried with their owner. Dreams were believed to be an important vehicle of communication with one's ancestors. Dreams were frequently acted upon. Perhaps to facilitate this valuable communication, headrest forms were conservative and usually replicated from father to son.'

Conner's observations of the Ngoni of Malawi illustrate how complicated ethnicity and style interaction can be. There, a single ethnic group use headrests of various styles; one is 'Swazi-like', another is lakeside Tonga in form, and a third seems an adaptation of a north-eastern Shona style. The styles relate to the ethnicity of a man or his ancestors before being assimilated into the Ngoni. Without more exact collection information we can only say that there is a strong possibility that this headrest is from the Zambezi river area but made by an intrusive Nguni speaking group such as the Ngoni. *WD*

Bibliography: Krieger, 1980, figs 514–19; Conner and Pelrine, 1983; Conner, 1991, p. 145; Johannesburg 1991, p. 33

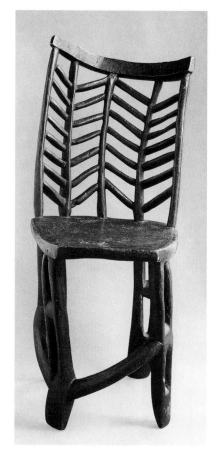

3.26

Carved chair

Zulu (Zulu Kingdom or Colony of Natal)
KwaZulu-Natal, South Africa
mid-19th century
wood
145 x 101 x 105 cm
Natal Museum, Pietermaritzburg

Carved chairs are known to have been produced throughout south-east Africa in the early to mid-19th century. This chair is one of at least two surviving said to have belonged to 19th-century Zulu kings. Like other examples in the genre (many of which are known only through illustrations and verbal descriptions) it is carved from a single piece of wood and is characterised by an asymmetrical treatment of the struts linking its legs. Despite these shared principles of design and execution, carved chairs from south-east Africa differed significantly one from another both in size and in the choice of motifs to decorate their backs and legs.

Probably inspired by European models acquired from Portuguese traders at Delagoa Bay, these chairs were reserved for the first Zulu king, Shaka, and his immediate successors. As such, they played an important role in affirming the king's political

authority over his subjects, none of whom were allowed to sit on chairs of any kind. But they certainly never acquired the ritual significance afforded the *inkatha*, which was used as a throne during the annual First Fruits ceremony when the king, dressed in a costume of natural fibres, affirmed his powers by renewing the fertility of the land. The *inkatha*, a large coil of grass containing body fluids from members of the king's regiments, was the quintessential symbol of Zulu unity.

By the mid-19th century the Zulu practice of using chairs as symbols of authority was being emulated by the leaders of neighbouring chiefdoms, some of whom appear to have bought chairs made by European craftsmen working in Natal (the British colony bordering on the Zulu kingdom) possibly with the aim of underlining the chief's wealth and status. In contrast, missionaries and other less affluent colonists who were unable to afford chairs of this kind appear to have bought comparatively inexpensive carved chairs made by local black craftsmen.

An inscription under the seat of this chair makes the questionable claim that it once belonged to King Cetshwayo, nephew of King Shaka and son of the third Zulu king, Mpande. Cetshwayo is said to have given it to the missionary the Rev. C. F. Mackenzie in 1858, but this is doubtful. Since Cetshwayo did not succeed his father until the 1870s, it is improbable that he himself actually owned any chairs or 'thrones' in the 1850s. Moreover, Mackenzie never actually visited the Zulu kingdom, and Cetshwayo is unlikely to have presented anyone with a gift of this kind, especially in the late 1850s when he was exceptionally suspicious of missionaries. Mackenzie probably acquired this chair from another source. *SK*

Provenance: 1916, donated to the museum by the great-niece of the Rev. C. F. Mackenzie, who was in Natal from 1855 to 1859

Bibliography: Angas, 1849, p. 55; Colenso, 1855, p. 124; Holden, 1866, pp. 252–3; Kotze, 1950, pp. 121, 158; Stuart and Malcolm, 1969, pp. 10–11; Webb and Wright, 1976, p. 44; Klopper, 1989; Delegorgue, 1990, p. 196

3.27a
Staff

Zulu (Zulu Kingdom or Colony of Natal)
KwaZulu-Natal, South Africa
19th century
wood, copper and brass wire
h. 143 cm; w. of ring 9 cm
Paarl Museum, Paarl, on loan to the
South African National Gallery,
PM 82/280

3.27b
Coiled snake staff

Natal chiefdoms
KwaZulu-Natal, South Africa
19th century
wood
h. 109.2 cm
Bowmint Collection

3.27c
Staff

Zulu (Zulu Kingdom)
KwaZulu-Natal, South Africa
19th century
wood
109.2 x 11.4 x 6.3 cm
Kevin and Anna Conru

Figurative and non-figurative staffs and clubs were produced throughout south-east Africa in the 19th and early 20th centuries. Many of these were made by carvers from Tsonga-speaking groups, who are known to have supplied the Zulu kingdom with staffs as part of the tribute they were forced to pay to Shaka and his successors. Tsonga-speaking migrants appear also to have produced figurative staffs for a non-indigenous market, like the example depicting a man with his legs bent up to his chest (cat. 3.27g). Among some Tsonga-speaking groups, figures on staffs may have prominent genitalia and were for probable use in initiation schools. Other staffs, surmounted either by strangely elongated heads or depictions of British soldiers wearing a variety of uniforms, seem to have been made by young men from the Colony of Natal, principally for their own use.

As this suggests, staffs were made for a variety of markets, even though most were evidently intended for use by chiefs. This latter category includes those with abstract or semi-abstract details like the two examples (cat. 3.27a,c) with horn-like projections and the generally very tall staffs surrounded by single or intertwining coiled snakes.

There is evidence to suggest that the style and iconography of the staffs used by chiefs varied considerably from one region to another. Thus, for example, in contrast to the coiled snake staffs, which appear to have been popular among groups in southern Natal, those featuring a variety of geometrically conceived motifs probably were associated only with important office bearers in the Zulu kingdom. Often surmounted by the horns of cattle (or similar motifs), staffs of this kind underline the importance of these animals as symbols of wealth and fertility and, perhaps more especially, as the means through which people maintained communication with royal and other ancestors. This is not to suggest that

all motifs found on chief's staffs were carved with the intention of conveying specific meanings. On the contrary, staffs seem also to attest, quite simply, to an appreciation of the artist's ability to juxtapose carefully balanced shapes and forms, sometimes accentuated through the addition of wirework patterns.

Clubs with bulbous heads, some of which were also covered with complex wirework, suggest a similarly careful attention to shape and surface detail. Clubs made of rhino horn were reserved for chiefs as symbols of status. During the reigns of Shaka and Dingane in particular, comparatively heavy, hardwood clubs were said to have been used to execute offenders. But, more often than not, these clubs were used for hunting. *SK*

Bibliography: Webb and Wright 1976, pp. 63–4; Hooper, 1981, pp. 157–312; Nettleton, 1989; Klopper, in Johannesburg 1991; Maggs, 1991

3.27d

Club

Northern Nguni
Swaziland or KwaZulu-Natal,
South Africa
19th century ?
rhinoceros horn
h. 90 cm; diam. 7.5 cm (head)
Jonathan Lowen Collection

3.27e

Club

Zulu (Zulu Kingdom or Colony of Natal)
KwaZulu-Natal, South Africa
19th century
wood, wire
60.9 x 8.8 x 8.8 cm
Bowmint Collection

3.27f

Club

Northern Nguni
Swaziland or KwaZulu-Natal,
South Africa
19th century
rhinoceros horn
49.5 x 10.1 x 10.1 cm
Bowmint Collection

3.27g

Figurative staff

Presumably migrant Tsonga-speaking
carver
KwaZulu-Natal, South Africa
late 19th or early 20th century
wood
22.8 x 6.3 x 6.3 cm
Bowmint Collection

3.28

Staff

Tsonga (?)
KwaZulu-Natal, South Africa
late 19th–early 20th century (?)
wood
106 x 10.1 x 6.3 cm
Kevin and Anna Conru

The Tsonga staff, while of an unusually stylised and sculpturally fluid form, exhibits the characteristics of classic Tsongan figural carving. The face has eyes with scorched pupils and brows, a broad triangular nose and the typically open oval mouth with the teeth carved in relief. The ears, beard and coiffure as well as the navel, breasts and ankles have been highlighted with pokerwork. He is wearing a conical headdress which has been decorated with alternating bands of natural wood and pokerwork, atypical because the majority of Nguni male figural works wear the married man's heading. Perhaps this represents an officer's helmet or another prestige insignia – a specimen in the Rijksmuseum voor Volkenkunde in Leiden wears a similar headdress. *KC*

3.29a

Tobacco pipe

Thembu
South Africa
19th century
wood, metal inlay,
horn mouth piece
10.2 x 30.6 x 2.6 cm
Kevin and Anna Conru

3.29b

Tobacco pipe

South Sotho or neighbouring
Cape Nguni
South Africa
wood
37 x 13.9 cm
National Museum of African Art,
Smithsonian Institution, Washington,
89-14-16

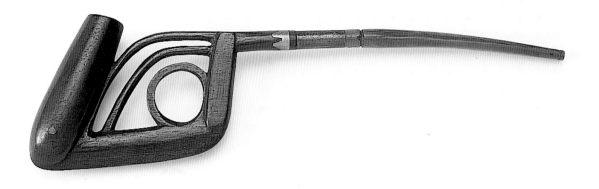

Carved tobacco pipes were widely used among Nguni-speaking people of the eastern Cape and their Sotho-speaking neighbours in Lesotho. Most pipes were made of a dense, dark wood; if the wood was light in colour, it tended to darken with the patina of use. Pipes were carved by men for use by both men and women. The length, style, decoration and size of a pipe were signifiers of social status, and pipes were often specifically displayed, either in use or when carried, as part of traditional dress. Smoking tobacco – as with the use of snuff – was an everyday activity but it was also associated with the power and generosity of individuals, as well as the ancestral spirits. Tobacco was often offered as a marriage gift and smoking was indirectly associated with fertility and procreation.

The two pipes exhibited here clearly illustrate two poles of aesthetic production. One (cat. 3.29a) is an example of the austere invention of shape; the rhythmical abstraction nevertheless plays itself out within the functional constraints of the pipe structure. The long bowl is typical of traditional eastern Cape pipes but invention emerges in the dramatic changes in the stem. Its shape in relation to the bowl creates a receptive space that is then bridged by thinly carved, arched forms and an open circle nestling against the curving stem. The sense of disjuncture, the clarity of form, delicacy of placement and directionality of this pipe make it a striking object.

The other (cat. 3.29b) is a fine example of the figurative trend also found within the region. Here the bowl of the pipe is literally a body with tapering cylindrical legs extending vertically downwards and ending in two tiny simplified feet. The bowl is fashioned into an elongated female torso, punctuated by a delicately carved pubic area, a navel and, culminating at the rim, two small breasts. The arms are thin and taut, and are clasped tightly against the side of the torso, cupping gently downwards towards the navel. The economy of this stylised human body is extraordinarily finely conceived and carved. The sheer stem of the pipe, which enters the lower back of the figure at an inclined angle, is in geometric contrast to the subtle figuration of the bowl. The absence of the head is often encountered in pipes of this type, and it is not certain if this example would originally have had a pipe cap in the form of a head or not. However, figurative pipes with delicately carved heads as stoppers are represented in South African museum collections.

Small personal objects like these pipes seem to have been passed on from hand to hand, family to family, linking clans and generations, and firmly binding the present to the past with all its ancestral significance and value. In addition, one senses in these carefully conceived objects the everyday pleasure given to maker, user and viewer. *KNe*

Exhibition: cat. 3.29b: Washington 1991
Bibliography: Shaw, 1938, pl. 95; Wanless, 1991, pl. 46

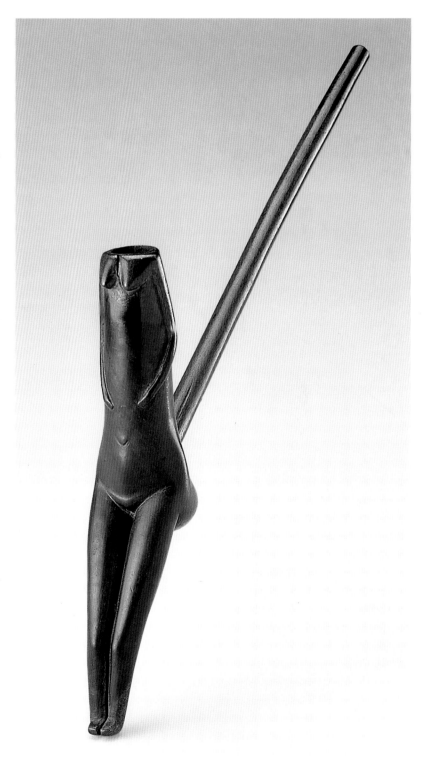

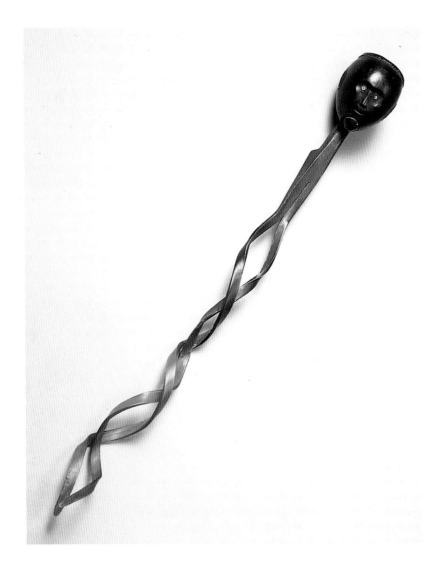

3.30c

Snuff container

South Sotho
Lesotho
horn
27.8 x 2.8 cm
Johannesburg Art Gallery, 406

3.30d

Snuff container

South Sotho
Lesotho
early 20th century
horn
59 x 3 cm
Johannesburg Art Gallery, 405

3.30e

Snuff container

Zulu
South Africa
horn
40.6 x 3.8 x 2.5 cm
Bowmint Collection

3.30a

Snuff container

Zulu
South Africa
horn
h. 36 cm
Staatliche Museen zu Berlin, Preussischer
Kulturbesitz, Museum für Völkerkunde,
III D 680

3.30b

Snuff container

Zulu
South Africa
horn
10.5 x 19.9 x 2.7 cm
Local History Museum, Durban, 95/248

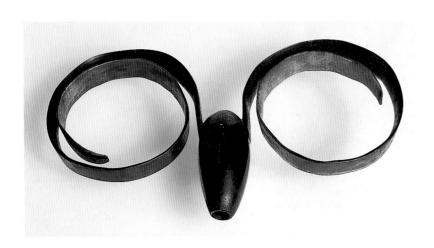

While most snuff containers tend towards smallness and discretion, there is a group of extraordinary examples that, by the addition of long extensions or figurative attributes, break with the usual austerity of form and size. In cat. 3.30d these extensions from the base of the container have been fashioned into very long spatulate blades that follow the curve of the horn from which it was made, while in cat. 3.30c the tail-like extensions resemble long comb-like tines. These distinctive snuff containers made from cattle or antelope horn were carved by men with enormous skill and care. The horn seems to have been soaked, carved and heated so as to take on and retain complex, splayed forms. The regular twists of the streamers in cat. 3.30e seem to allude to the horns of a kudu, a large southern African antelope, which was formerly widespread in the region. The figurative representation of a human head in cat. 3.30a rests upon extensions shaped into an elongated double helix. The head itself, provided with rudimentary eyes, nose and mouth, is crowned by a headring, a sign of age and status among Nguni-related groups.

These extravagant examples were probably 'show-off' pieces, designed and executed for chiefs and men of rank. Their scale and shape surely precluded them from being neatly tucked into an earlobe or worn from the neck or waist. Instead, it is likely that they would have to have been carried ostentatiously, displaying the uniqueness of the object and denoting the importance of the owner. The fact that such prized possessions were made of cattle horn underlines the close connection between the wealth that cattle represent and the related associations with the use of snuff and tobacco.

A less exuberant example (cat. 3.30b) of this type of horn snuff container, visually striking in its own right, is characterised by long, curled, circular strap-like extensions. These possibly allowed for the container to be worn around an arm or attached to a bag. Another kind of horn snuff container, historically found in southern Lesotho and bordering areas, is characterised by figurative features (cat. 3.30f–g). These distinctive containers made use of the natural hollow of the horn, which was plugged from below to seal the cavity. A small mouth was then made by drilling a hole into the horn, and was fitted with a stopper. In the antelope-shaped example (cat. 3.30g) the natural curve of the horn gives an alertness to the implied body of the animal. The tapering body culminates in a starkly stylised head with sharp, splayed horns. In the finely carved example depicting a long-necked mother with child clinging to her back (cat. 3.30f) the natural curve of the horn suggests an elegant forward gait. In both it and its companion male figure fine details of scarification, clothing and facial features are played off against the stronger rhythmic angles of arms and legs, all precisely carved in low relief on the surface of the horn. *KNe*

Provenance: cat. 3.30c: 1980s, purchased for the Brenthurst Collection, Johannesburg, from Mr. J. Lowen, London
Exhibition: cat. 3.30c: Johannesburg 1991
Bibliography: Shaw, 1935, p. 29; Wanless, 1991, p. 132

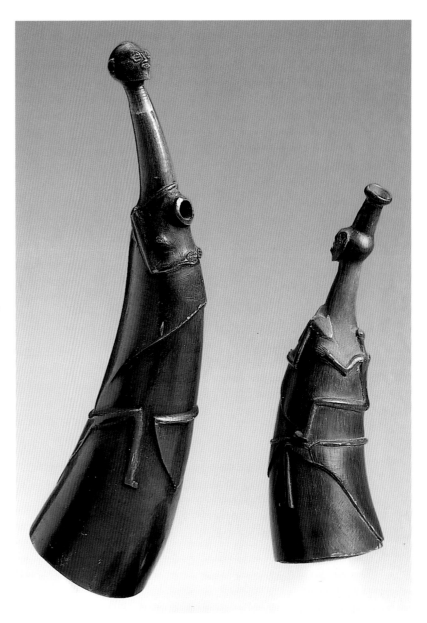

3.30f
Pair of snuff containers

South Sotho
Lesotho
horn
h. 17.5 cm (male), 12.5 cm (female)
Private Collection

3.30g
Snuff container

South Sotho
late 19th century
Lesotho
horn
19.2 x 4.3 x 4.5 cm
South African Museum, Cape Town,
SAM-AE 449

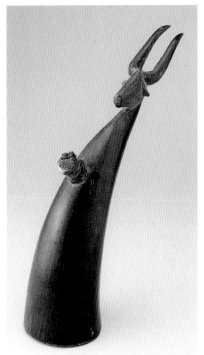

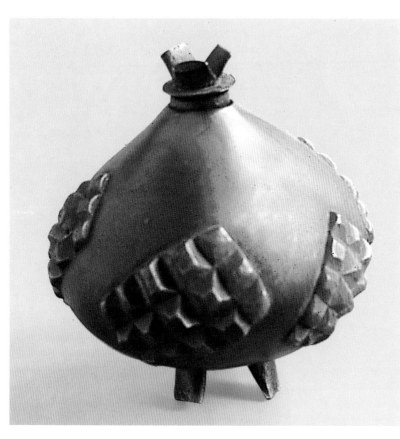

3.31a

Snuff container

Zulu
South Africa
rhinoceros horn, wood
7.5 x 6.2 x 6 cm
Natal Museum, Pietermaritzburg

3.31b

Snuff container

Zulu
South Africa
1880s
elephant ivory
12 x 9 x 8.8 cm
Natal Museum, Pietermaritzburg

3.31c

Snuff container

Tsonga
South Africa
wood
h. c. 18 cm; diam. c. 4 cm
Jonathan Lowen Collection

Throughout southern Africa the taking of snuff and smoking of tobacco are enjoyed, and valued as activities that help to sustain good social relationships. They also have highly significant associations with the ancestral world, with both virility and fecundity, and with the concomitant display of wealth, power and generosity. Snuff containers are among the smallest but most personal objects produced in southern Africa. Being discreet but portable tokens of status, receptacles for snuff were worn as accessories by both men and women. They adorned the waist, neck or arm and, among the Zulu, they were inserted through pierced earlobes. In addition, they were attached to cloaks or carried in bags.

Small as they are, snuff containers reflect the full range of aesthetic production, from abstract austerity and purity of line to figurative stylisations of human and animal form. References to cattle in shape and choice of material underscore the significance of cattle within a complex of beliefs associated with ancestral spirits, patriarchal authority and wealth.

The forms of snuff containers vary dramatically. Tiny gourds, calabashes or fruit-shells were often used, and the shape of a small gourd seems to have been the model for snuff containers carved from horn and ivory (cat. 3.31a–b). In a fine example exhibited here the bulbous body is raised on short legs. The use of rare materials, such as rhinoceros horn and elephant ivory, was the prerogative of chiefs and was associated with hunting prowess, as well as the regal power of these particular animals.

A pair of bulbous snuff containers (cat. 3.31c) joined by a carved wooden chain is typical of those produced by the Tsonga people of the northeastern Transvaal and Mozambique. These drop-like snuff containers have tapering stoppers, and are often found singly as well as in pairs. They are also frequently found attached to the ends of elaborate headrests. *KNe*

Provenance: cat. 3.31a–b: 19th century, Adams Loan to the museum

Bibliography: Davison, 1976, pp. 109–12, 145–6

A very distinctive type of snuff container, historically associated with Xhosa-speaking people in the eastern Cape, is made of a combination of hide scrapings mixed with blood and small amounts of clay. It has been suggested that these substances were collected from the hides of animals that had been offered to ancestors, thus giving the container a protective talismanic quality. The unusual mixture was worked over a clay core that was later removed when the modelled material had hardened to a stiff, leathery consistency. The outer surface of these particular snuff containers is usually spiky, the raised points having been made by lifting and stretching the surface membrane with a sharp implement while it was still malleable.

Many still have sharply pointed surfaces. This seems to indicate lack of wear; they might have been kept at home or safely within bags rather than being worn. These small sculpted forms were usually shaped like cattle or bulls with large horns. In an unusual example (cat. 3.32b) the upright form resembles a human figure, the container being the body and the stopper, with its spiky protrusions, a head with hair. However, the limbs point forward and, if placed on all fours, it resembles the cattle-like examples. In its subtle evocation of both animal and human features, this container recalls the relationship between humans and their domestic stock. The pervasive reference to cattle in this and many other forms of snuff container connects the social significance of snuff and tobacco with the spiritual power associated with these prized animals. *KNe*

Bibliography: Davison, 1976; Shaw and van Warmelo, 1988; Klopper, 1991; Wanless, 1991

3.32a

Snuff container

Cape Nguni
South Africa
hide scrapings, clay and blood mixture
10.1 x 6.3 x 11.4 cm
Bowmint Collection

3.32b

Snuff container

Cape Nguni
South Africa
19th century
hide scrapings, clay and blood mixture
13.6 x 6.6 x 4 cm
South African Museum, Cape Town,
SAM-AE 5934

Natal. Considering that it was said to have been collected in adjacent Pondoland, it is not unlikely that the apron belonged to a woman who had northern Nguni cultural affinities. Maternity aprons were made from the skin of an animal offered to the paternal ancestors for protection of the unborn baby. Retaining the shape of the animal in the apron is an explicit reference to this ancestral propitiation, and wearing the apron was believed to bring health and good fortune to the child. The significance, if any, of the particular beaded motifs is not known. Beads in themselves, however, were indicators of prosperity and thus proclaimed the status of the wearer. After the birth of the child, maternity aprons were often used to carry the baby on the mother's back.

This piece, which pre-dates 1889, provides an interesting example of a 19th-century technique that could be described as beaded embroidery. Other styles of beadwork that diversified and became widespread in south-east Africa were unbacked and comprised a lace-like beadwork fabric. With increased availability of imported commodities during the 19th century, cloth replaced many garments formerly made of animal skins, but the symbolic significance of skin maternity aprons assured their continuity into the 20th century.
EMS, PD

Provenance: 1889, Emmerling Collection
Exhibition: Cape Town 1993, no. 176
Bibliography: Hooper, Davison and Klinghardt, 1989, pp. 327–9, 355; Morris and Preston-Whyte, 1994, p. 40

3.33

Beaded apron

Southern Nguni
South Africa
19th century
hide, glass beads, sinew
50.2 (at centre) x 38.8 cm (at centre)
East London Museum, South Africa,
ELM ETH 1143

This striking apron follows the shape of the animal skin from which it was made, the hind legs forming extensions at its top for the attachment of ties, and the fore legs reduced to short flaps at the lower edge. The hide forms the base for beaded motifs in a range of colours, among which cobalt blue, white, pink and translucent yellow are most prominent.

Circular clusters of beads, arranged in irregular rows against a field punctuated with small raised loops, give the apron its distinctive appearance.

The collector did not record the context in which this garment was used, but it resembles the maternity aprons worn over the breasts and upper body by women in KwaZulu-

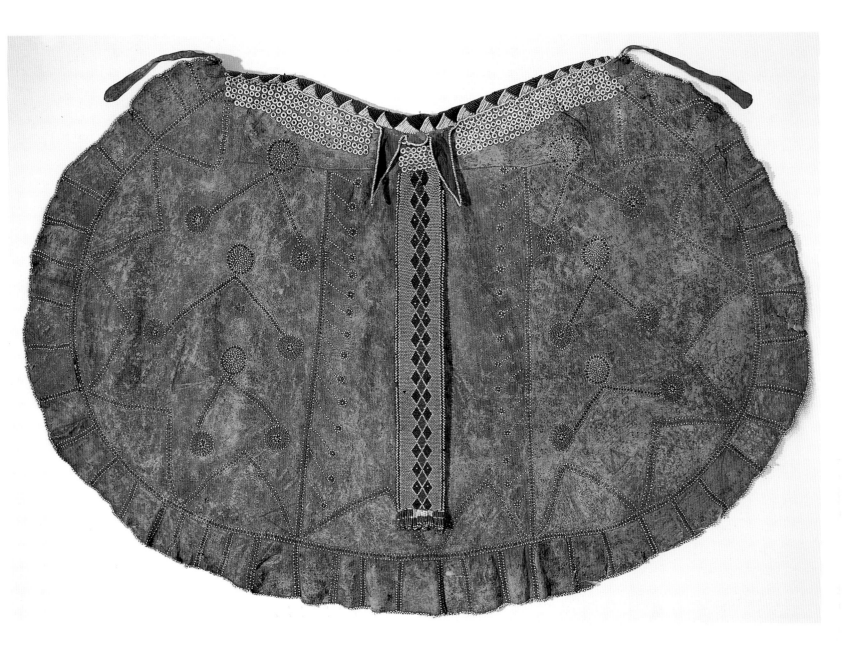

3.34

Cloak

Ndebele
South Africa
early 20th century
sheepskin, sinews, glass beads
h. 161 cm
Private Collection

Throughout southern Africa cloaks
made of animal skins preceded the
use of woollen blankets as wraps used
for warmth and for display on
ceremonial occasions. Among the
Ndebele people sheepskin cloaks,
associated with marriage, were worn
by women on important occasions
throughout their lives. Some months
before the wedding, the bride's father
prepared the skin that would be
softened, cut and sewn into the
characteristic semicircular shape of
the cloak. There was considerable
variation in beadwork ornamentation,
ranging from beaded patterns
covering the entire surface of the
garment to a simple beaded band at
the upper edge. Panels of beadwork
hanging down the centre back were
not uncommon. Photographs from the
1920s show brides wearing both

beaded and unbeaded cloaks. It is
likely that beadwork was added to a
cloak over a period of time. Although
the shape of this cloak is character-
istically Ndebele, the beadwork
ornamentation is suggestive of that
found among Sotho people, in
particular the Ntwane, who are
close neighbours of the Ndebele.

As a garment that simultaneously
concealed and revealed, a cloak was
invested with symbolic associations.
During marriage ceremonies the cloak
concealed the bride's body but
revealed her new social status; when
worn at the coming-out of a son's
initiation school, it signified maternal
status and pride; when worn by an
elderly woman, it commanded respect
for seniority. The cloak thus marked
the passage of time and was valued
highly by its owner. *PD*

Bibliography: Bruce, 1976, p. 143; Levy,
1990, pp. 56–7

3.35a

Beaded train (*nyoka*)

Ndebele
South Africa
before 1940
glass beads and cotton thread
168 x 19 cm
McGregor Museum, Kimberley,
MMK (E) 3064

3.35b

Beaded train (*nyoka*)

Ndebele
South Africa
before 1940
glass beads and cotton thread
172 x 26 cm
Private Collection, Johannesburg

3.35c

Beaded train (*nyoka*)

Ndebele
South Africa
before 1940
glass beads and cotton thread
187 x 19.7 cm
Standard Bank Collection of African Art,
University of the Witwatersrand,
Johannesburg, SBF 87.24.04

Long trains, made by Ndebele women
from imported glass beads, are among
the most accomplished examples of
beadwork artistry in southern Africa.
The conventional shapes of Ndebele
beaded clothing and ornament have
tended to remain fairly constant over
the last century but colour and design
choices have changed dramatically.
The three *iinyoka* exhibited here are
typical of the period before 1940
when Ndebele beadwork was
predominantly white, interspersed
with restrained geometric designs in
a limited range of colours.

The term *nyoka* means 'snake' but
there is no evidence to link beaded
trains to fertility or to the ancestors
whose presence is signalled by snakes.
Speculation also surrounds the
significance of the colour white,
which often reflects states of social
transition, separation or altered
consciousness, but field research
among the Ndebele has not provided
evidence on this issue. From the 1950s
onwards the use of colour became
bolder and designs more exuberant,
manifesting a proliferation of motifs,
including letters, numbers and
figurative images. Stylistic innovation
became a feature of Ndebele bead-
work. Some variations may have been
the result of emerging regional styles
but this has not been substantiated.

Ways of wearing *iinyoka* are varied
and individual. Some are designed
with a loop or headband attached so
that they can hang from the neck or
the head. Others are attached to the
back of a sheepskin cloak, made by a
bride's father for her to wear at her
wedding. Sometimes only one *nyoka* is
worn as a train but photographs from
the 1920s show women wearing two
iinyoka, one at the back and one in
the front. Other images show two
trains being worn, one from each
shoulder. In the spirit of innovation,
a modern bride may wear a Western-
style veil together with her con-
ventional beadwork.

Beadwork was used widely to
delineate the social position of
women. Changes in beaded apparel
marked progress through successive
stages of maturity and signified
differing social responsibilities.
Although in the past beadwork was
worn every day, it is now reserved for
important occasions, such as the
coming-out ceremonies that follow
initiation, weddings, funerals,

installations of age grade regiments, and parties for graduates who have completed college or university degrees. Old pieces of beadwork are unpicked and the beads recycled within the household, under the supervision of the senior women who decide what new items should be made, either for use by the family or for sale.

The Transvaal Ndebele originated among east-coast Nguni-speakers and moved into the area before or during the 17th century. Complex inter-relationships with Sotho-speaking groups of the central Transvaal occurred, resulting in varying degrees of shared custom and dress. Since the last decades of the 19th century, the Ndzundza Ndebele, who have become prolific beadworkers, have suffered repeated social dislocation. They responded to these conditions of deprivation by reviving significant social institutions, such as men's initiation, and by developing ways of communicating their particular cultural identity. Women took on the task of re-establishing domestic cohesion; they developed existing skills and extended them in new directions. In the course of doing so, they achieved fame as highly acclaimed bead artists and mural designers. *NL*

Bibliography: Tyrrell, 1968, pp. 79–89; Levinsohn, 1984, pp. 112–27; Carey, 1986, pp. 136–8; Delius, 1989, pp. 227–58; Levy, 1990; Christopher, 1994, pp. 69–71

3.36a

Pair of earplugs (*iziqhaza*)

Zulu
South Africa
20th century
pierced wood and paint
diam. *c*. 6 cm
Jonathan Lowen Collection

3.36b

Pair of earplugs (*iziqhaza*)

Zulu
South Africa
20th century
wood, vinyl asbestos, glue
and panel pins
diam. *c*. 6 cm
Jonathan Lowen Collection

3.36c

Pair of earplugs (*iziqhaza*)

Zulu
South Africa
20th century
pierced wood and paint
diam. *c*. 6 cm
Jonathan Lowen Collection

3.36d

Pair of earplugs (*iziqhaza*)

Zulu
South Africa
20th century
wood, vinyl asbestos, glue and panel
pins
diam. *c*. 6 cm
Jonathan Lowen Collection

The development of earplugs is related to the custom of ear-piercing, still widely practised in south-east Africa, especially among Zulu-speaking people. Historically, it was an important ceremony performed on every Zulu child before puberty. It incorporated some of the features of the circumcision and initiation ceremonies which are still practised by many southern Nguni but which fell into disuse among the Zulu during the early 19th century. In Zulu practice the earlobe was pierced with a sharp piece of iron; thereafter small pieces from the top of a corn stalk were placed in the newly made holes. As the ear healed, larger and larger pieces were put into the hole until it was big enough for pieces of reed to be used. Early records mention conical earplugs made of polished ivory, horn or baked clay; they also note that snuff boxes shaped like slender barrels were worn in the ear.

By the second quarter of the 20th century much larger plugs made of

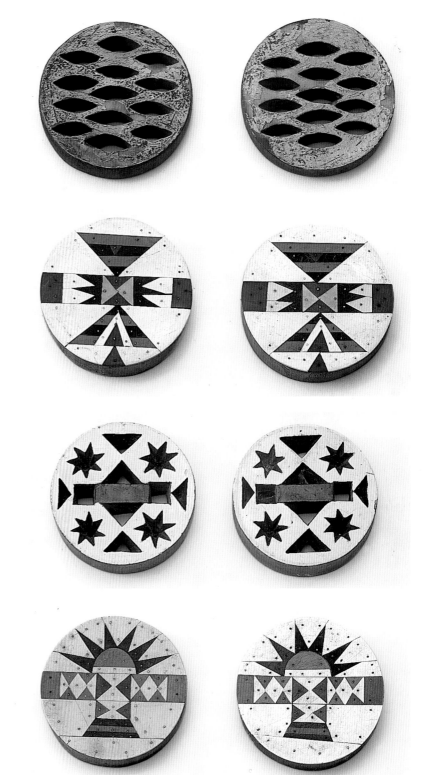

wood had come into fashion. According-ly, the hole in the earlobe had to be distended considerably. Three sizes of plug (about 45 mm, 55 mm and 70 mm in diameter) were commonly encoun-tered. The simplest and presumably earliest type consists of plain polished discs made from the wood of the red ivory tree (*Rhamnus zeyheri*), from which they took their name (*umnini*

or *umncaka*). They are often slightly convex and occasionally decorated with one or more metal studs. During the period from the 1930s to the mid-1940s, the relatively rare pierced and painted plugs were developed (cat. 3.36a,c).

Plugs of various woods with finely worked plastic mosaic overlays glued or nailed onto one or both sides had appeared by the late 1920s. Such plugs

(cat. 3.36b,d) reached their most intricate and sophisticated patterns (sometimes even incorporating letters of the alphabet) with the advent of vinyl asbestos as a flooring material around 1950. Most were made by Zulu craftsmen in Johannesburg for sale to fellow Zulu migrant workers. In the 1960s and 1970s vinyl asbestos was replaced by the thicker and more brittle perspex and occasionally by other plastics. As the new materials were more difficult to work, the designs became simpler, relying for their effect on larger bold areas of colour, a highly polished finish and, frequently, metal studs. They were usually overlaid on both sides and followed the regional patterns and colours of the Msinga district of KwaZulu, where many were produced. Finally, in the 1980s medium sized clip-on earplugs began to be made in Johannesburg. They consist typically of two 55 mm discs, connected in the centre by means of a tight rubber band. They have a perspex mosaic on one side and are painted white on the other.

The earplugs of the 1950s to 1970s tend to follow the colour conventions of regional beadwork. The colours available in vinyl asbestos closely resembled the colours of the glass beads traded in central KwaZulu at that time. They could be used to indicate the domicile of origin and possibly the clan affiliation of their owners, and certain colour combinations evoked associations with stages in the cycle of life. Most significantly, perhaps, the wearing of earplugs and the presence of conspicuously pierced earlobes identified a person as being Zulu.
FJ

Bibliography: Krige, 1936, pp. 81–7, 375; Bryant, 1949, p.141; Schoeman, 1968¹; Schoeman, 1968²; Jolles, 1994, pp. 52–9

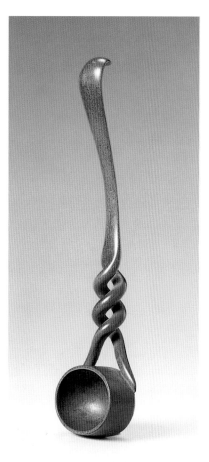

3.37

Spoon or ladle
probably Tsonga-related group
South Africa
wood
l. 20cm
W. and U. Horstmann Collection

Certain spoons, like many other African domestic objects, are aesthetically enhanced and exceed the function that is commonly assigned to them. In the south-eastern region of the subcontinent such elaboration is generally, but not exclusively, non-figurative and integrated into the form of the object. In this example, the subtly modelled handle curves gently, then becomes a double coil that eventually divides into two supports for a deep bowl. The bowl of the spoon, as well as the ornamental complexity of the handle, suggest it was used for serving rather than preparing food.

Historical references to spoons from south-eastern Africa go back to the early 18th century and they are illustrated in the accounts of many early travellers. Spoons embody many complex associations relating to ownership and are often linked to the circumstances of their acquisition. Those that were regarded as personal property were usually buried with their owners, while those purchased by the husband as part of his bride-price (*lobola*) were returned to the wife's family on her death. Such symbolic acts tend to be associated with women. In rare cases this association is made explicit in figurative representations. *RB*

Exhibition: Johannesburg 1991
Bibliography: Junod, 1962, i, pp. 145, 193; Earthy, 1968, p. 163; Witt, 1991, pp. 87–103; Bouloré, 1992, pp. 85–6; Ravenhill, 1992, pp. 70–4; Jones 1994, p. 30

3.38

Beer vessel (*uphiso*)
Zulu
Zululand, South Africa
19th century
ceramic
37.30 x 39 x 39 cm
Local History Museum, Durban, NN90/39

The final act in the British reduction of the Zulu Kingdom came on 4 July 1879, with the burning by Lord Chelmsford's troops of King Cetshwayo's capital, Ulundi/Ondini. Along with much war regalia that found its way into various collections, this vessel was taken as a trophy, either from an outlying garrison plundered along the advance or from the heart of the kingdom before its destruction. This type of pot (*uphiso*) was used for the transporting of sorghum beer from the brewing site to the regimental barracks or royal residence. It differed from the serving vessel in size and shape, having an almost spherical form to maximise volume, and a low collar to prevent spillage during transit.

'The perfection given in shape to all the Zulu pots', Bryant observed, 'was due to a natural ability in these people for describing the circle.' Zulu women handbuilt their ware by layering clay-rings, and after firing in a shallow pit, invariably finished it to a glossy jet black, using animal fat and a polishing pebble, with sifted soot and a special leaf-ash. The relief pattern of round studs is the most distinctive in the northern Nguni region, with variations seen today on carved wooden utensils. The studs may also be square or pyriform, and arrayed in either an unbroken chain

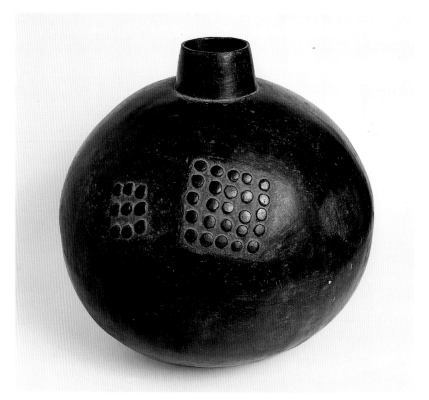

or zigzag, a succession of discrete squares or ovals, swallow-tails, circles, or large lozenges or diamonds (*izingxota*). The latter name was also given to the heavy brass gauntlets awarded to the Zulu Kingdom's men of distinction. Once the king had conferred the privilege of wearing these, they were taken to the royal smith for embellishment with one or other version of this pattern, against the gift of an ox. Thus the design probably carried the imprimatur of majesty, and indeed recent fieldwork has found it used most commonly by woodcarvers of the Emakhosini Valley, where the Zulu kings are buried – suggesting that it indeed originated in the area once dominated by the courts of Shaka's successors.

Elderly carvers assert that the clustered studs are a reference to wealth in cattle, which are not only central to Nguni cosmology and to relations between men and their ancestors, but also the chief form of bride-wealth. This makes it unsurprising that the pattern was produced not only *by* women but also *on* them: early photographs show that it was customary to beautify both wives and unmarried girls by cicatrising the belly, midriff, chest or upper arms in these various configurations. For this reason no doubt, the design is today known colloquially as *amasumpa* (warts), but this is probably a latter-day commoners' epithet for an emblem once exclusively the insignia of the ruling Zulu house, functioning above all as a symbol of royal patronage and power. In later years *amasumpa* possibly came to represent some aspect (not necessarily a head-count) of the groom's gift of cattle that to this day precedes every traditionalist Zulu-speaker's wedding. *RP*

Bibliography: Chubb, 1936, p. 185; Schofield, 1948, p. 188; Bryant, 1949, pp. 197, 401; Klopper, 1992, p. 125

3.39a
Earthenware vessel (*ukhamba*)
Zulu
KwaZulu-Natal, South Africa
clay
34 x 33 cm
Private Collection, Munich

3.39b
Earthenware vessel (*ukhamba*)
Zulu
KwaZulu-Natal, South Africa
clay
32.5 x 32 cm
Private Collection, Munich

Rimless pots made from fine brown or black clay are produced by women throughout the KwaZulu-Natal region. Pots of this kind are characterised by a smooth, glossy black finish achieved by refiring the already baked pots in a dry grass fire, before rubbing their surfaces with animal fat, usually with the aid of a small pebble. The use of incised lines or protruding mammillae to decorate such pots is widespread, although the practice of adding raised *amasumpa*, or 'warts', is by far the most common decorative technique adopted by Zulu potters. The patterns formed by these protrusions are known by different names, depending on how they are grouped. For example, *amasumpa* arranged in circles are known as *izidlubu*, while those forming a single continuous chain near the upper rim of the pot are called *uhanqu*. The design formed by wave-like zigzag bands of *amasumpa*, like that found on one of the pots shown here, is called *igwinci*. Pots of this kind are intended principally for serving and drinking a sorghum-based beer that is brewed in larger, comparatively roughly-made clay vessels. The drinking of this beer is associated, not only with the living, but also with the dead, to whom it is offered whenever ritual dictates that the ancestors must be remembered and appeased. Drinkers commonly spill small quantities of beer from their pots in what some people claim is an act of homage to their forebears.

Generally speaking, these beer pots are similar in style and decoration to the much smaller drinking-pots into which beer is sometimes decanted for individual consumption. But unlike the latter, their openings are usually covered with *izimbenge*, woven grass lids, many of which are decorated with beads. *SK*

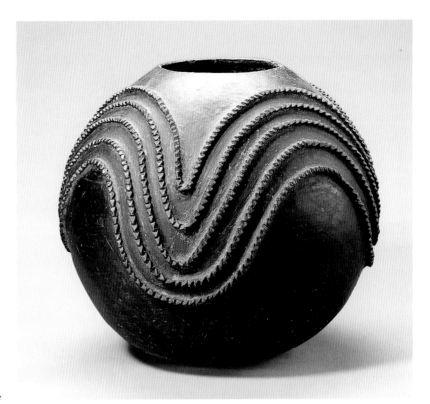

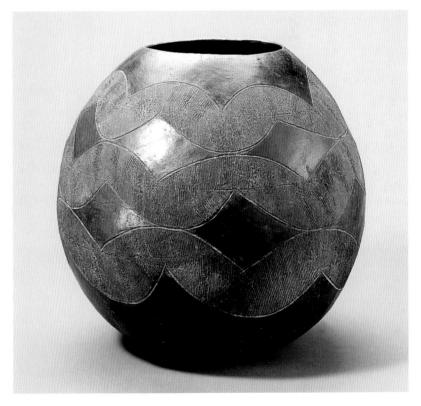

Bibliography: Bryant, 1949, pp. 398–401; Berglund, 1976; Levinsohn, 1983

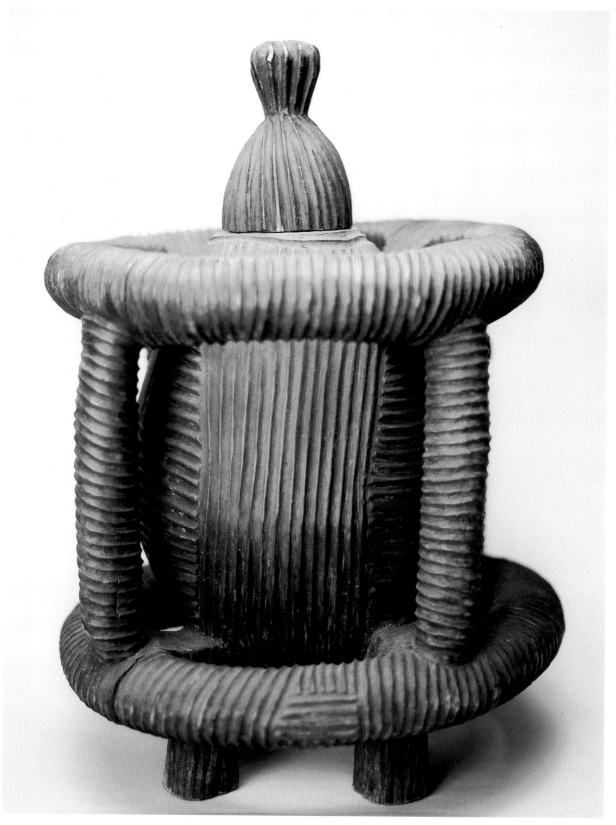

3.40a

Lidded vessel

Northern Nguni
Swaziland or KwaZulu-Natal, South Africa
possibly late 19th century
wood
h. 39 cm (vessel); 14.5 cm (lid)
Linden-Museum, Stuttgart, 18438

3.40b

Lidded vessel

Northern Nguni
Swaziland or KwaZulu-Natal, South Africa
possibly late 19th century
wood
52 x 32 cm
The Trustees of the British Museum,
London, 1954.23.570

These lidded vessels are comparable with similar vessels in public collections in Europe and South Africa, all of which are decorated with broad bands of deeply incised lines. Each is carved from a single piece of wood. The robust virtuosity of these vessels (achieved in part through the patterns created by such ridges) is reinforced by their chunky proportions. Only some of the works in this genre, like the examples displayed here, are surrounded by exterior structures. But vessels of this kind are otherwise so consistent in style and execution that they may well have been produced by a single carver or workshop.

The decorations found on these vessels invoke comparison with the patterns used in certain headrest styles from the south-east African region. But since hardly anything is known about their history or possible functions, it is not even certain that they were produced for an indigenous, African market. Indeed most (if not all) of them appear never to have been used as receptacles for liquids or cooked foods, suggesting that they may have been sold as virtuoso examples of African craftsmanship. An alternative but less probable explanation of their function is that they may have been commissioned by chiefs seeking to highlight their status through monumentally carved display objects. Unlike those owned by the heads of ordinary homesteads, the tall, slim milkpails commissioned by Zulu kings were generally lidded for fear that lightning might enter them. This tradition was probably linked to the belief that the king would never return as an ancestor if he drank milk thus affected. *SK*

Bibliography: Webb and Wright, 1976, p. 25; Berglund, 1976, pp. 37–42

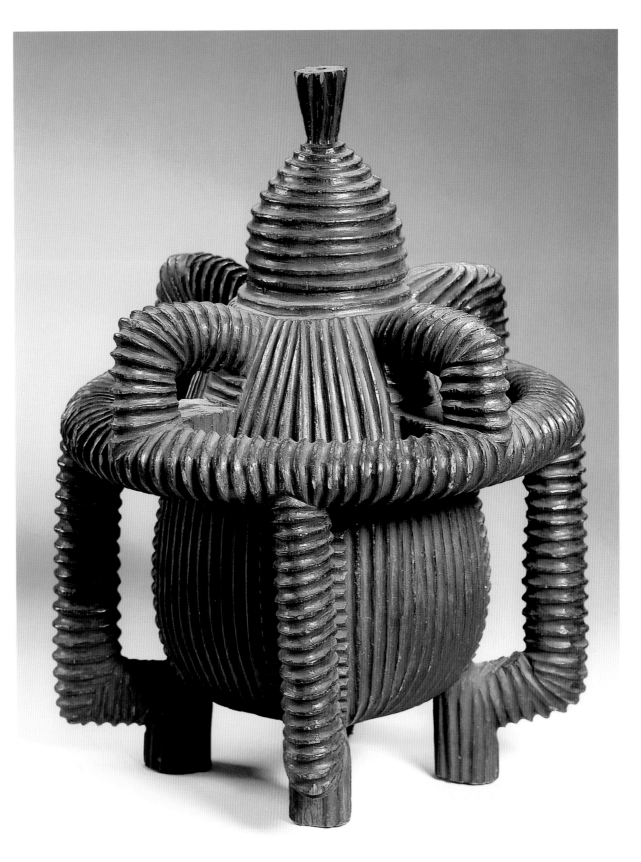

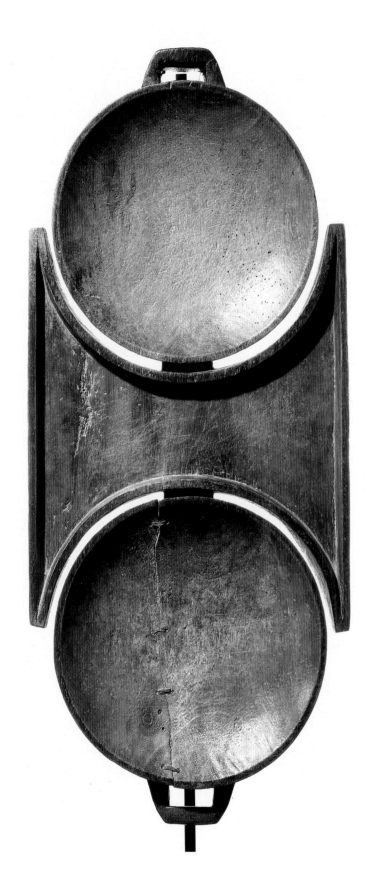

3.41a
Meat platter (*ugqoko*)
Zulu
KwaZulu-Natal, South Africa
wood
h. 80 cm
Private Collection

3.41b
Meat platter (*ugqoko*)
KwaZulu-Natal, South Africa
wood
l. 34 cm; w. 17 cm
W. and U. Horstmann Collection

Meat platters of various sizes, some of them big enough to hold large quantities of meat for communal distribution and consumption on special occasions, are still used throughout the area of present-day KwaZulu-Natal. Reserved for the roasted meat of ritually slaughtered goats or oxen, their widespread use underlines the continuing importance rural Zulu-speakers ascribe to their ancestors in securing the well-being of the living.

The styles of these platters vary considerably from one region to another, but unlike the two examples included in this exhibition, the majority are rectangular in shape, with rounded corners and two or four short legs. Most also have carefully executed decorative panels on the blackened underside of the bowl, probably because meat platters are often used to cover one another, partly to retain heat, partly to keep flies at bay.

Generally speaking, such platters are smeared with the fat of ritually slaughtered animals. This is done with the intention not only of sealing them against insect pests, but also because fat is commonly associated with the idea of ancestral protection. Most platters consequently acquire a deep patina that makes it very difficult to judge their age. Those with comparatively dusty surfaces, like the example with a 'head', breasts and womb-like bowl suggesting comparison with the female form, may well have been made for sale to European buyers. *SK*

Bibliography: Bryant 1949, p. 407; Indiana et al. 1980–1; Hooper, 1981, pp. 157–312; Klopper, in Johannesburg 1991

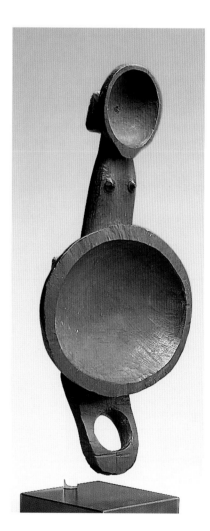

In these three figurines of indeterminate gender, presumably by the same carver, the treatment of such details as the hair, ear, facial features, arms, buttocks and legs is virtually identical.

In the late 19th and early 20th centuries numerous carvers from south-east Africa produced figurines for sale to a non-indigenous market. Most, but probably not all of these carvers appear to have been Tsonga-speaking migrants who left Mozambique for Natal in search of work. Many of them also made souvenir staffs or walking-sticks for the same market.

Typically, these figurines were sold as pairs, one male, one female, suggesting that they were inspired by the much larger figures some Tsonga-speaking carvers produced for use as didactic tools in male initiation ceremonies. But these differ from the initiation figures in several important respects. Perhaps, most obviously, they are generally stripped of the prominent genitalia found on initiation figures. Many also lack other important indicators not only of gender identity, but also of marital status, like headrings and topknots, although most of the female figurines either nurse or carry babies on their backs.

Partly because they are not paired in this way, the figurines shown here are quite unusual. Other differences between them and the paired figurines include the addition, to most of the latter, of poker-work details to accentuate certain features like beards. But they are similar to many of these figurines, and to souvenir figurative walking-sticks, in the treatment of their limbs, above all, the clear demarcation between the calves and thighs. *SK*

Bibliography: Nettleton, 1988; Klopper, in Johannesburg 1991; Nettleton, in Johannesburg 1991

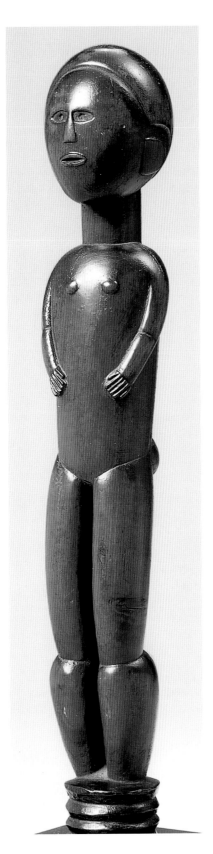

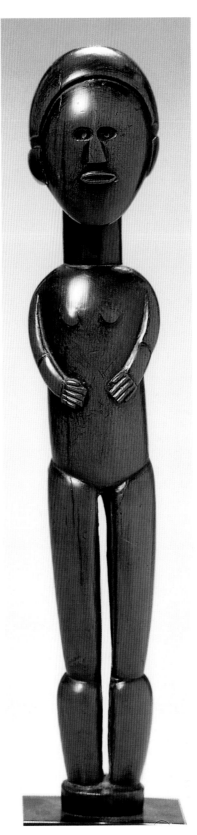

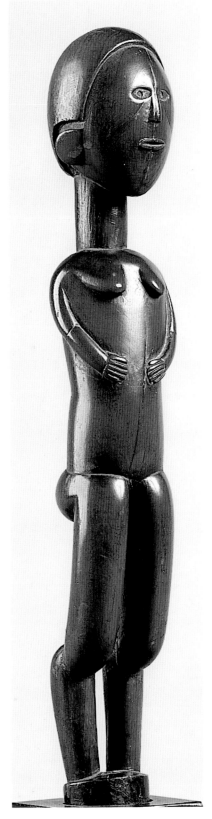

3.42a

Figurine

possibly Tsonga-related group
Mozambique or South Africa
probably late 19th or early 20th century
wood
h. 30 cm
Private Collection

3.42b

Figurine

possibly Tsonga-related group
Mozambique or South Africa
probably late 19th or early 20th century
wood
h. 29.5 cm
Musée Barbier-Mueller, Geneva, 1027.74

3.42c

Figurine

possibly Tsonga-related group
Mozambique or South Africa
probably late 19th or early 20th century
wood
30 x 4.8 x 5 cm
Private Collection, London

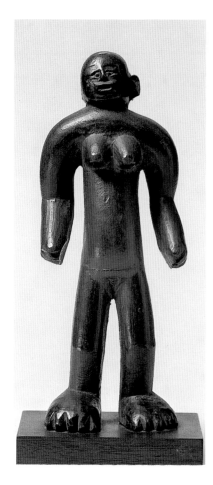

3.43

Figure

Tsonga (?)
South-east Africa
late 19th or early 20th century
wood
23 x 9.5 x 6 cm
Herman Collection

Figures of this kind are known from other collections in Europe, but very little is known of their origin. The style of carving has been defined as 'Zulu' by William Fagg, with one example from the Wellcome collection being provenanced to South Africa. This style is, however, unlike the only style of figurative carving that can securely be attributed to the Zulu-speakers of Natal, that of the baboon images carved on staffs. The very small head, the rough features and the treatment of the limbs are also unlike the carvings produced by the neighbouring Tsonga-speakers of Mozambique and the eastern Transvaal for use in initiations, but the treatment of the toes, the extreme enlargement of the feet and the horseshoe-shaped ear are concordant with stylistic features known from Tsonga-style carvings, both on

headrests and free-standing figures. A similar figure to this in the Museum für Völkerkunde in Vienna has a much more secure provenance, having been collected by Adolf Eppler in the 1880s among the 'Shangana Kaffirs', i.e. the Transvaal Tsonga. It was also one of a pair, pairs of male and female being typically produced for use in initiation ceremonies.

It might be suggested that this type of figure constitutes the output of a single, highly individualistic carver. The protuberant breasts and marked genitals suggest that this figure was not carved for European patrons, but for use in the community in which it was made. It was possibly made for use in initiation of young men among groups, such as the North Sotho, or of young women among the Venda-speakers, both of whose carving styles appear to have been quite diverse, and whose contacts with vassal Tsonga-speakers in the eastern Transvaal spanned over a century.

These groups used wooden figures as didactic aids in initiation schools, and the explicitness of this figure's genitalia suggest this as the most likely context for its use. It is also likely that, if such figures were made for indigenous use, they would have been clothed with cloth, leather or bead aprons to hide their genital areas when they were not in use, as is the case with many of the securely provenanced Tsonga and Venda figures.

Despite their small size and use of clothing, and contrary to popular belief and academic nomenclature, figures of this type were not used as 'dolls', i.e. as playthings. Moreover, as such figures have never been un-ambiguously provenanced to Natal, it does not make sense to perpetuate the myth of the notion of 'Zulu' figurative art, through attributing them to this, albeit famous, southern African political grouping. *AN*

Bibliography: Nettleton, 1988, pp. 48–51; Nettleton in Johannesburg 1991, pp. 32–47; Klopper, 1992, pp. 89–96

3.44

Carved milkpail (*ithunga*)

Zulu
KwaZulu-Natal, South Africa
wood
40 x 14 x 14 cm
W. and U. Horstmann Collection

The use of tall, slim milkpails has been common throughout the area of present-day KwaZulu-Natal since at least the mid-19th century. In most cases these milkpails are decorated with some delicately conceived motif on one or, more often, both sides. Usually, such motifs are situated well below the neck of the vessel, where they are said to serve as grips. Their primary function therefore seems to be to prevent the pail from slipping during the milking process.

Like this example, they sometimes have breast-like motifs carved near the neck of the vessel, thereby invoking associations with the female form, probably with the intention of suggesting lactation and hence, also, the idea of fertility. Women themselves are discouraged from touching their husbands' milkpails for the reason that these are associated with cattle and, through cattle, with their husbands' ancestors. This association also explains why, in the past, milkpails were regarded as heirlooms and passed on from one generation to another.

Milkpails of this kind are never used for storing milk, which is decanted into other containers, usually clay pots, wooden vessels shaped to look like the wide-bellied, narrow-mouthed clay pots commonly produced in the region, or calabash vessels. This milk is left to form sour milk, known as *amasi*. Once decanted, milkpails are placed upside down on a wooden pole, where they are left to drain and dry out between milking sessions. *SK*

Bibliography: Krige, 1936; Bryant, 1949; Raum, 1973, pp. 102, 515

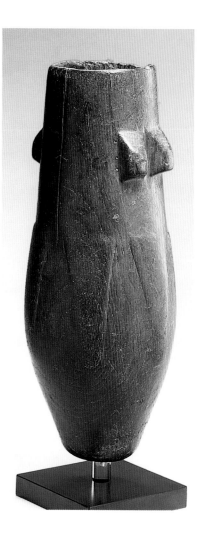

3.45

Figure

Tsonga
Northern Province, South Africa
19th century
wood, beads
75 x 12.6 x 10.2 cm
University Art Galleries, University of the
Witwatersrand, Johannesburg, Standard
Bank Foundation of African Art
Collection, SBF 82.20

Many African groups in the northern Transvaal made figures of wood for use in initiation ceremonies. The Tsonga-speakers who migrated into this area in the early 19th century appear to have adopted this practice, but it is unknown among those in Mozambique. It appears that Tsonga-speakers both attended the initiations for men conducted by such north-Sotho-speaking groups as the Lobedu, Kgaga and Pedi, and adopted these ceremonies themselves. Figures such as these were used in the instruction of initiates, young men passing from youth into manhood. They were most often used in pairs, one male and one female, to illustrate teachings about sexual and social mores.

This figure is made in a style that is specifically associated with Tsonga-speakers, with a general pole-like formation, thin arms, and legs divided into two bulbous units. The jutting jawline, open oval mouth, striated hair and spatulate hands are also typical. The hips and chest of this example are clearly differentiated from the rest of the torso, a feature not commonly found in most other figures of this type. Also while most other examples have clearly delineated genitals, this one does not. Other extraordinary features include the black staining of the whole figure and its bead eyes.

On top of the head is a ring which was worn by adult men of the Shangaan subgroup of the Tsonga (descendants of the Nguni-speaking group who, under Shoshangane, had fled from Shaka in the early 19th century and settled in Mozambique). Their migration into the Transvaal was caused by succession disputes in the mid-19th century and later by conflict with the Portuguese in the late 19th century. They maintained many customs practised by northern Nguni speakers such as the Zulu and Swazi, among which was the wearing of a headring (*isicoco*) by mature men. The headring, made of grass and wax, was sewn into the hair of a man who had reached maturity within his age-grade regiment. Figures such as this are reported to have been set up at the ceremony where the men of a regiment were given permission to wear the headring and thus to marry. Thus the figures (with their female partners) would appear to have specific reference to Tsonga notions of maturity and manhood. By the end of the 19th century such figures were being sold to European travellers at Marabastad, and by 1910 examples were made specifically for this trade in curios. The lack of genitals in this example suggests either that they were removed after the figure was collected or that it was one of the earliest 'tourist' examples, later versions of which were carved with bases, spears and shields. *AN*

Bibliography: Nettleton, 1988, pp. 48–51; Becker and Nettleton, 1989, pp. 12–13; Nettleton, 1991, pp. 32–47

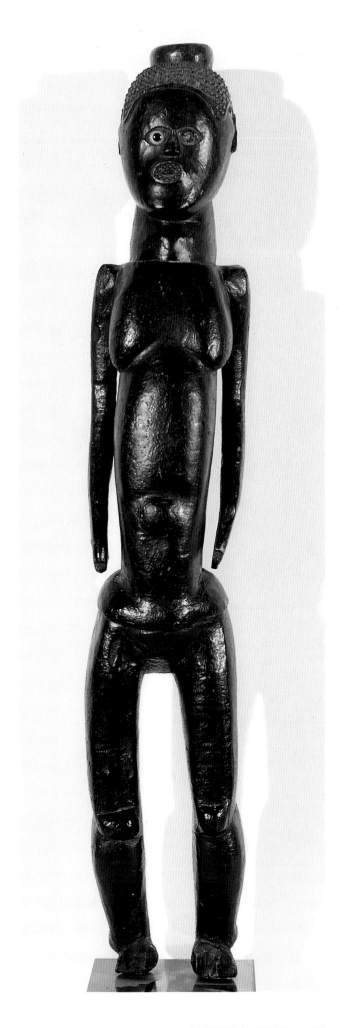

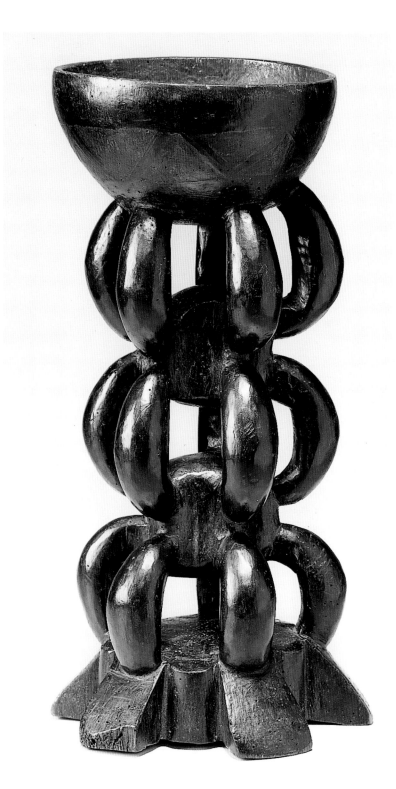

3.46

Bowl

possibly Tsonga, Shangaan,
Chopi or Lenge
South Africa
wood
h. 55 cm
Kevin and Anna Conru

A relatively small bowl is supported by intricately carved columns reminiscent of the chains and spirals found on spoons and sticks from this area. The columns bend and interweave in triple arches, each the height of the bowl. The purpose of the elaboration is not clear: such objects were not made for general use among the groups to which the piece could be attributed.

Round bowls with blackened surfaces and lighter triangular decorations, with no base or with small supports, are common in the Transvaal and Mozambique regions. In this region, as elsewhere, bowls were primarily functional but through relocation into the sphere of ritual they could transcend their utilitarian function. Among the Tsonga there are records of bowls being used for purification, and among the Lenge, because of the similarity of the triangular decoration on bowls with women's hairstyles, a bowl could be associated with the head and even represent it when turned upside down. The distinctive form of this bowl suggests a display of masterly skill.

The impetus to elaboration may have come from outside the carver's own social community. The piece may have been carved for exchange, for sale to a foreign visitor, or have been made to order by a colonial official. This might explain its eventual location in England. On the other hand it may have been a prestige object made to honour a local recipient. **RB**

Bibliography: Junod, 1962, ii, p. 130; Earthy, 1968, p. 50; Nettleton, 1991; Klopper, 1992

3.47

Dress ornaments (*omakipa*)

Ovambo
Namibia
c. 1937
leather, ivory, shell, glass beads
l. 27 cm (ANG. 1937.2207), 38 cm
(ANG. 1937.2325)
Powell-Cotton Museum, Birchington,
ANG.1937.2207/2325

Many Ovambo ivory clasp-buttons have recently appeared on the European and American markets where they have been without exception shown as individual objects rather than in any social context. They are a feature of women's prestige ceremonial dress in the area of Namibia on the Angolan border and among the Kwanyama in Angola itself.

They are perforated at the back in the manner of a toggle to admit leather thongs which bind them to belts or strands of beads. Early examples are found in conjunction with shell ornaments. In a Windhoek collection I have seen a complete harness of leather featuring about twenty-five *omakipa*.

The vocabulary of form is wideranging from narrow boat shapes through square pyramid to the more usual domed form sometimes culminating in a raised nipple in evident imitation of a breast.

They are usually made of elephant ivory softened by burial before working into the desired shape. Most are etched with conventional patterns of cross-hatching, though early examples can show more invention and less rigid formats. The etched marks are heightened by rubbing in various plant juices including one of a virulent crimson (sometimes almost purple). Some smaller *omakipa* are made from rhinoceros ivory while more recently bone has been used and even wood.

They are commissioned as gifts to the future bride by the groom. After marriage he will continue to add to his wife's collection which she wears on feast days to reflect his wealth. A full regalia would include loose straps also bearing these ivory clasps that swing freely in the dance.

Ironically a number of *omakipa* have recently found their way back to the world of female finery, made up as very expensive belts by a fashionable designer. **TP**

Bibliography: Lehuard, 1982, no. 42

3.48

Ritual bellows in the form of a buffalo

possibly Bayeyi
Botswana
late 18th century (?)
wood with copper
50 x 120 cm
National Museum Monuments and Art Gallery, Gaborone, Botswana

This impressive animal was found in a rock shelter in the Chobe National Park in association with another bellows (in the form of an elephant) and some undecorated pottery.

Ritual bellows are found in many areas of Africa from areas as distant from Botswana as Northern Mali (Dogon) and the Gabon (Fang, Mitsugho). Many descriptions of forges and bellows in the literature describe complicated rituals associated with firing and a wealth of symbolic reference. Certainly the accomplished depiction of a buffalo would have had no mere ornamental function but formed part of a larger system of myth and sacred allegory.

Without its attendant pipes and bags the animal seems to be an autonomous piece of sculpture, yet examination reveals a complex functional structure. The copper plates (fixed with copper nails) suggest the metal being worked. The stomach is hollowed out and on each side a row of holes indicate the position of the skin which was fixed over it. The pipe for the bellows travelled through the hollowed tail through which air passed with the operator sitting astride the animal to work the skin via handles. Such a fine and imposing bellows might perhaps have been reserved for ritual metal-working rather than the day to day activity of the forge.

The tentative dating and attribution is owed to Alec Campbell who supplied much of the information above. *TP*

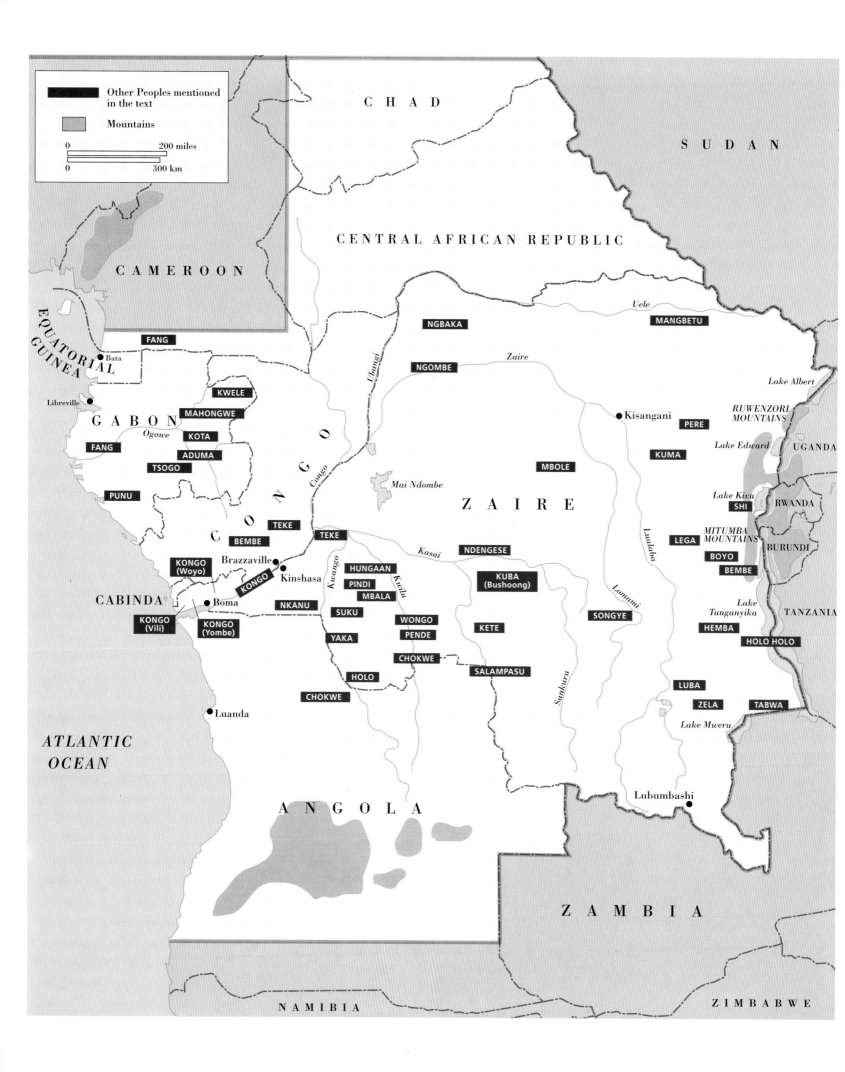

4 CENTRAL AFRICA

HISTORICAL AND CULTURAL ASPECTS OF CENTRAL AFRICA

Daniel Biebuyck

The central African region encompasses a vast area of rainforests, forest galleries, secondary forest formations and various types of open and wooded savannas. The region includes several countries, from southern Cameroon, Gabon, Equatorial Guinea (including Mbini), the Congo Republic and Cabinda to Zaire and northern Angola. There are cultural and historical overlappings between the populations inhabiting these countries and adjoining areas in the Central African Republic, the southern Sudan, Uganda, Rwanda, Burundi, Tanzania and Zambia. In numerous instances the national boundaries, as they were drawn up by the colonial powers, cut through the heartland of homogeneous cultural areas, such as Fang, Kongo, Cokwe, Luba, Lunda and Zande.

The majority of art-producing peoples in this region are Bantu-speakers (the Bantu languages constitute a large, highly differentiated subdivision within the Niger-Congo family of languages), the chief exceptions being found among ethnic groups straddling the boundaries of northern Zaire, the Central African Republic and the southern Sudan. Such ethnic groups as the Ngbandi, Ngbaka and Zande speak languages belonging to other subdivisions (called Adamava-Eastern) within the Niger-Congo family of languages.

The spread, differentiation and admixture of peoples and cultures in this region are the result of migrations extending over more than two millennia. Successive waves of population movements started in the south-western Grasslands of the Cameroon. At first they may have consisted of small-scale incursions from the savanna into the forest regions. Soon these early migrants were succeeded by groups taking several north-eastern and south-eastern routes, mostly circumventing the deep forest regions; subsequently there were crisscrossing movements in southern, north-western and western directions. In the course of these population shifts the immigrant groups encountered other nomadic and semi-nomadic hunters and gatherers, whose origins are uncertain, virtually all of whom were absorbed and assimilated by the newcomers. Archaeological and ethno-archaeological research in central Africa has revealed the existence of burial sites in the Upemba area of south-eastern Zaire dating back to the 6th century and offering in three different phases a complete Iron Age sequence. Moreover, these sites provide evidence of burial customs, pottery and basketry techniques that seem to anticipate the culture of historically known groups such as Luba. Early populations and their artistic activity are also evidenced by the pottery, axes and anvils in Katoto (south-eastern Zaire), the rock shelters with geometrical designs and other paintings in Lower Zaire, the famous wooden animal sculpture dating back to the 8th century found in central Angola and the stone tomb sculptures in south-western Zaire and Angola (cat. 4.1). Again many of these early artistic traditions were continued in the Luba and Kongo kingdoms and into modern times. The Pygmies (known under diverse names, such as Batwa, Bacwa, Bambuti), many of whom were until recently net and/or bow and arrow forest hunters and gatherers, are found in widely scattered areas throughout the region, and continue to exercise numerous privileged ritual and ceremonial rights with reference to the ownership of land and the enthronement of kings and chiefs. Even in those areas where they have disappeared or been completely absorbed, the memory of Pygmies is kept alive in oral narratives, genealogical recitations and ritual practices; their influences in music, song, dance techniques and even in dramatic performances are manifest everywhere (cat. 4.74).

The social and economic structures, the religious, philosophical and value systems of the peoples in the central African region vary widely in form and content, yet some important recurring patterns can

be discerned. Except for certain Pygmy groups, all populations in the region engage in some form of agriculture, based on the cultivation of bananas and plantains, root crops, cereals or a mixture of them all. All tend goats and sheep and keep chickens and dogs, but very few of the central African populations own cattle. Most groups fish (along the major rivers such as the Uele, Ubangi and Zaire specialist, semi-nomadic fishermen are found). Hunting game with dogs, nets, spears, bows and arrows, in collective battues, small groups or singly, and trapping using everything from snares and baited traps to pits and huge elephant crushers are still important subsistence activities in a large number of ethnic areas. The significance of hunting and trapping is deeply embedded in these peoples' ritual and world view regardless of whether there is game to hunt or not. Numerous important ceremonies and rites require collective battues, the search for particular animals and large-scale distribution of meat. Many durable parts of the animals are essential in the manufacture of artworks (cat. 4.29a,55).

The kinship and descent systems fall within the classic range of patrilineal and matrilineal organisations, the former being predominant in the north of this region, the latter among the southern groups. In some areas, particularly where the two systems meet, some populations adhere to more complex forms of organisation, such as bilineal (or double descent) and omnilineal (selective choices of tracing linkages through males and/or females) descent. As a general rule, the role of the father's group is significant in matrilineal population and of the mother's group (and extensions) in patrilineal societies. The different systems greatly influence the ways in which artworks are commissioned, used and transferred, but have little or no influence on the types and categories of art produced or the socio-ritual contexts in which it is used. In the rich artistic traditions of Zaire and overlapping areas, some of the ethnic groups who produce most art are found among the southern matrilineal populations, but this cannot be explained in terms of kinship and descent structures.

The range of political structures among the central African art-producing peoples is impressive. Although no major states rose to prominence through conquest, as they did in west or east Africa, several large kingdoms, some of them pluri-ethnic, have been recorded. Judging from the available evidence, some of these kingdoms flourished centuries ago and some, such as the Kuba, Luba and Lunda kingdoms, were still fully operative in colonial times and even survived to this century. Others, like the Kongo or Chokwe kingdoms, broke up into smaller, politically centralised or decentralised units at an early stage, either before or at the time of early contacts with the West. In many central African ethnic groups, however, the political organisation is of the petty state system (the ethnic group being divided into a number of small autonomous chiefdoms) or is conceived as a segmentary lineage system of inter-connected larger and smaller kinship units. In some groups, political integration is loosely based on the alliance, kinship and territory of a few adjoining villages and hamlets. Unlike other regions in west Africa, only a very limited number of types of artwork, of the vast artistic output, are exclusively for the use of kings, queens and their retinue (cat. 4.46,49). Few artworks can be labelled 'royal', but many of diverse type are linked with politico-religious leadership, and were for the use of chiefs, royal initiators, village headmen, lineage heads and elders.

Throughout the region, initiation rites constitute elaborate systems of central importance in the life of the people. Among the mandatory initiations are those for boys and young men at various ages; these are generally collective, periodic, long-lasting and characterised by rites of passage, including circumcision, seclusion, physical hardship and intensive learning (values, songs, dances, use of artworks) (cat. 4.71). Among the peoples of southern Zaire and northern Angola in particular these youth initiations and the sophisticated hierarchical organisations they require make use of many diverse artworks (cat. 4.27). Analogous initiations for girls and young women (e.g. Kongo, Ngbandi, Ngbaka) exist in several areas, but they are not well documented (except for Bemba-related populations in south-eastern Zaire and Zambia)

and most are less elaborate. Other types of mandatory initiations are 'vocational' in nature; they involve kings, chiefs, headmen, ritual experts, healers and herbalists, diviners, blacksmiths, some categories of sculptors, singers and dancers. In the course of these, sometimes prolonged, initiations preceded by apprenticeships, the initiates learn the values and secrets linked with their offices. A considerable number of sometimes very secret and rare artworks are associated with these initiations.

So-called voluntary initiations form the basis of access to, and membership of, associations, sodalities, semi-secret and secret societies. These hierarchically structured associations, most exclusively for either men or women, although some are for men and women together (as married couples), are based on initiation rites held at various stages in a person's life, possibly spanning a complete adult lifetime. Initiatory rites require the payment of fees and the distribution of gifts, food and goods, but also the large-scale participation of initiates. Based on specialised social, legal, moral, philosophical and artistic codes, these associations cut across socio-political structures, creating new forms of leadership, and frequently exercise an influence on the development of various exclusive and unique artworks.

Among the religious beliefs and practices that require the use of sculpture are the care and veneration of the dead, concerns about the destiny of the soul and life principles, ancestral cults, worship of nature spirits, divination and detection of evil-doers and witches, healing techniques, methods of inflicting and neutralising evil and sickness, consolidation of friendship and blood pacts, taking of oaths, personal and group protection and the enhancement of fertility. Among the few populations that have developed a pantheon of divinities, such as Shi, Hunde and Nyanga, artworks seem to be of little significance in their celebration. The most widespread and significant, if sometimes overrated, religious category is that of the ancestor cult (cat. 4.66). These cults of 'the living dead' take many forms and operate at several levels of the socio-political stuctures. In terms of art, the most important ancestral cults are addressed to founders of royal dynasties (cat. 4.37), clans and lineages, to kings and chiefs, to select founders and elders of lineages and villages and to their mothers or sisters.

The peoples of central Africa have a keen sense of beauty, although the canons on which the concepts of beauty are based are not always explicitly formulated. The embellishment of the human person through body adornment (dress, ornament, painting, cicatrisation, tattooing) and the enhancement of daily life through the use of refined objects (textiles, barkcloth, pots, cups, plates, baskets, mats, tools, utensils, weapons, various paraphernalia) (cat. 4.41–2) are central to the development of the visual arts.

In parts of eastern Zaire, Arab and Swahili raiders, infiltrating from east Africa, established control over many ethnic areas for many decades until the advent of the Belgian colonial forces. Whereas the presence of these external forces had a profound effect on various institutions and customs, the process of Islamisation in this part of Africa was limited mainly to areas along the western shore of Lake Tanganyika and parts of the hinterland, northwards to the area of Kisangani. In most of central Africa the colonial and missionary impact was not felt until the late 19th century, the major exceptions being those areas earlier affected by trade in slaves and ivory, and those near the Atlantic coast and the adjoining hinterland where Western contacts occurred as early as the 15th century. On the coast and in the hinterland, mainly inhabited by Kongo peoples and their offshoots, Christian influences manifested themselves in new forms of art made locally, such as crucifixes (cat. 4.2) and sculptures of the Virgin and St Anthony. Traces of Christian artistic concepts are apparent into the 20th century, particularly in some aspects of Kongo art (cat. 4.23). The actual dates of colonial contact and its intensity differed considerably from one ethnic territory to another, as did the responses of various ethnic groups. Colonial and missionary rule in some areas led to the severe repression of existing customs and institutions which were labelled 'subversive' or 'against the civilising efforts' of the colonial powers. In consequence some institutions and customs were modified and adapted to the changing conditions while others declined,

disappeared or functioned increasingly secretly. In a number of cases this had a drastic effect on artistic productivity. In other instances, in reaction to imposed legislation, reinvented protective and reactionary institutions emerged including new forms of secret societiess new healing and anti-witchcraft organisations and prophetic and messianic cults. Some of the new-fashioned institutions were favourable to the existing arts, and even produced some additional forms of art, others were temporarily or permanently opposed to the arts, which came to be regarded as external symbols of backwardness.

Central African populations have produced many kinds of visual arts: painting on the body, on screens, on sculptures, on houses; drawings in the sand, on walls, on cloth; tattooing and cicatrisation of various parts of the body; body adornment in many forms (headdresses, necklaces, earrings, bangles, belts) (cat. 4.47–8,74–5); textiles and barkcloth (cat. 4.75); beadwork (cat. 4.45); calabash engraving and painting; metalwork (cat. 4.43,89); pottery (cat. 4.20,57,65); basketry; fibrework and plaiting; architecture in the form of dwellings, gathering houses, shrines and initiation lodges. They have created an abundantly rich variety of sculpture.

Bibliographical note
The early stylistic synthesis of Olbrechts, 1946, remains a useful classic. Specific analyses of the central African region and particular arts occur in the studies published by Bastin, Beumers and Koloss, Cornet, Herreman and Petridis, Lema, Neyt and Perrois. Advances in our understandig of central African arts very much depend on small-scale comparative studies (on a specific area or ethnic cluster) and monographs. Such field-, museum- and archive-based contributions are made by, among others, Bastin, Biebuyck, Bourgeois, Burssens, Ceyssens, Cornet, de Sousberghe, Hersak, Laburthe-Thomas, Lehuard, Lema, Neyt, Nooter, Perrois, Roberts, Thompson and Bahuchet. General linguistic data is covered by Greenberg, 1966, and Guthrie, 1967–71, historical material by Vansina, 1978, archaeological evidence in de Maret, 1974.

CONCERNING THE MORPHOLOGY, FUNCTION AND USE OF SOME IMPORTANT TYPES OF SCULPTURE IN CENTRAL AFRICA

Frank Herreman

Sculptures are most often made from materials that are available locally. Some materials, such as metal and ivory, are employed for their symbolic meaning, supernatural properties, relative rarity or high value. Wood is the most common material. With the aid of an adze, the form is hacked out of a solid block, and further carved with a knife. As a rule, the sculpture is worked symmetrically and frontally. Colour, if it is to be applied, follows. For this, a variety of plant or animal dyes can be used. The colour may be transparent, mat or glossy. In some cases a mud bath and much polishing would produce a glossy surface ranging in colour from grey to black, covering the wood like a lacquer.

Small sculptures in ivory are found among only a small number of peoples. For example, they are made as finials for sceptres by the Kongo, as amulets by the Pende, the Hungaan and the Luba. There are also the miniature ivory masks and figures used by the Lega in the closed *bwami* association.

A number of peoples make use of strips of copper to overlay a section of the sculpture, usually the face. The best known are the reliquary statues of the Kota (see below). With several of the Kongo peoples and also among the Teke, small sculptures are cast using a lost-form technique. Striking illustrations of this are the Christ figures (cat. 4.2), inspired by examples brought to Africa by missionaries, that were wrought by Kongo casters. Knives and spears were forged in iron. With the exception of the figural ceremonial axes of the Songye, where the representation of human bodies or faces is fashioned in openworked blades, depictions of men or animals in wrought iron are extremely rare. The iron anthropomorphic figure from the Kuba (cat. 4.43) is almost unique; together with a second example, it is described as the oldest figurative representation originating from central Africa. These figures would seem to date from the 17th century. The first was perhaps part of a depiction of a miniature house with figures, or a proa (flat boat) with oarsmen. The figure's maker has broken with traditional symmetry in representing the arms with large expressive hands to striking effect.

The proportions of a sculpture do not as a rule coincide with actual anatomic proportions. Greatest attention is accorded the head; second in importance is the trunk. This hierarchy of emphasis reflects the importance accorded to those parts of the body: the head is the domicile of the soul, and the trunk – with representation of male and female organs – points to the significance of fertility, the guarantee of the community's continuing existence. In most cases, the arms and hands are fixed at the hips, with the legs short and carved with less attention to finish.

Reliquary figures among the Fang and the Kota

Although particular sculptures may have a similar function, their appearance may differ greatly. This is notably illustrated in the relic statuary of the different Fang groups (*nlo byeri*), and of the Kota and Mahongwe groups (*bwete*). They all use relic containers wherein the skulls of their prominent ancestors – chiefs, courageous warriors, village founders etc. – are kept. The preservation of relics in baskets or boxes is not limited to the Fang and the Kota; it is also encountered among a number of neighbouring peoples such as the Mitsogho and Masangho, the Punu and the Bandjabi. The Mbete, who claim to be descended from the Kota, also keep relics. However, they place them not in a basket or a box, but rather in an anthropomorphic statue, in the back of which is fashioned a cavity which serves as the relic recipient, and which may be closed with a cover.

The Fang live in an area that stretches from the south of Cameroon to the basin of the Ogooué, including Equatorial Guinea. Male or female protective figures are placed on top of their cylindrical relic containers, usually in a sitting position. As well as complete figures, there are also representations of human heads. These sculptures primarily serve to prevent the uninitiated from gaining access to the ancestral relics. They are also manipulated like marionettes, danced with and, as the ancestors' representatives, give audience to the descendants' complaints concerning the ancestors' neglect. Their design is very stylised, and differs according to their place of origin. Thus, the general composition of the northern statues is more taut and architectural than figures from further south. In the case of the latter, the muscles of the limbs – modelled in convex masses – are emphasised to a much greater degree. Still, in both cases we are probably seeing stylised representations of ideal beauty.

The Kota live mainly in the east of Gabon, and to a lesser extent in Congo (where the Mahongwe also live). In contrast to the Fang, who preserve their relics in boxes, the Kota and the Mahongwe use wickerwork baskets. The protective figures' lower ends are stuck into the relic containers, with the large

Fig. 1 Kota reliquary figures shown in their original setting. Engraving from Tour du Monde *by P. S. de Brazza, 1887–8.*

head and openwork lozenge shape below protruding from the basket's top (fig. 1). At first view their design differs considerably from the Fang statues, but, fabrication apart, closer inspection also reveals several similarities. The Kota reliquary figure is predominantly flat which emphasises its overall contour. Usually the elliptical face is decked with a painstakingly fashioned coiffure. A crowning element sits above, frequently in the shape of a crescent moon. The face is flanked by two planes, with sides generally rounded, which either follow the angle of descent or bend outwards at the bottom to finish in a point. The predominantly flat face may be modelled according to one of four variations: flat, concave, convex or concave-convex. The head sits upon a cylindrical neck, the lower part of which is an openworked lozenge shape. With Kota figures, this lozenge shape is represented frontally; with Mahongwe figures, however, it is in a crosswise position with respect to the face. The front of the wooden figure is covered in part or in whole by copper sheeting or strips. To this, iron sheeting is sometimes also applied. This possibly has a symbolic significance, though the explanation might also lie in the purely aesthetic satisfaction of colour contrast. Perhaps this holds as well for examples where brass and copper are used in combination. Eyes and mouth are also fashioned with copper wire and sheeting. Finally, one also encounters hammer-applied geometric patterns on the metal surface.

Exactly what is represented by the lozenge shape at the base of the figure is uncertain. One might advance the hypothesis of a stylised representation of the arms. Such a view might find support in a figure (cat. 4.90b) where the trunk is sculpted as a cylinder with a somewhat convex surface, and with the arms in low relief also forming a lozenge shape. A comparable representation, though somewhat more figurative than the previous example and with the arms carved away from the body, may be seen in a work from the eastern Kongo (cat. 4.28). One may posit the following hypothesis: head and arms (lozenge shape) represent only a part of the body. In use, the sculpture's lower end is stuck into the relic container, in this case a basket. In this way, the sculpture and relic container together form an entity, representing an entire human figure.

The same hypothesis may be applied to the case of the Fang: perhaps their sculpture, limited to reliquary heads, placed together with cylindrical relic containers, forms a complete figure. It has been proposed that the reliquary heads (cat. 4.91b,92) are of an earlier date than the sculptures that represent the entire body (cat. 4.93–5).

As mentioned above, there are major morphological differences between the sculpture of the Fang and that of the Kota. Yet in the sculpting of the head there are a number of points of consonance. The major difference is that the Fang heads are fully rounded, though in the first place they must be approached from the front – something that accords with the general principle of frontality that marks all African sculpture. The flat rendering of the Kota reliquary figures makes this notion even more pronounced. In both cases particular attention is paid to the elaborate coiffure. The Fang nearly always use copper nails or small copper plates to fashion the eyes, a practice also seen in Kota and Mahongwe sculpture where the face is entirely covered by metal. Finally, among both the Fang and the Kota one may distinguish face-types where the facial plane runs, respectively, from concave to flat to convex. Moreover, there are also a number of representations of the face where the convex and concave parts are combined (for instance, the forehead convex to the eyebrows, with the remainder of the face concave).

These morphological differences and similarities are proper to each respective culture, but also bear witness to a past history where all manner of contacts led to an exchange of a variety of cultural elements, something also reflected in the form-language, or style, of the sculpture. This, though, should be set within a context much broader than one limited to the Fang and the Kota. Still, this example proves that, as with other elements of culture, a people's form-language forms part of the group's identity.

The ancestor figure: from the conceptual to realism

One of the major forms of veneration in central Africa is that of ancestors. The origin of this is to be found in the human need for the maintenance of the family, clan or ethnic group. To this end, appeal is made to the supernatural. The spirits deemed appropriate to serve as intermediaries are those ancestors from whom one stems. They provide a constant example to their descendants. Among a number of groups (such as the Fang and the Kota) ancestor relics may be approached and touched; believers maintain that this offers the most direct means of absorbing their fertility-granting potential. This direct physical contact with relics is, however, not a general practice. A large number of central African peoples bury the remains of their dead, and some – as, for example, the Luba with their leaders – do this at hidden locations. Behind this is the idea that the soul of the deceased becomes free from its mortal remains and can float around. Since this might have negative consequences, there arose the need to create designated places where the spirits could reside: waterfalls, rocks, trees etc. Among certain peoples, leaders have sculptures made of their own ancestors. These function for them as a 'door to the supernatural', through which the desires of their community may be communicated by means of prayer. Origins of leadership are often traced back to mythical ancestors, founders of the clan or culture-heroes of the particular people. Thus it is the king of the Kuba himself who incarnates the culture-hero *moshambwooy*: when masked he performs the myth of origin, telling of his incestuous relationship with his sister *ngady amwaash*. The manner by which the proto-ancestors are handled in mask performances is not unique; they usually appear at the bidding of a closed association or of the political leaders who use the masks to perpetuate their positions. The same also largely holds true for the various authority symbols, employed by the political élite, upon which ancestor figures are often represented. A number of these sculptures may represent the rising generation of leaders. Among the Hemba the importance of ancestor figures is most clearly made manifest. The leaders take up position amid these statues, by way of indicating to their subordinates the origin and legitimacy of their rule.

The ancestor statuary of the Chokwe, Luba, Hemba, Tabwa, Pre-Bembe groups, Bembe and Boyo undoubtedly belong to central Africa's foremost representations of this sort. Most of these sculptures are symmetrical in composition and carved with the utmost care. Their expression is hieratic and often they exude a sense of tranquillity, wisdom and equilibrium. A number of elements, such as the representation of the coiffure, the headdress and other ornaments, serve to emphasise the figure's status and identify the character portrayed. One may wonder whether the artists who created these works were themselves inclined, or urged by others, to give them a personal, individual character. In certain cases these figures were named after those they were to represent, whose souls were to occupy such statues. In his publication *La Grande Statuaire Hemba*, Neyt examined a number of statues from a single people, the Hemba. The facial morphology of these figures ranges from the highly idealised to the very realistic. My own view is that here one may already speak of portraiture, something which, for that matter, holds as well for the Hemba statues in this exhibition (cat. 4.66b,d–e). This hypothesis is confirmed by Neyt and de Strycker: 'the Hemba artist often works with a model, whether a sculpture or a living person, generally the same person who is represented in the statue and, if that person is dead, the family would propose that member of the family who most resembles the deceased who is being honoured.'

Among the Chokwe, too, one encounters statues that represent former leaders, both male and female. It is interesting to compare these with the representations of the culture-hero Tshibinda Ilunga (fig. 2). Apart from stylistic differences dependent on their school of origin (the school of Moxico, the style of the land of origin, the school of Muzamba, and the style of the expansion period), one cannot rule out the notion that the representations of chiefs (cat. 4.36,38) have a more individualistic effect than the iconographic emphasis seen with the Tshibinda Ilunga.

Fig. 2 Chokwe figure (h. 40 cm) representing the culture-hero Tshibinda Ilunga. Instituto de Antropologia 'Prof. Mendez Correia', Porto

Power statues

In addition to reliquary figures and representations of ancestors and culture-heroes, a large number of central African peoples make use of objects – including sculptures – upon which or within which substances are applied that their users believe to contain supernatural properties. Among the Kongo peoples such ingredients are given the name *bilongo* (a term that we shall also use for other peoples). In the older literature these objects were termed 'fetishes'. At present, they are called 'power objects' or, in the case of sculpture, 'power statues'.

Power statues are frequently encountered among the peoples living in the region of the former Kongo Kingdom (cat. 4.6,7b), among the Teke, the Yaka and Suku, the Songye (cat. 5.93), and the Luba (cat. 4.63) and Tabwa. In some cases the presence of the *bilongo* is almost imperceptible, while in others it comprises an essential element in the sculpture's overall design. One can surmise that the priest or healer – in Zaire, usually known as *nganga* – was expected to activate the *bilongo* by accurately executing ritual practices, with the aim of neutralising misfortune and adversity. Upon completion of the ritual, the client or patient expects to be relieved of the negative influences with which he has been beset. Such healing practices were previously described as magical. It is, however, difficult to draw a clear distinction between religious and magical practices, given that during the course of a ritual both elements are so closely interwoven. Thus, the priest may also conduct practices of a magical nature. This is why, perhaps, it might be useful to retain a distinction between the supplicating (religious) and the coercive (magical). Maintaining that magical practices always have a negative aim and religious ones a positive would not seem to be wholly accurate. Both forms of contact with the supernatural aim at a positive result, at least from the bidder's point of view.

The nature of the components from which the *bilongo* is prepared may be quite diverse, but in the main consist of material of mineral, plant, animal or human origin. From the user's point of view, the *bilongo* is more important than the statue itself. But from their design it often appears that attention was paid to the notion of statue and substances as integrated entity. Furthermore, in most of these cases one must speak of two makers: the sculptor who creates the statue, and the *nganga* who adds the *bilongo*.

Both among the various Kongo peoples and among the Teke the figures' composition and modelling take into account the location in which the substances are to be placed (fig. 3). Thus, the arms are sometimes summarily treated, sometimes not at all, as this is where these ingredients are to be applied. The *bilongo* may also be an intrinsic component of the figure's general form: the crowning of the head (coiffure or headdress), the abdomen or some other part of the body. Among the Kongo peoples a small container is usually attached to the statue in which the *bilongo* is placed, usually at the abdomen and sometimes on the back. These receptacles are closed with a mirror.

When during rituals the statue comes into use, its form may still be subject to modification and embellishment. Such is the case with the 'nail figures', named for the multitude of nails that are hammered all over their bodies. This treatment may be applied when, for example, two feuding groups have decided to bury the hatchet. By way of empowering the ceremony, nails are hammered into the statue. Such treatment is also used to activate the *bilongo* which has been applied to the statue for a specific purpose.

Most African sculpture owes its creation to religious, economic and social needs. The creator of such objects is not making art for art's sake, but for use by the community or an individual as a medium for contact with the supernatural. Perhaps this is why the traditional African sculptor does not work directly from nature, rather basing his design on age-old tradition. His way of creating can thus be described as conceptual. Moreover, in many cases outside influences also play a role. These arose from a variety of circumstances, such as the migrations – voluntary or forced – of a particular group, the establishment

Fig. 3 Kongo figure (h. 37.8 cm) made to become a power statue but still missing the bilongo *which should be added by the* nganga. *Museum of Ethnography, Antwerp, AE.714*

of other peoples within another group's area, and the existence of trade contacts – all of which may be coupled with increased exposure to religious elements or currents from outside.

By the term 'conceptual', it is taken that the traditional African artist in the first place expresses that which he knows about things, rather than representing a direct reflection of that which he perceives visually. Statues, masks or other ritual objects must satisfy a number of requirements, and iconographic aspects must also be taken into account. All the same, this should not be over-stated, for one may recognise elements in the artistic representation which in fact make reference to reality – for example, coiffures, tattoos and prestige symbols such as headdresses and ornamentation in general.

Once the mask or statue is carved, it is consecrated and, thus endowed with ritual powers, is ready to function. Such sculpture becomes bound in an ambiguous relation with man: it is potentially both an ally and an enemy, and the powers it possesses must be courted with prayer and offerings. But these forces may also be compelled to do the bidding of the supplicant.

The plastic form-language of a culture contains a number of constantly recurring structural elements. This regularity is what one generally calls style. A second determining element in the creation of a sculpted work is the individual talent of the maker. The sculptor makes an object that optimally fulfils the demands required of it. The representation must answer to the iconographic norms that tradition sets for it. The sculptor must, at the same time, give expression to a number of spiritual, moral and other abstract principles which are associated with that which is represented. Believing in these, the sculptor will execute the work to the best of his ability, and his creation will acquire an artistic dimension.

In many cases the creative process does not end with the statue's or mask's fabrication and consecration. The subsequent ritual life of an object can alter its appearance, by the addition of offerings or the application of paraphernalia of diverse nature, in or on the sculpture. 'Charging' the object in this way is expected to induce the required function to begin or to increase its efficacy.

Bibliographical note
Brazza, 1887; Brazza, 1888; Fernandez, 1974; Neyt and de Strycker, 1974; Chaffin, 1979; Bastin, 1982; Perrois, 1985; Claerhout, 1988; Biebuyck, 1992; Fernandez, 1992; Neyt, 1995

4.2

Crucifix

Kongo
Zaire
18th–19th century
bronze, sheet metal, tacks, wood
29 x 19 cm
Bareiss Family Collection

According to oral traditions collected in the late 16th and early 17th centuries, the Kingdom of Kongo probably developed at the end of the 14th century as one of several modest states south of the River Zaire. Gradual expansion through alliances and military conquest made the capital, Mbanza Kongo, the centre of a large and powerful state. Portuguese sailors arrived there in 1483; at this time Portugal was a powerful mercantile nation, intent on establishing new commercial routes to the Indies. Its mercantile expansion was accompanied by a committed missionary spirit that actively sought to convert any peoples encountered to Catholicism. In 1499 Pope Alexander VI granted King Manuel I of Portugal patronage over all African lands that had been or were to be discovered by the Portuguese. In 1512 Manuel in turn sent a document to the king of Kongo, proposing a plan for the organisation of the Kongo state on the model of a Christian monarchy. Various local Kongo rulers were converted to Christanity, among them the king himself, who was baptised with the name of Alfonso I (1506–43). The process of conversion was visually reinforced by the widespread use of religious images, like the bronze figures of the Virgin Mary and the Portuguese-born Saint Anthony of Lisbon (also known as Saint Anthony of Padua), cast by Kongolese artists after Portuguese models, which became extraordinarily popular owing to the teaching of Capuchin priests.

Crucifixes played an equally important role in the elaborate ritual life of the Christian Kingdom of Kongo. Sometimes small orant figures are carved underneath Christ's feet and/or placed at the top of the cross. Occasionally, the small orant figure at the bottom represented the Virgin Mary, indicating her role as mediator between Humankind and Divine Glory. But the Saviour is also often shown alone (as here). His decidedly African features, portrayed as such in numerous other known examples,

4.1

Zoomorphic head

Central Angola
8th–9th century
wood
50.5 x 15.5 cm
Royal Museum for Central Africa,
Tervuren, Belgium, MRAC 14796

This is probably the oldest wooden sculpture of central Africa, if not of sub-Saharan Africa. (A sample from it has been dated by carbon-14 analysis.) Its remarkable state of conservation is explained by the fact that it was 3.5 m under the water table when discovered in 1928.

Carved out of the trunk of a *Pterocarpus angolensis D.C.* tree, it represents an animal with snout, eyes and small round ears. One can note two small holes, bored with a red-hot iron, on top of the head and at the

end of the tail. They were probably filled with hair-like fibres. It was most likely used as a horizontal mask or a headdress. The general shape of the head, with its broad muzzle, elongated snout and large nostrils, as well as the setting of the eyes, resemble closely the features of an aardvark (*Orycteropus*), the large solitary nocturnal insect eater. This pig-like animal is also suggested by the arched body, with its four legs and tail, as well as by the ripples on the body and forehead. As the ears of an aardvark are longer and more tubular, one cannot exclude that the figure may represent a zebra, a warthog, a hippopotamus or a composite imaginary animal. Originally, however, the ears may well have been bigger, so one can favour an aardvark identification.

Unfortunately, there is no ethnographic information on what the aardvark symbolises in this region, but the Tabwa of the southern Lake Tanganyika area are known to regard it as an animal especially 'good to think' since it evokes a wide range of essential oppositions (head/loins, closed/open, intellect/sexuality, culture/nature, human/animal, male/female, light/darkness, visible/invisible, good/evil). The burrowing abilities of this primordial creature are also considered important and it would not be surprising if this sculpture was buried on purpose.
PdeM

Provenance: 1928, discovered by C. Turlot in a bank of the Liavela River, central Angola

Bibliography: Van Noten, 1972; Roberts, 1985, pp. 24–5

distinguish Kongo crucifixes from their European counterparts. They raise questions about the production and reception of artistic forms within diverse cultures, pointing to the inevitable shifts in meaning that would gradually remove the Catholic connotations of Kongo crucifixes, turning them into vehicles for the transmission of original local concepts and beliefs. In particular, as it had been perceived by the Kongo people before the arrival of Europeans, the cross was a visual analogy of their own relationship to their world, a crossroads between 'this world' (*nza yayi*) and 'the land of the dead' (*nsi a bafwa*). Such shifts in meaning have remained in use into the 20th century. They were visually reinforced by shifts in form, as in the choice of decorative elements of local tradition such as the round bosses in this example. *TT*

Bibliography: Thiel and Helf, 1984, p. 93; MacGaffey, 1986, pp. 43–6; New York 1988, pp. 43–7; Maastricht 1992, pp. 57, 310

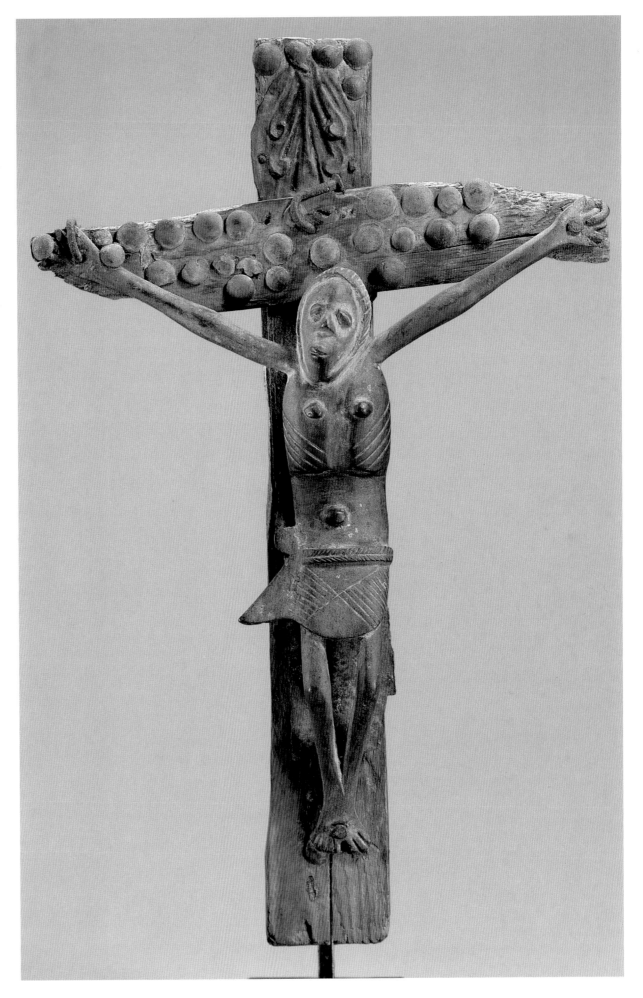

4.3

Staff handle (*mvuala*)
Solongo
Angola/Zaire
19th or 20th century
ivory
h. 11 cm
Private Collection, Brussels

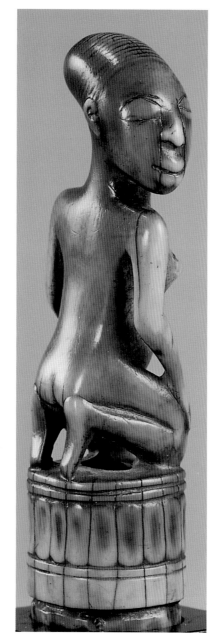

According to Lehuard this is a
Solongo piece. The Solongo people
live on both sides of the Zaire
estuary and along the Atlantic
coast from Banana to Ambrizete.

The staff is the insignia of power.
It is often presented to the future
chief at his initiation ceremony, or
is handed down from generation to
generation. Possession of the staff
permits its bearer to take part in
political and legal proceedings.

This figure combines two well-
known positions for this type of
statuette: the head turning sideways
(*kebo-kebo*: the turned head indicates
a person keeping watch), and the
kneeling position with hands on
thighs (*ye mooko va bunda*). Generally
speaking the kneeling position with
both knees on the ground is charac-
teristically female. It expresses def-
erence and obedience; the hand on
the thigh indicates waiting. The
woman is frequently depicted
squatting on her knees.

Carved sticks occur frequently in
the art of Lower Zaire and the sur-
rounding area (recently copies of
antique sticks have pushed the
number even higher). Ivory carving
techniques have produced some
exquisite works, indeed some
masterpieces. *JC*

Bibliography: Lehuard, 1976; Lehuard,
1989, i, pp. 112, 610–15

4.4

Staff handle (*mvuala*)
Yombe
Zaire
19th century
ivory, patina
h. 15.5 cm
Private Collection

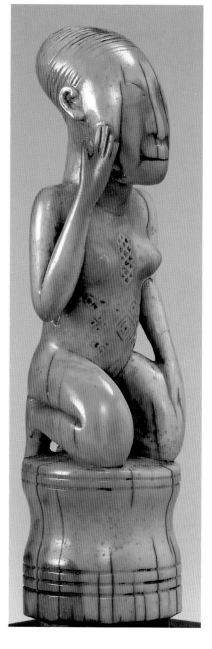

This handsome handle of a dignitary's
staff comes from a known workshop.
The Tervuren museum possesses a
piece so similar that it has been
suggested that both are by the same
sculptor, as is the one in the Musée
Barbier-Mueller in Geneva.

The handle shows a kneeling
woman with her left hand on her
thigh and the other placed against
her cheek, signifying contemplation.
The position is traditional, particu-
larly on staffs belonging to chiefs.
The elaborate hairstyle (*mpu*)
indicates an importance shared with
that of the chief. The naturalistic
style of carving is typical of Kongo
sculpture.

The copious scarification is
characteristic of the Mayombe area.
The women of the region of Lower
Zaire had some of the most elaborate
and elegant scarifications in all Africa.
They were associated mainly with
fertility. This pattern is based on a
lozenge, also to be found in the
decorative plaiting produced in this
area; the plaits often illustrate
proverbs (cf. cat. 4.17).

The staff symbolises the legitimacy
of its bearer, or of the person entrust-
ed with it. It connects his power with
the power of his ancestors. It is not
surprising that women should have
such an important role in this type of
artefact since it is their fertility that
allows power to be passed on down
the generations. *JC*

Bibliography: Lehuard, 1989, i; Tervuren
1995, no. 292

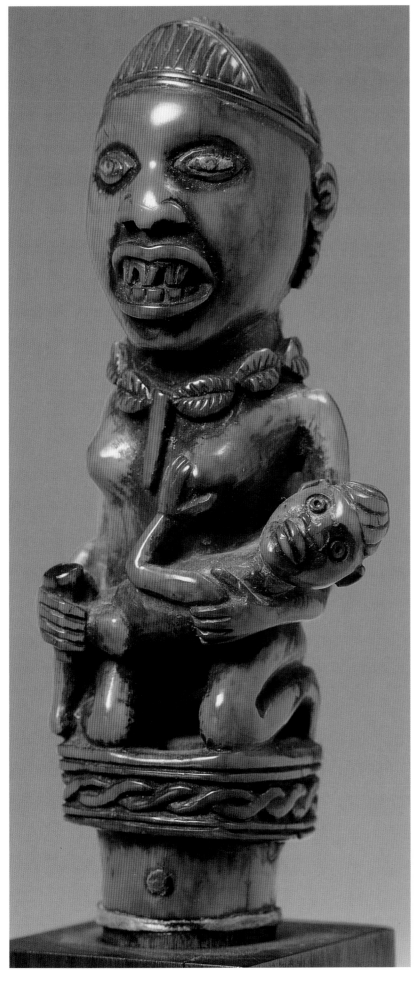

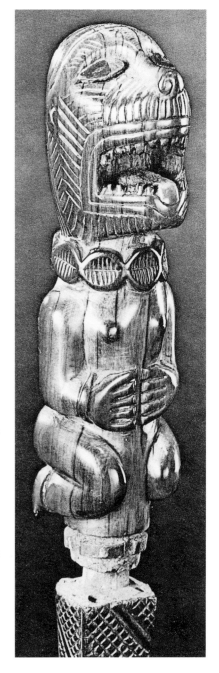

4.5a

Staff handle (*mvuala*)

Yombe
Zaire
19th–20th century
ivory
h. 14 cm
Private Collection

The theme of cat. 4.5a is motherhood. The founding-mother of the clan occupies a position of great respect; the art of Lower Zaire, with that of the Luluwa, is one of the richest in representations of mother-and-child groups.

The kneeling position is common in Kongo art. The therianthropic figure (cat. 4.5b) also features a similar cowrie necklace combining wealth and fertility. Sometimes there is only one kneeling figure. Generally both knees are on the ground and this position is called *mfunkama*. The groups often depict mother and child. 'The general impression conveyed by this type of sculpture, which is exquisitely detailed and finished, is that it stems from attitudes connected with submission – obedience, deference, devotion' (Lehuard).

In cat. 4.5a the mother holds her child without any expression of interest or affection, as is usual with such figures. The child is frequently missing. Even when both figures are carved with equal care the child is not regarded as essential. *JC*

Bibliography: Lehuard, 1976; Lehuard, 1989

4.5b

Staff handle (*mvuala*)

Yombe
Zaire
ivory
19.6 x 6 x 6.9 cm
The Walt Disney-Tishman African Art Collection, Los Angeles, 1985. AF. 051.121

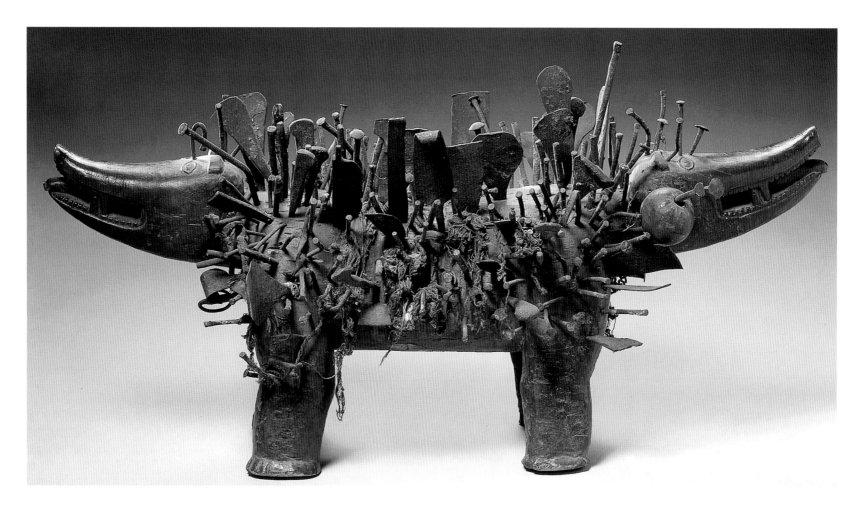

Kongo

Most of the objects widely admired as Kongo art fall into the category called *nkisi* (pl. *minkisi*), an untranslatable term. The Kongo, speakers of the Kikongo language, may number about three million people, distributed among the republics of Angola, Zaire and Congo on the Atlantic coast of central Africa. *Minkisi* are ritual procedures for dealing with problems ranging from public strife to theft and disease to the hope of seducing women and becoming wealthy. A *nkisi* as a ritual programme may include the *nganga*, the initiated expert who performs the ritual; his or her costume and other paraphernalia; the client; the prescribed songs to sing and rules to be observed; sacrifices, invocations, dancing, and drinking. *Minkisi* as found today in museums are no more than selected parts of the material apparatus necessary for the perform- ance of rituals in pursuit of particular goals. Most of them date from between about 1880 and 1920. Colonial administrators repressed the use of *minkisi*, which, though they continue in active use to this day, no

longer take the public and visually explicit forms of the past.

The basic idea of the *nkisi*-object is that of a container of forces directed to some desired end. The container held relics of the dead, or clay from the cemetery, which brought the powers of the dead into the *nkisi* and made it subject to a degree of control by the *nganga*. It also held *bilongo* (medicines), which metaphorically represented the uses to which this power was to be put. Other medicines were attached to the outside, where their function was to impress the public by their visual intricacy, suggesting the unusual capacities of such composite objects.

The outer attachments of some *minkisi* may consist of beautifully carved miniatures that serve as a reminder of their powers. Several of them represent in miniature the musical instruments that would be played during the activation of the *nkisi*, such as a slit-gong, a clapperless bell, and a double-ended wooden bell. *WM*

Bibliography: MacGaffey, 1991

4.6

Nkisi nkondi (Kozo)

Kongo
Cabinda
before 1900
wood, iron
h. 67.5 cm
Musée Barbier-Mueller, Geneva, 1021-35

Not all varieties of *nkondi* were nailed figures, and of those that were, not all were anthropomorphic. The appear- ance of the figure was part of the metaphorical apparatus that indicated to knowledgeable viewers the purpose and abilities of the *nkisi*; it was not a sort of portrait of its animating spirit. In Kongo thought, the land of the dead lies 'across the water' or 'in the forest', where in fact cemeteries are located. Wild animals are the livestock of the dead. Dogs live with human beings in the village, but they are not eaten like other domestic animals and they help hunters kill game in the forest. They are thought of as mediat- ing between the living and the dead, and thus between the seen and the unseen; it is said that dogs have 'four eyes', and that on the way to the land of the dead one passes through a village of dogs. Much respected on

the Cabinda coast in the 1880s, 'Kozo' was a retributive *nkisi* of *nkondi* type, in the form of a dog, but usually with two heads facing in opposite direc- tions. The empowering medicines were usually contained in a pack bound with resin or clay, on the animal's back. The figure is a state- ment about hunting down unknown wrong-doers, about moving between the two worlds of invisible causes and visible effects. Kozo is said to have dealt with women's affairs and to have been paired with Mangaaka, an anthropomorphic *nkondi* also widely known and respected, which was for men's affairs, but the nature of their relationship is hidden from us. This example of Kozo has accumulated a particularly impressive collection of nails and hoe blades, each testifying to some bitter grievance. *WM*

Exhibition: Washington 1993, pp. 41–2

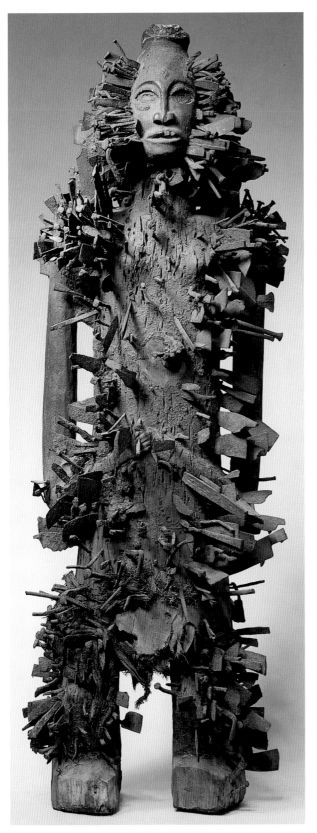

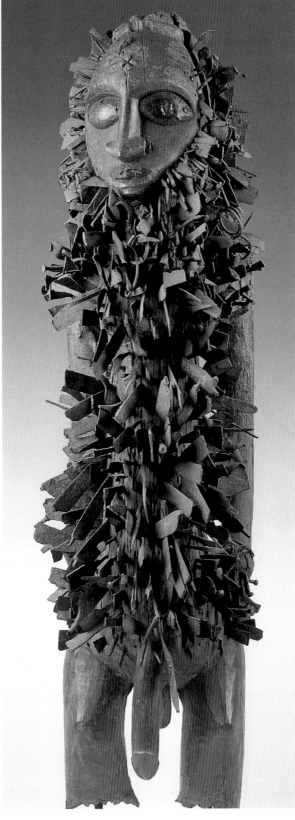

The extent to which a *nkisi nkondi* is covered with iron blades is an indication of its usage. Cat. 4.7a has only a small number of blades, while the other example is covered with iron blades more or less to the limit, indicating that it was well known and much resorted to by persons who felt a need for redress or relief. Cat. 4.7b is one of several similar long, thin figures, evidently produced by the same workshop in the Mayombe district of western Zaire. The top of its head once supported a resin-sealed pack of empowering medicines; others were probably contained in an accompanying bundle. In the centre of the forehead, the seat of intelligence and authority, the 'soul' of the *nkisi* is indicated by a lozenge shape, itself divided into four quadrants. The figure's left eye may once have been covered with realistic reflecting material, like the right, but may also have been intended to be 'blind'; this would mean that the *nkisi* had one eye for the things of this visible world and one for the nocturnal world of the occult. Whatever the case, the face is extraordinarily baleful; it seems both to surmount the bristle of metal advancing upon it and to threaten similar violence to designated enemies. The blades that crowd upon the body (most of them old hoe blades, but including a few European screws) carry relatively few of the tokens called 'dogs' (cf. cat. 4.8) that would have directed the *nkisi* to specific tasks.

Whereas the general appearance of cat. 4.7a is passive and suggests androgyny, cat. 4.7b is clearly male. The figure's exceptional genital endowment has nothing to do with fertility. Though there were many exceptions, *nkondi* were associated with virile symbols, since both hunting and justice were men's activities: most, male and female, were carved without genitals; those properly equipped would have worn a concealing cloth. For adults to expose their genitals is shocking and insulting, a supreme act of aggression. In the course of the ritual of activation specific to this *nkondi* the operator would have whipped off the cloth at appropriate moments, creating a calculated sensation. *WM*

Bibliography: MacGaffey, 1991, p. 136

4.7a

Nkisi nkondi

Kongo
Zaire
late 19th century
wood, metal, pigment
h. 180 cm
The Trustees of the British Museum,
London, 1905.5.25.2

4.7b

Nkisi nkondi

Kongo
Zaire
late 19th century
wood, metal, pigment
h. 108 cm
Museo Preistorico Etnografico
'L. Pigorini', Rome, 84204

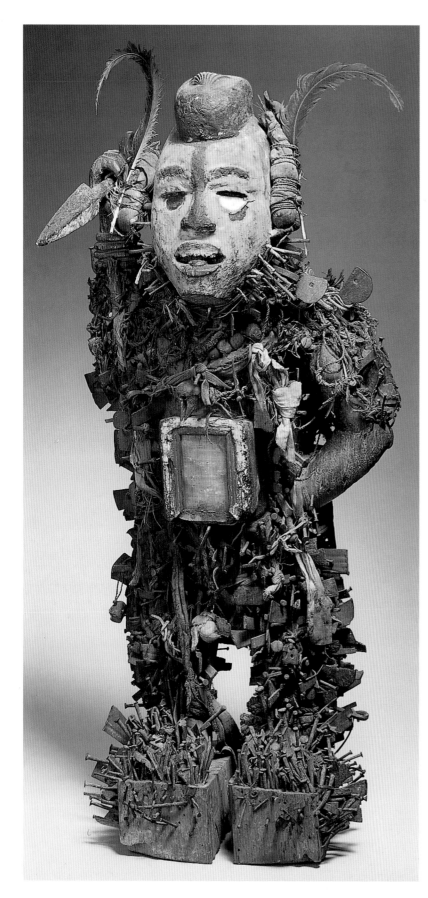

4.8

Nkisi nkondi

Kongo
Zaire
before 1878
wood, cord, iron, cloth
h. 83 cm
Royal Museum for Central Africa,
Tervuren, MRAC 22438

The most powerful, most spectacular and now (in the art world) the best-known Kongo *minkisi* belonged to the class called *nkondi*, a name which means 'hunter.' The business of *nkondi* was to identify and hunt down unknown wrong-doers, such as thieves and those who were believed to have caused sickness and death among their neighbours by occult means; *nkondi* could also punish those who swore false oaths and villages that broke treaties entered into under their supervision.

The container of *nkondi* found in museums is usually, as in this case, a wooden figure, to which medicines are added in one or more packets sealed with resin and located on the top of the head, on the belly, between the legs and elsewhere. The legs of this figure are wrapped in a miniature hunting net, to remind us that it hunts down its victims. Many other *nkondi* that did not attract the attention of collectors (and have therefore been lost) were contained in clay pots. To arouse the *nkisi* to go to work, it was both invoked and provoked. Invocations, often in extraordinarily bloodthirsty language, spelled out the problem, urging *nkondi* to punish the guilty party: 'Lord Mutinu! open your ears, be alert. The village, the houses, the people, do you not see us? My pig has disappeared, I can't hang on to a chicken, a goat, a pig, or any money in the house. The villagers, they have their animals, they have many children, they are content. I have not quarrelled with any one, man or woman. Mwene Mutinu, if anyone is angry with me and it is only a daylight matter, overlook it; but if it is witchcraft – proceed! Seize whoever is causing me harm, whether man or woman, young or old, plunder and strike! May his house and his family be destroyed, may they lose everything, do you hear?'

To provoke *nkondi*, gunpowder might be exploded in front of the container, insults might be hurled at it, but above all, in the case of a wooden figure, nails, blades and other hardware were driven into it. Angered by these injuries, *nkondi* would mysteriously fly to the attack, inflicting on the wrong-doer similar harm. A few days later, if anyone in the village were to fall ill with pains in his chest, it would be said that *nkondi* had found him out and punished him. To make sure the *nkisi* knew just what was expected of it, bits of rag, hair of the stolen goat, or some other token, called a 'dog', would be attached to it, often to the nails, each time it was invoked. As time passed, the *nkisi* visibly accumulated the evidence of successful cursing, adding greatly to its fearsome appearance. Though we do not know its name or history, we can tell by looking at it that this piece, in its day, was undoubtedly feared far and wide. *WM*

Exhibition: Washington 1993

4.9

Nkisi nkondi (*fragment*)

Kongo
Congo
19th century
wood
31 x 12.5 x 12 cm
Royal Tropical Institute/Tropenmuseum,
Amsterdam, 3113-2

This weathered figure, with its suggestion of perdurable vitality in the face of adversity, had probably long been abandoned to the weather by its original owners. The wood has been worn by the rain and eaten by grubs, but some of the holes in the chest appear to be the result of nails or blades driven in. If so – and the aggressive expression of the face seems to confirm the hypothesis – this is the 'ghost' of a *nkisi nkondi*. The rotten remains of the figure were cut off by the collector in the manner of an antique Italian bust. The head once carried a medicine pack, and the eyes were probably filled in by a piece of glass backed with red cloth. It is a tribute to the skill of the sculptor that the object still appears vital, angry and energetic. Among the reasons for abandoning a *nkisi* were that the owner felt it was no longer effective, or that he had converted to Christianity. A *nkisi* could be aroused by driving nails into it, insulting it, comparing it unfavourably to a lump of wood, and threatening to throw it away in the bush. *WM*

Provenance: ex collection J. Brummer, Paris; Jacob Epstein, London

Exhibition: Paris 1989

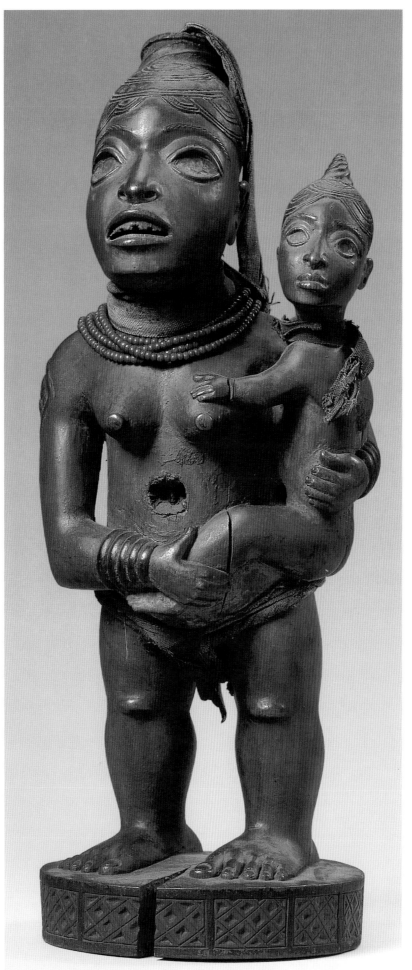

4.10

Nkisi nkondi (The wife of Mabyaala)

Kongo
Cabinda
before 1900
wood, glass, cord, beads
h. 35.5 cm
National Museum of Ethnology,
Leiden, 2668.2101

This exquisitely carved figure is one of at least two, both in the Leiden collection, that can be attributed to the same artist. The fine finish, the animated expression, the naturalistic pose, the delicate representation of the hair and the treatment of the nipples are distinctive. Most *minkisi* are anonymous, the collector not having bothered to record the name, but in this instance it is known that the figure is part of the material apparatus of a *nkisi nkondi* called Mabyaala. At the end of the 19th century, along the coast from what is now Pointe Noire, in Congo, to Boma, in the estuary of the Zaire, Mabyaala was one of the best known of the retributive *minkisi*, used to control crime and to sanction commercial relations. A number of named examples exist, but this is the only female one; she carries a child on her hip 'to show that she is a married woman'. The pack of medicines once fastened to her belly has fallen off, so that the figure, like all *minkisi* now in museums, is no longer empowered. *Nkondi* were often represented as a pair, man and wife. As an indigenous text of the period puts it, 'the powers of the male are more vigorous, but the female softens them; if they were two males, many houses would be burned by the lightning' (*nkondi* controlled storms, and used them to attack recalcitrant villages). The male Mabyaala who consorted with this woman has disappeared. In various museums, other items associated with Mabyaala, though belonging originally to different ensembles, include a bag of medicines and a spectacular cap of red feathers for the *nganga*. *WM*

Exhibitions: Paris 1989; Washington 1993, pp. 32–9

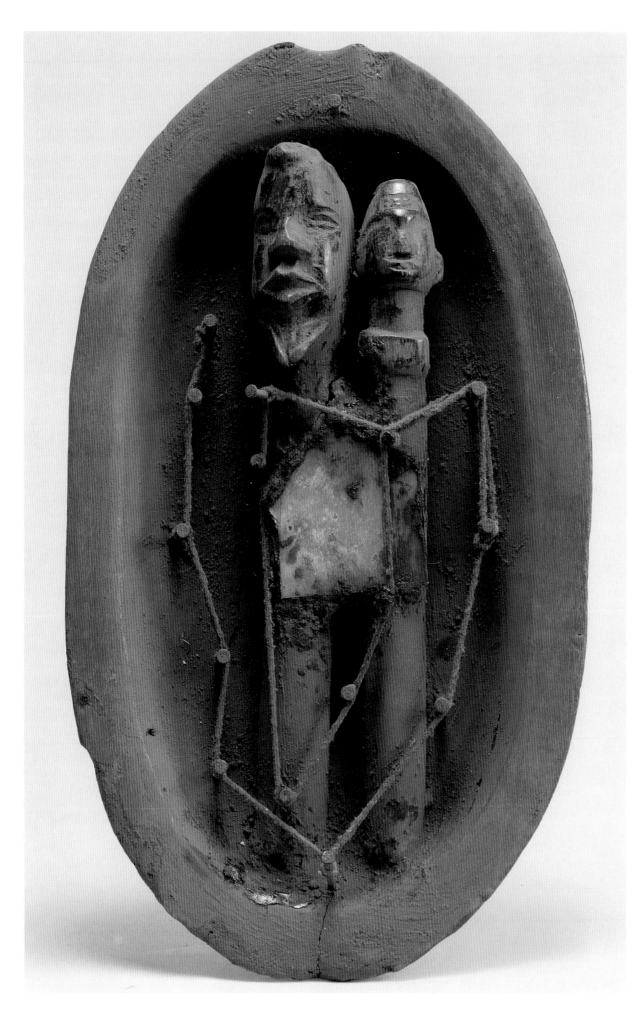

4.11

Nkisi

Kongo
Cabinda (Ngoyo)
late 19th century
wood, red clay, other materials
27.5 x 16 cm
Museu Nacional de Etnologia, Lisbon,
AO-253 (1971)

This unusual and enigmatic *nkisi* is in the form of a boat-shaped container in which two anthropomorphic figures, probably male and female, lie side by side. On top of the figures is a broken piece of mirror, under which are presumably packed the medicines, whose name and function can only be guessed. A mirror serves a *nkisi* as its 'eyes', with which to see things concealed from normal view; it is not necessary that anything be literally visible in the mirror. A cord has been tacked to the wooden base by means of small nails; it gives the necessary appearance of forces under control or contained, and thus open to direction by the operator, the *nganga*.

This *nkisi* may be expected to cure some ailment, which, like all ailments, requires that contact be made with the land of the dead, thought of as across the water. Red is an appropriate colour for mediation. This interpretation is not incompatible with the possibility that the piece is related in some way to the slave trade. It comes from Ngoyo, the area of a kingdom of that name on the coast north of the mouth of the Zaire, which was actively engaged in the slave trade until 1865. Perhaps the model for this boat is a slave ship; the slave trade was, and is, thought of as a trade in souls taken prematurely to the land of the dead across the sea. *WM*

Provenance: collected by Dr E. Veiga de Oliveira

Exhibition: Lisbon 1994

Bibliography: Martin, 1994, p. 76

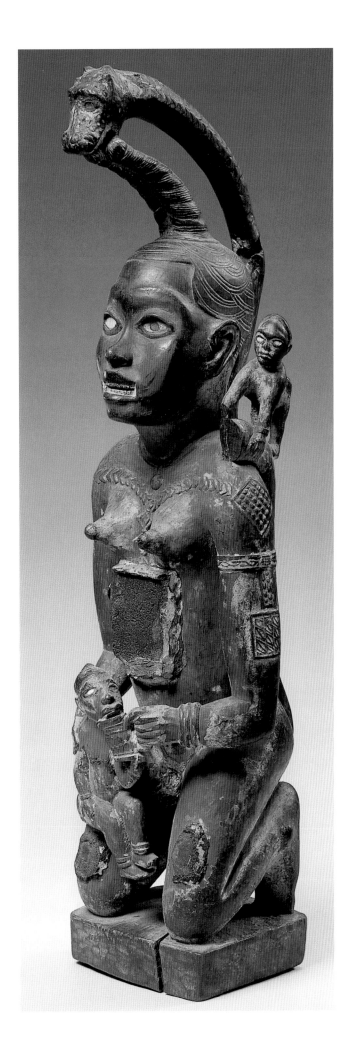

4.12

Devotional statue

Kongo (Vili)
Cabinda
19th century (?)
wood, glass
h. 44 cm
National Museum of Ethnology,
Leiden, 1354.47

This exceptional Kongo statue shows
a kneeling woman holding a child
(originally there were two more
children, on her shoulders, of whom
vestiges remain). Kongo sculptors
were able to depict the most complex
poses with a remarkable feeling for
bodily ornamentation. The intricate
details here in no way detract from
the powerful presence of the figure,
as the tilt of the head and the incisive
detailing of eyes and mouth convey.
The liveliness of the piece is due to
the careful carving of the half-open
mouth and the eyes; the latter have
glass inserts with an etched circular
pupil.

The hairstyle is exceptional. Pieces
of this type normally have a conical
hairstyle. In a few cases the point
becomes a plait curving forwards, its
end being bitten by a snake coming
from behind the head. When seen
from behind, the snake arises from
the lower back.

The upper part of the chest, the
shoulders and forearms are decorated
with elaborate scarifications which
pass under the richly decorated arm-
rings, the latter reminiscent of the
metal bracelets that are abundant
among the Kongo. On the thorax
and lower thighs symbols of power
increase the magical significance of
the piece, placing it firmly in the
category of mythological sculpture.
JC

Bibliography: Lehuard, 1989, i, pp. 220–31

These two stone figures belong to a well-known and important group of works generally known under the term *ntadi* (pl. *mintadi*). The name derives from the descriptions of them by their discoverer, Robert Verly. There are, however, other and arguably more appropriate names which are applied to them locally. One such is *tumba*, a term which comes from the vocabulary applied to Portuguese tombs in the area. Stone figures are intended to adorn tombs and commemorate family members credited with remarkable achievements during their lifetime.

Sculptures of this kind may date back to as early as the 16th century; some – in particular some mother and child figures – may in fact be older still. They come from a relatively restricted area lying in the north of Angola on the left bank of the River Zaire in the area between Matadi and Boma. Technically this is the area of the Kongo of Boma. In neighbouring areas the tradition of stone funerary monuments is replaced by funerary ceramics which are themselves of considerable variety of form.

These two figures show some of the variations of posture and gesture which characterise the stone images, and indeed which are also found in wooden figures. Attempts have sometimes been made to interpret these as stereotypes of various kinds. Verly thought a contemplative figure represented a 'thinker', a chief concerned for the welfare of his people. Cat. 4.13a might give rise to somewhat similar speculation. It is not impossible, however, that posture is related rather to the social standing of the deceased or even to the circumstances of death. Certainly the gesture which involves chewing a plant stem (cat. 4.13b) recalls the act of a chief who spat out pieces of a sacred plant on the assembled company on ritual occasions. *JC*

Bibliography: Cornet, 1978[1]

4.13a

Funerary monument (*tumba*)

Kongo
Boma, Zaire
19th–20th century
stone
38.2 x 15.2 cm
Royal Museum for Central Africa,
Tervuren, Belgium, MRAC 79.1.375

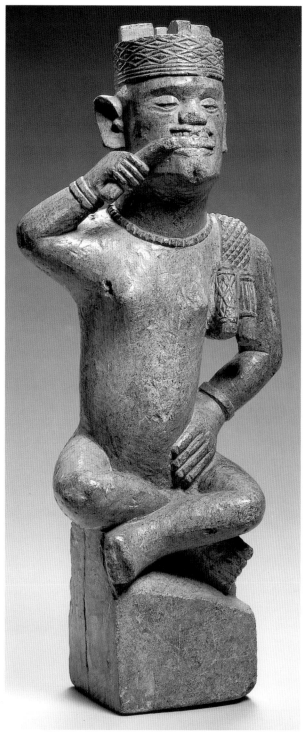

4.13b

Funerary monument (*tumba*)

Kongo
Boma, Zaire
19th–20th century
stone
h. 49 cm
Musée Barbier-Mueller, Geneva, 1021-17

4.14

Funerary monument (*ntadi*)

Kongo
Zaire
late 19th century
soapstone
h. 42 cm
The Trustees of the British Museum,
London, 1954.AF.13.1

Sculptures from this area depicting a mother and child are usually known in the art world as *ntadi* (pl. *mintadi*), which may not have been the indigenous term for them. After the British began to enforce their ban on slave-trading after about 1825, the trade shifted from Ngoyo, on the coast, to the estuary of the River Zaire, where boats could hide among swamps and islands. The town of Boma became a centre of wealth. In quarries nearby, sculptors began to produce stone figures as items of conspicuous display for purchase by the wealthy, including traders who came from inland with slaves. Because *mintadi* were not produced for specific religious purposes, the sculptors were free to invent a great variety of forms, many of them related to items of European origin which were then becoming common in the area. Most were intended for display on graves in honour of the deceased and (*ntadi*, 'watchman') as witnesses to the dead. The modern expression, near the coast, is *tumba*, from the Portuguese for 'tombstone', but inland the usual term for a grave monument is *kinyongo*. Maternity was a common theme indicating that the deceased was female; other *mintadi* portrayed aspects of chiefship. They were usually painted; they were not *minkisi* unless, as happened sometimes, medicine packs were added to them. Several distinct sites and styles of production have been identified. *Mintadi* ceased to be produced in the 1920s. *WM*

Provenance: collected by R. Verly

Bibliography: Kinshasa 1978; Washington 1981

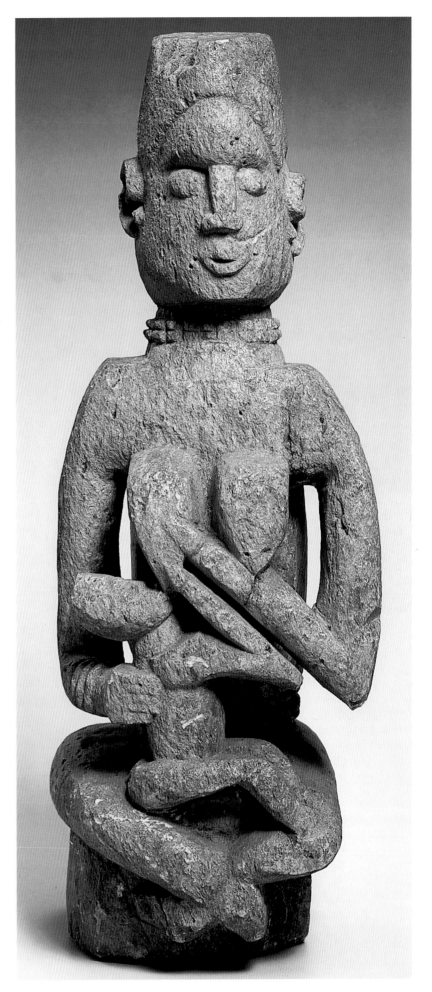

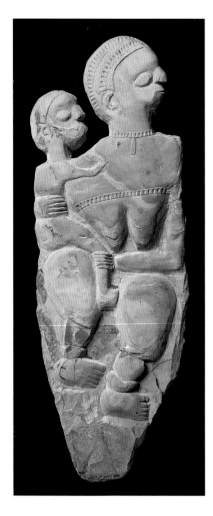

whereas lost-wax castings in shallow-relief such as the Benin plaques (cat. 5.60b–e) develop quite a different language.

These particular stelae are the largest bas-relief stone carvings in Africa outside the ancient Nilotic cultures and they seem uniquely to have been made for funerary purposes. *TP*

Provenance: 1904, excavated by Brevié
Exhibition: Paris 1932
Bibliography: Camps-Fabrer, 1966; Dembelé and Person, in Paris et al. 1993

4.16
Drum

Yombe
Cabinda
19th century
wood, hide
h. 77 cm
Museu Etnografico (Sociedade de Geografia de Lisboa), Lisbon, AB-927

In the lower reaches of the River Zaire, in Mayombe, among the Woyo and neighbouring peoples, the varieties of drum (an essential accompaniment to life) exceeded the forms in general use in central Africa to include some less familiar shapes. Some of these are double-headed drums with exceptionally long bodies. In earlier times, particularly in Loango, there was another curious style in which the drum was like a mere accessory perched above a complex carved base with a human figure, carried on the back of an animal, sometimes accompanied by snakes. The piece shown here belongs to the latter category.

On a plinth with broad moulding an unidentifiable animal, with four sturdy legs, carries the shell of the drum. This type of support is symbolic; perhaps it is the endorsement of the chief's source of power. The rectangular soundbox, traditionally fastened with a fragment of mirror, also contains the insignia of power and has the same symbolic meaning. The design of snakes and tiny human figures is also intended to render this venerable instrument sacred. *JC*

Provenance: collected before 1885
Bibliography: Bastin, 1994, no. 43

4.15
Stela

Solongo (?)
Zaire/Angola border
stone
61.5 cm x 21.5 cm
National Museum of Ethnology, Leiden, RMV 2668-803

The hands of a few very individual artists can be recognised in the stelae from Angola and Zaire, of which several examples survive in European museums. The most common theme is that of a mother and child with the mother either carrying the infant or suckling it.

Outside Egypt and Nubia shallow carving (bas-relief) is relatively rare in Africa. Wherever it crops up inventive solutions are found to the problems of representation in (so to speak) two and a half dimensions (cat. 3.13, 5.133a). In these stelae the most frequent technique is one of articulating the body as a series of independent lines, though the present example is more fluid in execution than most.

Sandcast metal objects, which are essentially one-sided (like those of the Teke), exhibit similar characteristics,

4.17a

Lid with proverbial images

(*taampha*)

Woyo
Zaire
19th or 20th century
wood
diam. *c.* 20 cm
National Museum of Ethnology,
Leiden, RMV 2966.18

4.17b

Lid with proverbial images

(*taampha*)

Woyo
Zaire
19th or 20th century
wood
diam. 20 cm
Afrika Museum, Berg en Dal,
The Netherlands, 29.636

4.17c

Lid with proverbial images

(*taampha*)

Kongo
Cabinda
19th or 20th century
wood
diam. 20 cm
National Museum of Ethnology,
Leiden, RMV 2966.45

African popular speech makes wide use of proverbs, especially in the areas around the mouth of the River Zaire; one important feature of this culture is the visual representation of such proverbs. Such representations come in many forms: designs on the walls of houses, patterns in beadwork and, particularly, the carvings on wooden lids of pottery vessels. These lids were used as a means of communication, two types being especially popular: the first served to endorse the status of chiefs (cat. 4.17b), the second to restore peace during domestic quarrels. When meals were served to the people involved, the carvings on the lids of the storage vessels would either demand respect for the chief or chiefs who had been invited or advise on subjects of family conflict.

The proverbs were represented symbolically in a great variety of ways, from figures in high relief to representations of fruit, weapons, shells and different signs in low relief. There was no script, only images. The interpretation of these proverb lids is difficult because the wording varies from area to area, and the translation of each proverb into an image is influenced by local custom. The problem of interpretation is compounded when there is a hierarchy of several symbols on a single object. The most important elements are placed in the centre of the lid. These sometimes occur singly, but sculptors have a tendency to surround them with allusions to other proverbs that complete or elucidate the principal saying; in addition, signs whose meaning is less straightforward and more general are used to fill the space.

These lids are to be found among a number of peoples: the Vili in Mayombe and, most frequently, the Woyo, both those living in Zaire and those from the Cabinda enclave.

The replacement of traditional cooking utensils with objects made of aluminium or plastic has caused the virtual disappearance of such wooden lids, and consequently of this original method of presenting wisdom in the form of sculpture. *JC*

Bibliography: Cornet, 1980; Faïk-Nzuji, 1986

4.18

Androgynous figure

Teke
Republic of Congo
wood, earth, cowries
h. 84.5 cm
Private Collection

The Teke are found mainly in the Republic of Congo between the Franceville region of Gabon and the River Zaire, on both banks of the river as far as Kinshasa in the Republic of Zaire and beyond. They are farmers and hunters and live in an area of plateaux covered by savanna, in villages grouped under a district chief with a 'notable' at the head of each. They cohabit on the bilateral matrilineal principle, i.e. with the maternal family or its close connections; within this close-knit structure, however, there is great mobility.

The Teke system of belief is based on an invisible world ruled over by one god, Nziam, the creator. The deceased are reborn into this world. Nziam has tutelary spirits, the forces of nature, as henchmen. These spirits receive prayers and supplications, conveyed either by religious or magical means. The intermediaries in this prayer are often given a material presence; they are presented as a collection of various items that are either invested with magical powers or are assumed to contain a natural spirit or the spirit of the deceased. These objects (relics or fetishes) are kept in a container or receptacle attached to a sculpture representing the dead ancestor.

The statue exhibited here must surely be an ancestor. It would be interesting to know why the effigy is androgynous. Study of the face reveals a connection with the face of the statuette of a seated figure shown in Brussels in 1988.

Many theories have been advanced about the origins of this statuette. Is it Teke? Bembe? Bwende? The style in fact is Teke, from the left bank of the River Zaire. Sculptures in this style are to be found in Belgian collections.

The figure is standing in a traditional pose, legs bent, head erect; the eyes, made of glass beads, are close to the nose, the brow bulges, the mouth is prognathous and slightly open to show the teeth. A hole in the centre of the teeth suggests that a removable piece could be added to give concrete

presence to the words of the ancestor. The area in the centre of the forehead bears a pattern of tattooed checks, indicating high office, and the forehead, temple and cheeks are densely covered with fine scarifications in specifically Teke patterns; the area around the eyes and mouth is not scarred. The ears are C-shaped, with the tragus in relief. The headdress worn by this person is reminiscent of the chignon of variable length worn by notables. *RL*

Exhibition: Brussels 1988, pl. XXVIII, p. 96

4.19

Statuette of an ancestor

Bembe
Republic of Congo
19th century
fabric, wood, fibre
h. 46 cm
Private Collection

The Bembe once inhabited the Republic of Congo, near its border with Zaire. They were responsible for hundreds of small, beautifully carved sculptures that for years went unrecognised. Monumental statuary, however, is more scarce; the figures usually represent an ancestor squatting like a tailor, with minimised lower limbs. *JC*

Bibliography: Söderberg, 1975; Lehuard, 1989, i

4.20

Pot

Kongo
Zaire
20th century
fired clay
h. 11 cm; diam. 15 cm
The Trustees of the British Museum,
London, 1910.10-26.3

African pottery is characterised by the
use of simple technology to produce
objects of total utility and great
beauty. The present pot is of a dis-
tinctive yellow clay and the striking
and unusual decoration is achieved
by splashing the surface with a very
thick, resinous, vegetable decoction
while it is still hot from baking.
The vegetable matter boils off rapidly,
leaving an effect almost of wood grain.
It is a technique used by a number of
peoples around the mouth of the
River Zaire.

African pots are largely hand made
by women and baked at relatively low
temperatures. The resulting terracotta
is composed of comparatively large
particles that are very resistant to
thermal shock. This means that
African pots can be placed directly
on a fire without shattering, as would
happen to pots made of finer clay
and baked at a higher temperature.
Because of the large particles, moisture
can evaporate readily through the pot
walls, so that pots used as water-
containers keep their contents well
below the temperature of their
surroundings. Where such porosity is
not required, pots are often sealed by
burnishing or applying vegetable
decoctions. Western-style glazes could
not be used at such low temperatures.
NB

Provenance: before 1910, collected by
Rev. J. Weeks

Bibliography: De Haulleville and Coart,
1907, pls 6–7; Barley, 1994, p. 30

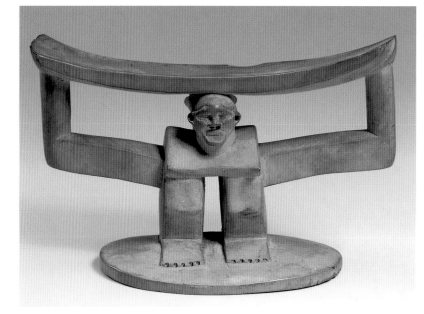

4.21

Headrest

Mbala
Zaire
c. 1900
wood
18 x 27 x 13 cm
The Trustees of the British Museum,
London, 1907. 5-28.13

Among the Mbala certain forms of
headrest – and notably those with
figurative supports – are known to
have been reserved for chiefs. Such
a restriction has been interpreted
as reflecting the fact that chiefly
authority rests upon the assent of the
people, that the chief must listen to
them as he does symbolically when
he rests his head upon the headrest.
An alternative interpretation, how-
ever, might be that the limitation to
chiefs has less to do with the exercise
of political wisdom and more with the
nature of hierarchy: in other words,
his authority is supreme, weighing
down upon his subjects.

This particular example was
collected by Torday in 1907 at the
Mbala village of 'Mossonge', one of
two he collected in a style identifiable
with a single Mbala artist. Another,
in the Tervuren museum (MRAC
20155), was collected among the more
distant Teke before 1914, though said
to have been of northern Mbala
origin. It is possible that they are the
work of a carver called Molime who
was admired and befriended by
Torday. A number of pieces in the
British Museum's Torday Collection
are known to be by this artist, though
the documentation does not confirm
which. This, however, is so distinctive
a style that the probability is that he
is indeed the creator of the works.
If, of course, the headrests were
carved exclusively for chiefs this
would also explain why they were
collected in diverse places. *JM*

Provenance: 1907, acquired for the
museum by Emil Torday

Bibliography: Biebuyck, 1985, p. 163

4.22

Drinking-vessel

Pindi or Suku
Zaire
c. 1904
wood
h. 9 cm
Staatliche Museen zu Berlin, Preussischer
Kulturbesitz, Museum für Völkerkunde,
III C 19806

This drinking-vessel has either been
mistakenly labelled 'Bakuba' or is a
Suku or Pindi trade article actually
collected among the Kuba. Similar
examples were collected by Frobenius
among the Pindi. As a distinct sign
of authority of a Suku headman or
regional chief, the carved, double-
mouthed drinking-vessel served for
the ritual drinking of palm wine.
The inviolability of the vessel was
reinforced by the motifs featured on
one or both sides of the vessel, which
depicts either the image of an ante-
lope horn as power-container, as in
this example, or that of the *hemba*
charm as a human face. The double-
mouthed drinking-vessel originates in
the gourd cup. The squat, pumpkin-
shaped gourd, when vertically halved,
results in two containers, the openings
(joined in the middle) resembling a
figure-of-eight. Carved from a single
block of wood, Suku vessels measure
an average of 9 cm in height by 11 cm
in length; they generally have a
rounded bottom. *APB*

Provenance: 1904, collected by Leo
Frobenius

4.23

Door

Holo
Zaire
wood
160 x 45 cm
Private Collection

This double-panelled door presents
Christian motifs in relief. A crucifix
is featured on the left panel with a
kneeling figure with hands held in a
praying posture on the accompanying
panel. Both motifs find their counter-
part in Holo charm imagery in
depictions of the enframed *nzambi*
charm and hands-to-mouth posture
in curative statuettes. *APB*

4.24

Relief panel

Pindi
Zaire
c. 1904
wood, pigment
h. 99 cm
Museum für Völkerkunde, Hamburg

This panel, collected from the Pindi
village of Kissala, was described as
a 'door with moon, *kitekki* [charm
figure] and two *kialu* ['lizards'].
Other doors found among the
neighbouring Mbala and Hungaan
similarly have celestial symbols
combined with reptile forms. The
kitekki is distinctly related to the
image found on a variety of Suku
drinking-vessels. *APB*

Provenance: 1904, collected by Leo
Frobenius

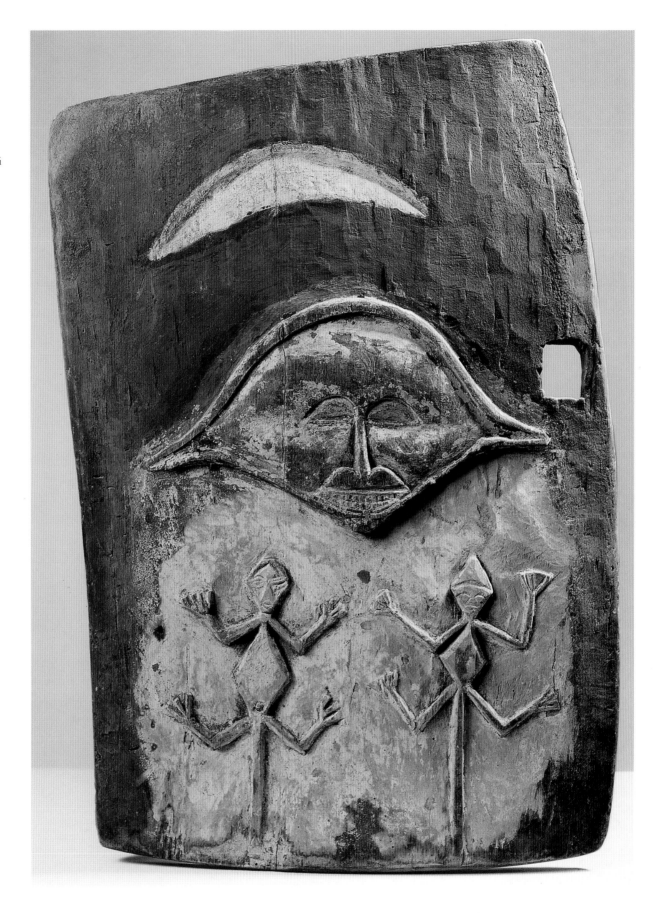

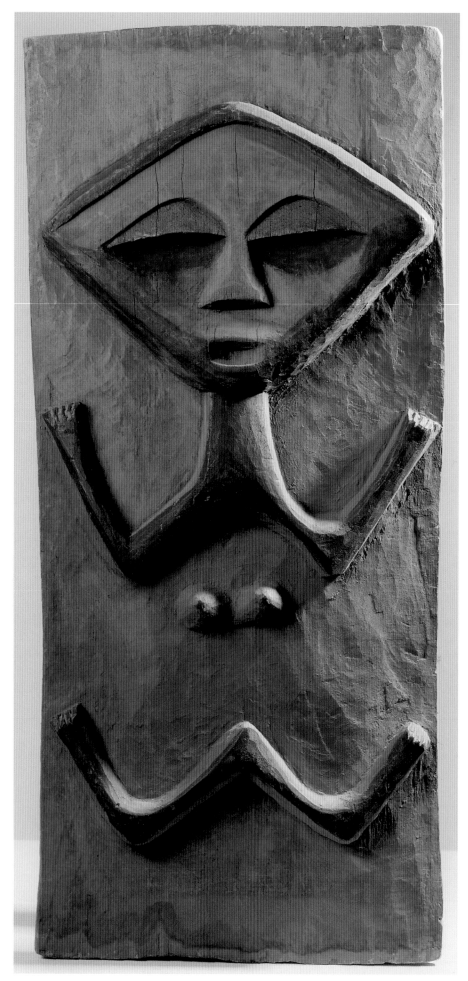

4.25

Panel

Hungaan
Kwenge Valley, Bandundu Province, Zaire
19th century
wood, pigment
99.2 x 45.3 cm
Museum für Völkerkunde, Hamburg,
5789.05

This panel exemplifies the 'displayed female motif' in which a figure is shown with splayed bent legs, exposing the genital area (see also cat. 4.26,85). In daily life within certain regions of west central Africa, notably the Kwango River region of Zaire and the Ngunie River of Gabon, female modesty is characteristic; complete female nudity for an adult is non-existent in a public setting. The imagery, then, is a reference to something other than daily practice.

Appearances of the same motif could be shown from elsewhere in Africa, in sculptured lintels of the Mileke of Cameroon, Chokwe chair stretchers from Angola or the stools of Zula chiefs from Zaire. It is a universal theme whose earliest appearance can be found at Chatal Huyuk in Anatolia, probably in the 7th millennium BC.

The displayed female motif by no means ensures that the message is essentially about women. As the feminist theorist Laura Mulvey suggests in her book *Visual and Other Pleasures* (Bloomington, 1989, p. 11), the image of woman comes to be used as a sign, which does not necessarily signify the meaning 'woman' at all. Rather it springs from a male consciousness. Even within a ritual usage, males are communicating with other males via such imagery: it is not only a product of male carvers and commissioned by male dignitaries, but in the Kwango River region is also intended for the initiation of young males into responsible men.

Certainly there are implied elements of satisfying sexual curiosity, viewing the female as sexual object and the female role as bearer of children. There may even be hints of castration anxiety, fear of social inadequacy and rejection by one's peer group. Ultimately, however, in the context of male initiation the meaning of woman is sexual difference, which reinforces male solidarity.

This highly conventionalised example in relief consists of two 'W' forms, one supporting the lozenge-shaped head and the other suspended below leaving the two breasts emerging from the flat panel. According to Frobenius's ethnographic notes, the panel is from an old door and depicts a *kitekki*, or charm figure, which is given a personal name; the Hungaan placed such doors in a house where a sick person was being treated. Similar doors were collected by Frobenius among the Pindi and Mbala. While the head shown on this panel has stylistic affinity to Hungaan miniature ivory and bone pendant figurines, the pendants present a female in a squatting position whose knees nearly touch. Probably both served an apotropaic and protective function. *APB*

Provenance: 1905, collected by Leo Frobenius

Bibliography: Frobenius, ed. Klein, 1985, pp. 19–20; Biebuyck, 1985, i, p. 159; Biebuyck, 1987, pl. 17

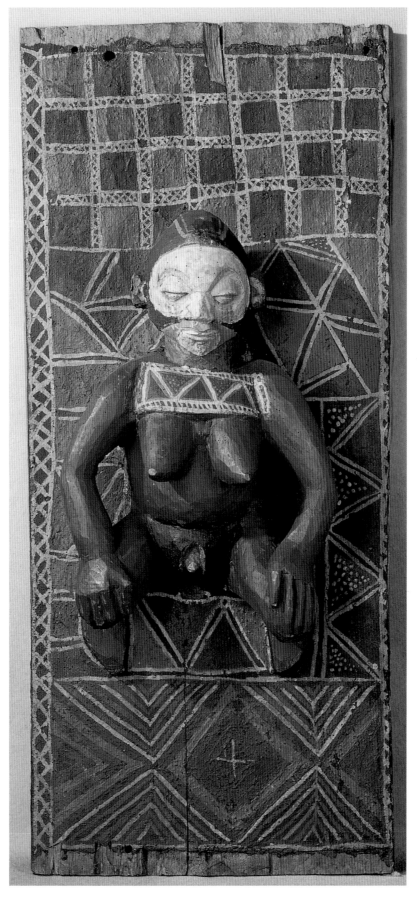

4.26

Panel

Nkanu
Zaire
wood, pigment
Laboratoire d'Ethnologie,
Musée de l'Homme, Paris, 32.15.11

Used in initiation to manhood ceremonies similar to *nkanda* of the Yaka, but here termed *kimeki*, Nkanu panels were exhibited in a special booth or hut with open front. This example shows a 'displayed female' (see cat. 4.25) in high relief seated at the centre, while the background is decorated with geometric shapes delineated within white cross-hatch zones. A beaded chest ornament is presented on this otherwise naked figure. Other examples show a male with large genitalia or a female giving birth as well as animal figures carved in relief. In comparison with similar depictions on Yaka masks, themes of sexuality and procreation dominate in this setting relating to male fertility and its protection. Sung verses and sexual depictions ridicule female attributes and celebrate sexual difference; male dominance is asserted and erotic indulgence given play. The initiate is led to identify himself in a dramatic and symbolic way with the human life cycle and with behaviour associated with its differing stages. In this context, male/female opposition is surpassed by an awareness of the importance of generational continuity for future life and well-being. *APB*

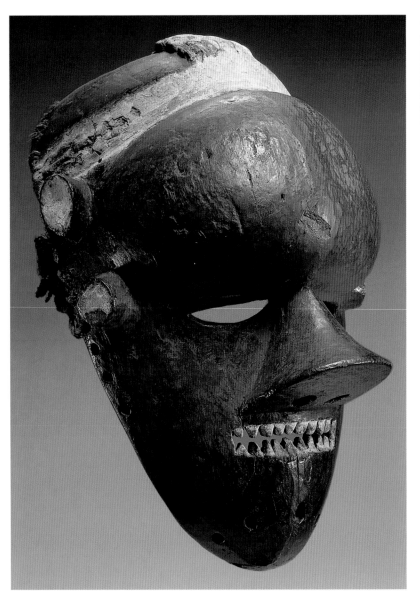

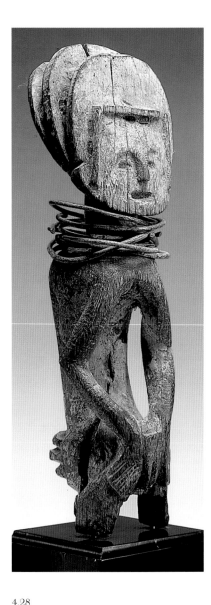

4.27

Mask (*kasangu*)
Sala Mpasu
Zaire
20th century
wood, pigment
32 x 22 x 24 cm
Felix Collection

4.28

Female statuette

Eastern Kongo
Zaire or Angola
wood, metal
34 x 10 x 10 cm
Felix Collection

Before the turn of the century the Sala Mpasu were part of a small enclave of loosely connected peoples in Kasai Province, Zaire. Social organisation centred on three institutions: matrilineal clans (*mupanga*; pl. *mipanga*), settlements (*ikota*) built around 'rich men', and the warriors' society (*mungongo*; pl. *bangongo*). Sala Mpasu masks were integral parts of the warriors' society whose primary task was to protect this small enclave against invasions by outside kingdoms. Boys were initiated into the warriors' society through a circumcision camp, then rose through its ranks by gaining access to a hierarchy of masks. Earning the right to wear a mask involved performing specific deeds and large payments of livestock, drink and other material goods. Once a man 'owned' the mask, other 'owners' taught this new member particular

esoteric knowledge associated with it. Mask performances were open only to those having the right to wear the mask. Possessing many masks indicated not only wealth but knowledge.

Individual masks were obtained sequentially by a warrior to form a series of increasingly elaborate masks controlled by a society (*ndoge*) within the warriors' organisation. Basic wood masks (*kasangu*) are painted while the senior mask (*mukinka*) is copper-covered; some have pointed teeth. Filing teeth was part of the initiation process for both boys and girls designed to demonstrate the novices' strength and discipline.

Since the turn of the century the Sala Mpasu have undergone drastic economic, political and social changes that have directly affected their art forms and related institutions. Attempt-

ing to change their fierce reputation, the Sala Mpasu have disbanded the warriors' society. Masks, however, are still being danced as part of male circumcision ceremonies. *ELC*

Exhibition: San Diego 1992

Bibliography: Jobart, 1925; Clé, 1937; Clé, 1948; Bogaerts, 1950; Pruitt, 1973; Cameron, 1988

This kneeling figure in modified 'displayed female' stance, arms turned back with hands resting on hips, wears a dignitary's hat and bears a metal ring about the neck, yet lacks female breasts. Similar kneeling ring-necked statuettes showing a high degree of naturalism commonly derive from the Zombo plateau of northern Angola. Little is known regarding their precise ritual use although in comparison with statuettes of their neighbours they are presumed to serve both curative and apotropaic functions. *APB*

4.29a

Statuette

Hungaan
Zaire
wood
h. 57 cm
Museum für Völkerkunde, Hamburg,
5248.05

4.29b

Statuette

Hungaan
Zaire
wood, horn, cord
h. 47 cm
Staatliche Museen zu Berlin, Preussischer
Kulturbesitz, Museum für Völkerkunde,
III C 3310

4.29c

Statuette

Yaka
Zaire
wood
41 x 9 x 8.5 cm
Musée d'Art Moderne de la Ville de Paris,
Girardin bequest, D. 62.1.3, on loan to the
Musée National des Arts d'Afrique et
d'Océanie, Paris

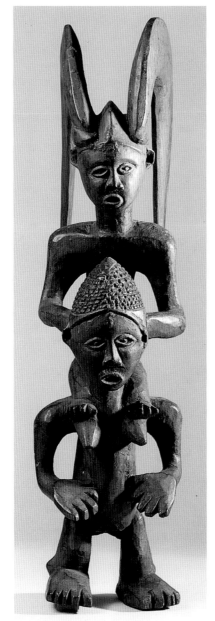

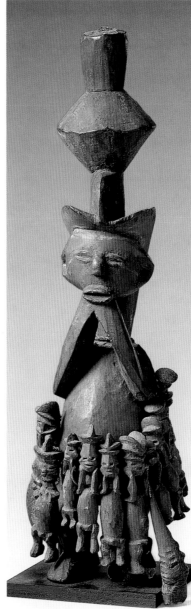

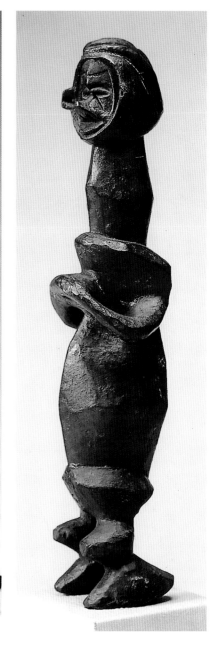

The pickaback motif exemplified in cat. 4.29a is not that of a woman carrying a small child, but presumably a male dignitary, as indicated by the horned coiffure. Being carried on the shoulders is usually a part of some rite of passage in which the person must be kept off the ground or be treated like a newborn child. Hungaan statuettes with straight or bent horns refer to those of a stylised pangolin or aardvark and have their parallel in Hungaan masks said to be worn when a chief marries a wife. Among the neighbouring Mbala, with whom the Hungaan mix, horned statuettes are termed *malwambi*.

Collected in 1886 by the first Europeans to cross the Kwilu region, another Hungaan statuette (cat. 4.29b)

balances a vessel above its head and carries a dog bell, horn container and ten miniature figurines around its waist. Hungaan carvings were associated with ritual experts (*nga* or *nganga*) who specialised in protection, healing and divination according to a particular ritual institution. Larger figures were placed upon a high table within a house, and the largest were termed grandfather or grandmother *mukisi*. Those termed *nkonki* protected houses, gardens, animals, traps and nets, while others were worn by women and children as personal guardians or were hung over doorways. The miniatures attached to this charm appear to represent children of the main figure, though among neighbours of the Hungaan

supplementary carvings are frequently loaned out to individuals as an extension of the power assemblage.

The Yaka statuette (cat. 4.29c) is a lineage *biteki*, a charm used to contain and control evil influences or a hereditary disease; it may also be used to protect property and inflict injury on witches or other malefactors. Sculptural contrasts in the projection and recession of parts of the human body are vigorously expressed in this object. *APB*

Provenance: cat. 4.29b: 1886, collected by Richard Kund and Hans Tappenbeck

Bibliography: Frobenius, 1907, p. 91; Kecskési, 1982; Biebuyck, 1985, i, p. 159; Dewey, 1993

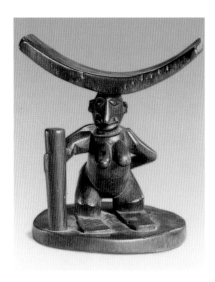

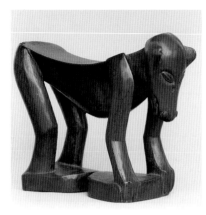

4.30a

Headrest

Yaka
Zaire
wood
19 x 16.5 cm
Museum Rietberg, Zurich, RAC 528

4.30b

Headrest

Yaka
Zaire
wood
19 x 16.5 cm
Private Collection, Paris

Headrests are items of furniture placed under one ear and along the side of the chin to support the head during sleep. They are positioned on sleeping mats in order to protect elaborate coiffures. Evidence of antecedents as remote as early pharaonic Egypt and as dispersed as the Bandiagara Cliffs of Mali and eastern Zaire in the Kisalian period attest to both the antiquity and the widespread use of this form of furnishing in Africa.

Cat. 4.30a has a female column as its central support and a rounded base. The figure grasps a large pestle, an item commonly used in conjunction with an hourglass-shaped mortar in the daily preparation of cassava (manioc) flour. Among the Yaka all tools partake of a gender-related topology. Even though the early morning sounds of women processing cassava at the mortar are ubiquitous, the pestle in certain ritual contexts displays an overt masculine signific-ance. The overall referent here in the context of the prominently breasted and unclothed female appears to be sexual. Moreover, the mortar is not shown, as the Yaka do not permit allusion to sex during the preparation or eating of meals.

The headrest in the form of a quadruped with swayback as support-ing platform may refer to diverse animals, including gazelles and felines. Cat. 4.30b appears to represent a dog. Among the Yaka, who term their headdresses *musawu*, canines are associated with the hunt (an exclusively male occupation and a source of male prestige) rather than being considered domestic pets. Although their keen sense of smell is linked metaphorically to the diviner's ability of clairvoyance, their sexual habits model the nocturnal promiscuity of sorcerers. *APB*

Bibliography: Dewey, 1993, pp. 16–17; Wassing, 1968, fig. 54; Zurich 1970, p. 282; Bastin, 1982, p. 10; Bourgeois, 1984, pp. 56–7; Devisch, 1993, p. 98

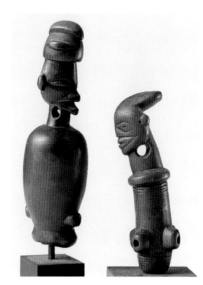

4.31a–c

Whistles

Pende
Zaire
wood
cat. 4.31a: 15 x 4.5 x 5 cm; cat. 4.31b: 11 x 3.5 x 35 cm; cat. 4.31c: h. 22 cm (not illustrated)
Herman Collection

It is often the case in the arts of Africa that the greatest refinement is found in the most utilitarian objects. The snuff bottles of the Zulu (cat. 3.30) are a case in point. A man or woman's essential possessions are seen by everyone; they become the focus for the greatest artistic inventions since prestige can be so easily (and daily) demonstrated. In other cultures the ubiquitous wristwatch can speak of wealth and sophistication. Forest people need whistles, which may become objects of personal adornment as well as giving pleasure in constant handling (which in turn makes them glow with wear and body oils).

Although as simple in musical structure as they are witty in style, the whistles of such peoples as the Pende or Teke are none the less capable (by means of half stopping the holes) of quite complicated utterances in the language of whistle-speech by which hunters can communicate across long distances. Two holes usually suffice to give the necessary range, and ears attuned to quarter-tones can detect a whole gamut of inflections from such limited means.

In many cultures (e.g. the Chokwe) the whistle is a prized possession whether in ivory or wood, and as a genre it is the netsuke of central Africa. *TP*

4.32

Pendant (*gikhokho*)

Central Pende
Zaire
ivory
6 x 4.5 x 2 cm
Private Collection

The Central Pende carve decorative pendants (sing. *gikhokho*, pl. *ikhokho*) in the form of miniature masks. Sculptors prefer elephant ivory when it is available because of its smooth, cool texture and because, if it is carved correctly, it does not crack with age. They also use the soft thigh bones of hippopotami. The latter can achieve much the same lustre and texture as ivory, but splits more easily and shows grooves from muscles and tendons that need to be disguised on the underside of the pendant. Some sculptors treat the ivory or bone first with special preparations to inhibit cracking and give the surface an enhanced slippery texture.

This lovely example shows a long history of use by its original owner that has shaped its appearance. The sculptors carve the pendants with the same sharply chiselled features as their wooden masks. The owners wear the pendants on cords or strings of beads around their necks, where in the course of the day they pick up sweat and (in the past) the red cam-wood powder used as a skin con-ditioner. Consequently, when the owners go to wash at the local stream, they scrub the pendants daily with abrasive fine sand to clean them and to preserve their colour. Although Westerners prize a golden patina,

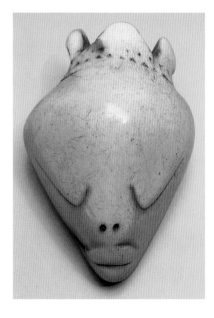

Pende clients worked to preserve the original white as long as possible. Even clients who kept their pendants for special occasions would have to scrub them from time to time with sand in order to keep the ivory or bone from darkening from house smoke.

This piece shows the effects of daily sand baths in the softening and blurring of its features. The extension of the nose and the eyelids are the first details to go. Comparison with works in the field indicates that this example received well over ten years of loving care that has resulted in the almost complete absorption of the features into the face.

There is some confusion in the literature about the role of these pieces. Recent fieldwork has clarified the issue. Although relatives and diviners sometimes made wood miniatures of masks for use in healing ceremonies, field associates stress that in contrast it was experienced sculptors who made the vast majority of pendants in ivory and hippopotamus bone as ornaments to embellish their clients' sense of beauty and style (*ginango*). *ZSS*

4.33
Male standing figure
Pindi (?)
Zaire
wood, pigment
h. 82.5 cm
Museum für Völkerkunde, Hamburg,
4490.05

Little is known about this unique piece. The Pindi (also called Pindji or Mpiin) are an ethnic group dispersed in small groups between the Kwilu and Loange rivers in Zaire. They live peaceably intermixed with numerous other groups or in enclaves within Pende territory. Consequently, there is great diversity in their material artefacts, although they retain a distinct ethnic and linguistic identity. Frobenius acquired this piece in 1905 in Belo where Pindji, Hungaan and Mbala are in close proximity. The ascription to the Pindji is not certain as Belo may have been a collection point where individuals from the neighbourhood brought Frobenius material to sell.

Until recently, scholars have tended to avoid or underemphasise complex frontier cultures like this one in favour of large, centralised conglomerations or states. One can only generalise from Pende material that sculpture in the region tends to be used for decoration of the chief's house; for the creation of points of contact where individuals may pray to God through the intercession of the dead; and for personal power objects.

There are two indications that this figure was closely associated with the chief. The spotting is a ubiquitous reference to leopards and to the chief's metaphorical kinship to this beast. Apart from cunning and ferocity, there are thought to be parallels between a leopard stealing chickens and livestock and the chief's prerogative to collect taxes. The pattern on the cap is also one frequently associated with chiefs. The statue's condition and full-standing posture suggest that it was made to be kept indoors. The Pende used such figures within the chief's ritual house in order to fix a spirit for the chief's protection from his rivals.

The gesture of reaching up with both arms extended is unusual. The sculptor has formally enhanced its power and directionality by stretching out the arms and greatly elongating the neck and torso. Thompson records

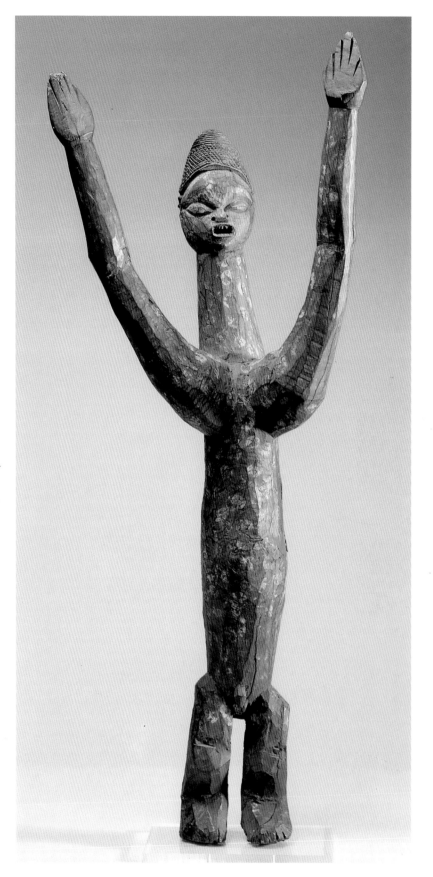

that the Kongo use a similar gesture with outstretched fingers (*yangalala*) to indicate joy and the shock of transcendent contact with the other world. Therein may lie a clue to the work's function. *ZSS*

Provenance: 1905, acquired in Belo by Leo Frobenius

Bibliography: Thomspon, 1981, pp. 176–7; Biebuyck, 1985, pp. 150–2; Frobenius, 1985; Bourgeois, 1990, p. 123

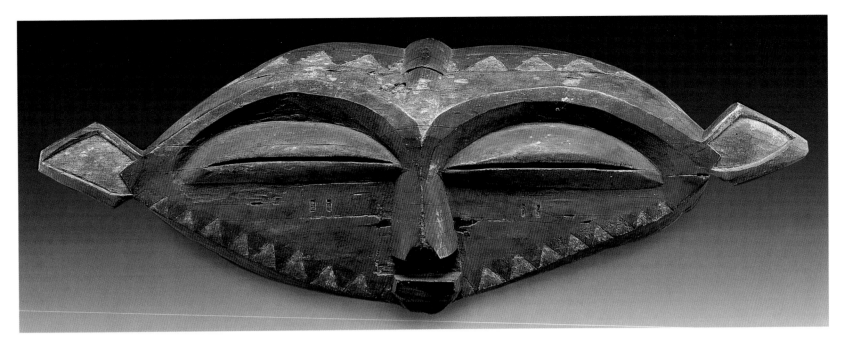

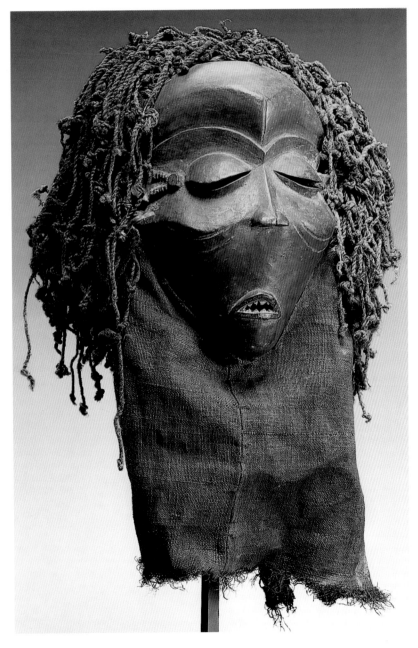

4.34

Mask (*Mbuya*)
Pende
Zaire
20th century
44 x 30 x 31 cm
wood, pigment, fibre, fabric
Felix Collection

The Pende are such sophisticated masqueraders that even their satirical masks (though in ritual there is no comedy without purpose) have a classical rigour. This mask belongs to the *travesti* tradition of men dressing as well-known feminine types (chief's wife, temptress, beauty queen etc.). This particular mask, probably the prostitute (*ngobo*), was danced in rites following boys' initiation. It was associated with a second initiation which traditionally would take place with a 'woman of the night'. The costume may be imagined covering the dancer and featuring large breasts of stuffed fibre.

In this mask the typical downcast eyelids of Pende sculpture, through whose narrow slit the dancer would see, are beautifully realised and the whole formal rhyme scheme echoes their seductive slant. This combined with the bold sweeping planes of the face creates a lofty formal rhythm seemingly at odds with the profane subject: such a paradox, even to the almost prim mouth, can also be found in the Japanese tradition and in Europe among the masks for the commedia dell'arte. *TP*

Bibliography: Petridis, 1993

4.35

Mask (*panya ngombe*)
Pende
Zaire
late 19th–early 20th century
wood
21.6 x 52.1 x 16.5 cm
The Detroit Institute of Arts
Founders Society Purchase, Eleanor Clay
Ford Fund for African Art, 79.37

Among the formidable range of Pende masks the human and animal are often linked, and in the West Kasai one particular type seems to share a masquerading and an architectural function. The lateral elongation of the *panya ngombe* mask relates to the wild cow/bull (or buffalo) which itself has chiefly associations and was danced by a masquerader in obviously regal dress, although this particular dancer (in a paradoxical role reversal that is to be expected in Pende masking traditions) is the one who collects offerings at the end of the initiation festivities.

Larger examples of this type of mask exist than the ritual itself would demand. These are referred to as *kenene* and served to decorate the lintels of major chiefs' houses. Here is one of the few cases in which absence of wear in a purportedly old mask should not arouse suspicion. *TP*

4.36

Statuette of a chief seated on a folding seat

Chokwe
Angola
before 1850
h. 45 cm (total); 29 x 17 x 19.5 cm (figure)
wood (*Crossopteryx febrifuga*), deep black patina; hair, brass, beads, upholsterers' pins
Museu Etnografico (Sociedade de Geografia de Lisboa), Lisbon, AB-924 S.G.L.

When one examines this complex piece of carving, it is difficult to believe that it is carved from a single log of wood; or that the sculptor had at his disposal only an adze, a small knife and a piece of red-hot metal wire to assist in the piercing of the openings.

The figure represents a local ruler (*mwanangana*), sitting on a Western type of chair that acts as a throne and clapping his hands in a gesture of greeting (*mwoyo*) in response to the homage paid to him by his subjects; he is wishing them a long life, health and prosperity. The traditional greeting was addressed to Kalunga, the Supreme Being, the All-Powerful, and is the equivalent of 'God bless you!'

The seat (or throne) is in the simplest of Western styles. The sculptor has shown more taste for opulence in other parts of the statue, although he was working within regional stylistic parameters, which have permitted attributions of this and similar creations to a single artist (or workshop) in the region of Moxico, south of the source of the Kasai. The small face, with its faint (but infectious) smile is surrounded with a finely plaited fringe decorated with a few red beads, the latter very unusual in Chokwe statuary. Lux, however, mentions this addition as being confined to the elders in his description of the hairstyles seen by him in the Songo area. An excellent photograph of four young Chokwe notables, each with a different hairstyle, taken by Fonseca Cardoso in 1904 in the region of Moxico, shows this style of fringe worn on the forehead by the man standing on the far left. Also very unusual are the great curved lashes supported at either end by the elliptical brass plate that emphasises each eye. The goatee beard, which has been dramatically shortened since 1985, used to be plaited and forked; it has lost the

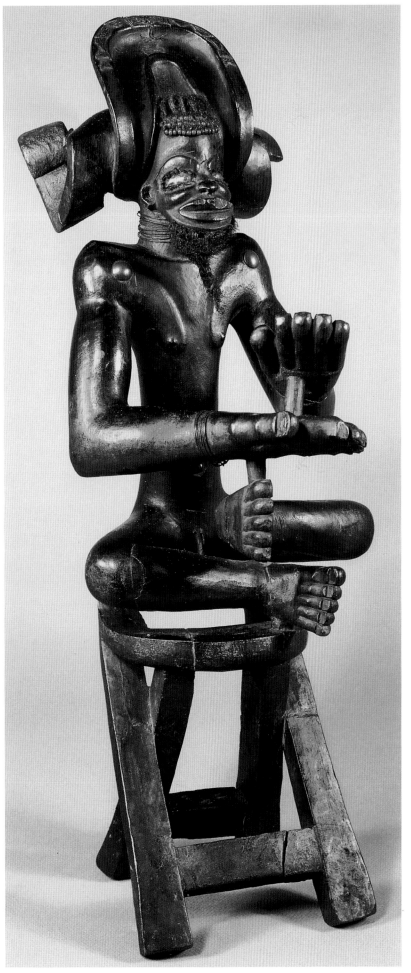

white and red beads that I saw threaded through its points in 1986. These details are not the only original features of this interesting sculpture. A border of interlocking triangles (*mapembe*) composed of fragments of brass wire carefully clipped together decorates the upper edge of the fan-shaped brim of the headdress. The usual curved side-wings appear originally to have been twisted into a spiral. *MLB*

Exhibitions: Rio de Janeiro 1922; Lisbon 1985, no. 115; Paris 1988, p. 79; Lisbon 1994, no. 116

Bibliography: Lux, 1880; Bastin, 1968, no. 8; Bastin, 1969, fig. 2; Bastin, 1981, fig. 11; Bastin, 1982, no. 64, pp. 130–1

**Figure of the 'civilising hero'
Chibinda Ilunga**

Chokwe
Angola/Zaire
before 1850
h. 39 cm
fine-grained wood, dark brown patina;
hair, cotton, fibres, large yellow glass bead
Staatliche Museen zu Berlin, Preussischer
Kulturbesitz, Museum für Völkerkunde,
III C 1255 (1880)

Some time before 1956 a Namuyanga
soothsayer in his eighties explained to
me the identity of Chibinda Ilunga,
the person commemorated in an
ancient piece in the Museu do Dundo
similar to this one (also undoubtedly
of Chokwe manufacture); the entire
Lunda people and anyone in their
sphere of influence were already
celebrating his memory. Victor W.
Turner's *Lunda Love Story* (1955)
gives a good résumé of the tale
written down by H. Dias de Carvalho
(1890) while staying at Musumba,
near the River Kalanyi. It was Dr Paul
Pogge, however, the first European
officially to have reached the capital
of the Mwata Yamvo empire in 1875,
who made a record of this dynastic
epic.

Chibinda Ilunga, the prince of
'sacred blood' (*mulopwe*), came from
the eastern Luba lands ruled over by
his father Kalala Ilunga. He was a
passionate huntsman and, having
crossed the Kalanyi-Bushimai, arrived
in an area owned by the young female
chieftain of the Lunda, Lweji. She
was the keeper of the traditional
symbol of authority, the bracelet or
lukano, inherited from her father,
Konde; the bracelet gives its possessor
seniority over other lineages and pre-
eminence at the Council of Elders.
At that period the Lunda lands,
between the Kalanyi and the Lulua,
knew nothing of centralised power
and their hunters still used only
bludgeons and catapults. The noble
stranger, raised in more sophisticated
court circles and venerated by his
retinue, used hunting weapons of
metal, their efficacy reinforced by
auspicious spells. Lweji, agreeably
impressed by his gifts of game and
attracted by her guest, welcomed
Chibinda Ilunga enthusiastically
to her domain; one day, after their
marriage, she handed him the sym-
bolic *lukano*. Her brothers and other
important elders were displeased by

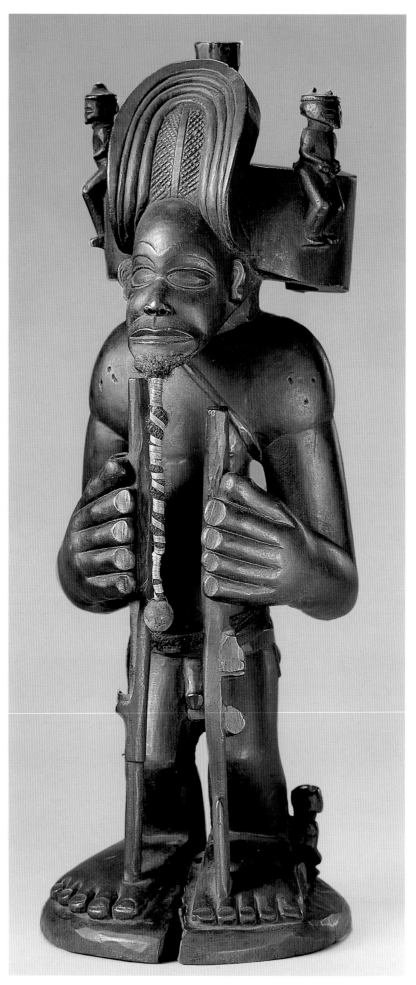

this seizure of power and left for the
west, beyond the Kasai, in search of
new lands. They took with them,
however, some of their newly
acquired customs and knowledge.
These they transmitted to the people
occupying the high wooded plateau,
the fertile valleys, the sources of the
Kasai and the Kwango, the land of the
Chokwe or Uchokwe (also known as
'Tchiboco'), a land rich in game,
favourable to the cultivation of cereals
and vegetables, and where honey
could be gathered in abundance.

Through an intricate series of
marriages they became completely
integrated into the local population
which, as luck would have it, already
had a long history of wood carving.
Thus, as powerful chiefdoms were
formed over the years, a court art
developed in each one. Their rulers,
wanting to commemorate this cultural
hero of yore, commissioned their
celebrated professional sculptors, or
songi, to make images of Chibinda
Ilunga. The prince was portrayed in
full hunting regalia (including, from
the end of the 18th or early 19th
century, a flintlock rifle), and his due
complement of charms. He was also
shown proudly wearing the royal
headdress of the Lord of the Chokwe
(*mwanangana*).

This masterpiece returns the hero
to his traditional role: he is a haughty
and dignified figure, in spite of his
powerful musculature and the ex-
aggerated size of his extremities.
His long, carefully tended beard
emphasises his aristocratic origins.
The miniature figures around him
are tutelary spirits, vigilantes, looking
out for game or a predator. *MLB*

Provenance: 9 November 1878, acquired
from a Chokwe trader met by Otto H.
Schütt on the road to Kimbundu, after the
crossing of the River Loange

Exhibitions: Paris 1988, p. 72; Maastricht
1992, no. 90

Bibliography: Schütt, 1881, p. 131; Alexis,
1888, p. 233; Dias de Carvalho, 1890,
pp. 50–112; Sydow, 1954, pl. 96–A; Bastin,
1961¹, fig. 1; Bastin, 1965, figs 9–11;
Krieger, 1965, fig. 268; Leiris and Delange,
1967, fig. 33; Bastin, 1978, pls III–IV;
Bastin, 1981, fig. 5; Bastin, 1982, no. 80

4.38

Female memorial effigy

Chokwe
Angola
before 1850
fine grained wood, dark reddish patina,
red ritual mud in eyes and mouth, hair
h. 35 cm
Staatliche Museen zu Berlin, Preussischer
Kulturbesitz, Museum für Völkerkunde,
1886, III C 2969

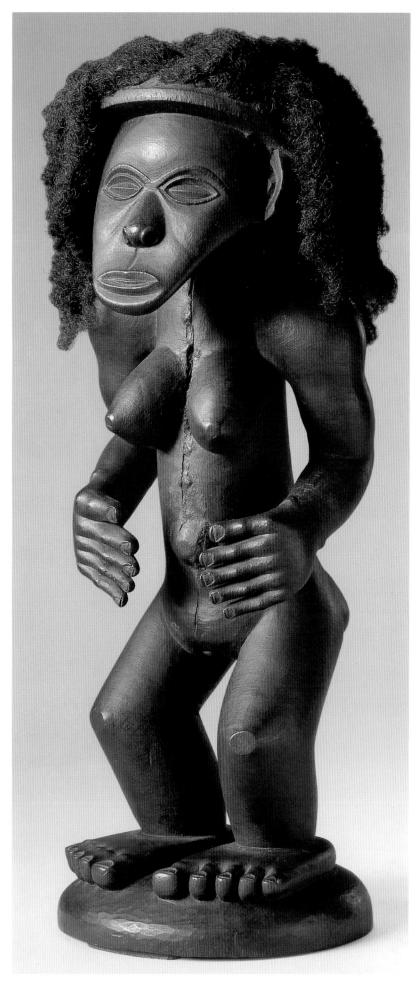

This powerful portrait probably represents the chief's leading wife (*namata*) or the queen mother (*mwanangana wa pwo*), both of whom had an important ritual position at court. In 1795 the caravan routes arrived at the upper reaches of the Zambezi, and this people, who lived in the interior at the sources of the Kwango, Kasai and Lungwe-Bungo rivers, were officially recognised in Benguela. The skill of their professional sculptors (*songi*) was recognised by all their neighbours, and indeed their renown must have reached the Atlantic coast, probably with the Ovimbundu as intermediary. This would explain how so much of their work was acquired from its country of origin by collectors in the last quarter of the 19th century.

Although modest in size, this piece is striking because of the extraordinarily vigorous way it projects itself into the three dimensions. Great care has been taken, nevertheless, with the carving of the face and the details of the hands and feet.

The stylisation of the face, projecting forwards in echo of the image traditionally depicted by the Chokwe in their masks, suggests categorisation of this effigy as belonging to the 'Muzamba school', at the source of the Kwango River.

Chokwe 'court art' is characterised by a certain naturalism, demonstrated in this exceptional example by the figure's opulent hairstyle. This is composed of real hair, plaited and fixed with pegs to the top of the head, behind a kind of diadem.

Baumann recorded oral testimony describing the composition of a court from an elderly notable whom he encountered at the source of the Kasai. The power of the local chief (*mwanangana*) was connected with the spiritual influence he wielded over the prosperity and fertility of his subjects; it was transmitted to him by ancestors of his dynasty at his enthronement. *MLB*

Provenance: before 1886, collected in Benguela by the explorer and diplomat Gustave Nachtigal

Exhibition: Berlin and Paris 1964

Bibliography: Sydow, 1926, pl. 23; Baumann, 1935, pp. 140–1; Fagg, 1964, fig. 76; Krieger, 1965, no. 306; Bastin, 1981, fig. 10; Bastin, 1982, ill. 97

b

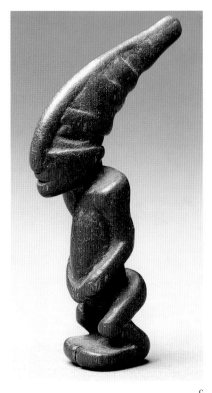

c

a

III C 34687a (cat. 4.39h), III C 31775b (cat. 4.39i), III C 43841 (cat. 4.38j), III C 33680 (cat. 4.39k), III C 34687b (cat. 4.39l), III C 34687c (cat. 4.39m), III C 31775a (cat. 4.39n), Jean and Noble Endicott (cat. 4.39o–p)

4.39a–p

Divination figures

Chokwe
Angola
early 20th century
patinated wood, beads
h. 4–7.5 cm
Staatliches Museum für Völkerkunde, Munich, 33-30-3 (cat. 4.39a), 33-30-6 (cat. 4.39b), 33-30-2 (cat. 4.39c), 33-30-1 (cat. 4.39d), 33-30-7 (cat. 4.39e), 33-30-4 (cat. 4.39f), 33-30-8 (cat. 4.39g)
Staatliche Museen zu Berlin, Preussischer Kulturbesitz, Museum für Völkerkunde,

Most of these small wooden carved objects were contained in a basket, called *ngombo ya cisuka*, used by the fortune-teller (*tahi*) of the Chokwe. This method of divination (*ngombo*), using a basket filled with a variety of symbolic objects which is shaken by the dignitary in charge (*kusuka*), is widespread among the Chokwe and was also adopted by some of their neighbours.

Divination is practised professionally only by a person designated and inspired by the spirit of *ngombo*. It takes place during a solemn public ritual. Normally a supplicant does not ask for prophecies about the future, but rather the causes of misfortune, sterility, illness, a death or even a scourge or epidemic afflicting a whole people.

The symbolic contents of the basket represent a diversity of items; they include carved wooden images of people, animals and objects, as well as vegetable and mineral subjects. Following a consultation, speedy atonement for the wrong done to

a person, or offence done to a spirit, can be imposed. When the influence of witchcraft is detected the 'eater of souls', who once would have been put to death, is nowadays permanently banned from the community.

The four *kalamba kuku wa lunga* figurines (cat. 4.39d,h,j,p), showing an ancestor squatting with his elbows on his knees and his hands on his head as

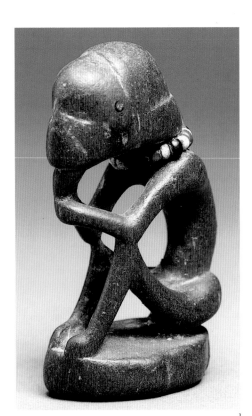

d

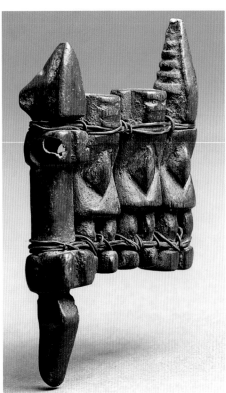

e

f

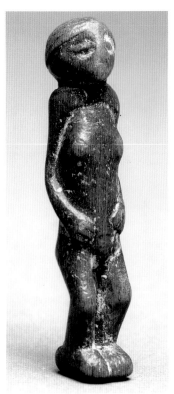

g

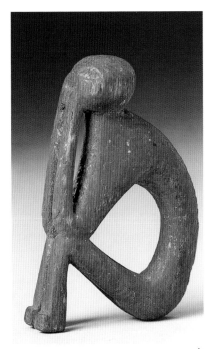

h

a sign of desolation (because his descendants have neglected their worship of him), illustrate the very individual way in which a sculptor can interpret a stereotype.

One important symbol evokes the spirit of *cikunza* (cat. 4.39c), auspicious for hunting and fertility. It is worn as an amulet on a gun or, by women, on a belt. It is personified in mask form (*mukishi*) during circumcision rituals, and is a benevolent patron of the initiation ceremonies performed when adolescents reach adulthood. This 'hunting amulet' is not really a divination figure, but Rodrigues illustrates three similar

objects collected in Angola for the collection of the Musée d'Ethnographie de Neuchâtel.

The female figurine *katwambimbi* (cat. 4.39a), the 'weeping woman', shown standing with her hands raised to her head, foretells an imminent death.

Cat. 4.39f shows a *mbata* man and woman coupling (*kumbata*: to get married); its meaning is highly complex, concerning the life of the couple as well as their relationship with their respective families.

Mufwaponde, the cripple (cat. 4.39n), denotes, according to Rodrigues, danger; if the head has been cut off (cat. 4.39l) the intervention of a sorcerer's black magic is to be feared.

The sorcerer, *cilowa* (cat. 4.39m), is carved schematically, his head being replaced by a ball of black wax, the surface of which is encrusted with the red and black fruit of the liquorice creeper. The small female figurine (cat. 4.39g) would seem to represent the spirit of *kakuka* (pl. *tukuka*) and relates to a sickness or possession suffered by women, to be cured or exorcised by an affliction ritual.

The figure of *kufu* (pl. *mufu*), a corpse, is usually represented by a fragment of wood (representing the bier pole) on which is hung a simulacrum of mortal remains (cat. 4.39b). Its presence at one side of the basket is a bad omen. It is most unusual for *mufu* to be evoked by such a complex scene as this – two men carrying the deceased, lying in a kind of palanquin (*tipoye*).

The four-footed animal (cat. 4.39k) appears to represent *muta*, the dog spirit, honoured in village sanctuaries by hunters and women seeking to become fertile. It is also represented on amulets, worn on a gun or at the waist. The example exhibited here is carved with exceptional suppleness.

The authors who have described the *ngombo ya cisuka* have never mentioned the small mask (female?) among the contents of the basket (cat. 4.39o). In fact it is only the Chokwe, neighbours of the Pende in Zaire, who have imitated their famous *ikhoko*, and this only since the turn of the century. The *ikhoko* is worn by men in memory of their initiation to adulthood, or for medicinal purposes.

These figures are usually made by the soothsayer or his assistants and are in no way considered works of art by the people using them. The contents are first consecrated by the professional soothsayer, then the configuration of objects obtained at the edge of the basket, at the 'eye' where the white clay (auspicious) meets the red clay (inauspicious), indicates the reply of the *ngombo* spirit that has been called up. It is a sensitive and diplomatic way of resolving private problems or conflict within the community. *MLB*

Bibliography: Krieger, 1969, figs 342–3; Rodrigues, 1985

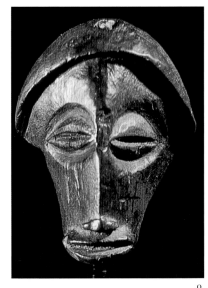

o

p

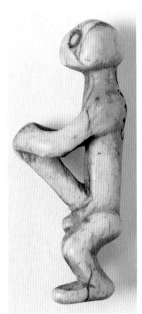

i

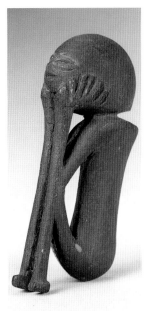

j

k

l

m

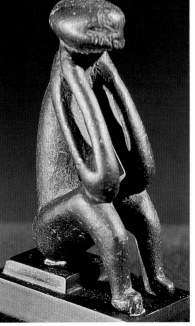

n

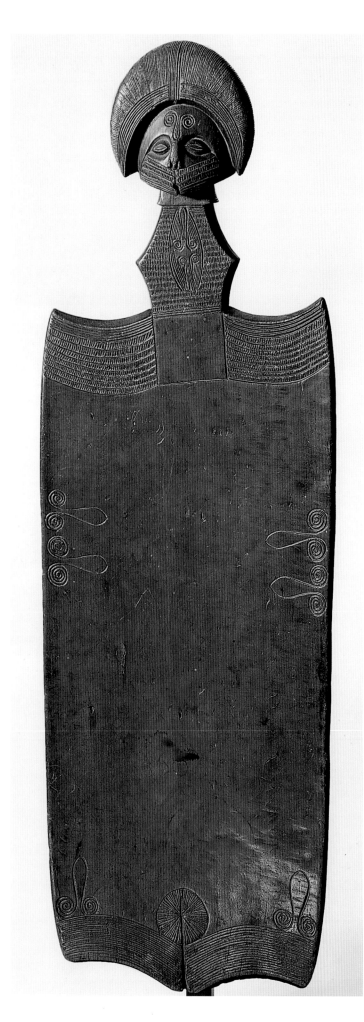

4.40

Bench or ceremonial bed

Chokwe
Angola
19th century
hardwood, chestnut brown patina
131 x 44 x 21 cm
Private Collection, Paris

The function of this unique piece, magnificently carved and bearing the patina of long years of use, is an enigma. It was certainly a ceremonial item, and seems to have belonged to a chief of the 19th century, when there was still an aura of splendour surrounding the 'ruler of the country' (*mwanangana*).

In 1985, when I came across it in a series of photographs sent me by its owner, I was able to confirm that there was good reason to think it was of Chokwe manufacture. The female hairstyle, although schematised in order to be presented in two dimensions, bears all the characteristics of the styles that had formerly been in fashion. The features were not far removed from those of the region. And the double spiral motif, *ukulungu*, abundantly repeated, exactly reproduced the classic earring design of the same name: this was a small item of female jewellery made of copper wire, skilfully coiled, also previously popular among the Chokwe.

The collector thought that this was a low table with four legs shaped like sawn-off cones, but no such piece of furniture was ever used by the Chokwe. Although for several decades tables were made on the (much enlarged) model of a four-legged stool with cross-pieces, covered in hide (already demonstrating Western influence dating back to the caravan trade of the mid-18th century), this novelty was introduced mainly to satisfy the demand of Europeans, particularly in Zambia.

The piece shown here is made of woven laths covered by a large mat which is often elegantly woven and decorated. In 1946, when he first began exploring the 'Tchibuco', the Uchokwe lands from which this people originally came, José Redinha de Saibes collected an item of furniture that was no less remarkable. This Portuguese ethnologist, formerly curator of the Museu do Dundo, entered the area where the Luachimo and Chiumbe rivers have their source and came upon the small chieftaincy of Kalundjika (north of present-day Dala), where the Chokwe and the Lwena lived side by side. One particular worthy claimed to be descended from the celebrated Chinyama, brother of Queen Liveji of the Lunda; Chinyama went off on a mission of conquest some 500 years earlier in the direction of the Upper Zambezi and became chief of the Lwena (or Luva) people. Among the objects Redinha acquired is a handsome couch with a base of stretched hide and a small back-rest whose two uprights each bear a female head with headdresses consisting of a broad grilloche band (Museu Nacional de Antropologia, Luanda).

Given the dimensions of this handsome piece, no more than a metre long, and exceptional in every way, it is possible to think that it was used as a ceremonial bench on which the chief could sit comfortably while holding an audience. *MLB*

Exhibition: Paris 1988, p. 92
Bibliography: Redinha, 1953, p. 143; Bastin, 1961[1], fig. 77

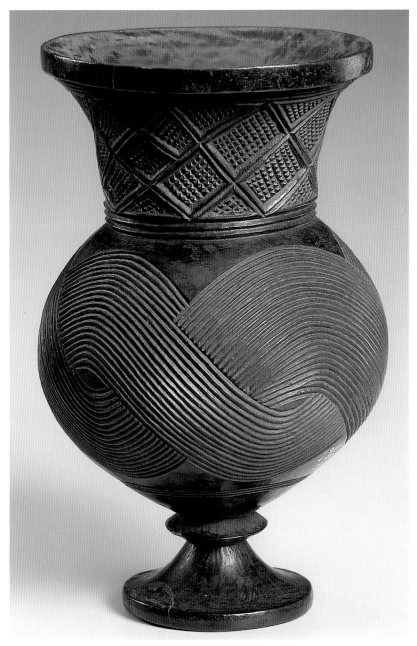

symmetry of this example almost suggests that it has been turned on a lathe rather than carved directly with adze and knife as is the case. Its elegance is among the perplexing pieces of evidence to underline an emerging paradox of this period in the exploration of central Africa – that the most accessible and refined objects, from an external perspective, derived from the remotest and last explored parts of the continent. At a time in Europe when the so-called 'primitivist' movement was interested in the arts of coastal and riverine Africa, and especially in areas of French occupation, these 'sophisticated' pieces from deep in equatorial Africa challenged prevailing assumptions. Wongo country, after all, is not known to have been traversed by any European before Torday, and at the time the Wongo had a fearful reputation. Cups with this degree of accessible aesthetic quality were in sharp contrast to the image summoned up by rumours of cannibalism, treachery and aggression. *JM*

Provenance: 1909, collected by Emil Torday

Bibliography: Torday, 1925; Hilton-Simpson, 1911; Mack, 1990

other clearly documented cups and seems to imply a degree of artistic licence and innovation suggestive of an expanded market.

In fact exercises in virtuosity which extend the canon of Kuba artistic expression are well enough known, even though the prevailing view of the 'tradition-bound' and 'formulaic' character of sub-Saharan African art tends to deny the possibility. After all, the famous Kuba king figures (not represented in this selection) appear to be the work of a limited number of innovative carvers. Cups in human form are known from many Kuba groups. Yet their very variety is already indicative of an exploratory approach. Vansina, for instance, speaks of a carver who, having created an image of a man riding an antelope, hollowed out the top and used it as a cup. Even if the cup here has indeed been created for an external market, its originality of conception is within the expectations of a Kuba court interested in virtuoso pieces. Indeed, it is arguable that the diversity of Kuba art was in fact greater in the 19th century than in more recent times – the impact of so-called tourist arts has contributed to standardising not expanding Kuba virtuosity. *JM*

4.41

Cup

Wongo
Zaire
wood
21 x 13 cm
The Trustees of the British Museum, London, 1910. 4-20.21

This cup is one of several collected for the British Museum in 1909 by Emil Torday among the Wongo (confusingly he referred to them as the Bakongo). It probably comes from a Wongo village in the area of Kangala, otherwise a Pende chieftaincy between the Luana and Loange rivers. The cup is among those described several times in the associated documentation as 'quaintly carved' and 'remarkably skilful' in execution.

Torday 'noticed at once a similarity in the patterns with which these cups were ornamented and those which we found among the Bushongo' (that is, the Kuba), another piece of evidence to support his theory that these two peoples are nearly related. The Wongo are not formally part of the Kuba kingdom, though they share features of the cultural and artistic life of their neighbours to the east. Indeed Torday's passage through their country was encouraged by the reasonable reports he had received of the Wongo from the Kuba king himself.

The Wongo in fact, like many peoples in the region, make several styles of cup for drinking palm wine, including some in human form. The

4.42

Cup

Kuba
Zaire
wood
h. 19 cm
Private Collection, Paris

This cup is identified with the Kuba, though whether it is in fact from within the central groups of the Kuba kingdom itself or from one of the Kuba-related peoples, such as the Wongo or Lele, is not clear. Likewise it is not certain whether it was made for a local client or perhaps at the behest of missionaries or visitors. It represents an impressive sculptural achievement. Its form, however, that of a seated figure, is not replicated in

Bibliography: Vansina, 1968, pp. 12–27; Rosenwald, 1974, pp. 26–31; Vansina, 1978; Cornet, 1982

characteristic of the Kuba style. The body is powerfully modelled and stands on thin legs. The companion statue in the same style is prolonged by a kind of support that seems to prove that both figures were fixed to a base, possibly an item of royal display.

The Bushoong, the royal tribe of the Kuba kingdom, attribute every metal sculpture that shows talent to Myeel. Admiration for his work was increased during the reign of King Mbopey Mabiintsch ma-Kyeen, who died in 1969; he asked his blacksmiths to copy some ancient pieces, but their attempts met with no success. Legend has it that Prince Myeel was a first-class blacksmith. He should have succeeded to the throne but his difficult character caused him to be passed over by the dignitaries responsible for choosing a successor. *JC*

Provenance: ex Pareyn Collection; 1920, acquired by the museum

Bibliography: Claerhout, 1976; Cornet, 1982

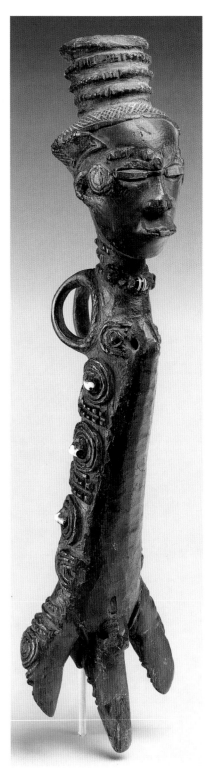

4.44

Figure

Ndengese
Zaire
wood, beads, copper
42.6 x 8.8 x 1.2 cm
Lent by the Metropolitan Museum of Art, New York
The Michael C. Rockefeller Memorial Collection, purchased by Nelson A. Rockefeller, 1978.412.618

The Ndengese are among the least prolific sculptors of west Africa. The quality of their royal figures, however, is such that the few examples that have survived are among the great treasures of the Tervuren and a handful of other museums. These have sumptuous body decoration in the style almost of the cloths made by their dominant near neighbours the Kuba. The serene faces of these statues are topped by an elaborate combination of coiffure and bonnet, the latter culminating in a projecting wooden cylinder. The Metropolitan Museum, as well as having such a figure, contains this variant which is seldom published. While possessing the characteristic scarifications, extended torso etc., it has an intensity which contrasts with the aloofness of the larger funeral effigies of notables (*totshi*). It bears many signs of ritual use and applications of palm oil. The presence of metal (copper) and beads also indicates its continuity of value to its original clientele. *TP*

Bibliography: Lewis and Delange, 1968

4.43

Statuette

Kuba
Zaire
18th century (?)
iron
h. 19.5 cm
Museum of Ethnography, Antwerp, AE 773

This unusual statuette belongs to a pair of royal Kuba ornaments. Its companion piece is in the same museum. Other metal statues and some prestigious weaponry are attributed by the Kuba to one of their princes, Myeel, who must have lived in the 18th century.

This statuette depicts a man with a long neck and triangular head; his facial features are not very prominent. The hairline has the sharp angles

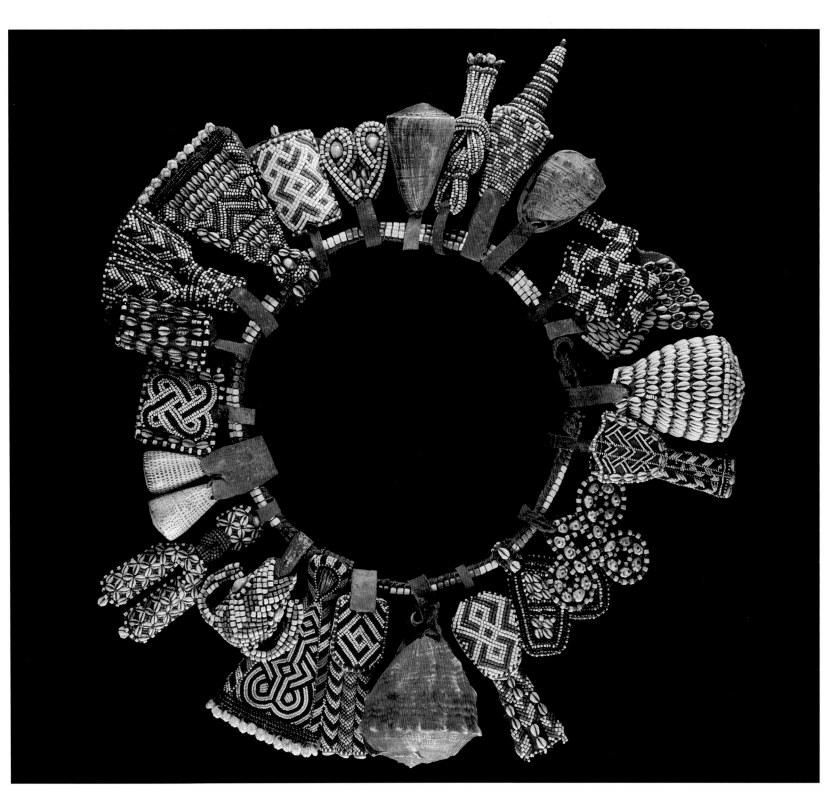

4.45

Beaded girdle

Kuba
Zaire
beads, shells, leather
The Minneapolis Institute of Arts
The Ethel Morrison Van Derlip Fund, 89.1

This superb girdle is a masterpiece of the inventive Kuba beadwork tradition. As so often in west and central Africa we find beadwork associated with, and being the perquisite of, royalty, as is true of the Yoruba in Nigeria (cat. 5.85) and the kingdoms of Cameroon (cat. 5.80). In a sense this type of girdle (*yet*) is the apotheosis of the charm bracelet, consisting as it does of a collection (and additions are made up to a seeming record of 80 charms, in the *yet* of King Kot Mabiintsh ma Kyeen) of traditional devices and signs realised in beadwork, together with shells that have a prestige value because of rarity (i.e. that have come from distant seas).

Some of the elements can be easily read by the uninitiated like the knot and the animal head with horns: others include bells, leaves etc. The decorative devices recall both the figuring on wood sculpture, body scarification and other designs that are familiar from textiles (cat. 5.93). Cowries, as might be expected on a display object connected with wealth and prestige, also figure largely, as they do in the exclusively royal belt (*nkap*) made of leopard fur. The *yet*, however, is the most flamboyant of all girdles and as can be seen in this example calls for design and bead application of the highest quality. *TP*

Bibliography: Cornet, 1982

4.46

Backrest

Zaire
early 19th century
wood
36 x 50 x 83 cm
The Trustees of the British Museum,
London, 1909.5-13.9

This backrest is one of several
acquired at the Kuba capital, Nsheng,
in the opening decade of the century
by Emil Torday. Others include an
example of the carved tusks which
were planted in the ground for the
king to lean against. When all else
failed he might sit on someone's back,
as can be seen in an early photograph
of the royal court. The divine char-
acter of the king is emphasised by the
fact that he must not come directly in
touch with the earth or sit directly
upon it. The backrest illustrated here
was apparently offered to Torday by
a senior official at the court, though
not by the king himself. The royal
associations of the backrest are,
however, apparent.

The most distinctive feature is the
ram's head. The same motif also
appears on beaded items of courtly
regalia, and is associated with one
form of mask. Although little is
recorded on Kuba domestic economy
in the otherwise extensive studies of
their society, it does seem that flocks
of sheep have been regarded as a royal
preserve. This is not unexpected for

sheep appear to have been a relatively
recent introduction. All such innova-
tions, like items of material culture
or new patterns, tend to be credited
to royal inventiveness. The image of
the ram connotes this royal attribute;
at the same time it acts as one of a
number of visual metaphors of the
ideal relationship of the king to his
people: powerful, dominant, the
source of fertility. *JM*

Provenance: 1909, collected in Nsheng by
Emil Torday

Bibliography: Vansina, 1978; Cornet, 1982,
p. 301; Mack, 1990, p. 66

4.47

Cushion cover

Kongo
Zaire, Angola
early 17th century (?)
raffia, pigment
24 x 47 cm
Pitt Rivers Museum, Oxford, 1886.1.254.1

This is one of forty or so 17th-century raffia palm fibre cloths from the kingdom of the Kongo that survive in European collections. The history of this particular cloth cannot yet be established with certainty, but it seems likely that it is the 'table-cloath of grasse very curiously waved' that was listed by the botanists and collectors the John Tradescants (father and son) in the catalogue of their collection published in 1656.

It has often been reported that the raised patterns on these cloths were produced by a technique of 'cut pile' embroidery similar to that used in the late 19th and early 20th centuries in making the so-called 'Kasai-velvets' produced by the peoples of the Kuba kingdom some 1120 km to the northeast. Closer examination, however, reveals that a weaving technique was used to produce the patterns on this particular cloth. Although plain weave has been widely employed in Zaire, in

some areas weft floats have also been used to create geometrical patterns, generally lozenges and zigzag lines. (When only one colour is used the result is similar to European damask, but the pattern may also use a contrasting colour for the supplementary weft.) Among the Kongo, Mongo and Pende peoples a technique has been developed in which the weft floats have been cut and the ends of the cut thread have been rubbed so as to create a pile cloth. Although woven cut-pile and embroidered cut-pile cloths look similar, the design of a cut-pile weave is limited by the necessity of repeating simple patterns, whereas the design of an embroidered cut-pile cloth is freer and may, as in some Kuba cloths, consist of what seem like randomly scattered motifs. Clearly, the similarities in the general style of the two traditions suggest historical links, but the actual art-historical relationship between Kongo and Kuba cloths has yet to be established: that the techniques used are different makes this more difficult than it has seemed to some scholars.

This particular cloth is unusual because not all the weft floats are cut, resulting in a combination of damask-like areas and areas of cut-pile tufts.

Because weft floats reflect and cut tufts absorb light, this also results in variations in the basic tan colour. Here greater emphasis has been created by painting some tufts with black pigment. The use of an additional colour makes this piece apparently unique; all other known Kongo cloths are monochrome. For a whole Kongo cloth to be filled with an oblique interlaced design is also unusual, most other known cloths being made up of isolated designs enclosed in squares, repeated within an overall pattern. Only two others bear a similar design. The first is a cloth in the Danish National Museum, the second a cushion cover once in the collection of Manfred Sittala, Milan, and now known only from its appearance in a mid-17th-century watercolour by Cesare Fiore.

The name and significance of the pattern here are unknown, but are recognisably Kongo. As the indigenous weaving industry died out after the establishment of European contact, it is only the motifs used that link this early Kongo art visually with the body and sculptural arts that are well known from 19th- and 20th-century accounts and collections. The designs are the same on both sides of the

cloth, though the fact that they do not match at the edges suggests it was made from two cloths (probably two parts of one larger cloth) rather than from folding a single cloth. The decorative edging of small but intensely packed pompoms, as well as the four large pompoms at the corners, are also made of raffia and are a common feature of Zairean textiles.

Raffia cloths and mats formed part of the accoutrements of the Kongo nobility. The form of this cloth suggests that it is a cushion cover without a filling, though a possible additional (or alternative?) role as a bag or purse is suggested by the small opening at one end and by the fact that the Kongo king is said to have had a cushion in which to keep his jewels. *JC, HvB*

Provenance: by 1656, John Tradescant (the Younger); 1662, Hester Tradescant; 1678, Elias Ashmole; 1863, Ashmolean Museum, Oxford; 1886, Pitt Rivers Museum, University of Oxford

Exhibition: Oxford 1994

Bibliography: Tradescant, 1656, p. 53; Loir, 1935; Trowell, 1960, pl. XIX; Stritzl, 1971; Bassani, 1977; Williamson, 1983, pp. 339–40; Van Braeckel, 1993; Coote, 1995

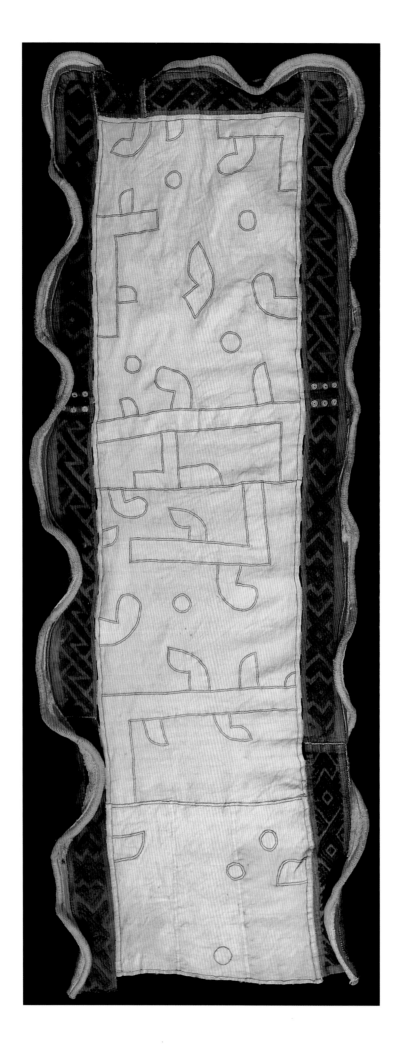

4.48a

Woman's overskirt (*ncaka kot*)

Bushoong
Zaire
early 20th century
raffia
162 x 63 cm
The Trustees of the British Museum,
London, 1947.AF.11.1

4.48b

Woman's overskirt (*ncaka kot*)

Bushoong
Zaire
early 20th century
raffia
97 x 37 cm
The Trustees of the British Museum,
London, 1909.5-13.411

The elaborate surface decoration of
woven raffia textiles is one of the
most distinguishing features of Kuba
arts of south-central Zaire. Kuba
raffia textiles are celebrated for such
decoration, which is achieved through
dyeing, appliqué and embroidery.
Woman's overskirts, or skirt wrappers,
like those exhibited here are made to
be worn over longer, ceremonial skirts.
They are worn by the Kuba for special
occasions, for instance funerals, when
raffia skirts and overskirts not only
adorn the corpse but are worn by
family and friends to celebrate the life
of the deceased.

Weaving among the Kuba, as
among other neighbouring groups,
is gender-specific and men alone are
responsible for all stages of the
preparation of fibre and completion
of weaving. The central panel of the
overskirt is assembled from doubled
sections of plain woven raffia cloth
woven by men on a single-heddle
loom. The garments are embroidered
by women using plain woven raffia
cloth as a foundation for both the
central panels and borders.

The central panels in cat. 4.48a
consist of embroidered and appliquéd
motifs widely spaced across the central
field. Black-dyed raffia thread is used
for the embroidery on the undyed
raffia cloth. This overskirt is an
example of the early 20th-century
Bushoong style in which there are a
few randomly spaced motifs. Each
motif is named – circle (*idingadinga*),
tail of a dog (*ishina'mbua*), leaves
(*kash*) – to correspond to the shape
it represents. This style of decoration
parallels that of the long skirts known
as *ncaka nsueha*, in which the entire

field of the design is covered with similar embroidered motifs. The borders, framing three sides of the skirt, usually combine overcast embroidery stitches and cut-pile designs which are overdyed when the garment is finished. They are completed with a serpentine outer edge created by overstitching a twisted hank of raffia fibre to the outer edges.

Cat. 4.48b illustrates a Kuba embroidery style known from the 18th and 19th centuries. It is interesting to note that the intricate embroidered patterns share the same vocabulary of design as those found on Kuba woodcarving and mats. This Bushoong style of embroidery is distinguished by the use of twisted raffia fibre (*mishiing*). Such textiles are also known as *buiin bu mishiing* or designs sewn from 'strings'. The entire surface of the raffia cloth is densely embroidered with geometric designs. Overskirts embroidered in this style may be overdyed with red or left undyed.

Cornet ascribes this type of embroidery to the Bushoong women living at the Kuba capital village of Nsheng. He proposes that this time-consuming work is the speciality of 'royal' women who are confined to their domestic compounds during pregnancy. Throughout the Kuba region, during periods of mourning (which may last from three to nine months), much time is also devoted to sewing and embroidery in order to replenish the supplies of ceremonial textiles which are used as gravegoods among the Kuba. *PJD*

Provenance: cat. 4.48b: 1907–9, Torday Congo Expedition

Bibliography: Torday and Joyce, 1910, pls VI, XXVIII; Torday, 1925, pp. 204–9; Adams, 1978, p. 30; Adams, in Vogel, 1981, pp. 232–3; Cornet, 1982, pp. 185–6, 194–7; Darish, 1989, p. 133; Zeidler and Hultgren, 1993, pp. 100–1

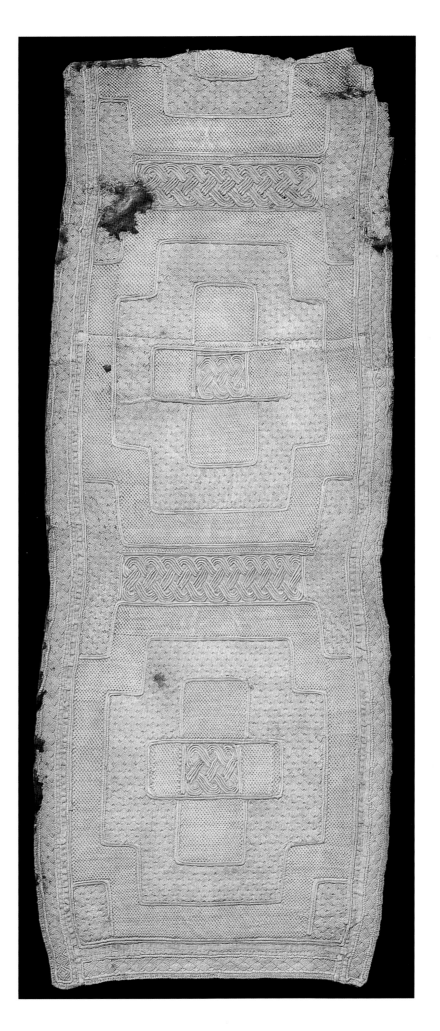

4.49

Mask (*ngady amwaash*)

Kuba
Zaire
wood, raffia cloth, beads, cowrie shells
1917 or earlier
38 x 43 x 20 cm
Peabody Museum of Archaeology and
Ethnology, Harvard University,
Cambridge, 17-41-50/B1909

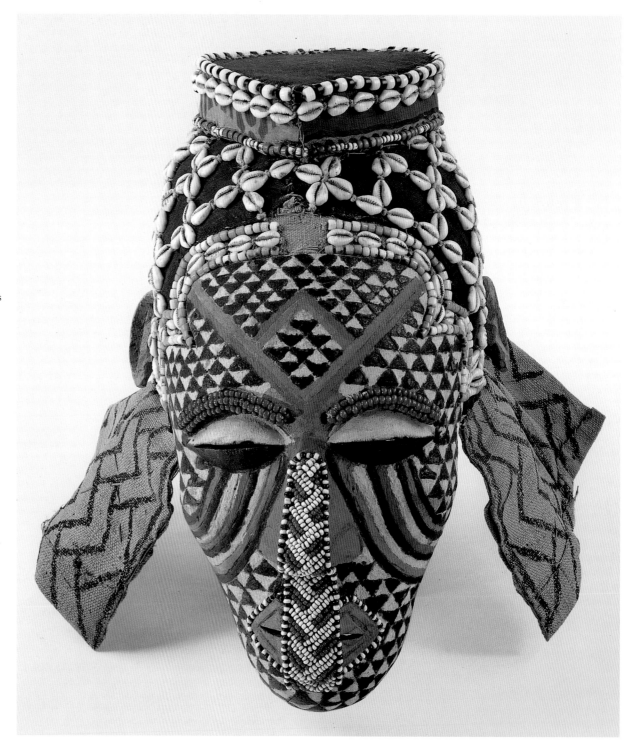

The Kuba have a series of three masks
that are used at public ceremonies, in
initiation and at funerals. Each is in
a quite distinctive style and has a
characteristic range of behaviour
associated with it.

The masks are 'royal' in several
senses. Most obviously many of the
events at which they perform, notably
initiation, are under royal patronage.
They also represent characters in
mythic history with primordial asso-
ciations or they express relationships
determined by royalty. Thus two
masks, *mwaash aMbooy* and *ngady
mwaash aMbooy*, recall Woot, a Kuba
equivalent to Adam, and Woot's sister-
cum-wife, whose incestuous union
created people. *Mwaash aMbooy* is
sometimes worn by the king himself,
establishing at one level an identity
of authority between royalty and
ancestral origins. The third mask,
bwoom, is more complex: according
to context or explanation of origin,
it is variously a prince, a commoner,
a pygmy or a subversive element at
the royal court. The masks do not
normally appear as a group, though
bwoom and *ngady mwaash aMbooy*
are sometimes understood to be
competing for the affections of the
female mask in the trio.

The example here is Woot's sister-
consort, *ngady mwaash aMbooy*.
Its feminine character is established
less by its visual appearance – it lacks
obvious determinants of gender such
as the exuberant artificial breasts
appended to some African masquer-
ades – than by its mode of perform-
ance. As in so much of Kuba art and
culture, the sense of visual and
intellectual order is apparent. The
court title *bulaam* at once comprises

the role of oral historian and of dance
instructor. The mask is associated with
a mythic character; the dance steps
that the mask duplicates are carefully
choreographed to imitate those of
women.

The motifs on the face of the mask
include lines beneath the eyes said to
represent tears, and distinctive tri-
angular shapes picked out in contrast-
ing colours. This latter motif is also
encountered in several other contexts
among which is a style of patchwork

barkcloth. An association with the
mask motif is appropriate because
barkcloth is regarded as an ancestral
form of clothing and is still worn
during periods of mourning. The
identity of the mask with the
primordial female ancestor is thus
enhanced by what appears to be a
carry-over from a motif associated
with ancestral costume. *JM*

Bibliography: Vansina, 1955; Vansina,
1978; Cornet, 1982, pp. 250–70

4.50

Drum

Bena Luluwa
Zaire
19th century
wood, hide
h. 117.5 cm
Staatliche Museen zu Berlin, Preussischer
Kulturbesitz, Museum für Völkerkunde,
III C 2672

The drum is decorated with bands of
engraved stripes and spots and bears
a human mask; the sturdy body
attached to the mask provides sup-
port for the drum.

The features are not typically
Luluwa, and must have been influ-
enced by a neighbouring style. The
large eyes are those of Luluwa statues,
however, further emphasised by white
encircling lines. The nostrils are
powerful. White occurs again on the
teeth in the half-open mouth. The
chin bears a small beard with three
distinct spikes.

The navel is surrounded by circular
scarified lines. The figure has his
hand on his penis. This links the piece
to a fertility cult, in the service of a
family ruling over one of the many
autonomous groups; this kind of
organisation was typical of the
Luluwa political system. *JC*

Provenance: 1885, collected from the Bena
Luluwa tribe by Hermann von Wissman
Bibliography: Biebuyck, 1992

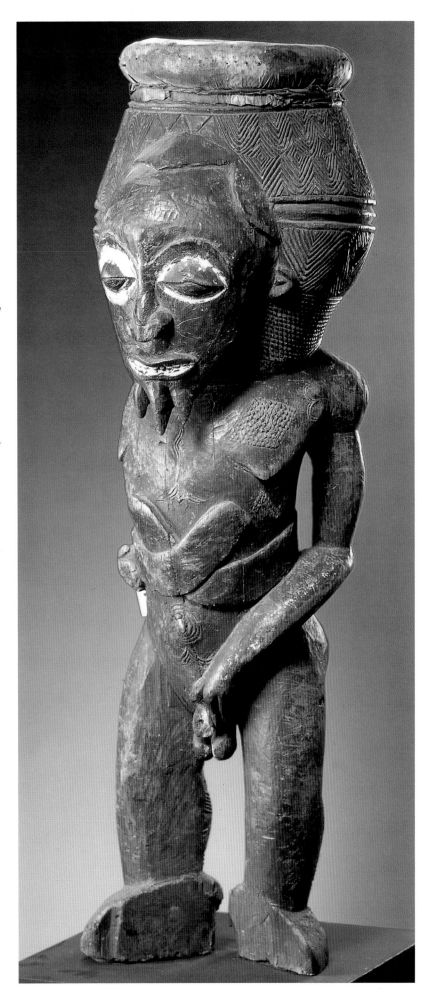

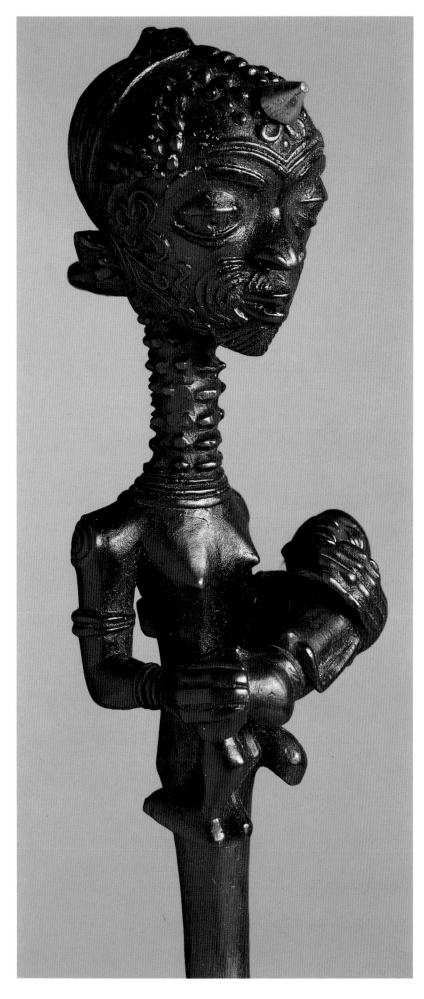

4.51

Statuette

Bena Luluwa
Zaire
19th–20th century
wood
35.5 x 8.5 cm
The Brooklyn Museum,
Museum Collection Fund, 50.124

Statues portraying mother and child
are frequently to be found among the
Bena Luluwa; they are linked to
fertility cults, notably the *bwanga bwa
tshibola*. Although many statuettes
show the complete figure, it is quite
common for the body to taper to a
point so that the object can be stuck
into the sand. This figure has a large
head on a very long neck, with much
detailed decoration. The number of
tattoos is remarkable, harking back to
an ancient Luluwa custom, long since
vanished and now known only from
old drawings.

 The figure bears a double message:
status and fertility. On the one hand,
the large Luluwa tribe was never
politically united and therefore there
were a large number of relatively
autonomous chiefs, which meant that
many local dignitaries had works of
art dedicated to them. On the other
hand, the statues belong to a fertility
cult that is still extant.

 Much of the ornamental detail is
probably symbolic. The distended
umbilical hernia, for example, refers
to the line of succession and the
dependence of successive generations
on their ancestors. *JC*

Bibliography: Maesen, 1954; Petridis, 1995

4.52

Mask

Kete
Zaire
19th century
wood, fibre, bark, paint
h. 154 cm
Museum für Völkerkunde, Hamburg,
4678.06

The Kuba kingdom was divided
between three large peoples, the
Bushoong (the royal tribe), the
Ngende and the Ngongo, who were
surrounded by about fifteen smaller
(sometimes very small) groups.
Of these, the Kete were the largest,
but also the farthest from the royal
centre of the kingdom.

This mask was made by the Bena Mwanika. More recent finds suggest that such pieces are not exceptional. Masks of this type include single figures and women holding babies. They were made to be worn ceremonially. This one is thought to be connected with a rite of passage.

The scarifications on the stomach and the chequered design on the cheeks, on the belt around the shoulders, around the stomach and at the base of the mask would suggest that this piece belongs to a Kuba substyle. The base has a small vision hole cut in it. *JC*

Provenance: 1905, collected by Leo Frobenius

Bibliography: Zwernemann and Lohse, 1985

4.53

Mask

Songye
Zaire
wood
h. 160 cm
The Trustees of the British Museum, London, 1979. AF. 1.2397

The Tetela-Hamba of north Kasai (among whom I stayed in 1953 and 1954) do not use masks – neither the groups of the savanna nor the forest dwellers – despite a firm belief to the contrary held by art historians. The Hungarian ethnographer Torday is at the source of this misunderstanding. The Sungu with whom he resided were located on the absolute southern periphery of the Tetela-Hamba areas, adjacent to the Songye. It is as good as certain that the so-called Sungu objects he collected at the beginning of this century belonged exclusively to the Songye culture. One mask was collected in Kasongo, 'the nearest Sungu settlement to the Songye at Tempa on the Sankuru' (Mack, 1990,

pp. 62–3). As it happens, it is also in Kasongo that 'Major' John White, who stayed at the Methodist mission of Minga from 1923 to 1926, acquired a mask that he ascribed to a Tetela witch doctor.

The location of Kasongo is, then, decisive. On a map of the territory of Lubefu acquired on site in 1953, this name appears as Kilolo Kasongo on the fifth parallel a few kilometres to the west of the Luedi River. This position corresponds precisely to an outpost called Mona Kassongo by Frobenius (1907, map no. 8). Mono Kassongo and Kilolo Kasongo are almost certainly one and the same. The village is actually situated in Songye country and not in Sungu country. Kilolo is a name meaning 'notable' in Songye (not in Tetela) and Kasongo is a proper name widespread only in Songye country. Furthermore, the term *moadi* (*mwadi*), attributed by Torday to the masks he collected in Kasongo, is also manifestly Songye in origin.

This remarkably beautiful mask with three fur horns is also unquestionably Songye, even though Torday designates it as Tetela. Indeed, the three-horn motif is found on a completely different type of mask that Torday does not hesitate to attribute to the Songye.

Another horned mask attributed to the Tetela is to be found in the Musée Barbier-Mueller in Geneva. Neyt's attempts to justify this attribution by endeavouring to draw a parallel between the three-horn motif and certain Tetela beliefs are futile. This mask was to all appearances crafted like the others by the Sungu's southern neighbours, the Tempa Songye of the former Lubefu territory, a population that remains unstudied. Three masks acquired in 1910 by the Royal Museum for Central Africa in Tervuren are formally ascribed to them. And, although they definitely differ from the British Museum mask exhibited here, Songye art – known principally through the works of the eastern regions – adheres to no strict canon. The myth of Tetela masks should now be laid to rest. *LdeH*

Bibliography: Frobenius, 1907; Torday and Joyce, 1922, pp. 29, 77; Hersak, 1986; Mack, 1990; Neyt, 1992; Hersak, 1995; de Heusch, 1995

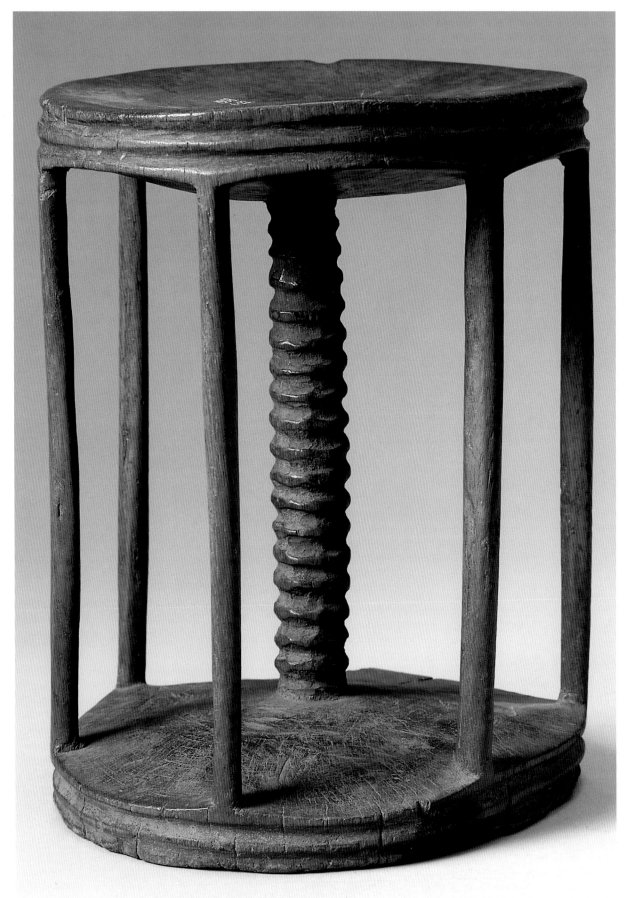

4.54

Stool

Songye-Sungu
Zaire
early 20th century
wood
24 x 29 x 17 cm
The Trustees of the British Museum,
London, 1908.6-22.67

This small wooden stool, like the large
mask (cat. 4.53), comes from Mokunji,
a village identified by its collector
Emil Torday as Batetela-Sungu. Luc
de Heusch argues in discussing the
mask that this group should properly
be identified as a western outlier of
the Songye. While Torday's Tetela
identification is wrong, it may be
that this group of objects could be
considered in terms of a Sungu
ethnicity and art style. Certainly, both
the mask form and this type of stool
are unknown in Tetela art and culture
and unusual in the context of Songye,
though the case de Heusch makes is
compelling enough.

 The stool is extraordinary in the
slender character of the outer and
central supports. Indeed, it is more
like a headrest in terms of size and
of the kinds of weight it might be
expected to support, yet its shape and
the evidence of wear on the upper
surface suggest that it was made to sit
on. Carved from the solid, it has been
extensively cut away. There is no
documentation associated with the
object that would indicate whether its
use is delimited in any way. Certainly
it would not appear to be of the scale
of a chiefly stool. It may be that it
was intended for use by women or
children. *JM*

Provenance: 1907, collected by Emil
Torday

4.55

Power figure (*nkisi*)

Songye
Zaire
wood, horn, metal
102 x 27 x 36 cm
The Trustees of the British Museum,
London, 1949. AF. 46.492

The term by which the Songye designate their magical figures – *nkisi* (pl. *mankisi*) – is encountered elsewhere in widely dispersed parts of central Africa. In southern Zambia, for instance, it is used by the Mbunda of their masks (cf. cat. 2.55). Equally, it is used among the Kongo on the Atlantic coast as a generic term with a wide range of reference: included here, however, are the magical figures that the Kongo, too, create (cat. 4.7). *Nkisi*, then, is a 'key word' deeply embedded in many different Bantu languages. Taken as a whole it becomes virtually untranslatable by reason of the the very diversity of objects, substances and activities that it serves to designate. What all the various usages have in common, however, is that they serve to comprise an assemblage of objects and entities whose efficacy and capacity to influence the affairs of the living depend upon some external agency, usually identified with spirits or with ancestors.

Among the Songye it is only magical figures that are identified as *mankisi*. Masks, to which Songye figures are in some senses contrasted, are identified separately (see cat. 4.53) under the term *kifwebe* (pl. *bifwebe*) – though elsewhere in the Bantu world they, too, may be included in the reference of the term. There are two kinds of *nkisi*. One, which is much smaller in scale (and by far the more numerous), is personal in application and ownership: restricted to individuals or, at most, to households or nuclear families. The examples illustrated here, however, are much larger and, in their deliberate attempt to embody strength and power, more formidable in conception. They function on behalf of complete communities, and occasionally – where their powers are widely extolled – they may serve a more extensive constituency.

The efficacy of *mankisi* has several sources. Most important are the many different types of substance and paraphernalia applied to the figures.

Most of these are regarded as inherently powerful or aggressive – substances such as parts of lions, leopards, snakes, bees and birds of prey; the sexual organs of crocodiles and earth from the tracks of elephants; human elements taken from such exceptional categories of person as suicides, sorcerers, epileptics or twins. Items of regalia may also festoon the figure, recalling the typical attributes of chiefly dress or of the hunter. The figures themselves are always male and have a combination of characteristics that constitute a generalised reference to ancestors.

The most important and detailed study of Songye masks and figures to date is by Hersak. She notes that the efficacious substances listed above are thought of as having been contrived at the beginning of creation and were originally contained in horns and calabashes; the figures shown here have such containers attached to the object. In general, however, the head and the swollen abdomen of the figure hold the empowering concoctions, which – as in Kongo ideas about their magical figures – may themselves be regarded as in a sense 'containers', vehicles of mystical force. There is no prescribed formula or choice of elements unerringly adhered to in the creation of a magical figure: each is empowered by a variety of such substances, assembled in varying combinations according to the preferences and experience of the ritual specialist, the *nganga*, who 'creates' the object. It is significant that the carved properties of the figures are considered secondary. It is unquestionably the substances applied subsequently that are the critical element; indeed the *nganga* credited with the creation of the object may or may not also be its sculptor.

As a result of the individual treatments the object receives, each figure is seen as imbued with its own identity and even its individual name, often that of a renowned chief. This, in due course, is further embellished by its biography of accomplishments, of causes effectively resolved. It is also treated and attended to individually: it is fed, anointed and receives sacrifices in its honour. It is also individualised in the sense that it has its own particular life cycle. In the end it will itself suffer physical decay, for all that it is kept in a special hut and has its

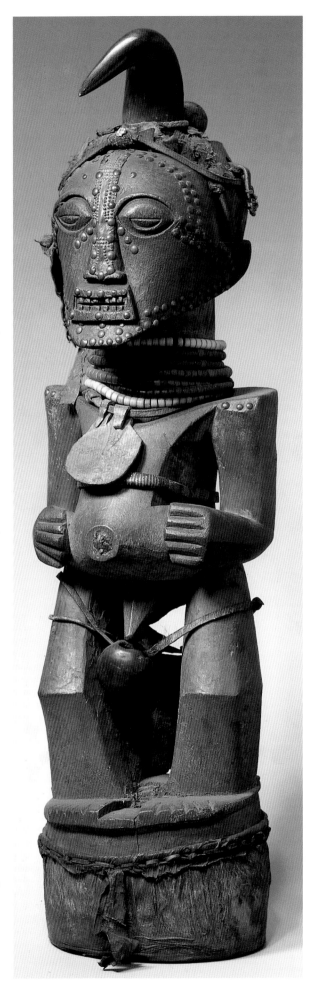

own designated guardian. Equally, should the *nganga* responsible for its existence himself die, its own powers are conceived as commensurately reduced and may come to be seen as in need of replacement.

Communal *mankisi* are used to achieve benign ends. The need of their magical intervention in human affairs may be signalled by such phenomena as persistent dreams of imminent danger among those charged with their care: premonitions expressed in visions of lightning and fire, or of deep ravines. To counteract these adverse signs the *nkisi* is brought out and manipulated by poles fitted into the holes that are carved under its arms. Like many things in the Bantu world associated with or identified as *nkisi*, the poles are retrieved from burial grounds. Each pole is held by a villager and the *nkisi* is walked through the village in public, attacking and challenging unseen yet threatening forces that may be present. Although dedicated to ensuring the health and welfare of the community, these figures are not exponents of the bedside manner but confrontational objects, objects with attitude. *JM*

Bibliography: Hersak, 1986, p. 118

4.56

Hilt of a knife with carved pommel

Songye
Zaire
19th century
metal, wood
h. 23 cm
Staatliche Museen zu Berlin,
Preussischer Kulturbesitz, Museum
für Völkerkunde, II C 4220

Figurative carvings such as the bearded head on the pommel of this ceremonial knife (its iron blade now missing) commonly appeared on the weaponry of the Songye and neighbouring Luba peoples. Chiefs and important men carried arms embellished in this way, including knives, axes, shields and, among the Luba, magnificent bowstands (cat. 4.62). Ornate parade knives, as well as symbolising the power and prestige of their owners, also acted as a visual means of declaring affiliation among the peoples of complex historical and ethnic background living in this region of southern Zaire.

The hilt of this knife is carved in a style associated with the western Songye. Heads of the type depicted on the pommel may represent benevolent ancestor figures, whereas those on the bosses of certain Songye shields represent the magical and malevolent figures which enforce the political and social control exercised by elders of the *kifwebe* secret society. Yet another representation of the human face may be found on the large, wrought-iron blades of axes made by the Nsapo, a people closely connected with the Songye, for use as symbols of power and prestige. In this instance, however, the heads are thought to represent subordinate peoples. *CS*

Bibliography: Hersak, 1985; Spring, 1993, pp. 84–93

4.57

Bowl

Classical Kisalian, 10th–14th century
Central Shaba, Zaire
terracotta
h. 17 cm; diam. 22 cm
Private Collection, Munich

The excavation of various sites in the Upemba depression, not far from the heartland of the Luba kingdom, revealed large burial sites with numerous gravegoods. Their study has made it possible to establish a complete sequence of occupation from the Early Iron Age to the present-day Luba peoples.

This fine bowl is typical of the gravegoods of the Classical Kisalian phase, dated by radiocarbon to between the 10th and the 14th centuries AD. Evidence of a hierarchical, hereditary society, starting with the Early Kisalian in the 8th–9th centuries, make this culture one of the early steps in the development of the powerful kingdoms of the savanna. The continuity and density of the occupation, as well as the persistence of certain customs from this time to the present, indicate that the Luba people have remained largely unchanged. *PdeM*

Bibliography: de Maret, 1985; de Maret, 1992

4.58

Divination board (*lukasa*)
Luba
Zaire
wood, beads, metal
27 x 14 x 4 cm
Felix Collection

The Luba works in this exhibition emphasise the role of art objects as texts, registers of knowledge, documents of history, ideology and culture. They served for the display of power, as historical documents, as a means of political validation, as instruments of prophecy and problem-solving, and as receptacles of spiritual vitality. The commission and production of Luba art flourished during the period of greatest political expansion, from the early 18th to late 19th centuries, when increasing numbers of rulers were installed as local manifestations of a broader concept of sovereignty. Works of art were used to forge alliances, to cement treaties and to settle debts (Reefe, 1981). Every object is a historical record of the dynamic cultural, artistic and ideological exchange and borrowing that has characterised the peoples of what is now south-eastern Zaire for several centuries.

Luba works of art are also concrete expressions of and vehicles for the ineffable dimensions of Luba ideology and religious belief. Insignia codify the secret precepts and principles of Luba government and spiritual authority, and many Luba insignia still serve as mnemonic devices, eliciting historical knowledge through their forms and iconography. Through oral narration and ritual performance, insignia serve both to conserve social values and to generate new values and interpretations of the past, as well as to effect social and political action.

For the Luba, the most prestigious historical pedigrees are those that can be traced to the founding ancestors. Although such stories might be considered 'myth' by Western historians, the Luba consider them the essence of truth: present events are legitimised by their relationship to the sacred past, as enshrined in the charters for kingship. These charters were sacred, to be guarded and disseminated by an association called Mbudye. Mbudye historians were rigorously trained 'men of memory' who could recite genealogies, lists of kings and all of the episodes in the founding charter

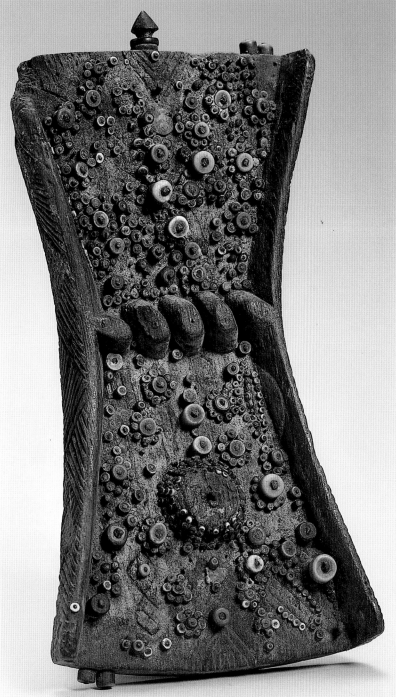

for kingship. Mbudye adepts created rituals for memory transmission in the 18th and 19th centuries, when the Luba kingdom was at its height. They also invented mnemonic devices to assist historical recitation (Reefe, 1977).

Principal among Luba memory devices is the *lukasa*, a hand-held, flat wooden object studded with beads and pins, or covered with incised or carved ideograms. During Mbudye rituals to induct rulers into office, a *lukasa* is used to teach sacred lore about culture heroes, clan migrations, and the

introduction of sacred rule; to suggest the spatial positioning of activities and offices within the kingdom or inside a royal compound; and to order the sacred prerogatives of the officials concerning contact with earth spirits and the exploitation of natural resources. Each *lukasa* elicits some or all of this information, but the narration varies with the knowledge and oratory skill of the reader.

Luba memory devices do not symbolise thought so much as stimulate it. They afford a multiplicity of meanings through their multi-

referential iconography. For example, coloured beads refer to specific culture heroes and the principal protagonists of Luba myth. Lines of beads refer to journeys, roads and migrations. A large bead surrounded by a circle of smaller ones refers to a chief encircled by his dignitaries. The iron pin refers to the king in whose honour the board is made, and the incised patterns encode royal secrets. Divided into male and female halves, the *lukasa* also encrypts historical information about genealogies and lists of clans and kings. Yet the reading of these visual 'texts' varies from one occasion to the next, depending on the contingencies of local politics, and demonstrates that there is not an absolute or collective memory of Luba kingship, but many memories and many histories. *MNR*

Bibliography: Fraser and Cole, 1972; Reefe, 1977, pp.48–50, 88; Reefe, 1981; Maret, 1985; Childs et al., 1989, pp. 54–9; Nooter, 1991; Dewey, in Los Angeles 1993; A. F. Roberts, 1993; Nooter and Roberts, forthcoming

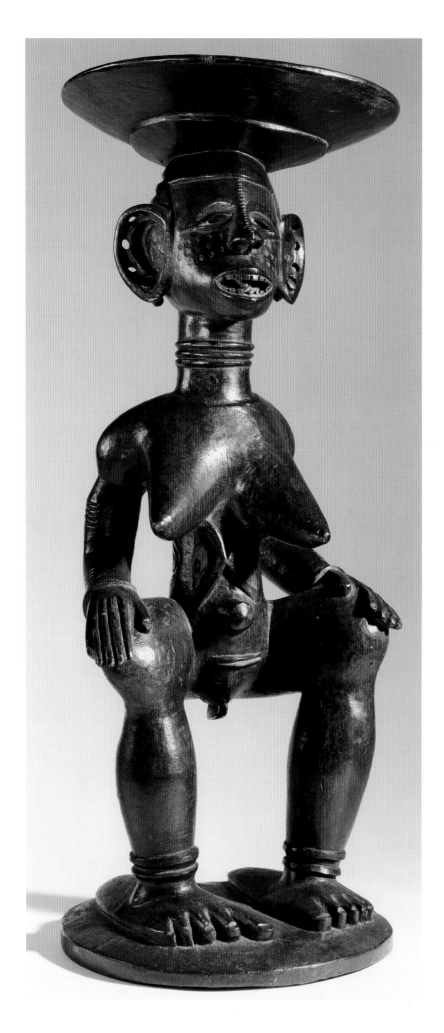

4.59

Stool

Luba/Maniema
Zaire (?)
wood
h. 52.5 cm
Private Collection

Luba and Luba-related stools used as thrones are often supported by a female caryatid. The stool shown here probably belonged to an east African chieftaincy, for while the overall conception of the stool is Luba, its execution and style are akin to pieces produced by groups as far east as the Makonde of Tanzania and Mozambique. Luba influence extended to lesser and greater degrees as far as Lake Tanganyika, on the border of eastern Zaire and western Tanzania, and many Luba works of art were collected in Tanzanian towns situated along the trade routes to east Africa, such as Tabora. Many groups borrowed Luba kingship ideology and practice, and copied their art forms. It is possible that this hybrid object represents the work of an east African artist emulating Luba style. Some stools depict the wives, sisters and mothers of chiefs, while others are more generic representations of women as the power behind the throne – a belief that is expressed in the Luba proverb 'Men are chiefs in the daytime, but women are chiefs at night'.

Not only did women fulfil specific political roles in Luba history as councillors, advisers, ambassadors, emissaries and even chiefs, but they were also thought to have enhanced spiritual powers. The great twin tutelary spirits of Luba kingship were always represented by pairs of unmarried women who served as priestesses to guard the sanctuaries where the spirits reside. Paired female figures are often shown in Luba sculpture as the supports of headrests (see cat. 4.60) and surmounting staffs of office. *MNR*

Bibliography: Nooter, 1991, p. 236

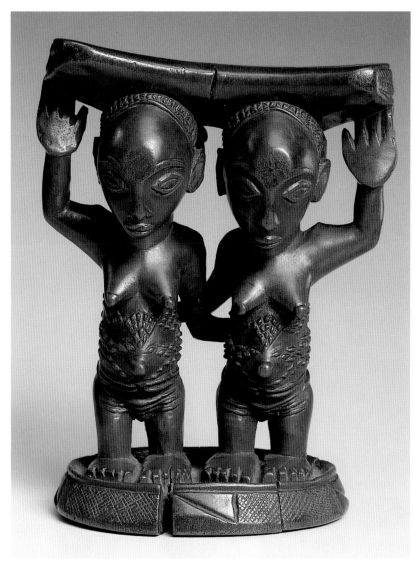

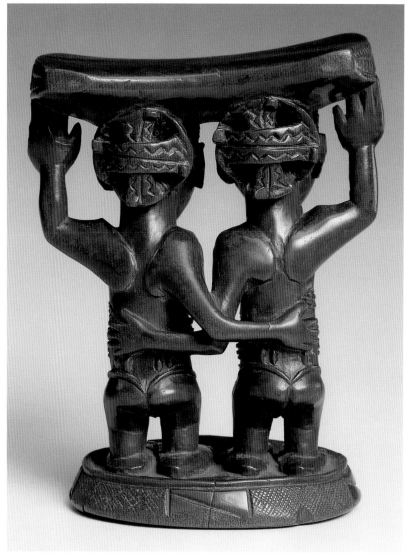

4.60

Headrest

Luba
Zaire
wood
17 x 13 x 9 cm
The Trustees of the British Museum,
London, 1956. AF. 27.270

A headrest serves as a pillow that is both cool and comfortable in a tropical climate, and protects elaborate hairstyles by raising the head above the surface of the bed. In addition to the great personal attachment that Luba people developed for their headrests, these were also seen as the seat of dreams. Luba consider dreams to be prophetic: dreams foretell important events, provide warnings and communicate messages from the other world. It is therefore fitting that headrests should be supported by the female priestesses who serve in real life as intermediaries and interlocutors for the spirits of the other world. The pairs of women on this headrest wear the two most popular hairstyles among the upper classes during the 19th century – the cruciform coiffure and the 'step' or 'cascade' style. These styles were not merely decorative; as with all Luba cosmetic adornments (scarification, genital elongation, hairstyling), there is a spiritual dimension to beautification. Women are rendered ideal receptacles for the containment of spirit through the embellishment and 'civilisation' of their bodies and heads. *MNR*

Provenance: 1956, given to the museum by Mrs Webster Plass
Bibliography: Dewey, 1993

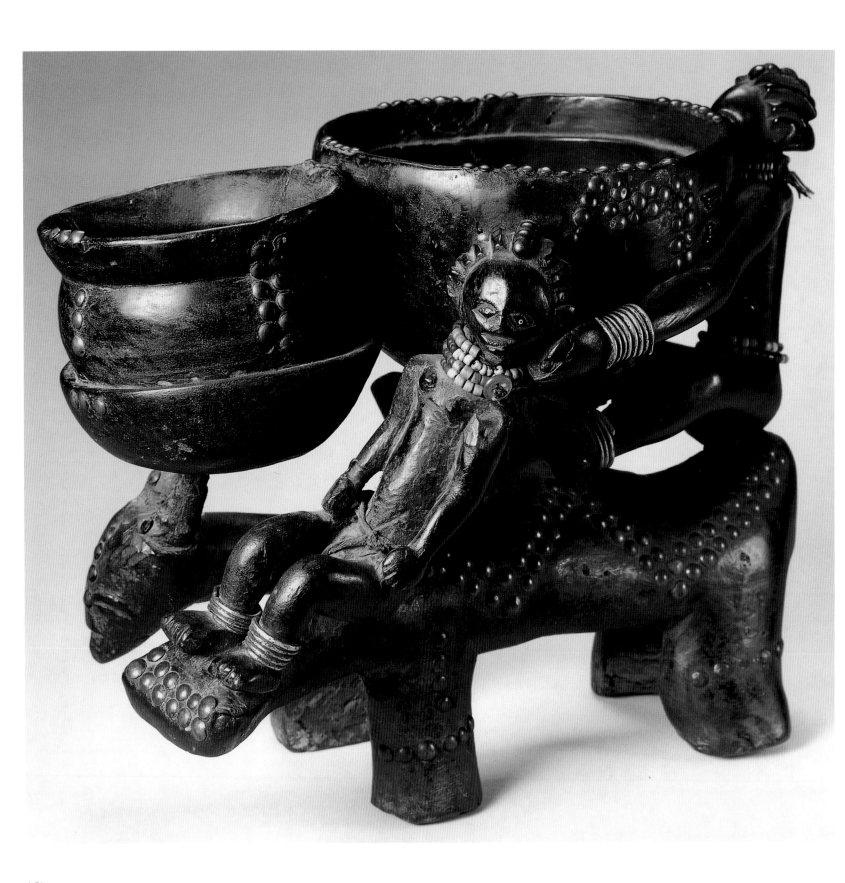

4.61a

Divination double-bowl

Luba
Zaire
wood, brass, beads, wire
32 x 42 x 26 cm
Felix Collection

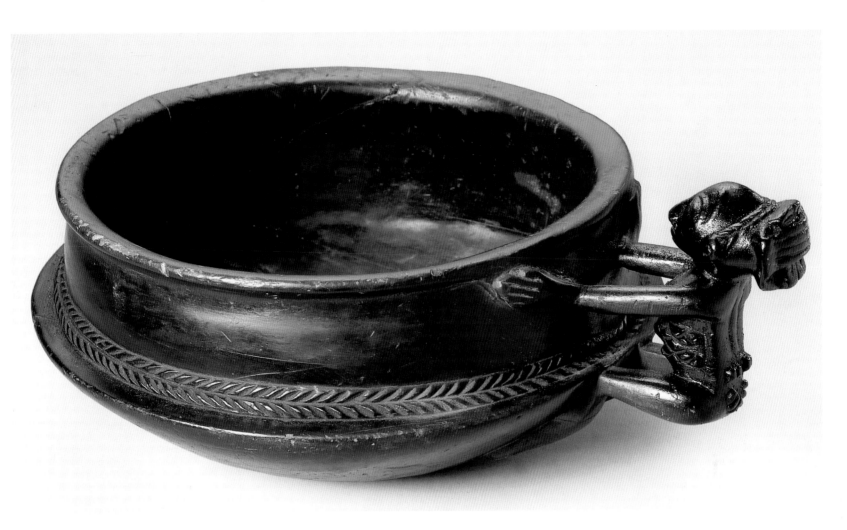

Diviners are the master problem-solvers of Luba society, addressing crises and conflicts that threaten individual and communal well-being. Chiefs have personal diviners whom they consult, just as the first Luba king came to power through the clairvoyance of the first diviner, Mijibu Kalenga. Diviners use baskets, gourds and sculptures as mnemonic devices to remind them of certain general rubrics of Luba culture, through which they can classify specific behaviour. Among the most important of their instruments is the sculpted image of a woman holding a bowl. Diviners display such figures during consultations to honour the wives of their possessing spirits. The representation of the spirit's wife in sculptural form underscores the role of the diviner's actual wife as an intermediary in the process of invocation and consultation, and reinforces the Luba notion of women as spirit containers in both life and art.

Among its diverse powers, the bowl figure is known to have curative capacities. The diviner mixes a pinch of kaolin from the figure's bowl with medicinal substances that will be administered to patients. The figure is reputed to have oracular powers: it serves as a mouthpiece for the spirit, and is capable of travelling from one place to another to gather evidence on suspected criminals. The bowl figure with two figures riding an antelope or a buffalo may be a specific reference to spirit possession: when the spirit takes possession of a diviner, it is said 'to mount the head', much as a rider mounts an animal. The founder of Luba kingship, Mbidi Kiluwe, is explicitly considered a hunting spirit who rides the lead animals of herds, directing them towards human hunters. It is likely that this sculpture was created to portray the founding hero. *MNR*

Bibliography: Roberts, 1993, p.74

4.61b

Bowl with small figure

Luba
Zaire
wood
h. 19.5 cm
Staatliche Museen zu Berlin, Preussischer Kulturbesitz, Museum für Völkerkunde, III C 19995

Bowstand

Luba
Zaire
wood
h. 120 cm
The Carlo Monzino Collection

Luba power was not centred in the hands of a single leader but was shared among specialists in various professions, most notably those of chiefs and titular officials, diviners and healers, and members of secret associations. Individuals in each of these institutions shared many of the same insignia, and were all initiated into the same basic body of sacred knowledge as taught through Mbudye initiations. Yet each also had its own special titles, roles and abilities as well as insignia.

Kings, client chiefs and certain high-ranking officials owned royal emblems in the form of stools, staffs, spears, weapons and bowstands. While these object types are seemingly utilitarian, Luba royal emblems have functions that surpass their original purpose: through their materials, forms and iconography, these works are symbolic of their owners' power and authority, wealth and worldliness. African arts of leadership are created as metaphorical extensions of a ruler's person, as aggrandisements of his or her presence. They extend the reach, expand the scope and elevate the stature of the leader.

Ironically, while it is often thought that royal emblems are highly visible and intended for public display and ceremony, many Luba insignia were seen rarely, if at all. Bowstands, for example, are among the most critical items in a Luba king's treasury and yet were never displayed in public. Rather, they were fastidiously guarded in the king's residence by a female dignitary named Kyabuta. For public ceremonies, the Kyabuta followed the chief with a simple bow held between her breasts (Maesen, personal communication, 1982). Within their protective enclosures, bowstands were regularly provided with prayers and sacrifices, and were subject to elaborate ritual and taboo.

Bowstands are owned by Luba kings in memory of the founder of Luba kingship, Mbidi Kiluwe, a renowned hunter and blacksmith who introduced advanced technologies in both arts. The formal development of the bowstand can be traced from a simple hunting tool for the suspension of bows and arrows and animal carcasses to a sacred symbol of kingship. The bowstand encodes the memory of the origins of kingship, for Mbidi Kiluwe's sacred possession was his bow, and the bowstand has come to stand for the very essence of kingship itself.

Bowstands also commemorate actual women in Luba history. A bowstand made by the same artist and nearly identical with the one shown here is accompanied by documentation which states that it depicts the chief's mother, named Ngombe Madia, who led the migration of her people from the territories of east Africa to the region of the Luvua River, where they settled. Bowstands, then, like staffs, spears and stools, are commemorative, either honouring important women in Luba royal history or sometimes using a female figure to depict the king himself, since kings were incarnated in the body of a woman following death. *MNR*

Provenance: ex de Miré Collection; Lefèvre Collection; Mendès-France Collection; Pinto Collection

Exhibitions: New York 1986; Florence 1989

Bibliography: Fraser and Cole, 1972; Roberts, 1994

4.63

Six-headed healing figure

Luba
Zaire
wood, metal, fibre
h. 46 cm
The Trustees of the British Museum,
London, 1910.439

Diviners use an array of sculpted
figures that serve as receptacles for
medicinal substances. Called *bankishi*,
some serve to catch thieves, others to
retrieve lost articles; still others are
for curing rites. By itself, the sculpted
human figure is considered to be void,
until charged with substances. These
compounds, called *bijimba*, contain
items thought to have rare and
enhanced powers, such as human
bones (life force) and the hair of
twins (fertility). These are embedded
into the cavities of horns, or simply
wrapped in cloth and then inserted
into a hole in the figure's head or
stomach. Sometimes *bankishi* have
multiple heads surrounding empower-
ing substances. The many heads signal
heightened powers of vision and
clairvoyance, and the ability of the
diviner to see in all directions
simultaneously. *MNR*

Mbidi Kiliwe and Kalala Ilunga are said to be Kunda, as are several other important chiefs and kings of the region. During the colonial period, small clans and chiefdoms in the Buli area were attributed Hemba ethnicity. Hemba refers to the east, and anyone living in that direction from the Luba heartland along the Lualaba River may be called this. Nowadays, people in the area call themselves Hemba, as a convenient identity in national politics.

Neyt attributes this stool and another at the Metropolitan Museum of Art in New York to the hand of Ngongo ya Chintu, a man who once lived in Kateba village. Stools of the sort were possessed and used by chiefs and kings, especially among peoples who were either Luba themselves or who emulated Luba sacred rule. Objects of the distinctive Buli style were used across a broad area. Often those possessing stools such as ones commissioned from the Buli workshop were members of the Mbudye Society, the purpose of which was to extol a Luba model of power, refined behaviour and communication with the world of spirits. Stools are still used as seats of power and prestige, but they are also places of memory, situating power and memory in the past and present, and their subtle iconography can be read as sculptural narrative. Stools join other mnemonic devices used by people in this part of central Africa to remember what is right and glorious. In particular, a stool may be considered a *kitenta* or 'spirit capital' – that is, a place joining a chief and his people to the ancestors and other spirits seeking to guide everyday affairs. Stools are not for sitting, then, except in the most exceptional of circumstances, when a chief or king means to demonstrate his position as sacred intermediary between worlds. Vogel has suggested that the long face and aged stature of Buli figures, as opposed to the youth and exuberance of caryatids supporting earlier Luba stools, may reflect political disintegration at colonial conquest and the end of the age of sacred royalty. *MNR, AFR*

Bibliography: Olbrechts, 1947; Vogel, 1980; Neyt, 1994, p. 95; Roberts and Roberts, forthcoming

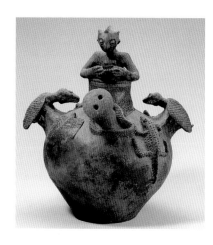

4.65
Pot

Luba (Zela)
Zaire
terracotta
40 x 38 x 34 cm
Private Collection, Munich

Luba art is well known for its royal arts and other sculptures in wood and metal, yet seldom are Luba ceramic arts exhibited or discussed. Pottery has played a central role in the critically important archaeological findings of the Luba region dating to the first millennium AD. Sequences of pottery types and styles have enabled archaeologists to identify periods and to establish the chronology of habitation and material culture in the area for a continuous span of 1500 years. Archaeological pots (e.g. cat. 4.57), while decorated with geometric patterns, do not possess figurative representation. A corpus of ceramics from the late 19th and early 20th century are, however, anthropomorphic and zoomorphic, with spouts sometimes formed in the shape of human heads. Cat. 4.65 shows an assortment of animals, including a tortoise and a lizard, encircling the body of the pot. *MNR*

Bibliography: de Maret, 1985; Childs et al., 1989

4.64
Stool

Hemba
Zaire
late 19th century
wood
52 x 27.5 x 22 cm
The Trustees of the British Museum, London, 1905. 6-13-1

This famous stool is one of about twenty objects considered to be from the 'Buli' school, after a village in south-eastern Zaire near the confluence of the Luvua and Lukuga rivers where several objects of the style have been collected. These are lands associated with the Kunda clan, thought by some to be ancient residents and the progenitors of Luba royalty. The Luba culture heroes

Luba

The ancestral statuary of the peoples living in the north of the province of Shaba (formerly Katanga) and in Maniema in the east of Zaire mainly appeared in Western museums and collections after the 1960s; the figures, with their characteristic cruciform plaited hairstyles, are both original and elegant. A few sculptures were known in Europe at the end of the 19th century, for instance the examples in the Museum für Völkerkunde in Berlin or the fine ancestral sculpture in the Museum of Ethnography in Antwerp (which entered the collections in 1931).

The later arrival of more than a hundred figures, collected from a clearly defined area of about 100 sq. km, revitalised understanding of the life and culture of these peoples. In former times this area was incorporated in the vast Luba culture that stretched from Kabongo, the capital, towards the Upemba depression and the region contained between the River Zaire and the lakes Tanganyika and Moero.

The Luba referred to people from the west as the 'Hemba', and this alluded to their way of pronouncing the language and to their manner of dress. Although the various ethnic groups living north of Lukuga professed to be 'Hemba', the complex social differences covered by the term need to be recognised. The southern groups, living in families, clans and chieftaincies, all traced their origins to a single place, the Hundu Mountains between Luama and Lulindi. These included the Niembo, the Honga, the Mambwe, the Nkuvu, the Muhona and many other groups. North of the Luika the Hemba groups mingle with others in a more complex fashion: the Zula, Bangubangu, Boyo and Bembi.

The veneration of ancestors is an important feature of life in large Hemba families. Fine statuary is ample evidence of this, but other ritual objects reflect an art that took many forms: the *kabeja*, a two-headed statuette connected with twins, and the *lagalla*, a large post in the shape of a head placed at the village boundary.

The statue with the ringed neck (cat. 4.66d) is a characteristic product of the workshops of the southern Niembo, around Mbulula. The figure

is admirably modelled, the curved torso setting off the shoulders and the belly that swells around the umbilical area. The ancestor's hands, placed on either side of his stomach, indicate that he is watching over his clan. The ovoid face is full and round, suggesting interior calm; the hair is dressed with a finely carved diadem in front, and with horizontal decorated plaits behind folding elegantly into the vertical plaits; these are supported by a square of raffia. This hairstyle is typical of one zone of the southern workshops, between the villages of Mbulula and Ilunga, in Honga country.

Cat. 4.66e comes from a village 130 km north of Makutano, in northern Hemba territory. The same general principles are observed: the ancestor has his hands on his stomach; he has a serene expression on his face, with half-closed eyes; and he has the same criss-cross hairstyle. The work is quite different from those of the south, however, in that this ancestor is of powerful, stocky build: the hair is built up high on the head; the ring of beard is prominent; and, on the back, a double-chevron motif echoes the motifs carved in crescent shapes on either side of a huge umbilical hernia.

Cat. 4.66b also comes from a village 130 km north of Makutano, but in Mambwe country, and is a product of the last of the southern styles made on the border with the south, near the Luika. The workshop is on the eastern side of the Hemba area. The face is more elongated, its eyes open, the flat cuts made by the chisel more in evidence. The less tangible signs of Hemba workmanship are nevertheless easy to spot.

The figure of an ancestor (cat. 4.66g), a magnificent carving of a dead chief, his eyes half-closed (to open no doubt on to another world), would lie in the half-light inside a hut. The conception of such figures was based on belief in an afterlife, as well as on the kinship system. Each ancestor is identified, assigned to a period and invoked; each confers on his owner a place in a branch of a carefully drawn-up genealogical tree relating the history of his family and the family's position on the land he inhabited. Large families among the Mambwe in the south would possess up to 20 statues, shared out among the dif

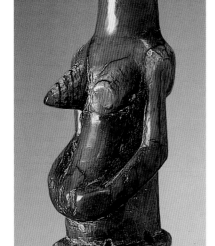

4.66a
Reliquary figure
Hemba
Zaire
ivory
h. 20 cm
Private Collection, Paris

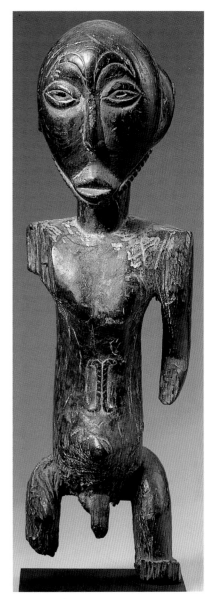

4.66b
Ancestor figure
Mambwe
Zaire
wood
h. 65.5 cm
Private Collection

ferent dwellings belonging to members of the same lineage.

The *lagalla*, guardian of the village, may be encountered several times in the same village. In Mambwe villages it always has two heads. The villagers make offerings to it. The exquisite cult statuette (cat. 4.66c) is evidence, at the northern limits of Hemba territory, of the survival of

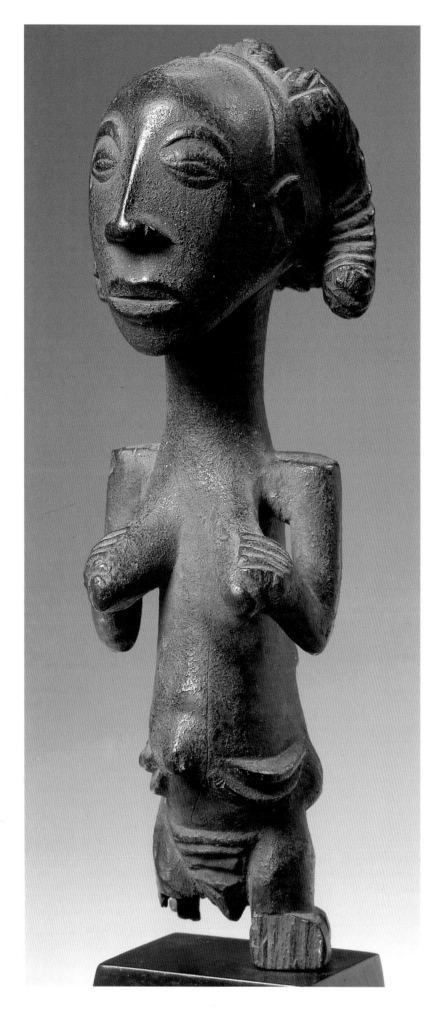

the great Luba culture that covered the whole region. This figure has plaited hair and holds her hands over her breasts. She reminds us of the importance of women in Luba culture as givers of life and nurture, and also of the gifts that transcend the visible and join the spirits of the natural world.

The astonishing figure from Frankfurt (cat. 4.66f) is carved from *Crossopterix febrifuga*. On a cylindrical trunk, 54 cm high, a standing male figure is carrying another male on his shoulders; the upper figure has half-closed eyes and a diadem over a cruciform hairstyle. This kind of work is extremely rare among the Hemba, although other examples of people being carried can be found in Kusu country, on the left bank of the River Zaire, and further east, among the Tabwa and the Tumbwe, near Lake Tanganyika. This carving is generally described as a chief being carried by a slave, since it was customary for royal personages to avoid contact with the earth. This same tradition can be found among the Bemba in Zambia, in the Luba kingdom and elsewhere. In some cases a woman is carried by a man. Sometimes a fiancée would be carried in the same manner by her betrothed or by a member of the family. Whatever the truth of the matter, this piece of Hemba sculpture seems to be of the head of an important family and the style suggests a Niembo chief, from the area near Mbulula where the southern style is at its purest.
FN

Provenance: cat. 4.66f: 1929, brought to the museum by A. Apeyer
Bibliography: Neyt and Strycker, 1975; Neyt, 1977, pp. 97–9, 296–7, 361, 499; Frankfurt 1983, pp. 24–5, 133; Maurer and Roberts, 1985, pp. 80, 88

4.66d
Ancestor figure
Niembo
Zaire
wood, raffia
h. 68 cm
Private Collection

4.66e
Ancestor figure
Northern Hemba
Zaire
wood
74 x 24 cm
Private Collection, Brussels

4.66c
Ancestor figure
Hemba
Zaire
wood
h. 25.5 cm
Private Collection

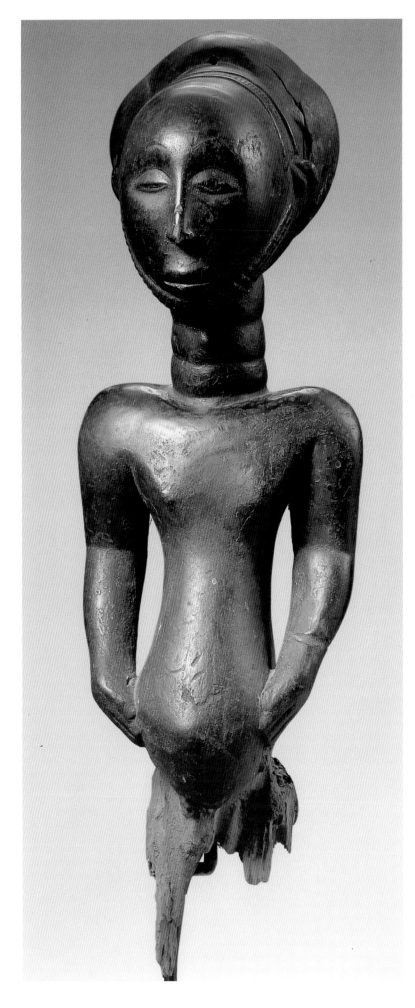
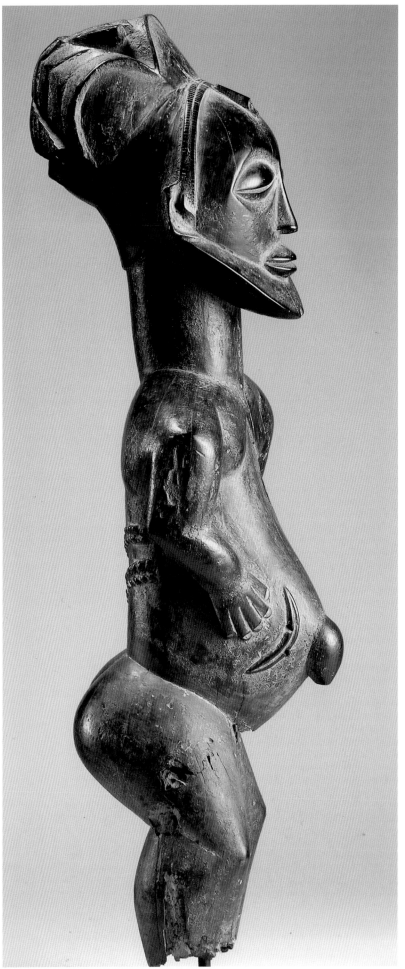

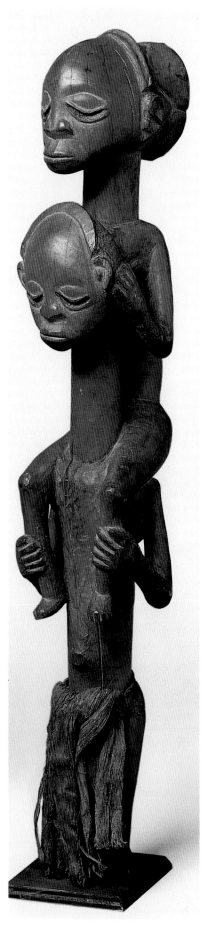

4.66f
Pickaback figure
Hemba
Zaire
wood, bark, fabric, fibre
h. 54 cm
Museum für Völkerkunde,
Frankfurt am Main, 26.543

4.66g
Ancestor figure
Mambwe
Zaire
wood
h. 32 cm
Private Collection

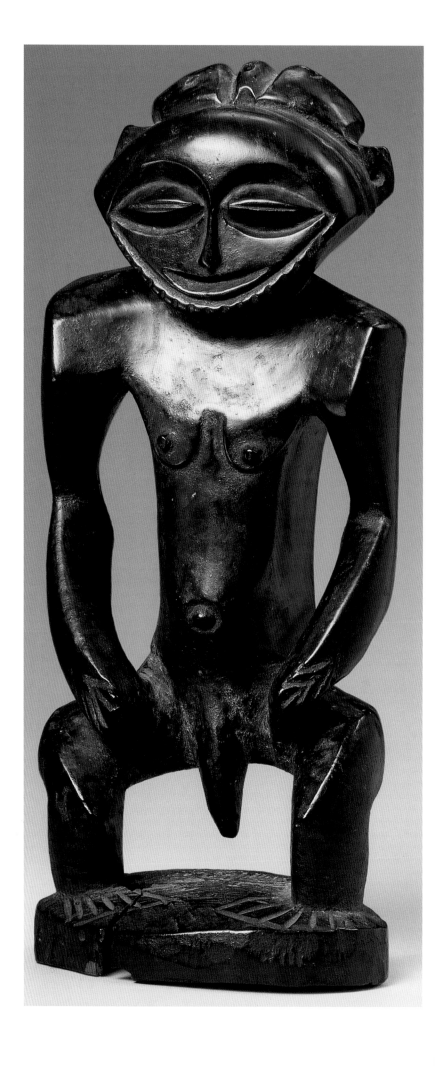

4.67a

Fly whisk handle

Boyo
Zaire
wood
h. 27.5 cm
Staatliches Museum für Völkerkunde,
Munich, 13.57.140

In the northern part of Maniema in
Zaire, on the outskirts of Luama, live
fragmented groups of people known
by the Arabs as the Boyo or Buye.
Among these, the Sumba are
generally considered to be the best
sculptors.

The beautiful fly whisk (cat. 4.67a)
features an impressive figure, evoking
the memory of an ancestor, on the
handle. The serene face on the front
is completed by a hairstyle with a
curved pleat behind. The figure has
its thorax thrust forward in a curious
fashion, and a bulging stomach. It also
has a backward thrust with a particu-
larly curvaceous back. The hatched
cuts, which possibly echo the spirals
on the conus-shell worn by the chiefs,
repeat the parallel curved lines on the
thorax, the shoulder blades, above the
hips and on either side of the legs, as
if all blank areas needed to be covered.
This piece, with its contrasting forms,
expresses the ambiguous and sacred
beauty of Boyo statuary better than
anything written or spoken could do.
How was H. Deininger allowed to
bring this treasure to Europe in 1913?
Very likely it was because it
constituted only a minor portion of
the chieftain's panoply.

The figure attributable to the Bembe
people, who live in politically frag-
mented local settlements, is simpler,
on a square base with angular sides
(cat. 4.67b). The characteristic face
has a high forehead and an almost
vertical face, making a triangular
shape with the nose in the centre.
The simplified hairstyle is similar
to the Boyo style; the shoulders curve
right round the body as round a cylin-
drical trunk, with the arms folded
(as here) over the chest. It is probably
a work of funerary art, though this is
known in only some of the Bembe
groups. *FN*

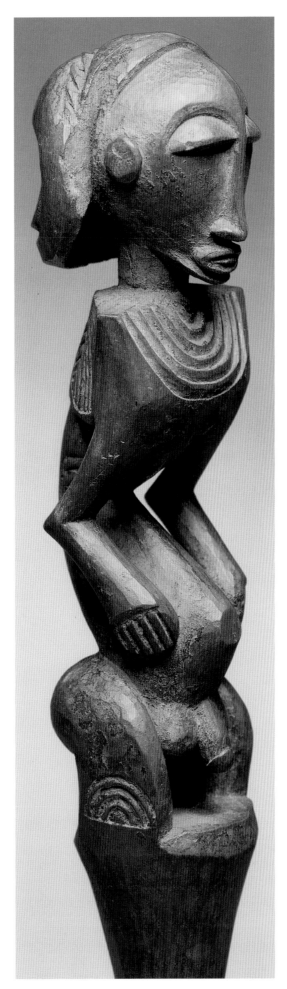

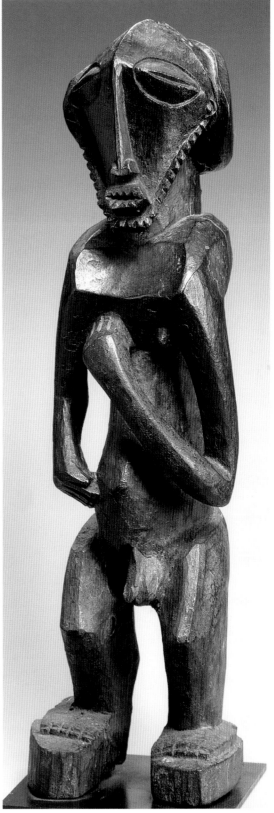

4.67b

Figure

Bembe
Zaire
wood
70 x 18 x 21 cm
Felix Collection

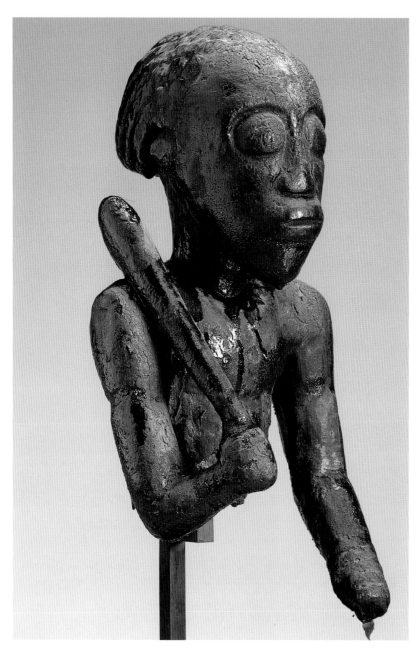

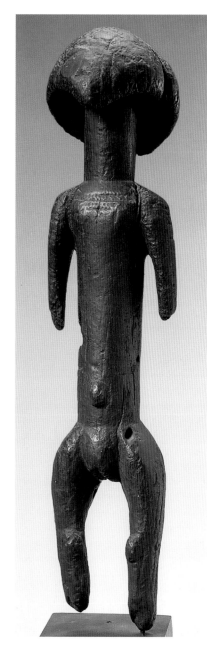

of the sort (cf. cat. 4.66f) are common to the region and much of central Africa, and generally they denote socio-political hierarchy. Kings, chiefs and title-holders might be carried on someone's shoulders, but so might brides and grooms during weddings, the victors of wrestling matches, young men and women emerging from initiation camps, or anyone else being offered momentary or pious respect. One can speculate that this figure represents a hereditary lineage chief carried on the back of a close kinsman. The chief is confident that he is being carried carefully (i.e. shown proper deference), and his resolute vision extends across lands with which he is identified. The glossy patina is probably from offerings of palm oil and beer, and years of soot from being stored in the thatched roof of a house. *AFR*

Bibliography: Kecskési, 1982; Roberts and Maurer, 1985, pp. 97–218

4.68

Bust

pre-Tabwa
Zaire
wood
h. 36 cm
Private Collection

This fragment is probably from people who once lived along the Lukuga River in south-eastern Zaire. It is an ancient object and, like several others to which it is stylistically related, may predate the arrival of current inhabitants of the region, who are of Tabwa ethnicity as followers of paramount chief Tumbwe. The figure is so similar in style to another fragment (Roberts and Maurer, 1985, pp. 102–3) that each object can be used to explain something of the other. Both have

strong, solemn faces, with forward-staring wide eyes and pursed lips suggesting determination. Both bear simple axes over the shoulders, of the sort carried by men throughout the region for their protection and utility. Chiefs usually possess more elaborate axes with carved handles and incised blades, but it is likely that such details were irrelevant to these sculptures.

More significant than the axe is what is left of the downward extended left arm. Rings around the wrist represent bracelets, probably of copper imported to the area from the nearby Copper Belt. The left arm of the figure not shown here is not quite so eroded, and its hand rests upon the head of a second figure carrying the first on his shoulders. Double figures

4.69

Figure

Tabwa (?)
Zaire (?)
early 20th century
wood
50.6 x 10.5 x 10 cm
Afrika Museum, Berg en Dal,
The Netherlands, 29–653

In the late 19th and early 20th centuries the Tabwa and surrounding peoples of south-eastern Zaire, north-eastern Zambia and south-western Tanzania carved small wooden figures to represent ancestors, great shamanistic healers and, perhaps occasionally, personified earth spirits. Called *mikisi*, such figures were kept by lineage elders in special buildings within their compounds, where the elders

sometimes slept to receive ancestral inspiration in their dreams. The figures had active powers to heal and protect, and many held charges of active magic. *Mikisi* might be placed near a sick person, or at the entrance to the village as a silent sentinel; they might be deployed in litigation, to ensure that a defendant told the truth, or placed near blacksmiths' forges or on hunting shrines, to keep evil forces from disrupting the transformative processes of work. Catholic missionaries considered such objects to be diabolical, and forbade their use. Most *mikisi* that still exist are in Western museums. *AFR*

Bibliography: Roberts, 1985

4.70a

Seated female figure

Tabwa
'Ujiji' style
Tanzania
late 19th century
wood, beads
85 x 38 x 36 cm
The Trustees of the British Museum,
London, 1954.23.3539

4.70b

High-backed stool

Tabwa
Zaire
late 19th century
wood
70 x 24 x 23 cm
The Trustees of the British Museum,
London, 1954.23.3196

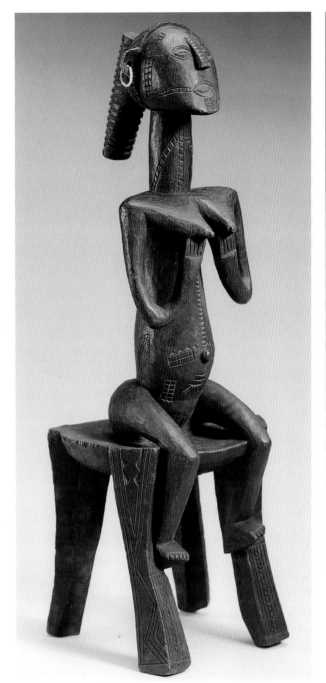

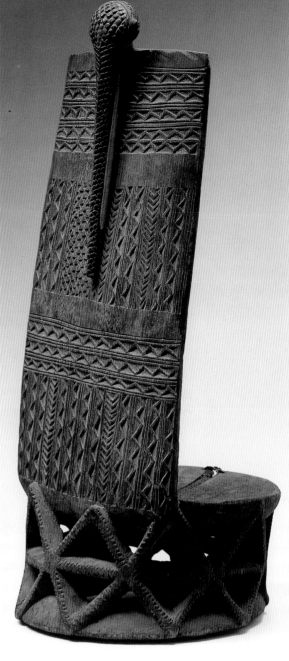

The style of the seated female figure (cat. 4.70a) is associated with the town of Ujiji, on the north-eastern shore of Lake Tanganyika. Around 1850 Ujiji became an important entrepot for caravan trade in slaves and ivory obtained west of the lake, in what is now Zaire. Local Ha and Tongwe formed a heterogeneous population with Luba, Tabwa, Bembe and others from the opposite shore, and the iconology and purposes of this figure reflect such an eclectic background. The treatment of the face, scarification and pendant coiffure are stylistically close to Tabwa sculpture. A number of Tabwa figures stand on stools, but are invariably male; while among Luba female figures commonly represent sacred kings. One other seated female figure is known from the same style area; it holds a bowl as a faint echo of Luba bowl-bearer figures. Similarly, by far the most common stance of both female and male Tabwa figures is with the hands placed either side of the navel, to stress the bonds with the mother's matrilineage; while Luba female figures often hold their breasts (as this figure does), where the secrets of sacred royalty are said to be held. A hypothetical purpose of this figure, then, is that it links the mixed populations around Ujiji with the glorious kingdoms west of Lake Tanganyika.

Stools such as the one upon which the figure sits are seats of power for Tabwa, Luba and related Zairian peoples. High-backed stools were once made by peoples across northern Tanzania, with the westernmost examples produced by Tabwa and Bisa (south-eastern Zaire and western

Zambia). The idea for such an artistic format was introduced to Tabwa by Nyamwezi ivory-hunters and slavers from central Tanzania. Only eight Tabwa high-backed stools are known. Four portray animals (three snakes and a Nile monitor lizard) associated with territorial spirits, linking the chief with the natural resources of his (or more rarely her) domain. The human figures or features on the other four stools refer to clan ancestors that 'embrace' the chief. The stool's back is decorated with the *balamwezi* motif, echoed in the triangular details of the openwork base. *Balamwezi* is Tabwa for 'the rising of a new moon',

and is a key metaphor: just as a new moon rises after several nights of utter obscurity, so will humans prevail over ignorance and 'dark' deceit, positive qualities that are embodied by the chief possessing such a stool.

The Tabwa created high-backed stools as 'statement art', in a conscious effort to invent traditions legitimising increased hegemony. As they participated in the late 19th-century ivory market and slave trade, certain Tabwa chiefs consolidated their political powers in imitation of neighbouring Luba, Bemba and Nyamwezi states. To this effect, they commissioned art and created ceremonies to confirm

their recently acquired 'royal' prerogative. Such arts flowered for a very short time, however, for by the mid-1880s European outposts in Tabwa lands had begun to stop the slave trade and, by the turn of the century, Tabwa 'royalty' was a moot issue.
AFR

Provenance: 1954, given to the museum by the Trustees of the Wellcome Historical and Medical Museum

Bibliography: Roberts, 1985; Roberts, 1994; Roberts and Maurer, 1985, pp. 246, 261–2, 277; Roberts and Roberts, forthcoming

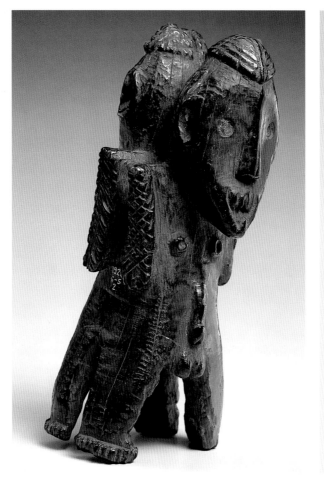

4.71b

Bifrontal figurine

Lega
Zaire
early 20th century
ivory
16 x 6.5 x 7.5 cm
The Trustees of the British Museum,
London, 1929.6-5.2

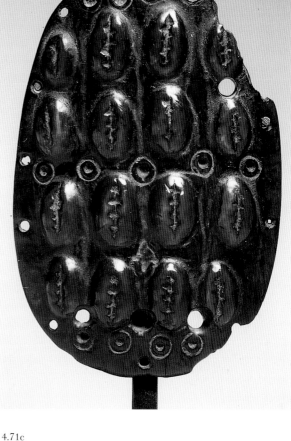

4.71c

Ritual ornament

Lega
Zaire
18th century (?)
ivory
h. 8.9 cm
Patricia Withofs Collection, London

4.71a

Spoon

Lega
Zaire
late 19th–early 20th century
ivory
23 x 53 x 39 cm
By courtesy of the Board of Trustees of
the Science Museum, London

The Lega inhabit the forest region in the forest region in eastern Zaire. They are a Bantu-speaking group who practise a mixed economy involving agriculture, hunting and fishing. They do not possess a centralised political organisation, and both men and women aspire to moral authority by gaining high rank in the *bwami* initiation association. Membership of *bwami* cuts across the divisions between patrilineages and local residential groupings, and its graded initiations help to bind the generations through commemorative rituals which celebrate the virtues of deceased former members. The highest ranking members of the *bwami* association commission, own, use and interpret all Lega sculpture. Many categories of object are used in connection with the association's

activities, including anthropomorphic figurines of various kinds (e.g. cat. 4.71b), zoomorphic figurines, masks (cat. 4.71d–f), hats, spoons (cat. 4.71a), miniature implements, ornamental disks and chips (cat. 4.71c), animal parts and found objects.

The Lega call most anthropomorphic figurines *iginga*, which they define as 'objects that sustain the teachings and precepts of *bwami*'. Each figurine symbolically represents a named personage with particular moral qualities or defects that are expressed through dance and sung aphorisms during the most important stage in initiations to the highest grades of the association. Plurifrontal figurines (e.g. cat. 4.71b) exhibit a variety of forms and represent a distinct type of *iginga* named

Sakimatwemtwe ('Mr Many-Heads'). The saying that often goes with this type of figure when it is displayed by itself is: 'Mr Many-Heads has seen an elephant on the other side of the large river.' The saying alludes to the status of the high-ranking initiate who, having undergone many initiations, has witnessed great things and possesses enhanced powers of understanding. The mask with two faces exhibited here (cat. 4.71d) represents a variation of the plurifrontal motif, and it may have been used to illustrate some of the same characters and concepts as the related figures.

Among the numerous artefacts owned and worn by high-ranking *bwami* members are a variety of roughly ovoid bone or ivory chips. These may be strung together to form

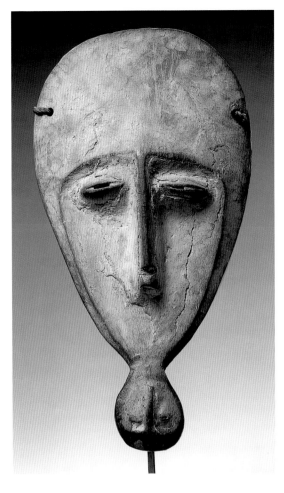

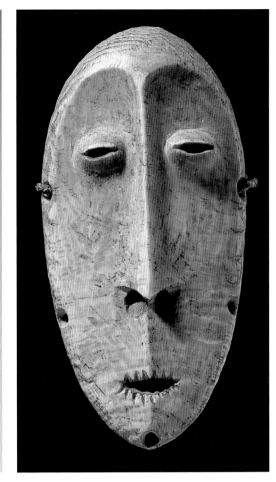

4.71d

Mask

Lega
Zaire
early 20th century
wood, pigment
28.5 x 15.5 x 4.5 cm
J. W. and M. Mestach

4.71e

Maskette (*lukwakongo*)

Lega
Zaire
wood, raffia, pigment
30 x 20 x 8 cm
Felix Collection

4.71f

Miniature mask (*idimu*)

Lega
Zaire
ivory
h. 10.5 cm
Private Collection

wristbands or they may be worn on necklaces as pectorals. Some are convex, as is the example exhibited (cat. 4.71c), and they are often decorated with the characteristic circle-dot motif. The example here is also decorated with an attractive cowrie shell design (strings of cowries are a standard item of exchange paid during all *bwami* initiations), and it may have served primarily as a prestige ornament. As a general rule, most of the simpler carved items and found objects used in *bwami* rituals serve mainly to illustrate ideas and principles rather than characters, as is the case with the masks and figurines.

Spoons carved in bone and ivory (cat. 4.71a) are prestige items owned by high-ranking *bwami* members and they are used during initiations to convey a variety of ideas. Like the bone and ivory from which they are made, spoons may serve as symbols of continuity. In certain contexts they are used symbolically to feed masked preceptors in order to demonstrate the privileged status of old initiates who like to feast on soft delicacies.

Wooden, bearded maskettes with heart-shaped, concave faces painted with white pigment (cat. 4.71e) are owned, in some areas, by every male member of the most advanced level of the second highest grade (*yananio*) of the *bwami* association. The maskettes (called *lukwakongo*) are not worn over the face. Participants in most rites display their maskettes as a group in conjunction with particular dance movements and aphorisms which vary depending on the context in which

they are used. In some rites they may be held in the hand or dragged by their beards, in others they may be fixed to hats or arranged on a miniature palisade. An initiand will generally 'inherit' his maskette either from a deceased kinsman who was himself formerly a member of the top level of the *yananio* grade or from a living relative who has graduated to the highest ranking grade (*kindi*). The *lukwakongo* maskette is passed on to the initiand by his personal instructor during a rite of the same name. It serves as an emblem of the initiand's new rank and symbolises his links with other *bwami* association members and with deceased former members.

Of the four families of masks used in connection with *bwami* the *idimu* group (cat. 4.71f) embody the highest

authority. They are used in various ways during the most advanced rites of the highest ranking *bwami* grade and are always displayed attached to a miniature palisade surrounded by other types of mask. *Idimu* masks are not intended to represent spirits or ancestors in any way, and individual masks serve as the supreme figureheads under which a collection of *bwami* communities rally. In the history of their use they embody a shared tradition and so help to validate the principles, rights and exchanges according to which the practices of the *bwami* association are structured. *ZK*

Bibliography: Biebuyck, 1973, p. 226; Biebuyck, 1985, p. 45; Biebuyck, 1986; Biebuyck, in Tervuren 1995, pp. 375–8

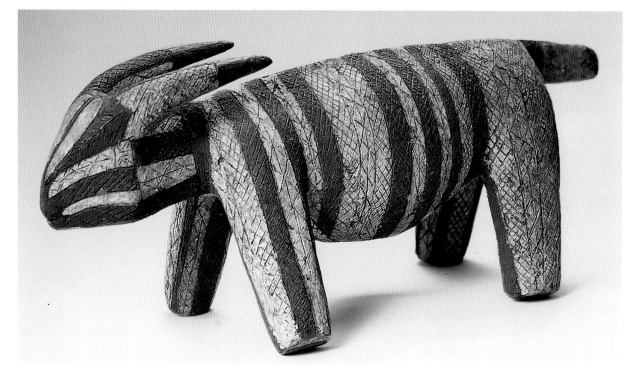

4.72
Panel with double faces

Shi
Zaire
wood, kaolin
h. 36 cm
Private Collection

This unusual piece is identified with the Shi who live in the vicinity of Lake Kivu in eastern Zaire. Their art and material culture is little documented, though at least one other object in this form is known (Felix, 1987, 1989). The same general style with a concave canoe-shaped base from which rise two heads in high relief also occurs among the neighbouring Komo. In no case, however, is the discussion of the significance and function of the carved panels conclusive.

Piecing together the little information (and indeed speculation) available, a number of observations arise. There is a general assumption that the panels and faces are somehow associated with primal ancestors (the two heads being assumed to be male and female) and with divination. In effect, this is a combination which in general terms goes readily together. On the one hand, ancestral authority, or the world of the spirits with which

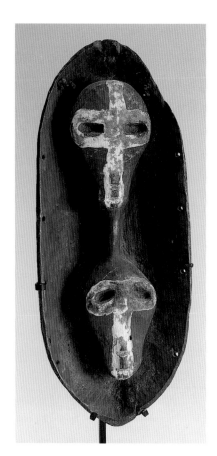

it is usually conflated, underlies much divinatory practice. On the other, the ancestors are not generally conceived as some remote and ineffectual point of reference but are usually seen as engaged in and having an oversight of everyday human affairs – an obvious point of contact with diviners and with their sources of special knowledge.

The use of white pigment to outline the eyes is also significant. In many parts of the Bantu world ocular vision is emphasised by outlining the eyes with white kaolin (cf. cat. 4.50). (A contrast with red is also characteristic of the symbolic colour spectrum of central Africa.) White is sometimes applied to the eyes of sculpture endowed with special powers, and also directly on the faces of diviners. All of this confirms the likely status of the objects, even if the precise ethnographic context remains to be confirmed. *JM*

Bibliography: Neyt, 1981, p. 37; Sieber et al., 1986, p. 139; Felix, 1987, p. 156; Felix, 1989, p. 264

4.73
Quadrupedic animal

Pere
Zaire
wood, pigments
27 x 69 x 24 cm
Felix Collection

The Pere, a group numbering only about 4000, are perhaps the least studied and least documented of all the peoples in equatorial Africa. Biebuyck provides summaries of what is recorded (see also Felix, 1987, for an equivalent piece to that exhibited here). The Pere claim historical links with the Komo, neighbours of the Shi (cat. 4.72), and with various Pygmy groups (cat. 4.74a). Indeed they have traditions of joint migration from Uganda with Pygmies to their present locations in north-eastern Zaire. None the less, their characteristic art forms show little indisputable linkage to those with whom they have the closest historical ties. The clearest connection is perhaps with the Lega, whose use of art objects in initiation as didactic references to social and moral conditions appears to be replicated among the Pere.

Whether this object may be a part of the initiatory complex is not at all certain. The only information about it indicates, somewhat vaguely, that it was used paired with another quadrupedic animal in ceremonies associated with hunting and fertility. Exactly how it might have been used

and to what effect is, however, unclear. Likewise, a cavity on the underside of the animal remains enigmatic. The most dramatic feature of the carving is the coloration on the flanks of the animal. This perhaps suggests a wild animal rather than a domesticated species and tends to support the speculative suggestion of a link to a hunting ritual. The only description of such rituals makes reference to the use of clay animal figurines in trapping elephants. Whether this figurine and its pair are part of the same complex remains for the present unclear; those reported appear to be crocodiles or iguanas. *JM*

Bibliography: Biebuyck, 1976, pp. 59–61; Biebuyck, 1986, pp. 246–9; Felix, 1987, p. 144, no. 9

4.74a
Barkcloth (*pongo*)

Ituri forager
Zaire
bark, pigment
90 x 58 cm
Private Collection, London

Women foragers of the Ituri Forest in north-eastern Zaire paint rhythmical, free, oscillating patterns on pieces of pounded inner bark which have been cut and hammered by men. Often working with a mixture of gardenia juice and carbon black, they employ the same rich repertory of motif and design that they apply in painting the bodies of their family and friends. In addition, women are the architects of the Ituri world. And they are the masters of the polyphonic, yodel-like style of singing special to Ituri foragers.

Ituri aesthetics links art and song. Both use polyphonic structures; contractions of intervals; macro-complications of structure in terms of successive passages; micro-complications of structure in terms of small motifs, modified at each repetition; staggered entrances and exits of line; and a strikingly playful multi-voiced mode of exposition.

These two barkcloths illustrate the spontaneity of Ituri painting. Shifting and contracting spaces between parallel lines build abstract rhythms and deliberate contrasts. At the left two different phrasings of tendril-like patterning about a narrow field of 'stars' and linear constructions lead the eye to an open field of parallel lines. Over these lines cross short parallel strokes, elegantly curved and flowing. Motifs vary at each repetition.

Cat. 4.74b nobly illustrates forager freedom of expression: the painter fills her space with interweaving, sapling-like lines, not unlike the trellis of sapling and vine with which she would make her home. Suddenly the design changes its mind. Lattice-like patterning evaporates. In its place emerge short, bisected rectangles of varying shape, length and positioning, like dominoes spilled or scattered on the ground. The artist has shown profound understanding of the realm of linear expression, moving from 'order' to 'chaos' and back again in one coherent composition.

The 'meaning' of this break-pattern art, eliding staggered accents

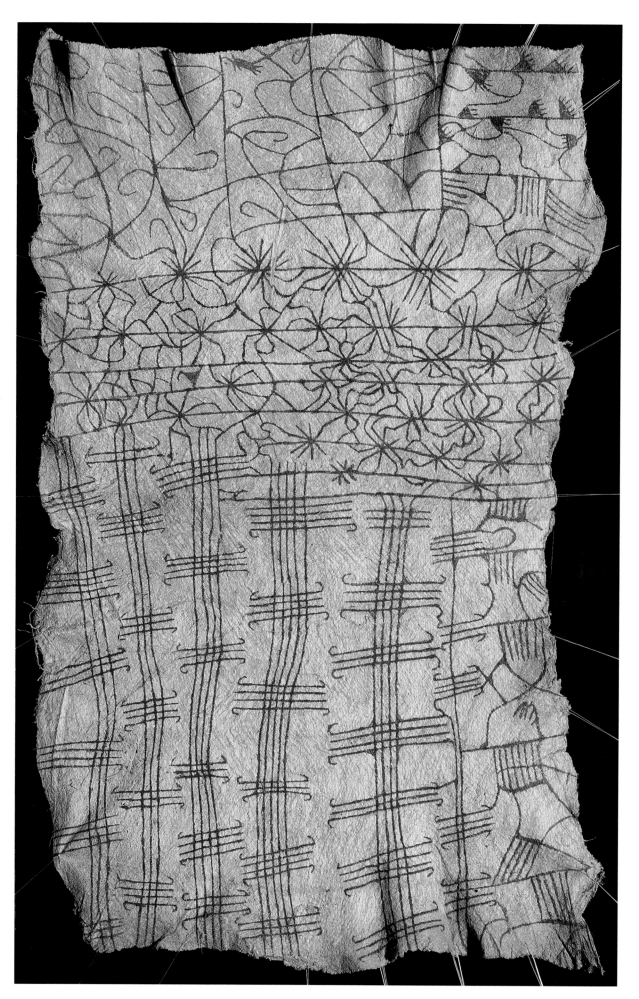

with stylised interlacing, is enigmatic. In ritual contexts it may encode a sylvan idiom, parallel, in its flowing rhythm, energy and abstraction, to polyphonic forest yodelling, the Ituri way of praising God.

Forager art has influenced painting in neighbouring Mangbetu, Lese-Karo and Komo villages. It is possible to see such influence reaching even further, to include women's art among the Shoowa and Kongo and, via forager pockets on the Cameroon Grasslands, women's inner-bark painting among the Ejagham and Bokyi. With these two *pongo*, then, we may sample an epicentre of women's style in the history of African art. *RFT*

Bibliography: Thompson and Bauchet, 1991; Thompson and Meurant, 1995

4.74b

Barkcloth (*pongo*)
Ituri forager
Zaire
bark, pigment
63 x 45.7 cm
Private Collection

4.75

Barkcloth

Mangbetu
Zaire
early 20th century
beaten bark, pigments
168 x 164 cm
Musée National des Arts d'Afrique et
d'Océanie, Paris, MNAN 1963.1116

Before the colonial era, barkcloth was
the main item of men's and women's
clothing in central Africa. The cloth
was wrapped over a belt, passing
under the legs when worn by men,
and when worn by women simply
draped over the belt in the front of
the body. Women also carried small
pieces of barkcloth and placed them
over wooden stools.

This cloth is constructed of three
separate pieces sewn together with
raffia. The soft cloth is made from
the bark of the fig tree (*Ficus roko*
or *Urostigma ktshyana*) that has been
beaten with a mallet made of ivory,
bone or wood. Large pieces of cloth,
such as this one, were used by men or
by women of high status. Women did
most of the painting on barkcloth,
using a fibre brush and paint from
the juice of the gardenia plant.
The designs on the cloth probably
represent material objects, both flora
and fauna, and manufactured objects.
Much of the iconography remains
undeciphered. Particular patterns are
said to represent, for example, spiders,
snakes, hairpins or houses. Pounding
the bark to give it the soft and flat
finish of cloth is done by both men
and women. The painting closely re-
sembles the designs used in women's
body painting (also done with gardenia
juice). Some of the geometric patterns
found on barkcloth resemble designs
incised on pottery or incised and
burnished onto carved furniture.
Irregular isolated patterns, as on this
piece, have also been applied to
wooden objects, such as on a Mangbetu
painted shield.

This example of barkcloth is un-
usual in that the composition has been
divided into four triangular sections,
traced along the diagonals. The whole
piece is enclosed by an unusual
double-line border. While a division
into sections is common, they are
more often arranged in vertical or
horizontal bands and the designs
usually continue to the edges of the
cloth with no outside border. Except
for the border and the triangulation,
the painting on this example com-
bines design elements that have been
associated with the aesthetics of both
the Mangbetu and the Mbuti or Sua
Pygmies (called Akka by the Mang-
betu). Some scholars associate the free

and asymmetrical juxtaposition of
patterns with a Pygmy aesthetic.
Others note that in central Africa
forest hunters and gatherers like the
Akka and the Mbuti have lived in
close social and economic collabora-
tion with farmers like the Mang-
betu. The techniques of bark-cloth
manufacture and many of the
designs are shared among several
groups in the region and it is now
difficult to specify ethnic affinities
or origins for particular styles and
designs. *ES*

Bibliography: Thompson and Bahuchet,
1991; Schildkrout and Keim, 1990

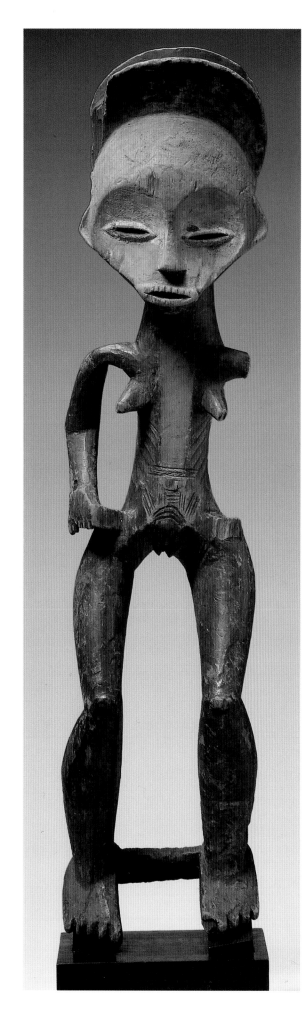

4.76
Hanging figure

Mbole
Zaire
wood
h. 69.5 cm
Museum of Ethnography, Antwerp,
AE 673

The artworks of the Mbole, who live
along the Lomami River, are princip-
ally related to the activities of a
pervasive and complex secret society
known as *lilwa*. Although the exact
role of the figures remains to be fully
documented, it is clear that they
evidence the juridical role of *lilwa*
and represent those condemned to
death by hanging. Their characteris-
tic form with shoulders and arms
hunched forward, in some examples
with the feet pointing downwards,
suggests a suspended posture. To that
extent they are unique within the
artistic canons of Africa, if we exclude
the specifically Christian imagery
developed in some places.

Death by hanging was the punish-
ment for a variety of serious trans-
gressions ranging from adultery to
sorcery or murder, and was a dramatic
public event. Normally the victims
were men, though this is one of the
rarer examples showing a woman.
The condemned had a length of liana
placed around the neck, and this in its
turn was attached to a springy, bent
tree. Once the tree was released, the
condemned person's body was cata-
pulted into the air. The sanction
represented by this form of execution
is emphasised by the hanging figures
which are guarded by the same high-
ranking initiate who acts as judge in
cases which carry this punishment.
The figures themselves bear the
names of victims.

The figures are kept secretly.
Initiates encounter them, often
mounted on a litter, on a number
of occasions during and after their
initiation. Their first sighting occurs
at the start of the initiation process
when they are beaten with sticks and
confronted with the images. Later
they learn the circumstances in which
the deceased came to be condemned
and the figures act as a powerful
warning against the transgression
of social rules. Where an initiate's
behaviour comes into question oaths
may be sworn on the figures. *JM*

Bibliography: Biebuyck, 1976

4.77
Five-seated stool

Ngombe area
Zaire
wood
197 x 20 x 11 cm
Peter Adler Collection

Across Africa people occasionally
make headrests or chairs with
multiple components, but it is not a
common phenomenon. In west Africa
the Nuna of Burkina Faso make
double stools or headrests that are
part of the diviner's equipment.
The diviners presumably use these to
dream on and consult with powerful
nature spirits in order to solve clients'
problems and predict the future.
Among such widely dispersed peoples
as the Tsonga and Shona of south-
eastern Africa and the Somali of
north-eastern Africa double headrests
are made for married couples, as is the
case with the Kuba and the Ngombe
in central Africa. Among the Ngombe,
Maes reports that when a married
person dies the surviving spouse must
sleep beside the corpse on the double
headrest during the period before
burial (when the body is displayed).
The form of these Ngombe headrests,
with strongly curved head platforms
and columnar supports, however, is
not at all like this five-part stool.

According to Felix, the faceting
seen on the sides of this stool is
typical of stool and figure carving in
the Ngombe area. The function of
the stool itself remains the subject of
much conjecture: some say that judges
would sit together on such stools while
the accused were brought before
them. The unity of the stools possibly
symbolised the judges' unanimous
decisions (an intriguing idea without
any proven basis). The Ngombe have
a warriors' society, Elombe, and the
stool could perhaps have been used as
a way of symbolically linking them to
a common cause. *WD*

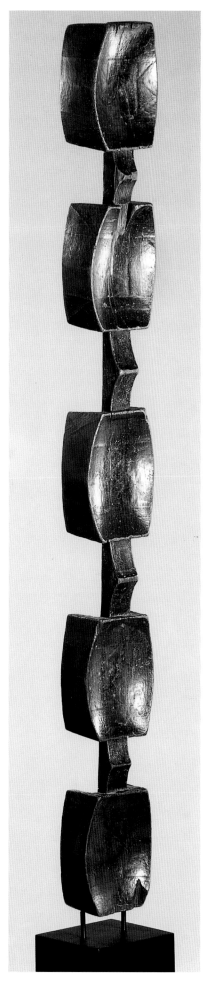

The Ekonda are one of the many Mongo-speaking peoples of central Zaire. As among related peoples, local authority was traditionally vested in a ritual chief (*nkumu*), a title conferred by village elders on a wealthy outsider who, in adopting the office, was obliged to pay for the authority invested in him. The past tense is likely to be appropriate here as Brown, who wrote the only extensive and accessible discussion of the *nkumu*, declared the office to have virtually died out 50 years beforehand.

The responsibilities of the *nkumu* included ceremonial, divination and the spiritual welfare of the community. He had the exclusive right to use several prestigious items of material culture, of which the pagoda-style hat (*botolo*) is the best known. Its fibre structure is tiered, and one or several brass plates are generally attached. The plates are made from beaten brass rods and are themselves a token of the wealth of the office-holder. Brass rods were a form of currency and quantities of them were handed over by the incoming *nkumu* as part of the installation ceremonies. Subsequently the hat worn in public on all occasions and at ritual events was often liberally smeared with a mixture of camwood and oil. *JM*

Bibliography: Brown, 1944; Arnoldi and Kraemer, 1995

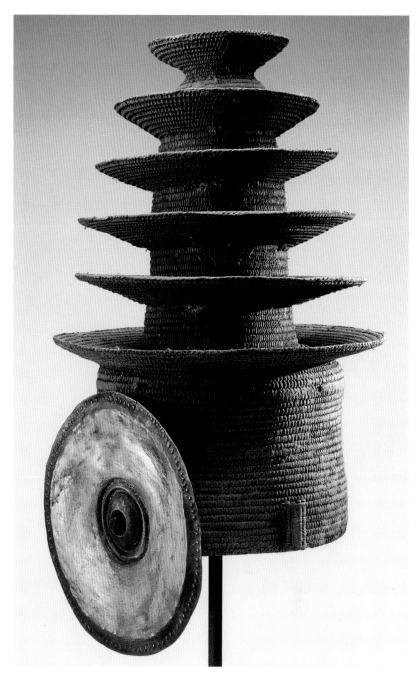

4.78

Hat (*botolo*)

Ekonda
Zaire
plant fibre, earth, brass
43.8 x 20.3 x 21 cm
The Museum of Fine Arts, Houston
Museum Purchase with funds provided by Mr Frank J. Hevrdejs in honor of Mr William James Hill at 'One Great Night in November, 1992'

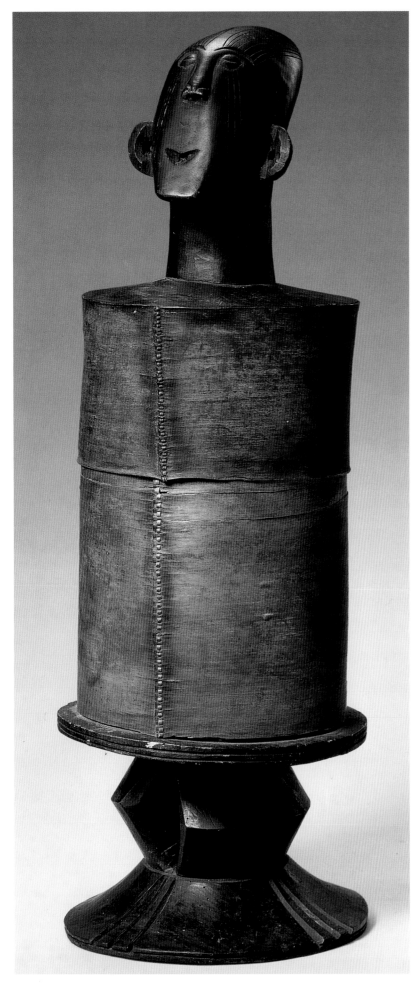

4.79

Box

Mangbetu
Zaire
wood, bark, fibre
h. 66 cm
Staatliche Museen zu Berlin, Preussischer
Kulturbesitz, Museum für Völkerkunde,
III C 19463

Wooden and bark boxes were commonly used in north-eastern Zaire for storing trinkets and medicines. This box was purchased in 1904 from Leo Frobenius; it is not known how Frobenius acquired it as he did not himself collect in this part of what was then the Congo Free State. Its large size may indicate that it was made for, or owned by, a chief or ruler. The wooden base, with an open-work central pedestal, is carved like a Mangbetu woman's stool, while the head is a typical stylised representation of a Mangbetu person with elongated head. The light and dark contrasting coloration is often found in this region and is sometimes said to have symbolic meaning, perhaps suggesting the two tones of the leopard.

In his description of travels in the 1870s through what is now the Sudan and Zaire, Schweinfurth described the Mangbetu court of King Mbunza as a centre for art, performance and the display of centralised power. Although the Mangbetu kingdom seems to have been considerably more fragmented than Schweinfurth believed, rulers like Mbunza did have large courts and a retinue of artists who made objects that were used and displayed in the court; these were given as gifts between rulers and, eventually, to visiting Europeans. By the beginning of Belgian colonial rule, which effectively reached north-eastern Congo in 1891, there were a number of competing chiefs in the Mangbetu-speaking regions, each with a court that echoed the form and style, if not the power, of Mbunza's. These rulers exchanged art objects as tribute and diplomatic gifts with other African leaders and with Europeans.

By the early 20th century dramatic changes had occurred in the arts of the area, partly because of the new markets and interest of foreign visitors. The beautiful Mangbetu villages, with their rows of large round houses covered with exterior murals, were photographed and

illustrated in European and American travel books. Working in wood, ivory and clay, as well as in wall paintings, artists increasingly turned to representational images, mainly of people, but also of animals and common objects of material culture. In the first two decades of the 20th century figurative art became much more prevalent, more stylised, and a form of portraiture developed.

The ruling class among the Mangbetu practised a form of head elongation and head wrapping, and the portrayal of this fashion came to typify the art of the area. Such utilitarian objects as boxes (made of bark and wood), pots, knives, ivory hairpins and musical instruments were increasingly adorned with representations of the wrapped elongated head and the women's fan-like coiffures. This genre built upon art forms that already existed in the area: the Bongo people in the Sudan made large wooden funerary trumpets surmounted by carved heads; the Azande of the Sudan and north-eastern Zaire made and played five-string harps, the necks of which were adorned with carved heads; and the Ngbaka played harps, not only with heads, but also with resonators, representing the human body, with projecting legs beneath representing the human form. *ES*

Provenance: 1904, purchased from
Leo Frobenius
Exhibition: New York 1990, no. 58
Bibliography: Schweinfurth, 1875;
Schildkrout and Keim, 1990

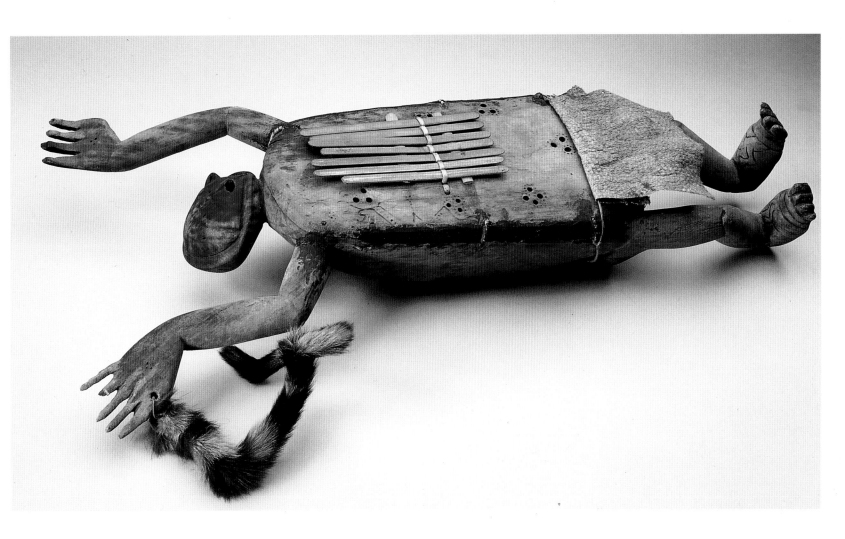

4.80

Mbira

Azande
Zaire
before 1914
wood, bamboo, barkcloth, animal tail,
brass
61.2 x 29.5 cm
American Museum of Natural History,
New York, AMNH 90.1/3317

The *mbira* (also known generically as *sanza* or lamellaphone or thumb piano) is a musical instrument played throughout sub-Saharan Africa. It generally consists of a hollow resonating chamber, over which are attached a single row, or multiple rows, of keys of different lengths; these are fitted at one end so that they can vibrate when plucked. This gentle and melodic instrument is usually played with the thumbs and sometimes the forefingers as an accompaniment to song. The musician, usually a man, would have used it to accompany ballads, particularly songs about personal experience. The *mbira* is not a court instrument, and would not have been played in ensembles. Many variations on this basic type of instrument are found, both in the number of keys and the material of which the keys are made (metal or wood); additional sound-producing elements that act as rattles are often incorporated.

This particular instrument was collected among the Azande people who live in the area that is now north-eastern Zaire and southern Sudan. The instrument represents a female,

possibly dancing, her arms, fingers and toes raised; her head is thrown back, and the expression on her face could be one of ecstasy. The sculptor has carved detailed genitalia that the clothing conceals.

This example was made by a Zande artist near Nala, a town in north-eastern Zaire. There are three other *mbira* in the same style, perhaps made by the same carver, in the Royal Museum for Central Africa at Tervuren, collected by Armand Hutereau in the same period. Unlike the others, however, the female represented in this example has a barkcloth skirt, a raffia back apron and carries a dance whisk. Her body is painted with small geometric designs surrounding holes in the resonating chamber. The traces of paint faintly indicate a style of body design that was popular among Mangbetu women at the turn of the century. The top of the resonating chamber has been sealed to the body cavity with pitch.
ES

Provenance: 1914, collected by Herbert Lang (American Museum of Natural History Congo Expedition, 1909–15)

Bibliography: Laurenty, 1962; Schmidt, 1989; Schildkrout and Keim, 1990

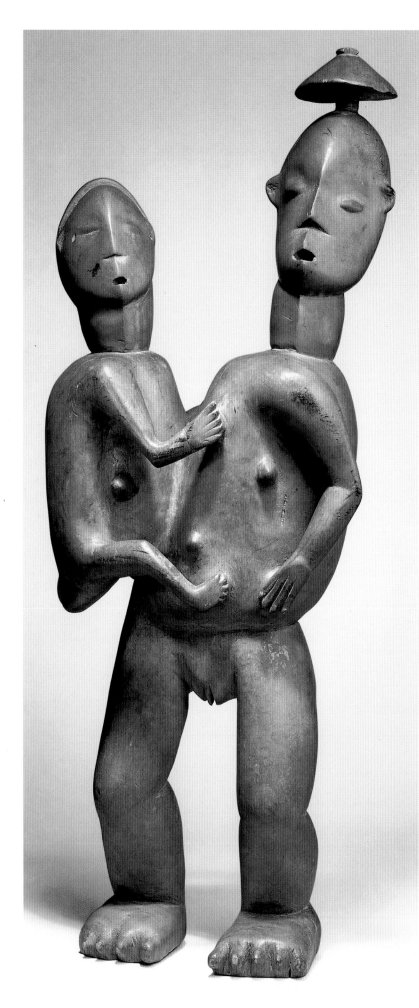

4.81

Mother and child

Azande
Zaire
c. 1914
wood
h. 60.2 cm
American Museum of Natural History,
New York, AMNH 90.1/3320

This mother and child figure is one of two such sculptures carved by an unknown Zande artist who was working at or near Nala around 1914. The same artist may have carved the *mbira* in this exhibition (cat. 4.80).

In the early colonial period the Azande of north-eastern Zaire and southern Sudan were organised into loosely confederated kingdoms, most of which were headed by members of the Avongara clan. Chiefs in some of the main centres seem to have employed artists who carved figures, some of which were given as gifts to other leaders, both African and European. The practice of using art as tribute encouraged the development of workshops in which rulers employed carvers who worked in distinctive styles. This work was usually made for secular rather than religious purposes.

Although the Azande sometimes carved figures for use on graves, there is no evidence that this piece was a funerary sculpture, or that it had any religious significance. It seems, rather, to be a rare and important example of a sculpture carved intentionally to be a work of art. No other mother and child figures in this particular style are known from the Azande, with the exception of one other made by the same artist. In this work the artist depicts the way in which mothers actually held their babies, straddling the sides of their bodies. Instead of depicting the waist band the mother would have used to hold the baby close to her side, the artist reveals the fusion of the bodies of the mother and baby. He also cleverly alters the conventional frontal posture of the female figure so that her body, which incorporates the body of the child, appears to be slightly turned towards the child. As in virtually all African sculpture, this composite figure still faces the viewer directly.

The mother's hairstyle shows the use of false hairpieces that were common among the peoples of north-eastern Zaire. Photographs of the period show Azande and Mangbetu women wearing woven hairpieces, made with hair, raffia and cowrie shells, attached to their braided hair. Sometimes the hair was arranged into such a form without the use of a separate hairpiece. *ES*

Provenance: *c.* 1914, collected by Herbert Lang (American Museum of Natural History Congo Expedition, 1909–15)
Bibliography: Mack, in Schildkrout and Keim, 1990, pp. 217–31

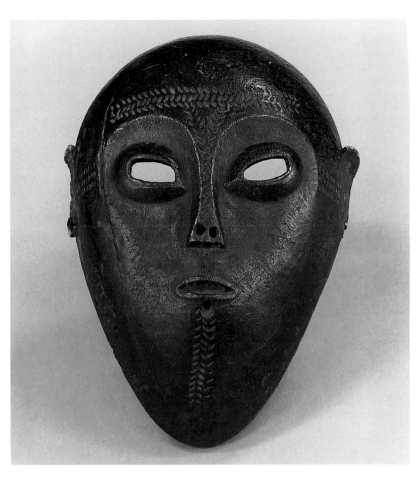

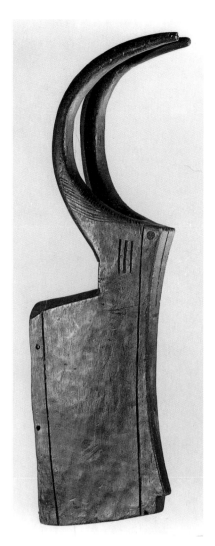

4.82

Mask

Ngbaka
Zaire
19th century
wood
33 x 25 cm
The Brooklyn Museum
Museum Expedition 1922, 22.1585
Robert B. Woodward Memorial Fund

Most masks from north-western Zaire are attributed to the Ngbaka (Bwaka, Ngbwaka). They were first seen in Europe in the early 1900s and the best-known style has a concave anthropomorphic face and scarification, as in that shown here. Most documented examples were worn at the festivals with which the extended male initiation rites ended.

Ngbaka masks present many art-historical problems. Their use was not widespread, and they were produced for purposes other than initiation ceremonies. Further, there were various mask styles among the Ngbaka and neighbouring groups. This diversity developed because northern Zaire was a zone of extreme cultural variety, a result of the intersection of two great ecological systems – the forest and grasslands – and several

great cultural traditions including Bantu, Sudanic, Chadian and Adamawan. Centuries of migration, wars, trade, intermarriage and cultural exchange produced a mosaic of societies organised on a relatively small scale and accustomed to frequent innovation and borrowing. Even where centralised societies such as the Zande and Mangbetu kingdoms existed at the time of the Belgian conquest (1890–c. 1920), they tended to be small, relatively recent in origin and composed of many heterogeneous peoples.

Customs appear to have varied widely among Ngbaka from different regions and many local groups show influences and borrowings from neighbouring cultures. Initiation masks such as this one seem to have been borrowed and adapted from the Mbanja (Banda), who live mostly to the north in the Central African Republic, but also among and around the Ngbaka. Evidence for this lies in the Mbanja-language songs that accompanied the masks and in the Mbanja names given to objects used in the initiations. It is even possible that Mbanja carvers were responsible for most mask production. In the late

1970s, masks of the sort shown here were still produced near Lake Kwada, but the few reports since then indicate the absence of mask use or, in some cases, the development of new mask styles.

Knowing the masks' provenance sheds little light on meaning and function, however. In none of the reported Ngbaka cases do the masks play the dramatic role which they occupy in some variants of the Mbanja initiation ritual. There the assembled initiates are first attacked and whipped by a masked older male and then ordered by the initiation director to fight off the masked attacker's assaults, seize him, strip and unmask him. The successful unmasking of the previous generation's masked representative is a condition for leaving the initiation camp.

Ngbaka borrowers use the masks differently and variably. In some accounts the director of the initiation dons the mask in order to announce the end of the seclusion of initiates in their bush camp; his appearance in the village simultaneously serves to frighten children and announce the beginning of post-initiatory celebrations. In other accounts the initiates themselves wear the masks, using them to entertain one another with laugh-provoking postures and antics. In still other accounts masks are worn by girls in the context of female initiation rites as they travel from house to house in their own and neighbouring villages, seeking gifts.

Thus the specific meaning and function of Ngbaka masks appears to vary depending on the group and its particular initiatory practice. While some attempts have been made to explain such variation in chronological terms, with 'serious' mask usages as anterior and sacred, and 'frivolous' usages as recent and profane, the frequent combination of serious and frivolous in well-documented African ritual practice casts doubt on this categorisation. Credible generalisations regarding the meaning and functions of these masks will be possible only as a result of more detailed local studies. CK, AA

Bibliography: Vergiat, 1936; Wolfe, 1955; Burssens, 1958¹; Burssens, 1958²; Katumba, 1983; Burssens, 1993

4.83

Animal head

Yangere
Chad
h. 55 cm
Laboratoire d'Ethnologie,
Musée de l'Homme, Paris, 04.17.19

The Kwele live in the northern part of Gabon, on the Congo border. They are to be found east of the Mekambo and in the Souanké region. Kwele culture – social organisation, way of life, beliefs, traditions – is still little understood, though Leon Siroto has contributed a number of articles on the subject. It is not known, for instance, why many of the masks bear very little sign of use. Kwele art can easily be identified by its characteristic treatment of the human face: the heart-shaped face is hollow or concave, with eyes that bulge slightly, surmounted by two elegant crescent-shaped eyebrows. The face is always white with a black background (forehead, cheeks).

As a contrast to their anthropomorphic masks, the Kwele also make zoomorphic masks (antelope, gorilla). The gorilla mask, known as *gou*, is one of the most spectacular.

The masks were created to strike terror into the hearts of the villagers; they were worn in the context of the activities of the initiation association, the *beete*, during ritual dances to ward off sorcery, to celebrate the circumcision of young men, at meetings connected with deaths in suspicious circumstances, and so forth. This type of mask has virtually the same ritual function as the *emboli* of the neighbouring MaHongwe in the region south of Mekambo: the same adult gorilla head shape is used, with its enormous sagittal crest. The Kwele *gou* mask is more naturalistic, with the roll of flesh below the eyes, the projecting jaw and the large canine teeth. The symbolism attached to the gorilla, which occurs particularly abundantly in the region of Djah, evokes the idea of the spirit of the bush in opposition to the men of the village; this is the force that regulates social and political life.

The *beete* rituals, when masks were used, died out around 1920 after concerted action by the French colonial administration and the Catholic missions. *LP*

Bibliography: Siroto, in Fraser and Cole, 1972

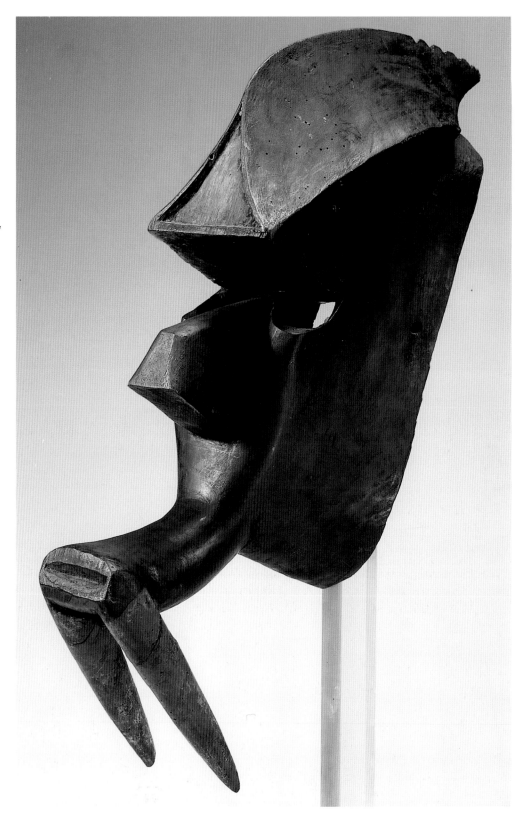

4.84

Mask

Kwele
Congo
early 20th century
wood, pigment
45 x 11 x 19 cm
Musée National des Arts d'Afrique et d'Océanie, Paris, MNAN 1963.189

4.85

Door

Punu
Gabon
19th century
wood
108 x 67 cm
Laboratoire d'Ethnologie, Musée de
l'Homme, Paris

This example of the 'displayed female
motif' (cf. cat. 4.25) is decorated with
an elaborate three-part coiffure, neck-
ring and body scarification. Punu
masks with a similar face were worn
by costumed stilt dancers and said to
represent the spirit of beautiful young
women who returned from the dead
to participate in village life. Similar
free-standing statuettes of young
females were attached to bags of
human relics. The whitened figure
in each instance makes reference not
only to the dead, but also to anti-
witchcraft techniques. Witches were
believed to be most active and
powerful at night, and whiteness
refers to light and clarity, which stand
in opposition to night and mystery.
In Gabon and much of central Africa
clairvoyants ring their eyes with white
clay (kaolin) as a strategy for
detecting witchcraft. *APB*

Bibliography: Griaule, 1947, fig. 51; Paris
1972, fig. 80; Perrois, 1979, fig. 276; Vogel
and N'Diaye, 1985, fig. 61

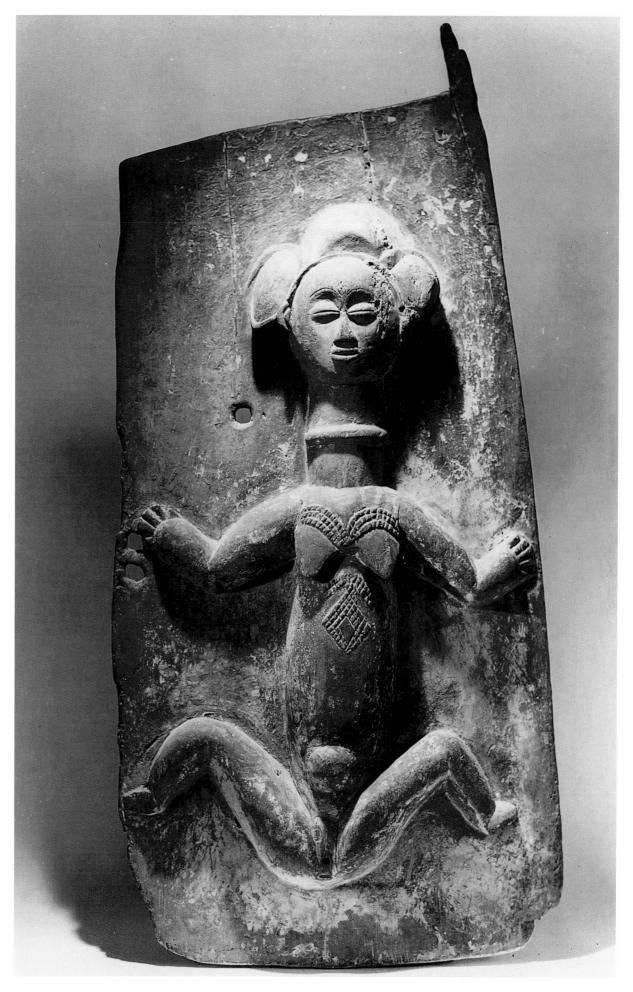

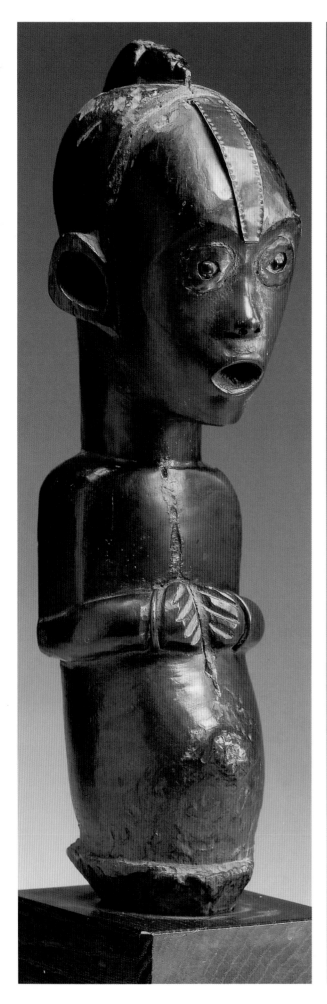

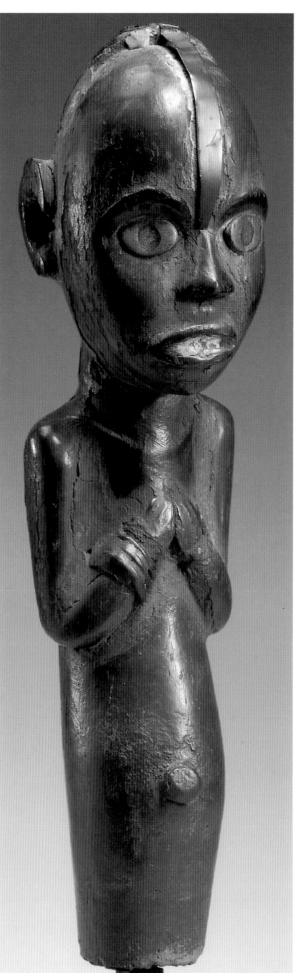

Reliquary figure

Tsogo
Gabon
early 20th century
wood, pigment, metal
h. 33 cm
Private Collection

4.86b

Reliquary figure

Tsogo
Gabon
early 20th century
wood, pigment, metal, glass
42.5 cm
Private Collection

Tsogo sculpture is connected exclusively with initiation societies, the most important of which is the *bwiti*. The Tsogo lived a very isolated life until the 1930s in the remote, inaccessible area of Upper Ngoumé in Gabon, a small population in comparison with the large neighbouring groups. They were organised in matrilineal clans. The *bwiti* spread throughout central Gabon, then subsequently through the central Ogooué region as far as the estuary; it reached its peak among the Fang in a form that subsumed all others. Joining the *bwiti* involved an initiation through many long and painful stages, followed by regular rituals during which the *iboga*, a hallucinogenic plant, used constantly by the Tsogo but not habit-forming, was taken. Tsogo artists, including musicians, were not specialists but were simply initiates of the group who had tried their hand at these activities in their youth, with the aim of contributing to the group. This explains why Tsogo artefacts – architectural pieces, ritual objects, masks and statuettes – are usually poorly finished and have a somewhat rustic appearance.

Among the objects connected with worship, the *bwiti* reliquary busts, called *mumba bwiti*, had no particular importance. These sculptures, used to protect relics and for therapeutic purposes, stood in baskets containing 'magic' substances and fragments of human bone. Ancestor worship, or *mombe*, was one of the many rituals of the initiation societies.

Stylistically Tsogo sculpture is remarkably homogeneous in the large head, body shaped like a Greek urn, shoulders hunched forward and forearms held close to the chest. The face is organised around the double arch of the eyebrows and the arrow-shaped patch on the forehead.

Tsogo sculpture is characterised by simple, sturdy forms that express in wood the enduring concerns of the society and its initiates with their fondness for *iboga* and the supernatural. *LP*

Provenance: cat. 4.86a: ex Jacob Epstein Collection

4.87
Mask

Aduma
Gabon (Upper Ogooué)
19th century
wood, pigment
h. 54 cm
Laboratoire d'Ethnologie, Musée de l'Homme, Paris, 84.37.4

This is one of the oldest known masks of Equatorial Africa and Gabon, and more specifically of the Ogooué basin. Its attribution to the Aduma derives from the fact that these people (who were fine boatmen, often hired by Europeans in early explorations of that region) provided it; yet its precise origin remains unclear. In fact this type of mask, called *mvudi* all over eastern Gabon, but also called *mbudi*, *bodi*, *mvuri* and *yoyo*, has been documented among most of the ethnic groups of the region, where contacts and exchanges are frequent: Nzabi, Obamba (Ambama) and Ndassa, Wumbu, Kanigui and Teke.

Pierre Sallée (1975) has described another people of the region as follows: 'The Okande (who have now almost disappeared) are, with the Aduma, the great boatmen of the Ogooué; they are regarded, upstream and downstream, as having been responsible for transmitting and circulating the typical sculptural forms of the peoples of the Upper Ogooué (Aduma, Bawandji, Obamba). Their forms are characterised by the juxtaposition of solid mass and surface, by geometrical patches of colour, and by the projecting forehead, which creates very deep eye sockets separated by the vertical line of the bridge of the nose.'

For the last half-century these masks have been used for celebratory dances associated with the major social rituals. Their former role is less well documented.

The geometrical elements of the face can also be found in both surface and relief features (projecting forehead, nose) of some of the *mbulu-ngulu* reliquary figures. *LP*

Provenance: *c.* 1883, collected between Lastoursville and Franceville; 1884, Musée du Trocadéro, Paris
Bibliography: Sallée, 1975

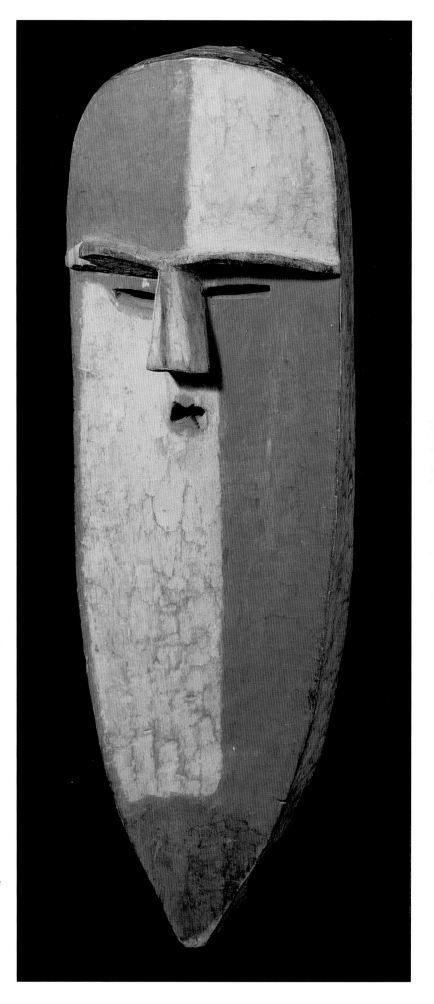

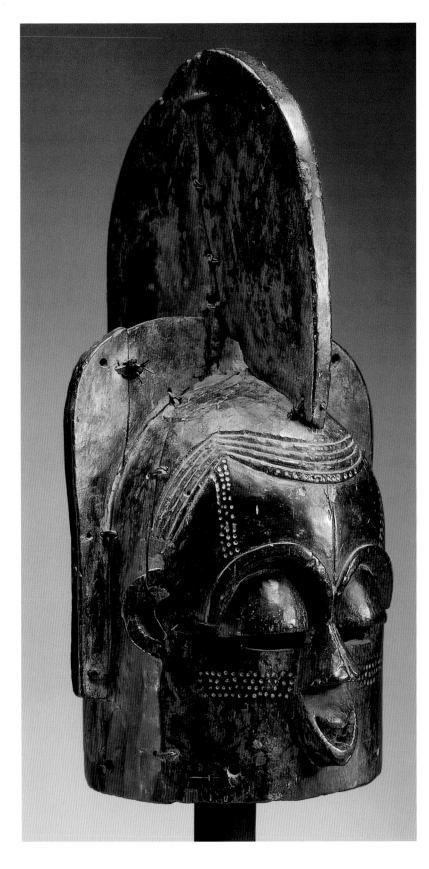

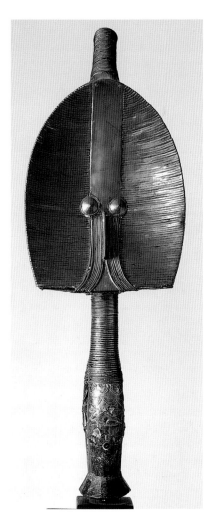

Most of the helmet masks collected in Kota territory come from the province of Ogowe-Ivindo, near Makokou and Mekambo in the eastern part of Gabon. These masks, known variously as *emboli* or *mbuto*, measure between 40 and 80 cm. In Kota villages the mask is worn during dances in celebration of the initiation of adolescent boys; the high point of the ritual is circumcision (*satsi*). The candidates for *satsi* range from eight- to ten-year-olds or boys in their late teens, since the festivities are not organised on a regular basis. During the 'pedagogical' part of the ritual the elders demonstrate to the young men that the masks are not monsters but human beings like themselves. The mask is also worn during anti-sorcery séances or for psychotherapeutic purposes.

Stylistically and morphologically, two subtypes exist, one full and round, the other angular. The treatment of the subject is nevertheless the same in both types: the mask represents a human head with a crest similar to the sagittal crest of the gorilla.

The mask covers the dancer's face completely and is supported by a basketwork frame with a generous fringe. The wooden face has a convex (as in the one exhibited here) or concave forehead; the lower edge of the brow is formed by strongly arched eye sockets. The eyes have enormously heavy (sometimes tubular) lids, which give the mask a gaze that must be disturbing to the uninitiated. Like the Kwele of the Congo and the Fang in northern Gabon, the Kota give their masks a double-arched eyebrow. These arches join to form the nose, which projects and has a flat base. Unlike the angular masks, in which the planes are all somewhat exagger-ated (brow, cheeks, the crest on the head), these rounded masks have a curious crescent-shaped mouth; the crescent motif is repeated at ear level. The face is decorated with dots and stripes to represent scarification. Some masks are painted white with red-ochre and black spots to symbolise the panther (*ngoy*), which embodies male vitality and the warlike virtues of the Kota and the MaHongwe. It was in these villages of the upper Ivindo that groups of men-panthers persisted the longest (until the 1930s). *LP*

4.88

Helmet-mask

Kota
Gabon
19th century (?)
wood
h. 62 cm
Private Collection

4.89

Reliquary figure

MaHongwe
Gabon
19th century
wood, metal
54.5 x 19 x 11 cm
Loed and Mia van Bussel Collection,
Amsterdam

It is nearly 30 years since it was realised that the reliquary figures inventoried as 'ossyeba' should really be attributed to the MaHongwe in the extreme north-east of Gabon near the Congo border. These populations have links with the Kota and are them-selves divided into subgroups, most notably the Bushamaye and the Bashake, who each produced objects in their own style. MaHongwe reliquary figures were placed over baskets con-taining relics of illustrious dead members of the lineage. The ancestor cult was called the *bwete*. The baskets would be preserved in temples within the village; they often had two figurines on top, one largish figure (about 50 cm high), the other much smaller (about 20 cm). The first was

supposed to represent the founder of the lineage and the second one of the descendants. The two figures were decorated very differently.

The large *bwete* figures of the sub-styles were invariably carved in the same fashion. One particularly remarkable feature is an abstract formulation of the anatomy of an extreme type. Although recognisably human because of its eyes and nose, the ancestor's face is severely formalistic: the face is pointed with a gentle hollowing from the brow to the mouth. The forehead has a broad metallic band across it and the cheeks are decorated with long curved moustaches made of narrow strips of metal, applied with great care. The skill with which the metal strips and patches are applied is one of the criteria by which the authenticity of these objects is assessed. This particular skill has been lost for nearly a century.

The hair tied at the back of the head has stylised plaits hanging from it; these are decorated with brass plaques, often bearing a design of punched holes.

The face of these *bwete* figures is certainly strange and highly conceptualised and in fact bears no relation to the Naja serpent head with which it is often compared. *LP*

Bibliography: Perrois, 1969

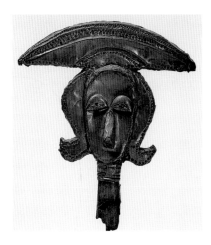

4.90a
Miniature reliquary figure
Kota
Gabon
early 20th century
wood, metal
23 x 18 x 6 cm
Herman Collection

4.90b
Reliquary figure on a stool
Kota
Gabon (Upper Ogowe)
19th century
wood, metal
h. 56 cm
Museum of Ethnography, Antwerp,
AE 60.51.3

The Kota of eastern Gabon, particularly those from the Upper Ogowe, have produced large quantities of statues of ancestors for ritual use; the statues are in wood decorated with a thin layer of copper or brass. Thanks to the diversity of these groups, scattered over a vast area covering the whole eastern part of Gabon and the regions bordering Congo in the south, a great variety of different styles has developed, some of them endogenous and some influenced by neighbouring styles. Ambete art, with its reliquary statues in painted wood (but without brass overlay), was thus probably responsible for inspiring Obamba and Ndassa sculptors.

The figure at cat. 4.90b, with his chest supported by a stool (*kwanga*), is reminiscent of Ambete pieces. Even the shape of the feet of the stool bears similarities with other stylised lower parts as made, for example, by the Fang. The figure appears to be masked, with a crest hairstyle of the same type as the hairstyle on classical reliquary figures. The face is simplified to a few lines and angles, with the brow projecting at right angles to the nose. This corresponds exactly to the *mvudi* masks from the same region (cf. cat. 4.87). The shape made by the arms, forming twin points on either side of the torso, is comparable to the lozenge-shaped torso of *mbulungulu* figurines. Reliquary figures on stools belong to a sculptural style that is midway between the flattened sculpture of the Obamba and the rounded shapes of the other local peoples. They are also to be found among the Kwele.

Miniature figures (e.g. cat. 4.90a) are extremely rare and the use to which they were put is not known. *LP*

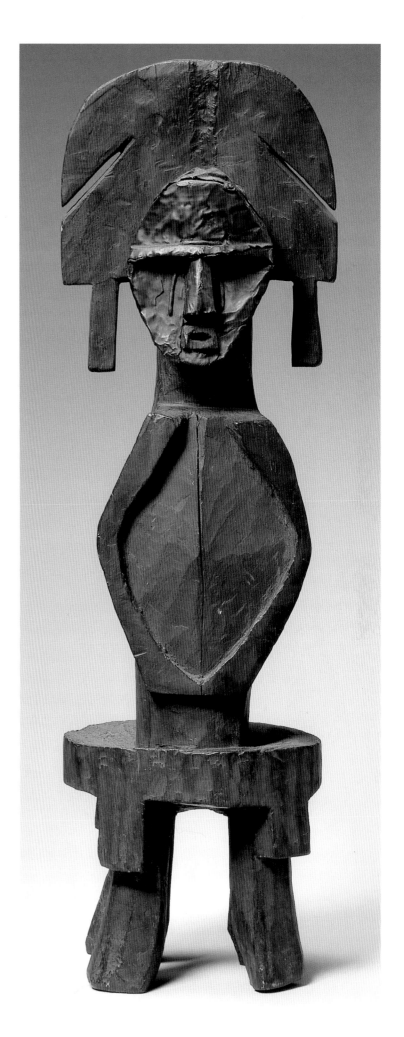

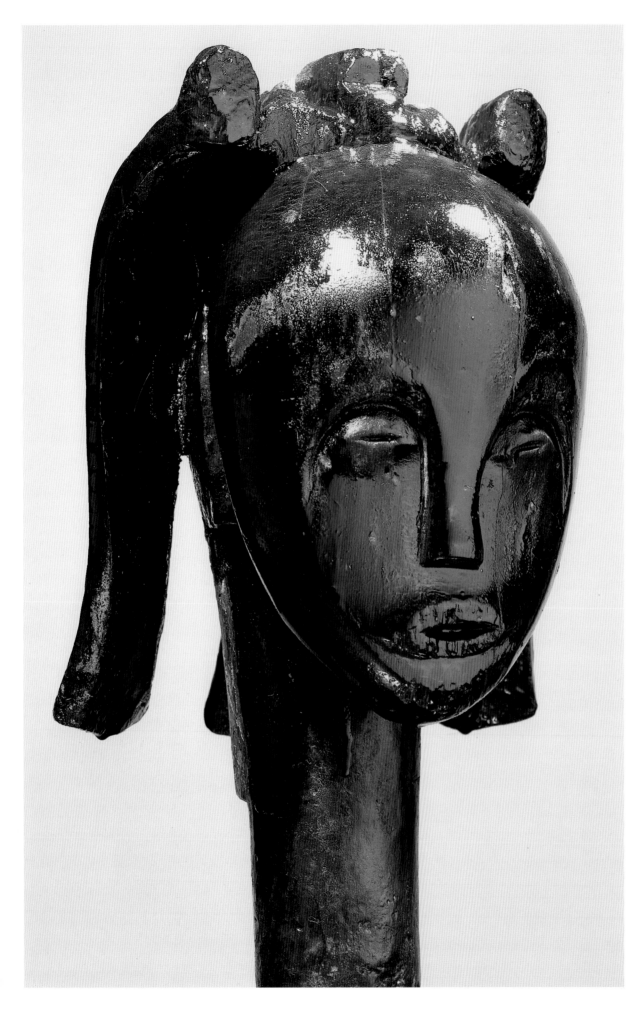

4.91a

Reliquary guardian figure

Fang
Gabon
19th century
patinated wood
34.9 x 19 cm
Private Collection

Fang reliquary chests, from southern Cameroon to the Ogowe Valley in Gabon, were generally surmounted by statuettes, but also sometimes by heads alone, particularly among the Ntumu (north-east of Rio Muni and the upper Woleu Valley) and the Betsi (Okano Valley and central Ogowe). The question of whether the style of the heads predates the style of the busts and erect statues was first raised by Tessmann (1913); in fact, the objects that were collected between 1880 and 1920 are not obviously any older than the statues. Because of their relative fragility (wood is difficult to preserve for any great length of time in an environment with a very unstable climate, where wood-eating insects are rife), they could be much scarcer than they actually are.

It is worth noting, however, that as far as representations related to the *byeri* (or cult of deceased ancestors of the lineage) are concerned, it appears from the relics still extant (mainly fragments of skull, or occasionally complete heads with jawbones) that the single head was the most common. It is also worth noting that during the theatrical ritual of the *melan* (one of the initiation rituals of the *byeri* during which the Fang 'reanimated' the deceased before calling them individually by name and presenting them to the young men being initiated) it was the statues that were used as puppets, not the single heads.

The *byeri* heads are stylistically very homogeneous, in contrast to the relative diversity of the whole figures. The only feature that varies is the hairstyle. Three different styles can be distinguished: the helmet-wig with multiple plaits (*ekuma*), the helmet with a central crest (*nlo-o-ngo*) and the transverse chignon. Fang hairstyles were always postiches made of hair, fibres and vegetable wadding, decorated with glass beads, cowries and metal chains. It is assumed that the heads with a chignon, where the hair itself was plaited close to the

scalp (high on the forehead and on the top of the head), represented females. The more richly decorated hairstyles, also plaited, are presumably masculine; they are significantly more common, which is to be expected in a patrilineal society.

The heads with transverse chignons are thought probably to be Betsi. The art of chignon-making and helmet hairstyles still survives among the women of Gabon: the Fang and the Myene women (particularly the Galoa and M'pongwe) amazed travellers with the originality of these creations in the mid-19th century. The heads made by the Ntumi and the Betsi are some of the most important artistic products of the Fang; the individual interpretation of the traditional model, in its finished form, reveals the quality of each artist.

The two heads exhibited here are among the most famous examples of classical Fang statuary. They have broad, admirably bulging brows, and the faces are carved in a soft heart-shape, with half-closed, almond-shaped eyes, a long, flattish nose and mouth pouting forwards. Minute differences in the treatment of the heads are perceptible: one artist has concentrated the face and brow into an ovoid shape, while his colleague has accentuated the flattened curves (a flat top to the skull) and elongated the face.

The delicacy of these carvings continues to surprise; they were produced in a village environment by people who had been constantly on the move since the beginning of the 19th century. This makes one wonder if the Fang statuary first discovered at the end of the 19th century is not the culmination of a long tradition, dating back to before the last migration of groups from the eastern savannas of Cameroon and central Africa. *LP*

Bibliography: Tessmann, 1913

4.91b
Reliquary guardian figure
Fang
Gabon
19th century
patinated wood
28.2 x 13.9 x 15.2 cm
Private Collection

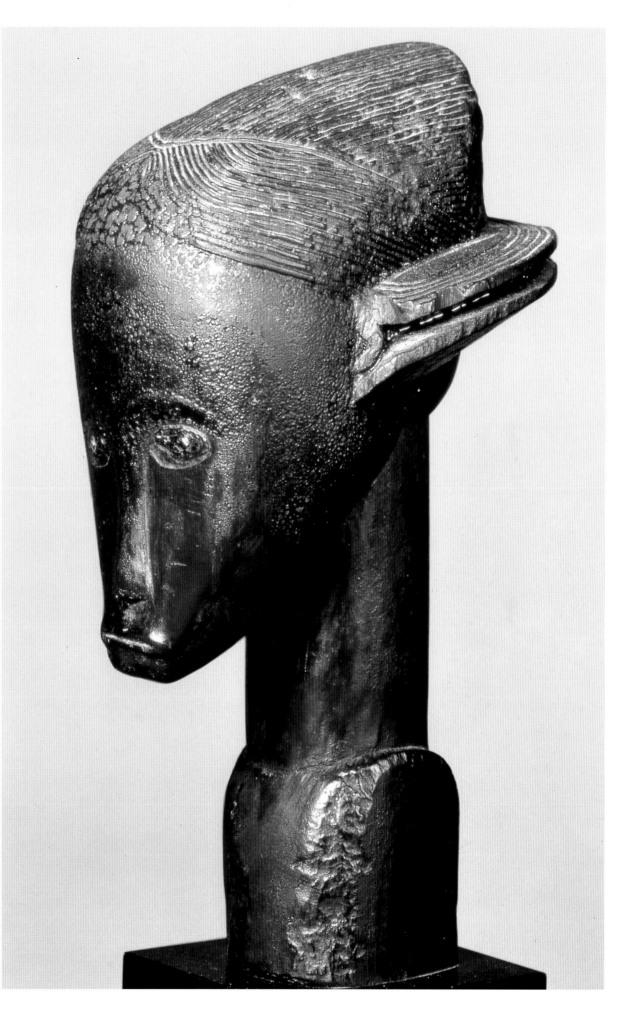

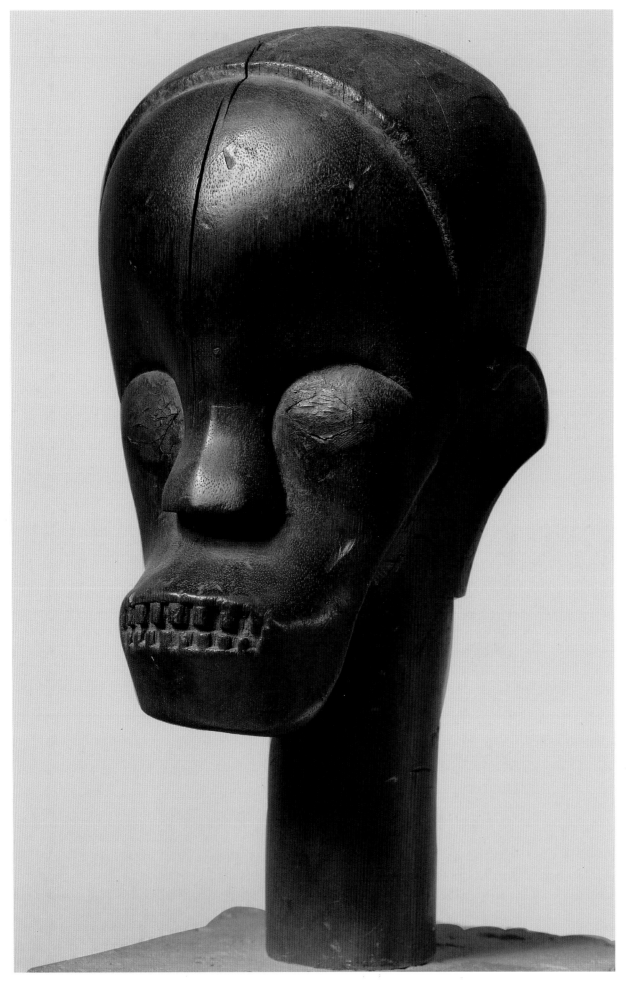

4.92

Reliquary head

Fang
Gabon (north of the Ogowe)
19th century
patinated wood
42.5 cm
Philadelphia Museum of Art,
1950, 134-202

The exaggeration of the projecting jaw of this Fang head, plus the very detailed rendering of the teeth, relate directly to its function as guardian of relics a century ago among Betsi families in northern Gabon. *Byeri* is the worship of illustrious dead members of the lineage (*ayon*) to elicit their indulgence – the dead are dangerous and must be kept at a distance from the living – and to beg for their grace, which will favour good fortune in this world. The present head, relatively large in size and massive, is typical of the sculpture of Fang groups living in the lower Ogowe Valley (and its tributaries from the right, the Okano and the Abanga) until the end of the 19th century. The head consists of a skull, effectively a sphere, placed on a cylindrical neck. The face projects far forward and is markedly convex between the elegantly curved brow and the jaw, the latter looking almost detached from the rest of the head.

The under part of the chin is also curiously hollowed out between the neck and the ears and on either side of the cheeks, although this cannot be observed from the front. It is not certain whether this hollowing out is original or whether some ritual use to which the head was put has caused this strange, misshapen result. The headdress is a simple bonnet enclosing the whole forehead and skull from one ear to the other and to the nape of the neck. The eyes are somewhat prominent, the pupils being decorated with inlaid brass patches, stuck on with resin. The double arch over the eye sockets, carved in a very smooth curve, is supported by a short, flat nose.

This striking piece presents a unique combination of originality and tradition, belonging as it does to a style that remained very homogeneous. Although the ancestral head conveys the required message, the slightly morbid interpretation of the usual Fang 'pout' transforms the face into a grimacing head of death. *LP*

4.93

Pickaback figure

Fang (Ngumba)
Cameroon
19th century
wood
h. 55.8 cm
Private Collection

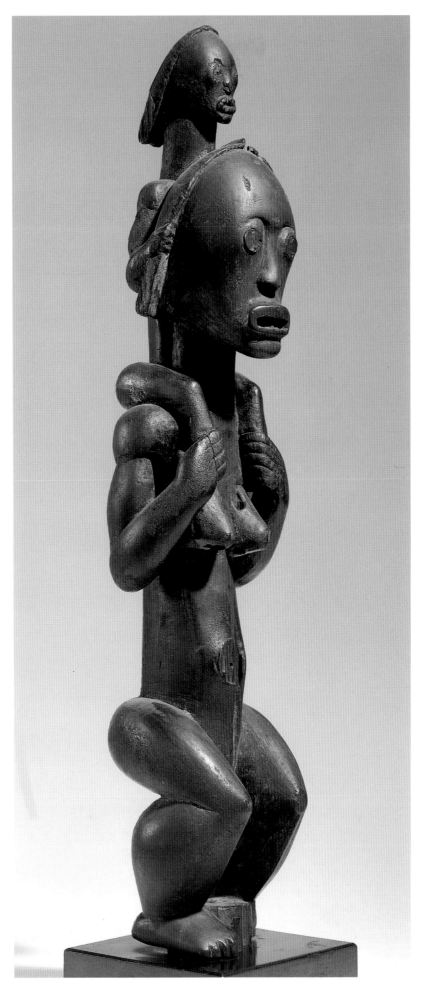

This exceptional statuette of a woman (mother?) and child has all the characteristics of the northern substyle of the Fang-Ngumba, first discovered at the end of the 19th century in the north of the Ntumu, in the area stretching from beyond Kribi to Bipindi and Lolodorf in the south of Cameroon.

Like many of the groups now part of the '*pahouin*' or Fang group, the Ngumba – who were Maka in origin and came from eastern Cameroon – intermarried with the Bulu, the Betsi and the Ntumu until finally they constituted a single group with its own identity, particularly as regards their arts and crafts. This cultural penetration must have taken place over more than a century during the great Fang migration which, by promoting a wave of lesser migrations from village to village, also caused a number of other groups to move from the north-west to the south-west of Atlantic equatorial Africa. Although it is not known whether or not the Fang came originally from Bahr el-Ghazal (as some traditions would have it), it has been ascertained that they emigrated from the savanna regions (in the north of Sanaga) to the rainforest. The Ngumba constitute a separate branch of the migration, distinct from the Nzaman and Betsi groups who made directly for Ogowe in Gabon.

The identifying feature of the Ngumba substyle is basically the elongation of the body (always represented naked) achieved by the contrast between short and massive legs (the thighs and calves particularly large), slightly bent, and a large head. Between the two the cylindrical body flares progressively from neck to stomach, supported by a very straight back. The shoulders and arms appear fixed to the torso. The child is carved separately (children in these parts are usually carried on the back, held in a band of cloth, or slung across the shoulder in a sort of small leather baby-carrier). *LP*

Provenance : ex G. de Miré Collection
Bibliography: Alexandre and Binet, 1958

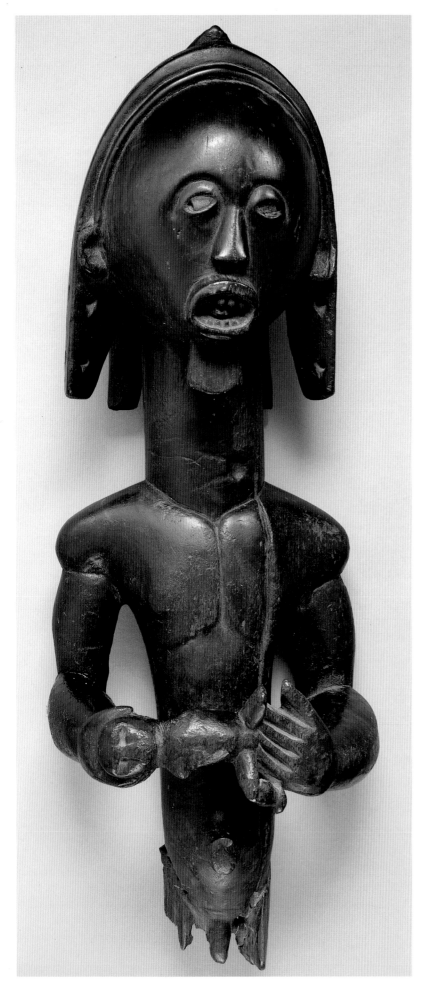
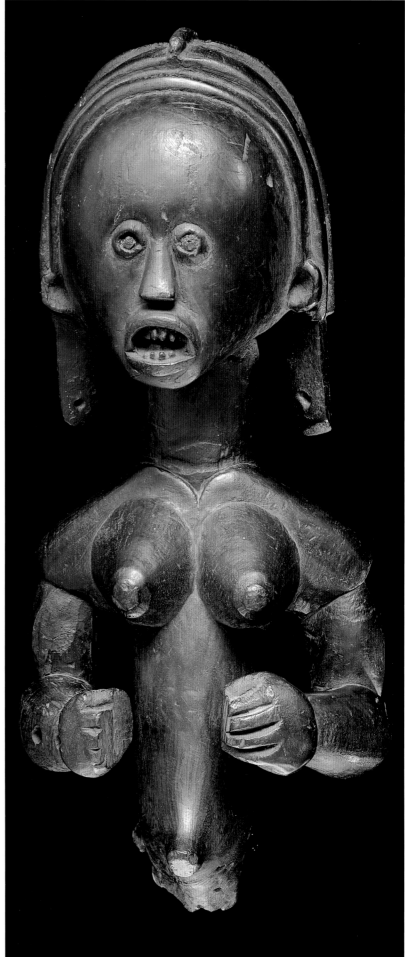

4.94a

Male figure holding a child

Fang (Ngumba)
Cameroon
19th century
wood, encrustation
57.2 x 22.9 x 17.8 cm
Peabody Museum of Archaeology and
Ethnology, Harvard University,
Cambridge, 30.2.50/B4974

4.94b

Female figure

Fang (Ngumba)
Cameroon
19th century
wood, metal
48.3 x 24.1 x 17.8 cm
Peabody Museum of Archaeology and
Ethnology, Harvard University,
Cambridge, 30.2.50/B4973

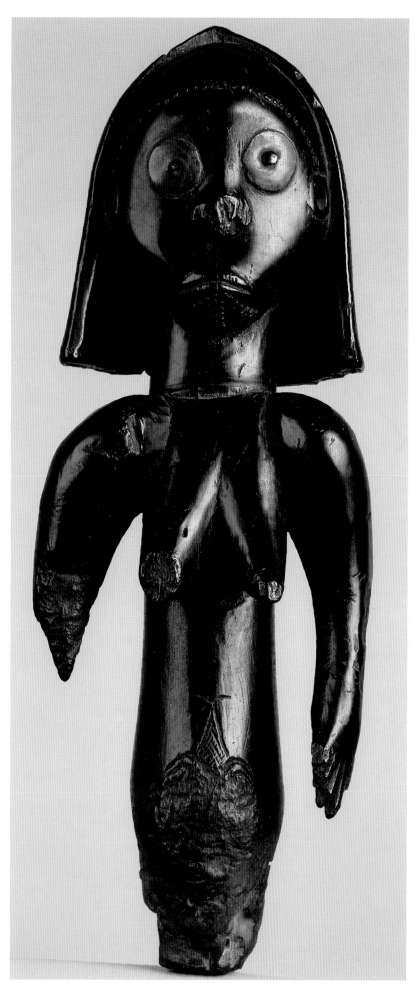

This pair of Fang-Ngumba statuettes from southern Cameroon, representing a man and a woman (now lacking their legs), is unique in including the sole surviving representation of a man holding a child. It is possible that the woman also originally held a child, as is suggested by the space between her hands. Another possibility is that the woman may have been holding an offertory dish. It is quite common, when objects are collected, for portions with religious significance to be deliberately broken off, as with the *byeri* statues of the Fang. Ngumba stylistic features here are very clear: the structure of the face with its bulging brow and the head shaped like an inverted pear with the features fixed to the surface.

Unlike the Betsi figures, also from the south, with their concave, heart-shaped faces, Ngumba faces are full and rounded. The mouth in particular, with its thick lips thrust forward and slightly open to reveal pointed teeth, constitutes almost a separate element,

more or less rectangular in shape. The man wears a stylised beard, parallel-epiped in shape. As in cat. 4.93, the heads of these two statuettes are on the large side, perched on a slender torso; this accentuates the elongated appearance of the body. The shoulders, simplified but with admirable fullness (like the arms and forearms), and the firm, round breasts of the young woman are extremely skilfully carved. The treatment of the eyes in each figure give them special prominence. The man's pupils are inlaid with fragments of glass, the woman's with metal nails. Interesting also are the holes for fixing feathers or glass bead necklaces, particularly at the base of the plaited hair. *LP*

4.95

Reliquary figure

Fang
Gabon
19th century
wood, copper
Priavte Collection, London

This hypnotic reliquary statue belongs to an identifiable school whose masterpiece is the large figure once owned by Epstein, which the present statue excels in grace though not in power. The large copper eyes fixed by a copper rivet give a baleful stare which in the original, dimly lit hut where reliquaries were kept was part of the guardianship of the sculptures. Traces of scarification around the umbilicus and the ridge of indentations over the forehead and chin also link this to the Epstein piece though the coiffure here is entirely individual. The balance of breasts and shoulders, making a double rhyme, forms a support like a fluted column for the head, which would otherwise seem out of proportion. *TP*

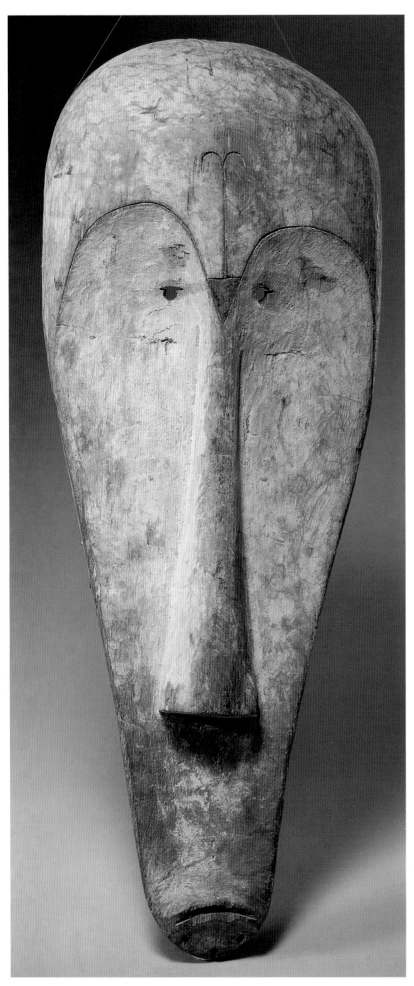

4.96a

Mask

Fang (Ntumu)
Rio Muni, equatorial Guinea
19th century
wood, pigment
h.78 cm
Staatliche Museen zu Berlin, Preussischer
Kulturbesitz, Museum für Völkerkunde,
III C 6000

4.96b

Mask

Fang
Gabon
19th century
wood, pigment
h. 65 cm
Laboratoire d'Ethnologie, Musée de
l'Homme, Paris, 65.104.1

Fang masks connected with the society known as *ngil* continue to arouse tremendous interest because there are so few authentic, well-documented examples in existence. Reference works include the Berlin mask (cat. 4.96a), collected before 1895 probably among the Ntumu of Rio Muni and belonging stylistically to the same family as the mask in the Art Museum, Denver (collected in 1890). The Denver example was found quite near Libreville, in the region of the Monts de Cristal, in the territory of the Betsi, which at that time stretched as far as the estuary of the Gabon River.

The understated beauty of these masks, with their simple shape, has long fascinated collectors: the Berlin mask was a major feature of the exhibition at the Museum of Modern Art, New York, in 1935. It is regrettable that those travellers and anthropologists who saw the masks in use did not attempt to find out more about them. The descriptions left by early ethnographers attributed only a 'decorative' or playful role to them; detailing social ritual in all its complexity occupied their time fully enough. At the end of the 19th century the *ngil* was an association existing over and above the clan, wielding political and judicial powers; its activity is attested in all the southern parts of Fang territory, around the Gabon estuary and the Monts de Cristal, in the south and north-east of equatorial Guinea (Rio Muni), the upper Woleu Valley, among the Ntumu people in the east, the Okak in the west and the Betsi in the south.

The masters of the *ngil* could travel from village to village without danger because their role as peace-keepers was recognised; they were considered particularly useful in combating sorcery and evil practices, and in adjudicating between clans in conflict and rival villages. Rather than provoking any aesthetic feelings, the mask was a symbol of fear and retribution. The usual punishment for people convicted of sorcery was death. When the master of the *ngil* was summoned to a village he would arrive at night with a troop of followers, a kind of militia in the pay of the *ngengang*: master and judge arriving by the light of rush flares must have greatly enhanced the

dramatic effect of the masks. The *ngil*, for those more interested in participating in it than being subjected to it, involved a very strenuous initiation ceremony. Its therapeutic rituals were complementary to those of the *byeri* (cf. cat. 4.91).

The masks themselves, seen without their fibre ruff and without the dancers' clothing of raffia strips, give a false impression of serenity. The deliberate anatomical distortion is consistent with the need to personify a terrifying, semi-human being. The mask's job was to confound the sorcerer, hunt down the social deviant, punish the criminal.

The stylistic features typical of the Fang are all here: very broad, quarter-spherical forehead, double arch over the eye sockets, heart-shaped face, projecting mouth, headdress with a central crest (typical of the southern Fang), semicircular scarring on the brow and cheeks exaggerated to inspire fear.

White (kaolin wash) is the colour of the dead or of spirits. Created as weapons of terror, the masks still suggest the tripartite power of healer, man and ethereal spirit. *LP*

Provenance: cat. 4.96a: collected before 1895; cat. 4.96b: ex A. Lefèvre Collection; 1965, acquired by the museum
Exhibition: cat. 4.96a: New York 1935

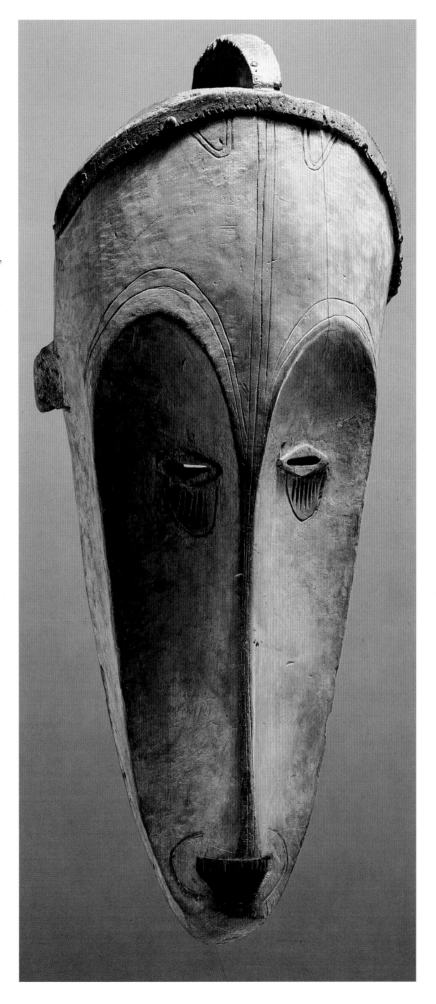

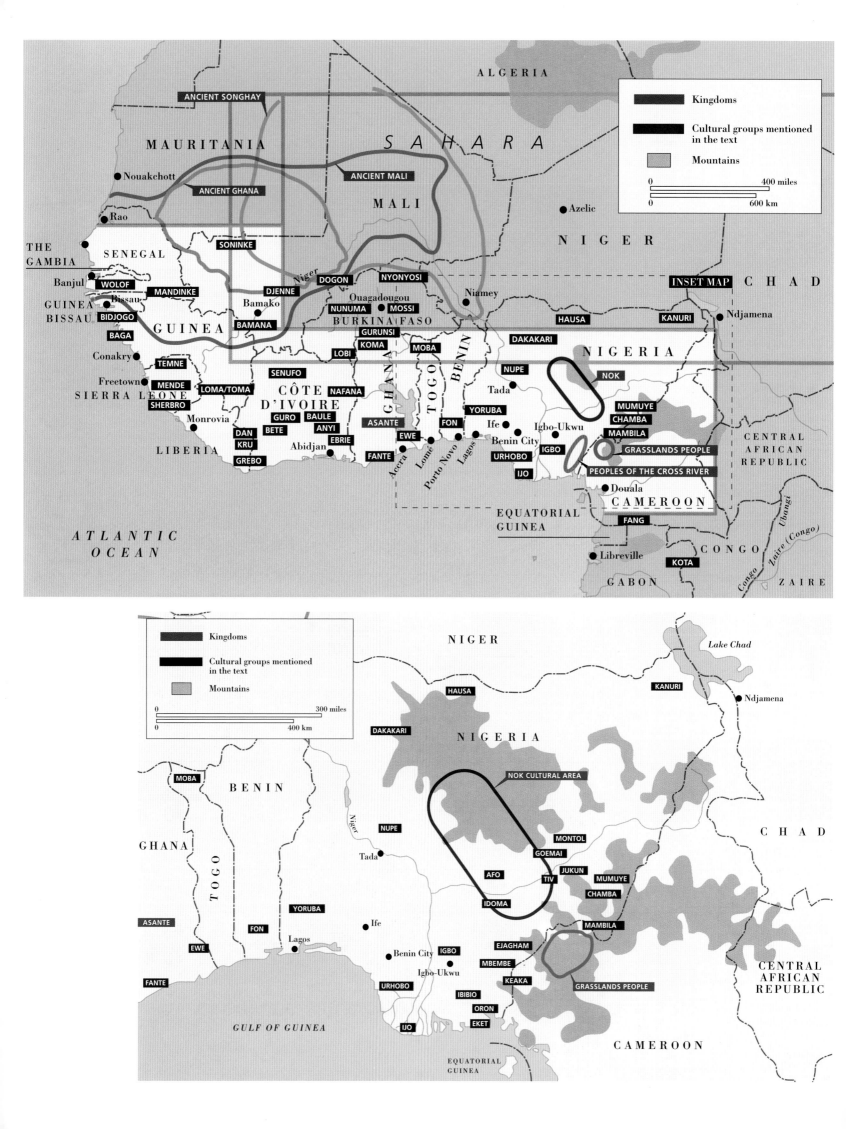

Top map legend:

- Kingdoms
- Cultural groups mentioned in the text
- Mountains

0 _____ 400 miles
0 _____ 600 km

Top map labels:

ALGERIA

ANCIENT SONGHAY

MAURITANIA

S A H A R A

Nouakchott

ANCIENT GHANA

ANCIENT MALI

M A L I

Rao

Azelic

N I G E R

THE GAMBIA

SENEGAL

SONINKE

Banjul · WOLOF

MANDINKE

DJENNE

DOGON

NYONYOSI

Niger

Niamey

INSET MAP

C H A D

Bissau · GUINEA BISSAU

BIDJOGO

BAGA

Bamako

NUNUMA

Ouagadougou

MOSSI

HAUSA

KANURI

Ndjamena

GUINEA

BAMANA

BURKINA FASO

GURUNSI

KOMA

MOBA

B E N I N

DAKAKARI

N I G E R I A

Conakry

TEMNE

LOBI

NUPE

NOK

Freetown · MENDE

SIERRA LEONE

SHERBRO

LOMA/TOMA

SENUFO

NAFANA

CÔTE D'IVOIRE

GURO

BAULE

ANYI

GHANA

TOGO

YORUBA

Tada

MUMUYE

CHAMBA

MAMBILA

Monrovia

DAN

BETE

EBRIE

ASANTE

EWE

FON

Ife

Igbo-Ukwu

CENTRAL AFRICAN REPUBLIC

KRU

LIBERIA

Abidjan

FANTE

Accra

Lome

Benin City

URHOBO

IGBO

GRASSLANDS PEOPLE

GREBO

Porto Novo

Lagos

IJO

PEOPLES OF THE CROSS RIVER

Douala

CAMEROON

ATLANTIC OCEAN

EQUATORIAL GUINEA

FANG

CONGO

Libreville

KOTA

GABON

ZAIRE

Congo

Zaire (Congo)

Ubangi

Bottom map (inset) legend:

- Kingdoms
- Cultural groups mentioned in the text
- Mountains

0 _____ 300 miles
0 _____ 400 km

Bottom map labels:

N I G E R

Lake Chad

HAUSA

KANURI

Ndjamena

DAKAKARI

N I G E R I A

C H A D

MOBA

B E N I N

NOK CULTURAL AREA

GHANA

TOGO

NUPE

MONTOL

GOEMAI

AFO

JUKUN

Tada

TIV

MUMUYE

CHAMBA

YORUBA

IDOMA

MAMBILA

ASANTE

FON

Ife

EWE

Lagos

Benin City

IGBO

EJAGHAM

FANTE

Igbo-Ukwu

MBEMBE

CENTRAL AFRICAN REPUBLIC

URHOBO

KEAKA

IBIBIO

GRASSLANDS PEOPLE

ORON

IJO

EKET

CAMEROON

GULF OF GUINEA

EQUATORIAL GUINEA

5 WEST AFRICA AND THE GUINEA COAST

John Picton

The conditions for a history of African art

Any introduction to the history of art in west Africa must take account of certain basic conditions. First, the sub-Saharan region of Africa has been substantially self-sufficient and innovative in regard to the inception of its pre-industrial technology, and, by implication, its visual arts. Second, west Africa is defined geographically by two episodes in prehistory: the formation of the Sahara, with its wide-ranging consequences, and the apparent dispersal of both the Bantu languages and an iron-working technology from what is now the Nigeria/Cameroon border region. Third, in this region the evolution of forms in local technology and tradition has often been contingent upon responses to the Mediterranean world and, after the 7th century AD, to Islam via trans-Saharan trade routes for as long as the Sahara has been a desert and to Europe via coastal trade from the late 15th century onwards; but these responses have been determined by local conditions. Fourth, any account of the history of art in sub-Saharan Africa is bound to seem rudimentary, given the extraordinary lack of data, especially when compared with what we know of European art; and very often the work of art itself is the only 'information' that we have about a given site or population.

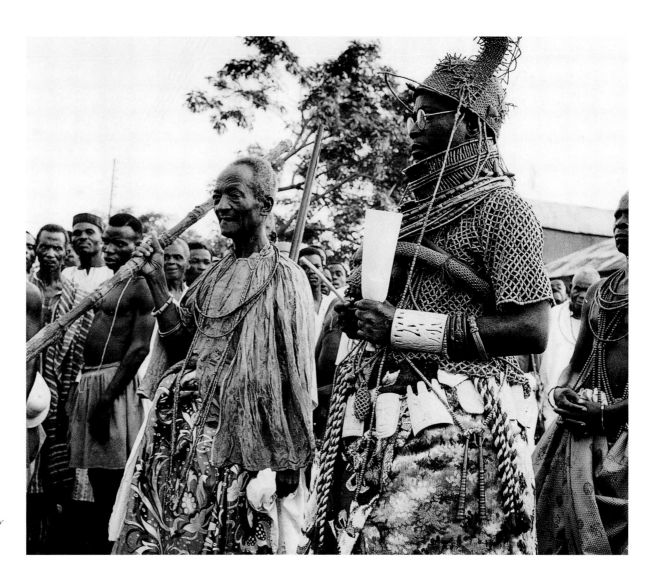

Fig. 1 Oba Akenzua II, King of Benin, Nigeria, 1933–78, wearing coral and ivory regalia at one of the great ceremonial events

327

The reasons for this lack are not hard to discover: the scant archaeological coverage of the continent compounded by theft and illegal excavation, and the absence of written records compounded by inadequate assessment and incomplete collection of oral tradition. Moreover, most of the 'classic' works of sub-Saharan African art, unless they are the products of excavation, date from the late 19th and early 20th centuries, a period in which colonial rule was imposed upon Africa, a fact with implications for the assessment of the visual arts that we do not yet know how to contend with. Progress has been made: here and there information can be recovered about individual artists; and the very fact that one can write about west Africa in the terms set out here is a measure of the advances that have been made, particularly in our understanding of prehistory. Yet it is only in regard to the 20th-century visual arts of Africa that we can begin to gather the volume of data that would be considered the art-historical norm elsewhere.

Prehistory and technology

Several years ago, the archaeologist John Sutton proposed an 'Aquatic Civilisation of Middle Africa' composed of settled communities of fisher-people along the once fertile watercourse of what is now the southern Sahara/Sahel region, stretching more or less across the entire breadth of the continent. While the idea of a single civilisation was too simplistic, and while subsequent investigation suggests considerable regional diversity, the basic facts on which his argument was based still remain. There were populations dependent upon fishing and upon harvesting wild grain – probably wild species of sorghum – which had evolved distinctive fishing and ceramic technologies, with a pottery tradition immediately recognisable by a 'dotted wavy line' decorative patterning thought to have been made by using the spiny vertebrae of fish. For example, the central Sahara site of Amekni, dating from c. 6100 BC, provides evidence which suggests that pottery making began at that time and that its inception was independent of both Western Asia and Ancient Egypt (which evolved a ceramic technology later than both Western Asia and the Saharan region), among a population which, genetically, was closely akin to that now inhabiting sub-Saharan Africa.

At this time, the central Saharan region still supported a wide range of wild mammal species, as we can see in the earliest rock engravings. From about 4000 BC, perhaps in response to the gradual onset of the drying up of the Saharan region, there was a shift to a cattle-keeping pastoral economy in the central Sahara, and the paintings and engravings of this period in the Sahara – the period in which it became a desert – are dominated by scenes of cattle herding. Moreover, archaeological evidence proves that there was a gradual north-east to south-west movement of pastoralists through the Saharan region, with, it can be reasonably inferred, pressure on the resources, the fish and the wild grain, of the communities of the so-called 'Aquatic Civilisation'. These climatic and demographic changes (which in the Nile Valley led to the inception of predynastic Egyptian civilisation) provided the conditions for people in the communities of what is now the Sahel region to start to domesticate plants in sub-Saharan Africa, a development that was independent of such changes elsewhere (including Ancient Egypt). Finally, it is probable that the border region between Nigeria and Cameroon was the area of dispersal, eastwards and southwards, of the Bantu languages and of an ironworking technology.

These are the episodes that define west Africa as a region, and define both its distinctive qualities and the period in which they were established. The period of the inception of metalworking in sub-Saharan Africa probably coincides with the period in which paintings and engravings of rock art of the Sahara frequently show horse-drawn wheeled chariots. Moreover, the distribution of these paintings and engravings, when plotted on a map, indicates the existence of routes across the Sahara that are uncannily like the western and central trade routes of medieval Islam as established from the 9th century onwards.

As to the origins of sub-Saharan metalworking, a technology essential to the practice of the visual arts, the presence of ceramic technology together with the evidence coming from the copperworking sites of Akjoujt (now in Mauritania) and Azelik (now in Niger) suggests that ironworking may have evolved locally and was not introduced by Phoenicians (via Carthage), Egyptians (via Meroë) or Arabians (via Aksum), as has been argued. It is well known that throughout sub-Saharan Africa the advent of iron-working was preceded by the continued use of stone tool technology without the intervention of a so-called Copper Age; whereas the discovery of copper smelting, for reasons of its lower melting point, is proven elsewhere to have been an essential prerequisite for the start of iron smelting. Thus it was assumed that this technology must have come to Africa from elsewhere, and discussion has revolved around the respective merits of the three possible sources just given, with Carthage and the trans-Saharan route as the most likely explanation. Yet, as the ability to control fire (the basis of both pottery and smelting) was already established late in the 7th millennium BC, and as there is evidence of early copper working sites in Akjoujt, Mauritania, and Azelik near Agadez in Niger from 2000 BC onwards, that entire discussion is rendered irrelevant and will remain so until we have some knowledge of the commodities of a trans-Saharan trade in its earliest beginnings. As yet we do not know if metals and/or the knowledge of metalworking figured in trade nor in which direction either might have passed.

Whatever one makes of these arguments, they are essential to an assessment of sites dated between 500 BC and AD 200 located across a wide area of what is now central Nigeria that provide unique evidence within west Africa for the existence of sculpture south of the Sahara. The medium of this sculpture is pottery, and though often referred to as 'terracotta', the clay fabric has the same coarse texture as most pottery, whether domestic or sculptural, in sub-Saharan Africa. But it should not be inferred that this is in some way a 'primitive' technology, notwithstanding the absence of both wheel and kiln. Coarse-textured clay was used in hand-building and bonfiring to create a pottery of a finely structured quality and of a utility adapted to the pre-industrial environment of Africa that cannot be matched by anything made with the wheel and the kiln. Moreover, these sculptures are not the rudimentary beginnings of an art but belong to a developed sculptural tradition. That they are its earliest evidence suggests a previous history yet to be discovered.

These sites, first identified by their pottery sculpture, are conventionally referred to as the Nok Culture, after the village on the southern escarpment of the Jos plateau close to the site where this sculpture was first described. Whether these sites represent a single population is open to question. In addition to the sculptures, Nok sites also provide the first clear evidence for iron smelting in the west African savanna. It was once suggested that the Nok Culture represented the very beginnings of ironworking, but it is now clear that, far from being unique, Nok Culture sites are only some of a series of sites across the savanna region south of the Sahara in east and west Africa dated to the last millennium BC, which provide early evidence for an ironworking technology. Nevertheless, Nok provides the earliest evidence yet available for a developed sculptural tradition in sub-Saharan Africa; and if the institutional arrangement whereby the potter is the wife of the smith, which still survives in many areas of sub-Saharan Africa, is of any antiquity (as the relationship between the two technologies suggests), then one might speculate that the earliest evidence for a developed sculptural tradition is also evidence of women working as sculptors. For, in addition to the simultaneous emergence of pottery sculpture and iron-working, at least some Nok sculptures are ring-built, a technique which is still used by women potters; and today potter-sculptors in the central Nigerian region are women.

Elsewhere, in Mali, at times comparable to Ife, we find more than one tradition of pottery sculpture, especially at the site of ancient Djenne (established as an urban centre in AD 800) in the inland Niger Delta, a site which also, possibly, provides the earliest evidence of urban living in sub-Saharan Africa.

These sculptures can be placed alongside those of Nok and Ife as evidence of the variety and wide distribution of pottery as a sculptural medium, but without suggesting any direct likeness, let alone continuity of style or influence. The later works in pottery, whether from archaeological sites, such as Koma in what is now northern Ghana, or Bankoni in southern Mali, or from the cemeteries character- istic of Akan communities in the more recent past, all suggest these same facts: that pottery is a medium widely used, and of considerable antiquity, yet neither ethnographic nor archaeological data yet exist whereby a history of art for this medium can be charted. The fact that this exhibition presents a broader selection of the material than has hitherto been brought together is in some part the result of illegal and undocumented excavations, the work of local entrepreneurs eager to satisfy the art-hungry savages of the Western world. From an art-historical point of view the tragedy is that one can know little or nothing of the original circumstances of this material, with the result that a history of art is reduced to a history of European engagement with it: all the rest is either circumstantial or imaginary. Ancient Djenne is simply not known in the manner of, for example, Ancient Egypt. Meanwhile, the loss of cultural property and the loss of ever knowing anything of its original circumstances is a double penalty for all the nation states of Africa.

Pottery sculpture is thus both ancient and widespread in west Africa, and it remains among the extant practices of the recent past that still, sometimes, survive. Its disappearance is less to do with changes in ritual practice than with technology. With few exceptions, pottery sculpture is the work of potters, almost invariably women, and as the use of ceramic wares has been superseded by recent industrial technology (most obviously the use of kerosene-burning cooking equipment and aluminium utensils, and the relatively higher costs of urban dependence upon wood as fuel) so the necessary skills are lost. Even when pottery has become a medium of education in the fine art curriculum of a school or university, the technical means are those of an industrialised society. Closely related to fired clay as a medium of sculpture is unfired clay, examples of which are widespread but largely uncollectable; within this tradition cement is frequently used for sculpture. However that may be, in the last millennium BC and the first millennium AD the smelting and forging of iron was practised throughout west and, indeed, the greater part of sub-Saharan Africa. During this same period the present-day distribution of lan- guages was established throughout Africa together with, we can probably assume, the bases of the social and aesthetic traditions of the recent past. The final stage of that process is the spread of ironworking and Bantu languages from the region now identified as the Nigerian-Cameroon border through eastern, central and southern Africa. By the end of the first millennium, the city and the state were already established: by 800 the city of ancient Djenne in the inland delta of the River Niger is estimated to have contained some 10,000 people, and the medieval state of Ghana at the headwaters of the Upper Niger was known to the Islamic world. A local bronze-casting technology had evolved at the 9th-century site of Igbo-Ukwu. By 1000 we have the beginnings of the rise of Ife in the forests west of the Lower Niger, while in the 11th century Ghana was converted to Islam.

The rock art of the Sahara has thus provided evidence of changing human and animal populations in response to the climatic changes that turned it into a desert. It also seems to show that for as long as the Sahara has been desert, people have been going backwards and forwards across it. This suggests a network of trade routes of great antiquity, certainly dating from before Islam took control of the Mediterranean access to west Africa and India, and of their products (especially west African gold and Indian pepper) which was the reason for the 15th-century Portuguese exploration of the west African coast and beyond. This trade was hardly likely to have stopped at the Sahel, and one can suppose that it disseminated local African innovations further afield and eventually enabled the religion and culture of Islam to reach west Africa (notwithstanding the trans-Saharan brass-casting technology of Ife and the indigenous tradition of

Igbo-Ukwu; many Asante vessels are from north Africa, while the early weights for gold-dust almost certainly fitted a system of Islamic origin). The area was originally technically self-sufficient but later absorbed elements from beyond the Sahara and others from coastal trade. This in turn implies a factor fundamental to any understanding of the social and art-historical significance of trade: the importance of local traditions in shaping responses to these worlds beyond west Africa and in domesticating their products. Two examples will show this clearly: the melting down of European brass in 16th-century Benin to create the plaques that embellished the royal palace; and, in the early 18th century, the unravelling of Dutch silks by the Asante to make use of the yarn in their own textiles.

Languages

Today in west Africa some languages are spoken by populations of a few hundred and some by populations of several million. They represent three of the four great language families of Africa: Nilo-Saharan, Afro-Asiatic and Niger-Congo. (Khoi-San languages are located only in the southern half of the continent; and I also exclude Indo-European languages that have dominated the institutions of education in colonial and post-colonial times.) It is worth remembering that not only are the languages themselves different one from another (and we are talking of differences of the order of that between English and Chinese), but each presupposes a conceptual order that is equally different.

The 'Middle Africa' of Sutton's 'Aquatic Civilisation' discussed earlier in this essay, whose subsistence technology was so crucial to all subsequent developments in west Africa, as well as to the Nile Valley, is presumed to have been dominated by speakers of Nilo-Saharan languages; though if so, their present distribution suggests a subsequent rupture by Afro-Asiatic-speaking populations. Today in west Africa, Nilo-Saharan languages are found among riverine communities of the Middle Niger and in the Lake Chad region. The Afro-Asiatic language group, now thought to have originated in the Ethiopian region, includes the Arabic and Berber (e.g. Tifinagh, the language of the Tuarag) of desert pastoralists, and Hausa and related northern Nigerian languages (as well as Coptic and ancient Egyptian, Hebrew, Somali and the languages of Ethiopia). The greater part of west Africa is, therefore, dominated by the Niger-Congo languages, and these have been grouped into six branches: West Atlantic, Mande, Voltaic, Kwa, Adamawa and Benue-Congo (i.e. Bantu-related and Bantu, which, as already noted, have spread to dominate the greater part of eastern, central and southern Africa). Recent analysis, however, has extracted Dogon from Voltaic and Ijo from Kwa as sufficiently divergent to merit consideration as separate branches, while reclassifying Kwa within the Benue-Congo branch alongside the Bantu-related languages.

As the name implies, communities of people speaking West Atlantic languages often live at the very edge of the continent where they have been pushed by the expansion of their Mande-speaking neighbours. West-Atlantic-speaking communities and languages include Wolof in Senegal, Baga in Guinea, Bidyogo in Guinea Bissau and Sherbro of coastal Sierra Leone, whose ancestors were almost certainly the sculptors of *nomoli*, stone images for local use, and of ivory sculptures for sale to Europeans in the 16th century. The Fulani language is also within this group, spoken by pastoral cattle herders, communities of weavers around the inland delta of the Upper Niger and town-dwelling households. The latter often provided the leaders of Islamic reforming movements such as the early 19th-century Fulani jihad that swept through the area that is now northern Nigeria and established new aristocracies in the Hausa emirates. Fulani-speaking people are spread from Senegal to the Sudan Republic, scattered among speakers of almost the entire range of west African languages as a consequence of seasonal transhumant movements from north to south combined with a measure

of migratory drift over several centuries; whenever the pastoralists have moved on, so groups of town-dwelling Fulani remain.

Inland from these coastal communities, the Mande languages predominate, especially in the western forests and savannas. These include Mende in Sierra Leone, Dan across the Liberia-Guinea-Ivory Coast borders, and Bamana in Mali. To their east there are peoples speaking Voltaic languages, such as Dogon in Mali, Senufo in Ivory Coast, Mossi, Bwa and Bobo in Burkina Faso; and these are populations that have all proved themselves to be fine and prolific sculptors, weavers and builders. The great Kwa group dominates the savannas and forests of eastern Ivory Coast as far as the Cross River in south-eastern Nigeria. This comprises, among others, the Akan/Twi-speaking communities of southern Ivory Coast (e.g. Baule) and modern Ghana (e.g. Asante), through Ewe and Fon to Nigeria and Yoruba, Edo, Nupe, Igbo etc. The Adamawa branch (e.g. Chamba) stretches eastwards from the upper Benue area; and finally we meet the Bantu and Bantu-related languages of the Cross River area, the forests and grass-lands of southern Cameroon, together with some of the communities of the Benue (Tiv, Jukun) and Middle Niger (Dakakari) regions of Nigeria.

The emergence of states and the metalworking arts

A powerful image of the place of west Africa within the medieval world is offered by Mansa Musa, emperor of Mali. In 1324, in the course of his pilgrimage to Mecca, he stayed in Cairo where he dispensed so much gold that, although everyone seemed to have benefited from his generosity, the value of gold, for a while, collapsed. At the time, and indeed until the discovery of the Americas, west Africa was the most important source of gold in Europe: English gold coins from the 14th century, for example, are of west African gold; and the Portuguese exploration of west Africa was intended to subvert the Moroccan control over European access to gold from Africa and pepper from India.

Both the empire of Ghana, the earliest-known state of sub-Saharan Africa, and that of Mali, founded by the mythic hero Sundiata at the end of the 12th century, were relatively well known to the Islamic travel writers of the time. The existence of these and later pre-colonial states, and their rise and fall, particularly in the western half of west Africa, appears to have been dependent upon Saharan salt, west African gold, trans-Saharan trade and access to the network of routes across west Africa. The major goldfields of Bambuk and Bure were located in what is now Senegal and Guinea, while the Akan gold-fields, essential to the formation in the late 17th/early 18th century of the Asante confederacy, are in modern Ghana. (In 1957 Nkrumah took Ghana, the name of the first state in sub-Saharan Africa, as the name of the first post-colonial independent nation.) Further east, in the region that is now Nigeria, the existence of the Hausa states, and the rise and fall of the Yoruba cities of Ife (11th–15th centuries) and Oyo (17th–19th centuries) cannot, however, be explained in terms of control over access to goldfields for the simple reason that there were none; but they were linked into the trans-west African/Saharan network via the Middle Niger.

One popular theory of how states are formed is that authority and wealth are concentrated at key points along trading routes and networks, and the transfer of wealth is controlled by an emergent élite class. This does not explain everything, partly because human history is always very much more complex than any theory will allow; and some of the most fruitful centres of art, such as Igbo-Ukwu, or the Opin villages of north-eastern Yoruba, are far from any well-beaten track. Moreover, one does not wish to perpetuate the notion that history is the history of states and kingdoms, as if there were no other forms of social and political order. Nevertheless, this theory does explain a good deal about the rise and fall of Ghana, Mali and their successors; and of Ife and Oyo. Added impetus was given to this process with the

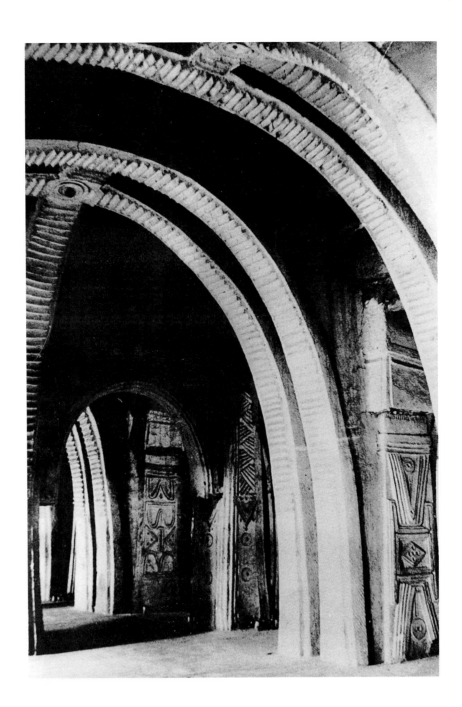

Fig. 2 Interior of the Friday Mosque, Zaria, Nigeria, built c. 1836 by Baban Gwani Mikhaila (Michael the Genius), the most famous of the Hausa architects

appearance of Europeans at the coast: Robin Horton noted the emerging centralisation of authority in the 18th and 19th centuries in those Niger Delta communities that entered into trade with Europeans. Some states, for instance Asante and Oyo, were on both the coastal and the trans-Saharan trade networks.

By the time the empire of Ghana was destroyed by Sanhaja Berbers in the 11th century it was already an Islamic state, and trans-Saharan and long-distance west African trade routes were controlled by Muslims. Indeed, the widespread conversion to Islam throughout west Africa is the clearest and most long-lasting result of the trans-Saharan trade routes. The presence of Islam has had profound formal implications for developments in architecture (fig. 2), sculpture, masquerade, textiles and double-heddle weaving; and the decorative arts throughout the region and the diverse relationships between Islamic and local ritual practice must also be taken into account. In many ways the most significant consequence of trans-Saharan trade for the history of art was the importation of copper and brass (copper alloyed with zinc, and always with a little lead to improve the fluidity of the molten alloy) and, possibly, a lost-wax brass-casting technology. Copper and brass, whether as ingots or as vessels, were major imports into west Africa. (Sculpture in wrought iron is less widely found in west Africa than brass: the most notable examples occur

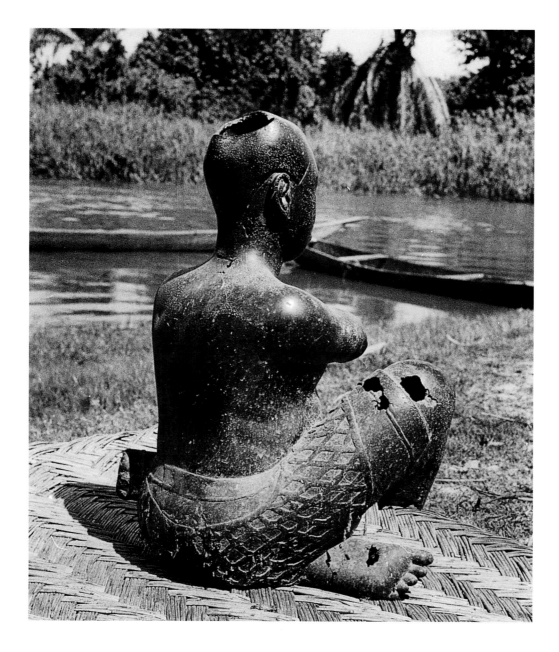

in Igbo, Edo, Yoruba and Fon communities in southern Nigeria and the adjacent Benin Republic, and in Bamana and Dogon communities in Mali. The linear and schematic qualities of this work are manifestly contingent upon the intractability of the medium.)

The art of Ife in particular, where the gods climbed down from heaven to make the Yoruba world, was developed first in pottery and then transferred to brass, using the lost-wax technique, in the course of its 'classic' period, the 11th to 15th centuries. The forms of Ife art owe nothing to an outside world, and the casting technology may or may not have been to hand; whereas the brass is certainly of trans-Saharan origin.

In contrast to Ife, the earlier (9th century) castings of Igbo-Ukwu are of a leaded bronze (an alloy of copper and tin, with lead) almost certainly of local derivation. The constituent metals were all available in the area (a fact hitherto overlooked) and the lost-wax method was employed in a manner that suggests it was an independent local invention. The very use of bronze at this date was unusual; elsewhere in the world brass was the most commonly used alloy (with bronze used only for specialist work). Why the castings of Igbo-Ukwu should appear where they do remains an enigma. One of the characteristic features of the region immediately to the west of the Lower Niger is the presence of settlements with walls or ramparts, indicating the need for protection from enemies. Ife was a substantial urban settlement

Fig. 3 The seated figure of Tada contemplating the River Niger. The apparent realism of the copper casting even records the rolls of fat characteristic of the middle-aged male waist

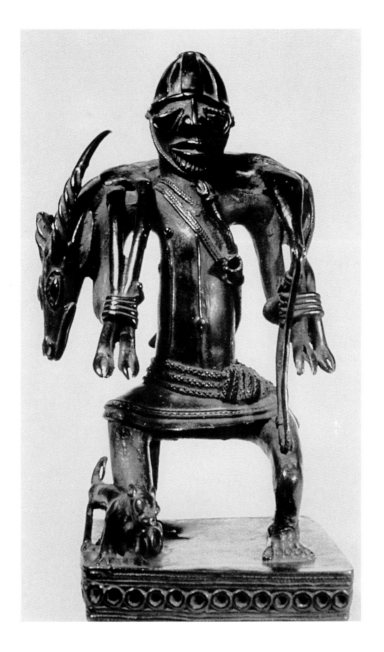

with paved courtyards, forest and city shrines, a glass-making industry, and a royal palace. By contrast, to the east of the Lower Niger, neither settlements nor defensive structures are characteristic which suggests the settlements were sufficiently isolated not to require defence. This makes the Igbo-Ukwu bronzes the more inexplicable, particularly as they are the earliest sub-Saharan evidence for the use of copper alloys in art.

The rise of Ife, beginning in the 11th century, can be easily explained: its key location controlled access to forest products by way of the trading networks of west Africa, which were to be dominated by, and linked into, the trans-Saharan trade route via the Wangara, the Muslim Mande-speaking traders of the empire of Mali. The celebrated seated figure of Tada is a case in point (fig. 3). This casting in Ife style was kept (until its removal to the National Museum, Lagos) in the obscure riverine Nupe village of Tada, where it was emblematic of Tsoede, the founding hero of the pre-jihad dynasty of Nupe kings. It also has stylistic similarities to works discovered at Ife. However, not far away, upstream along the River Niger, there is an isolated group of communities of Mande-language speakers. That these could be a surviving remnant of the traders of the empire of Mali who served to link Ife into that wider trading network might account for the apparent dominance of Ife (in so far as art can provide such evidence) over access to the forests of the Lower Niger region. In that case Tada, located north of Ife on the Middle Niger,

might have been the point at which the agents of Ife connected with the Wangara of Mali, and the authority of the agents of Ife might in some manner have been legitimised by the presence of the cast figure.

This hypothesis, though the best we yet have, does not explain the other figures also once located at Tada, also associated with Tsoede and now in the Lagos museum, for these are manifestly not in the style of the seated figure and thus, it is to be assumed, not Ife works. Nor does it explain the magnificent pair of figures, also emblematic of Tsoede, that were once at Jebba, the Nupe community on an island upstream from Tada. One is of an archer (Lagos museum), the other, of a standing woman, was stolen from its house in Jebba some 25 years ago. All one can say of this diverse group of castings is that they indicate the existence of other, as yet unlocated, copper-alloy casting centres in the Middle and Lower Niger region.

A great many other castings support this proposition. These include figure sculptures, figurative bells and vessels, all categorised by William Fagg as the Lower Niger Bronze industries, though he insisted that this was a merely provisional grouping defined more in terms of our ignorance of their origins than in terms of style. Perhaps the most notable and certainly the best-known of these castings is the extra-ordinary figure of a hunter bearing an antelope (fig. 4). It is of bronze, rather than trans-Saharan brass, as are all those of the same group that have been tested, which suggests that indigenous casting technology was more widespread in the proto-historic period of the Lower Niger region than has been supposed. We know of several centres of brass-casting in the region to the west of the Lower Niger dating to the late 19th and early 20th centuries: for example, as well as Benin City, there were the Yoruba-speaking cities of Ijebu-ode (whence casting was transferred to Abeokuta) and Owo, and the north-east Yoruba villages of Obo-Ile and Obo-Ayegunle, none of which has been investigated in regard to casting. There is no evidence as yet of casting at either Ife or Igbo-Ukwu, other than the works themselves, in the sense that while some of the sculptures appear as isolated artefacts, others were excavated within ritual configurations; but none has yet been excavated from a workshop. (The present-day casting workshop in Ife is a latter-day introduction with no continuity with any period before this century.) It is, of course, true that there is no excavated evidence for casting in Benin City before the present century, but the context is quite different; it would be hard to deny a substantial measure of visual continuity between the castings of the 16th century and the ritual and ceremonial environment of the present. As to the origins and sources of copper-alloy-casting in Benin City, it is worth noting that while at least one tradition in Benin itself identifies Ife as the source of the lost-wax casting technology (as part of the mythic package legitimising the present dynasty of kings), the works themselves suggest otherwise; given the high status of the Benin corpus this will be explored below.

The technique of brass-casting was used in the recent past, and is still practised in many locations in west Africa. In Cameroon, Fumban is the major centre, which once produced tobacco-pipe bowls, brace-lets and other decorative works, and today is still active, producing astonishing oversized replicas of Ife and Benin antiquities. In south-eastern Nigeria and in the Niger-Benue confluence there is evidence of casting traditions, not obviously derived from Igbo-Ukwu, that have not been studied. In Abomey, the capital of the Fon kingdom of Danhome, small-scale ornamental figurative castings have been produced since the introduction of the lost-wax technique by Akan casters in the 19th century. Akan (that is, Twi-speaking) casters are known for the brass weights for measuring gold and for covered vessels often incorporating human and animal tableaux. The same lost-wax technique was also employed for casting gold, whether as jewellery for chiefs or as figurative ornaments that encourage discourse in terms of proverbs or for state swords in the Asante confederacy. (Gold leaf applied to carved wood has also been used for chiefly regalia throughout the Akan region, in particular umbrella

finials, the tops of staffs for chiefs' spokesmen, and stools.) In the north of modern Ghana and in the adjacent regions of Ivory Coast and in Burkina Faso there is a complex of figurative and decorative casting traditions that include Frafra-, Mossi-, Dyula- and Senufo-speaking peoples. Of particular interest are the often complex metaphysical connotations of apparently commonplace artefacts. Further west, figurative brass-casting traditions exist among the Dan, Bamana and Dogon people, and castings are now coming to light that appear to have some temporal relationship with the pottery sculptures of ancient Djenne. The fact that such discoveries appear to be made largely in the context of a thieving that runs counter to archaeological investigation is, of course, a tragedy for historical understanding. Meanwhile, the works of art remain the only evidence of a people and a social and aesthetic context that we yet know little about.

The fact that in all the latter-day traditions a copper-zinc alloy is used may indicate that the technique originated from a trans-Saharan source, with the obvious exception of Igbo-Ukwu. Substantial quantities of brass were exported across the Sahara as rods or as ready-made vessels. On the other hand, the Lower Niger hunter is cast in bronze; the most plausible hypothesis is that it comes from an as yet unidentified early Yoruba-speaking casting centre other than Ife; and as far as we know all latter-day Yoruba casting employs brass. This suggests the possibility that the casting technology was an indigenous invention that in due course made use of sources of metal that rendered the technologies of mining, smelting and alloying obsolete (similar considerations explain the demise of the mining and smelting of local iron ore in the present century). Discussion of the early period castings of Benin also has to take into account the implications of alloy content. In any case, brass was an important export to west Africa in the coastal trade initiated by the Portuguese in the late 15th century; and the brass in common use at the present time, as in the recent past, is largely European scrap (or, of course, old castings).

Gold, in contrast, is a metal seemingly far less valued in art than copper and its alloys. Indeed, it was because of information to that effect garnered by the Portuguese from their military conquest of Morocco in the 15th century that they carried copper and brass manillas as a medium of trade in their explorations of the African coast, metal that helped the innovative developments in 16th-century Benin, in particular the development of the plaque form (cat. 5.60b–e). In the Asante confederacy, however, gold was a metal of social and political consequence in the casting of jewellery and regalia (cat. 5.103), in its imitation in yellow silk (cat. 5.93), and in its use as currency with the attendant casting of weights in brass (cat. 5.103–7). In mythic terms, the most significant artefact is the Golden Stool, conjured from the sky on a Friday in c. 1700 by Anokye the priest, thereby initiating the Asante confederacy and confirming Osei Tutu as its high king.

The history of art in Benin City

It is evident from oral tradition, and from the fragmentary reportage of European visitors to Benin from 1485–6 onwards, that the city, kingdom and empire experienced two major periods of economic and political growth. The first is centred on the late 15th-century king Ewuare, who is said to have wrestled with the god of the sea to obtain the coral beads essential to royal and chiefly regalia, who introduced the red barathea (a felted textile) a crucial element of ceremonial dress, and who instituted and defined the present orders of chiefly titles. Ewuare was succeeded by a series of warrior kings, the last of whom reigned in the latter half of the 16th century. The 17th century was a time of gradual decline until the fortunes of Benin were revived in the early 18th century by Akenzua. There followed another period of gradual decline ending with the destruction of much of Benin City and the exile of its king by the British in 1897. A subsequent revival started with the re-institution of kingship in 1914

(fig. 1). Probably there is now as much casting in Benin City as there ever was, a development as yet undocumented.

Much of the history of Benin seems to be represented in brass-casting, although there is no precise coincidence between art and politics; William Fagg categorised Benin art within three periods. For example, the early 18th-century resurgence of Benin is associated in oral tradition with the inception of new forms of casting which are also marked by stylistic developments that Fagg regarded as ushering in a late period. Fagg's middle period is likewise defined by innovation in form, in particular the rectangular plaques that were mounted on wooden pillars in the verandas of the royal palace until it was apparently rebuilt around or soon after 1700. The inception of the plaque form can be assigned to the period of the advent of Europeans for at least two reasons: first, because the imagery of the plaques includes the Portuguese themselves, who were not seen in Benin City until 1485–6 (and one could argue that the plaque form offered Benin artists the possibilities of an indigenous representation of their own art forms and ceremonial in art); and, second, because the plaques manifest an expansion of the brass-casting industry that can only be attributed to the availability of vast quantities of copper alloy.

In the course of twenty months in 1505–7, the last Portuguese agent expended 12,750 manillas (bracelets) in trade with Benin in Ughoton, and by this time the people of Benin preferred brass to copper manillas. Moreover, the demand for manillas increased so much that by 1516–17 a single ship was recorded carrying 13,000 in one voyage to Benin. In other words, the proposition is that the vast quantities of brass bracelets that the Portuguese used to trade with Benin found their way to the casters, thereby enabling the inception and casting of this form. Whether one can attribute the source of the essentially two-dimensional form of the plaque to a Portuguese source, such as illustrations in books (which can be proven as a source of much of the ivory-carving made in Benin in the early 16th century for the Portuguese) is a possibility that remains unproven.

The plaques seem to develop from an experimental phase, illustrated by the plaque of the Portuguese leopard hunters (Berlin), to an increasingly hieratic form of composition, which imposed a character on the art of Benin from which it never really escaped. The best illustration of this is the late period figure of a Portuguese musketeer (British Museum). The Portuguese monopoly of trade with Benin came to an end in the 1530s, and this figure is in early 16th-century dress. His musket, however, can be dated to the late 17th or early 18th century; and the alloy from which the casting is made, because of its high percentage of zinc, can be dated to the late 18th or early 19th century (fig. 5).

The early period castings are thought to predate the advent of European contact; and one group of cast heads displays a degree of naturalism uncharacteristic of castings that can fairly certainly be dated after the advent of Europeans. Dating these works is not simple. The famous ivory costume masks (British Museum and Metropolitan Museum of Art, New York) display an early period naturalism, with a row of bearded long-haired Portuguese heads around the top. In Benin today, these masks are said to represent Idia, the mother of Esigie, the early 16th-century king who, among other things, instituted the office, title and cult of the Queen Mother. Again, in Benin today these early period heads are regarded as trophies representing the decapitated heads of enemies in war. Art-historically they are probably the prototype of the memorial heads known from the middle period onwards and placed upon the altars dedicated to deceased kings. As to the composition of the alloys from which they have been cast, those early period heads that have been examined indicate a leaded gunmetal, that is, copper, tin and zinc, with a small amount of lead to improve the flow of the molten alloy; and, given that both local and trans-Saharan alloys might have been available, this fact alone suggests a greater complexity than the dynastic myths of Ife derivation would allow.

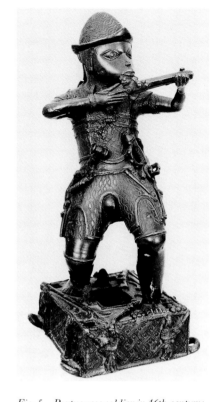

Fig. 5 Portuguese soldier in 16th-century dress, with early 18th-century musket, cast in brass no earlier than 1800. The British Museum, London

Sculptures, textiles, architecture, masquerade

Wood is by far the best-known sculptural medium of art in west Africa, as it is elsewhere in the sub-Saharan region. However, there is no real evidence to suppose that this represents anything other than a European predilection, rather than African taste, bearing in mind, first, the great variety of forms and styles of art in other materials, whether two- or three-dimensional, and, second, the traditional dependence of European and American connoisseurs upon the collected artefact and the manner in which this material has been placed within ready-made categories of 'art' and 'craft' (the latter taken to be of a lesser aesthetic status, a conclusion that flies in the face of what little we actually know of local values). Nevertheless, the range of forms achieved in addressing a block of wood with an adze (with few exceptions the fundamental carving tool of west Africa) never fails to astonish: one need only compare the fulsome works of the Grasslands of Cameroon with the schematic four-square Kalabari forms of the Niger Delta.

Compared with pottery and metalwork, wood is a relatively ephemeral medium, subject to the destructive effects of warfare, fire, rainwater and insects; and often objects have been preserved only by their removal from their original context to an art collection (there is, after all, a positive aspect, directly and indirectly, to the work of 'the art-hungry savages of the Western world'). Throughout much of the 19th century the Yoruba-speaking region, perhaps the most prolific single region in which sculpture has been produced, was ravaged by wars, one kingdom fighting against another. As a result, partly through destruction and partly through social disruption, there are very few extant sculptures in wood dating from earlier than the latter half of the 19th century, and no memory of sculptors other than those occasionally enshrined in the mythic praise-poetry of the gods and heroes. Sometimes the ephemerality of wood sculpture is institutionalised as in the Akoko-Edo communities (to the north of the Benin kingdom) where a set of monumental masks denoting age grades is produced once every seven years and abandoned in a forest grove following the celebrations at which a new set of elders abandons its youth.

The earliest wood sculptures that survived in their original circumstances at the turn of the present century (though now largely in museums) seem to be those ancestral memorials for which secure genealogical evidence suggests dates in the late 18th century, the ancestral figure sculptures of Oron at the mouth of the Cross River in south-east Nigeria (cat. 5.43), and the memorial screens of Kalabari house heads in the eastern Niger Delta. Claims for far greater antiquity have been made for material supposedly the work of the Tellem predecessors of the Dogon inhabitants of the Bandiagara cliffs of Mali (cat. 6.17–18), though the accuracy and status of such claims is uncertain.

One of the consequences of all this is that we can discern little of a history, in the sense of a narrative of developing forms in relation to and as part of inevitably changing contexts of ideas and practices. On the other hand, we know a good deal about such contexts as are extant at the present time, which permit inferences about the recent past. The commemoration of ancestors, whether from a relatively recent (Oron, Kalabari) or a mythic past (Dogon) has already been mentioned. Sometimes, however, figure sculptures are for display and advertisement, as in the processional *tye kpa* sculptures commissioned by Senufo women of the Ivory Coast; contrasted with these are the figures commissioned by Senufo *sandogo* diviners, also women, to represent the spirit familiars that grant them powers of divination. Closely related (conceptually) is the tradition of images of spirit spouses commissioned by Akan peoples in Ivory Coast and Ghana following divination. Then there are the Fon *vodun* (cat. 5.91c) or Bamana *boli* (cat. 6.7) traditions in which figurative images are compounded from materials that serve as tropes of energies that are actualised in ritual. Bangwa portrait statues of kings carved by professional sculptors can be contrasted with images carved by amateurs, steeped in magical medicines intended to damage thieves, for example, showing the cancerous swollen abdomen with which the thief will be afflicted who steals from the house where they are kept (hence the apparently pregnant male figures

from the Cameroon Grasslands; cat. 5.6). Figurative sculpture in the veranda posts of eastern Yoruba (Ekiti) kings (fig. 6) and other well-to-do men is essentially decorative, whereas central Yoruba shrine images mediate between deities and devotees who place sacrificial food upon their lips, and throughout most of the Yoruba-speaking region small figures are carved to replace twins that die in infancy. Thus, there are images as real ancestors, mythic heroes, twins, advertisements and decorative embellishments, spirit familiars and spouses, vehicles of energy and points of mediation. Whatever the institutional and functional bases of these traditions, it is also possible that the images can serve as a stimulus for the articulation of other social concerns.

As to the makers of these images, though there are a few reports of women sculptors working in wood (for example, women carving Dan masks in Liberia), for the most part sculptors in wood are men, sometimes trained by a formal process of apprenticeship, sometimes self-taught. These contrast with metal-workers, on the one hand, for whom the complexities of the technical procedures demand professional specialisation; and potters, on the other, whose skills are passed on informally in the domestic space of women's activities. In a few areas, research has demonstrated the links between style and individual artistry: this is true of the identifiable master-sculptors of the Opin and Ekiti regions of the Yoruba-speaking area; and also of Dan sculptors in Liberia.

Fig. 6 Veranda posts carved c. 1915 by Olowe of Ise-Ekiti for the palace of the Ogoga of Ikere. The posts are now in the USA

Sculpture in ivory is usually closely related to wood-carving, since the same craftsmen work in both materials, though ivory is a much more intractable medium. Indeed, the close-grained hardness of ivory makes for the execution of the finest detail, as evidenced in the first African art objects to reach Europe, the ivories carved in coastal Sierra Leone, Benin City and the Kingdom of Kongo sold in the early 16th century to Portuguese traders (cat. 5.132). Mende, Yoruba and Edo sculptors of the more recent past have continued to work in this medium. Stone is another related medium. It may be soft, as in the schist used especially in pre-16th-century Sierra Leone (cat. 5.133), and for the sculptures found at the Yoruba-speaking village of Esie (cat. 5.71–2); or hard, as in the sculptures of Ife, or in the most extensive grouping of sculptures in stone, the ancestral and chiefly commemorative sculptures in the forests of the middle Cross River in south-east Nigeria.

The earliest evidence of textile manufacture is provided in the 9th century at Igbo-Ukwu where small fragments of unpatterned bast-fibre cloth were excavated, preserved by their close contact with copper in an archaeological site. The assumption is that they were woven on an upright single-heddle loom of the kind that continues to be used by women in Nigeria. Elsewhere, textile fragments in cotton, and wool, using indigo dye, have been found at 11th/12th-century funerary sites in the Tellem caves in Mali. The relatively narrow web suggests that they were probably woven on a horizontal double-heddle loom as used mostly, though no longer exclusively, by male weavers throughout west Africa.

Cotton, wool, wild silk, raffia and bast are all indigenous to particular regions of west Africa, with cotton by far the most widely used. Local dye colours were available from vegetables, and, occasionally, minerals, with indigo, of which there are several plant species, pre-eminent. However, developments in pattern and design in west Africa have been substantially enhanced from at least the early 18th century onwards by the availability of imported ready-dyed silk and cotton yarns, and, later, rayon, viscose and lurex, to provide colours and textures not available within the range of local dyes. In some areas hand-spun, locally dyed cloths continue to be woven alongside factory-spun or dyed yarns; elsewhere the latter have supplanted the former. Nevertheless, the beauties of Asante (cat. 5.93) and Ewe (cat. 5.92) textiles in 19th- and 20th-century Ghana would not have been possible without novel yarns and colours, the use of which was enhanced by the innovative use of two pairs of heddles. Very different developments occurred along the coastal region from Guinea Bissau to Senegal, in and around the inland Niger Delta, and in the Yoruba-speaking region of Nigeria, but all to a greater or lesser degree contingent upon distinctive usages of imported yarns and colours within local traditions of weave structure and design.

Architecture, the other dominant feature of the west African visual environment, cannot be transferred to a gallery. Earthen buildings are particularly well adapted to the west African climate (in a way that cement, its usual 'modern' replacement, is not: with its lack of heat resistance, cement is the most unsuitable building material for the tropics). The forms were generally modular, composed and built up of small units, rectangular in the forests and circular in the savanna. With the appearance of Islam monumental rectangular forms, whether designed as palaces or mosques, dominate the urban savanna. Buildings provide scope for mural decoration whether moulded, impressed or excised in high or low relief, or painted, formerly applied in water-based earth colours but now in industrially manufactured paint. This is an art that is largely passed over for reasons of its uncollectability, yet mural painting by Yoruba women in shrines and palaces exhibits a diversity that is the equal of other Yoruba visual art forms, but it is essentially ephemeral given the use of water-based colours. In many areas, north-east Ghana for example, buildings, mural painting (again by women) and textile design are the dominant features of the visual environment.

Masquerade brings together performance, textiles and other fabrics, wood sculpture and assemblage.

Fig. 7 Masks of bark, palm fronds and cloth, worn at the festival of Ogun, god of iron, Ijero district, Ekiti-Yoruba, Nigeria

Yet perhaps more than any other medium it is difficult to encapsulate within a European museum: buildings can at least be photographed and drawn. One can admire the disembodied pieces, and some masks are complete in themselves as sculptures and as presumed vehicles of energy; yet the empty costume is just that. In masquerade it is the event, the performance that is paramount. Wooden masks are well known and frequently collected but there is a greater variety of masks made of insubstantial and often ephemeral materials that make little sense disembodied in a glass case (fig. 7). Moreover, masking is by no means a unified phenomenon, and the status of a mask within its local context must be taken into account.

In all performance traditions, masks are used for their strategic value in creating social distance, thereby enhancing dramatic impact within small-scale communities where everyone knows everyone else. Sometimes, however, the mask can become the literal embodiment of a metaphysical presence and energy; the performer is the mere animator of its progress within a community. Clearly, the issue of secrecy in regard to the identity of the performer is irrelevant in these examples; and even when there is talk of secrecy, this may simply be part of a distancing strategy without entailing any substantial ritual penalty for its breach. Secrecy is, in contrast, paramount in those masked institutions in which masks in effect deny human agency, when the 'official' story is that the mask hides a presence, wild or ancestral, that is too dangerous to see. In other words, the mask protects those outside from what is within; but the converse is also possible, for example south-western Yoruba *efe-gelede* masks which, far from denying the agency of the performer or embodying a metaphysical presence, protect the wearers from the gaze of the witches for whose entertainment they perform.

As to the overt social purposes served by masquerade, while there may be some dominant theme (e.g. entertaining, healing, judging, legitimising, executing, purging a community from thieves, initiating into adult status, reconciling people to the loss of an elder, and so forth), it is important to recognise the wide range of subsidiary social concerns also addressed through masked performances. The location of authority is a case in point; and so too is gender, for women do not participate in masked performance

(other than in the mythic past in many traditions, and in the Sande women's initiation organisation of Mende (cat. 5.136), Gola and other peoples of Sierra Leone and Liberia). Masquerades in some shape or form are almost ubiquitous throughout west Africa: the Asante confederacy is the one most obvious exception. Even in regions dominated by Islam masked performers entertain during the night feasts of Ramadan.

This account, essentially concerned with the status of works of art as contexts (the 'weaving together' of ideas-and-practices), reveals little or nothing of the relationship between aesthetic and social categories, let alone its development within the life histories of communities. This remains perhaps the most tantalising problem in west African art history, and it is to this that the discussion must now turn.

Categories and identities

It has been traditional in the Eurocentric documentation of the visual arts of west Africa to divide the region into the 'Western Sudan' and the 'Guinea Coast', a division that approximately conforms to the climatic/vegetational zones, and to place 'tribal' categories of style in one zone or the other; and occasionally authors shift works from one tribe to another, and tribes from one zone to another. This kind of listing of things according to possibly arbitrary and certainly externally-derived categories has fulfilled some useful purpose, but now the discussion must be moved on to take account of local histories and sensibilities.

Forms and styles vary from place to place, and it matters that we can locate them as originating in one place or another. On the other hand, a categorisation of this variability according to 'tribe' is at best over-simplistic, first, because the notion of 'tribe' is substantially a colonial fiction, and second, because the placing of differences in form and style is very much more complex than 'tribal' classification will allow. Of course individuals and communities manifest a sense of identity with others in groupings that may vary from a few hundred, as in the Akoko-Edo region north of the Benin kingdom, to fifteen or twenty million, as with the Yoruba-speaking peoples. Senses of identity and difference may be located variously in language, traditions of mythic origin, political affiliation, kinship, trading relationships, occupation, common inhabitance of an area of land; and the boundaries of that identity and difference may or may not be the same for each of these factors, thus imparting to that identity a potentially complex and multi-dimensional character (that must now also take into account the realities of national identities). Modern senses of ethnic identity have often come into existence in the contesting of colonial rule, and it is the exception rather than the norm to find isolated (whether socially or geographically) communities that fit within the idea of 'tribe'. The real work now, therefore, is to understand the processes of negotiating identity from within communities and the place of works of art therein. Differences of form and style can signify social categories: lineage, elder/junior, male/female, the cult of a deity, masking association, region (within the same language area), non-smiths/smiths, high or low rank media, artist, city/countryside, pastoral/sedentary, and so on, perhaps even signifying the differences between speakers of different languages; this work has hardly begun.

As with form so, in a sense, with vegetation, which, as one proceeds northwards from the Atlantic coast, changes from mangrove swamp to forest to open woodland to grassland to steppe to desert (except in the coastal region from Accra to Porto Novo where there is a break in the forest, and the savanna meets the Atlantic). Yet a 'Guinea Coast/Western Sudan' categorisation is, once again, an over-simplification, partly because of the different qualities of savanna, partly because persistent swidden farming has had the effect of turning forest into savanna, and partly because over several thousand years there have been environmental changes with successive wet and dry phases that have defined west Africa.

It will be obvious that whatever the organisational convenience of considering west African art according to climatic and vegetational zones, the fact is that we are not thereby dealing with aesthetic categories manifest in material itself; and it would be absurd to impose an environmental determinism on art. The tempting supposition that schematisation is characteristic of the savanna-sahel and naturalism of the forests is difficult to maintain when faced with the material itself. Quite apart from our complete lack of knowledge of local perceptions and the fact that what we contrast as naturalistic and as schematic pertains only to sculpture, naturalism and schematisation are each found throughout west Africa, as the material in this exhibition makes clear. Not only do 'Guinea Coast' and 'Western Sudan' not exist as discrete vegetational zones, neither are they coherent entities in historical, sociological or aesthetic terms.

Indeed, the key to any understanding of west Africa (whether art-historical or otherwise) lies precisely in the interaction of people, communities and forms across vegetational zones, language groupings, pre- and post-colonial states, masking and cult associations, and so forth. The facts of trading networks, among other kinds of relationship, whether local or longer-distance, east to west, north to south, along the Niger and Benue, among other rivers, or wherever (but ultimately mediating relationships between the different regions of west Africa, including the fact that links between different forest regions were invariably mediated via the savanna prior to the advent of European coastal trade), taken together with the continuities and disjunctions discussed in regard to Nok, Ife, Yoruba, Nupe, Igbo etc., all serve to set aside any residual usefulness of vegetational/climatic classifications of west African art. Long-distance trade routes, languages and technologies each provide a kind of structure and system to west Africa, and as such ultimately link the Sahara and beyond to the coast; but the mapping of these structures and systems will not bring them to coincide either with each other or with climate and vegetation.

Tradition and the 20th century

Art in west Africa did not somehow come to an end in the 20th century, and, whatever the form or medium of present-day art, the sense of tradition is as important as ever, enabling post-independence artists to work productively within a contemporary sense of national identity. In any case, popular misconceptions aside, west Africa was never the locus of static tradition, in which nothing changed until the local wars and European colonisations, and their attendant developments, in the 19th and 20th centuries. Although these developments are beyond the scope of this exhibition they merit attention if only to correct yet another absurdly simplistic division of west African art into the 'traditional' and the 'modern', or even worse, the 'contemporary'. The realities of material and social change cannot, of course, be denied; yet the persistence of many traditions inherited from the past alongside novel developments now institutionalised within the modern nation-states of west Africa is familiar.

The concept of tradition as such is not the problem, for without a handing on there is neither art nor society: rather it is through the external imposition of the category 'traditional' that problems arise. We no longer talk about 'primitive art', but, as we have noted, its auction-house substitute, 'tribal' art, is almost as problematic though for different reasons; and so 'traditional' art comes into being as the latest sanitised replacement. Yet, when, as is indeed the case, masked performers and art-school-trained painters inhabit the same city and period, what is the value of a categorisation that seeks to separate the 'traditional' from the 'contemporary'? In reality it prevents any understanding of a local sense of tradition, while defining as 'traditional' a bogus sense of authenticity located essentially in the past, as if Africa had no proper place in the century the rest of the world inhabits.

In any case, with certain obvious exceptions, the greater number of works in most museum collections, as in this exhibition, unless they are the products of excavation, are likely to have been made no earlier than the mid-19th century, and often much later, i.e. within the period of colonial rule. In the contemporary juxtaposition of forms inherited from the past and new developments in the present we find the formation of 20th-century ethnic identities. The development of school and university education, literacy, mission Christianity, the rise of a purified Islam, the new technologies and novel political institutions: each has had its effect with the demise of some traditions, the continuity of others and the inception of yet others. Moreover, the work of challenging colonial rule fell largely to a Muslim and Christian intelligentsia and this too had its art forms. Colonial rule was challenged in the writing of grammar books and histories by that local intelligentsia, and in the painting of pictures that even the most philistine colonial governor could recognise as art; and it was also challenged from within the traditions surviving from the past in images of ridicule and subversion. In the first decade of this century, the Nigerian painter Aina Onabolu (1882–1963) taught himself European-style painting and began his campaign for the establishment of art education within the colonial school system, though it was not until 1927 that a teacher was appointed, and even then it was a European (Kenneth Murray, later to found what is now the National Commission for Museums and Monuments in Nigeria). By the 1960s, when the countries of west Africa gained their independence, a survey of the visual arts would have included fine art and design departments at universities, self-taught sign painters, masked performers, potters, weavers, dyers, and sculptors in various media. In Nigeria there was a reaction against the kind of genre subject-matter encouraged in the art colleges at that time, in favour of a return to the traditions inherited from the past as a legacy of forms with which to represent a variety of identities, all Nigerian. In due course these developments would lead to the formation of artistic 'schools' based upon local design forms, the diversity nevertheless continuing to celebrate a Nigerian identity. The particular ritual and decorative needs of Christianity and Islam have also proved significant as sources of subject-matter and patronage. In the 1960s, too, 'summer schools' were started at which anyone with or without formal education could practise art. The best-known of these continues at Oshogbo in Nigeria. In general the various lines of development established in the contesting of colonial rule have continued to flourish and develop in the post-independence period, with enhanced state patronage, and the inception of national and private collections and galleries.

The point with which to conclude this essay, therefore, is not reinteration of slipshod notions of the demise of an 'authentic' African art, but rather emphasis on the vigour and variety of contemporary practice. Let us also remember how we persistently impose alien categories on the art and artists of west Africa: this tribe/that tribe, forest/savanna, art/craft, traditional/contemporary, and so on. Instead, let us attend to the manner in which individuals and communities place themselves in relation to the works of art of their choice. Let us listen to local artists, critics and patrons while there is still time (their patience cannot be taken for granted forever). Then we might learn to sense a little more than we do now of local perceptions of form, tradition and history; surely this is worth doing.

Bibliographical note

Willett, 1967; Ryder, 1969; Williams, 1974; Cole and Ross, 1977; Garlake, 1978; Shaw, 1978; Barley, 1984; Herbert, 1984; Vansina, 1984; Craddock and Picton, 1986; Picton and Mack, 1989; Picton, 1992; Dmochowski, 1990; Shaw et al., 1993; Picton, 1994[1]; Picton, 1994[2]; Picton 1994[3]; Willett, 1994

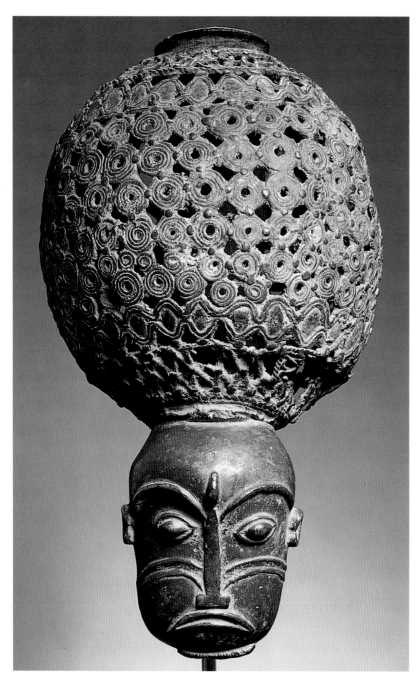

graph taken at Foumban, the capital of Bamum, by Oldenburg in 1912–13. An illustration of an early Bamum king at Foumban wearing a large circular headdress has been published. Such masks with depictions of royal headgear, decorated with special materials such as beads, cowrie shells, sheet brass and bells, were worn widely by retainers at palace festivals.

The piece shown here is of uncertain origin. It does not have the broad nose, bulging cheeks, open mouth and apparently smiling or laughing countenance which is associated with the large, elaborate prestige headgear or coiffure characteristic of so much Bamum mask and pipe sculpture. Its face bears little stylistic relationship to the Bamum as it has a down-curving mouth (the arch of which is echoed by that of the eyebrows and cicatrisation marks on the cheeks) and a sharply angled nose resembling an inverted 'T'; the central forehead bears the representation of a keloid; and the ears do not project prominently. It is none the less a remarkable piece, not least because of the very large filigree superstructure, decorated with coil, stud and undulating line motifs. At top and bottom of the superstructure the filigree pattern resembles the abstracted spider motif, a dominant element in Grasslands iconography. *KN*

Bibliography: Schädler, 1973, p. 293; Joseph, 1974, pp. 46–52; Lamb and Lamb, 1981; Northern, 1984

5.2
Cup

Duala
Cameroon
ivory, horn
105 x 69 x 54 cm
By courtesy of the Board of Trustees of the Science Museum, London, A 641447

The style of this piece is highly unusual within the corpus of African ivory carving. The cup, with its sensitive curves, nestles in a series of slim buttresses that converge in a stubbly handle, raising the suspicion of its having been cut down. Inevitably, the basic shape recalls the art form for which the Duala are best known, the elaborately carved canoe prows, *tange*, that they produce to this day.

The cup is said to have belonged to 'the King of the Duallas' and to have been used for taking 'medicine'. Given the ambiguity of this term in pidgin, its uses can only be guessed at, while Duala kingship was long divided between warring factions and so offers little hope of pinning down the cup's source.

In modern Cameroon the Duala people live mostly in and around the principal port of Douala, and until recently have been unjustly neglected by art historians as 'corrupted' by Western contact. Douala is documented as a source of raw ivory from the 18th century onwards, but very little is known of ivoryworking by them. *NB*

Bibliography: Wilcox, 1992, p. 263, no. 9

5.1

Pipe bowl

Western Cameroon
19th–20th century
bronze
38 x 19 x 21 cm
Afrika Museum, Berg-en-Dal,
The Netherlands, 564.1

In overall form this item has the appearance of a ceremonial tobacco-smoking pipe bowl from the Cameroon Grasslands, but the style of the face is not of this area. Copper-alloy objects were used as regalia of office, and were traded in restricted quantity from the markets of Bali, Bafoussan and Bamum. The technique of lost-wax casting is believed to have

originated among the Tikar of the Upper Mbam Valley, east of the Grasslands. In fact the Tikar, who do little, if any, casting today, believe themselves to be ancestors of the Bamum and certain other peoples of the Bamenda Highlands, whose metal crafts are well known.

Among many of the small kingdoms of the Cameroon Grasslands, including the Bamum, masks of carved wood or cast brass and ceremonial pipes of brass or pottery are often shown with large circular or hemispherical superstructures representing the crown of the Fon. This form of helmet mask, used in the Nia Festival, is shown in a photo-

5.3

Anthropomorphic mask

Wum
North-western Province, Cameroon
wood
24 x 21 x 33 cm
Charles and Kent Davis

The Bamum and Bamileke cultures of the central Grassland region have been studied in considerable detail; the densely populated region of north-western Cameroon, however, with its high plateaux and luxuriantly wooded extinct volcanoes, also has a rich artistic heritage, divided by scholars into five stylistic sub-groups. This mask is a fine example of the stylistic area between Wum and Fungom in the west.

In the Wum villages there are a large number of masks known as *juju*, which are brought out for the successive festivals, to celebrate the sorghum harvest in the dry season, or the great *ibinilumé* festival in December, or for the funerals of important people. This helmet mask carved from very hard wood is typical of the Wum style with its compact, geometrical shape, its wide open mouth, and its dilated nostrils and bulging eyes, the latter devoid of all expression. *EF*

5.4

Standing male figure

Kundu
Western Cameroon
late 19th–early 20th century
wood, pigment
h. 190 cm
Staatliche Museen zu Berlin, Preussischer
Kulturbesitz, Museum für Völkerkunde,
III C 10026

This piece is said to be from the
Kundu of south-west Cameroon,
whose art is little known. A fairly
naturalistic face is contained at the
centre of a diamond-shaped frame,
and at the back of the head is a large
rectangular structure with rounded
corners. The right hand is raised as
if to point a projectile such as a spear,
or possibly a staff. The body is naked;
light and dark pigment divide the
frontal view of the trunk vertically.

The flat structure at the rear of
the head is reminiscent of the stylised
European sea captain's hat of the days
of sail on the Guinea Coast, which is
worn by masked performers of the
Cross River leopard spirit cult, Ekpe.
This cult is diffused widely in eastern
Nigeria and western Cameroon and
lodges are found throughout forest
and savanna zones. Such a 'hat', how-
ever, would normally be worn with a
netted string or cloth costume cover-
ing the entire body, including face,
which is clearly not the case here.

Although most settlements in the
Rumpi Hills of south-west Cameroon
forestland possess lodges for the Ngbe
(leopard spirit society; cf. cat. 5.35),
there are remnants of all-male regu-
latory societies which existed before
the adoption of Ngbe. One such insti-
tution is the Kundu Musongo society,
which employed small wooden carv-
ings in the administering of oaths to
establish a person's guilt or innocence.
Larger figures, of which the present
piece appears to be an example,
were used to enforce dispute settle-
ments within the community, and
on ceremonial occasions carried on
member's backs in dance and
procession. *KN*

Bibliography: Northern, 1984, pp. 186–7;
Nicklin, 1991², pp. 3–18

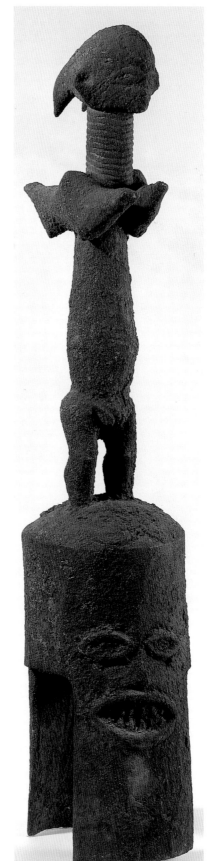

5.5

Mask

Keaka
Cameroon
wood
h. 125.7 cm
Private Collection

Like their neighbours the Anyang and
the Banyangi, on the border between
Nigeria and Cameroon, the Keaka are
related to the Ejagham (also called
the Ekoï), who are renowned for their
wooden masks covered in antelope
hide. The Keaka have developed a
rustic kind of sculpture which,
stylistically, marks the transition
between Igbo sculpture and the art
of the Grasslands. For initiation rites
and funerals they produce masks
(to date little studied and badly rep-
resented in public collections) of the
type of the rare example shown here.
This consists of a helmet representing
a human face with an open mouth
and almond eyes, surmounted by a
female statuette with rings round its
neck and, here, broken arms. *EF*

5.6

Male figure

Bamileke
Cameroon
wood
h. 125 cm
Staatliche Museen zu Berlin, Preussischer
Kulturbesitz, Museum für Völkerkunde,
III C 21121

The most striking feature of this large
wooden seated figure is the swollen
belly that contrasts with the stick-like
arms and the rudimentary feet,
possibly fastened to the earth. In a
smaller figure from the Cameroon
Grasslands, this would indicate that
it was involved in the (causing and)
curing of diseases of the belly.

Figures of this style and size are
usually identified as commemorative
figures, representing a local ruler and
commissioned at the time of his en-
stoolment (cf. cat. 5.14). The present
piece would seem to come from one
of the southern kingdoms. Thereafter,
the figures may enter into all manner
of ceremonial and cult activities that
vary widely from one fonship to
another. Similar large female figures
exist and it seems that male and
female are to be viewed as pairs, but
female statues are more variable in
their attribution. They are often
depicted as pregnant.

While male commemorative fig-
ures are usually carved with swollen
bellies, the extent of distension in the
present case is unusual. There seems
no need to see this as an implied
hermaphroditism, however, but
more as regal embonpoint with
a metaphysical dimension. *NB*

Bibliography: Harter, 1986, p. 54

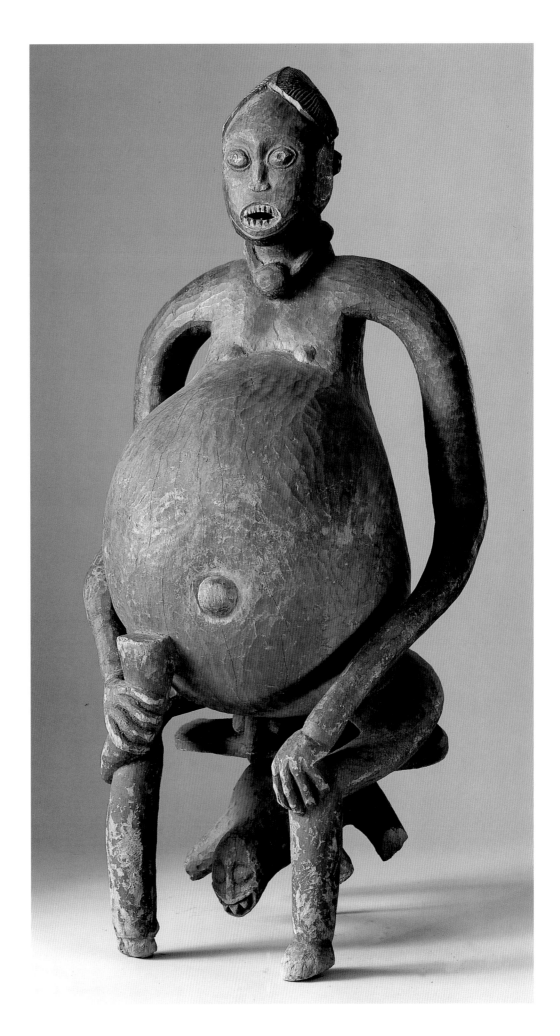

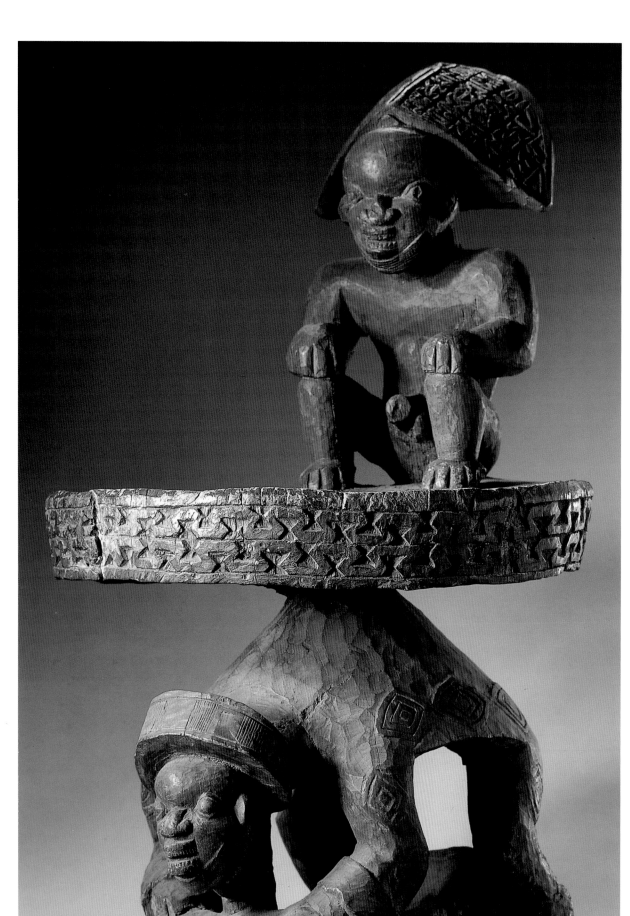

5.7

Royal throne with caryatid
Bamileke, Chiefdom of Banka
Bafang region, Cameroon
wood
h. 51 cm
Staatliche Museen zu Berlin, Preussischer
Kulturbesitz, Museum für Völkerkunde,
III C 22793

This throne was collected in the
early 20th century by a German
officer in Banka, a small kingdom
founded in the 17th century south
of the Bamileke plateau, in the
Bafang region. The back of the throne,
carved from a single piece of wood,
represents a seated king with his
genitals conspicuously on view, his
hands on his knees and a royal dia-
dem, richly embroidered or beaded,
on his head. The panel surrounding
him is decorated with a motif that
recurs frequently in the arts of the
Grasslands area – the so-called
'chicken's intestine' motif – and rests
on a caryatid representing either a
panther, symbol of royalty (here with
a human face) or a vanquished chief
wearing heavy bracelets round his
wrists, or alternatively a synthesis of
these two allegories. A relief pattern
of diamonds suggests the markings
of a panther skin. This type of throne
can be found all over the Bamileke
country and is an important element
of royal furnishing, often more
ceremonial than functional. The
caryatid represents power with various
symbols (panther, serpent, elephant),
while the back usually commemorates
a deceased prince. Some thrones, vari-
ously painted or covered with glass
paste beads, are up to two metres
high (as at Bandjoun). The treatment
of this powerful piece is reminiscent
of the style of Batié, a big centre for
Bamileke sculpture a little further
to the north. *EF*

Provenance: 1909, collected by Gnügge in
Banka

5.8

Royal mask representing an elephant

Bamileke, Chiefdom of Bafu-Fondong
Western Province, Cameroon
last quarter of 19th century
wood
46.5 x 38 x 90 cm
Musée National des Arts d'Afrique et
d'Océanie, Paris, AP 92-50

The elephant (known to the Bamileke as *so*), with the panther, is the symbol of royal power and is an important element of the arts of the Grasslands, particularly in the north and west of the Bamileke plateau: it appears on masks, drums, stools, seats, pipes and staffs. Masks, which can be made either of wood or of beaded fabric, appear at important royal ceremonials, at the funerals of kings, queens and dignitaries and at the harvest or spring festivals. They are used during a very dramatic dance, the *nso* or *nzen*, an elephant dance executed within the royal enclosure (the *tsa*) by princes and the nobility of the chiefdom who are members of powerful secret societies such as the Kwosi, the Kemjyeh or the Manjong.

This massive head is a stylised version of an elephant with its broad, round ears, slanting eyes, short trunk and elegantly curved tusks. It comes from the chiefdom of Bafu-Fondong, near Dschang to the west of the Bamileke plateau. For years Bafu-Fondong was in thrall to the neighbouring chiefdom of Baleveng; it won its independence in the 18th century with an uprising led by Prince Ndaptchu. Tradition holds this to have been carved in the last quarter of the 19th century, during the reign of Fon Kana I. *EF*

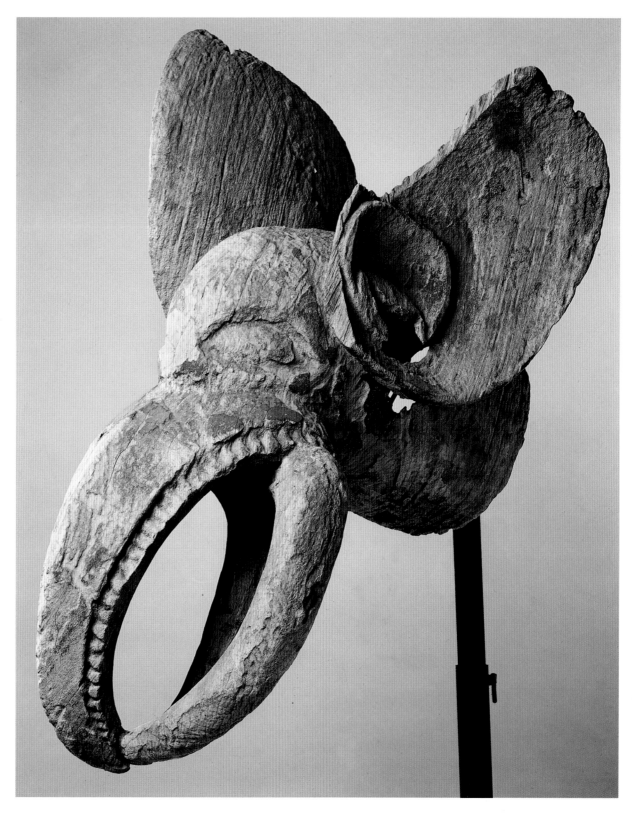

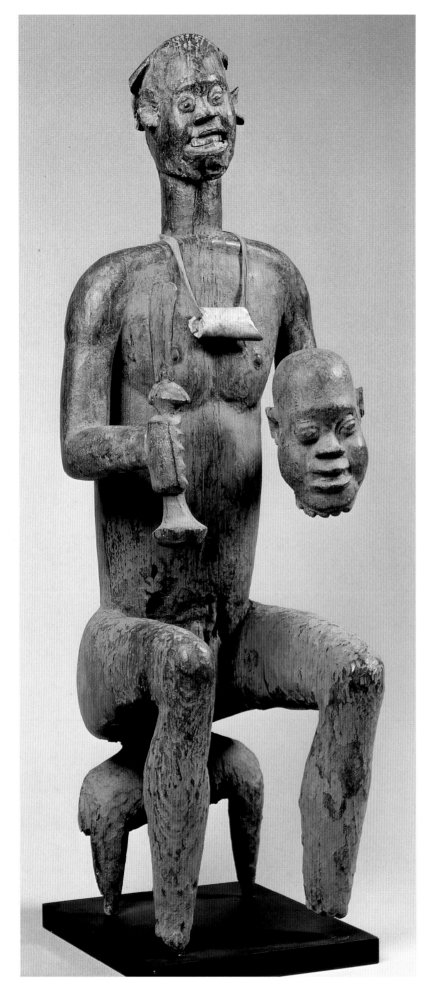

5.9

Bafum king returning from victory

Bafum area (Bafum-Katse kingdom, Ide/Esu)
Cameroon
early 19th century (?)
wood, hair, ivory, bone, bead, cloth
113 x 31.7 x 45.7 cm
The Walt Disney-Tishman African Art
Collection, Los Angeles, 1984.AF.051.110a,b

Few narrative sculptures in the art of west Africa need as little working out as this triumphant figure of a king of the old Bafum-Katse chiefdom. He has returned from battle and his upheld sword plus the severed head of an important (judging from its relative and significant size) enemy tell their tale of victory as does the expression of proud glee on his face. He sits on an animal that may be a leopard (its fragmentary state allows us only to guess) and wears round his neck a large Venetian bead of a chevron type (that is still sought after for prestige necklaces and is already much faked for market traders all over sub-Saharan Africa).

Human hair still clings to his chin and the whole effect of his expression is heightened by the band of implanted teeth engraved in ivory. Hyper-realistic touches such as this, plus the incontestable quality of the carving, have led the piece to be associated with an almost legendary artist of the beginning of the 19th century, one of the anonymous but famous masters that intrigue and frustrate the students of African art history. *TP*

Provenance: ex Tishman Collection
Bibliography: Hasterin, 1981

5.10

Basketry bowl

Oku
Cameroon Grasslands
20th century
plant fibre, pigment
h. *c*. 12 cm
Staatliche Museen zu Berlin, Preussischer Kulturbesitz, Museum für Völkerkunde, III C 24980

In West Cameroon, especially in the Grasslands region, a wide variety of basketry products is made for utilitarian and ceremonial purposes, especially for use as containers. The upper part of the present specimen is constructed from coiled basketry. In some localities the coils are so tightly wrapped and stitched that the basket can be used to hold liquids, notably palm wine. In this case the ascending coil which forms the bowl is decorated with oversewn needlework, and the tall pedestal is faced with alternate bands of light and dark coloured cordage.

This basket is from the Oku of the north-western Grasslands, whose neighbours to the south-west are the Babungo, and to the south-east the Banso. It was probably used for food storage. The social structure of the Cameroon Grasslands is hierarchical. Had such a pedestal basket been intended for palace use, it would have been adorned with cowrie shells or beads. Pedestal baskets were often equipped with a lid that could be secured with a string. *KN*

Bibliography: Gebauer, 1979; Northern, 1984

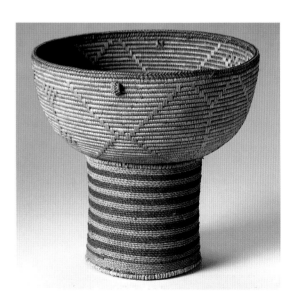

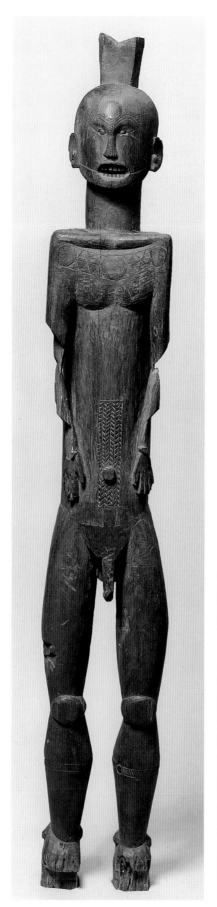
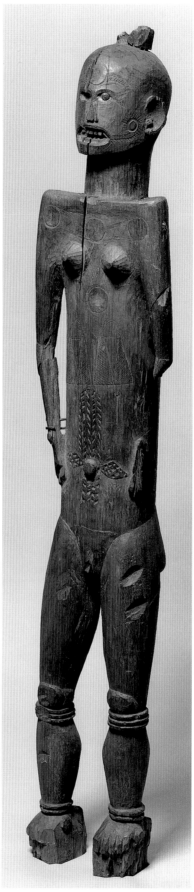

5.11a–b

Pair of figures

Koko
Cameroon
wood (with glass beads)
161 cm, 130.5 cm
Staatliches Museum für Völkerkunde,
Munich, 95.6/7

This remarkable pair of figures has
been in Europe for over a century.
Later sculpture from the Koko lack
their grandeur and severity. To say
that these are pole figures deprives
them of their dynamism by implica-
tion, yet this is the general type
(widespread in Africa) to which they
belong. The damage inflicted on the
arms of each figure is evidently not
accidental. Whether they were hacked
in this way by the Koko themselves in
order to destroy their potency is not
known. Similar damage was done
to Igbo standing figures by warring
groups this century. If their ritual
power was thereby forfeited their aes-
thetic quality remains. The formal
certainty of their making, with sharp
accents for the shoulders and power-
ful faces reminiscent of Cross River
figures, is offset by delicate scarifica-
tion motifs and, on the back of the
female, a pattern of spots that may
have some association with a leopard
cult. These two figures with their
remaining shafts below the feet and
weightbearing headpieces probably
served as flanking (?) supports for
the inner entrance to a sanctuary.

 The eyes are represented by
glass beads (unusually for the art of
Cameroon) but this factor is consistent
with the eclectic style of the pieces
about whose earlier history one would
wish to know more. *TP*

Provenance: 1895, acquired by the
museum from E. Zimmerer

Exhibition: New York 1987

Bibliography: Darminik, 1902; Bernatzik,
1947; Kecskési, 1987

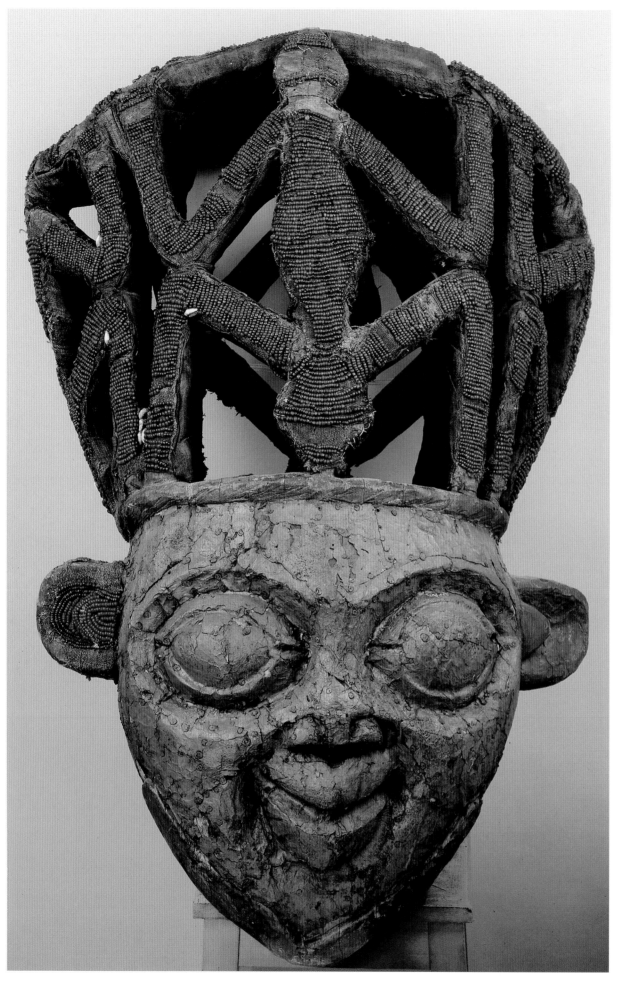

5.12

Royal mask

Bamum, Kingdom of Fumbam
Western Province, Cameroon
wood, copper, plant fibres, glass-paste
beads, cowries
h. 93 cm
Laboratoire d'Ethnologie, Musée de
l'Homme, Paris, Gift of Charles Ratton
35-6-1

This monumental helmet mask,
carved from a single piece of wood,
represents a human head wearing
an openwork diadem decorated
with lizards and crocodiles, some-
what reminiscent of the tiara sur-
mounting the large *tukah* mask
collected by Pierre Harter in the
Bamileke chiefdom of Bamendou
(cat. 5.16). The face has fine sheets
of copper pinned all over it. The
lizards in the diadem are decorated
with beads and cowries stitched on
to a woven raffia backing. These
spectacular masks were worn during
the annual ceremonies to celebrate
the first rains (*ndja*), or the bring-
ing in of the second harvest in
November–December. This mask
would not have been worn by the
king because of its great weight but
would have been carried by one of
his servants. Along with the other
masks and equipment for political,
administrative, legal or dramatic
ceremonial, it would have been
kept in a special area inside the
royal enclosure. *EF*

5.13

Buffalo mask

Bamum
Western Province, Cameroon
wood, fibre, glass-paste beads
63.5 x 28 x 15.2 cm
Maureen and Harold Zarember

Large animal masks were frequently
worn during masked ceremonials in
the Grasslands. The most popular
forms were elephants, monkeys, goats
and cattle; leopards, crocodiles, dogs
and birds were also occasionally
represented. The animals are not
always easily recognisable, particu-
larly when the representations are
intentionally hybrid. The masks

have to be studied in conjunction with animal mythology and symbolism. Horned masks occur among the Bamum, less frequently among the Bamileke. The commonest of all, the buffalo, represents strength, courage and power. Hunters were legally obliged to present the heads of all buffalos killed to the ruler; among the Bamum failure to comply with this could carry the death penalty. Buffalo heads were traditionally hung over the doorways of dwellings, or were attached to the posts supporting the roof awning, like the skulls of the enemy killed in combat; alternatively they might be used as seats. The horns were used as drinking-vessels and were decorated with carved patterns.

This handsome wooden mask is carved from a single piece of wood and is wrapped in a woven raffia fabric on to which are stitched small glass-paste beads, using a technique particular to the bead artists of the Grasslands. The beads are trading beads, and the old-fashioned blue and red tubular beads predominate.
EF

5.14
Royal stool
Bamum
Cameroon
wood, glass beads, cowries
175 x 50 cm
Museum für Völkerkunde, Vienna,
171.471

The connection between stool and power, especially when the stool incorporates a figure, will have already become apparent thus far in catalogue and exhibition. 'Enstoolment' is the term used among the Akan (and in other parts of west Africa) for enthronement of a chief. The announcement of this tendency in terms of artistic splendour reaches its peak among the kingdoms of Cameroon. Each court has its treasury where ritual goods are kept. Some of these can be of warehouse proportions and are filled with regalia, weapons and sculpture. The items which add most to the prestige of a Fon (more a king than a chief) are the often elaborate beadworked figures and stools. These are brought out on ceremonial occasions and even a minor visiting dignitary might see ranged before the

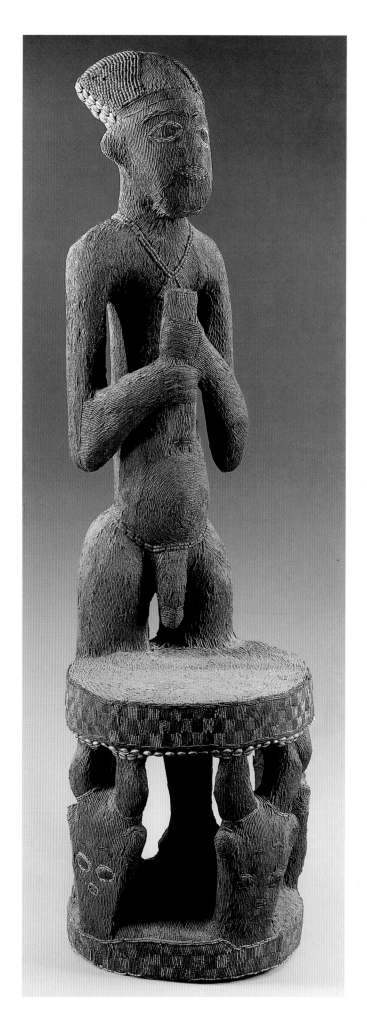

palace itself an impressive array of beaded sculpture, some of it dating back to the middle of the last century. The bright colours of imported beads (the role of Bohemia and Italy, for example, is not be underestimated in the history of African art) are used at maximum brilliance and brought together with the greatest impact of contrast. In African light this can be dazzling, whereas in the sobriety of a European museum the effect is somewhat strident, like bright Bermuda shorts on a British beach.

In this particular example from the Bamum in the north-east savanna region the artist (and here one need not hesitate to use the word since court artist is a highly regarded and non-hereditary role earned by merit; he is a professional) has used the tens (or probably hundreds) of thousands of beads, together with wealth-indicating cowries, with unusual fluency and subtlety. The small size of beads used usually indicates a date of manufacture after the beginning of this century: ancient beaded work usually features the longer beads seen in cat. 5.13.

This type of figured stool occurs throughout the Grassland kingdoms and is symbolic rather than practical. Costly and elaborate items of beadwork are the prerogative or in the gift of the Fon himself, and the presence of beadwork even in lesser objects would indicate royal connections, as is the case with the Yoruba (cf. cat. 5.85). Kaiser Wilhelm II, for example, received tribute in the form of beadwork stools from Fon Njoya of the Bamum in the early years of this century; the crafting of these examples helps to date the present stool as near that period. *TP*

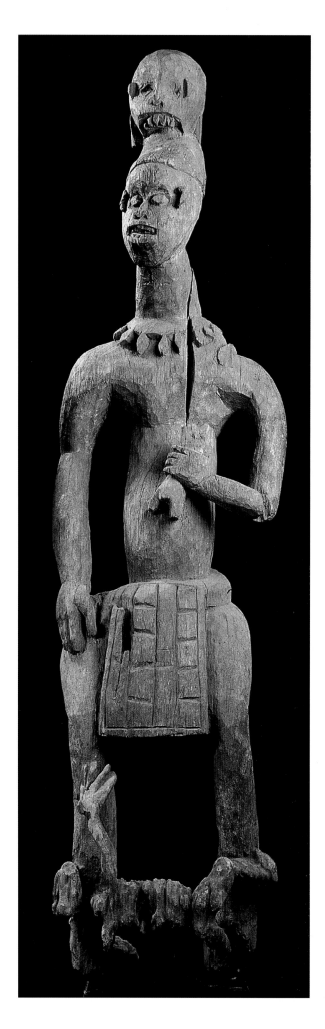

5.15

Fragment of a pillar representing King Tita Gwenjang (Fonyonga II)
By the sculptor Njinerat

Kingdom of Bali-Nyonga
North-Western Province, Cameroon
c. 1904–5
wood, pigment
143.5 x 36 x 22 cm
Musée National des Arts d'Afrique et d'Océanie, Paris, Pierre Harter Bequest, AP 92-32

This figure is one of the carved columns of the peristyle that supported the roof of the former royal palace of Bali-Nyonga, demolished in the 1950s during the reign of Garega II when a new stone palace was built; fortunately there are some photographs of it taken in 1943. The columns usually consisted of three figures, one on top of the other, with their backs to the door frame. They were taken down, sawn into three pieces and dispersed; some portions can now be seen in the museum in Bamenda. Pierre Harter acquired three fine fragments; this one was the lower part of a pillar immediately to the left of the entrance to the palace. It represents a Fon of Bali named Tita Gwenjang (Fonyonga II) who ruled in about 1870. He is wearing a necklace of panther teeth and holding a sword of which only the hilt remains; under his feet lies the corpse of an enemy. The royal headdress bears a skull that was originally between the feet of the person higher up on the column, his older brother and predecessor, Tita Nji. At the top there stood another figure (also saved by Harter), a warrior or servant, with arms akimbo. The chiefs of Bali are descendants of Chamba conquerors, a tribe of horsemen from northern Cameroon and Nigeria. They subjugated a large number of villages on the plain of Ndop on the borders of Bamenda. The Bali colonnade illustrated these military achievements; taking its inspiration from the traditional architecture and sculpture of the region it also confirmed the desire of local people to establish their chiefs from other parts of the country more securely. This particular column was apparently carved, with others, by a sculptor named Njinerat *c.* 1904–5. It bears the characteristic features of Grassland sculpture, particularly of Bamileke carving: the expressionist, almost grotesque treatment of the figures has the heads, shoulders, bodies and limbs sticking out awkwardly in all directions, with no attempt at symmetry. *EF*

Bibliography: Gebauer, 1943

5.16

Royal mask of the Kah Society

Bamileke, Chiefdom of Bamendou
Western Province, Cameroon
wood
85.7 x 69.5 x 53.5 cm
Musée National des Arts d'Afrique et
d'Océanie, Paris, Pierre Harter Bequest,
AP 92-13

This exceptional mask, carved from a single piece of wood, is the jewel of the Pierre Harter collection. In *Arts anciens du Cameroun*, Harter wrote: 'The royal treasure of Bamendou was one of the most impressive collections of the Grassfield. This is a monumental mask with an openwork hairstyle, named *tukah*, held in the possession of the Kah society, which was the equivalent of the council of ministers of the chiefdom. It carried considerable symbolic weight and combined various attributes. The transience of life is alluded to by the six lizards in the headdress, their sinous outlines being contained within the lobes, each of which, in turn, terminates in the curl of the lizards' tails. The continual renewal of the chiefdom is symbolised by various fertility symbols. The protuberant brow bulges like a pregnant stomach, and the two bloated cheeks like breasts swollen with milk; these two attributes also refer to the powerful twin forces of alliance and allegiance. The sacred act of procreation is evoked by the nose which appears to penetrate the cheeks (spread wide as female thighs) like an erect male organ. Finally, the perfect equilibrium of the whole, with its combination of spherical and ovoid masses, conveys a sense of the universal and the eternal.... According to the tenth Fon, Dongmo (1955–1976), *tukah* represented the power, the nobility and the endurance of the Bamendou through several generations. It was said to have been carved from a tree in the sacred wood planted by Jeugman, the founder, an *émigré* from Fodjomo (in the Bamenda region). The mask was displayed during a slow-moving quinquennial procession connected with the classes of the Majong. The weight and power of the mask meant that it was never worn on the head. It was carried at arm's length by the *wala*, who took turns at leading the parade, two by two, moving very slowly, and making frequent stops; it would take several hours to cover the few hundred metres between the dance floor and the hut where the mask in 1957 was guarded round the clock. When we came across the mask in 1957 it had been abandoned for years under the rubble of a deserted hut which no one dared to approach.'

This mask is reminiscent of the massive and even more stylised masks used by the Bamileke of Batcham and Bandjoum, known by the name of *tsesah*. EF

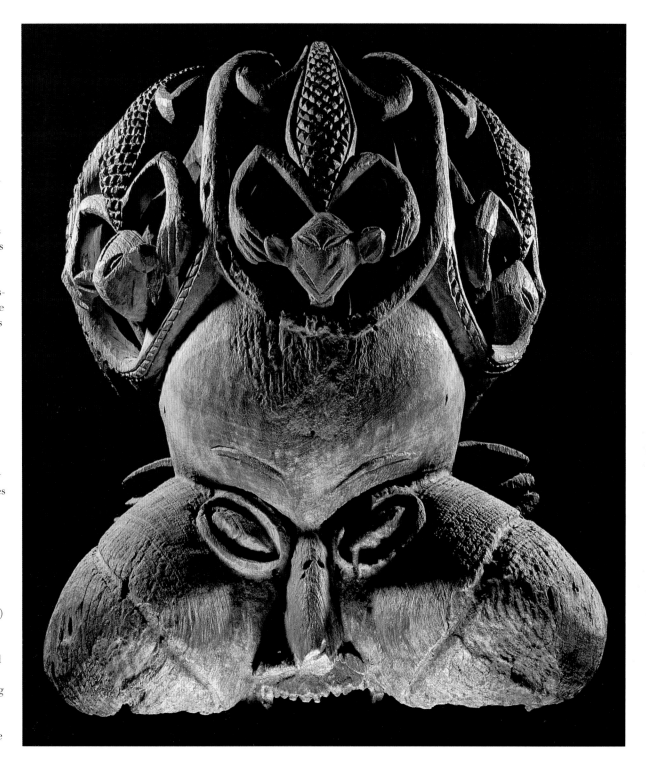

Provenance: 1957, collected by Pierre Harter in the chiefdom of Bamendou, between Dschang and Bafoussam

Bibliography: Harter, 1986

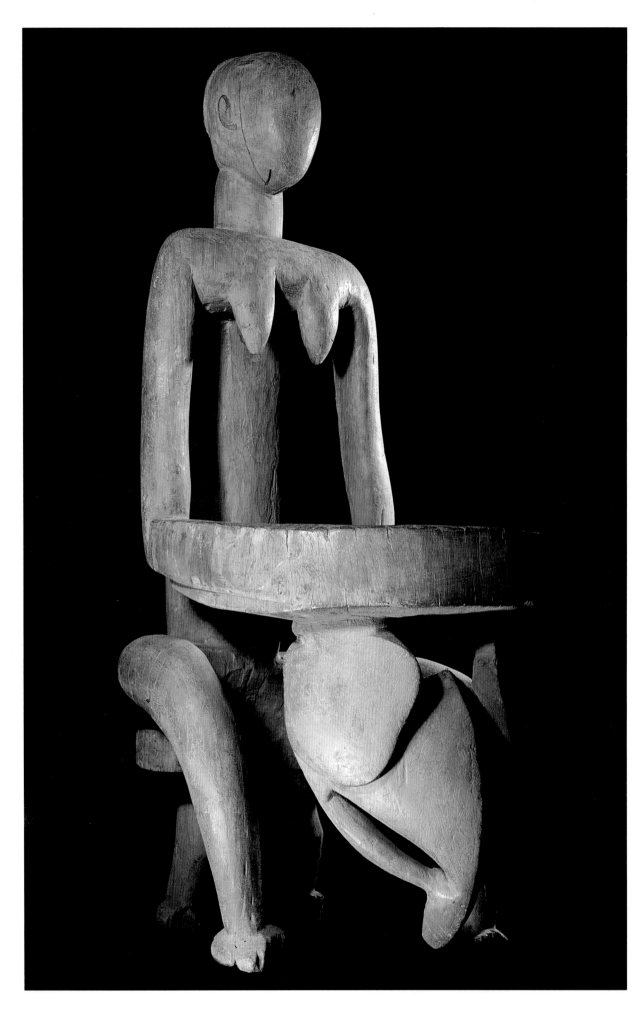

5.17

Calabash stand

carved by Kamteu (*d.* 1915)
Bamileke, Chiefdom of Foto
Dschang Region, Cameroon
c. 1910
wood
127 x 50.7 x 66.5 cm
Musée National des Arts d'Afrique et
d'Océanie, Paris, AP 92.39

This large statue of a seated queen
once stood by the throne in the royal
dwelling; in its arms the figure held
a removable calabash containing ritu-
al objects (a pipe and other personal
items) belonging to the Bamileke
ruler of Foto. The figure rests her
arms on a stylised elephant's head:
seen from the side, the feet of the
stool and the queen's legs combine
to make a convincing silhouette of
an elephant, and this lends the group
exceptional solidity and strength.
Like other items of royal furniture,
it was probably originally designed
to be covered with small glass paste
beads stitched to a framework of
woven raffia, which would explain
the absence of facial features. The
sculptor knew that the features would
be outlined in beads.

The torso is completely hollow;
this may have been to make it lighter,
or to form a receptacle for relics or
charms or to act as a sound box so
that a servant hidden behind the
stand could make the sculpture
'speak' during a ritual performance.
It was carved by Kamteu (*d.* 1915),
who was celebrated in the
neighbourhood of Banjout. *EF*

Provenance: 1975, presented to Pierre
Harter by the fon of Foto, Soffack

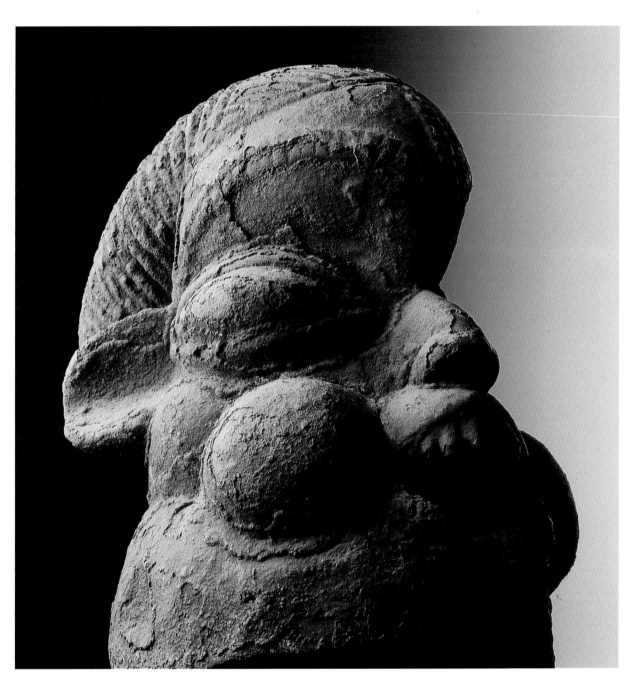

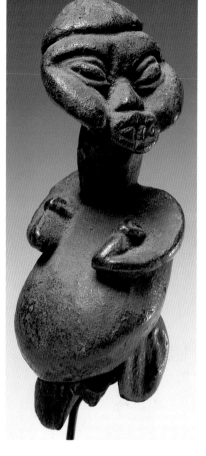

5.19

Statuette (*mu po*)
Bamileke, Chiefdom of Bangangté
Western Province, Cameroon
wood
15 x 5.5 x 5.5 cm
Private Collection

5.18

Mask of the Troh Society
Bangwa, Chiefdom of Foretia Fontem
region
Western Province
Cameroon
wood with a blackish crusty patina
27 x 19.7 x 27.5 cm
Musée National des Arts d'Afrique et
d'Océanie, Paris, AP 92-52

Among the Bangwa people of the
Fontem region, the secret society of
Troh (known as a 'night society') con-
sists of a council of nine notables; this
kind of politico-religious institution
is found all over the Grasslands, the
society in the neighbouring Bamileke
country being known as Kamvuu.
The grand master of the society is
the chief himself (the *fwa*), the other
members being the heirs of the nine
companions of the founder of the
dynasty. These nine notables are the
guardians of tradition whose duty it
is to supervise the selection of a new
chief, his enthronement and his
funeral. This helmet type of mask
is worn exclusively by the members
of the Troh, and is handed down by
them from father to son. Theoretic-
ally, therefore, each chieftancy posses-
ses only nine masks. This one comes
from Foretia, just north of Fontem.
Harter studied more than 50 of these
masks, some of them with two or
more faces. He noticed two distinct
styles, a Bangwa style, formalist in
tendency, and a naturalistic style
influenced by the Bamileke. This
Bangwa example represents a man's
face, grimacing slightly, his mouth
open to show filed teeth, wearing a
pointed headdress with the point
thrown backwards; the mask is made
up of a series of spherical shapes for
the brow, eyes, cheeks and so on.
The thick patina is the result of years
of ritual fumigation and libation, and
is a testimony to the mask's great age;
a member of the Troh has guarded
this symbol of his power with great
care. *EF*

Bibliography: Harter, 1986

Bamileke healers and soothsayers used
small wooden statuettes to represent
the patients in their magical-medical
practices; the patients would be treat-
ed at a distance. Sometimes the statu-
ettes have a cavity in the back into
which magical substances would be
placed and the cavity closed with a
band of leather or cloth. Some of
them, made of wood, ivory or a soft-
ish stone, would be carried by mask-
wearing members of the Kun'gan
secret society during their big rituals.

The statuettes measure between
10 and 40 cm in height; they are
called *mu po* in Bandjoun, *pu pueh* in
Bafang and *meu boun* in Bangangté
and generally depict a pregnant
woman with her hands on her chest
or under her chin. This symbol of
maternity occurs frequently in the
arts of the Grasslands, relating to the
fertility of the group and of the lands
belonging to the chiefdom. *EF*

5.20

Standing male figure

Mambila
Nigeria/Cameroon border
late 19th century (?)
wood
45 x 18 x 18 cm
Private Collection

Several stylistic conventions in this figure suggest that it might come from a group of small communities to the north of the Tikar Grasslands around the Nigerian/Cameroon border: the 'dished' rendering of the face; the gesture of hand or hands to chin or beard; the way in which the lower limbs are represented, with accentuated thigh, much reduced lower leg and large feet similar in form to the thighs; and the conical rendering of the stomach. Several peoples in this area produce such sculptures, including the Mfunte, Mbum, Kaka and not least the Mambila who occupy the plateau of that name.

Such figures are commonly described as ancestor figures, a description which is challenged. The gesture of the left hand or both hands to chin in Mambila sculpture is characteristic of *tadep* figures connected with a healing association called Suaga. The ritual paraphernalia were kept in granary-like storehouses adorned with painted screens (*baltu*). Two types of carved anthropomorphic figure were displayed in front of the storehouse: *kike* made from raffia palm pith, and *tadep* carved from wood. Both types were often made as a male-female pair and usually painted with black, red and white pigments. The style of the former is generally more abstracted than that of the latter. Larger *tadep* were also kept inside the storehouses. Although the Suaga complex remains central to the religious system of the Mambila, most figures and masks have been removed owing to their popularity among Western art collectors.

The style of this figure is indicative of that attributed to the Mambila, but the realism of the extended belly and the rounded structure on top of the head (reminiscent of the type of headgear worn by Cameroon Grassland elephant masqueraders to the south) are not typical. *KN*

Bibliography: Schneider, 1955; Fagg, 1968; Gebauer, 1979; Zeitlyn, 1994, pp. 38–47; Schwartz, n.d.

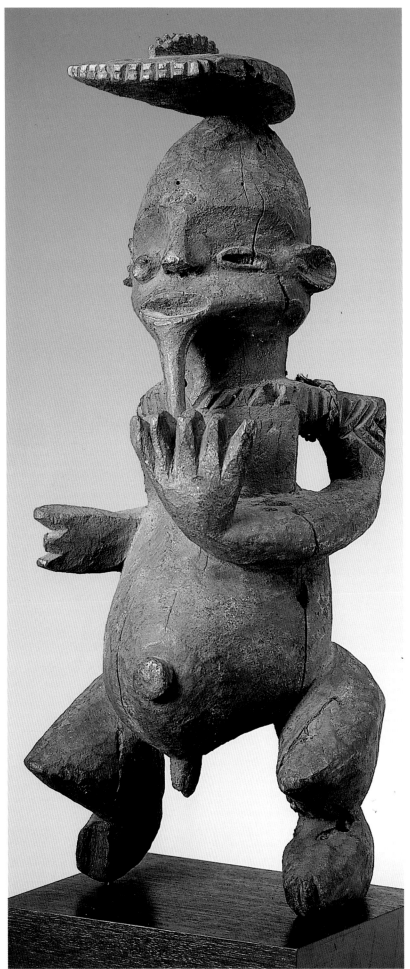

5.21

Double statuette

Mambila
Nigeria
stone
30 x 9.5 x 7.5 cm
Galerie Michael Werner, Cologne and New York

The Mambila, who inhabit the region between Nigeria and Cameroon, are famous for the originality of their sculpture. This consists mainly of wooden statues, frontal and very heavy; the figures invariably have big, expressionist heads, with hair often dotted with small wooden pegs and zoomorphic helmet masks in polychrome wood. The protruding eyes of the masks are reminiscent of the sculpture of the Grasslands. Also produced are less well-known sculptures in fired clay or soft stone, often of volcanic origin. This curious figure belongs to the latter type. It represents two people with their feet interlocked, a man and a woman in the coital position. Their heads, with very prominent features, are typical of the Mambila style. *EF*

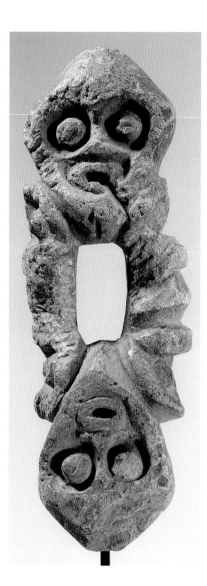

5.22

Standing female figure

Chamba
Nigeria
wood
51 x 16.5 x 13 cm
Fritz Koenig Collection

Chamba figures are less well-known than the often ungainly buffalo helmet masks that they share with their neighbours the Dakka in east Nigeria south of the Benue river. It was here that they migrated in the 17th century from the mountains on the Cameroon border, and remained in the face of Fulani invasions in the 19th century. The smaller wooden figures are a defence against snake poison and are stuck into the ground by means of an iron spike.

Larger figures are rarer and this fine example with the characteristic crest is one of the largest known. Other figures are typically found in the form of a joined pair with, so to speak, two legs between them. This particular sculpture is in the most reductive of Chamba styles, pared down in detail and concentrating with masterly success on relationships of volume. Like the double figures it seems to have been apotropaic in function. *TP*

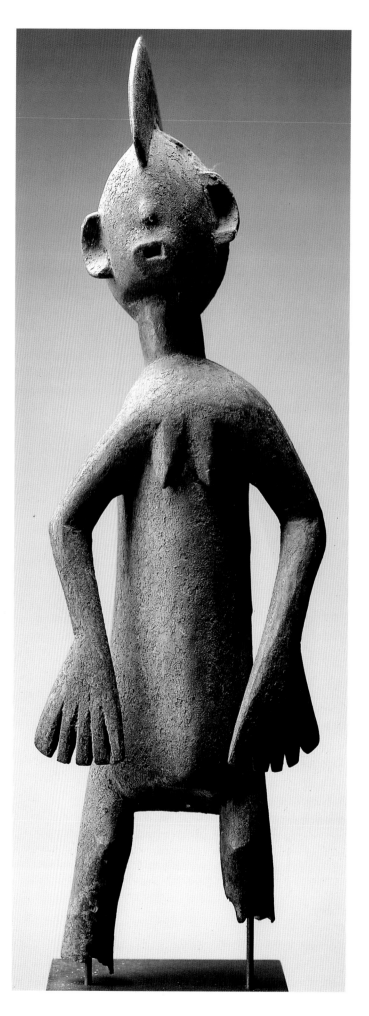

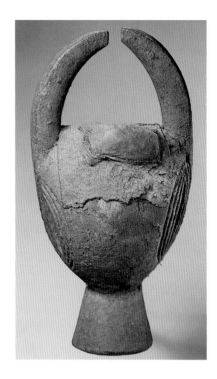

5.23

Mask
Loma (or Toma)
Liberia
20th century
wood
h. 75 cm
Museé Barbier-Mueller, Geneva, 1003-16

This abstract headdress is composed of three shapes: a central dome with two curved projections recalling animal horns at one end and an angular flange at the opposite end. Instead of placing it vertically over his face, the performer affixed it on top of his head. It was thus perceived horizontally, the way most people imagine and depict animals. A generous ruff of plant fibre hung from the lower edges and hid the upper body of the wearer. Thus the horizontal headdress functions as a mask. This example should be assigned to the Kantana people (known earlier as the Mama) of northern Nigeria where wild buffalo roam the bush. The Kantana employ several kinds of abstract horned headdresses at their ceremonies for crop fertility. A packet of symbolic medicines and traces of offering materials on this wooden carving indicate the intensity of their appeals.

The Kantana horizontal mask belongs to a group of headdress forms that have remarkably wide distribution mainly in west Africa. These exhibit a blunt elongated mouth, a cranium and pointed shapes, such

as horns or feathers, extending back from the head. McNaughton has listed over 80 ethnic groups who include this kind of mask in their repertory. These groups extend over 3000 miles of territory, occupy diverse physical environments, belong to eight linguistic groupings and diverge in local culture. The variety of these horizontal masks within the basic tripartite format is a tribute to the artistic creativity of the carvers. Examples vary from minimal abstract forms, such as this one, to elaborate figurative examples, in which we can recognise a long crocodile snout, a human-shaped nose and brow on the cranium, and identifiable antelope or buffalo horns for the third element. This combination refers to the environment in which the performances take place, by alluding to the powerful creatures of water and of land closely linked to the human presence. References to the surrounding world are made by a variety of other creatures such as snakes, hyenas, chameleons, elephants, hippopotami and birds. In articulating this imagery, local carvers have also imagined many gradations of realism and abstraction, thus producing a remarkably varied corpus of artistically devised objects.

This mask, which so prominently features creatures of the wild, appears in public on the head of a performer wearing a huge costume of fibre strands taken from the bush or forest, confirming the identity frequently assigned by its owners as a bush spirit. Often the masker carries two staffs which serve as animal forelegs. These animalistic apparitions are designed to bring the vitality of the outside world into the village in order to regenerate crops and increase the birth of children. Their typical behaviour includes extremely energetic, even threatening movements, which may be restrained through cords held by attendants or through man-made rhythms of drumming and song. This ritual suggests that the masquerader conveys the powerful non-human energies of the surrounding environment which however must come under control in order to benefit the community. *WS*

Bibliography: Fraser, 1962, pp. 38–52; Sieber and Ververs, 1974, fig. 14; McNaughton, 1991, pp. 40–53

5.24

Mask
Loma (or Toma)
Liberia
20th century
wood
h. 79 cm
Rosemary and George Lois Collection

The Loma are one of the numerous Mande-speaking populations who descended from the northern savanna region into the forested band of west Africa during the turbulent conditions of the later days of the Malian Empire (1230–1670). In recent times the majority (numbering 150,000) have occupied the hilly forested region of northern Liberia. In the past their most notable sculptural forms were long wooden masks that combined human and animal features. Only men wore these masks, which were fitted over the wearer's head horizontally. All functioned within the major men's association generally known as Poro. This association usually regulates land use, organises work groups and enforces regulations regarding initiation, marriage, trade and comportment.

The largest Loma mask was 1.82 m in height, with a long, movable, crocodile-toothed maul extending in front, a mid-section of human-like face with exaggerated nose and forehead, and a huge bunch of feathers of birds of prey stretching out at the back. For the Loma and their neighbours, the Bandi, this frightening image rep-

resented the major forest spirit (Dandai or Landa, Landai) which made manifest the power of Poro; one of its duties was symbolically to devour boys during initiation in order to give them rebirth as men.

While these huge masks are rare in collections, one encounters numerous examples of a mask that early reports identified as Nyangbai, the wife of the great forest spirit. Like the example shown here, this kind is of smaller dimensions and, lacking the extended maul, seems less threatening. It is worn directly over the male wearer's face. The upper part usually exhibits simplified (cattle or antelope) horn shapes and a rounded forehead overhanging a short, abstractly shaped nose and large, flat facial planes. Usually such female partners to big male masks help out at periods of initiation and make an appearance only at important funerals or crises. *MA*

Bibliography: Germann, 1933, pp. 118, 121; Eberl-Elber, 1937, pp. 42–5; Van Damme, 1987, pp. 9–12

Mumuye

The Mumuye are probably an amalgam of seven originally separate peoples who retreated under pressure to the rocky hills south of the Benue River.

These three works reflect the diversity of style within the Mumuye figure tradition. Few were known before the 1960s and were usually misidentified as Chamba (as was cat. 5.25a). The Chamba are southern neighbours of the Mumuye and were one of the invading groups that drove the ancestors of the present Mumuye to their present home. Cat. 5.25a is one of the earliest recorded examples and is unusual for the open, stool-like central area.

Despite the large variety of substyles, all figures tend to be elongated, ranging in size from 20 to 160 cm. The legs are usually angular, and ribbon-like arms wrap around the torso with elbows clearly marked.

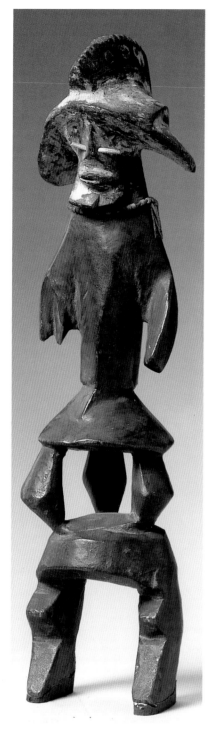

The heads may display a coiffure in the form of a crest. Scarification on face and body is delineated and the nasal septum is perforated for the insertion of a short section of a stalk of Guinea corn. Both scarification and nasal septum ornamentation reflect local custom.

A number of such sculptures have large ears with pierced and distended earlobes for the insertion of plugs, a practice visible in some Jukun figures from neighbouring areas. The Mumuye distinguish the gender of the figures on the basis of the shape of the ears; only Mumuye women distend their earlobes. In sculptures where secondary sex characteristics are absent or difficult to identify this may be the only clue to determining the gender of a figure.

The Mumuye occasionally used their figures for divination and healing, as did the north-western neighbours, the Montol and Goemai. Other figures, indistinguishable in form and style, reinforced the status of important elders, served as house guardians and/or were used to greet rainmakers' clients. *BH, RS*

Provenance: cat. 5.25a: 1922, acquired by the museum; cat. 5.25b: ex collection Jack Naiman

Bibliography: Fagg, 1963, pl. 138b; Rubin, 1969, figs 174–80; Fry, 1970, pp. 14, 89; Rubin, in Fry, 1978, pp. 106–8; Rubin, in Vogel, 1981, pp. 155–8; Sieber and Walker, 1987, pl. 35, p. 78; Robbins and Nooter, 1989, pl. 152

5.25a

Standing figure

Mumuye
Nigeria
wood
h. 30.4 cm
The Trustees of the British Museum, London, 1922. 6.10.3

5.25b

Standing figure

Mumuye
Nigeria
wood
h. 99 cm
Beyeler Collection, Basle

5.25c

Standing figure

Mumuye
Nigeria
wood
h. 110 cm
Private Collection, Paris

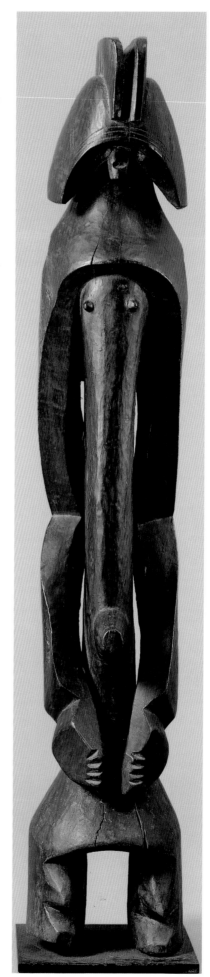

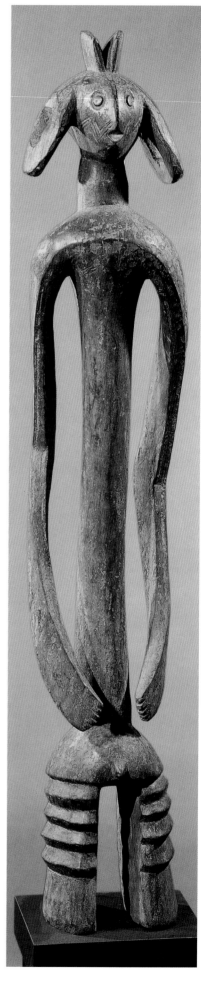

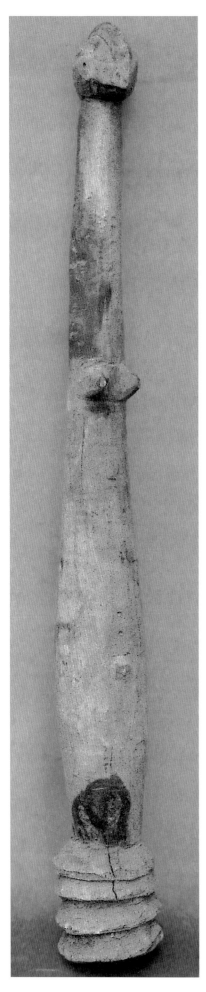

5.26

Figure

Benue to Cross River region
Nigeria
wood
100 x 11.5 cm
The National Commission for Museums
and Monuments, Lagos, 721.1246H

All we seem to have for this figure is
a location somewhere from the middle
Benue to the Cross rivers, a region of
diverse social environments with
many uses for figure sculpture as
other entries make abundantly clear.
It is an area, moreover, in which one
passes rapidly from places where there
is a well-developed stylistic configura-
tion, invariably mediated by institu-
tions of apprenticeship, to places
where neither a defined style nor
the means to inculcate it are present.
Nevertheless, whether to satisfy a
ritual need or for mere playfulness
(and one cannot tell from the sculp-
ture itself), men take to carving the
human figure often having had no
training in the use of a knife or an
adze. Indeed, their only experience
of the effect of a sharp blade on a
piece of wood may well have been
watching a smith prepare the haft
for a tool he has wrought. As a re-
sult a series of highly idiosyncratic
schematisations come into existence
which, in the absence of secure data,
defy attempts at precise geographical
location. *JWP*

5.27

Headrest

Jukun
Nigeria
bronze
63 x 90 x 50.5 cm
The National Commission for Museums
and Monuments, Jos, Nigeria

Two of these unusual headrests exist,
one of them in a damaged state: both
are in the Jos museum. Attribution to
the Jukun seems certain. Although
their great wooden figures are justly
well known despite the fact that only
a dozen or so have survived (of which
cat. 5.28 is the finest), they were also
accomplished smiths and casters
though not so prolific as their neigh-
bours the Tiv. The Tiv however seem
never to have produced an object so
technically difficult as this hollow-
cast headrest whose bronze walls
are as thin as the early Benin heads.

What is particularly interesting in
the survival of this piece is that un-
like the Tiv, the Jukun identify their
origins in the Sudan and their casting
knowledge from the area of the Sao
culture (cat. 6.60) near Lake Chad
after its dispersal. The height of
Jukun influence was in the 16th cen-
tury when its long vanished capital
Kwororafa thrived, which suggests
connections with other Nigerian
bronze-casting traditions. Metal-
lurgical analysis may yet provide
more clues. The extraordinary saddle-
like form of this impressive headrest
which may date from near the time of
Jukun power (perhaps a 17th-century
date is likely since the crotals which

hang from it are of an appropriate
type) has northern associations and
it should be remembered that the
Jukun were early converts to Islam.

It is objects such as this, which
occupy a place of transition both in
time and geography, that with the
future sophistication of the analysis
of alloys as well as stylistic studies
will provide the key to the complex
web of influence and achievement in
the ever absorbing story of Nigerian
bronzes in particular and those of
Africa in general. *TP*

Bibliography: Williams, 1974

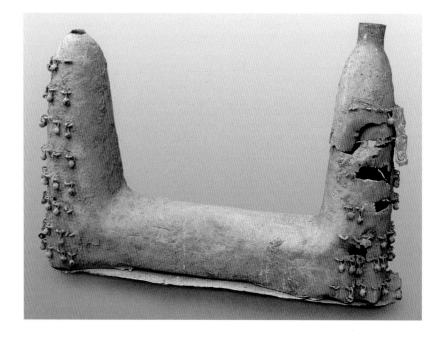

5.28

Female figure

Jukun
Nigeria
late 19th–early 20th century
wood
59.7 x 20 x 22 cm
The Menil Collection, Houston,
71-05 DJ

The Jukun live both north and south of the River Benue, dispersed across a wide swath of the middle belt of northern Nigeria. Distinctive to Jukun culture is the institution of divine kingship and the maintenance of cults providing access between the living and their ancestors. Figurative sculpture is made primarily by the northeastern Jukun, especially those living between the towns of Pindiga and Kona. Figures occur mostly in pairs, designated as husband and wife and often representing a deceased chief and his consort. These sculptures often had ancestral connotations, facilitating contact between living chiefs and their predecessors, who were enlisted to maintain community well-being or to avert disaster.

This female figure relates to the examples Rubin observed among the Jukun subgroup called the Wurbo, who live scattered along the banks of the River Taraba. Such figures were not specifically ancestral but were used in a possession cult called Mom which was instrumental in treating a variety of personal illnesses or in alleviating community crises like epidemic disease or crop failure. They were used to incarnate spirits, to whom offerings were made. Like other Wurbo figures, especially those Rubin saw in the village of Wurbo Daudu, this piece is carved of heavy hardwood and is distinguished by a pronounced facial overhang, distended earlobes with cylindrical ear plugs, sharply conical breasts, long arms bent forward and ending in large hands with deep gouges suggesting fingers, and rudimentary legs and feet. The surface details on this particularly striking female figure also reveal elements of Jukun regalia and body decoration: incised carving around the upper arm, forearm and waist represent cast brass ornaments, some with the openwork designs typical of Jukun craftsmanship; the deeply carved loaf-shaped projection from the top of the head captures an elaborate coiffure; and the markings at the sides of the face and across the chest depict patterns of scarification. Absent here, but typical of the genre, are small metal plugs inset in the eyes. *MCB*

Bibliography: Meek, 1931; Rubin, 1969, pp. 78–93; Rubin, 1973, pp. 221–31; Gillon, 1984; Rubin and Berns, in preparation

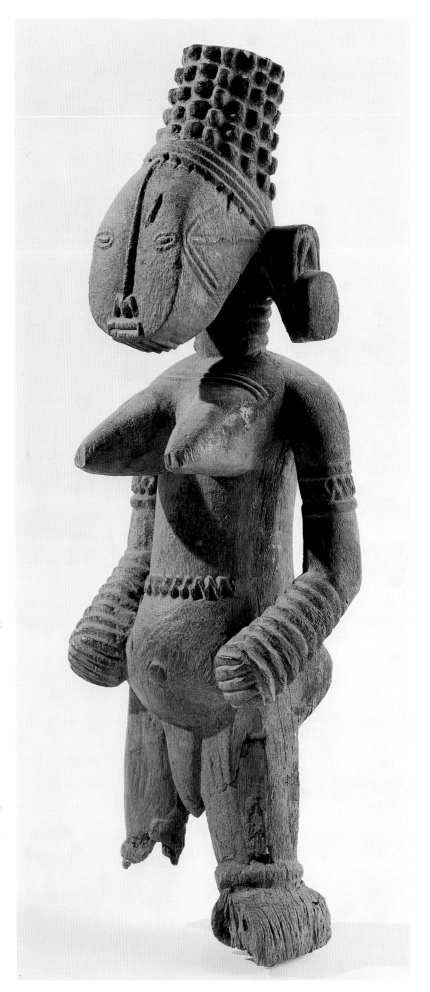

5.29

Male figure

Montol
Nigeria
20th century
wood
44.5 x 12.5 x 9.5 cm
Courtesy of the Trustees of the National
Museums of Scotland, Edinburgh,
A.1953.99

The Montol live in the region of
central Nigeria which is dominated
by the Jos Plateau. They are one of
a cluster of small Chadic-speaking
groups living within this rugged
terrain. They and their neighbours –
the Goemai, Tarok, Ngas and others –
share the practice of producing small
figurative sculpture for men's societies
concerned with healing. The Montol
call this society Komtin (known as
Kwompten among the Goemai and
Tarok), and its members employ
carved wooden figures in healing
rituals or in determinations of the
cause of illness. Like this example,
Montol figures have a squat, chunky
system of proportions, with body parts
rendered geometrically. Torsos are
columnar with broad chests and hips;
the arms typically hang unarticulated
at the sides of the body and the short
legs emerge from the hips in an
open-stanced, inverted 'U' formation.
The schematic, triangular head has
abstract features. Deep gouges in the
upper torso and face are rudimentary
references to body scarification pat-
terns practised by the Montol and
other groups in the area.

Little information has been
published on these Montol healing
figures. *MCB*

Exhibition: Purdue University 1974
Bibliography: Isichei, 1982, pp. 1–57;
Rubin and Berns, in preparation

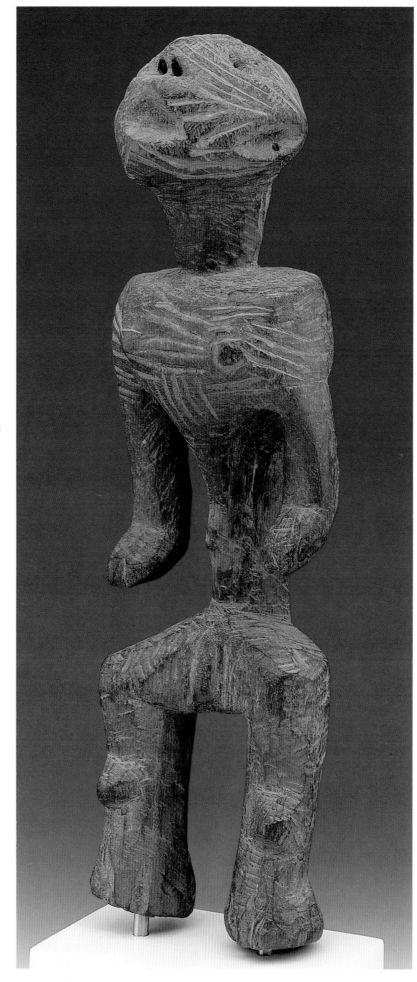

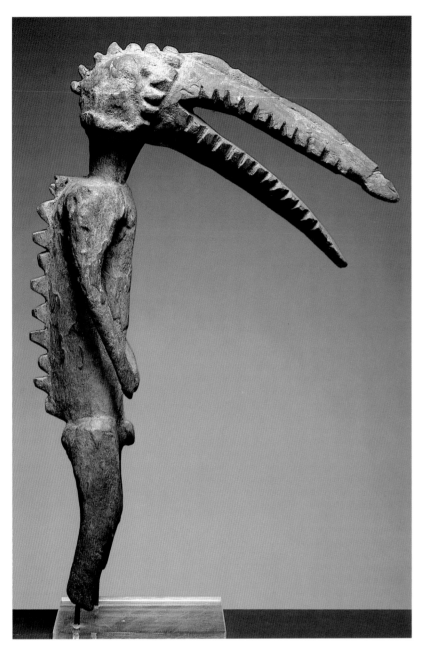

photographed in 1957 by Robin Jagoe, a British colonial officer (published by Sieber). The latter are quite unlike other Goemai examples, which lack the zoomorphic head and are used by diviners in healing ceremonies. They had appeared at a harvest ceremony near Shendam, the capital of the Goemai. It was probably also an ancestral rite, for the ceremony took place near the graves of deceased Long Goemais (paramount chiefs of the Goemai).

This may be the only figure of its type outside Nigeria that resembles the figures in Jagoe's photographs. In the absence of other data it may be considered to have ancestral and agricultural significance to the Goemai and be related to the celebration of deceased chiefs.
BH, RS

Bibliography: Sieber, 1961, figs 7, 29, 31; Klever, 1975, p. 225, fig. 101; Schaedler, 1992, p. 157, fig. 124

A wide range of bracelets, lip plugs, bells, pendants, beads, tobacco pipes, snuff bottles and other forms have been associated with prestige, coming-of-age and leadership. Unfortunately, almost no information about precise origin, use or meaning has been published.

It has been suggested that this figure comes from the Verre at the far eastern border of Nigeria or from the Tiv around the middle of the Benue valley. There exists no close parallel in the known corpus of works from either group. However, a number of aspects would suggest a Tiv origin, for instance the pose of the figure and the crotals hanging from what appear to be bangles. The precise origin of the metal figure tradition(s) of the Benue valley might never be established for the following reasons: the works have emerged without field data and it is too late to retrieve them; an unrecorded origin of the casting tradition may lie outside the Benue valley, either toward Lake Chad or to the south-east; or the casters may have been itinerant artisans.
BH, RS

Bibliography: Abraham, 2/1940, pls 6, 7B, 12A; Bohannan, 1957, pl. XIIa–c; Rubin, 1973, pls X, XI; Rubin, 1982, pl. H5

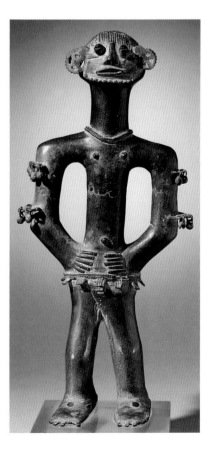

5.30

Standing figure

Goemai
Nigeria
wood
62 x 13 x 43 cm
Fritz Koenig Collection

The Goemai live to the north of the Benue River, opposite the Jukun. Their land is bisected by the Sheman-ker, a tributary of the Benue. Of the masks found among the Goemai one type is of particular interest because it relates to this figure and may be of an older, indigenous form that is shared by the Montol, northern neighbours of the Goemai. Called *gugwom* by both the Goemai and Montol, it is a horizontal mask with elongated croco-dile-like jaws. It officiates at the instal-lation and burial of chiefs and has a strong ancestral association; it is also used during the dry season and is associated with the success of agri-culture.

Gugwom masks resemble the head of this figure and of several others

5.31

Figure

Tiv (?)
Nigeria
copper alloy
h. 44.7 cm
Private Collection

Copper alloy figures from northern Nigeria are extremely rare, although castings with human elements, usually heads, occur among the far more frequent ornamental or utilitarian forms. Found along most of the Benue River valley many have been recorded among or attributed to the Egbira, Idoma, Tiv, Jukun, Abakwariga, Verre and several small groups in north-eastern Nigeria and the adjacent Cameroon Highlands.

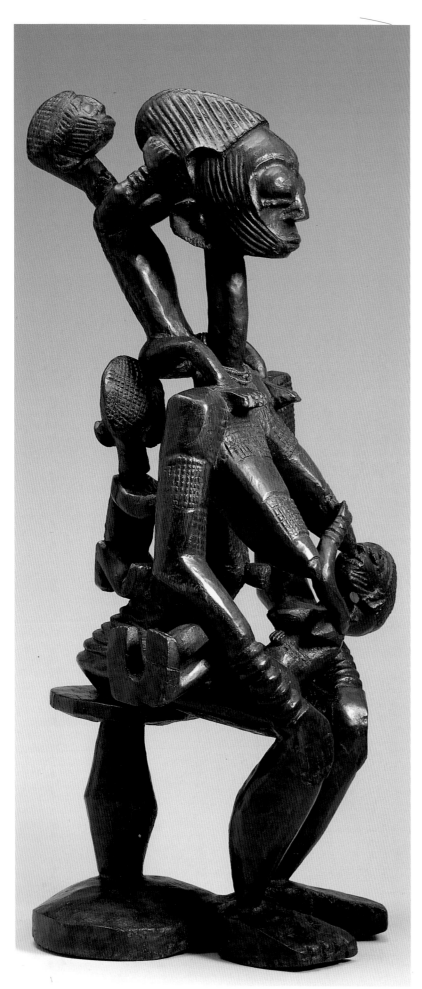

5.32a

Maternity figure

Afo (?)
Nigeria
19th century
wood
70 x 30 x 31 cm
Horniman Public Museum and Public
Park Trust, London, 31.42

Both of these sculptures are now
generally attributed to the Afo
(cat. 5.32a was for a time assigned
to the Yoruba, and cat. 5.32b to the
Jukun, although it is quite unlike
other Jukun figure carvings).
The maternity figure (cat. 5.32a)
is unusual not only because there are
three infants (rather than one) but
because instead of being carved from
a single block of wood, several pieces
of wood were pegged in its construc-
tion. William Fagg suggested that Afo
maternity figures represent an ances-
tral mother. Tschudi notes that 'every
community of any size possesses ...
a carved statuette representing a preg-
nant woman with a child on her back.
This is worshipped in ceremonies by
the men of the village praying for the
preservation of fertility in their wives.'
More generally it may be ancestral
and attend to the well-being and
health of the villagers.

In the early 1960s Rubin photo-
graphed a caryatid stool at the Jukun
village of Gidan Yaka on the south
bank of the Benue River about 20
miles from Wukari. In 1958 Sieber
photographed one among the Goemai
across the Benue River from the
Jukun. Although a number of ex-
amples in related styles have been
attributed to the Afo, none has field
provenance. Some are figures, others
are caryatids supporting a disc or a
bowl on top of the head. All known
instances are formally related and
represent a female figure, often with
an infant on her back. Many exhibit
facial and body scarification and a
large herniated navel, in which
respect they resemble cat. 5.32b.
However, facial scars similar to
both figures are found on Jukun and
Igala masks indicating that the Afo
are not alone in using this form of
scarification.

It seems that the stools were not
cult objects. Rubin describes the stool
he saw as 'an oath image used in cases
of theft, and prayed to in certain crisis
situations, such as drought'. Further,
he notes that there was an 'earlier
intimate association with a powerful
and revered ancestor'. None the less,
'the figure appears to stand outside
more usual ... channels of access to
the ancestor involved, such as masks
or figures'. The stool Sieber photo-
graphed was used as a seat for a
masked dancer to rest on; no other
association was offered.

Despite the formal and stylistic parallels for this type of object, it may be too easy to attribute all examples to the Afo. Kasfir notes that the 19th-century Fulani jihad 'scattered many of the [Benue] north-bank populations, and with them their cults and cult sculpture'. The result, she suggests, is 'a pantribal genre of mixed provenance, rather than a single point of diffusion'. The result may well be a style that evolved along both banks of the Benue from near its confluence with the Niger upriver for some 40 km.
BH, RS

Provenance: cat. 5.32a: early 20th century, collected by Major FitzHerbert Ruxton; 1931, acquired by the museum; cat. 5.32b: 1904, collected by Capt. Glaunig in Wukari (capital of the Jukun)

Bibliography: Underwood, 1947, fig. 21; B. Fagg, 1948, p. 125 and pl. K; B. Fagg, 1958; Sieber, 1958; Fagg, 1963, fig. 143b; Krieger, 1969, no. 231, pl. 230; Rubin, 1969, i, pp. 91–3, ii, figs 161–4; Tschudi, 1969–70, pp. 84, 95; Kasfir, in Vogel, 1981, p. 163; Sieber and Walker, 1987, cover, p. 39

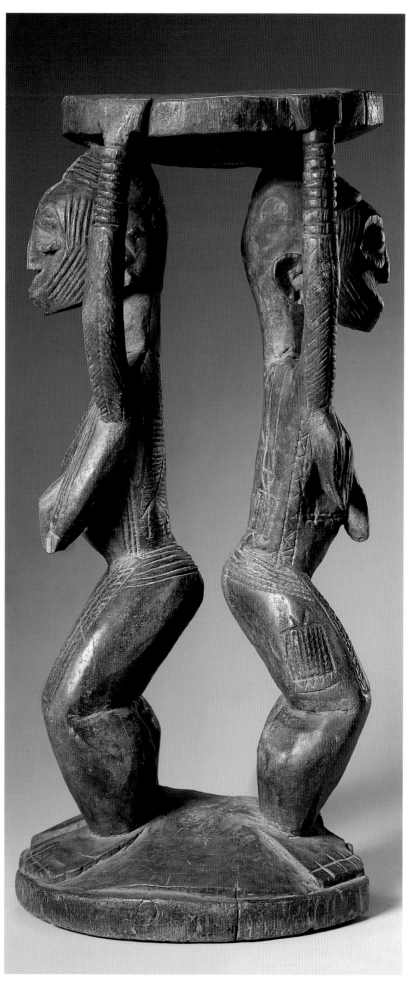

5.32b

Double caryatid stool

Afo (?)
Nigeria
19th century
wood
h. 57 cm
Staatliche Museen zu Berlin, Preussischer Kulturbesitz, Museum für Völkerkunde, III C 18455

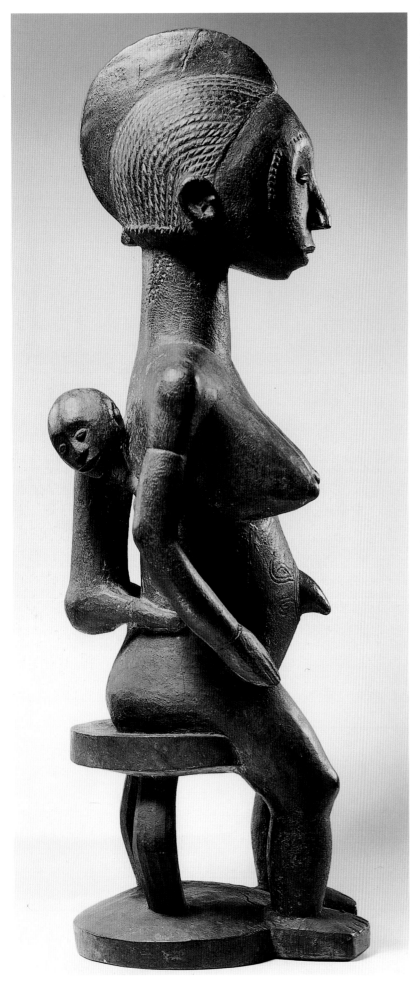

5.33

Female figure with child (*ekwotame*)
Idoma or Tiv
Nigeria
19th century
wood
h. 68.5 cm
Dr Laurence R. Goldman, Brisbane

Fewer than half a dozen figures in this style by at least two hands are known. One example was photographed by Sieber in the Idoma village of Oturkpo-Icho in 1958, resulting in a provisional attribution to the Idoma, the eastern neighbours of the Tiv; it is apparently by the same hand as this piece, which was formerly in the Epstein Collection. The name *ekwotame* ('image with breasts') may well be local. No other example has field data, precise origin, name or use. According to Kasfir, members of the family who owned the Oturkpo-icho figure stated that it was purchased in a Tiv village by the present owner's great-uncle about 1870; Sieber's informant (from the same family) reported that it was owned by his grandfather at least 50 years earlier, but did not mention a Tiv origin. Possibly the carving workshop was Tiv. The scarification around the herniated navel and on the face are characteristic of the Tiv; the work may have been carved by an Idoma artist active in a Tiv borderland.

There is some confusion with regard to the function of the sculpture. Sieber was firmly told that the piece he recorded was not a juju, but was placed next to the bodies of old men at their funerals. Kasfir reports that she was told that it was 'a very powerful "juju" and has by accretion incorporated wealth, fertility, luck and protection functions'. *BH, RS*

Provenance: ex collection Jacob Epstein
Bibliography: Sieber, 1961, fig. 5, pp. 8–9; Kasfir, 1979, pp. 337 ff., figs 94–100; Bassani and McLeod, 1989, fig. 230, p. 106

Large carvings made from a single piece of wood, often sculpted from a considerable portion of a tree, were widespread in the Middle Cross River region of south-east Nigeria, especially among such groups as the Bahumuno, Yakur and Mbembe of the Obubra area. A few free-standing carved pillars can still be seen among the Yakur. These usually serve to define ward territory within typically compact village settlements, the sites of annual ceremonies connected with the agricultural cycle. During the 1970s some communities around Obubra also possessed drums with finials carved in the round in either animal (e.g. monkey) or human form, representing the head or full body, the latter often seated. Given that these sculptures are carved from the same piece of timber as the slit drum itself, unusually for African carvings, the grain of the wood is horizontal – opposite to the axis of the head or figure in upright position.

Large slit drums were generally the property of the community or a specific male association such as the leopard spirit society (cf. cat. 5.35) or an age-set. They were used to summon able-bodied men to tackle an emergency such as fire or (formerly) slave-raiding forays or to inform communities (for drum language can carry over many miles) of important news, especially the death of a prominent person.

During the Nigerian Civil War of 1967–70, it is said that Biafran soldiers caused fear and confusion among the enemy by using giant slit drums to imitate artillery fire. Sadly, during the war and its aftermath, many pillars and drums in this area had portions lopped off them in order to satisfy the demands of the international art market, so that by the 1970s relatively few remained intact.

Both the Mbembe pieces shown here are weathered, having been exposed to tropical rainfall in the context of their original use. Such weathering serves to enhance rather than detract from the aesthetic quality and is probably indicative of a late 19th-century date. *KN*

Provenance: cat. 5.34a: ex collection Kamer
Bibliography: Forde, 1964; Harris, 1965; Eyo, 1977, pp. 220–2; Nicklin, 1981, pp. 259–60

5.34a

Drum finial: seated figure

Mbembe
south-east Nigeria
late 19th century
wood
h. 80 cm
Private Collection

5.34b

Standing figure

Mbembe
South-east Nigeria
wood
h. 85 cm
Private Collection

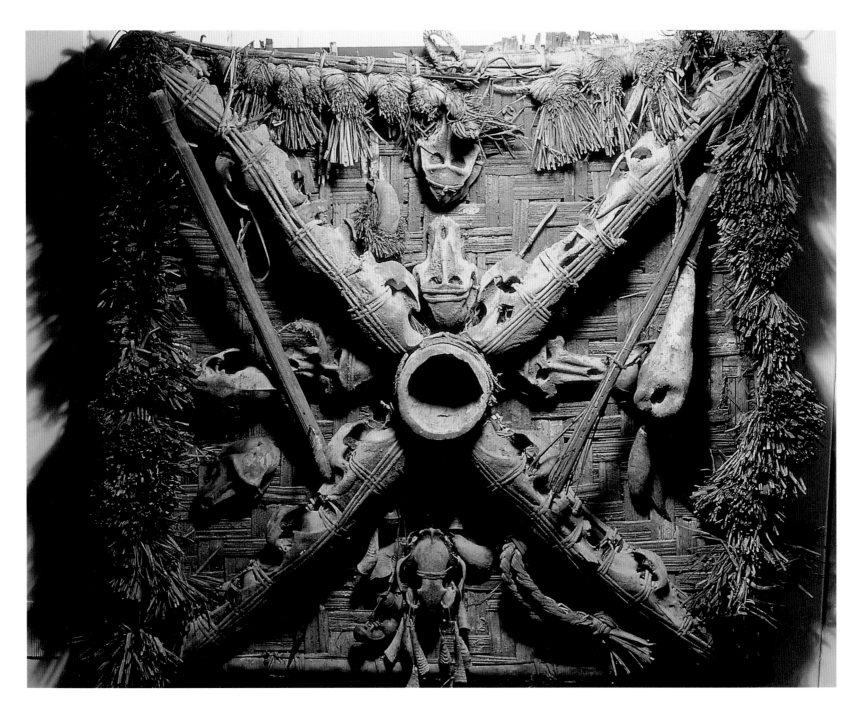

5.35

Emblem of the leopard spirit society

Ejagham
South-east Nigeria/south-west Cameroon
20th century
cane, wood, animal skulls, fibre
127 x 132 x 16 cm
Charles and Kent Davis

This is a fine example of an emblem of the Ngbe (leopard spirit society) of the Cross River borderlands of south-east Nigeria/south-west Cameroon. Talbot (1912) recorded such items for the Ejagham, and Ruel described those of the Banyang.

Ngbe, a major regulatory society of the Cross River region and its adjacent territories, may be seen either as a federation of distinctive sub-associations or as a graded unitary society. After initiation into the most junior echelon of Ngbe, often in childhood or adolescence, a man proceeds to join some or all of the sections of this all-male society, which have varying degrees of prestige and distinctive bodies of lore. Membership is granted by senior elders of the cult, upon payment of customary fees in cash and kind, in return for esoteric knowledge and, sometimes, regalia.

As well as having their own forms of masquerade costume, song and dance, sub-associations of Ngbe sometimes have their own emblem which is adorned with the skulls and horns of beasts consumed at the foundation feast. The Banyang screen (*nkpa*) described by Ruel was the property of the Bekundi sub-association of Ngbe. The basic structure of the *nkpa* is that of a mat, usually woven from palm leaves or palm-leaf midrib bark, strengthened at the edges with lengths of palm midrib decorated with raffia tufts. The specimen in question is equipped with a suspension loop, by which means it would have been attached either to the central pillar of the Ngbe lodge, or the wall behind which lay the inner sanctum.

Most Ngbe emblems have at the centre one or more membrane drums. Not only is such a drum essential to all Ngbe performances, but it is used by the society's crier in making announcements, and is thus a symbol of its legislative authority. The circular structure at the centre of the present specimen is probably the wooden body of such a drum, with its membrane missing. A more remarkable feature, however, is the lines of skulls, firmly secured with cane, which radiate from the centre, as diagonals, possibly an expression of the 'four quarter' motif painted on some Ngbe drum heads. Between the four quarters of the screen are several

skulls, of baboons, cows and canine animals, as well as goat and/or antelope skulls and horns. The overall configuration of the lines of skulls is reminiscent of certain motifs of the type associated in the Cross River region with a pictographic script called Nsibidi, and with a form of sacred calligraphy known as Anaforuana among Cuban members of Abakua (a form of Ngbe which found expression among the descendants of Cross River victims of the trans-Atlantic slave trade).

Other items incorporated into the screen include a baton-like staff, a palm-fibre broom and two loops of rope. Ceremonial brooms convey a number of meanings among Cross River peoples: they may be used in extending sign-language expressions or be carried in procession as devices to sweep away hostile 'medicines'. Among the Banyang of Cameroon, loops of cordage are employed by Bekundi initiates as signs which bar entry or deter theft. *KN*

Bibliography: Talbot, 1912, p. 264; Talbot, 1926, pp. 346–783; Ruel, 1969, pp. 220–1; Cabrera, 1970; Cabrera, 1975; Thompson, 1983, p. 241; Rubin, 1984, p. 68; Nicklin, 1991[1], pp. 3–5

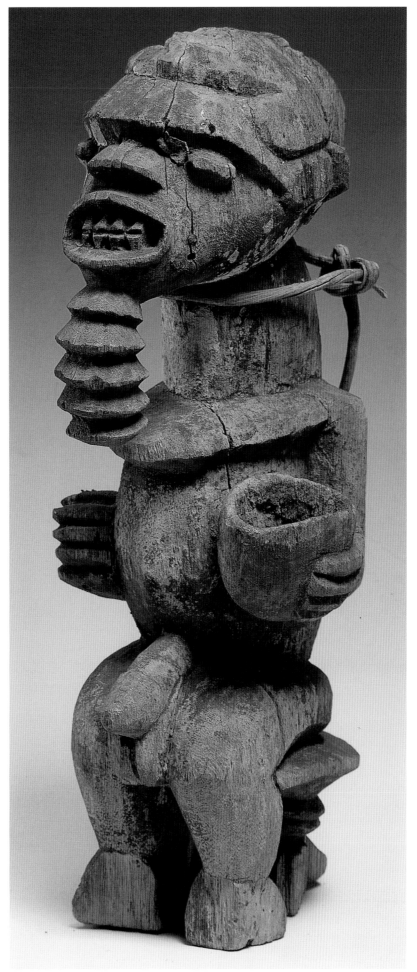

5.36

Seated male figure

Bangwa (?)
Western Cameroon
late 19th century (?)
wood
35 x 14 x 16 cm
The Trustees of the British Museum, London, 1920.11-6.5

Although this fine piece is given an Ekoi (Ejagham) attribution by William Fagg, there is little about the style of carving to confirm this. The mode of depiction of the coiffure/cap, brows, open mouth with prominent teeth and plaiting of the beard in segmented fashion are all reminiscent of western Grasslands style and specifically suggestive of masks and figures of the Bangwa, a Bamilike people at the western limit of distribution, adjacent to the forest-dwelling Banyang and Ejagham. The figure's seated posture is similar to that of carving styles even further to the west, for example among the Ibibio, Annang and Ogoni of southeast Nigeria. According to the museum's records it is from 'Nikim ... Befun country'.

It is possible that this is a Bangwa ancestral figure carved by an artist influenced by styles to the west, the dominant axis of overland trade routes leading to the port of Calabar in the lower reaches of the Cross River. Some Bangwa artists are known to have travelled long distances to work for distant patrons. *KN*

Bibliography: Fagg and Plass, 1964, p. 51; Brain and Pollock, 1971; Brain, 1980

5.37a

Carved monolith (*atal*)

Bakor, Ekoi (Ejagham)
Cross River, Nigeria
16th century (?)
basaltic stone
h. 114 cm
Musée Barbier-Mueller, Geneva, 1015.9

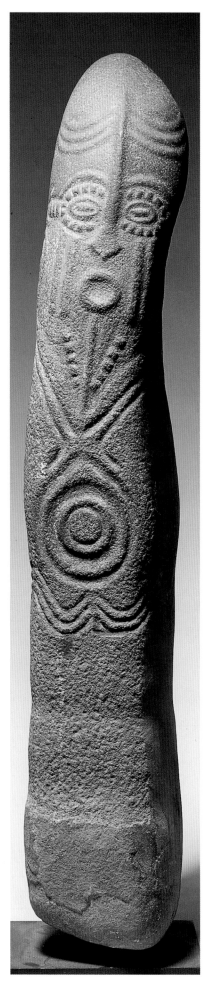

The deeply grooved features on cat. 5.37a depict an individual wearing a stocking cap commonly used today by village heads and other titled individuals in many parts of eastern Nigeria. The figure may therefore represent a chief or a titled official. He is shown with an elongated nose and segmented eyelids that encircle the almond-shaped eyes. On either side of the eyes are horizontal keloids, representing the raised tattoo marks that can still be seen today on the faces of elder men and women of the area. The mouth is a simple circle, while the navel is formed by equally simple concentric circles. Spirals on both sides of the body represent coiled manillas used as currency in the past. The curvilinear style of rendering the human features is peculiar to the monoliths of the Abanyom, Agba and Nnam groups of villages, particularly the Nnam.

This style is distinct from the more sculptural style seen, for example, in cat. 5.37b, which is peculiar to the Nta, Nde and Nselle groups of villages. The depiction of human form in this example approaches the sculptural in that an attempt has been made to separate the head from the torso with a deep, broad groove. The round eyes set under heavy eyebrows, the open mouth with the tongue sticking out, and the bearded, austere face all indicate the role of the individual portrayed. This figure is known as Ebiabu and stands for the society of that name, which was responsible for carrying out death sentences. The monolith was recorded *in situ* at Etingnta, the main village of the Nta group. A similar monolith, also called Ebiabu, has been recorded at Nna Orokpa, another Nta village.

These columnar basaltic stones on which human features were carved come from the basin of the Cross River or its tributaries. They are found almost exclusively within the five village groups of Nnam, Nselle, Abanyom, Nde and Akaju, who inhabit an area of over 900 sq. km in the middle of the Cross River area. Together, these groups of villages form a homogeneous linguistic group known as 'Bakor'. The Bakor language is a sub-dialect of the larger linguistic group known as Ekoi or Ejagham. The Ekoi or Ejagham are found in the easternmost part of southern Nigeria and in the contiguous area of the western Cameroon Republic. They are hoe agriculturists and their main crops are yam, cocoyam and maize. The men are hunters, but help in clearing the bush for women to farm. The unity of the 'Bakor' linguistic group, despite its former internecine warfare, has now been politically expressed in the joint celebration of the annual New Yam Festivals into which the carved monoliths are incorporated. Because these monoliths are almost exclusively found in the Bakor linguistic area, the term 'Bakor' is used here to refer to them (rather than 'Ekoi' or 'Cross River', terms that are too imprecise because they refer to a much wider and more diffuse geographical area than is relevant to these stones).

These monoliths were first described by a British District Officer, Charles Partridge, in 1905, who noted that at the Alok village of the Nnam group the monoliths were painted and offerings were made to them during the New Yam Festival. In 1968 Philip Allison made a comprehensive documentation of the monoliths, which number over 300 and which range in height from 90 to 180 cm. They are found mostly in abandoned village sites arranged in perfect, near perfect and segmented circles. When found in present-day villages, the monoliths are usually arranged in clusters of several stones or individually beside a big tree in the middle of the village. It seems that most of the monoliths found in the present-day villages were removed from old village sites and brought to the new settlements when the community moved. In their original setting the monolith circles enclosed areas that were used as a marketplace and as a community playground during the day and occasionally at night for secret ritual activities. Through historical reconstruction Allison dated the monoliths of Nta to the 16th century, when trade with Europeans in Calabar at the mouth of the Cross River brought prosperity to the inland peoples of the Cross River. This dating seems to be supported by a recent carbon-14 from Alok, but another carbon-14 date from Emangabe gave the date of around AD 200.

Allison gave the name *akwanshi* to the carved monoliths and it has since been widely used. Recent studies have revealed that the use of the term is incorrect. *'Akwanshi'* is used only by the Nta and Nselle groups to designate

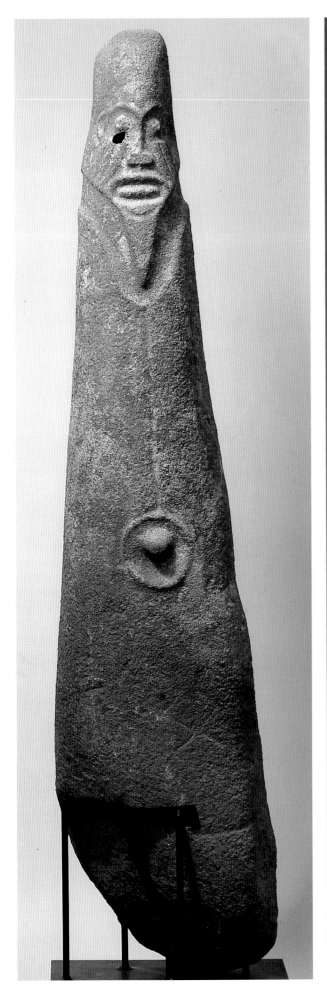

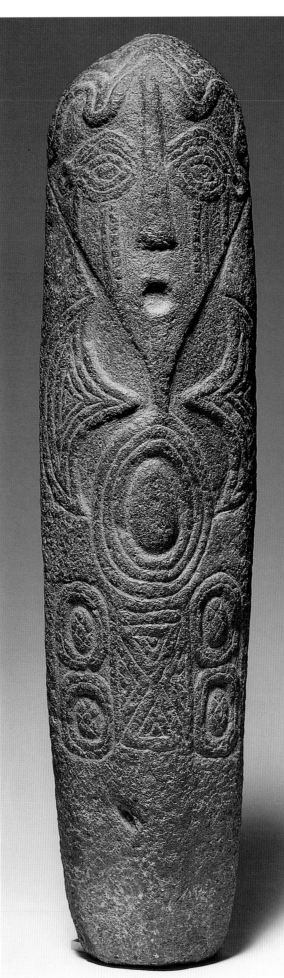

small uncarved stones representing dead ancestors of the family or lineage; they range in height from 7.5 to 15 cm. They are usually piled in a heap in the compound of the family or lineage head and sometimes within the circle of the village's larger monoliths. Among the Nnam, Abanyom and Akaju these small uncarved stones are known as *akuku*. On the other hand, the Nta group use the word *netal* to refer to the large carved monoliths for which the Nselle term is *alapatal* and the Nnam and Akaju term is *atal*. Although these large carved stones also represent dead ancestors, they refer more specifically to dead legendary figures linked to memorable events. For example, the carved monoliths may represent famous hunters or warriors, the personification of the very beautiful or the very ugly. Special functionaries in the society were also represented, for example, the figure of Ebiabu mentioned above. Hence, instead of the term *akwanshi*, the shortest version of all the designations of the carved monoliths is adopted here: *atal* (used by the Nnam, Abanyom and Akaju), also because it is cognate with the Nta *netal* and the Nselle *alapatal*. EE

Bibliography: Partridge, 1905; Allison, 1962; Allison, 1968; Eyo, 1984

5.37b

Carved monolith (*atal*)

Bakor, Ekoi (Ejagham)
Cross River, Nigeria
16th century (?)
basaltic stone
h. 174 cm
Private Collection, Brussels

5.37c

Carved monolith (*atal*)

Bakor, Ekoi (Ejagham)
Cross River, Nigeria
16th century (?)
basaltic stone
h. 84 cm
Private Collection, London

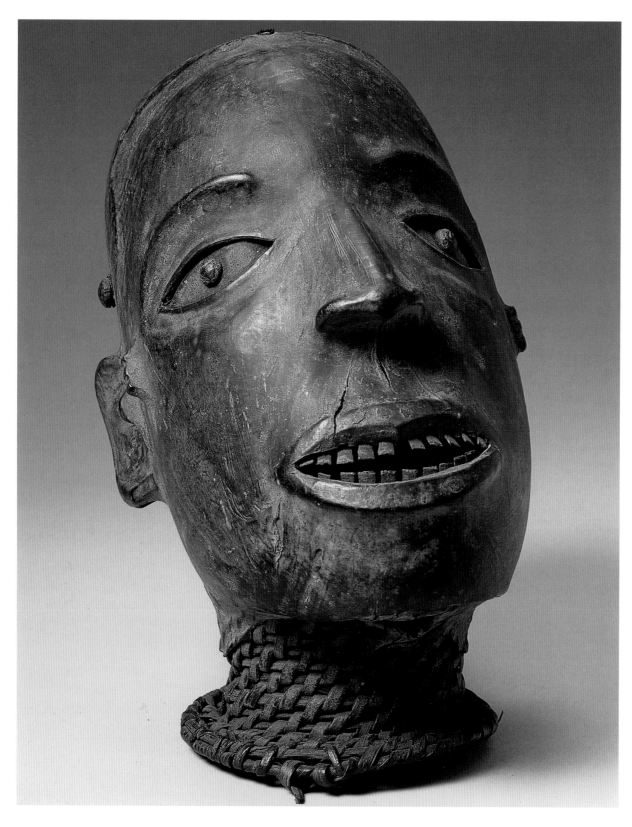

cane to represent the eyes and teeth; the pupils of the eye consist of a metal or wooden nail or peg.

Creases and folds in the skin covering of this piece, especially around the mouth, suggest either insufficient technical mastery or the artist's intention not to produce a smooth surface. The latter may reflect context of use, for skin-covered masks are often employed in pairs, a rather ugly and often aggressive male character or the 'Beast' (as probably represented in the present piece) interacting with a gracefully moving female character or 'Beauty'. The upward tilt of the head is characteristic of the former category of mask, often with those that most closely resemble a real human head carried above the performer's head. The bodies of both dancers would normally be entirely covered by a long gown, formerly of string netting, more recently of cotton cloth.

The patina of this cap mask indicates a lengthy period of use; between performances it was probably carefully wrapped in bark cloth or woven screw pine matting and stored in rafters near a continually smouldering hearth. It was customary to rub the mask with palm oil and to place it in gentle sunlight before use, so that the skin retained some flexibility and often achieved a degree of glossiness as this example has at its lips and the tip of the nose.

Masquerade performances generally took place at the initiation or funerals of members of the associations that owned them, and also at periodic rites connected with agriculture. Thompson suggested that the skin covering of a mask served as a magical agent to invoke ancestral spirits, thus eroding the barrier between living and dead participants in communal rituals.

The naturalistic style of this headdress, especially the careful delineation of the lips and eyes, indicates Middle rather then Upper Cross River origin, probably from one of the smaller Ejagham-speaking groups of people on the Cameroon side of the border, such as the Keaka. *KN*

Bibliography: Mansfeld, 1908; Nicklin, 1974, pp. 8–15, 67–8; Nicklin, 1979, pp. 54–9; Thompson, 1981, pp. 175–6; Nicklin, 1983, pp. 123–7

5.38

Skin-covered cap mask

Ejagham
Cameroon
19th century
wood, animal (?) skin, cane
h. 21.5 cm
Museum für Völkerkunde, Leipzig,
MAF 8705

This is a cap mask or headdress carved from wood, covered with skin and with a base of woven basketry for attachment to the head of the masquerader. Although there are authenticated cases of human skin being used to cover such masks, which are typical of the Cross River rain forests of the southern Nigeria/Cameroon borderland, the use of carefully de-haired and softened antelope skin is much more frequent. The techniques used in the production of skin-covered masks are more complex than those of most other African mask sculpture, as the subtractive process of carving is followed by an additive one involving not only the attachment of the skin to the wooden surface, but also inserts of metal or

5.39

Cap mask

Ejagham/Anyang
Cameroon
19th century (?)
wood, pigment, fibre
h. 29 cm
Private Collection, Paris

It is usual for mask makers of the
Cross River region to enhance the
realism of their work by applying a
layer of animal skin and then paint-
ing it with plant dye to accentuate
facial features. There is some evidence
in this piece of black or dark brown
pigment having been applied to the
face and head for this purpose, though
directly on to the wood. Other modes
of decoration normally associated
with skin-covered mask art are also
to be seen, for example the remains
of pegs, representing coiffure; and a
metal inset to form the eye, pierced
by a wooden peg depicting the pupil.
A vertical row of copper studs rep-
resents scarification marks on the
temples. The headdress does not,
however, have a basketry base of
the type often associated with skin-
covered cap masks.

William Fagg wrote on a mask
(in the Museum für Völkerkunde,
Frankfurt am Main, and described
by de Rachewiltz as a 'Girl's head
in wood, with a wig') that is in the
same style and possibly by the same
hand as this example. He correctly
asserted that 'the subtlety of the
artist's hand was such that the
addition of skin could only have
weakened the effect' of its superb
naturalism.

The colour and finish of the head-
dress indicate that it was once repeat-
edly rubbed with palm oil. Unlike
certain classes of African mask that
were allowed to decay after use, cap
masks and helmet masks were often
looked after with great care in periods
between masquerades. They were
regarded as valuable property by the
age-sets, warriors' and hunters' groups
who owned them. Nevertheless, this
piece has suffered some termite
damage. It is probably from a master
carver of the Anyang, a small
Ejagham-speaking group in south-
west Cameroon. *KN*

Bibliography: Fagg, 1965; de Rachewiltz,
1966; Nicklin, 1974, pp. 8–15, 67–8;
Nicklin, 1979, pp. 54–9

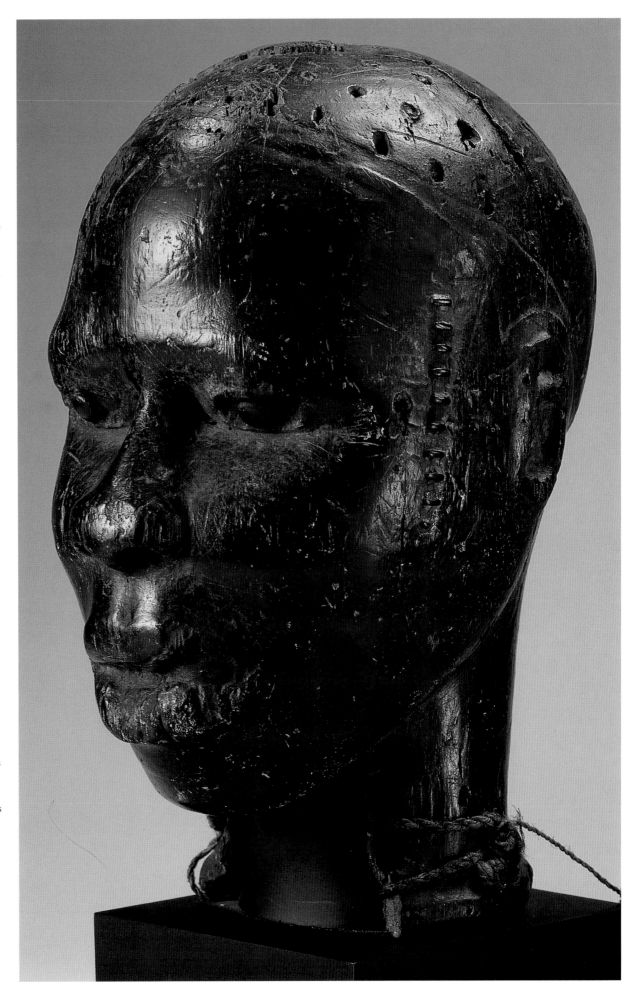

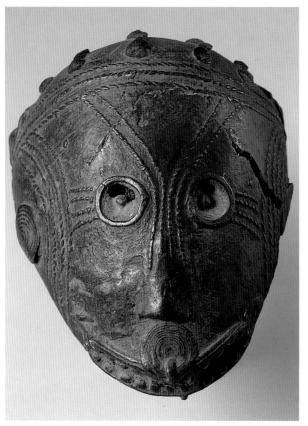

5.41

Zoomorphic head

Cross River, Nigeria
16th–17th century
copper alloy
h. 17 cm
Private Collection, London

This fragment of a copper-alloy sculpture depicts a zoomorphic head, perhaps that of a sheep. Its open mouth is bordered by a ropework pattern also used to form concentric circles around the disproportionately large, open eyes. The rope pattern is also employed horizontally in the nose area of the head and in criss-crossing the area between the nose and the eyes. This pattern is widely used on copper-alloy art objects from the Cross River, for example, on the therianthropic head (cat. 5.40). It can also be seen on some of the famous leaded bronzes from Igbo Ukwu (9th–10th centuries).

There is no known copper-alloy casting centre in the Cross River area comparable to Ife, Benin or Igbo Ukwu. Yet numerous copper-alloy artefacts have been found in the region, primarily in shrines. It has been suggested that the bells and other items were brought here through trade by itinerant Igbo metal smiths, but the possibility of a small-scale casting industry in the Cross River area itself should not be overlooked. For example, Keith Nicklin has recorded a site at Mbak Itam on the western bank of the Cross River as perhaps 'a major iron smelting and brass casting archaeological site'. It is believed that with the importation into eastern Nigeria of manillas, copper rods and twisted copper wires (including the *chittem* by European traders to be used as currency from the 16th century) some could have been melted down and used for the casting of such objects. *EE*

Bibliograhy: Shaw, 1970; Neaher, 1976; Nicklin, 1980; Nicklin, 1982

5.40

Head

Cross River
South-east Nigeria
18th century (?)
copper alloy, clay core
15 x 12 x 10 cm
Private Collection

This almost ovoid therianthropic object appears to possess human features combined with those of a fish or snake, probably a python. Rather than eyes, there are two eye sockets, ridged on the inside, and the upper and lower jaws have a series of projections, both pointed and curved, which look barbel- rather than tooth-like. At either side of the mouth, at the centre of the lip and on both temples are spiral motifs of a kind common to the decorative repertoire of Cross River metal and stone sculpture. Such motifs were executed on the human body and face until the later 19th century. Bands of skeuo-morphic stitchwork decoration run across the top of the forehead between eye and temple and also traverse the face from top of forehead to nose. The knobs and elongated projections towards the back of the head are reminiscent of a manner of representing plaited coiffure in some Cross River mask sculpture.

Field photographs taken by the present author in April 1977 identify the piece in question as being from the shrine of the tutelary deity Ojokobi in the Yakur town of Ugep (previously known as Umor) in the Obubra area of the Middle Cross River. It was part of a group of bronzes which included a standing male anthropomorphic figure, a quadruped with pointed nose and tail and a number of manillas. Guardianship of the Ojokobi shrine gave authority to rulership of the entire community and the title *Obol Lopon*. The earliest thermoluminescence date so far obtained for an authenticated Cross River bronze (a stylised leopard skull from Oron) is around mid-17th century.

Cross River bronzes were cast by itinerant metalsmiths from the Cross River Igbo areas of Arochukwu and Abiriba, who in some cases seem to have passed their skills on to indigenous, non-Igbo groups including the Yakur and Enyong Ibibio. The art had died out by the late 19th to early 20th centuries. Cross River bronzes and those of the Niger Delta to the west and the Benue Valley to the north have certain similarities in technique of production and decorative motifs, possibly because peripatetic craftsmen moved between these regions of eastern Nigeria. *KN*

Bibliography: Forde, 1964; Nicklin and Fleming, 1980, pp. 104–5; Fleming and Nicklin, 1982, pp. 53–7; Nicklin, 1982

5.42

Face mask

Middle Cross River
South-east Nigeria
20th century (?)
wood
h. 32.5 cm
Private Collection

This face mask is remarkable for the pronounced and protruding lips, for the area of the eye sockets in the form of an upper and lower rounded rectangle, as well as for a series of prominent vertical bars on the forehead. The teeth are roughly rendered in the large mouth. The overall impression is that of a man/ape, the latter characteristics derived from the mandrill (*Papio sphinx*), a species of west African baboon hunted for food in the Cross River rain forest.

Among various peoples of the Middle Cross River region of Ikom and Ogoja, age-sets and other groups perform masquerades involving a female 'Beauty' and a male 'Beast' (cf. cat. 5.38). While the female wears a wooden cap or helmet mask (sometimes skin-covered) and a long cloth gown, the male is dressed in a shaggy, net fibre costume, with or without a carved face mask. The latter typically behaves in an aggressive, lewd manner associated with ape behaviour. Such performances occur at funerary ceremonies and first fruit or 'New Yam' festivals connected with the beginning of the agricultural cycle.

The artistic treatment of the mouth of this face mask and the deeply scored brow is comparable with that of some Janiform helmet masks of the Middle Cross River. *KN*

Bibliography: Nicklin, 1981, pp. 170–1; Neyt, 1985, pp. 110–11

5.43a

Ancestor figure (*ekpu*)
Oron
South-east Nigeria
19th century
wood
104.5 x 30 x 26.5 cm
The National Commission for Museums and Monuments, Lagos

All three of these Oron ancestor figures from the Cross River estuary of the Palm Belt region of south-east Nigeria strongly display stylistic features characteristic of this genre: headgear appropriate for an elder (appearing to balance rather precariously on top of the head); plaited beard; abdomen in the shape of an elongated onion with depiction of scarification; a stylised representation of a short skirt worn below the navel; relatively small genitals and short legs. The arms are close to the body, the elbows bent at right angles, and the hands hold carved horn-like objects believed to be representations of palm-wine drinking-horns or symbols of senior lineage office. Scarification is shown in the temple area on both sides of the head.

Formerly, when an elder died, a length of hardwood such as camwood (*Pterocarpus*) was carved to represent him and joined others in the men's meeting-house (*obio*) of the village. Here, they were offered sacrifices and libations and appealed to for the well-being of the community and to avert disaster, especially the loss of fishing crews and canoes. As time went by and further carvings were added they came to symbolise lineage identity and the rights of their owners, or 'records in wood' as Nsugbe expressed it. They thus served to validate the authority of living village elders.

Nigeria's first Surveyor of Antiquities, the late Kenneth Murray, was appalled by the poor condition of many of the *ekpu* carvings owing to the decline of indigenous beliefs in the face of Christian proselytisation during the early years of the 20th century. In 1947 he published the first detailed description of the genre, upon which the above account is based. Since the Oron elders refused permission for any carvings to be removed from clan territory, he advocated the establishment of a museum at Oron in which to preserve the *ekpu* figures. Originally a small earth building was allocated by the

colonial authorities for this purpose, but owing to the danger of fire and a series of thefts in the late 1950s (which allowed a number of ancestor figures to reach collections in Europe and the USA), a proper museum was eventually built and opened to the public around the time of Nigerian independence in 1960.

At the outbreak of the Nigerian Civil War in 1967 there are believed to have been well over 600 *ekpu* sculptures arranged in impressive open storage at the Oron museum, but by the cessation of hostilities in 1970 only just over 100 pieces remained, many of the best examples having been looted or burnt as firewood in a refugee camp at Umuahia. The remnant of the Oron collection formed the core of a permanent exhibition opened at the rehabilitated National Museum, Oron, in April 1977.

Originally, Oron *ekpu* figures were held by the Nigerian Department of Antiquities on trust, a receipt being issued to the owners at the time of removal from the original site. The owners, usually represented by a lineage head or other senior elder, retained the right to conduct traditional ritual observances at the museum in honour of the deceased persons commemorated by the *ekpu* carvings. In practice, however, this rarely, if ever, took place. The process of placing the *ekpu* figures in a museum destroyed their traditional spiritual value.

However, as a principal component of the rehabilitated museum at Oron, the *ekpu* figures played an important part in the nation-building process instituted by the Nigerian Federal Government after the Biafran War, therefore acquiring a new and unexpected spiritual value. Today, many members of the Oron community are proud of the *ekpu* figures displayed at the waterside museum site, and appreciate them as unique expressions of their own cultural identity. (The people of Oron have a history of fear of exploitation and suppression by neighbouring groups such as the Eket to the west and Ibibio to the north).

Despite the fact that the *ekpu* figures as a whole are a relatively homogeneous group, significant stylistic variation does occur within the genre, as illustrated by the present selection. Note the unusually broad,

squat appearance of cat. 5.43a, with its elaborate high relief decoration, and the attenuated character of cat. 5.43c in which the formal lines of the sculpture are not lost despite missing portions of the limbs and beard. Cat. 5.43b is in a particularly good state of preservation and shows how crisply all the forms are realised and how their totemic vertical pile is effectively organised. These are all representative examples of what Fagg described as 'one of the finest and oldest styles of wood-carving which are still to be seen [in Nigeria]'.

Cat. 5.43c is from Eke Ebung in the *afaha* of Enwang, and was said to have been carved in honour of Anwana Odung Anko. *KN*

Bibliography: Murray, 1946, pp. 112–14; Murray, 1947, pp. 310–14; Fagg and Plass, 1964; Nsugbe, 1961, pp. 354–65; Eyo, 1977; Nicklin, 1977; Nicklin, 1990; Nicklin, in preparation

5.43b

Ancestor figure (*ekpu*)

Oron
South-east Nigeria
19th century
wood
135 x 19 x 18 cm
The National Commission for Museums and Monuments, Lagos

5.43c

Ancestor figure (*ekpu*)

Oron
South-east Nigeria
19th century
wood
136 x 19.5 cm
The National Commission for Museums and Monuments, Lagos, PD/69.U.5

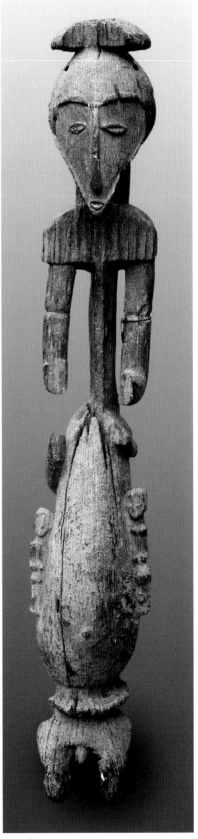

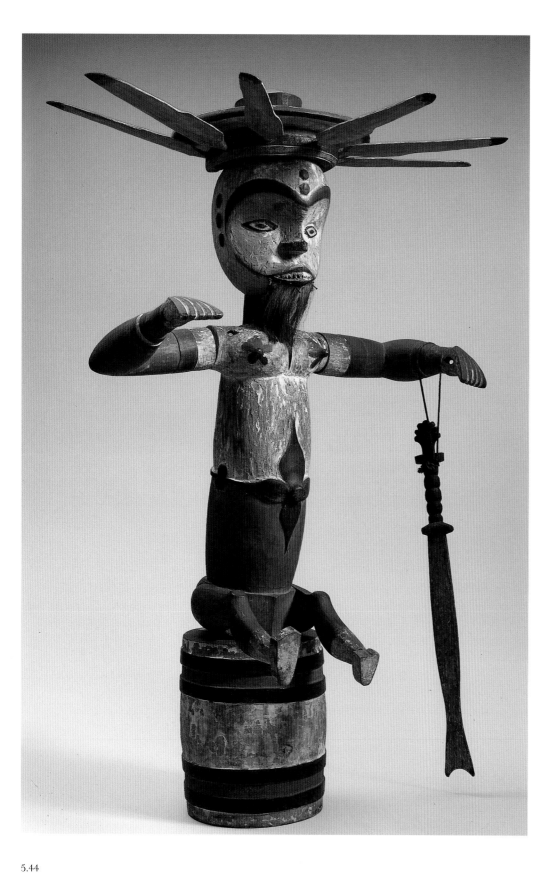

5.44

Male figure seated on a barrel

Ibibio
South-east Nigeria
19th century
wood, pigment
87 x 57 x 44 cm
Horniman Public Museum and Public
Park Trust, London, Crowther-Benyon
Collection, 37-48

This figure of a bearded man with feather headdress, seated on a barrel, is from the Eket area of coastal Ibibioland. It is probably from a memorial shrine (*ngwomo*) for a deceased head of a village (or village group) of the type shown in a photograph by the former colonial officer P. Amaury Talbot. The Horniman Museum also possesses a carved wooden shrine post similar to that in Talbot's photograph.

That the figure represents an elder is indicated by the addition to the carving of a goatee beard of ram's hair. The headdress, carved from wood and pigmented, is worn as a circlet beneath a representation of a 19th-century French sailor's hat, reflecting contact between the inhabitants of the coastal Ibibio area and European sailing ships in that period. The feathers represented here are those of the fish eagle, and the wearing of such a headdress is confined to initiates of one of the most exclusive of all Ibibio titles, *Inam*. The holder of *Inam* had to be at least 70 years old, wealthy and of impeccable moral rectitude. When he died he was believed to have the right to sit beside the creator god in the council of the underworld or afterlife.

At the centre of the forehead are two circular marks, one above the other, representing one of the modes of scarification formerly practised by the southern Ibibio. A further three marks on either temple are similarly arranged. The floral or leaf-like decoration of the abdomen is likely to represent body painting of the type known to have been executed for such occasions as initiation or burial.

Suspended from one hand of the figure is a representation of a bifurcated knife, an important part of the official's regalia. The arms and legs of the figure have been carved separately, and the manner in which the arms, in particular, are mortised to the trunk probably reflects the influence of European carpentry techniques. Similar influences are seen in the case of ancestor screens (*duein fubara*; cat. 5.57) made in the same period by the nearby Kalabari people of the Niger Delta. *KN*

Bibliography: Talbot, 1923; Fagg, 1963, pp. 124–5; Nicklin and Salmons, 1978, pp. 30–4; Neyt, 1979, pp. 15–22; Salmons, 1980, pp. 119–41; Barley, 1988; Nicklin, 1993

5.45a

Head pendant

Igbo (?)
Nigeria
10th century
bronze
h. 7.6 cm; diam. 4.8 cm
The National Commission for Museums
and Monuments, Lagos, 39.1.19

5.45b

Head pendant

Igbo (?)
Nigeria
10th century
bronze
8 x 4.5 x 5.5 cm
The Trustees of the British Museum,
London, 1956. AF. 15.p

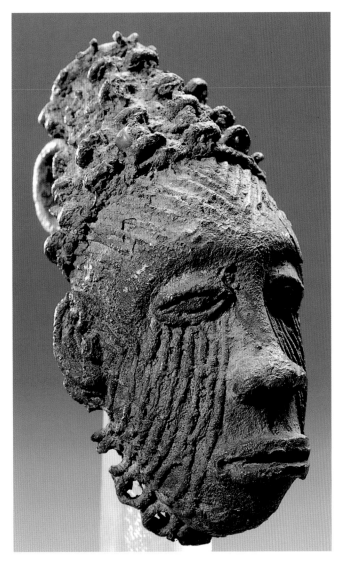
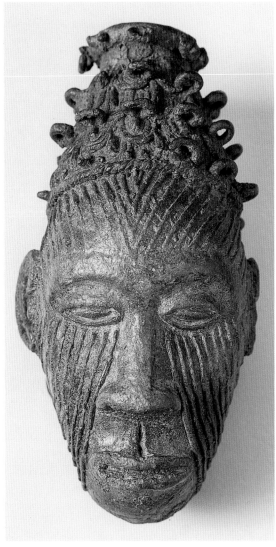

These pendant masks form a pair
from a large collection of remarkable
bronze castings found at Igbo-Ukwu
in south-eastern Nigeria, 40 km south-
east of Onitsha on the River Niger.
A number of bronze artefacts were
found accidentally in digging a cistern
shortly before the outbreak of World
War II. Excavations at the site in
1959–60 revealed further bronzes
and laid bare the manner of their
deposition. They were spread out at
no great depth in a rectangular area
in such a manner as to suggest they
had been protected by a lightly made
shelter. For some reason they were
abandoned in ancient time, the shelter
fell down, the bush grew over it and
the spot was forgotten.

As well as vessels and ornaments
cast in bronze, there were objects
made in copper, pottery vessels and
over 63,000 glass and carnelian beads.
There were calabashes with copper
handles attached, and the objects
cast in bronze included a number of
weapon-scabbards and highly ornate
attachments for ceremonial staffs.
This collection comprised objects
of a ritual and ceremonial nature.
They probably represent the regalia
of a dignitary who performed the
function of both king and priest.
There is still such a functionary in
that part of Igboland, known as the
Eze-Nri. He is the head of the title-
taking system, in which, in place of
hereditary chieftaincies and sub-
chieftaincies there is a hierarchy of
men who have earned their positions
by merit, as a result of hard work and
service to the community, and having
reached a financial position to be able
to pay the fees necessary for each
grade. Some titled men are distin-
guished by facial scarifications of
the kind portrayed on these little
face masks. They were probably
worn attached to a dignitary's regalia,
for they have each a large loop at the
back for the insertion of a thong.
The back also has a number of much
smaller loops, doubtless for the attach-
ment of copper chains in the manner
shown in cat. 5.47 for hanging beads
and crotals. There is a fair-sized
opening at the back for the extrac-
tion of the clay core on which the
wax (or latex) was shaped in manu-
facture by the lost-wax process.
All the objects from Igbo-Ukwu
that have been shown by analysis to
be alloys of copper and tin (usually
with the addition of some lead)
were cast by this method, whereas
the objects made of almost pure cop-
per were fashioned by hammering,
bending, twisting and chasing. There
were no objects of brass, as there were
no alloys containing significant
amounts of zinc.

During the investigations of 1959–
60, near the repository of regalia, a
kingly burial chamber was discov-
ered, the floor of which was nearly
3.5 metres below the surface of the
ground. In this wooden-lined vault a
man of distinction had been interred,
propped up on a copper-studded stool
and dressed in all his regalia. Various
rich objects were included, such as
three elephant tusks; these were too
badly preserved to ascertain whether
they were carved or made into horns.
There were over 102,000 glass and
carnelian beads. A third site at Igbo-
Ukwu was excavated in 1965. Here,
a quantity of ceremonial objects had
been intentionally disposed of, buried
in a pit dug for the purpose. A cluster
of radio carbon dates places these sites
in the 9th–10th centuries, and such
a date is confirmed by analysis of
the metal content of the bronzes.
Thus the Igbo-Ukwu materials are
the manifestation of an indigenous
technical and artistic flowering some
five centuries before this area had any
contact with Europe. *TS*

Provenance: cat. 5.45a: 1939, bought and
presented to the Lagos Museum by John
Field; cat. 5.45b: 1939, excavated by Isaiah
Anozie; 1956, given to the British Museum
by F. W. Carpenter

Bibliography: Shaw, 1970, p. 142, pls. III,
270–1; Shaw, 1975

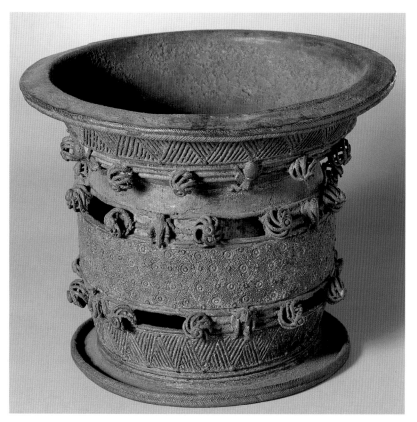

5.46

Bowl with integral stand

Igbo (?)
Nigeria
10th century
bronze
h. 20.3 cm
The National Commission for Museums
and Monuments, Lagos, 1939.1.1

A number of the Igbo-Ukwu bronze
castings show signs of being skeuo-
morphically related to objects previ-
ously made in other materials. So it
is with this bowl on its own pedestal
base, which almost certainly largely
copies a ceramic original; a number
of pottery bowls joined to their own
pottery pedestal bases were found in
the excavation. The two zones of
hatched triangles on the bronze at the
top and bottom of the stand can be
matched in pottery vessels. Separate
copper handles for calabashes were
also found, and were the prototypes
for the handles cast integrally with
bronze bowls imitating the shape of
calabashes. There are many other
examples of skeuomorphs in the
Igbo-Ukwu material.

This specimen may have been cast
in two or more pieces, which were
subsequently joined together with
additional molten metal. That this is
what was done in the cast of another
large vessel from Igbo-Ukwu has been

proved by means of sectioning it
across the join – but such an investi-
gation has not been carried out on
this particular bowl.

Stylistically, 'the strange rococo,
almost Fabergé-like virtuosity' of the
full range of Igbo-Ukwu work makes
it 'justly famous for a fragile, jewel-
like aesthetic of a delicacy to be com-
pared only with Roman pieces import-
ed at the Nabataean capital at Faras'
(Williams, 1974, p. 118). The Igbo-
Ukwu work makes the famous brass
heads of Ife seem less arresting, and
the later brasses of Benin seem less
brilliant, although Benin works are
much better known on account of
their quantity and because of a hun-
dred years of exposure to European
and American scrutiny. However, the
uniqueness of Igbo-Ukwu art presents
a tremendous problem – what were its
antecedents and its successors? Out of
what tradition did it grow? What be-
came of the style and standards it
embodied? There is a challenge to set
Igbo-Ukwu art in a wider geographi-
cal and chronological context than the
isolation it at present enjoys. *TS*

Provenance: 1939, excavated by Isaiah
Anozie; 1939, purchased and presented
to the Lagos Museum by John Field
Bibliography: Shaw, 1970, pp. 112–13,
pl. 5; Williams, 1974; Shaw, 1977

5.47

Double-egg pendant with beaded chains

Igbo (?)
Nigeria
10th century
bronze, copper, glass
h. 21.6 cm; l. 30 cm
The National Commission for Museums
and Monuments, Lagos, 79.R.5 (IS 367)

This object was discovered at Igbo-
Ukwu in the excavations of 1959–60.
The bronze double-egg pendant is
matched by a similar one recovered
in the cistern-digging some 20 years
earlier, but that example did not have
the attached chains, beads and crotals.
The double-egg with thong-loop at
the back is generically similar to the
masks with the facial scarifications
(cat. 5.45). Other pendants in this
category include four elephant heads,
two (very different) ram heads and a
leopard head. These all have small
loops for the attachment of copper
chains of beads, but the chains and
beads themselves are now missing;
it was only the excavated example
that revealed the use to which the
small loops on the castings were put.

The surface of each egg is smooth,
but bears three representations of
flies, and there are four on the arch
that connects the two eggs. The sym-
bolism and significance of this fly
motif, which occurs (along with other
insects) on some of the other bronze
castings, are difficult to fathom.
Lying between the two eggs is a
representation of a large bird, with
prominent bulbous eyes and its wings
curved back underneath its tail;
feathers are represented by raised
lines grouped concentrically in arches.
The crotals at the end of the chains
are small, clapperless jingle orna-
ments, and are cast in bronze. *TS*

Provenance: 1960, excavated by Thurstan
Shaw, on behalf of the Nigerian Federal
Department of Antiquities
Bibliography: Shaw, 1970, pp. 143–4,
pls 276–7

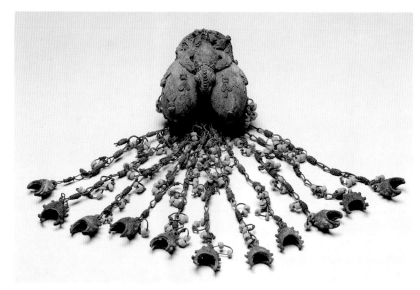

Globular ceramic vessel with everted rim

Igbo
Nigeria
10th century
fired clay
h. 40.6 cm
Department of Archaeology and
Anthropology, University of Ibadan, IJ 650

The body is globular below a widely-everted flat rim, making a wide-mouthed vessel with comparatively little constriction at the neck. Five heavy strap handles, placed equidistantly, joined the rim and the shoulder, but one of the handles is now missing. The outer surface of each handle is decorated with six or seven transverse ridges, crossed by oblique grooving, slanting in different directions on adjacent ridges, arranged in such a way as to be reminiscent of basketry. A wide deep groove runs round the outer edge of the rim, and a smaller, much less pronounced one, upon the upper surface of the rim just inside the edge. The neck is decorated with a heavy cordon bearing bold finger-tip impressions set slightly obliquely. Below this the whole of the upper half of the globular part of the pot is elaborately decorated. The groundwork of this decoration is made up of a system of concentric grooving, and with bosses below each handle. Part of the infill between the concentric circles, or parts of them, is made up of panels of straight parallel grooves or of small shallow pitting; the lower edge of the decorated area is bounded by four parallel grooves running right round the pot, but only approximately horizontally; they terminate some 12.7 cm apart by making the two inner grooves, and the top and bottom grooves, join in a round-ended fashion. The intervening space is filled with an exactly similar short stretch of four parallel grooves with rounded ends. Above this, in a space between two of the handles, is modelled a quadruped, which gives the impression of being superimposed on the other decoration, although it is in fact arranged integrally with it. This animal, with its spinal crest, coiled tail, opposed digits and body marked with triangular panels of fine cross-hatching, is believed to represent a chameleon; the body is humped up away from the body of the pot (which underneath it is plain), the animal

being attached only by the head, feet and tail. There is a similar applied figure in each of the other four spaces between the handles. To the right of the chameleon is a ram's head, with long downward-curving horns; to the right of this a coiled snake, with the back of the body decorated with a segmented pattern. To the right again is a curious, inanimate-looking, rectangular slab, covered all over with cross-hatching, and humped up in the middle away from the wall of the pot; what it represents is not known. Below it the ground pattern contains a sixth groove-surrounded boss, slightly smaller than the ones below the handles.

The fifth space between the handles is occupied by a coiled snake similar to the other except that the segmented pattern is carried right over the head to the mouth instead of stopping at the neck. The style of decoration, with deep concentric grooves and raised conical bosses, also ridged and grooved, is typical of ancient Igbo-Ukwu ware. Such pottery occurred plentifully on all three Igbo-Ukwu sites. Rouletting, common today in Nigeria and at Ife and Benin, does not occur on ancient Igbo-Ukwu pottery.

This specimen was found, almost upside down, in the disposal pit. It is likely that it was used for ceremonial purposes by a high-ranking man; at his death it was buried in the pit, along with all his other ritual trappings, since no one else would be entitled to use them. *TS*

Provenance: 1964, excavated by Thurstan Shaw, on behalf of the University of Ibadan

Bibliography: Shaw, 1970, pp. 215–16, pls 468–72

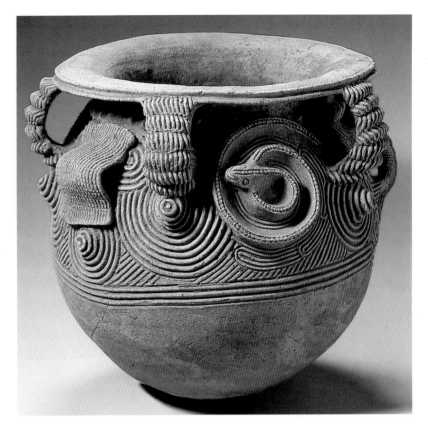

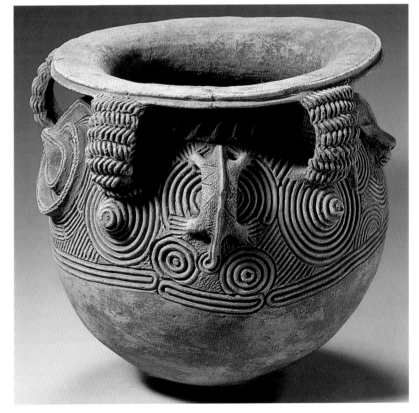

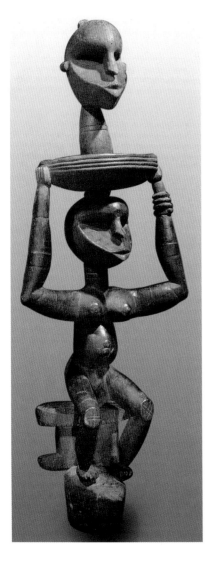

5.49

Headdress

Igbo
Ogbom, Nigeria
wood
82 x 31 x 21.9 cm
The National Commission for Museums
and Monuments, Lagos, L.G.33

Only scanty data survives on head-dresses called *ogbom* and on the dances associated with them, which were apparently last performed before 1940. These fine carvings were attached to basketry caps and were used in dance by men in festivals honouring Ala, the Igbo earth deity. Most *ogbom* headdresses celebrate fertile young women with ample breasts, as on this example, and the dances appear to have called attention to Ala's role in both human and agricultural fertility and increase. G.I. Jones reported that at one point women entered the arena to dance around the *ogbom* carrier, while Murray's account indicates that the

dance helped to make women fertile, with men enjoined to marry if the local population appeared to have de-clined since *ogbom* was last performed.

This specimen features a disem-bodied head-on-neck being carried by the seated young female on a plate or circular platform. Apparently a trophy head, from an Igbo area once known for headhunting, this iconography would appear to refer (at least in-directly) to the role of the heads of slain enemies in bringing power and increase to the receiving community. In this regard it is perhaps notable that an origin myth, found by Jeffries among the Nri Igbo, refers to the planting of heads from which, sub-sequently, grew yams, the favoured food of most Igbo people. *HMC*

Bibliography: Murray, 1941; Cole and Aniakor, 1984, pp. 15, 174–6; Jones, 1984

5.50a

Deity figure

Igbo
Nigeria
wood
130 x 24.5 cm
The National Commission for Museums
and Monuments, Lagos, 80.5.328

5.50b

Deity figure

Igbo
Nigeria
wood, paint, metal
h. 180 cm
Private Collection

The religious beliefs and practices of Igbo-speaking peoples identify a con-stellation of tutelary deities known as *alusi* or *agbara*. As the children or deputies of the high god Chukwu (lit. *chi*: 'god' or 'spirit'; *ukwu*: 'great'), they are accessible to human petition and sacrifice. These unseen, proximate deities (encompassing places, prin-ciples and people) include the earth, rivers and other prominent features of the landscape, markets (and the days on which they are held), war,

remote founding ancestors and legend-ary heroes. Overall the deities and their cults are considered responsible for the health, prosperity and general well-being of the people and the productivity of field and stream; they uphold the moral, social and ecological order. Each major cult has a priest and other attendants who pour libations weekly, offer blood sacrifices periodically and oversee an annual festival honouring the gods.

Such supernaturals are often sym-bolised by hardwood figures varying from about 45 cm in height to over life size. They are carved in con-ventionalised, symmetrical, rather static poses, and are given the attri-butes of titled individuals. They exist in several regional styles, and in any given area as many as a dozen or more are housed together as generic 'families' in more or less elaborate shrines usually at the centre of each village group, often adjacent to markets or dance grounds. Their shrine buildings or compounds are sometimes large and well decorated, especially in the north-central Onitsha/Awka region, but every-where minor gods may also be housed

in domestic compounds. Without col-lection data it is impossible to deter-mine which deity is represented by any one figure, for the many hundreds of known figures conform to generic types lacking deity-specific attributes. While male sculptors are invariably the creators of these figures, many different hands can be recognised in each style area. Women normally paint the images with celebratory pigments.

The standing figure (cat. 5.50b) probably comes from the Onitsha region. It is typical of figures from the still larger north-central area. Its size suggests that it may have been a principal deity, as 'family members' were normally smaller. Incised scarification patterns on the body are similar to those anyone could have as an indication of per-sonal beauty and fully socialised status. Shrine figures were redecor-ated by women supplicants of the cult before its annual festival. These cosmetic, beautifying pig-ments of orange-red camwood and/or white chalk were also affected by worshippers. In the north-central region deity 'families' were often displayed publicly during such festivities; they were lined up on the edge of a dance ground, where they received such presents as kola nuts, money and chalk from villagers. The assembly would also be given larger sacrificial offerings by cult officials along with prayers of thanks and petitions for a large harvest and prosperity. Elaborate meals were prepared and consumed and worshippers danced in the gods' honour.

The figure in cat. 5.50a is in the style of the Owerri/Mbaise region, where there is an emphasis on recti-linear, squared off forms in contrast to the more rounded styles of Onitsha/ Awka to the north. The arm position with hands held as if begging is interpreted as indicating the deity's readiness to receive sacrificial offers as well as its open-handedness and honesty. The incised body and facial scars indicate titled status. *HMC*

Bibliography: Cole, 1969; Cole and Aniakor, 1984, pp. 89–100

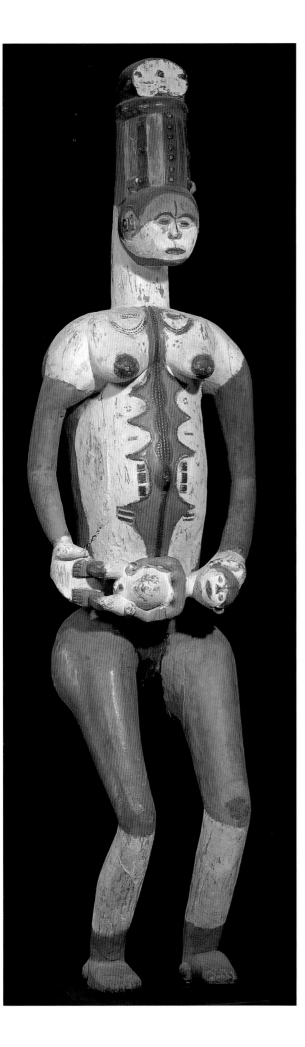

Woman seated on a stool

Northern Igbo/southern Idoma (?)
East central Nigeria
19th century (?)
wood, pigment
74 x 26 x 24 cm
Kathy van der Pas and Steven van de
Raadt

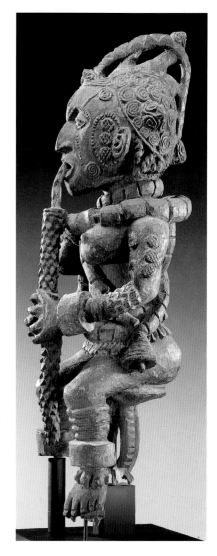

This female figure, seated upon
a stool, is elaborately adorned with
representations of ivory bangles at
wrist and ankle (the latter worn over
brass leg bangles) and strings of large
beads around the neck. A bell with
clapper is worn at the waist, above a
representation of a girdle, suspended
by a bead shoulder-loop. Coiffure is
also intricate, with tightly coiled
braids in the form of reversed spirals
covering much of the scalp, sur-
mounted by an arched structure.
Hands clasped at the front hold a
smoking or musical pipe to the
mouth. Complex scarification marks
are shown on the face and body,
notably a vertical row of cross-hatched
round keloids on either temple and
upper arm.

The sculptural style of the face is
reminiscent of that of some masks
from the transitional northern Igbo
and Benue Valley areas of eastern
central Nigeria. The facial features
are characteristic of the domed face
masks of the northern Igbo maiden
spirit masquerade *(mmuo)*. What
remains of the representation of
a carved wooden stool strongly re-
sembles that associated with title-
taking by élite men and women,
especially in northern central Igbo
country. These are often portrayed
in representations of seated figures
owned by lineage segments in respect
of the Ikenga cult.

The prominent buttocks and mark-
edly upright back are characteristic of
seated female figures connected with
concepts of fertility and lineage
among several Benue Valley groups,
including the Igala, Afo, Idoma, Tiv
and Igedde. Often these are maternity
figures, though this is not the case
here. This piece probably represents
a female ancestor, and would have
been employed in funeral ceremonies
connected with the matrilineage, an
institution called Ekwotame by the
Idoma. *KN*

Bibliography: Boston, 1977, pp. 62–3;
Wittmer, 1978, pp. 17–25; Cole and
Aniakor, 1984, pp. 120–5; Jones, 1984,
pp. 61–4; Neyt, 1985, pp. 101–8, 141–51

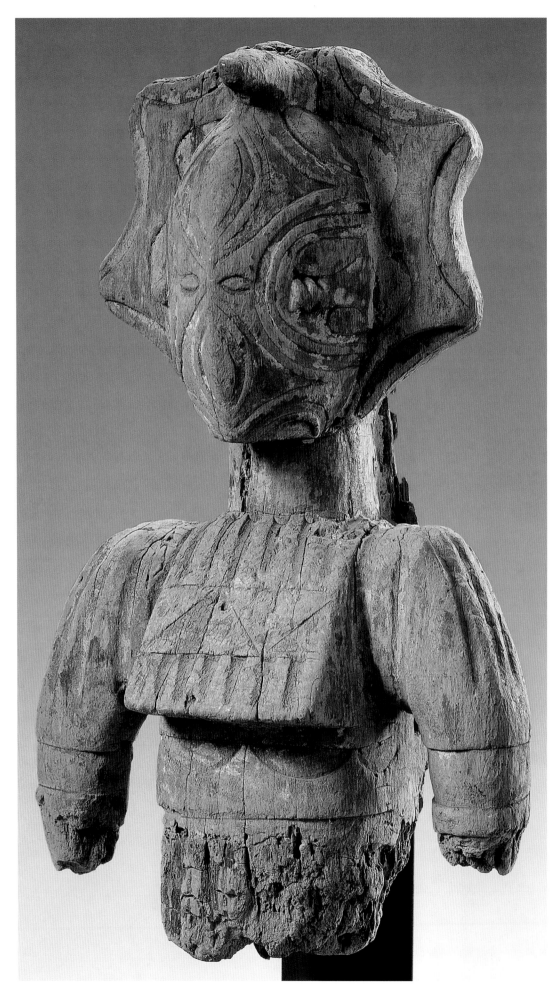

5.52

Torso

Igbo
Afikpo/Ohafia (?), Nigeria
wood
h. 66 cm
Private Collection

This fragmentary sculpture, consisting of a masked head on a torso, was more than likely part of an ensemble of life-size painted wood figures that embellished a men's meeting-house in Ohafia. A similar one, which is preserved as a national monument by the Nigerian Department of Antiquities, still stands in the Obu Nkwu ('House of Images') in Asaga Ohafia. The head appears to be wearing a calabash mask of the sort documented by Ottenberg in Afikpo villages, but analogous masks were also worn in Ohafia, Abiriba and other eastern Igbo communities, probably in connection with the Ekpe cult. In this example the neck of the calabash projects slightly over the forehead, and the mask face is incised in curvilinear patterns that were guidelines for pigments (now lacking because of weathering).

These shrines and meeting-houses once contained numerous figures (there are 22 at Asaga Ohafia of legendary ancestors, local gods, their servants, warriors, masqueraders and genre figures). More than a family, the group suggests part of an idealised community, somewhat like the sculptural programme of elaborate *mbari* houses in the Owerri region. Around the turn of the century there were many such shrine meeting-houses among eastern Igbo groups; most of them have long since been dismantled and their sculptures dispersed, although some have been rebuilt in cement block, with modern carvings or cement figures lining the walls, as in Asaga. *HMC*

Bibliography: Jones, 1937; Cole and Aniakor, 1984, pp. 95–7, pl. 18

5.53
Door

Igbo
Nigeria
wood
112 x 43 x 4 cm
The Trustees of the British Museum,
London, 1950.AF.45.545

Igbo doors are normally carved in hardwood – which is considered 'male' – including African oak (*Milicia excelsa*), for which the Igbo word is *oji* or *iroko*. Most embellished doors were used at main entrance portals of domestic compounds, typically those housing families of titled men and women. They may also adorn the compounds of tutelary deities, especially in the north-central Igbo region. Such fine portals are called 'doors of honour' (*mgbo ezi*).

Carved doors are generally associated with the Awka area, well known for its geometric style, usually referred to as 'chip carving'; but since similarly embellished doors are known from many Igbo subgroups, an Awka provenance is often unwarranted unless collection data indicate a specific place of origin. The curvilinear style of this door suggests that it might come from the area between Okigwi and Owerri rather than Awka. These patterns, carved by men, relate closely to women's styles of wall and body painting. While non-figurative, the motifs are usually named after similar designs found either in nature or on artefacts. Although it is true that the motif names betray something of the Igbo world view, individual door designs are rarely specifically symbolic.

Among the Igbo, as in most cultures, a decorated, elaborate portal serves to signal elevated status, relative wealth and good taste, while separating the more profane world of the outside, the village, from the family sanctuary, the dwelling areas and shrines within. Many such Igbo doors were further decorated with locally obtained white, orange-red and black pigments, adding brightness and thus visibility to compound entrances that from the outset were intended as visual magnets drawing attention to the habitations of prominent families or gods. *HMC*

Provenance: 1950, given to the museum by P. A. Talbot

Bibliography: Cole, 1969; Neaher, 1981; Cole and Aniakor, 1984, pp. 68–71

5.54

Yam altar

Igbo
Nigeria
fired clay
h. 40 cm
Trustees of the National Museums of
Scotland, Edinburgh, 1905.8

Fired clay altars or shrines with
elaborate figural tableaux were made
in the Ukwani Igbo region west of the
River Niger during the 19th and early
20th centuries. Only a handful of such
ceramics are known. Early reports
indicate their use in the yam cult
(yams being the main prestige crop
among most Igbo groups). This sculp-
ture appears to depict a male chief
and family head holding a decorated
drinking-horn in one hand, a fan in
the other, one or both of which were
most likely titled attributes in the
area. He is flanked by two pregnant
females (probably intended to rep-
resent his wives), who are heavily
scarified, finely coiffed and are also
holding fans. In front sits a child
(or servant) with a double gong,
along with a fowl, presumably a
sacrifice for the yam deity, Ifejioku,
and in the centre, a cylindrical *ikenga*
of the western Igbo type. An *ikenga*,
seen here as a 'shrine within a shrine',
typically received such offerings as
farm produce and prayers to the phys-
ical power – the power of the right
hand and arm. As a whole the group
would appear to illuminate the
centrality of the family in Igbo
culture along with the importance
of generous yam harvests to the
family's success and therefore its
status.

Women were the ceramic sculptors
in this region, as they were potters
and clay workers in most of tropical
Africa. This highly accomplished
sculptural group rises out of a hollow
ceramic base with a textured surface;
at the back it is attached to a kind of
openwork screen with several deco-
rative loops. *HMC*

Bibliography: Cole and Aniakor, 1984,
p. 80; Washington 1987, p. 96

5.55

Cap mask

Ogoni or Abua (?)
Niger Delta
20th century
wood
54 x 17 x 17 cm
J. W. and M. Mestach

At first glance this splendid piece
would appear to be 'a bird with wings
hanging by its sides and a broad tail
depending from the torso' (Maurer).
However, although it is probable that
the carver intended to suggest bird-
like features, the overall form could
also represent a human torso, while
the central portion of the work
closely resembles the head of a
ram or he-goat and the lower section
might depict a fish tail. Such an in-
triguing form is typical of that used
by a certain masquerade group living
in the Niger Delta, who are often
called upon to represent the close
interdependence of man and crea-
tures in this particular eco-system.

The Ogoni, who live on the peri-
phery of the eastern Delta, use face
masks representing goats, sheep,
antelope and other animals, often
with elaborate up- or down-curving
horns, for a youths' acrobatic dance
called *karikpo*. However, as no eye
holes pierce this mask, it could not
have been used as a face mask.
A number of holes at the back of
the main face or torso indicate that
the mask would have been worn on
top of the head, horizontally, attached
to a costume covering the body and
head of the performer.

The human head finial and fish-
tail projection are characteristic of the
headdresses employed by the Ijo and
their neighbours in their periodic
masquerades held in honour of the
water spirits (*owu*). As these are
believed to be capable of passing
between the earthly and spiritual
realm, and between land and water,
their masquerades will often combine
human, animal and fish attributes, as
in this mask. Although the head is
depicted in abstract form, it is not
carved in the geometric style usual for
the Ijo. It is therefore probable that it
comes from one of the neighbouring
Delta groups, such as the Ogoni or
Abua. *KN*

Bibliography: Horton, 1965, pp. 68–71;
Jones, 1984, pp. 159ff.; Nicklin and
Salmons, in preparation

5.56

Ceremonial staff

Ijo
Niger Delta
17th–18th century (?)
ivory, pigment traces
78 x 8 x 8.5 cm
Charles and Kent Davis

This sculpture depicts a maternity figure seated on a stool or chest above a kneeling male figure. The woman is shown wearing bracelets and large anklets, and the man bears a flintlock pistol, with trigger-guard and flash-pan clearly visible. The gourd-like container which is suspended by a thong from the right shoulder of the male figure could be interpreted as a medicine container, but in the context of southern Nigeria strongly suggests a powder-and-shot flask for recharging a muzzle-loading firearm.

The finial at the upper end of the staff gives the impression of a multi-layered or segmented hat, which, together with the prominent bangles and 'enthroned' position, suggests high social status. This extravagant headgear would appear to represent a headdress of the type worn by senior members of the Kalabari Ekine (water spirit society). Depictions of such headdresses occur in a large proportion of ancestral screens (*ndnen fubara*; cat. 5.57). The kneeling posture of the male, and lesser personal adornment, is indicative of the status of armed retainer. A remarkable feature of both figures is the depiction of a wide flat necklet or ruff, with hexagonal motifs (perhaps representing a line of beads) carved in high relief at the rim.

The facial features of both figures project from the flat surface of the background face. The eyes are cylindrical; the nose has a prominent bridge and bulging nostrils, and its base forms a straight, sharp line traversing much of the face. Mouths of figures are open, and the jaw of the female slightly prognatic. Such facial treatment gives this piece a definite Ijo attribution. This aesthetic convention is associated with the masks of the Ijo water spirit, Owu, generally comprising horizontal structures carried on top of the head with representations of the human face directed skywards. In fact the lateral projection on either side of the head of the male figure is stylistically reminiscent of the flat structure of

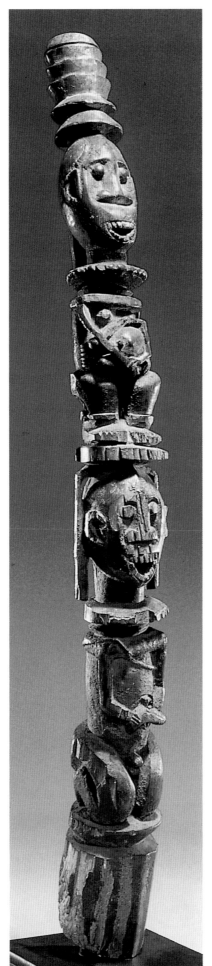

the typical Owu headdress upon which upward-facing human heads are carved.

However, the style of the faces of the ivory staff is most directly comparable with that of headdresses used by the Igbile water-spirit cult at Ughoton or Guratto, the old river port of Benin. In addition to close stylistic affinity, these are vertically aligned, and bear evidence of influence from the Ilage Yoruba area, whence the Igbile cult derives. Fagg compares these 'cone-head' Igbile masks to bronze bell-heads of the western portion of the Niger Delta; the style of rendering the bodies of the ivory staff figures is reminiscent of some of the finest of all Lower Niger bronze figures, notably the 'fluid' artistic treatment of both the slender upper limbs and the much fuller lower limbs, especially in the kneeling position.

Carved elephant tusks occur in a wide variety of contexts in southern Nigeria, most notably those placed on top of commemorative brass heads of Benin palace altars and side-blown horns which are part of the chiefly regalia of the Ibibio-speaking area and some inland forest communities in south-east Nigeria/south-west Cameroon. High-relief decoration is characteristic of these respective genres. Much less common is in-the-round carving of the whole or greater part of the tusk, as seen here. This compares with the tradition of the wooden ancestor figure (*ekpu*) of the Oron on the west bank of the Cross River estuary. Perhaps the best-known form of ancestral staff is the *ukhurne* of the Oba of Benin, which symbolises his 'power' as head of the royal line, and his incarnation of divine ancestors.

This ceremonial staff is unique among the known corpus of Ijo sculpture in any medium, remarkable for its attention to the detail of the two figures, especially the realism of the gun held by the male. Although most certainly Ijo, this piece presents an impressive amalgam of artistic influences reflecting its probable origin at the westernmost edge of the Delta. Its age and authenticity are attested by the smoothness and colour of the ivory, a chestnut tree of the kind imparted by repeated applications of palm oil in the past, and a smoke-blackened patina. The remaining part

of the base of the staff is friable, suggesting that it was kept for much of its existence in an upright position on the ground, presumably in a shrine. The top of the head of the nursing infant, though incomplete, shows no sign of fracture. Rather, it presents a smooth surface as though caused by the gradual shaving away of small amounts of substance over a period of time, conceivably for ritual purposes connected with fertility. KN

Bibliography: Talbot, 1926, fig. 178; Fagg and Plass, 1964, p. 147; Horton, 1965; Willett, 1971, p. 105; Dean, 1983, p. 42, pl. 10; Eicher and Erekosima, 1987; Barley, 1989, pp. 25, 62 ff.; Nicklin, 1989, p. 40; Ross, 1992, pp. 226–7, pl. E

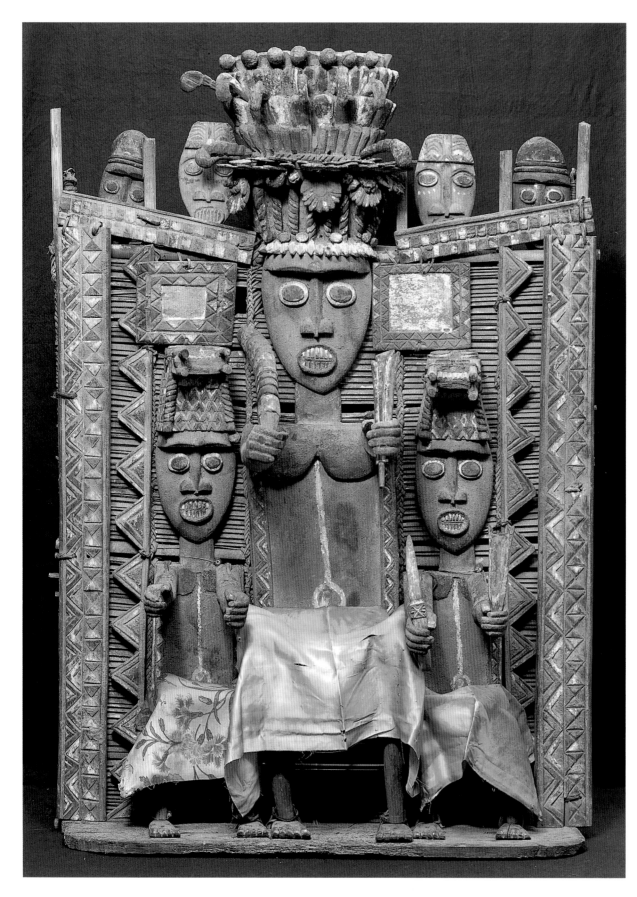

5.57

Funerary screen (*ndnen fubara*)
Kalabari
Nigeria
19th century (?)
wood, cane, raffia, natural pigment
127 x 94 x 40.5 cm
The Trustees of the British Museum,
London, 1950, AF.45.331

From the 15th century onwards, the
Kalabari were important middlemen
of the Atlantic trade. Through their
hands passed exports of slaves, ivory,
palm oil and pepper and imports of
brassware, gunpowder, alcohol and
other Western luxuries. Trade was
controlled by rival houses. Members
of the trading houses of slave origin
rose to positions of prominence and
in the late 18th century the dynamic
Amachree I assumed the kingship
itself. He was the first to be com-
memorated by a screen of this form.

As a foreigner, Amachree would be
denied access to traditional Kalabari
objects of power. Since Kalabari
culture has repeatedly used imported
objects as signs of identity, it seems
likely that these new shrines were
based on European two-dimension-
al images, prints and paintings –
imported screens for imported people.

The screens were made by the
family that provided pilots for
European vessels and so were able to
observe European reverential attitudes
towards religious and royal images.
The screens were kept in the meeting
house that was the headquarters of
the trading group and the spirits of
the dead were held to return to them
at least once every eight days to re-
ceive offerings and be apprised of
the affairs of the house.

Each screen depicts a particular
ancestor displayed in a masquerade
outfit, in this case the feathered
headdress of Alagba. The masquer-
ader holds an Alagba knife and a
carved tusk. Flanking figures wear
headpieces of the Otoba (hippopota-
mus) masquerade, coral beads and
imported satin or floral textiles.
The square shapes attached to the
back screen probably represent
mirrors that were used to embellish
headpieces. *NB*

Provenance: 1916, collected and donated to
the museum by P. A. Talbot.
Bibliography: Horton, 1965; Barley, 1988

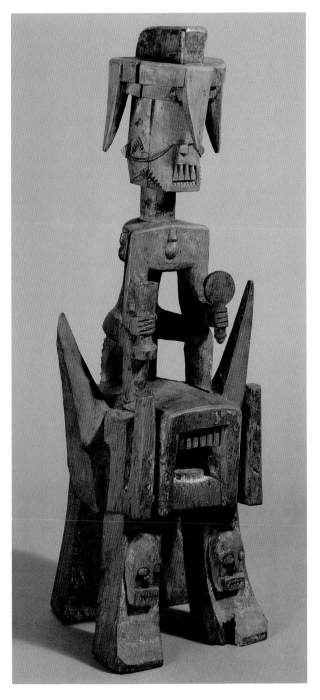

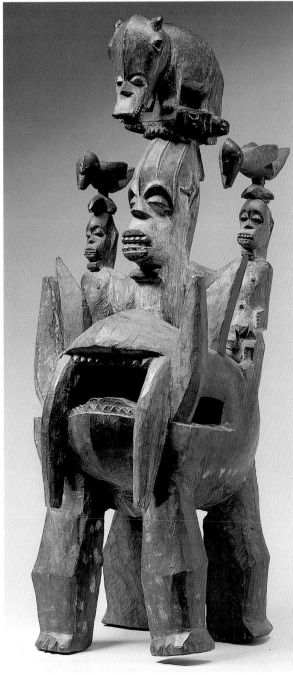

5.58a

Carved figure (*efri*)

Ijo
Nigeria
19th century?
wood
99 x 36 x 42 cm
The Trustees of the British Museum,
London, 1949.AF.46.188

5.58b

Carved figure (*ivwri*)

Urhobo
Nigeria
19th century (?)
wood, pigment
70 x 27 x 26 cm
The Trustees of the British Museum,
London, 1954.AF.23.428

The powerful Urhobo sculpture (cat. 5.58b) combines human, animal and bird-like qualities in a single complex figure. It stands on four massive legs that support a creature that is little more than a vast, gaping mouth, with great, curving incisors and rows of sharp teeth. The whole of this element arguably constitutes the stomach of the human figure that surmounts it. He, in turn, grasps two lesser figures, surmounted by birds, separately carved, and is himself supporting an elephant trampling heads under its feet. All the figures have prominent teeth and facial scarification and that in the centre wears a coral (?) bead at the neck as an indication of wealth and status.

Urhobo *ivwri* sculptures are associated with human aggression. The gaping mouth is seen as the focal point. The figures are involved in self-defence from outside attack and the focusing of individual hostility on external enemies. Relatively large sculptures such as this one might be expected to be owned by a whole group, who look to them for protection. Oral histories of individual pieces typically relate the bringing of an *ivwri* to the foundation of a new settlement. It is normally associated with a particular, successful and aggressive male warrior whose descendants take over the care of the piece. Such works accumulate dangerous powers that are controlled only with difficulty. The possession of such an object is an assertion of status. In previous centuries success was primarily measured in terms of the loss and gain of individuals through the operations of the slave trade, so that *ivwri* remain conceptually linked to slaving.

As part of a larger household shrine, the figure is merely the central element of a much more complex work. In use, such carvings would incorporate a separate triangular screen of slatted cane or wood, attached at the rear of the central figure. Among the Urhobo such an element is known as a 'wing' to empower the object to work at a distance. Fronds of feathery raffia may be hung from the 'wing'. Since this element is much more fragile than the centre sculpture, it has been lost in most museum pieces and indeed is regularly replaced in use. Although usually kept in semi-darkness on a shrine, in at least one case an *ivwri* is recorded as being placed on the head of a performer who dances with it.

The corresponding sculpture from the Ijo (cat. 5.58a) is a similar conception yet is different in so many particulars that the pieces read like the same statement in two different dialects. The Urhobo *ivwri* rounds out its forms wherever possible, while the Ijo *efri* squares all its shapes off. The function of the piece is the same as that of the Urhobo and exhibits the same aggression. Nowhere can the stylistic differences between neighbouring peoples be better demonstrated.

Although works of this kind are typically interpreted as handling impersonal forces, ritual objects in southern Nigeria frequently externalise parts of the human body – so that movements of the head, hand etc. may have strong moral implications and so make the parts of the body subject to control. The stomach can be seen as a symbol of personal greed and acquisitiveness and this sculpture directs and moderates its excesses.
NB

Bibliography: Foss, 1975

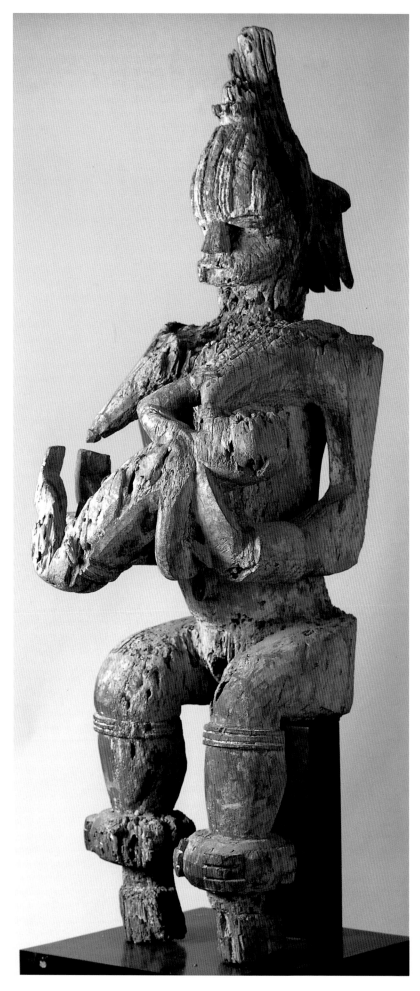

5.59

Carved figure (*edjo re akare*)
Urhobo
Nigeria
19th century (?)
wood
h. 142 cm
Musée Barbier-Mueller, Geneva

The Urhobo of southern Nigeria distinguish between the figures of spiritual beings and those of named ancestors and have different styles for each. This maternity figure is clearly in the former (*edjo*) style with its relative naturalism and rounded, non-geometric general forms. It assumes a characteristic half-seated pose and would have been supported against the mud wall of a shrine, with the posts below the feet embedded in the earth. Much abraded, it would once have been heavily encrusted with white chalk as a mark of spiritual purity and power. The lower limbs would have been wrapped in a white cloth and so less subject to erosion. The head bears the remains of raised facial scars and a complex peaked coiffure, *igbeton*, worn by women of high rank. A necklace curves over the shoulders and on the legs are hollow brass manillas that might be stuffed with aromatic leaves.

Figures of this kind were mainly associated with water-spirits or settlement founders; female carvings seem to have been kept on the fringes of the village near water while male figures were centrally located. The suckling pose does not necessarily imply that the powers of the spirit were concerned exclusively with childbearing. In African sculpture maternity is often seen as completing female identity and nurturing may be metaphorically applied more generally to relations between spiritual powers and life on earth. *NB*

Bibliography: Foss, 1975; Foss, 1976

5.60a
Head of a queen mother

Benin
Nigeria
16th century
brass
h. 35 cm
The Board of Trustees of the National
Museums and Galleries on Merseyside
(Liverpool Museum), 27.11.99.08

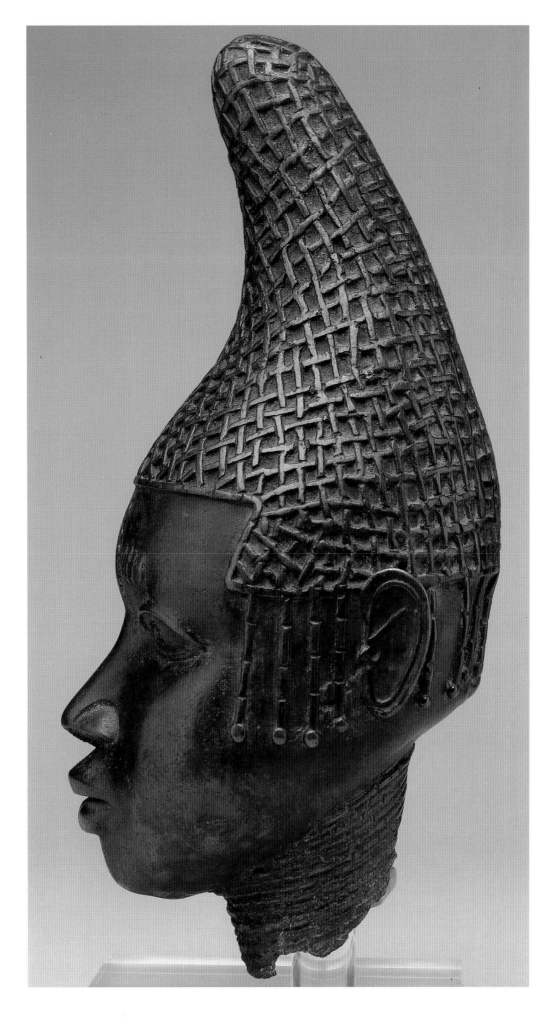

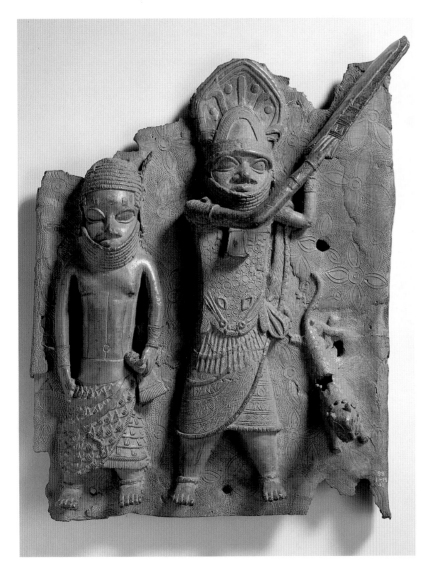

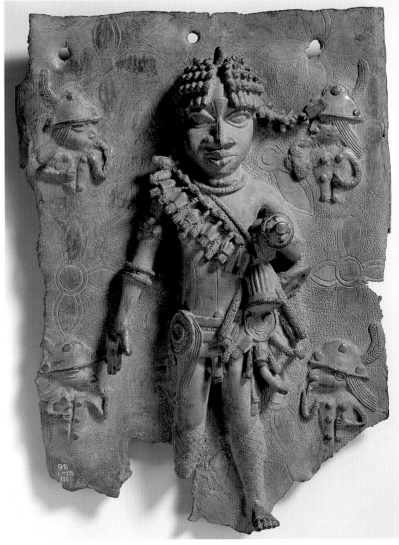

5.60b-e

Plaques

Benin
Nigeria
16th century
brass
50 x 37.5 cm; 44 x 32 cm; 45 x 39 cm;
50 x 40 cm
The Trustees of the British Museum,
London, 1988. 1-15.173; 1-15.111;
1-15.121; 1-15.40

When British forces entered Benin City in 1897 they were surprised to find large quantities of cast brass objects. The technological sophistication and overwhelming naturalism of these pieces contradicted many 19th-century Western assumptions about Africa in general and Benin – regarded as the home of 'fetish' and human sacrifice – in particular. Explanations were swiftly generated to cover the epistemological embarrassment. The objects must, it was supposed, have been made by the Portuguese, the Ancient Egyptians, even the lost tribes of Israel. Subsequent research has tended to stress the indigenous origins of west African metallurgy. Yet it was the naturalism that proved decisive. After some hesitation between the categories of 'curio' and 'antiquity', these objects became unequivocally 'art'. Their status was marked by the establishment of the resonant term 'Benin bronzes', despite their being largely of brass, the noble

material locating them firmly within the tradition of Western art studies.

Since then, a great deal of archaeological, historical, scientific and anthropological enquiry has been undertaken. Works have been classified by period according to the familiar art-historical terms Early, Middle and Late, with the last implying a tailing-off in quality. Controlled production, exclusively for the court and within a guild system, might seem to favour relatively simple models of development. Yet the precise chronology of much of the Benin corpus and its relationship to other African casting traditions remain open to question. Present datings depend largely on the acceptance that Benin casting traditions were derived from the naturalism of neighbouring Ife and on the direct connection (or at least as straight a line of descent as possible) of these to the 'stylised' forms of the late 19th century, bolstered here

and there with outsider descriptions of the Benin court, oral histories, thermoluminescent datings of clay cores and metal analyses. Whether differences of style are exclusively explicable in terms of date rather than difference of function or origin, however, remains problematic. As the capital of a centralised empire with fluctuating boundaries, Benin City had long disseminated regalia to vassal kingdoms and attracted both craftsmen and objects of power to the centre. Scholars have frequently attempted, on the basis of rather tenuous evidence, to repunctuate the corpus of works found in Benin City to create a classic genealogy in line with Western assumptions and exclude the rest.

The queen mother head (cat. 5.60a) is normally ascribed, on stylistic grounds, to the 16th century, i.e. the end of the Early period (Fagg, 1963). The title of queen mother was apparently introduced to Benin by the Oba

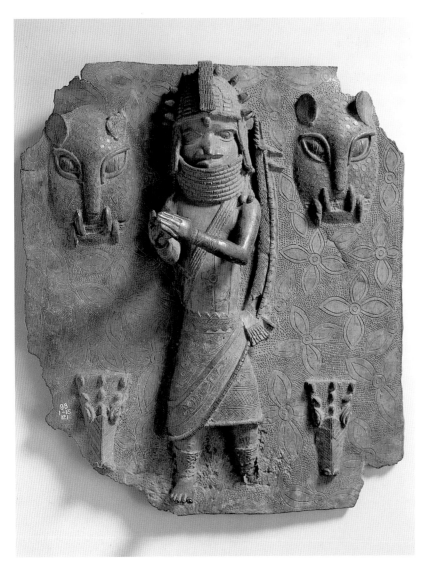

Esigie about the beginning of the 16th century to honour his own mother, Idia; the first brass memorial heads of this form are assigned to this period. The peaked headdress of coral beads is peculiar to the queen mother and, according to one version, is termed 'the chicken's beak'. While the Oba was associated with powerful aggressive animals such as the leopard, queen mothers had a special link with the cockerel, representations of which appeared on altars. This head was presumably kept on those same altars in the queen mother's palace at Uselu, outside the capital, Benin City. It seems generally to be the case that brass heads served as bridges between the spirit and the ordinary worlds but that no tradition of personal portraiture was known.

The positive images of Benin formed by early European visitors make much of the order and imposing architecture of Benin City. Among the features that strongly impressed West-

erners were the palace towers, surmounted by huge birds and ornamented with large brass pythons that zigzagged down the roofs to terminate in great heads with open jaws.

The python head (cat. 5.60g) is one of the finest examples of the genre. A box in the Berlin museum, in the form of a palace building, shows the serpent as continuing over the ridge of the roof and down the other side to end in a tail. Holes around the neck are for the attachment of the rest of the body; the tongue, lost in most examples of this kind, has survived. While many snake heads are entirely covered in scale-like marks, in this piece they are limited to a line four deep around the jaws, giving it considerable elegance. The python, as a creature moving both in the trees and under the ground, was one of the many animals believed by the people of Benin to operate as a messenger of the god Olokun, with whom the Oba specially identified.

At the end of the 17th century the pillars that supported the palace were of wood covered with brass plaques. Like coral and ivory, brass was a material with royal connotations and its use was strictly controlled. By the end of the 19th century and possibly long before that, the plaques had been abandoned in favour of a palace entirely of metal and were mostly dumped in a ruinous storehouse. Many have holes showing where nails were hammered through, and the plaques often seem to have been broken while being wrenched from the pillars. Their production is conventionally dated to the second half of the 16th century; indeed, Fagg refers to them as 'the sheet anchor' of the whole system of Benin chronology. This has not, however, made them immune to challenge.

Although plaques are nowadays normally interpreted in Benin City by analogy with photographs, it seems that most showed recurrent scenes of

ritual rather than unique events. Many can no longer be precisely identified.

The first (cat. 5.60b) deals globally with the place of the leopard within the Benin court. One of the praise-names of the Oba was 'The Leopard of the Town' and he alone was allowed to slay leopards as part of his ritual duties. Leopards would be captured as cubs to be raised within the palace and so tamed in preparation for their immolation. The leopard here is tame, as is shown by its collar. It is shaded with a shield, another prerogative of the Oba within the palace precincts, which strengthens the link between the ruler of the city and the ruler of the forest. The main human figure wears a cuirass, probably of felt and leather; it terminates in a leopard's head and a collar of leopard's teeth, emphasising the warrior's role as a shedder of blood. On his left hip the cloth is raised up into an unusual high 'tail'.

5.60f

Head of a dwarf

Benin
Nigeria
14th century
brass
h. 14.5 cm
Staatliche Museen zu Berlin, Preussischer
Kulturbesitz, Museum für Völkerkunde,
III C 12514

5.60g

Head of a python

Benin
Nigeria
18th century
brass
h. 42 cm
Staatliche Museen zu Berlin, Preussischer
Kulturbesitz, Museum für Völkerkunde,
III C 8514

Particularly striking is the rendering of the leopard, which is shown lying with its back legs crossed over each other; but the whole figure is arranged unforeshortened, from top to bottom within the conceptual frame.

The second plaque (cat. 5.60c) shows a single figure with elaborate coiffure. The braid that seems to be flying is unusual in the rather static idiom of Benin art and may not have been deliberate. A tasselled belt crosses the chest, supporting a sword and an unusual bag (?) and bell hang from the waist. The legs are painted or tattooed up to the knees in a fashion otherwise seen on naked pages; although this figure is dressed, his genitals are exposed, suggesting that he too may be a page. In Benin, in an idiom of overstatement, pages – like all unmarried youths – went naked until the Oba 'made them men' by giving them land, rich clothes and wives. The corners bear images of European heads, hatted and bearded with hands to their lips in a pose common elsewhere on the plaques. In other, clearer renditions they appear to be touching their beards in a gesture of respect.

The third plaque (cat. 5.60d) shows another court figure with the unusual high 'tail' rising from the point at which his cloth is tied over the left hip. In his hands he bears an enigmatic object that may be a musical instrument. A similar figure appears on the ivory sistrum (cat. 5.60n; see below), suggesting he may belong to the same ceremonial context, the Emobo ceremony that cleanses the city of evil forces. In the upper corners of the plaque are leopard heads, images of the Oba, while in the bottom are those of the crocodile, another messenger of the god Olokun.

The last plaque (cat. 5.60e) shows a heavily stylised palm-tree, possibly a Borassus palm in fruit. Two fallen leaves are arranged symmetrically on either side. A Benin informant suggested that some of the plaques illustrate proverbs but was unable to identify clearly which proverb might be involved here.

Dapper's famous 17th-century description of Benin City includes an engraving of the Oba processing with leopards and dwarfs. Both were apparently represented on the altars as aspects of the palace (the collec-

tions in Vienna and Berlin contain images of dwarfs). The head of a dwarf depicted here (cat. 5.60f) has been interpreted variously as male or female but the gender is not clear. The top and back are lacking and cracks in the chin and the roughness of the surface suggest that some of this may derive from unsuccessful casting. The face is strongly prognathous and the hair is only slightly suggested. Unusually, the nostrils are not pierced and the features weakly modelled. The neck ends in a necklace and is pierced as though for attachment.

A number of large standing figures are known from Benin, representing the Oba, attendants and European soldiers. Female figures of brass are comparatively scarce. That from Berlin (cat. 5.60h) immediately challenges notions of a classical Benin corpus. A closely similar one (in the Lagos collection) has a stand in a form normal in Benin works dated to the late 17th century. In common with many of the plaques, the arms are cast solid, without clay core. The necklace, crossed baldric, facial and body scarification are features all well known from classic Benin works but the style here is greatly at variance with these. The bulbous eyes and tubular legs, the extraordinary modelling of the hair and the square feet all recall a vast and heterogeneous corpus of southern Nigerian bronze castings that have not been assigned to any particular centre and are reduced to a spurious order by calling them the Lower Niger Bronze Industry. Attempts to identify the casting with figures of Benin myth and history remain speculative. Meanwhile, 'Benin' continues to spawn an increasingly numerous and dubious progeny – Owo, Ijebu etc. derived from vassal cities of the Benin empire – as a means of explaining its substyles in terms of outside influence.

Another piece in the same indeterminate position is the Berlin mudfish-headed figure (cat. 5.60i). It stands on massive, ill-formed feet, pierced at the front. The skirt extends to the left in the familiar Benin fashion, with two tabs hanging down. Large beads form a necklace and bandolier. The figure holds remnants of a snake in both hands. The 'whiskers' of the mudfish have been so modelled as to resemble

5.60h

Figure of a woman

Benin
Nigeria
17th–18th century (?)
brass
h. 48 cm
Staatliche Museen zu Berlin, Preussischer
Kulturbesitz, Museum für Völkerkunde,
III C 10864

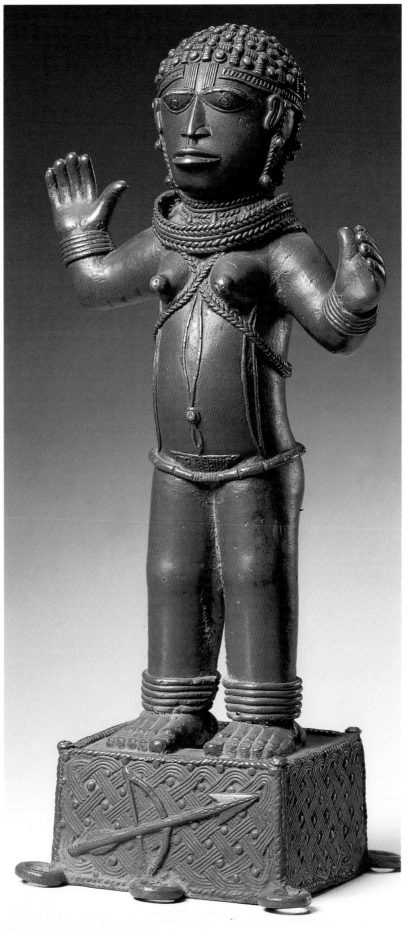

hair. European hair is similarly represented in Benin figures.

Mudfish were, like Europeans, regarded as messengers of the god Olokun who sent both wealth and children from over the sea. It is the distinguishing feature of such fish to retreat into the mud as a watercourse dries up. At the first rain they re-appear, vibrant with life. They are thus suitable images of intermediaries between the realms of the living and the dead. The portrayal of the Oba as a semi-mudfish is common in Benin, though more usually it is the legs that are assimilated with 'whiskers'. It is even related that the 14th-century Oba Ohen explained a stroke that made him lame in terms of this transformation.

Some time before 1907 a man digging a water-hole at Apapa, Lagos, accidentally discovered a ram's head pectoral (cat. 5.60j) at a depth of about three metres, along with a large hoard of other brass objects. It is a work of striking elegance, strongly modelled and with subdued orna-mentation. The central, semicircular panel has been edged in cast plait-work, while a simple geometric design has been punched into its flat surface. Large crotals are attached with wire. The horns of the ram have been spread to frame the hollow head that is surmounted by a suspension hoop, also in plaitwork. Stylistically, it recalls the Benin ram aquamaniles and the casting has a similar thinness and accomplished lightness.

Inevitably, its discovery in Lagos has encouraged speculation on more exotic origins. While the use of ram images is very common in many parts of southern Nigeria, it has been associated with influence from Ancient Egypt or the Yoruba kingdom of Owo. Yet tradition has it that Lagos

was a vassal of the Benin empire in the mid-16th century and the pectoral may well have been made at that time. As belligerent, domineering animals, rams were associated in Benin with male notables and were a favoured beast of sacrifice.

The small costume mask in the form of a human face (cat. 5.60k) is another non-canonical piece, so it is sometimes regarded as 'Lower Niger' rather than truly 'Benin'. It combines a headdress recalling Ife brass castings with scarification redolent of Benin. The use of iron to mark the pupils of the eyes is typically Benin, yet their form is unusual, as are the slits under-neath. These are known both from Ife brasswork and Benin ivorywork. The presence of loops at either side instead of at the back suggests that this mask may have been worn around the neck rather than on the left hip, as was more customary in Benin.

The manilla bracelet (cat. 5.60l) was presumably far too big to have ever been worn. Apart from being body decoration, manillas acted also as a reserve of value, as a ritual cur-rency and as religious paraphernalia. It is of ridged cross-section with flared ends and incised geometric markings. It demonstrates many of the problems involved in attributing items of south-ern Nigerian metalwork. Together with many other manillas of varied forms, it was part of the contents of a shrine in the Andoni Creeks (i.e. in Ibibio country, southern Nigeria) destroyed by the British administration in 1904 following allegations of manslaughter. This collection of metal material included bracelets apparently of Ijow manu-facture, Lower Niger figure sculpture, swords of an almost Art Nouveau style (otherwise undocumented), a Dutch ship's bell, bronze leopard skulls and a length of drainpipe. Metal analysis shows the bracelet to be a genuine bronze, not brass, indeed to be almost of pure copper. All the shrine material seems to have been painted with stripes of white kaolin, a common mark of sacrality. The very diversity of the hoard is likely to have been part of its power.

The large iron staff (*osun ematon*; cat. 5.60p) forms part of the equipment of a Benin Osun priest, a specialist who uses the power of leaves and forest plants. Made of iron, it has a branching, tree-like form that ends

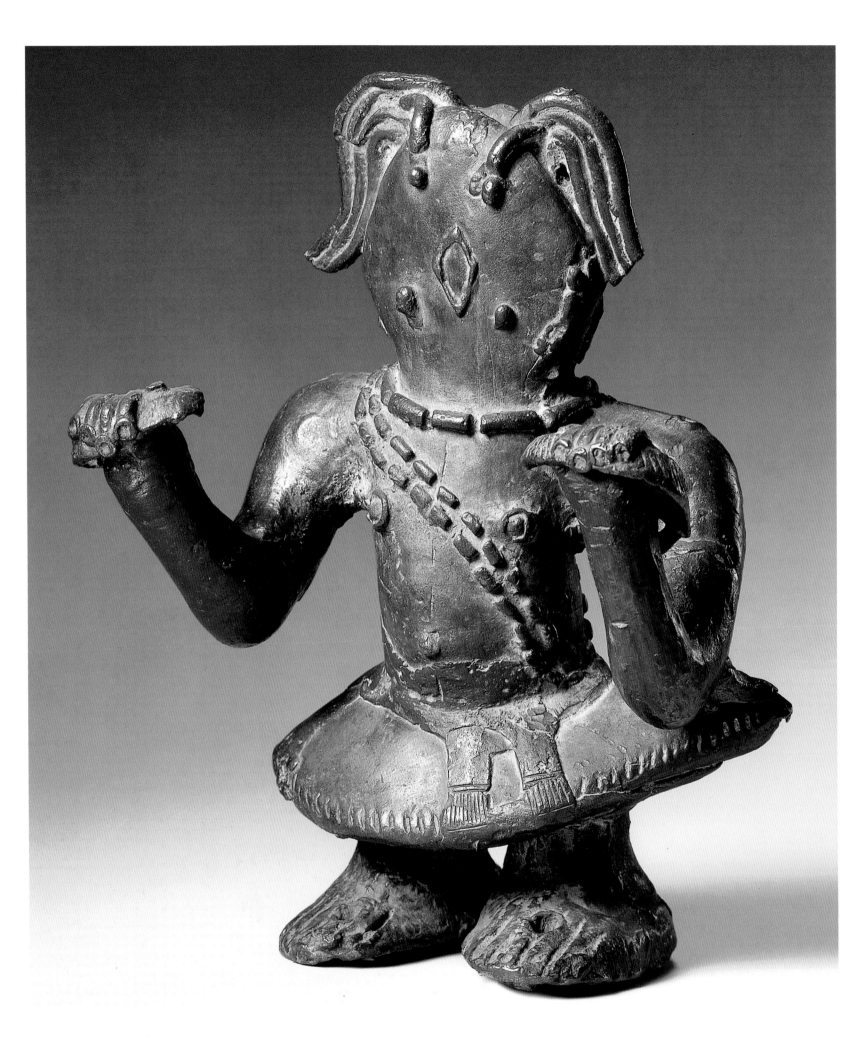

5.60i

Figure with mudfish head

Benin
Nigeria
brass
h. 38 cm
Staatliche Museen zu Berlin, Preussischer
Kulturbesitz, Museum für Völkerkunde,
III C 10873

5.60j

Ram's head pectoral

Apapa, Lagos
Nigeria
16th century
brass
h. 43 cm
The Trustees of the British Museum,
London, 1930. 4-23.1

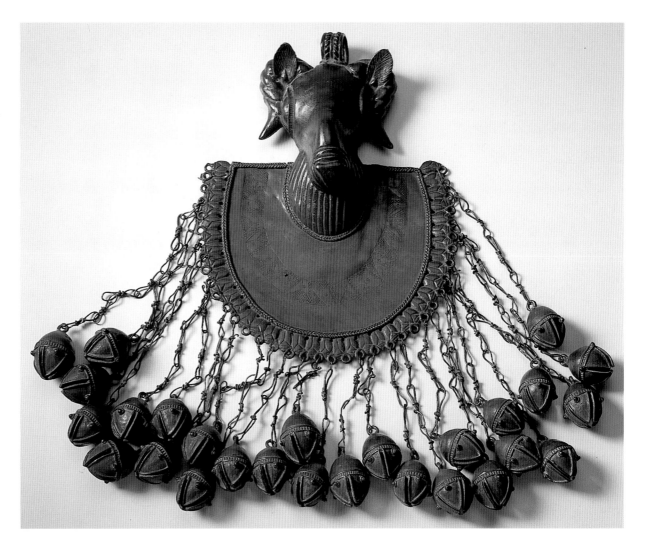

in representations of flame and sharp, piercing objects, such as animal horns and weapons. When complete, it would be surmounted by a grey heron, the lord of the witches. Planted in the earth, it is an important ritual object in the fight against witchcraft and held to be hot with power. Particularly effective is the chameleon represented on it, whose changing skin can be used at night by the Osun specialist to take photographs of the witches.

Benin art contains many skeuomorphs, objects habitually made in one material that are occasionally executed in others. The ivory and copper leopard (cat. 5.60q) is one such. One of a pair sent to Queen Victoria by Admiral Rawson, the commander of the British Punitive Expedition of 1897, its form recalls that of the brass aquamaniles, jugs used to contain water for royal ritual ablutions. Made from five principal pieces of ivory fitted together, it could not be used as a water container and the 'lid' just in front of the tail does not open. It has been convincingly argued that

the older brass leopards themselves were inspired by medieval European models that happily fitted into Benin political symbolism. The spots are executed in copper and are said to be made from 19th-century percussion caps used for the detonation of rifles. The eyes contained fragments of imported mirror. In this, the Benin artistic corpus reverses the received orthodoxies not merely about naturalism in African art but also about patterns of trade. In defiance of the 'imperial model', whereby raw materials were supposed to be taken from Africa for conversion into manufactures in the metropolitan heartland, Benin usually imported European products that were pulped to make finished goods of interest to the Oba and court. Most of the Benin 'bronzes' were, after all, made from European metal.

The ivory sistrum (cat. 5.60n) is a *tour de force* of the ivory carver's art. It is a musical instrument, containing two bells of different size, producing a dry, tapping sound when struck.

5.60k

Mask in human form

Benin
Nigeria
brass
15.5 x 9.5 x 6 cm
The Trustees of the British Museum,
London, 1962. AF. 13.1

5.60l

Manilla bracelet

Lower Niger
Nigeria
bronze, kaolin
15 x 20 cm
The Trustees of the British Museum,
London, 1905.4-13.2

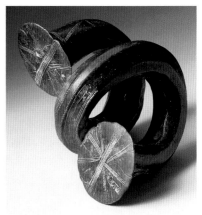

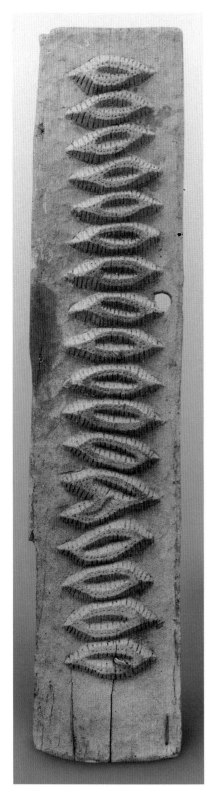

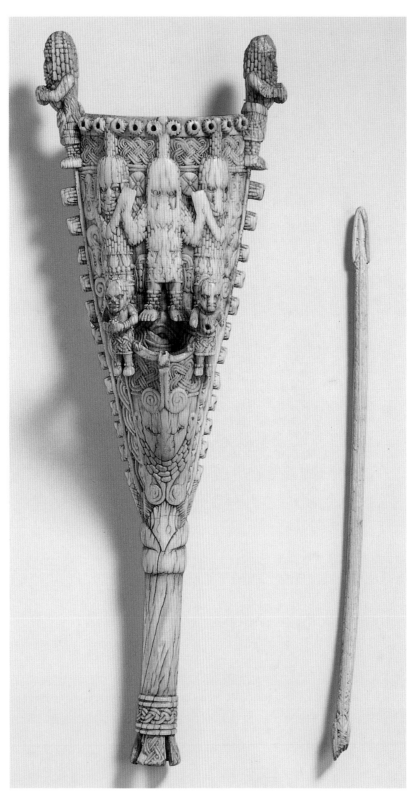

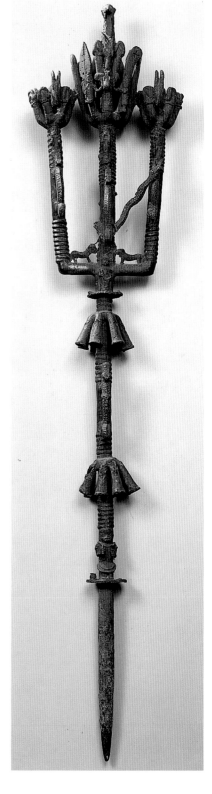

5.60m

Carved door

Benin (?)
Nigeria
wood
121 x 38.5 x 184 cm
The National Commission for Museums
and Monuments, Lagos, 74.I.422

5.60n

Sistrum

Benin
Nigeria
16th century (?)
ivory
h. 36 cm
The Trustees of the British Museum,
London, 1963. AF. 4.1

5.60o

Striker

Benin
Nigeria
16th century (?)
h. 28 cm
The Trustees of the British Museum,
London, 1964.AF. 7.1

5.60p

Staff (*osun ematon*)

Benin
Nigeria
iron
h. 180 cm
Staatliche Museen zu Berlin,
Preussischer Kulturbesitz, Museum für
Völkerkunde, III C 8506

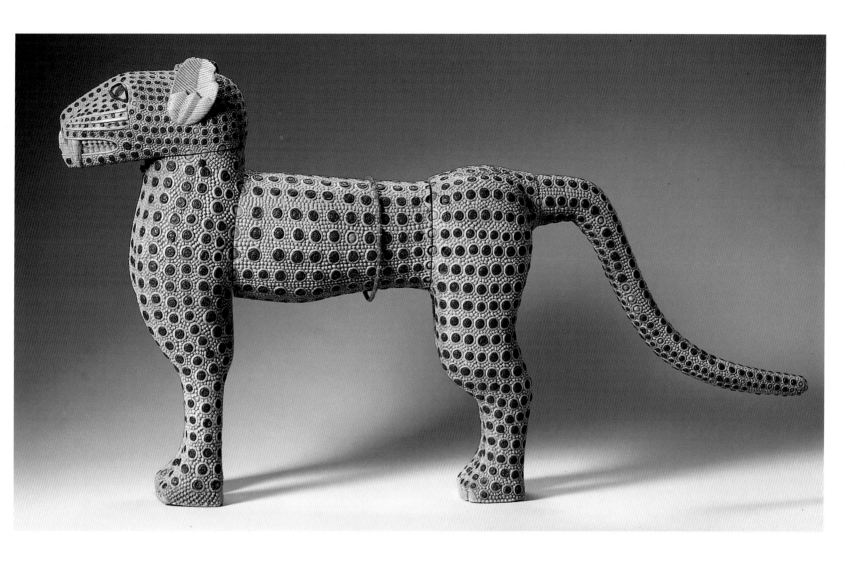

5.60q

Leopard

Benin
Nigeria
19th century
ivory and copper
47 x 88 cm
Lent by Her Majesty The Queen

On one side the Oba is depicted in human form, supported by two retainers. On the other, he incarnates the god Olokun with mudfish legs and a swinging crocodile in each hand. Human musicians mark the extremities of both vessels, which are edged with hollowed crenellations. Apart from the shaft of the handle, the surface is completely covered with fine, worn carving. The guilloche pattern of the end of the handle is repeated in various parts of the main vessels, fitted between representations of human faces, mudfish, snakes and – unusually – turtles, all recalling Olokun and his messenger animals. It shows the familiar 'chaining' technique whereby objects blend into each other. So the penis of the Oba becomes a hand that grips a bat. The Oba grasps a crocodile whose jaws, in turn, become another hand. The striker (cat. 5.60o) shows signs of having been completely covered with a criss-cross pattern, now greatly abraded, while its ends are again in the form of mudfish

heads. An instrument of this kind is used nowadays by the Oba at a ceremony to drive evil forces from Benin City.

It has been argued that the tradition of ivory carving in Benin differs from that of royal brass casting in that a separate guild is responsible for it, one that also undertakes woodcarving. Carving of wood and ivory was less affected than casting by the decline in the Late period, so that even 19th-century works such as the leopard (cat. 5.60q) and the carved Benin door (cat. 5.60m) are of relatively high quality. In the absence of clear information concerning provenance, the latter is hard to place. While elaborate doors were common in Benin City, and in Africa generally are part of a concern with status and the symbolic importance of thresholds, this particular door bears none of the motifs normally associated with Benin. *NB*

Provenance: cat. 5.60b–e: 1988, given to the museum by the Secretary of State for Foreign Affairs; cat. 5.60l: 1905, given to the museum by the British administration for southern Nigeria; cat. 5.60n: 1963, given to the museum by Mrs Webster Plass; cat. 5.60o: 1964, given to the museum by Lady Epstein; cat. 5.60q: 1897, given to Queen Victoria by Admiral Rawson

Bibliography: Fagg, 1960, pp. 33, 38; Fagg, 1963; Babatunde Lawal, 1975, p. 238; Dark, 1975, p. 40; Poyner, 1978, p. 193; Tunis, 1978; Ben-Amos, 1980, p. 53; Tunis, 1983

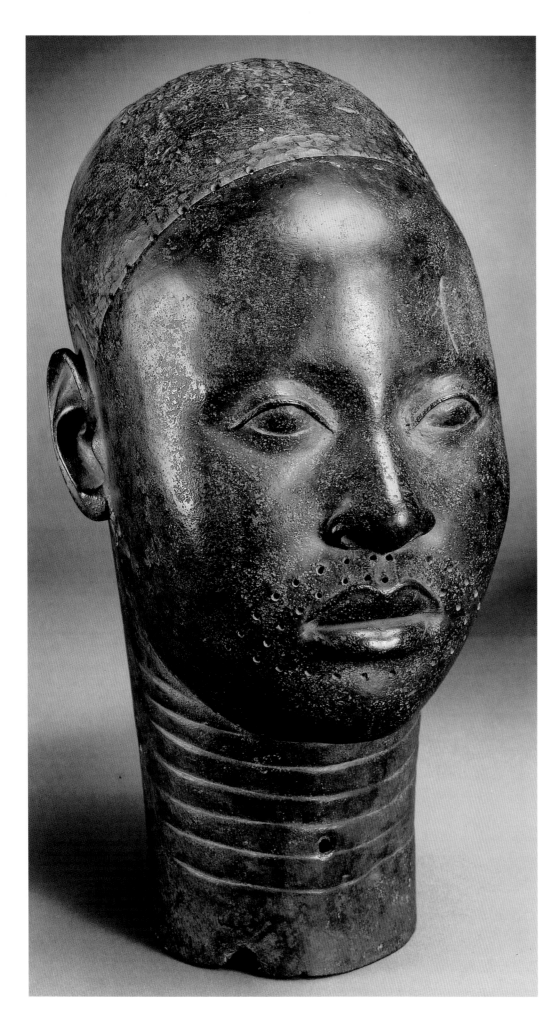

5.61

Head

Yoruba
Ife, Nigeria
12th–15th century
zinc-brass
31 x 9.5 cm
The National Commission for Museums
and Monuments, Ife, Nigeria, 11

In 1938 ground was being dug to
construct a house in Wunmonije
Compound, now immediately be-
hind the palace in Ife, but formerly
within the enclosing palace wall.
The workers found two groups of
castings. Most were of life-size heads
like this one, two were smaller than
life size and wore crowns and there
was the upper part of a figure that
closely resembles that of an Ooni
found in 1957 at Ita Yemoo. Their
portrait-like naturalism astounded
the Western art world despite the
fact that the German explorer and
ethnographer Leo Frobenius had
called attention to this art in 1910
when he found a crowned metal head
and a score of terracotta sculptures.
It was not considered in 1938 any
more than in 1910 that this could
really be the work of African sculp-
tors unless they had worked under a
European master. Soon after World
War II, William Fagg argued per-
suasively that they were indeed made
by Africans before Europeans first
landed on the Guinea Coast. The
Western critics were still astonished
in 1982 when this head and others
similar were shown in the exhibition
Treasures of Ancient Nigeria.

The head has been cast from a wax
original over a clay core. The top of
the head has been cut back on the
wax before casting to make it fit an
existing crown. Holes have been pro-
vided in the neck to allow it to be
attached either to a column or more
likely to a wooden body. It is not clear
how these heads were used. Perhaps
they carried the crown and other
emblems of office of a dead ruler in
a second burial ceremony to show
that, though the incumbent had died,
the office continued, or they may have
been used in annual rites of purifica-
tion and renewal for the ruler and his
people. *FW*

Exhibition: Detroit et al. 1980–3, no. 39
Bibliography: Fagg, 1963; Willett, 1967,
pl. II; Shaw, 1978

5.62

Mask head

Yoruba
Ife, Nigeria
12th–15th century
copper
33 x 19 cm
The National Commission for Museums
and Monuments, Lagos, IFE.17

This life-size mask is reputed to have
been kept on an altar in the palace at
Ife ever since it was made. It is said
to represent the early Ooni of Ife
Obalufon II, who is credited with
having introduced the art of bronze
casting. It is a masterpiece of the
bronzesmith's art for it is completely
flawless despite being cast in pure
copper without any addition of zinc,
tin or lead to help it to flow in the
enclosed mould. Molten copper
oxidises on exposure to air, forming
a thick skin that prevents it from
flowing in the narrow confines of the
mould, a fact that was known to the
smiths at Igbo-Ukwu in the 9th or
10th century. The Ife smiths seem to
have hit on the idea of excluding the
air by joining the mould to the
crucible and inverting the whole lot
when the metal was fluid enough.
The rough patches above the hairline
are where channels were provided in
the mould to permit the metal to
enter and gases to leave. They would
have been partially filled with metal
and then cut off. The holes above the
hairline were probably to carry a
crown. As in the life-size head, the
surface has been cut away over the
ears so that the crown could fit.
The holes round the mouth and jaw
carried a veil of beads, as is shown in
a very similar terracotta piece found
at the Obalufon shrine and sadly
stolen from the Archaeology Depart-
ment of the Obafemi Awolowo
University in Ife. The flange at the
back of the face has holes to allow
it to be attached to a costume. Clearly
this is a mask intended to be worn in
a representation of a king, but what
the performance was remains a
mystery. *FW*

Bibliography: Willett, 1967, pl. I; Shaw,
1978, pl. 83; Eyo and Willett, 1982, no.41

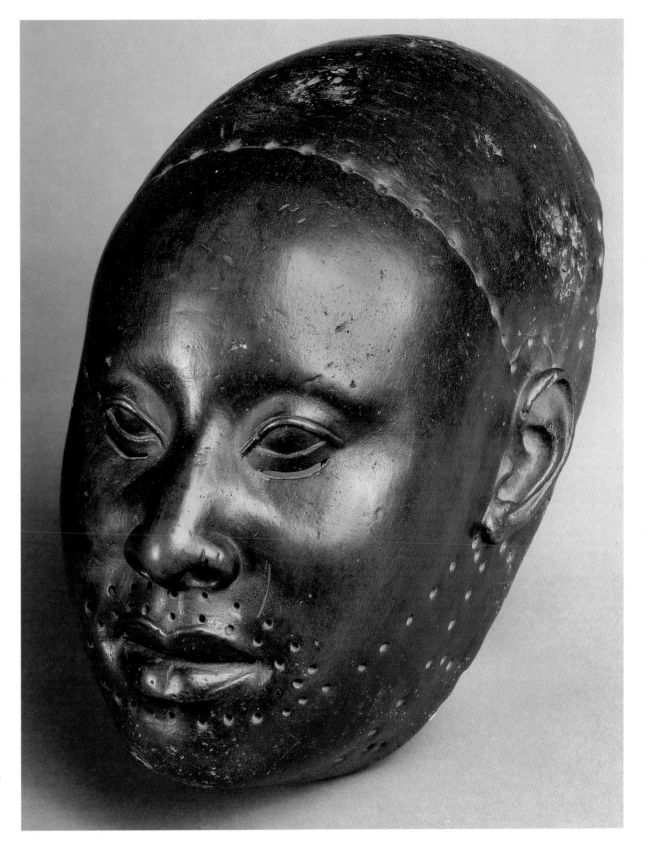

5.63

Figure of an Ooni

Yoruba
Nigeria
Ita Yemoo, Ife
12th–15th century
zinc-brass
47.1 x 17.3 x 16.3 cm
The National Commission for Museums
and Monuments, Lagos, 79.R.12

This is one of a group of sculptures
found in 1957 by workmen levelling
the ground to build the headquarters
of the Ife Co-operative Produce
Marketing Union. According to the
Ooni (King) of Ife at the time, it
represents the Ooni in the costume
worn for his coronation. The left hand
holds an animal horn that is filled
with a powerful medicine. The right
hand holds a wooden staff covered
with bead-embroidered cloth; this is
replaced after the coronation by the
irukere (lit. 'ram's beard'), the beaded
cow-tail flywhisk that is widely recog-
nised in Africa as a symbol of authority.
Being complete, this figure has proved
invaluable in interpreting the many
hundreds of fragments of terracotta
sculpture in the Ife Museum. Crowns
show considerable variety, but all have
some form of conical boss over the
forehead with a rising element above
it. The one worn here is the most
common form with a plaitwork riser
ending in a pointed tip. The heavy
collar with globular beads along the
inner edge is also typical, as are the
pair of beaded badges, shaped like a
bow-tie, which hang on the chest.
All the features represented here –
the mass of strings of beads covering
most of the chest, the longer rope of
much heavier beads, with a loop of
beads at their lowest point; the beaded
cuffs on the forearms and lower legs,
accompanied by narrow bracelets and
anklets – are regularly represented in
the terracotta sculptures. *FW*

Bibliography: Willett, 1967, pl. 6;
Eyo and Willett, 1982, no. 44

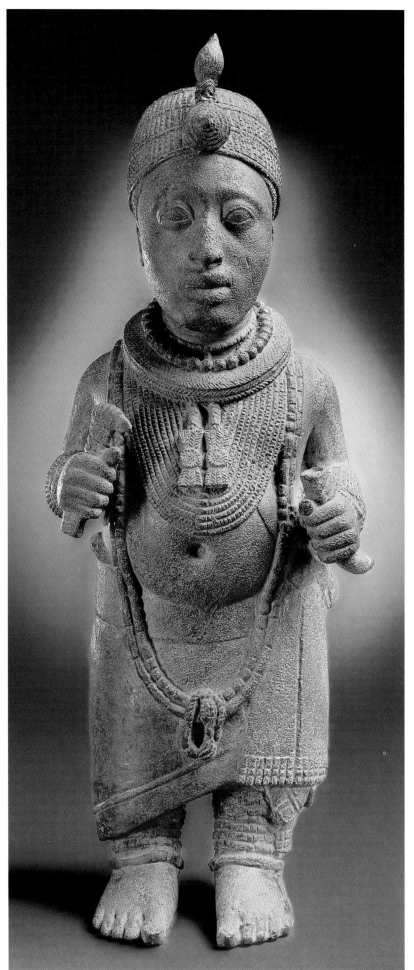

5.64

Seated figure

Yoruba
Tada, Nigeria
13th–14th century
copper
53.7 x 34.3 x 36 cm
The National Commission for Museums
and Monuments, Lagos, 79.R.18

This is without doubt the supreme masterpiece of the Ife smiths' art. Its proportions are naturalistic, whereas normally the head is a quarter or more of the height of the figure. The limbs and usually the torso are generally no more than cylinders, but here the legs and remaining parts of the arms are very lifelike. The figure wears a wrapper that is overlain with a net of beads. On the left hip a sash is tied round a folded cloth, perhaps the corners of the wrapper. (There is a similar hip ornament in terracotta from a life-size figure from the Iwinrin Grove.) Originally the right foot may have projected below the level of the base, which prompted William Fagg to suggest that it might have been intended to sit on a round stone throne (as cat. 5.66).

The metal used to cast this piece was almost pure copper. This sculpture, weighing in its broken state and without the enclosing mould about 18 kg, was too heavy to cast by joining the mould to the crucible, so it was probably cast by partly burying the mould in the ground and melting the metal in several sealed crucibles. When ready these would have been taken to the mould, their tops knocked off and the metal poured in. One can distinguish on the back of the figure the lines separating the different pourings of metal, as it chilled when running into the mould and did not fuse completely. Until recently this piece was kept in a shrine in the Nupe village of Tada on the River Niger 192 km north of Ife, where the villagers took it down to the river every Friday (they are good Muslims) and scrubbed it with river gravel to ensure the fertility of their wives and of the fish on which they live. This accounts for its smoothed appearance. Bernard Fagg persuaded the villagers that they were destroying the sculpture and with it the fertility they were trying to promote. He provided them with special cloths to keep it bright. By 1956 the cloths had worn out and the habit had been lost. The figure was already developing its dark protective patina.

It is not clear why this piece and several others were found so far north. It may well be that its location indicates the ancient northern frontier of the kingdom of Ife. *FW*
Bibliography: Willett, 1967, pl. 8

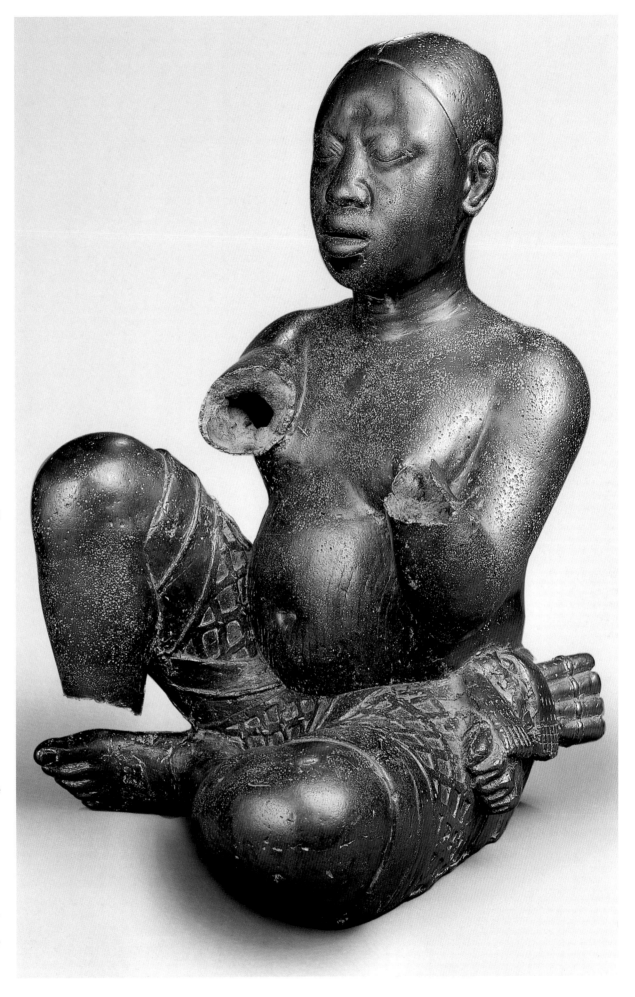

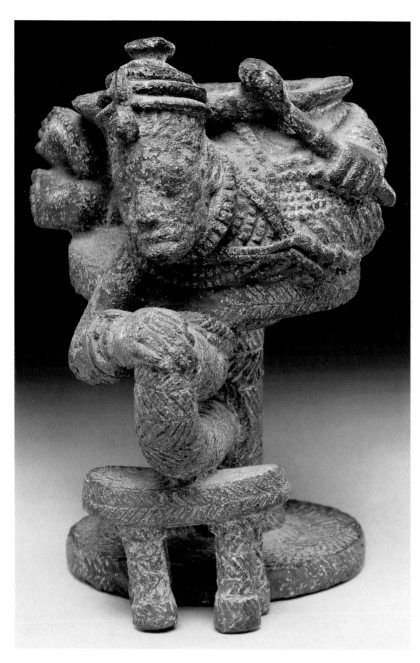

in a very important cult in which the highest form of sacrifice was offered. The bowl was probably intended to be a receptacle for a liquid, possibly of snail juice (used as an antiseptic when children are scarified), kept on certain shrines in modern Yorubaland. *FW*

Bibliography: Willett, 1967, pl. 9; Eyo and Willett, 1982, no. 46

5.66

Throne

Yoruba
Nigeria
Ile Oluorogbo, Ife
12th–15th century
quartz
h. 53 cm
The Trustees of the British Museum, London, 1896. 11.22.1

This is one of three stools made from vein quartz (one like this but with the loop broken off and the third a matching four-legged stool) that were given by the Ooni of Ife, Adelekan Olubushe, in 1896 to Captain Bower. They came originally from the shrine of Oluorogbo, who is said to be the messenger between earth and heaven and to have known the art of writing.

Veins of quartz outcrop around Ife. It is a very hard crystalline substance that fractures along the crystal faces. This makes it unsuitable for working by striking with hammer and chisel, so this elaborate shape must have been achieved very laboriously by abrasion, probably by rubbing with moist sand applied with blocks of wood. The mouldings around the top and bottom of the central column and at each end of the loop are almost circular in section (rather than being quadrants, as one would expect to find on worked stone). This led the sculptor Leon Underwood to suggest that the form had been created by a bronzesmith in whose craft it would be natural to apply a roll of wax to form such a moulding. However, it has been shown that the prototype of these stools was in wood and bark; the form was copied in terracotta, in which such a shape of moulding would be as easy to achieve as it would be in wax. *FW*

Provenance: 1896, given by the Ooni of Ife to Captain Bower, who passed it on to Sir Gilbert Carter; 1896, given to the museum by Sir Gilbert Carter
Bibliography: Willett, 1967, pl. 77

5.65

Vessel

Yoruba
Nigeria
Ita Yemoo, Ife
12th–15th century
zinc-brass
12.4 x 10.5 cm
The National Commission for Museums and Monuments, Lagos, L.192.58

Like the brass figure of an Ooni (cat. 5.63), this object, which the finders called an ash-tray, was found by accident. It is a solid, flawless casting and was cast upside-down. It represents a queen wearing the usual flanged crown, heavy beaded collar, a mass of necklaces over the chest with a heavy rope of beads outside them and the beaded badges

of office on the chest. She wears the usual beaded cuffs, bracelets and anklets. Her body is curved around an open bowl, which stands on top of a typical Ife throne; this is composed of two discs separated by a column from which projects a loop that curves back to join the lower side of the top disc (cat. 5.66). The surface is covered with herringbone decoration. The figure supports herself on the loop with her left arm. In her right hand she holds a staff with a human head like two that were found with this piece. On one example the head was gagged. It is impossible to tell whether the head on the queen's staff was gagged. There were also two staff-heads, each with two gagged human heads. It would appear that these castings were used

5.68

Stool

Yoruba
Nigeria
Igbo Apere Oro, Ife
12th–15th century
granite-gneiss
34.5 x 14 x 29 cm
The National Commission for Museums
and Monuments, Ife, Nigeria, 58.1.3

This is one of two stools from Igbo
Apere Oro ('the grove of the stools for
the bullroarer'). It is complete and is
the most elegant surviving simplifica-
tion of the four-legged stool, grooves
having been fashioned in the ends to
give the impression that the legs are
longer than they really are. This
feature also has the effect of making
the stool look less massive.

The Oro Society is very powerful.
To it the execution of criminals used
to be delegated. It no longer fulfils
this role, but it still employs the bull-
roarer – an oval piece of wood at the
end of a long twisted cord that is
whirled round so that the piece of
wood rotates through the air to pro-
duce a very eerie sound, intended to
scare away the uninitiated from its
secret night-time ceremonies. *FW*

Bibliography: Willett, 1967, pl. 78

5.67

Throne group

Yoruba
Nigeria
Iwinrin Grove, Ife
12th–15th century
terracotta
60 x 55.5 x 83 cm
The National Commission for Museums
and Monuments, Ife, Nigeria, 49.1.25

The Iwinrin Grove contained a num-
ber of life-size terracotta figures, now
sadly fragmentary, some of which
appear to have been intended to stand
on each side of this piece holding the
clothing of the seated figure. It rep-
resents a throne composed of a rect-
angular four-legged stool supporting
the loop of the spectacular form
of seat unique to Ife (cat. 5.66,68).
A cloth was draped over the seat and
the incumbent sat with his/her feet
astride the loop, resting on the four-
legged stool. The form of the looped
seat appears to be derived from a wide
cylindrical box made of bark with
wooden ends that is used in present-
day Ife to store ritual objects and to
serve as a seat for the priest during

ceremonies. The two parts are often
joined together with a loop of bark,
and the box/stool is commonly paint-
ed. Copies in stone of this form are
known with the decoration rendered
in relief. Excavations conducted in the
Iwinrin Grove at different times by
Bernard Fagg and Frank Willett
recovered not only some of the shards
incorporated into the present sculp-
ture, including the loins of the figure
seated on it, but also glass studs set in
a strip of copper, which must be the
prototype of the bands of decoration
shown by the present piece. The
figure was about two-thirds life size.
The head, wearing a beaded cap
swathed with cloth that matches the
herringbone pattern of the stool, was
stolen from the Ife Museum in April
1993. The incised herringbone
decoration resembles that of the
group of brass stools from Ita Yemoo,
and occurs on some of the other
terracotta representations of these
thrones. The successful firing of such
large sculptures in an open fire – for
they had no kilns – reflects the very
high degree of technical skill of

the Ife sculptors. Since in modern
Yorubaland both domestic and ritual
pottery is made by women, it may
well be that they made these
terracotta sculptures. *FW*

Bibliography: Willett, 1967, pl. 76

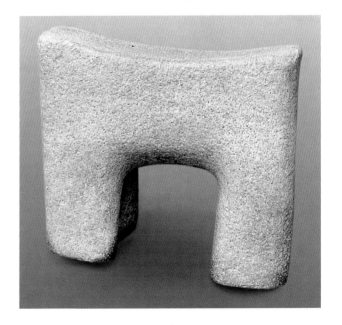

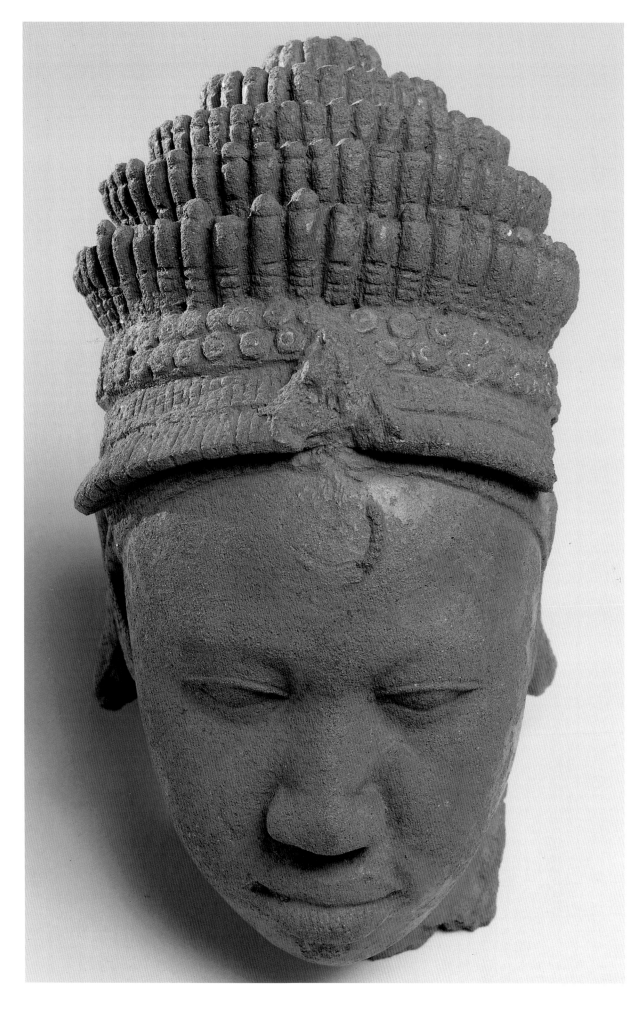

5.69

Head of a queen

Yoruba
Nigeria
Ita Yemoo, Ife
12th–13th century
terracotta
h. 25 cm; diam. 17 cm
The National Commission for Museums
and Monuments, Ife, Nigeria, 79.R.7

The accidental discovery of the cast
figures at Ita Yemoo in 1957 led to
excavations on the site. During the
first season the remains of a shrine,
composed largely of worn-out grind-
stones with terracotta sculptures, were
discovered. Four heads were found,
but as there were seven left feet there
must have been at least that number
of figures originally. Most had been
dug away and incorporated into the
walls of two nearby houses. One has
been demolished and has contributed
pieces that could be joined on to those
excavated. Two of the four heads were
without headdresses of any kind and
are thought to have been figures of
attendants. They are about two-thirds
life size. The other two wore crowns
and were three-quarters or more life
size. The flanged crown appears to
indicate that the wearer is a queen.
It has been possible to reconstruct
the front of a female body from the
excavated fragments but they do not
fit this head. It appears that at least
two queens were represented on the
shrine. Originally this head had a
crest on the front of the crown like
that worn by the brass figure of an
Ooni from the same site. *FW*

Bibliography: Willett, 1967, pl. IX;
Eyo and Willett, 1982, no. 50

5.70

Woman carrying two horns

Yoruba
Nigeria
Ife
12th–15th century
terracotta
24.9 x 10.5 cm
The National Commission for Museums
and Monuments, Lagos

There are a number of small figures
from Ife that appear to have originally
been parts of tableaux or groupings
of figures on a single support. None
of them survives intact. This piece
(apparently unfinished), with its head
turned to one side and its back flat, is
likely to have been part of such a
group. The face is delicately striated
to represent a scarification that is
typical of the art of Ife (although
long unused). The wrapper extends
from the armpits to the ankles, which
indicates that the figure is a woman.
In the Classical art of Ife, male fig-
ures wear wrappers from the waist
down, while women keep their breasts
covered; only in later works are
women represented with their breasts
uncovered. She carries a pair of
buffalo horns in her hands. Similar
pairs of horns appear on ritual pots
in Ife and there is a fragment of
terracotta from Owo that represents
a pair of horns apparently being
rubbed against each other. (They
are still used in this way, in the Ekiti
area of Yorubaland, as a ceremonial
musical instrument.) Buffalo horns
are associated nowadays with the cult
of Oya, goddess of the River Niger
and also of the powerful wind that
precedes a thunderstorm. Her tem-
perament is thought to resemble that
of a buffalo, one of the most feared
of west African animals because of its
unpredictability. The rubbing together
of buffalo horns may well be thought
also to represent the sound of rolling
thunder.

This piece was seized by the
Nigerian authorities as it was about
to be exported. It seems to have been
dug illicitly from the site of Obalara's
Land, which was being excavated at
the time by Peter Garlake. *FW*

Bibliography: Eyo and Willett, 1982,
no. 59

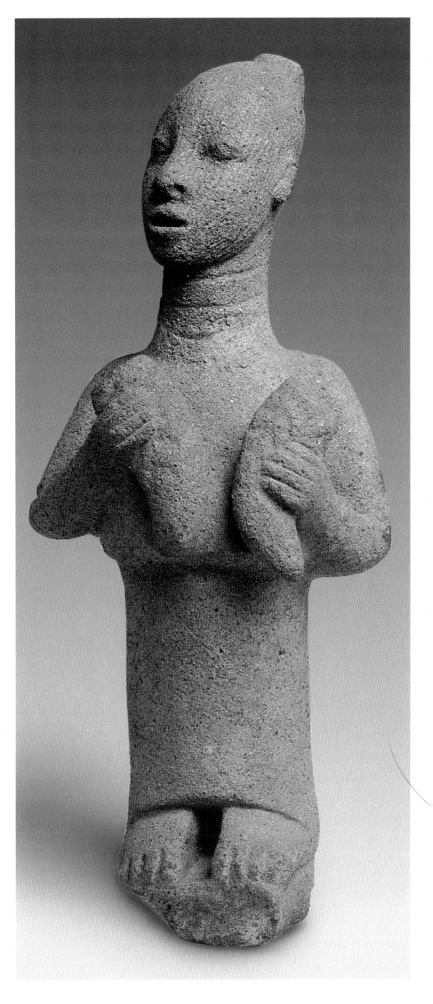

5.71

Seated male figure

Esie
Nigeria
12th–15th century
soapstone (talc schist)
67 x 30 cm
The National Commission for Museums
and Monuments, Lagos, HT.260

Esie stone carvings remain one of the
unsolved mysteries in the history of
Yoruba art. For centuries, thousands of
fragments and a few sculpted figures
lay in a grove in the present Igbomina
Yoruba town of Esie. The scene gave
the impression of deliberate destruc-
tion, if not desecration. In 1912
Frobenius called attention to similar
stone sculptures in neighbouring
towns, but dismissed them as 'poor
and degenerate in form'. The images
in Esie remained relatively undis-
turbed until the 1930s, when Ram-
shaw and then Murray appealed for
their preservation and conservation.
It was not until 1973–4 that Phillips
Stevens, Jr, undertook the cataloguing
and photographing of the entire
collection.

Esie oral traditions relate that
settlers from Old Oyo 'met' the stone

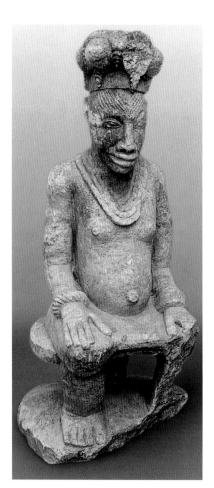

sculptures when they arrived in the
15th (or 16th) century. Other oral and
ritual traditions appear to confirm
that the sculptures and their mutila-
tion predate the ancestral memory
of the present inhabitants of Esie.
The disarray of the primary site,
vandalism over the years, and the
nature of the material itself has
made archaeological research difficult.
At another site, known as the Iwoto
Grove, thermoluminescent tests on
pottery found adjacent to soapstone
carvings (apparently unfinished
works) suggest dates ranging from
the 10th to the 18th centuries.

The quality of the artistry and the
distinct style indicates that the Esie
sculptures were once associated with
the flourishing culture that required
and could afford the celebration of
social roles in visual art. Archae-
ological evidence of iron smelting and
paved roads in the general vicinity of
Esie clearly indicate that an early and
well-developed culture existed in the
area. Oral histories (*itan*) in neigh-
bouring Igbomina towns frequently
refer to 'the people of Oba' who no
longer exist. Whether the Esie carv-
ings are to be associated with the Oba
culture is far from resolved, but seems
to be the most promising line of
inquiry.

This seated male figure is clearly
a portrait of one with authority.
His headdress (a type found on several
Esie figure sculptures) consists of a
cluster of twelve snail shells. He wears
a necklace consisting of three strands
of large beads and bracelets of vary-
ing design on his wrists. His forehead
is scarified with a V-shaped pattern of
ten or eleven lines. As with all of the
Esie seated figures, he sits on a stool
consisting of two circular platforms
connected by a cylinder. It is a type
of stone stool reserved for royalty in
ancient Ife, although there is little
else that suggests an Ife association
with these sculptures.

It is not only social position that the
artist depicts, it is dignity, composure,
age and authority that characterise
the subject of the sculpture. One senses
the once powerful body and is made
aware of the weight of the flesh in
the slight protrusion of the abdomen
and the hips. In spite of areas of
damage, the viewer recognises in
this work the high level of artistic
achievement by Esie carvers. *JP III*

Provenance: 1930s, first brought to
scholarly attention by British colonial
administrators and educators; permanent
loan to the National Museum in Lagos

Bibliography: Daniel, 1937; Clark, 1938,
p. 196; Frobenius, 1968, i, p. 318; Obayemi,
1974, p. 14; Stevens, 1978, pp. 1–87;
Afolayan, 1989, pp. 3–4, 8; Hambolu, 1989;
Onabajo, 1989, pp. 5, 7; Pemberton, in
Drewal, Pemberton and Abiodun, 1989,
pp. 77–89

5.72

Seated male figure

Esie
Nigeria
12th–15th century
soapstone (talc schist)
88 x 30 cm
The National Commission for Museums
and Monuments, Lagos, HT.68

Very few undamaged figures exist
among the thousands of stone carv-
ings found in the 1930s in a forest
grove in Esie, a small Igbomina
Yoruba town 100 km north of Ile Ife.
They appear to have been deliberately
destroyed and thrown together as an
act of desecration. As a consequence,
archaeological evidence of their age
and origin is extremely difficult to
determine. An analysis of oral

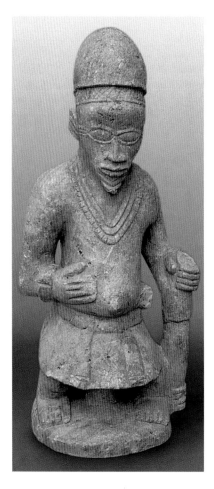

histories (*itan*) in Esie and surround-
ing Igbomina towns and recent
archaeological excavations suggest
dates between the 12th and 15th
centuries.

The carvings indicate a cultural
context of stability and a degree of
social and political organisation in
which a high level of artistry and a
distinctive style developed. Both male
and female figures are depicted – for
the most part persons of rank,
although there are images of slaves.
This seated male figure is depicted
wearing a plain, round cap that does
not completely cover his hair. As on
a few other Esie sculptures, he has
a short, pointed beard that slightly
elongates the face and forms a
counterpoint to the shape of the cap
and is echoed in the rows of beads
draped around the neck, showing
a concern for the play of forms.

As in the ancient art of Ife
(of approximately the same period)
the head forms one third of the total
sculpture. While there is no evidence,
archaeological or stylistic, for suggest-
ing a link between Ife and Esie sculp-
ture, the convention of the prominence
of the head and face in Yoruba figures
is found over the centuries and among
diverse Yoruba subgroups.

The social status and authority of
the figure is indicated by the staff
held in the left hand, bracelets on
each wrist, the skirt or loin-cloth
knotted in the front, the gesture of
the right hand to the stomach, and
the seated position. The Esie stone
sculptures are a celebration of social
rank and roles. Male figures wear
a variety of caps and females have
elaborate hairstyles. Both male and
female figures hold daggers on their
laps or in a raised position against
their right shoulder: a fragment of a
sheath is at the left hip of this figure.
Other sculptures depict men with
quivers of arrows on their backs or
cutlasses held at their side. At the very
least one receives the impression of a
warrior community and an equality of
leadership roles among men and
women. *JP III*

Provenance: 1930s, first brought to
scholarly attention by British colonial
administrators and educators; permanent
loan to the National Museum in Esie,
Nigeria

Bibliography: Stevens, 1978, pp. 1–87;
Pemberton, in Drewal, Pemberton and
Abiodun, 1989, pp. 77–89

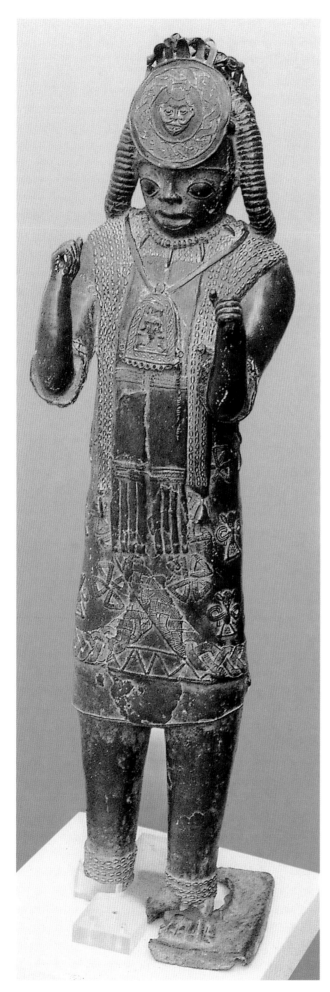

5.73a

Figure of a man

Tada village, Kwara State, Nigeria
early 14th century (?)
tin-bronze
115 x 26 cm
The National Commission for Museums
and Monuments, Lagos, 79.R.3

5.73b

Figure of a bird

Tada village, Kware State, Nigeria
early 14th century (?)
tin-bronze
137 x 24.3 x 82.5 cm
The National Commission for Museums
and Monuments, Lagos, 90.R.17

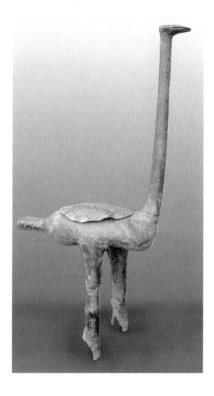

These are two of nine copper-alloy castings once in the Nupe village of Tada on the south bank of the Middle Niger. In 1969, after the theft of one of the two bronze figures at Jebba, an island village in the Niger upstream from Tada, they were removed to the Lagos museum. The other castings at Tada are a seated cast-copper figure in the style of Ife (cf. cat. 5.64), two smaller standing figures, another long-necked bird and an elephant. The Jebba castings were both standing figures, one an archer, the other (which was stolen) a woman. All are said to have been deposited at Tada and Jebba by Tsoede, founding hero of the Nupe kingship.

The standing figure shows a man wearing a richly embroidered or appliquéd tunic, draped with a cloth (?) hung with bells and cowry shells. Around his neck he wears a pectoral ornament of a ram's head and a necklace of leopard's teeth. His headgear features a pair of discs, and a horned human head with snakes coming out of the nostrils, surmounted by a row of birds. The significance of all this is unknown, though each element can be found elsewhere, in the arts of Ife, Owo and Benin.

Although these figures come from the Nupe-speaking region of what is now Nigeria, they also belong to the casting traditions of the Lower Niger region, including Igbo-Ukwu, Ife and Benin. Other scholars have proposed that they come from Old Oyo and Owo and while the figures are evidence of an important casting centre, probably within the Yoruba-speaking area, we have no idea of its location. The fact that the standing figure is of tin-bronze (almost certainly of local rather than trans-Saharan origin) confirms that it dates from before the first contact with Europeans and before coastal trade with Europeans brought in zinc-brass which was otherwise available through trans-Saharan trade. This dating is confirmed by measuring the thermoluminescence of the cores. The technical quality of the casting is not always of the highest and there is evidence that a series of burn-in repairs were made to complete the work. *JWP*

Bibliography: Shaw, 1973, pp. 233–8; Williams, 1974; Willett and Flemming, 1976, pp. 135–46; Eyo and Willett, in Detroit et al. 1980

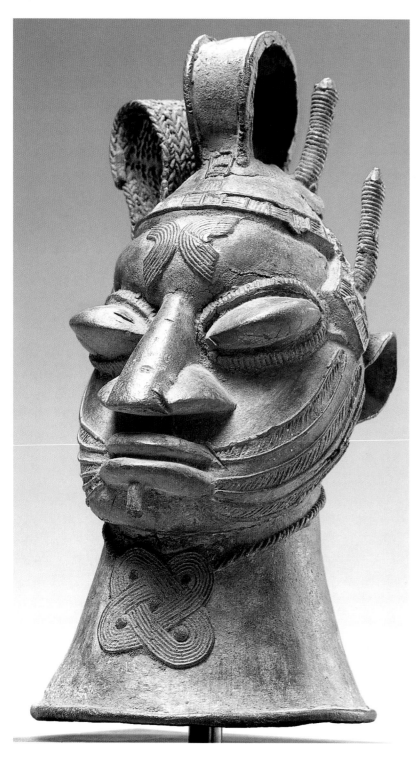

outwards from the corners of the mouth around the sides of the full face to the ears. This pattern occurs in relief faces on an Ijebu bronze stool that served in enthronement rites. The double crescent marks on the forehead appear most frequently in the arts of the Osugbo Society (cat. 5.77), whose members supervise the selection and installation of rulers. These same crescent marks also occur on the bronze stool. The wrapped projections that rise on the left side of the head and the long braided loop that descends on the right may refer to *itagbe*, woven cloths with wrapped tassels often draped on the head or shoulder during ceremonies. These cloths are owned by titled Osugbo elders and other prominent chiefs among the Ijebu-Yoruba. The interlace pendant necklace may symbolise the complexity and eternity of the life cycle of birth, life, afterlife and reincarnation. *HJD*

Bibliography: Thompson, 1970; Thompson, 1971, ch. 6; Fagg, 1981, p. 104; Fagg and Pemberton, 1982, pp. 38–9, pls 9, 39; Drewal, Pemberton and Abiodun, 1989, pp. 120–6.

This exhibition does not seek to be a round-up of canonical masterpieces and is content to ask questions where they arise and present enigmas where they occur (as with cat. 7.16 for example). A group of at least three stone figures that have an origin among the Yoruba and are said to come from a region in the Ife area and to have been found at abandoned shrines, do not seem at first to fit into a known pattern. Since their age is not known they are described by the rather loose term pre-Yoruba: a conjectured date might be in the region of 300 to 400 years ago.

The massive conception and skill of their carving, however, commands our attention. The protruding eyes placed almost at the sides of the head recall other Nigerian works including some variant twin figures (*ibeji*) whose stance they share. Early African stone and terracotta artefacts from the Nomoli of the Kissi (cat. 5.134) to the statuettes from Komaland (cat. 6.32) are all relevant in the attempt to place this (as yet) anomalous work in at least a stylistic territory. *TP*

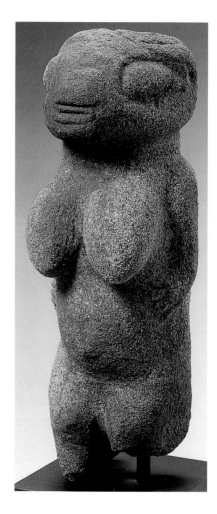

5.74

Face bell (*omo*)

Ijebu-Yoruba
Nigeria
18th or 19th century
bronze
25 cm
W. and U. Horstmann Collection

Brass face bells (*omo*) are owned by the Olisa and other prominent chiefs in Yorubaland, particularly among the Ijebu-Yoruba. Special sounds announce the presence of powerful persons. These chiefs, whose titles

may have come from the Edo kingdom at Benin, participate in enthronement rites. The paramount ruler of the Ijebu-Yoruba, the Awujale, may also have such a bell.

Worn on a sash over the right shoulder so as to hang down at the left hip, the face bell is associated with transitions and the transfer of power, each occupant casting one for his successor. Almost all examples of such face bells have three long striations (with or without textured patterns between them) that curve

5.75

Female figure

(Proto) Yoruba (?)
Nigeria
stone
53 x 16 x 22 cm
W. and U. Horstmann Collection

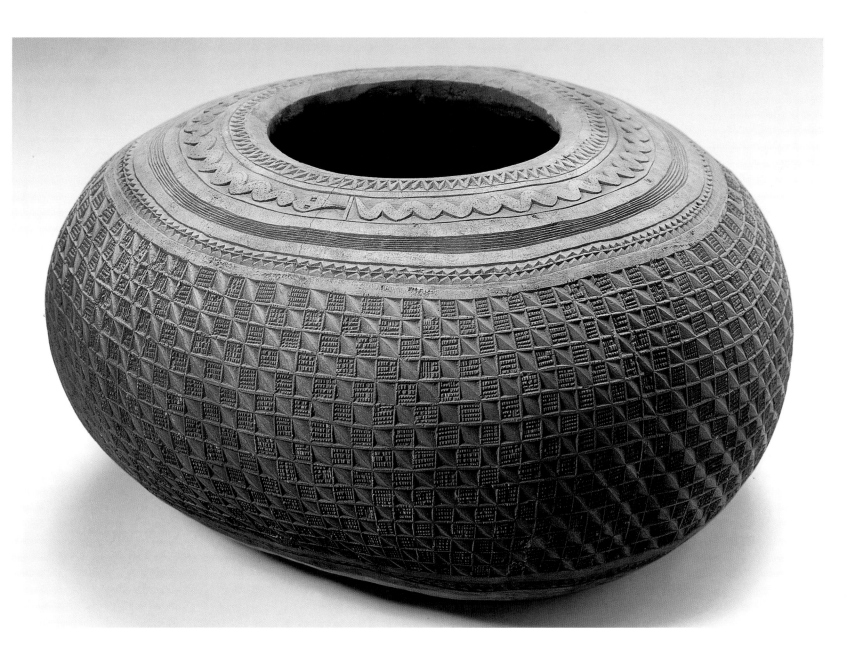

5.76

Gourd vessel

Yoruba (?)
Nigeria
19th century (?)
gourd
h. 35 cm, diam. 61 cm
The Trustees of the British Museum,
London, 1979. AF. 1.446

Calabash gourds of the *Cucurbitaceae* family are prevalent throughout sub-Saharan Africa, occurring in a great diversity of shapes and sizes. Naturally spherical, tubular and bottle-shaped fruits may all be further varied by tying the growing gourd.

The present gourd has a variable thickness that, in places, exceeds 4 cm, and the artist has exploited this for decorative effect. Except around the aperture, where a snake and various zigzag motifs are preserved in the outer integument, the smooth exterior has been completely removed. A chequerboard design of alternating bevelled diamonds and raised squares has been used to cover the entire surface of the vessel. To maintain the formal rigour of the pattern, the artist has had to vary the size of each motif and the depth to which it is cut to accommodate the irregularities of the vessel.

Carving within the depth of a gourd is a common Yoruba technique. Sometimes chalk may be rubbed into the design to accentuate the perception of depth, but there is no sign of this in the present piece.

Gourds vary enormously in the uses to which they are put. Large gourds form a prominent part of the altars of the Yoruba god of thunder, Sango, and it is not impossible that a work of such consummate artistry had such a role. *NB*

Bibliography: Trowell, 1960, pp. 47–51

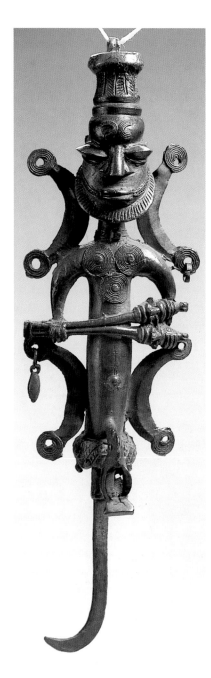

The Ogboni Society (or Osugbo as it is known among the Ijebu-Yoruba) is one of the most important institutions of Yoruba-speaking peoples. Consisting ideally of the eldest and wisest male and female elders in a community, the society decides the most serious judicial matters and metes out punishment for all criminals condemned to death. It also controls the selection and installation as well as the abdications and funerals of rulers, thus serving a wide variety of crucial political, judicial and religious functions.

Ogboni paired castings placed on iron shafts (straight or curved) and joined by a chain at the top are known as *edan*. Consisting of male and female figures, *edan* symbolises the original founding couple of a community, the witnessing presence of the guardians of ancient law (female and male ancestors), the female and male membership of the Ogboni lodge and, by extension, all men and women in the society. The theme of female/male co-operation and union is central to Ogboni ideology and practice. Opposed crescents on foreheads of Ogboni works are an ideogram for the themes of duality, complementarity and doubling.

Edan is cast upon the initiation of Ogboni members and serves a variety of important purposes. It is a public emblem of the omnipotence and omnipresence of the Ogboni Society in all community matters and, being portable, is carried by an Ogboni member as a sign of office, a message and a protective amulet. When worn by Ogboni members, it is draped around the neck and suspended down the chest. Those with curved or looped shafts (like cat. 5.77a) may have been used to carry things or as a ritual poker.

The visual emphasis given to sexual identity in *edan*, as well as the theme of the couple, convey the mystical powers of procreation. The genitals of both male and female *edan* figures are often dramatically displayed, a reference to momentous oaths. According to some Yoruba, the most powerful curse or invocation a woman (or man) can utter is pronounced while naked. Even when *edan* have heads on stems (like those being held by the male in cat. 5.77a), female and male genitals may appear – a visual reminder of the importance of the couple. In initiation rites the unclothed novice is washed by a titled elder in the presence of other members who are themselves naked. Similar procedures continue today, whereby all Ogboni members and guests remove footwear and bare their chests or shoulders before entering the lodge. Such acts connote honesty, openness, humility and reverence for the sacred. They affirm that no secrets will be kept among the membership and, at the same time, that no secrets will be revealed to outsiders.

Posture and gesture in *edan* evoke the solemnity of Ogboni ritual. Ogboni iconography portrays members performing ritual acts as part of their sacred governmental obligations. Large, bifaceted eyes, a distinctive and dramatic feature of Ijebu bronzes (e.g. cat. 5.74), may be the artist's way of suggesting the 'inner eye' or insight (*oju-inu*) of wise Ogboni elders who see and know about everything in the society.

The four arcs that frame the figure of cat. 5.77a may be abstractions of birds in profile, for these often flank

5.77a

Ogboni/Osugbo sceptre

(*edan Osugbo*)

Ijebu-Yoruba
Nigeria
late 19th century
brass, iron, bronze
h. 60 cm
By courtesy of the Board of Trustees of the Science Museum, London, A 10465

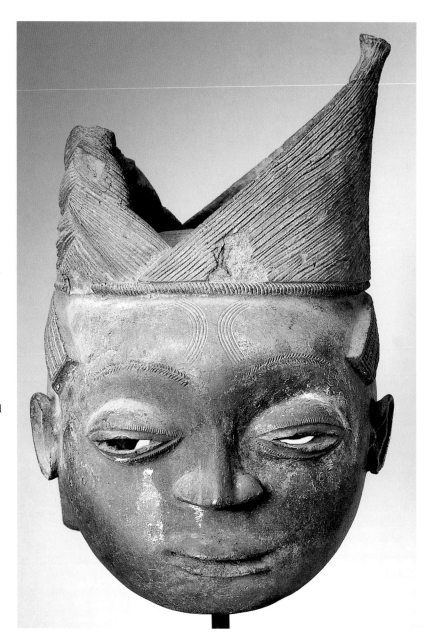

5.77b

Ogboni/Osugbo head

Ijebu-Yoruba
Nigeria
18th or 19th century (?)
terracotta
h. 38 cm
Private Collection, Brussels

figures in Ijebu *edan*. The arcs also echo the crescents on the forehead and the shape of the realistic bird at the base of the penis.

The terracotta head (cat. 5.77b) is possibly a fragment from a full female figure, one of a rare corpus of earthen sculptures used to decorate the inner courtyard of Ogboni Society lodges or *iledi*. An example of a complete figure of a kneeling woman (half of a male/female couple) is now in the Afrika Museum at Berg-en-Dal. The elaborate coiffure frequently appears in other Ogboni artworks and is a widespread and important hairstyle for the Ijebu-Yoruba, among whom it is associated with priests and priestesses of the gods, queens and other high-ranking women. Like the pairing of male and female imagery in *edan*, the mixing of media (iron and brass) and the use of clay in Ogboni art seem to express the central theme of uniting gendered entities – iron, symbolic of maleness, with brass, associated with femaleness, and earth as the abode of both female and male ancestors.
HJD

Bibliography: Morton-Williams, 1960; Ogunba, 1964; Williams, 1964; Atanda, 1973; Williams, 1974; Drewal, 1981, pp. 90–1; Fagg, 1981, p. 104; Witte, 1988; Drewal, 1989a; Drewal, Pemberton and Abiodun, 1989, pp. 136–43

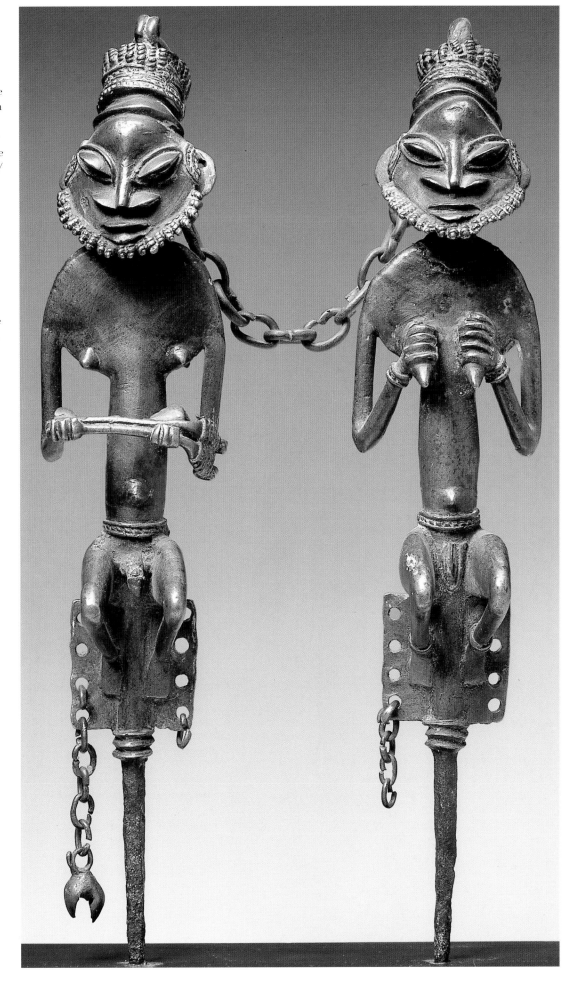

5.78a

Ogboni couple

Yoruba
Nigeria
19th century
bronze
h. 78.5 cm
Private Collection

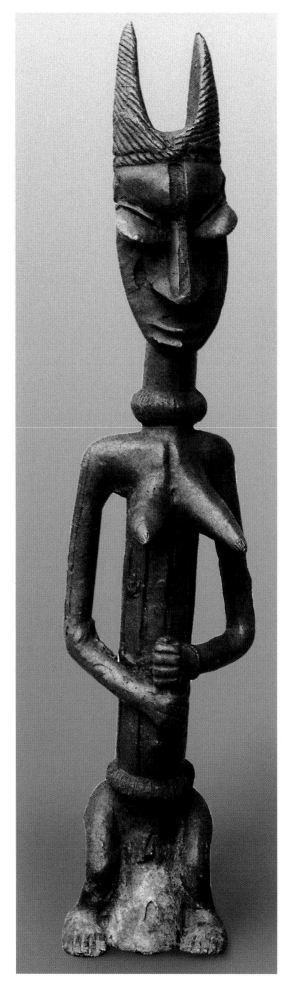

5.78b

Female Ogboni altar figure (*onile*)

Yoruba
Nigeria
18th–19th century
brass
106 x 20 x 16 cm
The National Commission for Museums
and Monuments, Lagos, 65.4.53

The Ogboni Society (also called
Osugbo) wields considerable religious
and political power among the Yoruba
because of its role as the vital link
between a given community and the
earth that sustains it. The Yoruba
personify the earth (*Ile*) as an ambi-
valent mother. For the same earth
goddess who nurtures humanity like
a child also receives the body of the
dead at interment. Without the
goddess's benevolence there will be
no peace and happiness in the world.
All members of the Ogboni regard
themselves as *Omo Iya*, 'the children
of the (same) mother', partly because
of their closeness to the goddess
whom they venerate and partly
because they regulate the social order
on her behalf. In pre-colonial times
the Ogboni functioned as a town
council, law court and electoral
college, punishing antisocial elements
and rewarding outstanding citizens by
recommending them to the king for
deferential titles. The most popular
emblem of the Ogboni is *edan* –
a pair of male and female brass fig-
ures usually joined at the top by an
iron chain (cat. 5.78a). Bigger, free-
standing versions of the *edan* pair,
called *onile* (owner of the House),
occupy special altars inside the
Society's lodge, mediating between
the Ogboni and the goddess. That the
pair represents the ambivalent nature
of the goddess is evident not only in
the perception of the male and female
figures as one object, but also in the
reference to them as '*Iya*' (Mother).
Apart from alluding to the inter-
dependence of the sexes in the
procreative process (among others),
the male figure alludes to the 'hard',
negative aspect of the goddess, and
the female to her 'soft', positive one –
a dualism also evident in the icono-
graphy of other Yoruba deities such
as Esu (the divine messenger) and Oro
(the collective power of the ancestral
dead). This phenomenon is implied
in popular sayings such as '*Tako,
tabo, ejiwapo*' ('Male and female go
together') and '*Tibi, tire, ejiwapo*'
('Good and evil go together'). Some
scholars have questioned the gender
status of the earth because they could
not find any reference to an earth
goddess in the *Odu Ifa*, a body of
sacred myths on Yoruba history,
culture and religion.

This female *onile* was one of a pair
originally housed in the Ogboni lodge
of Owu, a town destroyed during the
Yoruba civil wars of the 19th century.
The pair was removed from the lodge
shortly before the fall of Owu: one was
taken to Ede and the other (cat. 5.78b)
to Apomu, where the Nigerian National
Museum acquired it. This example
symbolises the enigma of the mater-
nal principle in the Yoruba universe.
The vertical thrust of the figure
echoes one of the praise-chants (*oriki*)
of the earth goddess hailing her as
being 'As succulent and erect as the
odundun (medicinal) shrub'; it also
recalls the uprightness and firmness
expected of an Ogboni adherent.
The full breasts and longish neck
with choker evoke maternal support,
beauty and grace. The placing of the
left fist on the right one (with the
thumb concealed) – a ritual salute of
the Ogboni – welcomes members to
the lodge, where the goddess as *onile*
provides an abode for both the living
and the dead. The exposed genitals
signify the procreative power with
which she renews life at the physical
and metaphysical levels. The schema-
tised pose, enlarged head and pro-
nounced facial features allude to her
transcendence: she is the invisible
third party to the deliberations of
the Ogboni, enforcing confidential-
ity, loyalty, equity, justice and self-
discipline. The horned coiffure
identifies her as a strong-willed
goddess who will visit her full wrath
on traitors and on all those engaged
in acts detrimental to the social order.
Hence the popular Yoruba saying '*Eni
da Ile, a ba Ile lo*' ('Whoever betrays
the earth will be overwhelmed by
her'). *BL*

Bibliography: Biobaku, 1952, p. 38; Beier,
1959, p. 2; Morton-Williams, 1960,
pp. 362–74; Williams, 1964, pp. 139–65;
Daramola and Jeje, 1967, pp. 132–3; Ojo,
1973, p. 51; Eyo, 1977, p. 180; Adeoye,
1989, pp. 340–4, 356–8; Drewal, 1989a,
pp. 151–74; Drewal, 1989b, pp. 117–45;
Lawal, 1974, p. 243; Lawal, 1995,
pp. 36–49

5.79
Lintel

carved by Olowe of Ise-Ekiti (*d.* 1938)
Yoruba
Ikere-Ekiti, Nigeria
wood
h. 127 cm
The Trustees of the British Museum,
London, 1925. N/N

African artists are rarely identified by name, yet traditional African art is not anonymous. The artists' names were known to their patrons and towns-people. If their art was highly regarded, they were known beyond the place where they lived. Their names are unknown to us because early collectors failed to ask, 'Who made this?'

The carver of this lintel is Olowe of Ise-Ekiti. He was born, probably around 1873, in Efon-Alaiye, one of the sixteen pre-colonial Ekiti-Yoruba kingdoms now located in the modern state of Ondo, Nigeria. While still a youth, Olowe was sent to the town of Ise to serve as a messenger in the palace of the Arinjale (King). At some point, Olowe demonstrated an apti-tude for carving wood and *oju-ona*, an 'eye for design', and was subsequently apprenticed to a master carver. Eventually, Olowe left his master to establish an atelier of his own.

Olowe served the Arinjale of Ise as a court artist. As his fame grew, he was given large commissions by sev-eral other Yoruba kings and wealthy families within a wide radius of Ise. He enhanced the prestige of their palaces with doors and elaborately carved posts to support the roofs of the verandas surrounding the court-yards as well as containers, drums and other objects.

Olowe carved an ensemble of a pair of doors and a lintel for the palace of the Ogoga at Ikere. In 1924 they were installed at the entrance to the exhibition in the Nigerian Pavil-ion at the British Empire Exhibition at Wembley. Olowe's style so impressed the British Museum that it attempted to buy the carvings from the African king. The Ogoga refused to sell the doors, but agreed to exchange them for a British-made throne. This was done, and the sculptures remained in England. Olowe, who was still alive, carved another set of doors and lintel as replacements.

Olowe's style is unique among Yoruba and other African carvers of

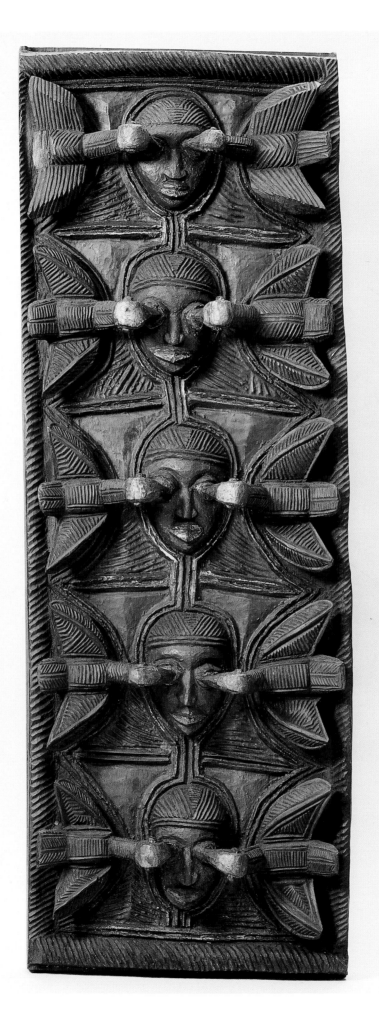

any period. Other sculptors carved figures on doors and lintels in low and even relief. Olowe's figures are not static and frontal, but appear to be active. In addition, Olowe carved with rich textures and vivid colours.

This lintel depicts five faces positioned between pairs of birds pecking at the eyes. This is a scene of human sacrifice. The birds are not just vultures, but sacred messengers of the gods. In Yoruba ritual, sacrifice is a means of communication between humans and the deities. Before the 19th century such acts were com-mitted only on occasions of utmost communal importance, such as festivals honouring the iron god, Ogun, or in rites connected with installing a new king. Human beings were the rarest and most precious type of sacrifice. The depiction of vultures in the feeding posture is a positive image that represents the divine acceptance of a sacrifice. *RAW*

Bibliography: Lawrence, 1924, pp. 12–14; Allison, 1944, pp. 49–50; Allison, 1952, pp. 100–15; Idowu, 1963, pp. 118–20; Fagg, 1969, p. XX; Awolalu, 1979, pp. 138–42; Walker, 1994, pp. 91–106

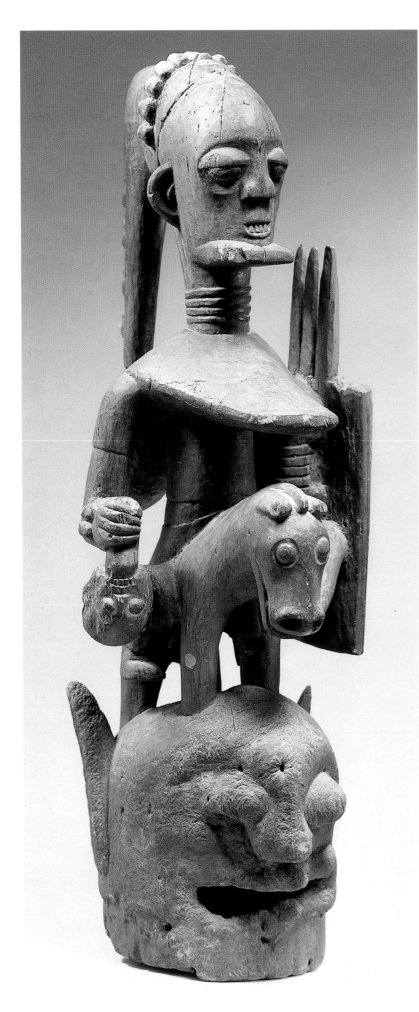

5.80

Helmet mask

Ekiti (Yoruba)
Nigeria
late 19th century (?)
wood
103 x 35 x 42 cm
The Trustees of the British Museum,
London, 1924.12-20.2

The north-eastern kingdoms and communities of the Yoruba speakers constitute a region of considerable institutional diversity in which the familiar 'classic' forms of Yoruba civilisation become increasingly rare as one proceeds east. In mask and in cult local forms often proliferate, and neither forms, nor the names of forms, nor the cults in which those forms are used, have a consistent distribution, even when some continuities persist, such as Ifa divination, the descent of kings – if they have them – from Oduduwa of Ife, and the cult status of iron.

The helmet mask with a superstructure carved from a single block of wood is known as an *epa*-type given the frequency of the generic term *epa*, but also as *elefon*, or *aguru*, depending upon local usage. Both *epa* and *elefon* are sometimes found in the same community as distinct mask forms. Sometimes the generic term for any mask form is *egigun*, sometimes *imale*, and there is a widespread belief that to carve an image or a mask and to sacrifice to it is to create a metaphysical presence.

The cult status of the masks is very varied, and the various usages are not mutually exclusive. Some are objects of display worn by young men to celebrate their transfer to a higher grade; some are used at the post-burial rites of deceased titled men; some masks are sacrificed to because of their inherent energy as *imale*; some masks attract a cult following because of their proven efficacy in healing; and some are displayed in public as part of the rites of an otherwise secret association. Some masks celebrate Ogun, the iron-wielding mythic hero, the focus of whose cult is in the central Ekiti village of Ire. (The feast of Ogun in many communities of cental Ekiti is the major annual celebration, often at the height of the rainy season. New yams are harvested and sacrificed to Ogun prior to general consumption.)

The present mask is carved in a style characteristic of the village of Oye-Ekiti, close to Ire, from which it can be inferred that it would probably have been performed during the feast of Ogun. It came to the museum in 1924, at a time when sculptors were still actively producing such work in this area. The eroded state of the face would be due to successive applications of sacrificial blood and palm wine (the only reason for suggesting it dates from the late 19th century). The figure surmounting the mask is a warrior on horseback with shield and spears in one hand and a severed head in the other; he wears the long cap in which hunters keep their powder dry. This is appropriate given the character of Ogun, although it is in any case one of the standard images carved on masks of this sort irrespective of cult status (others include mothers and children, leopards, dogs and rams). Identification of this mask as Ogun is, in other words, contingent upon its place of origin. The equestrian imagery does not derive from local warfare, but from the cavalry used by the Oyo kingdom and empire (the 'classic' models of Yoruba civilisation, which until the mid-20th century were the only Yoruba group consistently to use the term Yoruba of themselves) that dominated the region from the Middle Niger to the coast from the 17th to the 19th centuries, and by the emirate of Ilorin established in north-central Yoruba in the early 19th century by the Fulani jihad. Cavalry was of little practical use in the rocky terrain of Ekiti, but the images persist, embodying memories of the 19th-century intra-Yoruba wars in which Ekiti was trapped on one side or another in various shifting alliances. In these circumstances, the figure is an apt representation of energy and authority. *JWP*

Bibliography: Carroll, 1967; Ojo, 1978; Picton, 1994[1]; Picton, 1994[2]; Picton, in preparation

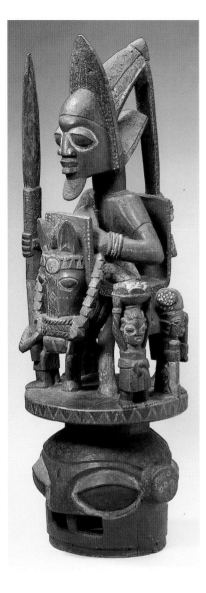

wearing the mask, to the top of a mound sometimes 8 feet high.

Opin is notable in the history of African and Yoruba art as one of the very few locations where it is sometimes possible, within the traditions inherited from the pre-colonial era, to study the corpus of work of known artists, to assess their place within a particular tradition and even to chart the development of an individual artist's work, at least since *c.* 1850 when the area was absorbed into the Ilorin empire. This mask was collected before 1910 and is very possibly the work of Bamgbose of Osi-Ilorin. In his day, Bamgbose was the leader of the Opin sculptors' guild, and his house was a meeting place for sculptors to discuss their work. He was the teacher of the better-known master, Areogun (*c.* 1880–1954), the dominant artist of Opin and northern Ekiti during the first half of the 20th century.

The leather helmet of the warrior on horseback identifies him as local rather than a soldier of Ilorin, who would have worn a turban surmounted by a basketry hat. But this detail makes little difference to the significance of the mask, just as the names sometimes given can include 'Warrior-Don't-Fight' (i.e. us), and 'Warrior-Help-Us-to-Fight' (i.e. them). The generic image of the warrior transcends the detail of whose warrior is fighting whom. *JWP*

Provenance: before 1910, collected by Churchill Bryant in Osi-Ilorin

Bibliography: Carroll, 1967; Ojo, 1978, pp. 455–70; Picton, 1994[1], pp. 46–59, 101–2; Picton, in preparation

5.81

Helmet mask

possibly carved by Bamgbose of Osi-Ilorin
Opin (Yoruba)
Nigeria
late 19th century (?)
wood
117 x 40 x 43 cm
The Trustees of the British Museum, London, 1964.AF.2.1

Opin originally consisted of a group of twelve villages to the north of Ekiti, within a radius of five miles from Osi-Ilorin (so-called because unlike Osi-Ekiti to the south, it had been brought into the Ilorin emirate in the 1850s with all the other Opin communities). In Opin, *aguru* masks such as this were used in the post-burial rites of titled men whose status was based upon personal achievement rather than on lineage. They were carried by the young men of a given age grade who in the course of their performance were expected to leap,

5.82

Presentation box in the shape of a woman kneeling with a cockerel

Yoruba
Nigeria
early 20th century
wood, kaolin
53 x 23 x 37 cm
Robert B. Richardson

The supplicant woman approaching a priest or diviner with an offering is one of the three most common images in the eastern Yoruba sculptural traditions of the Ekiti kingdoms. In this example, the woman wears the hairstyle of the new bride. The body of the cockerel is carved to form a box which itself is used in the presentation of gifts whether to an honoured visitor or to a deity. The back of the

cockerel, with its head and tail, is missing. The sculptor cannot as yet be identified, but he clearly belongs to the same school as Ayantola of Odo-Ehin in the Ijero-Ekiti kingdom, a sculptor who was still working in the 1960s. It is uncertain whether this piece is by Ayantola himself, made earlier in his career when his skills were greater than they were in his later years, or by his father. *JWP*

Bibliography: Carroll, 1967; Ojo, 1978, pp. 455–70; Picton, 1994[1], pp. 1–34; Picton, 1994[2], pp. 46–59, 101–2; Picton, in preparation

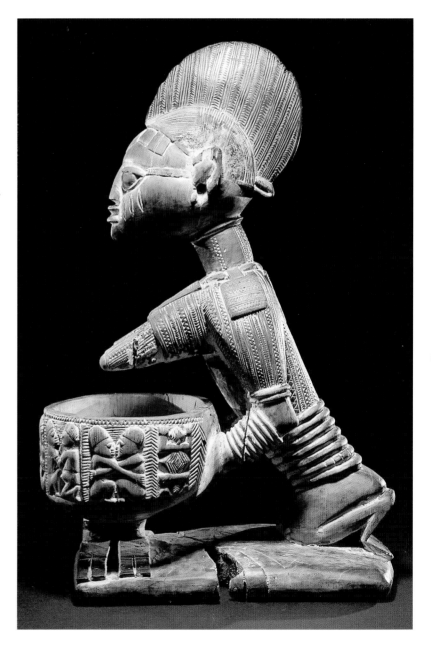

5.83a

Sango shrine figure with musicians

Yoruba
Nigeria
early 20th century
wood
h. 73.5 cm
Ian Auld Collection

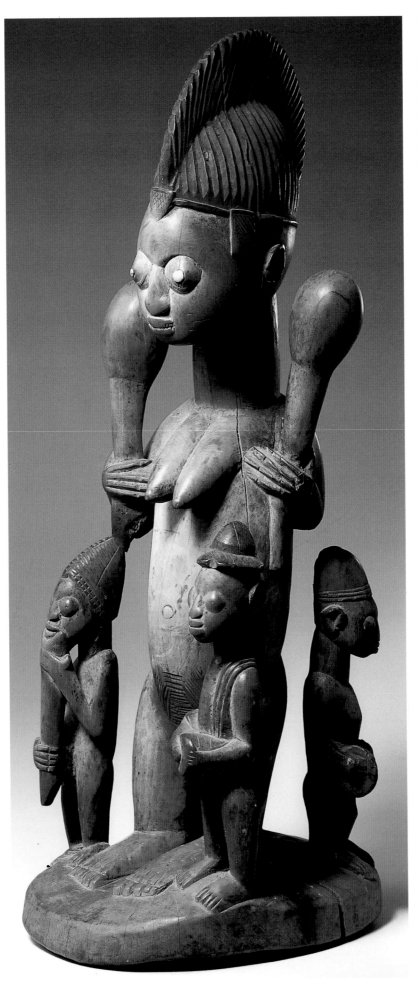

The devotees of Sango, the Yoruba deity (*orisa*) of thunder and lightning, place these carvings (*ere*) on altars dedicated to him. Yoruba oral traditions often identify Sango as one of the early kings (*Alaafin*) of Oyo-Ile. He is described as a strange and unpredictable character: violent, temperamental and vindictive, yet handsome, loving, caring and generous. He was a great warrior and magician who had the power to attract lightning, with which he vanquished his enemies on the battlefield. The circumstances surrounding Sango's death and deification are not clear. Some stories claim that he voluntarily abdicated the throne after a long reign in the 15th or 16th century and disappeared through a hole in the ground as a sign of his transformation into an *orisa*. Others allege that his subjects forced him to abdicate after becoming tired of his political intrigues and military escapades. In the end, he committed suicide. But shortly after, according to one legend, Oyo-Ile experienced a series of unprecedented and devastating thunderstorms that the king's former subjects interpreted as a manifestation of his retributive justice and wrath. As a result, they dedicated shrines not only to pacify him, but also to harness his power for communal benefit. Since his military successes reportedly laid the foundation for the political ascendancy and economic prosperity of Oyo-Ile, Sango worship was a state religion from the 17th to the early 19th centuries, when the kingdom was at the apex of its power.

As the controller of rainfall, Sango represents the dynamic, fecund principle in nature. This explains the emphasis on the female in Sango art and rituals. Initiation into the priesthood symbolically converts a devotee, regardless of gender, into a female medium subject to possession by Sango, thus providing an appropriate receptacle for the virile and fertilising power of the deity. During possession, a devotee becomes Sango incarnate, performing acrobatic dances and magical feats, speaking with the voice of the deity and praying for the well-being of the society.

The standing female figure (cat. 5.83a) represents a priestess, shaking rattle-gourds (*sere*) in praise of Sango, accompanied by musicians. Worn by male and female priests, the high-

crest coiffure (*agogo*) identifies her as a medium (*adosu*) awaiting the descent of Sango. Intended to beautify the carving, the blue dye (made by Reckitt's) on the coiffure and pelvis of the figure as well as the headdresses of the musicians is a modern substitute for indigo blue – a colour highly valued by the Yoruba because of its association with coolness. The composition, with its remarkable craftsmanship, complements the imagery of Sango in his praise-chants (*oriki*) as a lover of art, music and beautiful women. Ulli Beier photographed this particular carving at Ilobu (near Osogbo) in the 1950s during the annual Festival of Images (Odun Ere) in the town when sculptures from different shrines were displayed in public and carried in a dancing procession honouring all the *orisa*. However, in Beier's photograph, the dominant female figure was adorned with head-ties and beaded necklaces, while the musicians had their headgear painted white instead of blue. The change of colour reflects the constant and honorific renovations attending the use of sculpture in Yoruba religion. In style, pose and composition the carving is strikingly similar to a Sango altar figure in Ilobu, also photographed by Beier in the 1950s. The resemblance is so close (except that the drummer here wears a pith helmet instead of a dog-eared cap) that the two pieces would seem to have come from the same workshop, if not from the same hand. Beier identified the carver of the Ilobu piece as Maku of Erin, who died about 1955.

The kneeling figure with a bowl (cat. 5.83b) shares many stylistic elements with carvings from the Ilobu-Erin-Osogbo triangle. The double-axe motif on the coiffure is a metaphor for the thunderbolt (in the form of a polished stone axe) that, according to popular belief, Sango hurls down from the sky during thunderstorms. It also signifies the male–female interaction in Sango symbolism, recalling the stage during initiation ceremonies when a novitiate has a polished stone axe tied to his/her head to symbolise the union of the human and superhuman. The kneeling pose communicates respect, worship and supplication. The bowl carried by the figure is a 'give-and-take' symbol, obliging Sango to reciprocate the sacrifices

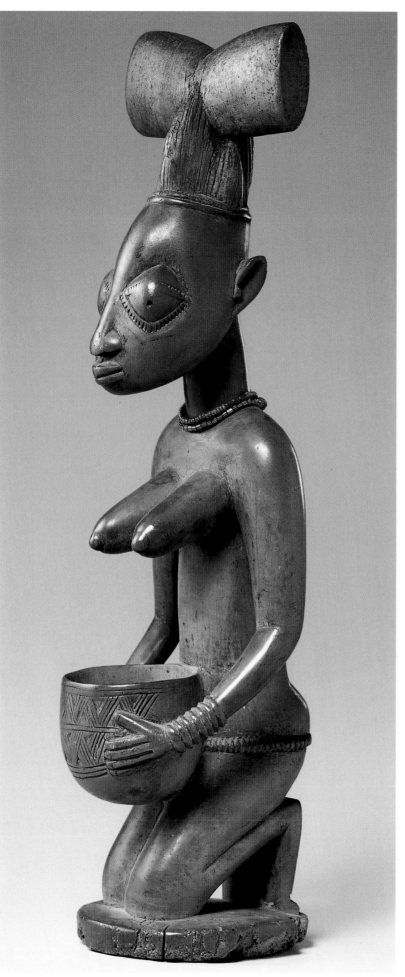

offered to him by showering the devotee with all the desirable things of life.

The stylised double-axe staff held by the kneeling female with a child on the back (cat. 5.83c) identifies her as a devotee of Sango. The child on the back signifies the protection and nurture expected from the deity. In some cases women who have had children after offering sacrifices place such sculptures in Sango shrines both as an expression of thanks and to implore the deity to protect the supplicant and her child. Because it is stylistically similar to the carvings of Abogunde of Ede, John Pemberton has suggested that this piece might have been carved by the same master. *BL*

Bibliography: Beier, 1954, pp. 14–20; Beier, 1957, pl. 20; Beier, 1960, pls 3, 7; Lawal, 1971; Pemberton, 1982, pl. 53; Pemberton, 1989, pl. 161

5.83b

Sango shrine figure with bowl

Yoruba
Nigeria
early 20th century
wood
h. 52 cm
Ian Auld Collection

Sango shrine figure with child

Yoruba
Nigeria
late 19th century
wood
h. 56 cm
Ian Auld Collection

5.84

Shrine figure with child

Yoruba
Nigeria
late 19th century
wood
h. 60 cm
Ian Auld Collection

Although the original context of this shrine figure is uncertain, the high-rise coiffure of the female is characteristic of carvings found in shrines dedicated to Oya, Sango's favourite wife and the goddess of tornado and the River Niger. Indeed, the figure is so close, stylistically and iconographically, to two carvings from an Oya shrine in Ilobu (photographed by Ulli Beier in the 1950s) that it might have been carved in Ilobu by the same artist. In popular imagination Oya is the gale accompanying the thunderstorm, felling trees, demolishing houses and catapulting roofs from one end of the town to another, heralding the thunderous majesty of Sango. Because of the collaboration between the pair, Oya's sacred symbol (a pair of buffalo horns) can be found on many shrines, while Sango's thunderbolts or carved double-axes adorn Oya's shrines. Like her husband, Oya is temperamental, and hence must be wooed with the same degree of emotional intensity. Mother and child figures on Oya's shrines have virtually the same significance as they do on Sango's.
BL

Bibliography: Beier, 1959, pl. 26; Pemberton, 1982, pl. 34

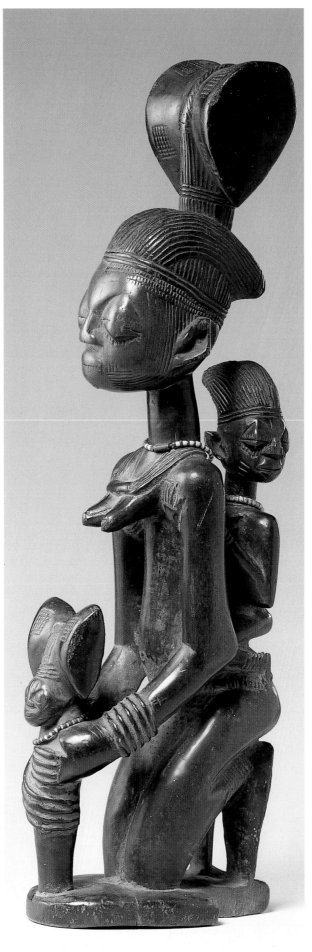

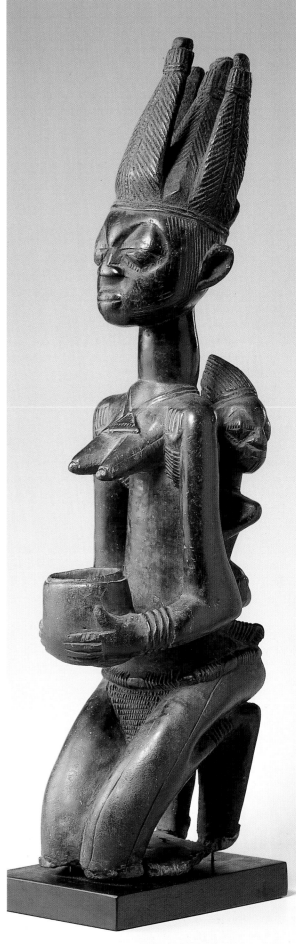

This extraordinary Yoruba display piece is said to have been commissioned by the Ogogo, the Oba (ruler) of Ikere, and given by him to a British envoy. As an expression of royal authority, beaded artwork was an appropriate gift from an Oba to the envoy of another kingdom.

The prominent female figure with a child on her back holds an offering bowl surmounted by a small bird. Four female servants surround her, their elaborate cockscomb hairstyles echoing that of the larger figure. Three hold bundles, and one kneels in front with the bowl resting on her head. The body of the central figure surmounts a conical form resembling an Oba's crown. Four male figures holding guns surround the base.

Among the Yoruba beads were the privilege of rulers and others who held positions of authority, such as Ifa divination priests. The conical beaded crown with a veil of beads (adenla) is the principal symbol of royal authority. On every crown a stylised human face appears at the front and sometimes on four sides or in a pattern of sixteen faces covering the entire crown. When a Yoruba ruler wears the crown, his head (ori ode) is covered, his face hidden by the veil of beads. His inner head, or personal destiny (ori inu), is inextricably related to the sacred authority (ase) of the crown and of all who have worn it. The peak usually features a bird, an image associated with the power of women, often referred to as 'our mothers', that is, the secret, hidden procreative power of women.

The display piece is an expression of the interrelationship of male and female powers underlying royal authority. The power of men is overt; they carry guns. The power of women is covert; women give birth, which is to say sacrifice, which is loss and gain. Without the power of 'the mothers', kings could not rule. In this example prominence is given to the woman. Her essential nature (iwa) and physical beauty (ewa) are conveyed through the child that she carries on her back, her elaborate hairstyle and the fullness of her breasts. It is, however, through the artistry of the beadwork, the rich and almost indiscriminate use of colour and pattern, that the sculpture conveys its sense of energy. From the bottom of the group of figures, the colours change from darker shades of blue and green, accented with touches of white, gold and silver, through brighter shades of blue, red, yellow and green to a more extensive use of gold and silver. The indigo blue in the crown of the woman's coiffure echoes the darker colours in the base of the work. In the hierarchical structure of the sculpture and controlled use of colour and patterns the artist shows what the Yoruba would call oju-ona ('eye for design') as well as oju-ina ('insight'), his understanding of his subject. *JP III*

Provenance: 1924, bought from Ogogo of Ikere-Ekiti by the British Empire Exhibition

Bibliography: Fagg, 1980; Cole, 1989, pp. 50–1; Drewal et al., 1989, pp. 166–9; Abiodun et al., 1991, pp. 20, 25

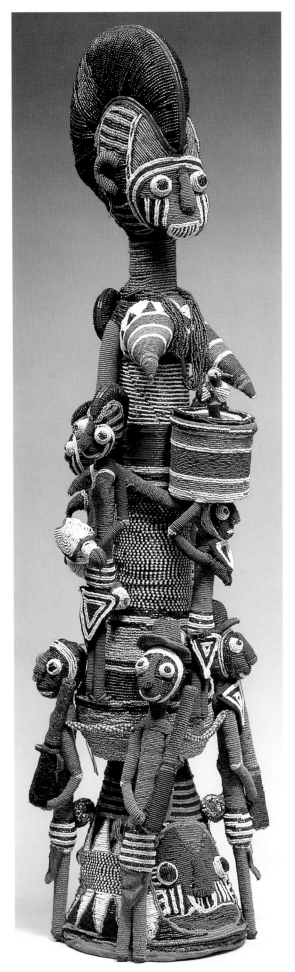

5.85

Display piece

Yoruba
Ekiti, Nigeria
early 20th century
cloth, basketry, beads, fibre
106 x 26 x 28 cm
The Trustees of the British Museum,
London, 1924.136

5.86

Headddress (*ere Gelede*)

Anago-Yoruba
Republic of Benin
late 19th/early 20th century
wood, traces of pigment
35 x 18.5 x 21 cm
Private Collection, Brussels

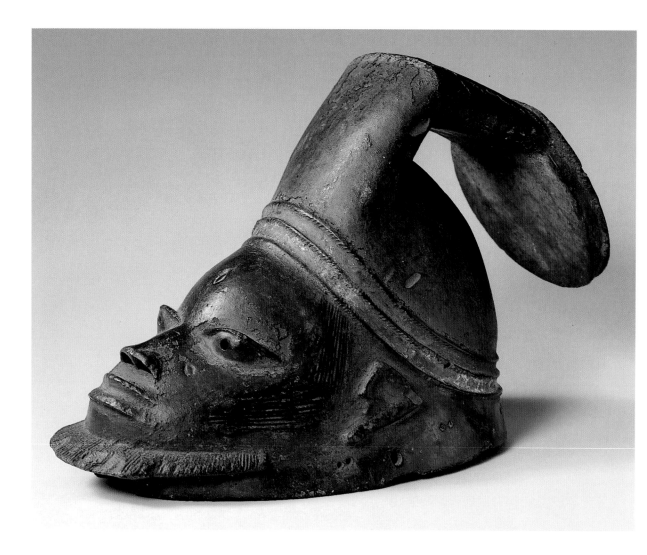

This Gelede society headdress, from the Anago-Yoruba who straddle the present border between Nigeria and the Republic of Benin, comes from the hand of an unnamed master who perhaps worked in the vicinity of Ifonyin. A mark of his distinctive style is the angularity of the ears. The mask depicts a northern (probably Oyo) Yoruba Muslim with boldly incised marks of ethnicity, his beard, and stylishly folded cloth cap. The artist has skilfully captured the fluid qualities of cloth. In a wonderful way he has played with, and reversed, a Yoruba saying about a person who dresses improperly as 'one who wears cloth like wood' (*o nro aso l'igi*). Here the master sculptor has used wood convincingly to evoke cloth.

Gelede pays homage to the spiritual powers of women, especially elderly ones, known affectionately as 'our mothers', *awon iya wa*. The powers possessed by such women, comparable with those of gods (*orisa*), spirits (*oro*) or ancestors (*osi*), may be used for the benefit or the destruction of society.

When manifesting their destructive side, such women are called *aje*. If angered, they can bring down individuals and communities. Gelede masking performances entertain and enlighten the community and 'our mothers', pleasing, placating and thus encouraging them to use their extraordinary powers for the well-being of society. Hence the performances are a sacrifice, an appeal to forces in the world using the aesthetic power of sculpture, costume, song and dance. They offer explicit commentary on social and spiritual matters, helping to shape society in constructive ways.

The themes in Gelede imagery may be grouped broadly into three categories: role recognition; satire; and concerns about the workings of various cosmic forces. These categories are often not mutually exclusive. In the first, individuals and/or groups are praised and honoured for their contributions to society. The second does just the opposite – it ridicules and damns anti-social persons or

groups. The third, by both explicit depictions or metaphoric allusions, treats cosmic forces affecting the community.

This mask focuses on the presence and impact of Muslims in Yoruba culture. It may have honoured their contributions as traders and leaders or satirised their attempts to eradicate indigenous religious beliefs and practices (such as Gelede itself). In the absence of specific details of this mask's 'life history', the precise intentions of its maker and users must remain open to speculation. *HJD*

Bibliography: Thompson, 1971, ch. 14; Drewal, 1981, pp. 114–16; Fagg and Pemberton, 1982, pls 2, 5, 29, 49; Drewal and Drewal, 1983; Drewal, Pemberton and Abiodun, 1989, ch. 8, fig. 251; Abiodun, Drewal and Pemberton, 1991, pp. 29–33

5.87

Staff

Yoruba
Nigeria
20th century (?)
wrought iron
73.5 x 33 x 19 cm
Ian Auld Collection

The best-known Yoruba wrought ironwork forms are those of Osanyin and Ifa, the gods of medicine and divination respectively. For Osanyin, the typical form is a substantial iron spike surmounted by a bird, with sixteen birds radiating out from the centre. The number sixteen refers to the Ifa divination system in which the diviner seeks to identify which of 256 (= 16 x 16) chapters in the memorised corpus of divinatory texts is appropriate to a supplicant's problems. The grouping of texts into 256 chapters also provides for the classification of medicinal plants and magical substances according to the particular character of each chapter. For Ifa, the typical form is a staff of the kind carried by a diviner in procession, surmounted by one or two birds. In both cases the birds refer to that metaphysical domain in which the resolution and healing of affliction occurs. Some wrought works take the form of the Osanyin spike, but the central bird is surrounded by images of tools used by a smith rather than by miniature birds. It is uncertain if this is for some other cult, or determined by some unusual conjunction of Osanyin and Ogun. The present example is puzzling in that the human figure bears no resemblance to the more usual works in this medium, but is rather closer to the cult ironwork of Danhome. Moreover, the presence of the miniature bow and arrow suggests a hunting deity, Oshoosi, whose cult is found especially in the south-west Yoruba region. *JWP*

Bibliography: Williams, 1974; Drewal, Pemberton and Abiodun, 1989

5.88

Divination bowl (*agere ifa*)

Yoruba
Nigeria
wood
28.5 x 21.5 cm
Private Collection

This superb carved and patinated Yoruba bowl, *agere ifa*, is supported by a horseman and flanked by soldiers, giving an impression of great lightness and strength. The size of retainers, horse and central figure are carefully balanced. Details of dress and equipment are rendered with great attention in a manner reminiscent of Abeokuta style. The mouth of the vessel is incised with a star-shaped pattern that focuses attention on the central source of power. It is used in the cult of Ifa divination as a fitting receptacle for the sixteen palm nuts and other equipment used by the practitioner and stored on an altar. *NB*

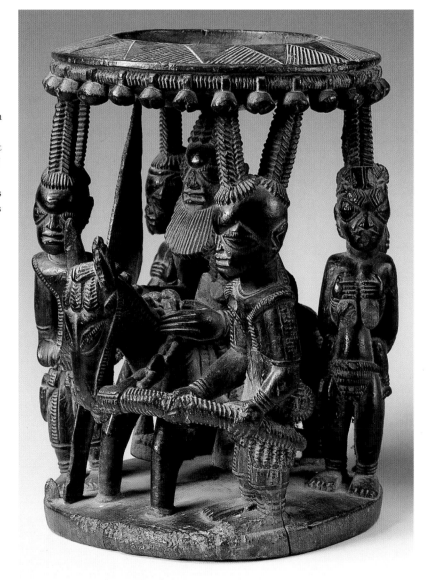

5.89

Ring

Yoruba
Nigeria
copper alloy
diam. 19 cm
National Museum of African Art,
Smithsonian Institution,
Washington, 89.17.1

This is one of a group of rings of a type that came on the market in the mid-1970s, reportedly having been found together in an illicit excavation in Ife. Their condition certainly suggests that they had been buried in the ground for some time. This piece shows a Yoruba ruler, intended to be seen as standing, although represented in high relief lying on the surface of the ring. The swelling of the chest suggests that this may be a queen rather than a king. A small crown is worn in the form of a truncated cone with decorative elements overhanging the ears on each side. This is not the type of crown usually represented in Ife art, which has a ring of large globular beads at the inner edge, and it lacks the pair of badges, shaped like a bow-tie, generally worn by royal figures in Ife. The crossed baldrics of beads are uncommon, though not unknown, in Ife. On the forehead are the addorsed crescents that indicate, in the Ijebu area of Yorubaland, member-

ship of the Oshugbo Society (known elsewhere as the Ogboni Society), a mark that is worn by both men and women. The right hand holds a short staff with a discoidal head.

At the feet of the principal figure lies a gagged human head, with the headless body of the victim lying face down, arms tied behind his back at the elbows. Long lines of scarification run up the spine and down each arm. Another gagged head lies at the victim's feet. A vulture pecks at the neck of a second victim, and a third head and victim bring us back to the main figure, beside whom, on the outer side of the ring, lie a tortoise and a pair of ceremonial staffs of the Oshugbo/Ogboni Society. Sacrificial victims used to be gagged to prevent them cursing their executioner, for such a curse would prove fatal. These objects might have been made to record the installation of Yoruba kings and been sent to Ife to demonstrate their allegiance. If so they would appear to be later than the other copper-alloy castings from Ife, since none of them shows the crown that is typical of Ife works of the Classical period. This one appears to have been cast in Ijebu. *FW*

Bibliography: Vogel, 1983

5.90

Torque

Yoruba
Nigeria
17th–18th century (?)
bronze
diam. 40 cm
Private Collection

Several of these elegant torques have emerged in recent years. In terms of massive casting they are feats in themselves and their working also commands admiration. Their ideal form is evidently as near a perfect circle as possible with the two pointed finials meeting with, so to speak, a kiss. Many fail or join with limited success: this particular example with its slender points achieves the intuited goal on both counts.

An initial analysis of the brass alloy suggests a date around the 18th century (though this is based only on two samples). It is possible that the function of such torques caused them to be made over a long period.

By the time of Ibn Battuta's famous tour (1354) stone moulds existed for making ingots and many elaborately twisted ingots are extant. This torque however is cast in its curved form rather than bent. The trade manilla

with its currency associations is evidently the root reference for such a piece and there can be no doubt that only the wealthy could afford an object of this weight (some are over 4 kilos); yet it seems to have had other functions than that of a financial indicator, being worn by women in a ritual dance involving cutlasses. This seems unlikely when one picks up the torque but it can easily be demonstrated that it sits well around the neck and could be worn in dance rituals even by a young girl.

Variants of the heavy cast torque are seen in ones or twos, but this form appears to have endured since many have been found buried in caches. Too much attention has perhaps been paid to the figurative castings of the Yoruba at the expense of their rich range of 'abstract' bronzes and of virtuoso brass castings such as this perfectly conceived and executed work. *TP*

Bibliography: Williams, 1974

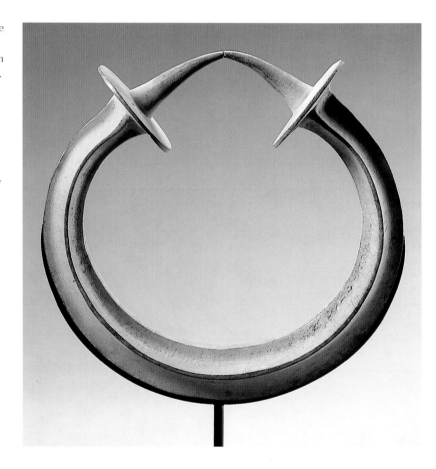

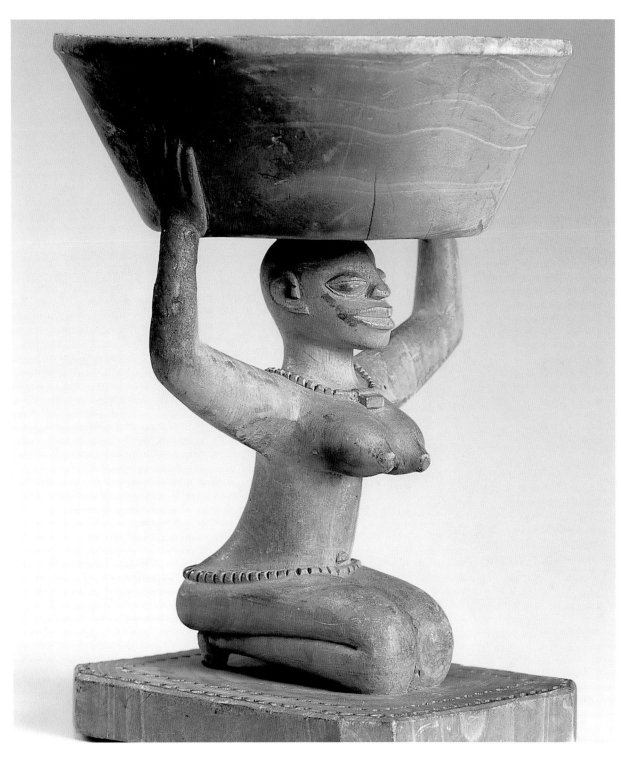

or proudly exhibiting brand new garments, depending on who is to be imitated. The primary function of a *bocio* figure is to dispel or trap evil that might mistake a sculpture for a real person's presence. The direction in which the figure looks is the one from which evil might come. The *bocio* delineates the frontier between the tamed forces of civilisation dwelling in the boundaries of a human settlement and the unbridled forces of the wilderness not so far away.

Although most *bocio* figures are found in Fon country and can be considered as cultural and ethnic markers, they are also carved by Yoruba or Yoruba-trained artists. This is not surprising since Yoruba influence is found throughout Fon art. The various wars between Fon and Yoruba helped such influences to take root through the arrival and maintenance of Yoruba artists and diviners in the Fon Kingdom of Abomey, where they played a significant role at the royal court.

Some of the carvings display this influence through themes such as caryatid bowl figures (cat. 5.91a) traditionally designed to contain offerings to Orunmila, the god who animates the Ifa divination system, to whom all human beings must submit regardless of beauty or fortune. Ifa is a geomancy that originated in Ife in Nigeria. Both Yoruba and Fon consider this city as their religious capital.

Bocio figures are relatively little known, and most of the time it is difficult to relate such figures to history. However, one of those exhibited here (cat. 5.91d) was brought back as war booty in 1893. It was found in the Royal Palace of Abomey together with two other gigantic figures. All three were said to be royal portraits, this one being of Ghezo (1818–58). Its red painted body covered with sharp iron ties and smeared with sacrificial remains suggests, however, that it more probably represents Gu, the god of iron, who assures success in battle. This linkage to war is also suggested by the lost cutlass it formerly held in its raised arm and by the protective arm and waist belts.

Bocio are also a frequent embodiment of extraordinary beings called *aziza*; half-way between man and beast, they alone may be endowed

5.91a

Caryatid figure with offering

Fon
Republic of Benin
wood
h. 18 cm
The Trustees of the British Museum, London, 1886. 7.17.5

South Benin woodcarving seems to be mainly concerned with human figure representation in various heights and forms. Those carvings are all known as *bocio*, a term difficult to translate, even if most people agree that it is an association of *bo* (charm) and *cio* (corpse). They are also named *atin vle gbeto* (wood resembling a human being). A *bocio* is considered to link the visible to the invisible: the end of the generally pole-shaped figure is stuck into the ground so as to emerge from the earth upon which

man (*gbeto*, i.e. master of the cosmos) has entire authority. The goal of a *bocio* is merely to capture the very essence (*yè*) of whatever it represents. It has no pretension to verisimilitude and should not be looked at as portraiture chasing a likeness.

The *bocio* is ubiquitous in Fon culture. It lies in front or at the rear of houses, next to shrines, in the middle of courtyards and in any other place where human beings can be present. One might also find it in the remote bush, clad in rags and tatters

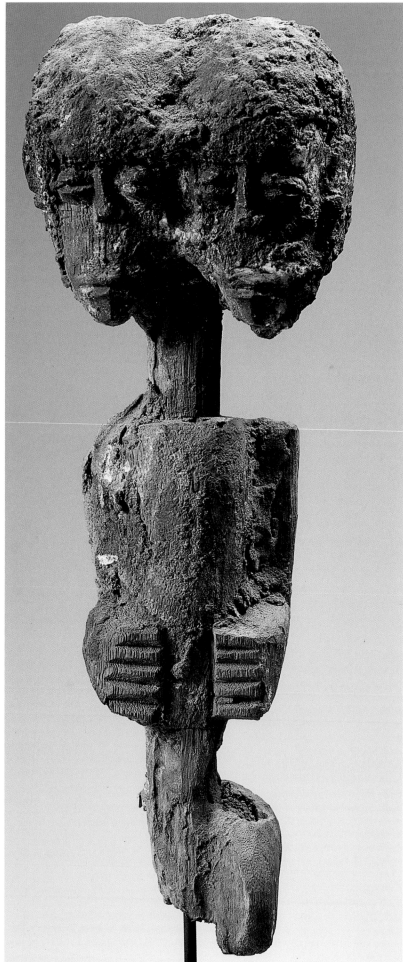

with double or triple faces on a single trunk. They are usually met by hunters who learn from them secrets of medical herbs, for instance. They are said to be dwarfs, hence the need to portray them as short and imposing.

Bocio can be just a minimal transformation of a log, and all the accidents linked to the growing of a tree can be animated by the carver, for whom nature itself affords whatever is necessary to representation. Permanent exposure to the elements continues the carving process, thus contributing to the appearance of being half-way between real and unreal. *CJA*

Provenance: cat. 5.91a: 1886, given to the museum by Mrs A. Turnbull; cat. 5.91d: Royal Palace of Abomey; 1893, taken to France as booty by Captain Founsagrives

Bibliography: Merlo, 1966; Adande, 1994; Blier, 1995

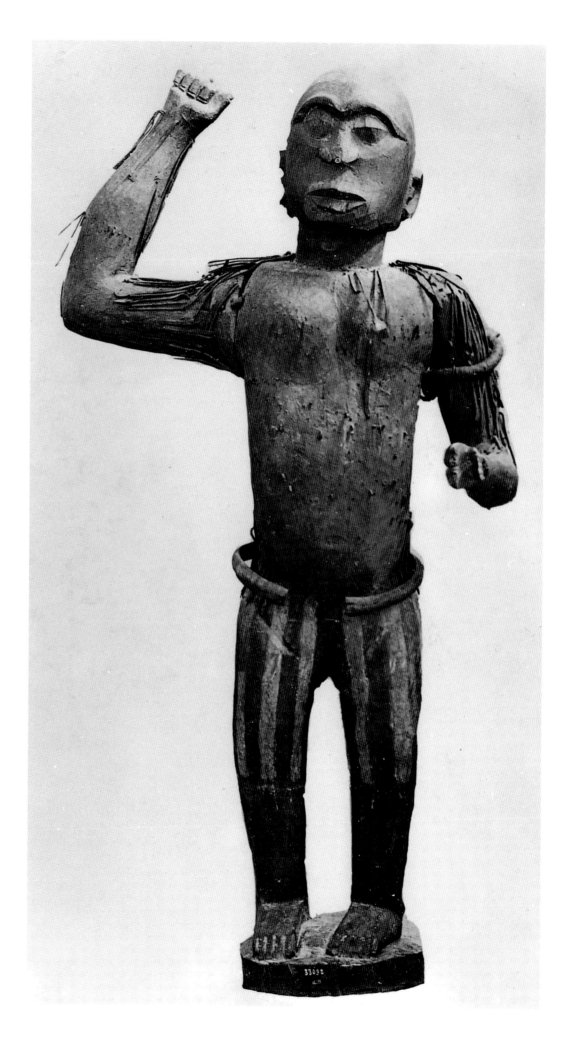

5.91b

Bocio

Fon
Republic of Benin
wood
h. 132 cm
Private Collection, Paris

5.91c

Bocio

Fon
Republic of Benin
wood
h. 44 cm
Private Collection, Paris

5.91d

Bocio

Fon
Republic of Benin
19th century
wood, iron
h. 168 cm
Laboratoire d'Ethnologie,
Musée de l'Homme, Paris

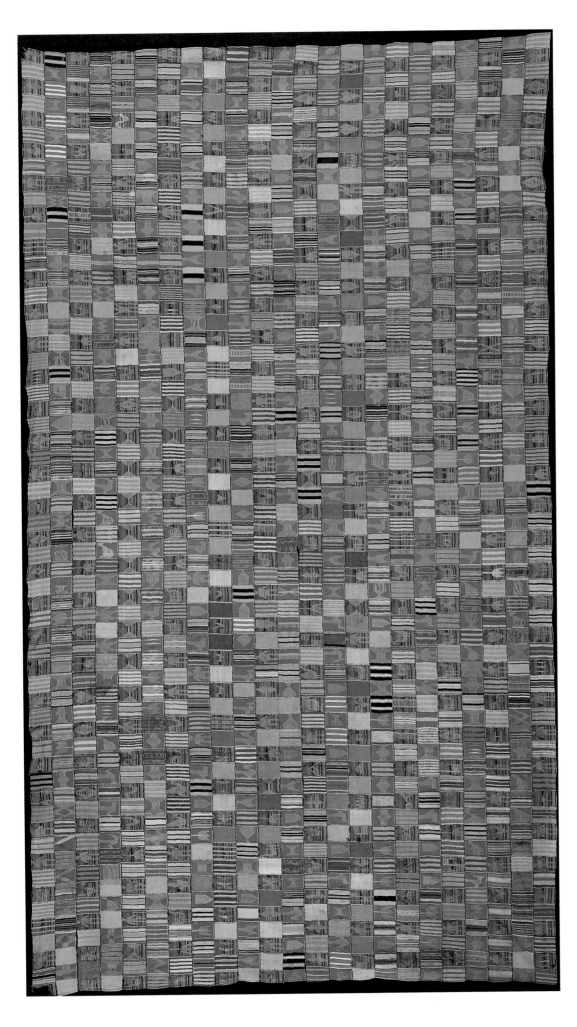

5.92

Cotton textile

Ewe
Ghana
early 20th century (?)
cotton
370 x 212 cm
Peter Adler Collection

Ewe weavers use the same type of
loom as Asante weavers, with two
pairs of heddles, making it possible
to alternate warp-faced and weft-faced
patterning within the 4-inch-wide
format; as with Asante textiles, the
weaving is planned so that when the
woven strip is cut and sewn together
edge to edge a regular design emerges.
In this cloth (for which the generic
term is *odanudo*, literally 'skilled
cloth'), almost certainly woven at
Kpetoe, one of a number of Ewe
weaving centres (each with its range
of styles), the warp-faced and weft-
faced areas are more or less equally
spaced, permitting the regular alter-
nation of blocks of colour; in designs
such as this one can grasp the logic
of the narrow-strip format. The juxta-
position of colour and design achieved
here is impossible to replicate on a
broader loom without evolving a
more complex double-warp structure.
The one point at which the differing
blocks are aligned rather than alter-
nated suggests that a strip is missing
at the centre of this cloth.

Comparison with the Asante
adwinasa textile (cat. 5.93) illustrates
the characteristic differences of the
two traditions. Ewe weavers employ
figurative motifs in the float-weave
embellishments and they habitually
ply cotton yarn of two colours to
weave the weft-faced areas; Asante
weavers do neither of these things.
Ewe weavers also make greater use
of imported machine-spun cotton, in
a wider range of ready-dyed colours
than Asante weavers, although they
also make use of silk yarn (and its
latter-day substitutes: rayon was in
use in Asante by the turn of the 20th
century). They often imitated Asante
designs in order to make the most of
the demand for '*kente*' (a word of
uncertain derivation) among the élite
in Ghana after its independence when
President Nkrumah had popularised
this cloth as a form of national dress.
There are other differences: unlike
Asante, the commissioning of highly
patterned cloth was not limited to
members of an Ewe chiefly élite.

In any case, Ewe weavers worked more for the market than on commission, and employed a wider variety of styles associated with different weaving centres but also with patterns intended to supply outside demand, such as the 'Popo' cloth woven for sale in the Niger Delta, or the 'Kongo' cloths intended for even further afield.
JWP

Bibliography: Menzel, 1972; Lamb, 1975; Picton and Mack, 1989; 2nd edn, 1992

5.93

Silk textile (*adwinasa*)

Asante
Ghana
19th century (?)
silk
200 x 110 cm
Private Collection, London

The Asante confederacy was a group of Akan kingdoms acknowledging the authority of Kumasi that came into being in the late 17th century with the mythic conjuring of the Golden Stool down from the sky on a Friday by Okomfo Anokye for Osei Tutu, the first Asantehene. Asante people dominated the trade networks linking savanna and coast in this part of west Africa, and throughout the 18th and 19th centuries their prestige, influence, wealth and authority steadily increased. This, together with the restriction on the use of silk to chiefly hierarchies and their courts, seems to have prompted the weavers to make formal experiments within the limits of their technical apparatus. Textiles known as *adwinasa* represent the high point of achievement among the weavers of Bonwire, which was (and still is) the centre of all Asante silk weaving.

In the past much Asante cloth was woven of cotton locally hand-spun to a fine quality unequalled elsewhere, and dyed in indigo to create a seemingly endless variety of striped patterns. In the early 19th century Asante weavers were first reported to be unravelling European silk cloths in order to

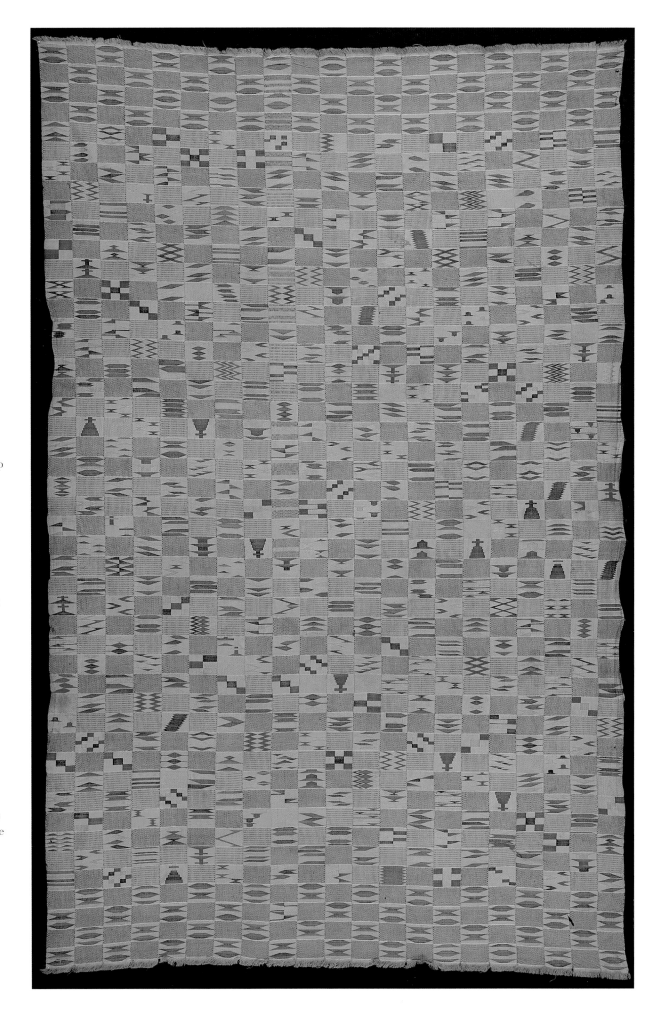

use the yarn in their own textiles; the use of silk, and the alternation of warp-faced and weft-faced plain weave within a single length of cloth (made possible by means of the addition to the loom of a second pair of heddles), are among the more characteristic features of Asante weaving. At first, silk may have been used sparingly in the weft-faced and float-weave patterning, but in due course it became normal to weave the entire cloth in silk. Yellow silk replicates the Asante court taste for gold ornament and the use of gold dust and nuggets as currency (otherwise rare in west Africa), though other colours are used. Silk textiles were woven only on commission from members of the royal and chiefly élite and were never sold in the marketplace (unless a piece was rejected: weaving in lengthy but narrow strips, which are then cut and sewn together edge to edge to form the completed textile, is generally characteristic of west Africa).

In the case of *adwinasa*, a term that means 'fullness of ornament' (*adwini*), the weft-faced banding is reduced to the minimum required to provide a formal structure within which the entire face of the cloth can be embellished with float-weave patterns. Each element in the design varies in scale, configuration and colour to ensure, in the finest *adwinasa* of the late 19th century, that no two pieces are ever the same. The motifs, whose significance varies, include items of weaving apparatus, chiefly regalia, and symbolic representations of proverbs and historical references. In this case the emphasis is on visual pleasure in formal elaboration within the context of chiefly authority. *JWP*

Bibliography: Menzel, 1972; Lamb, 1975; Picton and Mack, 1989; 2nd edn, 1992

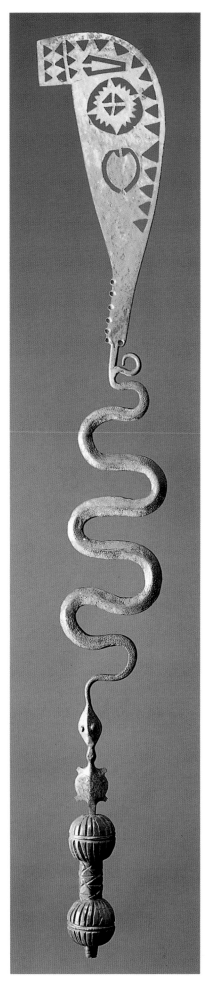

5.94

Ceremonial sword

Asante
Ghana
19th century
metal
150 x 26 cm
The Trustees of the British Museum, London, 1896.5-19.4

This Asante iron ritual sword, *afanatene*, was primarily an item of display. It would presumably once have had a wooden handle, possibly representational, covered in gold leaf. From this rises a tortoise that becomes the head of a snake whose sinuous body supports the blade itself. Such blades commonly show openwork representations of proverbial animals and, in the present case, geometric motifs.

Swords of many different kinds occurred within the Asante empire, conferring status on their possessors but also acting as a means of expressing centralised authority. The Asantehene himself, when seated in state, would be flanked by a three-pronged version of such a weapon. *NB*

Bibliography: McLeod, 1981, p. 91

5.95a

Kuduo

Asante/Akan
Ghana
19th century
copper alloy
h. 12 cm; diam. 18 cm
Private Collection

5.95b

Kuduo

Asante/Akan
Ghana
18th or 19th century(?)
copper alloy
h. 18.5 cm; diam. 15 cm
Private Collection

These two circular vessels with figuratively elaborated lids show the extent to which Asante and other Akan peoples developed remarkably diverse *kuduo* containers cast of copper alloys. Both vessels rest upon separately cast openwork lattice rings, distinguished by the fineness of their execution, which have been carefully fused to the *kuduo* themselves. On the lid of the first container is a triad of three-dimensional cast figures: a seated, bearded man flanked by two much smaller figures, representing musicians who are also seated and playing side-blown trumpets. Leg irons and a farmer's hoe complete this enigmatic composition, suggestive of the strong sense of social and political hierarchy found within Asante and other Akan cultures. The lid of cat. 5.95a is dominated by a bold low-relief rendering of a crocodile, its body splayed across the lid's diameter; the handle is worked in exquisite detail, echoing the design along the edge of the lid and at various points on the body of the vessel itself.

Kuduo were used in many ways by the Asante and Akan. They held gold dust and other valuables, but could also be found in important political and ritual contexts. Some *kuduo* were buried with their owners, while others were kept in the palace shrine rooms that housed the ancestral stools of deceased state leaders. Life and the afterlife, the present and the past, were enhanced and made more meaningful by the presence of these elegant prestige vessels. *RAB*

Bibliography: Mcleod, 1981; Brincard, 1983; Silverman, 1983; Garrard, 1983; Schadler, 1993, pl.66

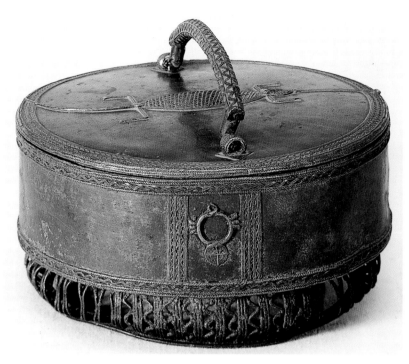

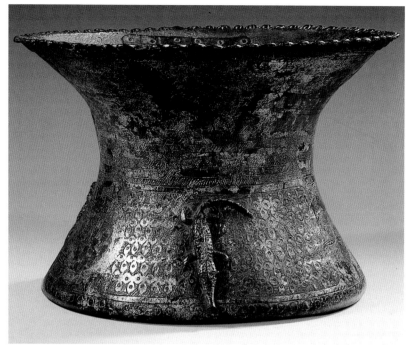

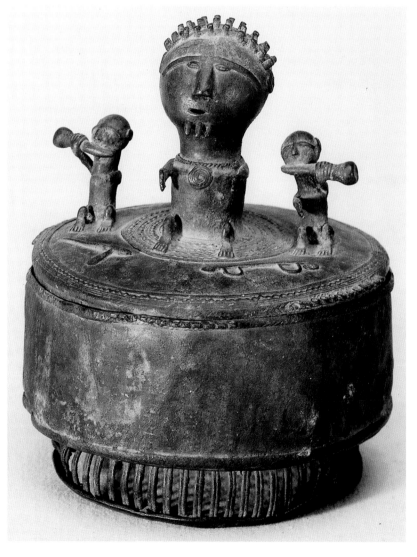

5.96

Kuduo

Asante
Ghana
18th or 19th century (?)
gilded copper alloy
h. 17.8 cm
George Ortiz Collection

The Asante culture has long been at
the vortex of historical events that tie
it not only to the European presence
on the coast of Ghana, but also to an
ancient network of trade ascending
from Muslim north Africa to the heart
of the Ghanaian forest. The Asante
people have themselves been active
historical agents; their artists have
always gladly accepted items imported
from the wider world, assimilating
and transforming them in a continu-
ing search for new and more fully
realised Asante cultural forms.

Inspired by 14th- and 15th-century
Arabic-inscribed basins from Mameluk
Egypt (six of which survive in varying
states of disrepair within greater
Asante) and other imported Islamic
bowl, goblet and cup forms, Asante
metalcasters also drew upon European
trade wares in the creation of luxury
containers for this highly class-
conscious society. Over generations
the Asante artistic imagination was
to reshape these models, resulting
in a remarkable range of containers

known as *kuduo*, vessels cast of various
copper alloys.

One of the most elegant is this fine
example, an open-mouthed vessel
with flared sides and a delicately
scalloped rim, which blends the purity
of medieval Islamic design with
Asante creative ingenuity. Its silhou-
ette is time-honoured among Muslim
craftsmen, and containers of this
shape, known as *tisht*, are still a
popular item in the *souks* of north
Africa. The measured and densely
worked bands of designs and the
medallions containing rosette patterns
that encircle this *kuduo* clearly echo
Islamic prototypes. The Asante artist
has enhanced this container, however,
by including three crocodile figures
and adding gold leafing to its surface.
RAB

Bibliography: Mcleod, 1981; Brincard,
1983, pl. G6, p. 114; Silverman, 1983;
Garrard, 1983

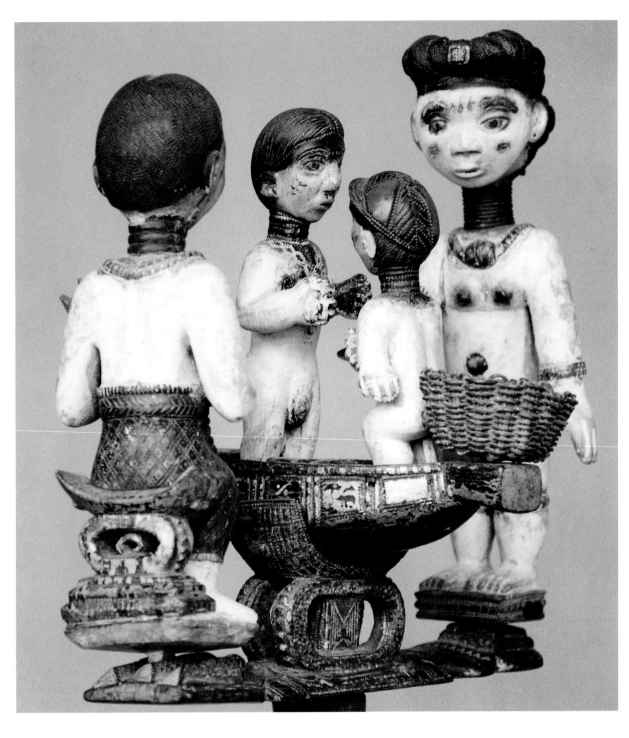

5.98

Drum

Fante
Ghana
c. 1940
wood
h. 87 cm
Private Collection, Paris

This anthropomorphic female drum is seated on the back of a lion with the feet of the drum resting on top of a much smaller elephant. The instrument was once the lead drum in an Akan popular band that performed at a variety of occasions including puberty celebrations, marriages and funerals. Special events aside, the primary motivation for this continuing tradition is social and recreational, with evening entertainments at the core of a community's leisure activities. Similar to their Euro-American counterparts, traditional Ghanaian bands are a product of frequently changing tastes in music and dance. The principal drum is the visual and musical focus of the group. Additional instruments in these primarily percussion ensembles may include clappers, gourd and metal rattles, gongs, other drums and human voices. Each style of music and dance has its own name. This drum is quite likely from one of the Fante groups called *ompe*, which has been translated as 'who doesn't like it'.

The elaborately carved 'master' drums of these bands are invariably female and are often referred to as the 'queen mother' of the ensemble. Despite this allusion and the regal presence of the lion and elephant, these drumming and dancing groups function as voluntary musical ensembles independent of Akan court structures. Nevertheless, drums like the present example borrow heavily from Akan royal notions about the art of being seated. Of all African peoples, the Akan probably have the most sophisticated vocabulary of stool and chair types, with a wealth of distinctive meanings and contexts of use. The scale of the drum figure relative to the two royal animals that support it obviously aggrandises the importance of the drum itself. Among the Asante, lion stools were once the exclusive prerogative of the Asantehene, and foot rests of any type were reserved for high ranking chiefs. The state treasury of Adanse Fomena still

5.97

Staff with painted figures

Fante
Ghana
20th century
wood, paint, glass
h. 220 cm
Dr. E. Wachendorff Collection

In most Akan societies the linguist plays an important role. Even today, in quite a small village, it would be discourteous to speak to the chief directly in the first person: he is to be addressed through his linguist who will not necessarily pass the message on but will be, as it were, the micro-phone through which you pay respects to his dignity or make any kind of negotiation. The linguist's staff of office marks him out in any gathering and is often, as here, decorated with various motifs including hands and snakes. The top of this example consists of a figure group of some complexity (though not untypically elaborate) which no doubt incorporates one of the proverbs of which the linguist must keep a store. In earlier times this might well have been covered in gold leaf (or simulation of such) as is still the custom among the Asante, Baule etc (cat. 5.117), but the present piece is of quite recent manufacture and is painted with brilliant oil-based paints.

Two figures occupy a boat (the Fante are grouped in the coastal regions south of Asante territories) which itself is placed upon a clan stool; two figures look on, one of them enstooled. An enigmatic basket completes the scene. The lively group in its fresh, frank and direct style will perhaps remind visitors to the exhibition of the recently publicised Asafo flags which also transmit narrative messages in clear colours.
TP

holds two brass elephants of European manufacture that serve as foot rests for the paramount chief. These concepts of elevation and enthronement have been borrowed by the drumming group to enhance their theatrical presentation.

The importance of the drum, and therefore of the group that once owned it, is further emphasised by the relief carving around the torso. Each distinct motif illustrates part of the conventionalised oral literature of the Akan – from praise names, proverbs and folk tales to riddles, boasts and insults. While some of these motifs may celebrate the prowess of the band, most are aphorisms that comment on the everyday life of the Fante. For example, to the left of the breasts a leopard confronts a tortoise, which illustrates the maxim: 'When the leopard catches the tortoise it turns it over and over in vain.' This common saying argues against aberrant behaviour and against challenging the natural order of things. In the same vein, at the back of the drum is a cat with a small bag around its neck facing a mouse. This motif warns: 'It is a foolish mouse that tries to steal from the cat.' *DHR*

Bibliography: Nketia, 1963; Cole and Ross, 1977; Ross, 1988; Ross, 1989

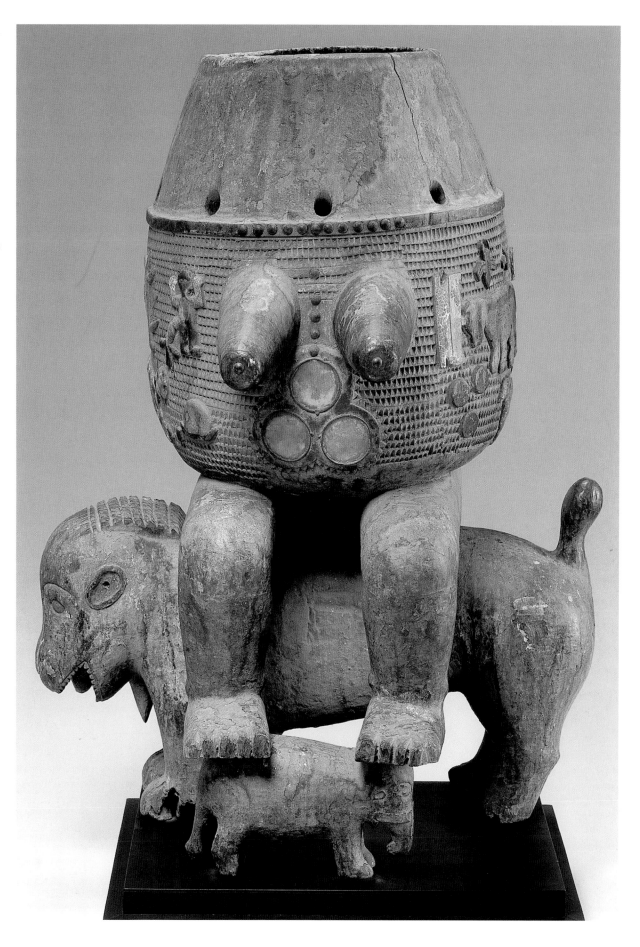

5.99a

Memorial head

Akan
Ghana
17th–19th century
terracotta
31 x 14 x 15 cm
Private Collection

5.99b

Memorial head

Akan
Ghana
17th–19th century
grey terracotta
25 x 17 x 19 cm
Private Collection, Munich

5.99c

Memorial head

Akan
Ghana
17th–19th century
red terracotta
27 x 16 x 11 cm
Private Collection, Munich

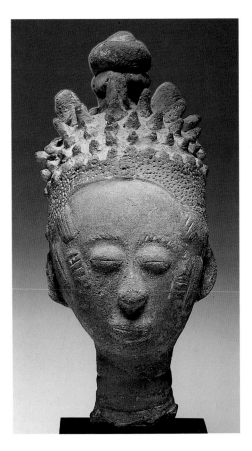

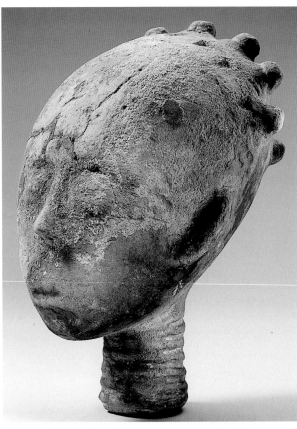

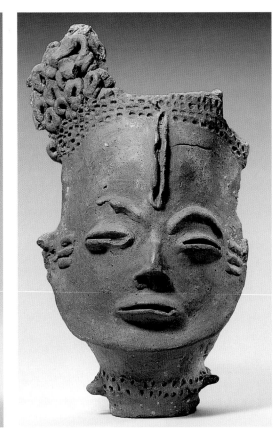

Although it is common for many of these terracottas to be labelled Asante, the vast majority are southern Akan, with the most northerly concentration of sculpture coming from Adanse Fomena. In scale the heads of the terracottas vary widely from small solid pieces two or three inches high to nearly life-size sculptures. Free-standing heads coexist with full figures, and styles range from abstract to highly naturalistic. While facial features may be simply modelled, considerable attention is paid to scarification patterns and to details of coiffure. Some terracottas are left unpainted while others have been painted with black or other colours. Years of exposure have removed much evidence of surface pigment.

Terracotta funerary sculpture has at least a 400-year history among the Akan in what is now southern Ghana. Pieter de Marees (1602) wrote of the burial of a chief: 'All his possessions, such as his weapons and clothes, are buried with him, and all his nobles who used to serve him are modelled from life in earth, painted and put in a row all around the grave, side by side.' Thermoluminescent tests confirm that a number of such sculptures date from at least as early as this account, although most fall within a 17th- to 19th-century span. The tradition continued in a few areas until the 1970s.

Probably the most detailed description of an ensemble of Akan funerary figures comes from the 19th-century missionary Brodie Cruickshank: 'They also mould images from clay, and bake them. We have seen curious groups of these in some parts of the country. Upon the death of a great man, they make representations of him, sitting in state, with his wives and attendants seated around him. Beneath a large tree in Adjumacon, we once saw one of these groups, which had a very

natural appearance. The images were some jet black, some tawny-red, and others of all shades of colours between black and red, according to the complexion of the original, whom they were meant to represent. They were nearly as large as life, and the proportions between the men and women, and boys and girls, were well maintained. Even the soft and feminine expressions of the female countenance were clearly brought out. The caboceer and his principal men were represented smoking their long pipes, and some boys upon their knees were covering the fire in the bowls, to give them a proper light.'

Memorial terracottas were created by female artists to honour deceased chiefs and other important elders, both male and female. As is clear from the above quotation, surviving members of the chief's entourage or family members of the deceased were also represented. The ensemble of

sculptures was not typically positioned on the grave, but rather at a sacred grove close to the cemetery where rituals were performed with libations, and offerings of food and prayers. In addition, a rich variety of ceramic vessels was assembled at the site to receive the offerings. In certain locales, selected pots were ornamented with elaborate figural or other representational motifs. Some of the smaller terracotta heads in collections may have been broken off such pots.

It is clear that Akan terracottas did not function exclusively as ancestral memorials in static funerary contexts. Fired clay sculptures have also been documented as processional figures and in shrine and stool rooms. *DHR*

Bibliography: De Marees, 1602, p. 185; Cruickshank, 1853, ii, pp. 270–1; Field, 1948; Sieber, 1972, pp. 173–83; Cole and Ross, 1977; Coronel, 1979, pp. 28–35

5.99d
Memorial head

Akan
Ghana
17th–19th century
terracotta
33 x *c.* 19 x *c.* 18 cm
Private Collection

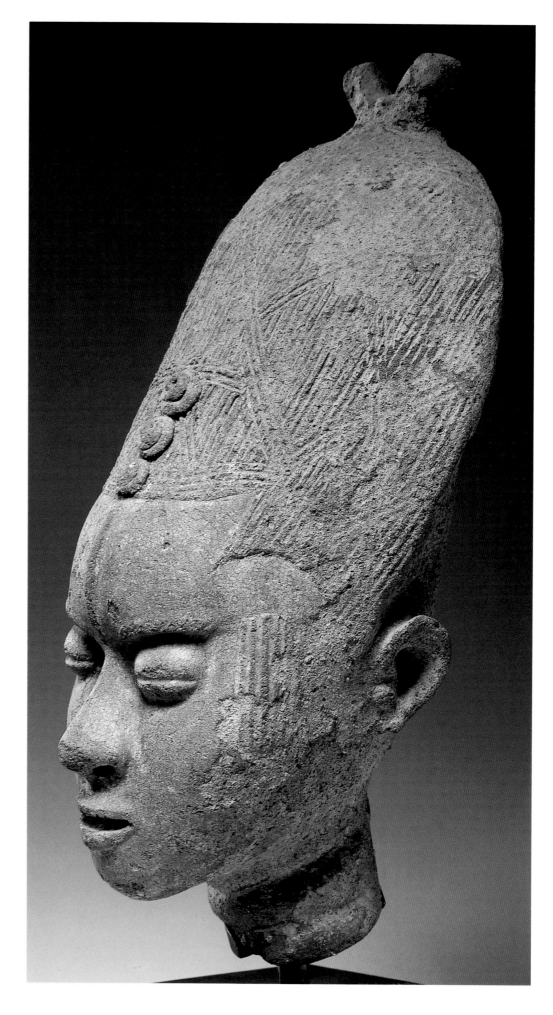

5.100

Pectoral disc

Akan (perhaps Asante)
Ghana
19th century
gold
diam. 8.5 cm
The Detroit Institute of Arts, 81.701

This jewel belongs to the varied class of disc-shaped gold ornaments which includes some of the most beautiful examples of Akan goldwork from Ghana. Usually such discs were worn as pectorals, suspended over the chest by a white cord. But usage varied, and sometimes they were attached to a cap, or used as the centrepiece of a neck-lace. In other instances they might be tied to the hair, or even worn around the ankle.

Such discs are usually referred to in the literature as 'soul-washer's badges' (*akrafokonmu*). Many served as pec-torals worn to indicate the status of the chief's *okra*, a young official who 'washed' or purified the chief's soul. But in reality these discs were multi-purpose objects which could function in a wide variety of contexts. Some were worn as the insignia of a royal messenger; others as that of a herald, linguist, war-leader, sub-chief or even a junior official. Occasionally they might be displayed by the chief himself. In the past they were sometimes worn by girls at puberty ceremonies, and today, in Asante, they can indicate the principal mourner at a funeral (being then referred to as *awisiado* rather then *akrafokonmu*).

In this example the absence of surface ornament serves to fix attention dramatically on the central motif, four arms radiating from a focal point. This is probably the Akan symbol of a crossroads (*nkwantanan*). It has proverbial significance, indicat-ing the power and authority of the

chief: 'the chief is like a crossroads, all paths lead to him'.

Several factors combine to suggest that this pectoral disc dates from the 19th century. During the 20th century the size of such discs has tended to increase, while their standard of workmanship has declined. The present example is relatively small. It is also of exquisite workmanship. In particular, it retains traces of an old and curious technique (abandoned in the 20th century): in the original wax model, the flat parts of the design were not cut out from a sheet of wax but rather built up from thin wax threads, which were laid side by side and subsequently smoothed.

Another detail is significant. The four small circular holes in the design, as well as the central hole, have not simply been punched in the wax model. Each hole has been most carefully reinforced by an applied circlet of wax thread. This superlative attention to detail recurs in a number of other early castings. It is found, for instance, in a series of magnificent crocodile heads cast in silver, which were almost certainly produced in the royal workshops of Asante before the fall of Kumasi in 1874. This raises the possibility that the pectoral disc is not merely of 19th-century date, but indeed part of the extensive loot which the British obtained from Kumasi at that time. *TFG*

Bibliography: Garrard, 1989, pp. 66–9, 225

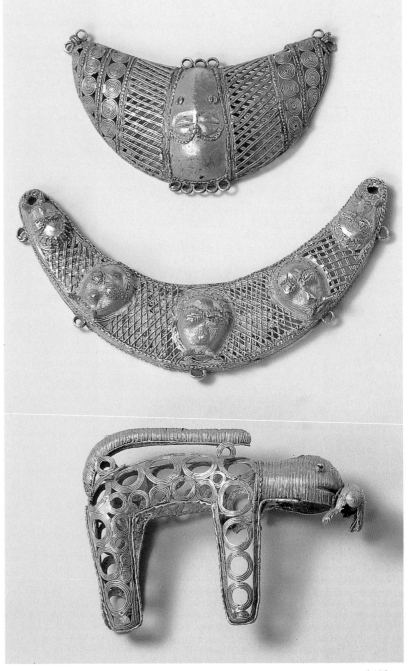

5.102a–c

5.101a–b

5.101a-b

Two pectoral discs

Akan
Ghana
gold
a: diam. 6 cm; b: diam. 10.8 cm
The Trustees of the British Museum,
London, 1818.11-14.6 and 1900.4-27.23

5.102d–i

5.102a–i

Gold ornaments

Lagoons region and Baule
Ivory Coast
19th–20th century
gold
h. *c.* 6–13 cm
Private Collection

For several centuries in southern Ivory Coast, gold ornaments such as these have been worn at public festivals. They were common to the Akan and Akan-related peoples of the Lagoons region and the Baule living further inland. Usually such jewels were attached to the hair, being provided with small loops for suspension through which threads were passed. Some could also be worn on a chain around the neck, for instance the crescent with five heads shown here (cat. 5.102b). Chiefs and dignitaries also attached such ornaments to the velvet of their crowns and caps, while disc-shaped ornaments were

sometimes used to embellish wooden stools.

The art of making this jewellery was introduced to the Ivory Coast centuries ago by Akan goldsmiths coming from Ghana (formerly known as the Gold Coast). Each ornament was initially modelled in fine wax threads over a charcoal core, and then invested in a clay mould and cast by the lost-wax process. This technique is still used today, though the modern products do not bear comparison with those made a few generations ago.

Human heads were a popular motif, as were crescent forms, snakes, tortoises, crabs, leopards, rams' heads,

and a great variety of other shapes. In the Lagoons region, wealthy persons used these gold ornaments to increase their status in the community, holding lavish ceremonies at which their accumulated treasure was publicly displayed. Even today, such ceremonies are reported from time to time, and as many as a hundred such ornaments may be exhibited, laid out on tables in the street. *TFG*

Bibliography: Garrard, 1989, pp. 100–8

i–vi

vii–xvi

Akan goldweights

Akan weights, in their immense diversity, served for weighing gold-dust over a period of about five centuries, from 1400 to 1900. They were used by all the various Akan and Akan-related peoples of southern Ghana and the neighbouring regions of the Ivory Coast.

From about the late 14th century gold mined in the Akan forest began to be traded northwards. It passed first to the towns of the west African Sahel, and thence across the Sahara desert to north Africa. To meet the needs of this trade the Akan began to make weights equivalent to those of their Sahelian trading partners. These weights were of two series, one based on an Islamic ounce used in the trans-Saharan trade, and the other on the *mithqal* of gold-dust (about 4.5 grams, or one-sixth of an Islamic ounce).

When the Portuguese began trading along the west African coast from the 1470s, the Akan made further weights to the standard of the Portuguese ounce. After 1600, when the Dutch introduced the heavier troy ounce, this series too was assimilated by the Akan. Thus the Akan eventually had four series of weights for trade with all their external partners. Over the centuries these became merged into one long traditional table of about 60 different units of weight, their origins being forgotten. Up to 1900 goldweights were made to all of these units.

As if the great variety of cast brass weights was not enough, the Akan also used seeds, pottery discs, European nest-weights and many scraps of European metal as aids in the weighing process. There was also a complex array of other apparatus including scales, spoons, shovels, sieves, god-dust boxes, brushes, touchstones and small cloth packets. In the Akan world the weighing of gold was a complicated and time-consuming art. *TFG*

5.103/i–xvi

Geometric goldweights

Akan
Ghana
15th–19th century
brass, some with copper plugs
h. *c.* 2–4 cm each
Private Collection, London

The first Akan goldweights were various geometric forms, which became increasingly diverse and elaborate over the centuries. They are by far the most common of Akan goldweights.

Of the weights exhibited here, nos i to viii are conventionally ascribed to the Early period (15th–17th century). No. viii, a truncated bicone, was a type common in the Roman and Arab worlds, and also in the Sahel region of west Africa, immediately south of the Sahara. The Akan initially traded their gold to this region, and the truncated bicone was probably one of the earliest, if not the earliest, type of weight that they adopted as the gold trade began.

Other early geometric forms made by the Akan characteristically have notched or indented edges and, very often, an incised or engraved surface decoration of fine lines, dots and punch-marks (nos ii to vi). Some are further embellished by inset copper plugs (no. vi). This technique of decorating cast brass was known in the Middle Niger region, for instance at ancient Djenne, and its reappearance among the Akan suggests that they may have had contact, at a very

early period, with goldsmiths from the Middle Niger region.

From about the 16th century onwards many early geometric weights had a raised surface decoration, often of bars and swastikas (no. iii). Some were more elaborate; no. viii is a superb large weight from a chief's treasury, probably of the 17th century. It comes from coastal Ghana and bears the symbol of a European key, perhaps representing some such proverb as 'Death has the key to open the miser's chest'. It represents the Akan unit of five *pereguan* (about 352 grams).

Late period weights of the 18th and 19th centuries took innumerable forms. Some are variations on the motif of the ram's horn (no. iv), signifying force and courage. Even more remarkable are the three-dimensional 'puzzle-weights' (nos vii–ix, xiii–xiv, xvi), whose fantastic forms reflect the imaginative genius of the Akan gold-smith.

All these various geometric weights continued to be used up to about 1900, when goldmining in the region was brought under European control, and the gold-dust currency replaced by colonial coinage. *TFG*

Bibliography: Garrard, 1980, pp. 274–87

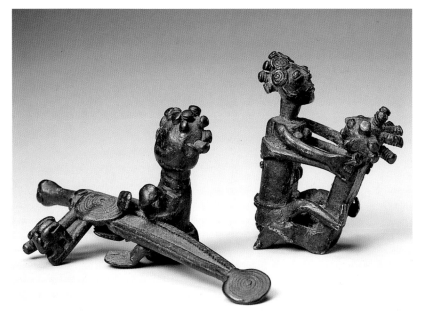

i–ii

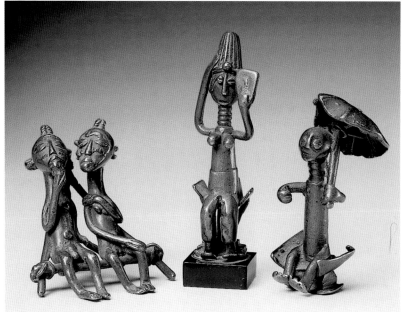

iii–v

5.104/i–x

Goldweights representing human figures

Akan
Ghana
17th–19th century
brass
h. *c.* 2–4 cm each
Private Collection, London

By the 17th century, if not before, Akan goldsmiths extended the range of their weight forms to include representations of human figures, animals, plants and seeds, man-made artefacts, etc. Such weights were still intended for practical use, being made to the correct weight standards. But they had a wider significance. Primarily they represented Akan proverbs, serving as a mnemonic device to call to mind a particular proverb or saying. It is even said that

vi–vii

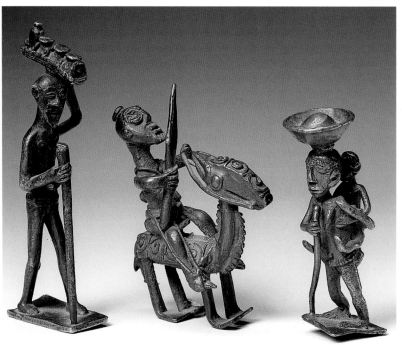

they were occasionally sent from one person to another as 'messages'. They also played an important role as objects for display and ostentation; many of the finest were made for chiefs' treasuries, but by the 19th century they seem to have come into general use among the population. The examples exhibited include the following:

No. i. Man tapping palm wine. Weights in this style may be 17th–18th century.

No. ii. Couple in sexual embrace. Although modern copies of this theme abound, genuine old examples are exceedingly rare, for the gold-smiths were reluctant to depict such a personal and private act. Probably 18th century.

No. iii. Two persons seated on a single chair, one with hand to mouth. This may represent the proverbial friends Amoaku and Adu, who met after many years' separation.

No. iv. Woman on stool, regarding her face in a mirror.

No. v. Man seated on stool, holding a parasol. Probably 17th century.

No. vi. Man playing *fontomfrom* drums. This would represent a proverb such as 'Firampon says he won't have anything to do with the drums: yet when they beat the talking drums they say "Condolences, Firampon".'

No. vii. Man playing an ivory side-blown trumpet.

No. viii. Man carrying palm-wine pots on his head. This weight was

cast by one of the most gifted 19th-century Kumasi goldsmiths; two other examples of his work are in the Museum of Mankind, London.

No. ix. Man on horseback carrying a spear. This may depict a warrior from the northern savanna. It is in the best style of the Asante region and dates from the 19th century.

No. x. Woman carrying a bowl on her head and a child on her back. This weight, in the Asante style of the 19th century, represents the proverb 'It is the hard-working woman who carries her child on her back and a load at

the same time' (Everyone admires an industrious worker who is prepared to take on another burden). *TFG*

Bibliography: Garrard, 1980, pp. 297–9; Garrard, 1982, pp. 60–2

viii–x

5.105/i–xii

Goldweights representing animals

Akan
Ghana, Ivory Coast
17th–19th century
brass
h. *c.* 2–4 cm each
Private Collection, London

The fauna of the west African forest is generously represented among Akan proverb weights, with many kinds of birds, mammals, reptiles, fish and arthropods being depicted. There were often several proverbs that could apply to a given weight. The present examples include the following:

No. i. Crocodile. A well-known proverb has it that 'The old crocodile swallows a pebble when the year ends' (Misfortunes are inescapable and we must accept them as a part of life).

No. ii. Antelope head. This may be a Baule casting from the Ivory Coast.

No. iii. Crocodile. This example, from the coastal region of southern Ghana, was cast without a tail. It may date from the 17th century (Early period).

No. iv. Scorpion. Among several applicable proverbs is the following: 'If the scorpion bites a good mother's child, the pain lasts until the hearth grows cold' (If there is a troublesome person in the house, you will have no peace until he leaves).

No. v. Flat-bodied fish with long fins.

No vi. Pangolin (?). This could represent the Asante proverb 'Don't sell me pangolin meat for I have no onions' (Don't bring me unnecessary trouble).

No vii. Bush cow, hollow casting, 18th century

No. viii. Elephant. This animal was often used as a symbol for a chief or powerful man, in proverbs such as the following: 'If you follow an elephant you don't lose your way' (If you follow an important man you are protected).

No ix. Embryo of a bird

No. x. Bird with a serpentine neck.

No. xi. Bird with a swastika design on its back. This casting is contemporaneous with the Early period geometric weights showing the swastika motif and dates probably from the 17th century.

No. xii. Leopard standing on another leopard. *TFG*

Bibliography: Garrard, 1980, pp. 292–6, 302–13

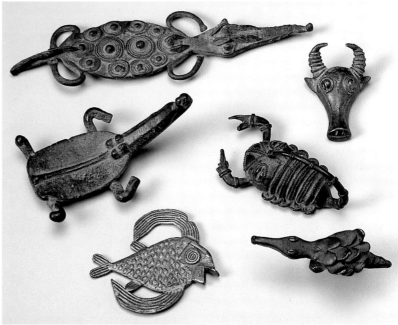

i–vi

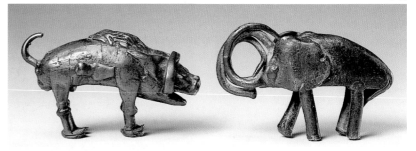

vii–viii

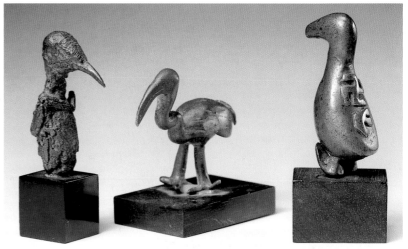

ix–xi

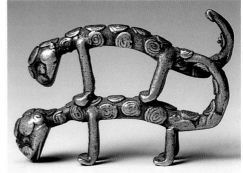

xii

5.106/i–xiv
Goldweights representing artefacts

Akan
Ghana, Ivory Coast
17th–19th century
brass
h. *c.* 2–4 cm each
Private Collection, London

This group of weights provides unique evidence of the range of artefacts used by the Akan in past centuries. It includes domestic furniture, items of culinary equipment, weapons and tools (some based on European originals), implements for use in agriculture and hunting, and an extraordinary range of objects connected with the paraphernalia of chieftaincy. The following small selection is included in the exhibition:

No. i. Woodcutter's axe.

No. ii. European padlock. Often associated with magical practices and sorcery.

No. iii. Stylised triangular padlock.

No. iv. Elephant-tail whisk. These were symbols of high status, used only by chiefs and important fetish priests. An appropriate proverb would be the following: 'The elephant's tail is short, but it whisks off flies with it' (Make use of what you have).

No. v. Hide shield with attached iron bells. Such shields were formerly used in warfare. This splendid weight would represent the proverb 'Though the covering of a shield wears out, its framework still remains' (The family head may die but the family endures).

No. vi. Horse-tail fan. These were carried in procession by certain attendants of the chief, whose duty it was to drive away evil spirits from before him.

No. vii. Ladder. This commonly represented the proverb 'The ladder of death is not climbed by one man alone' (We are all mortal).

No. viii. Load of kola nuts on a carrying rack. Kola nuts, transported in this fashion, were an extremely important item of trade between the Akan forest region and the savanna to the north.

No. ix. Akan stool.

No. x. Akan stool.

No. xi. Carved wooden board for the game of *Oware*. Among several applicable proverbs is the following: 'A stranger does not play *oware*' (Do not interfere in other people's affairs).

i–viii

ix–xiv

No. xii. A cooking-pot super-imposed on another pot, which rests on three hearthstones. An appropriate proverb might relate that the pot above cannot come to the boil until the one beneath has done so (stressing that we are all dependent on others).

No. xiii. Gold-dust chest or box (*adaka*), the lid decorated with twelve birds. Large wooden chests were found in a chief's treasury; small portable brass boxes were owned by many adults to hold gold-dust. In some cases the brass boxes were made to a specific weight standard, and could thus themselves be used as goldweights.

No. xiv. Upright chair (*asipim*). This kind of chair, highly prized by the Akan, was based on a 17th-century European original. *TFG*

Bibliography: Garrard, 1980, pp. 292–6, 302–13

5.107/i–xviii

Goldweights cast directly from nature

Akan
Ghana, Ivory Coast
17th–19th century
brass
h. *c.* 2–4 cm each
Private Collection, London

In the 16th century certain gold-smiths of Padua and Nuremberg developed a technique of casting directly from nature, by replacing the usual wax model with an actual animal such as a lizard or snake. The same technique has long been known in west Africa, where it was doubtless invented independently. The Akan goldsmith exploited this technique to the full, producing some very remarkable castings. These direct castings served as goldweights in the usual way, and were associated with traditional proverbs.

The following selection is shown:
No. i. Grasshopper.
No. ii. Small lizard with front legs tied to its tail. The significance of this gruesome weight is unclear, but the tied limbs suggest a prisoner.
No. iii. Two joined roots.
No. iv. Chrysalis.
No. v. Maize leaf tied into a knot. This represents the proverb 'If there

i–viii

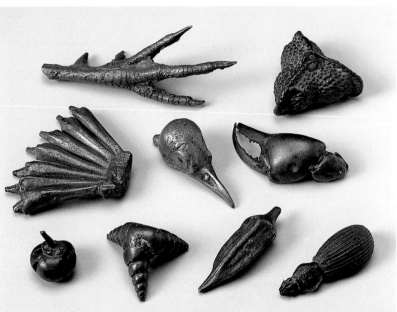

ix–xvii

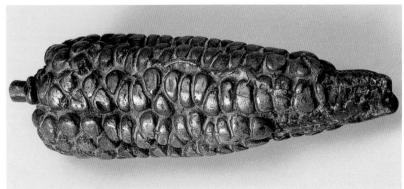

xviii

is trouble in a wise man's house, he ties it into a knot'.

No. vi. Water snail.
No. vii. Groundnut (peanut) pod.
No. viii. Winged seed.
No. ix. Chicken foot.
No. x. Pod of kola seeds.
No. xi. Cluster of seven immature plantain fruits. A well-known proverb for this weight was 'The plantain's descendants are without end' (said of a fruitful person).
No. xii. Bird's skull, including beak.
No. xiii. Crab claw.
No. xiv. Small, very sweet berry used in sauce.
No. xv. Group of three small water snails.
No. xvi. Okra fruit.
No. xvii. Beetle.
No. xviii. Corn cob. This old and massive casting of 469 grams may have been intended to represent a rare Akan weight unit equivalent to 16 Portuguese ounces (459 grams). *TFG*

Bibliography: Garrard, 1980, pp. 122, 290–1

5.108

Female figure

Bete
Ivory Coast
20th century
wood
h. 46.5 cm
Private Collection

Until recently sculpture by Bete carvers received little attention in the art world (no examples were published as being of Bete origin until 1964). A few dozen male and (mostly) female figures in the range of 80–100 cm in height were collected in the 1930s, but changes in Bete society after the 1920s diminished the production and use of objects associated with earlier religious rites.

This decline was partly due to the popularity of a syncretist cult that advocated destruction of such imagery and partly to the increasing commercialisation of agri-culture. From the 1930s onwards the Bete focused on expanding coffee and cocoa plantations and developed large urban trading centres at Gagnoa in the eastern region and Daloa in the west.

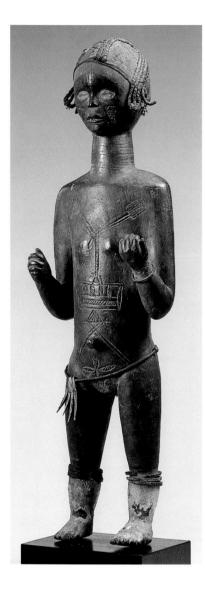

5.109

Female torso
Attie
Ivory Coast
ivory
h. 14.5 cm
Private Collection

This elegant female torso in well-patinated ivory is pierced at the bottom and hollow, and was probably carved as a staff-finial or flywhisk handle for a chief.

The hair is pulled up into a tight topknot. The head is bulbous and inclined at an angle. Arms and breasts are reduced to vestigial bumps resulting in a simple tubular form with flowing lines that would fit easily in the hand. Face, neck and sides of the chest show raised scarification. The pattern round the abdomen may be a beaded belt that preserves modesty.

This piece is attributed to the Attie (Ankye), one of the so-called Lagoon peoples of Ivory Coast, who use similar incised decorative patterns. It is rather different from the elaborately detailed style of the better known male figures in Western dress from this area but may have served a similar function as an object of adornment and exchange. *NB*

Bibliography: Visona, 1983

5.110

Female statuette (*nkpasopi*)
Lagoons region
Ivory Coast
20th century
wood, metal, glass
h. 24.5 cm
Musée Barbier-Mueller, Geneva, 1007.12

This finely sculpted statuette with its rigid pose, bulbous limbs and cupped hands is in a style typical of the lagoons region of the south-eastern Ivory Coast. As is commonly the case in this region, it has been beautified by the addition of glass waist-beads and a necklace of small disc-shaped metal beads of Baule origin. The figurine could have served in a variety of contexts. It may have been owned by a diviner, for use in conveying messages to the spirit world, or it may have been prescribed by the diviner for a client. Alternatively, it could have been intended to represent (and house) a man's 'spirit lover' from the other world, or it may have been displayed at certain traditional dances. Statuettes of similar form were put to all of these varied uses.

It is not practicable to attribute this carving to a particular ethnic group. The lagoons region, though relatively small, contains a mosaic of peoples speaking some fifteen languages, many of them established there since remote antiquity. Living in close proximity to each other, they have long used, copied and been influenced by each other's art forms, and also those of their northern neighbours, the Baule and Anyi. Statuettes of this form have been attributed to the Ebrie (Kyaman) and the Atie (Akye), but they were also known to the Gwa and Abe. Until such time as the ethnic identity of their carvers has been established, it is preferable not to assign a precise label to such works. *TFG*

Provenance: before 1939, Collection Josef Mueller

Bibliography: Visona, in Schmalenbach, 1988, p. 133; Visona, in Barbier, 1993, i, p. 371, ii, p. 170

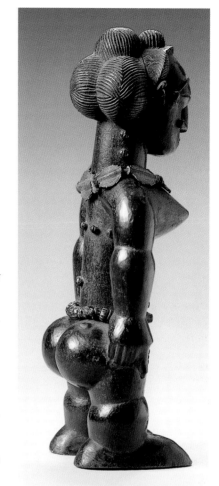

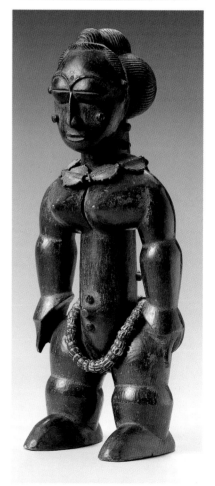

This division marks a difference in their early style of masks and figures: the eastern carvings show some similarity to the styles of their Guro neighbours, while the few known western sculptures bear a degree of resemblance to those of the Wè (Guéré) to the west. Bete figures exhibit a variety of simple hand positions, which are difficult to interpret, as well as touches of white pigment, as in the figure shown here.

From foreigners' brief comments on the figural sculptures collected in villages, it seems that a tall pair of male and female figures were preserved in a shelter to represent the founders of the site and community. This practice of honouring the ancestral founders who first cleared the forest or bush is known also in a number of other west African agricultural communities. *MA*

Bibliography: Herold, 1985, pp. 124–6; Fischer, 1989, pp. 46–7

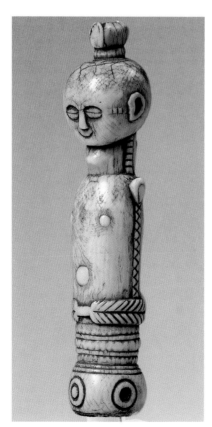

5.111
Seated female figure

Akye
Ivory Coast
early 20th century
wood
h. 64 cm
Musée National de la Côte d'Ivoire,
Abidjan, 42.3.317(A11)

The unique style of this sculpture
identifies it as a work from the region
inhabited by the Akye (Atie), a lagoon
people. It represents a woman, her
hair dressed into four cones, seated on
a stool of Akan form. The sculpture is
in blackened wood, and the arms have
been carved separately and then
attached.

Figures of this kind are said to
represent a spirit or ancestor, and to
have been used in a cult called *logbu*.
Little is known about them, however,
for they went out of use quite rapidly
between about 1910 and 1930. In 1914
the renowned Liberian prophet
William Harris arrived in the Ivory
Coast, and by the fervour of his
preaching induced whole popula-
tions – particularly in the lagoons
region – to abandon their statues
and traditional religious cults.
In consequence great quantities of
sculptures from the lagoons were
destroyed, and relatively few examples
survive in museums and private collec-
tions.

The present statue is one of several
examples now in the Abidjan museum,
which came from the collections
formed by Bédiat and Modeste in
the 1930s and '40s. *TFG*

Exhibitions: Vevey 1969; Paris 1989
Bibliography: Vevey 1969, pp. 206–7;
Paris 1989, pp. 52–3

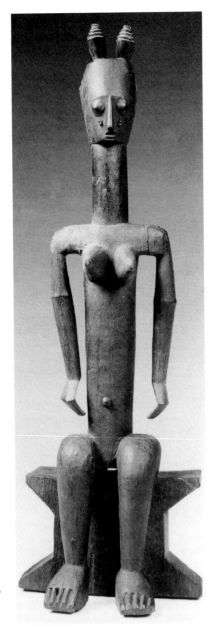

5.112
Female figure with anklets

Bondoukou region
Ivory Coast
late 19th–early 20th century
wood
h. 46 cm
National Museum of African Art,
Washington, 85.8.5

This very beautiful figure is carved
in a series of voluptuous interrelated
curves. The hair is neatly dressed in
a helmet shape with a crest running
from front to back; there are raised
scarifications at the sides and front of
the body; and further scarification is
shown beside each eye in the form of
three vertical strokes. The tiny arms
are held beneath the breasts, while
the hands and feet are rudimentary.
The figure wears a pair of large ellipt-
ical anklets or foot-rings. In 1968
William Fagg published another
female statue unquestionably in the
same style, but by a different hand.
Though outside the norms of Baule
and Anyi statuary, this figure has
features reminiscent of it, notably the
treatment of the face and abdomen.
Fagg concluded that it could plausibly
be attributed to the Anyi, and cer-
tainly to one of the smaller Akan
groups of whom they are the most
important. He added in a footnote
that two larger figures in the same
style had just entered the collection;
they were said to have been collected
at Wenchi, a northern Akan town in
the Brong-Ahafo region of Ghana.

A number of rare and remarkable
sculpture styles existed in the region
surrounding the Ivory Coast–Ghana
border. These statues, with their hints
of Anyi or Baule influence, are prob-
ably to be attributed to the Bondoukou
region, which has long been an artistic
melting-pot. Within a radius of 60 km
from Bondoukou are found a variety
of ethnic groups living in close
proximity, some of Akan origin
(Abron, Anyi, Domaa) and some of
Senufo and Voltaic origin (Nafana,
Fantera, Kulango). The present statue
could have been made by, or for, any
one of these groups. It should be
noted too that Wenchi, where the two
largest statues in this style are said to
have been collected, lies only 75 km
to the east along the main road from
Bondoukou. *TFG*

Bibliography: Fagg, 1968, fig. 91

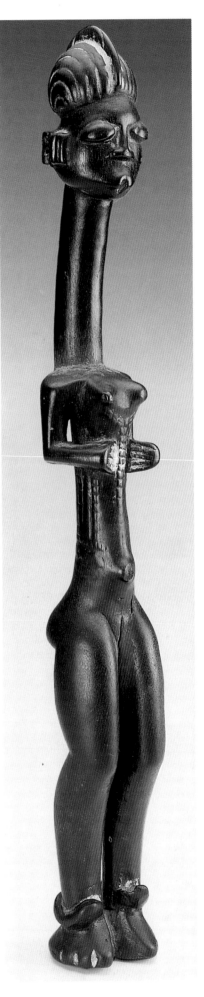

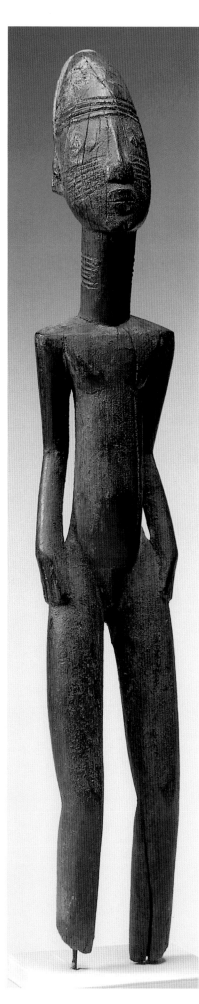

5.113

Male figure

Gurunsi or Dagara (?)
Burkina Faso
19th–20th century
wood
65 x 10.8 x 7 cm
Musée National des Arts d'Afrique et
d'Océanie, Paris, MNAN 79.2.2

This male statue of rare elegance
has a long tapering form, with a
deliberate exaggeration in the length
of the head, neck and thighs. Its
cheeks and neck carry panels of about
seven incised horizontal scarifications.
The shoulders are square and slight,
the arms held loosely to the sides, and
the fingers are summarily indicated
on the spade-shaped hands.

No close parallels seem to be known
for this sculpture. Its attribution to the
Kulango need not be taken seriously.
The lower two-thirds of the statue
(i.e. minus the head and neck) are
found to be 'almost Lobi'. Among the
myriad substyles of Lobi statuary
parallels can be found for the squared
shoulders, slight arms, abdomen,
buttocks and elongated legs of this
statue. It is the tall, forward-slanting
neck and the equally tall, backward-
slanting head which diverge most
markedly from Lobi style.

One is tempted to conclude that
if this is not a work by a brilliantly
idiosyncratic Lobi sculptor, it must
come from one of the peoples in close
proximity. Those peoples include the
Dagara/Dagari/Dagaaba, who live to
the north-east but in part share the
same territory as the Lobi. Even fur-
ther north-east are the various ethnic
groups who fall under the umbrella-
term 'Gurunsi': the Pwa (Pugula),
Sisaala, Kasena, Nuna, Nunuma, Ko
and others. A Nuna shrine-figure
strangely reminiscent of the present
statue, though not in the same style,
is in the Musée Barbier-Mueller.
This enigmatic statue doubtless
belongs to the rich but largely
unexplored tradition of shrine
sculpture in southern Burkina Faso.
TFG

Exhibition: Paris 1989 (attributed to
the Kulango)

Bibliography: Roy, 1987, pp. 252–3;
Roy, in Schmalenbach, 1988, p. 76; Féau,
in Paris 1989, p. 94

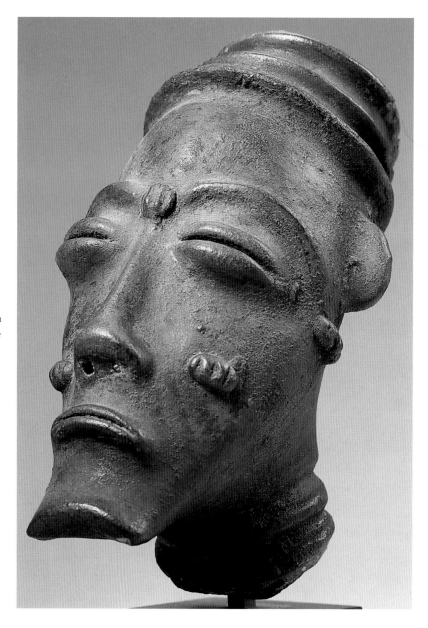

5.114

Funerary head

Sanwi
Ivory Coast
19th–early 20th century
fired clay
h. 18 cm
Private Collection

This terracotta head depicts a woman
of high status with her hair elabor-
ately dressed in three superimposed
rings. It may originally have been
attached to a short rudimentary body.
Its style identifies it as coming from
the region of Krinjabo, the capital of
the Sanwi people (an Akan subgroup),
in the south-eastern Ivory Coast.
Statuettes in the Krinjabo style often
retain their original smooth surface
finish, and some show traces of
painting. They were collected by
French officials at least as early as

1904, and may have been made
shortly before that time.

Such heads and figurines were
widely used in cults of the dead by
various Akan peoples of the south-
eastern Ivory Coast and southern
Ghana. They were regarded as an
actual 'portrait' of the defunct
personage. The Sanwi and some
Ghanaian groups give these statuettes
the collective name *mma*, meaning
children or little people.

The Akan have made funerary
sculptures in terracotta for at least
four centuries. Originally this was
done to honour a deceased king or
queen mother, who would be depicted
surrounded by elders and officials.
By the 19th century the custom had
become more general, and such
figurines were made for any notable
man or woman whether or not of

royal blood. The whole assemblage of statuettes, representing the deceased with attendants (who sometimes numbered dozens), would be set out, not in the cemetery itself but in a secluded part of the forest nearby. The shrine so constituted was known as a *mmaso*. Here at certain times reverence was paid to the deceased, offering of food and drink being made to his or her spirit accompanied by prayers. *TFG*

Bibliography: Duchemin, 1946, pp. 13–14; Amon d'Aby, 1960, pp. 67, 70–2; Garrard, 1984, pp. 167–90; Féau, in Paris 1989, pp. 55–9

5.115

Female figure (*blolo bla* or *asie usu*)
Baule
Ivory Coast
20th century
wood
h. 30 cm
Private Collection, New York

The Baule of central Ivory Coast are justly famous for their visual art traditions, especially figurative sculpture and masks. Baule figures have mistakenly been referred to as 'ancestor figures', but in fact they represent two types of spirit: spirit mates in the other world or bush spirits who inhabit nature beyond the edge of human settlements. Both types of figure are similar in form, and each type is referred to by the Baule as a 'person in wood' (*waka sran*). Unless collected *in situ*, the actual function of a figure cannot readily be determined.

The Baule believe that each person has a mate of the opposite sex who lives in the 'other world' (*blolo*); a man has an 'other-world woman' (*blolo bla*) and a woman has an 'other-world man' (*blolo bian*). The existence of this other-world partner is usually revealed through divination following a crisis of young adult life, such as inability to conceive or a problem related to marriage. To resolve the problem, one commissions the carving of a figure as a stand-in for the other-world mate and one typically spends one night a week alone to receive this person in dream visits; on the following day offerings are placed in a small bowl at the feet of the figure.

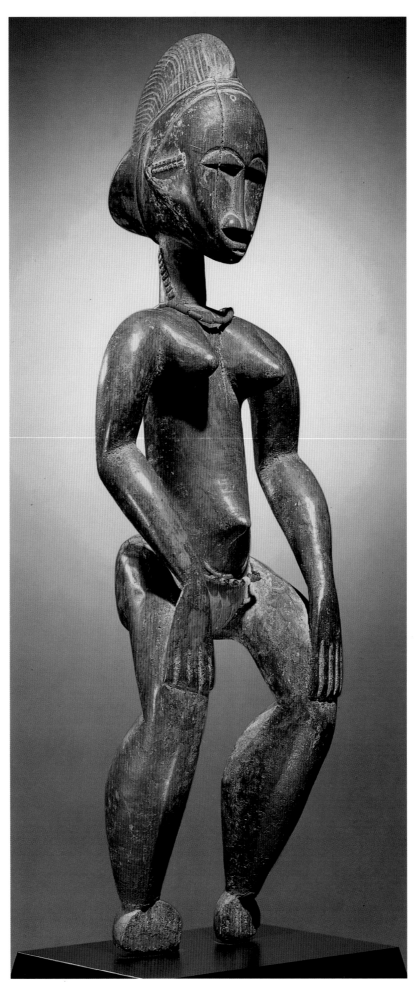

Figures are also carved as intermediaries to bush spirits who may intervene in a person's life to cause madness or to confer clairvoyance, thus enabling one to divine through trance dances. When they function to localise a troublesome spirit, these figures may receive libations and develop an encrusted surface. The figures used by diviners, however, are usually handled with care and often a figure is displayed near the diviner during a public performance.

This unusually strong female figure presents many characteristics of Baule figurative aesthetics: the head has a finely depicted coiffure and a composed face with downcast eyes, set off from the body by a strong neck; and the torso, with high, small breasts and gently swelling abdomen, is set off from the lower body by the aesthetically important, curving iliac crest of the pelvis that is further emphasised by the added hip beads. It is the artist's treatment of the limbs, however, that captures our attention: frontally, the emphatically long arms, which lead to the hands in a position of rest just above the knees, frame the torso and create a strong vertical axis to the figure; in profile, the long arms and legs reveal, in their flexed tension, not only a sense of composure but a sense of movement and power – an identity and character that makes communication possible. *PR*

Bibliography: Vogel, 1977; Ravenhill, 1980; Vogel, 1980; Ravenhill, 1994

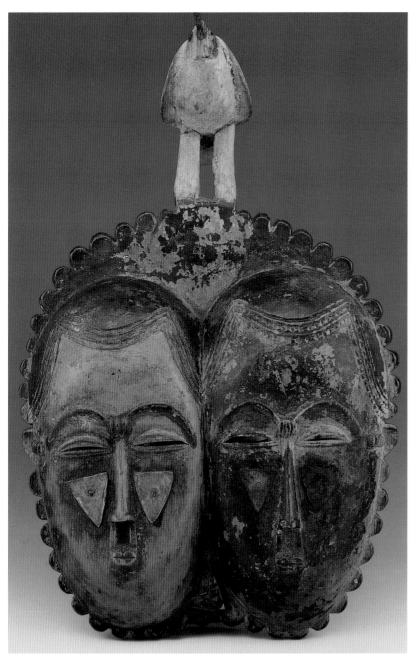

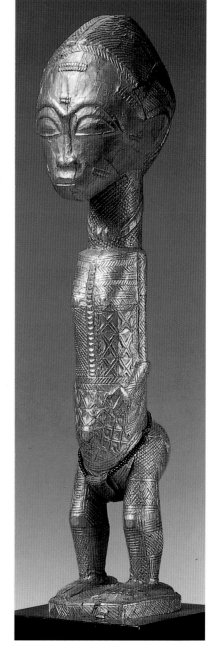

beard of masks attributed to the Yaure, into systematic distinctions that may be more imagined than real. What the supposedly different styles have in common is an emphasis on smooth, 'classic' beauty of the face as framed by a (usually) elaborate and textured coiffure; and an exploration of artistic creativity in the super-structural element(s). *PR*

Bibliography: Vogel, 1977; Ravenhill, 1980; Vogel, 1980; Ravenhill, 1994

5.116

Double face mask

Yaure, Baule or Guro
Ivory Coast
19th century
wood, metal
27.3 x 10.2 x 11 cm
Trustees of the National Museums of
Scotland, Edinburgh, 1907.272

Unlike the large helmet masks of often ferocious form, which are not supposed to be seen by Baule women, the small anthropomorphic or zoomorphic face masks that the Baule call *ngblo* can loosely be considered entertainment masks. They are worn by male dancers who perform in public theatres or who dance for funerals. The masks appear in suites, with ani-mal forms, both domestic (e.g. sheep or goats) and wild (elephant), preceding human face masks. These masks represent social roles or may be in-spired by the beauty of real people and hence be like portraits. Human face masks, as in this example, are often surmounted by a zoomorphic decorative element that demonstrates the artist's creativity and skill.

In central Ivory Coast there is considerable stylistic overlap between Baule, Yaure and Guro face masks, and it is difficult to ascertain actual attributions and distributions. The three separate ethnic 'styles' are principally a convenience covering attributions that codify supposed characteristics, such as the rick-rack

5.117

Gilded male figure

Baule
Ivory Coast
20th century
wood, gold foil
h. 26 cm
Private Collection, Paris

Wood sculptures covered in gold, called *sika blawa*, are made and used by the Baule as prestige items for public display. Most often the surface of the sculpture is carved with cross-hatching, striations and geometric patterns in order to create a faceted surface that, when covered with gold foil, gives rise to an interesting play of light. Figures, flywhisks and staffs are used as regalia to call attention to the power of chiefs or the social standing of a family when used in public display on ceremonial occasions.

The gold-covered figure, apart from its surface decoration, clearly follows Baule conventions of an artistic idealisation of the human form. The importance of facial aesthetics in appreciating personal beauty leads to an emphasis on the head, making it out of scale to the proportions found in nature. The composure of the body conveys a sense of being that is also found in the artist's interpretations of the gaze, the gaze of a sentient being, a 'person in wood' or *waka sran*. *PR*

Bibliography: Vogel, 1977; Vogel, 1980; Ravenhill, 1994

5.118

Door

Baule
Ivory Coast
19th–20th century
wood
h. 146 cm
Musée Barbier-Mueller, Geneva, 1007.3

Many of the most famous forms of
Baule art, such as masks and figures,
were not highly visible in their
original context. Figures were often
placed in private shrines in private
homes, and masks appeared on rela-
tively rare occasions, and then only
briefly. In traditional Baule society,
however, there were a number of art
forms that were intended to enjoy
high visibility, with the weaver's
heddle pulley being the publicly
displayed work of art *par excellence*.
Doors carved with low-relief figura-
tive or abstract decoration were
another form of public art, although
today they are no longer made.

After the crocodile or the monitor
lizard, the most common animal
depicted on Baule doors is the fish,
though the portrayal of two large fish
on this door is unusual. Representa-
tions of fish on Baule doors tend to
be orientated vertically and most
commonly a single large fish is carved
with its head to the top and with a
small prey in its mouth. The artist
who carved this door created a
dynamic composition of two plump
fish that seem to evoke complemen-
tarity and similar movement.
The different angles of placement
combine with a relatively high relief
for the fish and a low-relief planar
background framed by semicircles,
producing a three-dimensional work
that *in situ* would have been further
emphasised by the frame of a
doorway and the play of raking
sunlight. *PR*

Provenance: before 1939, acquired for
Josef Mueller Collection

Bibliography: Holas, 1953; Vogel, 1993,
p. 16

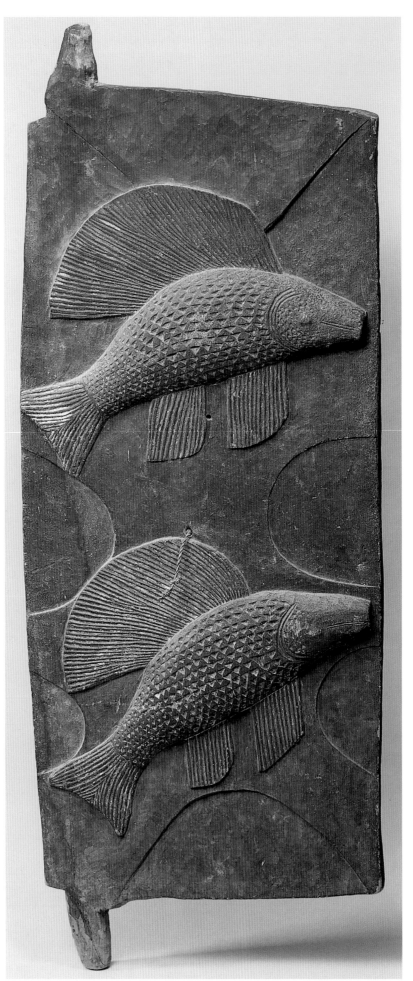

5.119

Mask (*sakrobundi*)

Nafana
Bondoukou District, Ivory Coast
19th century
wood, pigments
h. 146 cm
The Trustees of the British Museum,
London, 1934.2

This impressively sculpted and paint-
ed face mask is one of the treasures
of African art in the British Museum.
Collected at the very end of the
19th century by Captain Sir Cecil
Armitage, it was acquired at a critical
juncture in British and French rela-
tions on the west African coast. Both
powers were seeking to extend their
spheres of influence inland, and
competition between the two was
intense. Each dispatched numerous
official missions to the interior
between 1879 and 1889 in the hope
of establishing diplomatic and
commercial ties with Ardjoumani,
the powerful Abron ruler of Jaman.
Of particular interest to both was
Bondoukou (Bontuku), the principal
town of the kingdom and an ancient
Mande commercial emporium, for
they were not only aware of its
economic stature, but also recognised
its strategic position as the gateway to
the north and to Islamic territories
that were believed to stretch to the
Mediterranean. After nearly ten years
Ardjoumani accepted the French flag,
signed a treaty and opened the trade
routes between his kingdom and the
French post at Krinjabo on the coast.

It is from this period that the earli-
est accounts of *sakrobundi* emerge.
R.A. Freeman, a medical officer and
member of the British Mission from
Cape Coast to Bondoukou in 1888–9,
encountered *sakrobundi* in two com-
munities in the Gold Coast interior:
at the Bron town of Odumase and in
the Nafana village of Duadaso, only
ten miles east of the French frontier
at Bondoukou. He recorded his im-
pressions and sketched for posterity
'the Great Inland Fetish', a masked
presence concealed in a full-length
raffia costume. Thirteen years later
Delafosse documented the paramount
shrine of *sakrobundi* in the Nafana
community of Oulike, north-east of
Bondoukou, illustrating the mud
reliefs of a *sakrobundi* mask with
a coiled snake and staff on the walls
of the shrine. *Sakrobundi*, at this
time, was clearly a powerful spiritual

presence in Jaman and adjacent portions of the Gold Coast, and especially in Nafana villages within the shadow of Bondoukou (which was under the spiritual leadership of Imam Malik Timitay, the Muslim authority of the city).

Sakrobundi was to retain its influence, despite the growing colonial presence, well into the 1930s, when it was suppressed by French and British missionaries. Their assaults drove the masquerade itself out of existence, but the tutelary spirit survived and was still functioning in the 1960s. As the public face of a cult noxious to colonial sensibilities, the *sakrobundi* was retired or, as the Nafana elders of Oulike said, 'it was put to rest'. This *sakrobundi* mask from Jaman in the British Museum is a vivid example of the evanescence of masking traditions under duress. In its time this large, flat, oval-faced mask, crowned with horns and richly painted in red, white and black patterns, was undoubtedly a powerful spiritual presence. *RAB*

Provenance: collected by Sir Cecil Armitage

Bibliography: Underwood, 1953, fig. 20; Fagg, 1969, no. 128; Bravmann, 1974, pp. 102–6; Bravmann, 1979, pp. 46–7

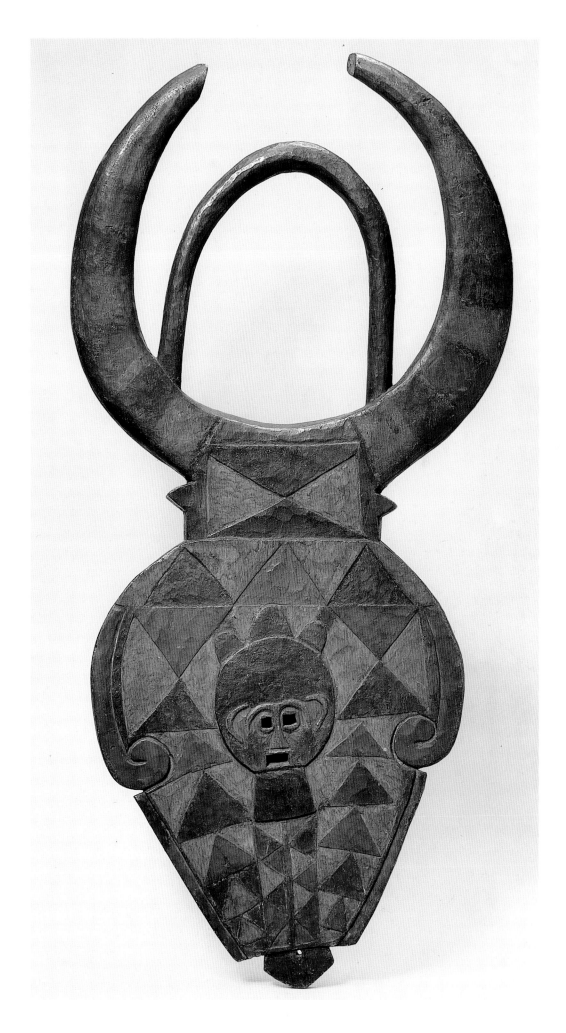

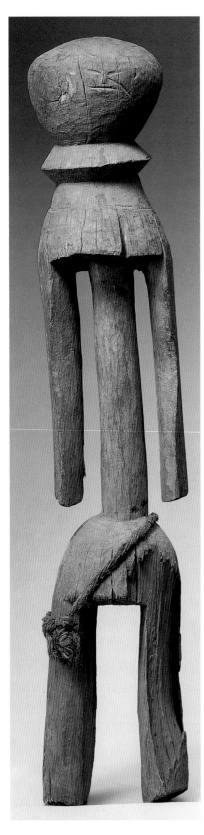

5.120

Shrine figure (*tchitcherik sakwa*)

Moba
Togo
19th century
wood
h. 125 cm
Museum für Völkerkunde, Leipzig

Among the Moba of northern Togo wooden figures called *tchitcheri* (sing. *tchitcherik*) are prescribed by diviners to enhance the efficacy of personal, household and village shrines. Carved of a single piece of wood, *tchitcheri* are rendered abstractly in human form. This figure conforms to broad stylistic conventions common among Moba figures: the ovoid head, neck ring, broad chest and flaring hips stand in marked contrast to the elongated, recessed torso and the vertical axis of the figure. As with many Moba figures, facial features are absent and the hands and feet are minimally carved. In some examples gender is evidenced by a carved penis, a vertical incision suggesting the vagina or small protruding breasts.

The large, broad size of this particular shrine figure probably characterises it as belonging to the category called *tchitcheri sakab* (sing. *tchitcherik sakwa*; *sakab* means 'old men'). In most field contexts these impressive statues are planted in the ground at least to groin level and sometimes to mid-waist. Some are embellished with a cotton smock or straw hat, or carry a hoe. They represent and are named after the ancient founding clan ancestors, or their children. They are associated with earth shrines, called *tingban*, maintained by particular families who serve as custodians to shrines dedicated to the earth.

Given the association of these images with founding ancestors, the general belief among the Moba is that the figures are 200 years old or more; thus, there is no contemporary tradition for carving new or replacement *tchitcheri sakab*. *CMK*

Provenance: 1900–1, collected by Dr H. Gruner

Bibliography: Zech, 1904; Frobenius, 1913, p. 430; Zwernemann, 1967, p. 118; Kreamer, 1987, pp. 52–5, 82–3

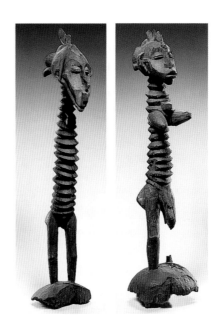

5.121

Pair of helmet mask crests

Senufo
Ivory Coast
early 20th century
wood, fibres
h. 76 cm and 73 cm
Musée National de la Côte d'Ivoire, Abidjan, A 1535/6

These two figures are the surviving crests from a pair of helmet masks that would originally have been about 100 cm high. Only a very small number of such helmet masks are known. The figures are carved without arms (in a few cases also without legs), and their bodies are dramatically reduced to a column of two-faceted rings.

Although these helmet masks come from the region inhabited by the Tyebara, a Senufo dialect group, they were neither made nor used by them. My enquiries in 1990 confirmed that they were used uniquely by the Fodonon, another Senufo dialect group, at the villages of Lataha and Seridjakaha. The Fodonon, however, had no sculptors, and therefore commissioned these masks from a third Senufo subgroup, the Kulebele, who were professional sculptors. The Kulebele carved these masks for the Fodonon at Koko, a quarter of Korhogo (about 15 km from Lataha), where the Belgian ethnographer Maesen collected the first known pair in 1939.

Pairs of such helmet masks were owned by the Fodonon men's secret societies known as 'Ponno' (the equivalent of the Poro societies of the Tyebara). Each society kept one male-female pair in its sacred forest. There were formerly seven men's Ponno societies at Lataha, though they have today been reduced to three by amalgamation. The masks came out at night for the funeral rites of a Ponno member, held some time after the actual interment. They also appeared at the great communal funeral commemorations held every few years. They were worn by initiates walking in procession around the village, and followed by others who struck each other with whips or bare hands or even threw burning straw on each other.

Around 1950 the practitioners of a new cult known as Massa arrived at Lataha and demanded that the Ponno societies abandon their sacred statuary. In the ensuing panic the sacred forests were emptied of their major statues, but by good fortune these, including the present crests, were rescued and preserved by French missionaries.

In 1990 the Ponno initiates of Lataha offered a convincing explanation for the ring-like bodies of these crests, and the absence of arms. At the commemorative funeral, which can take place long after the actual interment, the corpse is represented symbolically by a white cloth twisted into a rope and tied at each end. An initiate dances with this at the funeral rites; it is then carried to the cemetery and thrown on to the grave. All present then run back to the village without looking behind them. The ringed body of the sculpture is said to depict this twisted white cloth representing the corpse. *TFG*

Exhibition: Paris 1989

Bibliography: Clamens, 1953, pp. 78–9; Goldwater, 1964, pp. 21–2, figs 80–4; Förster, 1988, pp. 60–1; Diarrassouba, in Paris 1989, pp. 90–1; Koloss and Förster, 1990, pp. 14–16, 40; Convers, 1991, pp. 24–34; Glaze, in Barbier, 1993, ii, p. 14

5.122a

Dance-mask, female (*gu*)

possibly Igbo
Nigeria
wood
30 x 14 x 13 cm
Herman Collection

5.122b

Dance-mask, male (*zaouli*)

northern Guro
Ivory Coast
wood, fibres
27 x 16 x 10 cm
Musée National des Arts d'Afrique et
d'Océanie, Paris, MNAN 1963.184

5.122c

Dance-mask

Guro
Ivory Coast
wood
h. 35 cm
Museum Rietberg, Zurich
Collection Baron E. Von der Heydt,
RAF 510

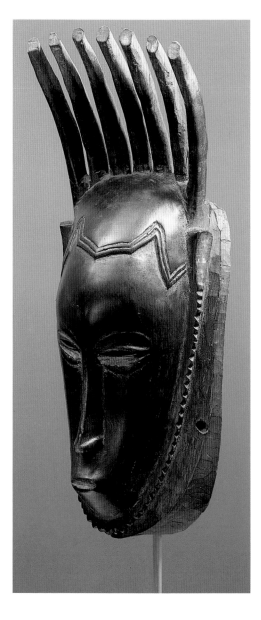

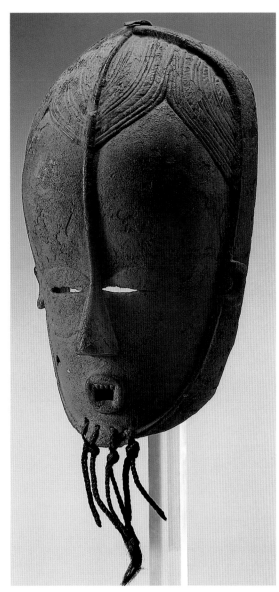

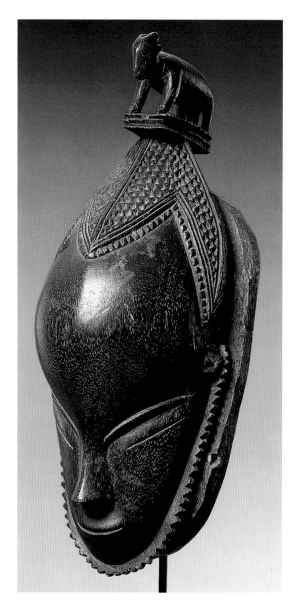

These dance-masks are examples of the refined styles found among the Guro of central Ivory Coast, whose sculpture is notable for its elegance and meticulous detail. They probably come from villages in the region of Zuenoula, among the northern Guro.

Such masks are used in a well-known village masquerade which generally has a 'cast' of three characters. One, known as *gu* (cat. 5.122a) – though this is possibly an Igbo mask – is a beautiful young woman, her hair dressed in a series of plaits some of

which combine to form a central crest. Another is *zaouli* (cat. 5.122b), an elderly man whose beard in this example is depicted by a fringe of short cords attached to the chin. The third character, *zamble* (not represented here), is an antelope, sometimes identified as the bushbuck (*Tragelaphus scriptus*), a species common in the region.

From time to time dance competitions are held between neighbouring villages at which these masks perform. Sometimes *zamble* appears

with *zaouli*, in which case the antelope is taken to be the sister or wife of the old man. Alternatively *zamble* dances with *gu*, in which case the antelope is the husband and the beautiful young woman his wife. At the close of the competition, the *gu*-mask representing the wife of the victorious *zamble* appears and together with him dances around the whole village.

Such masquerades in various forms are a popular entertainment in central Ivory Coast. They exist not only

among the Guro, a Mande group, but also among their eastern neighbours, the Yaure and Baule. All these peoples have produced sculptors of exceptional talent, and their dance-masks rank among the finest in west Africa. *TFG*

Exhibitions: cat. 5.122b: Le Havre 1965; Paris 1972, no. 75

Bibliography: Damman, 1966; Neauzè, 1967, p. 170

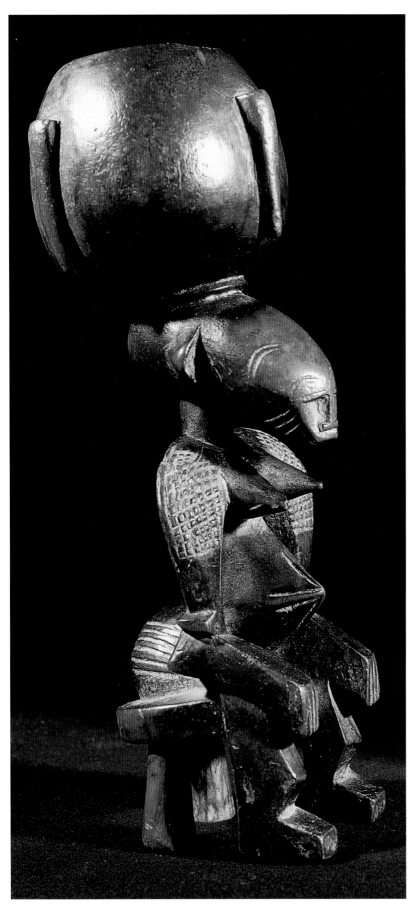

5.123

Diviner's figure

Senufo
Ivory Coast
20th century
wood
h. 29 cm
Jean and Noble Endicott

This small female statue, seated on a four-legged Senufo stool and bearing a bowl on her head, is a representation of a bush spirit. It would originally have had a female partner, depicted either free-standing or seated on a horse. Such a pair forms part of the essential equipment of the diviner or soothsayer (*sandoo*); the statuettes both represent and serve as the abode for the pair of bush spirits who are believed to be in communication with the diviner.

The practice of divination is universal among the Senufo, and practitioners of the art are to be found in every village. They consult the spirit in order to help a client resolve problems and obtain better fortune. Most diviners are women, though the calling is also open to men. The statuettes are set out with other paraphernalia in the tiny consulting room, and the diviner plies them with a long stream of questions in the course of the séance. In 1934 the missionary Father Knops noted an instance where a female figure of this kind, bearing a bowl on its head, was brought out into the open and danced around by all the members of the *sandogo*, the village divination society.

The bush spirits, variously called *mandeo*, *ndeo* or *tugu* (pl. *mandebele*, *ndebele*, *tugubele*), form the subject of a great quantity of Senufo sculpture. In addition to the diviner's personal statuettes mentioned above, it is common for a diviner to prescribe that the client himself obtain a pair of such statuettes to keep in his house. This is particularly the case where a client claims to have seen such a spirit in the bush, or in dreams, or where the diviner learns that a bush spirit is seeking to follow, befriend or trouble the client. The statuettes purchased by the client are in most cases a simple pair of matching, free-standing figures; the more elaborate figures, seated on horseback or bearing a pot on the head, are almost exclusively reserved for the diviner. *TFG*

Bibliography: Goldwater, 1964, pp. 24–5; Glaze, 1981, pp. 54–69; Förster, 1988, pp. 87–8; Glaze, in Schmalenbach, 1988, p. 81

5.124

Standing bird

Senufo
Ivory Coast
19th–early 20th century
wood
h. 149 cm
The Berggruen Collection, London

In former times many of the men's secret Poro societies in the Senufo region owned a large standing sculpture of a bird. This statue, kept in the sacred forest, was used in the rites for the admission of initiates to the final phase of training. It generally had a hollowed base, which permitted it to be carried on the head of an initiate. Some examples also have holes in the wings, through which cords were passed to steady the bird when carried.

The identification of this bird is uncertain. Its large curved beak suggests a species of hornbill, but there is no unanimity among the Senufo informants, who identify it variously as a hornbill, crow, vulture, eagle or buzzard. Older Senufo, however, usually name it as *sejen* or *fijen* (according to dialect), a term that simply means 'the bird'.

The significance of this bird is indicated more clearly by two other names. It is sometimes called *kasingele*, 'the first ancestor', which may refer either to the mythological founder of the human race or to the ancestral founder of the sacred forest.

Alternatively, it is named *poropia nong*, which means literally 'mother of the Poro child'. The statue is thus a primary symbol of the Poro leadership, indicating the authority of its elders. In the language of Poro these elders are collectively known as *katyleeo*, 'the old woman', since they stand in the position of 'mother' to the junior initiates. The juniors themselves are called *poro piibele*, 'children of Poro'. *TFG*

Bibliography: Goldwater, 1964, p. 28, figs 148–9; Förster, 1988, p. 75; Bochet and Garrard, in Barbier, 1993, ii, p. 31

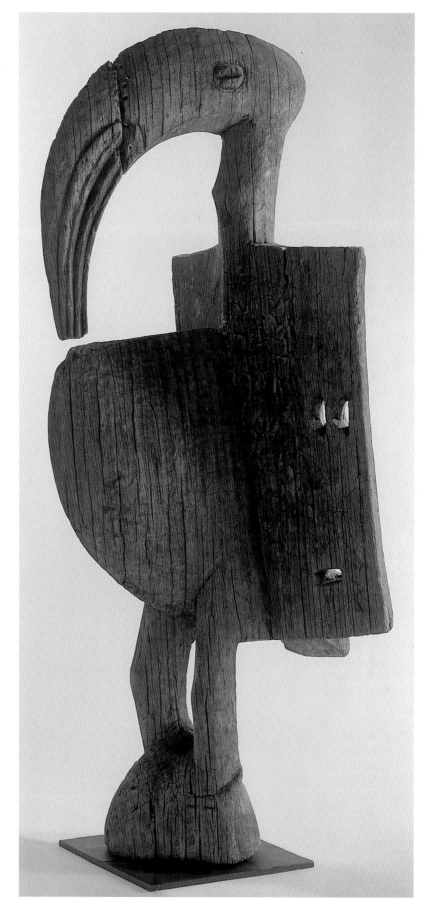

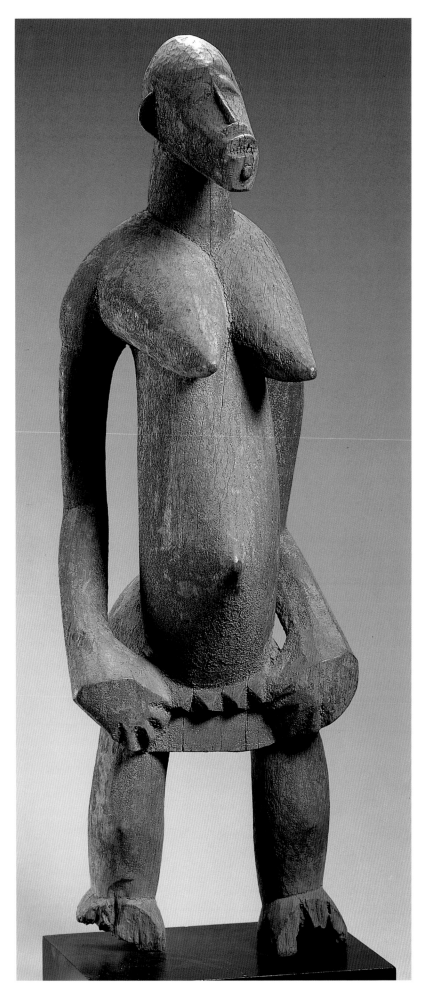

5.125

Female figure

Senufo
Ivory Coast
early 20th century
wood
h. 78.5 cm
Royal Tropical Institute/Tropenmuseum,
Amsterdam, 4133.29

While the Senufo blacksmiths and professional sculptors carved countless small statues, generally under 30 cm in height, those of larger size are relatively rare. This fine example of the larger category could have been used in a number of ways, but has no particular distinguishing features or attached ornaments that might enable its precise context of use to be established. Nevertheless its badly eroded feet suggest that it was used for display in a permanent fixed position, standing on the ground, and probably indoors rather than outdoors since the rest of the body is relatively well conserved.

Such large-scale statuary was occasionally commissioned in the past by the male Poro societies and by their female equivalent, the Tyekpa. In the case of the Poro, a pair of large statues was sometimes placed on public display at the wooden shelter where the initiates gathered to celebrate funerals, a custom now abandoned owing to frequent theft of the statues. The societies sometimes commissioned statues to be carried in procession on the heads of the initiates, or placed on the ground to serve as a focal point for dancing.

The present statue, on the other hand, is more likely to have been carved for the owner of a *yasungo*, a large 'fetish', shrine or power object on which sacrifices are made. Such shrines were often located indoors, away from public view. The nature of the *yasungo* shrines varied and in the absence of precise documentation it is difficult to say what role this statue may have played.

It may be noted that, while some pairs of statues are said to represent the 'first ancestor' (*kasingele*), the concept of portraying in sculpture an actual named ancestor seems to have been unknown. In the same way, the idea of sculptural portrayals of a living person fills the Senufo with horror. It was regarded as a dangerous and threatening act, inviting a curse on the head of the person depicted or, in the case of a woman, rendering her sterile. The sculptors say that if such a statue was made, it would be to harm a person. They add that if a girl tried to refuse them in marriage, they would retaliate (but only in jest) by threatening to carve a statue of her. *TFG*

Bibliography: Goldwater, 1964, pp. 23–5; Glaze, in Barbier, 1993, ii, p. 24

5.126

Ritual pounder

Senufo
Ivory Coast
early 20th century
wood
h. 95 cm
Museum Rietberg, Zurich, RAF 301

Among the finest of Senufo sculptures are the large ritual pestles or pounders carved as a male or female figure. These were formerly owned by many Poro societies both in the Ivory Coast and in Mali. Initially carved as pairs, it sometimes happened that one broke or decayed to the point of being un-usable, in which case a replacement would be commissioned, often from a different carver. It could thus happen that a functional 'pair' kept in the sacred forest was in fact by two different carvers.

The present example is one of the eight pounders removed from the various sacred forests of Lataha about 1950 on the orders of the Massa cult. It was no longer in use, having lost its base, and two male pounders were also badly damaged; but the five others were intact. A man from Lataha who was an initiate at the time recently identified the present pounder as coming from Kofile ('white forest'), one of the three sacred forests still existing in the village.

These sculptures were used mainly (but not exclusively) in the various rituals that took place before and after the burial of a deceased Poro elder. They are carried by initiates who visit the house of the deceased. One is sometimes placed beside the corpse in its shroud at the public ceremonies that follow. They then accompany the corpse to its burial place, swung and pounded on the ground in time to the solemn music of the Poro orchestra. When the interment is complete and the soil rapidly heaped over the grave – which occurs shortly before nightfall – a male initiate may, in a final and decisive gesture, leap into the grave with a pounder and beat the soil seven times. This pounding ensures that the spirit of the deceased person does not linger in the vicinity, but passes on its way to the 'village of the dead'. The pounders may also be used in supplementary rituals on the ensuing days.

In the Fodonon dialect spoken at Lataha the ritual pounder is called *ponno shon* ('person of Poro') or *pon pia* ('child of Poro'). It is also known as *denge* or *madengo* ('bush spirit'). Analogous names are given in the Tyebara dialect of Korhogo. In the literature the pounder has almost always been called a '*déblé*'; this is a corrupt rendering of the plural of the Tyebara name for a bush spirit – *ndeo* (pl. *ndebele*). Elsewhere, in dialect areas west of Korhogo, the carved pounder is simply known as *dol* (pl. *dogele*), a pestle. TFG

Provenance: ex collection Emil Storrer

Exhibitions: New York 1964; Zurich 1988; Berlin 1990

Bibliography: Clamens, 1953, pp. 78–9; Goldwater, 1964, pp. 22–3, fig. 94; Förster, 1988, pp. 68–70; Diarrassouba, in Paris 1989, p. 87; Koloss and Förster, 1990, pp. 14–20; Convers, 1991, pp. 31–4; Glaze, in Barbier, 1993, ii, p.22

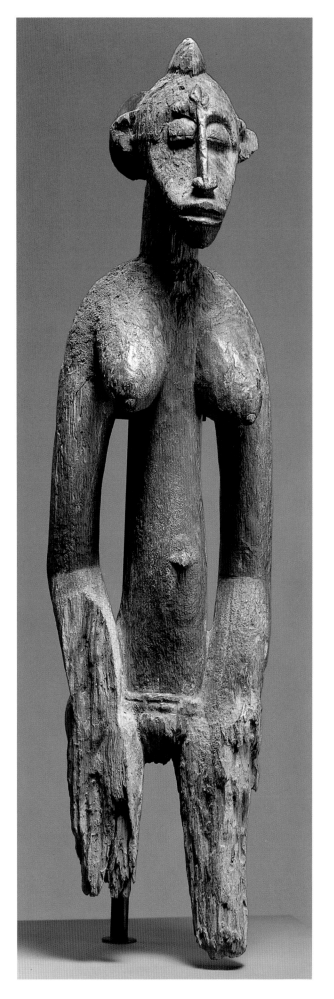

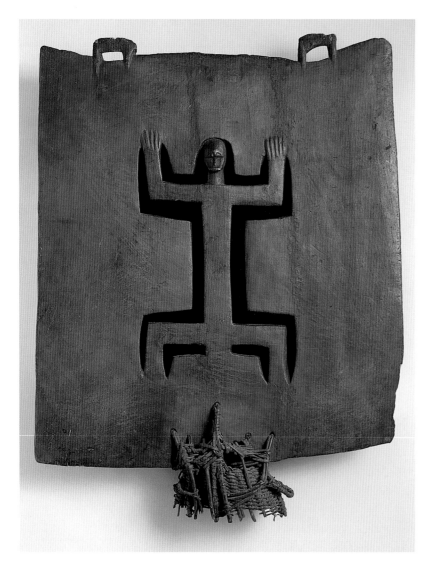

5.127

Ceremonial headdress

Senufo
Ivory Coast
20th century
wood, fibres
h. 98 cm
Musée National des Arts d'Afrique et
d'Océanie, Paris, MNAN 65.1.4

The Senufo Poro (a male initiaton
society) is not a monolithic organisa-
tion but a multitude of independent
village societies whose customs and
artistic traditions vary quite consider-
ably, not only from one region to
another, but even within the same
dialect group. The present headdress
provides a good illustration of this
tendency. It takes the form of a rect-
angular plank carved with a stylised
human figure, and supported on a
wicker headpiece. Ceremonial head-
dresses of this kind were unknown to
the Poro societies of the Tyebara and
Fodonon, but were apparently con-
fined to the Nafara in the region of

Sinematiali, some 30 km east of
Korhogo.

These headdresses were displayed
by the initiates at a great public
festival held to mark the conclusion
of the intermediate period of Poro
training, known as *kwonro*. After the
festival the initiates entered the sacred
forest to undergo a ritual death and
rebirth; this qualified them for the
final seven-year period of training
(*tyologo*) in the initiation cycle.

For their public appearance the
headdresses were painted with poly-
chrome designs of squares or spots in
natural pigments.

The custom of using them fell into
abeyance some decades ago. In the
literature they have been named both
as *kwonro* and as *dagu*. TFG

Bibliography: Goldwater, 1964, pp. 20–1,
figs 75–9; Knops, 1980, pp. 144, 199;
Förster, 1988, pp. 17–19; Féau, in Paris
1990, p. 162; Koloss and Förster, 1990,
p. 43; Glaze, in Barbier, 1993, ii, p. 18

Group of small masks

Miniature masks replicate the forms
of the much-admired face masks well
known from Liberia and the Ivory
Coast. For the peoples of this forested
region, the Dan, Mano and Wenion,
masks too small to be worn are power-
ful charms. They are kept hidden,
destined for personal protection or
enhancement, in contrast to the face
masks worn by performers on public
occasions for communal benefit. All
masks, no matter how delicate, comic
or crude their form or behaviour, are
invested with the powerful vitality of
the forest, a vitality that fosters well-
being and protection against harm.
This identification with the forest
imbues masks with such importance
that even tiny versions possess power.

Because performing with a wooden
face mask and costume was a wide-
spread practice until the 1960s, there
were tens of thousands of masks to be
found in the forest zone. The variety
of these regional masks is enormous,
although never departing from the
frontal facial form. The inhabitants
themselves class these performers and
their face masks into general social
categories such as male, female and
unusual or deviant types. Small Dan
masks modelled after these three
categories are included here: male,
female and distorted.

People of this region also categor-
ised masks according to social func-
tions, such as adjudicator, debt
collector, warrior, dancer, singer,
actor, hunter and delinquent. In
practice, before the 1960s there was
hardly a social activity that lacked
the involvement of an active masker:
enlisting workers to clear paths, re-
calling a runaway wife, entertaining
women cultivators, snatching feast
food to distribute to children, spying
on clandestine projects. These per-
formance masks were inspired by
dreams sent to men by forest spirits
who wished to be manifested and
honoured in the human community.

Each face mask had its own name,
which alluded to its specific nature or
powers, and its own porter, a male,
who performed in it. At his death, the
mask passed on to another member of
his family indicated by spirit-inspired
signs. In spite of the link between a
mask and its performer, masks belong-
ing to members of a lineage were
considered the possession of that

lineage and performances were
supervised by lineage elders.

One of the major motivations for
creating small masks derives from a
strict rule that protects the public
persona of the masked performer
spirit but denies acclaim to the
wearer. The human porter must
never identify himself as the mask
wearer or utter a public statement
on his relationship to a mask. He or
a lineage elder are, however, entitled
to commission a hand-sized model
(13– 15 cm), keep it as a private altar
and make sacrifices to it to advance
their interests in an undertaking or
to counter witchcraft, thus gaining a
personal advantage. Their frequent
sacrifices over this mask-altar with
bits of food, sauces, blood and oil
produce an encrusted surface, as
in the Mano example (cat. 5.128h).
Another way to enhance the porter's
importance is for him silently to
display a small model within the
councils of men, especially on visits
to other communities. This identifies
him as a mask porter or as a member
of a powerful lineage.

In the forest region the uses of
small masks are almost as varied as
for the larger versions. As sacred
objects they function within the rites
of men's secret societies. For example,
at Dan secret society initiations small
masks are placed on the path that
leads to the meeting place and aspir-
ing members must pay to have them
removed; along with other talismans
they are displayed on a tray to mem-
bers as representations of the benevol-
ent masked spirits of the area. A cir-
cumciser may wipe a small mask with
his knife to purify the blade of harm-
ful forces. Boys in the Dan circum-
cision camp try their hand at carving
small hand-sized masks and this may
lead to spirit-inspired dreams of
becoming a masked singer or dancer.

Among the Mano masks that share
most closely the styles and functions
of the Dan are miniatures used by
feminine style performers who carry
out tasks such as seeking food in the
village for the boys and girls in the
initiation camps or entertaining at
festivals. Other small Mano forms,
such as cat. 5.128o, which may have
been carved in commemoration of
powerful men or women of the family
or lineage, are kept at personal altars.
A stylistic variation occurs among the
northern Mano in the use of face

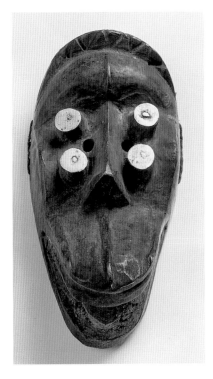

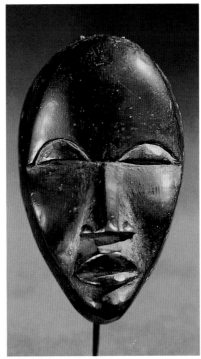

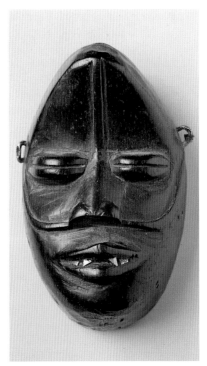

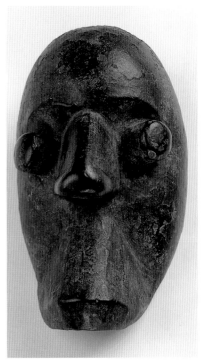

5.128a
Dan (Yacuba, Gio, Geh)
Liberia, Ivory Coast
20th century
wood
h. 15.5 cm
Museum für Völkerkunde, Vienna,
155.162

5.128b
Dan
Liberia, Ivory Coast
20th century
wood
h. 13.7 cm
Jean and Noble Endicott

5.128c
Wenion (Wè, Guéré)
Liberia, Ivory Coast
20th century
wood
h. 10.7 cm
Private Collection

5.128d
Dan (Yacuba, Gio, Geh)
Liberia, Ivory Coast
20th century
wood
h. 13.5 cm
Museum für Völkerkunde, Vienna,
126.166

5.128e
Dan (Yacuba, Gio, Geh)
Liberia, Ivory Coast
20th century
wood
h. 12 cm
Museum für Völkerkunde, Vienna,
126.168

5.128f
Dan (Yacuba, Gio, Geh)
Liberia, Ivory Coast
20th century
wood, vegetable fibre, copper
h. 17 cm
Musée National des Arts d'Afrique et
d'Océanie, Paris, A 83.1.2

5.128g
Dan (Yacuba, Gio, Geh)
Liberia, Ivory Coast
20th century
wood, cloth
12 x 7 cm
Herman Collection

5.128h
Mano
Liberia, Ivory Coast
20th century
wood, encrustation
h. 13.1 cm
Jean and Noble Endicott

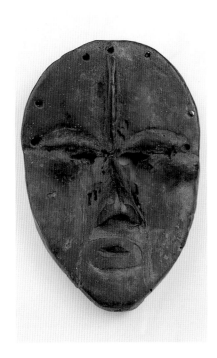

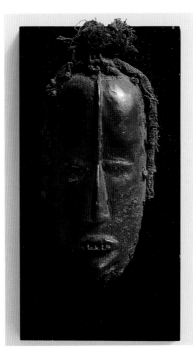

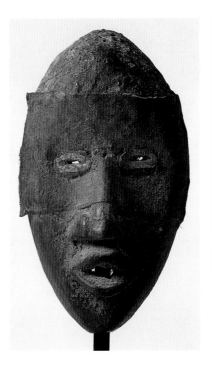

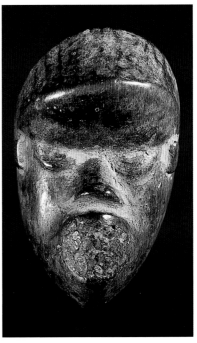

masks combining human and bird-beak features. These are associated with the ceremonies of the men's secret initiation society (*ge bon*). The reduced version shown here (cat. 5.128w) is not to be worn, but is placed in the initiation camp or field hut as a guardian against harmful spirits or theft.

Diviners initiate the commissioning of small masks for various purposes. For men seeking protection during forest work, travel or other risky situations, the diviner may recommend carrying a hand-sized feminine style of mask wrapped under their garments. On the diviner's advice a tiny mask form (5–6 cm) may be hung in a bag on a child's body to prevent or cure illness. Treated with sacrificial oil, these masks develop a glossy patina. Although women are prohibited from possessing performance masks, a woman from a Dan family owning such a mask may commission a miniature to take with her when moving to her husband's household. After consecration and sacrifices the tiny mask is hidden in her basket of personal possessions, thus preserving contact with its powers.

Miniature models showing exaggerated masculine features are fairly rare in contemporary collections. The majority of small masks are in a pointed oval style with feminine facial features. An example of each kind from the Dan, cat. 5.128d and 5.128e, was collected in Liberia in 1936. Two of the earliest Dan examples shown here (acquired 1868) were hand-sized models decorated with beards of plaited fibre or monkey hair, bone tubes, beadwork and animal skin, with a black gummy substance in the hollow of the backs. (The substance is probably the remains of magical medicines.) These elaborations are rarely found in collections of miniature examples, perhaps because of collectors' taste for sculptural form. Cat. 5.128f, which exhibits an elegant reserve similar to carvings by the Guro who live east of the Dan, shows traces of a cotton and fibre headdress around the mask. Various surface effects result from offerings of masticated kola nuts (a stimulant) and palm oil, rubbed on the wood surfaces in order to maintain contact and obtain spiritual power for the owner's endeavours. The red-dish cloth across the face of cat. 5.128g corresponds to its use on larger versions, the colour indicating the vitality that protects the owner and threatens enemies.

The small Wenion masks illustrate typical variations known and used currently. Cat. 5.128r, with its slit eyes and cylindrical projections ('cheekbones'), exaggerated features and palm-fibre beard, is readily recognisable as a model of the youthful warrior masker who does not engage in the overtly threatening behaviour of the 'fighting warriors' but displays remarkable spurts of energetic dancing. The other two Wenion examples (cat. 5.128c,m) exhibit a thick-featured, bearded feminine form favoured for dancers and entertainers. The raised welts on cat. 5.128c running upward from the nostrils represent a facial scar that used to be given to both men and women of the southern forest zone. Other kinds of feminine-style Wenion masks resemble fine-featured Dan masks.

The many small masks exhibited here illustrate the diversity of personal styles among Dan, Mano and Wenion carvers and possibly those from other forest zone populations such as the Konor, Mau or Tura to the north of the Dan and the Bete to the east. *MA*

Bibliography: Becker-Donner, 1940, pp. 94, 97; Schwab, 1947, pp. 277–8, 364–5; Holas, 1952, pp. 125–7; Fagg, 1955, pp. 160–2; Himmelheber, 1960, pp.161–2; Girard, 1967, p. 155, pl. VII; Verger-Fèvre, 1980, pls 22, J6, Jll; Gnonsoa, 1983; Fischer and Himmelheber, 1984, p. 107; Herold, 1985, pp. 142–6; Adams, 1988; Verger-Fèvre, 1989, pp. 123–4

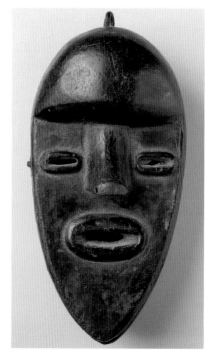

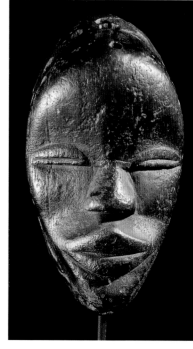

5.128i
Dan (?)
Liberia, Ivory Coast
20th century
wood
h. 14.6 cm
Private Collection

5.128j
Dan
Liberia, Ivory Coast
20th century
wood
h. 13.7 cm
Jean and Noble Endicott

5.128k
Dan (Yacuba, Gio, Geh)
Liberia, Ivory Coast
20th century
wood
h. 10.1 cm
Private Collection

5.128l
Dan
Liberia, Ivory Coast
20th century
wood
h. 10.1 cm
Private Collection

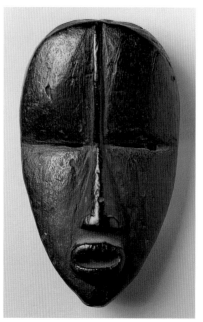

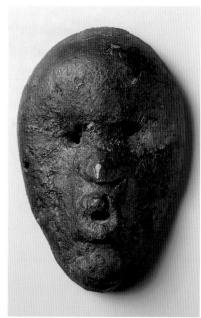

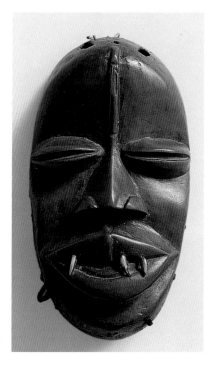

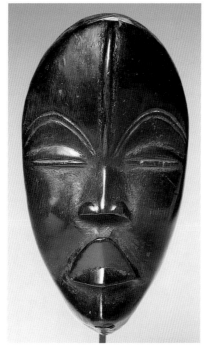

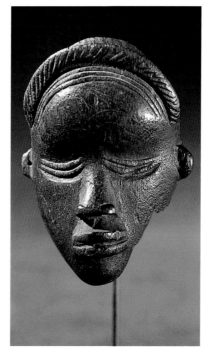

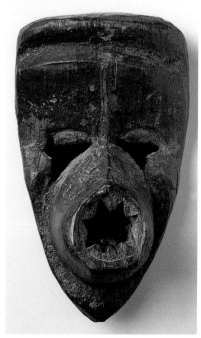

5.128m
Wenion (Wè, Guéré)
Liberia, Ivory Coast
20th century
wood, bone
h. 13.7 cm
Musée National des Arts d'Afrique et
d'Océanie, Paris, A 83.1.2

5.128n
Dan
Liberia, Ivory Coast
20th century
wood
14 x 7 x 3 cm
Private Collection, Paris

5.128o
Mano
Liberia, Ivory Coast
20th century
wood
h. 23 cm
Jean and Noble Endicott

5.128p
Dan (Yacuba, Gio, Geh)
Liberia, Ivory Coast
20th century
wood
h. 12.7 cm
Private Collection

5.128q
Mano
Liberia, Ivory Coast
20th century
wood
h. 10.7cm
Private Collection

5.128r
Wenion (Wè, Guéré)
Liberia, Ivory Coast
20th century
wood
h. 17 cm
Herman Collection

5.128s
Dan
Liberia, Ivory Coast
20th century
wood
h. 18 cm
Herman Collection

5.128t
Dan
Liberia, Ivory Coast
20th century
wood, cotton, iron
h. 15 cm
Musée National des Arts d'Afrique et
d'Océanie, Paris, A 67.1.8

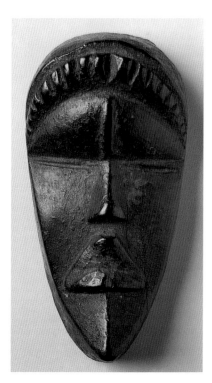

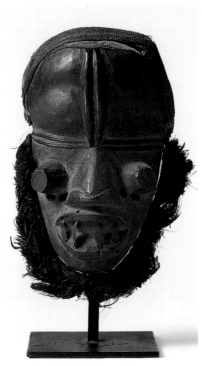

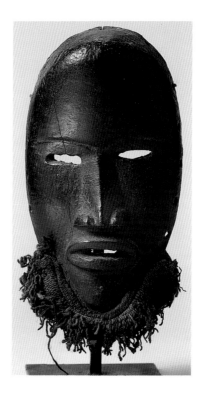

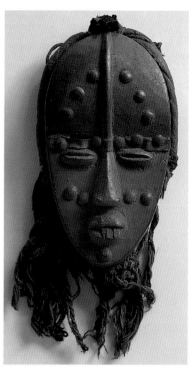

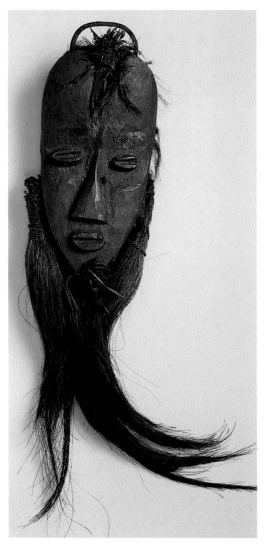

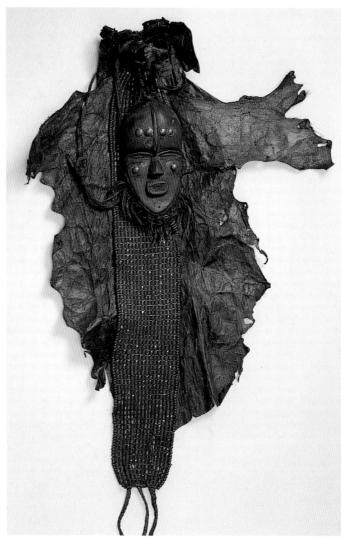

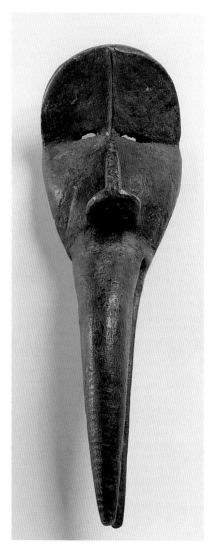

5.128u
Dan
Liberia, Ivory Coast
c. 1868
wood, fibre, animal skin, bone, beads,
gummy residue
37 x 9 x 5 cm
The Trustees of the British Museum,
London, 4572

5.128v
Dan
Liberia, Ivory Coast
c. 1868
wood, fibre, animal skin, bone, beads,
gummy residue
63 x 46 x 6 cm
The Trustees of the British Museum,
London, 4572

5.128w
Mano
Liberia, Ivory Coast
20th century
wood, metal
h. 23 cm
Museum für Völkerkunde, Vienna,
126.169

5.128x
Dan
Liberia, Ivory Coast
20th century
wood
h. 16.5 cm
Rosemary and George Lois Collection

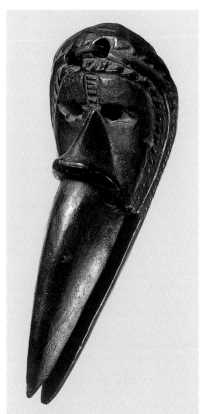

5.129

Many-eyed mask

Kru
Ivory Coast
20th century
wood, vegetable fibre
42 x 16 x 21 cm
Musée Ethnographique de Dakar,
CI, 55-1-52, on loan to the Musée National
des Arts d'Afrique et d'Océanie, Paris,
67.1.7

This spectacular mask with two rows of tubular eyes is a rare object and information about it is just as rare. Its unique feature is the exaggerated number of projecting cylindrical eye forms that elongate the facial planes. In a number of west African communities the phrase 'four eyes' refers to a person such as a seer or a witch to whom is attributed the power of seeing (with the extra pair of eyes) into realms and forces invisible to normal social beings. This metaphor may have inspired the multiplication of eye forms for masks, considering that masqueraders in numerous other communities are held to have such powers. Small holes for actual vision are punched alongside the nostrils.

Scholars now assign this mask to the Kru, a small population inhabiting the western coastal region of the Ivory Coast. The Kru are known to have produced a few other masks resembling this one, with a flattened base, one or more pairs of tubular eyes, a thin nasal ridge and a rectangular mouth with projecting parallel lips. The mask is carved from a single piece of wood, a practice that is typical of sub-Saharan African sculpture, although on some Kru masks the cylindrical eyes and other details are added.

In the coastal region masks were painted typically with irregular triangular or round areas of ochre and white pigment from local sources and laundry blue from markets. The dark surface of the mask seems to be the result of a coating of redwood powder and a vinyl glue, applied in a misguided effort to seal the many insect holes. The beard is attached to a fibre strand held by hooks on either side, but there are no holes along the sides for the attachment of a costume to hide the porter of the mask.

Masking was not a prominent institution among the Kru. No one has reported seeing this particular kind of long flat mask in use. In addition to this rare form, there are two other varieties of the abstractly featured Kru mask: one with a wooden disc or carved horns extending beyond the face; the other, with or without extensions, adds a massive forehead that projects over the face. The latter kind includes the two Kru masks owned by Picasso, undoubtedly collected in the Ivory Coast and attributed to the 'Grebo' as a general term covering the Kru and their neighbours in eastern Liberia.

Worn vertically, Kru masks were, according to reports, danced to celebrate fighting prowess or to mime a communal story. In one account the mask form was not destined for the dance, but with a small hollow in the back for protective medicines, it was set up in front of the chief's house as a mark of his office. Judging by photographs of masks collected from the coastal region in the 1890s and a few scenes of performance since 1960, a Kru mask when worn was fitted below a huge headdress consisting of an arc-shaped fibre framework covered with a band of cloth and trimmed with a stiff fringe of palm-leaf strips and long waving feathers (to spectacular effect). Otherwise the mask was obscured by being fastened within a panel of painted, plaited palm fibres that was set on top of the performer's head or attached in front of a conical bonnet, leaving the face visible. This method of attachment may account for the lack of holes on a number of Kru masks. It is possible, however, that some early 20th-century examples were made without holes for sale to French sailors who then traded their African 'antiquities' at the docks in Paris.

Seen vertically, the flat base and abstracted features of Kru masks may seem unique, but a consideration of Kru history makes it plausible that the origin of this unusual form lies in the contacts between the Kru and the Ijo peoples in southern Nigeria. For centuries the coastal Kru people have been favoured to work with European traders along the coast. Widely known as 'krumen' (a linguistic coincidence), they were sought after as cargo-loaders and sailors. In the second half of the 19th century they worked for English shippers in the palm-oil trade all the way to the Niger Delta region and beyond.

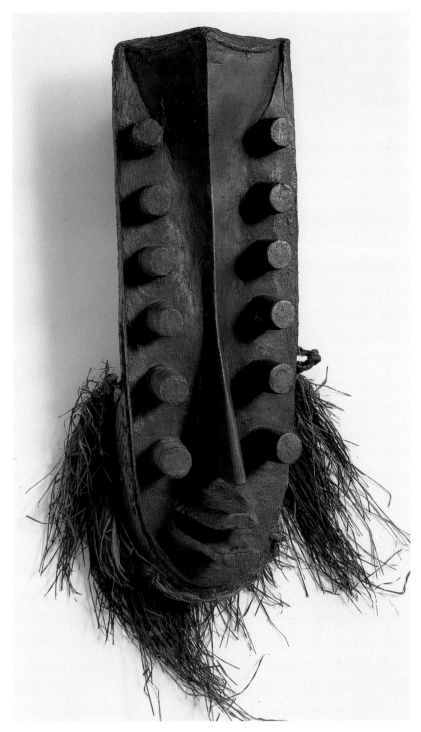

In this work they came in contact with the Ijo. Through handling transport and trade between the Niger Delta and inland markets, the Ijo, like the Kru, were accustomed to life on boats, and were also active in the English palm-oil trade. For their major cult of water spirit performances, the Ijo created severely abstract wooden masks that exhibit a structure comparable to those of the Kru. This kind of mask was placed on top of the performer's head and obscured with various forms of palm-leaf fibre ruffs or drapery; that is, the masks were worn horizontally rather than vertically. Because of the quantity of Ijo masks, their integration into a major cult and their greater visual elaboration, it is reasonable to consider them the inspiration for the abstract Kru masks. *MA*

Bibliography: Frobenius, 1898, pl. XI, figs 110–14; Vandenhoute, 1948, pl. XVI, p. 48; Krieger, 1960, fig. 16; Horton, 1965, pls 46, 68, 70; Brooks, 1972, p. 35; Holas, 1976, p. 70; Holas, 1980, cover, pls ff. p. 256; Verger-Fèvre, 1980, pl. H-4; Jones, 1984, pp. 160–3; Rubin, 1984, i, pp. 20–1, 260, 305; Herter, 1991, pp. 58–71; Verger-Fèvre, 1995, pp. 1–2

5.130

Human figure

Kru (?)
Liberia
19th century
wood, pigment
h. 107 cm
Staatliche Museen zu Berlin, Preussischer
Kulturbesitz, Museum für Völkerkunde,
III C 28582

This statue is one of the oldest
carvings from the coastal regions
of Liberia. It was purchased by
the Berlin museum in 1913 from
a respected English dealer, with the
following information: 'Kru, Liberia.
A very old specimen. Brought to
England before 1865.' No other
known figure is covered with incised
designs and coloured with red and
black pigments as this one is.

The sculpture of the Kru of Liberia
is little studied, and no information
is available on the use of this statue.
One might suppose – in view of the
way Kru men in the first half of the
19th century travelled as itinerant
labourers for European shipping trade
as far away as Gabon and regularly to
the West Indies – that this statue was
brought from some other region than
west Africa. This is unlikely for two
reasons. First, human figures,
although not common, were used
among other peoples of western
Liberia, both coastal and interior.
For example, at the entrance to a vil-
lage, travellers frequently encountered
a carved post of this height with a
human head at the top. Less visible
was the statue attached to a post
marking the headman's house altar.
Second – and more indicative of a
local origin – are the features that
recur in regional statuary, such as the
projecting brow, thin ridged nose and
oval, pointed face, and the rhythm of
the incised designs. The way in which
the carver sets up a repeating rhythm
of striped rectangular units at the
shoulders and then changes the in-
terior shapes, sizes and angle of place-
ment further down the column is a
fine example of a style of visual design
characteristic of artists' work on two-
dimensional surfaces in west Africa. It
forsakes symmetry for the benefit of
variety and individuality. *MA*

Provenance: before 1865, in England;
1913, purchased by the museum

Bibliography: Krieger, 1965, 1, pl. 18,
p. 24; Adams, 1989, pp. 35–43; Sieg-
mann, 1995

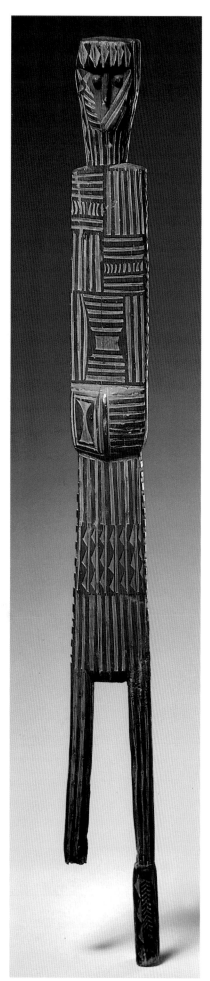

5.131

Standing female figure

Bete
Ivory Coast
20th century
wood
h. 74.9 cm
Maureen and Harold Zarember

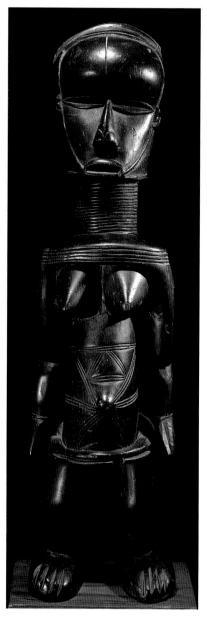

This forthright and well carved figure
is difficult to identify precisely, and
that makes it an interesting object to
examine. One of the features typical
of known Bete figures is not apparent
here, that is, the angled joining of the
legs at the groin. The figure may,
nevertheless, be a product of a Bete
carver's hand because style regions
did not have rigid boundaries. Usually
around the borders there would be
some interpenetration of neighbour-
ing carving styles. In addition, for lack
of research, we do not know how much
variation in carving styles occurred
within the Bete region.

To add to the difficulty, the intro-
duction of colonial administration in
the first half of this century changed
many ways of life in west Africa,
including carving styles. Especially
from the second quarter of the 20th
century, there were more opportun-
ities for travel and interchange of
visits and ideas. The result was that
carvers could more readily take on
commissions from distant chiefs and
stay for weeks at a chief's expense
while completing an order of masks,
figures and other carvings. The Dan
people who live to the west of the
Bete were noted as skilful carvers.
Their sculptors were especially likely
to circulate on invitation and certainly
their works became even more widely
known among their neighbours than
in earlier times.

These complex interactive situa-
tions may account for the numerous
Dan-like features on this Bete figure,
such as the straight vertical stance
with arms symmetrically posed.
The proportions of the major body
parts, that is, head, neck and torso
size with short legs, are also more like
Dan forms than Bete. In spite of the
Dan-like features, the head and facial
contours do not follow Dan models.

The arms on this figure are ex-
ceptionally long. On Dan figures in
general the arms occasionally extend
up to or slightly beyond the hip-line.
This in itself is unusual because a
consistent characteristic of figural
carving in the sub-Saharan region
is separation of body parts, achieved
notably through shortening the arms,
so that they do not link the torso and
hip mass.

The visual interest in this statuette
lies in the fine formal rhythm; there
is a play between the shaping of the
body parts and the repetition of strong
horizontals seen in the indentation at
eye level, the straight chin and
squared shoulders. These horizontal
forms are enlivened by small surface
effects such as the simple shape of the
eyes and mouth, neck striations,
shoulder banding and hip rings. *MA*

Bibliography: Fischer and Himmelheber,
1984, figs 110–11, 133–7; Herold, 1985,
figs 21–6

5.132

Saltcellar

Master of the Symbolic Execution

Sapi-Portuguese
Sierra Leone
16th century
ivory
h. 42 cm
Museo Preistorico Etnografico
'L. Pigorini', Rome, 1973, 104.079

The neologism 'Afro-Portuguese ivories', first used by William Fagg, designates a group of refined ivory works of art (saltcellars, pyxides, spoons, forks, dagger handles and oliphants) created between the end of the 15th century and the mid-16th by African Sapi artists of Sierra Leone and Yoruba or Edo artists of Benin, to be exported to Europe. The ivories show, in their shape and decoration, a perfect fusion of African and European figurative elements, the latter evidently suggested by Portuguese clients and therefore useful for dating works. The specimens from Sierra Leone were identified through convincing analogies between the ivories and early carvings in soft stone from the same region.

References to such saltcellars go back to the records of the treasurer of the Casa de Guiné (1504–5, the only book to escape the Lisbon earthquake of 1755), which mentions the collection of a tax of 25 per cent on '*saleiros*' and '*colhares*' of ivory imported from Africa to Portugal. The word '*salyros*' also occurs in a report (1506–10) by Valentim Fernandes, who wrote that the inhabitants of Sierra Leone 'are black and very talented in manual art, that is [they create] ivory saltcellars and spoons. They carve in ivory any work which we draw for them'. This draws attention to the fact that designs were submitted to African carvers by European clients.

The Sapi-Portuguese saltcellars may be divided broadly in two main categories: those with a conical base and others with an openwork, cylindrical base. The specimen here is of the second type, which normally shows fewer European elements than the first, both in shape and decoration.

The spherical lidded bowl resting on a platform might have been inspired by a container (gourd or terracotta) supported by a caryatid stool. The scene carved on the lid, a multiple execution, seems to refer to a practice of the country described in early chronicles. The executioner, however, and the two men seated on the base (next to two women showing scarifications) wear codpieces. The decoration is mainly of rows of beads alternating with straight lines and is typical of Manueline architecture, so called after Emanuel I, King of Portugal from 1495 to 1521. The head of the victim, the hand of the executioner and the improbable axe are recent restorations.

The gigantic size of the executioner compared with the victims suggests a symbolic representation of a great chief endowed with the power of life and death – hence the naming of the creator of the saltcellar as the 'Master of the Symbolic Execution'. He was a great, sophisticated and inventive artist, able to combine elegance with a high degree of compositional skill. Two equally perfect saltcellars can probably be attributed to him. *EB*

Exhibition: Washington 1991, no. 67

Bibliography: Fyfe, 1964; Ryder, 1964; Mota, 1975; Bassani and Fagg, 1988; Bassani, 1994

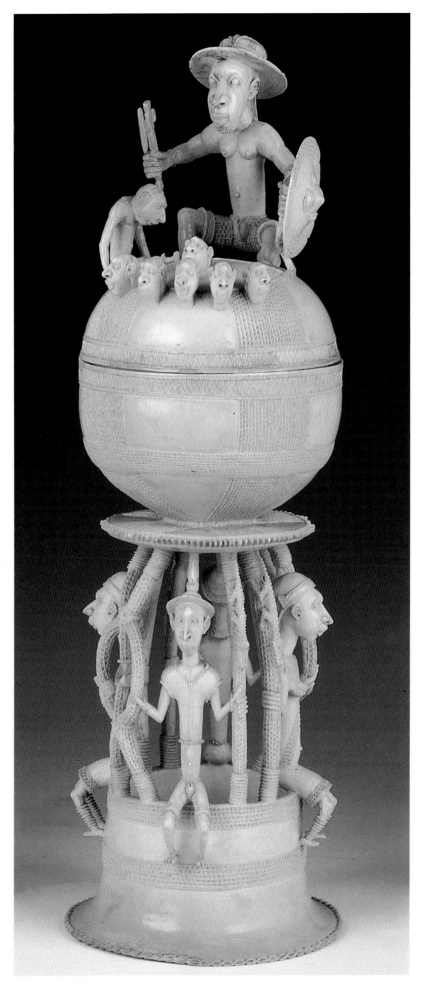

5.133a

Sculpted tablet

Sierra Leone
soapstone
43 x 31 cm
The Trustees of the British Museum,
London, 1924. 10.24.1

A small area of the Upper Guinea Coast, embracing adjacent parts of the modern states of Guinea, Sierra Leone and Liberia, is one of the few places in sub-Saharan Africa where people have carved in stone. The material used was usually steatite or soapstone, whose relative softness allows it to be carved with tools and techniques similar to those used in woodcarving. The sculptures made were for the most part human figure carvings between 7.5 and 15 cm in height; but there were also a significant number of sculpted heads, near life-size, on pedestal-like necks, some examples of sculpted animal figures, and at least one enigmatic sculpted stone slab.

Those found in south-eastern Sierra Leone close to the Atlantic coast are generally referred to today by the Mende term *nomoli* (pl. *nomolisia*) and are characterised by large rounded heads projected forwards from the neck, protruberant eyes, a fleshy nose with flaring nostrils, and full lips. A stylistically more varied group, found further inland, is nowadays referred to by the Kissi term *pomdo* (pl. *pomda/pomta*), even where the sculptures are known to have been found outside present Kissi homelands. These vary from simple columns on which a semblance of a human face has been roughly scratched to elaborate sculptures involving multiple figures and/or considerable descriptive detail.

It seems likely that the great majority of these sculptures are centuries old. The present inhabitants of the area find them buried in the soil or in watercourses in the course of preparing their farms, fishing or digging for diamonds. The Mende people believe that they were made by previous inhabitants or by spirits; they regard them as 'rice gods' and make offerings to them to increase their harvests. The Kissi for their part look upon them as manifestations of their deceased ancestors and place them in ancestral shrines. (There are a few instances of more recent stone carvings, but these seem generally to be regarded by local people as quite different from the ancient works.)

Scholars have concluded that these sculptures were probably made by ancestors of the present Kissi, Krim and Bullom peoples who originally occupied the areas where they are now found. Since most of these areas are today occupied by the Kono and Mende peoples, it is also argued that they must have been made before the latter settled in their current homelands. The date when this occurred is, however, still a matter of controversy.

There is no evidence that sculpting in stone was still being carried on in Upper Guinea when the Portuguese made their first contacts with the coast *c*.1460. Contemporary Portuguese descriptions of this part of west Africa make no reference to stone sculpture, and, despite some rather fanciful claims made in the past, no surviving examples of stone sculpture show features definitely derived from European models or definitely representing European dress or artefacts. It is, therefore, probable that the stone sculptures predate the mid-15th century, and some may be much older.

The Upper Guinea stone sculptures cannot be convincingly related to any other stonecarving tradition, in Africa or elsewhere. Their only close affinities are with sculptures in other

materials that are found in adjacent parts of Upper Guinea. A few rare examples of ancient woodcarvings that stylistically mirror the differences between the *nomoli* and *pomdo* figures have come to light within the last 20 years. So, too, have a few clay heads and figures. However, the major carving tradition that can be related to the stone sculptures consists in some 100 or so hybrid works of ivory sculpture made for the Portuguese by African craftsmen in Sierra Leone in the late 15th and early 16th centuries: the so-called Sapi-Portuguese ivories. (Sapi was the name the Portuguese gave to a number of peoples speaking related languages along the Upper Guinea Coast, including the Baga, the Temne and the Bullom; cf. cat. 5.137–8).

The function of these stone sculptures is not certain. A number of figures (and the pedestal heads) seem to show personages wearing ornaments (rings, bracelets), astride animals and carrying weapons, all of which are most probably indications of rank. It has been plausibly suggested that the persons represented are dead chiefs or notables. However, until stone figures have been discovered in the course of a properly conducted archaeological excavation, there is no means of putting this hypothesis to the test. The differences between certain of the stone carvings are in any case so great that it is unlikely that there was any single function that they were meant to fulfil. *WH*

Provenance: cat. 5.133b: 1909, given to the museum by Major G. Anderson

Bibliography: Thompson, 1852; Rutimeyer, 1901; Rutimeyer, 1908; Person, 1961; Dittmer, 1967; Tagliaferri and Hammacher, 1974; Lamp, 1983; Tagliaferri, 1989; Hart and Fyfe, 1993

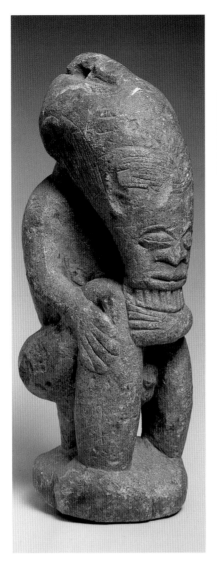

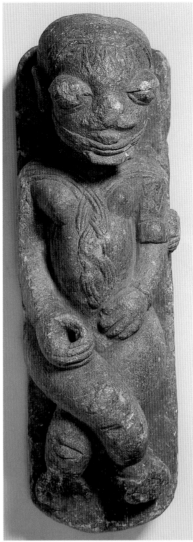

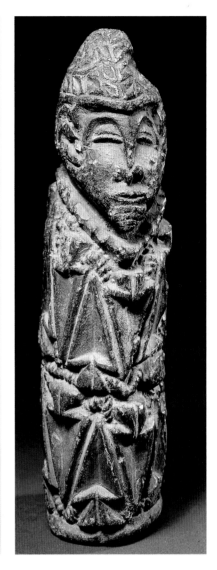

5.133b

Figure

Sapi
Sierra Leone
soapstone
h. 30 cm
The Trustees of the British Museum, London, 1909. 2-20.1

5.133c

Reclining Figure

Sapi
Sierra Leone
soapstone
h. 36 cm
The Trustees of the British Museum, London, 1904. 4-15.1

5.133d

Figure

Guinea
soapstone
h. 26 cm
Laboratoire d'Ethnologie, Musée de l'Homme, Paris, 52.13.1

5.133e

Head

Sherbro
Sierra Leone
stone
h. 24 cm
Musée Barbier-Mueller, Geneva, 1002-1

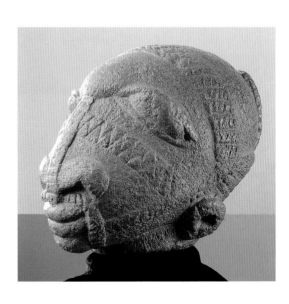

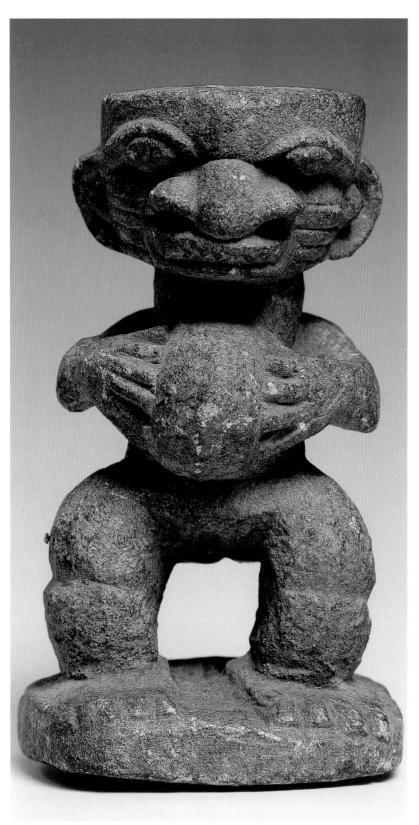

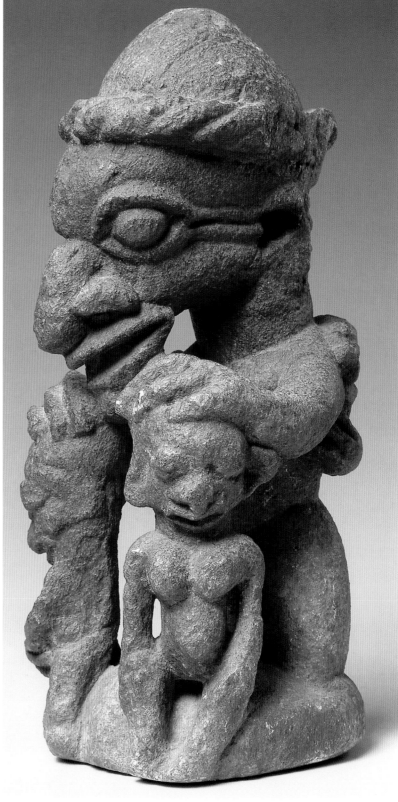

5.133f

Figure

Sapi
Sierra Leone
soapstone
h. 14 cm
The Trustees of the British Museum,
London, 1906. A. 5-25.2

5.133g

Figure

Sapi
Sierra Leone
soapstone
h. 18 cm
Pitt Rivers Museum, Oxford, 1934.24.2

In recent years a few extremely weathered wooden figures have come to light which seem stylistically to match the ancient stone sculptures dug up in Sierra Leone, Guinea and Liberia. It seems probable, therefore, that they are of similar age. One such figure has been carbon-dated to the period 1190–1394, the earliest dating for any work of art from this area. However, in the absence of any known archaeological context, this result must be treated with caution.

The two figures displayed here illustrate this stylistic matching. The stone figure (cat. 5.134a) is an unusually well-preserved example of the style of sculpture found among the Kono of eastern Sierra Leone and the Kissi of Guinea. Beneath a hooked nose the edges of the mouth are drawn back to reveal pointed teeth. There are well-defined body markings on the chest and around the projecting navel. This pointing of the teeth and body scarification were described among the Temne and Bullom in the 16th century, and are additional evidence linking the sculptures to the Sapi peoples. The squatting or kneeling posture of the figure is echoed in that of the wooden figure (cat. 5.134b), although the erosion of the surface of the latter means that little of the finer detail, if there was any, has survived. They show similar conventions in the representation of the head and face. The austerity of the carving style makes it uncertain whether the two figures are wearing a cap with a high crest running front to back or whether this represents a way of dressing the hair. *WH*

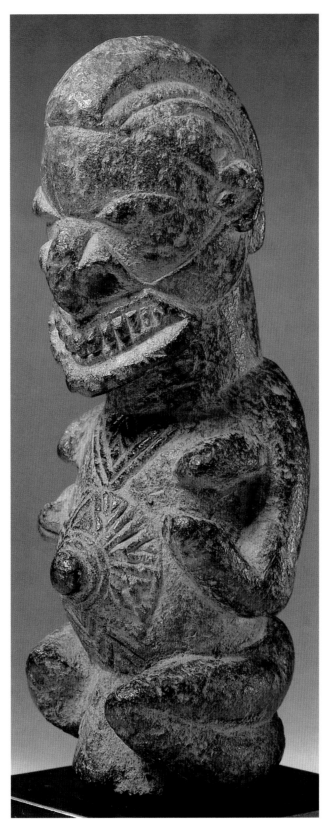

5.134a

Figure

Kissi, Guinea
c. 15th–16th century
soapstone
16.2 x 4.5 x 6 cm
L. Lanfranchi Collection, Milan

5.134b

Figure

Kissi, Guinea
c. 15th–16th century
wood
24.5 x 7 x 8.5 cm
Vittorio Mangiò

5.135

Female standing figure

Mende
Sierra Leone
20th century
wood
43.5 x 12 x 12 cm
Herman Collection

The large Mende population comprises numerous kinds of social structure, such as firmly marked kin groups, political hierarchies and societies for diverse purposes: training boys and girls in appropriate behaviour, protection against enemies or curing illnesses. Most bodily ills are believed to result from transgressions against the rules of conduct laid down by one sodality or another. The Njaye society of the Kpa Mende region, open to both men and women, offers a typical example. Its particular concerns are the treatment of mental illness and the means of increasing one's personal magnetism and fertility. The society possesses a secret 'medicine' that is the source of its power to enforce its rules on the community. Such medicines consist of natural substances such as plant materials and rocks, manipulated so as to be imbued with invisible powers.

The various sodalities employ sculpted figures as guardians and as curative agents. The majority represent the female figure, either seated or standing, with the hands touching the body and the arms held slightly apart from the torso. The statues are usually dressed with beaded or cloth aprons and bead necklaces. Such figures are placed in or near the sodality's processions when the society officials appear in public.

The statue could have been used in ritual or for prestige. Full-length figures with hands placed at or on the breasts were part of the curing ritual of the Sando society. All over the Mende region (except in Bonthe district) carved figures could serve as house ornaments. The possession of carvings of persons or animals 'to dress the house' added to the prestige of prosperous men. Between 1930 and 1961, British district officers encouraged regular displays of carvings at district meetings of paramount chiefs. It was a competitive display, and the winner received a money prize which was passed on to the carver. In Mende society any young male may apprentice or set himself up as a carver. Until he earns a virtuoso reputation, the carver works intermittently or travels to find clients. Nowadays carvers produce pieces at home which itinerant traders carry throughout the region and to international markets. *MA*

Bibliography: Hommel, 1974; Phillips, 1979, pp. 104–9

5.136

Helmet mask

Mende
Sierra Leone
20th century
wood
45 x 23 x 23 cm
Private Collection

In sub-Saharan Africa only men are normally permitted on ritual occasions to wear wooden masks. This black helmet mask is worn exclusively by women. The practice of women wearing masks seems to have been brought to several populations of Sierra Leone and Liberia, such as the Temne, Gola and Vai,

by the Mende and Mande-speaking people from the northern savanna. Because of the similarity of mask styles and the itinerant pathways of noted carvers, it is difficult to assign some masks to a particular ethnic group.

In the 19th century the Mende were organised into independent chiefdoms; families and individuals were ranked according to their land-use rights. Industrious rice farmers, the Mende number approximately two million people. The rituals of their women's society, called Sande, require the appearance of masked figures. Within such a large population there are many variations in local practices and carving styles, but there is broad agreement on the nature of the mask itself.

The mask presents an ideal of feminine beauty admired by the Mende: elaborate hairstyle, full forehead and small facial features. The gleaming surface signifies healthy, glowing skin. This particular mask is unusual because it lacks the swelling fleshy rolls alternating with deep incised lines at the neck or back of the head. These effects are considered marks of beauty and a promise of fecundity. The neck is broad to fit over the head of the woman who will wear it. Sande officials commission male carvers to produce the mask in secret. The surface is smoothed with the rough leaves of the ficus tree, then dyed black with a concoction made of leaves. Before use, it is anointed with palm oil to make it shine. (Modern carvers use black shoe polish.)

With this confining mask, the wearer (who has to be a good dancer and an official of the Sande) puts on a thick cotton costume covered with heavy fibre strands dyed black. Her dances may last for over two hours. The sacredness of the mask lies in its deeper meaning as a representation of the long deceased founder of Sande society. In pre-colonial times women could hold the position of chief of a village cluster; until the 1970s women politicians continued to use the Sande society to support and further their careers in modern government. With increasingly rigorous Islamisation, however, the Sande society is being seriously modified or even disbanded. *MA*

Bibliography: Phillips, 1979; Phillips, 1985

5.137

Seated female figure

Temne
Sierra Leone
early 20th century
wood, cloth, beads, cowrie shells, button, fibre
h. 43.5 cm
Museum of Ethnology, Rotterdam, 58629

The female figure seated on a stool is rare in Sierra Leone, where it is found only among the Temne, and used by the officials (*an-Digba*) of the women's Bondo association. The head of the local chapter may keep such a figure among her prized ritual possessions, hidden in her private room. It would be brought out in public on only one occasion, at the girls' initiation to adulthood.

Bondo is a universal association for women among the Temne, related to Sande among the Mende people to the south. The leadership has a hierarchy of five essential ranks: Soko, the highest, who wears a red cloth; a group of titled Digbas; Sampa, the dancer who wears a red mitred cap; several technicians in internship; and the 'Chimpanzees' (*ta-Wotho*), the Digbas in basic training. Initiation is usually held every three or four years, alternating with the initiation for boys, called Poro. Girls may be as young as six, or in their late teens, but are usually about thirteen, as the year-long initiation ritual serves as the principal marriage ceremony.

At the first ceremonies, when the girls are led to a sacred grove at the riverside, the figure may be carried by the Soko at the head of the procession, dressed in the costume of the well-known Bondo spirit, Nöwo (or Sowo). This is a quiet ceremony, not for public view, in which the girls file to the river for a ritual bathing and then proceed to a forest grove where they will receive a clitoridectomy, and retire for two weeks before the public opening ceremonies of initiation begin. The carrying of the figure ahead of the procession is meant to provide a model of feminine perfection available only through Bondo training, and to inspire the girls, who are naturally apprehensive about the unknown proceedings ahead.

The figure is called So-Nyande, the 'Beautiful So(ko)', combining Temne and Mende wording. She is an image of both a woman of high Bondo rank and her inherited official line, and seated as an initiate appears at the final ceremonies. The graduating Bondo girl is provided with a chair or stool, lavishly spread with cloths. Exquisitely coiffured, adorned with beads and a waist-cloth, and rubbed thoroughly with oil to enhance her black brilliance, she, like the figure, is an object of adoration.

This figure is very similar to another known carving by an artist working in the 1930s. While that figure is painted and polished black, this figure is thoroughly encrusted, indicating varying modes of ritual maintenance for the same type of object. *FL*

5.138

Shrine figure headdress

Baga or Bulunits
Guinea
19th century
wood, ram horns, encrustation
h. 40 cm
Laboratoire d'Ethnologie,
Musée de l'Homme, Paris,
33.40.86

This type of object was used principally as a shrine figure and also as a dance headdress. It was known among the northern Baga of the Sitemu subgroup as *a-Tshol*, meaning 'medicine'. Alternative names include *elek*. It takes the form of a head with an exceptionally long beak and a long neck inserted into a base structure.

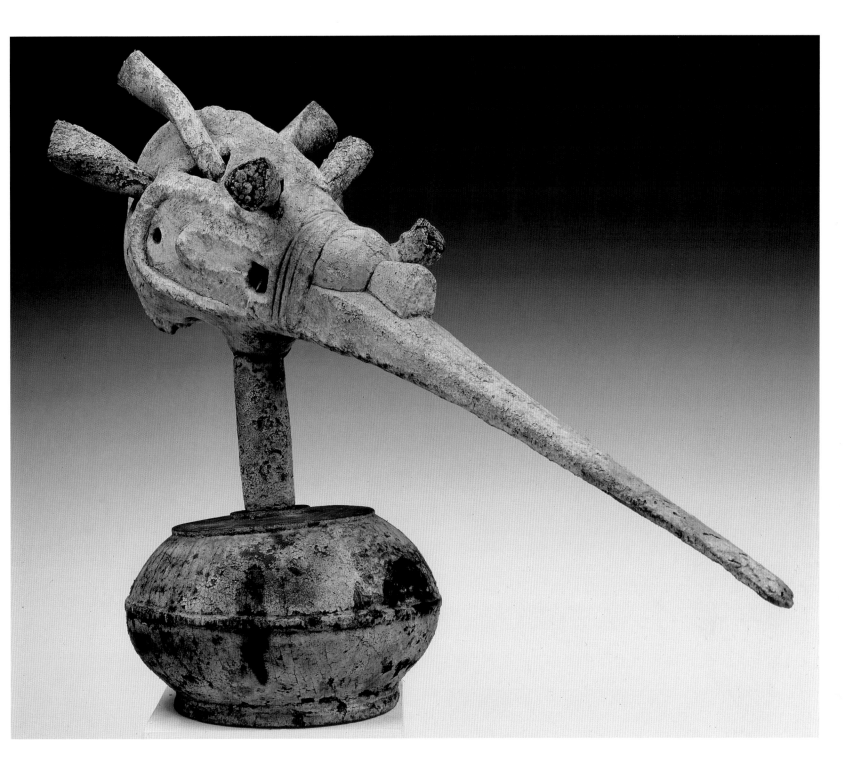

The head also has anthropomorphic aspects, such as a coiffure, ears, forehead and nose.

A-Tshol figures were placed in the young men's sacred grove as guardians during initiation. They were instrumental in rituals of healing, divination and the pursuit of justice. The use of the word 'medicine' throughout this region of Africa applies to any substance that is known to have powers of healing or protection, including horns, shells, bark and leaves. The *a-Tshol* shrine could hold a collection of these

materials and/or the wooden avian figure.

The *a-Tshol* was under the control of the eldest male member of a family as a symbolic incarnation of the lineage. It was used as an instrument of spiritual power in determining the cause of misfortune in the family or the community at large, generally attributed to the evil collusion of antisocial persons with malevolent spiritual forces. Through ritual performed at the shrine the elder was able to identify the evildoer and to prescribe retribution

for his acts, thus bringing an end to the misfortune.

Bearing the *a-Tshol* on top of the head in dance, the dancer wore normal clothing; a palm frond was attached to the base of the figure. The headdress was not attached to the dancer's head but was left to balance itself. It was said to take control and to guide the dancer's movements. Most of the larger examples, such as this one, are carved in two separate pieces joined by inserting the long neck into the spherical or cylindrical base. This suggests that the head

may have swivelled during dance. The dancer carried a knife in each hand and was surrounded in dance by devotees often going into trance.

This *a-Tshol* was collected in the Bulunits village of Monchon. The Bulunits are unrelated linguistically to the Baga, but they closely share a ritual culture with the contiguous Baga Sitemu and Pukur, and these three groups see themselves as a cultural unit. *FL*

Provenance: 1932, collected from Monchon by Prof. Henri Labouret

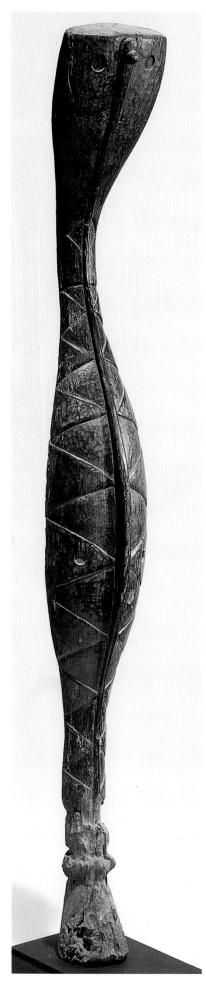

5.139

Sculpture in the form of a stylised serpent (*bansonyi*)

Baga
Guinea
wood, pigment
l. 210 cm
Private Collection, Paris

In Western museums Baga carved serpents are normally exhibited as static sculpture in a way that gives little idea of their traditional function as dance headdresses. In use they tower above a light framework that is borne on the shoulders and body of a dancer concealed beneath a raffia covering who moves rapidly amid cries and the firing of guns, shaking and twirling the structure to show off the bells, feathers and cloths attached to it. Confusion, agitation and motion are the keynotes of the performance, reflected somewhat mutedly in the curves and coloured zigzag markings of the residual sculpture and its balanced triangular head.

There is a certain confusion in the literature on these snakes, probably from a misplaced attempt to reduce the varied usages of fragmented and loosely related peoples to a single pattern, though African masquerades often have very broad portfolios. The serpent headdress is attested as involved in protecting boys at circumcision, curing droughts and appearing at funerals. Sometimes it appears in groups, it may be male or female and it has been interpreted by the cosmologically-minded as reconciling the spirit of the water with that of the bush. *NB*

Bibliography: Delange, 1962, pp. 3–23; Lamp, 1986, pp. 64–7

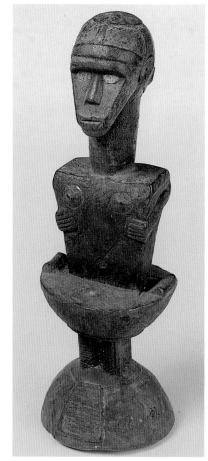

5.140

Altar figure

Bijogo
Bissagos Islands, Guinea Bissau
wood
h. 40 cm
Museum für Völkerkunde, Vienna, 136.066

The Bijogo recognise a large class of objects known as *iran* that act as locations for divinity. These may be of a variety of materials and forms including pots and wooden sculptures of either or both sexes. This altar figure, *iran otibango* (civilised spirit), with its prominent brow and brooding geometric features, is in a style typical of the island of CaEache. A common component of these carvings is a stool that subsumes the lower half of the figure. In this case, the body tattooing that is the mark of full initiation is transferred to the stool while the figure wears a medallion around its neck. Such sculptures are usually associated with fertility and successful agriculture and kept in village shrines. *NB*

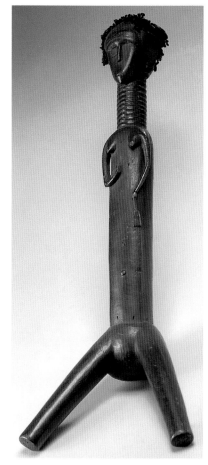

5.141

Dance doll

Bijogo
Bissagos Islands, Guinea Bissau
wood, human hair
54 x 21 x 50 cm
By courtesy of the Board of Trustees of the Science Museum, London, A 655925

Like many 'doll' figures of African children's sculpture, those from the Bissagos have been variously interpreted. They may be seen as educational toys, anticipating motherhood, as fecundity figures, augmenting natural fertility, and funerary figures, replacing dead children. Dolls of the present form, always female, with splayed legs, rudimentary breasts and reduced arms are seen principally as objects of play and dance props. Girls carry them on the hip as they would a young child. Rings of fat around the neck are a common attribute of beauty and the human hair on the head is cut as for a girl undergoing initiation.

It may be questioned how far this division corresponds to a Bijogo view. These sculptures apparently feature in the dances of female initiation, a period that conflates many roles. While the whole event seems to con-

tradict easy generalisations about African masquerade and drumming as exclusively male, it must be noted that girls undergo initiation on behalf of boys who have died before puberty. They are simultaneously identified with such boys and also viewed as their virgin wives. Only through possession of female bodies and the blurring of such lines can the boys complete all the necessary stages of existence in this world and re-enter the regular cycle of life. It is therefore unlikely that the dolls represent any single named person or concept but are more likely to be instruments of multiple identification. Such wooden figures are nowadays typical of the eastern end of the Bissagos archipelago. *NB*

Bibliography: Gallois Duquette, 1976, pp. 26–43; Gallois Duquette, 1983, pp. 132–4

5.142
Swordfish mask
Bijogo
Bissagos Islands, Guinea Bissau
wood, pigment
h. 127 cm
Private Collection

The Bijogo are known from early chroniclers' accounts for their daring raids on shipping along the African coast using huge canoes. Martial virtues were cultivated by an age-set system that associated young men with powerful beasts of the sea and land; masquerades had an important role. While young boys might wear calf and fish masks, older uninitiated youths wear those depicting wild bulls, sharks, hippopotami and swordfish. Their dances are unpredictable and violent to accord with the character of the animal represented and their own undomesticated nature. They spend much of their time grooming, dancing in various villages and developing love affairs.

 This mask would be worn with the proboscis pointing forward, the hollow at the rear resting on top of the head and fastened with ties of green raffia. Unlike a bull mask it would not cover the face. Typically, the dancer would also wear a large wooden dorsal fin attached to the middle of his back and would carry a shield and stick with bells while swooping and ducking in performance. Masquerade headdresses such as this are best known from the island of Uno. *NB*

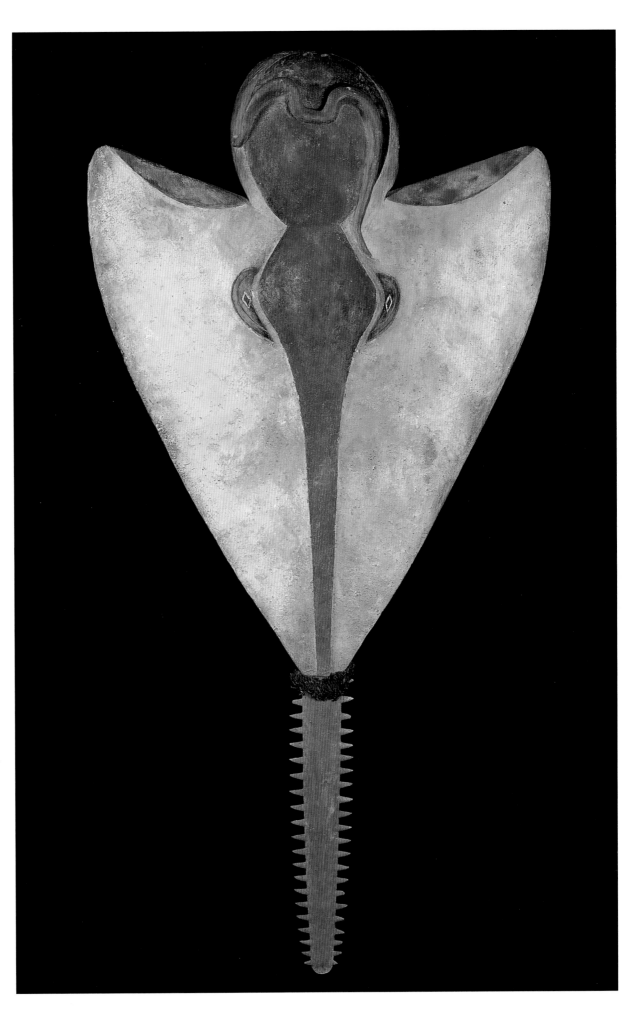

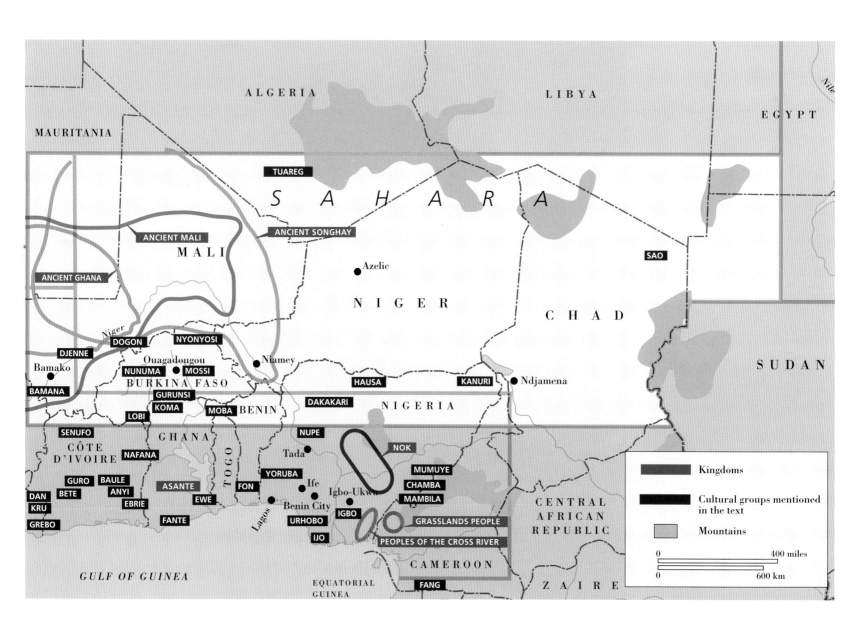

ALGERIA

LIBYA

EGYPT

MAURITANIA

S A H A R A

TUAREG

ANCIENT MALI

MALI

ANCIENT SONGHAY

SAO

ANCIENT GHANA

Azelic

N I G E R

C H A D

SUDAN

Niger

DJENNE

DOGON

NYONYOSI

Bamako

NUNUMA

Ouagadougou

MOSSI

Niamey

BAMANA

BURKINA FASO

HAUSA

KANURI

Ndjamena

GURUNSI

KOMA

DAKAKARI

N I G E R I A

LOBI

MOBA

BENIN

SENUFO

GHANA

NUPE

NOK

CÔTE
D'IVOIRE

NAFANA

Tada

MUMUYE

GURO

BAULE

TOGO

YORUBA

CHAMBA

BETE

ANYI

ASANTE

FON

Ife

Igbo-Ukwu

MAMBILA

DAN

EBRIE

EWE

CENTRAL
AFRICAN
REPUBLIC

KRU

Benin City

IGBO

GREBO

FANTE

Lagos

URHOBO

GRASSLANDS PEOPLE

IJO

PEOPLES OF THE CROSS RIVER

GULF OF GUINEA

CAMEROON

EQUATORIAL
GUINEA

FANG

ZAIRE

Kingdoms

Cultural groups mentioned
in the text

Mountains

0 400 miles

0 600 km

6 THE SAHEL AND SAVANNA

René A. Bravmann

Stretching across the continent, from the Atlantic to the Gulf of Aden, is the geographical zone known as the Sahel/Savanna. On maps it appears as a broad undifferentiated band lying between the Sahara and tropical forests, a vast land of steppes and tree-covered plains. In fact this apparent unity is an illusion, for the Sahel/Savanna is a rich mosaic of ecosystems that contain, in whole or in part, some of the great rivers of the continent – the Senegal, Niger, Volta and the upper stretches of the Nile. To move south from the desert's fringe is to begin a dramatic journey across a variety of ecological zones, from the stark aridity and fragility of sub-Saharan steppe to the relative moistness of woodlands and savanna. Along the Sahara's southern fringe only the heartiest of herders, people like the cattle-raising Fulani or Tuareg camel-breeders, have managed to overcome the rigours of this difficult land. The savanna and woodlands, on the other hand, are endowed with an abundance of plant and animal life that supports cereal and root agriculture and the raising of livestock, as well as providing consider-able resources for hunting and fishing. Every few hundred miles there are environmental shifts signalled by tilled fields of crops, ranging from sorghum and millet in the north to yams in the moist southern savanna. Archaeological evidence suggests that this is the area where African rice, bullrush millet and sorghum were first domesticated and that it has been home to some of Africa's earliest cities.

The Sahel/Savanna from Senegal and Mauritania to Lake Chad is distinguished by its place in the historical consciousness of Europe and the Muslim world. The accounts of travellers, geographers and men of letters, written in Arabic, shed light on the Sahel/Savanna from the 10th to the 17th centuries; these writings are particularly important in assessing the region's past. The earliest extant writings are those of al Masudi and Ibn Haukal; there is also the famous early 16th-century history of Africa by

Fig. 1 The home of the mayor of Walata, Mauritania, with painted wall decoration

Fig. 2 *Part of the mosque at Dougouba, Mali*

Leo Africanus that was translated into French and English within a generation of its appearance in Latin. These sources, together with later European accounts and oral traditions, have enabled historians to reconstruct the broad outlines of Sahel/Savanna history over the last 1100 years, from the empires of ancient Ghana and medieval Mali in the west to the states of Hausaland and Borno in the east. It is, one could say, history on a grand scale, based on the rise and fall of powerful political entities and of kingdoms and cities linked by trade routes stretching to north Africa, the Mediterranean world and the Near East. Nothing brings home the character of this zone better than the etymology of the term *sahel*: Levtzion tells us it derives from the Arabic word *sahil* meaning shore 'which is well understood if the desert is compared to a sea of sand, and the camel to a ship'. Hence, the towns which developed in the Sahel 'may be regarded as ports. These towns became both commercial entrepots and political centres.' Into these Sahelian ports, places such as Koumbi Saleh, Timbuktu, Gao and Kano, flowed the luxury goods of the Islamic world – brassware, copper, textiles, ceramics and precious Saharan salt in exchange for gold, ivory and other products from the Sahel/Savanna. In Arabic this zone is called the *bilad al sudan*, the land of the blacks, and it is here that Islam and African societies were to meet. While one cannot discount the European colonial presence or the broader impact of the West on the area (a historical phase effectively only a century old) these pale by comparison to the much more profound influence that Islam has had over the last millennium. Conversion to Islam in this region began at the end of the 10th century when the Sarakholle, a Mande people also known as the Soninke who lived in what is present-day

Mauritania, were converted by Muslim Sanhaja Berbers to the faith. Within a generation, Sarakholle converts spread the message of Islam into the Senegal River Valley, and shortly afterwards their religious zeal was felt as far away as the Niger River, in the areas of Takrur and Massina. From the 11th to the 17th centuries Muslim traders and clerics, the true propagators and cultivators of Islam, would introduce the religion to every major kingdom and state between the Atlantic and Lake Chad, and in some cases among more localised cultures as far south as the west African forest. The Islamic presence was dramatic. Political and economical institutions not only took on a decided cast, but much of life itself – the tone of daily existence and the arts and architecture – assumed the trappings of Islam. Intellectual life was also deeply affected, and important towns like Djenne, Timbuktu, Gao and Kano became vital centres of Islamic scholarship and learning. Famous Muslim leaders such as Mansa Musa of Mali, Askia Muhammad of Songhay and Idris Alooma of Borno (whose merits and deeds are kept alive by contemporary praise singers and authors) ruled over large and complex states that were known throughout north Africa and the Near East.

The Islamic presence can be seen and felt throughout this region, but African societies were not merely passive recipients of the faith: they actively shaped and moulded the religion in order to fit its calling within local circumstances. Everywhere in the Sahel/Savanna a synthesis developed between the message and requirements of Islam and traditional beliefs, values and sensibilities. There is no surer way of apprehending this African Islamic reality than by looking at the art and architecture of the region; the mosque, for example, the supreme architectural statement of a Muslim community, and usually constructed of the noblest and finest materials, has undergone a most dramatic restatement. Along the Niger River, in such places as Djenne, Mopti, Goundam and Timbuktu, mosques are built of the humblest materials, such as sun-baked mud (what the French call *pisé* and the Spanish *adobe*), yet in the hands of skilled masons such mosques have resulted in some of the most remarkable sculptural and architectural expressions of the faith (fig. 2). Built like fortresses, with battlemented walls and towers bristling with spikes, these mosques, with gently sloping minarets, have walls and buttresses pierced with projecting beams that serve as permanent scaffolding and help relieve their overall massiveness and horizontality.

Even in those areas farthest removed from the vital urban centres of Islam, and among the most traditional of peoples, the Muslim presence asserts itself in both dramatic and more subtle ways. Dogon art and culture, for example, long hailed as exemplars of traditional Sudannic civilisation, cannot be fully understood or appreciated without acknowledging the impact of Muslim mystical texts like the Kabbe, written early in the 20th century by the Fulani cleric and scholar Cerno Bokar of Bandiagra, and utilised in many Dogon rituals today. Songhay spirit possession, known as Ghimbala, so prevalent throughout the inland Niger Delta of eastern Mali, can ultimately make sense only if we acknowledge how it was reshaped during the 19th century by the Muslim reformer Sheikh Hamadu of Massina. Ghimbala itself is now the result of extraordinary accommodations, of a blending of Quranic and Songhay invocations, of sacrificial acts that are prescribed by the Quran and sanctioned by the traditional spirits that have always inhabited this Songhay-dominated portion of the Niger River. Possession ceremonies, the *batous*, follow an ancient calendar cycle but out of deference to Islam, especially the fundamentalist strain that has emerged in recent years in Mali, they are no longer held during Ramadan, the month of the fast. Likewise, we cannot really understand the historical complexities of Sahel/Savanna textile and clothing traditions if we fail to recognise the strong Muslim north African influences upon various techniques and an entire grammar of Islamic decorative designs.

Another distinctive feature of the artistic and cultural life of this region is the pervasiveness of 'castes', endogamous artisan populations that have long plied their skills over much of the area. They are found among many of the most prolific art-producing societies represented in this exhibition: Mande peoples

like the Bamana and Malinke; the Dogon, Senufo, Minianka, and among virtually all Tuareg, Fulani and Moorish populations. These artists are also exceedingly important in Bobo, Bwa and Kulango communities and their influence has been noted as far south as the forests of Liberia and Ivory Coast, where they reside among the Dan, Nafana and Abron. A minority, rarely exceeding ten per cent of their host populations, these ironworkers, sculptors, weavers, potters, leather-workers etc. have secured a place for themselves that defies their numbers. Socially situated between those of noble or freeborn status and the descendants of former slaves and servile peoples, they are generally described as virtual pariahs, feared and despised, which does not explain the vital roles they play. While we still know very little about their history, how they came into being and what political and cultural forces were responsible for their social segregation, it would be safe to say that they have occupied a critical place in Sahel/ Savanna creativity for centuries. A recent study on the development of these 'castes' based on medieval Arabic sources, the 17th-century Timbuktu chronicles known as the Ta'rikh al-Fattash and the Ta'rikh al Sudan, and a scattering of European accounts confirms that at least some of these artisan groups were an important component of 14th-century Malinke society. By 1500 they had spread among neighbouring Wolof and Soninke, and as far east as Songhay and various Fulani populations. That such specialised artisans existed at an even earlier date is strongly suggested by recent archaeological evidence from various sites within the inland Niger Delta and in Mauritania. Ancient Jene-Jeno, a flourishing urban centre by the middle of the first millennium AD, was most likely home to many artisans working in iron, gold and copper alloys. At Tegdaoust in the Mauritanian desert, tentatively identified with the historical trading centre of Awdaghust, impressive filigree gold jewellery and a cache of gold and silver dating from the 11th century have been uncovered, confirmation of the artistic sophistication of this early commercial centre.

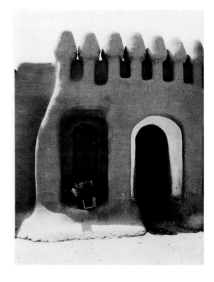

Fig. 3 The house of a marabout, Segou, Mali

If the historical particulars of these artisan families elude us, we are on much firmer ground when it comes to an understanding of their place within Sahel/Savanna societies in the more recent past and today. These groups were deemed so crucial by their hosts that they were almost never obligated to serve in the army and could not be enslaved, a fate that even the mightiest of nobles was not altogether certain of avoiding. These people were never members of castes in the classic sense of that term, for they were never defined as members of a particular social class by their hosts or by themselves. What distinguished them from others, most fully, was not their social status but the fact that they were people free to pursue their creative skills. They apparently always married among themselves, but beyond this they were rarely subjected to those forms of social segregation and discrimination commonly found in true caste systems. It might be more appropriate, therefore, to describe these artists as members of historic guilds who carried out specific creative activities within certain institutional frameworks, albeit loosely organised, that allowed them to control artistic production and encouraged high aesthetic standards.

How these guilds were able to maintain themselves and their autonomy over time is particularly intriguing. Many of the guilds and their members were attracted to the courts of chiefs and kings. They never themselves sought power, and could not by definition occupy positions of authority. That they worked for and supported those in authority and often served as the most trusted of political and spiritual advisers is certainly the case, but they not only remained aloof from struggles for political power, they would normally withdraw their services under such circumstances. Members of these guilds also demonstrated a degree of mobility that helped foster a strong sense of independence; they took their skills and knowledge from capital cities to commercial centres and villages, from one chiefdom to another, and at times from one host culture to others. Regarded as 'different', indeed often viewed with ambivalence, they could not be treated with disrespect or be subject to abuse for they could (and did) refuse to work, literally going on strike against repressive patrons or entire communities. In the end they were able to

preserve their autonomy because they remained productive artists, passing their skills on to subsequent generations. So long as they continued to work at their professions, neither their knowledge nor expertise could be taken from them.

What ultimately strikes the eye and mind as one looks at the many objects from the Sahel/Savanna brought together in this exhibition is the remarkable variety of artistic techniques they honour and the time range of creativity they reveal. The history of ceramic sculpture from this region has been totally revised in the last 25 years and is well represented by a number of anthropomorphic terracottas from the area of Djenne that are provisionally dated to the 11th to 15th centuries, from Bankoni also in Mali and dated between the 14th and 16th centuries, and from Komaland in northern Ghana, *c.* 13th–16th century. The sculptural sophistication of these pieces is stunning and they have much to teach us about variations in style and shifts in taste. Since most, however, have been collected under the most dubious of circumstances and thus without provenance, their ultimate value as objects of history is severely compromised.

Metalworking, in the form of a sophisticated filigree gold pectoral disc (13th–14th century) from one of the many tumuli in the area of Rao in north-western Senegal, the lively postured cast copper figurines from medieval Djenne (cat. 6.2), an unusual bronze cast helmet from Komaland (16th–17th century, cat. 6.33) and the 18th–19th century miniature equestrian found in Koro-Toro in Chad (cat. 6.60a), extend our vision of Sahel/Savanna metallurgy. Much has been learned about the dynamic trade in metals, especially copper and copper alloys, from archaeological investigations in Mauritania and Niger and by revisiting Arabic sources, suggesting that a mastery of widely divergent techniques, from hammering to casting in the lost-wax process, was already achieved by the end of the first millennium AD. The remarkable 14th-century Djenne bronze and iron figure (cat. 6.2e), and a figured Dogon staff of unknown date (cat. 6.13) are two of the iron sculptures that stand as testaments to the vitality of an ancient ironworking tradition that was found throughout much of the region.

Of the stone sculpture, particularly impressive is the delicately worked monolith from Tondidarou in Mali dated to the 12th century, one of numerous such sculptures found in conjunction with pre-Islamic burial mounds. Two Kurumba stone sculptures from Burkina Faso, the smaller one said to be 18th–19th century and the more fully figured example dated by Schweeger-Hefel, on the basis of oral traditions, to the 14th century, attest the long history of Kurumba settlement in the region of Lurum.

Finally there is a variety of vital wood sculpture from the region – masks, imaginative figurative forms, accumulative sculptures of mud, blood and wood that served as sacred altars, and a range of domestic items such as stools and pillow supports. Many come from the most prolific art-producing societies today, including the Bamana, Dogon, Mossi and Lobi.

Bibliographical note
McIntosh and McIntosh, n. d., pp. 215–18; Mauny, 1961; Levtzion, 1973; Meillassoux, 1975; Camara, 1976; Picton and Mack, 2nd edn, 1989; Richter, 1980; Diop, 1981; Glaze, 1981; Hopkins and Levtzion, 1981; Schweeger-Hefel, 1981; Sutton, 1982, pp. 291–313; Herbert, 1984; Vansina, 1984; Prussin, 1986; McNaughton, 1988; Tamari, 1991, pp. 221–50; Fibbal, 1994

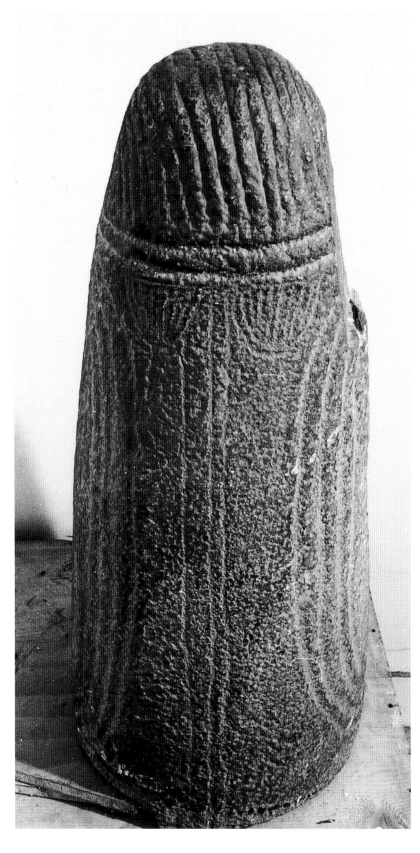

Northern Mali is rich in megalithic sites which often took the form of large clusters of standing stones, though most of these have either now fallen of their own accord or been disturbed. Many of the stones are simple phallic shapes and quite roughly hewn while some are elaborate in marking and reference with highly worked formal elements. The language of the engraved lines that appear on the more complex examples has much in common with other Saharan stone sculptures, the stelae from Morocco (cat. 7.14–15).

What is known as the first megalithic site in Tondidarou has yielded the finest group of these stones and probably constitutes the richest ensemble in Africa outside the Ekoi region of Nigeria, where what used to be known as Akwanshi stones (cat. 5.37) stand in abundance. The resemblance to these of the monoliths under discussion is remarkable (if coincidental) and many engraved motifs are common to both. Whether there is some connection between these designs and the entoptic phenomena discussed by Lewis-Williams in his examination of San rock art (cat. 3.4–5) in southern Africa has yet to be explored. That a common experience rather than a stylistic influence is the cause of this artistic congruence would certainly be the more likely explanation.

The huge umbilicus in association with a general phallic form of cat. 6.1b reminds one again of the economy of Neolithic sculpture so perfectly exemplified by the round-boss from Chad (cat. 6.58).

The name Tondidarou itself reflects the prominence of the local megaliths in the landscape since it is formed from the Songhay *tondi* (stone) and *dari* (standing). An interesting example of cultural appropriation (and a curious sidelight on the idea of context) is that the stones are now sometimes said to be people petrified by God because they opposed Islam.

The hard sandstone that is worked to make these objects suggests the use of metal tools, of which there have been associated finds in the region.
TP

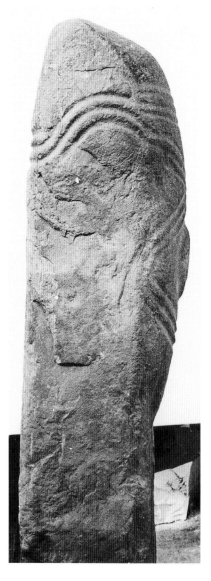

6.1b

Monolith

Tondidarou region, Mali
c. 7th century
sandstone
h. 80 cm
Laboratoire de Préhistoire,
Musée de l'Homme, Paris, 32.40.61

6.1b

Monolith

Tondidarou region, Mali
c. 7th century
sandstone
h. 132 cm
Laboratoire de Préhistoire,
Musée de l'Homme, Paris, 32.40.67

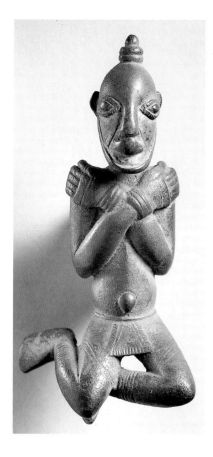

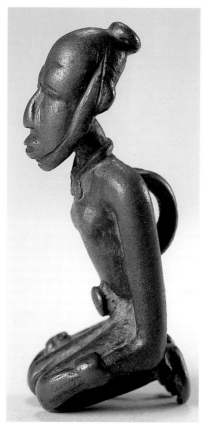

6.2a

Pendant figure

Djenne
Mali
bronze
h. 9.6 cm
Musée Barbier-Mueller, Geneva,
1004.125

6.2c

Pendant figure

Djenne
Mali
bronze
7.5 x 4 cm
Private Collection

6.2b

Kneeling figure

Djenne/Dogon
Mali
bronze
h. 6 cm
Private Collection

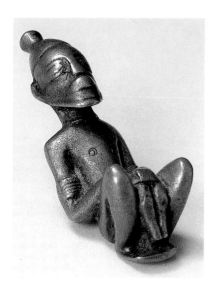

Djenne metalwork

The many hundreds of ancient sites in the region of the inland delta of the Niger have yielded an extraordinary harvest of metal objects. The first of these came to light early in this century, in a small excavation conducted by Lieutenant Desplagnes at Kili. More have been found in official archaeological excavations during the past 30 years. By far the greatest number, however, have emerged from the illicit pillaging of sites on a massive scale. This last activity is doubly harmful: it not only removes the objects concerned but also conceals or destroys the evidence as to their exact provenance, age, context, authorship and historical associations.

The objects obtained from official excavations include bracelets, earrings, small pendants, bells, parts of horse trappings, and small cuprous alloy figurines of a bird and a reptile. Those from clandestine digging are much more impressive, with an astonishing quantity of chains, necklaces, horse ornaments and finger-rings, as well as a variety of human figure amulets and pendants, equestrian figures, small animals and reptiles, complex pectoral ornaments, and even small pendants depicting masks or heads. Many of these are cast in cuprous alloys (brass and 'bronze'), others fashioned from iron, and in rare instances two or more metals are combined in the same work.

This metalwork is far from homogeneous, revealing disparate styles and techniques. At one extreme are tiny stick-like miniature figures, both human and equestrian, said by the looters to come from the region of Guimbala. Apparently found buried in pots, these began turning up in large numbers a few years ago. At the other extreme are superbly modelled small amulets in the form of crouching or kneeling human figures, in the classic style which has come to be labelled 'Djenne' or 'Dogon'. Between these extremes are the many bracelets and other body ornaments, horse trappings and the like, in a variety of styles and substyles. The looters attribute some of these to the region of Niafounke. Lacking the guidance of controlled archaeological excavation, or even scientific collecting, we cannot delimit the provenance of each style even in general terms, nor can we assign firm dates. It is true that some pendants in the 'Djenne' style so closely resemble the Djenne terracotta figurines that they may well be contemporaneous, dating from the same general period, the 12th to the 16th century. It is also true that much looted metalwork may come from sites at which tobacco pipes are not found, and which therefore date from before the 17th century. But these arguments are not particularly strong. Even if Djenne terracottas stopped being made at some particular point in time, this would not necessarily prevent the brass casters from continuing to make pendant figurines in similar style for some generations to come. And if, as seems likely, many looted items of metalwork come from burials, the absence of tobacco pipes need have no particular significance.

Thus, while some items – particularly the finer works in the Djenne style – may date from around the 12th to the 16th century, there seems no reason why some of the great mass of other objects could not be more recent: from the 17th, 18th or even 19th century. This is to be expected if, as seems likely, cuprous metals became increasingly available during this later period.

It has become customary to speak of a 'Dogon' style of art, with reference to wood sculptures and small 'bronzes', and a 'Djenne' style with reference to certain terracottas. Now that an increasing corpus of small 'bronzes' is known from the Djenne region, together with a few miraculous survivals in wood sculpture, it becomes apparent that this division is unrealistic. If we take several dozen of the small 'bronze' human figurines, for instance, we find some which conform to our preconceptions of what is Djenne and what is Dogon, but a whole spectrum of others in between. These castings cannot convincingly be divided into two groups. Rather, we seem to be confronted with works from a single broad 'style area', which embrace a variety of workshop and personal substyles extending no doubt over several generations or even centuries. We can observe the same phenomenon among spirit figure amulets from the wider Senufo region (southern Mali, northern Ivory Coast and western Burkina Faso).

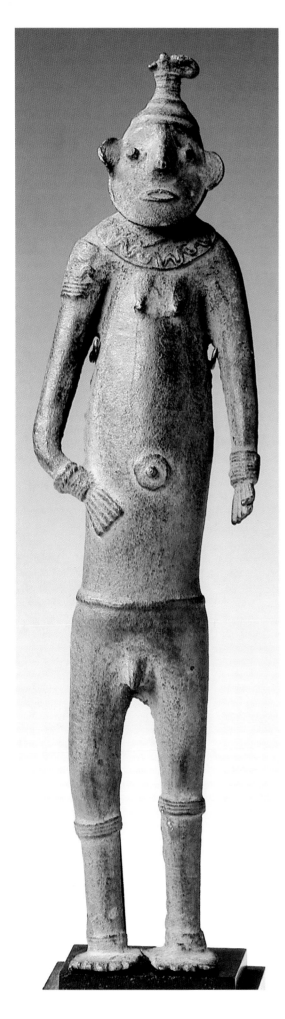

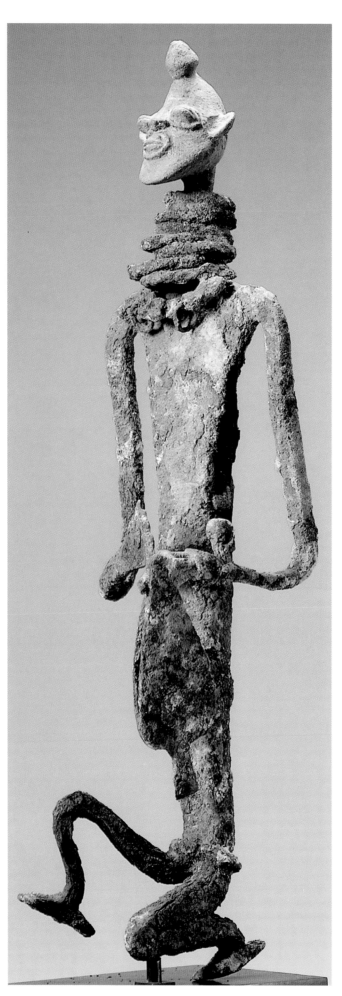

6.2d

Standing figure
Djenne
Mali
bronze
h. 24 cm
Private Collection

6.2e

Male figure
Djenne
Mali
iron, bronze
h. 49.5 cm
Private Collection

It need not be a matter of surprise that the metal arts of the Djenne and Dogon peoples prove to be inextricably linked, if not actually the same. In a very real sense the Dogon country was the hinterland of Djenne. The two are geographically close, and even today Dogon peasants and traders come regularly to the market in Djenne.

Misconceptions readily arise in the study of African art. We are impressed by the differences between the urbanised, Islamicised, mercantile Djenne people with their dramatic Sahelian architecture and the animist Dogon farmers with their separate language and their world of small huts and granaries. The two being so unlike, we may assume that their metal arts must spring from different sources. The reality may be otherwise. It seems more likely that there was a single specialist group of metal casters (ethnic identity unknown), who had workshops throughout the region and served both the Djenne and the Dogon.

Again we can draw a parallel with the Lorhon brass-casters of Burkina Faso and Ivory Coast. Their clients included not only the animist Lobi, Kulango and Senufo but also the Muslim Diula of Kong. Many of the brass castings commonly attributed to these four ethnic groups may not have been made by them, but rather by this separate artisan group, the Lorhon, and their descendants, who established workshops over a wide area.

It is even possible that the brass castings made for the citizens of ancient Djenne may ultimately prove to be ancestral to those made more recently for the Dogon, Senufo, Lobi, Kulango and other Voltaic peoples such as the Toussian. A remarkable Djenne human figurine published by Blandin, for instance, shows at the same time affinities with Dogon amulets and Kulango and Senufo spirit figures. It is conceivable that different branches of the far-flung Lorhon artisan clan may originally have been responsible for introducing brass casting among all these different peoples. Time and distance may not entirely have effaced the links which connect the brassworking styles of these peoples with the culture of ancient Djenne. *TFG*

Bibliography: Blandin, 1988, p. 33, fig. 1

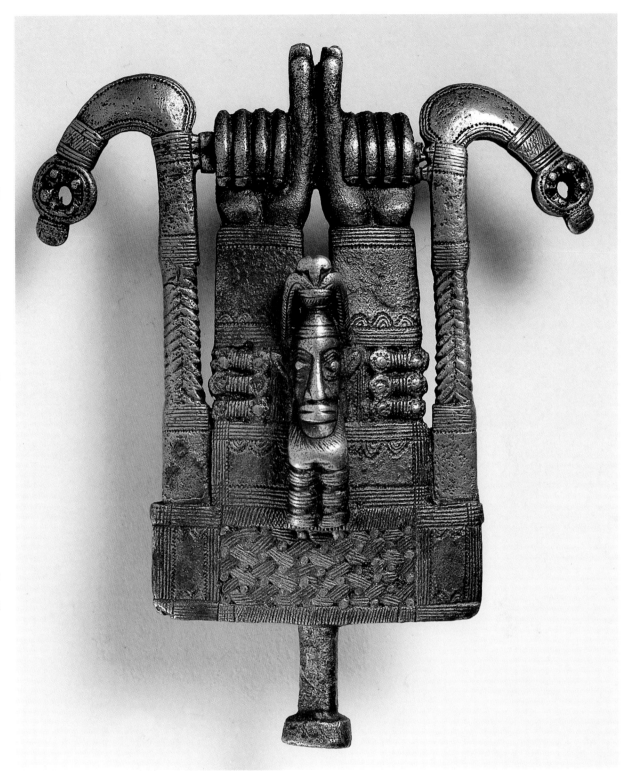

6.2f

Royal ornament

Djenne
Mali
copper, brass
h 11.4 cm
Musée Barbier-Mueller, Geneva, 1004-185

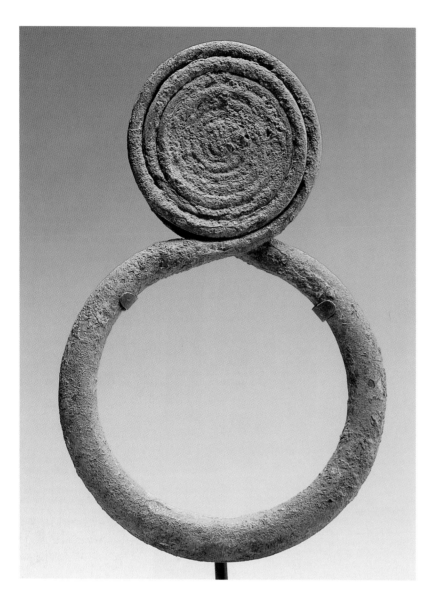

Djenne terracottas

During the period of French colonial rule, fragments of terracotta figures occasionally came to light on the sites of the long-abandoned villages scattered throughout the inland Niger Delta. At first little attention was paid to them. Nothing concrete was known of their function or context of use, and estimates of their age were guesswork. Within the last twenty years, however, carefully controlled scientific excavations, notably at Djenne-Jeno (the site of the ancient city of Djenne), have yielded more figures *in situ.* Thermoluminescence dates show that these were made over a period of several centuries, up to about the 16th century.

Unfortunately, the success of the official excavations led to an epidemic of pillaging by the local population. Hundreds, probably thousands, of ancient sites were ransacked and severely damaged. This activity brought to light an astonishing quantity of terracotta sculpture, often of superb quality, much of it intact or nearly so. This material adds a wholly new dimension to the terracotta arts of Africa, hitherto mainly known through the works of Nok and Ife in Nigeria.

The Malian terracottas occur over a vast region and in a number of distinct regional styles. Human figures predominate, sometimes of large size, and represented either singly or occasionally as a couple. There is also a series of magnificent equestrian figures representing warriors or hunters. Animals, and particularly snakes, were also depicted; small terracottas of coiled snakes are quite common. In the region of Djenne itself these terracottas are modelled in elaborate detail, and in a highly distinctive style. The human figures show a wealth of jewellery and body ornaments, as well as items of clothing. Body surfaces are sometimes ornamented with impressed stamps, or drawn lines or even with raised bumps suggestive of some dreadful disease. Elsewhere, notably to the far west towards Bamako, occur terracottas of much simpler style, in which body decoration is kept to a minimum or omitted altogether. This has been named the 'Bankoni style', after the region where many such works are said to have been found.

The function of this extraordinary statuary is not entirely clear, but appears to have been primarily religious. Medieval Arabic sources speak disapprovingly of the animist cults and idolatry then prevalent in the region. It may have been the spread of Islam, notably following the Moroccan invasion of the region in 1591, that led to the abandonment

6.3
Neck-ring

Djenne
Mali
copper alloy
43 x 23 cm
W. and U. Horstmann Collection

There are two neck-rings known like this one. The owner was told that it came from Djenne where it is so far without parallel. Unfortunately, almost all artworks originally from Djenne were looted so that very little is known about their provenance. The other known neck-ring, which is practically identical, was found in Ife around 1936 together with the granite head of a ram in the churchyard of St Philip's Missionary Society Church in Aiyetoro, during the digging of the grave of Samuel Oki. No closely similar neck-ring is represented in the art of Ife, so it is quite possible that it was imported from Djenne, for both

cities flourished at the same time. Moreover the composition of the Ife piece would be unique in the Ife body of metal castings. Typical Ife pieces are either of copper with only traces of other elements or of zinc-brass, usually with a substantial amount of added lead. The Ife neck-ring, by contrast, is a tin-bronze (with 9.4 per cent of tin, whereas 4.8 per cent is the highest amount of tin recorded from the other Ife pieces) with no detectable zinc at all. Very few copper-alloy artefacts from Djenne have been analysed. They show a wide variety of compositions, none corresponding to the Ife analysis. *FW*

Exhibition: New York 1992

6.4a
Equestrian figure

Djenne
Mali
wood
h. 71.7 cm
The Minneapolis Institute of Arts, 83.168

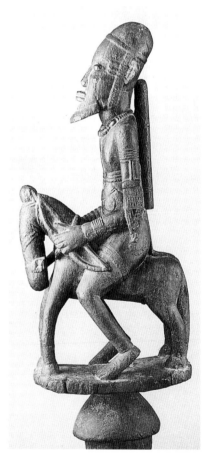

6.4b
Seated figure

Region of Segou
Mali
terracotta
h. 44.3 cm
Musée Barbier-Mueller, Geneva, 1004-13

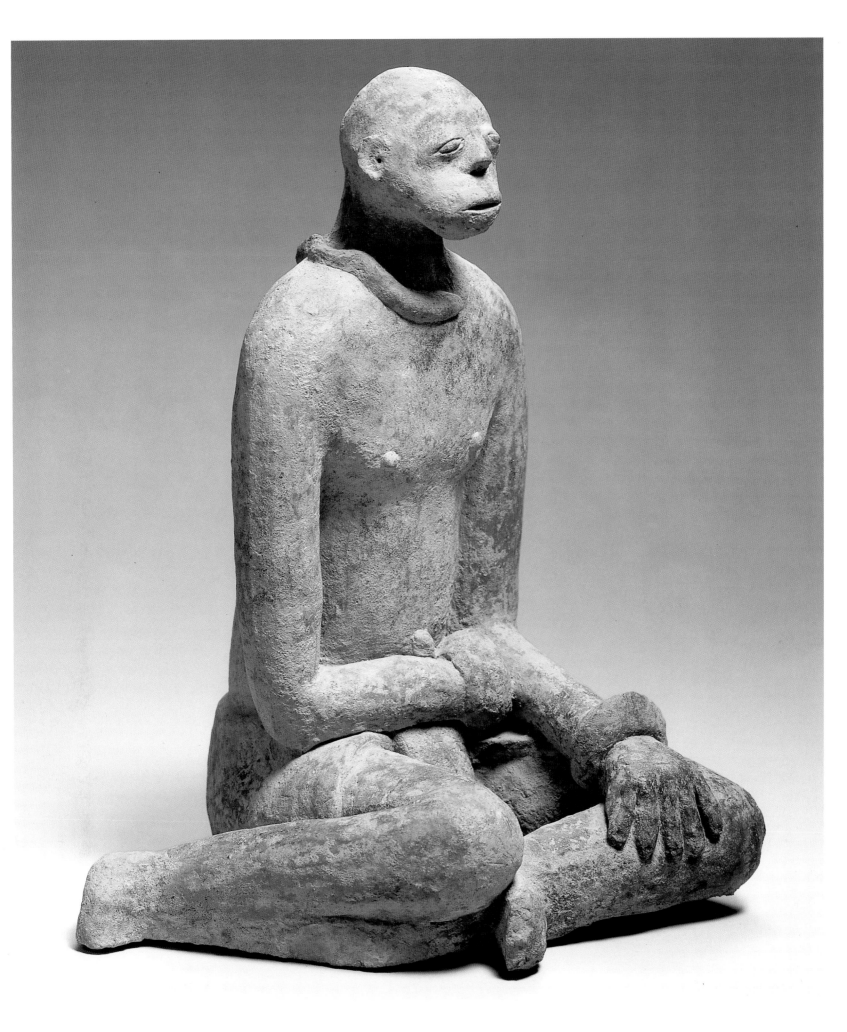

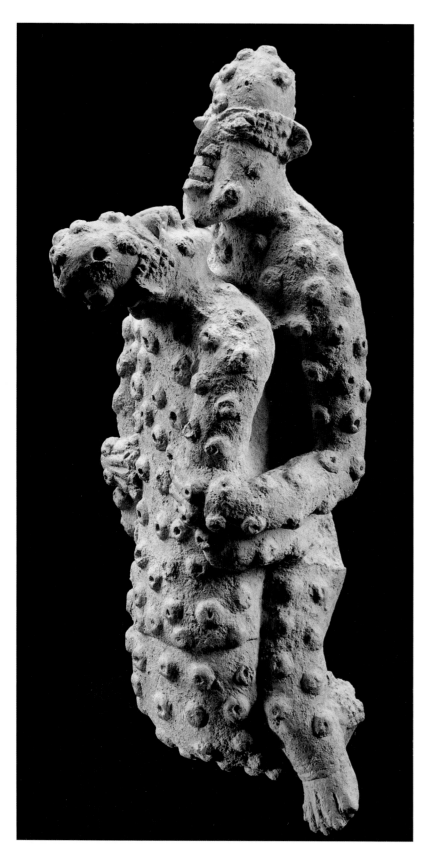

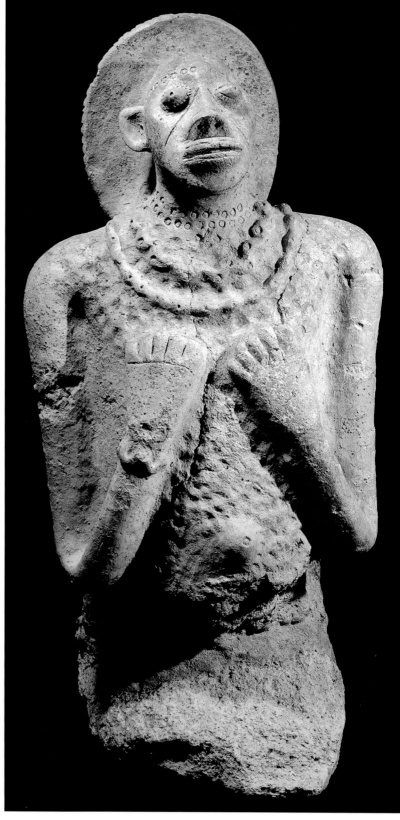

6.4c

Embracing couple

Djenne
Mali
terracotta
h. *c.* 40 cm
Private Collection

6.4d

Kneeling figure

Djenne
Mali
terracotta
55.2 x 30.4 x 28.5 cm
Maureen and Harold Zarember

of these statues and the cults and practices associated with them.

A variety of explanations can be proposed, ranging from guardian figures, spirit images and commemorative figures of the dead to depictions of traditional legends. Some of the human figures appear to be in attitudes of adoration. The wealth of serpent imagery suggests that snake cults were widely known, and these reptiles occupy a prominent place in the myths and folklore of the region.

The simple potter's art was also practised in Mali to a degree of excellence rarely achieved elsewhere in west Africa. From the Djenne region come countless small pots, jars and flasks in shapes of extraordinary delicacy and beauty. There are also larger vessels for grain and water storage, as well as for medicinal use, and some of the largest were used for human burials. All these come from the same sites as the terracotta figurines. Further west, the Bankoni region has yielded a series of unique long-necked zoomorphic pots. Until recently the wood sculpture of ancient Djenne was totally unknown. It was assumed that all such sculpture had perished centuries ago, although its existence could be inferred from certain comments in the medieval Arabic sources. Now, however, several examples of ancient Djenne wood sculpture have come to light. They are masterly works, carved with meticulous attention to detail and unmistakably in the same general style as the Djenne terracottas. The circumstances of their preservation and finding are not known to me, but since they seem virtually undamaged they could scarcely have come from the exposed sites of the delta itself. I have heard it said that they must have been hidden in caves in the Dogon country, and this seems the most likely explanation, for Dogon and Tellem statues have been found in such caves, preserved for centuries against destruction. The Djenne sculptures appear to date from the 15th or 16th century, and they could have been hidden in Dogon country by citizens of Djenne fleeing from the Moroccan invasion of 1591.

The wood sculptures of ancient Djenne also bear much resemblance to those of the Dogon themselves, and this is perhaps not surprising. Djenne, situated on the edge of the desert, is likely to have produced little wood suitable for sculpture, and supplies would have come from the nearest available source, probably the Dogon region. This being so, it is entirely feasible that the statues were actually carved by sculptors from the Dogon country. There is a need to re-evaluate the relationship between the Djenne peoples and the Dogon, as evidenced by the survival of these remarkable wood sculptures. *TFG*

6.4e

Female figure

Djenne
Mali
terracotta
45 x 16.5 x 18 cm
Private Collection

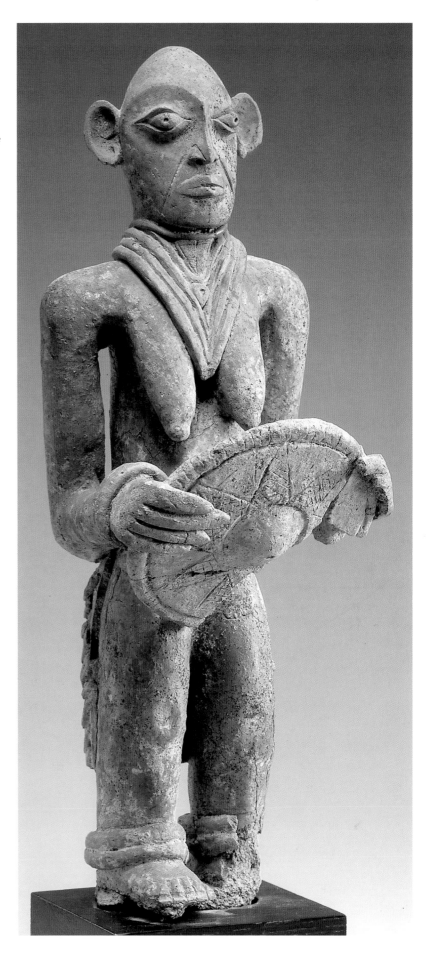

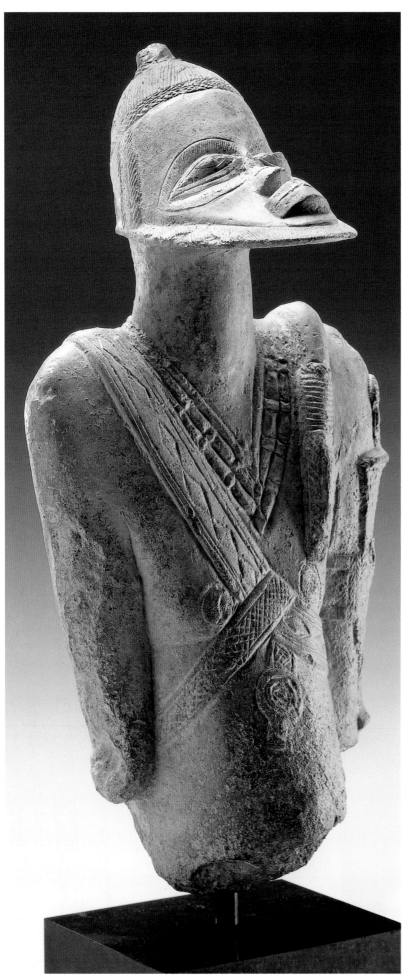

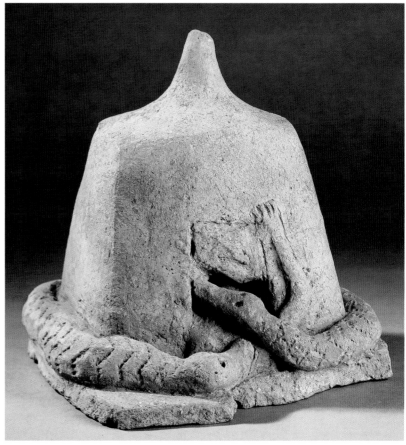

6.4f

Bearded figure (*fragment*)
Djenne
Mali
terracotta
h. 38.1 cm
The Detroit Institute of Arts
Founders Society, Eleanor Clay Ford Fund
for African Art, 78.32

6.4g

Shrine sculpture
Djenne
Mali
terracotta
22.7 x 22.2 x 22.7 cm
New Orleans Museum of Art
Museum Purchase, Robert P. Gordy Fund,
90.196

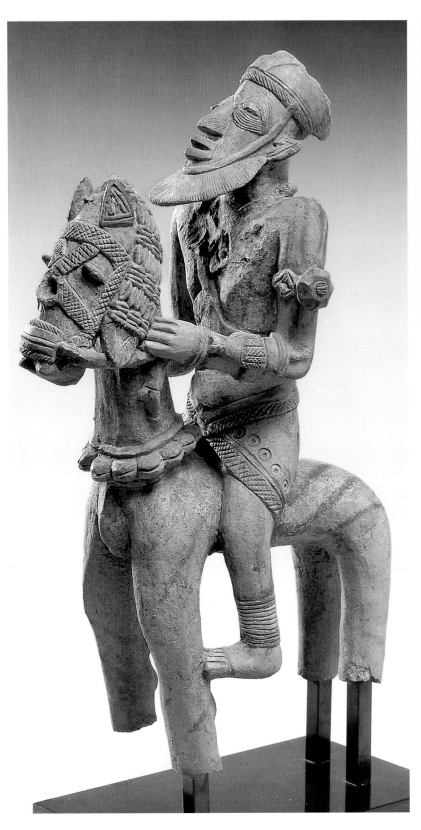

6.4h

Horse and rider

Djenne
Mali
terracotta
44 x 17 x 30 cm
Private Collection

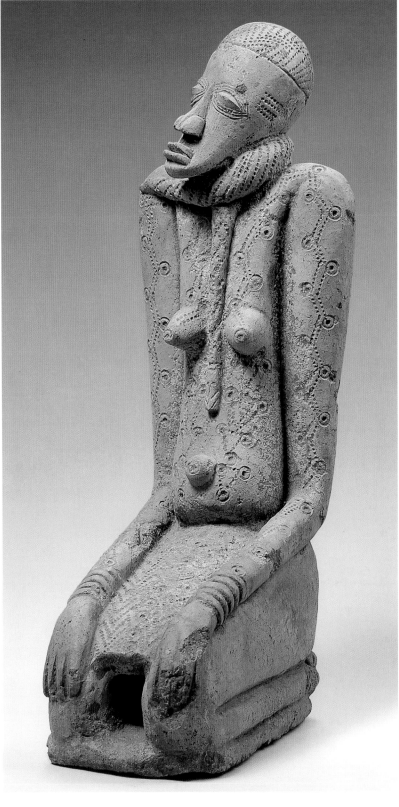

6.4i

Kneeling figure with snake

Djenne
Mali
terracotta
h. 57 cm
Private Collection

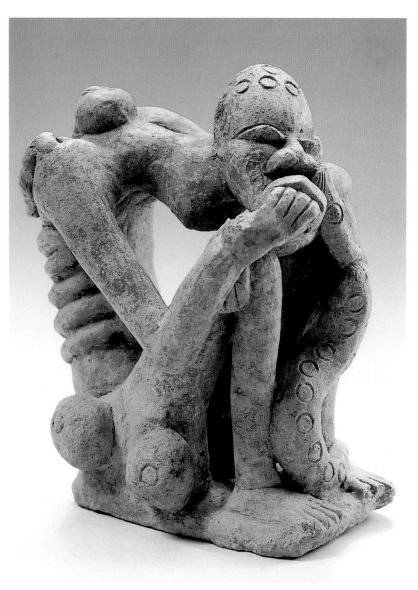

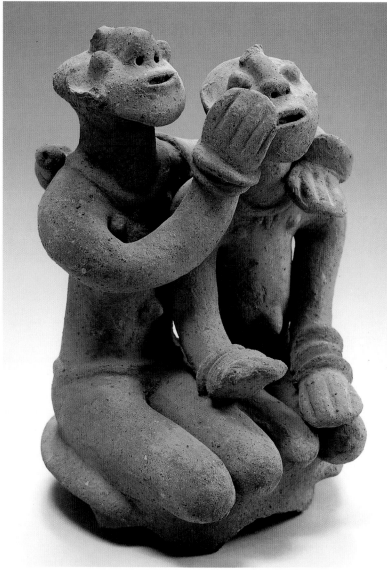

6.4j

Figure

Djenne
Mali
terracotta
h. 29.5 cm
Private Collection

6.4k

Pair of figures

Bankoni
Mali
terracotta
h. 33.8 cm
Private Collection

6.41

Three pots

Bankoni
Mali
terracotta
c. 54 x 22 x 22 cm
Private Collection

6.5a

Staff (*sono*)

Beafada, Badyaranke, Maninka or Fula
Guinea and Guinea Bissau
19th–20th century
copper alloy
69.9 x 4.1 x 3.8 cm
Lent by The Metropolitan Museum of
Art, New York
The Michael C. Rockefeller Memorial
Collection, Bequest of Nelson A.
Rockefeller, 1979.206.212

6.5b

Staff (*sono*)

Beafada, Badyaranke, Maninka or Fula
Guinea and Guinea Bissau
19th–20th century
copper alloy
h. 135 cm
Musée Barbier-Mueller, Geneva, 1001–32

Brass and iron staffs, called *sono*, form
part of what may be one of the oldest
continuous traditions of art in west
Africa. The bottom is often a spear
blade. In the central shaft, typically,
forged iron is thrust at regular inter-
vals into brass collars made by the
lost-wax casting technique and em-
bellished with geometric patterns.
The brass collars often include
angular extensions that create a
cage effect, or a pair of hook shapes
that sweep down, out and up again,
ending in small replicas of human
heads. The top of the staff is capped
with a brass finial, generally consist-
ing of an elaborately decorated cone
or globe upon which figures or
animals are mounted. These may
include equestrian figures with
attendants, some female and carry-
ing containers upon their heads,
some male with exaggerated genitalia.
Many of these males carry staffs or
weapons, and may be warriors. The
brass casting is fine enough for horses'
reins and people's hairstyles to be
wonderfully articulated.

These staffs, which have mistakenly
been attributed to the Soninke, seem
to possess a complex and somewhat
confusing genealogy. They are most
directly attributable to the Beafada (or
Biafada), Badyaranke (or Pajadinca),
Maninka (or Malinké) and Fula
(or Peul), all of whom have lived in
the area we know as the Republic of
Guinea and Guinea Bissau. To the
north in Senegal the ancient Mande
kingdom of Kabu used similar staffs,
and the same may well be true of
other states founded by Mande
colonists between the Gambia

and Corubal rivers described in
16th-century Portuguese accounts.
Still further north in The Gambia,
closely related staffs called *chono*
were found that featured more ab-
stract compositions and emphasised
iron but often included brass, as well
as silver. They were still being used
in the mid-20th century by Mandinka
groups along the Gambia River, the
descendants of 13th-century Mande
imperialists who mixed with local
populations and founded a cluster
of Mande expansionist states.

South-east of the Beafada and
Badyaranke, along the coast in Sierra
Leone, late 17th-century Portuguese
traders seem to have carried a number
of brass and iron staffs very much like
the present examples as gifts to Bulom
leaders in the area known as Ro-Ponka.
And further east in the Ivory Coast,

some Senufo seem also to have used
brass and iron staffs.

Inland, similar staffs, usually made
entirely of iron, have been used up
to the present by heartland Mande
groups such as the Bamana, Bozo and
Maninka. Many scholars feel that this
is the area where the staff originated.
The tradition could be as old as the
Mali empire.

The most plausible hypothesis is
that as early as the 13th century such
staffs were carried west and south by
groups of military leaders and entre-
preneurs who were pursuing the Mali
empire's expansionist policies.

The staffs from the Gambia River
have been used as insignia of leader-
ship and political power. It seems
likely that over all the centuries they
were viewed as vehicles to associate
their owners with the power and
historical glory of the Mali empire
and its leaders, even as the hinterland
kingdoms manoeuvred for independ-
ence and distance from any tangible
subordination.

Both Mande heartland peoples,
such as the Bamana, and Mande-
speaking peoples abroad in the hinter-
lands have had very long-standing
interest in making art from metal.
Mande have worked hard to be
centrally involved in west African
mining and trading of gold since at
least as early as the ancient Ghana
empire (which was flourishing by
the 8th century). Sculptures and
ornaments of all kinds, and in
tremendous abundance, were re-
corded by early Arab visitors to the
courts of the Ghana empire and the
subsequent Mali empire (early 13th
to the late 16th centuries), and oral
traditions credit many of this vast
area's greatest heroes as having been
members of famous metal-smithing
families.

The staffs also symbolise and
embody the occult powers articulated
in the spiritual beliefs of the area.
Metal is an excellent medium for
storing and harnessing enormous
amounts of energy, because smiths
can transfer it to the staffs during
their creation. They were used as
crucial religious objects in non-Islamic
cults. In the Republic of Guinea and
Guinea Bissau, for example, they
would be stuck into the side of sacred
trees, where they could amplify the
powers of their owners by influencing
the invisible forces constantly at work

in the natural and social worlds. They were also used as soothsaying devices and consulted before any dangerous undertaking, such as war. Chono versions along the Gambia River were intended to protect the kingdom and its capital, and even today medicines and amulets may be hung on the hooks to protect political office-holders.

Their symbolism remains largely unexplained, and it could well be that it was quite flexible. Equestrian imagery may invoke wealth and power, and refer to leadership or even particular rulers. Possessing a horse was a clear indication of power and wealth. The spear blade bottoms also suggest power generally and military prowess specifically.

In the more complex example (cat. 6.5b) the standing figures form an apparent entourage, an indication of status and prestige for the mounted figures.

Human heads at the ends of the hooks that sweep out from the iron shaft are almost ubiquitous on these brass and iron staffs. The simpler example (cat. 6.5a) features an assertively articulated male figure carrying a staff or weapon and standing upon two human heads which are themselves set on top of one another. This composition could well refer to dominance over a population or even over a defeated enemy. The heads could also refer, however, to a supporting population upon whom a leader depends for power. *PMcN*

Bibliography: Pereira, 1506–8 (1956); Koroma, 1939, pp. 25–8; Mota, 1960, pp. 625–62; Lampreia, 1962, nos 412–17; Mota, 1965, pp. 149–54; Weil, 1973; Bassani, 1979, pp. 44–7; Weil, 1981

6.6

Staff with female figure

(nege muso)
Bamana (Bambara)
Mali
iron
h. 161 cm
Private Collection

Staffs of this type are the most technically difficult of all the art-works Bamana and other Mande sculptors make. These sculptors are almost invariably members of the blacksmiths' clan. Typically, the shaft is forged out of several pieces, which are joined by inserting the top of one into a socket formed from the bottom of the next, and then heated and hammer-welded together. Frequently the shaft is expanded into cage-like protrusions, and on most examples hooks sweep down, out and up from the shaft, usually at the sockets. The hooks end in rounded knobs, which may be reminiscent of the little brass heads on the similar staffs called *sono* (cat. 6.5). Less frequently, as in this example, the sweeping hooks are inverted, and end in little iron rattles or bells, much like many Dogon staffs. Many of these staffs end in a spear blade at the base, but the creator of this piece has moved the blade from the bottom to the top (again like many Dogon examples) and embel-lished it with groups of five tooth-shaped extensions. The cages, inverted hooks and embellished spear blade work exquisitely together to create a powerful composition that frames and helps to highlight the marvellously sculpted female figure in the middle.

The figures on most staffs are standing women or equestrian men, and they are generally placed at the top, unlike our example. Here the figure carries a container on her head. The elongated limbs and flexed knees are typical, but the overall articulation and embellishment of this piece is masterly.

Mande blacksmiths overflow with the same spiritual energy (called *nyama*) that is said to animate the universe and allow for every action in it. This is the energy that makes amulets effective, and these staffs become amulets themselves, because as smiths forge them they also infuse them with *nyama*. They may also add additional power through secret recipes (cat. 6.8) that combine science and ritual.

These staffs were used in many situations: they could be set on top of the tombs of leaders and town founders, or in front of family residences to help honour ancestors. Some chiefs apparently used them as family insignia, and also used their power as amulets to enhance their own leadership abilities. Some staffs were considered so powerful that they could be employed to turn away attacking armies.

The Bamana secret initiation associations also used the staffs around their altars, or put them near or even in sacred trees. The beauty of the staffs was said to make the altars more powerful, as was the power embedded in the iron. This power strengthened the association, but the beauty of the staffs also enhanced funerals, when they were carried in procession, or regular business meetings, when members danced with them.

Symbolism, as in much Bamana sculpture, is ambiguous and subject to various interpretations. That is particularly true of the forged figures. They may be ancestors or characters from Mande legend, such as Muso Koroni, the first woman on earth, semi-divine, and bringer of tremendous chaos; or (if male) Ndomajiri, the world's first blacksmith and bringer of stability and medicines. The hat worn by this figure resembles those worn by hunters and sorcerers, and its presence on a woman signals awe-some occult power. The spear symbol-ises power in the more tangible world of aggressive military deeds. *PMcN*

Bibliography: Imperato, 1983; McNaughton, 1988

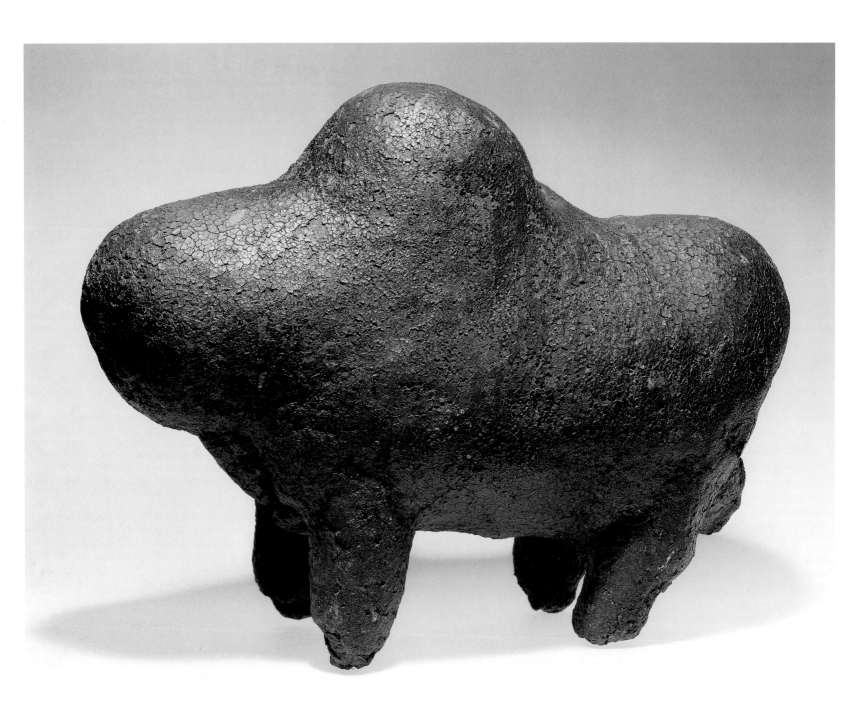

6.7

Altar figure (*boli*)

Bamana (Bambara)
Mali
wood, encrustation
Laboratoire d'Ethnologie,
Musée de l'Homme, Paris, 31.74.1091

Boliw (sing. *boli*) have become widely known in the West although ironically they are considered by Mande people to be secret objects. They are used by the Bamana secret initiation associations and harbour huge quantities of energy (*nyama*) that can be activated by the association priests and members to help accomplish goals (such as destroying anti-social sorcerers). They also serve as symbols of the Bamana universe, and association members help make them by bringing together a wide range of often esoteric ingredients, including animal bones, vegetable matter, honey and pieces of metal. Some colonial era authors claimed that human body parts were included. The surfaces are hard, with thick coatings of earth, impregnated with sacrificial materials such as the blood of chickens or goats, chewed and expectorated kola nuts, alcoholic beverages and millet. Both surfaces and interiors are created by enacting a complex array of the power recipes called *daliluw* (cat. 6.8), with the result that these objects are considered to be among the most potent of all Mande sculptures.

Many *boliw* seem to depict animals such as hippopotami or cows, and some are shaped like human beings. Sometimes, however, it is impossible to suggest what they might be. This fits with the Mande principle that very powerful things are opaque to general human understanding, and only the initiated will understand them. For others, the lack of understanding is ominous, and the murky ambiguity articulated in the shapes serves as a warning to stay away or risk great personal danger. Only skilled professionals are capable of engaging the powers contained in these instruments.

Some Mande feel they are devices to be used for the good of association members and the community. Others find them loathsome and fearsome, with too much power that dominates the members of the associations. Still others consider them to be just one more element in their social and spiritual landscapes, sometimes to be used, sometimes to be treated with caution.

Placement of these objects is not entirely clear. When the *ci wara* (cat. 6.10) association used them, they were kept in baskets, and association officials danced with them on their heads during meetings. *PMcN*

Bibliography: Dieterlen, 1951, pp. 92–3; Imperato, 1970; McNaughton, 1979; Brett-Smith, 1983; McNaughton, 1988

6.8

Mask in the shape of an animal head

Bamana (Bambara)
Mali
wood, encrustation
47 x 25 x 22 cm
Museum Rietberg, Zurich, RAF 206
Baron E. von der Heydt Collection

This mask is designed in the helmet configuration and horizontal alignment typical of Mande youth association masks or those of the secret initiation associations that specialise in the manipulation of occult power. Youth association masks do not possess sacrificial surfaces, however, so this example certainly belonged to a power association. Komo, Kono and Nama are the three best known. Kono is an unlikely candidate, because to our knowledge their masks are greatly elongated, so that they usually measure a metre or more from ear to snout. Komo masks can be up to a metre long, but they are generally around half that size, while Nama masks are most frequently even smaller. By size, then, this mask could be Komo or Nama.

Komo masks are renowned for their enormous and threatening mouths, while this mask's mouth is not quite so ferocious. Nama masks, on the other hand, are frequently articulated as birds' heads. In this example the overall configuration of the head is reminiscent of the wild boars that inhabit the Malian countryside. It therefore falls outside the most common range of imagery for either Komo or Nama. But, as in the case of other Bamana art forms (e.g. cat. 6.6), personal experiences, expertise and imagination can generate works that are decidedly out of the ordinary.

There are other Bamana power associations that are unknown to strangers, being very local or even one-of-a-kind branches in a single community. These come into being and continue to exist through the efforts of capable, convincing and often charismatic spiritual experts. The expertise involved is grounded in the power recipes, in what the Mande call *jiri don*, the science of trees, an ever-expanding and changing body of herbal knowledge that views the natural world both scientifically and ritualistically. While many people who possess the highly secret knowledge accept what they learn with no

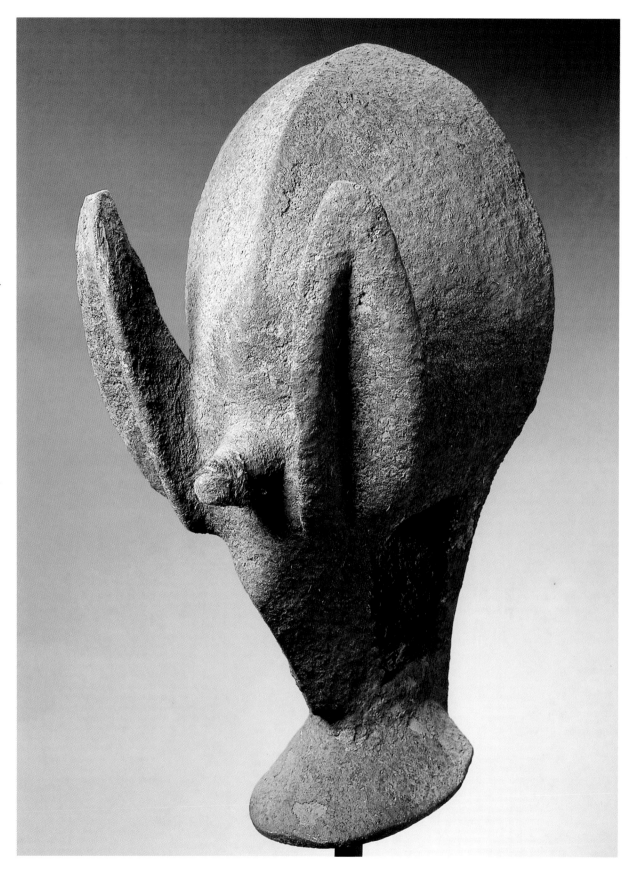

desire for alteration, others are very experimental with it. This leads to idiosyncratic sculpture.

In general, the power associations solved problems and did good works for their members and their com-

munities. Much depends upon the effectiveness of officials, however, including the leader or assistant who dances the mask at association meetings. *PMcN*

Bibliography: Zurich 1963, no. 7; McNaughton, 1979; MacNaughton, 1988; McNaughton, 1991; McNaughton, 1992

6.9a

Female figure (*nyeleni*)

Bamana (Bambara)
Mali
wood, iron, oil
h. 71 cm
Private Collection

6.9b

Female figure with container
(*jomogoniw* or *gwanden*)

Bamana (Bambara)
Mali
wood, oil
h. 130 cm
Private Collection

These two sculptures are associated with the initiation associations called Jo and Gwan in southern Mali. The most widely known uses for such figures are as memorials for deceased twins and insignia of initiation in the Jo association branches. Twin sculptures tend to be smaller, typically ranging up to about 50 cm in height, and they depict either males or females, depending on the gender of the deceased. Jo association figures tend to be a little larger, usually not less than 50 cm high; they always depict women, generally standing on a circular base. But there is so much room for overlap that often a particular figure cannot be attributed with any certainty. The smaller piece shown here (cat. 6.9a) is most likely a Jo association sculpture.

The Mande associations, known generally as Jow (sing. Jo), offer general social guidance and teach modes of behaviour. These associations were arranged in a hierarchical order of initiation, and increasingly complex and esoteric levels of knowledge were provided as members moved up the hierarchy. This hierarchy was disrupted by first the Tukulor in the late 19th century and then the French. But even before Tukulor domination these associations very likely exhibited considerable variation and flexibility.

In the southern Bamana area, within a rough triangle formed by the towns of Bougouni to the west, Dioila to the north and Sikasso to the east, the Bamana secret initiation associations are reduced to two, Jo and Gwan, which express their own forms of variation, such as having joint female and male membership.

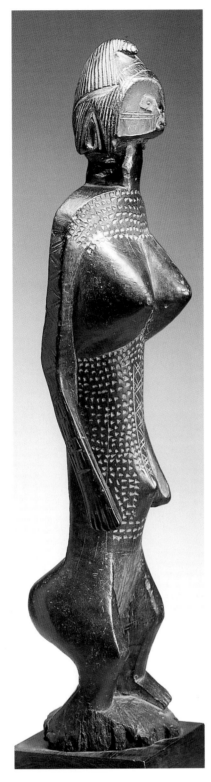

The Jo association is complicated, with internal subdivisions, elaborate rituals and ceremonies, and a six-year waiting period before initiation, which is for *jo kalan*, 'learning about the Jo'. When new Jo members return from their initiation retreats, they perform the songs and dances they have learnt, first for their own communities, and then on performance tours throughout their regions, which last several months.

Blacksmiths generally form their own group within the Jo and it is they who use figures such as cat. 6.9a when they tour and perform after their initiation. They hold them or set them in the performance arena as they sing and dance. The sculptures are called *jonyeleni* or *nyeleni*, which means 'little Nyele', a name often given to first-born daughters, which means 'pretty little one'. These sculptures are oiled and often embellished with clothes and jewellery, and they are carved to emphasise ideal attributes of feminine beauty. They may serve to express interest in and concern about the institution of marriage, in which newly initiated single men will soon be involved. They also help to make the blacksmith performances the most successful and entertaining of all the performing groups within the Jo.

Much larger sculptures, such as the second example shown here (cat. 6.9b) were also used, where they were called *jomogoniw*, 'little people of the Jo'. They were also used in the Gwan association (and called *gwandenw*, 'children of the Gwan'), a special division concerned with issues of fertility and childbirth.

These larger figures are cared for by senior members of the associations, and are displayed during their annual celebrations. They are washed to remove extraneous matter, re-oiled and adorned with clothing, and then sacrifices are made on the entrance to the house where they are kept. Ezra says people refer to the sculptures as 'marvellous things' (*kaba ko*), and 'things that could be looked at without limit'.

The annual Jo celebrations generally involve only two sculptures, depicting a man and women. The Gwan celebrations involve more elaborate groupings of up to seven. A seated woman with child (*gwandusu*) and a male (*gwantigi*), often seated, were the most important. The other figures were called companions, and each had its own name. They included a woman carrying a container on her head (as at cat. 6.9b), and a woman holding up her breasts in a gesture of nurturing. Often the women's stomachs swell gracefully, suggesting pregnancy or fertility. The display group was considered a kind of theatre, representing the nature and activities of the association. *PMcN*

Bibliography: Pâques, 1954; Zahan, 1960; Imperato, 1974, nos 66, 97; Imperato, 1975; Ezra, 1983; Imperato, 1983; Ezra, 1986

6.10 a–b

Two antelope headdresses

Bamana (Bambara) or Wasulunka
Mali
20th century
wood
a: h. 55 cm; b: h. 80 cm
Private Collection, London

Carved wood antelope headdresses
such as these are among the most
widely known and greatly appreciated
Mande types of art in the West.
In fact, few types of art from any-
where in Africa have received more
Western attention. They are used by
the Bamana agricultural associations;
the best known is called *ci wara*, the
lesser known *gonyon*. In both, the
headdresses are called *ci wara* ('*farmiy
anind*', '*farming beast*'). Similar sculp-
tures are called *sogoni kun* and are
used by the Wasulunka youth associ-
ation (*jon*) during farming festivals.
Goldwater popularised a regional
system of attribution for these head-
dresses. Carved headdresses that
extend upwards in a large curve with
openwork carving to represent the
antelope's neck and mane belong to
the 'vertical style' associated with the
eastern Bamana. Smaller headdresses
with pronounced horizontal exten-
sion, which are sometimes carved
more naturalistically, belong to the
'horizontal style' associated with
northern Bamana. Examples such
as these, that emphasise tremendous
variation, great ingenuity of form and
often extreme abstraction, belong to
the 'abstract style' generally associated
with southern Bamana and Wasulunka.
Here anteaters and aardvarks may
also be included in the sculpted com-
positions and frequently the formal
elements are so stylised that it becomes
difficult to sort them out. As in many
other types of Mande sculpture, the
creativity and expertise of sculptors
play prominent roles.

The *ci wara* association began as a
secret male initiation association that
taught agricultural skills and sought
to maintain the blessing of the super-
natural being (also called *ci wara*) that
first taught people to farm. Dances
were held in the fields and, instead
of masks, dancers put part of their
boli (cat. 6.7) in a basket and set it
on top of their heads. Later the carved
antelope headdresses were invented
and danced in male-female pairs.
Gradually the performances became
less secret so that ultimately entire

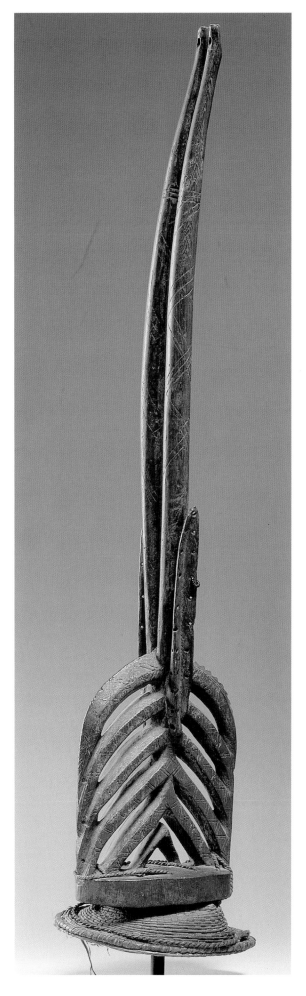

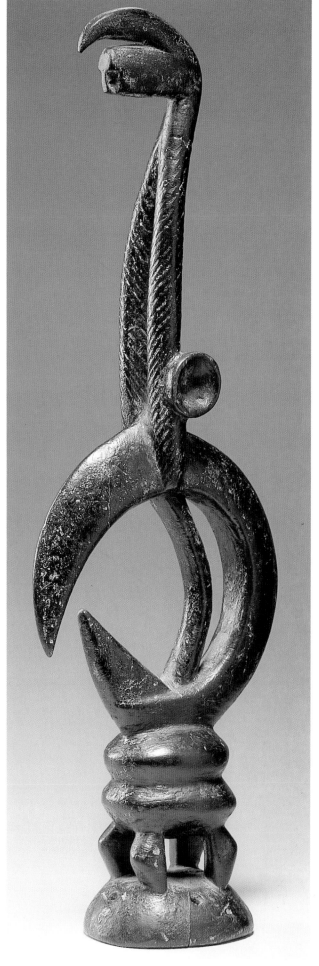

communities could attend, and the association became best known for its annual farming contests and accompanying performances.

The Mande often use animals in metaphors that comment upon social life and the human condition. Roan and dwarf antelopes are considered graceful and strong; aardvarks are determined and conscientious. These are values associated with farming, where strength, stamina, patience and foresight are all necessary to do a good job. In this regard another use of the phrase *ci wara*, which means 'farming animal' or 'farming beast', is important as praise for good farmers, for it likens the prowess of a person to the prowess of creatures that survive in the ultimate of difficult environments, the wilderness. *PMcN, DA*

Bibliography: Ganay, 1947; Ganay, 1949; Goldwater, 1960; Imperato, 1970; Imperato, 1974, pp. 19–21; Zahan, 1980; Brink, 1981, pp 24–5; Zahan, 1981, pp. 22–4; McNaughton, 1994, p 35

6.11

Pair of masks

Bamana (Bambara)
Mali
wood, organic matter, cotton fibre
25 x 17 x 12 cm (male);
37 x 16 x 11 cm (female)
Charles and Kent Davis

These masks are clearly carved in a Bamana style. The nose, mouth and the planes of the face all suggest that they come from areas where the initiation associations called Jo and Gwan are found. They bear a striking resemblance to the faces of the large carved wooden figures used by both of those associations. Although information on these masks is extremely limited, we may tentatively surmise that they belong to the Jo association, and possibly to the Gwan as well.

The Jo association is divided internally into several age grades, the most senior of which can be entered at the age of 36 when an applicant has successfully acquired the knowledge and moved through the process of formal initiation that mark passage upward in the association. Association leaders are picked

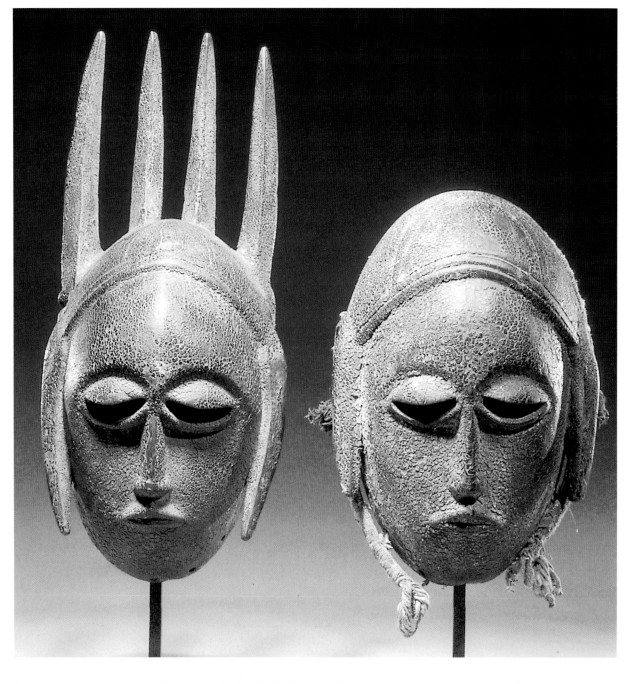

from the senior age group, and one of the most important leaders is *Nanfiri* which is also the name of an esoteric ritual object in his charge.

The ritual object, though small enough to be stored in a gourd, possesses tremendous supernatural power, and is used for swearing oaths. The official called *Nanfiri* is also very important: he has ritual roles at funerals, including the funeral of the head of the Jo, and he oversees and protects new initiates into the association during their induction ceremonies.

The Jo is one of the Bamana initiation associations that undertakes public performances, and when they

do the *Nanfiri* is a prominent dancer, so much so that he is called 'decoration' for the association. When dancing the *Nanfiri* wore a cotton cloth costume dyed red with painted designs in black. A hood with eye holes topped with porcupine quills and feathers covered his head. Similar cotton cloth costumes and hoods are fairly widespread in the general region of west Africa, extending south into Ivory Coast and north into Beledougou plains north of the Niger River.

In the 1980s Charlie Davis, a New Orleans dealer, told Ezra about wooden masks from southern Mali, which he understood to be called *Nanfiri* and to be part of the Jo and Gwan associations. It is possible that

certain branches of the associations decided to create masks for their *Nanfiri* office holders. Such a change would be consistent with the creativity that many Bamana people manifest. The organic materials on these masks could be sacrificial. One (described as female) has the row of horns quite common on Ntomo masks, which belong to another of the well-known Bamana associations. If as surmised these masks belong to the Jo and Gwan associations, and if they are a pair, we do not know who, besides the *Nanfiri* office holder, wore one. *PMcN*

Bibliography: Ezra, 1983, pp. 68–75; Ezra, 1995

Dogon

Dogon statuary is among the most discussed and least understood in Africa. A number of factors have contributed to this state of affairs. First, there is the obvious fact that the Dogon do not in any simple sense 'exist', having been defined and created as a convenience of colonial administration. Then there is the difference between anglophone and francophone styles of field enquiry, the former traditionally functionalist, the latter intellectualising and systematising, each perhaps saying more about the ethnographer than about the Dogon. There is also the matter of specialist as opposed to generalised exegesis in a culture where knowledge cannot be assumed to be equally shared by all so that varying interpretations may not be seen simply as contesting. Complicating the enquiry is the stern disavowal of knowledge that often follows on from conversion to Islam. Behind it all lurks the reality or otherwise of the Tellem, responsible for a sup-posedly ancient substyle but whose name seems to mean simply 'we found them'. The status of the works as art has inevitably become entangled with their ability to be unpacked into cosmic messages so that a style of exegesis has developed that sees Dogon sculpture as largely expressive of myth and constituting a form of congealed cosmology.

The statues themselves vary enorm-ously in size, form and surface patina-tion. This is not to say that art critics have not sought to establish rigorous styles and historical watersheds, but the value of such attempts is at best to impose a somewhat arbitary order on a mass of ill-digested data so that 'transitional forms' abound. It remains the case that we have very little reli-able information on what Dogon statuary was used for and by whom, a fact that has certainly entered into the way in which it has been used to bolster arguments for the universality of art. Interpretations home in on 'ancestral' figures and those involved in rainmaking. *NB*

Bibliography: Griaule, 1965; Laude, 1973; De Mott, 1979; Bedaux and Lange, 1983, pp. 5–59; Van Beek, 1991, pp. 139–67; Leloup, 1995

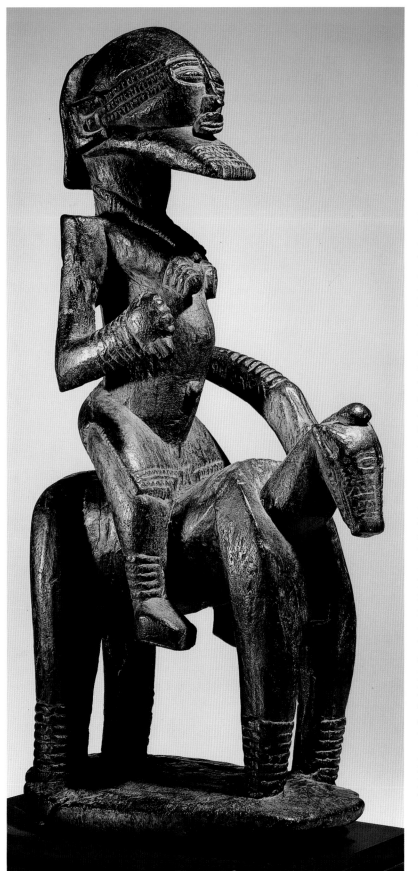

6.12

Equestrian figure

Dogon
Mali
18th century (?)
wood
h. 50 cm
Private Collection

The chronicles of Muslim travellers throughout the Sahara and Sahel tell of the existence of the horse in Mali's ancient empires. From the mid-11th century, royalty is known to have dis-played its authority, and kingdoms to have flourished their military might, with the aid of equestrian prowess. This equestrian figure exhibits such characteristics. Larger even than his powerful mount, the rider sits proudly upright, his feet secured in stirrups, his left hand holding the reins. His beard indicates that he has earned respected elder status, the scarification marking his temples suggests affilia-tion with or initiation into a particular social group. The jewellery that adorns his neck, arms and ankles – a motif repeated on the lower legs of the horse – denotes personal achieve-ment and wealth.

Among today's descendants of Mali's historic inhabitants are the Dogon: a society with neither the royalty nor the military of early empires, but whose sculpted eques-trian figures remain an adapted, and continually adaptable, sign of privilege and power. Riders may rep-resent warriors, invaders or emisaries from afar, respected deceased leaders of the local community, bush spirits that appear to passers-by, or the spiritual supremacy of the village priest or *hogon*, each of whom possesses a link to ancestral realms and has the means to own a horse and the power to discipline it to his will. *RH*

Bibliography: Law, 1980, p. 13; Ezra, in New York 1988, p. 40; Van Beek, 1988, p. 63; Cole, in Washington 1989, p. 121

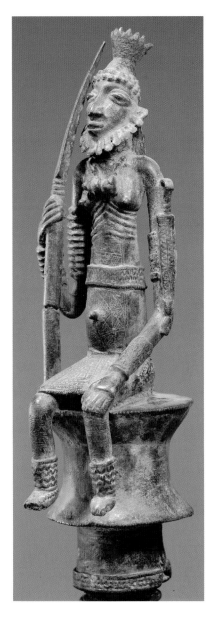

6.13

Staff

Dogon
Mali
copper alloy
h. 75 cm
Lent by The Metropolitan Museum of
Art, New York
Edith Perry Chapman Fund, 1975.306

6.14

Torso (fragment)

Dogon
Mali
wood
14 x 5 x 3 cm
Herman Collection

6.15

Kneeling female figure

Dogon
Mali
wood
Private Collection

The kneeling figure (male or female)
is a motif often found among Dogon
figurative sculpture and may be
representative of a long history of
trade in ideas and subjects among
the varied inhabitants of the region
reaching from Mopti and Djenne
to the Bandiagara escarpment.
This example exhibits features of
such historic sculpture as well as
characteristics considered highly
desirable in a Dogon woman. She
kneels devotionally; her eyes are cast
deferentially downwards; her head is
held high but modestly bowed on
top of a slender neck. Her youthful
breasts and rounded belly offer the
potential of childbearing. Her scars
suggest an ability to embrace the
responsibilities that come with
membership of adult society, and
her coiffure – its carved motif visually
echoing her scars – accentuates a head
that is outwardly well tended and in-
wardly properly educated. Her power-
ful thighs support a strong body, and
her fingers point toward the female
earth. Although her posture and com-
portment have been linked visually to
terracotta figures associated with early
Inland Niger Delta civilisations (and
the repetition of the kneeling pose
found among a number of historic
and contemporary figures suggests
ritual significance), we fully under-
stand neither the significance of the
pose nor the linkage between historic
and contemporary figures of this kind.
RH

Bibliography: de Grunne, 1988, pp. 50–5,
92

6.16

Mask

Dogon
Mali
wood
h. 58 cm
Private Collection

This unusual mask features elements
which, although common to Dogon
sculpture, are not generally combined
in one piece. This kneeling female
may be associated with Satimbe,
the ancestral female who discovered
masking and from whom masking
was appropriated for use within the
male domain. The figure may also
depict Yasigine, older sister of masks,
who has become synonymous with
the women's groups that provide
food, drink and other sustenance for
masquerade dancers during ritual
performances. Masks such as this
are danced during Dama, a post-
interment funerary rite mounted by
villages every several years, and Sigi,
a multi-village event undertaken
every 60 years. The imagery may be
female, but masks are danced by men.
The rites affirm the village as living
and distinguish it as a realm separate
from the spirits of the deceased.

In most known examples of the
Satimbe mask, the female figure
stands or sits, with arms raised, at
the crown of a mask that most often
represents an antelope. In this example,
the figure kneels, arms at her sides,
above a mask with a decidedly human
face. She may once have been adorned
with beads and have worn a raffia
skirt, serving both as a reminder of
the wilds where masking was dis-
covered, and to cover her lower body,
the sight of which is prohibited to
men. *RH*

Bibliography: Griaule, 1938, pp. 266–78

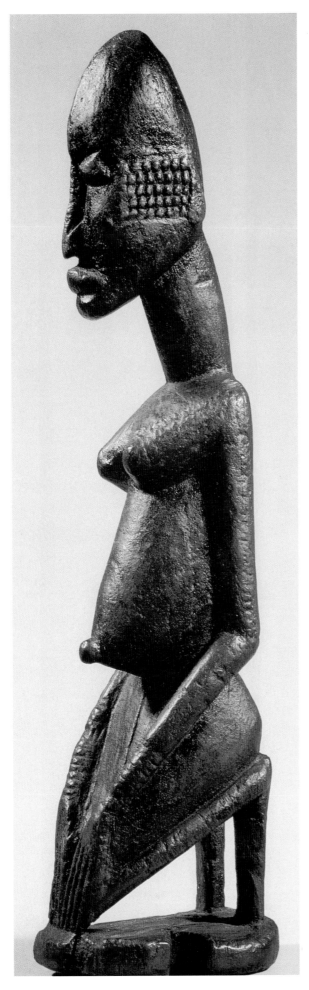

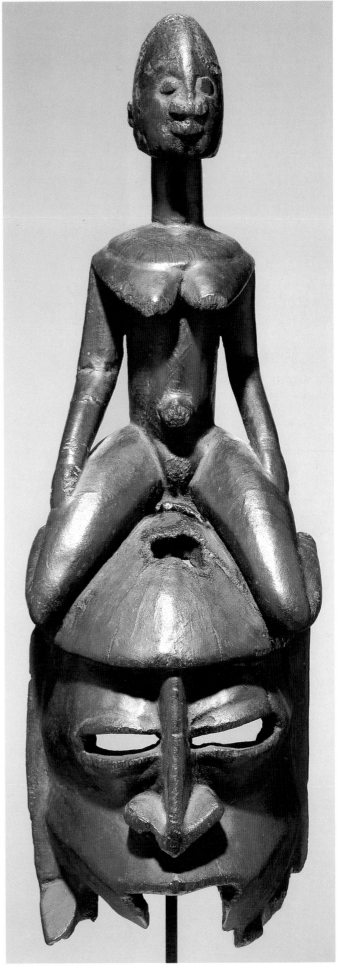

6.17

Plank figure

Dogon
Mali
16th–17th century
wood, encrustation
h. 45 cm
Musée Dapper, Paris
Lester Wunderman Collection

This sculpture is recognisable as the human form even though severely reduced to emphasise its essential significance. The body is conceived as a solid plank, carved in wood with its important relief features comprising a head and the suggestion of genitalia on the front, a smaller human figure on the back, and two arms ending in hands defined apart from the plank and raised above the head. The head is the seat of wisdom; genitalia are associated with procreation and continuity; the figure on the back may represent an infant, thus suggesting the plank figure is female, even though she lacks breasts. The raised arm motif is found in many contexts in Dogon art. Like kneeling figures whose hands on their thighs may denote supplication, the convention of hands raised into the air may indicate entreaty, especially for rain.

The surface patina is composed of accumulated layers of additive materials, suggesting the object is of a certain age and has been used in sacrifices. As a shrine figure, the object might be dedicated to familial ancestors who are praised and ritually fed throughout the year, but particularly at the beginning of the agricultural season. *RH*

Bibliography: Ezra, 1988, p. 59; Leloup, 1994

The supreme god, Amma, sent to earth four mythological beings to serve as ancestors to the Dogon people. Because these beings were lonely, and so that they might procreate, Amma bestowed a female twin on each of the four males, thus creating eight ancestors for the Dogon. Our figures represent these ancestors, or Nommo. Cat. 6.18c, a female figure, stands alone. In cat. 6.18b two figures stand side by side, complementary male and female physical bodies symbolic of lineage, procreation and continual increase. A thick encrustation of sacrificial material obscures most of the individualising characteristics carved into the wood substructures. Arms reach upwards, variously suggesting engagement in ritual purification or linkage between earth and sky.

The female figure (cat. 6.18c) stretches her arms upwards, and her hands meet above her head. Her legs extend downwards from planks that run along her sides. She stands on a disc which may have terminated in a single dowel, the figure intended to lean against a wall or to be planted in the floor of a shrine.

The Nommo pair exhibit similar characteristics: cylindrical bodies, arms raised, stylised and reduced features. The male has a beard, associating him with age and wisdom. The female wears a labret, or lip plug, to simulate a beard. The torsos are attenuated. The legs are disproportionately short and bent at the knee in a fashion common to Nommo. *RH*

Provenance: cat. 6.18c: 1956, given to the museum by Mrs Webster Plass

Bibliography: Leiris, 1933, pp. 26–30; Griaule and Dieterlen, 1986, p. 381; Zahan, 1988, pp. 56–7

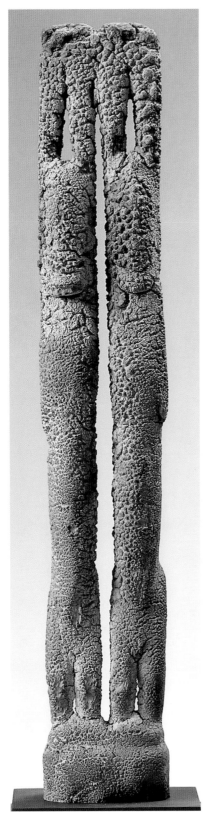

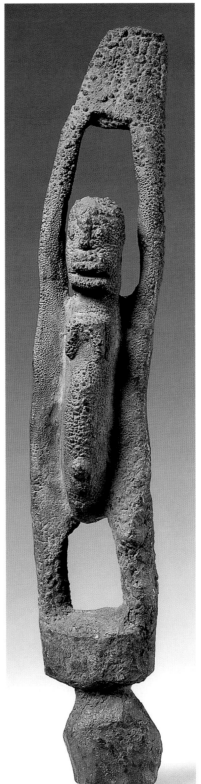

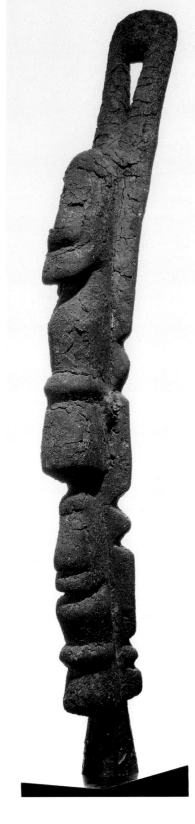

6.18a

Figure

Tellem
Mali
wood
h. 84 cm
Private Collection

6.18b

Couple with raised arms (*nommo*)

Dogon
Mali
wood, encrustation
h. 42 cm
Private Collection, Paris

6.18c

Figure with raised arms (*nommo*)

Dogon
Mali
wood, encrustation
50 x 9 x 6 cm
The Trustees of the British Museum,
London, 1956.AF.27.1

6.18d

Figure

Tellem
Mali
wood
h. 62 cm
Private Collection

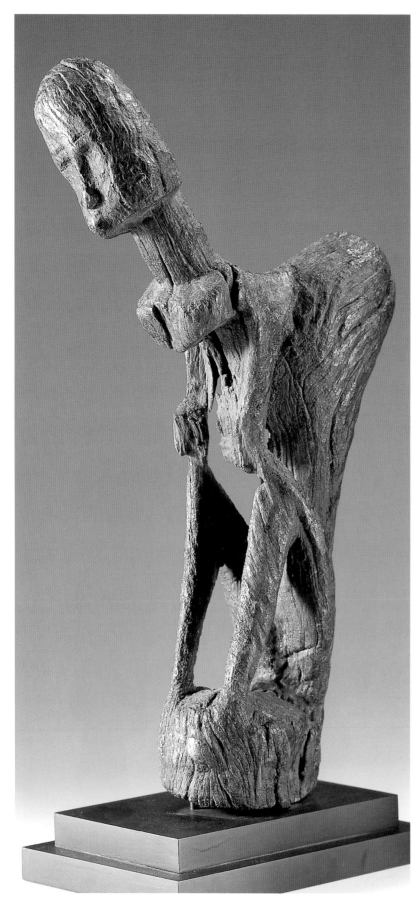

6.19

Hunchback figure

Dogon
Mali
wood
h. 43 cm
Private Collection, Paris

This figure is puzzling. Carved in a style reminiscent of many known Nommo sculptures, it portrays not a twin, but someone with a physical deformity. As is often the case with Nommo sculpture, the figure is carved from one piece of wood: a branch of a tree, sometimes with the physical imperfection of a crook, elbow or knot which is incorporated into the sculptural design. Here, arborial imperfec-.tion translates into human malformation.

The figure is seated, elbows hyperextended and resting on raised knees. The face is looking off to the right. The extremities are vestigial, although the feet and buttocks form three points on a contiguous drum-shaped base. The hump on the figure's back is the visual focal point. It exerts a pull on all areas of the form, drawing the viewer's eye away from the figure's face.

The entire surface is distressed. Cracks have appeared, perhaps through exposure to the elements in combination with the natural drying process of the wood. In places that project outwards, however subtly, the surface is shiny with oils – added through handling the piece or the addition of sacrificial materials; in grooves and recesses the surface has a light accumulation of oils and other matter which dulls the patina. *RH*

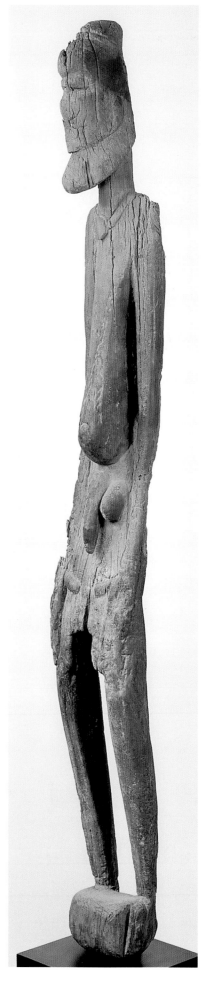

6.20

Male figure

Dogon
Mali
wood
h. 167 cm
Marc and Denyse Ginzberg

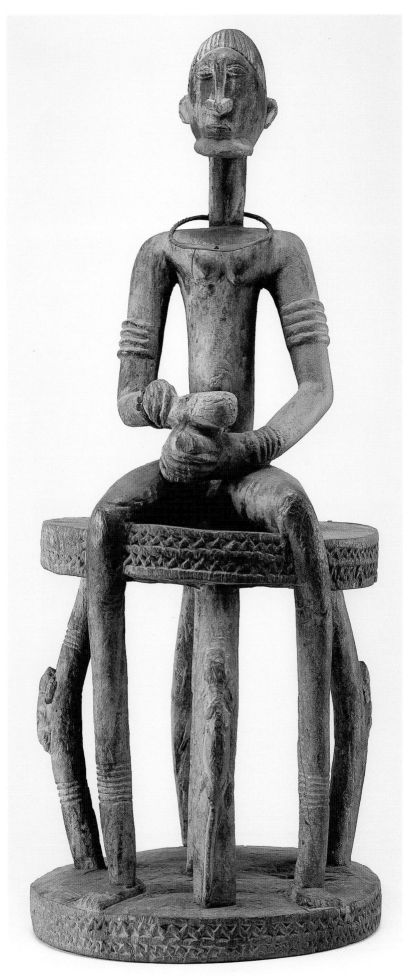

6.21

Seated male figure

Dogon
Mali
wood, iron
73 x 29 x 32 cm
Lent by The Metropolitan Museum of
Art, New York
The Michael C. Rockefeller Memorial
Collection, Given by Nelson A. Rockefeller
in 1965, 1978.412.455

An interpretation of Dogon cosmology
suggests that the universe is composed
of two discs – the earth and the sky –
connected by a tree at the centre.
In addition to the tree, if we were
to span the discs at each of the four
cardinal points with relief carvings
of ancestors, and seat a *hogon*, a
village priest of high authority, on
top of the upper disc, the configura-
tion would resemble this carving and
could be read as an *imago mundi*, a
primer on fundamental Dogon social
and belief structures.

 The object is carved from a single
piece of wood. The discs are incised at
their perimeters with motifs suggest-
ing the path of Lèbè Serou, the
ancestor incarnated as a serpent and
associated with the *hogon*'s power.
The discs are connected at the centres
by a straight unadorned cylinder –
the tree – and at the edges by four
bowed cylinders carved on their ex-
teriors with reliefs of human figures.
These figures, kneeling and standing,
may portray the four original Nommo
who mediate between the two realms.
The seated figure is the *hogon*, the
elder whose knowledge of both
spiritual and temporal affairs accords
him great local authority. *RH*

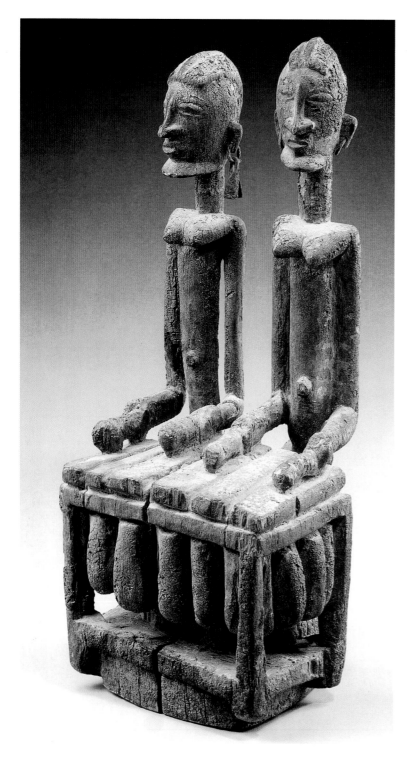

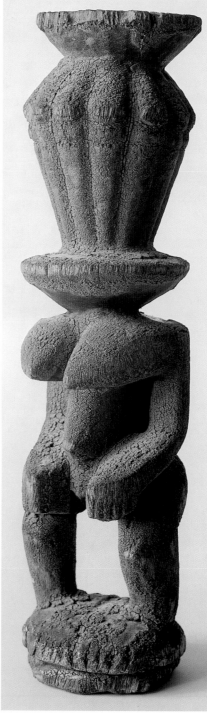

6.23

Female figure

Dogon
Mali
wood, encrustation
29.8 x 8.5 x 7.6 cm
The Menil Collection, Houston, X 053

'One cannot always pray ... at the altar, but a statue can' (Van Beek, 1988, p. 60). This female figure, with its coat of sacrificial material, is perhaps what is termed a *dege*, a protective statue, that doubles for an individual in a devotional context. In this sense, the *dege* is not an ancestral figure, but one representative of the living.

The figure is chunky in appearance. Its square shoulders, protruding breasts, hips and flexed knees all correspond to conventions of human anatomy as conceived by the Dogon sculptor. Likewise, its hands appear vestigial, and its feet are completely subsumed by the base on which the figure stands. The dual disc configuration of the head and the cluster of standing figures (barely visible through the sacrificial material) which form it and connect the two discs may be a reference to the two cosmological plateaux of heaven and earth (cf. cat. 6.21).

Our knowledge of Dogon figurative sculpture is limited. For the present, we can say with some confidence that this standing female figure, thick with accumulated sacrificial material, was most likely used as a substitute for its owner in a shrine context. *RH*

6.24

Double figure

Dogon
Mali
wood
h. 87 cm
Private Collection, Paris

According to a Dogon creation myth, the first human beings to come into the world were twins, and twins born today among the Dogon are considered to be endowed with significant quantities of *nyama* (power and energy) that makes all life possible. Twins born into a family constitute a special blessing, auguring a future of plenty, fertility and continuity of existence.

The sculpture is made from a single piece of wood and carved in patterns of angles and open-work. From the front, the figures are stacked

6.22

Balafon players

Dogon
Mali
wood
h. 44 cm
Private Collection

The *balafon* players sit side by side engaged in light popular entertainment. The figures retain visual characteristics that easily identify them as Dogon: the arrow-shaped nose, the trimmed beard at the jaw, the long gently swelling neck on top of severe shoulders and torso, and hips that seem in some ways disjointed. The surface of this wooden sculpture appears to have accumulated the kind of patina that usually results from the addition of sacrificial material. In this case, however, age and storage conditions may be responsible.

A *balafon* consists of planks of wood of varying lengths and thicknesses tied to an oblong frame; dried gourds, also graded, are fastened to the planks. As the *balafon* player strikes the planks, the vibrations resonate inside the gourds underneath.

One can find *balafon* players at a wedding or a party, in a market, or at school. The instrumental music will most likely be accompanied by songs – historic or contemporary – intended to instruct or simply to amuse. *RH*

Bibliography: Leloup, in Paris 1995

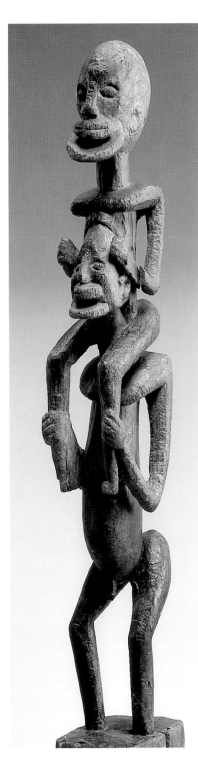

characteristics of twinning. Although twins are individual beings, they are connected forever through the fact of a single birth, giving them a single identity. Each, at times throughout his life, will carry the other – a lesson and metaphor not only for twins but for the entire extended family and village. *RH*

Bibliography: New York 1988, p. 48

6.25

Post (*togu na*)
Dogon
Mali
wood
601 x 68 x 12 cm
Fritz Koenig Collection

At least one *togu na*, or great shelter, can be found in every Dogon village. Most family compounds contain a *togu*, or sheltered meeting place. The *togu na* is built as a meeting place for the male elders of the village. It is an open structure with vertical elements that support a thatched roof. Near the cliffs, the vertical elements may be mud brick. In most cases they are carved posts that ideally number eight: three along the east and west sides and two in the interior. They are conceived as sequential, coiling in plan in the form of a snake. The roof is low so that the men inside must remain seated in discussion. The thatch, ideally composed of eight tiers layered at 90 degrees, helps keep the interior cool; the tiers refer, as do the posts, to the eight ancestral Nommo.

In its official capacity as a meeting house, the *togu na* is the site of government, arbitration, village business and cordial banter. It is the domain of men, but its vertical posts often exhibit female, androgynous or sexual imagery. Our example portrays a highly stylised, relief-carved, copulating couple. The female, standing on her head, has her arms raised in Nommo fashion. The dominant male stands on top of the female's feet and their exaggerated genitalia meet in symbolic union. The upper left fork of the post displays a snake in low relief. The snake refers to Lebe, one of the Nommo, whose domain is speech – which is the express purpose of the *togu na*. *RH*

Bibliography: Griaule, 1965, p. 98; Huet, 1988, pp. 34–6, 91

vertically. From the side, the two figures' limbs, torsos and buttocks zigzag down the bodies.

With one figure pickaback on the other, this piece may represent the phenomenon of twins as conceived both in spiritual and in earthly realms, leaving open the possibility of several interpretations. As Nommo, original ancestral twins, the double figure seems to match the myth; the four original Nommo were male, as are these two. As an earthly phenomenon, the figure portrays very practical

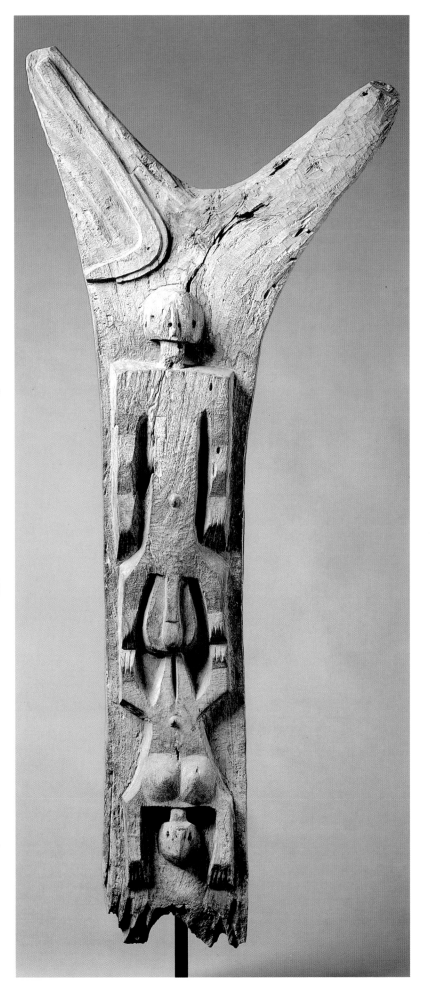

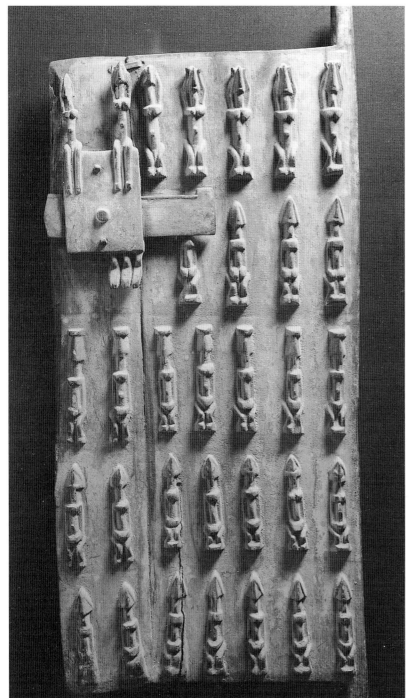

Staff

Dogon
Mali
iron
81 x 10 x 13 cm
Fritz Koenig Collection

Central to Dogon mythology are
the ancestral figures called Nommo
(cf. cat. 6.18b–c). The seventh Nommo,
the blacksmith, stole blistering hot
iron and a piece of the sun, then
slithered down the rainbow to earth.
During his descent, other Nommo
hurled lightning bolts at the black-
smith, bolts which he repelled with
his bellows. The blacksmith's earthly
landing was so violent that the impact
shattered his body, the breaks becom-
ing the human joints which permitted
human beings to work and dance.

This iron staff probably illustrates
the first part of this myth: the seventh
Nommo holding the bellows in his left
hand (signified by his shield) and, in
his right hand, either a lightning bolt
or the crooked staff of the ritual thief.
His form is reduced to its geometric
essentials. His body and limbs are
cylinders, his shield is a disc, his head
is a modified cone. The projection
from his chin suggests a beard and
therefore the status of an elder.

Historically, in most locales among
the Dogon the smelting of iron has
been an activity limited to a special
class of smiths, the *jemo*. Today, few
smiths continue to smelt their own
iron. Iron is available commercially
and although *jemo* continue to work
the forge, almost all purchase iron
from the Bandiagara or Mopti
markets. *RH*

6.26

Door with lock

Dogon
Mali
wood
h. 98.5 cm
Private Collection

6.27

Rock painting

Dogon
Mali
painted rock
h. 30 cm
Laboratoire d'Ethnologie,
Musée de l'Homme, Paris

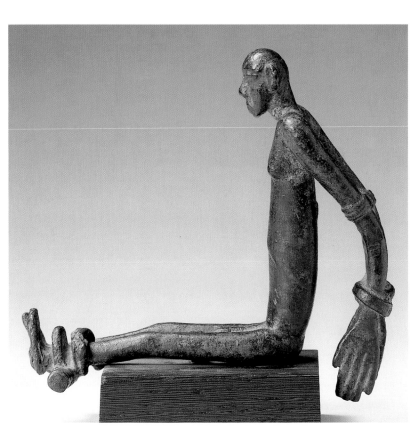

6.29a

Pendant of seated prisoner

Dogon
Mali
bronze
4.5 x 3 cm
Private Collection

6.29b

Pendant of two riders

Dogon
Mali
bronze
h. 9 cm (with base 11 cm)
Private Collection

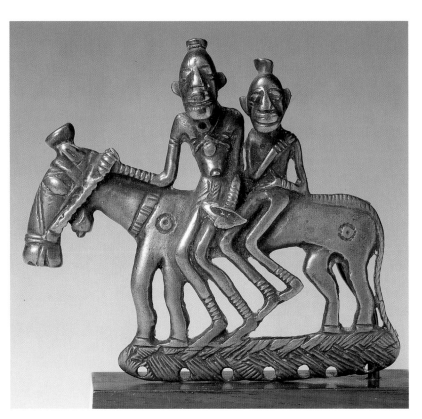

Small cast bronze or copper objects are known to have been worn as pendants, primarily by the village *hogon*. Although visually different from one another, the objects subtly express a common theme of subjugation and power.

To ride a horse, the rider must be more powerful than the horse. The two together, rider and horse, fuse human intelligence with animal strength and create a presence greater than the sum of its parts. Cat. 6.29b portrays two figures – flattened and frontal – apparently riding side-saddle on an over-burdened horse.

To take a prisoner means the taker is the mightier of the combatants. During the past 1000 years, the Inland Niger Delta region has been the site of violent rises and falls of empires, and the taking of, and trade in, slaves. Cat. 6.29a,c both show a man with ankles shackled and hands bound behind his back. The features and body are relatively naturalistic in contour and, unlike the equestrian figure, may be intended to be viewed in the round.

As articles of personal adornment, small cast metal objects have a lengthy history in the Inland Delta region. Copper may have arrived via early trans-Saharan trade; the archaeological site of Djenne has turned up objects in copper and is only 100 miles from the Bandiagara cliffs, current Dogon country. As early as the 11th century an exchange of ideas, technologies and goods is likely to have occurred between Inland Delta peoples and the historic inhabitants of Bandiagara. *RH*

Bibliography: New York 1988, p. 110; Washington 1989, p. 116

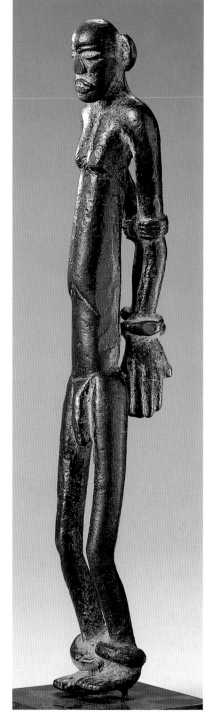

6.29c

Standing figure

Dogon
Mali
bronze
h. 21.8 cm
Museé Barbier-Mueller, Geneva, 1004-129

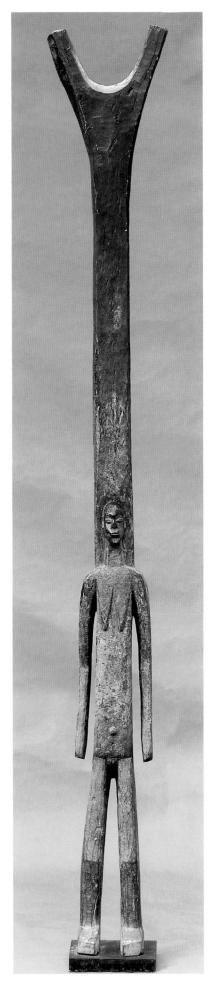

6.30
Shelter post
Mossi
Burkina Faso
20th century (?)
wood
262 x 23 x 16 cm
Private Collection

The fork at the top of this post indicates that it is a support post from one of the large sun-shelters beneath which Mossi chiefs meet with officials of their court and the members of their communities to hear pleas and to issue decisions about the affairs of the community. The figure represents a young woman who is offered as a wife by the chief to a deserving man in the community as a reward for loyalty and service. The first-born daughter of every such union is in turn offered to the chief to give in marriage, thus strengthening political ties in the community.

The posts are arranged in rows of three with from three to five rows of posts each about two metres apart, in the courtyard, or *samande*, of the chief's official residence. The central posts are paired, male and female, to represent the chief as the ideal ruler of all his people without regard to gender. The forks at the top held horizontal beams that in turn supported large bundles of straw, millet stalks and other fodder for animals. A few decades ago it was common to find decorated posts, but now, although the sun-shelters are common, almost all figurative posts have been collected by dealers and sold on the antiquities market. Even in towns where there is no chief such shelters are erected so that the people of the village can sit in their shade and work while they exchange news. Similar shelters are common among all Voltaic-speaking peoples, including the Kurumba in northern Burkina Faso and the Dogon in Mali (cat. 6.25) and Burkina who call them *togu na*. *CDR*

Bibliography: Roy, 1987, pp. 170–4

6.31a
Double figure
Mossi (*nyonyose*)
Burkina Faso
stone
15.2 x 9.2 cm
Museum für Völkerkunde, Vienna, 156.281

The Mossi people came into being in the early 15th century when a group of horsemen from northern Ghana rode into the valley of the White Volta River and conquered several farming peoples, including the Nuna and Lela in the west, the Dogon in the north-west and the Kurumba in the north. Some of these farming peoples fled ahead of the Mossi cavalry, notably the Dogon who fled to Bandiagara, while others remained behind and were integrated into a new society called Mossi (*mogho*, world; *moaga*, person; *mosse*, people). The conquering élite became rulers and belong to the social class called *nakomse*, while the conquered farmers became commoners called *nyonyose* or 'the ancient ones' in reference to their position as first owners of the land. The *nyonyose* hold a great deal of supernatural power which they have used to manipulate the forces of nature against their enemies. Thus all *nyonyose* are Mossi, but not all Mossi are *nyonyose*. In the far north the *nyonyose* in Lurum, Ouré, Bourzanga, Kongoussi, Tikare and Seguénega are descended from the ancient Kurumba, inhabitants of the region before 1500. These two stone objects are said to have been given to the prominent Sawadogo family by nature spirits (*kinkirsi*) before the Mossi conquest.

The large anthromorphic figure is from the town of Ouré and was used by local women to aid conception. A woman might offer prayers and sacrifices to the figure, then carry it on her back. If she is not strong enough to perform this feat, she will not be able to bear children. If she bears a child successfully she must offer thanks and sacrifices to the figure.

The smaller stone figure is a grindstone in the shape of paired phalluses, which are in turn incised with the features of a mother and child. There are deep grooves and a hole that might permit the figure to be worn suspended around the neck, and signs of extensive wear and handling in the places where one's hand naturally falls indicate very great age. In addition there are incised graphic patterns, including the 'X' which is ubiquitous on the masks of Voltaic peoples. *CDR*

Provenance: collected by Annmarie Schweeger-Hefel

Bibliography: Schweeger-Hefel, 1981, pp. 8, 54

6.32

Figure

Komaland
Ghana
13th–16th century
terracotta
28 x 8.5 x 10 cm
Private Collection

Komaland in northern Ghana has yielded up thousands of small terracotta sculptures mostly of small size from burial sites. Some of the small figures are in a rough and ready style which seems to replicate itself in monstrous fashion as if on a production line. There is, however, as in the present piece, a hint of the existence of a more refined tradition, more hieratic and austere. The wrap-around features of the present figure would be difficult without precedent to identify as African (similar difficulties are presented by the pre-Yoruba stone figure cat. 5.75) and the face alone would be a challenge in a visual quiz (in which most would think of South America) yet the pose recalls certain Djenne figures (cat. 6.4i for example) and seems to link this sculpture with the group of ancient civilisations of the valleys of the Niger, a connection that can only be supposition until further research is done. This connection is further endorsed by the prominent necklaces and wrist ornaments. The quiet dignity of the present figure which sits on a terracotta base which allows one to imagine the missing legs is in marked contrast to the wide-eyed and open-mouthed figurines that form the bulk of Koma material: the long span of time that the Koma culture endured before its enigmatic end suggests there are various stylistic periods: whatever the case, this piece must represent a 'high' style that is also testified to by some of the surviving bronzes, for all that they appear to be in general of later manufacture (cat. 6.33). *TP*

6.31b

Anthropomorphic figure

Mossi (*nyonyose*)
village of Ouré, Burkina Faso
15th century (?)
stone
45 x 24 x 13 cm
Private Collection

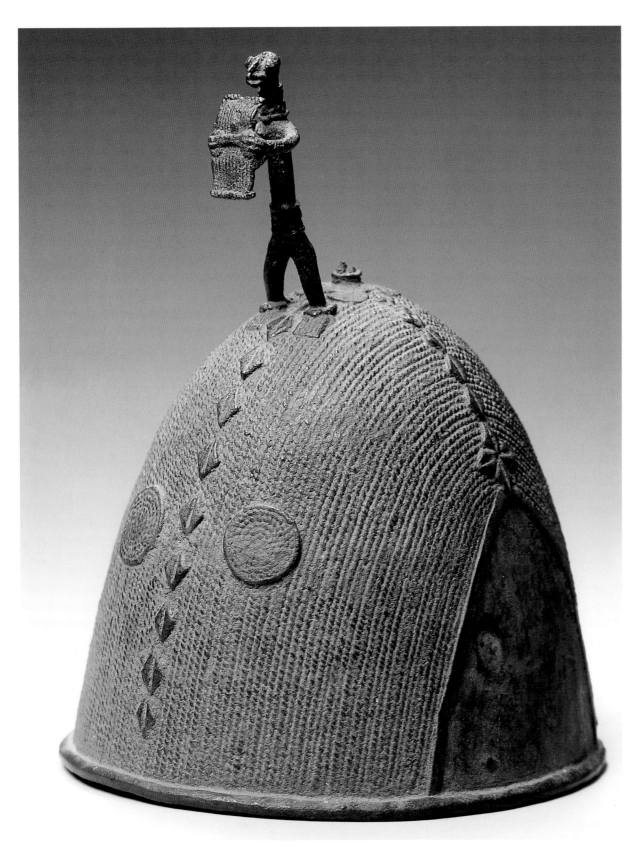

circle of stones. The burial mounds, which vary in dimension and range between 4 and 30 metres in diameter, probably represent a hierarchy reflecting the social, political or economic status of the occupants.

The burials are associated with domestic animal bones, the remains of the pre-interment parting feasts that were held at the mausolea by living clan members to honour the departed relations. Other associated material remains are milling stones, domestic pottery, iron and copper implements, weapons and ornaments, cowrie shell 'money', terracotta and cast metal sculptures.

The artefacts that constitute the most striking aspect of the culture feature human activities, domestic and wild animals, stools and amulets, and anthropomorphic elements (circumcised male genitals portrayed separately). According to Koma-Builsa ethno-histories the ancient artefacts were functionally related to totemic observances and ancestral veneration customs (the Builsa word *koma* or *kwoba* means father or ancestor).

The modern Koma-Builsa still make and use cultural objects which feature in the ancient sites either as actual objects or as motifs and icons on artworks. For instance, housewives own and use a bridal calabash helmet called *zuk-chin*, decorated all over with cowrie shells, which is also worn by male hunters.

This cast bronze helmet is probably a stylised cowriform variety of the *zuk-chin*. Others include human portrait heads, 'janus' heads, multiple heads and whole-bodied winged figures. Thermoluminescence indicates that the Iron Age Koma-Builsa culture flourished between the 13th and 19th centuries. This chronology is supported by the presence in the tombs of Indian Ocean cowrie shells and equestrian terracottas with motifs depicting horse-riding accoutrements (saddle, stirrup, double reins, bit and horseshoe), features introduced via the trans-Saharan trade routes after the 8th century. *JA*

Bibliography: Anquandah and Van Ham, 1985; Anquandah, 1987[1]; Anquandah, 1987[2]; Anquandah, n.d.

6.33

Helmet surmounted by figure

Koma-Builsa
Ghana
bronze
h. 23 cm
W. and U. Horstmann Collection

Artefacts of this type originate from Iron Age burial sites attributed to ancestors of the modern Koma-Builsa people, a sub-group of Mole-Dagbani-speaking people of northern Ghana. The Koma-Builsa occupy farming settlements in the valleys of the rivers Kulpawn and Sisili, tributaries of the White Volta. Over 40 Iron Age sepulchral sites are distributed over an area of about 90 by 100 km. Each site contains scores of tombs. The Iron Age bearers of the Koma-Builsa culture buried their dead in tombs surmounted by earthen super-structures each circumscribed by a

6.34

Mask

Nunuma
Burkina Faso
19th century
wood, pigment
123 x 48 x 23 cm
Musée des Arts Africains, Océaniques et
Amérindiens Vieille Charité, Marseilles,
991-001-001

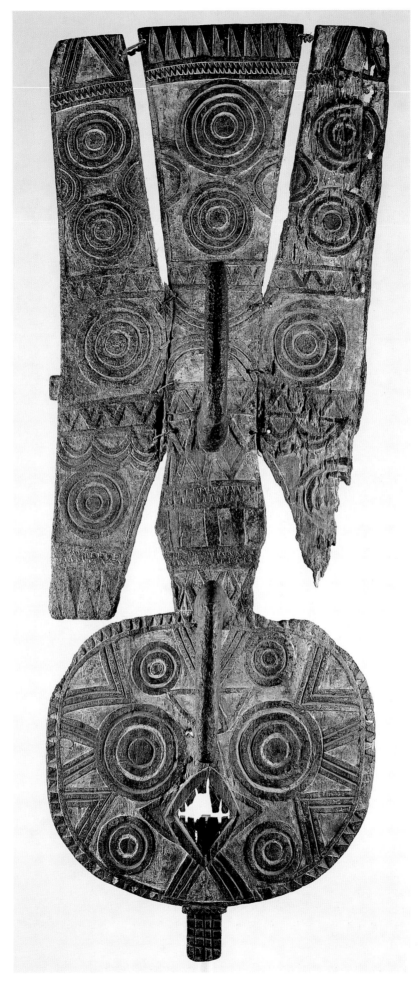

Just to the west of the Mossi plateau
live the Nunuma, one of the many
small Voltaic cultures commonly re-
ferred to in the literature as 'Gurunsi'.
Historically buffeted by the Mossi
kingdom, who raided them for slaves
and to whom they had to pay tribute,
and subject to the rising power of
Islam in the early 19th-century Holy
War and the establishment of the
state of Ouahabou by the Mande
Dafing cleric and reformer Al-Hajji
Mahmud, the Nunuma appeared to
have emerged from these events
intact. While Islam was to flourish
in major Dafing communities such
as Douroula, Safane, Boromo and
Ouhabou, Nunuma villages organised
along segmentary lineage principles
continued to maintain cherished
cultural and artistic traditions.

That this is still the case today is
strongly suggested by Roy's investiga-
tion of the arts at Tissé and in other
Nunuma villages, although why the
Nunuma were so little touched by
either Islam or the Mossi presence is
not explained. It may be that neither
Islam nor the Mossi could really
supplant those basic values which
have always guided Nunuma existence
– the inward-looking nature of these
villages, strongly centred upon notions
of family, the ancestors, farming and
masquerades. 'Decentralised' and
'stateless' are terms often used with
reference to people like the Nunuma;
leadership here is based upon the
guiding wisdom of lineage priests
and ritual specialists. Millet farming
is crucial for it not only sustains and
defines this world of villages, but its
cyclical nature allows the Nunuma
time to pursue other activities –
carving, painting, building and firing
pots – and to devote themselves to the
creation of elaborate masquerades.

A particularly splendid Nunuma
mask, this spiritual presence ensured
a community's health and shielded it
from destructive forces. Danced to the
sounds of flutes and drums, such a
mask would have infused those about
it with its own special potency. While
faintly reminiscent in its form of a
mask named *Budu*, this old and fre-
quently repaired example is a classic
statement of Voltaic masking. The
exquisite balance achieved between
the face itself and the superstructure,
the strong projecting bent beaks, and
the sensitively rendered surface designs
commonly found in Gurunsi masks
are elegantly brought together in this
masterpiece. *RAB*

Bibliography: Kamer, 1973; New York
1978; Roy, 1987, pp. 204–49, fig. 195

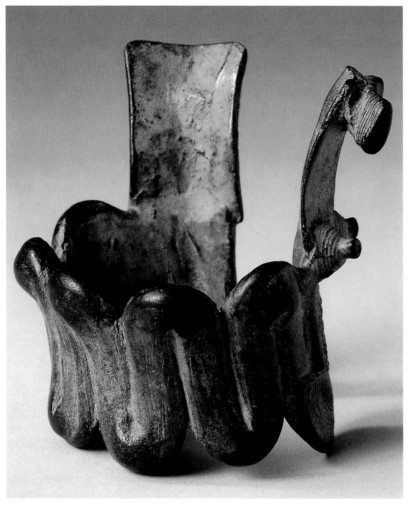

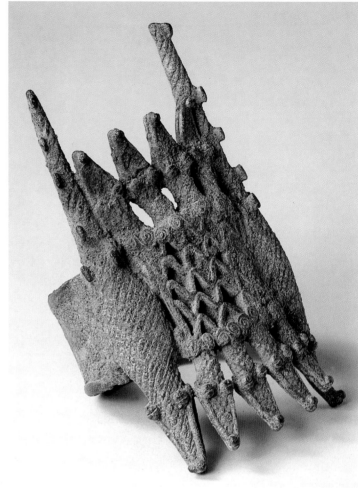

6.35a

Bracelet

Lorhon
Burkina Faso/Ivory Coast
18th century (?)
copper alloys
8 x 6.5 cm
Private Collection

6.35b

Bracelet with ten crocodile heads

Lorhon
Burkina Faso/Ivory Coast
18th century (?)
copper alloys
15.5 x 6 cm
Private Collection

6.35c

Armlet (?)

Lorhon
Burkina Faso/Ivory Coast
18th century (?)
copper alloys
diam. 23 cm
Private Collection

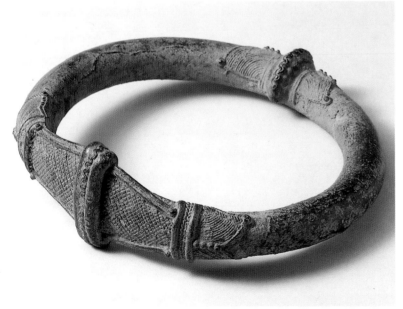

6.35d
Sceptre

Lorhon
Burkina Faso/Ivory Coast
18th century (?)
copper alloys
42 x 22.5 cm
Private Collection

6.35e
Bracelet

Lorhon
Burkina Faso/Ivory Coast
18th century (?)
copper alloys
h. 23 cm; diam. 8.5 cm
Private Collection

6.35f
Bracelet with crocodile head

Lorhon
Burkina Faso/Ivory Coast
18th century (?)
copper alloys
h. 17 cm; diam. 9.5 cm
Private Collection

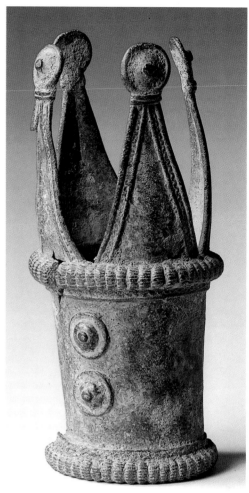

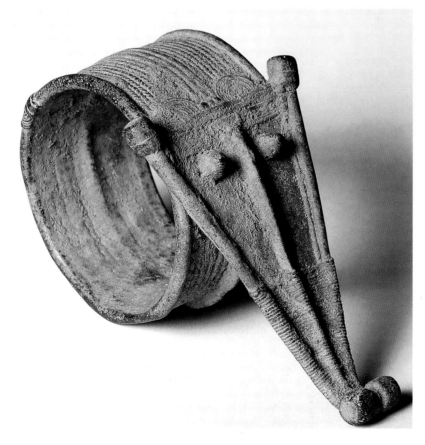

Just west of the Black Volta River, between Gaoua and Bouna, lie the remains of many stone buildings and associated pits or shafts cut deeply and with great precision into the lateritic soil, first noted by Delafosse in 1902. In 1913, while conducting brief surface excavations at Oyono, Labouret found a number of intriguing and finely cast copper objects and other items, but was unable to determine who might have been responsible for them. He suggested that this must have been an important and early goldmining area. On the basis of his data and a rereading of Leo Africanus's account of the flourishing gold trade in 16th-century Gao, Mauny later identified the area as the Lobi goldfields. While in the absence of sustained archaeological research little more can safely be said about the Lobi goldfields, I would suggest that this particular region appears to be yet another place where goldmining and a high degree of artistry in copper have been found side by side.

Labouret also describes the Lorhon or Nabe, an impressive group of artisans and renowned metalworkers living between Gaoua and the Kulango state of Bouna in northeastern Ivory Coast. Supplied with copper rods by Dyula traders, and enjoying the patronage of both the Lobi and Kulango, the Lorhon were pre-eminent in the field of metalcasting, a position they have maintained to the present. The quality of these two bracelets and of a third piece suggests Lorhon workmanship.
RAB

Bibliography: Delafosse, 1912; Labouret, 1920; Labouret, 1931; Mauny, 1961; Meyer, 1981; Scanzi and Delcourt, 1987

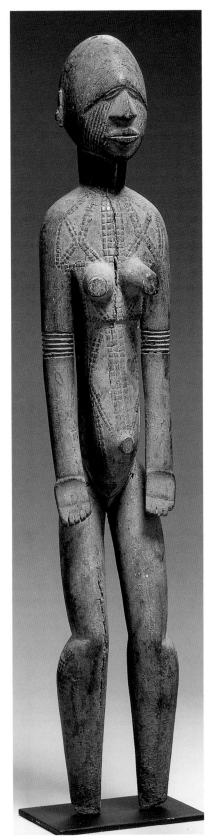

6.36

Diviner's figure (*dimbien*)
Nuna
Burkina Faso
20th century (?)
wood
h. 83 cm
Musée Barbier-Mueller, Geneva, 1005.4

This large and impressive figure was
used by a religious specialist or diviner
(*vuru*) among the Nuna people in
south-central Burkina Faso to rep-
resent a spirit from the wilderness
with which he could communicate
and whose supernatural power he
could control for the benefit of his
clients. Such figures are kept together
with non-figurative objects, including
jars, bottles and stones, on shrines in
dark corners of the diviner's home
where they become covered with
a thick crust of offering material,
especially millet porridge, beer and
chicken blood. All of that material
has been long-since cleaned from this
figure. It was collected near the Nuna
town of Leo in southern Burkina Faso
in the early 1970s by the (then)
director of the national museum.

The Nuna are one of several
peoples in Burkina Faso whose com-
munities are formed around the
worship of nature spirits, which in
turn establish religious laws that
control the moral and ethical conduct
of life in the communities. There are
traditionally no chiefs or other repre-
sentatives of secular power in these
communities, although the French
attempted to create such centralised
power during the colonial period.

Such figures serve the same func-
tion as the spectacular masks from the
same peoples; they make the invisible
nature spirits concrete and permit the
congregation to offer their prayers and
offerings. The geometric scarification
patterns on the chest and back are
part of a large body of graphic pat-
terns that are used by the Nuna and
their neighbours to communicate
visually religious laws and moral
values. Such patterns also appear
on their masks, on human bodies
and on pottery and the clay walls
of buildings. *CDR*

Provenance: ex Henri Kamer
Bibliography: Kamer, 1973, pp. 136–7; Roy,
1987, pp. 246–9, 252–3; Schmalenbach,
1988, p. 76

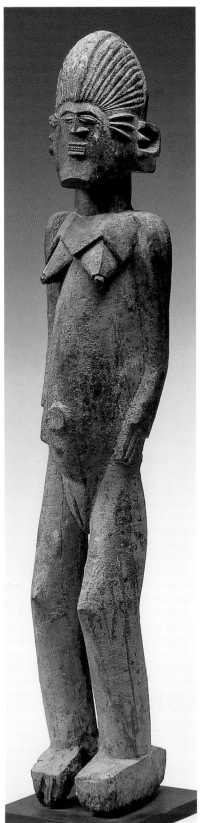

6.37

Standing female figure
Lobi
Burkina Faso/north-eastern Ivory Coast
20th century
wood
78 x 15.8 x 12.5 cm
Musée National des Arts d'Afrique et
d'Océanie, Paris, MNAN 66.17.1

In every Lobi house a small shrine
room (*thil du*) is set apart for the
worship of ancestral spirits. Here are
placed a variety of wooden statues,
some of large size, together with an
assortment of clay sculptures, iron
staffs, bottles, pots and the like.
Frequent sacrifices are made at these
shrines to ensure the goodwill of the
ancestors, and to avoid illness and
misfortune.

This large female figure doubtless
came from such a shrine. It is carved
in a dramatic and unusual style; it
could come from either north or south
of the international boundary be-
tween Burkina Faso and Ivory Coast.
The statue bears traces of sacrificial
blood and chicken feathers. Of un-
known significance are the three
raised scarification marks on each
temple of the figure. Such marks are
not normally depicted on Lobi statues,
and may suggest a foreign origin
either for the maker of the figure
or for the woman depicted. *TFG*

Exhibition: Zurich 1981
Bibliography: Meyer, 1981, p. 76

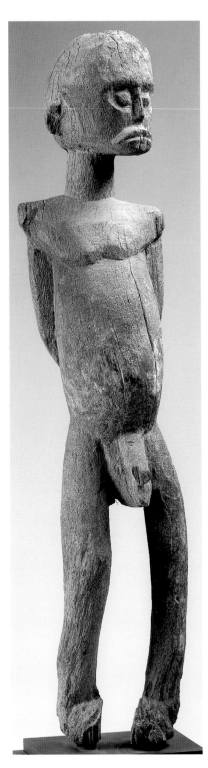

6.38

Male figure (*bateba*)

Lobi
Burkina Faso/north-eastern Ivory Coast
20th century
wood
h. 59 cm
Private Collection, Paris

In the corpus of Lobi statues (*bateba*) there is a distinct group which depicts gestures such as shock, despair or sadness: for instance one or both hands to the chin or the mouth, one or both arms crossed over the chest, or upraised, or held behind the back. Meyer names this group *bateba yadawora*, 'unhappy *bateba*'. It was explained to him that when a man became deeply unhappy for any reason, for example if he had suffered a bereavement, the statue would be unhappy or mourn in place of him, or take his misfortune away. The present statue evidently belongs to this class, having its hands behind its back and a particularly woebegone expression. *TFG*

Bibliography: Meyer, 1981, pp. 104–6

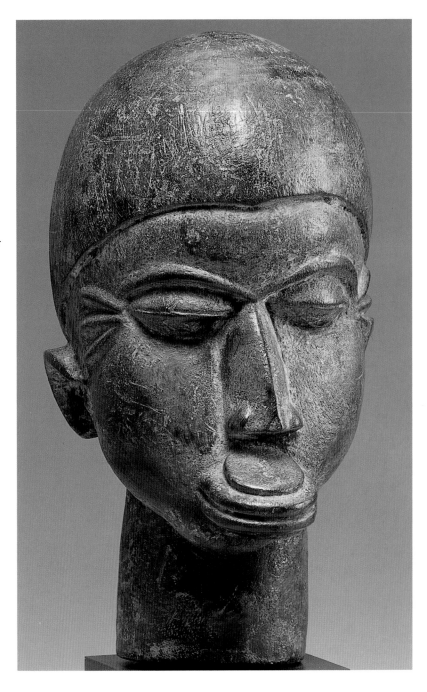

6.39

Head on post

Lobi
Burkina Faso/north-eastern Ivory Coast
20th century
wood
h. 31 cm
Private Collection, Paris

Large heads depicted on a post or stake form a unique category of Lobi sculpture. They are found on both sides of the international boundary which runs through Lobi territory. Many examples are sculpted with great care and attention to detail, and, unlike the full-bodied figures, they often show a triple scarification at the temple. The present example also depicts a lip plug. Until a generation ago the women of the region commonly wore lip plugs of wood or quartz, and these can still occasionally be seen.

These sculpted heads were fixed into the ground at various shrines, both in the shrine room and in the open air. They are also found with their spike set into the top of an external wall, where they served as guardians of the house. For this reason the end of the spike is often eroded, and in the present example it seems to have been cut away. *TFG*

Bibliography: Meyer, 1981, pp. 27–8, 35, 100–2

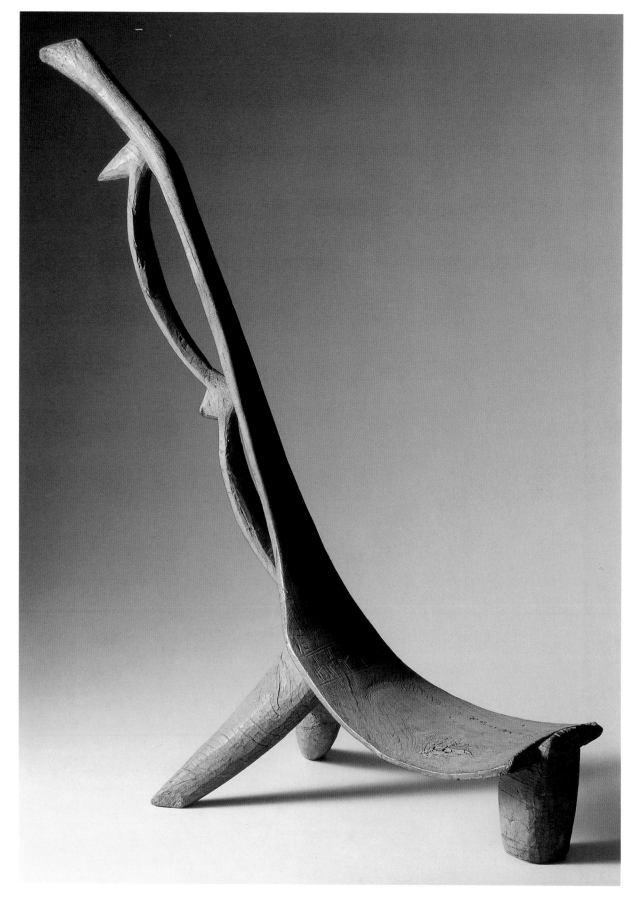

6.40
Chair
Nuna
Burkina Faso
20th century (?)
wood
81 x 67 x 28.5 cm
Musée de l'IFAN, Dakar, D. 67.1.16
On loan to Musée National des Arts
d'Afrique et d'Océanie, Paris

In remote villages in Burkina Faso it
is still possible to come across elderly
men reclining on stools such as this
one, smoking their pipes. Women also
have personal stools which invariably
have four legs, while men's stools have
three, for the numbers four and three
are associated with the female and
male genders in much of Africa.

Among the Nuna large stools are
passed from generation to generation
until their legs wear away. Among the
Lobi, who live just to the west of the
Nuna, such large stools, as well as
other personal property including
headrests, pipes and spoons, become
intimately associated with the spirit
of the owner after decades of use, so
that when the owner dies as a respect-
ed elder his (or her) stool is placed
on the family ancestral shrine as a
vehicle for communication from one
generation to the next. Neither the
Nuna nor the Lobi carve ancestor
figures, but such heirlooms stand in
the place of such figurative portraits.
This graceful stool comes equipped
with a handle that projects from the
back and whose surface gives evidence
of decades of use. *CDR*

Bibliography: Roy, 1987, p. 62

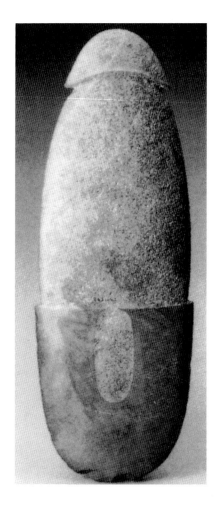

6.41

Polished stone axe

River Kilenge, Wuro Daudu, Adamawa, Nigeria
schist
h. 32 cm
The National Commission for Museums and Monuments, Jos, Nigeria, 64.J.161.2

This polished stone axe was found with a similar specimen under 6 feet of deposit near the River Kilenge at Wuro Daudu in Song District of Adamawa. The lower or blade end is highly polished, the remainder of the stone being fashioned by a delicate 'pocking' technique. Apparently never utilised, this remarkably well made implement could scarcely have been intended for ordinary use, and was in all probability a ceremonial object.

Polished stone axes occur throughout Nigeria and are frequently found re-used in secondary contexts, even incorporated on shrines in Benin. Neolithic in origin, they appear to have survived well into the Iron Age of west Africa. None, however, has been quite so beautifully crafted as the two Wuro Daudu specimens with their attenuated profiles, although larger, less refined examples have been reported from the Jos Plateau in the savanna region of Nigeria and the forested countryside around Benin.
AF

Provenance: found near the River Kilenge at Wuro Daudu, Song District of Adamawa, northern Nigeria; presented to the museum by the Lamido of Adamawa
Exhibition: Paris et al. 1993
Bibliography: B. Fagg, 1946, pp. 48–55; Shaw, 1978, p.44; Devisse, in Paris et al. 1993–4, p. 572

6.42

Gourd-shaped vessel

Nupe
Central Nigeria
late 19th–early 20th century
terracotta, brass fittings
38 x 32 cm
Private Collection, Munich

The Nupe live along the northern and southern banks of the middle Niger River in Nigeria. During the 19th century, they were conquered by Muslim Fulani who took over the leadership role of the Nupe ruling élite and incorporated the Nupe into the Islamic state called the Sokoto Caliphate. Nupe craftsmen work a wide variety of materials including wood, cloth, metal and ceramics. This ceramic vessel represents a collaborative effort on the part of a female potter and a male brass smith.

Pottery centres are located throughout Nupe country, especially at riverine sites where the finest sources of clay are found. Large gourd-shaped ceramic vessels like this one are produced in pottery centres, including the town of Muregi near the confluence of the Kaduna and Niger rivers. With a globular body and narrow funnel-like neck that terminates in a small bowl, these pots are among the most distinctive products of the Nupe pottery industry. Similar vessels are also made by Nupe and Gwari potters in the Kakanda, Bassa Nkwomo and Bassange regions located near the confluence of the Niger and Benue rivers. The vessels were an important commodity in the Nupe canoe trade from Jebba Island to the Niger–Benue river confluence. The widespread distribution of this distinctive vessel form suggests that it is a hallmark of the middle Niger River ceramic style.

Such vessels are used as storage containers for palm wine and water. The potter starts the base of the pot using a convex mould technique and after the base dries to a leather-hard state, she continues to build the walls with a pull-coil and scraping technique. The smaller bowl that forms the top of the pot is begun in the same way. A hole is cut in the bottom of the leather-hard smaller pot, which is then joined to the mouth of the larger pot by coils of clay to form the neck. The entire surface of the pot is textured with a stippled pattern made by rolling a roulette. The pot is then subdivided into several rows articulated by horizontal bands incised with a small stick. The surface has irregular small, smooth, burnished patches placed around the pot.

The vast majority of gourd-shaped vessels have a russet colour due to an oxygenated firing process. In some regions, however, the pot is basted with a locust-pod slip immediately after the firing which imparts a glossy brown sheen to the surface. In the past, after purchasing a ceramic storage vessel from the market place, a wealthy patron who wished to transform the pot into a prestige container would take it to a Bida brassworker, who dressed it with hammered brass fittings that were decorated with *repoussé* and *pointillé* designs. This ceramic vessel, whose lip, neck and belly are elaborately dressed with a series of brass bosses and fan- and canoe-shaped fittings, is similar in appearance to the most prestigious hammered brass vessels formerly produced by Bida brass smiths – the gourd-shaped *mange* vessel. Brass *mange* water jars were formerly purchased by the Fulani king of Bida, the Etsu Nupe, for his daughter's dowry and as gifts to members of the Fulani political élite. *JP*

Bibliography: Perani, 1973; Stossel, 1981

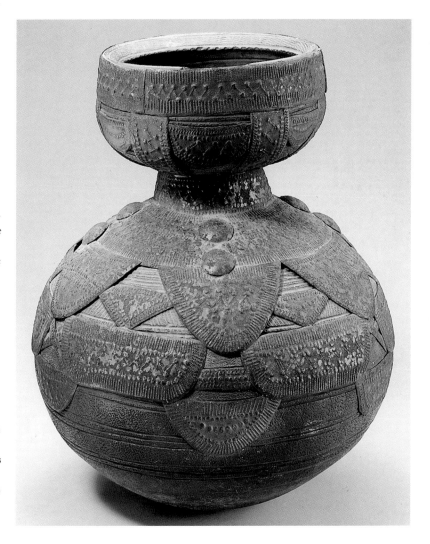

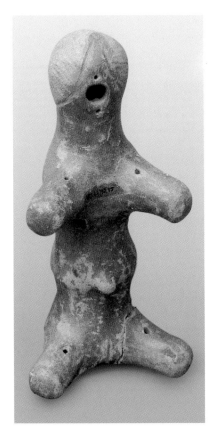

Radio carbon dates indicate that this tell site was occupied from about AD 100 to 700, and the stratigraphic evidence suggests that there was continuous occupation throughout that period. Domestic pottery, stone beads, ear or lip plugs, and bracelets together with numerous iron objects (rings, bracelets, arrow-heads, spear-heads, axes, knives) and the absence of any defensive structures suggest this was a small, peaceful, riverside settlement with an agricultural economy supplemented by hunting and fishing.

The role of the figures in this riverine community has never been established but their position in the art history of Nigeria later than much of the Nok material but earlier than Ife has been discussed in detail by Willett. *AF*

Bibliography: Priddy, 1970, p. 24; Eyo, 1977, p. 35; Willett, 1984, pp. 87–100

6.43

Figure

Borgu Division, Ilorin, Nigeria
c. AD 100–700
fired clay, red slip
20.5 x 10.5 x 8 cm
The National Commission for Museums and Monuments, Kaduna, Nigeria,
KD 89.R.240

This is an unusual terracotta figure with a surface finish of red slip. The body is hollow, swelling at the shoulders, at the midriff (where there is a protruding navel) and at the hips. The limbs are solid, but each one is perforated by a small hole. The head has a large circular hole or mouth, above and below which are additional holes of similar size to those on the limbs. Much of the head is covered by cord roulette impressions probably indicating hair. This is the only part of the figure not covered in red slip.

This specimen was one of only two examples (the other was incomplete) of red-slipped stylised figures. They were excavated from a tell site on the west bank of the River Niger about a quarter of a mile upstream of the southern tip of Rofia Island. The site, known only as RS 63/32, yielded numerous fragments of other figurines but none executed in the same 'abstract' style.

6.44

Grave sculpture

Dakakari
North-western Nigeria
late 19th–early 20th century
terracotta
77 x 23.5 cm
The National Commission for Museums and Monuments, Lagos, 2.19

The Dakakari reside in the hilly region north of Kontagora in north-western Nigeria. Dakakari ceramic grave sculpture belongs to a broad-based west African fired clay-earth-funerary-ancestral worship complex. Some of the better documented traditions include the ceramic sculpture of the Inland Niger Delta region of Mali and the Akan region of Ghana. For these and for the Dakakari, the earth where the deceased are buried is the source of clay used to make funerary sculpture.

Dakakari women produce utilitarian ceramic vessels for cooking and storage purposes. These are also used to mark the earthen tombs of ordinary men and women. However, for prominent men such as a lineage head, priest, renowned hunter, wrestler or skilled warrior, who have distinguished themselves by their exceptional accomplishments within

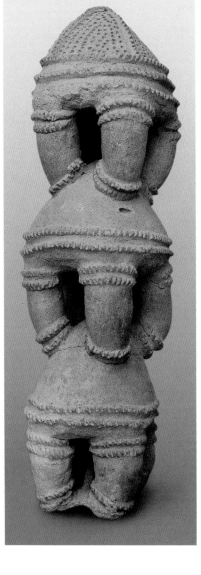

the community, ceramic sculptures are specially commissioned from Dakakari women to mark the family graves and to commemorate the ancestors. The tombs of these men may combine different styles of grave sculpture and vessels. The Dakakari bury their dead in shaft tombs that are located near the family compound. The family tombs of important men are defined by a two-foot-high stone wall. The centre of the tomb is filled with earth, which provides a platform for ceramic pots and grave sculpture. Annually, family members venerate the ancestors by pouring libations of guinea cornflour over the ceramic pots and sculptures.

Only a few Dakakari pottery families specialise in making figurative and non-figurative ceramic funerary sculpture, and in these families the production is probably the work of post-menopausal women.

The hollow-ware figurative sculptures are supported on spherical ceramic bases that are inserted into the earth and include stylised representations of standing humans, equestrian images and animals, especially antelopes and elephants. The sculptures representing elephants are spherical forms supported by four legs and trimmed on top with a wide comb shape that may derive from the silver haircombs worn by married Dakakari women. Elephant sculptures are the most expensive and prestigious of the grave markers and are associated with the graves of family heads and hunters.

This example belongs to a category of non-figurative Dakakari pagoda grave sculptures, which is characterised by an architectonic quality. Pagoda grave sculpture was more common during the 19th and early 20th century; visitors to the region in the 1940s noted that pagoda grave markers were disappearing. Pagoda grave markers are based on a stack of utilitarian pedestal storage pots that have been elaborated and rendered non-utilitarian by sealing the lid of the top pot. In a domestic context this type of pedestal pot would be used for storing honey or beer. Each vessel form in the stack is embellished with rows of raised ridges patterned with notched incisions that are identical to the decorative bands found on Dakakari elephant grave sculpture. It is in this category of non-figurative ceramic grave sculpture that the boundaries between utilitarian ceramic vessels and ritual ceramic sculpture become blurred. Generally, Dakakari graves are marked by an ensemble of ceramic forms that might include both figurative and non-figurative sculpture along with utilitarian pots. Each time a family member is buried, a pot or ceramic sculpture is added to the funerary ensemble. *JP*

Bibliography: Harris, 1938; Fitzgerald, 1944; Bassing, 1973; Berns, 1993

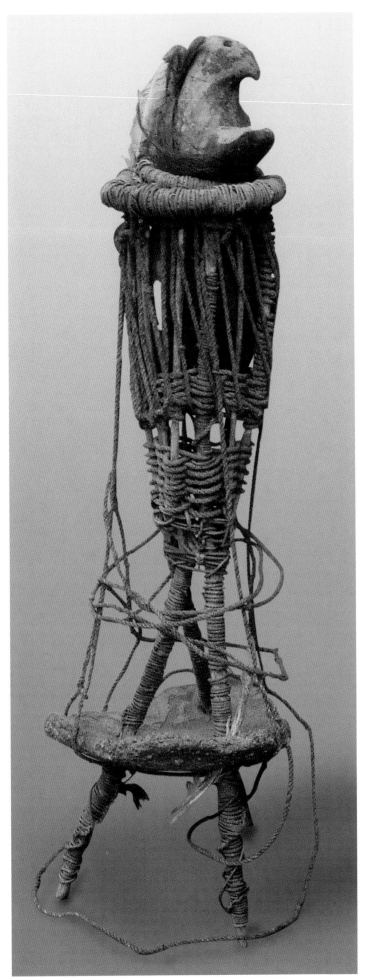

6.45

Tripod power object used for healing

Nok district
Nigeria
20th century
cane, string, feathers, animal parts,
terracotta
67 x 27 cm
The National Commission for Museums
and Monuments, Jos, Nigeria

From the Nok region, though we cannot know whether or not it is connected with the ancient civilisation that takes its name from the village of Nok, comes this extraordinary and elaborate construction whose ingenious structure is masked at first sight by its haphazard look. Described by the curator of the Jos museum as a fetish (a term now so general as to hold little meaning), it has more the appearance of an oracular device in which the attached wooden animal plays some part. The root of the edifice is an apparently broken piece of a pot through which some of the sticks pass. The choice of such an object for an aesthetically based exhibition not only indicates the expansionist tendency of art and its embrace but shows, as Collam so provocatively put it 50 years ago, 'how the African past is always one step ahead of the European present'. *TP*

Nok

Some of the most enigmatic and dramatic of terracottas which reflect the Nok iconography have appeared in private collections outside Nigeria. Some of these are seen here for the first time. These objects bear mute witness to an archaeological catastrophe equal to the looting of Cycladean statues and the tombs of the pharaohs, for without detailed archaeological investigation it becomes impossible to assess the role and function of these strange and intriguing works of art. A similar tragedy has befallen the terracotta sculptures of the Middle Niger basin. The terracotta works of art collectively referred to as the Nok Culture occur in central Nigeria, a country that has had controls restricting the export of antiquities across its borders since 1939. Associated with these exceptional figures are fragments of stone querns and ornaments, iron tools and quantities of broken pots and bowls. Soil conditions do not appear conducive to the preservation of much organic material and in the absence of skeletal remains much of what is known about those who lived at the time of Nok is derived from the evidence of the figures themselves. They favoured elaborate hairstyles, exploiting the sculptural qualities of African hair, arrayed themselves with necklaces, armlets, bangles and anklets, and appear in some fragments to be wearing some form of cloth.

Excavations at Taruga have confirmed that the makers of the Nok terracottas were not only users but smelters of iron. Their skills in making domestic pots and bowls were equal to the skills displayed in the making of the figures and they appeared to work stone into ornaments with equal ease. Accomplished representations of animals, human ailments and mythical beings all feature. They are remarkable for their humour, sense of caricature and sophisticated sculptural quality, echoes of which, in various media, can be found in later works such as those at Tada, Ife, Benin and among the Yoruba.

Radio carbon and thermoluminescent dating have confirmed that the early estimates of age based on geological and stratigraphic grounds are broadly correct, placing the Nok culture in the latter half of the first millennium BC and the first few centuries AD. Further precision in assessing the age of the Nok cultural material now depends on future archaeological research. *AF*

Bibliography: B. Fagg, 1977; Bitiyoung, in Paris et al. 1993–4, pp. 393–414; A. Fagg, 1994

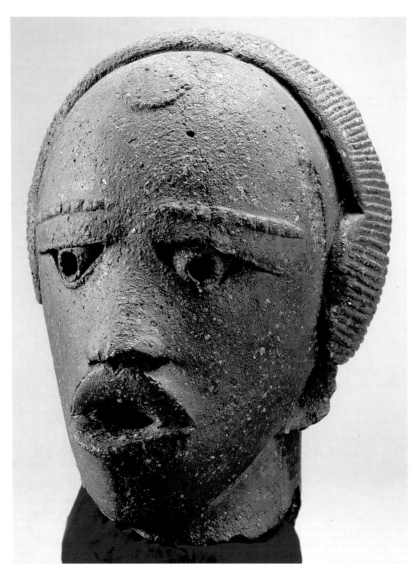

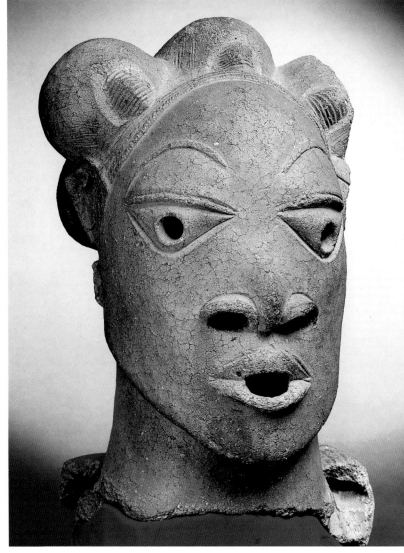

6.46

The Jemaa Head

Jemaa, Kaduna State, Nigeria
c. 500 BC
fired clay
25 x 17.5 cm
The National Commission for Museums
and Monuments, Lagos, 79.R.2

This near life-size terracotta head,
discovered in the course of mining for
tin in the Jemaa area, and then used
as a scarecrow for over a year in a
mineworker's farm, was reported in
1944. The head had been found in
alluvial tin-bearing deposits under
25 feet of sedimentary sands and
gravels. The aesthetic accomplishment
of the piece was obvious. The stylised
treatment of the face and the tech-
nical expertise evident in the Jemaa
Head were mirrored in the terracotta
monkey's head from Nok (Fagg, 1956).
A visit to Nok to study the site of the
discovery of the monkey's head
yielded another terracotta human
head and associated figurine frag-
ments in the same artistic tradition.
This group of fragmentary terracotta
figures formed the core of the corpus
of material known as the Nok Culture.
It was suggested on geological grounds
that these figures occurring in strati-
graphically similar deposits were some
2000 years old, but it was not until
1970 that a thermoluminescence
analysis of the Jemaa Head itself
suggested a date of about 500 BC. *AF*

Exhibition: Detroit et al. 1980–3

Bibliography: B. Fagg, 1945; Fagg, 1956;
B. Fagg and Fleming, 1970, pp. 53–5;
B. Fagg, 1977, p. 1

6.47

The Dinya Head

Nok Valley, Kaduna State, Nigeria
c. 500 BC–AD 200
fired clay
36 x 22.5 cm
The National Commission for Museums
and Monuments, Lagos, 79.R.1

Discovered in 1954 face down in
a narrow channel in the bedrock,
overlain by some 3.80 metres of
alluvial deposits, this spectacular life-
size terracotta head from the Nok
Valley is characteristic of the Nok
style. Broken at the neck, it appears
to have been part of a figure which
when complete would probably have
been at least 1.50 metres high. Finger-
marks of the maker are visible on the
interior but the exterior has been
tooled to a fine surface finish. While
its striking countenance is impressive
today, originally, as part of a com-
plete figure, it must have been awe-
inspiring. The buns of hair plaited at
intervals round the face are per-
forated, but why this is so remains a
mystery. This is the largest complete
Nok head to have been recovered and
preserved in Nigeria's museums,
although parts of even larger heads
exist, often too fragmentary to exhibit.

The Dinya Head was nearly
destroyed when unearthed by a tin-
miner's pickaxe but, fortunately, was
saved by the quick-witted actions of
a labourer who had worked part-time
for the Nigerian Antiquities Service.
The miner's destructive impulse was
probably due to the fact that these
terracottas often appeared in pockets
of the tin-bearing deposits when the
tin was running out. *AF*

Exhibition: Detroit et al. 1980–3

Bibliography: B. Fagg, 1956, p. 95;
B. Fagg, 1977, p. 13; Eyo and Willett, 1982,
p. 50

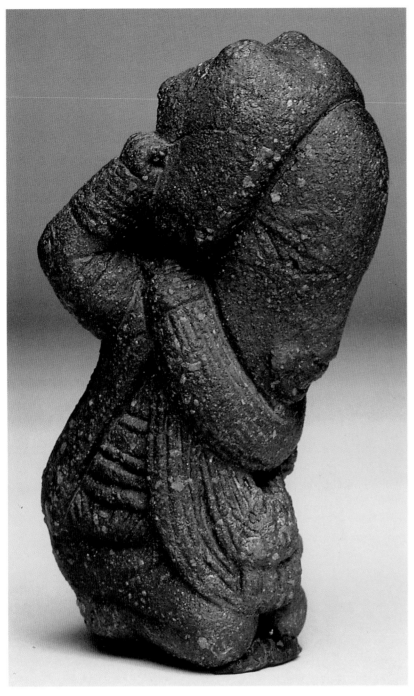

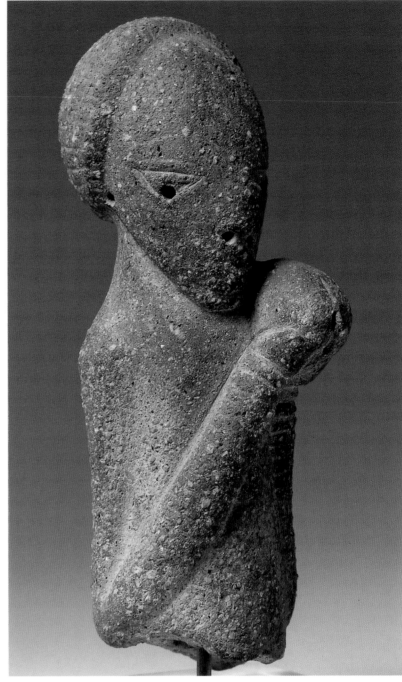

6.48

Figure

Bwari, near Suleja (formerly Abuja),
central Nigeria
c. 500 BC–AD 200
fired clay
10.6 x 6.2 cm
The National Commission for Museums
and Monuments, Lagos, 60.J.2

This beautiful figure was recovered
from the banks of the Makobolo
River. From the crown of the head
to the soles of its feet the detail is
meticulous. A mere 10.5 cm high, this
little figure has a tactile quality, like
Japanese ivory netsuke. Adorned with
necklaces, bangles and anklets, this

remarkably well-preserved complete
Nok terracotta is unique in complex-
ity, although fragmentary examples
of similar size have been recovered
from the Nok Valley and elsewhere.

Unlike larger examples of the Nok
artistic tradition the Bwari figure is
sculpted in solid clay. With a delicate-
ly moulded beard and what appear to
be tufts of hair at the corners of the
mouth (a feature present in a number
of other figures) this male figure
adopts a subservient posture in marked
contrast to some of the larger, clearly
female, Nok sculptures. The elaborate
stylisation of the hair with six buns
and what seem to be tresses hanging

down the back of the neck are
characteristic of many of the Nok
terracottas regardless of gender.

Circumstances surrounding the
discovery of this piece indicate an age
comparable to that of the Jemaa and
Dinya heads (cat. 6.46–7). *AF*

Provenance: 1960, recovered on the banks
of the Makobolo River during mining
operations
Exhibition: Detroit et al. 1982–3
Bibliography: B. Fagg, 1960; B. Fagg, 1977,
p. 15; Eyo and Willett, 1982, p. 59

6.49

Figure

Nok
Nigeria
terracotta
16.5 x 6 x 8 cm
Ian Auld Collection

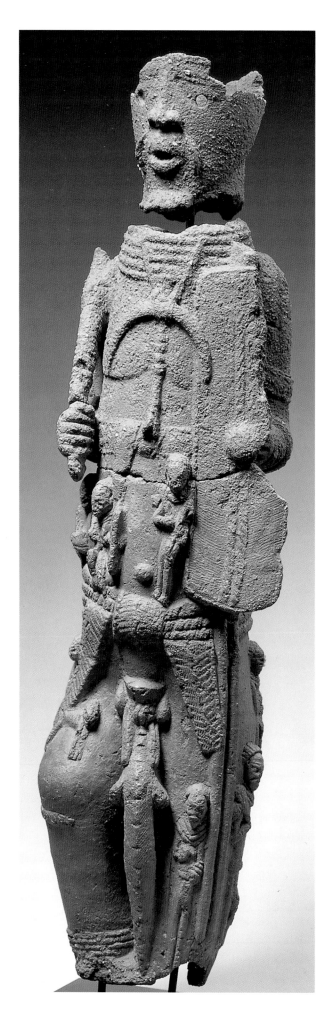

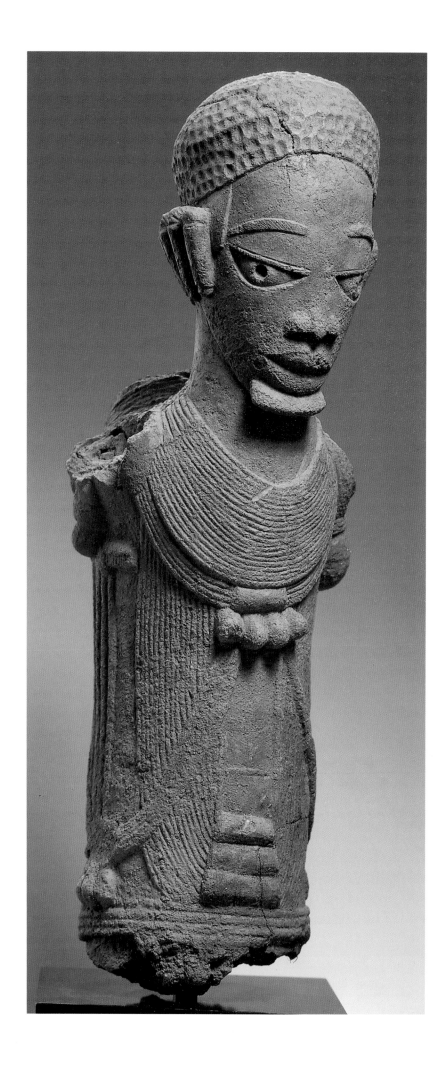

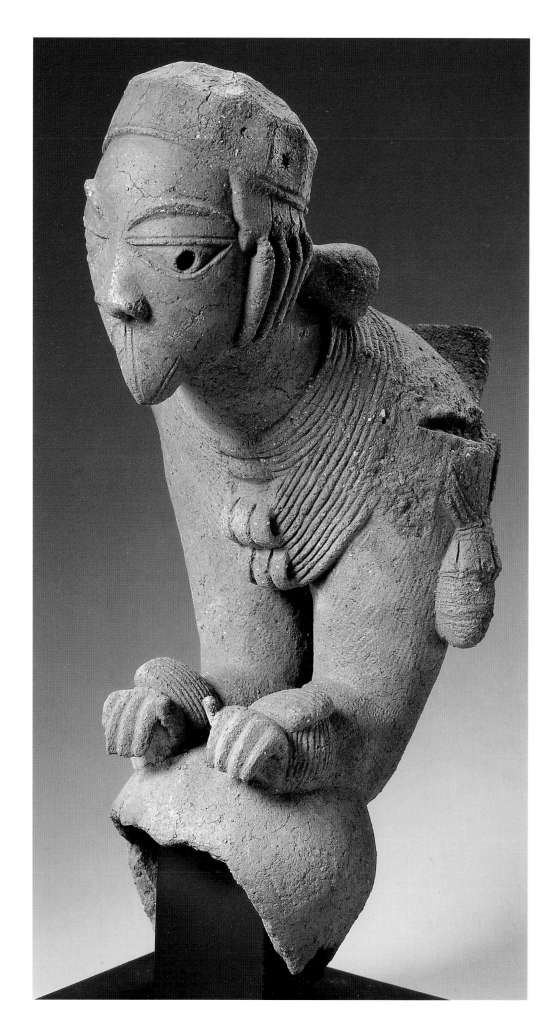

6.50

Warrior figure

Nok
Nigeria
terracotta
88 x 23 x 20 cm
De Meulder Collection

6.51

Two-headed fragment

Nok
Nigeria
terracotta
h. 66 cm
Private Collection, London

6.52

Human/bird figure

Nok
Nigeria
terracotta
47 x 20 x 22 cm
Private Collection

6.53

Kneeling male figure

Nok
Nigeria
terracotta
65.5 x 19 x 23 cm
Private Collection

6.54

Seated female figure

Nok
Nigeria
terracotta
58 x 25 x 19 cm
Private Collection

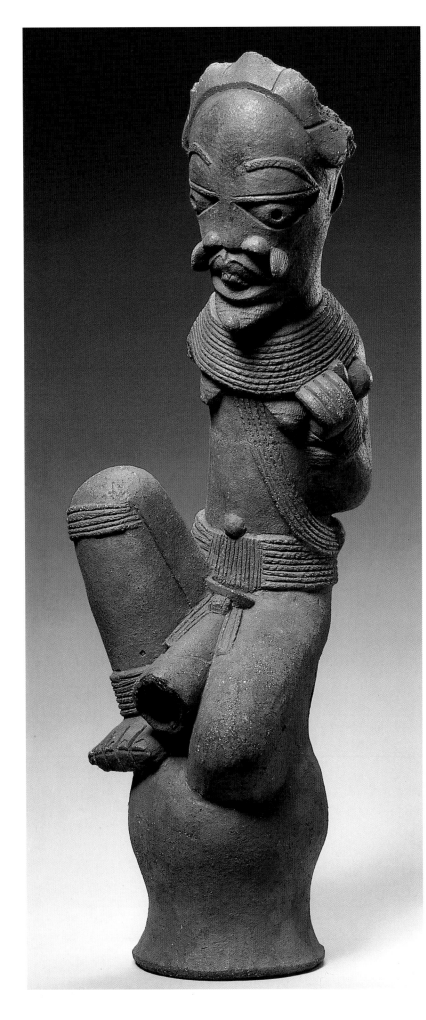
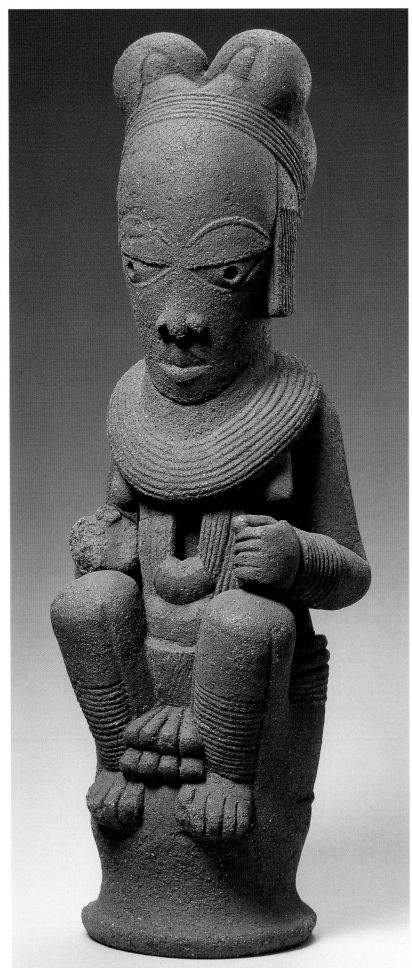

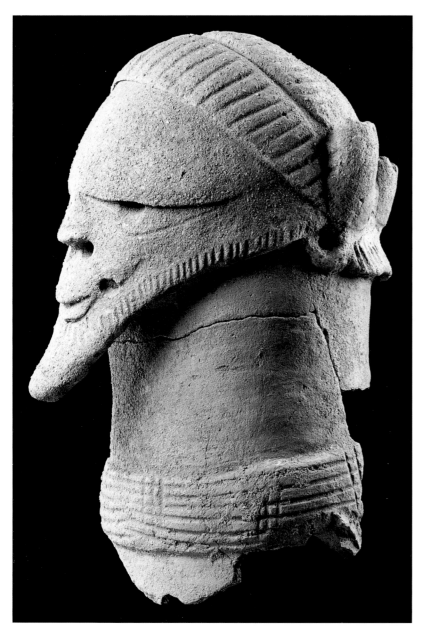

6.56

Quiver
Fulani
Nigeria
early 20th century
leather, wood, iron
h. 75 cm
Royal Tropical Institute/Tropenmuseum,
Amsterdam, 2404-10a/i

The Fulani, whether following a
pastoral lifestyle or practising a
mixed economy of cattle-raising and
agriculture, depend upon specialist
groups of artisans to provide them
with many of the essentials of life.
Blacksmiths (*waylube*) furnish them
with hoes, axes, knives and arrows
while the *lawbe*, or workers in wood,
create the mortars, pestles, bowls and
milk urns that all Fulani families use.
Although as herdsmen they make
their own sandals out of cowhide,
all other leather articles, which are
invariably beautifully embellished,
are made by the *gargasaabe*, leather-
working professionals who have
always worked for Fulani patrons.
Even the most humble object, such
as this quiver, is distinguished by quiet
elegance, a delicate balancing of form
and utility through the use of leather
strips, bands of varying cuts of dyed
hide and brass tacking. *RAB*

Bibliography: Urvoy, 1955; Dupire, 1962;
Beckwith and Van Offelen, 1981

6.57

Cushion support (*ehel*)
Tuareg
Niger
early 20th century
wood
129 x 25 cm
Drs Nicole and John Dintenfass

Among the Tuaregs of Niger elegantly
sculpted cushion supports are import-
ant items in any well-appointed house-
hold. They were carved by members
of the guild known as Enaden, liter-
ally meaning 'the other', blacksmiths
who have been instrumental in the
creation of precisely those things that
have forever distinguished the upper
classes of this society (the *imochar* or
warriors and the *insilimen* or religious
teachers) from the many vassal popu-
lations of the Tuareg world. Tuareg
terminology fully expresses the

6.55

Head
Sokoto
Nigeria
c. 200 BC–AD 200
terracotta
Private Collection

In the north-west of Nigeria, north of
Yelwa and the Dakakari (cat. 6.44), is
the Sokoto region, another part of the
great Niger Valley complex whose
archaeological riches have been the
focus of so much debate. Sokoto itself
is at the confluence of ancient trade
routes. Chance finds in the area have
included terracottas whose thermo-
luminescence datings point to a period
of a century or two earlier than the
average estimate for the Nok figures.

Those sculptures that have emerged
range from crude statuettes, some of

warriors (which seem like those of
Nok to have surmounted inverted
pots), to large almost life-size busts in
a distinctive austere style of which the
present example is typical. 'Sokoto'
terracottas seem to lack the ornate
trappings associated with larger Nok
works and some figures are bare of
any ornament. The heavy brow and
delicate features combined with a fine
beard have a severe aspect in com-
parison with which Nok heads on a
similar scale appear even sensual.
The thin pottery walls of this head
attest to a highly developed tech-
nique. It is to be hoped that prop-
erly conducted excavations will one
day give us enough information to
assess the connection between
these two seemingly isolated cultures.
TP

betwixt and between status of this artisan guild, a black population that, although regarded as culturally important, has always been socially marginalised. While the Enaden are primarily blacksmiths, they are also carvers and, more rarely, weavers. Whatever their medium, the products of the Enaden are among the most potent of hegemonic symbols – for in sitting and reclining upon the pillows and *ehel*, Tuareg nobles literally sit and lean upon these artists, dramatically re-enacting the historical relationship between themselves and the members of this guild. To observe a dignified, fully robed and turbaned Tuareg sitting in his tent is to witness the fullness of his authority and to realise that he is filled with a sense of personal superiority that cannot be wrested from him.

Ehel such as this example form part of the basic furnishing found in any upper-class Tuareg's tent, itself a hemisphere shaped of exquisitely woven and embroidered mats (*asaber* or *shitek*), dominated by geometric bands of subtle colour gradations and highlighted with carefully embroidered designs of dyed twine and leather. The Tuareg living-space appears almost to flaunt its beauty in the face of the desolate Sahel, to represent a private domain imbued with an aura of grace and refinement that defies its natural surroundings. Within these sparkling domes, *ehel* are used to pin the mat-woven walls against the exterior tent-poles. Like the interior roof props (calabash supports) and bed, *ehel* are carefully carved and often inlaid or embossed with delicate silver and copper detailing. In this particular specimen, the entire surface of the *ehel* has been opened up, creating a stunning set of patterns. *RAB*

Bibliography: de Gironcourt, 1914; Killian, 1934; Lhote, 1947; Gabus, 1958, i, pp. 89–95, ii, pp. 255–60; Bernus, 1981; Etienne-Nugue and Saley, 1987

6.58
Engraved boss
Chad
stone
h. 19 cm
Laboratoire d'Ethnologie,
Musée de l'Homme, Paris, 60.134.3

This small but impressive stone sculpture, found in the north-central Saharan area of Chad in the Bourkon region, now has the resonant title of the Omphalos of Edrichinga, because of its navel-like appearance. In many of the surviving stone sculptures and monoliths of the Sahara the navel is emphasised (cat. 6.1). Here, however, we have a conflation of the generative and nurturing elements since the nipple-like top makes the entire piece a stylised breast while the ridge running round the circumference makes an unambiguous phallic reference. The other markings are of a more enigmatic nature though their parallels are found in stelae from distant parts of north Africa (cat. 1.14, 7.8a) which date from the Neolithic to the Bronze Age. Since all other markings on the piece have evident sexual connotations one is tempted to read the vertical pair of grooves as a vaginal symbol. To suggest so much in such an austere and economical fashion is a feat of metaphorical compression making what is after all less than 500 cubic centimetres of worked stone have a charge of weight and density quite out of proportion to its size. *TP*

6.59
Beaker
Chad
ceramic
14.8 x 13.2 cm
Laboratoire d'Ethnologie,
Musée de l'Homme, Paris, 979.37.1

Discovered in Korotoro in the Sahara north of Chad, this painted beaker from the beginning of the Iron Age bears witness to the fact that Africa is not divided into east and west as it is represented in schematic maps (and, perforce, in the arrangement of exhibitions). The constant seepage, and occasional sweep, of trade and influence from side to side of the continent is less focused in history than relations between north and central Africa or east and south.

In decoration and even more particularly in form this vessel shows direct affinities with Nilotic ware, especially that of Ancient Nubia. The technique closely resembles that of Kerma pottery (cat. 1.77) which shares the characteristics of thin walls and slightly flared top, though Kerma ware shows a higher degree of refinement. The decorative elements seem to hark back to even earlier Nubian vessels of the A-Group (cat. 1.76) although they recur as well in much later times in the Sudan. *TP*

Provenance: given to the museum by Françoise Treinan-Claustre

6.60a
Horse and rider
Sao
Chad
bronze
11 x 11 x 3 cm
Private Collection

6.60b
Figure
Sao
Chad
terracotta
43 x 14.5 cm
Laboratoire d'Ethnologie,
Musée de l'Homme, Paris, 49.3.30

6.60c

Mask-like figure
Sao
Chad
terracotta
13.7 x 8.9 x 6.4 cm
The Menil Collection, Houston, X 065

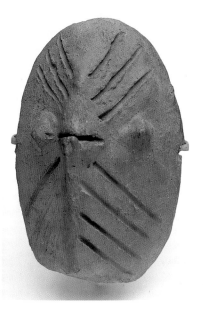

The very term 'Sao' indicates the vagueness of our knowledge of a complex of cultures once situated at the south-western shore of Lake Chad. It means in a pejorative Moslem usage 'pagans'. People from the north settled here from the 5th century onwards but the great epoch of Sao culture, characterised by walled cities and elaborate funerary rites, was from the 10th to the 16th centuries. From this time date the many thousands of mostly ceramic objects that have yet to be coherently interpreted.

Animal references abound and apart from a number of small incontrovertibly human heads in terracotta the majority of artefacts take on some animal or fish characteristics.

The scale of such objects is represented here by two sculptures of baked clay. The flat head (cat. 6.60c) in a style that is typical of the variations on a theme characteristic of Sao sculpture is, enigmatically, a human head with incised references to other creatures rather than to scarification patterns. Perhaps even the gills of fish are referred to. These have been called 'pebble heads' because of their resemblance to flat stones. Too many explanations of their use (maskoids, protective amulets, ritual weights for fishing nets etc.) have been evinced for it to be useful to pursue the matter of function.

Flat ceramic heads occur in other cultures of the valleys of the Niger but these are more stable in their descriptive style; the Sao maskoids seem in some way to be a language of markings, almost a shorthand of zoomorphic reference.

Characteristic of a larger and later style of what can easily be described by the conveniently vague term 'cult figure' is the theranthropic statue from Tago (cat. 6.60b). The sculpture may or may not represent a figure wearing a mask or even be intentionally ambiguous. The eyes made from impressed pellets of clay are standard in Sao representations of man and beast and perhaps too little is known about the culture for us to lay too heavy interpretative hands on it. The piece was found in association with more obviously human figures in the central shrine at Tago.

From what seems to be the end of Sao culture comes a group of brass equestrian figures, of varying size, found in the area. Cat. 6.60a is a characteristic example but of exceptional size. *TP*

Provenance: excavated by Lebeuf
Bibliography: Sinoto, n.d.; Lebeuf, 1971; Jansen and Gauthier, 1973

Scale
0 — 400 miles
0 — 600 km

EUROPE

Bou-Nora
Rokina
Carthage
Bir Bou Rekba
Tipasa
Gouraya
Algiers
Tunis
Kerkouane
Hammamet
Tangier
Tetouan
Cuicul
Dougga
Susa
Skhirat
RIF
Taounate
Timgad
Kairouan
Moknine
Rabat
Salé
Fez
Le Medracen
*KABYLIE
MTS*
Mahdia
Casablanca
Meknès
El Khroub
Sbeitla
El Djem
N'Kheila
MIDDLE ATLAS
TUNISIA
Safi
Tensift
M'ZAB
Sfax
Essaouira
Marrakesh
HIGH ATLAS
Medenine
Mogodor
Chichaoua
Dadès
Tataouine
Tripoli
Lepcis Magna
Taroudant
Ouarzazate
ANTI-ATLAS
MAGHRIB
Island of Jerba
Alexandria
LOWER EGYPT
Cairo/Fustat
Tindouf
ALGERIA
Al-Fayyum
Al-Bahnasa
Al-Ashmunein
Tadjentourt
Nile
Akhmim
LIBYA
Quft
Qus
RED SEA
Tabelbalet
EGYPT
MOROCCO
TASSILI N'AJJER
Imakassen
UPPER EGYPT
Tisnar
ADMER ERG
Aswan
TIBESTI
SAHARA
MAURITANIA
HOGGAR
Nouakchott
MALI
Rao
SENEGAL
NIGER
Niger
CHAD
SUDAN
THE GAMBIA
**GUINEA
BISSAU**
GUINEA
**BURKINA
FASO**
NIGERIA
GHANA
BENIN

7 NORTHERN AFRICA

PREHISTORIC NORTH-WEST AFRICA

**Timothy A. Insoll and
M. Rachel MacLean**

Geographically, north-west Africa has three distinct ecological zones: the coastal strip, bounded to the west by the Atlantic Ocean and to the north by the Mediterranean Sea; the characteristic Maghribian tell country; and the true desert of the Sahara. These three zones provide very different environments, and have evidence of cultural links with very different areas: the Mediterranean to the north; sub-Saharan Africa to the south; and the Nilotic Sudan to the east. These factors resulted in distinctive cultural adaptation and development, reflected in the archaeological record of the region throughout the prehistoric period, and particularly clearly in that of the Neolithic. It is during this era that artistic expression truly matured and flourished, leaving behind a wealth not only of enduring rock art but also of portable artefacts.

The Neolithic, which developed from the Palaeolithic or Old Stone Age (50,000–7000 BC), is characterised by a major change in subsistence strategy (the beginnings of domestication of both food crops and animals) and by other related changes in permanency of settlement and modification of technology. In north-west Africa the process of 'Neolithisation' was a very gradual one, Neolithic traits being only slowly adopted, from the 7th millennium BC, into the existing Epi-Palaeolithic way of life. In the last millennium BC the appearance of copper and bronze metallurgy heralds the beginning of the Bronze Age.

As a result of the distance in time and the variable preservation conditions existing in the region, the surviving objects – particularly the art objects – are predominantly of stone, though ceramic and bone also survive. Stone polishing was widespread, and drilling technology was highly developed, employing abrasives, needles and drills – techniques that survive today. Axes, hoes, adzes and beads were produced, which in the Sahara were made from semi-precious stones such as amazonite,

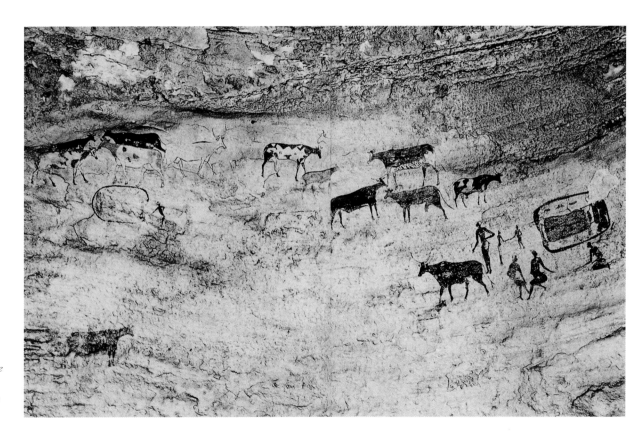

Fig. 1 Men with a shelter and herd of cattle, showing the Sahara before it became desert, rock painting in red-brown and white paint, the cattle c. 30 cm long, Cattle period, Sefar, Tassili-n'Ajjer

chalcedony and cornelian (as with the exceptional Saharan example, cat. 7.5). Pecked and polished hardstone bowls were also produced (cf. cat. 7.6a from the Moroccan coast and cat. 7.6b from the Tassili-N'Ajjer), which were used as mortars for grinding grains, berries and – importantly within the artistic context – for the production of vegetable dyes and the grinding of ochre for both rock and body painting.

It is, however, highly probable that artistic expression was not restricted to these materials alone, and that organic materials were also used. Indeed, it is likely that the human body itself may have functioned as an element for cultural artistic expression, as is indicated by certain depictions of individuals in regional rock paintings where tattooing and body painting are shown at Ouan Bender, Azzer and Ouan Derbaouen in Algeria/Niger. The extensive evidence for the grinding of pigments and ochres may be a result of this practice.

Groups in the Maghribian tell country developed a remarkable descriptive art tradition, portraying animals on engraved stone plaques and ostrich eggshells. In the Atlas Mountains rock engravings are found in the same style, often on a very large scale, depicting both humans and animals and, as a result of the stylistic similarity, it is presumed these are also of a Neolithic date.

In the Sahara a great flourishing of rock engravings and paintings (fig. 1) occurred during the Neolithic period, which have become one of the most studied artistic phenomena of the region. Related to this rock art, a truly magnificent tradition of stone sculpture developed: 38 animal sculptures and anthropomorphic cult figurines, carved from hard rock, such as basalt, dolerite and gneiss, have been recovered so far (the two idols from Tabelbalet, cat. 7.3, and the ram's head from Tadjentourt, cat. 7.4, are famous examples). This stylistic tradition based on bilateral symmetry and the absence of all unnecessary high relief is also characteristic of other more utilitarian stone objects.

With the Bronze Age, increasing desertification of the Sahara resulted in a restriction of settlement within the southern region and a realignment with the Mediterranean world. A concentration of archaeological material is found in the coastal regions and High Atlas, and is associated with a distinctive change in rock art style. Stylised representations of man and his material goods become the focus of these engravings, replacing the realistic portrayal of the natural world that characterised the Neolithic period, perhaps representative of a shift in man's conceptualisation of his environment, and his place within the wider world.

CARTHAGINIAN, NUMIDIAN AND ROMAN

R. J. A. Wilson

Certainly by the 8th century BC, and possibly earlier too, groups of Phoenician traders from what is now Lebanon had begun to settle suitable harbour sites along the coast of north Africa. One of these, Carthage, near present-day Tunis, was to grow into the leading Phoenician colony in north Africa and later into one of the greatest cities of the Roman world. The traditional foundation date given by the ancient sources is 814 BC, but the earliest archaeological material from both cemeteries and habitation sites at Carthage is not earlier than c. 725 BC, although it is possible that the earliest settlement and the oldest burials still elude discovery. The expansion of Carthage was rapid, and the city was soon founding settlements of its own; in time it came to dominate the whole of the north

African littoral from Morocco to western Libya, and controlled parts of Spain, Sardinia and Sicily as well. Yet despite the enormous commercial and military success of the Carthaginian state right down to its fatal encounters with Rome in the 3rd and 2nd centuries BC, it never developed a highly distinctive art of its own. Carthaginian artefacts of the 8th and 7th centuries BC are virtually indistinguishable from those of the Phoenician homeland, so that it is often difficult to separate the imported from the locally made (cat. 7.13). Then, from the 6th century BC, increasing Greek influence on Carthaginian art is detectable, for the most part via Greek Sicily, reaching a peak during the Hellenistic period before the destruction of Carthage by Rome in 146 BC. Throughout, Carthaginian iconography was also influenced by Egyptian art. The outcome was an amalgam rather than a truly original and distinctive Carthaginian style. There were, of course, some items which can be said to be characteristically Carthaginian, even if they occur elsewhere, such as the grotesque clay masks used as apotropaic symbols, especially in tombs (cf. cat. 7.9), or the elegant copper-alloy razors, often finely engraved, which are common in Carthage between the 6th and 3rd centuries BC: since Carthaginian men generally wore beards and they are found in women's graves as well as men's, their function may well also have been to ward off the evil eye. Also very distinctive, both in Carthage and elsewhere in its sphere of influence, are the limestone votive slabs (*stelae*), usually with simple but striking sculpture in low relief. Many display also the symbol of the supreme Carthaginian goddess, Tanit, indicated by a triangle surmounted by horizontal bar and a circular disc representing the sun (cat. 7.14–15).

Carthaginian civilisation also had a far-reaching impact on the indigenous peoples of the interior of the Maghrib, known collectively as the Numidians. Kings like Masinissa (who ruled 203–146 BC), a noted linguist, philosopher, and the father of 44 children, encouraged settled agriculture rather than nomadism and adopted Punic (Carthaginian) rather than Libyan as the language of court. Little is known archaeologically of Numidian settlements, but their funerary architecture, such as the great circular stone-built mausolea at Le Medracen and near Tipasa (in Algeria) or the square ones at El Khroub (Algeria), Dougga (Tunisia) and elsewhere show an eclectic taste, with a mixture of Greek, Carthaginian and Egyptian elements.

Under Roman rule the north African provinces flourished, largely as a result of efficient agricultural production. The amount of land under cultivation greatly increased, in some cases helped by extensive irrigation schemes, and the resulting African capacity for creating vast surpluses of grain and olive oil for export overseas, as well as other produce in lesser quantities (such as wine and figs), laid the foundations for Romano-African prosperity. The exotic fauna of north Africa, where elephants, lions and tigers roamed north of the Sahara, were rounded up for butchery in the amphitheatres of Italy and elsewhere. The much-prized yellow marble of Simitthus (Chemtou) was exported for prestige building projects, and even the pottery industry, producing huge quantities of rather ordinary red tableware from the 2nd century AD onwards, eventually captured markets the length and breadth of the Mediterranean. Other notable exports from Africa included fish-sauce (*garum*); wood, especially for furniture making, from the Mahgrib; and dyes, for which the island of Mogodor off western Morocco was famous.

The wealth generated by the landed élite expressed itself in the construction of both public buildings and of private houses and villas. Not only were the old Carthaginian settlements totally rebuilt in due course with buildings in the new idiom of Roman architecture – the fora, theatres, baths, aqueducts and ampitheatres found in most self-respecting Roman towns across the Empire – but towns also took root in areas of the interior where there had been little urban development in pre-Roman times. Some were formal foundations of retired Roman legionaries (*coloniae*), such as

the almost completely excavated towns of Cuicul (Djemila) and Timgad in Algeria; others were spontaneous creations of the new socio-economic order. The splendidly preserved remains of these and the temples on the forum at Sufetula (Sbeitla), the ampitheatre at Thysdrus (El Djem) or the building complexes erected at Lepcis Magna in Libya by that city's most distinguished son, the Emperor Septimius Severus (ruled 193–211), provide vivid testimony to the architectural sophistication of Romano-African civilisation.

In this climate of wealthy patronage it is not surprising that the arts also flourished (fig. 2). Vigorous local schools of sculptors working in both limestone and marble were established, turning out highly competent pieces both in relief and in the round; but a distinctive Romano-African style, characterised by somewhat flat, two-dimensional stylised relief sculpture, is best seen in votive dedications in sanctuaries. Good examples are the numerous *stelae* in honour of Saturn, who was worshipped in Roman Africa as a thinly disguised version of the Phoenician god Baal: in Africa religious conservatism died hard. The legacy of Carthage can also be seen by the continued use, even to the time of Saint Augustine in the late 4th century, of Punic (Carthaginian) as the principal spoken language in many districts. Artistically, however, the most significant and distinctive African contribution was made by the many mosaic workshops (*officinae*), which responded freely to the demand of their patrons for elaborate figured mosaics, especially from the later 2nd century onwards when African prosperity reached new heights. Rejecting the black and white style then favoured by Italian mosaicists, they adopted an original and creative approach to mosaic design which employed a rich and varied polychromy, and used the entire surface of a floor to create a decorative ensemble. Sometimes entirely ornamental patterns were used, but often figures were incorporated within the panels. These designs were soon joined by all-over figured compositions with ambitious scenes depicting the pastimes and triumphs of the patrons who commissioned them, from the amphitheatre and the circus, or from hunting or country life (cf. cat. 7.10). Processions of marine creatures, often whimsical and fantastic, were also common, but mythological scenes as such were rare. By the 4th century this highly popular and successful approach had been adopted by mosaicists working in Italy and several other provinces; in some cases, indeed, it seems certain that African mosaicists travelled abroad to fulfil specific commissions. After the adoption of Christianity, which spread gradually throughout much of north Africa in the course of the 3rd century, their abundant talents were also turned to the benefit of Christian patrons, in mosaic-paved churches and baptisteries alike.

Fig. 2 *Bust of a young man, possibly a portrait of Juba II (25 BC–AD 19), bronze, Musée d'Archéologie, Rabat*

THE ISLAMIC PERIOD

Nadia Erzini

Islam and the Arabic language have influenced north African art and culture since the 7th century AD (1st century AH) when, despite their small numbers, the Muslim armies of Arabia were able to dislodge the Byzantine Empire in north Africa. However, the Arabisation of north Africa was gradual and never complete; the indigenous peoples continue to this day to speak the local Berber languages (of Hamitic, not Semitic origin), although they practise Islam. It is this assimilation of Arab, Berber and (to some extent) sub-Saharan African cultures that gives Islamic north Africa its particular character.

Although north-west Africa, known in Arabic as the Maghrib, and including modern Algeria, Tunisia, Morocco and Mauritania, was initially subject to the central government at Damascus and Baghdad, independent dynasties soon emerged, such as the Idrisids (789–926) with their new capital at Fez, and the Aghlabids (800-909) at Kairouan. The Fatimids (909–1171) conquered most of north Africa, but were also replaced by local Berber dynasties, such as the Zirids. The invasions of the Bedouin tribes from Arabia in the 11th century further extended Islam and Arabic influence into the hinterland, and the Berbers retreated into the remote Atlas, Rif and Kabylie mountain regions and the Sahara Desert.

In the 11th to 13th centuries, two great religious reform movements, the Almoravids (1056– 1147) and the Almohads (1130–1269), led by Berber tribes from the western Sahara and the Atlas Mountains, reunited the Maghrib under a single rule from Marrakesh. These dynasties extended their rule into the Iberian peninsula, and the highly developed Hispano-Muslim or Andalusian art and architecture flourished in north Africa from this period onwards. The Marinid and Saadian dynasties of Morocco were particularly to benefit from the influx of Andalusian immigrant artisans and architects during and after the Catholic reconquest of Spain. The peculiarly conservative nature of north African art can be felt especially in the art of Morocco, where medieval and Andalusian forms have been reproduced faithfully until recent times, and are still part of the currency of decorative art. While Morocco remained in relative political and cultural isolation under the Alawi dynasty (founded in 1631), Algeria and Tunisia became part of the Ottoman Empire in the 16th century, and their art forms combine provincial Turkish and local north African elements. French and Spanish colonial occupation has dominated the region in recent centuries.

A major source of wealth for the Islamic dynasties in the pre-colonial period was the gold of west Africa, which was traded for north African manufactured goods (leather, textiles, arms and metalwork) and Saharan salt, through the towns of Timbuktu, Gao and Djenne. The western Sudan was conquered by the Moroccan dynasties of the Almoravids and Saadians, in the 11th and 16th century respectively. The Islamic arts of calligraphy and architecture spread into west Africa through trade and the foundation of religious fraternities.

The Muslim kingdoms of the western Sudan also expanded northwards into the western Sahara. Slaves from the western Sudan region were traded in north Africa until recent times, and certain peoples, such as the Gnawa in Morocco, with their traditional cowrie-shell ornaments, represent the continuity of the sub-Saharan artistic tradition in north Africa. Yet, it is difficult, to pinpoint precise examples of the influence of sub-Saharan Africa on north African art.

While the medieval entrepôts of north Africa and the western Sudan prospered from the trans-Saharan trade, much of that trade was carried out by Saharan nomads: the Arabic-speaking 'Moors' of the western Sahara and the Berber Tuareg of the central and southern Sahara. The introduction of the camel as a means of transport at the end of the Roman period made this arduous life possible.

The three main cultural traditions of north Africa are covered by this exhibition: the complex urban industries of Arab, Berber and Andalusian origin, with their emphasis on architecture and calligraphy as well as the decorative arts; the more primitive rural arts of the agriculturalist and pastoralist Berber peoples of the mountain and desert regions, which although of ancient origin, are limited by ethnographic documentation to a late 19th- and 20th-century date, and the portable artefacts of the nomadic peoples of the western and central Sahara, closely linked to their dependence on cattle and camels.

Rachel Ward

It is ironic that more imagination is needed to conjure up a picture of material culture produced 500 years ago in Egypt than under the pharaohs some 3000 years earlier. The spectacular tomb finds of pharaonic times dominate any view of the artistic production of Egypt. In contrast, Islam has no tradition of burying treasured items with the dead and so medieval gold and silverwork has been melted down, pottery and glass has shattered, gems have been reset and silks have decayed. Yet the medieval period, particularly between the 10th and 15th centuries, when Egypt was independent and Cairo was one of the greatest cities of the world, was another glorious interlude in the history of Egyptian art.

The buildings of medieval Cairo still evoke the splendour of these centuries, although they are badly in need of restoration and protection from the effects of earthquakes and modern pollution. Objects preserved in religious institutions and foreign treasuries are augmented by chance finds and excavations, especially at Fustat, the first Islamic capital of Egypt which later became a rubbish dump for the inhabitants of Cairo. These vessels and fragments of inlaid brass; lustred, gilded or enamelled glass; lustre or blue and white pottery; carved rock crystal and painted ivory; jewellery made from fine gold filigree with enamel insets; scraps of polychrome silk or embroidered muslin; and pieces of carved stone and carved or inlaid woodwork, all hint at a luxurious lifestyle for the wealthy of Cairo. But they are pale shadows of the treasures described in contemporary accounts of Egypt and in the vivid stories of the Arabian Nights, which are set in Baghdad in the Abbasid period but were written in 14th-century Cairo and mirror the high and low life of that city.

After the Arab invasion in 642, Egypt was absorbed into the growing Islamic Empire. For more than 300 years it was to remain a province ruled by a governor and forced to submit an annual tribute to the caliph. A fast turnover of governors stopped them from becoming seriously involved in patronage of art and architecture and the tribute demanded by the caliphate reduced the money available for major projects. During these centuries the Islamisation of Egypt was slow. Objects bearing Arabic inscriptions were probably made for the ruling class, but patronage by the local Coptic and Jewish communities ensured that earlier forms and styles continued to be produced. Many of the objects described as Coptic should probably be dated well after the Arab invasion.

A brief period of Egyptian independence, under Ahmad ibn Tulun and his successors (868–905), is marked by a surge of building activity, including the large congregational mosque which remains a landmark in Cairo (fig. 3). Palaces from this period have not survived but descriptions suggest that they were extremely opulent, with large gardens inhabited by exotic animals and grand reception halls with idiosyncratic features such as pools of quicksilver.

The triumphant arrival of the Fatimids in 969 and their foundation of a new capital, Cairo (Arabic: al-Qahira, 'the Victorious'), marks the beginning of five and a half centuries of independence, wealth and lavish patronage of the arts in Egypt. The Fatimids were a Shiite dynasty from north Africa who claimed descent from ʿAli, fourth Caliph and son-in-law of the Prophet Muhammad. They proclaimed themselves the true caliphs and set themselves up in direct opposition to the Sunni caliphate based in Baghdad. They exploited the geographical position of Egypt, which links Africa and Asia, the Mediterranean world and the East via the Red Sea. They established an immensely profitable trading network which brought, among other things, rock crystal and ivory from the eastern coast of Africa, gold from Nubia, spices and exotica from India and porcelain from China.

A number of mosques survive from the Fatimid period in Cairo and in towns on the main trading routes through Egypt. The finest of these have façades decorated with shell niches, foliated Kufic inscriptions and interlace ornament in carved stone. The Fatimids also introduced the practice of

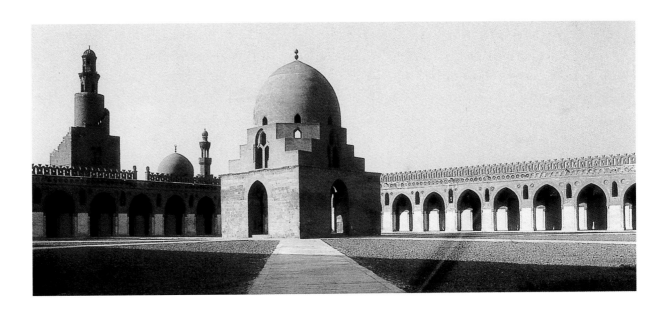

Fig. 3 Courtyard (sahn) *of the congregational mosque built by Ibn Tulun (AD 868–84). The central domed fountain was added by the Mamluk Sultan Lajin in 1296*

building monuments to holy men. These 'cities of the dead', housing estates of mausolea in vast graveyards which were (and remain) places for picnics and processions, were to become a feature of Egyptian religious architecture.

The luxury of the Fatimid court in Cairo was legendary. The caliphs built splendid palaces with gardens featuring pavilions of gilded marble. Their walls were decorated with frescos of hunting scenes, dancing girls, processions and other courtly activities. Some idea of how these may have looked is given by the cycle of courtly scenes on the painted wooden ceiling of the Cappella Palatina in Palermo, which was probably painted by a Fatimid artist in the middle of the 12th century.

Descriptions of the contents of Fatimid palaces survive: gold trees with mechanical singing birds and other automata, thrones of gold engraved with hunting scenes, pierced gold screens, enamelled gold jewellery, carved ivory hairpins, gem-encrusted mirrors, thousands of vessels in gold, silver, rock crystal, porcelain and rooms full of fine textiles. Some examples of Fatimid treasures have been preserved. These carved rock crystals (cat. 7.50), ivories (cat. 7.49) and embroidered textiles (cat. 7.51) confirm the quality of art produced in Fatimid Egypt. Other objects also reveal an interest in the details of everyday life. Among the scenes depicted on carved wood and ivory panels, lustre pottery or paper are a cockfight, a girl dancing with scarves, a reclining lady musician with her attendants, labourers bringing in the harvest, and a naked woman tattooed all over her body. Some images are blatantly Christian in their iconography (cat. 7.46), which suggests that the Coptic community continued to play an important role in patronage of the arts.

The Ayyubid ruler Saladin, famous in Europe for his defeat of the Crusaders, was also responsible for ousting the Fatimids from Egypt in 1171 and the restoration of Sunni Islam as the state religion. Later Ayyubid rule was weakened by internecine power struggles that prepared the way for a military takeover of Egypt by their Mamluk troops and the foundation of the Mamluk dynasty (1250–1517). The fall of Baghdad to the Mongols in 1258 and the subsequent installation of the caliphate in Cairo established Cairo as the spiritual, intellectual and political centre of the Islamic world.

Mamluk palaces have not survived, but a large number of religious buildings, almost all of them in Cairo, indicate the splendour and quality of architecture during this period (fig. 4). The Mamluks perverted the Fatimid tradition of erecting mausolea for holy men by building them for themselves. Religious institutions were built alongside on the understanding that they employed and supported the descendants of the founder after the inevitable confiscation of his wealth and possessions on his

death or fall from power. Their desire to make a public statement of piety and power encouraged the Mamluk sultans and officers to site these buildings in the centre of Cairo. Urban overcrowding tested the ingenuity of their architects as they wrestled with the problem of creating a grand façade and majestic interior within an irregular and usually small plot of land on a dark and narrow street.

These buildings were richly decorated in the style of the time: walls faced with different coloured marbles, granites and mother-of-pearl; enormous doors of pierced or inlaid brass or of carved wood inlaid with ivory; ceilings of painted wood; stone window screens pierced to let light through intricate geometric patterns. They were also provided with furniture and objects, often of elaborate workmanship; a carved or inlaid wood *minbar* (cat. 7.67), enamelled glass lamps (cat. 7.62), brass chandeliers (cat. 7.59), gold, silver or brass candlesticks, Qurans as well as inlaid brass or wooden chests to contain them and bookrests to support them when used.

Of all Islamic religious objects, Qurans, the visible word of Allah, are closest in spirit and prestige to the altarpieces of medieval Europe and they attracted the same critical attention from contemporaries. Mamluk Qurans are particularly fine. The famous seven-volume Quran ordered by the Mamluk Amir Baybars al-Jashnaqir was described by Ibn Iyas, a 16th-century historian, as one of the wonders of the age (cat. 7.55). Written in gold by Cairo's leading calligrapher, Shaykh Sharaf al-Din ibn al-Wahid, and decorated by the most skilled illuminators available, it took more than a year to complete and cost 1700 dinars.

As the wealthiest members of society, the Mamluk military élite dominated patronage of the arts, although merchants and court officials (Coptic, Muslim and Jewish) were often rich enough to buy fine objects. Buildings and artefacts commissioned by the sultan or his amirs are easily distinguished by the titular inscriptions and personal blazons which they used to decorate their possessions. Inlaid brass and enamelled glass vessels bearing their titles and blazons have survived in some quantity but

inventories indicate that gold and silver vessels were preferred and that rich individuals sometimes owned several thousand precious metal vessels. Not one of these has survived.

The Mamluks, like the Fatimids, derived much of their wealth from trade, especially spices from India which were sold to Europe at considerable profit. Their lucrative monopoly of the East-West trade via the Red Sea was undermined in the later 15th century when the Portuguese rounded Cape Horn and provided an alternative sea route between Europe and the East. The advance of the Ottomans in 1517 found a weakened regime which was no match for their superior fire-power. Egypt was subsumed into the Ottoman Empire and retained provincial status until the 19th century. Egyptian art and architecture became a pale reflection of fashions at the Ottoman court in Istanbul, although traditional skills, such as stone and wood carving, gave an Egyptian identity.

Cairo (like its predecessor Fustat) was the centre of the patronage and production of art and architecture throughout the Islamic period in Egypt. As the capital of a succession of wealthy dynasties and home to a large percentage of the Egyptian population, including almost all the most privileged members of society, that is not surprising. The geography of Egypt also encourages centralisation. The Nile creates a corridor of habitation and transport so that all roads, literally, lead to Cairo. Merchants travelled that corridor regularly, supplying local customers with goods from the capital on their way to more distant destinations.

Cairo's main rival as a centre of artistic production was Damascus, second city of the empire and capital of Syria, which had well-established workshops for metalwork, pottery, glass and other media. The Mamluks are known to have ordered special objects from Damascus – inlaid brass candlesticks, decorated wax candles, enamelled glass vessels. This makes the attribution of portable objects difficult, even those objects bearing the names of individuals known to have been resident in Cairo. Contemporary accounts and the objects themselves, however, testify to a steady migration of craftsmen from Syria to Cairo in response to the large market for luxury goods to be found there; it is therefore likely that most objects destined for the court were made locally in Cairo, especially those in delicate materials such as glass, which might have been damaged during a long journey.

The cosmopolitan character of Cairo strongly affected the art produced in the city. Rulers of Egypt, the most important patrons of art and architecture, included black Africans, north Africans, Arabs, Turks, Mongols, even, briefly, a woman (although she was reduced to marrying a second-rate general to consolidate her position). Court officials showed a similar racial mix. They often brought artistic notions with them from abroad: Ibn Tulun's mosque (fig. 3) reflects the great congregational mosque in Samarra. The Fatimids brought a well-developed architectural style with them from north Africa. The wealth of Cairo attracted craftsmen from across the Islamic world and even beyond. Individual craftsmen and architects usually remain nameless but occasionally there is a reference to Persian tilemakers or Armenian architects; or the name on a signed object indicates a craftsman's hometown in Mosul, Basra or Tabriz. Objects made in China, Iran, Europe and elsewhere circulated in the Cairo markets. Styles and techniques introduced by these foreign patrons, craftsmen and objects ensured that Cairo remained abreast of the latest artistic fashions. Equally, innovations conceived in Cairo radiated out to the numerous countries with which it had trading links.

Although the puzzle may be incomplete, the material and literary evidence from Islamic Egypt can be pieced together to create a picture of a sophisticated, urban culture that was admired throughout the Islamic world and beyond. As the 14th-century Tunisian historian Ibn Khaldun remarked in his monumental work on history and civilisation, *The Muqaddimah*: 'Today no city has a more abundant sedentary culture than Cairo. It is the mother of the world, the great centre of Islam and the mainspring of the sciences and the craft

**Two poles for hanging
leather bags**

Arab nomads or 'Moors'
Mauritania or western Sahara
20th century
wood
h. 134 and 136 cm
Linden-Museum, Stuttgart, A 39150/1

After leather, wood is perhaps the
most important material in Saharan
daily life, and is used for the poles and
beams of the nomads' tents on which
are hung bags, saddles, bows and
whips, as well as bed frames, dishes,
cups, milking bowls, spoons, mortars
and pestles. Various types of wood are
available, despite the encroaching
desertification of the oases. Along
with tent poles, beds are the most
elaborately decorated wooden items
in the life of the nomads. When in
use these beds are covered with
two or three mats woven of grass
and leather strips. They are light
enough to transport, upside down

but in one piece, on the back of a
camel.

The Tuareg bed frame (cat. 7.1d) is
decorated with silver, strips of copper
sheet and bronze studs. Metal is used
very little among the Tuareg, gener-
ally only for their arms, of iron inlaid
with copper. Copper is used sparingly
for ornamentation on wood, and rarely
for whole items such as cups or pots.
There is a small population of
nomadic artisans (often of black sub-
Saharan origin) among the Tuareg,
who specialise as blacksmiths and
arms-makers. Berber Jews, on the
other hand, primarily settled in the
oases of the northern Sahara such as
the M'zab in Algeria and the Dades
Valley in Morocco, supply silver
jewellery and coppersmithing. It is
curious that the elaborate wooden
objects are carved and turned by the
iron- and coppersmiths.

The bed frame consists of six poles,
2 metres in length, carried on two
transverse beams. Both the transverse
supports and the feet end in large

discs. This type is thought to recall
pharaonic Egyptian bed frames,
especially the finials in the form of
lotus flowers. The same lotus flower
finials and the decoration with strips
of copper sheet are also found on
Tuareg poles for various purposes.

Two types of tent are found in the
Sahara: the more common has one or
two central columnar supports, and
the Tuareg in the southern Sahara
have a barrel-vaulted tent on a semi-
circular frame. All the furnishings of
these tents are decorated, such as the
two poles for hanging leather bags
(cat. 7.1a) and the pole with three
prongs for holding a gourd or leather
container (cat. 7.1b). Each pole is
sharpened to a point for standing
upright in a nomadic encampment,
and the upper half is elaborately
carved and pierced with semicircles
and triangular and cruciform shapes.
These pieces are from the nomadic
'Moors' of Mauritania, but could
equally be Tuareg. The sculptural,
almost totemic, quality of the carving
recalls sub-Saharan sculpture.

Ceramics are little used in the
Sahara, and eating vessels are more
often made of wood. The wooden
bowl shown here (cat. 7.1c), used for
food or milk, is also from the 'Moors'
of Mauritania but exactly similar
shapes and decoration are also found
among the Tuareg. The bowl is of
turned wood, and the decoration is
quite fine, the parallel lines probably
executed mechanically on the lathe.
Larger examples have iron handles,
and old wooden vessels that dry out
and crack are repaired with rivets
of copper, as in the exhibited piece.

When milk is heated in one of
these wooden bowls, the vessel is
not placed over the fire, but instead
heated stones from the hearth are
placed in the milk. The Tuareg are
said to appreciate the taste of burning
in the milk, and the taste is also said
to keep away evil spirits. *NE*

Bibliography: Kilian, 1934, pp. 148–9,
152–3 and illustrations; Meunié, 1961;
Nicolaisen, 1963, p. 268, fig. 195a–b;
Du Puigardeau, 1967–70

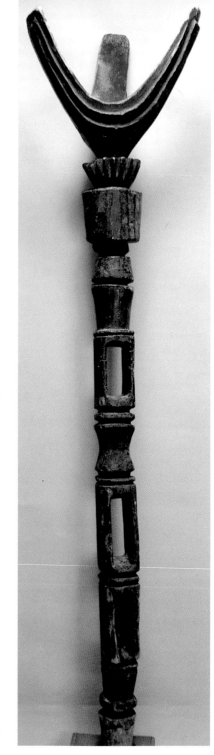

7.1b

**Pole for holding a gourd or
leather container**

Arab nomads or 'Moors'
Oualata, Mauritania
20th century
wood
h. 181 cm (total)
Linden-Museum, Stuttgart,
A 32629La/b

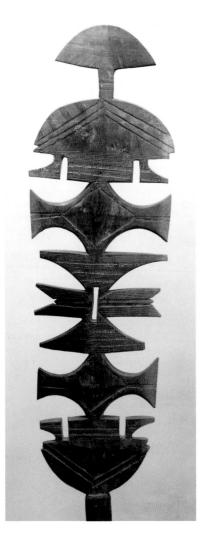

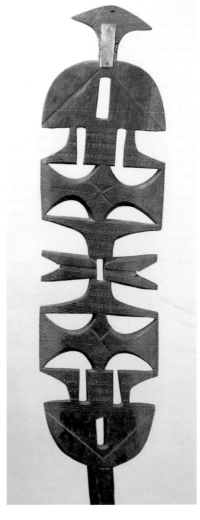

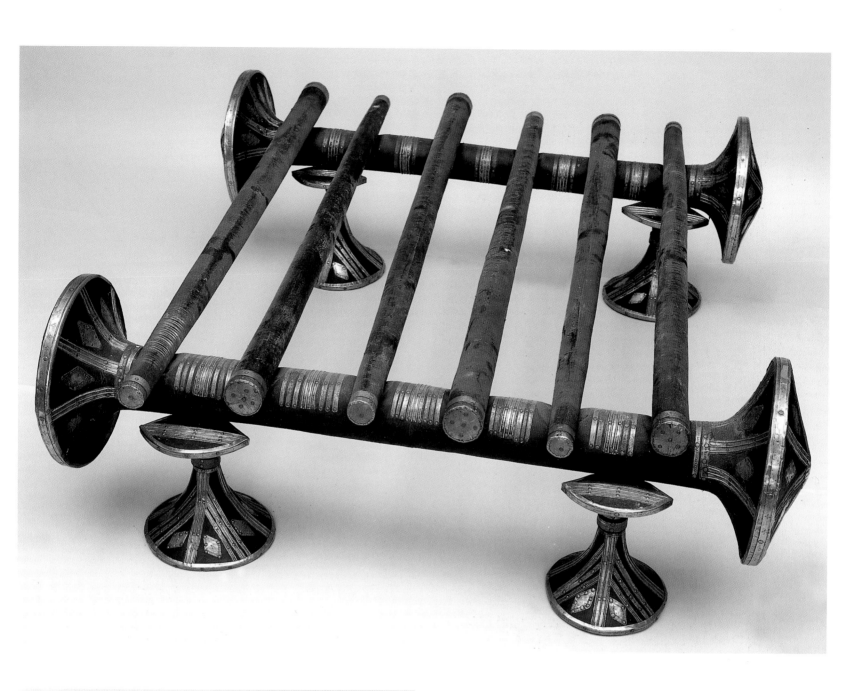

7.1c

Bowl

Arab nomads or 'Moors'
Mauritania or western Sahara
20th century (?)
wood
h. 20 cm; diam. 25 cm
Linden-Museum, Stuttgart, A 39152

7.1d

Bed frame (*tedabut*)

Tuareg
Sahara
20th century
wood, bronze, silver, copper
50 x 176 x 153 cm
Private Collection

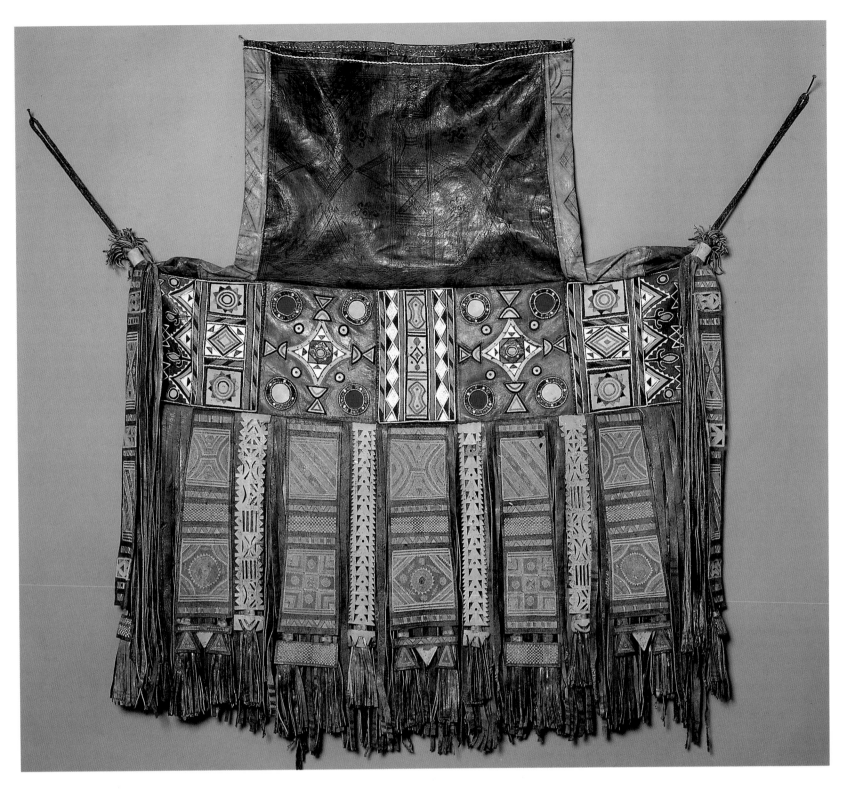

7.2a

Bag

Tuareg
Sahara
mid-20th century
leather
115 x 100 cm
Bert Flint

The modern populations of the
Sahara can be divided into two
geographic groups, the Berber-
speaking Tuareg who inhabit the
central and southern Sahara (modern
Algeria, Libya, Chad, Mali, Niger,
Burkina Faso and Nigeria), and the
Arabic-speaking 'Moors' who inhabit
the western Sahara, Mauritania, Mali
and western Algeria. They lead a
nomadic life, herding camel, goat and
sheep and conducting trade between

north and sub-Saharan Africa,
although during the 20th century
there has been increasing settlement.
In Mauritania a number of ancient
medieval oasis towns, such as Oulata,
Chengiti and Tindouf, have been
settled by the Moors, and in Algeria,
Libya and Chad there are oases
populated by agriculturalists and
artisans, mostly from the black
minority among the Tuareg. In the
Tibesti region of southern Libya and

northern Chad there are whole popu-
lations of black settlers, known as the
Tedda, who probably originated in the
western Sudan. A system of slavery
or vassalage of black peoples is still
practised by the Tuareg and Moors.

Apart from a small minority popu-
lation of metalworkers, the Tuareg
are self-sufficient, and produce their
own utensils, predominantly of
leather. They do not weave cloth, but
import cotton cloth and wool from

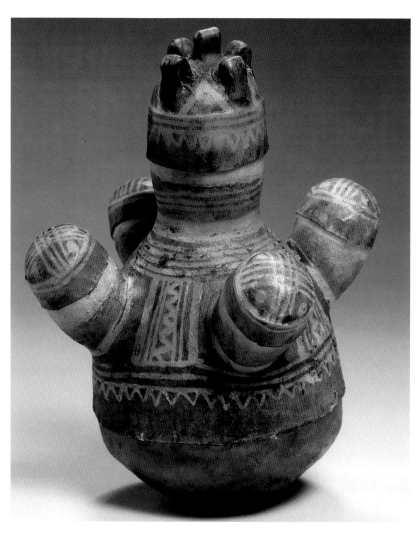

7.2b

Container (*botta*)

Tedda
Tibesti region, southern Libya and
northern Chad
20th century
leather
h. 23 cm; diam. 11 cm
Royal Tropical Institute/Tropenmuseum,
Amsterdam, 2760-140

7.2c

Butter jar

Arabic nomads or 'Moors'
Mauritania or western Sahara
20th century
leather, rope
h. 40 cm
Linden-Museum, Stuttgart, A 37289A/b

cross-hatching and zigzags, which are
scraped off the surface of the leather.

Cat. 7.2c is an example of a more
utilitarian leather object, a butter jar,
from the 'Moors' of Mauritania.
Among the Tuareg such containers
are made of camel skin covered with
goat leather, with leather stoppers and
goat-hair rope. Aside from the import-
ant role of milk in the nomadic diet,
butter is also used as a cosmetic,
applied to skin and hair, to counteract
the harsh desert climate. *NE*

Bibliography: Kilian, 1934, p. 148 and
illustrations; Nicolaisen, 1963, p. 93, fig.
161a–d; Prussin, 1986, p. 139, fig. 5.23a–b;
Sijelmassi, 1986, pp. 76, 78–9

sub-Saharan or north Africa. Goat
hair is used for making rope. Leather
is obtained primarily from goats and
sheep, and sometimes camels, and
is worked by women of the ruling
Tuareg and artisan class. Leather is
essential for the walls of their tents,
some articles of clothing, harnesses
and all types of container.

A large number of different types
are made to hold clothes and pro-
visions. The shapes of leather bags
vary but the most common are very
long, with the top part folding over
to make a closing flap, a type used by
men in north Africa as far north as
the Mediterranean. The shape of the
bag (cat. 7.2a), in which the body is
wider than the neck and opening, can
be identified with Tuareg women's
travelling bags.

Blue is the favourite colour for
leather, as well as for the robes and
veils of the Tuareg, known as the
'blue men' for the indigo that rubs off
on their skin. The blue-dyed leather is
often applied in openwork cut-out
designs on a background of brown

or black leather, and is painted or
embroidered with white, red and
black thread or leather thongs.
There is a taste for long flaps and
fringes. The leather can have a mat
or polished surface. The decorative
motifs, as in cat. 7.2a, are all geo-
metric: chequerboard, lozenge net,
equilateral triangle, circle, six-point
star, zigzag, spiral and the so-called
'Tuareg cross'. This decoration
resembles that of Moroccan Berber
and sub-Saharan Hausa textiles, and
contrasts with the more complex
repertoire of the towns of north
Africa.

Among the Tuareg, goat and sheep
leather is also moulded to make small
boxes for jewellery, make-up, perfume,
butter containers etc. The leather
container in the form of a bottle with
five necks and lids (cat. 7.2b) is from
the Tibesti people of the Tedda, or the
eastern extreme of the Tuareg
region,but exactly the same form and
decoration is found among the Air or
Ayr Tuareg of the southern Sahara.
The decoration consists of simple

shown here, have been cut down or deliberately broken. It is thought that these sculptures are anthropomorphic cult figures, perhaps linked with totemic and animistic beliefs. Before the arrival of Christianity and Islam during the course of the 1st millennium AD, it is known that the local Berber held such beliefs. Interestingly, Tuareg (Berber) women in the region have been recently recorded clumsily painting in the carved relief lines and adding facial features to these monoliths which suggests that they have a symbolic significance today.
TAI, MRM

Bibliography: Bouyssonie, 1956, pl. CVII; Balout, 1958, p. 157; Forde-Johnston, 1959, p. 47; Camps-Fabrer, 1966, pp. 282–5; Camps, 1982, pp. 581–2

7.3

Anthropomorphic monolith

Tabelbalet (Tassili-N'Ajjer)
Algeria
Neolithic
sandstone
Musée National du Bardo, Le Bardo, Tunisia

This sculpture was found in the Tabelbalet region of Algeria among nine similar sandstone objects. Minimum detail is used to create a stylised representation of a human figure: an oval relief line gives contour to the face, with accentuated, curved eyebrows beginning at the nose. Mouths are absent from all nine figures. The emphasis upon eyebrows and nose has led some scholars to interpret these sculptures as stylised owls. Within the Tabelbalet area, other items have also been recovered: arrowheads of chalcedony and a fine yellow-red flint, polished stone axes, inscribed fragments of ostrich egg-shell, and ceramics, which had been either basket-moulded or incised with a sharp point. The figures are rep-

resentative of the flowering of stylised stone sculpture during the Neolithic period in the Saharan region. Among the 38 animal and human figurines to have been recovered, the greatest concentration occurs in the Tassili-N'Ajjer. In addition to humans, various animals are represented, including sheep, antelopes or rodents. All these sculptures observe strict stylistic rules: the use of bilateral symmetry, the absence of high relief and an emphasis on anatomical detail. The characteristics and techniques of this tradition are repeated on more utilitarian stone objects, such as axes, grindstones and pestles.

Of the group of nine figurines recovered from Tabelbalet, two were noticeably larger than the others, one with a conical base, and the example shown here with a flat base, rounded at the edges. The finishing of these bases has been interpreted as indicating that they were intended to be driven into the ground, or supported by rocks, as tomb markers. The other figures, including the smaller example

7.4

Ram's head

Tadjentourt (Hoggar)
Algeria
Neolithic
basalt
h. 26.5 cm
Laboratoire de Préhistoire, Musée de l'Homme, Paris, 74.2.1

This stylised ram's head, oval in section and broken at one end, is made from a very dark basalt. The design has been flattened, and all detail perceived as unnecessary has been removed, creating the impression of a ram or antelope with only minimal design elements. This is an outstanding example of the Neolithic sculpture tradition of the Saharan region, which produced both stylised animal and human figurines in this distinctive restrained style, with its emphasis on bilateral symmetry. Of the 38 examples of these carved stone objects recovered from the Sahara, this head has been variously interpreted, being seen as a ram, an antelope, a fish, or an idol similar to the examples from Tabelbalet (cf. cat. 7.3); the twist of the horns found on the front of the figurine, however, suggests that it is probably a sheep or goat. Similar examples have been recovered, including an ante-

lope's head from Imakassen in the Tassili-N'Ajjer and the head of a bull carved in diorite from Tisnar in the Admer Erg. A second ram's head has been recovered from Tamentit, near Touat. As with the anthropomorphic figurines, which form part of this tradition, it is probable that the animal heads may have functioned as totemic objects. *TAI, MRM*

Bibliography: Bouyssonie, 1956, pl. CX; Camps-Fabrer, 1966, pp. 271–2; Camps, 1982, pp. 574–82

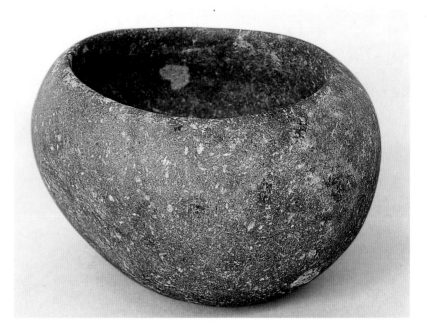

While axes manufactured from the less attractive and more common materials were probably used as tools, it is highly unlikely that this was the function of the rare examples manufactured in exotic materials, such as this one. It is believed that these were objects of intrinsic value, perhaps used as items for prestige exchange. In Europe extensive exchange routes of polished stone axes have been traced, using axes manufactured from materials with very limited distribution, and individual items have been seen to travel considerable distances. It is probable that this example represents a high aesthetic, social and symbolic value.
TAI, MRM

Bibliography: Forde-Johnston, 1959; Hugot, 1981, p. 599; Whittle, 1985

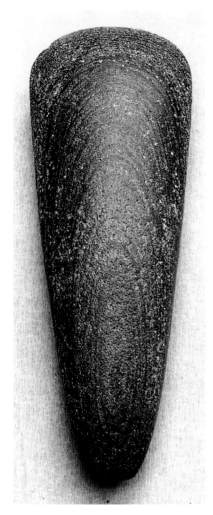

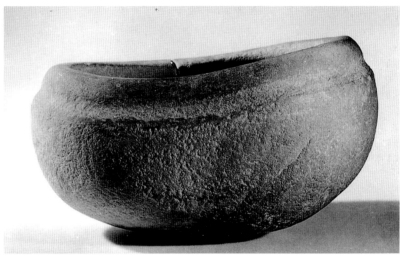

7.5

Polished stone axe

Sahara
Neolithic
greenstone
20 x 7.5 x 5 cm
Dr Klaus-Jochen Krüger

This Neolithic axe, the exact provenance of which is unknown, is a particularly striking example of a polished stone axe, an artefact found not only in this region but also throughout Europe and much of Africa. It is the choice of the material used rather than the quality of the workmanship displayed that gives this example its outstanding beauty. Axes manufactured in north-west Africa show great variety in both form and size: cylindrical axes are the most common form, while flat and rectangular axes are less frequent. Great variety is also seen in the material, both hard stone, such as granite, and more exotic semi-precious stones being selected. An entire tool-kit in green jasper, including flaked and partially polished stone axes, was found at the site of Ténéré in Niger.

7.6a

Stone bowl

Skhirat
Morocco
Neolithic
stone
h. 12.4 cm
Musée d'Archéologie, Rabat, 89.5.3.2

7.6b

Stone bowl

Tassili-N'Ajjer
Algeria
Neolithic
stone
h. 10 cm
Laboratoire de Préhistoire, Musée de l'Homme, Paris, 63.6.688

Stone bowls dating to the Neolithic period are found throughout north-west Africa, as these two examples, from the Moroccan coast and the central Sahara respectively, testify. The site of Skhirat, which is located on the road which joins Rabat and Casablanca, is better known for its Palaeolithic assemblages, though two fragmentary polished stone axes, a Neolithic development, were also found at this site. Although little is known about these bowls, they are representative of the high quality of stoneworking techniques developed at

the beginning of this period. Drilling equipment was perfected, utilising specialist tools – burins, needles and drills, and abrasive powders of fine sand and resins, these being used in conjunction with polishing and pecking to achieve a very high standard of craftsmanship. Stone bowls are frequently polished, the greater polish often found on the interior surface being interpreted as a result of use. In addition to stone bowls, an extensive range of polished stone tools was produced, including axes (see cat. 7.5), scrapers, hammers, grinding-stones, pestles and mortars, adzes and polishers or burnishers, objects both beautiful and functional.

Traces of ground ochres have been identified in the base of some bowls, indicating that they may have been used for the preparation of ochres for rock or body painting, or other decor-

ative purposes. Neolithic rock paintings from the Tassili-N'Ajjer clearly depict tattooing or painting on both male and female figures, and pieces of ochre and traces of other mineral pigments (zinc sulphide and galena having been found at many sites) have been interpreted as evidence of widespread bodypainting. They also appear to have been used for grinding wild berries, grains, dried grasses, vegetable dyes and medicines. It has further been suggested that these vessels were used for storage purposes, though the nature of the products stored is controversial. *TAI, MRM*

Bibliography: Forde-Johnston, 1959; Souville, 1973, p. 118; Hugot, 1981, p. 597; Camps, 1982

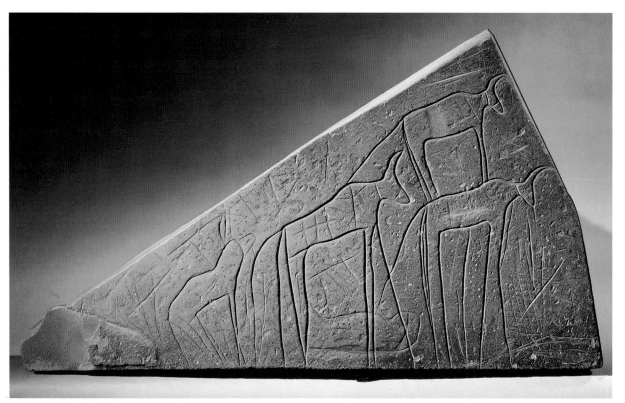

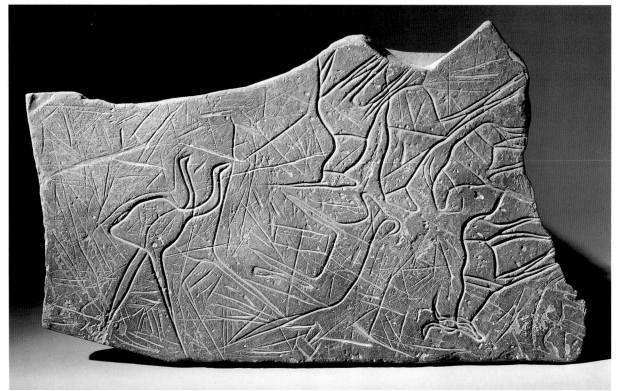

These are examples of the wider Neolithic engraving tradition found throughout this region, in both the Sahara and the Atlas Mountains. Such engravings are executed in a remarkably naturalistic style, depicting both man and animals on small stone plaques and ostrich eggshells, and, on a much larger scale, on rock faces. The technique used in most of them is the smooth U- or V-shaped incision. Cat. 7.7b depicts, on the left-hand side, a striding ostrich in outline and, on the right-hand side, six four-legged animals, four with horns. Scholars have interpreted the species represented as including oryx, other antelope, sheep, goat and hyena. It has also been suggested that certain of the geometric designs on the plaque, including the V-shaped marks between the legs of the ostrich and the rectangular pattern in the centre of the plaque, are later additions, since they do not display the same degree of patination.

The realism of these images has made them useful in the study of wild fauna in the Saharan and tell regions during the Neolithic, and as a source of information on domestication of animals in the region. The Sahara was not, at the beginning of the Neolithic period, the desert that it is today.

Concentrations of wildlife occurred at the large lakes then in the region, and included animals now found only well to the south of the Sahara. An extensive flora, including willow, hazel and ash, supported animal and human populations. These animal species, which are abundantly represented in the rock and ostrich eggshell engravings, were to disappear from the Sahara in the 1st millennium BC. *TAI, MRM*

Exhibition: Basle 1977

Bibliography: Haas, in Basle 1977, pp. 8–9; Hugot, 1981, p. 601; Camps, 1982, pp. 608–9

7.7a

Rock engraving

Lemcaiteb (Saquia al Hamra)
Western Sahara/Morocco
Neolithic
stone
h. *c.* 84 cm
Museum für Völkerkunde, Basle,
III.21.319

7.7b

Rock engraving

Lemcaiteb (Saquia al Hamra)
Western Sahara/Morocco
Neolithic
stone
h. 84 cm
Museum für Völkerkunde, Basle,
III.21.320

7.8a

Stone stela

N'Kheila
Casablanca Region, Morocco
Bronze Age
stone
84 x 54 x 11 cm
Musée d'Archéologie, Rabat, 89.5.2.3

The concern with the depiction of wildlife, and of man's relationship with both wild and domestic animals, central to the art of the Neolithic period, disappears in the Bronze Age. People and their manufactured goods become the focus of rock engravings and carvings, and this change is linked with the appearance of geometric designs and schematic symbols, which serve further to remove them from the naturalistic settings of the former period. These three objects reflect this, with their use of circular and geometric decoration and a central preoccupation with stylised human figures, and clearly contrast with the Neolithic engraved stone plaque from Lemcaiteb (cat. 7.7b). On the first stela (cat. 7.8a) a sexless naked body is separated from the circular motifs typical of the Bronze Age by two sinuous borders. The circular and geometric motifs employed here have frequently been interpreted in other contexts (e.g. Australian Aboriginal rock art and that of the San in southern Africa) as the images perceived while in a trance-like state, possibly drug-induced (cf. cat. 3.8). As can be seen, the rock engraving (cat. 7.8c) employs similar roundels, and what may possibly be interpreted as a highly stylised figure of a (shamanistic?) dancer. The second stela (cat. 7.8b) has previously been given a Neolithic date, but the design elements used, circular and sinuous relief, appear to have a greater affinity with the characteristic Bronze Age motifs illustrated on the other items. It is possible that it may represent a transitional stage between these two distinct periods.

This has been interpreted as reflecting a dramatic shift in conceptual system, and a re-evaluation of the relationship between man and his world, evidence perhaps of increasing socio-political complexity associated with significant technological change. The end of the humid period in the mid-3rd millennium BC, and the resultant desertification of the Sahara,

led to the concentration of the Bronze Age population in Saharan oases and along the coastline of the Maghrib. The unity of Africa which had existed throughout the Neolithic period was now disrupted and the Bronze Age population along the coastal strips became isolated. Links between these groups and the Iberian peninsula in the west and Sicily, Malta, Sardinia and southern Italy in the east grew stronger, a fundamental change that may also have influenced artistic styles. *TAI, MRM*

Bibliography: Souville, 1973, p. 294; Desanges, 1981, pp. 425–6; Camps, 1982, pp. 612–61

7.8b

Stone stela

Sahara
Neolithic
stone
59 x 30 x 2.4 cm
Dr Klaus-Jochen Krüger

7.8c

Rock engraving

Morocco
Bronze Age
stone
h. 52 cm
Musée d'Archéologie, Rabat, 89.5.1.5

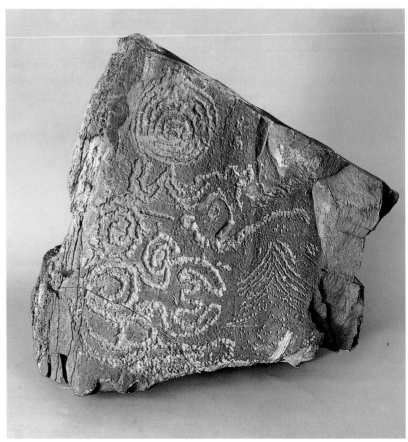

7.9a	7.9b	7.9c
Mask with negroid features	**Grimacing mask**	**Mask of a bearded man**
Tunisia	Tunisia	Tunisia
late 7th or early 6th century BC	late 6th or early 5th century BC	c. 500 BC
terracotta	terracotta	terracotta
21 x 15.5 x 11 cm	16 x 13 x 10 cm	20 x 14.5 x 8.5 cm
Musée National du Bardo, Le Bardo, Tunisia	Musée National du Bardo, Le Bardo, Tunisia	Musée National du Bardo, Le Bardo, Tunisia

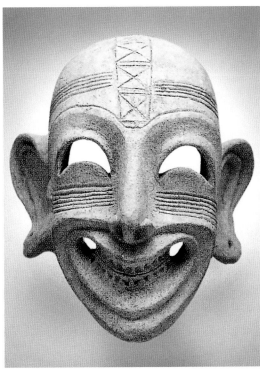
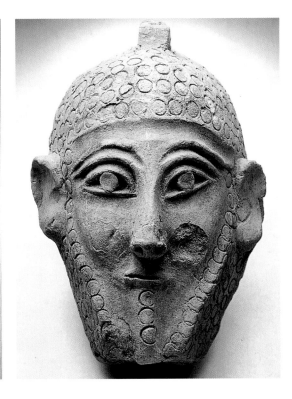

These masks are good examples of a type of artefact widespread in the Phoenician settlements of north Africa. The earliest come from the Phoenician homelands of the eastern Mediterranean (Lebanon, Syria) and date to the 11th and 10th centuries BC; thereafter the masks have a long history of use to the 2nd century BC. Most western examples come from tombs and clearly have an apotropaic function, possessing magical properties to frighten off evil spirits from the tomb; they have also been found in sanctuaries. It has been suggested that the grotesque image represents a specific deity, such as the demon Humbaba of Mesopotamian origin, but this is not certain. The life-size masks may have been worn by worshippers in religious processions, the eye holes allowing visibility. On the Sicilian island of Mozia (the Phoenician colony of Motya) they seem to have been used to cover the faces of the human sacrificial victims in the sanctuary where this rite was carried out (*tophet*). Most masks, however, are smaller than life-size and may have been used to cover statuettes and other effigies. In view of the fact that the vast majority of these masks come from tombs, most may have been made specifically as gravegoods. Cat. 7.9a belongs to the earliest type known from the cemeteries of Carthage, with apparently negroid features: there is a large flat nose, protruding ears, prominent almond-shaped eyes sloping downwards towards the nose, and a mouth with only one side turned up, giving the face an awkward leer. The division between the upper and lower parts of the face is marked by a sharp change of plane (carination), as commonly on such masks; there are three raised button-like knobs (warts?), made up of concentric circles, on the central axis of the head between the crown and the eyebrows, the middle one being surmounted by a crescent design.

Cat. 7.9b is a rather later version of the type of mask with negroid features. The grinning face is typical, an effect produced by giving the mouth a distinct U-shape and turning up its corners. This differs from cat. 7.9a in having crescent-shaped eyes and a raised and pointed rather than a flattened nose; teeth are also shown, and the mask bears decoration in the form of horizontal scored lines.

Also decorative is the upright rectangular scored panel with three crosses, extending from the crown of the head to the bridge of the nose. As with cat. 7.9a, its principal function was apotropaic. Virtually identical masks with the same scored pattern of decoration are known from elsewhere at Carthage and also from San Sperate in Sardinia.

The terracotta mask of a bearded man (cat. 7.9c), with staring eyes, prominent nose and ears, triangular chin and perfunctory mouth, is placed somewhat off centre. The hair and the beard are indicated by a series of impressed open circles, in the case of the beard sometimes overlapping with each other; in addition there are three further circles shown below the mouth. A suspension hole projects from the top of the head. This striking terracotta is another example of the apotropaic mask designed to ward off evil spirits; this example, however, differs from most in displaying no grimace and in having solid rather than hollow eyes. *RJAW*

Provenance: cat. 7.9a: 1890s, Carthage, Dermech district, from a burial; cat. 7.9b: Carthage, from a burial; cat. 7.9c: Carthage, south slope of Byrsa Hill

Exhibitions: cat. 7.9a: Venice 1988, no. 231; Paris 1995, p. 45; cat. 7.9b: Paris 1995, p. 45; cat. 7.9c: Paris 1995, p. 37

Bibliography: cat. 7.9a: Gauckler, 1915, pl. CXCVIII; Picard, 1965–6, pp. 11–12, pl. I.1; Yacoub, 1970, fig. 10; Ciasca, in Venice 1988, pp. 356–9; Lancel, 1995, p. 61, fig. 37; cat. 7.9b: Picard, 1965–6, very similar is Paris 1982–3, no. 45; cat. 7.9c: Picard, 1964, p. 67, pl. 24; Picard, 1965–6, 19–20, no. 23 with pl. V.19; Moscati, 1973, pl. 24; Lancel, 1995, p. 62, fig. 38

7.10

Mosaic panel showing a woman dancing

Tunisia
c. AD 400
limestone, marble
201 x 154 cm
Musée de Carthage

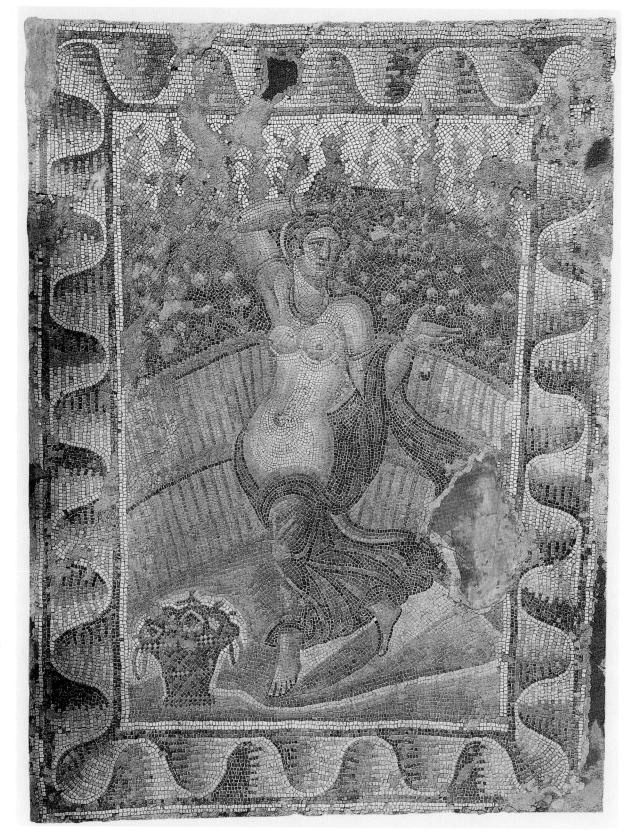

This mosaic panel shows a young woman, naked from the hips up, with a shawl over her left arm; she wears a necklace, two armlets and a pair of bracelets. She is shown dancing or lightly stepping to the left; both the direction of her gaze, over her left shoulder, and the gesture of her left hand suggest that she is not alone. On her head she carries a basket from which roses are falling; a further basket of roses, with handles, stands in the lower left corner of the mosaic. In the background, behind a curved high fence, is a thicket of rose bushes. The border of the panel shows a simple ribbon pattern.

The panel is one of four at the corners of a cold room (*frigidarium*) in a richly appointed detached bath building in a rural location 30 km south of Carthage. Of the other three corner panels, there is one almost identical to that shown here, and the other two depict half-naked girls pouring water from an uplifted jug. Interpretation is uncertain. It has been suggested that the four represent the seasons, but then different attributes would be depicted in each panel, not two pairs of two almost identical scenes. The centre of the pavement in the *frigidarium* depicted a marine procession with Neptune and Amphitrite, along with nereids and tritons, disporting themselves on the backs of a wide variety of often fantastical marine creatures. The main scene of the floor is therefore unrelated to the subject of the four corner panels. It seems certain that the bath building was located on a private villa estate and belonged to a wealthy landowner, but the whereabouts of the main villa building awaits discovery. Figured mosaics are very common in north Africa; the mosaic industry flourished in response to the demands of wealthy landowners who wanted to invest the profits they had made from agriculture in ostentatiously decorated dwellings in town and country alike. North Africa was particularly prosperous in the late Empire, and this mosaic dates from just before the end of a particularly active period of demand for such floors, which declined sharply with the Vandal control of the central part of north Africa (Tunisia and eastern Algeria) from the 420s. *RJAW*

Provenance: 1980s, Sidi Ghrib, from the cold room (*frigidarium*) of a bath building

Exhibition: Paris 1995, p. 309

Bibliography: Ennabli, 1986, p. 42, pl. XIII

7.11

Head of a priest

Egypt
2nd century BC
black basalt
19.5 x c. 14.5 x 17.5 cm
Württembergisches Landesmuseum,
Stuttgart, 1.26

This head of a bearded man, with
broad forehead, heavy eyelids and
prominent nose, is typical of sculpted
heads in Ptolemaic Egypt; in particu-
lar the neat coiffure, sitting like a
cap on its wearer's head (rather than
rising naturally from the contour of
the scalp), is paralleled on numerous
heads of this period, and represents a
fashion in Egyptian sculpture that can
be traced back to the Old Kingdom.
The man can be identified as a priest
both by the diadem with perfunctory
rosettes which he wears in his hair,
and also by the sculpted panel on the
rear side of the head. This depicts two
divinities, one lion-headed and
crowned by the sun-disc, the other
falcon-headed with a double crown;
they face right towards a priest,
who raises both hands in adoration.
The gods, who lack specific attributes,
must be Horus and Uto, who were
worshipped in the temple at Buto
where the head was found. The priest
is shown on the panel as shaven-
headed in time-honoured priestly
fashion, in contrast to the head itself
which portrays him in secular style
with close-cropped curly beard.
The wearing of beards did not
become fashionable in Egypt until
the 2nd century BC. *RJAW*

Provenance: Kom el Far'în-Buto (Delta)

Exhibition: Stuttgart 1984, no. 110

Bibliography: Brunner-Traut and Brunner,
in Stuttgart 1984, p. 139

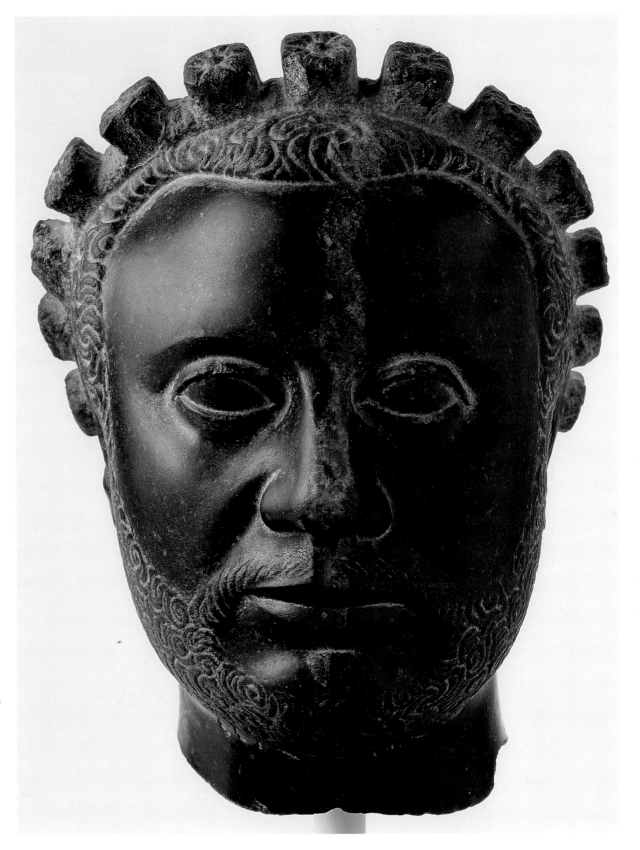

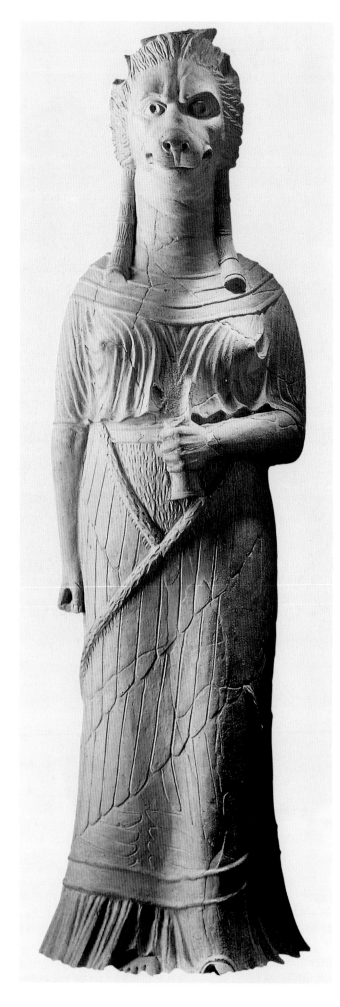

7.12

Statue of a lion-headed goddess
Tunisia
1st century AD
terracotta
150 x 46 x 36.5 cm
Musée National du Bardo, Le Bardo,
Tunisia

This remarkable terracotta statue shows a standing female figure in a full-length robe, the lower part of which is swathed with a pair of bird's wings. In place of a human head is that of a lion (rather than a lioness), with staring, fierce expression. The goddess holds an item of uncertain identification (now damaged) in her left hand. The statue is one of a number of distinctive large-scale terracottas to come from a sanctuary site at Bir Bou Rekba dedicated to the principal deities of the Carthaginian pantheon, Baal and Tanit, and to their Roman successors and equivalents, Saturn and Caelestis. The open-air sanctuary is of unusual type, consisting of three terraced courts with altars, votives and tiny chapels to house the cult image (but no full-scale temple). The iconography of the goddess is ultimately borrowed from that of the Egyptian lioness-headed goddess Sekhmet, a symbol of solar force; but the identity of the figure exhibited here as an unusual symbol of Africa itself can be established on the basis of a Roman silver coin (a *denarius*) of 47/6 BC, where a very similar lion-headed figure is named as the *genius terrae Africae*, the 'protective spirit of the land of Africa'. The figure on the coin is shown holding the symbol of Tanit, a triangle surmounted by a horizontal line and a circle. This lion-headed version of the *genius terrae Africae* is known only from two other representations, at Tiddis and Bir-Dirbal, both in Algeria. The personification of Africa in antiquity was more usually shown as a woman whose head is surmounted by an elephant's trunk and tusks.
RJAW

Provenance: 1908, Bir Bou Rekba, near Hammamet

Exhibitions: Venice 1988, no. 215; Paris 1995, p. 103

Bibliography: Merlin, 1910, pp. 44–7; LeGlay, 1961, pp. 97–100; Yacoub, 1970, fig. 26; Bisi, in Venice 1988, pp. 332–3

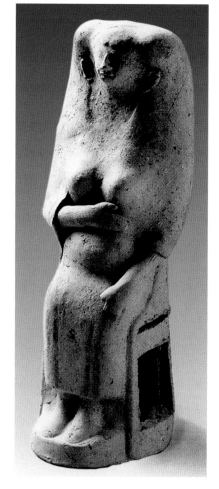

7.13

Statuette of a seated goddess
Tunisia
c. 700 BC
terracotta
25 x 9.5 x 10 cm
Musée National du Bardo, Le Bardo,
Tunisia

This statuette represents a mother goddess seated on a high-backed throne. She holds her right hand across her enlarged belly and her breasts are prominent; she is clearly represented as pregnant. She wears a long robe down to her feet, which also envelops her head, leaving only her ears and forearms bare. Her hair is arranged in great tresses falling either side of the head, a style ultimately of Egyptian origin. Her robe is decorated with black lines, her ears are painted red, and there are other traces of blue and red paint as well: originally the entire surface would have been highly painted. The terracotta, from one of the early graves at Carthage, is identical to examples from the homeland of the Phoenicians (in what is now Lebanon), the people who settled Carthage. This example is almost certainly either a Phoenician import

brought by an early settler, or made in Carthage by an artist who had got hold of a Phoenician mould for making such terracottas. The pregnant mother goddess probably represents the Phoenician goddess Astarte, goddess of love and fecundity. *RJAW*

Provenance: 1902, Carthage, necropolis in the Dermech district, tomb 310

Exhibitions: Paris 1982–3, no. 30; Paris 1995, p. 102

Bibliography: Gauckler, 1915; Cintas, 1970, pl. XIII, fig. 51; Lancel, 1995, p. 65, fig. 41 (identical to Venice 1988, no. 38, from Phoenicia, in Musée du Louvre, Paris)

7.14

Stela in honour of Tanit and Baal

Tunisia
3rd–2nd century BC
limestone
59 x 33.5 x 16 cm
Musée de Carthage

This stone slab comes from the *tophet* of Salammbô at Carthage (cf. cat. 7.15). In a central rectangular recessed panel is sculpted a simple representation of the Tanit symbol, a solid triangle surmounted by a horizontal bar and a circle, with a crescent moon above. The inscription, in neo-Punic script, reads: 'To the Lady, to Tanit; Face of Baal, and to the Lord, to Baal Hammon; vowed by Bodmilquart, son of Hanno, son of Milkyaton, son of Bery, son of Ty.' Over 6000 stelae have been found in the *tophet* (and over 20,000 cinerary urns), giving some idea of the extent of the popularity of the worship of the supreme Carthaginian deities which continued unabated from the late 8th century BC to the

destruction of Carthage in 146 BC. The cremated remains were not always of humans: animals were sometimes substituted from the start, and constitute as much as 30 per cent of 7th- and 6th-century burials; but this practice declined in the late period, when human sacrifices account for 88 per cent of cremated offerings. The Romans prohibited human sacrifice, but it may have continued in some parts of north Africa into the third century AD: Tanit and Baal continued to be worshipped, but in a new, thinly Romanised guise as Caelestis and Saturn. *RJAW*

Provenance: Carthage, the sanctuary known as the *tophet*

Exhibition: Paris 1995, p. 109

Bibliography: CIS i.3, no. 5507 (text); Lapeyre and Pellegrin, 1942, pl. II (photograph of the stele *in situ*); Hours-Miedan, 1950, pl. Vle (sketch); on the *tophet*, Stager, 1980 (incl. earlier bibliography); Aubet, 1993, pp. 212–17

7.15

Stela in honour of Tanit and Baal

Tunisia
4th century BC
limestone
79 x 19 x 15.5 cm
Musée de Carthage

This stela and cat. 7.14 come from the *tophet* of Salammbô at Carthage. The *tophet* was an open-air sanctuary

covering 6000 square metres in which were deposited cinerary urns containing the remains of new-born infants and young children, sacrificed in honour of the all-powerful goddess of the Carthaginians, Tanit, and her consort Baal-Hammon. The urn was sealed at the top with a stone pillar, replaced from the 6th century BC onwards by a stone slab. This example belongs to the final phase of Carthage before its destruction by Rome in 146 BC, at a time when Hellenistic Greek culture was exerting a powerful influence on Carthaginian art.

Underneath a central gable with flanking projections is a stylised Ionic capital, with the customary volutes on either side and the egg and dart

decoration (*ovolo*) in between. Below it is the symbol of Tanit, consisting of a triangle surmounted by a horizontal bar (here hooked at the ends, perhaps to suggest hands) and a small circle. Above it is a crescent moon; Tanit is queen of heaven as well as earth. The Tanit symbol is flanked by a pair of wands with entwined snakes at the top, and a ribbon tied to the middle. This *caduceus* is the symbol usually associated with the Greek god Hermes (the Roman Mercury), messenger of the gods and conductor of souls to the underworld. The inscription, in neo-Punic script, reads: 'To the Lady, to Tanit, Face of Baal, and to the Lord, to Baal Hammon; vowed by Himilco, son of Abmelqart, son of Baalhannon, son of Baalamasos'. Just as modern Christian names are sometimes chosen from Biblical names, so Carthaginian personal names often incorporate the names of their deities: the last two here refer to Baal, and Abmelqart alludes to another Carthaginian deity Melqart, the equivalent of Heracles (the Roman Hercules). *RJAW*

Provenance: Carthage, the sanctuary known as the tophet

Exhibition: Paris 1995, p. 109

Bibliography: CIS I.3, no. 5589, with pl. XXVI, 14

7.16

Cut metal figure

Volubilis, Morocco
metal
Musée d'Archéologie, Rabat

The attractive archaeological museum at Rabat houses many masterpieces, some of which are shown in this exhibition (notably cat. 7.8a,19). One of the main displays consists of the finds at the site of Volubilis which show a range of Roman objects from fine imported sculpture to the most humdrum utensil and give a good picture of life in Roman Africa. Anomalous among these are some votive images which have a local and uncolonial flavour, cut in metal, well crafted and in a direct, expressive style. They do not have the air of a debased provincial Roman style but a vivacity all their own. This particular example, for all its missing forearm, sums up the essence of these unusual artefacts which seem to have more in common with rock-painting silhou-

ettes in the region than with outside influences. Underneath the veneer and artifice of styles imposed by colonising powers (often expressed by indigenous craftsmen in a second-hand fashion) the *genius loci* remains in waiting. All this of course is conjecture since we know nothing about either the maker of this piece or its function; all we do know, which gives good reason for its inclusion here, is that it was made purposively by a knowing hand and that it adds to the rich variety of the art that comes out of Africa. *TP*

7.17

Relief of eight divinities

Tunisia
probably 2nd or 1st century BC
limestone
65 x 159 x 28 cm
Musée National du Bardo, Le Bardo, Tunisia

This unusual stone has a recessed rectangular panel in its upper half in which are depicted seven men and one woman in flat relief. The male figures are identical, with stylised wig-like hair; they are bearded, and wear long-sleeved garments pinned by a circular brooch on one shoulder. The female figure, fourth from the right, has similar wig-like hair, but she also wears drop earings and armlets as well as a band or diadem in her hair. The relief almost certainly depicts the indigenous deities of the Numidian peoples of the interior of north Africa, and in the absence of the slightest trace of Roman influence in the relief's iconography or style, it probably predates Roman control of north Africa, belonging to the period when the Numidian kingdoms were at their height in the 2nd and 1st centuries BC. If so it is a rare surviving example of Numidian relief sculpture. Chemtou (Simitthu), near which this relief was found, was an important Numidian settlement, and its famous quarries of yellow marble (*giallo antico*) were then being exploited for the first time. That the worship of these multiple divinities in the Chemtou region continued into the Roman period is shown by a rough cut relief, also showing eight divinities, still visible

in the Roman quarries at Chemtou. Neither cat. 7.17 nor the quarry carving is inscribed, but Latin inscriptions elsewhere in north Africa normally refer to these indigenous deities as the *dei Mauri* ('the Moorish gods'). The inscription on a 3rd century AD relief from Béja in northern Tunisia, about 70 km from Chemtou, names the seven deities it depicts as Macurtam, Macurgum, Vihina, Bonchor, Varsissima, Matilam and Lunam, names which are certainly native Libyan in origin (only Bonchor may owe something to the Carthaginian world). Since these names are unknown elsewhere, it is impossible to say if any of these gods are represented on this relief; indeed another pantheon of five, known collectively as the *dii Magifae* and carrying the quite different names of Masiden, Thiliva, Suggan, Lesdan and Masiddica, is documented near Tébessa in eastern Algeria; while another clutch of godlings, also in Algeria, delight in the names of the *dii Ingitozoglezim*. We know little about these indigenous cults in pre-Roman and Romen north Africa; the Chemtou panel provides a rare glimpse of one such pantheon. *RJAW*

Provenance: 1965, found at Borj Helal, near Chemtou, north-west Tunisia

Exhibition: Paris 1995, p. 193

Bibliography: Bénabou, 1976, pp. 187–330; Fentress, 1978; Horn and Rüger, 1979, pl. 24; Fantar, 1986, p. 137, no. II.123

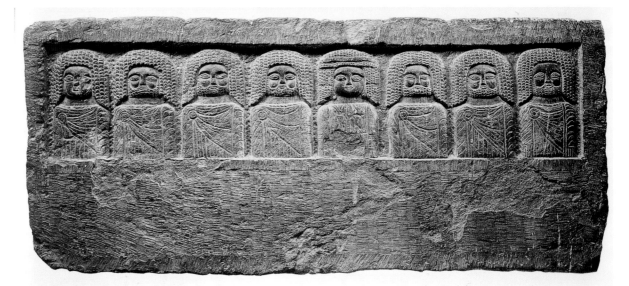

7.18

Gravestone

Kairouan, Tunisia
AD 1052 (444 AH)
marble
h. 114 cm
Musée des Arts d'Afrique et d'Océanie,
Paris, A.94.3.2

Although the Quran specifies that the dead should be buried immediately after death in the desert under an unmarked stone, funeral art developed in Tunisia as it did throughout Islam. This gravestone comes from the cemetery of Ganah al Ahdar, Suqran, Kairouan. It is a monolithic column surmounted by a turban, phallic in shape and reminiscent of a number of gravestones to be found in sub-Saharan Africa, for instance in Tandidarou. In later centuries, funeral stones were purely geometric in shape.

The epitaph is beautifully written in a flowery Kufic script; it consists of twelve lines sculpted in relief in a multi-lobed niche. Two scutcheons decorated with foliage adorn the upper part of the niche and a three-petalled flower the lower.

The inscription begins with the *bismillah*, 'In the name of Allah the Merciful', and the *tasliya*, 'that the Blessing of Allah fall on Mohammed and his kin'; it continues with verse 182 from the Sourate III, verse 182: 'Every soul must taste death. A man only gains the Day of Judgement through his deeds...he who is shifted from below the underworld and who enters Paradise may reckon that he has gained Life and the whole world...life is but a...'. The inscription ends with the name of the deceased: 'this tomb belongs to Abu Baker Ali al-Lawati-al-Kusa'i, may the Blessing of Allah be upon him...he died on Friday 11 Rajab 444 (6 November 1052)'. *MFV*

Provenance: Private Collection, Paris

7.19

Gravestone (*mashhada*) of the Marinid sultan Abu Ya{c}qub Yusuf

Chellah, near Rabat
Morocco
1307
marble
81 x 51 x 14 cm
Musée Archéologique, Rabat, 89.5.2.4

This gravestone was discovered at Chellah, the necropolis of the Marinid dynasty of Morocco, outside Rabat, in 1881. It reuses a Roman stela with a dedication in Latin to a governor of Betica (southern Spain) of the 3rd or 4th century. The Arabic inscription identifies it as the gravestone of the Marinid sultan Abu Ya{c}qub Yusuf (r. 1286–1307); the cursive inscription of the main panel refers to him as the just ruler, the warrior for religion, the martyr, the prince of believers and the defender of the faith. A quotation from the Quran, in angular Kufic script, runs around the frame.

This is one of the finest artefacts preserved from late medieval north Africa. Its composition, with a blind cusped arch on columns, and a delicate arabesque scroll and shells in the spandrels, is typical of a gravestone (*mashhada*) current in north Africa and Spain by the 11th century. These stelae were intended to stand upright at the head and foot of a grave, or were embedded in walls, and were often used in conjunction with a long prismatic gravestone that covered the actual tomb (*mqabriyya*). Several other tombstones of both types have been preserved that were made for other members of the Marinid court at Fez. The quality of the marble and of the carving of this royal tombstone can also be matched in the gravestones of the Nasrid dynasty of Granada, today in the Museo Nacional de Arte Hispanomusulmán in the Alhambra. *NE*

Provenance: 1881, discovered at the necropolis of Chellah, near Rabat
Bibliography: Paris 1990, p. 20

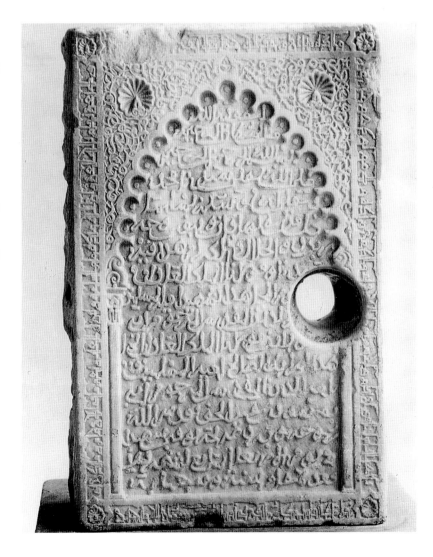

7.20

Mosaic panel (*zallij*)

Fez
Morocco
glazed earthenware
h. 150 cm
Musée Dar al-Batha, Fez

Glazed ceramic tiles as well as glazed
vessels were introduced into north
Africa with the Islamisation of this
area; the earliest known tiles date to
the 9th century. The technique of
cutting monochrome tiles into smaller
pieces and producing mosaic panels of
different colours seems to date from
the 12th century, when it appeared
in north Africa and Islamic Spain,
probably developed as an alternative
to expensive glass and stone mosaic
(cf. cat. 7.63). It also provided an
alternative to polychrome tiles, whose
lead glaze had a tendency to run, and
did not allow several colours on one
tile, a technique perfected in the
Islamic east. Cut-tile mosaic is known
in Morocco as *zallij*, meaning glazed
or vitrified, and this Arabic word is
probably the source of the Spanish
azulejo, meaning tile. Fez was inter-
mittently the capital of Morocco from
the 8th century to the 20th, and few
other towns in north Africa have such
a continuous tradition of medieval
urban culture and crafts. The indus-
tries of architectural decoration are
synonymous with this sophisticated
urban life, and were essential for the
mosques and luxurious houses of Fez,
some of which survive from the 14th
century. Many of the *zallij* panels in
the Musée Dar al-Batha come from
medieval houses since demolished;
other panels can be enjoyed *in situ* as
pavements and dadoes of the build-
ings of Fez and other towns. The most
famous panels are perhaps those of
the Alhambra palace in Granada.
The complex geometry attained in
medieval *zallij* panels was usually
based on stellar designs, with the
numbers of the points of the stars
based on multiples of eight, and
necessitated an virtuosity of tile-
cutting and laying. This restrained
example uses only square pieces to
make a chequerboard design. *NE*

Bibliography: Marçais, 1954; Paccard,
1980, i, pp. 349–493; Damluji, 1992

During the Abbasid, Timurid and Safavid periods (13th–16th centuries), numerous artistic centres flourished from Merat to Tabriz, producing collections of poetry and chronicles.

This copy of the *Dala'il al-Khairat* is dedicated to Abu Abdallah Muhammad Ben Rahmuni, the Husayni Sharif, and to those chosen by God afterwards. In this town of Algiers, Allah's Protectorate, in the year 1066. This collection of prayers is written in north African cursive script, *maghribi*

These two pages are illuminated on both sides. The recto bears a picture of the Mosque at Mecca, with the Kaaba at the centre (towards which the prayers of the whole of the Muslim world are directed), a stylised version of the *minbar* (pulpit) and the Zamzam well. The verso bears a text about the first mosque in Medina.

On the recto of the second page are drawings of the tombs of the Prophet and his two companions, Umar and Abu Bakr. The dimensions of the chamber are given, as well as the place where the Angel Gabriel appeared. On the verso is a labyrinth with a genealogy of the Prophet descending from Adam and Eve. In the centre a multi-lobed arch surmounts the golden lamp flanked by two rose windows. Below this are written the names of Adam and Eve.

Maghribi script developed in Andalusia but found its true flowering in north Africa from the 12th century onwards. It became the official script of north Africa. *MFV*

Provenance: 1946, given to the museum by Mme Denan
Exhibition: Venissieux 1982
Bibliography: Berque, 1959

7.21

Two folios from a Quran manuscript

Tunisia
late 10th century
parchment, inks, gold leaf
13.5 x 20 cm
The al-Sabah Collection, Dar al-Athar al-Islamiyyah, Kuwait, LNS 65 MS (a, g)

These parchment folios belong to a fragmentary Quran codex with 93 leaves, each with seven lines to a page. Representative of the Quran manuscripts produced in Kairouan, the text is written in broken cursive or curvilinear Kufic with red and green diacritics. The verse stops are indicated by gold rosettes, and the mark for the fifth verse is the Arabic letter for 'h'.

The folio illustrated above contains verses from the Quran (VI: 1-2), with the chapter title written in gold. A gold palmette with touches of white, blue and green extends from the title into the margin. The folio illustrated below is the left half of either a double frontispiece or finis-

piece and was conceived as an oblong with a palmette extension. The geometric design in the rectangle consists of interlacing circles and squares painted in gold and accentuated by green, blue, brown and black. The floral elements in the border link the geometric composition and marginal extension.

Bibliography: New York et al. 1995

7.22

Illuminated pages from the 'Dala'il al-Khairat' ('*Guide to Blessings*')

(one illustrated)
Algiers
AD 1655 (1066 AH)
paper, gilding, inks, watercolour
17 x 12 cm each
Musée National des Arts d'Afrique et d'Océanie, Paris, M.1962.1488.1/2

7.23

Four segments of a necklace

(*qannuta*) (two illustrated)

Moknine
Tunisia
17th century (?)
gold, filigree and *cloisonné* enamel
4 x 2 cm each
Musée National des Arts d'Afrique et
d'Océanie, Paris, MNAM 1968.5.27.1/4

Tunisian jewellers were working
with precious metals well before the
Christian era. The quality of their
techniques (filigree, chasing, *cloisonné*,
engraving, etching, *repoussé*) was
famous all over the Mediterranean.
The arrival of Jews and Muslims
expelled from Andalusia between the
14th and 17th centuries meant that
the art of the court of Granada
(especially jewellery) survive.

These bobbin-like elements,
resembling small tubular containers,
are intended to hold the scrolls of the
Torah; this would have given them a
religious significance, in fact would
have made them into little talismans.
They are reminiscent of 14th- and
15th-century jewellery from Granada,
particularly the elements found in
necklaces of the Nasrid dynasty,
which were also called *qannuta*. Some
scholars think that these are derived
from ancient forms – Greek, Roman
or Byzantine – handed down from
generation to generation from the
Caliphate of Cordoba to the Maghrib.
MFV

Provenance: ex collection Paul Eudel,
Paris

Exhibitions: Lons-le Saunier 1970; Paris
1971; Paris 1977; Paris 1995

Bibliography: Sugier, 1968, p. 151;
Gargouri-Sethom, 1983; González,
1994, p. 189

7.24

Lady's belt (*hzam*)

Fez
Morocco
19th century
silk lampas
323 x 41 cm
Musée National des Arts d'Afrique et
d'Océanie, Paris, M.70.4.14

The art of silk weaving has existed
in Morocco at least since the 14th
century. Ibn Khaldun mentions it in
his *Muqaddimah*. Garments and belts
of woven silk and gold were made in
Fez according to a traditional method
that came from Spain but originated
in Byzantium, and was adopted in
Baghdad before spreading through
the western provinces of the medieval
Muslim world. The craftsmen of Fez
used traditional 'drawlooms', from
which modern looms are directly
descended. One of the most remark-
able workshops of Fez belonged to the
Ben Sherif family, active since the
second half of the 19th century. These
silk belts, ornamented with gold, were
worn by women on special occasions,
over a matching kaftan; they would
be folded in two except by women
belonging to families descended from
the Prophet, who wore them full-
width. They were also used as gifts
among the aristocracy, following the

form and style of the ancient *tiraz*
(see cat. 7.51).

The oldest type of belt (16th and
17th century) is straight, relatively
short and very soft; from the 18th
century on, however, and particularly
in the 19th century, belts were broader
and longer, and were coated with a
kind of size that made them very
stiff. Their decoration was extremely
varied, combining Byzantine, Hispano-
Moresque and Ottoman elements with
paisley patterns or with 19th-century
European motifs as used in the silk
mills of Lyons or the velvet workshops
of Genoa. Prophylactic designs – the
hand, Solomon's seal or the *mihrab* –
are also common, epigraphic designs
less so. These designs have been
compared to the heraldic devices of
Granada. Floral patterns came into
their own in the 19th century.

These showy belts were fashionable
at court until the end of the 19th
century. *MFV*

Provenance: ex collection Colonel and
Mme Bernard, Paris; 1970, given to the
museum by Mme Bernard

Exhibition: Paris 1977

Bibliography: Vogel, 1920; Golvin, 1950;
Ricard, 1950, pp. 41–8; Bernès, 1974

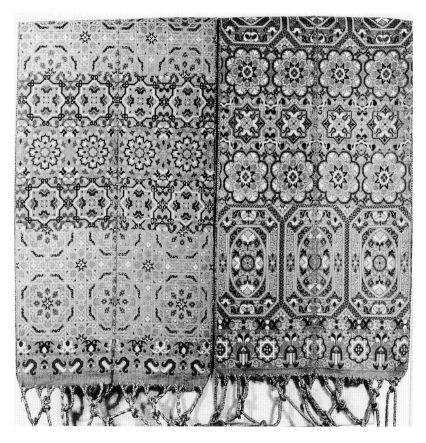

7.25a

Blue and white dish

probably Fez
Morocco
19th or early 20th century
glazed earthenware
diam. 46 cm
The Brooklyn Museum, 74.2
Anonymous gift in honour of
Charles K. Wilkinson

7.25b

Green and white bowl

Tamgrout
Southern Morocco
early 20th century
glazed earthenware
diam. 30 cm
Musée Majorelle d'Art Islamique,
Marrakesh

Glazed ceramic vessels and tiles have been a feature of north African town life since the early Islamic period. Moroccan examples took on a particular character in the 17th and 18th centuries, owing in part to the political and cultural isolation of the Saadian and 'Alawi dynasties that ruled in this period. Techniques, decoration and shape easily distinguish Moroccan from the contemporary ceramics of the rest of the Islamic world, in particular from those of the rest of north Africa (Algeria and Tunisia), under Ottoman Turkish domination at this time. Moroccan

vessels such as these dishes were kitchen wares, for eating from or storing food, as well as being enjoyed for their ornamental value. Glazed ceramic dishes in this tradition are still produced and commonly used in Moroccan cuisine today, for cooking as well as presenting food. The potting of the earthenware body is often heavy, with the decoration applied freehand, since these Moroccan dishes were produced rapidly and in large numbers.

The glazed ceramic industry was in the main limited to the towns of Fez, Meknes and Tetouan, and later in the 19th and early 20th centuries to Safi and Rabat as well as the small centres of Tamgrout and Ouarzazate in the south of Morocco. In the rural areas, on the other hand, only unglazed ceramics were produced. The common glazed ceramic vessels fall into four groups: blue and white; polychrome (blue, green, black, purple, yellow and white); monochrome (usually green-glazed); and bichrome (green and white or green and yellow).

Although the use of the interlace of blue band inset with panels of fine floral decoration is well known, the

blue and white dish (cat. 7.25a) has an unusually dynamic composition. It forms a part of a group of Moroccan ceramics decorated with the paisley motif, taken (as the name implies) from imported textiles.

The green and white bowl (cat. 7.25b) is also unusual with its exceptionally daring and simple composition — half of the vessel merely dipped into the green glaze. This design is identified with the relatively recent production at Tamgrout, a small oasis town in southern Morocco, with an important *zawiya* or religious fraternity and library. *NE*

Bibliography: Sijelmassi, 1986, pp. 96–8, 206, 218–19; Vossen and Ebert, 1986, p. 494; Hakenjos, 1988, figs 92, 96–8, 141

7.26

Coffer (*sanduq*)

Morocco, probably Fez
14th–16th century
wood with iron fixtures, traces of red and yellow paint
87 x 45.5 x 61 cm
Musée National des Arts d'Afrique et d'Océanie, Paris, m. 87.8.1

This wooden coffer is luxuriously carved with Arabic inscriptions and architectural motifs in a style that is otherwise known only from wooden architectural elements in Fez. It is difficult to date otherwise than to the 14th–16th century. The square ends and tendrils of the Kufic inscriptions on the box appear to be benedictory and do not assist in the identification of the piece. The shape of the pyramidal cover resembles those of the ivory caskets of medieval Islamic Spain and Sicily. The large size of this wooden chest suggests, however, a different use from that of the ivory caskets, perhaps to store books or documents in a mosque or clothes and furnishings in a house.

Bibliography: Cambazard-Amahan, 1989; Paris 1990, n. 418

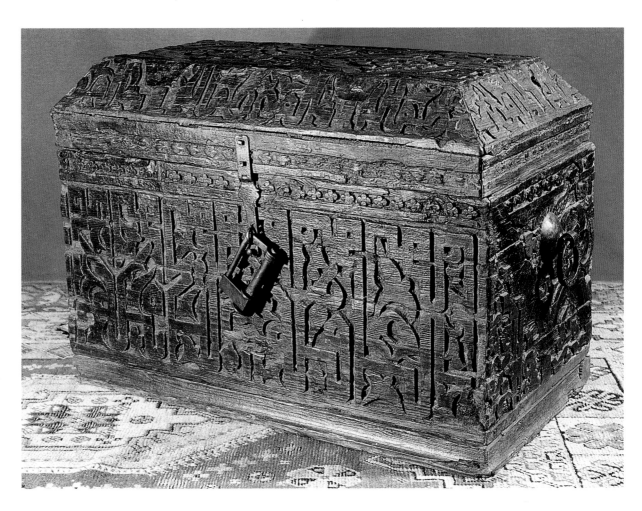

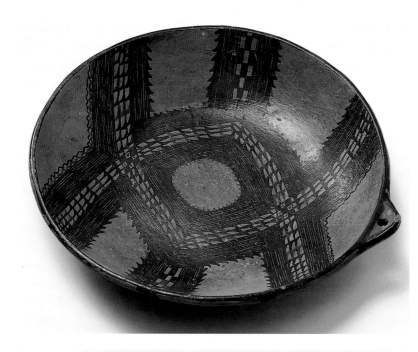

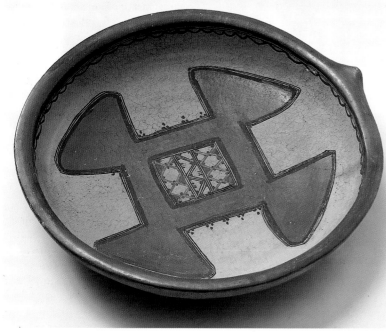

7.27a

Couscous dish

Ait Smail, Halouane or Ijebbaren village
Grande Kabylie, Algeria
early 20th century
terracotta, paint
diam. 39 cm
Musée National des Arts d'Afrique et
d'Océanie, Paris, M.1972.3.2

7.27b

Couscous dish

Maatka (?)
Grande Kabylie, Algeria
early 20th century
terracotta, paint
diam. 44 cm
Musée National des Arts d'Afrique et
d'Océanie, Paris, M.1972.3.3

Rural pottery is made throughout the Maghrib, and has developed very little since prehistoric times. This pottery is related to the antique pottery found in the burial grounds of Sicily and Greece; stylistic influences brought to this part of the world by the Phoenicians can be found in fragments unearthed in Gouraya, Tiddis, Rokina or Bou-Nora. Although the forms have undergone a gradual process of refinement and the decoration has become increasingly rich, the techniques used by women modelling clay today in Kabylie or Aurès have scarcely altered since Neolithic times.

Apart from some isolated centres in the Sahara, Algerian pottery is made in places along the country's west–east axis, following the mountain ranges.

The most interesting moulded pots, with the shapeliest curves, the purest lines, the most harmonious and original forms (multiple jugs, oil lamps), come from Kabylie. The village women who made them adopted simple, functional and beautiful forms. They took their decorative motifs from the world around them – symbols and magic signs to protect them from misfortune.

Making pots has always been the work of women: they make them annually, selling any items that are surplus to requirements in the local market to augment the family income. Each stage of manufacture has its own ritual, from the choice of a propitious day for each operation (choosing, soaking and kneading the clay, then modelling, drying, polishing and painting) until the final firing. The decoration, usually carried out after firing, is done with a rudimentary brush and natural pigments: kaolin, iron oxides, decoctions of *lentiscus*, century plant and juniper. In certain villages the pottery is painted with a resinous varnish immediately after firing; this gives a yellow colour and ensures that the pot is watertight. A piece of leather is used to burnish the varnished surface. Firing takes place over an open fire of fig branches and cow dung mixed with straw, formed into cakes and dried in the sun. These cakes (*tichichines*) burn slowly, producing excellent embers. *MFV*

Provenance: ex collection Sorensen, Algiers, and collection Olagnier-Riottot, Paris; given to the museum by Mme Olagnier-Riottot

Exhibitions: cat. 7.27a: Bourges 1977; Venissieux 1982; cat. 7.27b: Evreux 1974

Bibliography: Van Gennep, 1911; Bel, 1939; Camps, in Lybica, 1955; Balfet, 1956; Moreau, 1976; Sned, 1982

7.28

Ceramic 'milk jug'

Bani Ouarain tribe, Rif Mountains
North-eastern Morocco
20th century
terracotta, paint
52 x 50 x 32 cm
Yvette Wiener

The Berber regions of Morocco fall
into three large cultural and linguistic
groups: the Rif Mountains in the
north; the Middle and High Atlas
Mountains; and the Anti Atlas Moun-
tains and the Sus Valley in the far
south. Many of the tribal languages
or dialects are mutually incompre-
hensible, and the tribes are further
distinguished by their dress, jewellery
and other artefacts.

Although glazed and unglazed
ceramic vessels were produced in
towns all over Morocco, only unglazed
ceramics were produced in the rural
Berber-speaking areas. To this day,
only women manufacture pottery
in the Rif, while men dominate the
urban industries of Fez, Asfi etc.
Historically, the only rural pottery
produced came from northern
Morocco. Moroccan Berber pottery
is sometimes painted with simple
rectilinear designs, but its main
aesthetic interest lies in its sculptural
forms. Some of the forms, such as the
two-handled amphora with a pointed
base, appear to have a Classical
precedent, as does some of the painted
and burnished decoration (cat. 7.27),
and indeed the extent of Berber
ceramic production roughly coincides
with the area of Phoenician, Greek
and Roman influence in north Africa.

This vessel has a bulbous ovoid
body with a tall tapering neck and two
handles. Its decoration is painted in
brown or manganese between the first
and second firing. The simple linear
painted design is closely related to
tattoos given to women in Rif and
other Berber areas, often on the chin,
forehead, hands and feet, as well as to
the linear decoration found on some
Berber carpets.

Some of the Rif Berbers are sub-
sistence farmers, and others semi-
nomadic pastoralists, herding sheep
and goats. If indeed this vessel served
as a milk jug or butter jar, presumably
its distinctive shape would have been
useful for transportation by donkey.
Equally the handles and horizontal
body would have permitted the vessel
to be hung and shaken back and forth

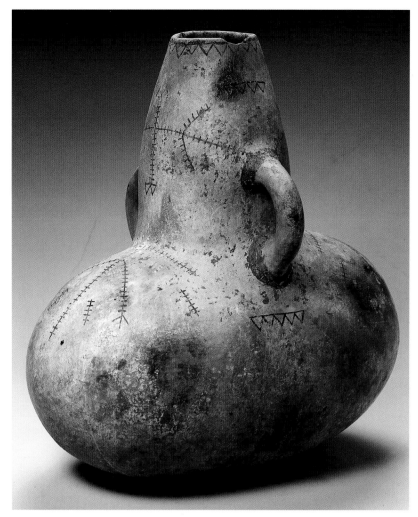

for making butter. This shape is one of
the most characteristic of the artefacts
of the Bani Quarain tribe, Taounate
province, in the region of Taza. *NE*

Bibliography: Hakenjos, 1988, fig. 234

7.29

Couscous bowl

southern Morocco
early 20th century
wood, earthenware
25 x 65 cm
Linden-Museum, Stuttgart, A36337

Dishes used for the day-to-day pre-
paration and serving of food in north-
west Africa are generally made of a
robust ceramic, frequently glazed in
red and brown. This wooden vessel is
a good example of such a common
eating dish, which, though dating
from the earlier part of this century,
is equally representative of tradi-
tional wood and ceramic types today.
The bowl shown is intended for the
serving of couscous, the national dish
of Morocco, its simple design and
plain colours contrasting with the
exotic nature of many couscous dishes.
Couscous, which is made from granu-
lated wheat, can be coloured bright
yellow with turmeric or saffron, and
is served piled high with colourful
steamed vegetables and spiced meats.
Eating is an important communal
experience throughout Africa, and
the large size of this dish reflects
this common cultural attitude to the
sharing of food. Indeed, the serving
of couscous at the end of a meal
symbolises the total satisfaction of
the guest through the generosity of
the host. Culinary influences, and
hence influences on food vessel types,
have passed in both directions, south
from the Maghrib and north across
the Sahara, and have contributed to
the richness of the cuisine throughout
these regions. *TAI, MRM*

Bibliography: Ministère de l'Economie
Nationale, 1958; Carrier, 1987; Wolfert,
1989, p. 107

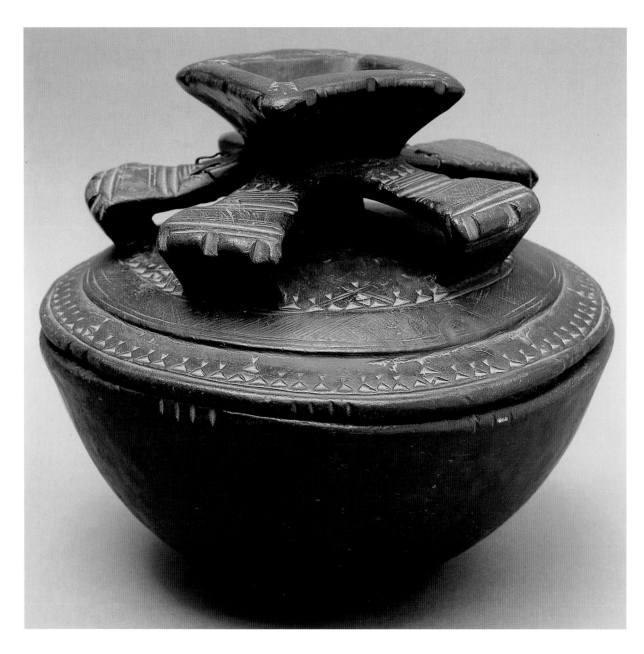

7.30

Dish with lid

Algeria
early 20th century
wood
25 x 29 cm
Bert Flint

Clear parallels for this wooden bowl have been difficult to find, and, while certain elements in its design appear to be typically Moroccan, it could also be thought to have affinities with the material culture of nomadic groups, such as the Tuareg, who inhabit areas further to the south, and more distantly, with that of sub-Saharan sedentary groups. Wooden containers, along with leather-work, basketry and metal, are preferred by those whose transhumant lifestyle precludes the use of less durable materials, such as ceramics. The low relief carving which has been used to decorate the surface of this vessel is, however, a recurrent theme in the Islamic world, where an intermittent antipathy to representational art-forms has led to a development of often complex geometric patterns. The intricate

carving of the raised handle indicates that this vessel was the work of an accomplished craftsman, able to conceive and execute a three-dimensional design which incorporates both simple surface patterns and more complex structural elements. Interestingly, similar structural elements can be seen in wooden vessels used by the Tuareg which exhibit influences from the sedentary sub-Saharan groups, those termed '*de style nègre*'. The combination of elements from these three distinct areas and cultures in this one vessel is of particular interest.
TAI, MRM

Bibliography: Gabus, 1958, p. 152; Ettinghausen, 1976, pp. 62–3; Cribb, 1991

7.31

Bowl for dried fruit

Tamgrout
Morocco
early 20th century
glazed earthenware
diam. 50 cm
Musée Majorelle d'Art Islamique,
Marrakesh

This fruit platter is made of a robust ceramic and is glazed in an olive green. Very similar green glazes were being used throughout the Occidental Muslim world as early as the medieval period, and the use of greens and browns in ceramic decoration, to the exclusion of other colours, is characteristic of the work of these Islamic craftsmen. The distinctive olive-green glaze is created by mixing varying amounts of ferric oxide with copper, usually with a lead glaze, which permits a much greater range of colours to be used than alkaline glazes, the other basic glaze type. The pedestal and rim of the dish shown are decorated with simple horizontal channelling. As with couscous dishes (cf. cat. 7.29), the basic simplicity of the design and decoration of this dish contrasts with the variety of colours and shapes of the fruit it is used to display, and the large size of the vessel indicates its communal function. Traditionally Moroccan meals are finished with the presentation of a large platter piled high with carefully arranged fruits, fresh in summer and dried in winter. The pedestal dish used for the presentation of items such as fresh fruit is a common vessel type found throughout the modern Islamic world.
TAI, MRM

Bibliography: Robert-Chaleix, 1983, p.280; Wolfert, 1989, p. 236; al-Hassan and Hill, 1992, pp. 166–8

7.32

Stool

Morocco
wood
h. 26 cm
Museum für Völkerkunde, Leipzig

Carved from a single piece of wood, this stool reflects in its design the shape of the tree trunk from which it has been manufactured. Gently waisted, the central decorative bosses are restricted by the maximum diameter of the trunk and hence echo the top and base to create a balanced design. The production of this item in a Moroccan context is particularly interesting, as the use of stools in this area is not common, seating traditionally being upon mats and cushions or low divans. The use of wooden stools is, however, extremely common in sub-Saharan Africa and is seen throughout the continent, where any man of status will have his own wooden stool, either inherited from his ancestors or acquired personally. The tradition of carving in the round could also be said to be more typical of sub-Saharan Africa; though the technique is used in Morocco, the employment of low relief carving, often embellished with inlays of various materials (e.g. bone or ivory), is more common. The shape of the stool is highly reminiscent of the hollow tree-trunk drums which are made throughout the continent, the central bosses resembling the wooden pegs to which the drum skin, stretched tight across the upper opening, is attached, possibly reflecting a distant relationship.
TAI, MRM

Bibliography: Ministère de l'Economie Nationale, 1958; Willett, 1971

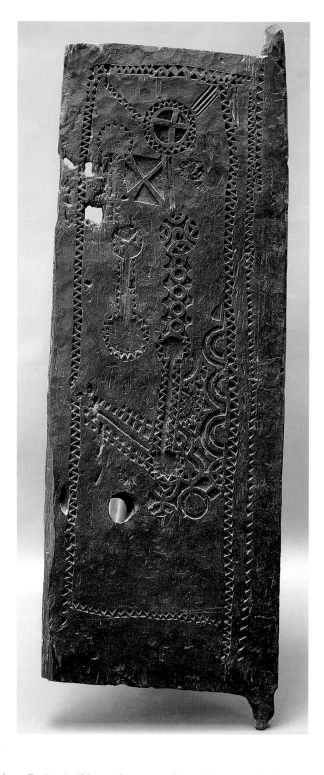

7.33a

Granary door

Berber
High Atlas, Morocco
early 20th century
wood
160 x 58 x 9 cm
Bert Flint

7.33b

Door

Berber
Middle Atlas, Morocco
late 19th century
wood
187 x 66 x 4 cm
Bert Flint

These doors come from Berber buildings in southern Morocco, an area with a remarkable architectural tradition, particularly to be seen in the *qasbas* or forts of the Anti-Atlas and Saharan oases. These buildings are constructed of mudbrick and *pisé* or adobe, and despite the technical handicaps of this material, reach impressive size and height. Additional visual impact is given by the tall corner towers with crenellations and other simple decoration in brick. The immediate visual similarity with

the vernacular architecture of the Yemen and Afghanistan has been remarked, but there is no evidence for any other than a local source for this tradition, whose architectural influence can be felt in the monumental *pisé* mosques of Mali. The ephemeral nature of mudbrick ensures that none of the existing structures can be dated to earlier than the 19th century, although this tradition is much older. The military exteriors of a variety of buildings – not only forts, but whole fortified villages, fortified granaries,

single houses or castles – reflect a time when central government had little control in these areas and raiding and banditry between tribes was common. These constructions vary enormously in size; some have a square outline and an orthogonal plan, while others appear to have grown organically. There is little decoration except on the entrances and doors. Urban influence from nearby Marrakesh can be seen in the use of pointed horseshoe arches with surrounding moulding frames and friezes of brick decoration on the main entrances of the *qasbas*.

These two doors are from a granary (cat. 7.33a) and the interior of a house (cat. 7.33b is a leaf from a double door). They turn on wooden pegs set in stone and metal gudgeons, but their latches and locks are of wood, and their construction and decoration are comparatively simple. Superficially, they resemble other Berber wooden artefacts, such as the famous Kabylie chests of Algeria. However, a single homogeneous culture cannot be suggested, as the only similarity between the different Berber areas lies in the simplicity of the geometric designs used.

The granary door, with its representation of a frog and a snake, serves to protect the harvest from both natural and supernatural enemies. The frog is traditionally believed to embody a *jinn*, or otherworldly spirit, and should be avoided or appeased. The snake has an ancient history as the protector of homes, and as such is often left offerings of food and encouraged to stay in the foundations of a house. Apotropaic animals such as snakes, lizards, centipedes and scorpions are also to be found on Berber silver jewellery of southern Morocco. The representation of animals (indeed of any living thing) is very rare in north African art, as it is not permitted according to the strict interpretation of Islamic law, but here the animal representation reflects the pre-Islamic practices that survive among the Muslim Berbers. *NE*

Bibliography: Paris 1925, pp. 27–30, nos 33–51; Meunié, 1962, pl. 11; Paccard, 1980, i, pp. 28–39; Curtis, 1983; Sijelmassi, 1986, p. 253

7.34
Interior door
Fez (?)
18th or 19th century
carved and painted wood with iron fixtures
239 x 130 x 7 cm
Egee Art, London

The architectural traditions of medieval Islamic Spain and north Africa were preserved with extraordinary faithfulness in Moroccan cities such as Fez, Meknes, Marrakesh, Rabat-Salé and Tetuan. Of the three decorative industries of tilework, wood and stucco, woodwork is perhaps the most conservative and most difficult to date. Thus this door could have been made any time in recent centuries. The form and decoration have changed little since the medieval period; there are two main door leaves and two smaller wicket gates cut out of the main leaves, the latter lacking in this example. The main doors turn on wooden pegs set in stone and metal gudgeons. The doors can be closed from the interior and exterior of the rooms with an iron bolt, missing in this example. Both sides are usually decorated, and in this case the 16-pointed star predominates. The floral motif on the outer borders confirms the post-medieval, 18th- or 19th-century date.

This is a door to a room of an important house, said to be from Fez, but which could equally well be from any other town. The type of door is inextricably linked with the plan and elevation of these urban houses: rooms were grouped around a courtyard and often the only source of light and ventilation for the rooms was through the tall doors. The extreme height of the doors corresponds to the height of the rooms. At different seasons and times of day, either the main doors or the wicket gates could be opened. As elsewhere in Islamic society, women in Morocco were segregated from men who did not belong to their immediate family. However, as Moroccan houses were not equipped with harems or different areas for men and women, so these doors also served to screen women from view when male visitors were present.

Bibliography: Barrucand, 1978; Paccard, 1980, i, p. 231, ii, pp. 224, 274, 280–1, 426–51; Revault et al., 1985, 1989, 1992

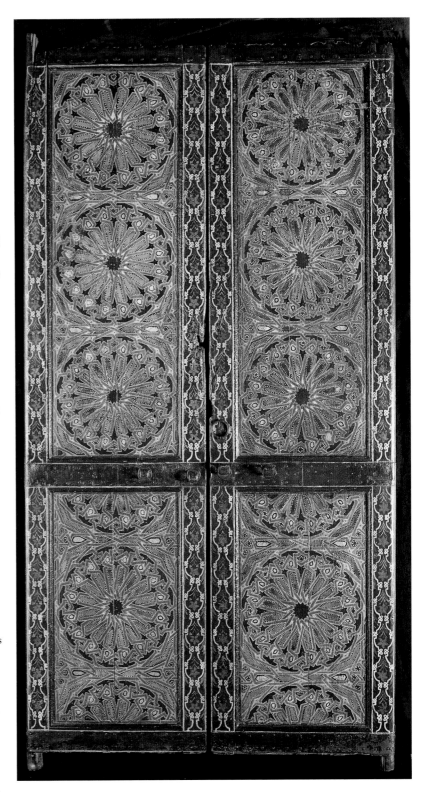

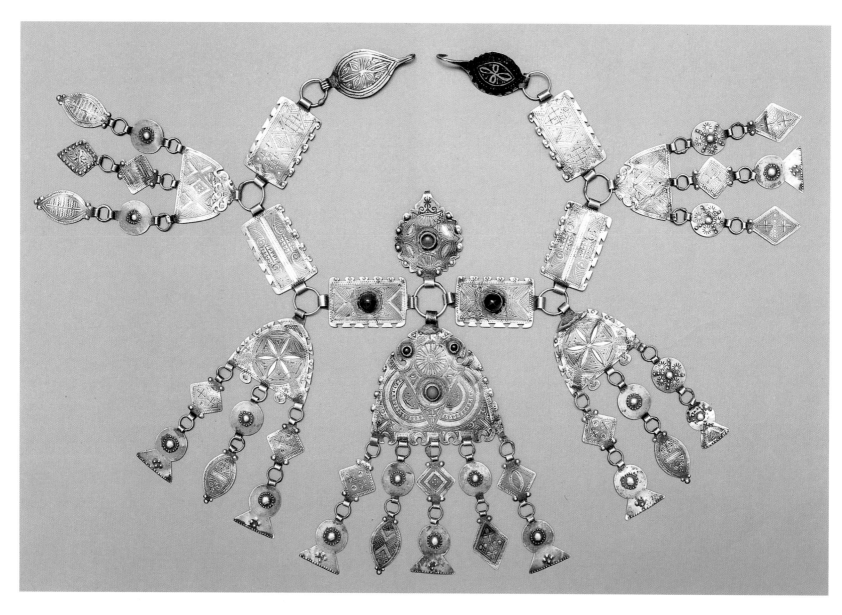

7.35a

Pectoral or head ornament

Berber groups of Anti-Atlas Mountains
Tarudant region, southern Morocco
20th century
silver, niello, glass
19 x 45 cm
Bert Flint

7.35b

**Fibulae (*bzayim*) with connecting
chain and central ovoid bead**
(*taghmut*)

Berber groups of Anti-Atlas Mountains,
Ait Ouaouzguite
20th century
silver, *cloisonné* enamel, glass
h. 147 cm
Musée Barbier-Mueller, Geneva, 1000-35

'Berber' is the general name given
to the indigenous peoples of north
Africa, whose cultures have survived
in remote mountain and desert
regions, despite the Arabisation of the
plains following the Islamic conquest.
The Berber languages are completely
different from those of the Semitic
family, although many Berbers today
speak both Berber and Arabic. Most
Berbers are Muslims, but there is a
small Jewish minority. Their tradi-
tional material culture is easily
distinguished from the Arab and
Andalusian culture of the towns.
In Morocco this Berber culture is
particularly rich and varied, and the
inability of the central government
based in Fez, Meknes, Marrakesh or
Rabat to control the mountain peoples
ensured that it flourished in relative
isolation until the French and Spanish
colonial domination of the 20th
century.

While jewellery in the cities was
often made of gold inset with precious
stones, Berber jewellery is character-
istically made of silver decorated with
niello and *cloisonné* enamel, and set
with glass or semi-precious stones.
Both in cities and in Berber regions,
the jewellers were often Jews. The
jewellery was worn exclusively by
women (Islamic strictures about the
wearing of precious metals seem not
to have curtailed its use), usually
given as part of their bride-price.

The pectoral or head ornament
(cat. 7.35a) probably comes from the
Ida or Ndif people near Taroudant
in southern Morocco. It consists of
various plaques of thin sheet silver,
inlaid with niello, decorated with
granulation and inset with red glass
cabochons.

The two fibulae with a connect-
ing chain and a central ovoid bead
(cat. 7.35b) are used by Berber women

to hold a cloak or loose garment at the
shoulder. These fibulae have ancient
Classical and early medieval proto-
types, but their striking triangular
shape is characteristic of Berber
jewellery of the Anti-Atlas Mountains.
Both the triangular form and the
ovoid shape of the bead are under-
stood as symbols of female fertility.
The elaboration of the silver engrav-
ing and the enamel make this a
particularly fine example. *NE*

Exhibition: Paris 1977, no. 559

Bibliography: Besancenot, 1953,
nos 124–8, 135 ; Jacques-Meunié, 1960–1;
Sijelmassi, 1986, pp. 151, 153, 158–9, 166;
Rouach, 1989, p. 174, fig. 290

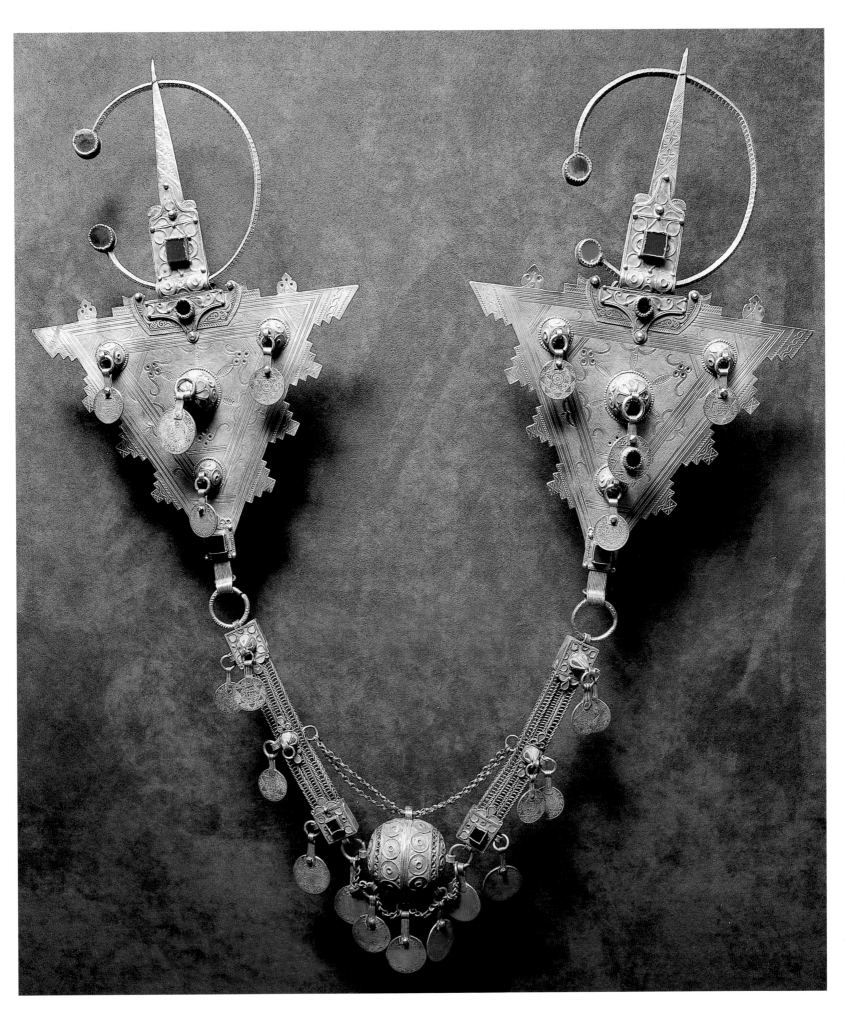

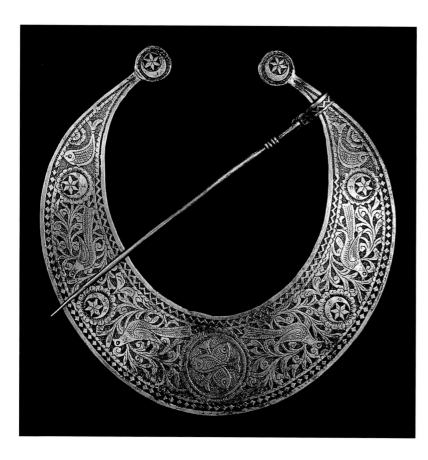

7.36

Fibula (*hlal*)
Medenine, Tataounine
Tunisia
late 19th century
silver
diam. 17.4 cm; w. 4.4 cm
Musée National des Arts d'Afrique et
d'Océanie, Paris, MNAM 66.7.13

Rural jewellery, often in solid silver, chased, moulded or engraved, and decorated with cornelians, coral, lapis lazuli or glass, is striking for its unusual curved forms, the rhythm of its concentric geometrical designs and the diversity of its decorative themes. In southern Tunisia the jewellery is often impressively large and heavy, reminiscent of that from Libya.

This fibula is designed to fasten a draped garment; it is crescent-shaped, with a silver ball fashioned from a cube with cut corners at either end. The design, chased on a matt background, consists of foliage with lively birds on either side of a flower formed from a crescent and a star. At the centre of the fibula there are three intertwined fish, carved in a circle with great freshness. The same motif can be found on wooden marriage chests painted in the 18th century and, in slightly different

form, on an Egyptian cup of the 18th Dynasty.

The crescent motif comes from ancient oriental astronomical designs used in Carthage in Punic times, either separately or in association with the star. Islam has kept both motifs, both for their design qualities and because they were associated with beneficent popular beliefs. The Ottomans took the crescent and star as their emblem and Husayn Bey, Bey of Tunis in 1824, adopted it as the emblem of Islam itself. The fish motif is very popular in this land of sailors; it is associated with the idea of fertility and with protection against the evil eye, hence its appearance on all wedding garments. The bird appears in innumerable stories and embodies the notion of rebirth. *MFV*

Provenance: ex collection Renié, Paris

Exhibitions: Lons-le-Saunier 1970; Paris 1977; Paris 1995

Bibliography: Eudel, 1906, p. 181; Sugier, 1967; Gargouri-Sethom, 1983

The Berber carpets made in the plains and mountain areas of north Africa constitute a rich and varied group of pile and flat-woven textiles. Each Berber group has distinctive compositions, motifs, techniques and colours on its carpets. Berber rugs are woven by women on vertical heddle looms. The rugs form part of the traditional furnishings of the house or tent, where they cover a damp floor or are used as mattresses or blankets, wall-hangings or prayer rugs. The raw material is usually black or white sheepswool; sometimes goat hair is used. The wool may be left its natural colour or dyed with plants or minerals. In the Atlas Mountains ochres made from metallic oxide are quite common; in the plains of Marrakesh the madder that grows along the banks of the River Tensift produces some astonishing reds. The wool is washed, sorted, combed, carded and dyed before being woven. The setting up of the warp on the loom is a complicated procedure that needs the skill of an older woman, but younger women are not allowed to escape this chore.

The most interesting Moroccan carpets are produced in three areas: by Berber transhumants of the Middle Atlas Mountains; by the Berber farmers of the High Atlas Mountains to the south; and by the Arabic-speaking farmers of the plains around Marrakesh and the central Atlantic plains. The carpets of the Middle Atlas are represented by examples from two tribes: the Zemmour and the Bani M'Guild.

The Zemmour are nomads on the plateaux that lie to the north and west of the Middle Atlas; the land is favourable to crop-growing and grazing. The Zemmour weave rugs whose smooth, velvety surface owes much to the even regularity of the knotting; their pile is shorter than that of the rugs woven by the groups living in the higher regions.

The Zemmour carpet (cat. 7.37a) has a red background and features two kinds of knot: the Ghiordes knot over three threads, and the Berber knot over four threads. The design of diamonds, triangles, chevrons and checks, in yellow, pale green and blue, is organised on vertical lines. The 'x' motif, used by the Berber tribes to identify their possessions, is used extensively, in highly elaborate forms. The patterned area of the carpet has

no border, which helps give the impression of a limitless design.

Another carpet from the Middle Atlas Mountains (cat. 7.37b) is Bani M'Guild in origin, from the area to the south of Meknes. The carpet is flat-woven, and the colours are predominantly dark red with white, orange, yellow and pink motifs. The composition creates an interesting juxtaposition of horizontal and vertical panels, inset with panels of lozenges and triangles. The motifs in white appear to be embroidered but are in fact woven into the design.

The carpets of the settled Berber farmers of the High and Anti-Atlas are represented by an example from the Ait Ouaouzguite or the Glawa (cat. 7.37c). Its formal composition suggests an inspiration in urban carpets, perhaps those of Rabat. It is a pile carpet, using a variety of colours: purple, green, blue and white on a red background.

Carpets from the plains around Marrakesh and the Atlantic coastal plains, which are populated by sedentary Arabic-speaking tribes, are represented by two examples (cat. 7.37d–e). The area between Marrakesh and Essaouira, populated by nomadic Arab tribes who may have come from Egypt to set up their camps along the River Tensift in the 16th century, is heavily influenced by nearby Berber culture and carpetmaking in particular. The carpets woven in this area are known as 'Chichaoua carpets' after a former market.

The free, asymmetrical designs of some of the carpets of this region differ dramatically from the rigid geometric patterns of other regions. The motifs include wavy lines, triangles, diamonds and chevrons symbolising running water; unusually, they may also represent humans and animals – stylised fish, serpents, centipedes, scorpions and snakes, as well as houses, tents, teapots and rivers. The patterns are sometimes grouped around a central lozenge-shaped medallion. Their symbolism is not always clear, but some have suggested that the carpets document the transformation of tribal existence from a nomadic to a sedentary life. Others have seen the influence of the western Sudan in the compositions and the bright colours.

White, yellow, green, blue and black designs are used on a red ground, but

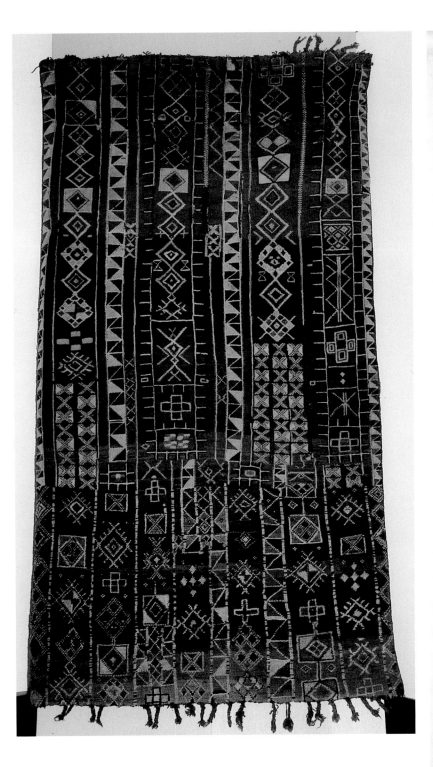

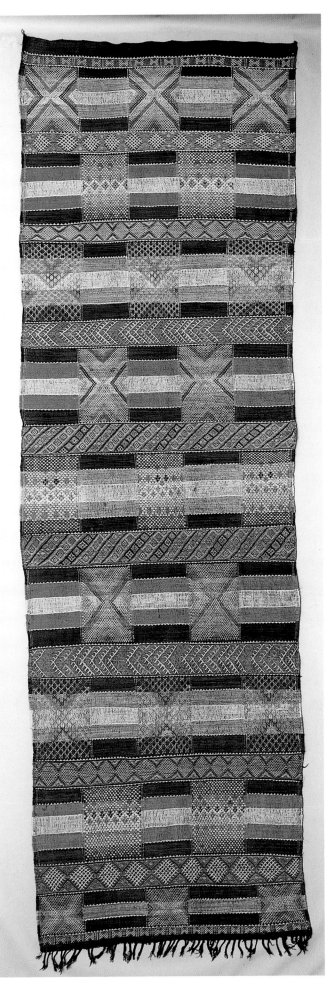

7.37a

Carpet (*zerbiya*)

Berber, Zemmour
Middle Atlas Mountains, Morocco
early 20th century
wool
290 x 160 cm
Musée National des Arts d'Afrique et
d'Océanie, Paris, M.77.4.7

7.37b

Carpet (*zerbiya*)

Berber, Bani M'Guild
Middle Atlas Mountains, Morocco
20th century
wool, cotton
150 x 480 cm
Bert Flint

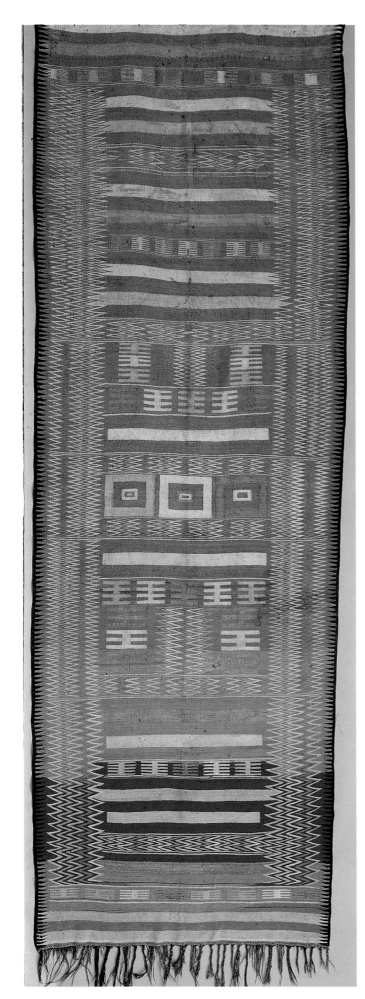

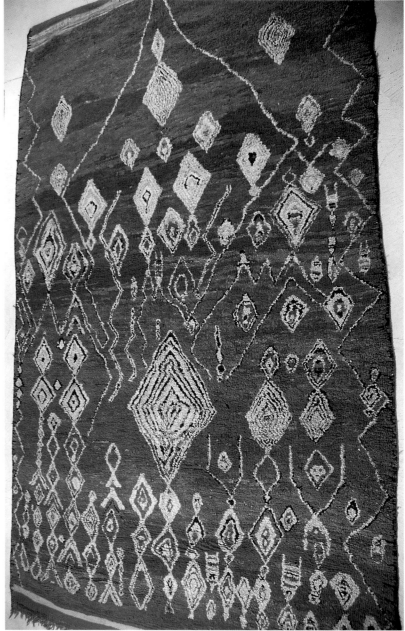

7.37c

Carpet (*zerbiya*)

Berber, Bani Ouaouzguite
High Atlas Mountains, Morocco
20th century
wool
Musée Dar si Said, Marrakesh

7.37d

Carpet (*zerbiya*)

Chiadma
Plains of Marrakesh, Morocco
early 20th century
wool
344 x 204 cm
Musée National des Arts d'Afrique et
d'Océanie, Paris, M.88.1.1

the colours tend to vary in tone and intensity more than in other regions. These two carpets from the plains of Marrakesh, like most of the rugs of this region, are woven with a pile. The Chiadma carpet-makers always used vegetable dyes: madder for the reds, pomegranate skin for the yellow, henna for the orange and indigo for the blue. These carpets are large in size, with big, tightly packed Ghiordes knots; the lacy black edges are made of a mixture of sheepswool and goat hair, which makes them very strong. This type of carpet is no longer produced; modern Chiadma carpets, as well as the carpets of the neighbouring Rehamna tribes, favour abstract designs with multi-coloured check patterns.

This type of weaving, still done on very traditional lines in the Atlas Mountains, is beginning to change owing to immigration and economic development. The woven object is no longer made just for family use but has a commercial value. The weavers now group together in private or co-operative workshops and their creativity is restricted by the need to fulfil specific commissions and by productivity targets. Nevertheless, the technical quality of the rugs has been maintained; traditional designs and colour schemes continue to be followed, despite the use of chemical dyes. *MFV, NE*

Provenance: cat. 7.37a: ex collection Dr Lelong, Marrakesh; cat. 7.37d: ex private collection

Exhibition: Washington 1980

Bibliography: Ricard, 1923, 1932, 1934; Baldoni, 1942; Chantreaux, 1945; Ricard, 1950, 1952; Flint, 1974; Sijelmassi, 1986; Flint, 1987

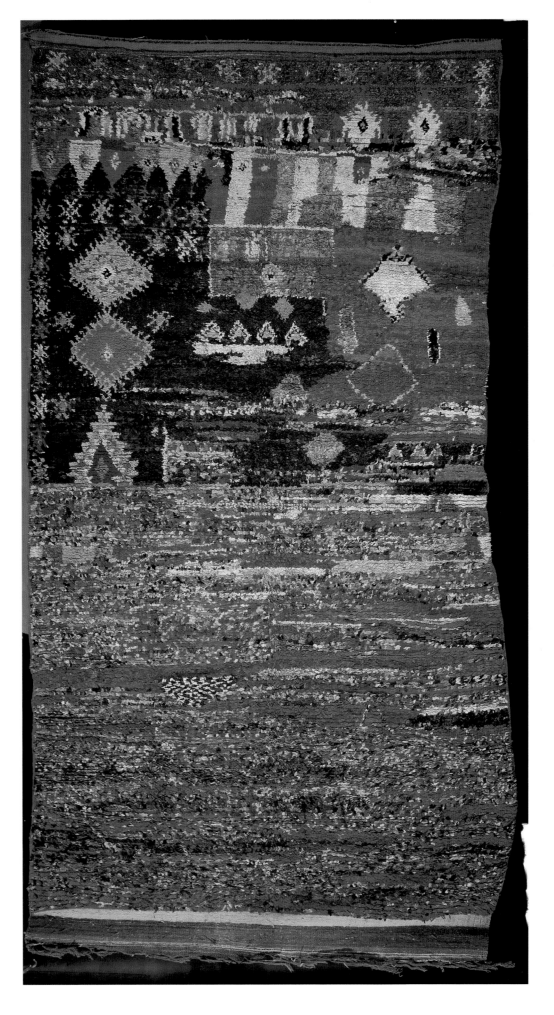

7.37e

Carpet (*zerbiya*)
Ouled Bousebaa, Chichaoua region
Plains of Marrakesh, Morocco
20th century
wool
350 x 186 cm
Private Collection, London

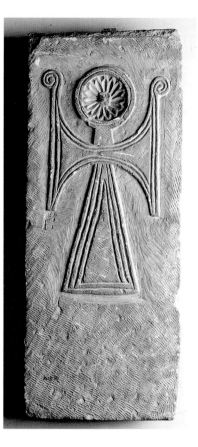

The basket-shaped capital (cat. 7.38b) is carved with a motif of vine leaves and bunches of grapes; on the interlaced stems remain traces of red pigment and on the leaves brown pigment, a fact which testifies that Coptic sculpture and architecture were painted. This finely carved architectural element can be ranked with the best Byzantine sculpture; the interlacing of stems, leaves and grapes is superbly realised in stone, with emphatic contrast of light and shade. Stems and leaves are highly detailed and the grapes seem to emerge from the background foliage. Around the base of the capital runs a band of pearls and geometrical motifs. Most of the capitals from the Monastery of Apa Jeremias at Saqqara are characterised by these effects of light and colour, whereas capitals from other sites in Egypt convey a sense of strength and stability. Early churches and monasteries in Egypt had neither high ceilings nor many windows; yet, while not brilliantly lit, their carved capitals and friezes provided an element of colour. *CM*

Provenance: cat. 7.38b: Saqqara, Monastery of Apa Jeremias

Exhibition: cat. 7.38b: Paris and Milan 1989–90

Bibliography: cat. 7.38b: Duthuit, 1931; Gabra, 1993

7.39

Panel

Coptic
Egypt
7th–8th century (?)
limestone
c. 100 x 50 cm
Museum of Coptic Art, Cairo, 8015

This panel is carved with a *crux ansata* or looped cross, a shape based on the hieroglyph *ankh* ('life'). Its head is round and features a stylised flower. The two arms end in scroll-like curves on the upper part; the body of the cross is a triangle with a triple carved border. Because of its lack of inscription it is difficult to say if this panel was used as a decoration for a wall or as a tombstone.

During the late Coptic period, following the Arab conquest, the cross became the typical funerary stone decoration; crosses could be framed by an arch, or in *ankh* shape, and be accompanied by birds with open wings or other animals. The earliest known examples of the cross in Coptic art date from the 4th century. The *crux ansata* began to appear in the 5th century. The motif of the Latin cross seems to have been introduced from the Mediterranean during the Byzantine era. *CM*

Bibliography: Beckwith, 1963; Atiya, 1991

7.38a

Capital

Coptic
Egypt
painted stone
43 x 42 cm
Museum of Coptic Art, Cairo, 7978

7.38b

Capital

Coptic
Egypt
6th century
limestone
33 x 40 x 40 cm; diam. 21 cm
Museum of Coptic Art, Cairo, 8260

7.40a–b

Two kohl pots

Coptic
Egypt
4th–5th century
ivory
h. *c.* 7 cm each
Museum of Coptic Art, Cairo, 1076, 7600

These two small bottles are containers for kohl, a black lead ore used as make-up for the eyes. They may also have been used as perfume or oil bottles. Cat. 7.40a is cylindrical; it has a lid and two small handles on the sides of the body. The surface of the body is decorated with engraved parallel lines. The lid is conical with a small handle on its top and an engraved line on its upper part. Cat. 7.40b has a bulbous body and a long neck; the lower part of the neck is engraved with three incised parallel lines. The surface of the body is decorated with three bands of incised decoration separated by two parallel incised lines. The pots probably belonged to a rich owner: ivory was expensive, even if widely used, and oil and perfumes were luxury items. *CM*

Bibliography: Badawy, 1978; Atiya, 1991

7.41

Beaker with animal handle

Coptic
Egypt
bronze
h. *c.* 12 cm; diam. 10 cm
Museum of Coptic Art, Cairo, 5086

This cylindrical vessel, used as a drinking-cup, has four small flat feet and a handle in the shape of a stylised feline; there is no decoration on the body of the beaker. The animal on the handle is in a vertical position with the legs attached to the body of the vessel. The head is inclined towards the rim; the mouth is open, the eyes are carved and the ears are shown in relief. The form of the vessel is sober, yet the feline handle gives it an elegance typical of Coptic metalwork. In Coptic Egypt metal-workers took their ideas from Rome, Byzantium and later from the Muslim world. It is difficult to determine whether the object is Christian or not: not all craftsmen were Christian. The Coptic era embraces the end of paganism, the conversion to Christianity and the beginning of the Islamic period. *CM*

Bibliography: Gayet, 1902; Strzygowski, 1904; Atiya, 1991, v; Benazeth and Gabra, 1992

7.42

Two ostraka

Coptic
Egypt
7th–8th century
limestone
10 x 10 cm each
Museum of Coptic Art, Cairo, 4661, 4748

These two ostraka were probably used to try out various geometrical patterns and letters. The smaller ostrakon, drawn in black ink and painted with a fine brush, bears the Star of David inscribed inside a stylised flower and a rosette on the right; the remaining space is filled with letters, perhaps the names of the monks or craftsmen responsible. The larger piece has a more complex decorative pattern: the three interlacing bands in black ink are probably a trial design for a manuscript or painting, and the letters may be signatures or practice script. Ostraka are found throughout Egypt from the New Kingdom to the Coptic period. The word is derived from the Greek for pottery fragment: in ancient Greece votes were cast on pot-shards on the banishment of citizens (hence 'ostracise') but the meaning has been extended to include shards bearing marks, drawings and inscriptions of various kinds. The use of ostraka for such inscriptions was a result of the high price of papyrus and parchment and of an obsessive need to write everything down.

Ostraka began to be used even for important documents such as official contracts. In some Egyptian monasteries the libraries were filled with ostraka of official letters and literary texts. *CM*

Bibliography: Atiya, 1991, vi

7.43

Panel

Coptic
Egypt
5th century
limestone
c. 60 x 100 x 60 cm
Museum of Coptic Art, Cairo, 7061

This is a fragment of a larger decorative panel, probably a pediment or a niche-head. It represents Daphne being transformed into a tree. She is naked, with her hair arranged in a Greek coiffure and both arms raised, holding two symmetrical and stylised foliated stems. Figures from pagan mythology, such as Venus, Dionysus, the Nereids, and Leda and the Swan, mainly taken from the Hellenistic repertoire, are found in Coptic sculpture throughout Egypt. Owing to the syncretism of Coptic Christianity, Coptic artists were able to depict nude pagan figures, their font of inspiration in a country imbued with such a heterogeneous cultural heritage, without fear of causing offence. The sculpture is in the so-called 'Ahnas Style', which was not confined to Ahnas (a major centre at the entrance to the Fayum oasis from the valley) but influenced sculpture throughout Egypt. The manner of representing Daphne may be termed 'soft', with a smoothness of carving in the shape of the body, stylised facial features and vivacity of movement (as opposed to the 'hard' style, with more static characteristics). *CM*

Provenance: Ahnas

Bibliography: Gayet, 1902; Beckwith, 1963; Badawy, 1978

7.44

Textile

Coptic
Egypt
4th–5th century
linen
147.3 x 183 cm
The Trustees of the British Museum,
London, EA.43049

This large tapestry in coloured wools
and undyed linen is decorated with
three vertical bands and two large
human figures. The vertical bands
show dancing male and female
figures. In the side bands the female
figures wear long pleated dresses and
the males flying cloaks. The dancers
are on a background of vine tendrils;

the border of both bands is composed
of heart-shaped motifs. The central
band has a formalised floral border;
inside a scroll pattern there are male
dancing figures, each with a cloak.
The left side of the tapestry features
a standing male figure holding a
reversed spear; he is dressed in a short
green skirt, partly covered by a cloak
fastened on the left shoulder, and
wears a necklace and a pointed hat
(the latter probably of western Asiatic
origin). The spear and the hat prob-
ably indicate that he is of divine or
heroic stature. The female figure on
the right is drawing a bow. A quiver
with three arrows is slung on her

back. Both figures have a border
composed of stylised red flowers.
The dress and posture of the figures
suggest that they represent Artemis
and one of the hunters associated with
her – Actaeon, Orion or Meleager.

The treatment of the figures and
the stressed whites of the eyes, heavy
eyebrows and stylised hair marks the
divergence of Coptic art from classical,
Greco-Roman forms. The vertical
bands with added roundels became
a typical feature of Coptic textiles
in later periods and the mythical
figures turned into the saints and
angels of the following centuries.
CM

Provenance: Akhmim (?)

Bibliography: Badawy, 1978; Quirke and
Spencer, 1992

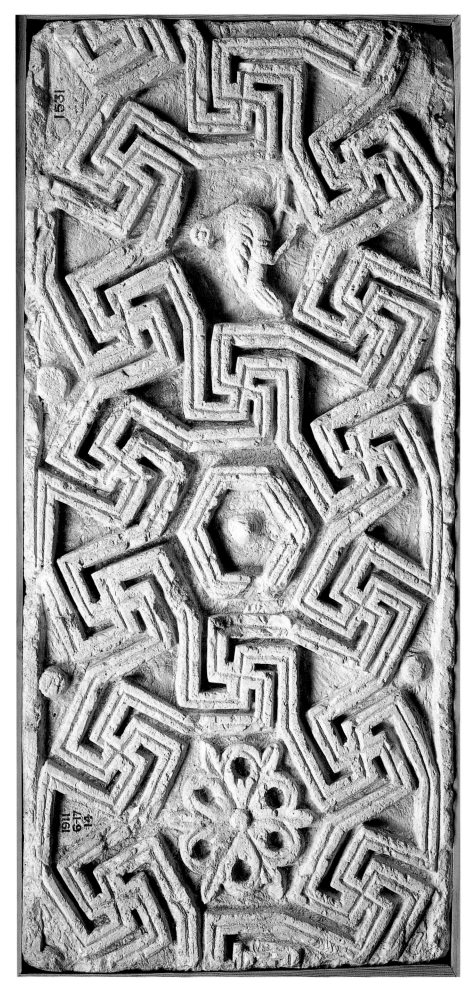

7.45

Panel

Coptic
Egypt
limestone
5th–7th century
31.2 x 62.4 cm
The Trustees of the British Museum,
London, EA.1531

This limestone panel is engraved
with three circles, each formed by six
swastikas; the swastikas further to the
right and left of the central circle
are also part of the two side circles.
Different subjects are engraved in the
centre of each circle: the one on the
left is filled with a rosette of petals
and lancet-like leaves; the middle one
has a hexagon with a central relief
boss; and the one on the right features
a dove with its head turned back-
wards. The panel is not finished on
either side. It belonged to a longer
decorative frieze, which may be
identified by the position of the bird
as having been horizontal; given its
heaviness and format, it probably
comes from a wainscot. The intricate
motifs carefully carved in a refined
technique confirm the *horror vacui*
of Coptic sculptors. During the 7th
and 8th centuries AD Coptic art, and
especially sculpture, reached stylistic
independence. Although there are still
elements of Greco-Roman motifs and
iconography, these have been absorbed
and modified by local artists. While
the provenance of this piece is un-
certain, a convincing parallel may
be cited from Saqqara. *CM*

Provenance: Saqqara, Monastery of Apa
Jeremias (?)
Bibliography: Quibell, 1912; Duthuit,
1931; Badawy, 1978

7.46

Panel

Coptic
Egypt
4th–5th century
limestone
h. 40 cm
Staatliche Sammlung Ägyptischer Kunst,
Munich, AS 5528

This panel represents a naked kneeling youth with short curly hair and both arms raised; he is carved within an arch and hands and legs are badly damaged. It may represent the New Testament story of the man cured of paralysis, a theme symbolising salvation in early Christian art and found in other Coptic sculptures. The posture, with both hands raised probably carrying a bed, distantly recalls the figure of the pharaonic god Shu carrying the sky.

It is difficult to date this work precisely, but the 4th–5th century would seem likely. In their earliest attempts to represent Christian subjects the Egyptians drew on late Hellenistic, Roman and ancient Egyptian iconography. Coptic artists reused motifs they had seen throughout Egypt, left by previous artists, or reinterpreted motifs seen by the artisans in the nearest countries of the Mediterranean. Motifs, including mythological subjects, Egyptian gods and goddesses and animals, that did not have too manifestly pagan connotations were adopted to serve the Christian creed. The clearest example is Isis suckling Horus, interpreted as the forerunner of all later statues and paintings of the Madonna and Child. *CM*

Bibliography: Beckwith, 1963; Badawy, 1978

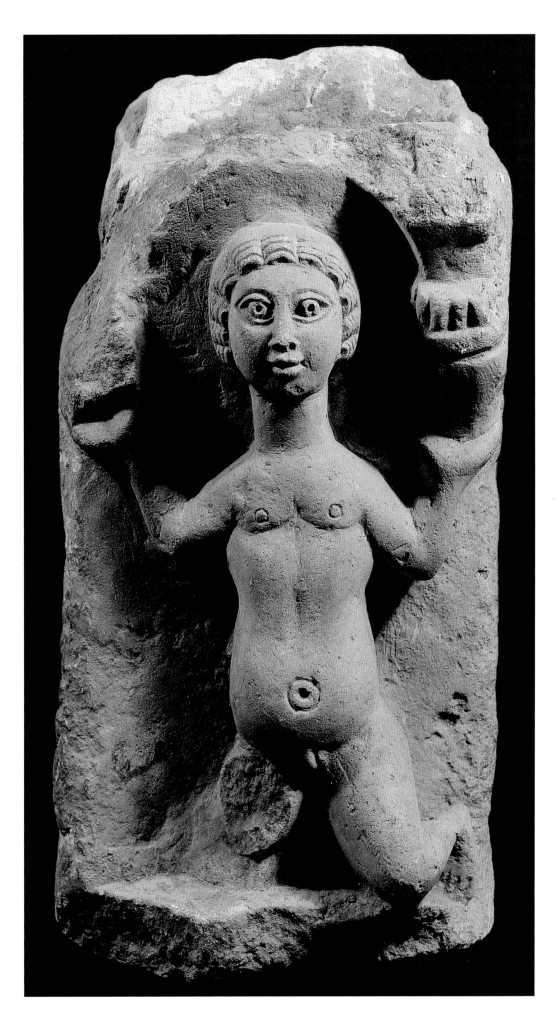

7.47

Carved panel

Egypt
second half of 9th century
wood
58 x 45 cm
Museum of Islamic Art, Cairo, VII 13173

This arched panel, made from a thick
block of a local type of wood called
aziza, is carved with a design based
on the heads and necks of two geese,
ending in floral designs of stylised
leaves. The carving is in the 'bevelled'
style in which the carved edges of one
design slope into the next, leaving no
space behind the designs. The *horror
vacui* aesthetic of this style was to
become one of the main character-
istics of Islamic art. The style origin-
ated during the 9th century in
Samarra, capital of the Abbasid
Caliphate on the Tigris in Iraq, and
was used for wall decorations in both
stucco and wood. The bevelled style
became popular in Egypt during the
reign of Ahmad ibn Tulun (868–884),
a great patron of art and architecture,
who employed builders, stucco carvers,
carpenters and even musicians to
make his capital equal to Samarra.
AY

Exhibition: London 1976, no. 437,
pp. 282–3

7.48

Panel from a cenotaph

Made for the grave of Muhammad b.
Fatik Ashmuli (?)
Cairo
AD 967 (356 AH)
marble
39 x 75 cm
The Trustees of the British Museum,
London, OA.1975.4-15, 1

This rectangular marble panel from a
cenotaph is carved on both sides with
Arabic inscriptions. The inscription on
the outer side consists of the begin-
ning of the *basmala*, 'in the name of
God the Merciful'; that on the inner
side again begins with the *basmala*,
followed by the name of the deceased,
Muhammad b. Fatik Ashmuli (?)
and the date of his death in the
month of Jumada II AD 967 (356 AH).
The inscriptions are both in the angu-
lar Kufic script but they are markedly
different in style. The ornamental
Kufic on the outer surface creates a
monumental effect. It is carved in
high relief with rounded letter forms,
several terminating in leafy forms,
within a raised frame. The simpler
but elegant Kufic on the inner surface
is incised into the stone and ornament
is limited to the barbed tops of the
letters.

The bevelled sides and the incom-
plete outer inscription indicate that
this panel would have been at the
head of a low screen or open cenotaph
erected around the grave. Three other
panels, two adjoining to form the long
side of a similar cenotaph and another
short side, are in the Islamic Museum
in Cairo. Their outer surfaces are
carved with parts of chapter CXII
from the Quran. This panel probably
formed the beginning of the same or
a similar Quranic quotation.

Differences in epigraphy suggest
that these panels come from three
different cenotaphs but they must
have been produced in the same
workshop over a short period of time
in the mid-10th century. Another long
panel in the Gayer Anderson Museum
in Cairo is closer in style and may
have been part of the same sarco-
phagus. It is missing its lower part but
the inscription ends *al-hamdu lillah*
('praise be to God'), which occurs
many times in the Quran. *RW*

Exhibition: London 1976, p. 302, no. 477

7.49

Four chess pieces

Egypt (?)
10th–11th century
ivory
The Trustees of the British Museum,
London
(a) King or Queen, 1856.6-12.4
h. 3.8 cm
(b) King or Queen, 1862.8-9.2
h. 5.6 cm; diam. 5.1 cm
(c) King or Queen, 1877.8-2.8
h. 3.8 cm
(d) Knight, 1881.7-19-47
h. 5.4 cm; diam. 3 cm

It is generally accepted that the game
of chess as we know it originated in
India. From there it reached Persia
during the Sassanian period (c. 6th
century), and became very popular
during the Islamic period. References
to chess in Arabic literature appear as
early as the 8th century (Umayyad
period), and treatises on chess and

names of great masters (such as al-
cAdli) start to appear in the mid-9th
century; a testimony to the popularity
of the game. From the Arab world the
game passed to the West: examples of
abstract pieces based on Islamic mod-
els include the 10th/11th-century
Venafro chessmen, probably of Italian
manufacture.

Contadini (1995) has divided ivory
chess pieces of the Islamic period into
two categories. The first includes
pieces with human or animal shapes.
The second consists of abstract pieces,
in two different styles: style set A,
which was especially popular during
the 10th to 12th centuries; and style
set B, which came to the fore in the
13th century.

The pieces exhibited here are
wonderful examples of style set A.
In this style the King and Queen have
an identical shape variously inter-

preted as a stylised human figure on a throne or a ruler on a throne on top of an elephant's back. The Queen is always smaller than the King, but given that the pieces in question come from different sets (judging from their relative sizes, and the type of ivory and decoration) it is impossible to distinguish them. The Knight has a protuberance reminiscent of a horse's head (as opposed to the Bishop, which has two protuberances, reminiscent of an elephant's tusks).

The pieces are decorated with incised concentric circles, dots and lines. This type of decoration is frequently found on Islamic abstract chess pieces, dice and draughtsmen, and also appears on Roman draughtsmen and dice. *AC*

Provenance: (a): 1856, purchased by the museum from J. Webb; (b): 1862, purchased by the museum from Baron von Estorf; (c): 1877, purchased by the museum from Rev. Greville J. Chester, who had acquired it in Catania, Sicily; (d): 1881, purchased by the museum from Rev. Greville J. Chester

Bibliography: Dalton, 1909, pl. XLVIII, nos 225–8; Contadini, 1995, fig. 47

7.50

Ewer
Egypt
Fatimid
last quarter of 10th century
rock crystal
h. 18 cm; diam. *c.* 12.5 cm (at base); thickness of crystal *c.* 2.5 mm; thickness of relief *c.* 0.5 mm
Tesoro della Basilica di San Marco, Venice, 80

Rock crystal occurs in crystals of hexagonal form, some only tiny specks, others as long as a metre. Because of its purity, beauty and permanence, it has been fashioned into objects of particular rarity from quite early times. The art of carving rock crystal reached a peak in the central lands of the Islamic world between the 8th and 11th centuries. This Fatimid jug is a fine example of a group of six precious rock crystal ewers with a relief-cut decoration made in Egypt in the 10th and early 11th century. The object has been carved from one piece of rock crystal and decorated by means of a bow drill by artisans who specialised in the carving of precious stones. The decoration, a pair of lions in heraldic posture, one on either side of the jug and separated by scrolls of interlaced branches and palmettes, is extremely fine. The thumb rest is in the form of a ram. The object is of particular importance because it bears a Kufic inscription around the shoulder with

the name of the Fatimid caliph al-ᶜAziz, who reigned between 975 and 996. It is therefore securely dated to the last quarter of the 10th century and can be used as a point of reference for dating other rock crystal objects. The inscription reads *baraka min Allah lil-Imam al-ᶜAziz bi-llah* ('May the blessing of God be on the Imam al-ᶜAziz bi-llah'). The piece is mounted with a gold and enamel European mount of the 16th century or later.

About 180 such Islamic rock crystals survive. Many of these are now in royal and church treasuries of western Europe, some having arrived as early as the 10th century; others were found in archaeological excavations, notably those at Fustat. *AC*

Exhibitions: London 1984, pp. 224–9, no. 31; Berlin 1989, p. 194, fig. 215; Venice 1993–4, p. 153, no. 61

Bibliography: Lanci, 1845–6, ii, pp. 133–4, iii, pl. XLIV, fig. 3; Lamm, 1929–30, i, pp. 192–3, ii, pl. 67, no. 1; Erdmann, in Hahnloser, 1971, pp. 112–13, no. 124, pls XCVIII–XCIX

7.51

Textile with embroidered calligraphic band

Egypt
Fatimid
10th–early 11th century
linen and silk
17.8 x 49.7 cm
The Trustees of the British Museum,
London, 1901.3-14,20

This textile belongs to a special type known as *tiraz*. This is a general term for embroidery, but it is also used more specifically to refer to calligraphic or decorative bands found on garments for both men and women. Although the term *tiraz* ultimately refers to embroidered decoration, it is applied freely to bands created by other techniques, including weaving, painting and printing. In fact, the term *tiraz* is so imprecise that it is also used to designate the whole fabric industry.

During the Fatimid period the production of *tiraz* was a state monopoly, continuing earlier trends. According to Ibn Khaldun, writing in the 14th century, under the Umayyads and the Abbasids the cloth mills that supplied the royal wardrobe were housed in the palace and called *dar al-tiraz*. But under the Abbasids there was already a state-controlled *tiraz* workshop in Egypt. Most surviving examples, including this one, are from the Fatimid period. They mainly come from burial sites in Egypt.

The textile shown here is a splendid early Fatimid calligraphic *tiraz*. It is a yellowish, linen fabric decorated with an embroidered epigraphical band in blue silk. The inscription is in Kufic (angular) script and repeats *al-mulk lillah*, or 'sovereignty is God's'. *AC*

Provenance: 1901, entered the museum as part of the Major W. J. Myers Collection

7.52

Carved panel

Egypt
11th century
wood
28 x 255 cm
Museum of Islamic Art, Cairo, VII 4063

This wood panel is carved with hunting, dancing and music scenes and was originally painted in red, turquoise, black and white. It is one of several which decorated the reception hall in the residential apartment of Sayyida al-Mulk, the sister of the Fatimid Caliph al-Hakim (966–1021), in the western Fatimid palace built by the Caliph al-ᶜAziz (975–996).

The wood panels were later reused in the hospital (*maristan*) built by Sultan Qalawun in the 13th century. There are other examples of wood being reused in different contexts in Cairo as Egypt has little native wood and imported wood was expensive. In the hospital they were placed upside down, probably because the figural designs were considered impious at that time. The courtly scenes depicted on this and the other panels evoke aristocratic life during the Fatimid period. Genre scenes of this type have a long history in Egypt, from the Pharaonic period to the Islamic era. *AY*

Exhibition: Cairo 1969, no. 220, p. 232
Bibliography: Herz, 1913, pp. 169–74, pls XXVIII-XXIX; Wiet, 1930, no. 21; Pauty, 1931, pp. 48–50, pl . XLVI; Marçais, 1935–40, pp. 240–57; Lamm, 1935-6, pp. 69–80; Hasan, 1956, no. 343, p. 442

7.53

Bowl

Egypt
Fatimid
first half of 12th century
white earthenware painted in lustre on a
white glaze
h. 9.6 cm; diam. 22.3 cm
The Board of Trustees of the Victoria and
Albert Museum, London, C.49-1952

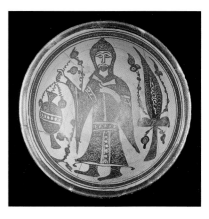

The bowl has a high cylindrical footring, convex sides and a slightly outturned lip. Inside, framed by two broad bands, is painted a figure traditionally identified as a 'Coptic priest', swinging a censer suspended by chains from his extended right hand. Beside him, to the right, is a cypress. Inner markings are everywhere scratched through the lustre, forming spiral designs.

The technique of lustre painting seems to be an Islamic invention. It appears on glassware as early as the 8th century and on pottery by the 9th century. The effect is achieved by applying a mixture of silver and copper oxides over the glaze and refiring it in a reduction kiln which extracts oxygen from the oxides and reduces them to a metallic state.

On the outside of this bowl a band of lustre is painted around the lip, and the inscription *saᶜd* in Kufic characters is written twice as a mirror inscription (and not with characters written in reverse, as is often stated). The inscription has long puzzled scholars. Butler thought that it was the 'attempt of a Copt in early Muslim days to render in Arabic the original Greek for prior or abbot'. But the bowl is now generally accepted as belonging to a group of vessels so inscribed, although the use of a mirror inscription remains unexplained. There has been much debate whether *saᶜd* is the name of a specific potter or painter; whether it should be interpreted literally as 'good luck' (a perfectly reasonable possibility, although the good-luck formula found on other contemporary objects is usually *saᶜada*, 'happiness, prosperity'); or whether *saᶜd* is the name of a workshop. This last hypothesis is the

one I think most likely. The relatively large amount of material with *saᶜd* inscriptions is so varied in type, style and iconography that it is unlikely to be the work of a single person.

Even during Islamic times the Copts were famous for their work in metal, their textiles and pottery, and there was a large Coptic community in Fustat (old Cairo), where the kilns were situated. It is hardly surprising, therefore, to find Christian imagery in luxury pottery which could well have been made by or for a Copt. Another striking example is provided by a shard painted in lustre with the head of Christ surrounded with a crossed nimbus. *AC*

Provenance: found near Luxor (?); ex Dikram Garabed Kelekian Collection

Bibliography: Kelekian, 1910, pl. 6; Butler, 1926, p. 54, pl. XI; Lane, 1947, pp. 22–3, pl. 26A; Caiger-Smith, 1973, p. 37, pl. B; Féhérvari, 1985, p. 105

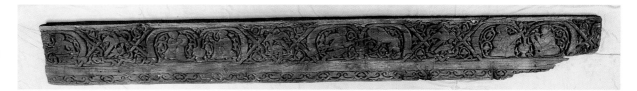

7.54

Water jar and stand (*kilga*)

Cairo
12th century and later
alabaster (jar), marble (stand)
h. 97 cm (jar and stand);
47 x 27.5 x 65 cm (stand)
Manchester City Art Galleries, 1934.255

Carved from a single block of marble, the *kilga*, or jar stand, consists of a rectangular open-topped base on four legs with a projecting basin. The exterior of the *kilga* is finely carved with a variety of flutes and arcades. Two female figures decorate the corners, two lion heads jut out above the basin and an Arabic benedictory inscription in Kufic script of the 12th century runs around the outer edge of the stand.

Originally the *kilga* would have held an unglazed earthenware jar (*zir*) which both cooled the water inside through condensation and cleaned it as it slowly filtered through the low-fired, porous body. The inhabitants of medieval Cairo used water polluted by local refuse and sewage. Ibn Ridwan, chief physician at the Fatimid court and author of a medical topography of Cairo written in the early 11th century, describes the purification of contaminated water: 'The best thing is not to use this water until it has been purified several times [by boiling and filtering] . . . the purified part is placed in a jar; only what seeps through the porosities of the jar will be used.'

Many *kilgas* were later furnished with stone jars. The jar associated with this *kilga* has a pointed base and was therefore always intended for suspension in a stand. Cups or ladles would have been attached to the rim so that water could be scooped out; the stone would have kept the water cool but would not have allowed it to permeate through into the basin and so the original function of the *kilga* would have been annulled.

Kilgas often demonstrate an unusual combination of Muslim and Coptic iconography. Here figures of seated females with hands raised, the traditional pose of a Christian at prayer, are combined with Arabic benedictory inscriptions. *RW*

Provenance: 1934, bequeathed to the galleries by John Yates

Bibliography: Ibrahim, 1978; Knauer, 1979, p. 71

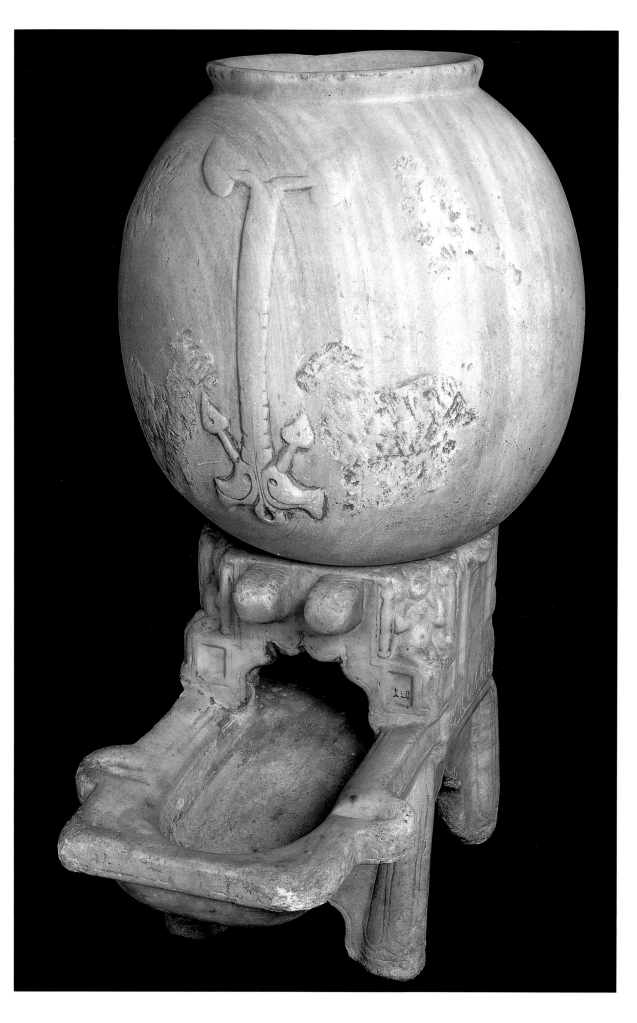

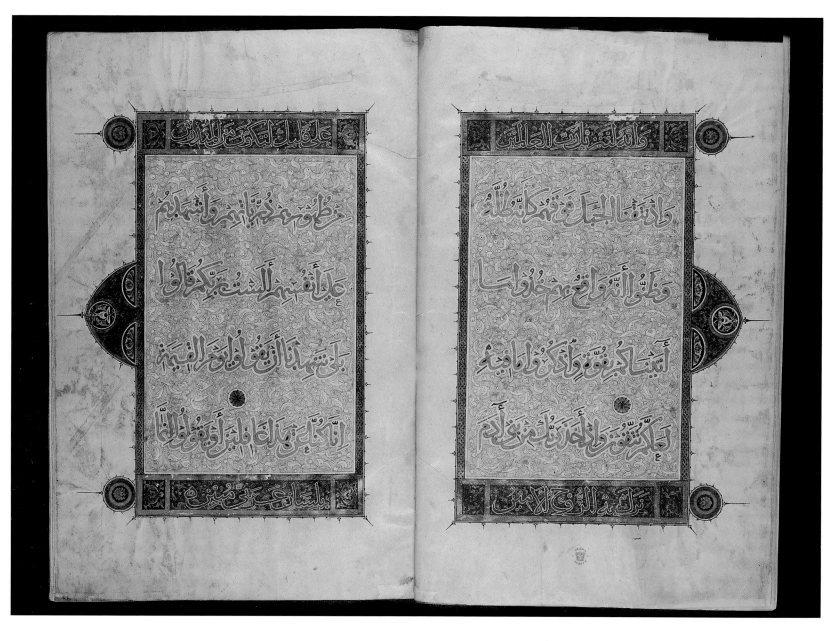

7.55

Volume of a seven-part Quran

Cairo
Egypt
AD 1305 (705 AH)
47 x 32 cm
The British Library, London, Add. 22408

This is volume three of a large Quran in *asba^c* (seven divisions), written in *thuluth-ash^car* script with a double page frontispiece and fine illumination throughout. It was copied by Shaykh Sharaf al-Din Muhammad ibn al-Wahid and illuminated by Abu Bakr, known as Sandal, for the Mamluk amir Rukn al-Din Baybars al-Jashnaqir (later Sultan al-Muzaffar Baybars 1309–10).

This is the earliest dated Mamluk Quran; it stands at the beginning of an exceptionally rich period of Quran production and is one of the finest of

them all. The writing of the Quran is recorded by several Mamluk historians. The fullest description is given by Ibn Iyas: 'In that year [AD 1305–6 (705 AH)] the *atabak* Baybars al-Jashnaqir began to build his *khanqah* which is in the square of Bab al-^cId opposite Darb al-Asfar. It is said that when the building was completed, Shaykh Sharaf al-Din ibn al-Wahid wrote a copy of the Quran in seven parts for the *atabak* Baybars. It was written on paper of Baghdadi size, in *ash^car* script. It is said that Baybars spent 1600 dinars on these volumes so that they could be written in gold. It was placed in the *khanqah* and is one of the beauties of the age.' (James, 1988).

The calligrapher Ibn al-Wahid (*d.* 1311) was one of the best calligraphers of the 14th century and his

Qurans attained high prices. This one is written in gold outlined with a fine black line, a technique which was usually reserved for *sura* (chapter) headings.

The illumination of this and two other volumes was the work of Sandal, who signs this volume in the marginal medallion of the final colophon page. Sandal was also highly regarded by his contemporaries. The double frontispiece in this volume has a central star-polygon surrounded by interlocking geometric shapes which is characteristic of his style. *RW*

Exhibitions: London 19761, nos 66–9; London 19762, no. 527

Bibliography: Lane-Poole, 1886, pp. 225–6; Lings and Safadi, in London 19761, no. 62; Atil, 1981, p. 23; James, 1984, pp. 147–57; James, 1988, no. 1, pp. 34–75, 220

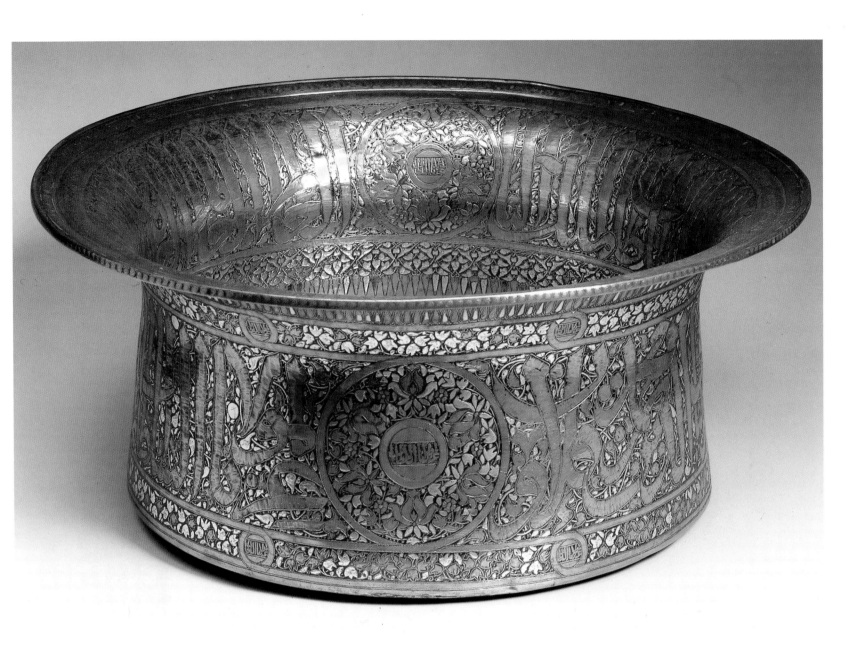

7.56

Basin

made for Sultan al-Nasir Muhammad ibn Qalawun

Cairo or Damascus
c. 1320–41
brass, gold, silver
h. 22.7 cm; diam. 54cm.
The Trustees of the British Museum, London, OA.1851. 1-4, 1

Majestic inscriptions in Mamluk *thuluth* script, originally inlaid with gold, decorate the interior and exterior of this large basin. They give the name and titles of the Mamluk Sultan al-Nasir Muhammad ibn Qala'un, who ruled between 1293 and 1341: 'Glory to our master the Sultan al-Malik al-Nasir the wise, the efficient, the warrior, the champion of the faith, the defender Nasir al-Dunya wal-Din Muhammad

ibn Qala'un, may his victory be glorious.'

Small medallions containing the epigraphic blazon of the sultan ('glory to our master the Sultan') are at the centre of the floral roundels which punctuate the inscriptions and are repeated in the narrow leafy borders on the exterior of the basin. The base is decorated with a large roundel filled with swimming fish.

Large basins like these were among the most prestigious of Mamluk metalworkers' productions. The fish in the base confirm that they functioned primarily as ablution vessels but their size and shape made them appropriate for a number of other uses also. The historian al-Jazari (1260–1338) describes a circumcision ceremony organised by Sultan Khalil for his brother Muhammad (before he

became sultan) at which each amir had to throw as many gold dinars as he had mamluks into a basin. The 14th-century Italian pilgrim Sigoli describes wedding festivities in Cairo during which women guests put gifts into a large basin placed by the side of the bride.

The long reign of Sultan al-Nasir Muhammad coincided with a period of prosperity and relative stability in the Mamluk empire. The sultan was responsible for making peace with his Mongol neighbours in Iran, after nearly a century of war between the two empires; this encouraged trade between Iran and Egypt and introduced a range of Chinese and Persian luxuries to the Mamluk court. The effect of these can be seen here in the lively lotus flower design in the main roundels, probably inspired by

roundels on Chinese textiles. The sultan was an active patron of art and architecture. He and his officers were responsible for commissioning many other inlaid brass vessels and were probably largely responsible for the blossoming of the Mamluk fine metalworking industry during the 14th century. *RW*

Provenance: 1851, acquired by the museum

Exhibition: Washington 1981, no. 26, pp. 88–91

Bibliography: Lane-Poole, 1886, pp. 227–8, 190; Migeon, 1907, ii, p. 206, fig. 164; Migeon, 1927, ii, pp. 76–7, fig. 253; Ross, 1931, p. 318; Wiet, 1932, appx. no. 183; Sigoli, 1948, pp. 167–8; al-Jazari, 1949, pp. 28–9; Barrett, 1949, p. xviii, pl. 28; Zaki, 1956, nos 508–9, figs 508–9; Aslanapa, 1977, p. 76, fig. 9; Ward, 1993, p. 111, fig. 88

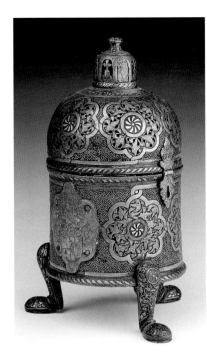

7.57

Incense burner

Egypt
14th century
brass inlaid with silver and gold
h. 20.5 cm; diam. 14 cm
Museum of Islamic Art, Cairo, VII 15129

This brass incense burner has a cylindrical body on three legs surmounted by a separate domed top and inlaid with silver and gold designs in bands, mostly containing floral ornament. The fastening of the domed lid with its tiny floral decoration appears to be a later addition. It may have been added at the same time as the second smaller dome which has a cross inside, suggesting that these later additions may have been an attempt to convert the vessel to Christian use. *AY*

Provenance: ex Ralph Harari Collection

7.58

Perfume sprinkler (*qumqum*)

Egypt
middle of 14th century
brass inlaid with silver and gold
h. 22.5 cm; diam. 7.6 cm
Museum of Islamic Art, Cairo, VII 15111

This brass perfume sprinkler (*qumqum*) has a pear-shaped body with a flaring foot and long tapering neck (the neck is a later replacement). The surface of the vessel is inlaid with silver and gold inscriptions and designs, the latter including lozenge patterns, *chinoiserie* floral scrolls, flying birds, geometric motifs and arabesques. The underside of the base is decorated with an embossed nine-petalled rosette with a foliate scroll in the recessed surround. The main inscription frieze contains the name and titles of Sultan Hasan: 'Glory to our lord the Sultan al-Malik al-Nasir Nasir al-Dunya wal-Din al-Malik al-Nasir Hasan.' The radial inscriptions in the three large medallions contain shorter versions of the same inscription. Small roundels in the frieze above and below the main inscription contain the sultan's epigraphic blazon 'al-Malik al-Nasir'. *AY*

Exhibitions: Cairo 1969, no. 79; London 1976, no. 255

Bibliography: Wiet, 1932, appx no. 255, p. 217; Mostafa, 1958, no. 70, fig. 29; Mostafa, 1961, pp. 48–9, fig. 42; Atil, 1981, no. 31, p. 98

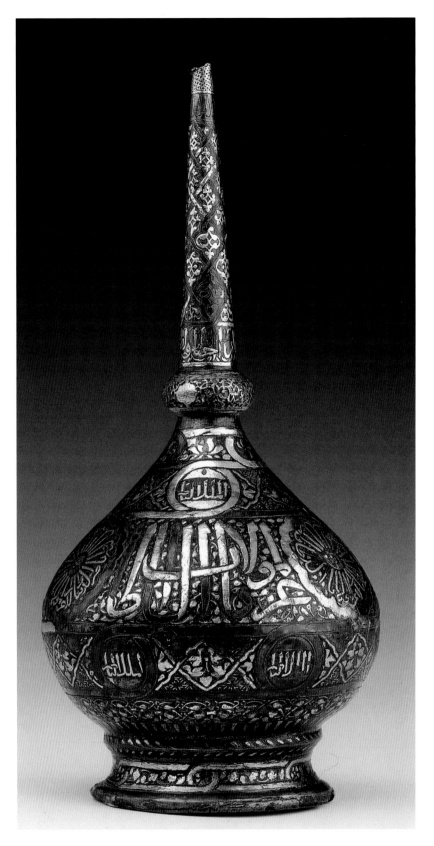

7.59

Chandelier
Egypt
c. 1360
brass
h. 220 cm; diam. 65 cm
Museum of Islamic Art, Cairo,
VII MIA 92

This octagonal brass chandelier is constructed in three tiers; with a domed top and eight legs, it has pierced and engraved decoration. Four shelves with crenellated edges around the chandelier have holes in which to insert glass oil lamps. Six more lamps would have been inserted into the cross-shaped holders above the dome. The chandelier would have been suspended from the ceiling but its legs enabled it to be placed securely on the floor while the lamps were being filled.

The fine *thuluth* inscription featured in the central section of the chandelier was engraved on a separate sheet of brass before being fixed in place. It contains the name and titles of Sultan al-Nasir Hasan (1347–51 and 1354–61): 'Glory to our lord the Sultan al-Malik al-Nasir, the learned, the reformer, the just, the conqueror, defender of the faith, defender of castles and frontiers, the helper, the victorious, sultan of Islam and all Muslims, killer of unbelievers and polytheists, reviver of justice among peoples, defender of the world and faith, Hasan son of Sultan al-Malik al-Nasir, the defender of the world and faith Muhammad, son of al-Malik al-Mansur Qalawun, may his victory be glorious.' *AY*

Provenance: found at the madrasa of Sultan Hasan, Cairo

Bibliography: Wiet, 1930, no. 54; Wiet, 1932, pp. 1–7, pl. XII

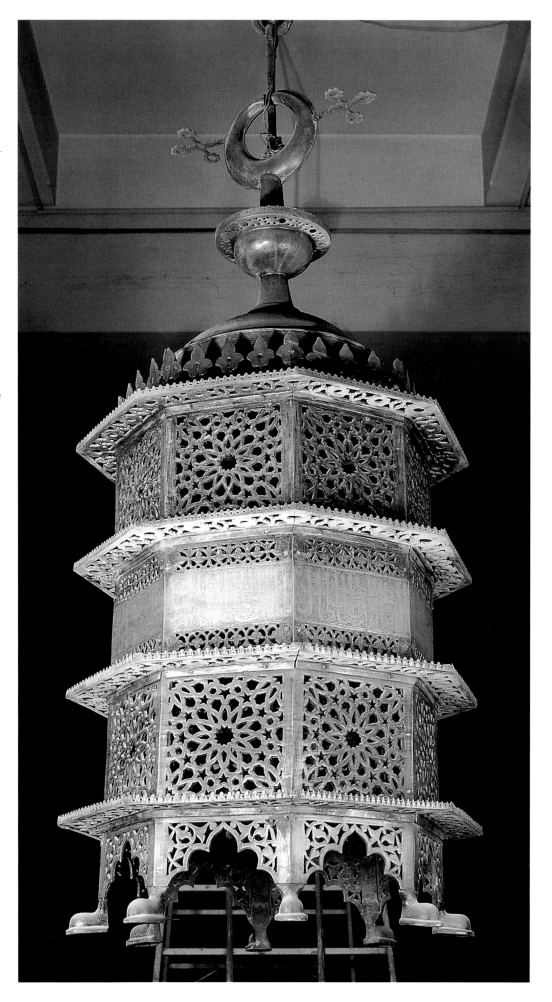

shown in contemporary paintings held by sultans and courtiers, sometimes with a matching glass decanter placed nearby. Fish often feature in the decoration of these beakers as a pun on their function. Eels are rarer; they may have been intended to add a note of local realism as eels are plentiful in the Nile. The sight of fish and eels frolicking in red wine would have reminded the drinker of marine life seen through the muddy waters of the Nile.

The beaker was acquired in Quft (Koptos), 10 km north of Qus in Upper Egypt. During the Mamluk period, Qus was the administrative centre of the area and the third city of Egypt (after Cairo and Alexandria). Its strategic position on the Nile where it bends close to the Red Sea made it an important trading post for merchants travelling between Cairo and east Africa, Arabia or the Indian Ocean and its markets were renowned. Local Copts filled many of the administrative posts in the area, working under Mamluk governors and officials appointed by the sultan in Cairo. The lack of Mamluk titles decorating this vessel suggests that it was owned by a wealthy member of the Coptic community of Quft, but it was probably made in Cairo. *RW*

Provenance: 1879, bought by the museum from the Rev. Greville Chester who had acquired it in Quft (Koptos) in Upper Egypt

Bibliography: Schmoranz, 1899, fig. 29; Read, 1902, p. 222, figs 2–3; Dillon, 1907, p. 163; Honey, 1927, p. 290; Lamm, 1930, p. 343, pl. 138.1; Tait, 1979, p. 19, fig. E

7.61

Mosaic panel

Egypt
14th or early 15th century
marble, mother of pearl
26 x 101 cm
Museum of Islamic Art, Cairo, VII 3075

This panel has different coloured marbles and mother-of-pearl set into plaster to form a series of four semi-circular arches surrounded by geometric designs. It would originally have been set into the wall as part of a dado. It has been suggested that it came from the mausoleum of Barsbay (1422–38). Stone mosaic panels were frequently used as architectural decoration during the Mamluk period in Egypt. The composition of this one, particularly the semicircular arches made from bands of different coloured stones, reflects the use of *ablaq* (polychrome stone) in contemporary architecture. The use of different colours in architectural panels such as this one demonstrates the preoccupation of Mamluk craftsmen with polychrome decoration – seen in the enamelled glass, painted pottery and inlaid metalwork of the period. *AY*

Bibliography: Herz, 1906, p. 57, no. 23; Herz, 1907, p. 54, no. 23; Wiet, 1930, no. 15; Mostafa, 1961, p. 34, fig. 7; Atil, 1981, no. 107, pp. 212–13, no. 1

7.60

Glass beaker

Cairo
1300–20
glass, gilding, enamel
h. 11 cm; diam. (rim) 7.1 cm
The Trustees of the British Museum, London, OA.79.5-22, 68

across the world – to China, Europe, the Middle East, Arabia and other parts of Africa.

Delicate glass beakers such as this one provided a luxurious alternative to heavy, thick-walled, pottery drinking-vessels. Filled with red wine, they are

This cylindrical glass beaker with flaring rim is decorated with fish and eels in red enamel and gilded. Glass vessels with decoration were among the most sought-after products of Mamluk craftsmen. Many bear the official titles and blazon of the sultan or one of his officers. Others were decorated in a less specific style and sold to wealthy Egyptians or exported

7.62a

Mosque lamp

made for the Mamluk Amir Sayf al-Din
Shaykhu
Cairo
c. 1350–5
glass, gilding, enamel
h. 35 cm
The Trustees of the British Museum,
London, OA.G.1983.497

7.62b

Mosque lamp

made for the Mamluk Amir Sayf al-Din
Shaykhu
Cairo
c. 1350–5
glass, gilding, enamel
h. 35 cm
The Trustees of the British Museum,
London, OA.S.333 (OA+521)

Enamelled and gilded glass lamps
were commissioned in large numbers
for the many mosques built in Cairo
by the Mamluk sultans and their
amirs. These lamps, in the shape of
a footed vase with wide body, flaring
neck and handles for suspension,
follow a type known in both metal
and glass since the 6th century.
In Byzantium suspended lamps of
this shape were sometimes used as
a symbol of a holy place and this
practice was continued during the
Islamic period. The symbolism of the
lamp was made more potent by a verse
in the Quran (XXIV, 35) in which the
light of a lamp is compared to the
light of God. Many Mamluk mosque
lamps, including these three examples,
are inscribed with part or all of this
verse: 'God is the Light of the heavens
and the earth; /the likeness of His
Light is as a niche wherein is a
lamp/(the lamp in a glass,/the glass
as it were a glittering star)/kindled
from a Blessed Tree,/an olive that is
neither of the East nor of the West/
whose oil well-nigh would shine,/
even if no fire touched it.'

Two lamps (cat. 7.62a–b) are also
decorated with a bold inscription
frieze containing the name and titles
of Sayf al-Din Shaykhu al-Nasiri:
'By order of the noble and high
excellency, the lord, the well-served
Sayf al-Din Shaykhu al-Nasiri, may
God make his victory glorious.'
Shaykhu's blazon of a red cup on a
gold ground with red upper field and
dark blue lower field appears in the
centre of the roundels on the neck
and the underside of each lamp.

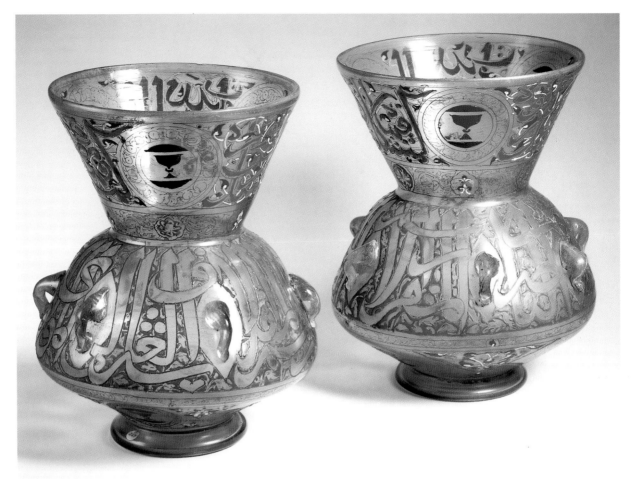

Shaykhu was a mamluk of Sultan
al-Nasir Muhammad ibn Qala'un, but
rose to prominence during the 1340s.
After he helped to put Sultan al-Nasir
Hasan on the throne for his second
reign in 1354 he was effectively ruler
of the Mamluk empire until he was
murdered at court in 1357. Shaykhu's
wealth and influence made him an
important patron of art and archi-
tecture in Cairo; more than eleven
mosque lamps inscribed with his
name, titles and blazon have survived.
A fragment of one of these is known
to have come from Shaykhu's mosque
at the foot of the citadel, which was
completed in 1349; that is likely to be
the origin of the present examples
too. The mosque was considered to be
one of the finest of its time. In 1355
he built a *khanqah* (Sufi monastery)
opposite, and these two remain
important architectural landmarks
in Cairo. He also commissioned inlaid
brass objects, including a fine tray
inscribed with his name and titles
in gold and silver.

The third lamp (cat. 7.61c) bears
the titles of Sultan al-Zahir Barquq
(1382–99). He was the first in a long
line of Circassian sultans after more

than a century of rule by Sultan
Qala'un and his descendants. In 1386
his madrasa, built next to the complex
of Sultan Qala'un and the mosque of
his son Sultan al-Nasir Muhammad
and intended to outshine them both,
was completed. He furnished this
building with numerous enamelled
glass lamps, many of which are pre-
served in the Museum of Islamic Art
in Cairo. This lamp is typical of the
group and probably came from the
same building. *RW*

Provenance: cat. 7.62a: 1983, given to the
museum by the descendants of F. Ducane
Godman; cat. 7.62b: 1868, given to the
museum by Felix Slade's executors

Bibliography: cat. 7.62a: Godman, 1901,
p. 72, pl. 72; Lamm, 1930, pl. 192.10;
cat. 7.62b: Franks, 1862, no. 4966, p. 388;
Nesbitt, 1871, no. 333, p. 61 and pl. VIII;
Nesbitt, 1878[2], pl. LXV, p. 57; Garnier,
1884, i, p. 295; Lane-Poole, 1886,
pp. 216–17; Schmoranz, 1899, p. 48;
Migeon, 1907, p. 355; Migeon, 1927, ii,
p. 135; Wiet, 1929, appx. no. 60, p. 165;
Tait, 1979, p.135, fig. 168

7.62c

Mosque lamp

made for the Mamluk Sultan al-Malik
al-Zahir Barquq

Cairo
c. 1386
glass, gilding, enamel
h. 30cm
Austrian Museum of Applied Arts, Vienna,
GL 3034

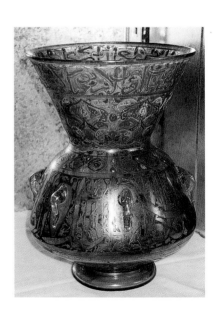

7.63

Mosaic panel

Egypt
14th or 15th century
stone, marble, plaster
28 x 28 x 1.6 cm
University of Pennsylvania Museum
of Archaeology and Anthropology,
Philadelphia, NEP 58

This wall panel is made up of cut
stone in different colours, creating
a 'square Kufic' inscription within
a geometric border. The inscription
reads: 'There is no God but Allah,
Muhammad is the messenger of
Allah, may Allah bless him.'

Mosaics of cut stone of contrast-
ing colours were popular in Mamluk
Egypt. They were used particularly
as surrounds to fountains and, as here,
panels to be set into walls. The earliest
example of a square Kufic mosaic
panel in Cairo is in the mausoleum
of Sultan Qala'un (1285) but during
the 14th and 15th centuries they
became very popular and can still be
seen on the walls of Mamluk build-
ings, such as the grand portal to the
mosque of Sultan Hasan (1356).

The term 'square Kufic' is used to
describe inscriptions contained within
a square or rectangle where the ver-
ticals and horizontals of individual
letters are aligned with the outer
border. Square Kufic has been com-
pared with Chinese seals, in which
the character is also inscribed within
a square, but the format may have
evolved independently on Islamic
coins. From an early period Islamic
coins bear inscriptions arranged in a
square, sometimes even framed by
one, and it was a natural step to move
from that to square Kufic in which the
inscription is read clockwise around
the square as the coin is turned in
the hand.

The same inscription, arranged
in an identical format, appears on a
series of coins minted at Tabriz by the
Il-Khanid ruler Abu Sa^cid (1317–35).
This direct quotation from an Il-
Khanid coin is one of many examples
of Mongol influence on Mamluk art
after Abu Sa^cid and the Mamluk
Sultan al-Nasir Muhammad made
peace in the 1320s, after nearly a cen-
tury of war between their empires.
RW

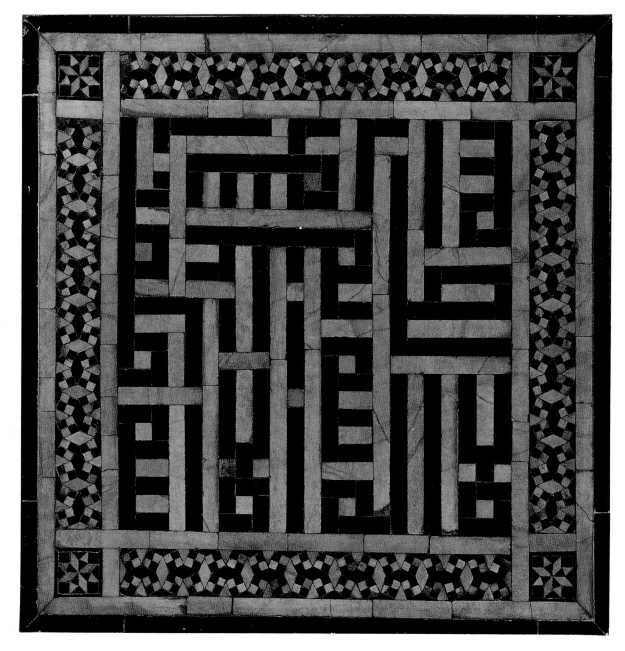

7.64

Panel with inscription

Egypt
Ottoman period, 18th century
wood
30 x 77 cm
Museum of Islamic Art, Cairo, VII 11758

This wooden panel is carved with a religious inscription in square Kufic script in three lines. The inscription is in praise of God and calls upon the reader to depend upon him, but it is slightly ambiguous in places and may be missing a fourth line. This type of script became popular in Egypt in the 13th century and continued in use into the 18th century. Its angular forms are particularly suitable for architectural settings and it was widely used to decorate buildings throughout the Islamic world. Another panel from the same donation to the Cairo museum (no. 11742) is also inscribed in square Kufic with part of a verse from the Quran (LXI,13): 'Help from God and a nigh victory.' *AY*

Provenance: 1933, given to the museum through the endowment of ex-Prince Kamal al-Din Hussein

7.65

Panel in the name of Sultan Qa'itbay

Egypt
1468–96
ivory set in wood
9.2 x 33.8 x 1.5 cm
Museum of Islamic Art, Cairo, VII 2334

The carved ivory panel bears an elegant *thuluth* inscription which can be translated as: '[Glory to] our lord the Sultan al-Malik al-Ashraf Qa'itbay, may his victory be glorious.' Sultan Qa'itbay, who ruled from 1468 to 1496, was a discerning patron of art and architecture. He commissioned several buildings in Cairo and would have provided them all with the necessary furniture and fittings. This panel is said to be from the madrasa of Qa'itbay completed in 1472–4. It would probably have been fixed to a wooden *minbar* (cat. 7.67) or to a door. *AY*

Exhibitions: Cairo 1969, no. 41; London 1976, no. 155

Bibliography: Wiet, 1930, no. 39; Atil, 1981, no. 105, pp. 210–11

under the patronage of the Mamluk sultans, others have argued that they may have been produced in north Africa, Syria or Anatolia. Again, while many believe that production started in the 15th century under the patronage of the Mamluk Sultan Qa'itbay (and his heraldic blazon does feature on one surviving fragment), others argue that these carpets were not produced until after the Ottoman conquest of Egypt in 1517. Although it is possible that such luxury objects were produced for the ruling Circassian and Turkish military élite in Egypt, it is also possible that the carpets were chiefly made for export to the West. The squarish shape of this and other examples might indicate that they were made to be spread over European tables. The geometric design does, however, look characteristically Mamluk and has parallels in woodwork, book illumination and other media, but there is much debate about its meaning (if any). The central octagonal medallion has been interpreted as a stylised representation of a royal sunburst, of a central Asian mandala, of the Dome of the Rock in Jerusalem, of a courtyard fountain, or as the reflection of a coffer-vaulted ceiling beneath which the carpet would be spread. *RI*

Provenance: ex Imperial Hapsburg Collection

Exhibition: London 1983, p. 62, no. 22

Bibliography: Sarre and Trenkwald, 1926–7, i, pl. 47; Erdmann, 1962, pp. 14–15

7.66

Carpet

Mamluk
Egypt
15th–16th century
wool
265 x 240 cm
Austrian Museum of Applied Arts,
Vienna, T 8346

This is a typical example of a large group of luxury carpets thought to have been produced in Egypt in the late 15th or early 16th century. Except for one example entirely in silk, Mamluk carpets are woven from a lustrous wool and this, together with the density of the knotting and the intricacy of the designs, gives them a characteristic sheen. The range of colours is invariably restricted; vermilion, brilliant blue and green predominate. In most cases kaleidoscopic designs are organised around three octagonal medallions or (as here) one central medallion. The borders feature alternating cartouches and rosettes, while the field between the border and the central octagon is filled with complex designs based on eight-pointed stars and eight-lobed rosettes as well as characteristically Egyptian papyrus and lancet motifs.

Mamluk carpets are among the most controversial objects in Islamic art history. These exquisite textiles seem to have no real precursors in medieval Egypt and there is hardly any relevant textual evidence. There is no consensus about where the carpets were made, when they were made or why. Although many scholars believe that they were woven in Cairo

7.67

Minbar for the Sultan Qa'itbay

Egypt
Mamluk
end of 15th century
wood inlaid with ivory
612 x 304 x 113 cm
The Board of Trustees of the Victoria and
Albert Museum, London, 1050-1869

The *minbar* (pulpit) is one of the main furnishings of a Friday (congregational) mosque. It is placed to the right of the *mihrab* (the niche which gives the direction to Mecca), and is used by the imam leading the prayers or delivering the sermon.

The wooden *minbar* shown here bears the name and titles of the Mamluk Sultan Qa'itbay, who reigned between 1468 and 1496, but it is not known from which mosque it comes. It is sometimes reported in the literature to come from Qa'itbay's madrasa at Qal^cat al-Kabsh in Cairo, but a *minbar* exists there still. As Lane-Poole put it: 'As one Sultan would sometimes place a pulpit in the mosque of another, and Kait Bey was especially generous in this kind of restoration, it is possible that the pulpit did not come from any of his own mosques'. This *minbar* consists of seven steps leading to a small landing, surmounted by an onion-shaped dome with a *muqarnas* (stalactite) decoration around its base. At the top of the dome there is a finial of three small spheres surmounted by a crescent, as found in Mamluk architecture, for example on top of the dome and minaret of the Qa'itbay complex in Cairo. The *minbar* has a door with two wings surmounted by a *muqarnas* decoration which shows traces of painting representing flowers and leaves in red and green. The triangular sides are decorated with a pattern of grooved strapwork radiating from sixteen-point stars, the various sections of which are filled with small, finely carved ivory tiles. The balustrades consist of rectangular panels decorated in a similar way; in their geometrical organisation they are reminiscent of full-page illuminations in Mamluk Qurans. A wooden *minbar* obviously based on the one shown here is that made in 1480 for the mosque of Qajmas al-Ishaqi, one of Qa'itbay's amirs; it remains *in situ* and is almost identical in shape and decoration. Qa'itbay's *minbar* is possibly one of the last examples of Mamluk wood-work to use ivory inlay; that of Qajmas al-Ishaqi has bone inlay, reflecting the current economic need to use inexpensive materials.

The word *minbar* is often pronounced, and therefore transcribed, as *mimbar*, but it comes from the root 'n-b-r' which in Arabic means 'high, elevation, stand'; it is more probably a loan-word from the Ethiopic, with the sense of 'seat, chair'. The *minbar* was primarily the throne of the Prophet in his capacity as a ruler, for the proclamation of important announcements. It is reported that the Prophet's *minbar* consisted of two steps and a seat. It was portable and indispensable for later rulers when they wished to make a public appearance. The *minbar* was used by early Islamic rulers or their governors as a seat from which to address the Muslims at the Friday worship, in keeping with the additional use of mosques in the Umayyad period as places of political assembly. Its function as a purely religious pulpit seems to have been established towards the end of the Umayyad period, and by the 8th century it had started to become a standard item of mosque furniture throughout the Islamic world.

As a symbol of authority the *minbar* was an important feature not only of the mosque, but also of the community. Muslim towns could be categorised according to whether or not they had a *minbar*, cities with more than one being considered prosperous.

The shape of the present *minbar*, with a domed canopy, a doorway and decorative elements consisting of stars and polygons made up of carved pieces of wood, became standard in Egypt, Syria and Turkey from the Fatimid period onwards. During the Mamluk period elaborate inlay of ivory, mother-of-pearl and various types of wood began to be used. The *minbar* on exhibition is a superb example of this late Mamluk type. *AC*

Provenance: from the Meymar Collection; 1869, purchased by the museum

Exhibition: Paris 1867

Bibliography: Lane-Poole, 1886, pp. 113–15, fig. 34; Sourdel-Thomine and Spuler, 1973, no. 309; Blair and Bloom, 1994, pp. 109–10, fig. 141

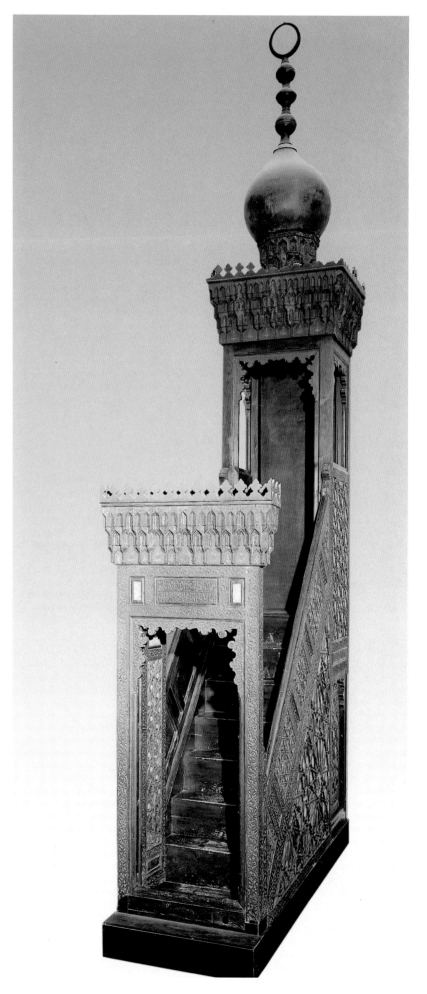

BIBLIOGRAPHY

ABBINK, 1994 J. Abbink, 'Review of Sleeping Beauties', *Museum Anthropology*, 18 (3), 1994, pp. 81–2

ABIODUN, DREWAL and PEMBERTON, 1991 R. Abiodun, H. J. Drewal and J. Pemberton, *Yoruba Art and Aesthetics*, Zurich, 1991

ABRAHAM, 1940 R. C. Abraham, *The Tiv People*, London, 1934, 2nd edn 1940

ABRAHAMS, 1967 R. G. Abrahams, *Peoples of Greater Unyamwezi, Tanzania*, London, 1967

ABRAHAMS, 1981 R. G. Abrahams, *The Nyamwezi Today: A Tanzanian People in the 1970s*, Cambridge, 1981

ADAMS, 1974 B. Adams, *Ancient Hierakonpolis*, Warminster, 1974

ADAMS, 1977 W. Y. Adams, *Nubia, Corridor to Africa*, London, 1977

ADAMS, 1978 M. Adams, 'Kuba Embroidered Cloth', *African Arts*, 12 (1), 1978, pp. 24–39, 106–7

ADAMS, 1988[1] V. Adams, *Predynastic Egypt*, Aylesbury, 1988

ADAMS, 1988[2] M. Adams, 'Double Perspectives: Masking Among the Wè/Guéré, Ivory Coast', *College Art Journal*, 47 (2), 1988, pp. 95–102

ADAMS, 1989 M. Adams, 'Beyond Symmetry in Middle African Design', *African Arts*, 23 (1), 1989, pp. 35–43, 102–3

ADANDE, 1994 C. Adande, 'Le Bochio: Une sculpture de rien qui cache tout', in *Mélanges Jean Pliya*, Cotonou, 1994, pp. 111–34

ADEOYE, 1989 C. L. Adeoye, *Igbagbo ati Esin Yoruba*, Ibadan, 1989

ADIE, 1952 J. J. Adie, 'Zanzibar Doors', *Guide to Zanzibar*, Zanzibar, 1952, pp. 114–16

AFOLAYAN, 1989 F. S. Afolayan, 'The Esie Lithic Culture: Perspectives from the Igbomina Tradition', paper presented at the Seminar on Material Culture, Monuments and Festivals in Kwara State, National Museum, Esie, Nigeria, 1989

AGIRI, 1972 B. A. Agiri, 'The Ogboni among the Oyo-Yoruba', *Lagos Notes and Records*, 3 (2), 1972, pp. 50–9

AL-HASSAN and HILL, 1992 A. Y. Al-Hassan and D. R. Hill, *Islamic Technology: An Illustrated History*, Cambridge, 1992

AL-JAZARI, 1949 Al-Jazari, *La chronique de Damas d'al-Jazari*, trans. J. Sauvaget, Paris, 1949

ALDRED, 1971 C. Aldred, *Jewels of the Pharaohs*, London, 1971

ALDRED, 1975 C. Aldred, *Akhenaton and Nefertiti*, Brooklyn Museum, New York, 1975

ALDRED, 1979 C. Aldred, in *Le temps de pyramides*, ed. J. Leclant, Paris, 1979

ALDRED, 1980[1] C. Aldred, *Egyptian Art*, New York and Toronto, 1980

ALDRED, 1980[2] C. Aldred, *Egyptian Art in the Days of the Pharaohs, 3100–320 B.C.*, London, 1980

ALDRED, 1988 C. Aldred, *Akhenaten, King of Egypt*, London, 1988

ALDRICH, 1990 J. Aldrich, 'The Nineteenth-century Carved Wooden Doors of the East African Coast', *Azania*, 25, 1990, pp. 1–18, pls 1–16

ALEXANDRE and BINET, 1958 P. Alexandre and J. Binet, *Le groupe dit Pahouin*, Paris, 1958

ALEXIS, 1888 M. Alexis, *Le Congo belge illustré*, Liège, 2/1888

ALLDRIDGE, 1901 T. J. Alldridge, *The Sherbro and its Hinterland*, London, 1901, pp. 144–9

ALLEN, 1976 J. Allen, 'A Somali Headrest', *MILA Institute of African Studies, University of Nairobi*, 5 (2), 1976, pp. 42–58

ALLEN, 1989 J. de Vere Allen, 'The *Kiti Cha Enzi* and other Swahili Chairs', *African Arts*, 22 (3), 1989, 54–64

ALLISON, 1944 P. A. Allison, 'A Yoruba Carver', *Nigerian Magazine*, 22, 1944, pp. 49–50

ALLISON, 1952 P. A. Allison, 'Travelling Commissioners of the Ekiti Country', *Nigerian Field*, 17, 1952, pp. 100–15

ALLISON, 1962 P. Allison, 'Carved Stone Figures in the Ekoi County of the Middle Cross River', *Man*, 15, 1962

ALLISON, 1968 P. Allison, *Cross River Monoliths*, Lagos, 1968

ALMAGRO, 1965[1] M. Almagro, *La Necrópolis Meroitica de Nelluah*, Madrid, 1965

ALMAGRO, 1965[2] M. Almagro, *La Necrópolis Meroitica de Nag Gamus*, Madrid, 1965

ALMAGRO et al., 1965 M. Almagro et al., 'Excavations by the Spanish Archaeological Mission in the Sudan, 1962–3 and 1963–4', *Kush*, 13, 1965, pp. 78–95

ALPERS, 1966 E. A. Alpers, 'The Role of the Yao in the Development of Trade in East Central Africa, 1698-ca. 1850', diss., University of London, 1966

ALPERS, 1969 E. Alpers, 'Trade, State and Society Among the Yao in the Nineteenth Century', *Journal of African History*, 10, 1969, pp. 405–20

AMON D'ABY, 1960 F. J. Amon D'Aby, *Croyances religieuses et coutumes juridiques des Agni de la Côte d'Ivoire*, Paris, 1960

ANDREWS, 1984 C. Andrews, *Egyptian Mummies*, London, 1984

ANDREWS, 1990[1] C. Andrews, *Ancient Egyptian Jewellery*, London, 1990

ANDREWS, 1990[2] C. Andrews, *Egyptian Mummies*, London, l990

ANDREWS, 1994 C. Andrews, *Amulets of Ancient Egypt*, London, 1994

ANGAS, 1849 G. F. Angas, *The Kafirs Illustrated*, London, 1849

ANQUANDAH, 1987[1] J. Anquandah, 'L'art du Komaland. Une découverte récente au Ghana septentrional', *Arts d'Afrique Noire*, 62, 1987, pp. 11–18

ANQUANDAH, 1987[2] J. Anquandah, 'The Stone Circle Sites of Komaland: Northern Ghana in West African Archaeology', *African Archaeological Review*, 5, 1987

ANQUANDAH, n. d. J. Anquandah, 'Koma-Builsa – its Art and Archaeology' [unpublished MS]

ANQUANDAH and VAN HAM, 1985 J. Anquandah and L. van Ham, *Discovering the forgotten 'civilisation' of Komaland, Northern Ghana*, Rotterdam, 1985

ANTWERP 1975 *Afrikaanse beeldhouwkunst nieuw zicht op een erfgoed/Sculptures africaines nouveau regard sur un héritage*, exh. cat. ed. P. Guimot, Antwerp, 1975

ARBERRY, 1955 A. J. Arberry, *The Koran Interpreted*, London, 1955

ARMITAGE and CLUTTON-BROCK, 1980 P. L. Armitage and J. Clutton-Brock, 'An Investigation of the Mummified Cats held by the British Museum (Natural History)', *Museum of Applied Science Centre for Archaeology Journal*, Mummification Supplement, 1 (6), l980, pp. 185–8

ARNOLDI, 1986 M. J. Arnoldi, 'The Artistic Heritage of Somalia', in *Somalia in Word and Image*, ed. K. S. Loughran et al., Washington, 1986

ARNOLDI and KRAEMER, 1995 M. J. Arnoldi and C. M. Kraemer, *Crowning Achievements: African Arts of Dressing the Head*, Los Angeles, 1995

ARUNDALE, BONOMI and BIRCH, 1840 *Gallery of Antiquities Selected from the British Museum*, 1840

ASLANAPA, 1977 O. Aslanapa, *Yüzyıllar Boyunca Türk Sanati*, Ankara, 1977

ASSELBERGHS, 1961 H. Asselberghs, *Chaos en Beheersing: Documenten uit Aeneolithisch Egypte*, Leiden, 1961

ASTUTI, 1994 R. Astuti, 'Invisible Objects: Mortuary Rituals among the Vezo of Western Madagascar', *RES*, 25, 1994, pp. 111–22

ATANDA, 1973 J. A. Atanda, 'The Yoruba Ogboni Cult: Did it exist in Old Oyo?', *Journal of the Historical Society of Nigeria*, 6 (4), 1973, pp. 365–72

ATIL, 1981 E. Atil, *Renaissance of Islam: Art of the Mamluks*, exh. cat., Washington, 1981

ATIYA, 1991 A. S. Atiya, *The Coptic Encyclopedia*, New York, 1991

AUBET, 1993 M. E. Aubet, *The Phoenicians and the West*, trans. M. Turton, Cambridge, 1993 [*Tiro y las colonias fenicias de Occidente*, 1987]

AWOLALU, 1979 O. J. Awolalu, *Yoruba Beliefs and Sacrificial Rites*, London, 1979

AYRTON et al., 1904 E. R. Ayrton et al., *Abydos*, iii, London, 1904

BADAWY, 1978 A. Badawy, *Coptic Art and Archaeology: The Art of the Christian Egyptians from the Late Antique to the Middle Ages*, London, 1978

BAGINSKI and TIDHAR, 1980 A. Baginski and A. Tidhar, *Textiles from Egypt 4th–13th Centuries*, 1980

BAINES, 1975 J. Baines, 'Ankh-sign, Belt and Penis Sheath', *Studien zu altägyptischer Kultur*, 3, 1975, pp. 1–24

BAINES and MALEK, 1980 J. Baines and J. Malek, *Atlas of Ancient Egypt*, Oxford, 1980

BAKRY, 1969 H. S. K. Bakry, *Zeitschrift der deutschen morgenländischen Gesellschaft*, suppl. 1, 1969, p. 21

BAKRY, 1971 H. S. K. Bakry, *Mitteilungen des deutschen archäologischen Instituts, Abteilung Kairo*, 27, 1971, pp. 138–9, pls 30–1

BALDAOUI, 1942 J. Baldaoui, *Les tapis*, 1942

BALFET, 1956 H. Balfet, 'Les poteries modelées d'Algérie', in *Libyca*, Algiers, 1956

BALOUT, 1958 L. Balout, *L'Algérie préhistorique*, Paris, 1958

BALTIMORE et al. 1993–6 *African Zion: The Sacred Art of Ethiopia*, exh. cat. by M. Heldman with R. Grierson and S. C. Munro-Hay, Walters Art Gallery, Baltimore et al., 1993–6

BALTY et al., 1988 J. C. Balty, H. de Meulenaere, D. Homes-Frédéricq, L. Limme, J. Strybol and L. Vandenberghe, *Musées royaux d'art et d'histoire. Bruxelles. Antiquité*, Musea Nostra 11, Brussels, 1988

BARBIER, 1993 J. P. Barbier, ed., *Art of Côte d'Ivoire from the Collections of the Barbier-Mueller Museum*, 2 vols, Geneva, 1993

BARLEY, 1984 N. Barley, 'Placing the West Africa Potter', in *Earthenware in Asia and Africa*, ed. J. Picton, London, 1984

BARLEY, 1988 N. Barley, *Foreheads of the Dead: An Anthropological View of Kalabari Ijaw Ancestral Screens*, Washington, 1988

BARLEY, 1989 N. Barley, *Native Land*, London, 1989

BARLEY, 1994 N. Barley, *Smashing Pots: Feats of Clay from Africa*, London, 1994

BARRETT, 1911 W. E. H. Barrett, 'Notes on the Customs of the Wa-Giriama', *Journal of the Royal Anthropological Institute*, 41, 1911, pp. 20–8

BARRETT, 1949 D. Barrett, *Islamic Metalwork in the British Museum*, London, 1949

BARRUCAND, 1978 M. Barrucand, 'Structures et décors des charpentes alaouides à partir d'exemples de Meknès', *Bulletin d'archéologie marocaine*, 11, 1978, pp. 115–56

BASLE 1977 *Als die Sahara grün… Würfelsbilder aus der Saguia el-Hamra*, exh. cat. by S. Haas, Museum für Völkerkunde, Basle, 1977

BASSANI, 1976 E. Bassani, 'I Mintadi del Museo Pigorini', *Critica d'Arte*, 1976, pp. 49–64

BASSANI, 1977 E. Bassani, 'Oggetti africani in antiche collezioni italiane', *Critica d'arte*, 42 (151), 1977, pp. 151–82

BASSANI, 1979 E. Bassani, 'Sono from Guinea Bissau', *African Arts*, 12 (4), 1979, pp. 44–7, 91

BASSANI, 1989 E. Bassani, *La grande scultura dell'Africa Nera*, Florence, 1989

BASSANI, 1994 E. Bassani, 'Additional Notes on the Afro-Portuguese Ivories', *African Arts*, 27 (3), 1994, pp. 34–45

BASSANI, E. Bassani, 'Les sculptures Vallisnieri', *Africa-Tervuren*, 14 (1), pp. 15–22

BASSANI and FAGG, 1988 E. Bassani and W. Fagg, *Africa and the Renaissance*, New York, 1988

BASSANI and McLEOD, 1989 E. Bassani and M. M. McLeod, *Jacob Epstein Collector*, Milan, 1989

BASSING, 1973 A. Bassing, 'Grave Monuments of the Dakakari', *African Arts*, 6 (4), 1973, pp. 36–9

BASTIN, 1961[1] M.-L. Bastin, *Art décoratif Tshokwe*, Lisbon, 1961

BASTIN, 1961[2] M.-L. Bastin, 'Quelques oeuvres Tshokwe de musées et collections d'Allemagne et de Scandinavie', *Africa-Tervuren*, 7 (4), 1961, pp. 101–5

BASTIN, 1965 M.-L. Bastin, 'Tshibinda Ilunga: à propos d'une statuette de chasseur ramenée par Otto H. Schütt en 1880', *Baessler-Archiv*, new series, xiii, 1965, pp. 501–37

BASTIN, 1968 M.-L. Bastin, 'L'art d'un peuple d'Angola: i, Tshokwe', *African Arts*, 2 (1), 1968, pp. 40–6, 60–4

BASTIN, 1969 M.-L. Bastin, 'Quatre statuettes anciennes de chef Tshokwe', *Africa-Tervuren*, 15 (1), 1969, pp. 1–8

BASTIN, 1976 M.-L. Bastin, 'Les styles de la sculpture Tshokwe', *Arts d'Afrique Noire*, 19 (3), 1976, pp. 16–35

BASTIN, 1978 M.-L. Bastin, *Statuettes Tshokwe du héros civilisateur 'Tshibinda Ilunga'*, Arnouville, 1978

BASTIN, 1981 M.-L. Bastin, 'Quelques oeuvres Tshokwe: une perspective historique', *Antologia di Belle Arti*, 17–18, 1981, pp. 83–104

BASTIN, 1982 M.-L. Bastin, *La sculpture Tshokwe*, Meudon, 1982

BASTIN, 1984 M.-L. Bastin, *Introduction aux arts d'Afrique noire*, Arnouville, 1984

BASTIN, 1988 M.-L. Bastin, 'Les Tshokwe du pays d'origine', in *Art et Mythologie, Figurines tshokwe*, Paris, 1988, pp. 49–68

BASTIN, 1992 M.-L. Bastin, 'The Mwanangana Chokwe Chief and Art (Angola)', in *Kings of Africa: Art and Authority in Central Africa*, Maastricht, 1992, pp. 64–70

BASTIN, 1994 M.-L. Bastin, *Sculpture angolaise. Mémorial de cultures*, exh. cat., Lisbon, 1994

BATES and DUNHAM, 1927 O. Bates and D. Dunham, 'Excavations at Gemai', *Harvard African Studies*, 7, 1927, pp. 1–122

BAUMANN, 1935 H. Baumann, *Lunda. Bei Bauern und Jägern in Inner-Angola*, Berlin, 1935

BAUMGARTEL, 1955 E. Baumgartel, *The Cultures of Prehistoric Egypt*, i, London, 1955

BAUMGARTEL, 1960 E. Baumgartel, *The Cultures of Predynastic Egypt*, ii, Oxford, 1960

BAUMGARTEL, 1970[1] E. J. Baumgartel, *Petrie's Naqada Excavation: A Supplement*, London, 1970

BAUMGARTEL, 1970[2] E. J. Baumgartel, 'Some Additional Remarks on the Hierakonpolis Ivories', *Journal of the American Research Centre in Egypt*, 7, 1970, pp. 7–14

BAXTER and ALMAGOR, 1978 P. J. W. Baxter and U. Almagor, eds, *Age, Generation and Time*, London, 1978

BEAUMONT, 1990[1] P. B. Beaumont,'Kathu Pan', in P. Beaumont and D. Morris, *Guide to archaeological sites in the Northern Cape*, Kimberley, 1990

BEAUMONT, 1990[2] P. B. Beaumont, 'Wonderwerk Cave', in P. Beaumont and D. Morris, *Guide to archaeological sites in the Northern Cape*, Kimberley, 1990

BEAUMONT and VOGEL, 1984 P. B. Beaumont and J. C. Vogel, 'Spatial Patterning of the Ceramic Later Stone Age in the Northern Cape Province, South Africa', in *Frontiers: Southern African Archaeology Today*, ed. M. Hall et al., BAR International Series 207, Oxford, 1984, pp. 80–95

BEAUMONT and VOGEL, 1989 P. B. Beaumont and J. C. Vogel, 'Patterns in the Age and Context of Rock Art in the Northern Cape', *South African Archaeological Bulletin*, 44, 1989, pp. 73–81

BECKER 1991 R. L. Becker, 'Headrests: Tsonga Types and Variations', in *Art and Ambiguity: Perspectives on the Brenthurst Collection of Southern African Art*, exh. cat., Johannesburg, 1991, pp. 58–76

BECKER and NETTLETON, 1989 R. Becker and A. Nettleton, 'Tsonga-Shangana Beadwork and Figures', in *Ten Years of Collecting: The Standard Bank Foundation Collection of African Art*, exh. cat., Johannesburg, 1989, pp. 9–15

BECKER-DONNER, 1940 E. Becker-Donner, 'Kunst und Handwerk in No-Liberia', *Baessler Archiv*, 23 (2/3), 1940

BECKWITH, 1963 J. Beckwith, *Coptic Sculpture*, London, 1963

BECKWITH and VAN OFFELEN, 1983 C. Beckwith and Van Offelen, *Nomads of Niger*, New York, 1983

BEDAUX, 1977 R. Bedaux, *Tellem*, Berg en Dal, 1977

BEDAUX and LANGE, 1983 R. Bedaux and A. Lange, 'Tellem, reconnaissance archéologique d'une culture de l'Ouest africain au Moyen Âge: La poterie', *Journal de la Société des Africanistes*, 53, 1983, pp. 5–59

BEIDELMAN, 1967 T. O. Beidelman, *The Matrilineal Peoples of Eastern Tanzania*, London, 1967

BEIDELMAN, 1971 T. O. Beidelman, *The Kaguru: A Matrilineal People of East Africa*, New York, 1971

BEIER, 1954 U. Beier, 'Festival of the Images', *Nigeria*, 45, 1954, pp. 14–20

BEIER, 1957 U. Beier, *The Story of Sacred Wood Carvings from One Small Yoruba Town*, Lagos, 1957

BEIER, 1959 U. Beier, *A Year of Sacred Festivals in One Yoruba Town*, Lagos, 1959

BEIER, 1960 U. Beier, *Art in Nigeria*, Cambridge, 1960

BEL, 1939 M. Bel, *Les arts indigènes féminins en Algérie*, Algiers, 1939

BELEPE BOPE MABINTSH, 1978 'Les oeuvres plastiques africaines comme documents historiques', *Likundoli*, 1978 [unpublished MS]

BELEPE BOPE MABINTSCH, 1988 *La triade des masques Bwoom Mosh'ambooy et Ngady a mwaash*, 1988

BELZONI, 1820 G. Belzoni, *Narrative of the Operations and Recent Discoveries within the Pyramids, Temples, Tombs and Excavations in Egypt and Nubia*, London, 1820

BEN-AMOS, 1980 P. Ben-Amos, *The Art of Benin*, London, 1980

BÉNABOU, 1976 M. Bénabou, *La résistance africaine à la romanisation*, Paris, 1976

BENAZETH and GABRA, 1992 D. Benazeth and G. Gabra, *L'art du métal au début de l'ère chrétienne*, Paris, 1992

BENT, 1896 J. T. Bent, *The Ruined Cities of Mashonaland*, London, 1896

BERGLUND, 1976 A.-I. Berglund, *Zulu Thought-Patterns and Symbolism*, Cape Town, 1976

BERLIN 1974 *Frühe Stufen der Kunst: Propyläen Kunstgeschichte*, 13, ed. M. Mellink and J. Filip, Berlin, 1974, p. 244, pl. XXXI

BERLIN 1976 *Ägyptische Kunst aus dem Brooklyn Museum*, exh. cat. ed. J. S. Karig and K.-T. Zauzich, Ägyptisches Museum der Staatlichen Museen, Preussischer Kulturbesitz, Berlin, 1976

BERLIN 1989 *Europa und der Orient, 800–1900*, exh. cat. ed. G. Sievernich and H. Budde, Martin-Gropius-Bau, Berlin, 1989

BERLIN and MUNICH 1994 *Tanzania: Meisterwerke Afrikanischer Skulptur*, exh. cat. with introductory text by M. Felix and M. Kecskési and contributions by G. Blesse et al., Haus der Kulturen der Welt, Berlin, 1994; Städtische Galerie im Lenbachhaus, Munich, 1994

BERLYN, 1968 P. Berlyn, 'Some Aspects of the Material Culture of the Shona People', *Native Affairs Department Annual*, 9 (5), 1968, pp. 68–73

BERNATZIK et al., 1947 H. A. Bernatzik et al., *Afrika: Handbuch der angewandten Völkerkunde*, Innsbruck, 1947

BERNES, 1974 J. P. Bernes, *Brocarts et soieries de Fès en Maroc: Costumes, broderies, brocarts*, Paris, 1974, pp. 26–50

BERNS, 1993 M. C. Berns, 'Art, History and Gender: Women and Clay in West Africa', *African Archaeological Review*, 11, 1993, pp. 129–48

BERNUS, 1981 E. Bernus, *Touaregs Nigériens*, Paris, 1981

BERQUE, 1959 J. Berque, *Les Arabes*, Paris, 1959, cover illus.

BERTRAND, 1898 Bertrand, *Au pays des Ba-Rotsi*, 1898

BESANCENOT, 1953 J. Besancenot, *Bijoux arabes et berbères du Maroc*, Casablanca, 1953

BEUMERS and KOLOSS, 1992 E. Beumers and H. J. Koloss, eds, *Kings of Africa*, exh. cat., Maastricht, 1994

BIEBUYCK, 1973 D. P. Biebuyck, *Lega Culture: Art, Initiation and Moral Philosophy among a Central African People*, Berkeley, 1973

BIEBUYCK, 1976 D. P. Biebuyck, 'Sculpture from the Eastern Zaire Forest Regions: Mbole, Yela and Pere', *African Arts*, 10 (1), 1976, pp. 54–61

BIEBUYCK, 1981[1] D. P. Biebuyck, 'Plurifrontal Figurines in Lega Art (Zaire)', in *The Shape of the Past: Studies in Honour of Franklin D. Murphy*, ed. G. Buccellati and C. Speroni, Berkeley, 1981, pp. 115–27

BIEBUYCK, 1981[2] D. P. Biebuyck, *Statuary of the pre-Bembe Hunters*, Tervuren, 1981

BIEBUYCK, 1985 D. Biebuyck, *The Arts of Zaire: Southwestern Zaire*, Berkeley, 1985

BIEBUYCK, 1986 D. P. Biebuyck, *The Arts of Zaire: Eastern Zaire, The Ritual and Artistic Context of Voluntary Associations*, Berkeley, 1986

BIEBUYCK, 1987 D. P. Biebuyck, *The Arts of Central Africa: An Annotated Bibliography*, Boston, 1987

BIEBUYCK, 1992[1] D. Biebuyck, *Kings of Africa*, Maastricht, 1992, p. 315

BIEBUYCK, 1992[2] D. P. Biebuyck, 'Religie in Central-Afrika', in Maastricht 1992, pp. 29–31

BIOBAKU, 1952 S. O. Biobaku, 'An Historical Sketch of Egba Traditional Authorities', *Africa*, 22 (1), 1952, pp. 35–49

BIOBAKU, 1956 S. O. Biobaku, 'Ogboni, the Egba Senate', in *Proceedings of the Third International West African Conference, Ibadan, December 12–21, 1949*, Lagos, 1956, pp. 257–63

BITIYONG, 1993–4 Y. Bitiyong, 'Culture Nok, Nigeria', in *Vallées du Niger*, exh. cat. ed. J. Devisse, Paris, 1993–4

BLACKING, 1969 J. Blacking, 'Songs, Dances, Mimes and Symbolism of Venda Girls' Initiation School, Part 4: The Great Domba Song', *African Studies*, 28, 1969, pp. 215–66

BLACKING, 1985 J. Blacking, 'The Great Enclosure and Domba', *Man*, 20, 1985

BLAIR and BLOOM, 1994 S. Blair and J. Bloom, *The Art and Architecture of Islam 1250–1800*, New Haven, 1994

BLANDIN, 1988 A. Blandin, *Afrique de l'Ouest: Bronzes et autres alliages*, Louvain, 1988

BLANDIN, 1992 A. Blandin, *'Fer Noir' d'Afrique de l'Ouest*, Salon-de-Provence, 1992

BLEEK and LLOYD, 1911 W. H. I. Bleek and L. C. Lloyd, *Specimens of Bushman Folklore*, London, 1911

BLIER, 1995 P. S. Blier, *Vodun: Art, Psychology and Power*, Chicago, 1995

BLOCH, 1971 M. Bloch, *Placing the Dead: Tombs, Ancestral Villages and Kinship Organizations in Madagascar*, London, 1971

BLOCH, 1982 M. Bloch, *Death and the Regeneration of Life*, Cambridge, 1982

BLOHM, 1933 W. Blohm, *Die Nyamwezi: Gesellschaft und Weltbild*, Hamburg, 1933

BLOOD, 1935 A. Blood, *The Dawn of a Diocese*, London, 1935

BOGAERTS, 1950 H. Bogaerts, 'Bij de Basala Mpasu, de Koppensnellers van Kasai', *Zaire*, 4 (4), 1950, pp. 379–419

BOHANNAN, 1957 P. Bohannan, 'Artist and Critic in an African Society', in *The Artist and Critic in Tribal Society*, ed. M. H. Smith, New York, 1957, pp. 85–94

BONNENFANT, BONNENFANT and AL-HARTHI, 1977 P. and G. Bonnenfant and S. H. S. al-Harthi, 'Architecture and Social History at Mudayrib', *Journal of Oman Studies*, 3 (2), 1977, pp. 107–35, pls XXVII, XLa–b, XLIa–c, XLIIa

BONNET, 1990 C. Bonnet, ed., *Kerma, royaume de Nubie*, Geneva, 1990

BONTINCK, F. Bontinck, 'La provenance des sculptures Vallisnierie', *Africa-Tervuren*, 25 (4), pp. 88–91

BOONE, 1986 S. Boone, *Radiance from the Waters*, New Haven, 1986

BOSCH, 1930 Rev. P. Fr. Bosch, *Les Banyamwezi: Peuple de l'Afrique Orientale*, Munster, 1930

BOSTON, 1977 J. S. Boston, *Ikenga Figures among the Northwest Igbo and the Igala*, London, 1977

BOSTON 1982 *Egypt's Golden Age: The Art of Living in the New Kingdom 1558–1085 BC*, exh. cat. ed. E. Brovarski, S. Dolland, R. Freed, Museum of Fine Arts, Boston, 1982

BOSTON and DALLAS, 1992 *Mummies and Magic: The Funerary Arts of Ancient Egypt*, exh. cat. by S. d'Auria, P. Lacovara, C. M. Roehrig, Museum of Fine Arts, Boston, Dallas Museum of Art, 1992

BOTHMER, 1948 B. V. Bothmer, 'A Pre-dynastic Egyptian Hippopotamus', *Bulletin of the Museum of Fine Arts*, Boston, 265, 1948, p. 69

BOTHMER, 1949 B. V. Bothmer, 'The Dwarf as Bearer', *Bulletin of the Museum of Fine Arts*, Boston, 47, 1949, p. 9 ff

BOTHMER, 1979 B. V. Bothmer, 'Ancient Nubia and the Northern Sudan: A New Field of Art History', *Meroitica*, 5, 1979, pp. 177–80

BOTHMER, 1982 B. V. Bothmer, 'On Realism in Egyptian Funerary Sculpture of the Old Kingdom', *Expedition*, 24 (1), Winter 1982, pp. 27–39

BOUDRY, 1933 R. Boudry, 'L'art décoratif malgache', *Revue de Madagascar*, pp. 12–71

BOUKOBZA, 1974 A. Boukobza, *La poterie marocaine*, Casablanca, 1974

BOULORÉ, 1992 V. Bouloré, 'Review Cuillers-Sculptures', *African Arts*, 25 (1), 1992, pp. 85–6

BOURGEOIS, 1984 A. Bourgeois, *Art of the Yaka and Suku*, Meudon, 1984

BOURGUET, 1968 P. du Bourguet, *L'art copte*, Paris, 1968

BOURRIAU, 1981 J. D. Bourriau, ed., *Umm el-Ga'ab : Pottery from the Nile Valley before the Arab Conquest*, exh. cat., Fitzwilliam Museum, Cambridge, 1981

BOURRIAU, 1985 J. Bourriau, 'Technology and Typology of Egyptian Ceramics', in *Ancient Technology and Modern Science*, ed. W. D. Kingery, *Ceramics and Civilization*, i, Columbus, OH, 1985, pp. 27–42

BOURRIAU, 1987 J. Bourriau, 'Pottery Figure Vases of the New Kingdom', *Cahiers de la céramique égyptienne*, i, 1987, pp. 81-96

BOUYSSONIE, 1956 J. Bouyssonie, *Collections préhistoriques: Musée d'Ethnographie et de Préhistoire du Bardo (Alger)*, Album 1, Paris, 1956

BRAIN, 1962 J. Brain, 'The Kwere of the Eastern Province', *Tanganyika Notes and Records*, 58–9, 1962, pp. 231–41

BRAIN, 1972 R. Brain, *Bangwa Kinship and Marriage*, Cambridge, 1972

BRAIN and POLLACK, 1971 R. Brain and A. Pollack, *Bangwa Funerary Art*, London, 1971

BRAVMANN, 1974 R. A. Bravmann, *Islam and Tribal Art in West Africa*, Cambridge, 1974

BRAVMANN, 1979 R. A. Bravmann, 'Gur and Manding Masquerades in Ghana', *African Arts*, 13 (1), 1979, pp. 44–51

BRAVMANN, 1983 R. Bravmann, *African Islam*, Washington, 1983

BRAZZA, 1887–8 S. de Brazza, '3 explorateurs dans l'Ouest Africain', *Le Tour du Monde*, 1887–8

BRETT-SMITH, 1983 S. C. Brett-Smith, 'The Poisonous Child', *Res*, 6, Autumn 1983, pp. 47–64

BRINCARD, 1982 M. T. Brincard, ed., *The Art of Metal in Africa*, New York, 1982

BRINK, 1981 J. T. Brink, 'The Antelope Headdress (Chi Wara)', in *For Spirits and Kings: African Art from the Tishman Collection*, ed. S. Vogel, New York, 1981

BRITISH MUSEUM guide, 1909 British Museum, *A Guide to the Egyptian Galleries (Sculpture)*, London, 1909

BROOKLYN 1978 *Africa in Antiquity: The Arts of Ancient Nubia and the Sudan*, exh. cat. by S. Wenig, Brooklyn Museum, Brooklyn, 1978

BROOKS, 1972 G. Brooks, *The Kru Mariner in the Nineteenth Century*, Newark, DE, 1972

BROVARSKI et al., 1982 E. Brovarski et al., eds, *Egypt's Golden Age: The Art of Living in the New Kingdom 1558–1085 BC*, exh. cat., Boston, 1982

BROWN, 1944 H. D. Brown, 'The Nkumu of the Tumba: Ritual Chieftainship on the Middle Congo', *Africa*, 14, 1944, pp. 431–47

BROWN, 1971 J. Brown, 'Borana Kalacha Cire Perdue Casting', *Kenya Past and Present*, 1 (1), 1971

BRUCE, 1976 H. J. Bruce, 'The arts and crafts of the Transvaal Ndebele', in *Africana Byways*, ed. A. H. Smith, 1976, pp. 133–50

BRUNNER-TRAUT, 1956 E. Brunner-Traut, *Die altägyptischen Scherbenbilder (Bildostraka) der deutschen Museen und Sammlungen*, Wiesbaden, 1956

BRUNTON, 1927 G. Brunton, *The Badarian Civilization*, British School of Archaeology in Egypt, xlvi, Cairo, 1927

BRUNTON and CATON-THOMPSON, 1928 G. Brunton and G. Caton-Thompson, *The Badarian Civilization and the Predynastic Remains near Badari*, London, 1928

BRUSSELS 1976–7 *Égypte éternelle: Chefs d'oeuvre du Brooklyn Museum/Egypte's Glorie: Meesterwerken van het Brooklyn Museum*, exh. cat. ed. H. De Meulenaere and L. Limme, Palais des Beaux-Arts, Brussels, 1975–6

BRUSSELS 1977 *Arts premiers d'Afrique noire*, exh. cat. by P. Guimot, Studio 44, Brussels, 1977

BRUSSELS 1988 *Des animaux et des hommes: Témoignages de la Préhistoire et de l'Antiquité*, exh. cat., Crédit Communal, Brussels, 1988

BRUSSELS 1992 *Beauté fatale. Armes d'Afrique centrale*, exh. cat. by J. Cornet et al., Crédit Communal, Brussels, 1992

BRUYÈRE, 1937 B. Bruyère, *Rapport sur les fouilles de Deir-el-Medineh (1934–35)*, Fouilles de l'Institut Français Archéologique de l'Orient du Caire, XV, 2: *La nécropole de l'Est*, Cairo, 1937

BRYANT, 1949 P. T. Bryant, *The Zulu People, as they were before the White Man Came*, Pietermaritzburg, 1949

BUDGE, 1904 E. A. W. Budge, *British Museum: A Guide to the Third and Fourth Egyptian Rooms*, London, 1904

BULTÉ, 1991 J. Bulté, *Talismans Égyptiens d'heureuse maternité*, Paris, 1991

BURSSENS, 1958[1] H. Burssens, 'La fonction de la sculpture traditionnelle chez les Ngbaka', *Brouse*, Leopoldville, 1958, pp. 10–28

BURSSENS, 1958[2] H. Burssens, *Les peuplades de l'entre Congo-Ubangi (Ngbandi, Ngbaka, Mbandja, Ngombe et Gens d'Eau)*, Tervuren, 1958

BURSSENS, 1962 H. Burssens, *Yanda-beelden en Mani-sekte bij de Zande*, Tervuren, 1962

BURSSENS, 1993 H. Burssens, 'Mask Styles and Mask Use in the North of Zaire', in F. Herreman and C. Petridis, eds *Face of the Spirits. Masks from the Zaire Basin*, Ghent, 1993

BURSSENS and GUISSON, 1992 H. Burssens and A. Guisson, *Mangbetu. Art de cour africain de collections privées belges*, Brussels, 1992

BURSTEIN, 1993 S. M. Burstein, 'The Hellenistic Fringe: The Case of Meroe', in *Hellenistic History and Culture*, ed. P. Green, Berkeley, Los Angeles and Oxford, 1993, pp. 38–54

BURTON, 1860 R. F. Burton, *The Lake Regions of Central Africa*, 2 vols, London, 1860

BUTLER, 1926 A. J. Butler, *Islamic Pottery: A Study Mainly Historical*, London, 1926

CABRERA, 1970 L. Cabrera, *La Sociedad secreta Abakua narrada por viejos adeptos*, Miami, 1970

CABRERA, 1975 L. Cabrera, *Anaforuana ritual y simbolor de la iniciacior en la sociedad secreta Abakua*, Madrid, 1975

CAIGER-SMITH, 1973 A. Caiger-Smith, *Tin-Glaze Pottery in Europe and the Islamic World*, London, 1973

CAIRO 1969 *Exhibition of Islamic Art in Egypt 969–1517 AD*, exh. cat., The United Arab Republic, Ministry of Culture, Cairo, 1969

CAMARA, 1976 S. Camara, *Gens de la parole*, Paris, 1976

CAMBAZARD-AMAHAN, 1989 C. Cambazard-Amahan, *Le décor sur bois dans l'architecture de Fès*, Paris, 1989

CAMBRIDGE 1981 *Umm el-Ga'ab: Pottery from the Nile Valley before the Arab Conquest*, exh. cat. by J. Bourriau, Fitzwilliam Museum, Cambridge, 1981

CAMBRIDGE and LIVERPOOL 1988 *Pharaohs and Mortals: Egyptian Art in the Middle Kingdom*, exh. cat. by J. Bourriau, Fitzwilliam Museum, Cambridge and Liverpool, 1988

CAMERON, 1988 E. L. Cameron, 'Sala Mpasu Masks', *African Arts*, 22 (1), 1988, pp. 34–43

CAMPS, 1955 G. Camps, 'Recherches sur l'antiquité de la céramique modeleé et peinte en Afrique du Nord,' in *Libyca*, III, Algiers, 1955

CAMPS, 1982 G. Camps, 'Beginnings of Pastoralism and Cultivation in North-West Africa and the Sahara: Origins of the Berbers', in *The Cambridge History of Africa*, ed. J. D. Clark, i, Cambridge, 1982, pp. 548–623

CAMPS-FABRER, 1966 H. Camps-Fabrer, 'Matière et art mobilier dans la préhistoire Nord-Africaine', *Mémoire centre de recherches anthropologiques, préhistoriques et ethno-graphiques*, Algiers, 1966

CANBERRA and MELBOURNE 1990 *Civilisation: Treasures of the British Museum*, exh. cat., Australian National Gallery, Canberra, l990; Museum of Victoria, Melbourne, l990

CAPART, 1905 J. Capart, *Primitive Art in Egypt*, trans. A. S. Griffith, London, 1905

CAPART, 1909 J. Capart, 'Vase préhistorique à décor incisé', *Bulletin des Musées royaux d'art et d'histoire*, 2 (2), 1909, p. 8

CAPE TOWN 1993 *Ezakwantu. Beadwork from the Eastern Cape*, exh. cat. ed. E. Bedford, South African National Gallery, Cape Town, 1993

CAREY, 1986 M. Carey, *Beads and Beadwork of East and South Africa*, London, 1986

CARRIER, 1987 R. Carrier, *Taste of Morocco*, London, 1987

CARROLL, 1967 K. Carroll, *Yoruba Religious Carving*, London, 1967

CELIS, 1970 G. Celis, 'The Decorative Arts in Rwanda and Burundi', *African Arts*, 4 (1), 1970, pp. 40–2

CERULLI, 1959 E. Cerulli, *Scritti vari editi ed inediti*, Rome, 1959

CEYSSENS, 1984 J. H. Ceyssens, *Pouvoir et parenté chez les Kongo-Dinga du Zaire*, Nijmegen, 1984

CHAFFIN, 1980 A. Chaffin, 'Complément d'information sur "L'Art Kota"', French/English, *Arts Afrique Noire*, 33, 1980, pp. 42–3

CHAFFIN and CHAFFIN, 1979 A. and F. Chaffin, *L'Art Kota; les figures de relinquaire*, Meudon, 1979

CHAMPION, 1967 A. Champion, *The Agiryama of Kenya*, London, 1967

CHANTREAUX, 1945 G. Chantreaux, 'Les tissages décorés chez les Beni-Guild', *Hespéris*, 32, 1945, pp. 19–33

CHAPLIN, 1967 J. H. Chaplin, *The Prehistoric Art of the Lake Victoria Region*, diss., Makerere University College, Kampala, 1967

CHIKWENDU et al., 1989 V. E. Chikwendu et al., 'Nigerian Sources of Copper, Lead and Tin for the Igbo-Ukwu Bronzes', *Archaeometry*, 31 (1), 1989, pp. 27–36

CHILDS et al., 1989 S. T. Childs et al., 'Iron and Stone Age Research in Shaba Province, Zaire: An Interdisciplinary and International Effort', *Nyame Akuma*, 32, 1989, pp. 54–9

CHRISTOPHE, 1959 L. Christophe, 'La statue de Ramsès Ier', *La Revue du Caire*, 22e année, xlii (226), June 1959

CHRISTOPHER, 1994 A. J. Christopher, *The Atlas of Apartheid*, Johannesburg, 1994

CHUBB, 1936 E. C. Chubb, 'The Zulu Brass Armlet "Ingzota": A Badge of Distinction', *Man: a Monthly Record of Anthropological Science*, 36, 1936, pp. 251–69

CINTAS, 1970 P. Cintas, *P. Manuel d'archéologie punique*, Paris, 1970

CLAERHOUT, 1988 A. Claerhout, *The Ethnographic Museum Antwerpen*, Tielt, 1988

CLAERHOUT, A. Claerhout, 'Two Kuba Wrought-Iron Statues', *African Arts*, 9 (4), pp. 60–4

CLAMENS, 1953 C. Clamens, 'Notes d'Ethnologie Sénoufo', *Notes africaines*, 59, 1953, pp. 76–80

CLARK, 1938 J. D. Clark, 'The Stone Figures of Esie', *Nigerian Magazine*, 14, 1938, pp. 106–8

CLAYTON, 1993 A. Clayton, *Christianity and Islam: A Study of Religious Appropriation among Makonde*, diss., Manchester University, 1993

CLÉ, 1937 C. Clé, 'Faits divers chez les Basala Mpasu', *Missions de Scheut*, 8, 1937, pp. 247–9

CLÉ, 1948 C. Clé, 'Les Basala Mpasu: Quelques aspects de leur vie', *Missions de Scheut*, 1948, 5, pp. 120–2; 6, pp. 143–7; 10, pp. 246–9; 11, pp. 269–71

COLE, 1969 H. M. Cole, 'Art as a Verb in Igboland', *African Arts*, 3 (1), 1969, pp. 34–41

COLE, 1989 H. M. Cole, *Icons: Ideals and Power in the Art of Africa*, Washington, 1989

COLE and ANIAKOR, 1984 H. M. Cole and C. C. Aniakor, *Igbo Arts: Community and Cosmos*, Los Angeles, 1984

COLE and ROSS, 1977 H. M. Cole and D. H. Ross, *The Arts of Ghana*, Los Angeles, 1977

COLENSO, 1855 J. W. Colenso, *Ten Weeks in Natal*, Cambridge, 1855

COLLECTIF, 1982 *À la rencontre de la poterie modelée en Algérie*, Algiers, 1982

COLLETT et al., 1992 D. P. Collett, A. E. Vines and G. E. Hughes, 'Dating and chronologies of the Valley Enclosures: Implications for the interpretation of Great Zimbabwe', *African Archaeological Review*, 10, 1992

CONNER, 1991 M. W. Conner, *The art of the Jere and Maseko Ngoni of Malawi, 1818–1964*, diss., Indiana University, 1991

CONNER and PELRINE, 1983 M. W. Conner and D. Pelrine, *The Geometric Vision: Arts of the Zulu*, West Lafayette, 1983

CONTADINI, 1993 A. Contadini, 'Gli scacchi di Venafro', in *Eredità dell' Islam – Arte Islamica in Italia*, exh. cat., Milan, 1993, no. 6, pp. 71–2

CONTADINI, 1994 A. Contadini, 'A figurative Islamic ivory chess piece', *Scacchi e scienze applicate*, 12, 1994, pp. 3–4

CONTADINI, 1995 A. Contadini, 'Islamic Ivory Chess Pieces, Draughtsmen and Dice in the Ashmolean Museum', *Islamic Art in the Ashmolean Museum: Oxford Studies in Islamic Art*, Oxford, 1995

CONVERS, 1991 M. Convers, 'L'aventure de Massa en Pays Sénoufo', *Primitifs*, 6, 1991, pp. 24–4

COONEY, 1949 J. D. Cooney, 'Royal Sculptures of Dynasty VI', *Actes du XXIe Congrès International des Orientalistes (Paris – 23–31 Juillet 1948)*, Paris, 1949

COOTE, 1995 J. Coote, 'A Table-Cloth of Grasse Very curiously Waved', *Pitt Rivers Museum News*, no. 5 (Summer 1995)

CORNET, 1972 J. Cornet, *Art de l'Afrique noire au pays du fleuve Zaire*, Brussels, 1972

CORNET, 1978[1] J. Cornet, *Pierres Sculptées du Bas-Zaire*, exh. cat., Institut des Musées Nationaux, Kinshasa, 1978

CORNET, 1978[2] J. Cornet, *A Survey of Zairian Art, The Bronson Collection*, Raleigh, NC, 1978

CORNET, 1980 J. Cornet, *Pictographies Woyo*, Milan, 1980

CORNET, 1982 J. Cornet, *Art Royal Kuba*, Milan, 1982

CORNET, 1993 J. Cornet, 'Masks among the Kuba Peoples', in *Face of the Spirits: Masks from the Zaire Basin*, Antwerp, 1993, pp. 128–43

CORONEL, 1979 P. C. Coronel, 'Aowin terracotta sculpture', *African Arts*, 13 (1), 1979, pp. 28–35

CORY, 1956 H. Cory, *African Figurines*, New York

COSTA, 1988 B. Costa, 'Preparazione per un Corpus dei Poggiatesta nell'Antico Egitto: classificazione tipologica', *Egitto e Vicino Oriente*, xi, 1988, pp. 39–50

CRADDOCK and PICTON, 1986 P. Craddock and J. Picton, 'Mediaeval copper alloy production and West African bronze analysis: part II', *Archaeometry*, XXVIII (1), 1986

CRIBB, 1991 R. Cribb, *Nomads in Archaeology*, Cambridge, 1991

CRUICKSHANK, 1853 B. Cruickshank, *Eighteen Years on the Gold Coast of Africa*, London, 1853

CUNARD, 1970 N. Cunard, ed., *Negro*, abridged with introduction by H. Ford, New York, 1970, p. 431 [1st edn 1934]

CURTIS, 1983 W. Curtis, 'Berber Collective Dwellings of the Northwest Sahara', *Muqarnas*, 1, 1983, pp. 181–209

DALTON, 1909 O. M. Dalton, *Catalogue of the Ivory Carvings of the Christian Era, with Examples of Mohammedan Art and Carvings in Bone in the Department of British and Medieval Antiquities and Ethnography of the British Museum*, London, 1909

DAMLUJI, 1992 S. Damluji, ed., *Zillij: The Art of Moroccan Ceramic*, Reading, 1982

DAMMANN, 1966 E. Dammann, 'Albert Schweitzer', *Tribus*, 15, 1966, pp. 7–10

DANIEL, 1937 F. de F. Daniel, 'The Stone Figures of Esie, Ilorin Province, Nigeria', *Journal of the Royal Anthropological Institute*, 67, 1937, pp. 43–9

DARAMOLA and JEJE, 1967 O. Daramola and A. Jeje, *Awon Asa ati Orisa Ile Yoruba*, Ibadan, 1967

DARISH, 1989 P. Darish, 'Dressing for the next Life: Raffia Textile Fabrication and Display among the Kuba of south-central Zaire', in *Cloth and Human Experience*, ed. A. Weiner and J. Schneider, Washington, 1989, pp. 117–40

DARK, 1975 P. Dark, 'Benin Bronze Heads: Styles and Chronology', in *African Images: Essays in African Iconology*, ed. D. McCall and E. Bay, New York and London, 1975

DASEN, 1993 V. Dasen, *Dwarfs in Ancient Egypt and Greece*, Oxford, 1993

DAVIES, 1991 W. V. Davies, ed., *Egypt and Africa: Nubia from Prehistory to Islam*, London, 1991

DAVIS, 1989 W. Davis, *The Canonical Tradition in Ancient Egyptian Art*, Cambridge, 1989

DAVISON, 1976 P. Davison, 'Some Nguni Crafts: The Use of Horn, Bone and Ivory', *Annals of the South African Museum*, 70 (2), 1976, pp. 79–155

DAVISON, 1989 P. Davison, 'The Art of the Lobedu', in *African Art in Southern Africa: from Tradition to Township*, ed. A. Nettleton and D. Hammond Tooke, Pretoria, 1989

DE HAULLEVILLE and COART, 1907 A. de Haulleville and M. Coart, 'La céramique', in *Notes Analytiques sur les Collections Ethnographiques*, 2 (1), 1907

DE MAREES, 1987 P. de Marees, *Description and Historical Account of the Gold Kingdom of Guinea*, 1602, trans. A. Van Danzig and A. Jones, Oxford, 1987

DE MARET, 1971–92 P. de Maret, Jean Hiernoux et al., *Fouilles archéologiques dans la vallée du Haut-Lualaba, Zaire*, Musée Royale de l'Afrique Centrale, Tervuren, 1971–92

DE MARET, 1974 P. de Maret, *Fouilles archéologiques dans la vallée du Haut-Lualaba, Zaire: Sanga et Katongo*, Tervuren, 1974

DE MARET, 1985[1] P. de Maret, *Fouilles archéologiques dans la vallée du Haut-Lualaba, Zaire: II. Sanga et Katongo, 1974*, Tervuren, 1985

DE MARET, 1985[2] P. de Maret, *Fouilles archéologiques dans la vallée du Haut-Lualaba, Zaire: III. Kamilamba, Kikulu et Malemba-Nkulu, 1975*, Tervuren, 1985

DE MORGAN, 1895 J. De Morgan, *Fouilles à Dahchour, Mars-Juin 1894*, Vienna, 1895

DE MORGAN, 1903 J. De Morgan, *Fouilles à Dahchour, en 1894–5*, Vienna, 1903

DE MOTT, 1979 B. de Mott, *Dogon Masks: A Structural Study of Form and Meaning*, Ann Arbor, 1979

DE RACHEWILTZ, 1966 B. de Rachewiltz, *Introduction to African Art*, London, 1966

DE VOOGT, 1994 A. J. de Voogt, 'Review of Bao (Mankala): The Swahili Ethic in African Idiom', *The Capteyn*, May 1994

DEACON, 1984 J. Deacon, 'Later Stone Age People and their Descendants in Southern Africa' in *Southern African Prehistory and Paleoenvironments*, ed. R. G. Klein, Rotterdam, 1984, pp. 221–328

DEACON, 1988 J. Deacon, 'The Power of Place in Understanding Southern San Rock Engravings', *World Archaeology*, 20, 1988, pp. 129–40

DELAFOSSE, 1912 M. Delafosse, *Haut-Sénégal-Niger*, Paris, 1912

DELEGORGUE, 1990 A. Delegorgue, *Travels in Southern Africa*, i, Pietermaritzburg, 1990

DELIUS, 1989 P. Delius, 'The Ndzundza Ndebele: Indenture and the Making of Ethnic Identity', in *Holding Their Ground: Class, Locality and Culture in Nineteenth and Twentieth Century South Africa*, ed. T. Lodge et al., Johannesburg, 1989

DEMEL, 1932 H. Demel, 'Ein ägyptisches Salbengefäss aus dem Alten Reich', *Jahrbuch der Kunsthistorischen Sammlungen in Wien*, new series, 1932, pp. 3–8, figs 1–4

DEMEL, 1947 H. Demel, *Ägyptische Kunst*, Vienna, 1947

DENBOW, 1986 J. R. Denbow, 'Patterns and Processes: A new look at the later prehistory of the Kalahari', *Journal of African History*, 27 (1), 1986

DENIS, 1974 W. Denis, *Icon and Image*, London, 1974

DER MANUELIAN, 1994 P. der Manuelian, *Living in the Past: Studies in Archaism of the Egyptian Twenty-sixth Dynasty*, London, 1994

DERRICOURT, 1974 R. M. Derricourt, 'A Soap Stone Sculpture from Rhodesia', *South African Archaeological Bulletin*, 29, 1974, pp. 38–40

DESANGES, 1981 J. Desanges, 'The Proto-Berbers', in *General History of Africa*, ii: *Ancient Civilisations of Africa*, ed. G. Mokhtar, London, 1981, pp. 423–40

DETROIT et al. 1980–3 *Treasures of Ancient Nigeria*, exh. cat. by E. Eyo and F. Willett, Detroit Institute of Arts et al., 1980–3

DEVISCH, 1993 R. Devisch, *Weaving the Threads of Life*, Chicago, 1993

DEWEY, 1986 W. J. Dewey, 'Shona Male and Female Artistry', *African Arts*, 19 (3), 1986, pp. 64–7, 84

DEWEY, 1993 W. J. Dewey, 'Declarations of Status and Conduits to the Spirits: A Case Study of Shona Headrests', in *Sleeping Beauties: The Jerome L. Joss Collection of African Headrests at UCLA*, exh. cat., Fowler Museum of Cultural History, Los Angeles, 1993, pp. 98–133

DIAS, 1961 J. Dias, *Portuguese Contributions to Cultural Anthropology*, Johannesburg, 1961

DIAS and DIAS, 1964–70 A. J. Dias and M. Dias, *Os Macondes de Moçambique*, 3 vols, Lisbon, 1964–70

DIAS DE CARVALHO, 1890 H. Dias de Carvalho, *Expedição portuguêsa ao Muatiânvua (1884–1888). Ethnographia e história tradicional dos povos da Lunda*, Lisbon, 1890

DICK-READ, 1964 R. Dick-Read, *Sanamu: Adventures in Search of African Art*, London, 1964

DIETERLEN, 1951 G. Dieterlen, *Essai sur la religion Bambara*, Paris, 1951

DILLON, 1907 E. Dillon, *Glass: The Connoisseur's Library*, London, 1907

DINKLER, 1970 E. Dinkler, ed., *Kunst und Geschichte Nubiens in christlicher Zeit*, Recklinghausen, 1970

DIOP, 1981 A. B. Diop, *La société Wolof: Tradition et changement*, Paris, 1981

DITTMER, 1967 K. Dittmer, 'Bedeutung, Datierung und kulturhistorische Zusammenhänge der "prähistorischen" Steinfiguren aus Sierra Leone und Guinée', *Baessler Archiv*, 40, 1967, pp. 183–238

DMOCHOWSKI, 1990 Z. R. Dmochowski, *The Traditional Architecture of Nigeria*, i–iii, London, 1990

DORF, in preparation S. Dorf, 'The Hierakonpolis Door-socket: A New Study', in preparation

DOWSON, 1992 T. A. Dowson, *Rock Engravings of Southern Africa*, Johannesburg, 1992

DRENKHAHN, 1986 R. Drenkhahn, *Elfenbein im Alten Ägypten*, Erbach, 1986

DREWAL, 1981 H. J. Drewal, 'Staff (Edan Oshugbo)' and 'Mask (Gelede)', in *For Spirits and Kings: African Art from the Tishman Collection*, ed. S. Vogel, New York, 1981, pp. 90–1, 114–16

DREWAL, 1989[1] H. J. Drewal, 'Artists of the Western Kingdoms', in H. J. Drewal, J. Pemberton and R. Abiodun, *Yoruba: Nine Centuries of African Art and Thought*, New York, 1989, pp. 212–31

DREWAL, 1989[2] H. J. Drewal, 'Meaning in Osugbo Art: A Reappraisal', in *Man Does Not Go Naked: Textilien und Handwerk aus afrikanischen und anderen Ländern*, ed. B. Engelbrecht and B. Gardi, Basle, 1989, pp. 151–74

DREWAL, 1989[3] H. J. Drewal, 'Art and Ethos of the Ijebu', in H. J. Drewal, J. Pemberton and R. Abiodun, *Yoruba: Nine Centuries of African Art and Thought*, New York, 1989, pp. 117–145

DREWAL and DREWAL, 1983 H. J. and M. T. Drewal, *Gelede: Art and Female Power among the Yoruba*, Bloomington, 1983

DREWAL, PEMBERTON and ABIODUN, 1989 H. J. Drewal, J. Pemberton and R. Abiodun, *Yoruba: Nine Centuries of African Art and Thought*, New York, 1989

DU PUIGARDEAU, 1967–70 O. Du Puigardeau, 'Arts et coutumes de Maures', *Hespéris-Tamuda*, 8, 1967, pp. 111–230; 9, 1968, pp. 329–458; 11, 1970, pp. 5–82

DUCHEMIN, 1946 G. J. Duchemin, 'Tête en terre cuite de Krinjabo (Côte d'Ivoire)', *Notes africaines*, 29, 1946, pp. 13–14

DUNHAM, 1955 D. Dunham, *The Royal Cemeteries of Kush II: Nuri*, Boston, 1955

DUNN, 1931 E. J. Dunn, *The Bushman*, London, 1931

DUPIRE, 1962 M. Dupire, *Peuls Nomades: Étude descriptive des WoDaabe du Sahel Nigérien*, Paris, 1962

DÜSSELDORF et al. 1988–9 *Afrikanische Kunst aus der Sammlung Barbier Mueller, Genf*, exh. cat. ed. W. Schmalenbach, Düsseldorf, Kunstsammlung Nordrhein-Westfalen et al., 1988–9 [also published in French and English edn]

DUTHUIT, 1931 G. Duthuit, *La sculpture copte*, Paris, 1931

EARTHY, 1968 E. D. Earthy, *Valenge Women: The Social and Economic Life of the Valenge Women of Portuguese East Africa*, London, 1968 [1st edn 1933]

EAST LANSING 1994 *Ethiopia: Traditions of Creativity*, exh. cat. by R. Silverman, Michigan State University Museum, East Lansing, 1994

EBERL-ELBER, 1939 R. Eberl-Elber, 'Die Masken der Männerbünde in Sierra Leone', *Ethnos*, 2 (2), 1939, pp. 38–46

EDWARDS, 1978 I. E. S. Edwards, *The Pyramids of Egypt*, London, 1978

EGGEBRECHT, 1993 A. Eggebrecht, ed., *Pelizaeus-Museum Hildesheim: Die Ägyptische Sammlung*, Mainz, 1993

EICHER and EREKOSIMA, 1987 J. B. Eicher and T. V. Erekosima, 'Kalabari funerals: celebration and display', *African Arts*, 21 (1), 1987

ELKAN, 1958 W. Elkan, 'The East African Trade in Wood Carvings', *Africa*, 57 (2), 1958, pp. 314–23

EMERY and KIRWAN, 1938 W. B. Emery and L. P. Kirwan, *The Royal Tombs of Ballana and Oustul*, Cairo, 1938

ENGEL, 1864 C. Engel, *Music of the Most Ancient Nations*, London, 1864

ENNABLI, 1986 A. Ennabli, 'Les thermes du thiase marin de Sidi Ghrib (Tunisie)', *Fondation Eugène Piot: Monuments et Mémoires*, 68, 1986, pp. 1–59

ERDMANN, 1962 K. Erdmann, *Europa und der Orientteppich*, Berlin, 1962

ESSEN, 1961 *see* Vienna 1961

ETIENNE-NUGUE and SALEY, 1987 J. Etienne-Nugue and M. Saley, *Artisanats Traditionnels Niger*, Dakar, 1987

ETTINGHAUSEN, 1992 R. Ettinghausen, 'The Man-made Setting', in *The World of Islam*, ed. B. Louis, London, 1992, pp. 57–72

EUDEL, 1902 P. Eudel, *L'orfèvrerie algérienne et tunisienne*, Algiers, 1902

EUDEL, 1906 P. Eudel, *Dictionnaire des bijoux de l'Afrique du Nord*, Paris, 1906

EVANS-PRITCHARD, 1929 E. E. Evans-Pritchard, 'The Bongo', *Sudan Notes and Records*, 12 (1), 1929, pp. 1–61

EVERS, 1982 T. M. Evers, 'Excavations at the Lydenburg Heads Site, Eastern Transvaal, South Africa', *South African Archaeological Bulletin*, 37, 1982, pp. 16–30

EYO, 1977 E. Eyo, *Two Thousand Years of Nigerian Art*, Lagos, 1977

EYO, 1984 E. Eyo, 'Alok and Emangabe Stone Monoliths, Ikom', in *Arte in Africa*, Florence, 1984

EYO and WILLETT, 1982 *see* Detroit et al. 1980–3

EZRA, 1983 K. Ezra, 'Figure Sculptures of the Bamana of Mali', diss., Northwestern University, 1983

EZRA, 1986 K. Ezra, *A Human Ideal in African Art: Bamana Figurative Sculpture*, Washington, 1986

FAGG, A., 1994 A. Fagg, 'Thoughts of Nok', *African Arts*, 27 (3), 1994, pp. 79–83

FAGG, B., 1945 B. Fagg, 'A Preliminary Note on a New Series of Pottery Figures from Northern Nigeria', *Africa*, 15 (1), 1945, pp. 21–2

FAGG, B., 1946 B. Fagg, 'Archaeological Notes from Northern Nigeria', *Man*, 1946, pp. 48–55

FAGG, B., 1948 B. Fagg, in *Man*, November 1948, p. 140

FAGG, B., 1956[1] B. Fagg, 'A Life-size Terracotta Head from Nok', *Man*, 1956, p. 95

FAGG, B., 1956[2] B. Fagg, 'The Nok Culture', *West African Review*, 1956

FAGG, B., 1958 B. Fagg, personal communication, 1958

FAGG, B., 1977 B. Fagg, *Nok Terracottas*, Lagos, 1977, 2/1990

FAGG, B. and FLEMING, 1970 B. Fagg and S. J. Fleming, 'Thermoluminescent dating of a terracotta of the Nok Culture', *Archaeometry*, 12 (1), 1970, pp. 53–5

FAGG, 1949 W. B. Fagg, *Traditional Art of the British Colonies*, London, 1949

FAGG, 1955 W. Fagg, 'Two Early Masks from the Dan Tribes in the British Museum', *Man*, 55, 1955, pp. 160–2

FAGG, 1960[1] W. B. Fagg, *The Epstein Collection*, London, 1960

FAGG, 1960[2] W. Fagg, *Nigerian Tribal Art*, London, 1960

FAGG, 1963 W. Fagg, *Nigerian Images: the Splendor of African Sculpture*, London and New York, 1963

FAGG, 1964 W. Fagg, *Afrique. 100 tribus – 100 chefs-d'oeuvre*, Paris, 1964

FAGG, 1964 W. B. Fagg, *African Sculpture: an anthology*, London, 1964

FAGG, 1965 W. Fagg, *Tribes and Forms in African Art*, New York and London, 1965

FAGG, 1968 W. B. Fagg, *African Tribal Images*, Cleveland, 1968

FAGG, 1969 W. B. Fagg, *African Sculpture*, Washington, 1969

FAGG, 1969 W. B. Fagg, 'The African Artist', in *Traditions and Creativity in Tribal Art*, ed. D. Biebuyck, Berkeley, 1969, pp. 42–57

FAGG, 1980 W. B. Fagg, introduction to *Yoruba Beadwork, Art of Nigeria*, by John Pemberton III, exh. cat., New York, 1980

FAGG, 1981 W. Fagg, 'Figure of an Ogboni or Oshugbo Chief', in *For Spirits and Kings: African Art in the Tishman Collection*, ed. S. Vogel, New York, 1981, p. 104

FAGG, and PEMBERTON, 1982 W. Fagg and J. Pemberton, *Yoruba Sculpture of West Africa*, New York, 1982

FAGG, and PLASS, 1964 W. B. Fagg and M. Plass, *African Sculpture*, London, 1964

FAIK-NZUJI, 1986 'Lecture d'un taampha, planchette à proverbe des Woyo', *Arts d'Afrique Noire*, 1986

FALGAYRETTES et al., n. d. C. Falgayrettes et al., *Cuillers-Sculptures*, Musée Dapper, Paris, n. d.

FANTAR, 1986 M. Fantar, ed., *30 ans au service du patrimoine*, Tunis, 1986

FANTAR, 1995 M. H. Fantar, *Carthage: la cité punique*, Paris, 1995

FARIS, 1972 J. C. Faris, *Nuba Personal Art*, London, 1972

FAZZINI, 1972 R. A. Fazzini, 'Some Egyptian Reliefs in The Brooklyn Museum', in *Miscellanea Wilbouriana*, i, Brooklyn, 1972, pp. 33–70

FAZZINI et al., 1989 R. A. Fazzini et al., *Ancient Egyptian Art in The Brooklyn Museum*, Brooklyn, 1989

FEDDERS and SALVADORI, 1977 A. Fedders and C. Salvadori, *Turkana, Pastoral Craftsmen*, Nairobi, 1977

FÉHÉRVARI, 1985 G. Féhérvari, *La ceramica islamica*, Milan, 1985

FELIX, 1987 M. L. Felix, *100 Peoples of Zaire and their Sculpture*, Brussels, 1987

FELIX, 1989 M. Felix, *Maniema: An Essay on the Distribution of the Symbols and Myths Depicted on the Masks of Greater Maniema*, Munich, 1989

FELIX, 1990 M. L. Felix, *Mwana Hiti: Life and Art of the Matrilineal Bantu of Tanzania*, Munich, 1990

FELIX, KECSKÉSI et al., 1994 M. Felix, M. Kecskési et al., *Tanzania: Meisterwerke Afrikanischer Skulptur*, ed. J. Jahn, Munich, 1994

FENTRESS, 1978 E. Fentress, 'Dii Mauri and Dii Patrii', *Latomus*, 37, 1978, pp. 507–16

FERBER et al., 1988 L. S. Ferber et al., *Masterpieces in The Brooklyn Museum*, Brooklyn, 1988

FERNANDEZ, 1974 J. W. Fernandez, 'La Statuaire Fan-Gabon', *African Arts*, 8 (1), 1974, pp. 76–7

FERNANDEZ, 1992 J. W. Fernandez, 'Met andere ogen: een beschouwing bij een collectie draagbare kunst van de Fang (en Kota) (Gabon)', in Maastricht 1992, pp. 32–6

FIELD, 1948 M. J. Field, *Akim Kotoku: An Oman of the Gold Coast*, London, 1948

FILER, in preparation J. M. Filer, 'Attitudes to Death with Reference to Cats in Ancient Egypt', *Proceedings of The Archaeology of Death in the Ancient Near East*, in preparation

FINKENSTAEDT, 1980 E. Finkenstaedt, 'Regional Painting Style in Prehistoric Egypt', *Zeitschrift für Ägyptische Sprache und Altertumskunde*, 107, 1980, pp. 118–19, fig. 5

FISCHER, 1989 E. Fischer, 'Bété', in *Corps sculptés, corps parés, corps masqués*, ed. E. Féau and Y. Savané, Paris, 1989, pp. 46–7

FISCHER and HIMMELHEBER, 1984 E. Fischer and H. Himmelheber, *The Arts of the Dan in West Africa*, trans. A. Biddle, Zurich, 1984 [*Die Kunst der Dan*, 1976]

FISHER, 1987 A. Fisher, *Africa Adorned*, London, 1987

FITZGERALD, 1944 R. T. D. Fitzgerald, 'Dakarari Grave Pottery', *Journal of the Royal Anthropological Institute*, 1944, pp. 43–57

FLEMING and NICKLIN, 1982 S. J. Fleming and K. W. Nicklin, 'Analysis of two bronzes from a Nigerian Asunaja Shrine', *Museum of Applied Science Centre for Archaeology Journal*, 2 (2), 1982, pp. 53–7

FLINT, 1974 B. Flint, *Formes et symboles dans les arts maghrébins*, ii: *Tapis et tissages*, Tangier, 1974

FLINT, 1987 B. Flint, *Tapices marroquies*, exh. cat., Seville, 1987

FOCK and FOCK, 1979–89 G. J. Fock and D. M. L. Fock, *Felsbilder in Südafrika*, 3 vols, Cologne, 1979–89

FORDE, 1964 D. Forde, *Yako Studies*, London, 1964

FORDE-JOHNSTON, 1959 J. Forde-Johnston, *Neolithic Cultures of North Africa*, Liverpool, 1959

FÖRSTER, 1988 T. Förster, *Die Kunst der Senufo*, Zurich, 1988

FOSS, 1975 W. Foss, 'Images of Aggression: *Ivwri* Sculpture of the Urhobo', in *African Images: Essays in African Iconology*, ed. D. McCall and E. Bay, New York and London, 1975

FOSS, 1976 W. Foss, 'Urhobo Statuary for Spirits and Ancestors', *African Arts*, 9 (4), 1976, pp. 12–23

FRANKFURT AM MAIN 1983 *Luba Hemba*, exh. cat., Museum für Völkerkunde, Afrika-Sammlung 1, Frankfurt am Main, 1983

FRANKS, 1862 A. W. Franks, 'Glass', *Catalogue of the Special Exhibition of Works of Art on Loan at the South Kensington Museum, June 1862*, exh. cat. ed. J. C. Robinson, London, 1862, pp. 381 ff.

FRANZ, 1969 M. Franz, 'Traditional Masks and Figures of the Makonde', *African Arts*, 3 (1), 1969, pp. 42–5

FRASER, 1962 D. Fraser, 'The Legendary Ancestor Tradition in West Africa', in *African Art as Philosophy*, ed. D. Fraser, New York, 1962, pp. 38–53

FRASER and COLE, 1972 D. Fraser and H. M. Cole, *African Art and Leadership*, Madison, 1972

FREEMAN-GRENVILLE, 1962 G. S. P. Freeman-Grenville, *The East African Coast*, Oxford, 1962

FRISHMAN and HASAN-UDDIN, 1994 M. Frishman and K. Hasan-Uddin, eds, *The Mosque: History, Architectural Development and Regional Diversity*, London, 1994

FROBENIUS, 1898 L. Frobenius, *Die Masken und Geheimbünde Afrikas*, Halle, 1898

FROBENIUS, 1907 L. Frobenius, *Im Schatten des Kongostaates*, Berlin, 1907

FROBENIUS, 1913 L. Frobenius, *Und Afrika sprach*, 3 vols, Berlin, 1913

FROBENIUS, 1968 L. Frobenius, *The Voice of Africa*, 2 vols, New York, repr. 1968

FROBENIUS, 1985 L. Frobenius, *Ethnographische Notizen aus den Jahren 1905 und 1906*, ed. H. Klein, Stuttgart, 1985

FRY, 1970 P. Fry, 'Essay sur la statuaire mumuye', in *Objets et Mondes: La revue du Musée de l'Homme*, X (1), 1970, pp. 3–28

FRY, 1978 J. Fry, ed., *Twenty-five African Sculptures*, Ottawa, 1978

FYFE, 1964 C. S. Fyfe, *Sierra Leone Inheritance*, London, 1964

GABRA, 1993 G. Gabra, *Cairo: the Coptic Museum and Old Churches*, Cairo, 1993

GABUS, 1958 J. Gabus, *Au Sahara: Arts et Symboles*, Neuchâtel, 1958

GALAVARIS, 1979 G. Galavaris, *The Illustrations of the Prefaces in Byzantine Gospels*, Vienna, 1979

GALLOIS DUQUETTE, 1976 D. Gallois Duquette, 'Informations sur les arts plastiques des Bidyogo', *Arts d'Afrique Noire*, 18, 1976, pp. 26–43

GALLOIS DUQUETTE, 1983 D. Gallois Duquette, *Dynamique de l'art bidjogo*, Lisbon, 1983

GANAY, 1947 S. de Ganay, 'Un jardin d'essay et son autel chez les Bamana', *Journal de la Société des Africanistes*, 17, 1947, pp. 57–63

GANAY, 1949 S. de Ganay, 'Aspects de mythologie et de symbolique Bambara', *Journal de psychologie normale et pathologique*, 41 (2), 1949, pp. 181–201

GÄNSICKE, 1994 S. Gänsicke, 'King Aspelta's Vessel Hoard from Nuri in the Sudan', *Journal of the Museum of Fine Arts, Boston*, 6, 1994, pp. 14–40

GARGOURI-SETHOM, 1986 S. Gargouri-Sethom, *Le bijou traditionnel en Tunisie*, Aix-en-Provence, 1986

GARLAKE, 1973 P. S. Garlake, *Great Zimbabwe*, London, 1973

GARLAKE, 1974 P. S. Garlake, 'Excavations at Obalar's Land, Ife: An interim report', *West African Journal of Archaeology*, 4, 1974

GARLAKE, 1977 P. S. Garlake, 'Excavations on the Woye Asiri family land in Ife, Western Nigeria', *West African Journal of Archaeology*, 7, 1977

GARLAKE, 1978[1] P. Garlake, *Kingdoms of Africa*, London, 1978

GARLAKE, 1978[2] P. S. Garlake, 'Pastoralism and zimbabwe', *Journal of African History*, 19 (4), 1978

GARLAKE, 1982 P. S. Garlake, 'Prehistory and ideology in Zimbabwe', *Africa*, 52 (3), 1982

GARLAKE, 1995 P. S. Garlake, *The Hunter's Vision*, London, 1995

GARNIER, 1884 E. Garnier, 'Collections de M. Spitzer. La Verrerie', *Gazette des Beaux-Arts*, 1884, pp. 293 ff

GARRARD, 1980 T. F. Garrard, *Akan Weights and the Gold Trade*, London, 1980

GARRARD, 1982 T. F. Garrard, 'Erotic Akan Goldweights', *African Arts*, 15 (2), 1982, pp. 60–2, 88

GARRARD, 1983 T. Garrard, 'A Corpus of 15th to 17th Century Akan Brass Castings', in *Akan Transformations: Problems in Ghanaian Art History*, Los Angeles, 1983, pp. 30–53

GARRARD, 1984 T. F. Garrard, 'Figurine Cults of the Southern Akan', *Iowa Studies in African Art*, Iowa City, 1984, pp. 167–90

GARRARD, 1989 T. F. Garrard, *Gold of Africa*, Munich, 1989

GARSTANG, 1907 J. Garstang, 'Excavations at Hierakonpolis, at Esna, and in Nubia', *Annales du Service des Antiquités de l'Égypte*, 8, 1907, pp. 132–48

GARSTANG, 1928 J. Garstang, 'An Ivory Sphinx from Abydos', *Journal of Egyptian Archaeology*, 14, 1928

GAUCKLER, 1915 P. Gauckler, *Nécropoles puniques de Carthage*, Paris, 1915

GAYET, 1902 A. Gayet, *L'art copte*, Paris, 1902

GEBAUER, 1979 P. Gebauer, *Art of Cameroon*, New York, 1979

GERMANN, 1933 P. Germann, *Die Völkerstämme im Norden von Liberia*, Leipzig, 1933

GEUS, 1980 F. Geus, *Rapport annuel d'activité, 1978–79*, Lille, 1980

GEUS, 1984 F. Geus, 'Excavations at el Kadada and the Neolithic of the Central Sudan', in *Origin and Early Development of Food-Producing Cultures in North-eastern Africa*, ed. L. Krzyzaniak and M. Kobusiewicz, Poznan, 1984, pp. 361–72

GIBBAL, 1994 J. M. Gibbal, *Genii of the River Niger*, trans. B. F. Raps, Chicago, 1994

GIESSEKE, 1930 E. D. Giesseke, 'Wahrsagerei bei den BaVenda', *Zeitschrift für Eingeborenensprache*, 21 (1) 1930, pp. 257–310

GILBERT, 1989 M. Gilbert, 'Akan terracotta heads: gods or ancestors?' *African Arts*, 22 (4), 1989, 34–43

GILLON, 1984 W. Gillon, *A Short History of African Art*, London and New York, 1984

GIRARD, 1967 J. Girard, *Dynamique de la société ouobé: loi des masques et coutume*, Paris, 1967

GLAZE, 1981 A. J. Glaze, *Art and Death in a Senufo Village*, Bloomington, 1981

GNONSOA, 1983 A. Gnonsoa, *Masques de l'Ouest Ivoirien*, Abidjan, 1983

GODMAN, 1901 F. D. Godman, *The Godman Collection of Oriental and Spanish Pottery and Glass*, London, 1901

GOLDWATER, 1960 R. Goldwater, *Bambara Sculpture from the Western Sudan*, New York, 1960

GOLDWATER, 1964 R. Goldwater, *Senufo Sculpture from West Africa*, New York, 1964

GOLLNHOFER et al., 1975 O. Gollenhofer, *Art et artisanat tsogho*, Paris, 1975

GOLVIN, 1950 L. Golvin, 'Le "Métier à la Tire" des fabricants de brocarts de Fès', *Hespéris*, XXXVII, 1950, pp. 21–52

GONZÁLEZ, 1994 V. González, *Émaux d'Al Andalus et du Maghreb*, Aix-en-Provence, 1994

GRANT, 1864 J. A. Grant, *A Walk across Africa*, Edinburgh, 1864

GREENBERG, 1966 J. Greenberg, *The Languages of Africa*, Bloomington, 1966

GRIAULE, 1938 M. Griaule, *Masques Dogons*, Paris, 1938

GRIAULE, 1947 M. Griaule, *Descente du troisième verbe chez les Dogons du Soudan*, Paris, 1947 [repr. from *Psyché*, 2, pp. 13–14]

GRIAULE, 1965 M. Griaule, *Conversations With Ogotemmêli: An Introduction to Dogon Religious Ideas*, 1965

GRIAULE and DIETERLEN, 1986 M. Griaule and G. Dieterlen, *The Pale Fox*, 1986

GRIFFITH, 1911 F. L. Griffith, *Karanog: the Meroitic Inscriptions of Shablul and Karanog*, University Museum, Philadelphia, 1911

GRIFFITH, 1925 F. L. Griffith, 'Oxford Excavations in Nubia', *Liverpool Annals of Archaeology and Anthropology*, 12 (3–4), 1925, pp. 57–172

GROBLER and VAN SCHALKWYK, 1989 E. Grobler and J. A. van Schalkwyk, *Reflection of a Collection*, Pretoria, 1989

GRUNNE, 1988 B. de Grunne, 'Ancient Sculpture of the Inland Niger Delta and Its Influence on Dogon Art', *African Arts*, 21 (4), 1988, pp. 50–5, 92

GULLIVER, 1959 P. H. Gulliver, 'A Tribal Map of Tanganyika', *Tanganyika Notes and Records*, 52, 1959

GUTHRIE, 1967–71 M. Guthrie, *Comparative Bantu: An Introduction to the Comparative Linguistics and Prehistory of the Bantu Languages*, 4 vols, London, 1967–71

HABERLAND, 1963 E. Haberland, *Galla Süd-Äthiopiens. Völker Süd-Äthiopiens. Ergebnisse der Frobenius Expedition 1950–52, und 1954–56*, 1963

HÄGG, 1987 T. Hägg, ed., *Nubian Culture: Past and Present*, Stockholm, 1987

HAHNLOSER, 1971 H. R. Hahnloser, ed., *Il Tesoro di San Marco: Il Tesoro e il Museo*, ii, Florence, 1971

HAKENJOS, 1988 B. Hakenjos, *Marokkanische Keramik*, Stuttgart and London, 1988

HALL, 1905 M. Hall, *Great Zimbabwe*, London, 1905

HALL, 1938 R. de Z. Hall, 'A Tribal Museum at Bweranyange, Bukoba District', *Tanganyika Notes and Records*, 5, 1938, pp. 1–4

HALL, 1987 M. Hall, *The Changing Past: Farmers, Kings and Traders in Southern Africa, 200–1860*, Cape Town, 1987

HALLPIKE, 1972 C. R. Hallpike, *The Konso of Ethiopia: A Study of the Values of a Cushitic People*, Oxford, 1972

HAMBOLU, 1989 H. M. Hambolu, 'An Archaeological Up-date on the Mystery of the Esie Stone Figures', paper presented at the Seminar on Material Culture, Monuments and Festivals in Kwara State, National Museum, Esie, Nigeria, 1989

HANISCH, 1980 E. O. M. Hanisch, 'An Archaeological Interpretation of Certain Iron Age Sites in the Limpopo/Shashi Valley', diss., University of Pretoria, 1980

HARLEY, 1941 G. Harley, 'Notes on the Poro in Liberia', *Papers of the Peabody Museum*, Cambridge, MA, 19 (2), 1941

HARLEY, 1950 G. Harley, 'Masks as Agents of Social Control', *Papers of the Peabody Museum*, Cambridge, MA, 32 (2), 1950

HARRIES, 1944 L. Harries, *The Initiation Rites of the Makonde Tribe*, iii, Livingstone, 1944

HARRIES, 1988 P. Harries, 'The Roots of Ethnicity: Discourse and the Politics of Language Construction in South-East Africa', *African Affairs*, 346, 1988, pp. 25–52

HARRIES, 1989 P. Harries, 'Exclusion, Classification and Internal Colonialism: The Emergence of Ethnicity among the Tsonga-speakers of South Africa', in *The Creation of Tribalism in Southern Africa*, ed. L. Vail, London, 1989

HARRIS, 1938 P. G. Harris, 'Notes on the Dakarari People', *Journal of the Royal Anthropological Institute*, 1938, pp. 114–53

HARRIS, 1965 R. Harris, *The Political Organisation of the Mbembe, Nigeria*, London, 1965

HART, 1984 W. A. Hart, 'So-called Minsereh Figures from Sierra Leone', *African Arts*, 18 (1), 1984, pp. 84–6

HART, 1990 G. Hart, *Eyewitness Guides: Ancient Egypt*, London, 1990

HART, 1993 W. A. Hart, 'Sculptures of the Njayei Society among the Mende', *African Arts*, 26 (1), 1993, p. 46

HART and FYFE, 1993 W. A. Hart and C. Fyfe, 'The Stone Sculptures of the Upper Guinea Coast', *History in Africa*, 20, 1993, pp. 71–87

HARTER, 1986 P. Harter, *Arts Anciens du Cameroun*, supplement to *Arts d'Afrique Noire*, XL, Arnouville, 1986

HARTLE, 1970 D. Hartle, 'Preliminary Report of the University of Ibadan's Kainji Rescue Archaeology Project 1968', *West African Archaeological Newsletter*, 12, 1970, pp. 7–19

HARTWIG, 1969[1] G. Hartwig, 'A Historical Perspective of Kerebe Sculpturing – Tanzania', *Tribus*, 18, 1969, pp. 85–102

HARTWIG, 1969[2] G. Hartwig, 'The Role of Plastic Art Traditions in Tanzania', *Baessler-Archiv*, 17, 1969

HARTWIG, 1976 G. Hartwig, *The Art of Survival in East Africa: The Kerebe and Long-Distance Trade, 1800–1895*, New York, 1976

HARTWIG, 1978 G. Hartwig, 'Sculpture in East Africa', *African Arts*, 11 (4), 1978

HASAN, 1956 Z. M. Hasan, *Atlas al-funun al-zukhrufiyya wa'l tasawir al-islamiyya*, Cairo, 1956

HAWKESWORTH, 1932 G. Hawkesworth, 'A Note on the Making of Kadaru Pottery', letter to Sir Harold MacMichael, 1932, archives of the Horniman Museum and Public Park Trust, London

HAYES, 1953 W. C. Hayes, *The Scepter of Egypt*, i, 1953

HECHT et al., 1990 D. Hecht, B. Benzing and G. Kidane, *The Handcrosses of the IES Collection*, Addis Ababa, 1990

HECKEL, 1935 B. Heckel, *The Yao Tribe: Their Culture and Education*, iv, London, 1935

HELCK, 1977 W. Helck, 'Fremdvölkerdarstellung', *Lexikon der Ägyptologie*, ed. W. Helck and W. Westendorf, ii, Wiesbaden, 1977, cols 315–21

HENDRICKX, 1992 S. Hendrickx, 'Une scène de chasse dans le désert sur le vase pré-dynastique Bruxelles, M. R. A. H. E. 2631', *Chronique d'Égypte*, 67, 1992, pp. 5–27

HENDRICKX, 1994 S. Hendrickx, *Antiquités préhistoriques et protodynastiques d'Égypte*, Guides du département égyptien, 8, Musées Royaux d'Art et d'Histoire, Brussels, 1994

HERBERT, 1984 E. Herbert, *The Red Gold of Africa*, Madison, 1984

HEROLD, 1985 E. Herold, 'Traditional Sculpture of the Bete Tribe, Ivory Coast', *Annals of the Näprstek Museum*, 13, 1985, pp. 81–165

HERREMAN, 1985 F. Herreman, *De Wenteling om de Aslija: Mumuye-beeldhouwwerken uit Nigeria*, Ga-maart, 1985

HERREMAN and PETRIDIS, 1993 F. Herreman and C. Petridis, eds, *Face of the Spirits: Masks from the Zaire Basin*, Antwerp, 1993

HERSAK, 1986 D. Hersak, *Songye Masks and Figure Sculpture*, London, 1986

HERSAK, 1995 D. Hersak, 'Colours, Stripes and Projection: Revelations on Fieldwork Findings and Museum Enigmas', in *Object Signs of Africa*, ed. L. de Heusch, Ghent, 1995

HERTER, 1991 P. Herter, 'Les peuples Krou de la Frontière Eburneo-Libérienne', *Primitifs*, 6, 1991, pp. 58–71

HERTER, 1993 P. Herter, 'Wè Masks', *Art of Côte d'Ivoire*, ed. J.-P. Barbier-Muller, i, Geneva, 1993, pp. 184–219

HERZ, 1906 M. Herz, *Catalogue raisonné des monuments exposés dans le Musée National de l'Art Arabe*, Cairo, 1906

HERZ, 1907 M. Herz, *Descriptive Catalogue of the Objects Exhibited in the National Museum of Arab Art*, Cairo, 1907

HERZ, 1913 M. Herz, 'Boiseries fatimides aux sculptures figurales', *Orientalisches Archiv*, 3 (4), Leipzig, 1913, pp. 169–74

HEUSCH, 1995 L. de Heusch, 'Beauty is Elsewhere: Returning a Verdict on Tetela Masks', in *Object Signs of Africa*, ed. L. de Heusch, Ghent, 1995

HILDESHEIM 1985 *Nofret – Die Schöne: Die Frau im Alten Ägypten*, exh. cat. ed. B. Schmitz, Roemer- und Pelizaeus-Museum, Hildesheim, 1985

HILDESHEIM and MAINZ 1990 *Suche nach Unsterblichkeit: Totenkult und Jenseitsglaube im alten Ägypten*, exh. cat., Hildesheim and Mainz, 1990

HILTON-SIMPSON, 1911 W. H. Hilton-Simpson, *Land and Peoples of the Kasai*, London, 1911

HIMMELHEBER, 1960 H. Himmelheber, *Negerkunst und Negerkünstler*, Brunswick, 1960

HIMMELHEBER, 1966 H. Himmelheber, 'Masken der Guéré II', *Zeitschrift für Ethnologie*, 91 (1), 1966, pp. 100–8

HINTZE et al., 1971 F. Hintze, K. H. Priese, S. Wenig and C. Onasch, *Musawwarat es Sufra*, i, 1–2, *Der Löwentempel*, Berlin, 1971, 1993

HOFFER, 1973 C. Hoffer, 'Mende and Sherbro Women in High Office', *Canadian Journal of African Studies*, 6 (2), 1973, pp. 151–64

HOFMANN 1991 I. Hoffmann, *Steine für die Ewigkeit: meroitische Opfertafeln und Toten-stelen*, Vienna, 1991

HOLAS, 1952 B. Holas, *Les masques Kono*, Paris, 1952

HOLAS, 1953 B. Holas, *Portes sculptées du Musée d'Abidjan*, Dakar, 1953

HOLAS, 1976 B. Holas, *Civilisations et arts de l'Ouest Africain*, Paris, 1976

HOLAS, 1980 B. Holas, *Traditions Krou*, Paris, 1980

HOLDEN, 1866 W. C. Holden, *Past and Future of the Kaffir Races*, London, 1866

HOLLIS, 1909 A. C. Hollis, 'A Note on the Graves of the Wa-Nyika', *Man*, 9, 1909, p. 145

HOLM, 1963 E. Holm, 'Sfinks', *Tydskrif vir geesteswetenskappe*, March 1963, pp. 47–54

HOLMES, 1992 D. Holmes, 'Chipped Stone-working Craftsmen, Hierakonpolis and the Rise of Civilization in Egypt', in *The Followers of Horus*, ed. R. Friedman and B. Adams, Oxford, 1992, pp. 37–44

HOLY, 1967 L. Holy, *The Art of Africa: Masks and Figures from Eastern and Southern Africa*, London, 1967

HOLY, 1971 L. Holy, *Zambian Traditional Art*, NECZAM, 1971

HOMBERGER, 1991 L. Homberger, ed., *Spoons in African Art*, Zurich, 1991

HONEY, 1927 W. B. Honey, 'A Syrian glass goblet', *Burlington Magazine*, June 1927, p. 289

HOOPER, 1983 L. Hooper, 'Some Nguni Crafts. Part 3: Woodcarving', *Annals of the South African Museum*, 70 (3), 1983

HOOPER, DAVISON and KLINGHARDT, 1989 L. Hooper, P. Davison and G. Klinghardt, 'Some Nguni crafts: skin-working technology', *Annals of the South African Museum*, 70 (4), 1989, pp. 313–404

HOPE, 1987 C. A. Hope, *Egyptian Pottery*, London, 1987

HOPKINS and LEVTZION, 1981 J. F. P. Hopkins and N. Levtzion, *Corpus of Early Arabic Sources for West African History*, New York, 1981

HORN and RÜGER, 1979 H. G. Horn and C. B. Rüger, eds, *Die Numider. Reiter und Könige nördlich der Sahara*, Bonn, 1979

HORTON, 1965 R. Horton, *Kalabari Sculpture*, Lagos, 1965

HORTON, 1987 M. Horton, 'The Swahili corridor', *Scientific American*, 257, 1987

HOULIHAN and GOODMAN, 1986 P. Houlihan and S. Goodman, *The Birds of Ancient Egypt*, Cairo, 1986

HOURS-MIEDAN, 1951 M. Hours-Miedan, 'Types de décor des stèles de Carthage. Les représentations figurées sur les stèles de Carthage', *Cahiers de Byrsa*, 1, 1951, pp. 15–76

HUET, 1988 J. C. Huet, 'The Togu Na of Tenyu Ireli', *African Arts*, 21 (4), 1988, pp. 34–6, 91

HUFFMAN, 1984 T. N. Huffman, 'Expressive Space in the Zimbabwe Culture', *Man*, 19, 1984, pp. 593–612

HUFFMAN, 1985 T. N. Huffman, 'The Soapstone Birds from Great Zimbabwe', *African Arts*, 18 (3), 1985, pp. 68–73

HUFFMAN, 1986 T. N. Huffman, 'Iron Age Settlement Patterns and the Origins of Class Distinction in Southern Africa', in *Advances in World Archaeology* 5, ed. F. Wendorf and E. Close, New York, 1986, pp. 291–338

HUGOT, 1981 H. J. Hugot, 'The Prehistory of the Sahara', in *General History of Africa,* i: *Methodology and African Prehistory*, ed. J. Ki-Zerbo, London, 1981, pp. 585–610

HULTGREN and ZEIDLER, 1993 M. L. Hultgren and J. Zeidler, *A Taste for the Beautiful: Zairian Art from the Hampton University Museum*, Hampton, VA, 199

HUNTINGDON and METCALF, 1979 W. R. Huntingdon and P. Metcalf, *Celebration of Death: The Anthropology of Mortuary Ritual*, Cambridge, 1979

HUNTINGFORD, 1955 G. W. B. Huntingford, *The Galla of Ethiopia. The Kingdoms of Kafa and Janjero*, London, 1955

IBRAHIM, 1978 L. A. Ibrahim, 'Clear fresh water in Cairene houses', *Islamic Archaeological Studies*, i, Cairo, 1978, pp. 1–26

IDOWU, 1963 E. B. Idowu, *Olodomare, God in Yoruba Belief*, New York, 1963

IMPERATO, 1970 P. J. Imperato, 'The Dance of the Tyi Wara', *African Arts*, 4 (1), 1970, pp. 8–13, 71–80

IMPERATO, 1974 P. J. Imperato, *The Cultural Heritage of Africa*, Chanute, 1974

IMPERATO, 1975 P. J. Imperato, 'Bamana and Mininka Twoin Figures', *African Arts*, 8, 1975, pp. 53–60

IMPERATO, 1983 P. J. Imperato, *Buffoons, Queens and Wooden Horsemen: The Dyo and Gouan Societies of the Bambara of Mali*, New York, 1983

INDIANAPOLIS 1980–1 *African Furniture and Household Objects*, exh. cat. by R. Sieber, Indianapolis Museum of Art, Indianapolis, 1980–1

INGRAM, 1931 W. Ingram, *Zanzibar: Its History and its People*, London, 1931

INSKEEP, 1971 R. R. Inskeep, 'Terracotta Heads', *South African Journal of Science*, 67, 1971, pp. 492–3

INSKEEP and MAGGS, 1975 R. R. Inskeep and T. M. Maggs, 'Unique Art Objects in the Iron Age of the Transvaal South Africa', *South African Archaeological Bulletin*, 30, 1975, pp. 114–38

ISICHEI, 1982 E. Isichei, *Studies in the History of Plateau State, Nigeria*, London, 1982

JACQUES-MEUNIÉ, 1951 D. Jacques-Meunié, *Greniers citadelles au Maroc*, Paris, 1951

JACQUES-MEUNIÉ, 1960–1 D. Jacques-Meunié, 'Bijoux et bijouteries du Sud Marocain', *Cahiers des arts et techniques d'Afrique du Nord*, 6, 1960–1, pp. 57–72

JACQUES-MEUNIÉ, 1961 D. Jacques-Meunié, *Cités anciennes de Mauritanie, provinces de Tagannt et du Hodh*, Paris, 1961

JACQUES-MEUNIÉ, 1962 D. Jacques-Meunié, *Architecture et habitats du Dadès*, Paris, 1962

JAHN, 1994 J. Jahn, ed., *Tanzania: Meisterwerke Afrikanischer Skulptur*, Munich, 1994

JAMES, 1974 T. G. H. James, *Corpus of Hieroglyphic Inscriptions in The Brooklyn Museum, i: From Dynasty I to the End of Dynasty XVIII*, Wilbour Monographs, vi, Brooklyn, 1974

JAMES, 1984[1] D. James, 'Some observations on the calligrapher and illuminators of the koran of Rukn al-Din Baybar al-Jashnagir', *Muqarnas*, ii, 1984, pp. 147–57

JAMES, 1984[2] T. G. H. James, *Egyptian Painting*, London, 1984

JAMES, 1988 D. James, *Qur'ans of the Mamluks*, London, 1988

JAMES and DAVIES, 1983 T. G. H. James and W. V. Davies, *Egyptian Sculpture*, London, 1983

JANSEN and GAUTHIER, 1973 G. Jansen and J. G. Gauthier, *Ancient Art of the Northern Cameroons: Sao and Fali*, Oosterhout, 1973

JAQUES, 1940 A. A. Jaques, 'Carved Headrests of the Shangaans', *Sunday Times*, 9 April 1940

JAQUES, c. 1941 A. A. Jaques, 'Shangaan Head-rests', lecture delivered to the Fine Arts Society of Johannesburg, c. 1941

JAQUES, 1949 L. Jacques, 'Art indigène et appuis-tête', *Bulletin de la Mission suisse dans l'Afrique du Sud*, 49 (633), 1949, pp. 333–40

JAROŠ-DECKERT, 1987 B. Jaroš-Deckert, *Statuen des Mittleren Reichs und der 18. Dynastie*, Vienna, 1987

JENKINS, 1970 J. Jenkins, *Music of Eritrea*, iii, 1970, record no. TGM103

JENSEN, 1936 A. E. Jensen, *Im Lande des Gada*, Stuttgart, 1936

JENSEN, 1942 A. E. Jensen, 'Das Gada-System der Konso und die Altersklassensysteme der Niloten', *Ethnos*, 19, 1942, pp. 1–22

JENSEN, 1954 A. E. Jensen, 'Elementi della cultura dei Conso', *Rassegna di studi etiopici*, 2, 1954, pp. 217–59

JOBART, 1925 A. Jobart, 'Chez les Bassalam Pasu du Haut kasai', *Bulletin de la Societé Belge d'Études Coloniales*, 82, 1925, pp. 280–92

JOHANNESBURG 1989 *Ten Years of Collecting: The Standard Bank Foundation Collection of African Art*, exh. cat., ed. D. Hammond-Tooke and A. Nettleton, University of the Witwatersrand Art Galleries, Johannesburg, 1989

JOHANNESBURG 1991 *Art and Ambiguity: Perspectives on the Brenthurst Collection of Southern African Art*, exh. cat. by P. Davison et al., Johannesburg Art Gallery, Johannesburg, 1991

JOHNSTON, 1904 H. Johnston, *The Uganda Protectorate*, London, 1904

JOLLES, 1994 F. Jolles, 'Messages in Fixed Colour Sequences? Another Look at Msinga Beadwork', in *Oral Tradition and its Transmission, the Many Forms of Message*, ed. E. Sienaert, M. Cowper-Lewis and N. Bell, Durban, 1994, pp. 47–62

JONES, 1937 G. I. Jones, 'Ohafia Obu Houses', *Nigerian Field*, 6 (4), 1937, pp. 169–71

JONES, 1979 P. R. Jones, 'Effects of raw materials on biface manufacture', *Science*, 204, 1979, pp. 835–6

JONES, 1984 G. I. Jones, *The Art of Eastern Nigeria*, Cambridge, 1984

JONES, 1994 A. Jones, 'A Collection of African Art in Seventeenth-century Germany: Christopher Weickmann's *Kunst- und Naturkammer*', *African Arts*, 27 (2), 1994, pp. 28–3, 92

JOSEPH, 1974 M. B. Joseph, 'Dance Masks of the Tikar', *African Arts*, 7 (3), 1974, pp. 46–52

JUNOD, 1962 H. A. Junod, *The Life of a South African Tribe*, 2 vols, New York, 1962 [1st edn 1912]

KAMER, 1973 H. Kamer, *Haute-Volta*, Brussels and Paris, 1973

KAMER, 1974 H. Kamer, *Ancêtres M'bembé*, Paris, 1974

KANTOR, 1944 H. J. Kantor, 'The Final Phase of Predynastic Culture: Gerzean or Semainean?', *Journal of Near Eastern Studies*, 3, 1944, pp. 110–36

KANTOR, 1948 H. J. Kantor, 'A Predynastic Ostrich Egg with Incised Decoration', *Journal of Near Eastern Studies*, 7, 1948, pp. 46–51

KASFIR, 1979 S. L. Kasfir, *The Visual Arts of the Idioma of Central Nigeria*, diss., School of Oriental and African Studies, London, 1979

KASFIR, 1984 S. L. Kasfir, 'One Tribe, One Style? Paradigms in the Historiography of African Art', *History in Africa*, 11 (1), 1984, pp. 163–93

KATUMBA, 1983 N. B. M. Katumba, 'La circoncision chez les Ngbaka', *Africa: Revista do Centro de Estudos Africanos da USP (São Paulo)*, 6, 1983, pp. 3–33

KAYSER, 1973 H. Kayser, 'Die ägyptischen Altertümer im Roemer-Pelizaeus-Museum in Hildesheim', *Wissenschaftliche Veröffentlichung Pelizaeus-Museum*, 8, Hildesheim, 1973

KECSKÉSI, 1982[1] M. Kecskési, 'The Pickaback Motif in the Art and Initiation of the Rovuma Area', *African Arts*, 16 (1), 1982, pp. 52–5

KECSKÉSI, 1982[2] M. Kecskési, *Kunst aus dem Alten Afrika*, Munich, 1982

KEIMER, 1949 L. Keimer, *Bibliotheca Orientalis*, 6, 1949, p. 139, n. 10

KELEKIAN, 1910 *Kelekian Collection of Persian and Analogous Potteries*, Paris, 1910

KELLY, 1977 J. N. D. Kelly, *Early Christian Doctrines*, London, 5/1977

KELTERBORN, 1984 P. Kelterborn, 'Toward Replicating Egyptian Predynastic Flint Knives', *Journal of Archaeological Science*, 11, 1984, pp. 433–53

KEMP, 1989 B. J. Kemp, *Ancient Egypt: Anatomy of a Civilization*, London and New York, 1989

KENDALL, 1982 T. Kendall, *Kush: Lost Kingdom of the Nile*, Brockton, MA, 1982

KENDALL, 1994 T. Kendall, 'Le Djebel Barkal: Le Karnak de Koush', *La Nubie (Les Dossiers d'Archéologie*, 196), 1994, pp. 46–53

KENT, 1970 R. Kent, *Early Kingdoms in Madagascar, 1500–1700*, New York, 1970

KERCHACHE, 1993 J. Kerchache, *Art of Africa*, New York, 1993

KIDANE and WILDING, 1976 G. Kidane and R. Wilding, *The Ethiopian Cultural Heritage/L'Héritage Culturel Ethiopien*, Addis Ababa, 1976

KILLIAN, 1934 C. Killian, 'L'art des Touareg', *La Renaissance*, 1 (7–9), 1934, pp. 147–55

KILLEN, 1980 G. Killen, *Ancient Egyptian Furniture, i, 4000–1300 BC*, Warminster, 1980

KINAHAN, 1990 J. Kinahan, 'Four thousand years at the Spitzkoppe: changes in settlement and land use on the edge of the Namib Desert', *Cimbebasia*, 12, 1990, pp. 1–14

KINAHAN, 1991 J. Kinahan, *Pastoral nomads of the Central Namib Desert: The people history forgot*, Windhoek, 1991

KINGDON, 1994 Z. Kingdon, *A Host of Devils: The History and Context of the Modern Makonde Carving Movement*, diss., University of East Anglia, 1994

KINSHASA 1978 *Pierres sculptées du Bas-Zaire*, exh. cat. by J. Cornet, Institut des Musées Nationaux, Kinshasa, 1978

KLEVER, 1975 U. Klever, *Bruckmann's Handbuch der afrikanischen Kunst*, Munich, 1975

KLOPPER, 1989 S. Klopper, 'Carvers, Kings and Thrones in Nineteenth-century Zululand', in *African Art in Southern Africa: From Tradition to Modernism*, ed. A. Nettleton and D. Hammond-Tooke, Johannesburg, 1989

KLOPPER, 1991 S. Klopper, '"Zulu" Headrests and Figurative Carvings', in *Art and Ambiguity: Perspectives on the Brenthurst Collection of Southern African Art*, exh. cat., Johannesburg, 1991, pp. 80–103

KLOPPER, 1992 S. Klopper, *The Art of Zulu-speakers in Northern Natal-Zululand: An Investigation of the History of Beadwork, Carving and Dress from Shaka to Inkatha*, diss., University of the Witwatersrand, Johannesburg, 1992

KNAUER, 1979 E. R. Knauer, 'Marble Jar-Stands from Egypt', *Metropolitan Museum Journal*, 14, 1979, pp. 67–102

KNOPS, 1980 P. Knops, *Les anciens Senufo 1923–35*, Berg en Dal, 1980

KOLOSS and FÖRSTER, 1990 H. J. Koloss and T. Förster, *Die Kunst der Senufo, Elfenbeinküste*, Berlin, 1990

KOROMA, 1939 V. H. Koroma, 'The Bronze Statuettes of Ro-Ponka, Kafu Bolom', *Sierra Leone Studies*, 22, 1939, pp. 25–28

KOTZE, 1950 D. J. Kotze, ed., *Letters of the American Missionaries, 1835–1838*, Cape Town, 1950

KOZLOFF, 1983 A. P. Kozloff, 'Symbols of Egypt's Might', *Bulletin of the Egyptological Seminar*, 5, 1983, pp. 61–6

KOZLOFF and BRYAN, 1992 A. P. Kozloff and B. M. Bryan, *Egypt's Dazzling Sun: Amenhotep III and his World*, Cleveland, OH, 1992

KREAMER, 1987 C. M. Kreamer, 'Moba Shrine Figures', *African Arts*, 20 (2), 1987, pp. 52–5, 82–3

KRIEGER, 1960 K. Krieger, *Westafrikanische Masken*, Berlin, 1960

KRIEGER, 1965–9 K. Krieger, *Westafrikanische Plastik*, i-iii, Berlin, 1965–9

KRIEGER, 1978, 1990 K. Krieger, *Ostafrikanische Plastik*, Museum für Völkerkunde, Berlin, 1978, 2nd edn 1990

KRIGE, 1988 E. K. Krige, *The Social System of the Zulus*, Pietermaritzburg, 1988 [1st edn 1936]

KRIGE and KRIGE, 1943 E. J. Krige and J. D. Krige, *The Realm of a Rain-Queen: A Study of the Pattern of Lovedu Society*, London, 1943

KRONENBERG and KRONENBERG, 1960 A. and W. Kronenberg, 'Wooden Carvings in the South Western Sudan', *Kush*, viii, 1960, pp. 274–81, pls XL–LII

KRONENBERG and KRONENBERG, 1981 W. and A. Kronenberg, *Die Bongo Bauern und Jäger im Südsudan*, Wiesbaden, 1981

KUBIK, 1978[1] G. Kubik, 'Boys' Circumcision School of the Yao: A Cinematographic Documentation at Chief Makanjila's Village in Malawi, 1967,' *Review of Ethnology*, 6 (1–7), 1978, pp. 1–37

KUBIK, 1978[2] G. Kubik, 'Nzondo – Girls' Initiation Ceremony among the Yao at Makanjia's Village in Malawi, 1967', *Review of Ethnology*, 6 (1–7) 1978[2], pp. 37–51

KÜHNEL, 1971 E. Kühnel, *Die islamischen Elfenbeinskulpturen: VIII. –XIII. Jahrhundert*, 2 vols, Berlin, 1971

KUNSTHISTORISCHES MUSEUM, 1988 Kunsthistorisches Museum, *Führer durch die*

Sammlungen, museum guidebook, Egyptian and Near Eastern section by E. Haslauer and H. Satzinger, Vienna, 1988

LABOURET, 1920 H. Labouret, 'Le mystère des ruines du Lobi', *Revue d'ethnographie et des traditions populaires*, i, 1920, pp. 178–96

LABOURET, 1931 H. Labouret, *Les tribus du Rameau Lobi*, Paris, 1931

LABURTHE-TOLRA and FALGAYRETTES-LEVEAU, 1991 P. Laburthe-Tolra and C. Falgayrettes-Leveau, *Fang*, Paris, 1991

LAMB, 1975 V. Lamb, *West African Weaving*, London, 1975

LAMB and LAMB, 1981 V. and A. Lamb, *Au Cameroun: weaving-tissage*, Douala, 1981

LAMM, 1929–30 C. J. Lamm, *Mittelalterliche Gläser und Steinschnittarbeiten aus dem Nahen Osten*, 2 vols, Berlin, 1929–30

LAMM, 1935–6 C. J. Lamm, 'Fatimid Woodwork, its Style, and Chronology', *Bulletin de l'Institut d'Égypte*, 18, 1935–6, pp. 69–80

LAMP, 1983 F. Lamp, 'House of Stones: Memorial Art of Fifteenth Century Sierra Leone', *Art Bulletin*, 65, 1983, pp. 219–37

LAMPREIA, 1962 J. D. Lampreia, *Catálogo-inventário da Secção de Etnografia do Museu da Guiné Portuguesa*, Lisbon, 1962

LANCEL, 1995 S. Lancel, *Carthage, A History*, trans. A. Nevill, Oxford, 1995 [1st edn, *Carthage*, 1992]

LANCI, 1845–6 M. Lanci, *Trattato delle simboliche rappresentanze arabiche e della varia generazione de' musulmani caratteri sopra differenti materie operati*, 2 vols, Paris, 1845–6

LANDSTROM, 1970 B. Landstrom, *Ships of the Pharaohs*, London, 1970

LANE, 1947 A. Lane, *Early Islamic Pottery*, London, 1947

LANE-POOLE, 1886 S. Lane-Poole, *The Art of the Saracens in Egypt*, London, 1886

LANGLOIS, 1954 P. Langlois, *Arts soudanais: Tribus dogons*, Brussels, 1954

LANSING, 1934 A. Lansing, 'The Burial of Hepy', *Bulletin of The Metropolitan Museum of Art*, xxix, 1934, pp. 27–41

LAPEYRE and PELLEGRIN, 1942 G-C. Lapeyre and A. Pellegrin, *Carthage punique (814–146 avant J-C)*, Paris, 1942

LAUDE, 1973 J. Laude, *African Art of the Dogon: The Myths of the Cliff Dwellers*, New York, 1973

LAURENTY, 1962 J-S. Laurenty, *Les Sanza du Congo*, Tervuren, 1962

LAW, 1980 R. Law, *The Horse in West Africa*, London, 1980

LAWAL, 1970 B. Lawal, *Yoruba Sango Sculpture in Historical Retrospect*, diss., Indiana University, 1970

LAWAL, 1974 B. Lawal, 'Some Aspects of Yoruba Aesthetics', *The British Journal of Aesthetics*, 14 (3), 1974, pp. 239–49

LAWAL, 1975 B. Lawal, 'Yoruba-Shango Ram Symbolism: From Ancient Sahara or Dynastic Egypt?', in *African Images: Essays in African*

Iconology, ed. D. McCall and E. Bay, New York and London, 1975

LAWAL, 1995 B. Lawal, 'À YÀ GBÓ, À YÀ TÓ: New Perspectives on Edan Ogboni', *African Arts*, 28 (1), 1995, pp. 36–49, 98–100

LAWRENCE, 1924 C. T. Lawrence, 'Report on the Nigerian Section, British Empire Exhibition', *West Africa*, 1212, 1924, pp. 12–16

LEAKEY, 1977 L. S. B. Leakey, *The Southern Kikuyu before 1903*, 3 vols, London, 1977

LEBEUF, 1953 J. P. Lebeuf, 'Lebrets et greniers des Falis', *Bulletin de l'Institut Français de S. Afrique*, 15, 1953, pp. 1321–8

LECLANT, 1976 J. Leclant, 'Kushites and Meroites: Iconography of the African Rulers on the Ancient Upper Nile', in *The Image of the Black in Western Art*, i, New York, 1976, pp. 89–132

LEE, 1979 R. B. Lee, *The !Kung San: Men, Women and Work in a Foraging Society*, Cambridge, 1979

LEE, 1984 R. B. Lee, *The Dobe !Kung*, New York, 1984

LEFEBVRE and VAN RINSVELD, 1990 F. Lefebvre and B. van Rinsveld, *L'Égypte: Des Pharaons aux Coptes*, Brussels, 1990

LEGESSE, 1973 A. Legesse, *Gada: Three Approaches to the Study of African Society*, 1973

LEGLAY, 1961 M. LeGlay, *M. Saturne africain: Monuments* i, Paris, 1961

LEHUARD, 1974 R. Lehuard, *Statuaire du Stanley-Pool*, Arnouville, 1974

LEHUARD, 1976 R. Lehuard, *Les Phemba du Mayombe*, Arnouville, 1976

LEHUARD, 1982 R. Lehuard, 'Omakipa', *Arts d'Afrique Noire*, 42, 1982, pp. 20–5,

LEHUARD, 1989 R. Lehuard, *Art Bakongo, les Centres de Style*, 2 vols, Arnouville, 1989

LEHUARD, 1993 R. Lehuard, *Art Bakongo: les masques*, Arnouville, 1993

LEIBOVITCH, 1959 J. Leibovitch, 'Étuis à fard zoomorphes de l'Ancien Empire égyptien', *Atiqot*, 2, 1959, pp. 118–20

LEIRIS, 1933 M. Leiris, 'Objets rituels dogon', *Minotaure*, 2, 1933, pp. 26–30

LEIRIS and DELANGE, 1967 M. Leiris and J. Delange, *Afrique noire. La création plastique*, Paris, 1967

LEMA GWETE, 1980 Lema Gwete, *Kunst aus Zaire. Masken und Plastiken aus der Nationalsammlung*, Bremen, 1980

LESLAU, 1957 W. Leslau, *Coutumes et croyances des Falaches (Juifs d'Abyssinie)*, Paris, 1957

LEURQUIN and MEURANT, 1990 A. Leurquin and G. Meurant, 'Tanzanie méconnue', *Arts d'Afrique Noire*, 73 and 75, 1990

LEUZINGER, 1960 E. Leuzinger, *The Art of the Negro Peoples*, London, 1960

LEUZINGER, 1972 E. Leuzinger, *The Art of Black Africa*, London, 1972

LEUZINGER, 1978 E. Leuzinger, ed., *Afrikanische Skulpturen*, Zurich, 1978

LEVINSOHN, 1983 R. Levinsohn, 'Amacunu Beverage Containers', *African Arts*, 16 (3), 1983, pp. 53–6

LEVINSOHN, 1984 R. Levinson, *Art and Craft of Southern Africa: Treasures in Transition*, Johannesburg, 1984

LEVTZION, 1973 N. Levtzion, *Ancient Ghana and Mali*, London, 1973

LEVY, 1990 D. Levy, 'Continuities and Change in Ndebele Beadwork: *c.* 1883 to the Present', diss., University of the Witwatersrand, Johannesburg, 1990

LEWIS-WILLIAMS, 1974 J. D. Lewis-Williams, 'The syntax and function of the Giant's castle rock paintings', *South African Archaeological Bulletin*, 27, 1974, pp. 49–65

LEWIS-WILLIAMS, 1981 J. D. Lewis-Williams, *Believing and Seeing: Symbolic Meanings in Southern San Rock Paintings*, London, 1981

LEWIS-WILLIAMS, 1983 J. D. Lewis-Williams, *The Rock Art of Southern Africa*, Cambridge, 1983

LEWIS-WILLIAMS, 1984 J. D. Lewis-Williams, 'Ideological Continuities in Prehistoric Southern Africa: The Evidence of Rock Art', in *Interfaces: The Relationship of Past and Present in Hunter-gatherer Studies*, ed. C. Schrire, New York, 1984, pp. 225–52

LEWIS-WILLIAMS, 1988 J. D. Lewis-Williams, 'The World of Man and the World of Spirit: An Interpretation of the Linton Rock Paintings', *Margaret Shaw Lecture*, 2, 1988, pp. 1–16

LEWIS-WILLIAMS, 1990 J. D. Lewis-Williams, *Discovering Southern African Rock Art*, Cape Town, 1990

LEWIS-WILLIAMS and DOWSON, 1989 J. D. Lewis-Williams and T. A. Dowson, *Images of Power: Understanding Bushman Rock Art*, Johannesburg, 1989

LEWIS-WILLIAMS and DOWSON, 1994 J. D. Lewis-Williams and T. A. Dowson, eds, *Contested Images: Diversity in Southern African Rock Art Research*, Johannesburg, 1994

LILLE 1994 *Nubie. Les cultures antiques du Soudan*, ed. B. Gratien and F. le Saout, Lille, 1994

LINDBLOM, 1920 G. Lindblom, *The Akamba in British East Africa*, Uppsala, 1920

LINGS, 1976 M. Lings, *Qur'anic art of illumination and calligraphy*, London, 1976

LINGS and SAFADI, 1976 M. Lings and Y. Safadi, eds, *The Qur'an: A British Library Exhibition*, exh. cat., London, 1976

LINZ 1989 *Ägypten: Götter, Gräber und die Kunst: 4000 Jahre Jenseitsglaube*, exh. cat., Linz, 1989

LISBON 1994 *Sculpture angolaise. Mémorial de cultures*, exh. cat. by M.-L. Bastin, Museo Nacional de Etnologia, Lisbon, 1994

LOIR, 1935 H. Loir, *Le tissage du raphia au Congo Belge*, Brussels, 1935

LOMBARD, 1973 J. Lombard, 'Les Sakalava-menabe de la côte Ouest: La société et l'art funéraire', in *Malgache, qui es-tu?*, Neuchâtel, 1973

LONDON 1862 *Catalogue of the Special Exhibition of Works of Art on Loan at the South Kensington Museum*, exh. cat. ed. J. C. Robinson, London, 1862

LONDON 1976 *The Arts of Islam*, exh. cat., Hayward Gallery, London, 1976

LONDON 1976 *The Qur'an: A British Library Exhibition*, World of Islam Festival, London, 1976

LONDON 1981 *Asante: Kingdom of Gold: The Power and Splendour of a Great Nineteenth-Century West African Kingdom*, exh. cat. by M. McLeod, Museum of Mankind, London, 1981

LONDON 1982 see Detroit et al. 1980–3

LONDON 1983 *The Eastern Carpet in the Western World from the 15th to the 17th century*, exh. cat. ed. D. King and D. Sylvester, Arts Council of Great Britain, Hayward Gallery, London, 1983

LONDON 1984 *The Treasury of San Marco Venice*, exh. cat., British Museum, London, 1984

LONDON AND NEW YORK 1979–83 *African Textiles: Looms, Weaving and Design*, exh. cat. by J. Picton and J. Mack, Museum of Mankind/British Museum, London, 1979–82; American Museum of Natural History, New York, 1983; London, 1979, rev. edn 1989

LORENZ, 1991 H. Lorenz, ed., *Spoons in African Art*, Museum Rietberg, Zurich, 1991

LORQUIN, 1992 A. Lorquin, *Les tissus coptes*, Paris, 1992

LOS ANGELES 1993 *Sleeping Beauties: The Jerome L. Joss Collection of Headrests at UCLA*, exh. cat. by W. Dewey, Fowler Museum of Cultural History, University of California, Los Angeles, 1993

LOUGHRAN, 1986 K. S. Loughran et al., eds, *Somalia in Word and Image*, Washington, 1986

LOVICONI, 1991 A. Loviconi, *Regards sur la faience de Fès*, Paris 1991

LUXOR MUSEUM 1979 *Catalogue*, Luxor Museum of Ancient Egyptian Art, Cairo, 1979

MAASTRICHT 1992 *Kings of Africa: Art and Authority in Central Africa*, exh. cat. ed. by E. Beumers and H.-J. Koloss, Foundation Kings of Africa, Maastricht, 1992

MacCALMAN, 1964 H. R. MacCalman, 'Grosse Domschlucht Brandberg: A new discovery of prehistoric rock art in South West Africa', *IPEK*, 21, 1964, pp. 91–3

MacGAFFEY, 1986 W. MacGaffey, *Religion and Society in Central Africa: The Ba-Kongo of Lower Zaire*, Chicago and London, 1986

MacGAFFEY, 1991 W. MacGaffey, *Art and Healing of the BaKongo: Commented by Themselves*, Stockholm, 1991

MacGAFFEY and HARRIS, 1993 W. MacGaffey and M. D. Harris, *Astonishment and Power*, Washington, 1993

MACK, 1982 J. Mack, 'Material Culture and Ethnic Identity in Southeastern Sudan', in *Culture History in the Southern Sudan*, ed. J. Mack and P. Robertshaw, Nairobi, 1982, no. 8, pp. 111–30

MACK, 1986 J. Mack, *Madagascar: Island of the Ancestors*, London, 1986

MACK, 1990 J. Mack, *Emil Torday and the Art of the Congo, 1900–1909*, London, 1990

MACK and COOTE, in preparation J. Mack and J. Coote, 'East Africa: Domestic and other arts', in *The Dictionary of Art*, London, in preparation

MACK, SCHILDKROUT and KEIM, 1990 J. Mack, E. Schildkrout and C. A. Keim, *African Reflections: Art from Northeastern Zaire*, New York and Washington, 1990

McINTOSH and McINTOSH S. K. McIntosh and R. J. McIntosh, 'Current Directions in West African Prehistory', *Annual Review of Anthropology*, 12, pp. 215–58

McLEOD, 1981 M. McLeod, *The Asante*, London, 1981

McNAUGHTON, 1979 P. R. McNaughton, *Secret Sculptures of Komo: Art and Power in Bamana (Bambara) Initiation Associations*, Philadelphia, 1979

McNAUGHTON, 1982 P. R. McNaughton, 'Language, Art, Secrecy and Power: The Semantics of Dalilu', *Anthropological Linguisitics*, 24 (4), 1982, pp. 487–505

McNAUGHTON, 1988 P. R. McNaughton, *The Mande Blacksmiths: Knowledge, Power and Art in West Africa*, Bloomington, 1988

McNAUGHTON, 1991 P. McNaughton, 'Is there History in Horizontal Masks?: A Preliminary Response to the Dilemma of Form', *African Arts*, 24 (2), 1991, pp. 40–53, 88–9

McNAUGHTON, 1992 P. R. McNaughton, 'From Mande *Komo* to Jukun *Akuma*: Approaching the Difficult Question of History', *African Arts*, 25 (2), 1992, pp. 76–85, 99–100

McNAUGHTON, 1994 P. R. McNaughton, 'Antelope Headdress', in *Vision of Africa: The Jerome L. Joss Collection of African Art at UCLA*, ed. D. Ross, Los Angeles, 1994

MAES, 1929 J. Maes, *Les appuis-tête du Congo Belge*, Annales du Musée Royal du Congo Belge, ser. VI (i) 1, Tervuren, 1929

MAESEN, 1954 A. Maesen, 'Statuaire et culte de fécondité chez les Luluwa du Kasaï (Zaïre)', *Quaderni Poro*, 1954, 3, pp. 49–58

MAESEN, 1959 A. Maesen, *Arte del Congo*, Rome, 1959

MAESEN, 1960 A. Maesen, *Umbangu. Art du Congo au Musée de Tervuren*, Brussels, 1960

MAGGS, 1984 T. Maggs, 'The Iron Age South of the Zambezi', in *Southern African Prehistory and Palaeoenvironments*, ed. R G. Klein, Rotterdam, 1984, pp. 329–60

MAGGS, 1991 T. Maggs, 'Metalwork from Iron Age Hoards as a Record of Metal Production in the Natal Region', *South African Archaeological Bulletin*, 46, 1991, pp. 131–6

MAGGS and DAVISON, 1981 T. Maggs and P. Davison, 'The Lydenburg Heads and the Earliest African Sculpture South of the Equator', *African Arts*, 14 (2), 1981, pp. 28–33

MALEK, 1986 J. Malek, *In the Shadow of the Pyramids*, London, 1986

MALEK, 1993 J. Malek, *The Cat in Ancient Egypt*, London, l993

MANSFELD, 1908 A. Mansfeld, *Urwald-Dokumente*, Berlin, 1908

MARCAIS, 1935–40 G. Marcais, 'Les figures d'hommes et de bêtes dans les bois sculptés d'époque Fatimite', *Mélanges Maspéro III (Orient Islamique)*, Cairo, 1935–40, pp. 240–57

MARCAIS, 1954 G. Marcais, *L'architecture musulmane d'occident*, Paris, 1954

MARCQ-EN-BAROEUL, 1977 *L'Égypte des pharaons*, Marcq-en-Baroeul, 1977

MARSEILLES, 1990 *L'Égypte des millénaires obscurs*, exh. cat., Musées de Marseille, Marseilles, 1990

MARSHALL, 1976 L. Marshall, *The !Kung of Nyae Nyae*, Cambridge, MA, 1976

MAUNY, 1961 R. Mauny, *Tableau géographique de l'ouest Africain au Moyen Âge*, Dakar, 1961

MAURER, n. d. E. M. Maurer, *The Intelligence of Forms: An Artist Collects African Art*, Minneapolis, n. d.

MAURER and ROBERTS, 1985 E. Maurer and A. F. Roberts, eds, *Tabwa. The Rising of a New Moon: A Century of Tabwa Art*, Ann Arbor, 1985

MAYES, 1959 S. Mayes, *The Great Belzoni*, London, 1959

MEAUZÉ, 1968 P. Meauzé, *African Art*, London, 1968

MEDHIN, 1980–2 T. W. Medhin, 'La préparation traditionelle des couleurs en Éthiopie', *Abbay*, 11, 1980–2, pp. 219–24

MEEK, 1931 C. K. Meek, *A Sudanese Kingdom: An Ethnographical Study of the Jukun-speaking Peoples of Nigeria*, London, 1931

MEILLASSOUX, 1975 C. Meillassoux, ed., *L'esclavage en Afrique précoloniale*, Paris, 1975

MENZEL, 1972 B. Menzel, *Textilien aus Westafrika*, Berlin, 1972

MERCIER, 1979 J. Mercier, *Ethiopian Magic Scrolls*, New York, 1979

MERLIN, 1910 A. Merlin, *Le sanctuaire de Baal et de Tanit près de Siagu*, Notes et Documents, iv, Paris, 1910

MERLO, 1966 C. Merlo, *Un chef-d'oeuvre d'art Nègre: Le buste de la Prêtresse*, Anvers-sur-Oise, 1966

METROPOLITAN MUSEUM OF ART, 1902 *Handbook no. 13, Musical Instruments of all Nations*, iii, New York, 1902

MEURANT, 1986 G. Meurant, *Shoowa motieven. Afrikaans textiel van het Kuba-rijk*, Brussels, 1986

MEYER, 1981 P. Meyer, *Kunst und Religion der Lobi*, Zurich, 1981

MICHALOWSKI, 1974 K. Michalowski, *Faras: Die Wandbilder in den Sammlungen des Nationalmuseums zu Warschau*, Warsaw and Dresden, 1974

MIDANT-REYNES, 1987 B. Midant-Reynes, 'Contribution à l'étude de la société prédynastique: Le cas du couteau "Ripple-Flake"', *Studien zur altägyptischen Kultur*, 14, 1987, pp. 185–224

MIDDLETON and KERSHAW, 1972 J. Middleton and G. Kershaw, *The Central Tribes of the North-Eastern Bantu*, London, 1972

MIGEON, 1907 G. Migeon, *Manuel d'art musulman*, Paris, 1907

MIGEON, 1927 G. Migeon, *Manuel d'art musulman*, Paris, 1927

MILLER and VAN DER MERWE, 1994 D. E. Miller and N. J. Van der Merwe, 'Early Metal Working in Sub-Saharan Africa: A Review of Recent Research', *Journal of African History*, 35, 1994, pp. 1–36

MILLS, 1982 A. J. Mills, *The Cemeteries of Qasr Ibrim*, London, 1982

MINISTÈRE DE L'ÉCONOMIE NATIONALE, 1958 Ministère de l'Économie Nationale, *L'Artisanat au Maroc*, Casablanca, 1958

MITCHELL, 1956 J. C. Mitchell, *The Yao Village: A Study in the Social Structure of a Nyasaland Tribe*, Manchester, 1956

MONNERET DE VILLARD, 1923 U. Monneret de Villard, *La scultura ad Ahnas: Note sull'origine dell'arte copta*, Milan, 1923

MONTET, 1960 P. Montet, *La nécropole royale de Tanis, iii: Les constructions et le tombeau de Chechanq II*, Paris, 1960

MOREAU, 1976 J. B. Moreau, *Les grands symboles méditerranéens de la poterie algérienne*, Algiers, 1976

MORRIS, 1988 D. Morris, 'Engraved in Place and Time: A Review of Variability in the Rock Art of the Northern Cape and Karoo', *South African Archaeological Bulletin*, 43, 1988, pp. 109–21

MORRIS, 1990 D. Morris, 'Sculptured Stone Heads from the Kimberley Area and the Western Orange Free State', in P. B. Beaumont and D. Morris, *Guide to Archaeological Sites in the Northern Cape*, Kimberley, 1990

MORRIS, 1994 D. Morris, 'An Ostrich Eggshell Cache from the Vaalbos National Park, Northern Cape', *Southern African Field Archaeology*, 3 (1), 1994, pp. 55–8

MORRIS and PRESTON-WHYTE, 1994 J. Morris and E. Preston-Whyte, *Speaking with Beads. Zulu Arts from Southern Africa*, London, 1994

MORTON-WILLIAMS, 1960 P. Morton-Williams, 'The Yoruba Ogboni Cult in Oyo', *Africa*, 30 (4), 1960, pp. 362–74

MOSCATI, 1973 S. Moscati, *The World of the Phoenicians*, trans. A. Hamilton, London, 1973 [*Il mondo dei Fenici*, 1966]

MOSTAFA, 1958 M. Mostafa, *Unity in Islamic Art*, Cairo, 1958

MOSTAFA, 1961 M. Mostafa, *The Museum of Islamic Art: A Short Guide*, Cairo, 1961

MOTA, 1960 T. da Mota, 'Descoberta de bronzes antigos na Guiné Portuguesa', *Boletim Cultural da Guiné Portuguesa*, 15, 1960, pp. 625–32

MOTA, 1965 T. da Mota, 'Bronzes antigos da Guiné', *Actas do Congresso Internasional de Etnografia*, 4, 1965, pp. 149–54

MOTA, 1975 A. T. Mota, 'Gli avori africani nella documentazione dei secoli XV–XVII', *Africa*, 30 (4), 1975, pp. 580–9

MIDDLETON and KERSHAW, 1972

MURDOCK, 1959 G. P. Murdock, *Africa: Its Peoples and their Culture History*, New York, 1959

MURPHY, 1967[1] R. T. A. Murphy, 'Luke, Evangelist, St.', *New Catholic Encyclopedia*, viii, New York, 1967, pp. 1066–7

MURPHY, 1967[2] R. T. A. Murphy, 'Luke, Gospel according to St.', *New Catholic Encyclopedia*, viii, New York, 1967, pp. 1067–72

MURRAY, 1911 M. A. Murray, 'Figure Vases', in *Historical Studies, 1910*, British School of Archaeology in Egypt Studies, ii, London, 1911, pp. 40–6

MURRAY, 1941 K. C. Murray, 'Ogbom', *Nigerian Field*, 12 (2), 1941, pp. 127–31

MURRAY, 1946 K. C. Murray, 'The Wood Carvings of Oron. The Need for a Museum', *Nigeria Magazine*, 23, 1946, pp. 112–4

MURRAY, 1947 K. C. Murray, 'Ekpu: the ancestor figures of Oron, Southern Nigeria', *Burlington Magazine*, 89, 1947, pp. 310–4

MUSCARELLA, 1974 O. W. Muscarella, *Ancient Art: The Norbert Schimmel Collection*, Mainz, 1974

MUSÉE ROYAL DU CONGO BELGE, 1899 Musée royale du Congo Belge, *Annales*, i, 1899

MUSEUM RIETBERG, 1978 Museum Rietberg, *Afrikanische Skulpturen*, Zurich, 1978

NALDER, 1937 L. F. Nalder, *A Tribal Survey of Mongala Province*, London, 1937

NEAHER, 1976 N. C. Neaher, *Bronzes of Southern Nigeria and Igbo Metalsmithing Traditions*, diss., Stanford University, Stanford, 1976

NEAHER, 1981 N. Neaher, 'An Interpretation of Igbo Carved Doors', *African Arts*, 15 (1), 1981, pp. 49–55, 88

NEEDLER, 1984 W. Needler, *Predynastic and Archaic Egypt in the Brooklyn Museum*, New York, 1984

NESBITT, 1871 A. Nesbitt, *Catalogue of the Collection of Glass Formed by Felix Slade*, London, 1871

NESBITT, 1878[1] A. Nesbitt, *A Descriptive Catalogue of the Glass Vessels in the South Kensington Museum*, London, 1878

NESBITT, 1878[2] A. Nesbitt, *Glass*, London, 1878

NETTLETON, 1984 A. Nettleton, *The Traditional Figurative Woodcarving of the Shona and Venda*, diss., University of the Witwatersrand, Johannesburg, 1984

NETTLETON, 1985 A. Nettleton, *The Figurative Woodcarving of the Shona and Venda*, diss., University of the Witwatersrand, Johannesburg, 1985

NETTLETON, 1988 A. Nettleton, 'History and the Myth of Zulu Sculpture', *African Arts*, 21 (3) 1988, pp. 48–51

NETTLETON, 1989 A. Nettleton, 'The Not-so-new: "Transitional Art" in Historical Perspective', in *Diversity and Interaction: Proceedings of the Fifth Annual Conference of the South African Association of Art Historians*, Durban, 1989

NETTLETON, 1989[1] A. Nettleton, 'The Crocodile Does not Leave the Pool: Venda Court Arts', in *Art of Southern Africa: From Tradition to Township*, ed. A. Nettleton and D. W. Hammond-Tooke, Johannesburg, 1989, pp. 67–83

NETTLETON, 1989[2] A. Nettleton, 'Venda Art', in *Ten Years of Collecting: The Standard Bank Foundation Collection of African Art*, exh. cat., University of the Witwatersrand Art Galleries, Johannesburg, 1989, pp. 3–8

NETTLETON, 1990 A. Nettleton, '"Dream Machines": Southern African Headrests', *South African Journal of Art and Architectural History*, 1 (4), 1990, pp. 147–54

NETTLETON, 1991 A. Nettleton, 'Tradition, Authenticity, and Tourist Sculpture in 19th and 20th Century South Africa', in *Art and Ambiguity: Perspectives on the Brenthurst Collection of Southern African Art*, exh. cat., Johannesburg, 1991, pp. 32–7

NETTLETON, 1992 A. Nettleton, *Headrests of Southern, East and Central Africa*, report submitted to the CSD, Pretoria, 1992

NETTLETON and HAMMOND-TOOKE, 1989 A. Nettleton and D. Hammond-Tooke, eds, *Art of Southern Africa: From Tradition to Township*, Johannesburg, 1989

NEW YORK 1978 *Traditional Sculpture from Upper Volta*, exh. cat. by N. Skougstad, African-American Institute, New York, 1978

NEW YORK 1980 *Yoruba Beadwork. Art of Nigeria*, exh. cat. by John Pemberton III, introduction by W. B. Fagg, Pace Gallery, New York, 1980

NEW YORK 1988[1] *Art of the Dogon: Selections from the Lester Wunderman Collection*, exh. cat. by K. Ezra, The Metropolitan Museum of Art, New York, 1988

NEW YORK 1988[2] *Africa and the Renaissance: Art in Ivory*, exh. cat. by E. Bassani and W. B. Fagg, ed. S. Vogel, Center for African Art, New York, 1988

NEW YORK 1990 *Africa Explores: 20th Century African Art*, exh. cat. by S. Vogel and I. Ebong, Center for African Art, New York, 1990

NEYT, 1977 F. Neyt, *La grande statuaire hemba du Zaïre*, Louvain-la-Neuve, 1977, 2nd edn 1995

NEYT, 1979 F. Neyt, *L'Art Eket: Collection Azar*, Paris, 1979

NEYT, 1981 F. Neyt, *Arts traditionnels et histoire au Zaire. Cultures forestières et royaumes de la savane*, Louvain-le-Neuve, 1981

NEYT, 1985[1] F. Neyt, *The Arts of the Benue: to the Roots of Tradition*, 1985

NEYT, 1985[2] F. Neyt, 'Tabwa Sculpture and the Great Traditions of East-Central Africa', in E. M. Maurer and A. F. Roberts, *Tabwa, the Rising of a New Moon: A Century of Tabwa Art*, Seattle, 1985, pp. 65–89

NEYT, 1992 F. Neyt, 'Les masques tetela existent-ils?', in *Art tribal*, Geneva, 1992

NEYT, 1993 F. Neyt, *Luba. Aux sources du Zaire*, Paris, 1993

NEYT, 1994 F. Neyt, *Luba: To the Sources of the Zaire*, Paris, 1994

NEYT, 1995 F. Neyt, *La grande statuaire Hemba*, Louvain-la-Neuve, 1995

NEYT and STRYCKER, 1974 F. Neyt and L. de Strycker, *Approche des arts Hemba*, Villiers-le-Bel, 1974

NEYT and DE STRYCKER, 1975 F. Neyt and L. de Strycker, 'Approche des arts hemba', *Arts d'Afrique noire*, supp. to vol. 11, Villiers-le-Bel, 1975

NGALA, 1949 R. Ngala, *Nchi na Desturi za Wagiriama*, Nairobi, 1949

NICKLIN, 1974 K. Nicklin, 'Nigerian Skin-covered Masks', *African Arts*, 7 (3), 1974, pp. 8–15; 67–8

NICKLIN, 1977 K. Nicklin, *Guide to the National Museum, Oron*, Lagos, 1977

NICKLIN, 1979 K. Nicklin, 'Skin-covered masks of Cameroon', *African Arts*, 12 (1), 1979

NICKLIN, 1980[1] K. Nicklin, 'Archaeological Sites in the Cross River Region', *Nyame Akuma*, 16, 1980

NICKLIN, 1980[2] K. Nicklin, 'The Cross River Bronzes', in *The Art of Metal in Africa*, ed. M.-T. Brincard, New York, 1980, pp. 47–50

NICKLIN, 1981 K. Nicklin, 'Rape and restitution: the Cross River region considered', *Museum* (Unesco), 33 (4), 1981

NICKLIN, 1982 K. Nicklin, 'An anthropomorphic bronze from the Cross River region', *Tribal Art Bulletin: Musée Barbier-Mueller*, 16, 1982

NICKLIN, 1989 K. Nicklin, 'A Lower Niger Bronze Female Figure', in *Important Tribal Art*, London, 1989

NICKLIN, 1990 K. Nicklin, 'The epic of the Ekpu: ancestor figures of Oron, South East Nigeria', in *Politics of the Past*, ed. P. Gathercole and D. Lowenthal, London, 1990

NICKLIN, 1991[1] K. Nicklin, 'An Ejagham emblem of the Ekpe Society', *Tribal Art Bulletin: Barbier-Mueller Museum*, 1991

NICKLIN, 1992[2] K. Nicklin, 'Ekpe in the Rio del Rey', *Tribal Art Bulletin: Barbier-Mueller Museum*, Geneva, 1991

NICKLIN, 1993 K. Nicklin, 'Celui qui voulait être Dieu', *Arts d'Afrique Noire*, 85, 1993

NICKLIN, in preparation K. Nicklin, *Ekpu: The Oron Ancestor figures. Southeastern Nigeria*, in preparation

NICKLIN and FLEMING, 1980 K. Nicklin and S. J. Fleming, 'A bronze "Carnivore Skull" from Oron, Nigeria', *Museum of Applied Science Center for Archaeology Journal*, 1 (4), 1980

NICKLIN and SALMONS, 1978 K. Nicklin and J. Salmons, 'S. J. Akpan of Nigeria', *African Arts*, 11 (1), 1978

NICKLIN and SALMONS, 1984 K. Nicklin and J. Salmons, 'Cross River art styles', *African Arts*, 18 (1), 1984

NICKLIN and SALMONS, in preparation K. Nicklin and J. Salmons, 'Arts of Southeastern Nigeria', in *Arts of Nigeria*, ed. E. Eyo, in preparation

NICOLAISEN, 1963 J. Nicolaisen, *Ecology and Culture of the Pastoral Tuareg with Particular Reference to the Tuareg of Ahaggar and Ayr*, Copenhagen, 1963

NKETIA, 1963 J. H. K. Nketia, *Drumming in Akan Communities in Ghana*, London, 1963

NOOTER, 1984 N. I. Nooter, 'Zanzibar Doors', *African Arts*, 17 (4), 1984, pp. 34–39, 94

NOOTER, 1991 M. H. Nooter, *Luba Art and Statecraft: Creating Power in a Central African Kingdom*, diss., Columbia University, New York, 1991

NOOTER, 1994 N. I. Nooter, 'Ostafrikanische hochlehnige Hocker: Eine transkulterelle Tradition', in *Tanzania: Meisterwerke Afrikanischer Skulptur*, ed. J. Jahn, Munich, 1994

NORDSTRÖM, 1973 H. A. Nördstrom, *Neolithic and A-Group Sites*, Stockholm, 1973

NORTHERN, 1984 T. Northern, *The Art of Cameroon*, Washington, 1984

NOWACK, 1954 E. Nowack, *Land und Volk der Konso*, Bonn, 1954

NSUGBE, 1961 P. O. Nsugbe, 'Oron Ekpu figures', *Nigeria Magazine*, December 1961, pp. 357–65

OBAYEMI, 1974 A. M. U. Obayemi, 'Soundings in Culture History: The Evolution of the Culture and Institutions of the "Northern Yoruba, the Nupe and the Igala" before A.D. 1800', paper presented at the Niger-Benue Seminar, Ahmadu Bello University, 1974

OBERLE, n. d. P. Oberle, *Provinces Malgaches*, n. d.

O'CONNOR, 1993 D. O'Connor, *Ancient Nubia: Egypt's Rival in Africa*, Philadelphia, 1993

OGUNBA, 1964 O. Ogunba, 'Crowns and "Okute" at Idowa', *Nigeria*, 83, December 1964, pp. 249–61

OJO, 1973 J. R. O. Ojo, 'Ogboni Drums', *African Arts*, 6 (3), l973, pp. 50–2, 84

OJO, 1978 J. R. O. Ojo, 'The symbolism and significance of Epa type masquerade headpieces', *Man*, 12, pp. 455–70

OLBRECHTS, 1946 F. M. Olbrechts, *Plastiek van Kongo*, Antwerp, 1946 [*Les arts plastiques du Congo belge*, Antwerp]

OLBRECHTS, 1947 F. Olbrechts, *Plastiek van Kongo*, Antwerp, 1974

OLIVER and CROWDER, 1981 R. Oliver and M. Crowder, *The Cambridge Encyclopedia of Africa*, Cambridge, 1981

ONABAJO, 1989 O. Onabajo, 'Esie Stone Sculpture: The State of the Research and Future Direction', paper presented at the Seminar on Material Culture, Monuments and Festivals in Kwara State, National Museum, Esie, Nigeria, 1989

O'NEILL, 1883–4 H. O'Neill, 'Journey from Mozambique to Lakes Shirwa and Amaramba', *Proceedings of the Royal Geographical Society*, 11, 1883–4, pp. 632–47

O'NEILL, 1885 H. O'Neill, 'Journey in the District West of Cape Delgado Bay', *Proceedings of the Royal Geographical Society*, 5, 1885, pp. 393–404

ORBELI, 1936 I. Orbeli, *Shahmatah*, Leningrad, 1936

OXFORD 1994 *Kuba Textiles*, exh. brochure by J. Coote and S. Mee, Pitt Rivers Museum, Oxford, 1994

PACCARD, 1980 A. Paccard, *Le Maroc et l'artisanat traditionnel islamique dans l'architecture*, Paris, 1980

PAGE, 1976 A. Page *Egyptian Sculpture in the Petrie Collection*, Warminster, 1976

PAGER, 1980 H. Pager, 'Felsbildforschung am Brandberg in Namibia', *Beiträge zur allgemeinen und vergleichenden Archaeologie*, 2, pp. 351–7

PANKHURST, 1990 R. Pankhurst, *A Social History of Ethiopia*, Addis Ababa, 1990

PANKHURST and INGRAMS, 1988 R. Pankhurst and L. Ingrams, *Ethiopia Engraved: An Illustrated Catalogue of Engravings by Foreign Travelers from 1681 to 1900*, New York, 1988

PAPSTEIN, 1994 R. Papstein, ed., *The History and Cultural Life of the Mbunda Speaking Peoples*, Lusaka, 1994

PÂQUES, 1954 V. Pâques, 'Bouffons sacrés du cercle de Bougouni (Soudan français)', *Journal de la Société des Africanistes*, 24, 1954, pp. 625–32

PARIS, 1925 A. Paris, *Documents d'architecture berbère sud de Marrakesh*, Paris, 1925

PARIS 1977 *Islam dans les collections nationales*, exh. cat., Grand Palais des Champs Elysées, Paris, 1977

PARIS 1982–3 *De Carthage à Kairouan: 2000 ans d'art et d'histoire en Tunisie*, exh. cat., Musée du Petit Palais, Paris, 1982–3

PARIS 1987 *Tanis: L'or des pharaons*, exh. cat., Galeries Nationales du Grand Palais, Paris, 1987

PARIS 1989[1] *Corps sculptés, corps parés, corps masqués: Chefs-d'oeuvre de Côte-d'Ivoire*, exh. cat., Galeries Nationales du Grand Palais, Paris, 1989

PARIS 1989[2] *Objets interdits*, exh. cat., Fondation Dapper, Musée Dapper, Paris, 1989

PARIS 1990 *De l'Empire romain aux villes impériales: 6000 ans d'art au Maroc*, exh. cat., Musée du Petit Palais, Paris, 1990

PARIS 1992–3 *Le roi Salomon et les maîtres du regard: Art et médecine en Éthiopie*, exh. cat. ed. J. Mercier and H. Marchal, Musées Nationaux/Musée National des Arts d'Afrique et d'Océanie, Paris, 1992

PARIS 1995 *Carthage: L'histoire, sa trace et son écho*, exh. cat., Musée du Petit Palais, Paris, 1995

PARIS and MILAN 1989–90 *L'Égypte copte en Égypte-Égypte: Chefs d'oeuvre de tous les temps*, exh. cat. ed. D. Benazeth and G. Gabra, Paris and Milan, 1989–90

PARIS et al. 1993–4 *Vallées du Niger*, exh. cat. ed. J. Devisse, Paris, 1993–4

PARTRIDGE, 1905 C. Partridge, *Cross River Natives*, London, 1905

PAUTY, 1931 E. Pauty, *Le bois sculpté jusqu'à l'époque Ayyoubide*, general cat., Museum of Islamic Art, Cairo, 1931

PAYNE, 1993 J. C. Payne, *Catalogue of the Predynastic Collection in the Ashmolean Museum*, Oxford, 1993

PEDLEY, 1980 J. G. Pedley, ed., *New Light on Ancient Carthage*, Ann Arbor, 1980

PEMBERTON, 1982 J. Pemberton, 'Shango Shrine Sculpture' and 'Figure with Bowl', in W. Fagg and J. Pemberton, *Yoruba, Sculpture of West Africa*, New York, 1982, pls 34, 53

PEMBERTON, 1989 J. Pemberton, 'The Oyo Empire', in H. J. Drewal, J. Pemberton and R. Abiodun, *Yoruba: Nine Centuries of African Art and Thought*, New York, 1989, pp. 146–87

PENNY, 1993 N. Penny, *The Materials of Sculpture*, New Haven and London, 1993

PERANI, 1977 J. Perani, *Nupe Crafts: The Dynamics of Change in Nineteenth and Twentieth Century Weaving and Brassworking*, diss., Indiana University, Bloomington, IN, 1977

PÈRE, 1988 M. Père, *Les Lobi: Tradition et changement: Burkina Faso*, 2 vols, Paris, 1988

PEREIRA, 1956 D. P. Pereira, *Esmeraldo du Situ Orbis. Côte occidentale d'Afrique du Sud Marocain au Gabon (1506–1508)*, trans. R. Mauny, Bissau, 1956

PERHAM, 1976 M. Perham, *East African Journey: Kenya and Tanganyika 1929–30*, London, 1976

PERICOT-GARCÍA et al., 1967 L. Pericot-Garcia et al., *Prehistoric and Primitive Art*, New York, 1967

PERROIS, 1969[1] L. Perrois, *Gabon: culture et techniques*, general cat., Musée des Arts et Traditions de Libreville, Paris

PERROIS, 1969[2] L. Perrois, *Aspects de la sculpture traditionnelle du Gabon: Anthropos*, St-Augustin, ill., 1969

PERROIS, 1972 L. Perrois, *Statuaire fang*, Paris, 1972

PERROIS, 1977 L. Perrois, *Sculpture traditionelle du Gabon*, Paris, 1977

PERROIS, 1979 L. Perrois, *Arts du Gabon. Les arts plastiques du Bassin de l'Ogoue*, Paris 1979

PERROIS, 1985 L. Perrois, *Art ancestral du Gabon*, Geneva, 1985

PERROIS and DELAGE, 1990 L. Perrois and M. S. Delage, *Art of Equatorial Guinea. The Fang Tribes*, New York, 1990

PERSON, 1961 Y. Person, 'Les Kissi et leurs statuettes de pierre dans le cadre de l'histoire ouest-africaine', *Bulletin de l'Institut Français de l'Afrique Noire*, 23B, 1961, pp. 1–59

PETRIDIS, 1995 C. Petridis, *Trésors d'Afrique. Musée de Tervuren*, 1995, pp. 330–5

PETRIE, 1917 W. M. F. Petrie, *Tools and Weapons*, London, 1917

PETRIE, 1927 W. M. F. Petrie, *British School of Archaeology in Egypt: Objects of Daily Use*, London, 1927

PETRIE, 1939 W. M. F. Petrie, *The Making of Egypt*, London, 1939

PETRIE, 1953 W. M. F. Petrie, *Ceremonial Slate Palettes*, London, 1953

PETRIE, n. d. W. H. F. Petrie, MSS Notebook no. 137, n. d.

PETRIE and QUIBELL, 1896 W. M. F. Petrie and J. E. Quibell, *Naqada and Ballas 1895*, British School of Archaeology in Egypt, i, London, 1896

PHILLIPS, 1978 R. Phillips, 'Masking in Mende Sande Society Initiation Rituals', *Africa* (London), 48 (3), 1978, pp. 265–76

PICARD, 1964 G. C. Picard, *Carthage*, trans. M. and L. Kochan, London, 1964 [*Le Monde de Carthage*, 1956]

PICARD, 1965–6 G.-C. Picard, 'Sacra punica: Étude sur les masques et rasoirs de Carthage', *Karthago*, 13, 1965–6, pp. 1–115

PICARD and PICARD, 1968 G.-C. and C. Picard, *The Life and Death of Carthage*, trans. D. Collon, London, 1968 [*Vie et mort de Carthage*, 1968]

PICTON, 1992[1] J. Picton, 'Desperately seeking Africa, New York 1992', *Oxford Art Journal*, XV(2), 1992

PICTON, 1992[2] J. Picton, 'Technology, tradition and lurex', in *History, Design and Craft in West African Stripwoven Cloth*, Smithsonian Institution, Washington, 1992

PICTON, 1994[1] J. Picton, 'Art, identity and identification: a commentary on Yoruba art historical studies', in *The Yoruba Artist*, ed. H. J. Drewal, J. Pemberton III, Washington, 1994, pp. 1–34

PICTON, 1994[2] J. Picton, 'Sculptors of Opin', *African Arts*, 27 (3), pp. 46–59, pp. 101–2

PICTON, 1994[3] J. Picton, 'A tribute to William Fagg', *African Arts*, XXVII (3), 1994

PICTON, in preparation J. Picton, 'The horse and its rider in Yoruba art: images of conquest and possession', in *Cavalieri dell'Africa: Storia, Iconografia, Simbolismo*, Milan, in preparation

PICTON and MACK, 1979 J. Picton and J. Mack, *African Textiles*, London, 2nd edn, 1989

PINDER-WILSON, 1973 R. Pinder-Wilson with C. Brooke, 'The Reliquary of St. Petroc and the Ivories of Norman Sicily', *Archeologia* (Society of Antiquaries of London), 1973, pp. 168–243

PLASCHKE and ZIRNGIBL, 1992 D. Plaschke and M. Zirngibl, *African Shields: Graphic Art of the Black Continent*, Munich, 1992

POGGE, 1880 P. Pogge, *Im Reiche des Muata Jamvo*, Berlin, 1880

PORADA, 1980 E. Porada, 'A Lapis Lazuli Figurine from Hierakonpolis in Egypt', *Iranica Antiqua*, 15, 1980, pp. 175–81

PORTER and MOSS, 1964–81 B. Porter and R. Moss, eds, *Topographical Bibliography of Ancient Egyptian Hieroglyphic Texts, Reliefs and Paintings*, i (2), iii (1–2), Oxford, 1964–81

POSNANSKY and CHAPLIN, 1968 M. Posnansky and J. H. Chaplin, 'Terracotta Figures from Entebbe, Uganda', *Man*, 3 (4), 1968, pp. 644–50

POSSELT, 1924 W. Posselt, 'The Early Days of Mashonaland and a Visit to the Zimbabwe Ruins', *National Affairs Department Annual*, 2, 1924, pp. 70–6

POWELL-COTTON, 1904 P. H. G. Powell-Cotton, *In Unknown Africa*, London, 1904

POWER, 1951 J. H. Power, 'Two Sculptured Heads in the McGregor Museum, Kimberley', *South African Archaeological Bulletin*, 6, 1951, pp. 54–5

POYNER, 1978 R. Poyner, *The Ancestral Arts of Owo Nigeria*, diss., University of Indiana, Bloomington, IN, 1978

PRIDDY, 1970 A. J. Priddy, 'RS 63/32: An Iron Age Site near Yelwa, Sokoto Province: Preliminary Report', *West African Archaeological Newsletter*, 12, 1970, pp. 20–32

PRIESE, 1977 K. -H. Priese, 'Eine verschollene Bauinschrift des frühmeroitischen Königs Aktisanes (?) vom Gebel Barkal', in *Ägypten und Kusch*, Berlin, 1977, pp. 359 ff.

PRINS, 1965 A. H. J. Prins, 'A Carved Headrest of the Cushitic Boni: An Attempted Interpretation', *Man*, 221, 1965, pp. 189–91

PRUITT, 1973 W. Pruitt, *An Independent People: A History of the Sala Mpasu of Zaire and their Neighbours*, diss., Northwestern University, 1973

PRUSSIN, 1986 L. Prussin, *Hatumere. Islamic Design in West Africa*, Berkeley and London, 1986

PUCCIONI, 1936 N. Puccioni, *Antropologia e etnografia della genti della Somalia*, Bologna, 1936 [English trans., 1960]

PULLINGER and KITCHIN, 1982 J. S. Pullinger and A. M. Kitchin, *Trees of Malawi: with some Shrubs and Climbers*, Malawi, 1982

QUAEGEBEUR, 1983 J. Quaegebeur, 'Trois statues de femme d'époque ptolémaïque', in *Artibus Aegypti: Studia in honorem Bernardi V. Bothmer a Collegis Amicis Discipulis Conscripta*, ed. H. De Meulenaere and L. Limme, Brussels, 1983, pp. 109–27

QUIBELL, 1900 J. F. Quibell, *Hierakonpolis, i: Plates of Discoveries in 1898*, London, 1900

QUIBELL, 1912 J. E. Quibell, 'Excavations at Saqqara', *The Monastery of Apa Jeremias*, Cairo, 1912

QUIBELL and GREEN, 1902 J. E. Quibell and F. W. Green, *Hierakonpolis*, ii, London, 1902

QUIRIN, 1979 J. Quirin, 'The Beta Israel (Falasha) and the Process of Occupational Caste Formation, 1270–1868', *Proceedings of the Fifth International Conference on Ethiopian Studies*, Chicago, 1979, pp. 133–43

QUIRKE and SPENCER, 1992 S. Quirke and J. Spencer, *The British Museum Book of Ancient Egypt*, London, 1992

RANDALL-MacIVER and MACE, 1902 D. Randall-MacIver and A. C. Mace, *El Amrah and Abydos*, London, 1902

RANGELEY, 1963 W. H. J. Rangeley, 'The Ayao', *Nyasaland Journal*, 16 (1), 1963, pp. 7–27

RANKE, 1980 H. Ranke, 'The Egyptian Collections of the University Museum', *University Museum Bulletin*, 15 (2–3), 1980, pp. 26, 30, fig. 14

RAUM, 1973 O. F. Raum, *The Social Functions of Avoidances and Taboos among the Zulu*, Berlin, 1973

RAVENHILL, 1980 P. Ravenhill, *Baule Statuary Art: Meaning and Modernization*, Philadelphia, 1980

RAVENHILL, 1992 P. L. Ravenhill, 'Preview: The Art of the Personal Object', *African Arts*, 25 (1), 1992, pp. 70–5

RAVENHILL, 1994 P. Ravenhill, *The Self and the Other: Personhood and Images among the Baule, Côte d'Ivoire*, Los Angeles, 1994

READ, 1902 C. H. Read, 'On a Saracenic Goblet of Enamelled Glass of Medieval Date', *Archaeologia*, 58 (1), 1902, pp. 217 ff.

REDINHA, 1953–5 J. Redinha, *Campanha Etnográfica ao Tchiboco (Alto-Tchicapa)*, i–ii, Lisbon, 1953–5

REEFE, 1977 T. Reefe, 'Lukasa: A Luba Memory Device', *African Arts*, 10 (4), 1977, pp. 48–50, 88

REEFE, 1981 T. Reefe, *The Rainbow and the Kings*, Berkeley, 1981

REEVES, 1985 C. N. Reeves, 'Tutankamuss and his Papyri', *Göttinger Miszellen*, 88, 1985

REEVES, 1990 C. N. Reeves, *Valley of the Kings: The Decline of a Necropolis*, London, 1990

REINISCH, 1865 S. Reinisch, *Die aegyptischen Denkmaeler in Miramar*, Vienna, 1865

REINOLD, 1987 J. Reinold, 'Rapports préliminaires des campagnes 1984–85 and 1985–6', *Archéologie du Nil Moyen*, 2, 17–67, 1987

REINOLD, 1991 J. Reinold, 'Néolithique soudanais: les coutumes funéraires', *Egypt and Africa*, ed. W. V. Davis, London, 1991, pp. 16–29

REINOLD, 1994 J. Reinold, 'Le Cimetière Néolithique KDK. 1 de Kadruka (Nubie Soudanaise)', in *Études Nubiennes*, ii, ed. C. Bonnet, Geneva, 1994, pp. 93–100

REISNER, 1915 G. A. Reisner, 'Accessions to the Egyptian Department during 1914', *Bulletin of the Museum of Fine Arts*, Boston, 13, 1915, p. 32, figs 10, 34

REISNER, 1923 G. A. Reisner, 'Excavations at Kerma. Parts I–III', *Harvard African Studies*, 5, Cambridge, MA, 1923

REISNER, 1931 G. A. Reisner, *Mycerinus: the Temple of the Third Pyramid at Giza*, Cambridge, MA, 1931

REVAULT et al., 1985–92 J. Revault et al., *Palais et demeures de Fès*, 3 vols, Paris, 1985–92

RICARD, 1927–34 P. Ricard, *Corpus des tapis marocaines*, 4 vols, Paris, 1927–34

RICARD, 1932 P. Ricard, *Les tapis marocains*, 1932

RICARD, 1934 P. Ricard, *Corpus des tapis marocains*, iv, Paris, 1934

RICARD, 1950 P. Ricard, 'Une lignée d'artisans: Les Ben Cherif de Fès', in *Hespéris*, 1950, pp. 41–8

RICHARDS, 1956 A. I. Richards, *Chisungu: A Girls' Initiation Ceremony among the Bemba of Northern Rhodesia*, London, 1956

RICHTER, 1980 D. Richter, *Economics and Change: The Kulebele of Northern Ivory Coast*, La Jolla, CA

RIEFENSTAHL, 1982 L. Riefenstahl, *Vanishing Africa*, New York, 1982 [trans. from German original by K. Talbot]

RIEFSTAHL, 1968 E. Riefstahl, *Ancient Egyptian Glass and Glazes in The Brooklyn Museum*, Wilbour Monographs, i, Brooklyn, 1968

ROBBINS and NOOTER, 1989 W. M. Robbins and N. I. Nooter, *African Art in American Collections*, Washington, 1989

ROBERT-CHALEIX, 1983 D. Robert-Chaleix, 'Céramiques découverts à Tegdaoust', in J. Devisse et al., *Tegdaoust III*, Paris, 1983, pp. 245–94

ROBERTS, 1985 A. F. Roberts, 'Social and Historical Contexts of Tabwa Art', in *The Rising of a New Moon: A Century of Tabwa Art*, ed. A. Roberts and E. M. Maurer, Seattle, 1985, pp. 1–48

ROBERTS, 1993 A. F. Roberts, 'Insight: or Not Seeing is Believing', in *Secrecy: African Art that Conceals and Reveals*, ed. M. H. Nooter, New York, 1993

ROBERTS, 1994[1] A. F. Roberts, 'Formenverwandtschaft: Ästhetische Berührungspunkte zwischen Völkern West-Tanzanias und Südost-Zaires/Usanifu sawa katiya watu wa Tanzania ya Magharibi na watu wa kusini mashariki ya Zaire/A Sharing of Forms: Æsthetic Commonalities among Peoples of Western Tanzania and Southeastern Zaire', in *Tanzania: Meisterwerke Afrikanischer Skulptur/Sanaa za Mabingwa wa Kiafrika*, ed. J. Jahn, Munich, 1994, pp. 350–70

ROBERTS, 1994[2] A. F. Roberts, ed., *Staffs of Life: Rods, Staffs, Scepters and Wands from the Coudron Collection of African Art*, Iowa City, 1994

ROBERTS, forthcoming A. F. Roberts, *Memory: Luba Art and the Making of History*, New York, forthcoming

ROBERTS, M. N., 1994 M. N. Roberts, 'Sculpted Narratives of Luba Staffs of Office', in *Staffs of Life*, ed. A. F. Roberts, Iowa City, 1994

ROBERTS and MAURER, 1985 A. Roberts and E. Maurer, eds, *The Rising of a New Moon: A Century of Tabwa Art*, Seattle and Ann Arbor, 1985

ROBINS, 1986 G. Robins, *Egyptian Painting and Relief*, Aylesbury, 1986

ROBINSON, 1959 K. R. Robinson, *Khami Ruins*, Cambridge, 1959

RODRIGUES de AREIA, 1985 M. L. Rodrigues de Areia, *Les symboles divinatoires. Analyse socio-culturelle d'une technique de divination des Cokwe de l'Angola (ngrombo ya cisuka)*, Coimbra, 1985

ROEDER, 1921 G. Roeder, 'Der Priester als Anubis an der Mumie', in *Alt-Hildesheim*, 3, Hildesheim, 1921, pp. 31–5

ROEDER and IPPEL, 1921 G. Roeder and A. Ippel, *Die Denkmäler des Pelizaeus-Museums zu Hildesheim*, Berlin and Hildesheim, 1921

ROEHRIG, 1992 C. H. Roehrig in *MMAB*, Spring 1992, pp. 32–5

ROLLEFSON, 1992 G. O. Rollefson, 'A Neolithic Game Board from Ain Ghazal, Jordan', *Bulletin of the American Schools of Oriental Research*, 286, 1992, pp. 1–6

ROSCOE, 1911 J. Roscoe, *The Baganda*, London, 1911

ROSCOE, 1923 J. Roscoe, *The Bakitara or Banyoro*, Cambridge, 1923

ROSENWALD, 1974 J. B. Rosenwald, 'Kuba king figures', *African Arts*, 7, pp. 26–31

ROSS, 1931 E. D. Ross, *The Art of Egypt through the Ages*, London, 1931

ROSS, 1988 D. H. Ross, 'Queen Victoria for Twenty-Five Pounds: The Iconography of a Breasted Drum from Southern Ghana', *Art Journal*, 47 (2), 1988, pp. 114–20

ROSS, 1989 D. H. Ross, 'Master Drums from Akan Popular Bands', in *Sounding Forms: African Musical Instruments*, exh. cat. by M.-T. Brincard, American Federation of Arts, Washington, 1989, pp. 78–81

ROSS, 1992 D. H. Ross, ed., *Elephant. The Animal and its Ivory in African Culture*, Los Angeles, 1992

ROUACH, 1989 D. Rouach, *Bijoux berbères au Maroc dans la tradition judéo-arabe*, Paris, 1989

ROUTLEDGE and ROUTLEDGE, 1968 U. S. Routledge and K. Routledge, *Vital and Prehistoric People: The Akikuyu of British East Africa*, London, 1968

ROUTLEDGE S. Routledge, *The Akikuyu*, London, 1910

ROY, 1987 C. Roy, *Art of the Upper Volta Rivers*, Paris, 1987

ROY, 1992 C. Roy, *Art and Life in Africa: Selections from the Stanley Collection, Exhibitions of 1985 and 1992*, Iowa City, 1992

RUBIN, 1969 A. Rubin, *The Arts of the Jukun-speaking Peoples of Northern Nigeria*, diss., Indiana University, Bloomington, 1969

RUBIN, 1973 A. Rubin, 'Bronzes of the Middle Benue', *West African Journal of Archaeology*, 3, 1973, pp. 221–31

RUBIN, 1982 A. Rubin, 'Bronzes of North-eastern Nigeria', in *The Art of Metal in Africa*, ed. M.-T. Brincard, New York, 1982, pp. 43–6

RUBIN, 1984[1] W. Rubin, ed., 'Modernist Primitivism', in *'Primitivism' in 20th Century Art*, i, 1984, pp. 1–79

RUBIN, 1984[2] W. Rubin, ed., *'Primitivism' in 20th Century Art*, New York, 1984

RUBIN and BERNS, in preparation A. Rubin and M. C. Berns, eds, *The Arts of the Benue River Valley*, Los Angeles, in preparation

RUDNER, 1971 J. Rudner, 'Ostrich Eggshell Flasks and Soapstone Objects from the Gordonia District, North-western Cape', *South African Archaeological Bulletin*, 26 (103–4), 1971, pp. 139–42

RUDNER, 1983 I. Rudner, 'Paints of the Khoisan Rock Artists', *South African Archaeological Society, Goodwin Series*, 4, 1983, pp. 14–20

RUEL, 1969 M. Ruel, *Leopards and Leaders: Constitutional Politics among a Cross River People*, London, 1969

RUSILLON, 1912 H. Rusillon, *Une culte dynastique avec évocation des morts chez les Sakalaves de Madagascar, 'le tromba'*, Paris, 1912

RUSSMANN, 1989 E. R. Russmann, *Egyptian Sculpture: Cairo and Luxor*, Austin, TX, 1989

RUSSMANN, 1994 E. R. Russmann, 'Relief Decoration in the Tomb of Mentuemhat (TT 34)', *Journal of the American Research Center in Egypt*, 31, 1994, pp. 1–19

RUSSMANN, 1995 E. R. Russmann, 'A Second Style in Egyptian Art of the Old Kingdom', *Mitteilungen des Deutschen Archäologischen Instituts, Abteilung Kairo*, 51, 1995, pp. 94–5

RÜTIMEYER, 1901 L. Rütimeyer, 'Über westafrikanische Steinidole', *Internationales Archiv für Ethnographie*, 14, 1901, pp. 195–205

RÜTIMEYER, 1908 L. Rütimeyer, 'Weitere Mitteilungen über westafrikanische Steinidole', *Internationales Archiv für Ethnographie*, 18, 1908, pp. 167–78

RYDER, 1964 A. F. C. Ryder, 'A Note on the Afro-Portuguese Ivories', *Journal of African History*, 5, 1964, pp. 363–5

RYDER, 1969 A. F. C. Ryder, *Benin and the Europeans*, London, 1969

SALEH and SOUROUZIAN, 1987 M. Saleh and H. Sourouzian, *Official Catalogue: The Egyptian Museum Cairo*, Mainz, 1987

SALMONS, 1980 J. Salmons, 'Funerary shrine cloths of the Annang Ibibio, South-east Nigeria', in *Textiles of Africa*, ed. K. G. Ponting and D. Idiens, Bath, 1980

SAMAIN, n. d. A. Samain, *La langue Kisonge*, Brussels, n. d.

SAMPSON, 1974 C. G. Sampson, *The Stone Age Archaeology of Southern Africa*, New York, 1974

SAN DIEGO 1992 *Reclusive Rebels: An Approach to the Sala Mpasu and their Masks*, exh. cat. by E. L. Cameron, San Diego Mesa College, San Diego, 1992

SAN FRANCISCO 1975 *Images for Eternity: Egyptian Art from Berkeley and Brooklyn*, exh. cat. by R. A. Fazzini, M. H. de Young Memorial Museum, San Francisco, 1975

SAN JUAN 1979 *Escultura del Antiguo Egipto del Museo de Brooklyn*, exh. cat. by R. S. Bianchi, Museo de la Fundación Arqueológica Anthropógica e Histórica, Puerto Rico, 1979

SARRE and TRENKWALD, 1926–7 F. Sarre and H. Trenkwald, *Old Oriental Carpets*, 2 vols, Leipzig and Vienna, 1926–7

SATZINGER, 1987 H. Satzinger, *Ägyptisch-Orientalische Sammlung: Kunsthistorisches Museum Wien*, Munich, 1987

SATZINGER, 1994 H. Satzinger, *Das Kunsthistorische Museum in Wien: Die Ägyptisch-Orientalische Sammlung*, Zaberns Bildbände zur Archäologie 14, Mainz, 1994

SATZINGER, in preparation H. Satzinger, 'Eine Pavianstatue mit Königsfigur (Wien ÄS Inv. -Nr. 5782)', *Beihefte, Studien zur altägyptischen Kultur/Acts of IVth International Congress of Egyptologists, Munich 1987*, in preparation

SÄVE-SÖDERBERGH, 1967–8 T. Säve-Söderbergh, 'Preliminary Report of the Scandinavian Joint Expedition, Archaeological Investigations between Faras and Gemmai – November 1963–March 1964', *Kush*, XV, 211–50

SCANZI, 1993 G. F. Scanzi, *L'art traditionnel Lobi*, Bergamo, 1993

SCANZI and DELCOURT, 1987 G. F. Scanzi and J.-P. Delcourt, *Potomo Waka*, Milan, 1987

SCHAEDLER, 1973 K. F. Schaedler, *African Art in Private German Collections*, Munich, 1973

SCHAEDLER, 1992 K. F. Schaedler, *Gods, Spirits, Ancestors: African Sculpture from Private German Collections*, Munich, 1992

SCHAEDLER, 1993 K. F. Schaedler, *Gods, Spirits, Ancestors – African Sculpture from Private German Collections*, Munich, 1993

SCHARFF, 1928 A. Scharff, 'Some Prehistoric Vases in the British Museum and Remarks on Egyptian History', *Journal of Egyptian Archaeology*, 14, 1928, pp. 261–76

SCHARFF, 1929 A. Scharff, *Die Altertümer der Vor- und Frühzeit Ägyptens*, ii, Staatliche Museen zu Berlin, Mitteilungen aus der Ägyptischen Sammlung 5, Berlin, 1929

SCHILDKROUT and KEIM, 1990 E. Schildkrout and C. A. Keim, *African Reflections: Art from Northeastern Zaire*, New York, Washington, 1990

SCHMALENBACH, 1953 W. Schmalenbach, *Die Kunst Afrikas*, Basle, 1953

SCHMALENBACH, 1988 W. Schmalenbach, *African Art from the Barbier-Mueller Collection, Geneva*, Munich, 1988

SCHMIDT, 1981 P. R. Schmidt, *The Origins of Iron Smelting in Africa: A Complex Technology in Tanzania*, Providence, RI, 1981

SCHMIDT, 1989 C. E. Schmidt, 'African Mbirea as Musical Icons', in *Sounding Forms: African Musical Instruments*, ed. M.-T. Brincard, New York, 1989, pp. 73–9

SCHMITZ, 1913 R. Schmitz, *Les Baholoholo*, Brussels, 1913

SCHMORANZ, 1899 G. Schmoranz, *Old Oriental Gilt and Enamelled Glass Vessels*, Vienna and London, 1899

SCHNEIDER, 1955 G. Schneider, 'Mambila Album', *Nigerian Field*, 20, 1955, pp. 112–32

SCHNEIDER, 1973 B. Schneider, 'Body Decoration in Mozambique', *African Arts*, 6 (2), 1973, pp. 26–31

SCHOEMAN, 1968[1] H. S. Schoeman, 'A preliminary report of traditional beadwork in the Mkhwanazi area of the Mtunzini district, Zululand', *African Studies*, 27 (2), 1968, pp. 57–82

SCHOEMAN, 1968[2] H. S. Schoeman, 'A preliminary report of traditional beadwork in the Mkhwanazi Area of the Mtunzini District, Zululand', *African Studies*, 27 (3), 1968, pp. 107–54

SCHOLFIELD, 1948 J. F. Scholfield, *Primitive Pottery: an Introduction to South African Ceramics, Prehistoric and Protohistoric*, Handbook Series No. 3, South African Archaeological Society, 1948

SCHULZ, 1992 R. Schulz, *Die Entwicklung und Bedeutung der kuboiden Statuentypus: Eine Untersuchung zu den sogenannten 'Würfelhockern'*, 2 vols, Hildesheim, 1992

SCHUTT, 1881 O. H. Schutt, *Reisen im Sudwestlichen Becken des Congo*, Berlin, 1881

SCHWAB, 1947 G. Schwab, 'Tribes of the Liberian Hinterland', *Papers of the Peabody Museum*, Cambridge, MA, 31, 1947 [with contributions by G. Harley]

SCHWARTZ, 1971 A. Schwartz, *Tradition et changements dans la société Guéré*, Paris, 1971

SCHWARTZ, n. d. N. Schwartz, 'Mambilla – Art and Material Culture', *Milwaukee Public Museum/Publications in Primitive Art*, 4, n. d.

SCHWEEGER-HEFEL, 1981 A. Schweeger-Hefel, *Steinskulpturen der Nyonyose aus Ober-Volta*, Munich, 1981

SCHWEINFURTH, 1873 G. Schweinfurth, *Im Herzen von Afrika*, Leipzig, 1873 [also published in English]

SCHWEINFURTH, 1875 G. Schweinfurth, *Artes Africanae: Illustrations and Descriptions of Productions of the Industrial Arts of Central African Tribes*, Leipzig and London, 1875

SCHWEITZER, 1948 U. Schweitzer, *Löwe und Sphinx im Alten Ägypten*, Ägyptologische Forschungen, 15, Glückstadt and Hamburg, 1948

SEEBER, 1980 C. Seeber, 'Maske', in *Lexikon der Ägyptologie*, iii, Wiesbaden, 1980, pp. 1196–9

SEIDEL and WILDUNG, 1975 M. Seidel and D. Wildung, in *Das alte Ägypten: Propyläen Kunstgeschichte*, xv, ed. C. Vandersleyen, Berlin, 1975

SEIPEL, 1983 W. Seipel, *Bilder für die Ewigkeit: 3000 Jahre ägyptischer Kunst*, Heidelberg, 1983

SELIGMAN, 1911 C. G. Seligman, 'An Ausumgwa Drum', *Man*, 11, 1911, p. 7

SELIGMAN, 1917 C. G. Seligman, 'A Bongo Funerary Figure', *Man*, XVIII, 67

SELIGMAN, 1980 T. Seligman, 'Animism and Islam: A Mask from North-East Liberia', *Apollo*, 111 (216–7), 1980, pp. 63–5

SELIGMAN and SELIGMAN, 1932 C. G. and B. Seligman, *Pagan Tribes Of The Nilotic Sudan*, London, 1932

SETTGAST and GEHRIG, 1978 J. Settgast and U. Gehrig, *Von Troja bis Amarna: The Norbert Schimmel Collection, New York*, Mainz, 1978

SHACK, 1966 W. A. Shack, *The Gurage: A People of the Ensete Culture*, London, 1966

SHACK, 1972 W. A. Shack, *The Central Ethiopians: Amhara, Tigrina and Related Peoples*, London, 1972

SHAW, 1935 M. Shaw, 'Some native snuff-boxes in the South African Museum', *Annals of the South African Museum*, 24 (3), 1935, pp. 141–62, pls 24–31

SHAW, 1938 M. Shaw, 'Native pipes and smoking in South Africa', *Annals of the South African Museum*, 24, 1938, pp. 277–302, pls 86–99

SHAW, 1970 T. Shaw, *Igbo-Ukwu: An Account of Archaeological Discoveries in Eastern Nigeria*, London, 1970

SHAW, 1973 T. Shaw, 'Note on trade and the Tsoede bronzes', *West African Journal of Archaeology*, 3, pp. 233–8

SHAW, 1975 T. Shaw, 'Those Igbo-Ukwu Radiocarbon Dates: Facts, Fictions and Probabilities', *Journal of African History*, 16 (4), 1975, pp. 503–17

SHAW, 1977 T. Shaw, *Unearthing Igbo-Ukwu*, Ibadan, 1977

SHAW, 1978 T. Shaw, *Nigeria*, London, 1978

SHAW, 1990 R. Shaw, *Early Pastoralists of South-Western Kenya*, Nairobi, 1990

SHAW T. Shaw, 'The Nok Sculptures of Nigeria', *Scientific American*, 244 (2), pp. 154–66

SHAW et al., 1993 T. Shaw, P. Sinclair, B. Andah, A. Okpoko, eds, *The Archaeology of Africa*, London, 1993

SHAW and VAN WARMELO, 1988 E. M. Shaw and N. J. Van Warmelo, 'The Material Culture of the Cape Nguni', *Annals of the South African Museum*, 58 (4), 1988, pp. 447–949

SIEBER, 1958 R. Sieber, unpublished field photographs, K2–4, 5, 1958

SIEBER, 1961 R. Sieber, *Sculpture of Northern Nigeria*, New York, 1961

SIEBER, 1972[1] R. Sieber, 'Kwahu Terracottas: Oral Traditions and Ghanaian History', *African Art and Leadership*, ed. D. Fraser and H. Cole, Madison, 1972, pp. 173–83

SIEBER, 1972[2] R. Sieber, *African Textiles and Decorative Arts*, New York, 1972

SIEBER, 1980 R. Sieber, *African Furniture and Household Objects*, Bloomington, 1980

SIEBER and VERVERS, 1974 R. Sieber and T. Ververs, *Interaction: The Art Styles of the Benue River Valley and East Nigeria*, Indianapolis, 1974

SIEBER and WALKER, 1987 R. Sieber and R. A. Walker, *African Art in the Cycle of Life*, Washington, 1987

SIEBER, NEWTON and COE, 1986 R. Sieber, D. Newton and M. D. Coe, *African Pacific and Pre-Columbian Art in the Indiana University Art Museum*, Indianapolis, 1986

SIEGEL, 1977 R. K. Siegel, 'Hallucinations', *Scientific American*, 237, 1977, pp. 132–40

SIEGMANN, 1995 W. Siegmann, verbal communication to M. J. Adams, 7 April 1995

SIGOLI, 1948 S. Sigoli, 'Pilgrimage of Simone Sigoli to the Holy Land', trans. T. Bellorini and E. Hoade, in *Publication of the Studium Biblicum Franciscanum*, 6, 1948, pp. 157–201

SIJELMASSI, 1986 M. Sijelmassi, *Les arts traditionnels au Maroc*, Paris, 1986

SILVERMAN, 1983 R. A. Silverman, 'Akan Kuduo: Form and Function', in *Akan Transformations: Problem in Ghanaian Art History*, Los Angeles, 1983, pp. 10–29

SIMPSON, 1977 W. K. Simpson, *The Face of Egypt: Permanence and Change in Egyptian Art*, Katonah, 1977

SMITH, 1949 W. S. Smith, *A History of Egyptian Sculpture and Painting in the Old Kingdom*, Boston, 1949

SMITH, 1981 W. S. Smith, *The Art and Architecture of Ancient Egypt*, rev. with additions by W. K. Simpson, Harmondsworth and New York, 1981

SNOEK, 1981 M. A. Snoek, *Les arts décoratifs Mangbetu: Negwe et Roko*, Brussels, 1981

SÖDERBERG, 1975 B. Söderberg, 'Les figures d'ancêtres chez les Babembe', *Arts d'Afrique Noire*, 13–14, 1975, pp. 14–37

SOURDEL-THOMINE and SPULER, 1973 J. Sourdel-Thomine and B. Spuler, *Die Kunst des Islam*, Berlin, 1973

SOUROUZIAN, 1991 H. Sourouzian, 'A Bust of Amenophis II at the Kimbell Art Museum', *Journal of the American Research Centre in Egypt*, 28, 1991, pp. 55–74

SOUVILLE, 1973 G. Souville, *Atlas préhistorique du Maroc*, i: *Maroc Atlantique*, Paris, 1973

SPEKE, 1863 J. H. Speke, *Journal of the Discovery of the Source of the Nile*, Edinburgh, 1863

SPENCER, 1980 A. J. Spencer, *Catalogue of Egyptian Antiquities in the British Museum, V: Early Dynastic Objects*, London, 1980

SPENCER, 1993 A. J. Spencer, *Early Egypt: The Rise of Civilization in the Nile Valley*, London, 1993

SPEYER et al. 1993–4 *Götter, Menschen, Pharaonen/Dioses, Hombres, Faraones/ Das Vermächtnis der Pharaonen*, exh. cat. ed. W. Seipel, Kunsthistorisches Museum, Vienna, 1993–4

SPRING, 1993 C. Spring, *African Arms and Armour*, London, 1993

STAGER, 1980 L. E. Stager, 'The rite of child sacrifice at Carthage', in *New Light on Ancient Carthage*, ed. J. G. Pedley, Ann Arbor, 1980, pp. 1–11

STAHL, 1986 A. Stahl, 'Early food production in West Africa: Rethinking the role of the Kintampo culture', *Current Anthropology*, 27, 1986

STANLEY, 1878 H. M. Stanley, *Through the Dark Continent*, 2 vols, London, 1878

STANNUS, 1922 H. S. Stannus, 'The Wayao of Nyasaland', *Varia Africana III, Harvard African Studies, the African Department of the Peabody Museum of Harvard University*, 3, 1922, pp. 229–372

STAYT, 1931 H. A. Stayt, *The Bavenda*, Oxford, 1931

STEVENS, 1978 P. J. Stevens, *The Stone Images of Esie, Nigeria*, Ibadan, 1978

STOCKHOLM 1961 *5000 år egyptisk konst*, exh. cat., National Museum of Ethnology, Stockholm, 1961

STÖRK, 1984 Contribution to *Lexikon der Ägyptologie*, Wiesbaden, 1984, pp. 257–63

STOSSEL, 1981 A. Stossel, *Nupe Kakanda Basa-Nge*, Munich, 1981

STRITZL, 1971 A. Stritzl, *Raffiaplüsche aus dem Königreich Kongo* [with English summary], Vienna, 1971

STRZYGOWSKI, 1904 J. Strzygowski, *Koptische Kunst*, Vienna, 1904

STUART and MALCOLM, 1969 J. Stuart and D. Malcolm, eds, *The Diary of Henry Francis Fynn*, Pietermaritzburg, 1969

STUHLMANN, 1910 F. Stuhlmann, *Hand-werk und Industrie in Ostafrika*, Hamburg, 1910

STUTTGART 1973 *Religiöse Kunst Äthiopiens – Religious Art of Ethiopia*, exh. cat., Institut für Auslandsbeziehungen, Stuttgart, 1973

STUTTGART 1984 *Osiris, Kreux und Halbmond: Die drei Religionen Ägyptens*, exh. cat. ed. E. Brunner-Traut and H. Brunner, Stuttgart Landesmuseum, Mainz-am-Rhein, 1984

SUGIER, 1968 C. L. Sugier, 'Les bijoux de la mariée à Moknine', *Cahiers des A. T. P.*, Tunis, 1968, p. 151

SUGIER, 1977 C. L. Sugier, *Bijoux tunisiens: Formes et symboles*, Tunis, 1977

SUMMERS, 1949 R. Summers, 'An Ancient Ivory Figurine from Khami Ruins', *Man*, 49, 1949, p. 96

SUMMERS, 1961[1] R. Summers, 'Excavations in the Great Enclosure', *Occasional Papers of the National Museums of Southern Rhodesia*, 3 (23A), 1961, pp. 236–88

SUMMERS, 1961[2] R. Summers, 'The Zimbabwe Bird', *Rhodesian Countryman*, 1(3), 1961, pp. 2–4

SUMMERS, 1963 R. Summers, *Zimbabwe: A Rhodesian Mystery*, Cape Town, 1963

SUTTON, 1982 J. E. G. Sutton, 'Archaeology in West Africa: A review of recent work and a further list of radiocarbon dates', *Journal of African History*, 23 (3), 1982, pp. 291–313

SWANN, 1910 A. Swann, *Fighting the Slave Hunters in Central Africa*, London, 1910

SWANTZ, 1970 A. Swantz, *Ritual and Symbol in Transitional Zaramo Society*, Uppsala, 1970

SWEENEY, 1993 D. Sweeney, 'Egyptian Masks in Motion', in *Göttinger Miszellen*, 135, 1993, pp. 101–4

SYDOW, 1926 E. von Sydow, *Kunst und Religion der Naturvölker*, Oldenburg, 1926

SYDOW, 1954 E. von Sydow, *Afrikanische Plastik*, Berlin, 1954

SZABO and BUTZER, 1979 B. J. Szabo and K. W. Butzer, 'Uranium series dating of lacustrine limestones from pan deposits with Final Acheulean assemblage at Rooidam, Kimberley District, South Africa', *Quaternary Research*, 11, 1979, pp. 257–60

TAGLIAFERRI, 1989 A. Tagliaferri, *Stili del potere*, Milan, 1989

TAGLIAFERRI and HAMMACHER, 1974 A. Tagliaferri and A. Hammacher, *Fabulous Ancestors*, New York, 1974

TAIT, 1979 H. Tait, ed., *The Golden Age of Venetian Glass*, London, 1979

TALBOT, 1912 P. A. Talbot, *In the Shadow of the Bush*, London, 1912

TALBOT, 1923 P. A. Talbot, *Life in Southern Nigeria*, 4 vols, London, 1923

TAMARI, 1991 T. Tamari, 'The Development of Caste Systems in West Africa', *Journal of African History*, 32 (2), 1991, pp. 221–50,

TAYLOR, 1978 M. Taylor, *The Lewis Chessmen*, London, 1978

TAYLOR, 1991 J. H. Taylor, *Egypt and Nubia*, London, 1991

TERRACE, 1968 E. Terrace, *Connoisseur*, September 1969, pp. 49–56

TERRASSE, 1938 H. Terrasse, *Kasbas berbères de l'Atlas et des oasis*, Paris, 1938

TERVUREN 1995 *Treasures from the Africa-Museum*, exh. cat., Royal Museum for Central Africa, Tervuren, 1995

TESSMANN, 1913 G. Tessmann, *Die Pangwe*, 2 vols, Berlin, 1913

TEW, 1950 M. Tew, *Peoples of the Lake Nyasa Region*, London, 1950

THACKERAY, 1983 A. I. Thackeray, 'Dating the Rock Art of Southern Africa', *South African Archaeological Society, Goodwin Series*, 4, 1983, pp. 21–6

THIEL and HELF, 1984 J. F. Thiel and H. Helf, *Christliche Kunst in Afrika*, Berlin, 1984

THOMPSON, 1852 G. Thompson, *Thompson in Africa*, New York, 1852

THOMPSON, 1970 R. F. Thompson, 'The Sign of the Divine King: An Essay on Yoruba Bead Embroidered Crowns with Veil and Bird Decoration', *African Arts*, 3 (3), 1970, pp. 8–17, 74–80

THOMPSON, 1971 R. F. Thompson, *Black Gods and Kings: Yoruba Art at UCLA*, Los Angeles, 1971

THOMPSON, 1981 R. F. Thompson, 'Headdress', in *For Spirits and Kings. African Art from the Paul and Ruth Tishman Collection*, ed. S. Vogel, New York, 1981

THOMPSON, 1983 R. F. Thompson, *Flash of the Spirit. African and Afro-American Art and Philosophy*, New York, 1983

THOMPSON and BAHUCHET, 1991 R. F. Thompson and S. Bahuchet, *Pygmées? Peintures sur écorce battue des Mbuti (Haut-Zaire)*, Paris, 1991

THOMPSON and CORNET, 1981 R. F. Thompson and J. Cornet, *The Four Moments of the Sun: Kongo Art in two Worlds*, Washington, 1981

THOMPSON and MEURANT, forthcoming R. F. Thompson and G. Meurant, *Mbuti Design: Painting by Women of the Ituri Forest*, London, forthcoming

THORNTON, 1980 R. J. Thornton, *Space, Time and Culture among the Iraqw of Tanzania*, New York, 1980

TOKYO et al., 1983–4 *Neferut net Kemit : Egyptian Art from The Brooklyn Museum*, exh. cat. by R. A. Fazzini et al., Isetan Museum of Art et al., 1983–4

TORDAY, 1925 E. Torday, *On the Trail of the Bushongo*, Philadelphia, 1925

TORDAY and JOYCE, 1910 E. Torday and T. A. Joyce, *Notes ethnographiques sur les peuples communément appelés Bakuba ainsi que les peuplades apparentées: les Bushongo*, Brussels, 1910

TORDAY and JOYCE, 1922 E. Torday and T. A. Joyce, *Notes ethnographiques sur les peuplades habitant les bassins du Kasaï et du Kwango oriental: peuplades de la forêt, peuplades des prairies*, Tervuren, 1922

TORNAY, 1975 S. Tornay, 'La culture matérielle Nyangatom', *Ethiopie d'aujourd'hui*, Paris, 1975

TÖRÖK, 1970 L. Török, 'On the Chronology of the Ahnas Sculpture', *Acta Archaeologica Academiae Scientiarum Hungaricae*, 22, Budapest, 1970

TÖRÖK, 1988 L. Török, *Late Antique Nubia*, Budapest, 1988

TÖRÖK, 1995 L. Török, *The Birth of An Ancient African Kingdom: Kush and her Myth of the State in the First Millennium BC*, Lille, 1995

TÖRÖK, in preparation L. Török, *Meroe City: an Ancient African Capital. John Garstang's Excavations in the Sudan*, London, in preparation

TOWNSHEND, 1992 P. Townshend, 'Bao (Mankala): The Swahili Ethic in African Idiom', *Paideuma*, 28, 1992, pp. 175–91

TRADESCANT, 1656 J. Tradescant, *Museum Tradescantianum, Or a Collection of Rarities Preserved at South-Lambeth near London by John Tradescant*, London, 1656 [*The Tradescant Collection*, facs. repr., London, 1980]

TRAORE, 1965 D. Traore, *Comment le noir se soigne-t-il? Ou médecine et magie africaines*, Paris, 1965

TRIESTE 1986 *Massimiliano: Da Trieste al Messico*, exh. cat. ed. L. R. Loseri, Trieste, 1986

TRIMINGHAM, 1952 J. S. Trimingham, *Islam in Ethiopia*, Oxford, 1952

TRIST and MIDDLETON, 1887 J. W. Trist and J. H. Middleton, in *Proceedings of the Society of Antiquaries*, 2nd ser., 11, 1887, pp. 333–5

TROUGHEAR, 1987 A. Troughear, 'Kamba Carving: Art or Industry?', *Kenya Past and Present*, 19, 1987, pp. 15–25

TROWELL, 1941 M. Trowell, 'Some Royal Craftsmen of Buganda', *Uganda Journal*, 8 (2), 1941, pp. 47–64

TROWELL, 1960 M. Trowell, *African Design*, London, 1960

TROWELL and WACHSMANN, 1953 M. Trowell and K. P. Wachsmann, *Tribal Crafts of Uganda*, Oxford, 1953

TSCHUDI, 1969–70 J. Tschudi, 'The Social Life of the Afo, Hill Country of Nasarawa, Nigeria', *African Notes*, 6 (1), 1969–70, pp. 87–99

TUNIS, 1978 I. Tunis, 'The Enigmatic Lady', *Baessler-Archiv*, xxvi, 1978, pp. 57–89

TUNIS, 1983 I. Tunis, 'A Note on Benin Plaque Termination Dates', *Tribus*, 32, 1983, pp. 45–53

TURNER, 1955 V. W. Turner, 'A Lunda love story and its consequences: selected texts from traditions collected by H. Dias de Carvalho at the court of Mwatianvwa in 1887', *Rhodes-Livingstone Journal*, 19, 1955, pp. 1–26

TYRRELL, 1968 B. Tyrrell, *Tribal Peoples of Southern Africa*, Cape Town, 1968

UCKO, 1965 P. J. Ucko, 'Anthropomorphic Ivory Figurines from Egypt', *Journal of the Royal Anthropological Institute*, 95, 1965, pp. 214–39

UCKO, 1968 F. J. Ucko, *Anthropomorphic Figurines of Predynastic Egypt and Neolithic Crete with Comparative Material from the Prehistoric Near East and Mainland Greece*, Royal Anthropological Institute Occasional Paper 24, London, 1968

UCKO, 1970 P. J. Ucko, 'Penis Sheaths: A Comparative Study. The Curl Lecture 1969', *Proceedings of the Royal Anthropological Scoiety 1969*, London, 1970, pp. 27–67

UCKO and HODGES, 1963 P. Ucko and H. W. M. Hodges, 'Some Predynastic Egyptian Figures, Problems of Authenticity', *Journal of the Warburg and Courtauld Institutes*, 26, 1963

ULLENDORFF, 1968 E. Ullendorff, *Ethiopia and the Bible: The Schweich Lectures*, Oxford, 1968

UNDERWOOD, 1947 L. Underwood, *Figures in Wood of West Africa*, London, 1947

UNDERWOOD, 1952 L. Underwood, *Masks of West Africa*, London, 1952

UNIVERSITÉ DE MADAGASCAR, 1963 Université de Madagascar, *Art Sakalava*, Antananarivo, 1963

URBAIN-FAUBLÉE, 1963 M. Urbain-Faublée, *L'art malgache*, Paris, 1963

URVOY, 1955 Y. Urvoy, *L'art dans le territoire du Niger. Études nigériennes*, xi, Niamey, 1955

VAJDA, 1955 L. Vajda, 'Human and Animal Plastic Figures from the Kilimanjaro Region', *Neprajzi eretesitc*, 37, 1955, pp. 181–90

VALLOGGIA, 1980 M. Valloggia, 'Deux objets thériomorphes découverts dans le mastaba V de Balat', *Livre du centenaire de l'Institut français d'archéologie orientale, Mémoires de l'Institut Français d'Archéologie Orientale du Caire*, 114, 1980, pp. 143–51, pls. xi–xviii

VAN BEEK, 1988 W. E. A. van Beek, 'Functions of Sculpture in Dogon Religion', *African Arts*, 21 (4) 1988, pp. 58–65, 91

VAN BEEK, 1990 W. E. A. van Beek, 'Enter the Bush: A Dogon Mask Festival', in *Africa Explores: 20th Century African Art*, exh. cat. by S. Vogel and I. Ebong, Center for African Art, New York, 1990, pp. 56–73

VAN BEEK, 1991 W. E. A. van Beek, *Dogon Restudied: A Field Evaluation of the Work of Marcel Griaule*, 1991

VAN BRAECKEL, 1993 H. van Braeckel, 'Versieringstechnieken op Kuba-textiel', in *African Majesty*, exh. cat., Antwerp, 1993, pp. 20–39

VAN DAMME, 1987 A. van Damme, *De Maskensculptuur binnen het Poro-Genootschap van de Loma*, Ghent, 1987

VAN GENNEP, 1911 A. van Gennep, *Études d'Éthnographie algérienne*, Paris, 1911

VAN NOTEN, 1972 F. van Noten, 'La plus ancienne sculpture sur bois de l'Afrique centrale?', *Africa-Tervuren*, 18, 1972, pp. 133–6

VAN WARMELO, 1932 N. J. van Warmelo, *Contributions towards Venda History, Religion and Tribal Ritual*, Pretoria, 1932

VAN WARMELO, 1940 N. J. van Warmelo, *The Copper Miners of Musina and the Early History of the Zoutpansberg*, Pretoria, 1940

VAN WARMELO, 1971 N. J. van Warmelo, 'Courts and Court Speech in Venda', *African Studies*, 30 (3), 1971, pp. 355–70

VANDENHOUTE, 1948 P. Vandenhoute, *Classification stylistique du masque Dan et du masque Guéré de la Côte d'Ivoire, A. O. F.*, Medelingen van het Rijksmuseum voor Volkenkunde, Leiden, no. 4, 1948

VANDERSLEYEN, 1975 C. Vandersleyen, ed, *Das alte Ägypten: Propyläen Kunstgeschichte*, xv, Berlin, 1975, p. 223, pl. 1302

VANDIER, 1952 J. Vandier, *Manuel d'archéologie égyptienne*, i: *Les époques de formation: Les trois premières dynasties*, Paris, 1952

VANDIER, 1958 J. Vandier, *Manuel d'archéologie egyptienne*, iii: *Les grandes époques: La statuaire*, Paris, 1958

VANLATHEM, 1983 M.-P. Vanlathem, *Cercueils et momies de l'Égypte Ancienne*, Brussels, 1983

VANSINA, 1955 J. Vansina, 'Initiation Rituals of the Bushong', *Africa*, 25, pp. 138–55

VANSINA, 1964 J. Vansina, 'Les noms personnels et structure sociale chez les Tyo (Téké)', *BSARSOM*, 4, 1964, pp. 794–804

VANSINA, 1966 J. Vansina, *Introduction à l'ethnographie du Congo*, Kinshasa, 1966

VANSINA, 1968 'Kuba Art in its Cultural Contexts', *African Forum*, 3, 4, pp. 12–27

VANSINA, 1973 J. Vansina, *The Tio Kingdom of the Middle Congo, 1880–1892*, London, 1973

VANSINA, 1978 J. Vansina, *The Children of Woot, A History of the Kuba Peoples*, Madison, 1978

VANSINA, 1984 J. Vansina, *Art History in Africa*, Harlow, 1984

VANSINA, 1990 J. Vansina, *Paths in the Rainforest*, Madison, 1990

VASSILIKA, 1995 E. Vassilika, *Egyptian Art*, Cambridge, 1995

VENICE 1988 *The Phoenicians*, exh. cat. ed. S. Moscati, Palazzo Grassi, Venice; Milan, 1988

VENICE 1993–4 *Eredità dell'Islam: Arte Islamica in Italia*, exh. cat. ed. G. Curatola, Doge's Palace, Venice, 1993–4; Milan, 1993

VERGER-FÈVRE, 1980 M. N. Verger-Fèvre, *Masques faciales de l'ouest de la Côte d'Ivoire dans les collections publiques françaises*, ii, Mémoire École du Louvre, Paris, 1980

VERGER-FÈVRE, 1989 M. N. Verger-Fèvre, 'Dan', in *Corps sculptés, corps parés, corps masqués*, ed. E. Féau and Y. Savané, Paris, 1989

VERGER-FÈVRE, 1995 M. N. Verger-Fèvre, letter to M. J. Adams, 25 April 1995

VERGIAT, 1936 A. M. Vergiat, *Les rites secrets des primitifs de l'Oubangui*, Paris, 1936

VEVEY 1969 *Die Kunst der Elfenbeinküste*, exh. cat., Musée des Beaux-Arts, Vevey, 1969

VIAL, 1980 G. Vial, *Ceintures marocaines du 16ème au 19ème siècle*, exh. cat., Bern Riggisberg, 1980

VIENNA et al. 1961 *5000 Jahre Ägyptische Kunst*, exh. cat. ed. Egon Komorzynski et al., Kunsthistorisches Museum, Vienna, 1961

VIENNA 1992 *Gott. Mensch. Pharao: Viertausend Jahre Menschenbild in der Skulptur des alten Ägypten*, exh. cat. by W. Seipel et al., Kunsthistorisches Museum, Vienna, 1992

VIENNA 1994 *Pharaonen und Fremde: Dynastien im Dunkel*, exh. cat. by S. Quirke, Historisches Museum, Vienna, 1994

VIENNA MUSEUM GUIDE, 1988 *see* Kunsthistorisches Museum, 1988

VINNICOMBE, 1976 P. Vinnicombe, *People of the Eland: Rock Paintings of the Drakensberg Bushmen as a Reflection of their Life and Thought*, Pietermaritzburg, 1976

VINSON, 1994 S. Vinson, *Egyptian Boats and Ships*, Princes Risborough, 1994

VISONA, 1983 M. Visona, *Art and Authority among the Ayke of the Ivory Coast*, diss., University of California, Santa Barbara, 1983

VOGEL, 1920 S. Vogel, *Soieries marocaines*, Paris, 1920

VOGEL, 1977 S. Vogel, *Baule Art as the Expression of a World View*, Ann Arbor, 1977

VOGEL, 1980[1] S. Vogel, *Beauty in the Eyes of the Baule*, Philadelphia, 1980

VOGEL, 1980[2] S. Vogel, 'The Buli Master and Other Hands', *Art in America*, 68 (5), 1980, pp. 133–42

VOGEL, 1981 S. Vogel, ed., *For Spirits and Kings: African Art from the Paul and Ruth Tishman Collection*, New York, 1981

VOGEL, 1983 S. Vogel, 'Rapacious Birds and Severed Heads: Early Bronze Rings from Nigeria', *Art Institute of Chicago Centennial Lectures: Museum Studies 10*, Chicago, 1983, pp. 330–57

VOGEL, 1985 S. Vogel, *African Aesthetics: The Carlo Monzino Collection*, Milan, 1985

VOGEL, 1988 S. Vogel, ed., *ART/artifact*, Munich, 1988

VOGEL, 1993 S. Vogel, 'Door', in *Art of Côte d'Ivoire*, ii, Geneva, 1993

VOGEL and N'DIAYE, 1985 S. Vogel and F. N'Diaye, *African Masterpieces from the Musée de l'Homme*, exh. cat., Center for African Art, New York, 1985

VOLMAN, 1984 T. P. Volman, 'Early Prehistory of Southern Africa', in *Southern African Prehistory and Palaeoenvironments*, ed. R. G Klein, Rotterdam, 1984

VON BEZING and INSKEEP, 1966 K. L. von Bezing and R. R. Inskeep, 'Modelled Terracotta Heads from Lydenburg, South Africa', *Man*, 1 (1), 1966, p. 102

VON BISSING, 1900 F. W. von Bissing, *Ein Thebanischer Grabfund aus dem Anfang des Neuen Reichs*, Berlin, 1990

VOSSEN and EBERT, 1986 R. Vossen and W. Ebert, *Marokkanische Töpferei*, Bonn 1986

WADA, 1984 S. Wada, 'Female Initiation Rites of the Iraqw and the Gorowa', *Senri Ethnological Studies*, no. 15 (Africa 3), 1984, pp. 187–96

WALKER, 1994 R. A. Walker, 'Anonymous Has a Name: Olowe of Ise', in *The Yoruba Artist*, ed. R. Abiodun, H. J. Drewal and J. Pemberton III, Washington and London, 1994

WALTON, 1954 J. Walton, 'Carved Wooden Doors of the Bavenda', *Man*, 54, 1954, pp. 43–6

WALTON, 1975 J. Walton, 'Art and Magic in the Southern African Vernacular Architecture', in P. Oliver, *Shelter, Sign and Symbol*, London, 1975, pp. 117–34

WANLESS, 1987 A. Wanless, 'Headrests in the Africana Museum. Part 5', *Africana Notes and News*, 27 (5), 1987, p. 203

WANLESS, 1991 A. Wanless, 'Public Pleasures: Smoking and Snuff-taking in Southern Africa', in *Art and Ambiguity: Perspectives on the Brenthurst Collection*, exh. cat. by P. Davison et al., Johannesburg Art Gallery, Johannesburg, 1991, pp. 125–43

WARD, 1993 R. Ward, *Islamic Metalwork*, London, 1993

WASHINGTON 1980 *From the Far West: Carpets and Textiles of Morocco*, exh. cat., Textile Museum, Washington, 1980

WASHINGTON 1981[1] *The Four Moments of the Sun: Kongo Art in Two Worlds*, exh. cat. by R. F. Thompson and J. Cornet, National Gallery of Art, Washington, 1981

WASHINGTON 1981[2] *Renaissance of Islam: Art of the Mamluks*, exh. cat. by E. Atil, Washington, 1981

WASHINGTON, 1984 *African Mankala*, exh. brochure by R. A. Walker, National Museum of African Art, Smithsonian Institution, Washington, 1984

WASHINGTON 1987 *African Art in the Cycle of Life*, exh. cat. by R. Sieber and R. A. Walker, National Museum of African Art, Smithsonian Institution, Washington, 1987

WASHINGTON 1989 *Icons: Ideals and Power in the Art of Africa*, exh. cat. by H. M. Cole, National Museum of African Art, Washington, 1989

WASHINGTON 1991[1] *Exploring African Art, The Art of the Personal Object*, exh. cat. by P. Ravenhill, National Museum of African Art, Smithsonian Institution, Washington, 1991

WASHINGTON 1991[2] *The Art of the Personal Object*, exh. cat. by P. Ravenhill, National Museum of African Art, Washington, 1991

WASHINGTON 1991[3] *Circa 1492: Art in the Age of Explorations*, exh. cat. ed. J. A. Levenson, National Gallery of Art, Washington, 1991

WASHINGTON 1993 *Astonishment and Power*, exh. cat. by W. MacGaffey and M. D. Harris, National Museum of African Art, Washington, 1993

WASSING, 1968 R. Wassing, *African Art: Its Background and Traditions*, New York, 1968

WAYLAND, 1930 E. J. Wayland, *Annual Report of the Uganda Geological Survey*, Entebbe, 1930

WAYLAND, BURKITT and BRAUNHOLZ, 1933 E. J. Wayland, M. C. Burkitt and H. J. Braunholz, 'Archaeological Discoveries at Luzira', *Man*, 33, 1933, pp. 25–9

WEBB and WRIGHT, 1976 C. de B. Webb and J. Wright, eds, *The James Stuart Archive*, i, Pietermaritzburg, 1976

WEIL, 1973 P. M. Weil, 'The *Chono*: Symbol and Process in Authority Distribution in Mandinka Political Entities of Senegambia', unpublished paper, 1973

WEIL, 1981 P. M. Weil, personal communication, 1981

WEMBAH-RASHID, 1971 J. A. R. Wembah-Rashid, 'Isinyago and Midimu: Masked Dancers of Tanzania and Mozambique', *African Arts*, 4 (2), 1971, pp. 38–44

WEMBAH-RASHID, 1974 J. A. R. Wembah-Rashid, ed., *Introducing Tanzania through the National Museum*, Dar es Salaam, 1974

WEMBAH-RASHID, 1989 J. A. R. Wembah-Rashid, personal communication, Nairobi, 1989

WENDT, 1974 W. E. Wendt, '"Art mobilier" aus der Apollo 11 Grotte in Südwest-Afrika, die ältesten datierten Kunstwerke Afrikas', *Acta Praehistorica et Archaeologica*, 5 (1), 1974, pp. 1–42

WENIG, 1978 S. Wenig, *Africa in Antiquity: The Arts of Ancient Nubia and the Sudan*, Brooklyn, 1978

WERBROUCK, 1932 M. Werbrouck, 'Ostraca à figures', *Bulletin des Musées Royaux d'Art et d'Histoire*, 4, 1932, pp. 106–9

WERBROUCK, 1953 M. Werbrouck, 'Ostraca à figures', *Bulletin des Musées Royaux d'Art et d'Histoire*, 25, 1953, pp. 93–111

WERE and WILSON, 1968 G. Were and D. A. Wilson, *East Africa through a Thousand Years: A History of the Years A.D. 1000 to the Present Day*, London, 1968

WERNER, 1906 A. Werner, *The Natives of British Central Africa*, London, 1906

WEST LAFAYETTE 1974 *Interactions: The Art Styles of the Benue River Valley and East Nigeria*, exh. cat. by R. Sieber and T. Vevers, Creative Arts Department, Purdue University, West Lafayette, 1974

WESTERDIJK, 1988 P. Westerdijk, *The African Throwing Knife*, Utrecht, 1988

WESTERMANN, 1912 D. Westermann, *The Shilluk People and their Language and Folklore*, Philadelphia, 1912

WEULE, 1909 K. Weule, *Native Life in East Africa*, trans. A. Werner, London, 1909

WHITEHOUSE, 1987 H. Whitehouse, 'A Statuette of Ptah the Creator, "Beautiful of Face"', *The Ashmolean*, 12, Summer–Autumn 1987, pp. 6–8

WHITTLE, 1985 A. Whittle, *Neolithic Europe: A Survey*, Cambridge, 1985

WIET, 1929 G. Wiet, *Catalogue général du Musée Arabe du Caire: Lampes et bouteilles en verre émaillé*, Cairo, 1929

WIET, 1930 G. Wiet, *Album du Musée Arabe du Caire*, Cairo, 1930

WIET, 1932 G. Wiet, *Catalogue général du Musée Arabe du Caire: Objets en cuivre*, Cairo, 1932

WILCOX, 1992 R. Wilcox, 'Elephants, Ivory and Art: Duala Objects of Persuasion', in *Elephant: The Animal and its Ivory in African Culture*, ed. D. Ross, Los Angeles, 1992

WILKINSON, 1943 C. K. Wilkinson, 'Chessmen and Chess', *Bulletin of the Metropolitan Museum of Art N. S. I*, 1943, pp. 271–9

WILKINSON, 1971 A. Wilkinson, *Ancient Egyptian Jewellery*, London, 1971

WILLETT, 1967 F. Willett, *Ife in the History of West African Sculpture*, London, 1967

WILLETT, 1971[1] F. Willett, *African Art*, London, 1971

WILLETT, 1971[2] F. Willett, *African Art. An introduction*, Thames & Hudson, London, 1971

WILLETT, 1984 F. Willett, 'A Missing Millennium? From Nok to Ife and beyond', in *Arte in Africa*, ed. E. Bassani, Florence, 1984

WILLETT, 1994 F. Willett, *African Art*, 2nd edn., London, 1994

WILLETT and FLEMING, 1976 F. Willett and S. Fleming, 'Catalogue of some important Nigerian copper-alloy castings dated by thermoluminescence', *Archaeometry*, 18 (2), pp. 135–46

WILLIAMS, 1964 D. Williams, 'The Iconology of the Yoruba Edan Ogboni', *Africa*, 34 (2), l964, pp. 139–65

WILLIAMS, 1974 D. Williams, *Icon and Image: A Study of Sacred and Secular Forms in African Classical Art*, New York, 1974

WILLIAMS, 1988[1] B. Williams, *Decorated Pottery and the Art of Naqada III*, Münchner Ägyptologische Studien 45, Munich, 1988

WILLIAMS, 1988[2] B. Williams, 'Narmer and the Coptos Colossi', *Journal of the American Research Centre in Egypt*, 25, 1988, pp. 35–59

WILLIAMSON, 1983 L. Williamson, 'Ethnological Specimens in the Pitt Rivers Museum attributed to the Tradescant Collection', in *Tradescant's Rarities: Essays on the Foundation of the Ashmolean Museum 1683 with a Catalogue of the Surviving Early Collections*, ed. A. MacGregor, Oxford, 1983, pp. 338–45

WILLIS, 1966 R. Willis, *The Fipa and Related Peoples of South-West Tanzania and North-East Zambia*, London, 1966

WILLOUGHBY and STANTON, 1988 K. L. Willoughby and E. B. Stanton, eds, *The First Egyptian*, Columbia, SC, 1988

WILMAN, 1933 M. Wilman, *The Rock Engravings of Griqualand West and Bechuanaland, South Africa*, Cambridge, 1933

WILSON, VAN RIJSSEN and GERNEKE, 1990 M. L. Wilson, W. R. R. Van Rijssen and D. A. Gerneke, 'An Investigation of the "Coldstream Stone"', *Annals of the South African Museum*, 99, 1990, pp. 187–213

WITT, 1991 J. Witt, 'Spoons in Southeast Africa', in *Spoons in African Art. Cooking – Sewing – Eating: Emblems of Abundance*, exh. cat., Zurich, 1991, pp. 87–103

WITTE, 1988 H. A. Witte, *Earth and the Ancestors: Ogboni Iconography*, Amsterdam, 1988

WITTMER, 1978 M. K. Wittmer, *Three Rivers of Nigeria: Art of the Lower Niger, Cross and Benue; from the collection of William and Robert Arnott*, Atlanta, 1978

WOLF, 1957 W. Wolf, *Die Kunst Aegyptens: Gestalt und Geschichte*, Stuttgart, 1957

WOLFE, 1955 A. W. Wolfe, 'Art and the Supernatural in the Ubangi district' *Man*, 55 (76) 1955, pp. 65–7

WOLFE, PARKIN and SIEBER, 1981 E. Wolfe, D. Parkin and R. Sieber, *Vigango: The Commemorative Sculpture of the Mijikenda of Kenya*, Bloomington, 1981

WOLFERT, 1989 P. Wolfert, *Good Food from Morocco*, London, 1989

WOODS, 1974 W. Woods, 'A Reconstruction of the Triads of King Mycerinus', *JEA*, 60, 1974, pp. 82–93

WOOLLEY and RANDALL-MacIVER, 1910 C. L. Woolley and D. Randall-MacIver, *Karanog: The Romano-Nubian Cemetry*, iii, iv, Philadelphia, 1910

YACOUB, 1970 M. Yacoub, *Le Musée du Bardo: musée antique*, Tunis, 1970

ZAHAN, 1960 D. Zahan, *Sociétés d'initiation Bambara: le N'domo, le Koré*, Paris, 1960

ZAHAN, 1980 D. Zahan, *Antilopes du soleil: arts et rites agraires d'Afrique noire*, Vienna, 1980

ZAHAN, 1981 D. Zahan, 'Antelope Headdress: Female (Chi Wara)', in *For Spirits and Kings: African Art from the Tishman Collection*, ed. S. Vogel, New York, 1981

ZAHAN, 1988 D. Zahan, 'The Boat of the World as a Pendant', *African Arts*, 21 (4), 1988, pp. 56–7

ZAKI, 1956 M. H. Zaki, *Atlas al-funun al-zukhrufiya wa'l tasawir al-islamiya*, Cairo, 1956

ZANGRIE, 1947–50 Zangrie, 'Les institutions, la religion et l'art des Ba Buye; Groupes Ba Sumba du Ma Nyema (Congo Belge)', *Ethnographie*, 45, 1947–50, pp. 54–80

ZECH, 1904 G. Zech, 'Land und Leute an der Nordwestgrenze von Togo', *Mitteilungen von Forschungsreisenden und Gelehrten aus den deutschen Schutzgebieten*, 17, 1904, pp. 107–35

ZEITLYN, 1994 D. Zeitlyn, 'Mambila Figurines and Masquerades', *African Arts*, 27 (4), 1994, pp. 38–47

ZETTERSTROM, 1976 K. Zetterstrom, *The Yamein Mano of Northern Liberia,* Uppsala University Occasional Papers, vi, Uppsala, 1976

ZETTERSTROM, 1980 K. Zetterstrom, 'Poro of the Yamein Mano, Liberia', in *Ethnologische Zeitschrift Zürich*, i, ed. M. J. Adams, 1980, pp. 41–59

ZIRNGIBL, 1983 M. Zirngibl, *Rare African Short Weapons*, Grafenau, 1983

ZURICH 1961 *see* Vienna 1961

ZURICH 1963 *African Sculpture*, exh. cat. by E. Leuzinger, Museum Rietberg, Zurich, 1963

ZURICH 1991 *Spoons in African Art. Cooking – Serving – Eating: Emblems of Abundance*, exh. cat. ed. L. Homberger, Museum Rietberg, Zurich, 1991

ZUURMOND, 1989 R. Zuurmond, *Novum Testamentum Aethiopice: The Synoptic Gospels*, Stuttgart, 1989

ZWERNEMANN, 1967 J. Zwernemann, 'Remarques sur des statuettes des Gurma au Nord du Togo', *Notes africaines*, 116, 1967, p. 118

ZWERNEMANN and LOHSE, 1985 J. Zwernemann and W. Lohse, *Aus Afrika: Ahnen – Geister – Götter*, Hamburg, 1985

PHOTOGRAPHIC CREDITS